Art Past Art Present

SIXTH EDITION

David G. Wilkins Bernard Schultz Katheryn M. Linduff

Editor in Chief: Sarah Touborg Sponsoring Editor: Helen Ronan Editorial Assistant: Christina DeCesare Director of Marketing: Brandy Dawson Executive Marketing Manager: Marissa Feliberty Marketing Assistant: Irene Fraga Senior Managing Editor: Mary Rottino Production Liaison: Barbara Taylor-Laino Operations Supervisor: Brian Mackey
Director, Image Resource Center: Melinda Patelli
Manager, Rights and Permissions: Zina Arabia
Manager, Visual Research: Beth Brenzel
Manager, Cover Visual Research & Permissions:
Karen Sanatar
Art Director: Pat Smythe
Interior Design: Ilze Lemesis

The authors and Prentice Hall are grateful to the following academic reviewers who helped shape this new edition:

Gisele Atterberry, Joliet Junior College Diana Chou, John Carroll University

Teresa Eckerman-Pfeil, University of Texas Brownsville Alison C. Fleming, College of the Holy Cross

Phylis Floyd, Michigan State University Marian J. Hollinger, Fairmont State University Deborah S. Jamieson, University of Florida Jerry D. Meyer, Northern Illinois University

Credits and acknowledgments borrowed from other sources and reproduced, with permission, in this textbook appear on pages 651–54.

Copyright © 2009, 2005, 2001, 1997, 1994, 1990 by Pearson Education, Inc., Upper Saddle River, New Jersey, 07458. Pearson Prentice Hall. All rights reserved. Printed in China. This publication is protected by Copyright and permission should be obtained from the publisher prior to any prohibited reproduction, storage in a retrieval system, or transmission in any form or by any means, electronic, mechanical, photocopying, recording, or likewise. For information regarding permission(s), write to: Rights and Permissions Department.

Pearson Prentice Hall™ is a trademark of Pearson Education, Inc. Pearson® is a registered trademark of Pearson plc. Prentice Hall® is a registered trademark of Pearson Education, Inc.

Pearson Education LTD. London Pearson Education Singapore, Pte. Ltd

Pearson Education, Canada, Ltd Pearson Education–Japan

Pearson Education Australia PTY, Limited

Pearson Education North Asia Ltd Pearson Educación de Mexico, S.A. de C.V. Pearson Education Malaysia, Pte. Ltd

Pearson Education, Upper Saddle River, New Jersey

This book was designed and produced by Laurence King Publishing Ltd, London www.laurenceking.co.uk

Every effort has been made to contact the copyright holders, but should there be any errors or omissions, Laurence King Publishing Ltd would be pleased to insert the appropriate acknowledgment in any subsequent printing of this publication.

Senior Editor: Susie May Picture Researcher: Amanda Russell Cover Design and Interior Layout: Robin Farrow

Front cover: Joyce Kozloff, Targets, 1999–2000. Wood, maps, 9" (2.74 m) diameter.

Contents

Getting Started xii

I. EXPERIENCING ART 1

Experiencing Art 2

How to Experience Art 3

Viewing Art 4

Understanding Style 4

Art, Time, and the Cycles of Life 4

Analyzing Three Works 6

Analyzing Art 8

Analyzing Architecture 8

Analyzing Sculpture 12

Analyzing Ritual Art 14

Analyzing Installation Art 14

Analyzing Painting and Related Media 15

The Artist in History 18

2. PREHISTORIC ART 21

Prehistoric Art 22

The Paleolithic Period 22

The Discovery of Paleolithic Painting 23

Paleolithic Art 23

The Neolithic Period 25

Neolithic Art and Architecture 25

Prehistoric Art and the Prehistoric Artist 28

POINTS OF CONTACT Prehistoric Figurines

of Women 29

THEME Ritual and Art 30

3. ANCIENT ART 33

Introduction to Ancient Art 34

History 35

Art of Ancient Societies 36

ART PAST/ART PRESENT The Concept of the

Classical in the West 36

The Ancient Artist 37

POINTS OF CONTACT Greek Artists/Scythian

Patrons 37

THEME The Presence of the Artist 38

Sumerian Art 40

Ancient Egyptian Art 44

History 44

Religion 46

Art of Ancient Egypt 46

The Egyptian Artist 47

Ancient Egyptian Art: The Palette of

Narmer 48

The Egyptian Pyramids 50

The Egyptian Temple 52

TECHNIQUE Post-and-Lintel Construction 54

TECHNIQUE How to Read Architectural

Diagrams 55

Egyptian Tomb Paintings and Painted

Reliefs 56

TECHNIQUE Figure-Ground Relationships 57

The Indus Valley Civilization 58

Aegean Art: Minoan and Mycenaean 60

Ancient China: The Shang Dynasty 64

TECHNIQUE Chinese Piece-Mold

Bronze Casting 65

Assyrian and Early Persian Art 66

Mesoamerica: The Olmec 68

Etruscan Art 70

Ancient Greek Art 72

History 72

Intellectual and Scientific Activities 74

Religion 75

Ancient Greek Art 75

The Ancient Greek Artist 75

Greek Vase Painting 76

The Development of Greek Sculpture 78

TECHNIQUE Greek Lost-Wax

Bronze Casting 81

TECHNIQUE Contrapposto in Sculpture 83

TECHNIQUE The Classical Orders 84

ART PAST/ART PRESENT The Impact of the

Ancient Greek Orders 85

Greek Doric Architecture 86

TECHNIQUE Greek Temple Construction 87

The Parthenon, Athens 88

4. LATER ANCIENT ART, 400 BCE TO 200 CE 93

Introduction to Later Ancient Art 94

POINTS OF CONTACT The Silk Road 95

THEME Engineering 96

Nomadic Art in Siberia: Pazyryk 98

The Qin Empire in China 102

Hellenistic Art 104

History 104

Art of the Hellenistic Period 104

Hellenistic Painting 104

Hellenistic Sculpture in Pergamon 106

The Han Dynasty in China 108

Early Buddhist Art 110

Dongson Culture in Vietnam 112

The Art of the Roman Republic 114

History 115

Republican Architectural Developments 115

The Roman House and Villa 116

The Art of the Roman Empire 118

History 118

The City of Rome 119

Roman Imperial Art 121

Technology, Organization, and Engineering 122

Roman Religion and the Mystery Religions 123

The End of Rome's Empire 124

The Roman Artist 124

Roman Frescoes and Illusionism 126

TECHNIQUE Fresco Painting 128

TECHNIQUE Illusionism 129

Roman Architecture:

The Flavian Amphitheater 130

TECHNIQUE Roman Engineering: The Arch, the

Vault, and Concrete 132

Roman Architecture: The Pantheon,

Rome 136

Mesoamerican Art: Teotihuacán 138

5. ART FROM 200 TO 1000 143

Introduction to Art from 200 to 1400 144

ART PAST/ART PRESENT Naming the Middle

Ages in Europe 144

History 146

Art and the Christian Church 147

A Denial of Naturalism 147

The Scroll and Book 147

The Artist 148

POINTS OF CONTACT Muslims in China 149	6. ART FROM 1000 TO 1400 197
THEME Religious Architecture 150	Introduction to Aut from 1000 to 1400 1000
Jewish Art:	Introduction to Art from 1000 to 1400 198 History 199
The Synagogue at Dura Europos 152	POINTS OF CONTACT Amber Necklaces in
Early Christian Art 154	
History 154	Burials in Eastern Asia 201 THEME Narrative Art 202
Art 155	
Early Christian Architecture 156	Romanesque Art in Europe 204 History 205
Buddhist Architecture and Painting at	Art and the Pilgrim 205
Ajanta, India 158	The Bayeux "Tapestry" 206
The Shinto Shrine at Ise, Japan 160	The Romanesque Artist in Europe 206
Byzantine Art 162	Romanesque Architecture at Conques 208
History 162	Romanesque Sculpture 210
The Icon and Iconoclasm 163	Moai Ancestor Figures, Polynesia 212
The Byzantine Artist 163	Angkor Wat: Cult of the God-King 214
Byzantine Architecture: Hagia Sophia 164	The Japanese Narrative Scroll 216
Byzantine Art: San Vitale, Ravenna 166	Gothic Art 220
TECHNIQUE Mosaic 169	Abbot Suger 221
Anglo-Saxon Metalwork and Hiberno-	History 221
Saxon Illumination 170	Art 221
The Chinese Imperial City of Chang'An 172	The Franciscans 223
Buddhist Art at Horyuji 176	The Gothic Artist 223
TECHNIQUE Dougong-style Bracketing 178	The Gothic Cathedral: Chartres 224
Hindu Art at Ellora 180	TECHNIQUE Proportions of Gothic Cathedrals,
Islamic Art at Córdoba 182	1160-1230 224
Carolingian and Ottonian Art 186	TECHNIQUE Gothic Engineering 228
	Gothic Sculpture 230
The Monastery in the West 188	Gothic Stained Glass 232
Buddhist Art in Indonesia 190	TECHNIQUE Stained-Glass Technique 233
Chinese Art: Landscape Painting 192	The Great Mosque at Jenne 234
ART PAST/ART PRESENT Chinese Aesthetic	The Chinese Capital City in Beijing:
Theory 195	The Forbidden City 236
	Early Italian Painting 238
	Giotto, The Arena Chapel Frescoes 240
	TECHNIQUE Tempera and Fresco, 242

The Royal Art of African Kingdoms $\ 244$

7. FIFTEENTH-CENTURY ART 247

Introduction to Fifteenth-Century Art 248

Fifteenth-Century Worldwide Developments 250

The Idea of a Renaissance 252

Naming the Styles 252

European History 252

Italian Renaissance Humanism and Art Theory 253

European Intellectual Activity 254

Changing Patterns of Patronage in Europe 254

The Fifteenth-Century Artist in Europe 257

POINTS OF CONTACT The Travels of

Marco Polo 257

THEME Portraiture 258

Early Renaissance Sculpture

in Florence 260

TECHNIQUE Carving in Wood 261

Flemish Painting:

The Limbourg Brothers 262

Flemish Painting: Robert Campin 264

Italian Renaissance Painting: Masaccio 266

TECHNIQUE Scientific Perspective 268

Flemish Painting:

Hubert and Jan van Eyck 270

Flemish Painting: Jan van Eyck 272

TECHNIQUE The Development of Oil Painting in

Flanders 274

Italian Renaissance Architecture:

Filippo Brunelleschi 276

Machu Picchu:

The Peruvian Mountain Retreat 278

The Italian Renaissance Palace 280

Portraiture 282

Italian Renaissance Painting:

Andrea Mantegna 286

TECHNIQUE Foreshortening 287

Italian Renaissance Painting: Sandro

Botticelli 288

Italian Renaissance Painting:

Leonardo da Vinci 290

Italian Renaissance Painting: Leonardo's

Last Supper 292

Italian Renaissance Sculpture:

Michelangelo's Pietà in St. Peter's 294

8. SIXTEENTH-CENTURY ART 297

Introduction to Sixteenth-Century Art 298

History 299

Intellectual and Scientific Developments 300

Religious Reform and Art during the Sixteenth

Century 301

The Sixteenth-Century Artist 304

POINTS OF CONTACT Chinese Porcelain

in Europe 305

THEME The Nude/The Body 306

Italian Renaissance Sculpture:

Michelangelo 308

TECHNIQUE Stone Sculpture 309

Italian High Renaissance Portraiture 310

German Printmaking: Albrecht Dürer 312

TECHNIQUE Printmaking: Engraving

and Woodcut 314

New St. Peter's, Rome 316

Michelangelo, Sistine Chapel Ceiling 318

ART PAST/ART PRESENT Vasari and Modern

Scholarship 321

Raphael, Stanza della Segnatura 322
High Renaissance Painting in Venice 324
Hieronymus Bosch, "Garden of Earthly
Delights" Triptych 326
German Painting: Matthias Grünewald,
Isenheim Altarpiece 328
Titian's Altarpieces 330
TECHNIQUE Venetian Painting 332

Later Michelangelo and the Development

of Mannerism 334

Early European Landscape Painting 336

Sixteenth-Century Painting 338

Islamic Art of the Ottomans 340

Veronese and the Impact of the

Counter-Reformation 342

The Art of Zen Buddhism in Japan 344

Bernini's Works for St. Peter's 366

The Dutch Baroque Group Portrait 368

Mughal Art of India: The Taj Mahal 370

Baroque Architecture:

Francesco Borromini 372

Bernini, Ecstasy of Saint Teresa 374

TECHNIQUE The Art of Drawing:

Rembrandt 376

TECHNIQUE Printmaking: Etching and

Drypoint 378

Spanish Painting: Diego Velázquez 380

Baroque Classicism: Nicolas Poussin 382

Rembrandt: Late Paintings 384

Dutch Still-Life Painting 386

The Palace at Versailles 388

Japanese Screens and Architecture 390

European Landscape Painting 392

9. SEVENTEENTH-CENTURY ART 347

Introduction to Seventeenth-Century Art 348

History 348
Intellectual and Scientific Activity 350
The Styles of Seventeenth-Century European
Art 351
Seventeenth-Century European Art 351
The Seventeenth-Century Artist in Europe 352
POINTS OF CONTACT "Seeing" the New
World 355
THEME Relating to Nature 356

Seventeenth-Century Architecture in Japan 358 Caravaggio and his Influence 360 Baroque Genre Painting 362

Peter Paul Rubens 364

10. EIGHTEENTH-CENTURY ART 395

Introduction to Eighteenth-Century Art 396

History 397
Intellectual and Scientific Activity 399
Eighteenth-Century Art 400
The Eighteenth-Century Artist 401
POINTS OF CONTACT Chinoiserie 405
THEME Representing Women 406

Eighteenth-Century Painting in Europe 408
Eighteenth-Century Art in Korea 412
Rococo Architecture and Sculpture 414
Eighteenth-Century Portraiture 416
Neoclassical Architecture 418
Neoclassical Painting and Sculpture 420

11. NINETEENTH-CENTURY ART 425

Introduction to Nineteenth-Century Art 426

History 427

The Industrial Revolution around the World 429

European Intellectual and Scientific Activities 430

Art 431

ART PAST/ART PRESENT Looking Beyond the

Art: Romanticism 431

The Impact of French Painting on World Art 433

The Styles of Nineteenth-Century Art in

the West 434

The Nineteenth-Century Artist 436

POINTS OF CONTACT British Architects in

India 437

THEME The Artist as a Revolutionary 438

The Continuation of Neoclassicism 440

Francisco Goya 442

Romanticism 444

Romantic Landscape Painting 446

Japanese Woodblock Prints 448

TECHNIQUE Japanese Woodblock

Technique 449

Honoré Daumier and the Political Print 452

TECHNIQUE Lithography 453

Romantic Revival Architecture 454

American Romantic Painting 456

Revolutionary Art vs. Academic Art $\,458$

New Materials and Engineering in

Architecture 460

TECHNIQUE New Materials in Architecture 463

Late Nineteenth-Century Revival

Architecture 464

Édouard Manet 466

Early Photography and Photographic

Technique 468

Late Nineteenth-Century Sculpture 470

Impressionism 472

TECHNIQUE Impressionism 474

Edgar Degas, Berthe Morisot, and

Mary Cassatt 476

American Realism: Thomas Eakins and

Henry Tanner 478

Auguste Rodin and Camille Claudel 480

Winslow Homer 482

TECHNIQUE Watercolor and Gouache 483

Post-Impressionism: Gauguin and Seurat 484

Post-Impressionism: Vincent van Gogh 486

ART PAST/ART PRESENT The Value of Art:

van Gogh 489

Post-Impressionism: Paul Cézanne 490

The Beginnings of the Skyscraper 492

Edvard Munch 494

12. ART FROM 1900 TO 1949 497

Introduction to Art from 1900 to 1949 498

History 498

Intellectual and Scientific Activity 500

Art from 1900 to 1949 501

The Artist 504

THEME The Home and the Palace 506

Fauvism 508

African Art and Ritual 510

Photography 512

Cubism and its Influence 514

TECHNIQUE Collage and Assemblage 519

Native American Art 520

ART PAST/ART PRESENT Women in

Pueblo Society 523

Frank Lloyd Wright, Robie House 524

TECHNIQUE The Cantilever 525

Native American Ceremonial Art from the	Index 634
Northwest Coast 526	Picture Credits 651
Abstraction in Sculpture 528	Text Credits 655
Malevich and the Russian Avant-Garde 530	Acknowledgements 655
German Expressionism: Die Brücke and	
Der Blaue Reiter 532	MAPS
Fantasy 534	IMI
Dada 536	Prehistoric Europe and Africa 24
De Stijl and the Bauhaus 540	The Ancient Near East 41
Diego Rivera and Mexican Mural Painting 544	Ancient Egypt 44
Surrealism 548	Ancient Greece 73
Modernism in American Painting 552	Ancient Asia 111
Pablo Picasso, Guernica 556	Ancient Italy 114
Sculpture of the 1930s and 1940s 558	Mesoamerica 138
International Style Architecture 562	The Near East 153
	Asia 161
13. ART FROM 1950 TO 1999 565	Medieval Europe 163
The 1950s 566	Japan 219
The 1960s 576	14th-century Europe 223
The 1970s 580	Africa 245
The 1980s 586	15th-century Europe 253
The 1990s 596	16th-century Europe 300
	17th-century Europe 349
14. ART IN THE NEW MILLENNIUM 607	18th-century Europe 397
	19th-century Europe 428
Art in the New Millennium 608	19th-century United States and Canada
	454
World Map 622	20th-century Europe 499
Glossary 623	20th-century United States 501
Bibliography 631	Sub-Saharan West Africa 511
	World 622

Features

Art Past Art Present introduces art across time and around the globe with an integrated, balanced, and accessible text, high-quality images, and special features that help ease the reader into an understanding of key ideas and technical concepts.

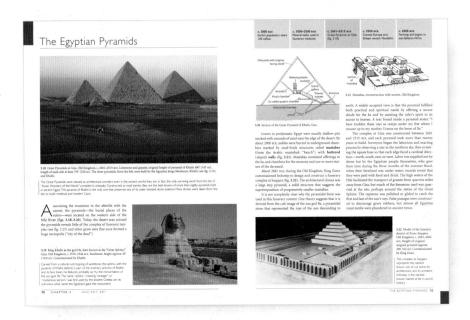

CLEAR AND FLEXIBLE ORGANIZATION

Each topic is organized into two- and four-page units, and provides a clear and concise treatment of a limited number of artworks.

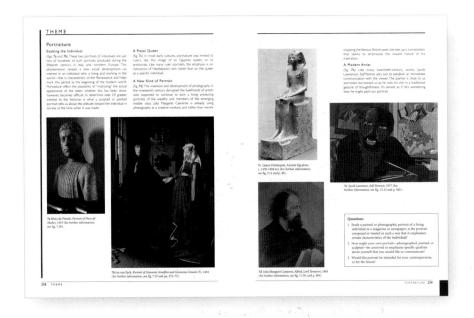

THEMES

One theme is explored in each chapter. Topics such as Portraiture, The Nude/The Body, and Ritual Art help demonstrate and expand understanding of common themes found in art across time, cultures, and geography.

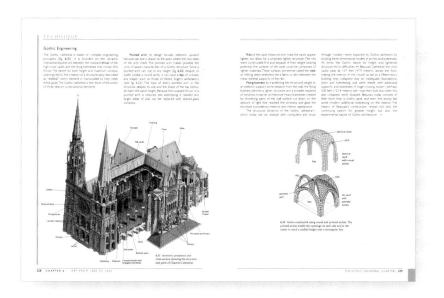

Technique boxes explaining a wide variety of materials and techniques appear throughout the book to make these often complex concepts more accessible. New color diagrams and illustrations bring more dynamism to the learning process.

TIMELINES AND NEW MAPS

Small, carefully placed timelines provide chronological connections that aid in comprehending the complexity of human artistic development across the globe. New colorful and more detailed maps help place the art in its geographical context.

New! Points of Contact

This new boxed feature explores the exciting nature of cultural exchange by examining a single work that is a product of the interaction of cultures. Topics such as The Silk Road and Chinoiserie remind us of the pivotal importance these interchanges had on the development of art.

ART PAST/ART PRESENT

This boxed feature occurs at points appropriate for the analysis of the art of the period under discussion vis-à-vis the modern world. Topics are wide-ranging, from Chinese Aesthetic Theory to Women in Pueblo Society.

Getting Started

WHY ART PAST ART PRESENT?

rt Past Art Present is based on the idea that works of art communicate to us across time and history. Works of art engage us on a visual level, but further study reveals how they can remind us of the diversity and communality of human experience. To understand the visual language of art and be receptive to its communication, however, requires active participation. How can we begin to establish a dialogue between ourselves and works of art? How can we achieve an understanding of past and present art from other societies? And, in an age teeming with information, how do we move from information to knowledge and understanding? Art Past Art Present has been designed to help us begin to answer these questions. The book opens with a chapter called "Experiencing Art" (pp. 1–19) that will help establish the language and tech-

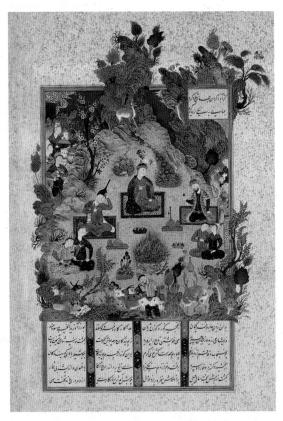

Sultan Muhammad, *The Feast of Sadeh and the Discovery of Fire by the Persian King Hushang*, from the *Tahmasp Shah-nameh*, c. 1520–25. Manuscript illumination, $9\frac{1}{2} \times 9\frac{1}{6}$ " (24 × 23 cm). Metropolitan Museum of Art, New York. Commissioned by Shah Isma'il and his son Tahmasp.

The Persian national epic, the *Shah-nameh*, was originally composed by the poet Firdawsi between 975 and 1010. This *Shah-nameh*, which contains 258 miniatures, was created in the royal studios in the Persian capital at Tabriz. For further information, see fig. 8.57.

niques useful for analyzing art and for understanding art and artists within a historical context.

WHAT IS THE BASIC APPROACH OF ART PAST ART PRESENT?

In creating *Art Past Art Present*, we accepted the underlying assumptions that art results from the human experience of life and that art is itself fundamentally expressive. We wanted to offer the reader a clear, concise, and integrated treatment of a limited number of works from around the world.

WHY IS HISTORY SO IMPORTANT IN UNDERSTANDING WORKS OF ART?

In Art Past Art Present, the works are discussed within a historical framework to emphasize the circumstances under which they were created and to encourage us to question how they might originally have been viewed and how they may have functioned; such an approach is known as contextualism. We urge the study of art in concert with history, politics, religion, geography, society, and culture in general, including music, dance, and literature, in order to more fully understand the scope and diversity of human history. Chapters 2 through 12 of Art Past Art Present each open with an overview of developments in history and art for each time period: prehistoric, ancient, later ancient (400 BCE to 200 CE), 200 to 1000, 1000 to 1400, fifteenth century, sixteenth century, seventeenth century, eighteenth century, nineteenth century, and the first half of the twentieth century. The second half of the twentieth century (Chapter 13) is treated differently, in decades, and Chapter 14 is dedicated to the new art of the twenty-first century. A section at the end of each overview discusses the role and status of artists during this period; when possible, self-portraits of artists are illustrated in this section. Following the overviews for each period, there are two-, four-, six-, and eight-page units that start with a key work. These key works establish a chronology for Art Past Art Present.

WHY SUCH A DISTINCT CHRONOLOGICAL APPROACH?

If you thumb through *Art Past Art Present* looking at the top of the right page of each unit, you'll see a series of timelines with dates that are chronological in sequence. In our minds there is historical truth in this chronology, for it means that the works and related events are presented roughly as they happened; such a chronology reminds us that Donatello, Ghiberti, and Van Eyck (pp. 260–75), for

630 Mohammed returns to Mecca 656 Standardized text of the Koran is completed

example, were all working at about the same time, or that the rock-cut Hindu temple at Ellora (pp. 180–81) was being carved at the same time that the Muslims were erecting the huge mosque in Córdoba (pp. 182–83). Such an interweaving of works offers insights into contemporary developments around the globe. At the same time, the organization of *Art Past Art Present* in units means that the teacher or reader can focus on each unit independently.

WHAT IS THE POINT OF THE TIMELINES LIKE THE ONE SEEN AT THE TOP OF THIS PAGE?

These timelines list historical events and cultural developments from the period in order to build context for the works of art being discussed. (The darker blue box on the timeline denotes the work of art currently under discussion.) While there is no direct connection between the fact that the earliest Buddhist architecture in Japan (pp. 176–79) was built in the seventh century, during the same period when Muhammad began preaching openly, or that Shakespeare's *Hamlet* was written at about the same time that Caravaggio's *Christ with the Doubting Thomas* (see fig. 9.14) was painted, such chronological connections help us build a more complex sense of the development of human accomplishment and historical events around the globe.

WHAT KIND OF IMPORTANT INFORMATION IS FOUND IN THE CAPTIONS TO THE ILLUSTRATIONS?

The main point of the captions is to provide some of the basic facts that identify the work of art:

Name of artist if known: While many works are anonymous, we know many artists not only by name but also as personalities. An artist's birth and death dates are given when their name is first mentioned in the text; nationality is given in the index.

Title: Titles only became necessary when people began listing works or displaying them, and chroniclers, collectors, and art historians have had to invent titles for many works; you may sometimes notice that the title of a work of art in one book is different from that given in another. Some historic or popular titles are inaccurate, as is the case with Rembrandt's *Militia Company of Captain Frans Banning Cocq* (see fig. 9.25), which is now popularly but incorrectly known as *The Night Watch*.

Date: The date of creation is always a useful piece of information, but many dates are uncertain or questionable. When a date is uncertain, we have used c. (from "circa," the Latin term for "about") before the date. We

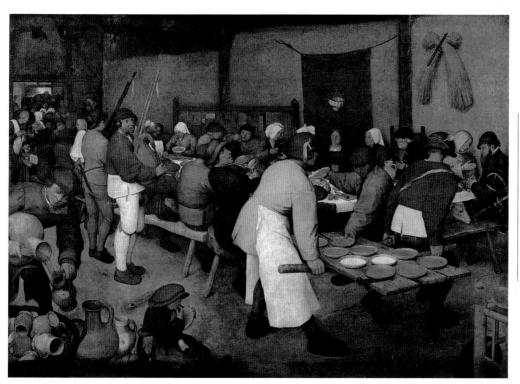

Pieter Bruegel the Elder, Peasant Wedding Feast, c. 1566. Oil on wood, 3' 8%" × 5' 4%" (1.16 × 1.63 m). Kunsthistorisches Museum, Vienna, Austria.

The bride is the smug woman seated in front of the suspended cloth with a crown above her head. To either side are the groom and the couple's parents. To the right, a priest is in conversation with a distinguished-looking man who probably represents the landowner for whom these peasants worked. For further information, see fig. 8.56.

don't know the exact date for Leonardo's *Portrait of a Woman* (now known as the *Mona Lisa*, see fig. 8.18), but we think it was painted sometime between 1503 and 1505; hence the date given in the caption is c. 1503–05.

Materials: This is an important category, because artists are often restricted in the kinds of materials available. Each material offers its own potential and restrictions, and understanding the role of the materials (the medium) in the artist's creative experience is often helpful.

Size: Size is given in feet and inches and centimeters and meters, height before width. This is another crucial category, because understanding the size of a work can help us to better understand its impact when seen in the original.

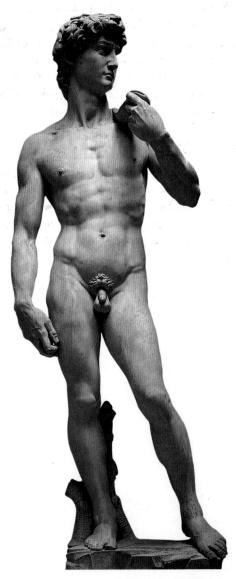

Michelangelo Buonarroti, *David*, 1501–04. Marble, height of figure without pedestal 17' (5.18 m). Galleria dell' Accademia, Florence, Italy. Commissioned by the Cathedral Administration to be placed on a buttress below the dome of Florence Cathedral (see fig. 7.31). For further information see fig. 8.15.

Original and present location: In the past, many works were created by the artist for a specific setting, but few survive as originally placed. This loss of context means that we often need to try to recreate some sense of the original setting. The survival of Michelangelo's Sistine Chapel ceiling (pp. 318–21) and Soami's Zen Buddhist dry garden (fig. 8.1) in their original setting demonstrates how important setting can be in understanding a work of art. Present location tells us where we can go to see a work.

Patron: In most earlier periods, works of art were commissioned from the artist by a patron. The patron could be an individual, a family, a social group, a ruler, a government, and so forth. Knowing who needed and who paid for the work can often add insight into our understanding of its function and context.

WHAT SHOULD BE READ FIRST, THE CAPTIONS OR THE TEXT?

The factual information in the captions is mainly useful for identification purposes, but longer captions allow us to include additional information and discussion about that specific work. We would recommend that the captions be read first, followed by the text, which generally focuses on the broader cultural and historical ideas that are helpful in understanding the work of art.

WHY ARE SOME WORDS IN THE TEXT PRINTED IN BOLDFACE?

Boldfaced terms identify terms that are included in the glossary (pp. 623–30), where each is defined and where reference is made to a specific work of art illustrating or demonstrating the term.

WHY ARE THERE SO MANY QUOTATIONS IN ART PAST ART PRESENT?

These passages are either historical documents that are roughly contemporary in time with the creation of the work or quotations from artists themselves. The words of those who lived when these works were created have, for us, particular authority. This is contextualism at its best, because it allows us to read what was being said about the work at the time of its creation.

THEMES

A series of nine double-page spreads devoted to art historical themes such as *The Nude/The Body, Representing Nature*, and *The Artist as a Revolutionary* are found throughout the book. Each of these thematic discussions presents a group of works that can be more fully understood when seen in

context with other works representing the same theme. These spreads demonstrate some of the common themes found in artistic developments over history and around the globe. As a group, the works demonstrate how a comparison and contrast between works from different periods can illuminate how art has changed over time.

MAPS

Detailed maps help you determine the location of works of art and architecture discussed in the book, while a world map (p. 622) offers a global overview.

TECHNIQUE BOXES

Technique boxes have been placed in the text chronologically, at the moment when the particular technique originated or when it was most important for artistic developments. Clear diagrams accompany descriptions of, among others, *Chinese Piece-Mold Bronze Casting* and *Printmaking*.

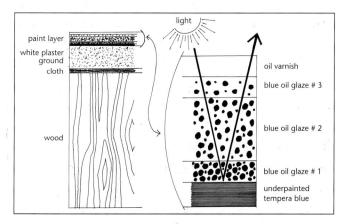

Schematic diagram of a section of a Flemish fifteenth-century oil painting, demonstrating the luminosity of the medium. The arrow suggests how light penetrates translucent oil glazes. For further information, see pp. 274–75.

ART PAST/ART PRESENT BOXES

These boxes are placed chronologically at points where it seemed appropriate to discuss the relationship between the art of the time and the modern world. Examples include *The Impact of the Ancient Greek Orders* and *Chinese Aesthetic Theory*.

Points of Contact Boxes

Points of Contact boxes are a new feature in the sixth edition and are found in the introduction to each chapter. Contacts between cultures have taken place since the earliest times and have allowed for the movement of objects and materials, as well as of people and ideas, across cultural borders. Interaction can provoke many reactions and create many responses among visual artists. When, then, and under what conditions do artists accept, adopt, adjust, import, and/or slavishly copy art from beyond their own local traditions? Does the interaction cause an active, generative force in the visual arts? Does it significantly alter and enlarge the vision of artists, and sometimes their audiences as well? These are the kinds of problematic questions that will be considered in this feature. Topics include *The Silk Road* and *Chinoiserie*.

BC or BCE, AD or CE?

The dating system used throughout this book is the Western system, which is based on the year of the birth of Christ as a dividing point. Many other cultures, including China, Israel, and the Muslim world, use a system based on historical events that are important to them; for business purposes, however, these cultures often use the dating system common in the West. The traditional designations used in Western culture for the periods before and after the birth of Christ have been BC ("Before Christ") and AD ("Anno Domini," "the year of the Lord"), but in this book we have adapted more neutral designations for these periods: BCE ("Before the Common Era") and CE ("Common Era").

WHY INCLUDE A BIBLIOGRAPHY?

We see *Art Past Art Present* as your first introduction to the larger and more complex world of art that has been created over the centuries and around the globe, not to mention the new art being created in our own times. The bibliography on pp. 631–33 lists books in English that will lead you further into this world. Happy reading!

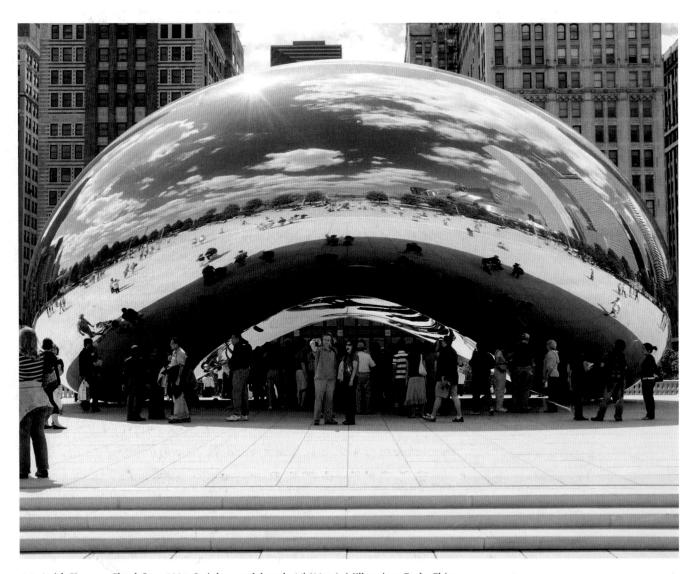

 ${\bf 1.1}\ \ Anish\ Kapoor,\ {\it Cloud\ Gate},\ 2004.\ Stainless\ steel,\ length\ 66'\ (20\ m).\ Millennium\ Park,\ Chicago.\ Commissioned\ by\ the\ City\ of\ Chicago.$

Nicknamed "Da Bean" by the public, the sculpture weighs approximately 110 tons and had to be constructed on site by a group of workers. Total cost was 23 million dollars.

Experiencing Art

A BRIEF INSIGHT

Public art is often controversial because its intended audience is large and diverse; the situation can become complicated when the cost is borne by taxpayers who may resent a work purchased with public money. One successful recent example, however, is *Cloud Gate*, by Anish Kapoor (b. 1954), an enormous, highly-polished abstract sculpture commissioned by the city of Chicago for a new park located between a major commercial avenue and the shore of Lake Michigan (fig. 1.1). *Cloud Gate* has been acclaimed by Chicago's citizens and has already become a new symbol for the city.

While the arching shape exemplifies the refinement that characterizes much abstract art, this is not a work that can be appreciated in isolation. Its mirror-like surface reflects the skyline of the city, the trees of the surrounding park, and the milling crowds that enjoy its public setting. As you move around it, *Cloud Gate*'s curving surfaces warp the cityscape and transform the clouds above, turning your attention to the city, then to the sculpture, then to nature, then back to the city again. The sculpture is so large that you can walk under the arched opening, where a steeply domed shape pulls a reflection of you and the other viewing public upward to create complex abstract patterns. Children delight in finding themselves, reversed, in the reflective surface, amidst the surging crowds. If the purpose of a work of public art is to be life-enhancing by engaging a wide spectrum of society, *Cloud Gate* easily fulfills that expectation.

Experiencing Art

magine—you and a friend are enjoying an afternoon at an art museum. As you walk through the galleries, viewing paintings and sculptures, you come across the entrance to a darkened room. Intrigued, you enter and encounter your first experience with video art (fig. 1.2).

The image of a procession of men carrying a body wrapped in a white cloth immediately seizes your attention. An association with funeral processions in the Middle East, as viewed on TV news broadcasts, enters your mind. You take a seat on one of the benches in the darkened video gallery, stay, and watch.

Your initial assumption about the setting of the action is confirmed as the video proceeds. Set against a sparse, rocky setting at water's edge, scenes of the procession are contrasted with those of a group of women, dressed in black, digging in the sand with their hands. You recognize that they are wearing chadors, the head and body covering worn by women in many Islamic countries, and that their hands are digging into the sand to create a grave. The rhythms of the funeral procession and the digging of the grave are emphasized by a sound track that throbs with ever-increasing volume. Just outside the scene of burial, a child erects a small mound of stones.

What you see forces you to ask questions: why is the

severe reality of a funeral procession and mourners being shown as a work of art? Why does gender define the actions portrayed? How is the experience of viewing a work of video art different from viewing paintings and sculpture in the museum? What are the connections between the various elements of the video: the action, dress, and setting, the changes of camera angle, and the sound? And, what is the difference between this video and funerals that you have attended?

As you and your friend become more and more absorbed in the pulsating rhythm of the images, fire and dust suddenly envelop the desolate landscape. The video ends.

As the lights come up, you and your companion search for words to articulate the experience of the last few minutes. The narrative told in the video is obvious, but you also sense that there are profound meanings in its images, sounds, and events. The title of the work of art, displayed on the wall by the entrance, catches your attention: *Passage*.

Now, your emotions and thoughts begin to organize themselves into an initial response. You realize that the visual and sound components of the video have been reduced to a fundamental essence, and that rituals of burial, while specific to different cultures, often share a transcendent theme:

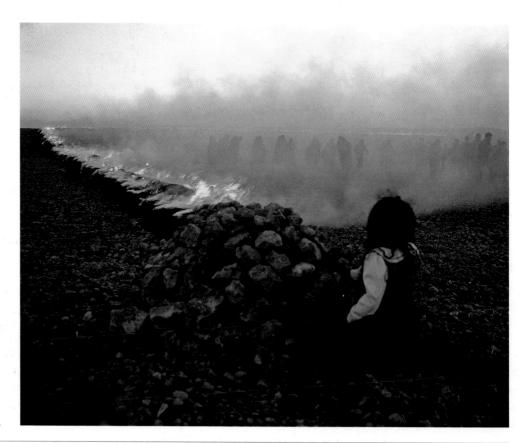

1.2 Shirin Neshat, still from *Passage*, 2001. 35mm film still, 11 minutes 40 seconds in length.

the cycle of life—birth, death, and belief in re-birth. With intense symbolic content, an artistic interpretation of this cycle has been shared with you. You have peered into the vision of an artist: a different view of the world, and the intensity of the human experience within it, has been opened to you.

Your encounter with this video art remains with you, and, later, through a web-search, you discover that the artist, Shirin Neshat, was born in Iran, exiled in 1979, and recently has been working in New York City. When she returned to Iran in 1990, she found that her homeland had been fundamentally transformed by the 1979 Islamic Revolution. Her alienation from her homeland impelled Neshat to explore, in photographic and film media, the psychological realities of exile. Could she find a way to express what it meant to live in a place but not to belong to it, and could she offer insights on the conflicting views of Islam she sensed within Iran and in the West? Neshat has stated that:

those of us living in the state of the "in between" have certain advantages and disadvantages. The advantage of being exposed to a new culture and in my case the freedom that comes in living in the USA. The disadvantages of course being that you will never experience again being in a "center" or quite at "home" anywhere.

Speaking of her work, Neshat states:

I'm an artist so I'm not an activist. I don't have an agenda. I'm creating work simply to entice a dialogue and that's all.... I'm creating a very brief experience for people so that they can take away with them not some heavy political statement but something that really touches them on the most emotional level.

As you read the artist's statement, the word "dialogue" jumps out at you: *Passage* engaged you, both with sight and sound, and the video led you on a journey of awareness. Neshat caused you to become a participant in a cultural dialogue, and you have come to understand the communicative language of art, sensing, on an intuitive level, an attempt to fathom one of the impenetrable mysteries of human existence.

Shirin Neshat's *Passage* is a work of our time, making use of electronic communications media that are powerful forces in contemporary society. If this does not agree with our traditional preconceptions about art, then perhaps it may lead us to examine the premises of our outlook and the role of art in shaping our conceptions of the world. Neshat

demonstrates how art can communicate across time and culture, and can raise issues that can touch the heart of our experience.

How to Experience Art

When you encounter an unfamiliar work in a gallery or museum—or even as you're walking down the street—begin your communication with it by asking questions. To start to understand the work as visual expression or historical experience—or as both—you might start by asking one or more of the following questions:

- Does this work communicate specific emotions and feelings? What is its expressive content?
- Does it belong to a clearly recognizable artistic tradition? Is it related to a particular **historical style**?
- Who was the artist (or artists), and did the artist's personal attitudes play a role in the creation of the work?
 Does the work demonstrate individual style?
- What can a visual examination and analysis of the work tell us? How can a formal analysis be useful?
- How are the visual elements of the work arranged?
 What is its composition?
- What materials is it made of? What is the medium?
- How have the artist or artists used these materials? What **techniques** were employed to make the work?
- Did someone commission the artist or artists to create the work and did they also pay for it? Who were the patrons?
- Why was it made? What purpose did it fulfill? What was its function when it was first created?
- Was it created for a specific location, and did the artist adjust the composition for that location? Has the artist used collocation?
- What is its subject matter and what does it represent?
 What are its iconography and iconology?
- What can it tell us about the ideas, beliefs, or attitudes current in the period when it was created? What is its **historical significance** and its **historical context**? Who is or was its audience?
- As a member of the audience, you can also ask what it is that you bring to this work, and how your personal history and experiences affect your response to the work. What is your personal response?

These questions are not a comprehensive list, nor do all these questions apply to every work. The key concept in each question is restated using **boldfaced** terms that are part of a specialized vocabulary useful for sharing ideas about works of art.

Viewing Art

he life-sized sculpture of an armored warrior shown here (fig. 1.3) was found, along with thousands of similar figures (see figs. 4.11–4.13), in the tomb of the Chinese Emperor Qin Shi Huangdi. What is it about this figure that commands our attention? How does this figure, so far removed from our contemporary experience, engage us? Art's power to communicate rests on an analysis of a work's visual qualities and an understanding of the work's expressive content and its relationship to its historical period. One central goal of art history, then, is to increase our understanding of sometimes puzzling works from past cultures, and even from our own. Thinking about art globally can guide us to an understanding of the diversity of cultural traditions that comprise our global community, each on its own terms.

UNDERSTANDING STYLE

To construct a framework for analyzing art created in the past, as well as in the present, modern art historians use classifications that rely on the concept of **style**. The word "style" (from the Latin *stylus*) originally referred to a writing instrument, but over time the meaning changed to

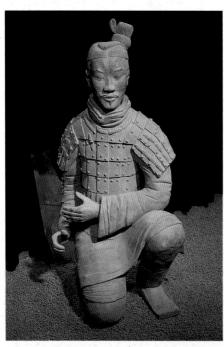

1.3 Ancient Chinese, Terra-cotta warrior, 210 BCE. Terra-cotta, lifesize. Lintong, Xi'an, Shaanxi Provincial Museum, People's Republic of China. Commissioned by Emperor Qin Shi Huangdi.

The position of this figure's hands suggest that he once held an actual weapon; this and other materials used for warfare were stolen when the tomb was raided shortly after its completion.

include the manner—or art—of handwriting. Each of us writes differently, and our handwriting has a personal quality related to whether we are left-handed or right-handed, how we learned to write, and even the period in which we live. Documents from past centuries easily demonstrate how handwriting styles have changed over time. In art history, historical style is the term used to describe how the appearance of a work of art is tied to the period during which it was created. Works of art from the same historical period and culture often share similar visual characteristics. In Western art history, specific periods and cultures tend to be examined within a chronology, or time sequence, and the history of art is sometimes presented as a succession of period styles.

The term "style," however, can also have a more intimate meaning, referring to the particular manner of visual expression created by an individual artist. This is known as **individual style**. Individual style can change as the artist develops and matures. Relationships may also be detected between the individual style of an artist and the historical style of the time in which he or she lived. To study style, art history uses a technique called **formal analysis**, which is an examination of the visual aspects of a work and how its parts are united to produce a distinctive historical and individual style. The vocabulary of formal analysis, introduced in some of the questions at the end of the previous section, helps us to describe the visual structure of works of art.

ART, TIME, AND THE CYCLES OF LIFE

Each of us experiences cycles throughout our lives. We greet the new year with anticipation, celebrate birthdays as milestones, and perhaps even feel renewed with the passing of one academic term and the start of another. While an understanding of such rhythmic repetition is common, different societies generally understand life's patterns in one of two different manners: with a linear view of time and history that emphasizes the notion of development or with an emphasis on the idea of repetitive cycles of renewal.

Our understanding of works of art is bound to our perception of time. As an academic discipline, art history developed in the nineteenth century, utilizing the concept of style as the basis for a classification system. Viewing the history of art as a "succession of period styles" implies a linear perception of time and history—one in which events and their consequences are part of an evolutionary continuum of time, moving from a beginning toward, progressively, an end. This viewpoint was expressed by the Romanian philosopher and historian, Mircea Eliade, when he wrote, in *Cosmos and History*:

From the seventeenth century on, linearism and the progressivistic conception of history assert themselves more and more, inaugurating faith in an infinite progress ... [that became] predominant in the century of "enlightenment," and [was subsequently] popularized in the nineteenth century by the triumph of the ideas of the evolutionists.

Such a concept of time and history is particularly strong among Western cultures.

An alternate view is to be found in many of the traditional societies that flourished in the past and that are still active in some places in the world today. Their view of the passage of time as cyclical implies a periodic regeneration of time and, by this act, a constant renewal of history. Eliade's observation on "linearism and the progressivistic conception of history" is particularly relevant to the formation of Art History as an academic discipline, for just as this concept of the relationship between time and history began to dominate Western philosophical thought, the study of art within history was being recognized as an independent field of study in European and American universities. While literature on art and artists had existed in Western cultures since ancient times, a systematic study using the title of "history of art" only appeared in the 18th century, in examinations of the classical civilizations of ancient Greece and Rome. Then, during the first half of the 19th century, professorships in art history were established in European universities. In the West, ideas about linearism guided the organization of the academic study of Art History into a chronology of period styles.

Works of art participate within different systems of time in different ways. Imagine, for example, viewing a Bwa mask (see fig. 1.16) presented in a glass case in a museum. Such a display imposes Western values on the mask, preserving it, like a painting or sculpture, for generations. While such a presentation of the Bwa mask preserves it materially, to see the mask in such a display obscures its original cultural function (see pp. 510-11). The mask reveals its essence when seen as part of a ritual that links seasonal cycles to the ordered rhythms of the cosmos. Within traditional societies, such as the Bwa, Eliade states:

Objects or acts acquire a value, and in so doing become real, because they participate, after one fashion or another, in a reality that transcends them.... The object appears as the receptacle of an exterior force..."

When the Bwa mask is joined with the fiber body suit and movements of the ritual dancer and accompanying sounds,

this totality of experience links earthly seasonal cycles to what are understood to be the rhythms of the cosmos. In the minds of Bwa participants and observers, these enactments are efficacious in connecting the physical and spiritual worlds.

But whether time is viewed as a linear or cyclical progression, works of art, however defined, often act as a response to metaphysical and other questions and issues that we humans have confronted throughout our long history. As mentioned in our discussion of Shirin Neshat's Passage, we often respond intuitively to those broad issues that help us to define our experiences as human beings. The experience of the events of life, from our birth to our death, from our views of an afterlife to our relationship to

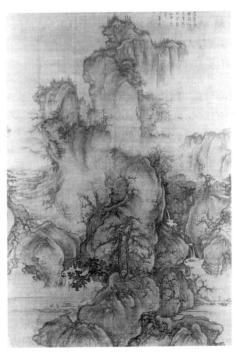

1.4 Guo Xi, Early Spring, Northern Song Dynasty, 1072. Hanging scroll, ink, and slight color on silk, length 62½" (158.75 cm.). National Palace Museum, Taipei, Taiwan, Republic of China.

The inscription on the upper right of the picture is an example of calligraphy by Emperor Qianlong (1736–95) of the Qing Dynasty (1644-1911). In China, inscriptions are often added long after the paintings were executed. They are sometimes written directly on the painting, as in this example, or in a separate space added to the work, as in Sailboat in the Rain by Xia Gui (see fig. 5.53). An inscription by a noted scholar or emperor added prestige to the painting. The poem added to Early Spring reads:

Leaves are twisted on the trees and the stream is melting, On the top are dwellings of the immortals. We do not need a willow tree to tell the season. The mountain is already misted with the coming of spring.

the cosmos, from our belief in some kind of supreme being or beings to our personal, psychological self-examination—all of these themes have been expressed through works of art at various points in human history. Art is a profound form of human communication that allows us to understand how people, through time and across cultures, have reconciled themselves with many of the issues that we face today. Art is a transcendent force that links us to both past and future generations.

ANALYZING THREE WORKS

To begin to understand the many ways in which works of art can be approached, we shall consider in some detail examples from different historical and cultural periods.

The sculpture of the Chinese warrior proclaims stability and permanence. While the face and armor are individualized, the rigid posture and self-contained composition create a sense of constancy, which reinforces the vigilant purpose of the figure. The value of stability is also declared in the work of another Chinese artist, Guo Xi (c. 1020–90), who painted *Early Spring* (fig. **1.4**) about 1,200 years after the guardian figure was created. This scroll painting represents a mountainous landscape with parts of the scene obscured by dense atmosphere. Waterfalls cascade down the lower portion of the mountain to the right. The monumentality of the mountain is reinforced by its central and dominant position—it occupies almost the entire painted surface of the scroll. The craggy rocks and skeletal trees suggest that we are also viewing the understructure, the essence of nature.

Our perception of the Chinese guardian figure as both stable and rigid results from several visual elements. The **axis**, an imaginary center line passing through the kneeling figure, conforms to a vertical line. Vertical and horizontal components appear to be balanced and in equilibrium. The vertical axis communicates a contained, balanced stability. The vertical axis also contributes to the stiff posture of the figure, which is reinforced by the compact outlines of the sculpture.

The enormous mountain in Guo Xi's painting peaks in the center of the composition; this work too has an **axial composition**. Although curvilinear elements and diagonal elements can be seen in the painting—for example, in the bending branches, the flow of water over the tiered falls, and the outcropping of rock at the bottom—the soaring verticality of the central mountain dominates the scene. Set within a rectangular format, the visual authority of this axial mountain establishes stability within the composition.

Apollo and Daphne (fig. 1.5), created in Italy by Gianlorenzo Bernini (1598–1680), communicates an expressive content that is markedly different from Early Spring and the Chinese warrior sculpture. This sculpture, with its emphasis on dramatic movement, is from the Baroque period in Western art; its stylistic qualities of visual, dynamic flux are shared with painting and architecture

from that period. The figures, representing the mythological story of Apollo and Daphne, express a transient moment forever caught in time. This Baroque sculpture is also **naturalistic**, for the figures, drapery, landscape, and tree segments all reproduce the appearance of these forms in nature. (The term *realism*, which is sometimes confused with *naturalism*, refers to subject matter drawn from everyday life.)

Unlike the formal qualities of the two earlier works, which emphasized axial stability and stasis, Bernini's sculpture is composed primarily on a diagonal axis. Diagonal components, which break the equilibrium of the vertical and horizontal, communicate movement. *Apollo and Daphne* seems open and expansive. This openness is due to the extension of the figures' limbs and drapery out into the immediate space; here the surrounding space is energized by the sculptural form.

Each of these works makes a distinct impact on us. The individual expression of each work is related to the **media** (materials) and **technique** that the artist employed. The Chinese guardian figure was modeled from clay and was originally painted to enhance the naturalistic effect. In contrast, the subtle atmospheric, spatial, and structural effects

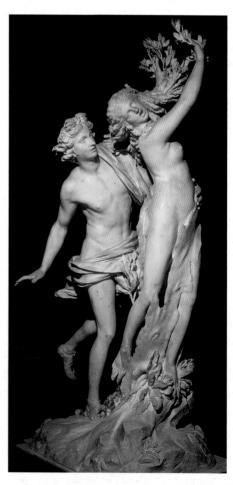

1.5 Gianlorenzo Bernini, *Apollo and Daphne*, 1622–25. Marble, height 8' (2.43 m). Galleria Borghese, Rome, Italy. Commissioned by Cardinal Scipione Borghese.

in *Early Spring* are achieved by Guo Xi's adept handling of brush and ink. The stability communicated by these Chinese works, each in their own distinctive way, is contrasted by the open and dynamically expansive quality of the *Apollo and Daphne*. The medium of Bernini's sculpture contributes to this effect, as it is Italian marble, which is soft and relatively easily carved when it is first quarried.

The subject matter of the three works is also distinctive. The art-historical examination of subject matter is expressed on two levels: What is the subject matter? And what is its meaning within the work's historical context? **Iconography** (from the Greek *eikon*, "image," and *graphein*, "to describe" or "to write") is the art-historical study of the specific subject matter of the work, while **iconology** (from the Greek for "image discourse") interprets the *meaning* of the subject matter as it can be understood within the historical culture that produced it.

The Chinese warrior was created, along with thousands of other soldiers, government officials, horses, and horsedrawn vehicles, to guard, within a mammoth underground complex, the tomb of Emperor Qin Shi Huangdi. The founder of the Qin Dynasty, in 221 BCE, it was under his rule that a number of provinces were, by military conquest, consolidated, an effective bureaucracy was established, and sections of an existing fortification were joined to create what we today call "The Great Wall of China." The iconography of this figure is that of a soldier performing his duty, guarding and providing military strength for the emperor, while the function of the statue was to provide a soldier to serve the emperor in the afterlife. The subject of Guo Xi's painting is the landscape, a visual investigation of the appearance and structure of nature in China. Inquiry into the iconology of these works, however, leads to the realm of historical significance and historical context, for religious, political, social, economic, scientific, philosophic, and other values can all come to bear on the interpretation of a work's meaning and function.

Within the Chinese tradition, landscape paintings were not simply depictions of nature; rather, they were intended to express the continuing essence of the living, natural world. Artists such as Guo Xi were highly educated, and the paintings they created were thought to enrich the human spirit by allowing the individual viewer, through contemplation, to become aware of a universal order that governs natural and human affairs. In the Western tradition, values of stability, permanence, and constancy were often associated with the human figure in art, but in China these qualities were expressed in landscape painting. The underlying stability of the two Chinese works probably bears some relationship to the powerful centralized government that controlled China during the periods when the works were created.

The iconography of Bernini's sculpture is drawn from a specific literary source from ancient Rome, Ovid's *Metamorphoses* (I, 545–59), written in the late first century BCE or the early first century CE:

So ran the god and [Daphne], one swift in hope,
The other in terror, but he ran more swiftly,
Borne on the wings of love, gave her no rest,
Shadowed her shoulder, breathed on her streaming hair
Her strength was gone, worn out by the long effort
Of the long flight; she was deathly pale, and seeing
The river of her father, cried, "O help me,
If there is any power in the rivers,
Change and destroy the body which has given
Too much delight!" And hardly had she finished,
When her limbs grew numb and heavy, her soft breasts
Were closed with delicate bark, her hair was leaves,
Her arms were branches, and her speedy feet
Rooted and held, and her head became a tree top,
Everything gone except her grace, her shining.

Although the figures of Apollo and Daphne are represented naturalistically, they are legendary figures from Greek mythology. As described in the passage from Ovid, the god Apollo desires the lovely Daphne, daughter of a river god. She prays to her father to be delivered from Apollo's unwanted advances, and when Apollo finally catches her, her father transforms her into a laurel tree. In Bernini's sculpture, Daphne's left side is metamorphosing into a trunk, while her fingers and hair become branches and leaves. The expression Bernini puts on Apollo's face is a complex mixture of joy, at the attainment of his goal, and wonder, as his hand embraces Daphne only to touch not flesh but bark.

The iconology of Bernini's sculpture communicates both general and particular aspects of Italian Baroque culture. It demonstrates the popularity in seventeenth-century Italy of literature and art from ancient Greece and Rome—Ovid's writings were popular sources for learning Latin, so all educated people would have known this tale. Besides delighting visitors, *Apollo and Daphne* also showed off the intellectual and artistic taste of its **patron**, Cardinal Scipione Borghese, an important member of the Roman aristocracy and an official of the Catholic Church.

Discerning style, formal analysis, iconography, iconology, function, and historical context are beginning steps to understanding the meaning of a work of art. Works of art themselves are far from being mute—but to hear them speak, we must be open to the expression and content of their language.

Analyzing Art

our personal approach to works of art may begin with queries about their historical or cultural significance; with an interest in individual style and the biography of the artist; or with an examination of subject matter. But the most fundamental approach is to look carefully at the work as a visual object and to begin to analyze how it communicates to us. This is called **formal analysis**. The following sections have been designed to help you understand how to apply the broad principles of formal analysis to architecture, sculpture, ritual art, installation art, and painting and other two-dimensional media.

ANALYZING ARCHITECTURE

Three-dimensional space is real space. Artists and architects who work with real space often use it as a positive element in a composition or design. This perception of space, and the merging of interior with exterior space, is, for example, a key feature in understanding the architecture of the Katsura villa near Kyoto, Japan (fig. 1.6). The design of these rooms, inspired by some of the tenets of Zen Buddhism, creates a subtle integration of the building with its environment. The architectural features are restrained and simple; wooden supports reveal their natural beauty, and the translucent paper of the sliding screen walls produces a soft interior light. As the sliding walls are moved, different vistas of the garden appear and the spatial definitions of the rooms change. The emphasis on delicate horizontals and verticals makes the irregularity of nature even more evident; the distinction between the

artificial and the natural is emphasized. The design of this Japanese royal retreat shows us how architectural space and real space can interpenetrate—an understanding that also guided the design of Fallingwater, by Frank Lloyd Wright (1867–1959).

Both the twentieth-century Fallingwater (fig. 1.7) and the sixteenth-century Villa Rotonda (fig. 1.8) by Palladio (1508–80) were designed as country homes for private patrons: Fallingwater for the Kaufmann family of Pittsburgh, who used the home as a summer retreat, and the Villa Rotonda for a retired official of the Catholic Church, who used the villa for receptions and entertaining. Like the Katsura villa, each structure communicates a particular architectural effect, and each relates to its setting in a different manner.

The most striking feature of Fallingwater is the way the structure responds to the site, a characteristic of many of Wright's designs. The architect once commented: "A good building is one that makes the landscape more beautiful than it was before."

In creating Fallingwater, he integrated the design with the natural environment, while at the same time establishing in the landscape a forceful abstract arrangement of rectangular forms. The large terraces allowed the Kaufmanns and their guests to enjoy the sun and views into the surrounding forest.

The ledges of rock that form the falls at the site create a horizontal pattern. This is echoed in the thrusting, horizontal terraces above, which project out from a massive vertical core faced with local stone quarried near the site. Nature's

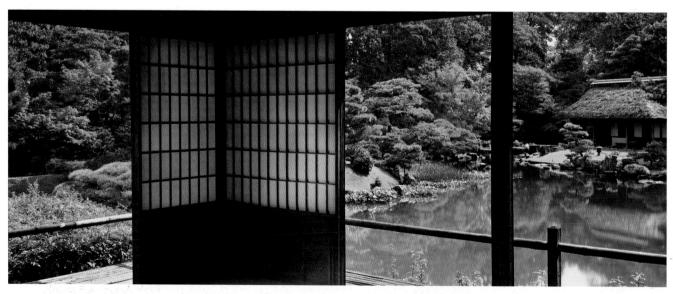

1.6 Villa, pond, and garden of Katsura Imperial Villa, near Kyoto, Japan, 1620–23. Commissioned by Prince Hachijo Toshihito and his son Toshitada. See also figs. 9.50 and 9.51.

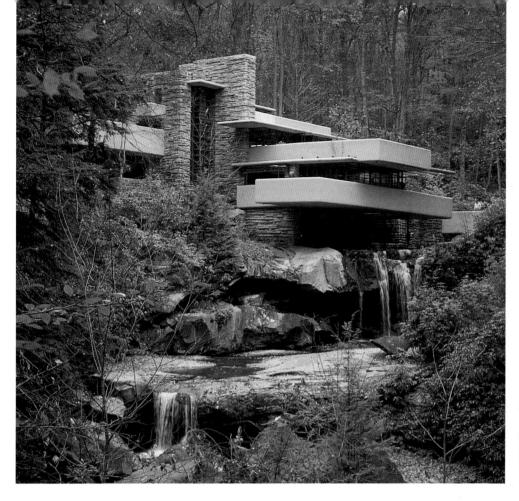

1.7 Frank Lloyd Wright, Fallingwater, Bear Run, in the Allegheny Mountains of southwestern Pennsylvania, 1936. Commissioned by Pittsburgh business executive Edgar Kaufmann.

design has been reinterpreted and reinforced by the abstract architectural forms integrated within it.

Situated very differently—on the crest of a hill and backed by a wooded area—the Villa Rotonda is an impressive and commanding structure. Its four porches, set at right angles to each other and extending from a central domed core, dominate the site. These porches serve a practical as well as an aesthetic function, for they afford the guests varied views of the surrounding countryside and, since each is partially enclosed on the sides, they offer the possibility of always being able to find a shady spot away from the hot Italian summer sun.

The exterior design of the Villa Rotonda expresses a stable harmony. Symmetry governs the entire arrangement, and vertical and horizontal elements are carefully balanced. The visual equilibrium revealed on the exterior also governs

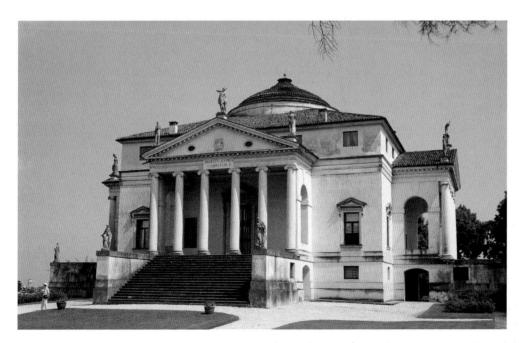

1.8 Palladio, Villa Rotonda (also known as the Villa Almerico and the Villa Capra), Vicenza, Italy, c. 1567-70. Commissioned by Paolo Almerico, Apostolic Referendary of Popes Pius IV and Pius V.

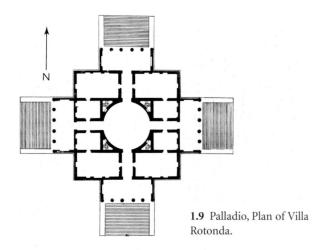

the interior design. The plan (fig. 1.9) is composed of proportional geometric shapes: a central, circular space is circumscribed by a square plan. From the central space, halls radiate to each porch. The cross axes of the halls are aligned with the cardinal points—north, south, east, and west. This desire to orient a building in relation to a perceived order in nature was an aspect of the Renaissance aesthetic that formed the basis of Palladio's architecture.

In contrast, the exterior design of Fallingwater is asymmetrical. A unified composition is achieved, nevertheless, by balancing the horizontal thrust of the terraces against the vertical massing of the central core. Another unifying feature is the adherence to rectangular forms throughout. The asymmetrical balance of Wright's exterior concept also

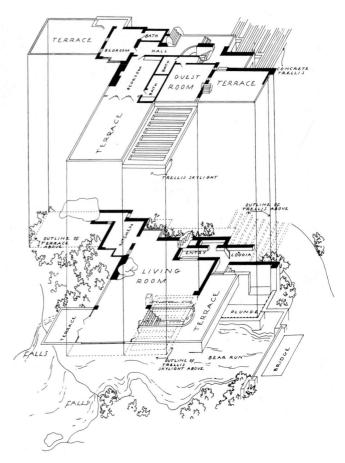

1.10 Frank Lloyd Wright, Plan of Fallingwater drawn in perspective.

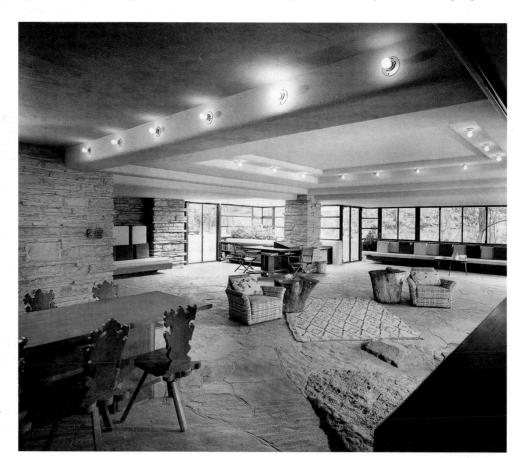

1.11 Frank Lloyd Wright, Interior, Fallingwater.

This historic photo shows the living room area of Fallingwater when the house was first completed in 1936. Note the rows of built-in light bulbs in the recessed section of the ceiling, which was a revolutionary way to use indirect ambient lighting in a domestic setting. Later these bulbs were covered with translucent screens to hide them.

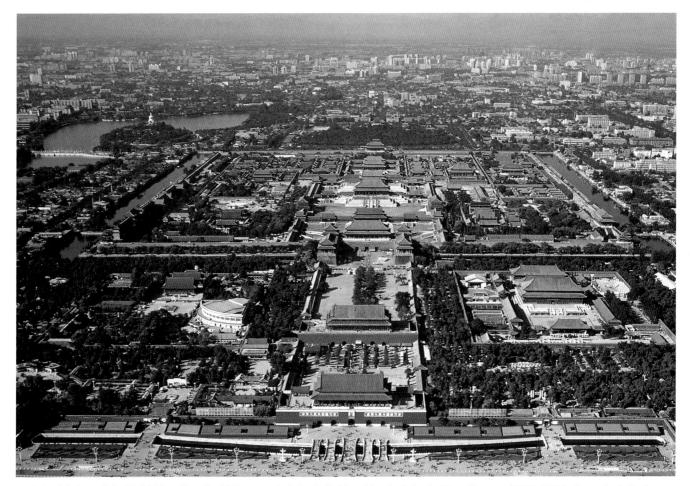

1.12 Aerial view of the Forbidden City, the Chinese capital city in Beijing. First built in the Yuan Dynasty (1279–1368), then rebuilt in the Ming (1368–1644) and Qing (1644–1911) Dynasties, and refurbished during the rule of the People's Republic of China (1949–present). See also pages 236-37.

The area enclosed is sixteen miles in circumference. Although the old walls of Beijing were removed in the latter half of the twentieth century, the palace walls have been retained and the palace as a whole has been maintained as a museum under the People's Republic of China.

characterizes the plan and interior (figs. 1.10 and 1.11). Rooms and hallways repeat the rectangular forms of the exterior. Like the Villa Rotonda, the rooms also correspond to the cardinal points, but Wright's asymmetrical design allows for the largest room, the living room, to have a southwest exposure, which maximized the Kaufmanns' enjoyment of the afternoon sun. Following a concept similar to that expressed in the Japanese pavilion (see fig. 1.6), Wright extends the rooms of the house into the space of the environment, while in Palladio's design the distinction between the building and its environment is firmly stated.

The Villa Rotonda was built to accommodate many guests, and its plan provided easy access into and out of the building; the symmetry of the halls and rooms around the central space allowed for clearly understood patterns of circulation. Fallingwater, by contrast, was designed for a family of three, and although the living room and terraces are large, the bedrooms are small and the halls narrow. As a private home for a small family, Fallingwater had no need for expansive patterns of circulation.

The principles of construction used to build the Villa Rotonda have a long tradition in architectural history. They include the use of walls, the post-and-lintel system (see fig. 3.26), and the arch (see fig. 4.50). The design confers a stable dignity on the building that recalls the tradition of ancient Greece and ancient Rome.

In contrast, the manner in which Fallingwater's terraces are thrust out over the waterfall creates a dramatic effect. This adventurous architectural achievement was accomplished by the use of modern construction materials that have a high tensile strength—that is, they strongly resist the strain of the architectural load and the pull of gravity. In Fallingwater, the terraces are made of concrete reinforced with steel rods. The availability of these materials gave Wright the possibility of using the cantilever, a horizontal projection into space.

Architecture serves both utilitarian and aesthetic purposes. Buildings are expressions of their time. As we encounter different forms of architecture, we would do well to recall the understanding of John Ruskin, the influential

nineteenth-century English art critic, who wrote, "All architecture proposes an effect on the human mind, not merely a service to the human frame."

The Villa Rotonda, the Katsura Imperial Villa, and Fallingwater are all country estates and their architecture can be studied in isolation. Buildings located in urban centers, on the other hand, are juxtaposed with other structures, often of varied uses, and must be examined as part of a larger context. While some cities have grown organically and randomly over time, many urban centers were developed on the basis of a rigorous geometrical model that must have been defined almost as soon as the city was founded. Among the earliest examples of this are Mohenjo-Daro in the Indus Valley (see fig. 3.31); the Chinese imperial city of Chang'an (see fig. 5.32); and the Roman imperial foundation at Thamugadis, in north Africa (see fig. 4.40). Such controlled designs imply a centralized authority and notions of efficiency and utility within society. Illustrated here as an example of such urban organization is the Chinese imperial palace in the capital city of Beijing (fig. 1.12). The capital in Beijing was established by the Mongols in 1267 and designed on Chinese principles under the direction of Liu Bingzhong. The Mongol capital was a triple-walled city of almost perfect geometric regularity, a feature retained until the present day. When Marco Polo, the Italian businessman and adventurer, arrived in 1275, he admired the regularity of its plan.

While in some cultures such a rigorous geometrical layout might have been established primarily for efficiency, in China it symbolized the relationships between heaven and earth, as well as between the ancestors and the ruling emperor. The emperor reported periodically to the ancestors regarding the conditions of his people and prayed for their welfare.

ANALYZING SCULPTURE

Like architecture, sculpture is an art of real space, and space is an integral element in analyzing sculpture. Depending upon the composition of the sculpture, the surrounding space can play a role in the effect and communication of the work. Minuteman (fig. 1.13), by Daniel Chester French (1850-1931), and Cubi XIX (fig. 1.14), by David Smith (1906-65), though very different in appearance, nevertheless share a similar spatial involvement.

The bronze statue of the Minuteman at Concord was commissioned to celebrate the centennial of the famous Revolutionary War battle fought there. The heroically scaled statue depicts the citizen-soldier of the American Revolution poised with a plow in one hand and a musket in the other. The figure stands alert and determined. The sculpture is representational, and although the medium is bronze, the artist has finished the surface to create the illusion of different textures: the flesh suggests the anatomical structure beneath; the folds of the clothing respond to the body and to gravity; and these textures contrast with the cold metallic handle of the plow. Such representational qualities help us recognize the forms and realize the sculpture's commemorative, historical purpose.

David Smith's *Cubi XIX* is a **nonrepresentational** work of art, for it does not imitate actual figures or objects. In Smith's sculpture, the medium is stainless steel. Smith has wire-brushed the surface of the steel, giving it a textural unity. The brushed steel surfaces reflect, in a diffused way, the atmospheric light around them. The sculpture changes its appearance in response to atmospheric conditions; it might appear dull gray-blue on an overcast day or reflect a slight golden glow on a sunny day.

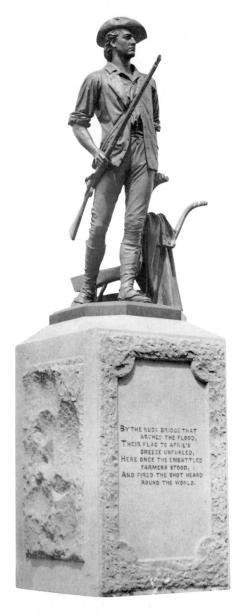

1.13 Daniel Chester French, Minuteman, 1874–75. Bronze with granite base, height 7' (2.13 m). Old North Bridge, Concord, Massachusetts. French was commissioned by the Town of Concord at the suggestion of American writer Ralph Waldo Emerson.

CHAPTER I

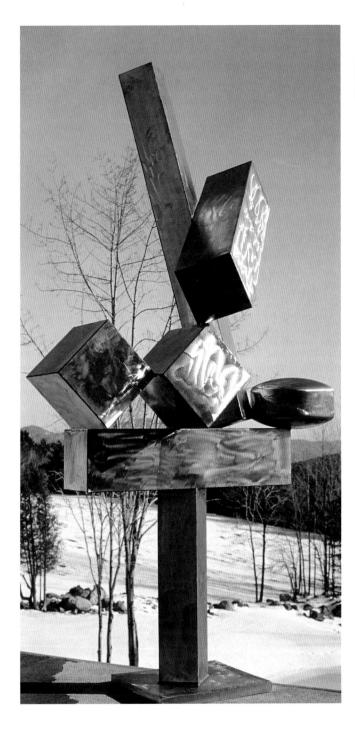

Both Minuteman and Cubi XIX are examples of sculpture in the round, that is, sculpture finished on all sides, to be viewed from many different vantage points. And, as already noted, these sculptures share a similar relationship with space. Both have forms that develop from a vertical axis—the arms and right leg of Minuteman and the geometric steel forms of Cubi XIX. Both sculptures are set on bases. The large granite base of Minuteman contributes to our recognition of the statue as a commemorative work; Cubi XIX's base primarily offers support, but its design is in keeping with the nonrepresentative composition. The composition of each work is also animated by the suggestion of 1.14 David Smith, Cubi XIX, 1964. Stainless steel, height 9' 5%" (2.86 m). © Estate of David Smith. Photograph by David Smith.

The abstract title reinforces the sculpture's nonobjective content. It is the nineteenth in a series of twenty-eight sculptures by Smith that combine rectangular and cylindrical stainless-steel forms.

movement. With Minuteman, this sense is created by the contrast of the vertical axis of the figure with the diagonals of the right leg and musket. Cubi XIX offers an interplay of vertical, horizontal, and diagonal forms.

The compositions of French's Minuteman and Smith's Cubi XIX urge us to regard the sculptures from different viewpoints. The diagonal of the Minuteman's musket, which is reinforced by the implied movement of the right leg, creates an oblique motion that invites us to walk around the sculpture. In a similar way, diagonal elements draw us around Cubi XIX to consider how the composition changes from varying points of view. Both sculptures heighten our awareness of the three-dimensional space in which they, like we, exist.

Sculpture in the round contrasts with relief sculpture, in which the figures are usually projected out from the surface of the material, traditionally carved stone or cast metal, from which the sculpture is created (fig. 1.15). Relief sculpture typically offers a single primary viewpoint, and the figures may project in different degrees from the surface. Light hitting the varied levels of relief allows us to read the forms, whether they are in low relief (bas-relief) or in high relief, in which the figures project substantially from their background. (The Egyptians also excelled at an unusual type of low relief known as sunken relief, see fig. 3.12, in which the

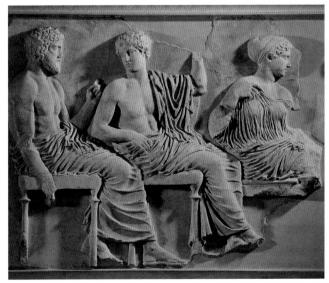

1.15 Phidias and Workshop, east frieze of the Parthenon, 447-422 BCE. Detail: Poseiden, Apollo, Artemis (Seated Deities). Relief, Pentelian marble, height approx. 3'7" (1.1 m). Athens Acropolis Museum (see also fig. 3.76).

forms are recessed into the surface). Our example of relief sculpture is from the Classical Period of Ancient Greek Art (see pp. 76–91); it depicts Greek deities seated while viewing a procession of Athenians in honor of the Goddess Athena (see fig. 3.76 for another portion of this frieze). Here the contrast between figure and planar as surface is readily apparent; later relief sculptures (see fig. 7.21) become more picturesque, combining different degrees of relief in the same sculpture.

ANALYZING RITUAL ART

Minuteman and Cubi XIX are alike in yet another way; as a sculptural object, each remains stationary. Although movement is implied in each sculpture, movement actually occurs only when the viewer walks around each work. The situation is radically different in the case of the Bird of the Night (Butterfly) mask from the Bwa ethnic group in Africa (fig. 1.16), which comes alive when worn in ritual dance.

In ritual, the *Bird of the Night* figure appears after the first rains of the season. The mask adorns a dancer whose other garments cover the entire body. The fluttering movements of a butterfly are imitated by the dancer. In these rituals, the mask, created by a carver, is united with the raffia garment, with musicians, and with the movements of the dancer—a combination intended to express the essence, not an exact visual representation, of the butterfly. The purpose of the mask is thus only fulfilled in the context of the ritual as a whole. To try to understand this Bwa mask as a sculptural form, we must, then, consider it within the dynamic context of live performance, and within the social and spiritual context of the village and the participation of onlookers. Although the villagers may remain static, the mask, garment, and dancer energize the space of the village

through actual movement. On a more profound level, the ritual is meant not merely to transform the space of the village but also to affect the quality of life.

Some works of contemporary art share another quality with the Bwa mask, garment, and ritual: they are ephemeral, lasting for only a short time (see fig. 14.1). The creation of the mask, its use, and its eventual disintegration are part of a cyclical continuation of daily life and ritual within many African societies. The concept of permanence, which underlies much Western art, is not an intended characteristic of this work. In fact, the emphasis on permanence in Western art has been challenged of late as ephemeral forms of conceptual, performance, and earth art (see Chapters 13, 14) gain currency.

Analyzing Installation Art

Installation art, too, denies the Western tradition of the work of art as a singular static object by fashioning an environment, often temporary, within a museum, gallery, or other public space. Although there are almost as many types of installation art as there are examples, many of these works set out to charge and transform the space within which the viewer is moving. Celestial Book: Mirror for Analyzing the World, by Xu Bing (b. 1955), for example, is an installation first shown in Beijing in 1988 that has been modified and shown in various spaces all over the world (fig. 1.17). Under the influence of Chan Buddhism (Zen Buddhism in Japan), Xu designed four thousand characters that no one could read, even though each looks like a Chinese character. He then used traditional printing techniques to produce long scrolls and books that could be exhibited in various manners depending on the space available for the installation; in the first Beijing show, the

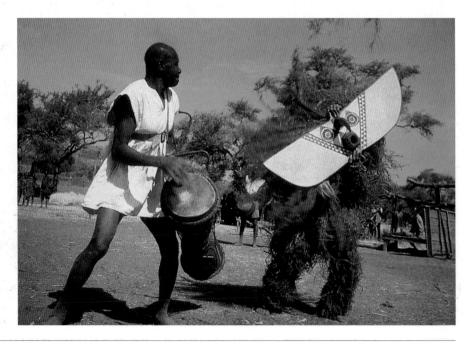

1.16 Ritual dancer of Bwa culture wearing the painted wooden *Bird of the Night* (*Butterfly*) mask and raffia body suit, 20th century. Wood, paint, and raffia. Upper Volta River region, Burkina Faso.

1.17 Xu Bing, Celestial Book: Mirror for Analyzing the World, 1988. Installation with printed paper. Installed February 5, 1989, National Academy of Art, Beijing, People's Republic of China.

scrolls were draped from the ceiling. According to Xu's interpretation of Chan thought, what is important is the laborious artistic process needed to create the work. The work of art is useless in itself. Xu compared his process of creation to the mindless diligence of Chan Buddhist labor, which was thought to empty the mind of useless knowledge and lead to enlightenment. In China his installations

were judged to be extravagant, and critics argued that they expressed nihilist, absurdist, and tragic feelings.

Especially since the mid-twentieth century, new art forms like installation art have continued to challenge the concept of the work of art as a singular object. More recently, computer technology has opened a vast new field of artistic experimentation, often engaging the viewer in different and even interactive ways. Usually referred to as New Media Art (see fig. 14.5), such art forms utilize computers, the Internet, and digital imagery to create art whose method of delivery and presentation involve the viewer in a more immediate and responsive dialogue.

ANALYZING PAINTING AND RELATED **M**EDIA

An understanding of space is also crucial for understanding the traditional medium of painting. Artists who have worked with two-dimensional surfaces usually have attempted either to create the illusion of three-dimensional space or to accept and emphasize the flatness of that surface. The distinction is apparent in the two paintings illustrated here.

In Philosophy (fig. 1.18), Raphael (1483–1520) painted recognizable figures and architecture from the visual world. Raphael's painting is illusionistic, for the objects represented seem to be tangible and weighty, and appear to exist within actual space. In contrast, the painting by Piet Mondrian (1872–1944) does not have forms that resemble

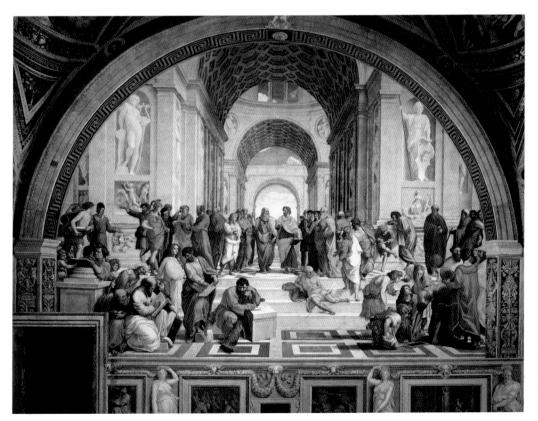

1.18 Raphael, Philosophy (popularly known as The School of Athens), Stanza della Segnatura, Vatican, Rome, Italy, 1509-11. Fresco, $19 \times 27' (5.8 \times 8.2 \text{ m}).$ Commissioned by Pope Julius II. For more information see pp. 322-23.

those in the visual world (fig. 1.19). The work is **nonobjective**, or nonrepresentational.

Traditionally, a **painting** can be defined as a two-dimensional surface to which liquid colors or inks have been applied. Flatness, the most distinctive attribute of paintings, is a starting point in their analysis. The flat surface is known as the **picture plane**, and in Mondrian's painting the two-dimensional colors and shapes reinforce the flatness of this plane. In illusionistic paintings, such as Raphael's, the picture plane seems transparent, like a large window.

Both paintings are made up of shapes. Mondrian's are black lines and squares or rectangles of a single color. Raphael's shapes, which are more properly defined as forms because of the manner in which they seem to exist in three dimensions, are naturalistic objects: figures, statues, and the interior of a massive building. In both paintings, elements are organized into a composition. Raphael's is arranged to emphasize the figures of Plato and Aristotle, who stand at the center of the composition. Groups of ancient philosophers frame them, and the diminishing architectural vaults above draw attention to them. The receding lines of the floor pattern converge at a central point, bringing further clarity to the composition, which is balanced, symmetrical, and centralized.

The composition of Mondrian's painting is neither centralized nor symmetrical, but it is balanced. We are

1.19 Piet Mondrian, *Composition No. 8, 1939–42, with Red, Blue, and Yellow.* Oil on canvas, 2' 5½" × 2' 2½" (74 × 68 cm). Kimbell Art Museum, Fort Worth, Texas. © 2004 Mondrian/Holtzman Trust c/o hcr@hcrinternational.com

1.20 Color wheel.

When color is studied in terms of light, black is understood as the absence of color and white as the mixture of all colors. On the color wheel, red, yellow, and blue (numbered I above) are known as primary colors because all other colors are made of a combination of these hues; the secondary colors are orange, green, and purple (numbered 2 above). Complementary colors, often juxtaposed by artists to achieve vivid coloristic contrasts, are the colors directly opposite each other on the color wheel, such as blue and orange or red and green.

drawn to the edges of the composition by the red, yellow, and blue found there. These colors are placed so that they balance each other, with no single color dominating. Mondrian's composition, however, might be described as decentralized, for it leads us to the periphery without concentrating our attention on any single area or element. His painting seems simple, but he has developed such a perfect balance that any change in color or composition would destroy the work's equilibrium.

Mondrian's composition is easier to analyze than Raphael's, for it exists completely in two dimensions. Raphael's composition must be analyzed both in terms of the patterns on the two-dimensional surface and as an illusion of three-dimensional reality. Note, for example, that when we analyze the painting as a two-dimensional object, the lines of the pavement converge toward a central point, but in actual space, these lines would be parallel to each other. This controlled spatial effect is a system of creating depth (perspective) known as scientific perspective. Other devices used by Raphael to help create his illusion are atmospheric perspective (the sky shades from blue toward white in the background, and distant forms are blurry and

softened in color), **diminution** (forms in the distance are smaller), and **overlapping** (forms are placed in front of other forms). For a diagram of the painting see fig. 7.20.

Raphael's medium was the technique of painting directly on a wet plaster wall, known as **fresco**, or *buon fresco*; Mondrian's medium was **oil paint** on canvas. Both artists used a technique of smooth, regular brushstrokes. Because most of the forms in both paintings are sharply defined, with precisely delineated edges, they can be termed **linear** (the opposite effect, in which broad, free brushstrokes are used to define form, is termed **painterly**; for an example see figs. 8.49 and 8.50).

Raphael's colors are naturalistic, that is, taken from nature, which enhances his illusionism. Mondrian's selection of **hue** (the property that gives a color its name) is restricted to the **primary colors**: red, blue, and yellow. Raphael changed the **value** (relative darkness or lightness of the color) and **intensity** (the level of richness or saturation of the color) of his colors to suggest the changes in value and intensity that result when light hits a form and creates highlights and shading; these changes are called **modeling**. Mondrian used pure colors, which are colors at their maximum or full intensity.

Raphael's painting was created during the Renaissance in Italy; it is one of a series of paintings created for Pope Julius II in the Vatican (see fig. 8.36). Philosophy reveals the abilities of a Renaissance artist to reproduce natural effects within a harmonious and clear composition. Mondrian's painting, on the other hand, is related to his personal philosophy and to the principles of the de Stijl movement (see p. 540). While searching for a truly "universal means of expression," Mondrian wrote that beauty and harmony could only be expressed by "abstraction of form and color, that is to say, in the straight line and the clearly defined primary color." His search for pictorial balance must be related to the search for political balance and peace in the years following World War I. Despite their pronounced differences, these two paintings share a surprisingly similar expressive content: they are orderly, serene, and, ultimately, calming. Both artists achieve visual harmony and balance. The formal analysis we have undertaken for each painting has a clear relationship to the historical and cultural background important for each work.

In addition, these works also conform to the common expectations that paintings adorn walls or ceilings. In some cultural traditions, however, two-dimensional works can only be seen in more intimate circumstances. A horizontal hand scroll (fig. 1.21) is meant to be viewed by one person or, at most, a limited group of people, in a quiet, contemplative atmosphere. And unlike the paintings by Raphael

1.21 A scholar studying a Japanese hand scroll. For illustrations of portions of a hand scroll, see the Japanese scroll of *The Tale of Genji* illustrated in figs. 6.20, 6.21.

and Mondrian, a scroll painting is not seen in its entirety at one time. Usually only one or two feet of a longer scroll can be seen at a time, as you unroll it from right to left. This format is intensely personal, with you controlling the pace of the journey; time thus becomes an important element in the experience of the work. The movement of simultaneously turning the two ends of the scroll to advance it cannot be rushed, which encourages contemplation. Raphael's large-scale illusionism is typical of much of Western art, but the more abstracted vision of nature seen in the typical Chinese hand scroll is consistent with the small-scale intimacy of the scroll format and the emphasis on the surface of the painting that is apparent when you unroll it. When the viewing is complete, you roll and tie the hand scroll and place it in a box out of sight for safekeeping.

Somewhat similar to the experience of looking at a hand scroll over time is the manner in which we experience a film or video (see fig. 1.2). But in these media the experience of time is controlled by the rate at which the image evolves and is not in our control, as it would be in viewing a hand scroll.

Whether we are considering a work of art as public as an installation in a civic building or as intimate as a hand scroll, the artist's ability to transform our experience—and even our environment—is an important factor in the constantly evolving art at the beginning of the twenty-first century.

The Artist in History

irtually all cultures have nurtured specialists who design and embellish many types of objects, from everyday items to works made for political purposes or for use in religious ritual. Sometimes those who were considered best at such expression were recognized as "artists" and became respected for their special skill; in some cultures they were encouraged to sign their works. Although not all such creators were recognized as artists, the visual arts—grand or modest, public or private, religious or secular—are a common feature of human culture, and those who create these works are often fundamental to their particular society. Individuals in some cultures, such as fifth-century China and fifteenth-century Italy, wrote down their aesthetic aspirations, setting out to convey in words the deeply held values expressed in their visual arts. In the chapters that follow, you will find brief discussions of the role of the artist during particular periods of history (for examples, see pp. 304–5, 436–37). These sections show how the social position of the artist has varied from culture to culture and period to period, as well as how the expectations of society affect the choices artists make.

When we study finished works of art, it is important to try to picture each artist's creative process. While the steps used by artists in making specific works are often difficult to imagine, in this section we illustrate three examples that show artists at work (figs. 1.22 to 1.24).

In many earlier cultures, and still occasionally today, works of material culture were produced by groups of individuals working together. In ancient Greece, for example,

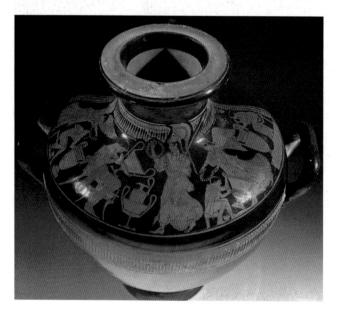

1.22 Ancient Greek, "Leningrad Painter," *Greek Potters at Work*, detail of Greek vase, c. 450 BCE. Private Collection, Milan, Italy.

1.23 Wodaabe woman decorating a calabash, northeast Nigeria, c. 1981. The woman may be decorating the calabash for her personal use.

the production of art was generally viewed as a manual profession that was taught in workshops; it was not related to what the Greeks defined as the liberal arts—mathematics, grammar, philosophy, and logic—which were characterized by intellectual, speculative thinking. This workshop tradition is illustrated in *Greek Potters at Work* (fig. 1.22). Apprentice vase painters, some female, are working side by side with the head of the shop. No Greek vase signed by a woman is known, however, suggesting that women most often must have worked in the more menial areas of vase production.

In many later periods and diverse places, art continued to be identified as a manual profession. In some periods artists formed **guilds**—legal organizations rather like trade unions—that governed production. While guilds assured professional standards, they also reinforced the distinction drawn between the manual arts—including the production of works of art—and the so-called liberal arts.

The individual artist was recognized early in China, where the oldest continuous painting tradition was nurtured. Many Chinese painters were also poets, calligraphers, government officials, antiquarians, scholars, collectors, connoisseurs, and mystics. Painters (see fig. 6.5) were part of the cultured elite or *literati* that were the main participants in the Chinese classical tradition. Among the Chinese aristocracy, painting, poetry, and **calligraphy** were revered as the three "perfections," as media necessary to preserve social, political, and aesthetic values.

The traditional Western classification of the visual arts as manual or mechanical arts was transformed in the fifteenth century, when artists and writers began to emphasize the scientific and intellectual aspects of art. The liberal arts were incorporated into the education of artists, and it was argued that arithmetic, for example, was necessary for the study of proportion. Artists began to be seen as professionals versed in both the practice and the theory of art. This was accompanied by new social status: artists became the companions of intellectuals, princes, popes, and emperors. Discussion of art theory became commonplace, and treatises defined the nature of art and discussed its developing history. By the later sixteenth century, academies began to replace the workshop tradition in educating artists, as seen in a painting depicting the members of London's Royal Academy attending a class with live models (see fig. 10.13).

Early in the nineteenth century, changing economic and social conditions began to transform Western cultural values, and the concept of the artist as a member of the avant-garde (French for "progressive") was born. Many artists became intent on leading society toward a modern and often utopian vision of life. In our own time, the parameters within which visual artists work have changed. Happenings, installations, and video and performance art have blurred the distinctions between the traditional media of the visual arts and such other art forms as speech, music, dance, film, and video (see chapters 13 and 14).

In many places, the role of the artist is much the same in the modern world as it was in the past. In the tribal cultures of Africa, for example, the artist was traditionally a prominent member of the community and in Africa today artists still hold a respected position, although their social status is not the same everywhere. And there often continues to be a distinction between the arts practiced by men and women.

In many places in Africa, techniques are learned and handed down from mother to daughter or from father to son, and certain crafts became family enterprises. An example of the distinctive kind of traditional art being produced with regularity in Africa are gourds called calabashes that are important in both daily and ceremonial life; these are produced by women of the Wodaabe tribe (fig. 1.23). Only a few calabashes are used to hold porridge and milk; a greater number are treasured as ceremonial possessions (newborn babies are traditionally bathed in calabashes). A calabash is covered with patterns: triangles, half moons, suns, and sinuous lines. The designs are thought to protect both the receptacle and its contents. In our definition, the makers of these beautiful objects must surely be artists.

In western culture, the notion of the artist as an isolated creative genius was first espoused in ancient Greece and then revived during the Renaissance. In 1949, the pioneer of electronic flash photography Gjon Mili (1904-84) photographed the modern artist Pablo Picasso (fig. 1.24). Mili set up his camera in a dark room and asked Picasso to draw with a flashlight; photographing the movement with his shutter open, Mili then used a flash to capture the artist's final gesture as he completed drawing a centaur (an ancient Greek mythological beast with a human torso on the body of a horse). The result might be called a double work of art, for the photograph captures a drawing by Picasso that would not otherwise have been preserved. Picasso's shorts and sandals suggest the artist's childlike naturalness, while the spontaneity of his creative process is documented in the unusual "drawing" recorded here. The photograph provides us with an intimate look at the creative process that would have been impossible in earlier centuries.

What we call art has assumed many forms and functions in world history, and the role of the creative individuals we call artists has constantly been reformulated.

1.24 Gjon Mili, Picasso Drawing with Light, 1949. Commissioned by Life Magazine.

2.1 The "Great Serpent Mound," Peebles, Adams County, Ohio. Fort Ancient culture (?), North America. Prehistoric in the Americas, c. 1070 CE. Length 1,254′ (382 m), average width 20′ (6 m), height approx. 4–5′ (1–1.5 m).

The "patron" would probably be the entire community, and perhaps everyone participated in the construction. The Fort Ancient culture was a Mississippian group that lived in the central Ohio Valley from c. 900 to c. 1600 CE.

Prehistoric Art

A BRIEF INSIGHT

The function of prehistoric works like this large snake-shaped mound in Ohio is uncertain because we have no documentation to help us interpret their meaning. Prehistory is defined as the period before writing, and without written records we have only the works themselves and archaeological evidence to help us interpret them. For many prehistoric cultures, even the archaeological evidence is slight. Nevertheless, the importance of the animal world for prehistoric cultures is evident in the works that survive, including mounds like this one and others shaped like animals; representations of deer carved on bone fragments; and the bulls, deer, bison, and other animals painted and carved on cave walls and cliffs.

In other known Mississippi River valley mounds, which were used for the placement of sacred objects or as burial sites, a superstructure was formed over a pit that was dug in what was to be the eventual shape of the mound. Clay or earth was then piled over this superstructure to complete the mound.

The tremendous scale and complex pattern of what is today known as the "Great Serpent Mound" (fig. 2.1) indicate that it almost certainly had a religious purpose for those who built it; it may have functioned as a site for prehistoric ritual, perhaps as part of a celebration of the life cycle (birth, puberty, death), or as a way of defining the tribe's relationship with nature. Whatever its original use, the mound survives as a thought-provoking reminder of our human ancestors.

Prehistoric Art

n a cave at Lascaux, France, painted animals—cattle, horses, bulls, bison, and deer—roam across walls and ceilings (fig. 2.2). The naturalism of these Paleolithic images is striking, for the animals are represented by means of a lively application of line and color that reveals careful observation and a profound understanding of the animals' anatomy and movement. In some areas, the natural undulation of the cave's surface matches the painted forms to give the animals a subtle three-dimensionality, and their apparent animation would have been enhanced by the flickering flames of the lamps or torches used for illumination when they were painted. These images, created in the period known as prehistory—the time before the development of writing—present many mysteries; their function and meaning are uncertain.

THE PALEOLITHIC PERIOD

The origins of image-making go back at least as early as the Paleolithic (c. 35,000–8000 BCE), a period characterized by

the use of worked stone tools (the term "Paleolithic," "Old Stone Age," is derived from the Greek words *palaios*, "old," and *lithos*, "stone"). Most Paleolithic people were migratory hunter-gatherers who journeyed in bands of twenty to thirty or even more family members. Their contact with other groups may explain similarities in Paleolithic art over vast geographic areas. As they followed the migrations of animal herds, it is presumed that men hunted while women, in addition to bearing and caring for children, gathered mainstay dietary staples—plants, fruits, nuts, and fish.

The Paleolithic period overlapped the last Ice Age, when glacial ice extended to southern areas of the northern hemisphere. During the warmer months, when temperatures reached 60° Fahrenheit, people probably lived in tents covered with animal skins. As cold weather approached, however, many sought protection in rock shelters, in mammoth-bone shelters, or in mouths of caves. But some caves were sought out for other purposes, which we still do not fully understand; it is in these caves that we find one kind of remarkable prehistoric art.

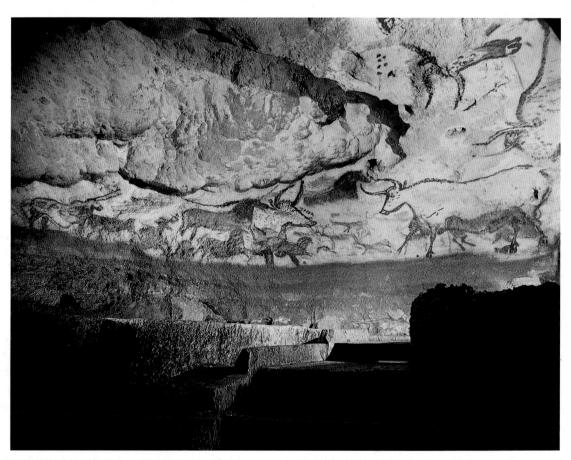

2.2 *Bulls*, rotunda, Lascaux cave, Dordogne, France. Paleolithic in Europe, c. 15,000–13,000 BCE. Cave painting, animals life-size.

THE DISCOVERY OF PALEOLITHIC PAINTING

During the summer of 1879, a Spanish archaeologist was digging near the entrance of a cave near Altamira, in northern Spain. He was hoping to find artifacts like the prehistoric tools with images of animals that had, beginning in 1840, been unearthed in France. His young daughter wandered into the cave, and soon her cries were heard. When her anxious father entered, he found her excitedly pointing to images of bison-animals that had disappeared from Spain more than 12,000 years earlier—painted on the ceiling. Cave art had been discovered. But the paintings at Altamira were not to be accepted as prehistoric until 1902; only after similar discoveries elsewhere would archaeologists accept the fact that such imagery and style could have been achieved by prehistoric people. Lascaux, the most impressive of these sites (fig. 2.3), was not discovered until 1940, and new discoveries during the late twentieth century continued to expand our knowledge of European Paleolithic cave painting.

PALEOLITHIC ART

Near the entrance of the cave at Lascaux, in an area known as the rotunda (see fig. 2.2), a grouping of bulls was painted on the cave walls. Look at the two bulls on the right. The smaller one, the first to be painted there, is represented in a quiet pose, as if grazing, facing right; its shape is created as a solid area of color. Painted over it at some later date is the outline that defines a large bull ambling to the left. Only a few details, such as the eye and shoulder vein (a target for the hunter?), are drawn within the contour lines. Both images were created by artists sensitive to the anatomy and liveliness of these wild animals.

Sometimes Paleolithic artists drew directly on the wall with red, yellow, brown, or black minerals or earth, but more often they created pigments by grinding minerals and mixing them with animal fat, vegetable oil, or bone marrow. They could apply these paints to the wall using a brush made of animal hair or a frayed stick; dots of color were sometimes pressed onto the wall with their fingers. Broader areas of color could be applied by blowing paint through a hollow reed or bone or by spitting the paint, mixed with saliva, against the wall. Whatever technique was employed, the skill was often remarkable, not only in the fluid execution of the forms, but also in the exacting observation and memory of the artist, who reproduced these naturalistic animal forms—some seemingly in movement—by lamp or torchlight.

In Paleolithic cave art, painted or sculpted images of animals often make use of natural protrusions in the cave wall or floor. The human imagination was evidently inspired by areas of natural relief that suggested the forms

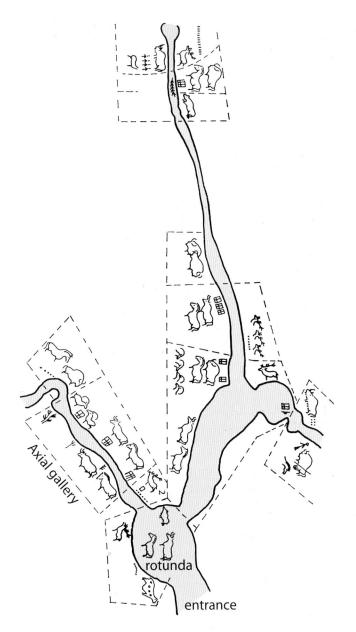

2.3 Plan of the Lascaux cave.

Like most cave paintings, those at Lascaux are not all near the entrance and many are rather difficult to reach, supporting the theory that they are ritualistic rather than decorative. One recent theory suggests that the caves chosen to be painted were those that offered strong echoes suggesting the presence of the spirit world. In these same caves clapping hands create the sound of thundering herds of animals.

of a particular animal; by adding paint or by carving, representational images were created. The theory that art originated in such an "image by chance" was stated in the West by the fifteenth-century artist and theoretician Leon Battista Alberti. In his book *On Sculpture*, Alberti writes about the birth of sculpture:

I believe that the arts of those who attempt to create images and likenesses ... originated in the following way.

They probably observed in a treetrunk or clod of earth and other similar inanimate objects certain outlines in which, with slight alterations, something very similar to ... nature was represented. They began ... [to] take away or otherwise supply whatever seemed lacking to effect and complete the true likeness.

Alberti had not seen cave art, but recent archaeological discoveries have lent support to his supposition. Alberti's desire to explain the goal of art as representational is related to European attitudes about the visual arts. Where the attempt to create what might be termed "inner likenesses" dominates, as in China, Japan, Africa, Polynesia, and much of South and Southeast Asia, works are judged not on observational accuracy but on the ability to convey behavior, expression, or character.

In cave art, some animal images are shown pierced with spears or points, possibly as a practical demonstration to younger hunters. The location of the paintings and the overpainting of images on successive occasions, perhaps hundreds or even thousands of years apart, suggest that they may have served a ritual purpose. The practice of recreating the animals through representation may in some cases have been an attempt to capture their life spirits and thus help ensure a successful hunt. Whatever the function of the images, it seems to have been important that they be lively and identifiable by species. The rare occurrences of the human figure in Paleolithic art range from the representational to the schematic, but the majority are sticklike figures. Perhaps it was feared that too naturalistic a representation could capture the life spirit of the human being portrayed.

Of the sculptures that survive from the Paleolithic era, one type—involving about 150 sculptures from central Europe, Eurasia, and as far east as China—poses unique

problems of interpretation. Barely a few inches in height, these figures represent females whose breasts, abdomens, hips, and thighs are enlarged (fig. **2.4**). Traditionally, these figures have been viewed as images of fertility, perhaps for use in a ritual dealing with childbearing, and the exaggeration of the parts of the body related to reproduction is a conscious abstraction by the artist. Scholars have also suggested that these figures made reference to the qualities

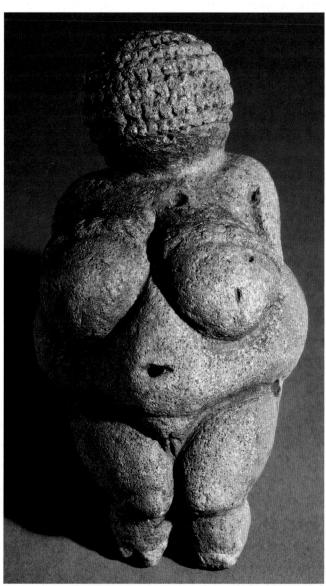

2.4 Statuette of a Woman, found at Willendorf, Austria. Paleolithic in Europe, c. 25,000–20,000 BCE. Stone, height 4½" (11 cm). Museum of Natural History, Vienna, Austria.

Statuettes such as this one have been traditionally, but improperly, known as Venuses. Other similar figures are carved from mammoth ivory or modeled in clay. The navel of this figure is a natural indentation in the stone. Whether such works were made by particular artisans on demand or by individuals for their own use is unknown. The earliest known example of a carved figure is a similar representation of a woman (the Lady of Berekhat Ram) that evidence suggests was made at least 230,000 years ago.

needed by the "ideal" Ice Age woman, with the fat accumulation desirable to conceive and bear healthy children during periods of food scarcity. Other explanations propose that these figures functioned as guardian figures, or even simply as dolls. Recent scholarship has demonstrated that, as a group, they display various stages in a woman's life, from youth, maturity, and pregnancy to old age. Some archaeological evidence suggests that they were both made and used by women. Our uncertainty about the function of these sculptures is directly related to the limited evidence we have about Paleolithic life and culture.

THE NEOLITHIC PERIOD

About 10,000 BCE, a more moderate climate increased the food supply for the hunter-gatherers. During the Mesolithic (Middle Stone Age), the period that followed the Paleolithic era and lasted varying lengths of time in different parts of the world, techniques of gathering food became more efficient, and the cultivation of plants began. These developments led to the Neolithic era (New Stone Age) in about 8000 BCE in the Middle East, Africa, and Asia, and about 5000 BCE in Europe. The Neolithic period is characterized by the domestication of plants and animals and the development of a sedentary lifestyle. Some hunter-gatherers settled into larger, kinship-based communities, probably as a result of several factors, including defense (scenes of human conflict are found in Mesolithic rock painting), economy, changing ecology, and religion. Job spe-

cialization developed at this time. Architecture of stone, mud bricks, and timber provided more permanent homes, and the development of pottery for storing and protecting food also contributed to a stabilized environment. In western Europe, Eurasia, Korea, Japan, and parts of Southeast Asia, Neolithic peoples raised large stone monuments, as at Stonehenge (see fig. 2.8).

NEOLITHIC **A**RT AND ARCHITECTURE

A modest clay pot is evidence of one of the most consequential transitions in the development of humanity (fig. 2.5). Its design reveals its function as a container for food, and the twisted cord impressions suggest an aesthetic desire to make the object look pleasing. These designs, however, may also be explained as an aid in firing; they allowed heat to more thoroughly enter the body of the clay. Firing at high temperatures would make the pot water-tight. Pottery was important to the stabilized living environment of the Neolithic period because fired clay vessels were essential for cooking, transporting, and storing food.

The origins of pottery vessels are uncertain, but we now know that pots, first fashioned in the Mesolithic period, became a standardized production in the Neolithic. Early clay pots may have been molded over a round stone or hand-built by coiling (building up the walls of the vessel by successively adding long ropes of clay and then smoothing the joints). The pots were usually fired in open pits over fires of wood or dung, but soon special furnaces called kilns were developed for the firing of clay objects. The patterns on some early vessels may have been adapted from weaving patterns. Perhaps wet clay was used to strengthen and waterproof woven baskets, and clay vessels were then made in imitation of the clay-impregnated baskets. By approximately 3000 BCE, the potter's wheel, a revolving stand for forming clay vessels, was in use throughout western Asia and in parts of China; it greatly increased productivity and encouraged the development of new modes of decoration. Pottery-making also signaled economic changes, for the making of clay vessels apparently became a specialized activity of craftworkers, who could trade their wares for other goods within their own community. Later, pottery was sometimes traded from one community to another.

Çatal Hüyük, a sophisticated settlement of about 10,000 people that prospered from approximately 6700 to 5700 BCE, has provided additional information about developments during the Neolithic period. Besides agriculture

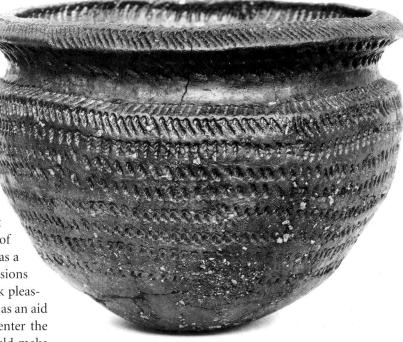

2.5 Pot, found in the River Thames near Hedsor, Buckinghamshire, England. Neolithic in Europe, c. 3100-2500 BCE. Terra-cotta, height 5" (12.7 cm). The British Museum, London. Whether such works were made by artisans or by individuals for their own use is unknown.

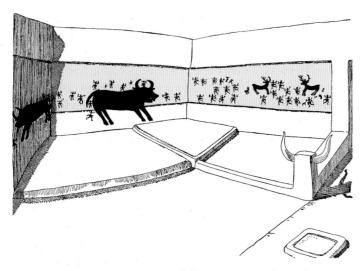

2.6 *Animal Hunt*, restoration of Shrine AIII.1, Çatal Hüyük (Turkey). Neolithic in the Middle East, c. 6000 BCE.

and animal breeding, Çatal Hüyük was also an important center for trade. One of the shrines excavated there contains a painting of a red bull surrounded by miniature human figures (fig. 2.6). Unlike Paleolithic paintings, which were executed directly on cave walls or ceilings, here a surface of white plaster was prepared first. If a new painting was required, another layer of plaster was laid over the previous painting to avoid the superimposition seen in some Paleolithic painting. The bull here probably relates to a religious ritual, for it was most likely a symbol of the male deity, embodying strength and fertility; bull skulls and horns were found in some shrines. The bull at Çatal Hüyük lacks the naturalism and vitality of its Paleolithic predecessors; it is less descriptive of a particular animal and more a diagrammatic symbol. This transformation might be the result of a different function for the image of the bull, or it might also reflect an abstraction brought about by sequential repetitions of an earlier painting of a bull. This more schematic rendering of the animal and the increase in the number of human figures portrayed are characteristic of Mesolithic and Neolithic painting. But the treatment of human and animal figures varied considerably in different Neolithic communities.

In Nigeria, on the Jos Plateau, Neolithic finds have confirmed an early figurative sculpture tradition in sub-Saharan Africa. Among the most striking of these terracotta (fired clay) human and animal figures are the Nok heads (fig. 2.7), so called because of their initial discovery in the tin mines of the village of Nok. Apparently, these heads were once joined to fully modeled figures. In a tradition characteristic of much of African art, the features of the heads are both emphatically naturalistic and powerfully abstracted. Whether or not such heads were meant to be an early form of portraiture is unknown. The placement and function of the Nok sculptures also is not known; it has

been argued that some of them were finials to decorate secular, civic, or sacred architecture. Other scholars stress the likelihood that such figures honored ancestors, probably in part to communicate with the spirit world of the deceased. Recent scholarship suggests that these works may have been made by women. As with other prehistoric art, more extensive archaeological investigation is needed in order to begin to interpret their use.

On the North American continent, the most conspicuous remains from the Neolithic period are giant earth mounds, such as the Great Serpent Mound in Ohio (see fig. 2.1). One of a number of mounds in the form of animals, the Great Serpent Mound consists of a low embankment, nearly a quarter of a mile long, which depicts a giant serpent uncoiling. Although the builders and purpose of this mound remain unknown, the Great Serpent Mound may have been associated with the prehistoric Fort Ancient Amerindian culture. Most earthworks are oriented toward

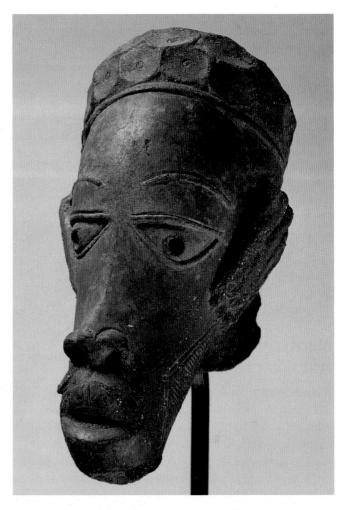

2.7 Head, Nok culture, Africa. Prehistoric in Africa, c. 600 BCE–250 CE. Fired, burnished terra-cotta, height, 1' $1\frac{1}{2}$ " (4.1 m). The Cleveland Museum of Art, Cleveland, Ohio.

Notice the decorated cap worn by the figure, and the triangular area of tattooing or scarification on the cheek.

the east, perhaps invoking a ritual of renewal involving the rising sun.

During the Neolithic period in western Europe, orientation toward the sun was also found at Stonehenge in England (fig. 2.8), an extraordinary stone monument erected during this period. Among the common types of stone monuments erected during this era for burials and ritual spaces were stones weighing several tons that were raised upright. A single large block is known as a megalith, or as a menhir when it is placed upright. When placed in a row, menhirs become a cromlech. Such monuments are not unique to Neolithic Europe but are also found across central Asia and into East and Southeast Asia dating from the Neolithic period.

The testimony of prehistoric monuments in Europe remarkably later than elsewhere—is best evoked by the remains of Stonehenge, where an outermost ring of smaller stones set flush to the ground surrounds an inner ring, or

cromlech. The innermost group of stones is composed of pairs of stones with lintels (trilithons); they form a horseshoe that defines an axis within the circular plan. The axis at Stonehenge is established through this horseshoe by the heel stone, which leads the eye to the point on the eastern horizon where the sun rises on the dawn of the summer solstice. Other stones seem to have been aligned in relation to the setting sun on the winter solstice and various phases of the moonrise.

The arrangement of the stones at Stonehenge reveals the importance of celestial events for Neolithic peoples. The emphasis on the summer solstice implies that it was the most important of these events. The scale of the complex and the difficulty of construction suggest that Stonehenge was also a setting for religious rituals, again with the summer solstice as the major festival. This union of religion with celestial events is common in many early belief systems. An understanding of the regular cycles of the seasons

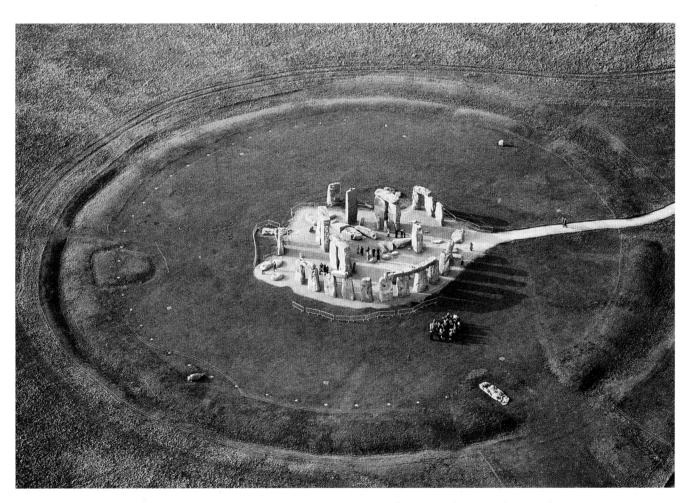

2.8 Stonehenge, Salisbury Plain, Wiltshire, England. Neolithic in Britain, c. 2750-1300 BCE. Earth markings and megaliths of gray sandstone and igneous bluestone; diameter of outer embankment about 300' (91 m), diameter of outer circle of stones 106' (32.3 m); original height of tallest stone approx. 24' (7.7 m).

Stonehenge was constructed in four stages between c. 2750 and 1300 BCE. Some of the megaliths were transported as far as 190 miles, probably dragged on sleds and floated on rafts. They may have been raised using a series of levers. Earthen ramps were constructed to place the lintel stones. The entire community probably supported and participated in the construction.

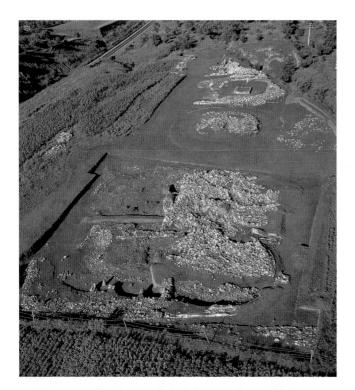

2.9 Ritual Center, Hongshan Culture. Prehistoric in China, c. 3500-3000 BCE. Main square area approx. $50' \times 50' (15.2 \times 15.2 \text{ m})$. Excavated at Dongshanzui, Lianoing Province, People's Republic of China.

The imposition of geometric shapes onto the landscape and their orientation to the cardinal points of the compass, as here, are elements found in many prehistoric sites around the world. Like most prehistoric monuments, the "patron" would most likely have been the entire community.

based on celestial observation is also intimately related to the planting and cultivation of crops (an especially difficult problem where there is a short growing season), and thus both ritualistic and practical needs may have been served by Stonehenge.

In the Middle Neolithic in Asia, during the fourth millennium BCE, sophisticated developments were underway. In China, several cultures began to produce refined jade artifacts signaling trends toward social inequality, craft specialization, and public architecture; one of these cultures, called the Hongshan, was centered on the Liao River drainage in northeast China. A variety of ritual features were recovered there, and their size and careful spatial organization illustrates an attention to activities far beyond a daily subsistence routine (fig. 2.9).

At Dongshanzui, several round and square features were excavated. The enclosing walls and an open area identified by the archaeologists as a "plaza" create the impression that this site was a compound. While no daily or utilitarian artifacts were identified there, human figurines of clay, jade animal carvings, and painted clay cylinders were found in large numbers. A human burial accompanied one of the circular stone pavements. A large site, it probably

served as a communal ritual center for, and was maintained by, surrounding villages.

At another Hongshan site at Niuheliang, graves included hardstone, carved jade artifacts shaped like birds, pigs, turtles, and what are today called "pig-dragons" (fig. 2.10). Found near the bodies of the deceased, these jade objects, which are pierced so that they could be suspended, probably decorated a dress or head gear. The pig-dragons are thick disks with a slit at the position of the nose or mouth that suggest the rudiments of a fantastic animal with a pig-shaped head and a curled body. Exactly what these composite animals signified is still controversial.

PREHISTORIC ART AND THE PREHISTORIC ARTIST

Prehistoric art embraced a variety of forms and media. There were carvings in ivory and other materials, modeled clay figures, an array of tools and functional objects, such as sewing needles and spears, and even musical instruments.

2.10 Pig-dragon, Hongshan Culture. c. 3500 BCE. Jade (nephrite), height $6\frac{1}{2}$ " (9 cm). Shanghai Museum, Shanghai, People's Republic of China.

CHAPTER 2

The earliest known flute, for example, was carved of bone about 30,000 BCE.

Study reveals that the efficiency of tools and instruments increased as civilization passed from the Paleolithic into the Neolithic era. Many of these tools had geometric designs or outlines of fish or other animals incised or carved into them.

If much prehistoric art was in fact used in rituals, then those who created the images may have been the individuals in the community who functioned as shamans or mediators with the spirit world. The ability to lead rituals and to create images may have been a specialized talent that was perpetuated through one or a few persons in each group. Perhaps they were recognized in their communities as having superhuman powers that would allow them to make efficacious images that could help lead the community to spiritual experience. If so, then it is possible that the images were produced in rituals observed by most or all of the community; they could thus be understood as public art in the most profound sense.

In settled Neolithic communities, the creation of pots, stone knives, and other objects most likely resulted from a developing division of labor. Artisans were often specialists; they were potters, stone carvers, leather workers, and others whose works are lost to us because their materials were perishable. This early production must have been carried on both by specialists and by families. Pottery probably began as a family activity, but as the demand increased, the most skilled potters became specialists who were allowed to concentrate on the production of pots instead of other tasks.

POINTS OF CONTACT

Prehistoric Figurines of Women

This fragment of a clay female figurine (fig. 2.11) is one of many similar examples found in a Neolithic ritual site in present-day northeast China. It was excavated in a location known as the Goddess Temple. Neolithic figurines of this sort have been found across Eurasia and as far west as central Europe. Some examples, including the famous statuette from Willendorf, in Austria (see fig. 2.4), are much earlier in date (Paleolithic period, c. 25,000-20,000 BCE). Because of the vast differences in time and location, we cannot assume that there was contact between the groups who created the figurines, but their continued creation and use suggests shared values. Previously it was presumed that these common ideas originated from some single impulse or insight and were then diffused across space and time. Although that could be possible, it is more likely that groups in different locations and times spontaneously shaped and used similar iconography and perhaps even invested it with comparable meaning.

Paleolithic statuettes like the one from Willendorf were used by people engaged in hunting and food gathering who lived in widely scattered groups; their other implements that have come down to us, which are mainly made of bone and stone, suggest use for differentiated activities and reveal the culture's dependence on what nature can provide. While images of men play a leading role in cave painting in association with scenes of the hunt, female figures predominate in small sculpture. Most think that these statuettes are a sign of respect for, or even veneration of, female fertility. A similar interpretation has been given to the statuettes from Niuheliang, but in this case the lifestyle was based on cultivation of crops and animals and was thus sedentary rather than nomadic. But women continued their roles as child bearers and nurturers, and perhaps such statuettes were intended to venerate those vital contributions.

2.11 Clay Figurine of a Woman. Found in 1981, excavated in 1983, in a square stone mound with rows of stone coffins, Niuheliang, Liaoning, China. Neolithic Period, Hongshan Culture, c. 3200 BCE. Unbaked clay, height 4¾" (12 cm). Liaoning Provincial Institute of Archeology and Cultural Relics, Cultural Bureau of Chaoyang City, Liaoning, PRC.

Ritual and Art

Ritual Art and Ritual Practice

(figs. 2a and 2b) The shrine excavated at Catal Hüyük is abandoned and, to us, mysterious. Although the images painted on the walls clearly represent bulls and human figures, and bull horns form part of the decoration, there is little evidence that would explain how these images and this room once functioned. From what we have learned about shrines in other prehistoric and historic societies, however, it seems reasonable to assume that the Catal Hüyük shrine originally provided the setting for a ritual. Ritual function also seems logical for some other prehistoric sites, including Stonehenge in Great Britain (see fig. 2.8). Without the discovery of additional evidence we cannot presume to accurately reconstruct these prehistoric rituals. However, our assumption that these sites contained and directed ritual activities is an important factor in helping us to understand their original function. If we enliven one of these sites in our imaginations with human figures wearing some kind of distinctive garments and, perhaps, chanting, playing musical instruments, and dancing, then we can begin to sense some of the magic that such a site once offered. Even if our imaginative reconstruction is wrong in all its details, it nonetheless can provide us with a generalized notion of how such sites once functioned and how much we lose if we don't indulge in such a re-creation. The African ritual illustrated is likewise incomplete, for our reproduction lacks the movement, the rhythmic drumming, and the location of the ritual within a Bwa village. In this case the site of the ritual is not a special structure, but the village as a whole, and the observers would include the whole community. Ritual is common to all human societies; it can be religious, political, civic, social, familial, domestic, or personal—or a combination of these. Many examples of what we today call art were created to play a role in a specific ritual, and our understanding of such works is enhanced if we perceive them within their original ritual context.

An Ancient Roman Ritual

(fig. 2c) These paintings seem to document rituals performed by members of a cult that worshiped Bacchus, the ancient Roman god of wine and fertility. Because the cult of Bacchus was secret, these paintings provide insight into important moments in cult behavior and ritual, including flagellation and divination. What is missing are not only the transitional developments between these moments of high drama, but also the sounds and the emotions of the participants as they enacted their roles within this particular, and probably secret, space.

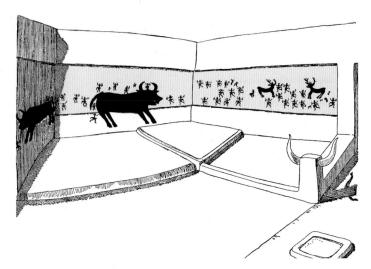

2a *Animal Hunt*, shrine from Çatal Hüyük (Turkey), c. 6000 BCE (for further information, see fig. 2.6 and pp. 25–26).

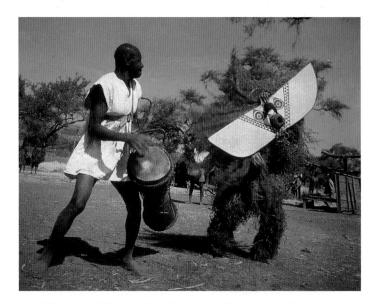

2b African ritual dancer, Bwa culture, twentieth century (for further information, see figs. 1.16 and 12.14, 12.15).

Christian Ritual

(fig. 2d) Although examples similar to the objects depicted here survive in museums and church treasuries, this painting shows such objects in use during the ritual of the mass. Note the rug, the cross and altarpiece on the altar, the cloth that decorates the altar front, and the book from which the priest is reading the service. Candles are commonly used in religious ritual, as seen here. The garments of the priest distinguish him from the other

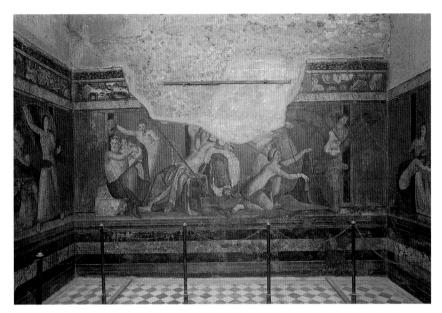

2c Ancient Roman frescoes from the Villa of the Mysteries, c. 30 BCE (for further information, see fig. 4.42 and pp. 126–27).

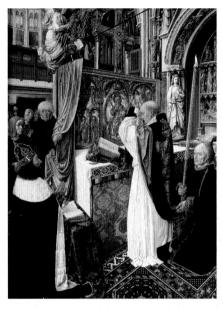

2d Master of Saint Giles, The Mass of Saint Giles, c. 1500 (for further information, see fig. 5.6 and p. 148).

figures and suggest his role in the ritual enactment. What we are seeing, however, is just one moment during the mass; we miss the processions at the beginning and end, the gestures, the sound of readings and bells, and the smell of incense. Hidden behind the priest on the altar would be a chalice for wine (for an example, see fig. 6.24) and a tray for

Contemporary Art and Ritual

(fig. 2e) The many rituals that survive in our modern world include not only religious services, but also holiday parades, presidential inaugurations, graduation ceremonies, and, it can be argued, going to the art museum, the opera, the ballet, and other performances. Concerts by popular groups now often include scenery and lights, and demand choreographed responses from the audience; the same is true of cult films, such as The Rocky Horror Picture Show. In a secular society, cultural rituals come to play an increasingly important role. While many cultural activities are passive in nature (as when spectators view a performance), installation art, as seen in this example by Ann Hamilton, demands participation. Installation art is temporary, lasting only as long as the exhibition in which it is featured; it is then dismantled after being documented by photography. Often we can enter the work, as here, and we may even be asked to change it by moving something or taking something away with us. We thus come to play a role in a ritual designed by an artist.

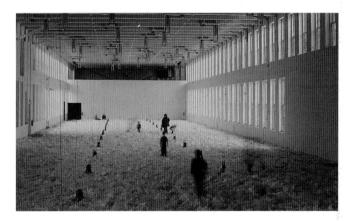

2e Ann Hamilton, Corpus, installation at Massachusetts Museum of Contemporary Art, North Adams MA, 2004 (for further information, see fig. 14.16 and p. 618).

Questions

- 1. What repeated rituals in life are meaningful to you: a religious service, a concert by a popular group, a family event such as a holiday meal or family reunion?
- 2. Do these rituals involve visual objects?
- 3. How would a photograph of one of your rituals be incomplete in suggesting the richness and complexity of your experience and response?

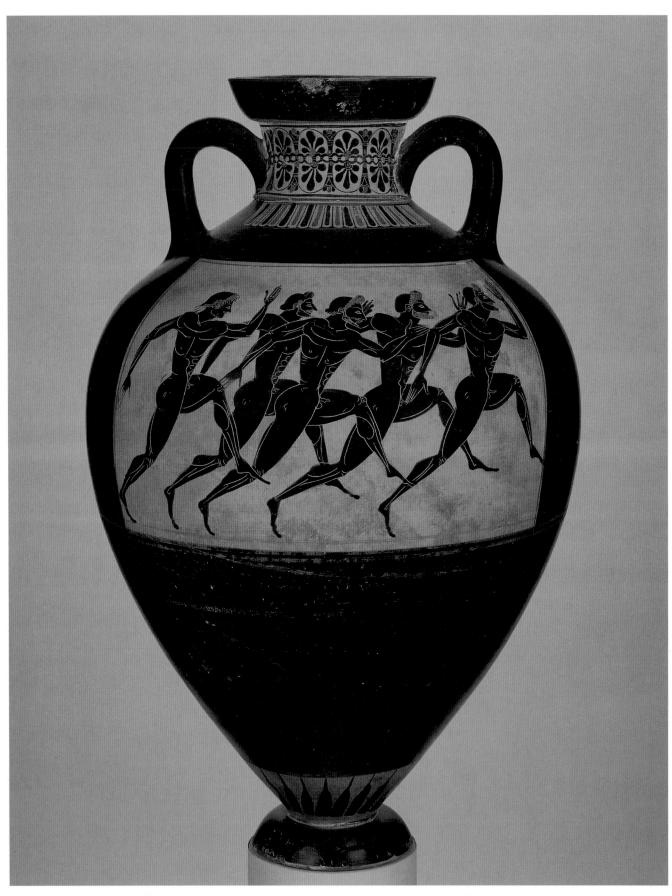

3.1 Panathenaic Amphora with Runners, Ancient Greek. c. 520 BCE. Painted terra-cotta, height 2' $\frac{1}{2}$ " (62 cm). The Metropolitan Museum of Art, New York. Commissioned by the Panathenaic organizing committee.

Ancient Art

A BRIEF INSIGHT

uring the ancient period of human history, complex societies developed in many parts of the world and, because of the invention of writing and the preservation of documents, we have a new kind of evidence that tells us much about these groups and their ideals and activities. During the ancient period, complex and highly decorated structures were erected to house rulers or honor gods, and paintings, sculptures, and other objects were created to fulfill various functions. The object shown here (fig. 3.1) was the prize awarded to the winner of a race at competitive games held in ancient Greece; the most famous of these games, held at Olympia, became the basis for today's Olympic Games, in which athletes from all over the world compete. This particular container was made for the games held in the most important of all the ancient Greek cities, Athens. This type of vessel, known as an amphora, was used for storage; in this case, as a prize, it was filled with oil made from olives grown on special trees. The container is not merely functional, for the manner in which it rises from its narrow base and the integration of the handles into the overall shape reveal an interest in beauty, as does the patterned decoration on the base and neck. The sprightly runners identify the object as the prize for the Athenian race, while the manner in which they are drawn reveals the Greek interest in representing the human body.

Introduction to Ancient Art

'he remarkable scene found on the back of this hand mirror (fig. 3.2)—a winged man huddled over an object on an altar-is unexpected, and is at first enigmatic. But because our knowledge of ancient cultures is much greater than our understanding of prehistory, we have evidence that this scene represents a practice common among many ancient peoples. It was widely believed that the interpretation of natural occurrences and objects provided omens that could predict future happenings. The flight patterns of birds, the location of lightning, the cracks on a bone thrown in a fire, or, as depicted here, the "reading" of spots on the liver of a sacrificed animal, were important ways in which ancient peoples tried to comprehend both present and future. The owner of this mirror would have felt reassured that divination could be used in determining decisions and choosing appropriate behavior.

The transformation from prehistory to what we today call the ancient world is founded in the invention of writing. This happened in different locations at different times, as we shall see. In this text the end of the ancient world is dated to about 200 CE because this marks the beginning of the expansion of the religions of Judaism, Christianity, and Buddhism.

It is the emergence of writing in the ancient period that enables us to determine the subject of this mirror. The name "Calchas" written in Etruscan script on the mirror identifies the diviner practicing here. The subject and style of the engraved design are drawn from the traditions of Greek mythology, which were popular with the Etruscans, the people who created and used the mirror. Like many surviving ancient objects, Etruscan mirrors are most often excavated from tombs, where they were buried with their owners so that they could be used in the afterlife, And, like many objects that survive from the world's ancient cultures, this Etruscan mirror served both practical and religious purposes.

Beyond being an example of ancient art, the Etruscan mirror is also a reflection of the particular society that created and used it. The Etruscan civilization (see also pp. 70–71) was a loosely bound federation of city-states in central Italy that in time paralleled the ancient Greek. Because the Etruscans' written language has yet to be fully translated, our knowledge of their beliefs and practices is largely derived from the archaeological evidence of their burial practices. They apparently believed in an afterlife that was a continuation of their earthly existence, and their grave goods suggest that the deceased were commonly buried with many of the goods they used in life. The **naturalism** evident in the figure of the winged Calchas, the surrounding

3.2 Calchas Divining the Future, Etruscan, c. 400 BCE. Bronze, engraved back of a mirror, diameter 6" (14.8 cm). Vatican Museums, Rome, Italy. The highly polished bronze surface of the reverse would have functioned as a mirror; the handle does not survive.

grapevine, the table, and the vase, characterizes a style of representation often found in the ancient Western civilizations of Greece, Etruria, and Rome, but it is unlike the more abstracted styles practiced in ancient China and India.

Abstraction characterizes a distinctive group of figurative sculptures (fig. 3.3) created in the Cycladic Islands in the Aegean Sea during this period. Also associated with funerary practices, these sculptures, which range in size from a few inches in height to almost life size, were not freestanding; they were found lying on their backs within burial sites. The majority of these figures, which originally would have had details painted on the marble surface, are female, yet in the absence of written documentation their purpose remains unknown. Whether they represent goddesses or fertility figures is conjectural, and it is uncertain if the clean, abstracted appearance is the result of an aesthetic choice or one dictated by ability and technique in carving marble.

Twentieth-century archaeological investigations have uncovered a wealth of objects in grave settings in China. In clear contrast to the naturalism of the Etruscan mirror, ancient Chinese bronze vessels, like this *fang ding* (fig. **3.4**), first attract our attention because of the combination of powerful yet simple shapes with overall geometric designs. However, what at first seems to be nonrepresentational patterning on this *fang ding* is a combination of parts of animals, beasts, and birds. The main motif is the *taotie*, or monster mask, the most famous pattern used on early

3.3 Figure of a woman, Cycladic, c. 2500 BCE. Marble, height 15 3/4" (40 cm). Nicholas P. Goulandris Foundation; Museum of Cycladic Art, Athens.

Chinese bronzes. The typical taotie is symmetrical, with stylized representations of eyes, ears, an open jaw, and feet. Sometimes the ears resemble those of oxen or cows; other times they appear to be closer to those of deer. Why references to certain animals were made is not known, but the image always suggests power and presumably also shows respect for the animal kingdom.

Vessels such as this were created to hold offerings of food and wine during Chinese ceremonies dedicated to the veneration of ancestors. Sets of these containers were placed on family altars and were buried in tombs of members of the ruling and aristocratic classes. These early bronze vessels sometimes had inscribed dedications to the deceased; beginning about 1000 BCE, inscriptions refer to historic events and legal transactions, and are an important source of information about ancient Chinese life. The tombs where such vessels have been found also contained bronze weapons, some of which are inlaid with semiprecious stones, as well as

3.4 Fang ding, Chinese, from Tomb 1004, Houziazhuang, Anyang, Henan Province, China. Shang Dynasty, c. 1150 BCE. Bronze, height 2' 6" (80.1 cm). Academia Sinica, Taipei, Taiwan, Republic of China. Commissioned by a member of the Shang imperial family.

ceramic vessels and objects carved from jade and other stones. These luxurious objects were intended to confirm the political, military, and spiritual power of their patrons.

Anyang (see map, p. 161), where this fang ding was excavated, was the last capital of the Shang Dynasty (c. 1766–1122 BCE); the vessel's decoration also may have referred to the royal clan that ruled China during this period. The taotie on all four sides of the fang ding, for example, is thought to be the emblem of the Shang Dynasty. The animal forms that create the vessel's patterns are believed to represent mediums through which earthly beings could communicate with the spirits of their ancestors. This idea may be related to shamanistic religious practices in China and elsewhere in which communication with the spirit world was aided by animals that were thought to have special powers of transcendence. A priest or holy person, often wearing a mask or ritual dress made of animal parts (horns, feathers, skins), was understood to change not only appearance but also state of being, to transcend this world to that of the spirits; in some cultures these beliefs and practices have continued into the twenty-first century. The interrelationship between the spiritual and physical worlds demonstrated in many ancient objects is evidence that a spiritual underpinning governed much of everyday life during the ancient period.

HISTORY

As husbandry, communal living, and the other distinguishing characteristics of Neolithic culture continued to emerge, some geographical areas gradually developed a more complex, urban existence. In fertile river valleys where abundant food was available—the Tigris and Euphrates in Mesopotamia, the Nile in Egypt, the Indus and Ganges in India, and the Yellow River in China—urban civilizations developed.

The first cities became administrative and/or religious centers for the surrounding territory, and many monumental works of public architecture are symbols of the new central governing authority. As these cities and their territories grew in size and population, production became specialized and a division of labor developed, often reinforcing class distinctions. In some cultures, the administrative authority of the political/military and religious classes, which often existed in a symbiotic relationship, was supported by a system of taxation or tribute.

Systems of writing and mathematics evolved in response to the needs of the new urban centers. The promulgation of laws and the keeping of records helped to provide order and continuity within the new complexity of urban life. Writing and mathematics also made possible the advent of literature and science.

These aspects of a more complex and interrelated urban lifestyle were present in different measures in societies beginning about 4000 BCE, but their development was not uniform. In Mesopotamia and Egypt, they began about 4000 BCE; they date to about 2200 BCE in India and 2000 BCE in China. In the Americas, settled life was only known in the first millennium BCE. In western Europe, civilization emerged noticeably late, as is indicated by the realization that the prehistoric monument of Stonehenge (see fig. 2.8) dates from the same period as historical developments in Sumer and Egypt.

ART OF ANCIENT SOCIETIES

What we know about ancient civilizations comes largely from analyses of archaeological remains, artifacts produced by skilled artisans, and literature written by ancient authors. Literary remains are virtually nonexistent (or cannot be translated) from some ancient cultures, however, and most of the artifacts from archaeological investigations provide only a limited sample of evidence. Nevertheless, most early peoples produced materials that can help us understand their attitudes about spiritual, political, social, and economic matters.

Monumental architecture and public works such as temples, baths, amphitheaters, and granaries reflect societies that cared about issues of public as well as spiritual health. In the west, some large-scale architectural and sculptural monuments were dedicated to a combination of political and spiritual ideas, while in China spiritual and political power were more often expressed through ritual vessels and burial practices than architecture. Although many ancient sculptures and paintings represented deities or leaders, some examples also recorded everyday activities.

Works of ancient art and architecture were made from a wide variety of enduring media, from common limestone to the most precious metals and gems, but "perishable" arts such as literature, dance, and music are largely lost to us. In many cultures they may have been as significant as their surviving visual counterparts, and thus our understanding of each ancient culture is in some way partial and incomplete. Nevertheless, study of the remains that have come to light provides clues to the common as well as the distinctive traits of human behavior worldwide.

The naturalism seen in the representation on the Etruscan mirror was based on developments in Greek art and culture that influenced not only the Etruscans, but also the Romans. Ancient Greek texts on many subjects have helped us to reconstruct their attitudes about art and to explain the naturalism that was such an important basis for ancient Greek developments. The first-century CE Roman writer Pliny the Elder, for example, describes a contest between two late-fifth-century BCE Greek artists:

[Parrhasios] entered a contest with Zeuxis, and when the latter depicted some grapes with such success that birds flew up to the [painting], Parrhasios then depicted a linen curtain with such verisimilitude that Zeuxis, puffed up with pride by the verdict of the birds, eventually requested that the curtain be removed and Parrhasios' picture shown.... When Zeuxis understood his error, [he] conceded defeat ... because he himself had only deceived birds, but Parrhasios had deceived him, an artist. It is said that afterward Zeuxis painted a picture of a boy carrying grapes, and when the birds flew up to them, he approached the work and, in irritation with it, said, "I have painted the grapes better than the boy, for if I had rendered him perfectly, the birds would have been afraid."

(Pliny, Natural History, XXV)

The interest of Greek painters in rendering naturalism of appearance was paralleled by Greek sculptors' interest in convincing poses, subtle anatomical features, and spontaneous movement, as we shall see. These Greek interests had a profound influence on later developments in the Mediterranean area.

ART PAST/ART PRESENT

The Concept of the Classical in the West

The terms *classic* and *classical* are widely used today, yet they have a number of different—and potentially confusing—meanings. In the context of ancient Greek art, for example, the term *Classical period* refers to a particular period within the development of Greek art (see pp. 81–91); it received that name because in the nineteenth century it was seen as the high point of Greek art and culture (see pp. 440–41). The term *classical*—with a small c—has a broader meaning, referring generally to the

principles of order, harmony, balance, and clarity that are evident in much Greek and Roman art and architecture; this usage is based on the importance of these works during the Renaissance and later periods. An even broader usage is evident in the terms classics and Classical World, which are used today to refer to the study of the literary and other accomplishments of the Greeks and the Romans. And when we speak of something as a "classic," we imply there is agreement that the work has a timeless significance.

THE ANCIENT ARTIST

In most ancient civilizations, artists—the men and women who created what we now commonly refer to as works of art—were counted among the ranks of laborers, and their products were seen as the result of manual effort. Most works of art were the products of groups of trained artists working together in workshops, with various individuals undertaking differing aspects of the process of production (see p. 18). Because apprentices in these workshops learned traditional forms and techniques, a continuity of artistic and iconographic formulas was ensured.

During the ancient period, most works were commissioned by patrons, but because historical records are scarce, often we do not know their names. This does not mean that we should forget their important role in defining to the artist the kind of work they needed and how they felt it should function; in this period, art was very much a collaboration between the person(s) who commissioned the work and the artist and workshop that produced the finished product.

The role of rulers in ordering works of art to bolster their regime and express their wealth and beneficence was a common one during this period. Although rulers sometimes took pride in employing artists of significant talent, these instances did not contribute greatly to the social or economic prestige of the artist. In Greece, the personality and individual style of a number of artists are documented. Although these artists were personally admired, their profession was nevertheless viewed as lacking the philosophical and educational values of the liberal arts. Later Roman patrons valued Greek works of art as well as Greek artists, but Roman artists usually remained anonymous.

In China and India, embellished objects such as cast bronzes and stone carvings were designed and produced by craftspeople who usually worked together as a team; their specialized knowledge may have given them distinctive status in their communities. The creation and construction of ancient religious and urban complexes required cooperation, specialization, and overall coordinated management—prerequisites for ancient civilization. In the modern world, recognition of the role of the individual creator is considered important, but it was not an important factor in most ancient societies.

As we move into our discussion of the ancient world and later historical eras, we will adhere to a relatively strict chronological development. This means we may move, for example, from Europe to China, Japan, and then India before returning to Europe. Our goal here is to emphasize developments around the globe and to compare the differing artistic responses made by ancient cultures to similar questions about the meaning of life.

POINTS OF CONTACT

Greek Artists/Scythian Patrons

This elaborate gold pectoral (collar) was discovered in a burial mound of a nomadic people known today as the Scythians (fig. 3.5). The preciousness of this object, still immediately apparent today, derives from both its rare material and its style, for the execution of the delicate decoration and the tiny, naturalistic figures and animals is astonishing. Because they were nomadic, the Scythians carried their wealth with them in gold objects, but few other Scythian burial goods demonstrate such refined craftsmanship. The subject matter of the scenes, which combines battles between real and fantastic animals with scenes of animal husbandry, indicates that this work was made for a Scythian patron. It has been demonstrated that other Scythian gold grave goods were produced by ancient Greek artists and that there was trade between the Greeks and Scythians on the shores of the Black Sea. The highly naturalistic treatment of the animals and scenes on the pectoral led scholars to conclude that the artists who made it were Greeks, working in the naturalistic tradition first established by the Greeks (see pp. 36, 75), for a Scythian patron; recently, however, it has been suggested that the pectoral is the product of Scythian artists who had been trained to work in the Greek style. Whatever the case, this object demonstrates the intimate contact between two different peoples in the ancient world.

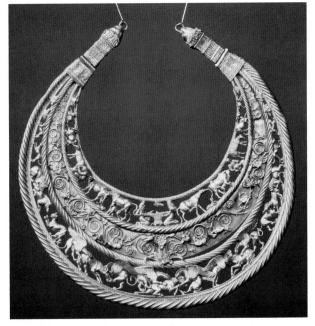

3.5 Gold Pectoral, Greek/Scythian (?), 4th century BCE. Gold, diameter 12" (30.5 cm). Kiev, Museum of Historical Treasures.

The pectoral was discovered in the Tovsta Mohyla burial mound. The weight of the gold is 2.48 pounds (1.125 kg).

The Presence of the Artist

The Artist as an Individual

(figs. 3a and 3b) The signature of Exekias on this ancient Greek pot and the name Polykleitos that can be associated with the sculptured figure from the same period reveal an important new attitude about art and artists. When artists sign their works or when artists are discussed as individuals in contemporary writings, both of which happened in ancient Greece, it means that the artist is being recognized in society as an individual, one whose creations are distinct from those of other artists. Polykleitos, who created the original *Doryphoros*, was literate (in some societies artists

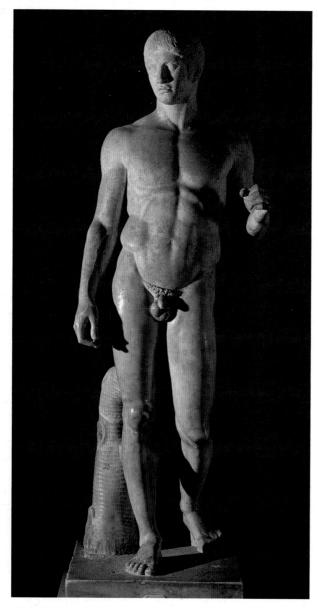

3b Polykleitos, *Doryphoros* (spear carrier), Roman marble copy after lost bronze Greek original, c. 450 BCE (for further information, see fig. 3.66 and pp. 81–83).

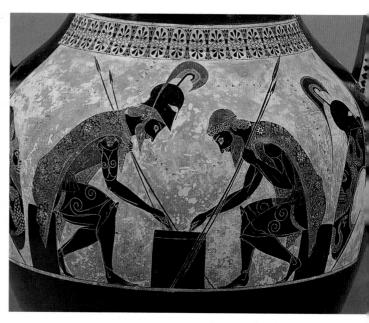

3a Exekias, *Achilles and Ajax Playing Draughts*. Black-figure decoration on amphora, c. 530 BCE (for further information, see fig. 3.58 and p. 76).

have been illiterate) and he wrote a book, The Canon (now lost), to record his theories about the harmonious proportions of the human body. While we have isolated examples of named artists in other ancient societies-Imhotep, the ancient Egyptian architect (see p. 51), is probably the earliest named artist in world history—the survival of the names of dozens of artists from ancient Greece is a new phenomenon. The notion of individual accomplishment and the fame it can engender is not limited to artists, and among the well-known figures of ancient Greece are Pericles the ruler-patron, Herodotus the historian, Sophocles the playwright, Plato the philosopher, and many others. The fact that artists shared in this development represents the earliest documented moment in human history when artists achieved high status and cultural significance as individual creators.

The Proud Artist

(fig. 3c) Although the ideal of the famous artist virtually disappeared from Western art during the Middle Ages, it reappeared with the changes that characterized the Italian Renaissance. Lorenzo Ghiberti completed two sets of bronze doors for the Baptistery in Florence. Both are signed and both offer a self-portrait; the self-portrait from the second set is illustrated here. For the second doors, Ghiberti added a pretentious inscription that praised his "marvelous art." Ghiberti also wrote one of the first autobiographies, in which he recorded his sense of his own importance and listed his works. Ghiberti was clearly concerned with personal fame, an idea that re-entered Western culture at the time of the Renaissance.

3c Lorenzo Ghiberti, Self-Portrait, 1425-52 (for further information, see figs. 7.10, 7.21, 7.22).

3e Yasumasa Morimura, Portrait (Futago), 1988 (for further information, see fig. 13.39).

The Active Artist

(fig. 3d) The number and character of self-portraits in a society indicate attitudes about artistic status. A selfportrait can reveal an artist's personal ideas about his or her role in society. In this example, painted when it was

3d Artemisia Gentileschi, Self-Portrait as the Allegory of Painting, 1630 (for further information, see fig. 9.8).

difficult for a woman artist to be successful, Artemisia paints herself as painting, taking advantage of the fact that the word for "painting" in Italian is the feminine noun la pittura.

The Contemporary Artist

(fig. 3e) In a tradition that goes back to the nineteenth century, Morimura's Futago exposes the artist as an individual personality; this manipulated photograph features the artist in two guises. He was the model for both the nude and the maid. His choice of a subject drawn from Western art (compare Manet's Olympia, fig. 11.46), the depiction of the artist himself (disguised but recognizable), and the manner in which he combines costumed figures with painted backgrounds would hint to any expert that this is by Morimura. In other words, this artist has developed a personal iconography and style that reveal his presence in his works.

Ouestions

Individuals who live in Western democratic societies are usually highly conscious of their individuality. One aspect of this is the individualized signature that we are encouraged to develop, which is so personal that it can be used as a legal test on financial documents such as checks and credit card receipts.

- 1. How are the design and format of your signature distinctive; are these elements intended to tell the viewer something about yourself?
- 2. How is your sense of individual identity conveyed to others by the manner in which you dress or by the objects with which you surround yourself?

Sumerian Art

ur study of individual cultures of ancient art opens with an impressive large carved stone vessel more than 5,000 years old (fig. 3.6). Its reliefs of processions and offerings reveal the importance of ritual and ritual objects, while the clarity of representation that characterizes the figures and their gestures suggests the rigid repetition and controlled movements typical of a ritual intended to please or placate the god or gods that directed the community's destiny. The vessel is, however, only a reminder of what must have been public events full of chants, music, movement, and perhaps incense.

In the Middle East, civilization began in Egypt and Mesopotamia at about the same time, between 4000 and 3000 BCE. Sumerian civilization was flourishing by about 3200 BCE, when the Sumerians brought the Tigris and Euphrates rivers under control for irrigation. At its height, the Sumerian civilization included more than a dozen loosely unified city-states fortified with walls, gates, and towers. Each had a population of between 10,000 and 50,000 inhabitants.

The Sumerians developed a flourishing agricultural economy, along with trade, commercial enterprise, and technological innovation, notably the invention of the wheel. The Sumerians also invented a writing system. One scholar attributes a number of "firsts" to the Sumerians, including the first schools, the first historian, the first love song, and the first library catalogue. Sumerian developments in ethics, education, and written law were influential in later cultures. Sumerian literature too was noteworthy—the epic *Gilgamesh*, which tells how a king's quest for glory and immortality ends when he discovers that even the bravest heroes must face death, has been called the first great poem in the West.

Sumerian religion was polytheistic, with more than 3,000 gods and goddesses. It was also animistic, encompas sing virtually all aspects of nature. The divine, which was manifested in nature, was present in every object, and each city had a patron deity. Groups of standing Sumerian figures, found within shrines, are identified by inscriptions as representations of gods, priests, and individuals (fig. 3.7). They would have faced a cult statue of the main god or goddess, which may have had a more abstract form. The worshipers have rigidly clasped hands and large inlaid eyes. The statuettes of individuals presented the life spirit of the donor as a continuous and vigilant prayer—a permanent substitute for the donor.

The awe-inspiring sculpture shown in fig. 3.8 presumably surmounted the entrance of a temple. The central figure—a lioness-headed eagle with wings spread—is

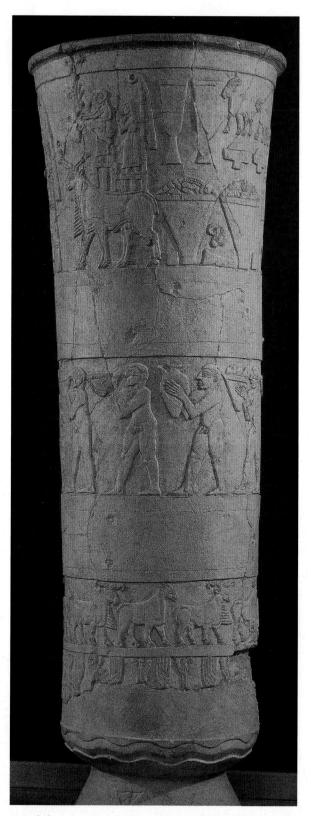

3.6 Vessel, found at Uruk (modern Iraq). c. 3200–3000 BCE. Alabaster, height 3' (91.4 cm). Iraq Museum, Baghdad. The reliefs celebrate the goddess of fertility through offerings of fruit.

c. 4500 BCE Farming is adopted in the Ganges plain in India c. 3200-3000 BCE Vessel found at Uruk (fig. 3.6)

C. 3000 BCE Potter's wheel in use in China

c. 3000-2000 BCE Chinese bamboo pipe utilizes five-tone scale c. 2600 BCE Oxen are first harnessed to plows

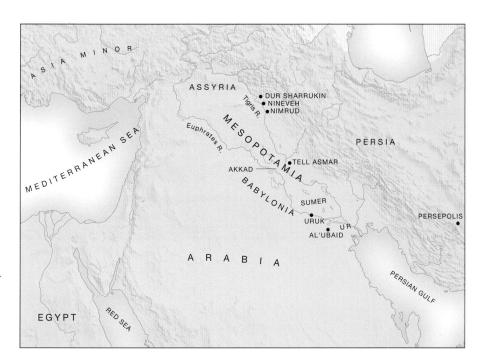

3.7 Worshipers and Deities, found at the Temple of Abu in Tell Asmar (modern Iraq). c. 2750 BCE. Gypsum, height of tallest figure approx. 2' 3" (68.6 cm). Iraq Museum, Baghdad, and The Oriental Institute, University of Chicago.

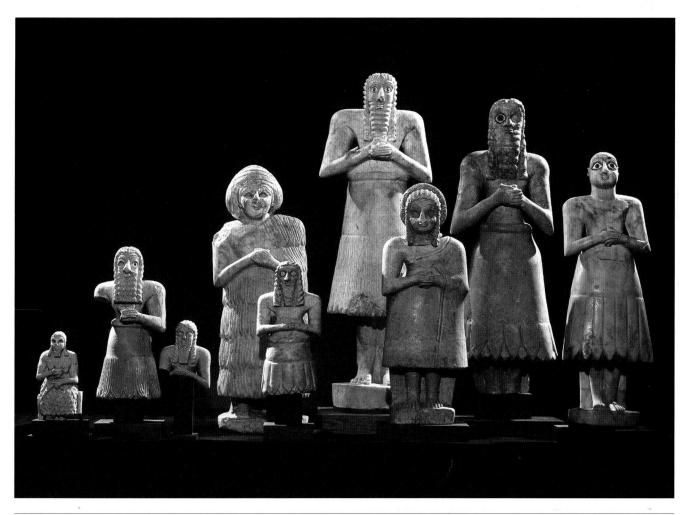

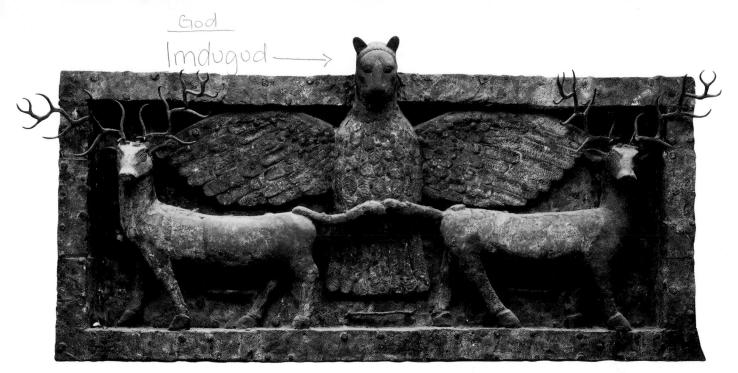

3.8 Storm God and Two Stags, lintel from a temple at Al'Ubaid (modern Iraq), c. 2500 BCE. Copper sheets over wooden core (restored), length 7' 10" (2.59 m). The British Museum, London.

Imdugud, the force that exists within a storm cloud. This frontal deity with outstretched wings is framed by symmetrically placed stags, which surely represent other natural forces. It creates a composition that is commanding in its simplicity.

The most impressive structure of a Sumerian city was the **ziggurat** (from the Akkadian "pinnacle" or "mountaintop"). The Greek historian Herodotus gave us a verbal picture of a ziggurat: it dominated the city, had spiral ramps, and at its apex, a temple with a large couch and table of gold to be used by the god when he came down to earth. The best-preserved ziggurat is at Ur (fig. **3.9**), the city thought to be the childhood home of the Old Testament figure Abraham. The structure was built on the ruins of earlier ziggurats by several Sumerian kings, including Ur-Nammu, who wrote one of the earliest codes of law. This ziggurat's main deity was Ur's patron, the moon god Nanna-Sin. At the New Year festival, processions ascended the three staircases and proceeded through a ceremonial gateway to a temple with a cult statue and sacrificial altar.

The Sumerian mother goddess was Ninhursag, the "Woman of the Mountain," and the mountains were the source of the water that nourished their fields. As human-made sacred mountains, ziggurats enabled rulers and priests to ascend to the residence of the gods to ask for divine guidance. An early Mesopotamian text refers to a ziggurat as the "bond between heaven and earth."

3.9 Reconstruction of Ziggurat, Ur (modern Iraq), c. 2100 BCE. Fired brick over mud-brick core, original height approx. 70' (21.3 m), base $210 \times 150'$ (64×45.7 m). Commissioned by several Sumerian rulers, including Ur-Nammu.

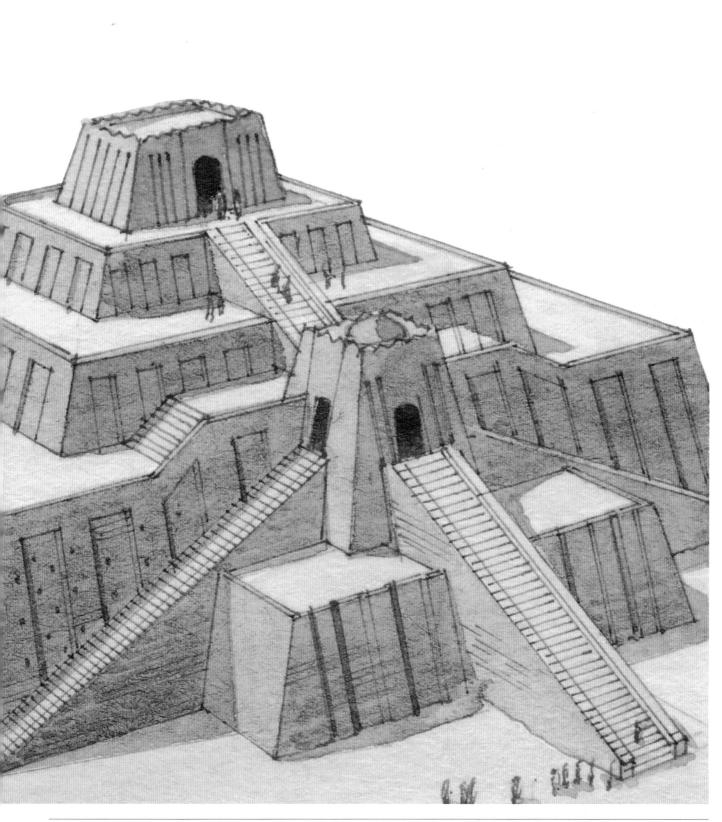

Ancient Egyptian Art

he over-lifesize figure of Khafre, shown majestically seated on his throne (fig. 3.10), expresses the absolute authority of the Egyptian ruler. The idealized body is as architectonically rigid as the throne, and the effect of the figure is grand and intimidating. Khafre's head, which seems to be a generic Egyptian type rather than a specific portrait, is embraced by the wings of the Egyptian sky god Horus, represented as a falcon, to symbolize the god's divine protection.

The statue, carved from an extremely hard stone and compactly composed, gives the appearance of being able to last forever. And, indeed, the solid, rigid character of this sculpture was the artist's way of meeting an extraordinary

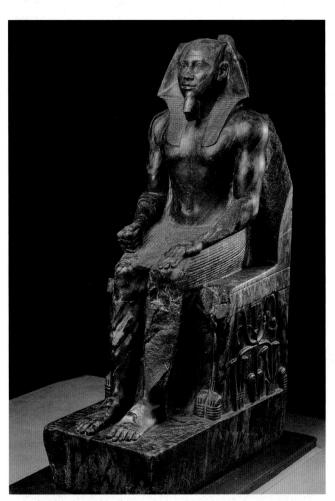

3.10 Khafre, Old Kingdom, c. 2570–2544 BCE. Diorite, height 5' 6" (1.68 m). Egyptian Museum, Cairo.

This is one of a number of similar sculptures found in King Khafre's Valley Temple at Giza (see fig. 3.23), site of the three Great Pyramids from the Old Kingdom (see fig. 3.18). The temple is located along the causeway that connects Khafre's pyramid with the colossal statue of Khafre as the god Hu, later known as the "Great Sphinx" (see fig. 3.19). Commissioned by Khafre.

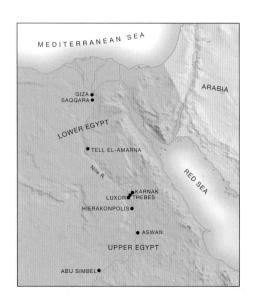

demand—that of creating a sculpture that to serve its purpose had to endure for eternity. The Egyptians believed that the ka, the part of the human spirit that defined a person's individuality and that would survive on earth after death, needed a physical dwelling place. The corpse of Khafre was mummified to provide this home, but if this mummy should decay or be destroyed, one or more sculptures of the deceased ruler could provide a home for the ka. The need to provide for the ka—as well as to accommodate other beliefs about death—underlay the creation of much of the surviving art and architecture from ancient Egypt.

HISTORY

The Nile River plays a central role in Egyptian geography, civilization, and art; the Greek historian Herodotus wrote that Egypt was the "gift of the river." The 900 miles of the river sustained life in an otherwise arid desert region, and Neolithic settlements along its banks date from as early as 8000 BCE. The Nile, swollen by torrential rains, flooded its banks every summer and deposited fertile silt to support agricultural development. The flanking desert protected the rich Egyptian civilization from foreign invaders. The economy prospered, and crop production included flax for the making of linen and papyrus for paper and rope.

By the fifth millennium BCE, settlements along the Nile coalesced into distinct cultural areas. The northern area was known as Lower Egypt because of the flow of the Nile from the south to the north; Upper Egypt was to the south. Around 3150 BCE, a legendary king now identified with Narmer (see pp. 48–49) united Upper with Lower Egypt, establishing a political state that endured almost continuously for more than 2,000 years.

3.11 Hatshepsut, New Kingdom, c. 1478–1458 BCE. Limestone, height 6' 6" (1.98 m). The Metropolitan Museum of Art, New York. Hatshepsut, an early example of a documented female monarch, governed Egypt from about 1478 to 1458 BCE. Commissioned by Hatshepsut.

This vast expanse of Egyptian history is subdivided into three major periods of political stability and cultural and economic growth known as the Old, Middle, and New Kingdoms. The Old Kingdom (c. 2700–2190 BCE) was characterized by an expansion of the central authority of the ruler, who oversaw Egypt's local administrative provinces. Its economic prosperity is evident in the funerary precinct at Giza, which includes the three largest pyramids in Egypt (see fig. 3.18). Political unrest led to the end of the Old Kingdom when an economic depression, perhaps caused in part by lavish expenditures, was compounded by a famine, and local governors of the provinces broke the central authority of the ruler.

The Middle Kingdom (c. 2040–1674 BCE) saw a reunified Egypt. Sesostris III strengthened the central government, and new trade routes were established, stimulating the economy. The Middle Kingdom ended when a group of foreign settlers, the Hyksos, took advantage of a weakened

government and of a new weapon—the horse-drawn chariot—to establish a separate kingdom.

Within a century, however, the Hyksos were expelled and Egypt entered a final period of cultural and economic prosperity, the New Kingdom (c. 1552-1069 BCE). The architectural remains of the New Kingdom reveal a vigorous economy, political stability, and the assured power of the ruler. This latter quality is reflected in the statue of the female ruler Hatshepsut (fig. 3.11).

There was an important, if short-lived, political disruption in Egypt during the New Kingdom. The reign of Akhenaten (ruled 1352-1336 BCE), known as the Amarna period because his capital was located near present-day Tel el-Amarna, witnessed the transformation of many traditional cultural and artistic values. Akhenaten, whose name means "One Who Is Effective on Behalf of Aten," was devoted to the worship of a single god, Aten. Akhenaten mandated the worship of Aten as the official state deity, and during his reign tried to change the complex polytheistic foundation of Egyptian religion to monotheism. Viewing the relief of Akhenaten with Nefertiti and their children (fig. 3.12), we see that some of the usual conventions of Egyptian art have been retained, such as the simultaneous combination of frontal and profile views (see p. 49). But the artist has imparted a new naturalism to the figures. Unlike the earlier geometric treatment of the figure, the bodies of Akhenaten and his family are given sensuous, curving forms that contribute to the relaxed intimacy of the scene. The fact that Akhenaten's queen is seen on the same scale as the ruler

3.12 Akhenaten with Nefertiti and their Children, New Kingdom, c. 1348–1336/5 BCE. Limestone, 13 × 15" (33 × 38 cm). Staatliche Museen zu Berlin Preussischer Kulturbesitz, Ägyptisches Museum, Germany. Commissioned by Akhenaten and/or Nefertiti.

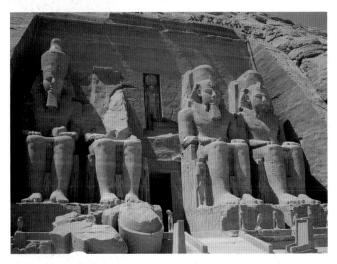

3.13 Temple of Ramesses II, Abu Simbel, New Kingdom, c. 1279–1212 BCE. Height of sculpture approx. 67' (20 m).

In 1968, these gigantic figures of sandstone, which had been cut directly into the cliff side, were disassembled and raised more than 200 feet (61 m) to save them from being flooded by the lake created when the Aswan Dam was built. Originally commissioned by King Ramesses II, who dedicated the temple to himself as a god; the moving of the statues was commissioned by the United Nations.

himself reveals the unexpected equality that seems to have characterized the Amarna period; in other Egyptian periods, women are usually shown as smaller in scale. The god Aten, represented as the disc of the sun with rays terminating in human hands, presides over this domestic scene. Akhenaten was neglectful of foreign affairs, and his rule weakened Egypt. After the Amarna period, the rigid conventions of older ways returned. Many of the images of Akhenaten were destroyed, and an attempt was made to, quite literally, erase him from history. Subsequent rulers established an authoritative continuity with their predecessors. The statues of Ramesses II (ruled 1279-1212 BCE) that flank the entrance to his mortuary temple at Abu Simbel (fig. 3.13) recall the formal rigidity of the Old Kingdom statue of Khafre (see fig. 3.10). But the colossal size of these sculptures reveals the grandeur typical of the New Kingdom. The Ramesses dynasty, which lasted until 1085 BCE, was the last significant dynastic family of the New Kingdom. During the following centuries, the power and splendor of the empire abated, and in 332 BCE Egypt was conquered by Alexander the Great.

RELIGION

Egyptian religion was a complex faith that included polytheism, magic, politics, and a steadfast belief in an afterlife. Wonder at the forces of nature and the spirit of animals led to the development of polytheism, with local gods or goddesses being affirmed in different communities. Early depictions of these deities include representations as animals,

such as Horus (the sky god as a falcon), or as animal-headed humans, such as Anubis (a jackal-headed god associated with mummification).

For the Egyptians, whom Herodotus described as "religious to excess," magic was an important part of their religion. Believing that the spiritual world governed all aspects of life, the Egyptians even accompanied the commonplace practice of taking medicine with ritualistic incantations. Religion was also bound to politics. The ruler was viewed as a god who had absolute authority in secular and religious matters. During some reigns, the god or goddess worshiped by the ruler would become the center of the state religion and be imposed over local religious practices.

Extensive religious ritual accompanied the belief in an afterlife, and the most important entity of the human soul to be served in the afterlife was the ka. The Egyptians believed that after death the ka would require an earthly abode. Thus, the body of the deceased should be preserved through mummification (the word "mummy" is from the Arabic mumiya, meaning "bitumen"—a petroleum substance mistakenly believed to have been used in mummification), and statues of the deceased should also be provided in case of the accidental loss of the mummy. The process of mummification, strictly governed by religious ritual, took seventy days. The lungs, stomach, liver, and intestines were removed to separate containers called canopic jars, while the body was treated with chemical solutions to draw out moisture before being wrapped in as many as twenty layers of linen. The world of the afterlife was associated with the sunset and, therefore, the west; a song inscribed on an early tomb reveals the reward for the ka: "The span of earthly things is a dream, but a fair welcome is given him who has reached the West."

ART OF ANCIENT EGYPT

Providing service to the *ka* was a mainstay of artistic production in Egypt. Tomb walls were sculpted and/or painted with everyday scenes (see figs. 3.29, 3.30) to recreate a pleasant environment, and small servant figures were provided to perform common duties. Woodworkers constructed and stone-carvers decorated a series of coffins, which fit inside each other. A stone coffin is called a **sarcophagus** (from the Greek *sarkophagos*, "flesh-eating stone").

In addition to the artistic preparations made especially for the use of the *ka* in the afterlife, jewelry and items of personal use were placed in the tomb. The throne of King Tutankhamen (fig. **3.14**) displays the conspicuous wealth of the New Kingdom, while the relaxed figurative poses on the back of the throne demonstrate influence from the Amarna period.

Although much of preserved Egyptian art relates to funerary practices, the desire to provide the *ka* with the means for enjoying life as it was experienced before death

meant that this art also is an important record of everyday experience. Tomb paintings, for example, document the labor of the lower classes as well as festive occasions for the nobility, but even commonplace scenes adhere to timehonored conventions of artistic practice. The strict grid of proportions (fig. 3.15) and the combination of frontal with profile views create the static figure typical of Egyptian art.

During the Amarna period of the New Kingdom, a sculptor named Thutmose was a court artist to the royal family of Akhenaten and Nefertiti. The portrait bust of Queen Nefertiti (fig. 3.16) was discovered in his workshop, and its unfinished state—note the absence of the left eye—suggests that it might have served as a studio model, awaiting the queen's approval to be re-created in another medium. The portrait bust in Egypt reached back into the Old Kingdom; this New Kingdom interpretation conveys the fluid stylization and naturalism that characterized Amarna royal art.

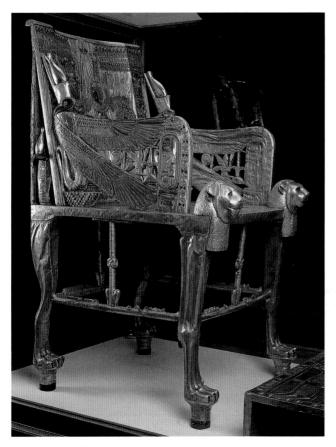

3.14 Throne of King Tutankhamen. New Kingdom, c. 1336/5-1327 BCE. Gold, silver, colored glass paste, glazed ceramic, and inlaid calcite, height 45" (1.14 m). Egyptian Museum, Cairo. Commissioned by Tutankhamen.

The top of the throne's footstool, a portion of which is glimpsed in the righthand corner, has a representation of defeated enemies. Tutankhamen, whom we popularly know as King Tut, was a ruler of relatively minor importance in Egyptian history. He followed Akhenaten's son and died at an early age. Tutankhamen's fame is primarily due to the fact that his tomb furnishings were largely intact when discovered by the British archaeologist Howard Carter in 1922. 3.15 Diagram of the ancient Egyptian proportional system as reconstructed for the statue of Hatshepsut (see fig. 3.11).

Egyptian workshops used a strict proportional scheme that allowed the efficient execution of painted and sculpted figures. A squared grid, drawn on the wall or on three sides of a block of stone, was used to demarcate the height and width of each figure's shoulders, waist, feet, and other body parts, following a standard formula. When applied to a block of stone, this system allowed unnecessary areas of the block to be chiseled away by unskilled assistants.

THE EGYPTIAN ARTIST

In ancient Egypt, as in most early civilizations, no distinction was drawn between the artists who designed sculptures and paintings and the skilled laborers in workshops who brought their concepts into being. Artists labored as members of the lower classes. The exception was the architect, who enjoyed the status of a court official. Imhotep, the first recorded artist of Western history, designed the Old Kingdom funerary complex at Saqqara (see fig. 3.22). His fame was so great that by the New Kingdom he was deified as the god of learning and medicine.

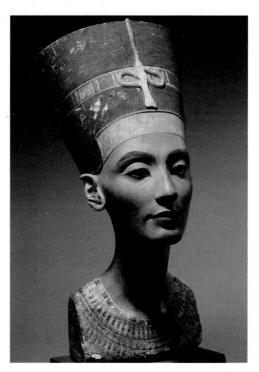

3.16 Queen Nefertiti. New Kingdom, Amarna period, c. 1360 BCE. Limestone and plaster, height 19" (50 cm.). Ägyptisches Museum, Staatliche Museen, Berlin.

Ancient Egyptian Art: The Palette of Narmer

n the past, important historical developments often led to the creation of objects that commemorated or interpreted the event. One of the earliest surviving works of Egyptian art, the Votive Palette of King Narmer (fig. 3.17), was apparently created to mark the unification of Egypt. Narmer, who has been identified with Menes, the first king of the first Egyptian dynasty, appears three times. As the largest figure on side A, he wears the crown of Upper Egypt and brings under his control a figure who probably represents Lower Egypt. At the bottom of side A are two more defeated antagonists and small symbols of a fortified city and a gazelle trap that suggest victories in the city and countryside. The nearby human-headed figure with six papyrus blossoms, being held captive by the god Horus (shown as a falcon) almost certainly refers to the submission of Lower Egypt to Upper Egypt. The use of symbols to represent complex ideas is an innovation that points to the development of Egyptian hieroglyphs, in which figures or pictures signify words or sounds. At the bottom of side B, Narmer himself appears as a symbol—a horned bull, victorious over an enemy and the enemy's fortified city. Near the top of side B, Narmer, wearing the crown of Lower Egypt and accompanied by a processional retinue, views the decapitated corpses of enemies, their heads between their legs. The central symbol at the top of both sides represents Narmer's name and his palace. It is flanked by horned animals representing the sky mother, Hathor, to whose shrine the palette was probably offered. In addition to Narmer's assumption of the two crowns, the union of Egypt is also suggested by the joining of two fantastic, long-necked lionesses on side B,

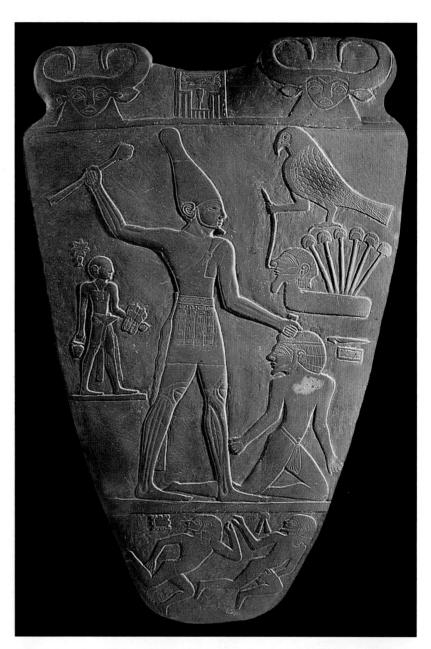

3.17 Votive Palette of King Narmer (sides A and B). Predynastic, c. 3150–3125 BCE. Slate, height 2' 1" (64 cm). Egyptian Museum, Cairo.

The shieldlike shape and shallow indentation reveal that this is an enlarged, ceremonial version of an everyday object—a palette used for the grinding of pigments for eye shadow. This palette was found at Hierakonpolis, a sacred city of prehistoric Egypt. Probably commissioned by Narmer.

c. 3300-3000 BCE Hieroglyphic script is developed in Egypt

c. 3150-3125 BCE Votive Palette of King Narmer (fig. 3.17)

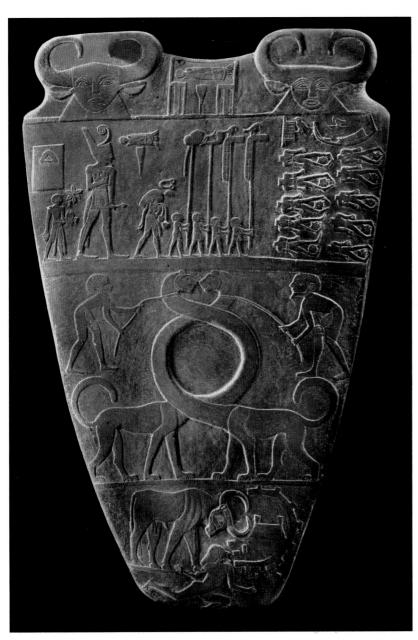

6 very important piece.

their serpentine necks intertwined to form the shallow indentation that refers to the function of the object as a palette.

A number of the most important surviving works of art from predynastic Egypt are similar palettes or fragments of palettes. The decoration is usually about political subjects. Apparently the larger versions of these palettes were displayed as votives (gifts made to a god or goddess), and they may also have been used to grind and mix the pigments that adorned the eyes of the cult statue of the deity. The Votive Palette of King Narmer probably had several functions: as an object to be used in a religious ritual; as a votive offering to the god or goddess (most likely Hathor); and as a commemoration of the military and territorial victories of Narmer. Such a union of political statement with religious ritual is typical of Egyptian art and culture.

Narmer is, in every case, represented as unnaturally larger than his subordinates and enemies through the use of hierarchical scale, which is common in Egyptian religious and political art. Narmer's large scale and the lucid design make the meaning of the palette more easily comprehensible. The human figures are presented in a design that clarifies the parts and their interrelationships—legs, head, and arms are seen in strict profile, while the torso and the eye are seen directly from the front. These renderings demonstrate the same clarity seen in the three-dimensional figure of Khafre (see fig. 3.10), but here they are united and suppressed into what is essentially a twodimensional medium: low relief (see pp. 13-14). As unrealistic as this representation is, it is easily read and it emphasizes strength. This style of representing the figure continued in Egyptian art for more than 3,000 years.

The Egyptian Pyramids

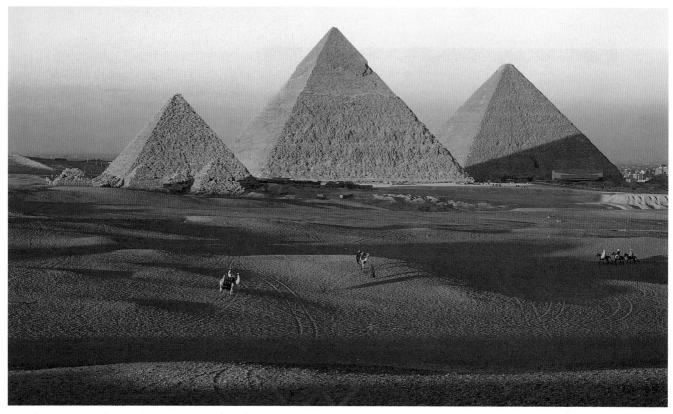

3.18 Great Pyramids at Giza. Old Kingdom, c. 2601–2515 BCE. Limestone and granite, original height of pyramid of Khufu 480' (147 m), length of each side at base 755' (230 m). The three pyramids, from the left, were built by the Egyptian kings Menkaure, Khafre (see fig. 3.10), and Khufu.

The Great Pyramids were viewed as architectural wonders even in the ancient world; they are, in fact, the only surviving work from the list of "Seven Wonders of the World" compiled in antiquity. Constructed as royal tombs, they are the best known of more than eighty pyramids built in ancient Egypt. The pyramid of Khafre is the only one that preserves any of its outer dressed stone exterior. Many stones were taken from the site to build medieval and modern Cairo.

ssociating the transition to the afterlife with the sunset, the pyramids—the burial places of the rulers—were located on the western side of the Nile River (figs. 3.18–3.20). Today, the desert area around the pyramids reveals little of the complex of funerary temples (see fig. 3.23) and other grave sites that once formed a huge necropolis ("city of the dead").

3.19 King Khafre as the god Hu, later known as the "Great Sphinx," Giza. Old Kingdom, c. 2570–2544 BCE. Sandstone, height approx. 65' (19.8 m). Commissioned by Khafre.

Carved from a natural outcropping of sandstone, the sphinx, with the pyramid of Khafre behind, is part of the funerary precinct of Khafre, and its face bears his features, probably as Hu, the reincarnation of the sun god Re. The name "sphinx," meaning "stranger" or "mysterious person," was first used by the ancient Greeks; we do not know what name the Egyptians gave this monument.

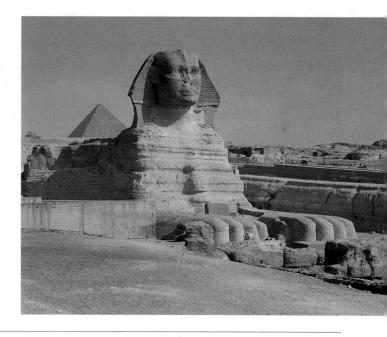

c. 3000 BCE Earth's population nears 100 million

c. 3000-2500 BCE Mineral baths used in Sumerian medicine

c. 2601-2515 BCE Great Pyramids at Giza (fig. 3.18)

c. 2500 BCE Central Europe and Britain remain Neolithic c. 2000 BCE Farming and begins in sub-Saharan Africa

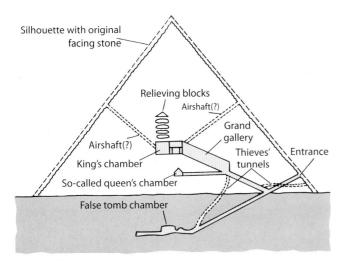

3.20 Section of the Great Pyramid of Khufu, Giza.

Graves in predynastic Egypt were usually shallow pits marked with mounds of sand near the edge of the desert. By about 2900 BCE, nobles were buried in underground chambers marked by mud-brick structures called mastabas (from the Arabic mastabah, "bench") with battered (sloped) walls (fig. 3.21). Mastabas contained offerings to the ka, and chambers for the mummy and one or more statues of the deceased.

About 2681 BCE, during the Old Kingdom, King Zoser commissioned Imhotep to design and construct a funerary complex at Saqqara (fig. 3.22). The architectural climax was a large step pyramid, a solid structure that suggests the superimposition of progressively smaller mastabas.

It is not completely clear why the pyramidal form was used in this funerary context. One theory suggests that it is derived from the cult image of the sun god Re, a pyramidal stone that represented the rays of the sun descending to

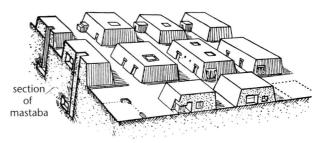

3.21 Mastabas, reconstruction with section. Old Kingdom.

earth. A widely accepted view is that the pyramid fulfilled both practical and spiritual needs by offering a secure abode for the ka and by assisting the ruler's spirit in its ascent to heaven. A text found inside a pyramid states: "I have trodden these rays as ramps under my feet where I mount up to my mother Uraeus on the brow of Re."

The complex at Giza was constructed between 2601 and 2515 BCE, and each pyramid took more than twenty years to build. Surveyors began the laborious and exacting process by observing a star in the northern sky, then orienting the square base so that each edge faced a cardinal direction—north, south, east, or west. Labor was supplied not by slaves but by the Egyptian people themselves, who gave their time during the three months of the summer flood, when their farmland was under water; records reveal that they were paid with food and drink. The high waters of the Nile facilitated the transport of granite from quarries miles away from Giza, but much of the limestone used was quarried at the site, perhaps around the statue of the Great Sphinx. The capstone was polished or gilded to catch the first and last of the sun's rays. False passages were constructed to discourage grave robbers, but almost all Egyptian royal tombs were plundered in ancient times.

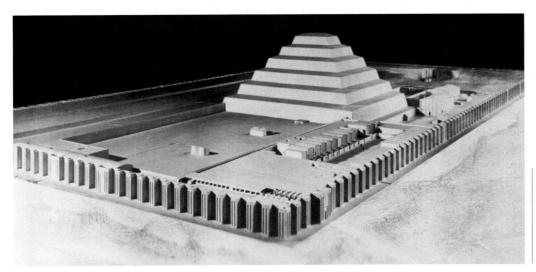

3.22 Model of the funerary district of Zoser, Saggara. Old Kingdom, c. 2681–2662 BCE. Height of original stepped pyramid approx. 200' (62 m). Commissioned by King Zoser.

The complex at Saggara represents the earliest known use of cut stone for architecture, and its architect, Imhotep, is the earliest known named artist in world history.

The Egyptian Temple

his Old Kingdom temple (fig. 3.23), composed of spaces defined by large, square columns, is quite simple, but over time the Egyptian temple evolved in response to the rituals enacted there (see figs. 3.23-3.28). Beginning with a long row of sphinxes flanking the avenue to the entrance, the organization of a New Kingdom temple is strictly axial, relating to the progress of the king's procession, and is characterized by bilateral symmetry (the forms are identical on both sides of the central axis). As the procession advanced, the king passed through a clear sequence of architectural spaces, beginning with the open road flanked by sphinxes, then moving into the sacred precinct through the pylon, whose broad sloping towers and flagpoles flank the central doorway. He then proceeded into one or more colonnaded courtyards open to the sky and framed on two or three sides by rows of columns. Next he entered a large room filled with columns known as the **hypostyle** hall (see fig. 3.26). The only light here filtered down from the clerestory, the raised area along the central axis, where there are long vertical openings (for later examples of clerestories, see figs. 5.12, 6.28, 6.31). The final sequence of rooms, all fully enclosed, became progressively smaller, lower, and darker until the priest and/or the king entered the most sacred chamber, which contained the cult statue. The Temple at Luxor (fig. 3.24) was exceptional, for there were two sacred chambers; the one at the very back, which was entered directly from the exterior wall, was where the sacred boat of Amun was placed after carrying the king across the Nile from Karnak.

The enormous New Kingdom temples at Luxor and Karnak (see figs. 3.24, 3.26) are among the largest religious structures ever built. They played an important role in Egyptian religion and politics, especially the annual festival of Opet, a twenty-four-day celebration of the New Year, when the Nile was at full flood. At this time, the king and his family came to Karnak to participate in the procession that accompanied the golden

3.23 Valley Temple of Khafre, Giza. Old Kingdom, c. 2570–2544 BCE. Limestone and red granite. Commissioned by Khafre.

Post-and-lintel construction is exemplified in this temple, and it was here that twenty-three portrait statues of Khafre, including fig. 3.10, were originally housed. The roof structure has collapsed. A causeway led from the temple to the pyramid of Khafre (see fig. 3.18), some 600 yards (550 m) farther from the Nile.

c. 3000 BCE
Copper manufacture is known in China

c. 2700 BCE
Maize is domesticated in
Mesoamerica

2570–2544 BCEValley Temple of Khafre at Giza (fig. 3.23)

c. 2500 BCE First, limited writing is developed in Indus Valley civilization c. 2300 BCE
Beginning of the Bronze
Age in Europe

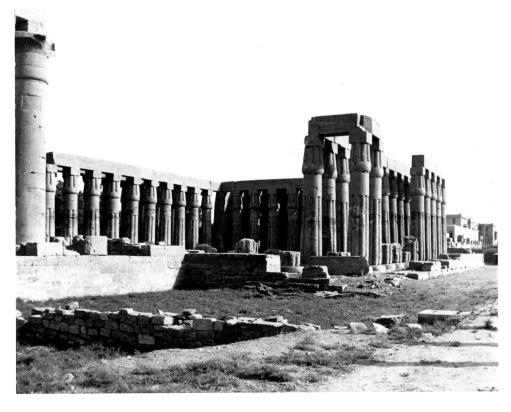

3.24 Courtyard built by Amenhotep III, Great Temple of Amun-Mut-Khonsu, Luxor. New Kingdom, c. 1390–1352 BCE. View of hypostyle hall and courtyard. The temple is dedicated to Amun, the sun god; his consort, Mut; and his son Khonsu, the moon god. Commissioned by Amenhotep III.

statue of Amun, the chief Egyptian deity, to the shrine of his wife (the goddess Mut) and son (Khonsu, the moon god) at Luxor. The king, who was traditionally identified with Amun, emerged from the **pylon**, or entrance gate, at dawn, so that he was framed by the pylon's flanking towers while the sun rose behind him (fig. 3.25). Such ritual reinforced his identification with the sun god.

The hierarchical and exclusive quality of Egyptian society is expressed in these temples, for only a select few could follow the king into the courtyard, and fewer yet into the hypostyle hall. The enormous walls that enclose the sacred enclosure (more than a mile long at Karnak) excluded the multitudes and reminded them of their inferior social, political, and religious status, as did the overwhelming scale of the structures themselves.

Temple architecture stressed stability, weight, monumentality, and durability. These temples were meant to endure, and Amenhotep III (ruled 1390–1352 BCE) described a temple he had built at Thebes as: "... an eternal, everlasting fortress of fine white sandstone, wrought with gold throughout; it is made very wide and large, and established forever."

The massive stone walls of Egyptian temples were solid, without windows; weight and stability were further expressed by the heavy cornices and battered walls of the

pylon. Virtually all surfaces were covered with low or sunken relief carvings that emphasize the mass and weight of the stone. The hypostyle hall was a veritable forest of thick columns (at Karnak, the largest were sixty-nine feet tall and twelve feet in diameter, with a circumference of almost thirty-three feet; see fig. 3.26), and the effect was claustrophobic and intimidating. The solidity and magnitude of these temples reflect the stability and control of the civilization that created them and, because so much of ancient Egyptian ritual centered on the role of the ruler, it must be accepted that these monuments are primarily political in nature.

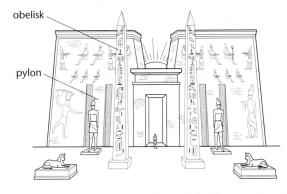

3.25 Reconstruction drawing of a typical pylon gate, showing the rising sun emerging above the central doorway at dawn.

Post-and-Lintel Construction

The type of construction used for Egyptian hypostyle halls and colonnaded courtyards (fig. 3.26; see also fig. 3.24) is known as post-and-lintel, the post being the vertical supporting member, usually a cylindrical column, and the lintel being the horizontal member, often known as the entablature (see fig. 3.23). The only simpler types of construction are the wall and the mound. The engineering dynamics of post-and-lintel are straightforward—the weight of the lintel presses downward on the post, which must be strong enough to support the lintel's weight. If the lintel is too long or lacks sufficient tensile strength (longitudinal strength sufficient to support itself without breaking), it may collapse in the middle or shear and break where it meets the post. When columns are used, they are usually

decorated, especially at the top, or **capital**. In Egypt, the column and capital may resemble greatly enlarged papyrus, date palms, or bundled reeds (see figs. 3.24, 3.26)—forms that may derive from the use of bundled natural elements in early Egyptian architecture. Although the post-and-lintel system is simple, the rhythmic placement of the columns and the relationship of vertical to horizontal allow many architectural and aesthetic variations.

Egyptian builders were restricted by the available materials, which included vast amounts of stone but virtually no wood. The dense and brittle nature of the local stone kept the lintels short and the posts heavy and close together. The hypostyle hall was virtually the only large enclosed space that could be constructed.

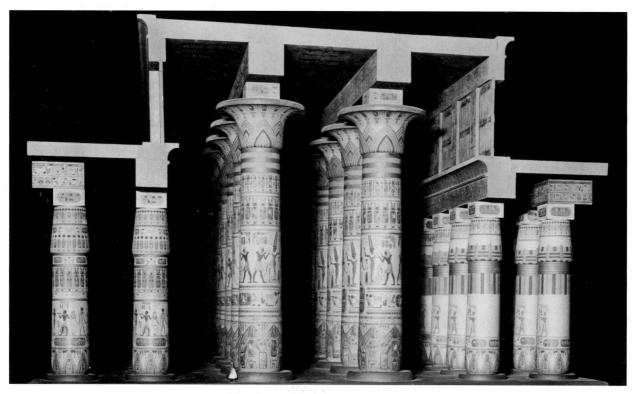

3.26 Model of central section, hypostyle hall, Temple of Amun, Karnak. New Kingdom, c. 1294–1212 BCE. The Metropolitan Museum of Art, New York.

The small figures in the model reveal the huge scale of the hall. The columns and capitals of this hypostyle hall are so large that dozens of people could stand on top of one of the capitals, and it takes at least eight people, holding hands, to span the circumference of a column near the base.

How to Read Architectural Diagrams

The drawings of architecture in this book are meant to aid in your understanding of principles of design and construction. Some of these diagrams reveal how a building would look if it were sliced through, as in a plan (or ground plan; fig. 3.27), which shows the building as if cut off approximately one foot above the floor level. In the plan, solid lines are structure, with openings indicating doors and windows; lighter lines indicate floor patterns; dotted or light lines are used to indicate the patterns of the ceiling (see fig. 6.23). A cross section shows the building sliced through from side to side (see figs. 3.38, 5.15), while a longitudinal section slices the building from front to back (fig. 3.28). An elevation shows the exterior surfaces and their decoration diagrammatically, not as the human eye would see them (see figs. 4.21, 8.29). A relatively recent kind of diagram is the isometric projection, which offers a view of the exterior and/or interior from a specific point of view. In figs. 3.28 and 4.29, the projection is cut away and combined with a ground plan and longitudinal section. Because of the partial nature of any single one of these diagrams, an understanding of a building usually requires mentally combining information from the examination of several diagrams.

Today, buildings are erected using architect's diagrams similar to those discussed, but we still do not know much about the use of drawings by architects, engineers, and construction crews in the past. The earliest surviving examples date from the Gothic period, in the thirteenth century. In some earlier periods, architects and engineers apparently laid out the plan of the building full scale on the ground, and used sticks and string to transfer measurements as necessary during construction.

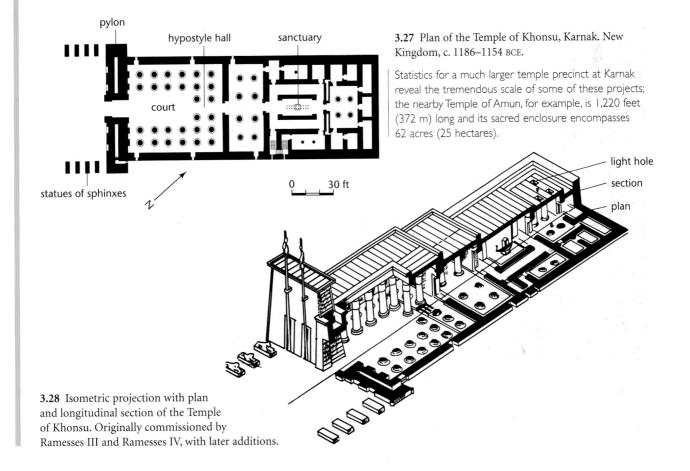

Egyptian Tomb Paintings and Painted Reliefs

he walls of Egyptian tombs were decorated with painted, low-relief sculptures or with paintings on plaster applied over the walls. The requirement that tomb decoration preserve pleasant everyday life for the delight of the *ka* throughout eternity means that these paintings tell us a great deal about ancient Egyptian life and customs, and have a broad human interest and appeal.

The largest single scene among the hundreds of painted reliefs in the Old Kingdom tomb of a government official named Ti depicts a hippopotamus hunt, with Ti standing in the boat (fig. 3.29). The emphasis on this particular scene suggests that it has a deep significance, and the hunt here probably refers not only to the general concept of victory

but also specifically to Ti's victory over death. Ti is represented in the typical Egyptian style, and the composition emphasizes clarity and repeated patterns. The Egyptian artist had to work within the strict limitations imposed by the function of the work; invention was not prized, and a new viewpoint or treatment might render the object or experience unavailable to the *ka* in the afterlife. This approach, which is not naturalistic, uses only frontal and profile viewpoints—the characteristic points of view in Egyptian art.

The zigzag pattern that represents the water of the Nile in this relief is based on the hieroglyph for water, which is also the hieroglyph for the Nile itself; in Egypt, the Nile was

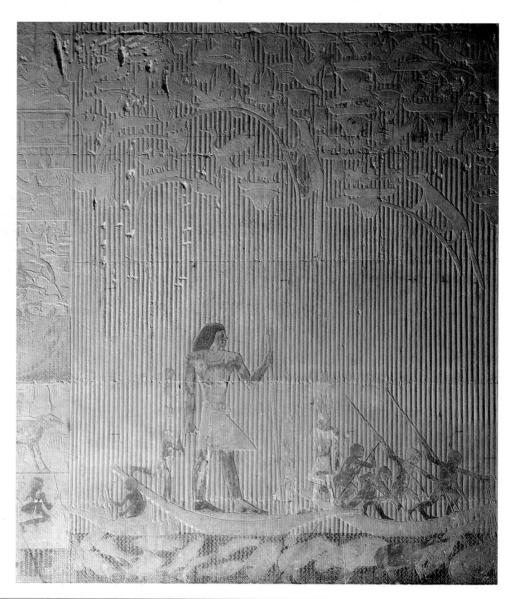

3.29 *Ti Watching a Hippopotamus Hunt*, in the Tomb of Ti, Saqqara. Old Kingdom, c. 2510–2460 BCE. Painted limestone, height approx. 3' 10" (1.17 m). Commissioned by Ti, overseer of the Sun Temples of Kings Neferikare and Nyuserre.

On the wall opposite this painted relief are three small openings intended to allow three lifesize statues of Ti to gaze permanently at this hunting scene.

3000–2500 BCE
Ancient civilizations
begin astronomical
observations

c. 2510–2460 BCE Ti Watching a Hippopotamus Hunt (fig. 3.29) c. 2350 BCE
Urukagina, king of
Lagash, promulgates the
first surviving law code

c. 2100 BCE Abraham departs from Ur c. 2000 BCE
Main stage of
Stonehenge completed
in Britain (see fig. 2.8)

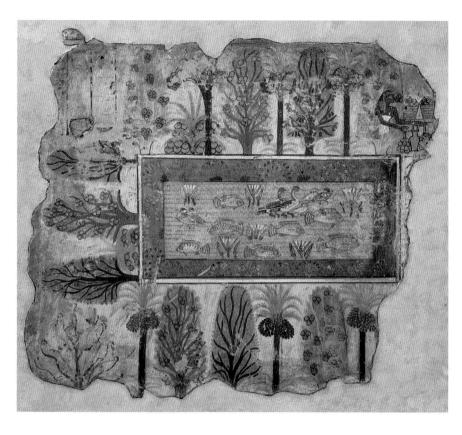

3.30 *Pond in a Garden*, fragment from the Tomb of Nebamun, Thebes. New Kingdom, c. 1400 BCE. Paint on plaster wall, 2' × 2' 4" (61 × 71 cm). The British Museum, London. Commissioned by Nebamun, "scribe and counter of grain."

water, and water was the Nile. The parallel lines that create a foil for the organic shapes of the figures and animals indicate a setting deep in the marshes, for these are the stems of the same reeds that burst into leaf and blossom near the top of the relief. In this upper area, predators stalk birds, creating striking patterns against the geometric stalks as well as a metaphor for the hunt taking place below.

Pond in a Garden (fig. 3.30), from a New Kingdom tomb, with its rectangular pool with ducks, fish, and lotus blossoms surrounded on all sides by flowering and fruit-bearing trees, provides a demonstration of the Egyptian approach to representation. Completeness and clarity were demanded of the Egyptian painter, for anything not clearly

included in the tomb painting would not be available to the ka in the afterlife. This explains why each object has to be shown in its most easily recognized view—the pond is represented as if seen from above, while everything else is in profile. The relationships among the objects in reality are also made clear in the representation: fish, ducks, and lotus blossoms are seen as within the pool, while the trees surround it. The trees are seen right side up and sideways, but not upside down—those at the bottom side of the pool are upright. Despite the lack of a consistent viewpoint for the scene and the flatness with which each object is rendered, we can still easily recognize that this is, indeed, a pond in a garden.

TECHNIQUE

Figure-Ground Relationships

The distinct contrast that can be noted between forms and background in most works of art is called the figure—ground relationship. In *Ti Watching a Hippopotamus Hunt*, for example, we read the humans and the cat, birds, fish, foliage, and boat as "positive" elements (figures) isolated against "negative" backgrounds (the ground) behind them. A similar effect can be noted when works of

sculpture and architecture are isolated and stand out against or within their surroundings. In analyses of works of art, the positive—negative, figure—ground relationship is always an important component. In some modern works, artists have achieved visual ambiguity by allowing the positive and negative forms to assume virtually equal importance in the composition.

The Indus Valley Civilization

t about the same time as the Old Kingdom in Egypt and Neolithic building activity at Stonehenge, the first civilization in South Asia arose at a group of sites in the Indus River Valley, in modern-day Pakistan and India (see map, p. 161). Many of these Indus Valley civilization sites are divided into two major areas: a lower, usually eastern, section of domestic buildings, craft workshops, and private shrines; and an elevated section in the west containing public ritual buildings. A number of similarities among these sites—consistent use of a writing system; modular sizes of baked brick for houses and public buildings; settlement layouts; pottery styles; systems of weights and measures-suggest that a central administration controlled production and distribution of goods and services. Such a body probably controlled trade within the Indus Valley and outside at least as far as Mesopotamia. There is evidence that they imported raw materials, exotic stones, gold, copper, and tin, but few manufactured or prestige goods from outside have been found.

What is surprising is that the Indus Valley sites lack royal burials, great funerary structures, monumental art, and other symbols of prestige and authority. The absence of larger, more ornate houses and exotic luxury goods suggests that there was no wealthy class. So it would seem that the model of a kingdom or empire, headed by a priest-king and supported by a royal clan holding authority through dynastic succession, did not apply here, as it did in the ancient palace-temple societies of Egypt, Mesopotamia, China, and Mesoamerica. In addition, there is little evidence of the military influence often found in other ancient empires. The raised platforms seem to define social and functional space, and were not intended to provide an area to defend citizens from external enemies.

Mohenjo-Daro (fig. 3.31) is an important Indus Valley site because of the age, scale, and richness of the finds, including numerous stone seals, the majority of which are engraved with an animal and a short inscription. That the most frequently represented animal is a profile view of a

3.31 Reconstruction of the Great Bath, granary, and houses, Mohenjo-Daro, Indus Valley (modern Pakistan), c. 2100–1750 BCE. The total area of the excavated site is approximately 12 square miles (31 sq km).

Of the buildings excavated at Mohenjo-Daro, the most spectacular is the Great Bath, used for ritual bathing, which measures 40 by 30 feet and was sunk about 8 feet below the surface of the surrounding pavement. It was built from meticulously laid bricks set in gypsum plaster over a waterproof bitumen layer. A nearby well provided the water, which could be emptied through a massive drain. Excavation of Mohenjo-Daro, which is located northeast of present-day Karachi, Pakistan, was begun on a grand scale between 1922 and 1927 under John Marshall of the Archaeological Survey of India; since 1931, a number of other teams have worked at the site. Evidence suggests that Mohenjo-Daro, like other Indus Valley sites, was occupied from about 2700 to 1500 BCE; the stratified settlement debris investigated by archaeologists was 100 feet (30.5 m) deep. The ancient center rises 40 feet (12.2 m) above the surrounding plain; the highest point is formed by an artificial platform of mud and mud bricks.

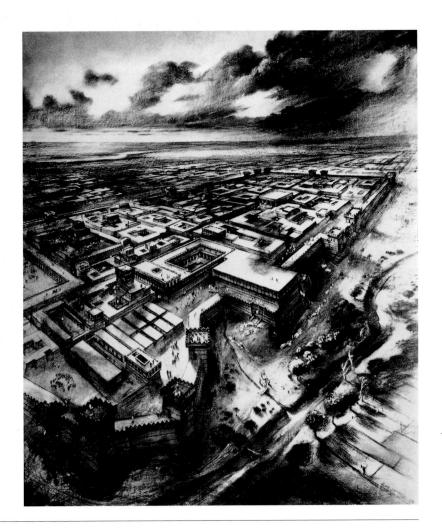

c. 2100-1750 BCE Great Bath, granary, and houses, Mohenjo-Daro (fig. 3.31)

c. 2000 BCE Potatoes are domesticated in Peru

c. 1900 BCE Earliest Chinese bronzes are cast

c. 1600 BCE The chariot is introduced into Egypt

c. 1500 BCE Rice cultivation is adopted in Korea

3.32 Seal with Ithyphallic Figure, found at Mohenjo-Daro, Indus Valley (modern Pakistan), c. 2100-1750 BCE. White steatite, height 1' %" (31.4 cm). National Museum, New Delhi, India.

The seals found at Mohenjo-Daro are rectangular or square, unlike the cylindrical seals found in ancient Mesopotamian centers.

bull, the beast of burden revered in later Hindu India, suggests that there may be some connection between these early finds and later Indian religious developments. A similar conclusion is suggested by our example, with its depiction of a frontal male figure wearing buffalo horns and surrounded by animals (fig. 3.32). He is depicted ithyphallic (with an erect phallus) and is seated in the position of yogic meditation. The writing on the seal still defies translation, although nearly 4,000 other inscriptions have been identified. This exceptional figure may be a precursor of the Hindu god Siva, the "Lord of the Animals," thought to have procreative powers, or it may be a representation of a chief with concerns for appeasing the wild kingdom. We do know that seals were used for administrative purposes, such as sealing bales of merchandise or marking storage boxes, and most inscriptions seem to record the names and administrative titles of their users, but the writing has not been fully deciphered.

Excavators have also found, inside many houses, a large number of small, elaborately dressed terra-cotta figures of women. These statuettes are thought to be part of private devotion to the powers of fertility, and, in fact, emphasis on the female procreative powers continues today in both Hindu and Buddhist iconography in Asia.

The lower, eastern part of Mohenjo-Daro had a grid of streets and lanes roughly oriented north-south and east-west, with blocks of houses entered through narrow lanes. Although the houses varied in size, they all had rooms arranged around a central courtyard, usually with a well in a small room off the court, and a bath and latrine draining through the wall into either a soak pit or a covered drain under the street surface. Some two-story houses had brick stairs and tubular drainpipes extending from the upper story. Plumbing installations for the provision of water, bathrooms with polished brick floors, and the exterior drains found here are without parallel in other early historic societies.

Although there are public buildings on the raised platform that is the highest part of the site, including a large granary and the Great Bath, no large community temple has so far been located at Mohenjo-Daro. The entire raised platform may have served as a ritual center, for at related sites, fire altars have been identified in the raised platform areas, as well as in private houses.

The reason for the collapse of the Indus Valley civilization is not fully known, but it is often explained as a result of natural events such as earthquakes, which changed the course of the rivers, causing the population to desert its settlements.

Aegean Art: Minoan and Mycenaean

uring the second millennium BCE, two distinct cultures flourished in the Aegean area (see map, p. 73). As in many other early civilizations, the animal was an important motif in both cultures, as evidenced by the *Bull Leaping* fresco from Knossos (see fig. 3.33) and the Lion Gate at Mycenae (see fig. 3.37). The contrast between the fluid movement of the jumping bull and the severe rigidity of the guardian lions, however, reflects the differences between these cultures.

The ancient Minoan civilization, named in modern times after King Minos from Greek mythology, flourished on the island of Crete. The origins of the Minoan civilization, which was based on agriculture and a wide seafaring trade, are unclear. Archaeological evidence has long been interpreted as showing that an early culture, Minoan I, developed about 2000 BCE to 1700 BCE and was followed by Minoan II, which declined relatively abruptly after about 1450 BCE. Recent findings, however, indicate that a volcanic eruption, which was probably the cause of the rapid

decline, occurred about 1620 BCE, thus throwing off previously accepted dating by several hundred years. Because the date question is still unresolved, we shall use broad dates for works of art for the Minoan culture. Natural catastrophes, perhaps volcanic eruptions with related earthquakes and tidal waves, may have caused the end of Minoan culture—and may, in fact, be the historical explanation for the legend of the city of Atlantis, which is said to have disappeared beneath the sea.

The earliest Minoan artifacts exhibit a preference for abstract curvilinear designs that in the Minoan II culture were joined to representational forms to create dynamic and lively images, as in the *Bull Leaping* **fresco** (fig. **3.33**). This fresco depicts a ritual or ceremonial event held in the central court of the palace at Knossos, in which trained athletes grasped the horns of a charging bull and vaulted over its back. An undulating rhythm defines the bull's forward motion; the line of its neck is continued in its elongated, curving body, lending grace to what must have been a

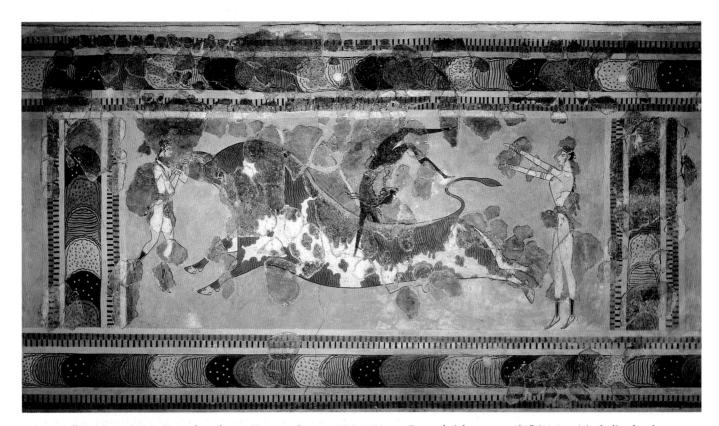

3.33 *Bull Leaping*, Minoan. From the palace at Knossos, Crete, c. 1750–1450 BCE. Fresco, height approx. 2' 8" (72.8 cm) including borders. Archaeological Museum, Heraklion, Crete.

The Greek myth of Theseus and the Minotaur may have been based on the bull-leaping ritual demonstrated here and the labyrinthine structure of the palace at Knossos (see fig. 3.35). This fresco was not complete when it was found, and the fragments have been pieced together and the missing areas painted in; this gives the impression that the painting is better preserved than it is. There is no guarantee that the restored areas are accurate in every detail.

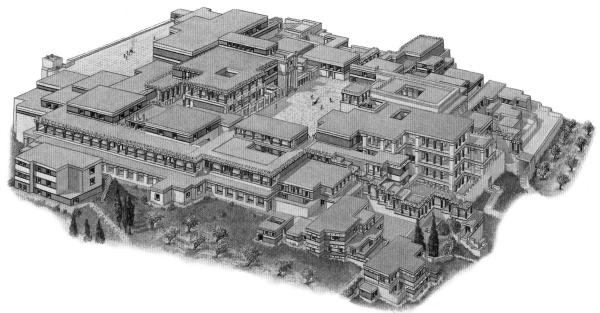

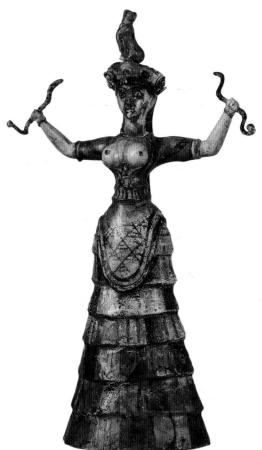

3.34 Snake Goddess or Priestess, Minoan. Found at the palace at Knossos, Crete, c. 1800–1550 BCE. Faience, height 11' 5/8" (34.3 cm). Archaeological Museum, Heraklion, Crete.

Faience is a type of earthenware decorated with glazes that was used as early as the predynastic period in Egypt.

3.35 Reconstruction view of the palace at Knossos, Crete, c. 1800-1300 BCE. Commissioned by a series of Minoan kings.

strenuous and dangerous activity. Bright, contrasting colors add to the vitality of the scene.

Excavations at the palace at Knossos have also brought to light statuettes related to Minoan religion. Although the Minoans' belief system remains mysterious, figures such as this small, snake-brandishing woman (fig. 3.34) may represent a goddess, perhaps the earth mother, or a devotee.

The remains of palaces indicate that the royal residences were combined with administrative offices, servants' quarters, and ceremonial and storage rooms. At Knossos, these rooms are grouped around a central courtyard in a rambling, labyrinthine design that seems to have developed over time without a predetermined plan, rooms being added as they were needed (fig. 3.35).

The interior decorations of the palace exhibit the lively, rhythmic qualities common in Minoan art; brightly colored fresco paintings depict scenes of ceremony, ritual, and animal and marine life (fig. 3.36).

As the Minoan culture began to decline, the Mycenaean rose to supremacy in the Aegean area. This Bronze Age culture, which flourished about 1400-1100 BCE, was named for the walled city of Mycenae on the Greek mainland, which was known for its fortifications. It was the military force from this culture that, as the ancient Greek poet Homer wrote, "launched a thousand ships" to attack Troy.

The only entrance into Mycenae was through the monumental architectural gateway now known as the Lion Gate **3.36** View of restored chamber in the palace at Knossos, Crete, c. 1700–1400 BCE. Commissioned by a Minoan king or queen.

Like the *Bull Leaping* fresco from the palace seen in fig. 3.33, the scattered fragments of decoration that survived from this room have been reconstituted and restored in an attempt to give an indication of the original decorative program.

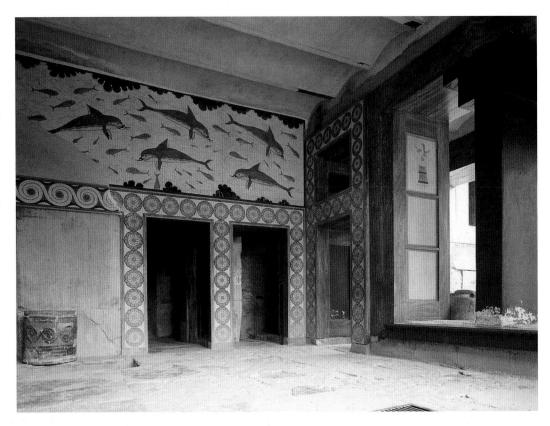

(fig. 3.37). Atop the lintel, a relief sculpture displays symmetrical bodies of lions flanking a column that rests on altars. The scale of the relief and the stylized yet subtle animation of the lions' bodies proclaim the heraldry of royal power.

Homer's *Iliad*, the epic poem that tells of the war between the Trojans and the "Greeks" or Hellenes—a group that included the Mycenaeans—was long considered to be a product of human imagination, but its vividness intrigued Heinrich Schliemann, a German business executive and amateur archaeologist. In 1870, he began to excavate sites in Asia Minor, a peninsula between the Black Sea and the Mediterranean Sea, where he found the archaeological remains of Homer's Troy, and in Greece, where he excavated Mycenae. The investigations spurred by Schliemann's discoveries gave credence to the legends of ancient Greece and brought to light the robust activity of the ancient Aegean area.

3.37 Lion Gate, Mycenae, Greece, c. 1300–1200 BCE. Limestone, height of carved slab 9' 6" (2.9 m).

This historic photograph shows Heinrich Schliemann, the director of the excavation, standing to the left of the gate. The woman seated to the right is his Greek wife, Sophia. The huge slab on which the lions are carved fills a triangular opening in the construction, which helps to relieve weight on the lintel. The missing heads were originally attached with dowels. It is possible that they were carved or cast from a different material, and they may have represented human heads.

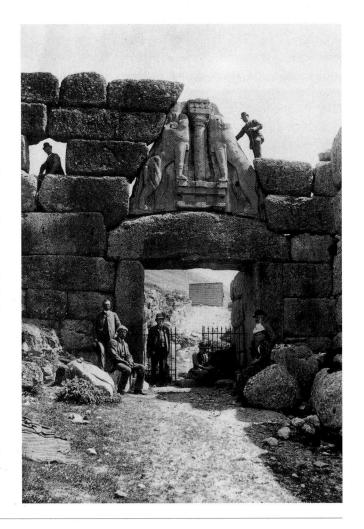

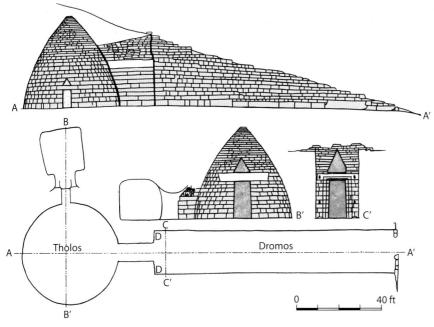

3.38 Plan and sections of the tholos tomb popularly known as the Treasury of Atreus, Mycenae (after A. W. Lawrence), c. 1300-1200 BCE. Stone, height approx. 45' (13.7 m). Because of their shape, such tholos ("round") tombs are also known as beehive tombs.

The Mycenaeans were the descendants of Greekspeaking peoples who invaded the peninsula of Greece between about 2000 and 1700 BCE. They were active traders, especially with the Minoans, and Mycenaean goods have been excavated in Italy and Syria. Mycenae was only one of a number of fortified towns that shared a common culture and language, although each was ruled by an independent monarch. Mycenaean kings were buried in large round tholos tombs accompanied by their personal treasures, including weapons. The tomb shown here (fig. 3.38) is remarkable for its size and the precision of its cut stone blocks, some of which weigh several tons.

the Mycenaeans, offers a more abstract mode of representation. The gold funeral mask from a royal tomb excavated at Mycenae was once probably placed over the face of a deceased king (fig. 3.39). While offering some individual characteristics, such as the mustache and beard, the arched eyebrows and treatment of the ears display a more abstracted approach.

The Mycenaean culture ended when the Dorians entered the peninsula from the north in about 1100 BCE and conquered the Mycenaeans, but their legacy and that of the Minoans nourished the evolution of later Greek culture.

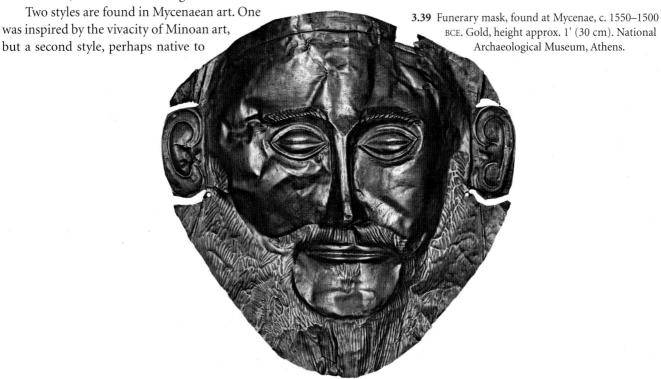

Ancient China: The Shang Dynasty

he fang ding shown here (fig. 3.40) is from the Tomb of Lady Hao at Anyang; its undisturbed chamber vielded a tremendous amount of magnificent tomb furniture, making it the best-preserved tomb ever excavated at Anyang, the last capital of the Shang Dynasty (occupied c. 1300–1050 BCE). The tomb was an oblong shaft approximately thirteen feet by eighteen and a half feet. Along the eastern and western walls, at a depth of about twenty feet, were elongated niches with sacrifices: sixteen human beings and six dogs. Tomb furniture was placed in eight layers both above and on the chamber top, in the chamber between its walls and the coffin, and inside the coffin itself. Of the total of 1,900 burial objects, about 460 were bronze vessels, tools, and weapons; almost 750 were jade; and about 560 were bone objects. There were also some sculptures and ivory carvings and five pottery vessels. In addition to the 1,900 pieces, there were nearly 7,000 cowrie shells, presumably used as currency. The ritual objects of bronze, jade, bone, and other materials served both the living and the dead. Specially shaped bronze vessels containing offerings of food and drink were used in highly formalized rites dedicated to deceased ancestors, who were believed to protect the living. The immense wealth of this tomb and others at Anyang (see map, p. 161) indicates that the Shang had control of and created great resources.

Some of the earliest examples of Chinese writing are Shang inscriptions on bronze vessels and on animal bones or turtle shells, used as oracles, that were excavated there. Inscriptions on more than 190 bronze vessels from the tomb identify Lady Hao's status and death date. The use of the Shang clan emblem, the *taotie*, on her tomb materials confirm her acceptance into the Shang elite. She also seems to have retained cultural affiliation with her non-Shang parent culture, as evidenced by the jade hawk (fig. 3.41) and frontier-style bronze knives, horse gear, and mirrors also found in her tomb.

Shamanism was reflected in the rituals and burial at Anyang, which paid homage to ancestors and to the spirits of the natural world. Many of the materials used at these ceremonies were decorated with the *taotie* mask that was the emblem of the ruling clan (see pp. 34–35). By claiming that communication with the spirit world, including ancestors, was only possible through the use of such vessels, the rulers and the elite may have been creating and maintaining their status separate from the masses. Because they controlled the production of bronze as well as the ceremonies that made use of bronze vessels and weapons, they demonstrated their dual power—access to the spirit world and military domination.

3.40 *Fang ding*, from the Tomb of Lady Hao, Anyang, Henan Province, China. Shang Dynasty, c. 1200 BCE. Bronze, height 1' 4¾" (42.5 cm). Cultural Relics Bureau, Beijing, People's Republic of China. Commissioned by Lady Hao or her family.

Our knowledge of ancient China has been greatly enriched by archaeological findings in the tombs of the Shang, the first documented historical Chinese dynasty (c. 1766–1122 BCE). The richest finds have been near modern Anyang, a ceremonial center for the Shang that included the royal burial grounds as well as official temples and palaces built on pounded-earth platforms.

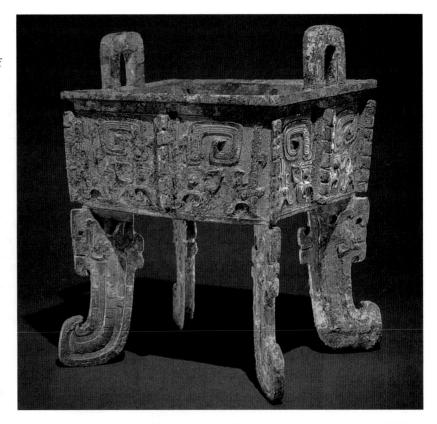

c. 1500-1200 BCE Polynesian islands first settled

c. 1360 BCE Population of Thebes, Egypt, is 100,000

c. 1200 BCE Fang ding from the Tomb of Lady Hao (fig. 3.40)

c. 1200 BCE Women are professional musicians in Egypt

c. 1100 BCE Dorians enter Greek Peninsula

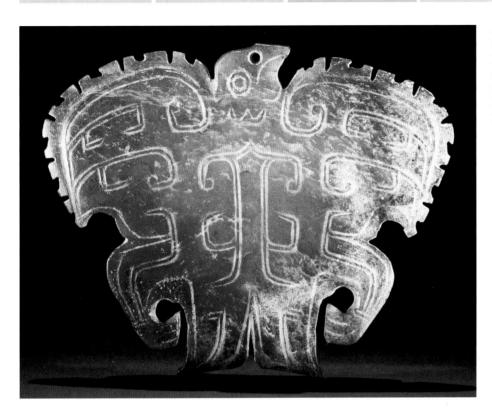

3.41 Pendant in the shape of a hawk, from the Tomb of Lady Hao, Anyang, Henan Province, China. Shang Dynasty, c. 1200 BCE. Jade, height 23/8" (6 cm). Cultural Relics Bureau, Beijing, People's Republic of China. Commissioned by Lady Hao or her family.

TECHNIQUE

Chinese Piece-Mold Bronze Casting

In ancient China, the industries involved in making bronze vessels and ritual implements were located in Anyang. The production of bronze, an alloy of copper, tin, and

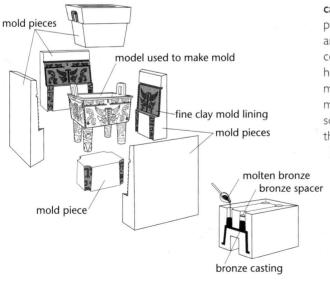

section view of mold assembled and overturned for casting

sometimes other minerals, was a sophisticated activity. It required coordinated teams of miners, metallurgists to refine the ores for the alloy, designers, and foundrymen to control the hot metal, which becomes molten at 1800 degrees. The process used was a sophisticated piece-mold casting method, which depended on knowledge of the properties of different clays. First, the designer produced an exact model of the desired final product in fine clay, complete with the incised designs on the surface. Next, heavy clay was packed around the model to create the mold. Then, after the model was removed, the parts of the mold were carefully reassembled, using bronze spacers in some places to maintain uniform wall thicknesses. Finally, the entire assemblage was packed in sand (not shown here) and pre-heated, and molten bronze was poured

> into the mold to form the cast vessel (fig. 3.42). After the casting cooled, details on the surface of the bronze were filed and polished to produce a sharp design and shiny surface.

> > **3.42** The technique of bronze casting in ancient China as shown for the fang ding in fig. 3.40.

Assyrian and Early Persian Art

he Assyrians and Persians successively controlled Mesopotamia. The Assyrians established a powerful kingdom in northern Mesopotamia from the ninth through the seventh centuries BCE, while the early, or Achaemenid, Persians were centered in southern Mesopotamia during the sixth and fifth centuries BCE (see map, p. 41). Both cultures were known for their powerful kings, who tried to conquer and control vast territories. The Assyrians in particular were feared for their atrocities during war, but the Persians, who for a brief period even conquered Egypt, tried to establish a reputation for benevolent rule and had greater success in creating a huge empire.

Assyrian and early Persian palaces were similarly decorated, with low reliefs lining the palace rooms and passages.

In Assyrian palaces, the themes were ritualistic, honorific, militaristic, or any subject that would impress the visitor with the unquestionable power and undeniable majesty of the royal personage. This sense of commanding omnipotence can also be seen in other palace sculptures, such as the *Lamassu* (fig. 3.43), which seems to have been intended to intimidate visitors—especially foreign ambassadors—before they entered into the presence of the Assyrian king. The threatening content is supported by the treatment of the stone; its high polish emphasizes its density, while the patterns and fine detail of the beard and wings stress the massive scale and powerful forms. The figure is given five legs to present a convincing stance from both the front view, on approach, and the side, in passing.

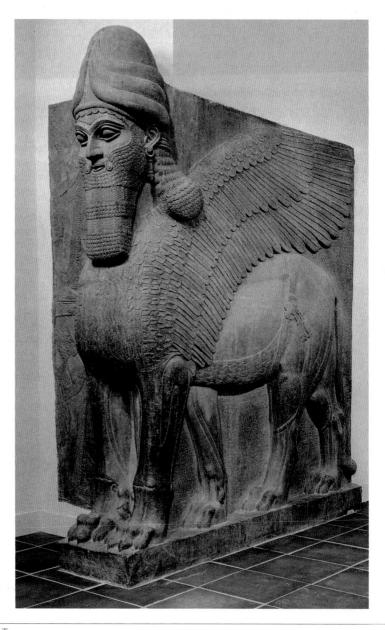

3.43 Human-Headed Winged Bull (*Lamassu*), Assyrian, from the Palace of Assurnasirpal II, Nimrud, 883–859 BCE. Limestone, height 10' 2" (3.11 m). The Metropolitan Museum of Art, New York. Commissioned by King Assurnasirpal II.

c. 1000-960 BCE David rules as king of Israel

c. 950 BCE First Chinese book on mathematics is written

883-859 BCE Human-Headed Winged Bull, Assyria (fig. 3.43)

c. 800 BCE Upanishads, sacred Hindu texts, are first written

776 BCF Earliest known Olympian Games, in Greece

3.44 Dying Lioness, Assyrian, from the North Palace of Ashurbanipal, Nineveh (modern Kuyunjik, Iraq), c. 645-635 BCE. Limestone, height of figure approx. 1' 2" (16.5 cm). The British Museum, London. Commissioned by King Ashurbanipal.

The Assyrian palace where the Lamassu stood covered many acres (10.1 hectares) and had more than 100 courtyards and rooms. Here and at the ancient sites of Nimrud and Nineveh, continuous low reliefs depicted Assyrian military victories and the subsequent pillage and carnage. The reliefs emphasized the Assyrian king's strength in battle or in sport. In one series, he is shown engaged in a hunt in which lions were released from cages. The king is represented victorious in his chariot, surrounded by dead and dying animals. In the detail pictured (fig. 3.44), a lioness is shown in her death throes, dragging her paralyzed legs behind her and moaning in pain.

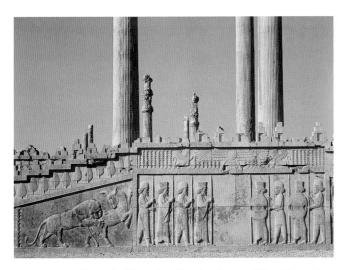

3.45 Royal audience hall (Apadana) and stairway of the Palace of Darius, Persepolis (modern Iran). Early Persian, c. 500 BCE. Commissioned by King Darius.

The early Persian Palace of Darius at Persepolis (fig. 3.45) had grand staircases decorated with reliefs. The reliefs depict seemingly endless processions and scenes in which, following an old Middle Eastern tradition, a fierce beast is represented attacking a domesticated animal. Such scenes are open to a number of levels of interpretation. On one level, they probably symbolize Persian power and victory, but they may also refer to political and even to cosmic conflict.

These imposing staircases led to a sequence of magnificent square throne rooms and ceremonial chambers filled with large columns. The largest chamber was 250 feet square (23.2 sq m), with columns at least forty feet (12.2 m) high. The capitals—the decorated elements at the tops of the columns—are unusual and uniquely Persian, with gigantic figures of paired bulls (fig. 3.46). Stylistically, the debt of the Persians to Assyrian art is evident in the contrast between bold, simple masses and fine, abstract detail, but the Persian compositions have an increased refinement and elegance.

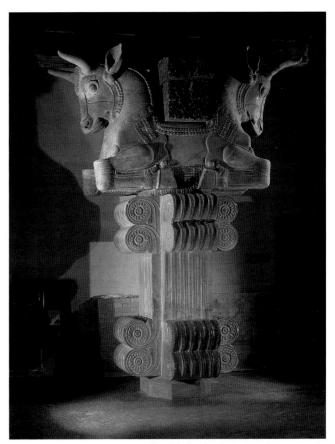

3.46 Bull capital, from the Apadana, Palace of Darius, Persepolis (modern Iran). Early Persian, c. 500 BCE. Width 12' 3" (3.73 m). The Louvre, Paris, France. Commissioned by King Darius.

Mesoamerica: The Olmec

his colossal head was one of nine found at the site known as San Lorenzo in La Venta, Mexico (fig. 3.47; see map, p. 138). A total of sixteen of these heads have been found in the region, which was occupied between 900 and 600 BCE by a people now known as the Olmec. Although the heads represent an idealized type, each has a different expression, and the motifs and symbols

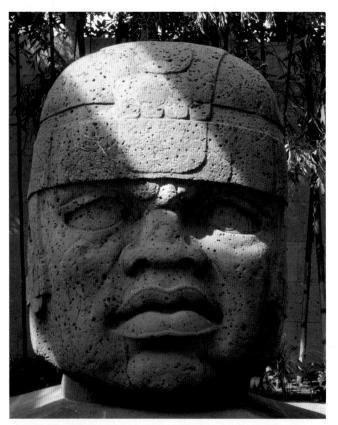

3.47 Colossal head, from San Lorenzo, La Venta, Mexico. Middle Formative Period, c. 900 BCE. Basalt, height 7' 5" (2.4 m). La Venta Park, Villahermosa, Tabasco, Mexico.

The region of southern Veracruz and neighboring Tabasco has been called the Olmec heartland, for it is there that the greatest concentration of Olmec monuments and sites are located, in an area little more than 125 miles in length by about 50 miles in width. Much of this area, which is characterized by high rainfall and a tropical rainforest, is swampy lowland. The La Venta site is located on an island in a sea-level coastal swamp near the Tonalá River, about 18 miles inland from the Gulf of Mexico. The island has slightly more than two square miles of dry land, but little household debris has been found there. The nearest arable land is along the Tonalá River, which may have been the site from which the rulers of La Venta depended for food production and labor force. Some of the colossal heads like this one weigh up to 20 tons, and since the nearest basalt to the La Venta site is about 80 air miles to the west, archaeologists surmise that the stone was floated to the island on rafts.

that decorate their headdresses vary. These differences suggest that they may be portraits—perhaps depictions of dynastic rulers. The importance of commemorative sculptures that convey the qualities that justified leadership is evident in later Mesoamerican works, and it is reasonable to presume that these heads lie at the root of this tradition. The Olmec is one of the most ancient Mesoamerican civilizations to be identified, but we know neither what they called themselves nor where they came from.

It is commonly held by archaeologists that the Olmec civilization was a theocracy. Peasants supported the rulers with their agricultural surplus and their labor in return for assurance that the rituals carried out by priests in the ceremonial centers would bring some degree of security to their lives and agricultural livelihood. The Olmec religion had a complex iconography illustrating their religious beliefs. The most notable was the jaguar god seen in fig. 3.48.

The Olmec were accomplished carvers, creating colossal heads of basalt, stone stelae and altars, finely carved jade celts (axes), figurines (fig. **3.49**), and pendants. A combination of carving, drilling (using a reed and wet sand), and delicate incising was used to finish these objects on all sides.

The ceremonial site at La Venta is a linear complex of clay constructions along a north–south axis (fig. 3.50). Excavation has revealed a huge pyramid of packed clay that probably derives from the ancient notion of a burial mound or funerary monument (compare figs. 3.18, 4.55, and 5.49). To the north are two long, low mounds on either side of the axis, with a low mound in the center. A fence of basalt columns once surrounded the central plaza. Finally, along the centerline is a large terraced clay mound.

3.48 Mosaic pavement representing an abstract jaguar mask, one of three from La Venta, Tabasco, Mexico. Middle Formative Period, 900–600 BCE. Pavement covered with layer of mottled pink clay on a platform of adobe brick, $15 \times 20'$ (4.6×6 m).

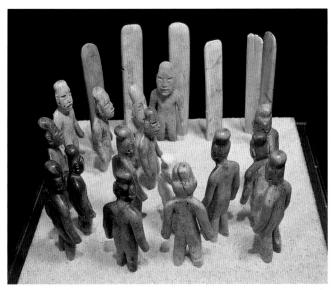

3.49 Ceremonial group of sixteen figures. Middle Formative Period, c. 1000 BCE. Serpentine, jade, and conglomerate figures, jade axes; height of figurines between 6%" × 7%6" (15.7 and 18.3 cm). Votive offering no. 4 found at La Venta, Tabasco, Mexico. Museo Nacional de Antropología, Mexico City.

A number of buried offerings were found at the site, including three rectangular pavements (see fig. 3.48). Each consists of almost 500 blocks of serpentine laid out in the form of a highly abstract jaguar mask. These pavements were also apparently offerings, as they were covered soon after construction.

Mesoamerica is a term used by archaeologists for an area that includes the southern half of Mexico, Guatemala, Belize, and parts of Central America; it encompasses the central plateau of Mexico, the tropical coastal plain on the Gulf of Mexico where the Olmec lived, the flat limestone expanse of the Yucatán peninsula, and the region of mountains and lowland forests of Guatemala and Belize. The diverse peoples of Mesoamerica shared cultural traits, such as ceremonial centers with pyramids and temples built around plazas (see figs. 3.50, 4.55), monumental sculpture, a fifty-two-year religious calendar, divinatory books, pictorial manuscripts, a ceremonial ball game, and an annual cycle of seasonal rites. The populations in elite centers had highly specialized religious, military, and trade organizations (see pp. 138-41), and were supported by various forms of agriculture as well as by tribute from conquered peoples. The great mass of people lived in hamlets and villages scattered through the countryside. Central markets allowed produce and products to change hands. Maize, amaranth, beans, and squash were primary staples of the diet, but many other vegetables and fruits such as cacao

(chocolate), tomatoes, avocados, and peanuts were widely cultivated. In this, as in many other areas of the Amerindian world, the varieties of domesticated plants far exceeded those available in medieval Europe.

Like other Amerindians, the people of Mesoamerica neither worked in metal nor used the wheel. On the other hand, the Olmec, Teotihuacán, and Maya, as well as the populations of Oaxaca and Veracruz, transported and erected stone monuments weighing many tons (see fig. 3.47). They built enormous pyramids and handsome cities (see pp. 138-41), and priestly astronomers tracked celestial phenomena and developed sophisticated mathematical and writing systems. Monuments built at sacred sites affirmed a basic religious contract for maintaining continuity between people and the cycles of life in the world around them. Ritual centers and activities provided visual expression of the order and coherence of society within the structures and rhythms of nature.

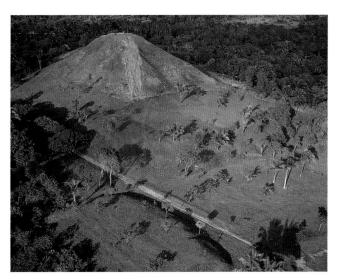

3.50 Great Pyramid and Ritual Complex at La Venta, Tabasco, Mexico. Middle Formative Period c. 900–600 BCE. 1½ miles (2.4 km) in length, height of pyramid approx. 110' (33 m).

An estimated 800,000 person hours were needed to construct the main pyramid. Originally, different colored clays were used for the floors, while the sides of the platforms were painted in red, yellow, and purple. Facing these painted structures were a large number of monuments sculpted from basalt, including four colossal heads like the one seen in fig. 3.47. La Venta was deliberately destroyed in ancient times; the fall must have been violent, as twenty-four of the forty sculpted monuments were intentionally mutilated. Even though this probably occurred as early as 400-300 BCE, offerings continued to be made at the site following its abandonment as a cult center, suggesting that it maintained its significance for centuries. La Venta, a powerful and holy place in the Olmec heartland, was perhaps in part sacred because of its inaccessibility.

Etruscan Art

he breasts, arms, hands, and head that personalize this abstracted container (fig. 3.52) may have been enhanced by a wig made of real hair, most likely from the deceased, and by pieces of jewelry. As a container for the ashes of the deceased, it would have been placed in her tomb and surrounded by other possessions, which probably would have included a hand mirror (see fig. 3.2). Other personal details may have been added to the urn in paint. This type of ash urn is only one of the ways in which the Etruscans honored the dead.

The origin of the people we know as the Etruscans is debated, but by the eighth century BCE they had established themselves in a group of cities in Etruria (present-day Tuscany, in central Italy) and were the most important power on the Italian peninsula (see map, p. 114). These cities were fiercely independent and had distinctive burial practices. During the seventh and sixth centuries BCE, Etruscans ruled as kings of Rome, and by the fifth century they controlled most of central Italy. They were active traders, and their works in bronze, especially armor, were exported throughout the ancient world. During the fourth and third centuries BCE, the Etruscan cities were defeated and annexed by the Romans, and the Etruscan culture was absorbed into the Roman sphere.

Etruscan inscriptions have been translated, but there is no surviving body of Etruscan literature, so like many other, earlier, prehistoric civilizations, Etruscan civilization is studied primarily from archaeological remains. Like other early Mediterranean cultures, including Egypt, the Etruscans believed that the body or ashes of the deceased should be accompanied by household and other everyday objects to guarantee a satisfying afterlife. Thus, much of our knowledge of the Etruscans is based on their tombs, carved in rock and/or frescoed, and on the tomb furnishings, which included gold and bronze objects of superb artistry (see fig. 3.2) and fine imported goods, such as Greek vases.

On one Etruscan sarcophagus, a couple reclining on a banqueting couch engages us with beguiling smiles (fig. 3.51). The construction of a terra-cotta group of this scale and complexity is an impressive technical accomplishment, but equally remarkable is the representation of their relaxed positions and their inner delight. That this work's original function was as a sarcophagus suggests the Etruscans' relatively content and reconciled outlook on death. Reclining in this manner is a Greek tradition, but the representation of a man and a woman reclining together is typically Etruscan. It suggests a respect for women that was unknown in Greece and rare in other early cultures.

3.51 Etruscan sarcophagus with reclining couple, from Cerveteri, Tuscany, Italyk c. 525–500 BCE. Terra-cotta, length 6' 7" (1.9 m); the figures are lifesize. Museo Nazionale di Villa Giulia, Rome, Italy. Probably commissioned by the family of the deceased.

A similar sarcophagus in the Louvre in Paris has many traces of color suggesting that this one may also have been naturalistically painted.

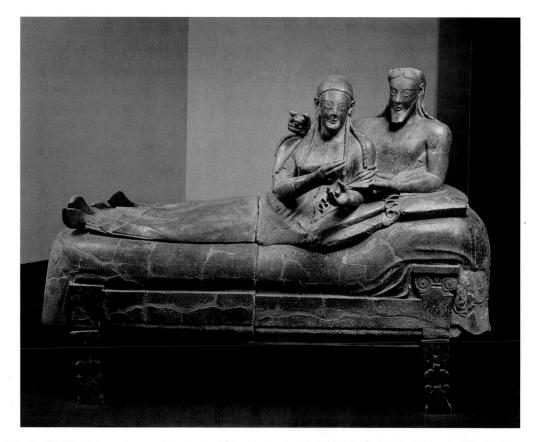

587-539 BCE Some Jewish Bible texts are written

c. 550 BCE Daoism is founded by the Chinese philosopher Laozi

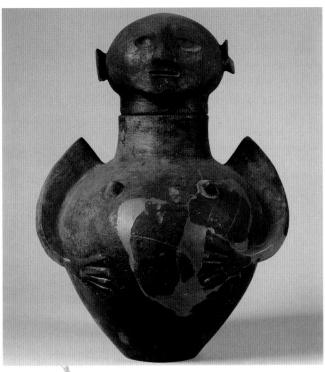

3.52 Ash urn, found at Castiglione del Lago, Italy, c. 650-600 BCE. Terra-cotta, approx. 1' 6½" high (47 cm). Archaeological Museum, Florence, Italy. Probably commissioned by the family of the deceased.

Etruscan burial practices, which varied widely from city to city, included cremation, as here, and inhumation.

Many Etruscan works were inspired by Greek examples, but the Etruscans' style is generally bolder and simpler and displays little interest in the symmetry so favored by the Greeks. Much Etruscan iconography emphasizes everyday activities, but there are also frequent references to Greek myths, and it is clear that divination (see fig. 3.2) was an important Etruscan activity. Especially in such large-scale pieces as the sarcophagus and in figures and decoration used on architecture, Etruscans made important technical innovations in the use of terra-cotta, a fired clay. Most Etruscan artists did not sign their works; there seems to have been no cult of the artist, as there was in Greece.

Simple bright colors, bold geometric and natural patterns, and clearly drawn figures combine in Etruscan tomb paintings to create a lively and vigorous effect. Typical Etruscan themes include banqueting figures—referring to the banquets that were part of the Etruscan funeral ritual complete with the dancers and musicians that provided entertainment, as well as scenes of pleasurable daily life to be enjoyed by the deceased. In the Tomb of Hunting and Fishing (fig. 3.53), a profusion of wildlife guarantees success in the hunt; above, the deceased (and perhaps the living) are shown banqueting.

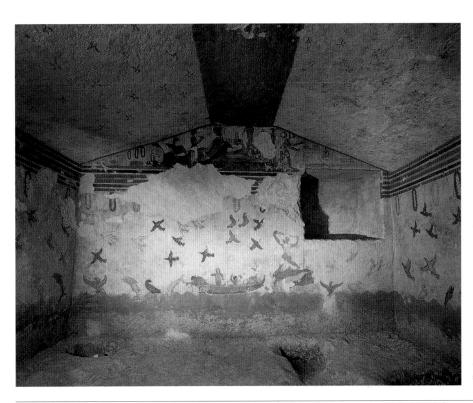

3.53 Tomb of Hunting and Fishing, Tarquinia, Italy c. 510-500 BCE. Fresco. Probably commissioned by the family of the deceased.

Ancient Greek Art

n the midst of a chaotic combat (fig. **3.54**), the over-life-size figure of the Greek god Apollo majestically restores order. As in many ancient communities, bringing order, both natural and human as well as actual and symbolic, is a major preoccupation of political and religious leaders. Here Apollo occupies the axis of the composition, and his calm yet commanding presence contrasts with the outburst of surrounding activity. His idealized human physique and dignified bearing make him an appropriate introduction to the study of ancient Greek art.

This Apollo is part of a group of figures that originally decorated the triangular end (or **pediment**; see fig. 3.74) of the **gable** (pitched) **roof** of the Temple of Zeus at Olympia. The composition is clear, the movement is bold and direct, and the details of anatomy and drapery are easily read by the viewer standing fifty or more feet below. The sculptures illustrate a mythological subject. Among the guests at a wedding feast are drunken centaurs (half-human, half-horse creatures) who attempt to abduct the Greek women; after a fierce battle, they are subdued. This theme had an immediate significance for the Greeks of that time: their victory over the Persians in 479 BCE was symbolically

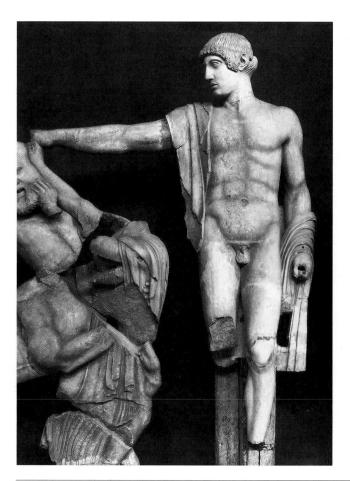

expressed in the victory over the centaurs. On a more profound level, the calm presence of Apollo represents the mastery of reasoned order over brute force. The scene had a special meaning because of its location at Olympia, for during the Olympian Games, a truce was observed among the Greek city-states.

HISTORY

About 1100 BCE, a people called the Dorians entered the Greek peninsula from the north and overwhelmed the Mycenaeans. Gradually a new culture evolved. By the eighth century BCE, the two great Homeric poems, the *Iliad* and the *Odyssey*, had been composed, and there were a number of independent city-states. Each city-state (*polis*) commanded the loyalty of its citizens in local religious, military, and economic matters, and their fierce independence prevented the political unification of Greece. In 776 BCE, the first Olympian Games were held. Called once every four years, they were held in honor of Zeus, ruler of the gods. Winners gained personal fame and were often honored in art. The winners of the footrace at similar games held in Athens, for example, were honored with prizes such as the **Panathenaic amphora** (see fig. 3.1).

During the eighth century BCE, developing commerce among the city-states led to a prosperous economy which was, in part, based on slave labor. One of the major products was pottery, and a Geometric-style vase (fig. 3.55), with its bands of simple repeated patterns, demonstrates the artistic beginnings of the Greeks. The animals on the neck of the vase are arranged in a repeated rhythm. In the largest, central band are rather abstracted figures representing female mourners pulling their hair at a funeral; the deceased lies on his bier. The scene is related to the purpose of such vases, which was to mark a grave site and thus play an important role in honoring the dead. Oil, poured into the vases to commemorate the deceased, flowed through the open bottom and into the ground.

During what is known in art as the Archaic period, from the seventh to the early fifth century BCE, trade routes expanded, and the Greeks began to colonize areas of southern Italy and Asia Minor. At this time, the Greeks began to produce life-size figurative sculpture and to construct marble temples.

3.54 Apollo and the Battle of the Lapiths and the Centaurs, detail from the west pediment, Temple of Zeus, Olympia, 470–456 BCE. Severe style. Marble, over-lifesize. Archaeological Museum, Olympia, Greece. Pausanias, who wrote a guidebook to Greece based on his travels there between 143 and 161 CE, attributes the pediments at Olympia to the artists Alkamenes and Paionios.

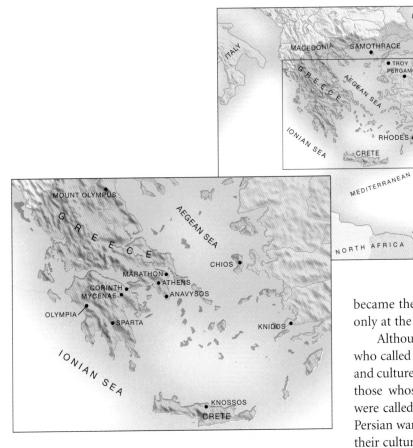

became the preeminent political and economic center, but only at the cost of jealousy from the other city-states.

BLACK SEA

ALEXANDRIA

EGYPT

RHODES

Although beset by internal political conflicts, the Greeks, who called themselves Hellenes, shared a common language and culture. They divided the world into two types of people: those whose native language was Greek, and others, who were called barbaroi ("barbarians"). In the aftermath of the Persian wars, the self-aware Greeks continued to define how their culture was distinct from that of the barbarians.

The early fifth century BCE was a time of significant artistic and political changes. In both sculpture and painting, a more naturalistic rendering of the human figure emerged. In architecture, the forms of the Greek temple underwent a process of visual refinement that gave them a new sense of elegance.

In 490 BCE, the Persians invaded Greece. The city-states formed a defensive alliance and defeated the invasion force at Marathon, about twenty-six miles northeast of Athens. After the battle, a courier ran to Athens bringing news of the victory; he fell dead of exhaustion after exclaiming, "Rejoice, we conquer." His run is commemorated in today's twenty-six-mile marathon races. Ten years later, the Persians captured and sacked Athens, but in 479 BCE the Greeks again defeated the Persians, this time at the naval battle of Salamis. During the thirty years following the second Persian defeat, Athens, which had agreed to supply the navy for the Greek military alliance, continued to collect taxes from the other city-states. During this period, Athens

3.55 Mourners around a Bier, c. 750 BCE. Geometric style. Terra-cotta, height 5' 1" (1.55 m). National Archaeological Museum, Athens, Greece. Probably commissioned by the family of the deceased.

The decorated pottery vessels of the Greeks, regardless of use, are traditionally known as vases. Vases such as this one are sometimes referred to as Dipylon vases because they were found at the Dipylon Cemetery in Athens.

The mid-fifth century BCE in Greece is known as the Classical period of art and culture. Its center was Athens, where a politician named Pericles was chief general of the city from 460 to 430 BCE. The Athenian government is often cited as the first democracy in the Western world, although only free men were allowed to vote.

Pericles used the wealth of Athens and the taxes collected from other city-states for an ambitious campaign of renewal, including rebuilding the temples destroyed by the Persians on the Acropolis (from the Greek *akros*, "highest," and *polis*, "city"), an outcropping of rock that dominates the center of Athens (fig. 3.56). To the Greeks, it was the sacred location where Poseidon, god of the sea, and Athena, goddess of wisdom, had contested for control of the city. Poseidon caused salt water to flow from a spring, but Athena's gift of an olive tree was deemed more beneficial and the city was thus dedicated to her. As late as the second century CE, a saltwater spring and an olive tree could still be found on the Acropolis.

Pericles seems to have recognized the value of providing an intellectual, physically healthy, and aesthetically pleasing environment for the citizens of Athens. Later, when war had broken out in Greece, he offered a funeral oration for Athenian soldiers:

Our constitution is called a democracy because power is not in the hands of a few, but of the people. Our laws secure equal justice for all in their private disputes, and our public opinion welcomes and honors talent in every brace of achievement; what counts is not membership in a particular class, but the actual ability a man possesses.

Yet ours is no mere work-a-day city. No other provides so much recreation for the spirit—contests and sacrifices all the year round, and beauty in our public buildings to cheer the heart and delight the eye day by day.

We are lovers of the beautiful without being extravagant, and lovers of wisdom without being soft. We regard wealth as something to be used properly, rather than as something to boast about.... We decide and debate, carefully, and in person, all matters of policy, for we do not think there is an incompatibility between words and deeds.

Our city is an education to Greece.

As the political dominance of Athens grew, so did the resentment of the other city-states. The Peloponnesian War, which erupted in 431 BCE, plunged Greece into turmoil. When the war ended in 404 BCE, the power of Athens was broken, and Sparta and Corinth assumed a more prominent role in the political affairs of Greece. By the later fourth century BCE, however, a new force from the north commanded attention, and the next chapter of ancient Greek history was written by two Macedonian kings, Philip and Alexander (see pp. 104–7).

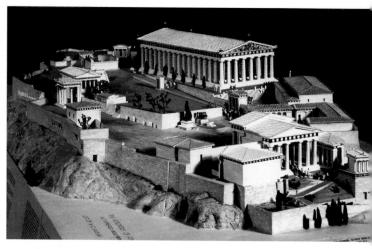

3.56 Reconstruction model of the Acropolis, Athens, c. 400 BCE. Royal Ontario Museum, Toronto, and J. Walter Graham.

The pedimented building in the right foreground is the Propylaea; the name means "gateway to a sacred or secular precinct." It was the only entrance to the Acropolis, and the building to its left is the earliest known example of a building built for the display of works of art; because art is inspired by the Muses, it was called a museum. For the Parthenon, see pp. 88–91.

INTELLECTUAL AND SCIENTIFIC ACTIVITIES

The love of wisdom that Pericles described found expression in philosophy and science as well as in art. From the mid-fifth through the fourth centuries BCE, philosophy developed from the speculative questioning of Socrates and the ideal forms of Plato to the natural observations by Aristotle. The Greek admiration for the human mind and for our ability to reason is a new development in Western culture and this, in concert with the Greek admiration for the beauty of the human body, has important implications for art. The philosophical questioning of the Greeks, in fact, helps to explain why their artistic forms were constantly evolving.

At the heart of the Greeks' world view was the belief that human reason—and especially mathematics—could understand and define the rational order inherent in the universe. In the sixth century BCE, Pythagoras wrote of the relationship between mathematics and musical harmony, noting that a stretched string, when plucked, produces a certain note by its vibration. When the string is measured and plucked at points that correspond to exact divisions by whole numbers—1/2, 1/3, etc.—the vibrations produce a harmonious chord. If the string is plucked at any other interval, the sound seems discordant. To the Greeks, this discovery had a powerful impact. If the sounds of nature were governed by the order of mathematics, then the universe itself must obey the harmony of mathematical concurrences. This notion of a universal harmony that could be perceived by human reason came to govern the rules of art and architecture during the Classical period.

RELIGION

The Greeks worshiped numerous gods and goddesses, who ruled over all aspects of life and death. Leader among the gods was Zeus (see fig. 3.64); Hera, wife of Zeus, was queen of the gods and protector of women. Apollo was the Greek god of rational thought and also of music, while his counterpart, the popular and hypnotic Dionysos, patron of drama and song, represents the irrational aspects of human life, fertility, and the powerful energy of the life force. Although some Egyptian gods had been represented in human form, it was the Greeks who fully anthropomorphized their deities, giving them both human form and human attributes.

Sacrifices to the gods were joined with great festivals that might include athletic games, such as the Olympian and other games, and theatrical productions. Greek theater developed from the rituals honoring Dionysos. The Greek Sophocles, Euripides, playwrights Æschylus, Aristophanes wrote plays to be performed during an annual Athenian festival honoring Dionysos. These plays are characterized by their profound and subtle expression of human motivation and behavior.

ANCIENT GREEK ART

The philosophical questioning that pervaded Greek intellectual life helps to explain why Greek art underwent a dramatic evolution of successive styles over a relatively short, 500-year period. The beginnings are represented in the Geometric phase (see fig. 3.55). The abstract features of Archaic period sculptures (see figs. 3.61 and 3.62) were transformed into the Severe style (see figs. 3.54, 3.63, 3.64) and then into the idealized representations of the Classical period (see figs. 1.15, 3.66, 3.74-3.76), which sought to equate the perfection of art with the harmonies of the natural order. By the time of Alexander the Great (ruled 336-323 BCE), the realistic and emotionally dramatic representations of what is known as the Hellenistic style were common (see figs. 4.14, 4.16). In painting, flat shapes (see fig. 3.55) gave way to elements of illusionism (see figs. 3.57 and 4.15); (see p. 36 for a discussion of a Greek painting competition), while in architecture proportions and decorative elements underwent a progressive transformation toward a more refined ideal (compare figs. 3.69 and 3.71). The continuous process of revision characteristic of Greek art is only one manifestation of the questioning and philosophical Greek mind. Greek art and architecture has had a profound impact on many later cultures, including our own. The Romans copied famous Greek illusionistic paintings and mosaics—for example, the Unswept Floor by Sosos (fig. 3.57). And the Greek architectural orders, so popular in the Renaissance and later periods, have been revived in the Postmodern style (see fig. 13.27).

THE ANCIENT GREEK ARTIST

The Greeks valued both intellectual and physical achievements, so it is not surprising that they would begin to praise the artist as an individual with unique talents. An exceptional development in the seventh century BCE, with virtually no precedent in earlier cultures, occurred when artists began with regularity to sign their works. Such signatures are an indication of personal pride; they might also have been a form of advertising. Literary sources from both ancient Greece and ancient Rome offer descriptions and criticisms of works of art that were considered famous. By the fourth century BCE, such references begin to include comments on the personalities of specific artists and anecdotes about their lives. An ancient discussion of the fourthcentury BCE painter Apelles, recorded by the Roman author Pliny, reveals the respect enjoyed by a successful artist:

Nevertheless the painter who surpassed all those who were born before him and all those who came later was Apelles.... He produced volumes, which contain his doctrine.... He ... was also gifted with a courteous nature and ... was on quite good terms with Alexander the Great.

3.57 Heracleitus, The Unswept Floor. Mosaic variant of a secondcentury BCE painting by Sosos of Pergamon. Second century CE. Musei Vaticani, Rome, Italy.

Greek Vase Painting

uring the Archaic period, the decorative bands prevalent on earlier Geometric vases (see fig. 3.55) were relegated to the base and neck, and increased surface area was given to figurative narration. This vase (fig. 3.58) depicts the Greek warriors Achilles and Ajax playing draughts (an ancient game related to checkers) during a lull in the Trojan War, which Greece waged against Troy after a Trojan named Paris abducted Helen, wife of the king of the Greek city-state Sparta. The signature "Exekias painted me and made me" indicates an artist talented in both pottery and painting—a rarity in ancient Greece, where a division

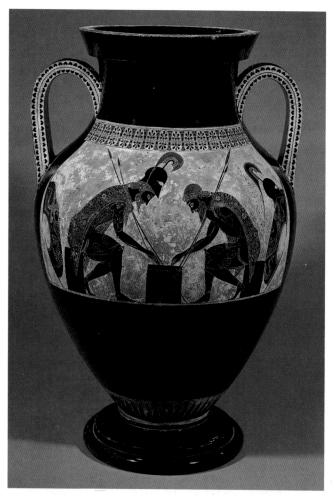

3.58 Exekias, *Achilles and Ajax Playing Draughts*, detail of blackfigure decoration on an amphora, c. 530 BCE. Painted terra-cotta, height 2' (61 cm). Exekias was both painter and potter of this vase. Museo Gregoriano Etrusco, Vatican Museums, Rome, Italy.

The stories represented on Archaic vases, which usually told of Greek mythological or historical events, were at first illustrated with black figures on a red background. Works in this style are known as black-figure vases.

of labor was usually practiced in the production of vases (see fig. 1.22). The composition, with its strong symmetry and the manner in which scene and decoration are related to the shape of the vase, reveals the Greek search for balance and harmony.

The various shapes of Greek vases developed according both to purpose and to the Greek interest in aesthetic forms. By the Archaic period, specialized forms had become associated with specific functions (fig. **3.59**).

After a vase was formed, but before it was fired, the painter, using slip (a mixture of clay particles in water, sometimes combined with wood ash), painted black figures in silhouette. Details of the decoration and of the figures' anatomy, drapery, and armor were made by incising lines into the surface before firing. Working with a sharp pointed tool known to modern artists as a burin, the artist engraved lines through the slip, exposing the terra-cotta color beneath. As the vase was being fired, the air vents in the kiln were closed, causing the entire vase to turn black for a period as the red iron oxide of the terra-cotta was converted into black and magnetic iron oxides. When the air vents were again opened, the iron in the clay body returned to its redorange color except in those areas covered by slip. In the firing, the slip had formed a glazed surface coating, sealing these areas from the air. They remained black, creating the black figures and decoration on the vase. On black-figure vases, the artist delighted in decorative geometric patterns that asserted the two-dimensional quality of the figures.

Around 530 BCE, a new technique that reversed the figure—ground colors was introduced, perhaps by a student of Exekias known as the Andokides Painter. This technique, the **red-figure style**, presents figures and objects silhouetted against the painted black background. Details of anatomy and costume are painted on, rather than incised into, the surface of the vase.

The vase with the *Death of Sarpedon*, signed by Euxitheos and Euphronios, was created shortly after the introduction of this new technique (fig. **3.60**). The scene, described in Homer's *Iliad* (XVI, 426 ff.), depicts the body of Sarpedon, a fallen Trojan hero, being carried from the battlefield by personifications of Sleep and Death. The god Hermes, who will lead Sarpedon's soul to Hades, stands behind. The figures convey a physical and emotional presence that is new to Greek vase painting. Somber facial expressions betray the tragic loss. We sense the physical strain required to lift the body, while diagonal patterns of limbs and flowing blood pull the composition downward. Details of anatomy and drapery are more naturalistically rendered than in the black-figure style. Also, the rendering

c. 600 BCE Earliest Maya temples are built in Mexico

580 BCE Nebuchadnezzar begins building the Hanging Gardens of Babylon

c. 550 BCE Indian vina is forerunner of hollow string musical instruments

c. 530 BCE Exekias, Achilles and Ajax Playing Draughts (fig. 3.58)

497 BCE Death of Pythagoras, who developed theory of musical harmony

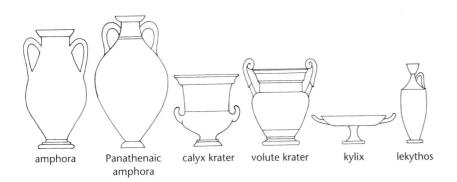

3.59 Typical Greek vase shapes. The amphora and Panathenaic amphora are containers to store wine, olive oil, honey, or water. The calyx krater and volute krater are bowls for mixing wine with water, which was the Greek custom. The kylix is a drinking cup, and the lekythos is a container for olive oil.

of some parts of the body as if seen in sharp recession is an early example of foreshortening. The greater naturalism is made possible by use of the brush, in contrast to the incising tool employed by the black-figure painter.

The level of artistry reached in these vases testifies to a refined understanding of both functional and visual values. The black-figure amphora has two handles for carrying and an opening large enough to admit a ladle. The broad opening of the red-figured calyx krater made possible the

mixing of water and wine. In each of our examples, the painter has adapted the composition to the form of the vase. The arched backs of Achilles and Ajax echo the inward curvature of the amphora, while the composition on the calyx krater, with the horizontal body of Sarpedon balanced by the vertical pose of the attendants and the parenthetical effect of Sleep and Death, emphasizes the inverted trapezoidal form of the vase. Greek vases were exported and were highly valued throughout the ancient Mediterranean area.

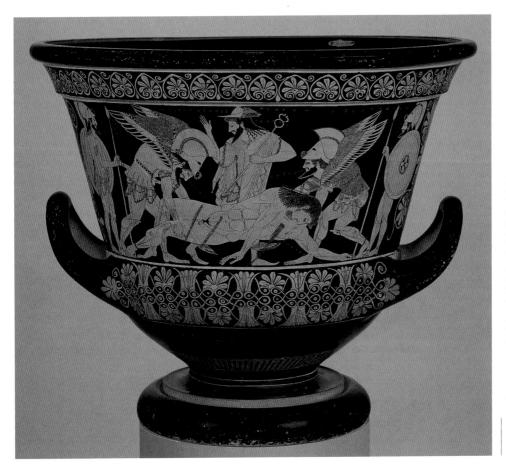

3.60 Euphronios (painter) and Euxitheos (potter), Death of Sarpedon during the Trojan War, red-figure decoration on a calyx krater, c. 515 BCE. Painted terracotta, height 1' 6" (45.7 cm). Italian State Collections. This vase was purchased by the Metropolitan Museum of Art in New York in 1972, but the Italian government later argued that it had been excavated in Italy by tomb robbers and smuggled out of the country illegally; in 2006, the museum agreed to return the vase, along with 21 other works, to Italy.

Red-figure vases feature red figures against a black ground. For another example see fig. 1.22.

The Development of Greek Sculpture

glance at the six ancient Greek figures illustrated chronologically in this section reveals that Greek sculpture gradually evolved from the rigidly posed figure seen in fig. 3.61 to the relatively relaxed figures seen

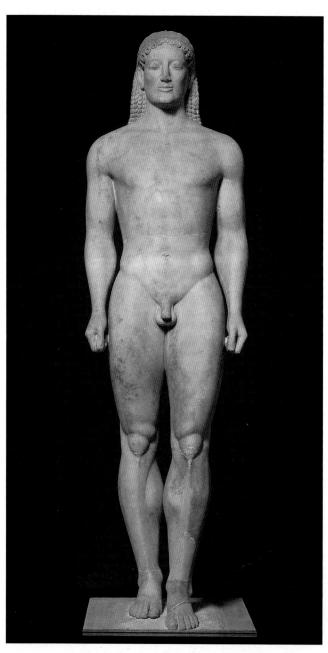

3.61 Kouros, from the Tomb of Kroisos, Anavysos, Greece, c. 520 BCE. Archaic style. Marble with traces of the original red paint on the hair, headband, and pupils of the eyes, height 6' 4" (1.93 m). National Archaeological Museum, Athens. Commissioned by the family of Kroisos or his military comrades.

The inscription on the base reads: "Stop and grieve at the tomb of the dead Kroisos, slain by wild Ares in the front rank of battle." in figs. 3.66 and 3.67. While this development shows an increasing naturalism, note that at the same time these figures represent the ideal human form. The notion that art evolves has become commonly accepted in Western art, while in Egypt and Asia, by contrast, the notion of a respected tradition that changes only slightly, if at all, has been more prevalent. The evolution of art and architecture that characterizes ancient Greek art can be directly related to Greek developments in philosophy .

When studying the evolution within ancient Greek art, art historians have evolved names for the progressive styles: Archaic (c. 650–480 BCE); Severe (or Transitional or Early Classical; c. 480–450 BCE); Classical (450–400 BCE); and, for want of a more descriptive term, Fourth-Century, as discussed below.

The earliest large-scale Greek sculptures (Archaic, c. 600 BCE) are indebted to Egyptian prototypes that were certainly known to the Greeks, who had a trading station in Egypt as early as the mid-seventh century BCE. But by about 520 BCE, when the kouros ("youth"; plural: kouroi) seen in fig. 3.61 was created, the new direction that Greek art would take was already evident. The Greek figure represents an athletic ideal and demonstrates a new understanding of the organic nature of the human body. Although the Greek figure maintains a stance derived from Egyptian models, with one leg advanced and the hands clenched at the sides, the stone passages that connect the forward to the rear leg and the arms to the torso in an Egyptian figure have here been carved away. When Greek sculptors eliminated these connectors, they released their figures, it might be said, from the stone. While an Egyptian figure seems frozen for all eternity, in keeping with its function to provide an eternal, indestructible home for the ka of the Egyptian patron, the Greek figure seems agile and about to take action. And, in contrast to Egyptian sculptures, most Greek male figures are nude. Greek athletes competed nude at the games held during religious festivals, but their nudity also demonstrates new Greek attitudes concerning the beauty and integrity of the human body. The slight smile, which suggests a confident assurance consistent with the buoyant energy of the body, recognizes the psychological and emotional aspects of human life in a manner foreign to most Egyptian figures, where any kind of transitory response was avoided. These Greek nude male sculptures were set up as votive offerings at shrines and were used as grave monuments. The youthful figures sometimes marked the tombs of older men, which reveals that they represented a philosophical and aesthetic ideal and were not intended to depict specific individuals.

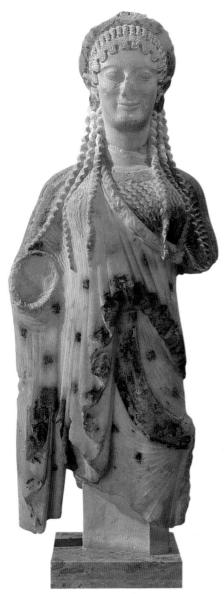

3.62 Kore, from Chios (?), c. 510 BCE. Archaic style. Marble fragment with traces of the original red, blue, and violet paint, height approx. 1' 10" (55.9 cm). Acropolis Museum, Athens, Greece. Such Archaic sculptures of female figures are much rarer than their male counterparts.

The Archaic, sixth-century female figure seen in fig. 3.62 is known as a kore (plural: korai); the early examples are always shown dressed, and even two centuries later the representation of the nude female figure will be rare (see below, fig. 3.67). The function of the early female figures seems to vary; those found in cemeteries were probably dedications to the deceased, while those found in shrines may represent the goddesses Hera or Athena. The gentle swelling of the body beneath the drapery suggests the same interest in the organic and sensuous qualities of the human

figure seen in the early male figures, while the pleated drapery and plaited hair reveal an interest in rich visual effects not unlike the contrasting patterns we will see developing in Greek architecture (see fig. 3.68). This particular example preserves some of the color that was originally painted on these marble figures to make them more lifelike.

The Severe style kouros known as the Kritian Boy, because it is similar to works attributed to the Greek sculptor Kritios, represents the figure in a pose that combines flexed and relaxed muscles (fig. 3.63). Although the kouros's feet are lost, enough of the figure survives to reveal that it was represented in the relaxed and naturalistic position known since the Renaissance as contrapposto (from the Latin *contrapositio*, "counterpositioning"; see box on p. 83).

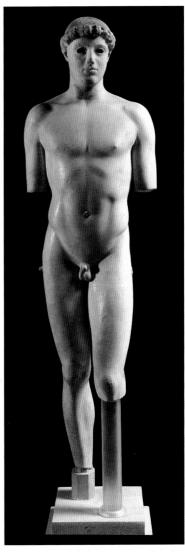

3.63 Kouros, also known as the Kritian Boy, c. 480 BCE. Severe style. Marble fragment, originally with inlaid eyes, perhaps in glass and/or stone, height 3' (86 cm). Acropolis Museum, Athens, Greece.

Because the weight of the body is supported on one leg, while the other is bent and relaxed, the other parts of the body are readjusted in space. The counterpositioning of the parts of the body can be demonstrated when we realize that, in such a pose, both the relaxed leg and the opposite shoulder move forward in space. Note too that one side of the pelvis is higher than the other. Contrapposto suggests the potential for movement, creating a figure that possesses a momentary quality. And a sculpted figure standing in contrapposto becomes freestanding, a **sculpture in the round**, that requires being seen from multiple viewpoints. Contrapposto banishes the static Egyptian views (frontal, left profile, right profile) that had conditioned Greek sculpture at its origins.

To understand the revolutionary quality of this kouros, we must try to imagine how such a sculpture would have

been viewed at the time. The pose must have seemed startlingly new and amazingly naturalistic, and these effects are enhanced by a softness and organic unity in the articulation of the muscles. The sculptor appears to have breathed life into the stone itself. The development of this naturalistic view of sculpture would affect western European sculpture for centuries (see figs. 8.15, 11.15).

The larger-than-life size bronze figure shown here (fig. 3.64) originally held something in his right hand; as the figure is usually identified as Zeus, this would probably have been Zeus's symbol, a lightning bolt. An energetic movement is communicated by his tensed muscles and distended veins, by the buoyant position of the feet, and by the arms, which are outstretched for balance and to help the god focus on his victim. His left foot is supported on the heel and outside edge, while the right touches only with the ball and toes; thin bronze spikes in the soles held the figure in position on its base. Zeus's pose expresses the perfect physical development of the god and his complete physical control, while his severe facial expression complements the aggressive action.

The figure's position would be impossible in marble, for marble's lack of tensile strength would not allow the outstretched arms, while the raised feet and slender ankles could not support the weight of the upper body were the figure to be executed in marble. Because of its greater possibilities for both naturalistic effects and convincing movement, bronze became the favored sculptural medium of the Greeks after the Archaic period (on the technique, see the box opposite). But few ancient Greek bronzes have survived because they could so easily be melted down and the bronze reused for weapons or other purposes. In this figure, the color of the bronze suggests a suntanned, oiled body (the Greeks oiled their bodies when exercising), and the inlaid eyes and teeth, fringed sheet bronze eyelashes, and inlaid colored lips and nipples reinforce the naturalistic impact.

3.64 Zeus (?), c. 460 BCE. Severe style. Bronze with inlaid eyes and teeth, lips and nipples overlaid in copper, and eyebrows overlaid in silver, height 6' 10" (2.9 m). National Archaeological Museum, Athens, Greece.

Lost in an ancient shipwreck, this sculpture was found in the sea near Cape Artemision in 1926. It is sometimes alternatively identified as representing Poseidon, god of the sea, or generically called "the Artemision god."

Greek Lost-Wax Bronze Casting

The earliest known bronze monumental sculptures in Greece date from the late sixth century BCE, but they were preceded by the casting of bronze body armor, which may have suggested and supported the development of bronze sculpture. Ancient Greek bronzes are hollow-cast of an alloy of copper and tin by what is known as the lost-wax method (fig. 3.65). A sculptor begins by forming a mass of clay (or some other malleable material) into the rough shape of the planned sculpture, but slightly smaller. This is covered with a layer of wax of the thickness desired for the finished bronze and modeled to approximate the surface finish of the planned sculpture. This wax coating is then encased in another layer of damp clay. When it has dried, the wax is melted away, leaving a hollow mold between core and exterior (supports hold the two in place). Molten bronze is poured into the mold. After it cools and hardens, the mold is broken or cut away, leaving bronze that has assumed the form first created in wax.

It is difficult to cast large figures in bronze, for the bronze can cool before it has reached the full extent of the mold. The ancient Greek bronzes discussed here were therefore cast in several sections. The arms of the figure often identified as Zeus (see fig. 3.64), for example, were cast separately, but how many other separate pieces were cast to create the rest of the figure is unknown pending further technical examination. In the case of draped figures, actual cloth, impregnated with wax, may have been used to help form the costume, and it has also been suggested that the ancient Greek sculptors may have created body parts using clay molds made from living human figures.

After casting, the bronze was tooled and polished (worked with tools and an abrasive) to achieve the finished surface. In the case of the figure being discussed here, the lips and nipples were highlighted and given a realistic reddish cast by being overlaid with copper or with bronze of a high copper content, while the eyebrows seem to have been overlaid with silver. Fringed sheetbronze eyelashes, inlaid stone and/or glass eyes, and teeth of silver, marble, or ivory were applied after the polishing of the bronze was complete. These additional colors and materials enhanced the beauty of the work, impressed the observer with the skill of the artists, and, most importantly, played a vital role in achieving the verisimilitude desired by the Greeks.

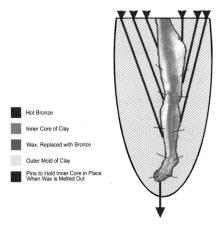

3.65 Lost-wax bronze casting. Conjectural reconstruction of technique for fig. 3.64, Zeus (?). To compare Chinese piece-mold bronze casting c. 1200 BCE, see pp. 64-65.

The Classical style is here represented by a marble copy of a bronze figure by Polykleitos known as the Doryphoros ("Spear-Carrier", fig. 3.66). That Polykleitos originally named the statue "The Canon" is revealed by the second-century CE physician Galen, in his text on Greek aesthetic theory:

Beauty ... arises ... in the commensurability [proportion] of the parts, such as that of finger to finger, and all of the forearm to the upper arm, and ... of everything to everything else, just as it is written in the Canon of Polykleitos. For having taught us in that book all the proportions of the body, Polykleitos supported his treatise with a work; he made a statue according to the tenets of his treatise, and called the statue, like his book, the Canon.

Both Polykleitos's original text and his bronze demonstration piece are lost, but numerous surviving marble copies testify to its significance in the ancient world.

The *Doryphoros* was considered an ideal figure because its proportions adhered to common fractions (exact divisions by whole numbers) of the figure's height. Because Polykleitos's original figure and text are lost, the precise measurements of his Canon remain undetermined, but the proportional scheme promoted by the later Roman writer and architect Vitruvius indicates the kind of system Polykleitos developed: the head (from the crown of the hair to the chin) was one-eighth of the total height, the width of the shoulders was one-quarter the height, and so on, until the proportions of every anatomical feature were woven into a system of mathematical measurements. The Doryphoros can be understood as a visual example of the

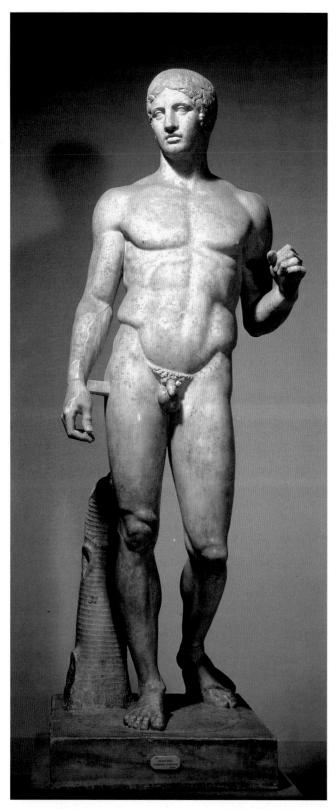

3.66 Polykleitos, *Doryphoros* (*Spear Carrier*). Roman marble copy after a lost bronze original of c. 450 BCE. Classical style. Marble, height 7' (2.12 m). National Archaeological Museum, Naples, Italy.

This copy is generally considered to be the best version of Polykleitos's lost figure named *The Canon*, but the spear that it once carried is missing, and the original bronze figure would not have had the tree trunk behind the right leg or the marble bar supporting the right arm.

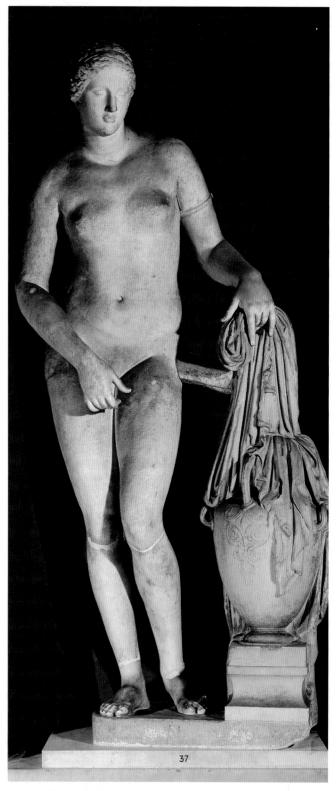

3.67 Praxiteles, *Aphrodite of Knidos*. Roman copy (c. 180 CE) after lost original, c. 360–330 BCE by Praxiteles. Marble, height 6' 10%'' (2.1 m). Vatican Museum, Rome, Italy.

The first-century CE Roman writer Pliny tells us that Praxiteles made two similar statues, one clothed and one nude, and that the Knidians daringly bought the nude example. Pliny tells us that a stain on the back of the figure was "an indication of lust" left by a man who had hidden himself in the shrine during the nighttime in order to embrace the statue.

statement by the ancient Greek philosopher Protagoras that "man is the measure of all things." Such a demonstration of mathematical relationships could lead to a dull sculpture, but the *Doryphoros* exhibits a firm muscular structure that is enlivened by the contrapposto stance.

A century before the *Doryphoros* was created, the Greek philosopher and mathematician Pythagoras had argued that mathematical proportion was the basis of musical harmony (see p. 74); Polykleitos's *Canon* and *Doryphoros* can be related to this Greek impetus to find agreement between natural and mathematical harmony. Later, the ancient Roman architect Vitruvius would report that the proportions governing the human figure in Greek art also determined the proportions of their temples: "Further, it was from the members of the body that [the Greeks] derived the fundamental ideas of measures." Vitruvius defines proportion, in a manner similar to our understanding of the Polykleitian *Canon*, as "a correspondence among the measure of an entire work, and of the whole to a certain part selected as a standard."

The fourth century was a time of creativity and stylistic experimentation. One leading artist of the period was Praxiteles, who sculpted a statue of Aphrodite (Venus), the goddess of love and beauty, which was purchased by the city of Knidos, in Asia Minor, and installed in a shrine

there that was open on all sides so that the sculpture's beauty would be visible from all directions (fig. 3.67). Contemporary documentation testifies that Praxiteles's *Aphrodite* was the first monumental figure in Greek art to depict the female nude in three dimensions. Her nudity is explained by the vase and drapery under her left hand: she is represented either entering or leaving her bath. Lucian, a second-century BCE Greek rhetorician who saw the statue, observed: "... the recalcitrant and solid nature of the stone has been transformed in each limb.... [As we viewed the figure from behind], unforeseen amazement at the goddess' beauty seized us."

The *Aphrodite* is freestanding and is composed as sculpture in the round. The diagonal movement of the right arm and hand and the slightly lifted left leg lead our eyes across and, by implication, around the body. Unlike earlier Greek sculpture, which primarily has a frontal orientation (see fig. 3.62), Praxiteles's *Aphrodite* invites us to admire the sculptor's ability to create a complex composition in space with multiple viewpoints. In less than two centuries, Greek figural sculptors have developed a complete understanding of how to represent the ideal human body, male and female, in convincing three-dimensionality. Later sculptors in the Western tradition would often be inspired by these Greek accomplishments.

TECHNIQUE

Contrapposto in Sculpture

The relaxed stance seen in the *Spear Carrier* (see fig. 3.66) first developed in ancient Greek sculpture had a powerful and long-lasting influence. During the Italian Renaissance, when this stance was one of many features of ancient art that were revived, it became known by the term contrapposto. In ancient Greek art, contrapposto emerged tentatively during the period that art historians have named the Severe, or Transitional, period. One of the earliest surviving examples is the kouros known as the *Kritian Boy* (see fig. 3.63), but in that case the twisting of the figure in space—the natural outcome of balancing the body over one supporting leg—is only delicately suggested. With the *Spear Carrier*, the twisting of the body and the tilting of the pelvis are more evident.

The origin of this pose in ancient Greek sculpture can be understood as an outcome of the Greeks' interest in the ideal nude human body, in athletic achievement, and in understanding how the parts of the body work together organically. The development of contrapposto is also related to the development of sculpture in the round; the twisting of the body encourages us to view it from different viewpoints to fully understand the pose.

The ancient Romans adopted contrapposto along with many other Greek artistic ideas; the impact of the

pose is evident in the *Augustus* (see fig. 4.32). But the interest in contrapposto did not last long after the rise of Christianity. Although contrapposto can still be seen in the Early Christian figure of the *Good Shepherd* (see fig. 5.11), the otherworldly ideals of Christianity eventually rendered the relaxation and informality of the contrapposto pose inappropriate (see, for example, the pose of the Gothic *Beau Dieu* from Amiens, fig. 6.33).

Contrapposto reappears in the Italian Renaissance as a result of the joint interests in naturalism and ancient art. In Saint Mark (see fig. 7.12), the sculptor Donatello manipulates the drapery to emphasize the contrapposto, using fine, flutelike lines of material to emphasize the supporting leg and broader, draped patterns to accentuate the relaxation of the other leg. Notice how Saint Mark's right shoulder drops back in contrast to the forward position of his left knee. (For other Renaissance examples of contrapposto, see figs. 7.37, 8.15). Michelangelo sometimes exaggerated the twist of the contrapposto pose to achieve a dramatic, emotional effect, as in his Saint Matthew (see fig. 8.16); in the Renaissance, this more twisted pose was known as the figura serpentinata.

The Classical Orders

An **order** gives aesthetic definition and decoration to the post-and-lintel structural system (see p. 52). Between the seventh and fifth centuries BCE, the Greeks developed three architectural orders—the Doric, Ionic, and Corinthian—which have been in virtually continuous use up to the present day. The Greeks' invention and development of these orders (fig. **3.68**) reveal a philosophical and analytical approach to architecture. An order is composed of a group of specific architectural elements that are designed to integrate with each other and with the building as a whole. An order also dictates the proportional scheme governing the interrelationships of the parts. The elements of an order include the **column**,

with its capital, and the entablature, composed of architrave, frieze, and cornice. A column can be decorated with vertical lines or raised areas, known as flutes, which accentuate its cylindrical and vertical quality.

The classical orders became the most basic design element for architecture. They were used not only as supports but also as decoration on buildings that were not post-and-lintel construction (for example, the Flavian Amphitheater known as the "Colosseum"; see fig. 4.46). Half-round decorative columns were often attached to a supporting or enclosing wall. These are known as half columns or engaged columns. When they are flattened, they are called pilasters.

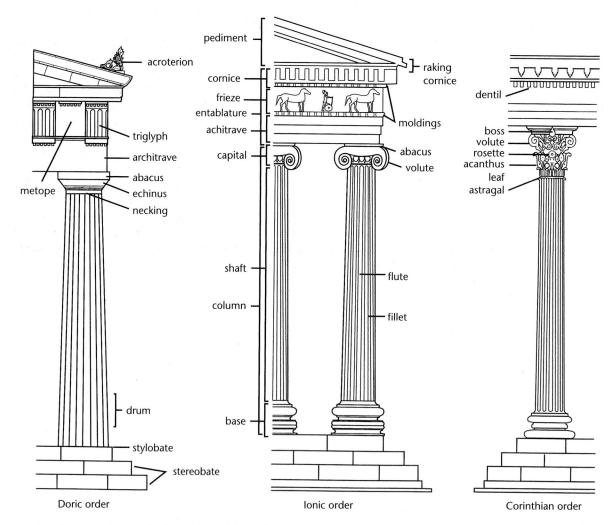

3.68 Diagram of Doric, Ionic, and Corinthian orders, not to scale.

The Impact of the Ancient Greek Orders

The ancient world may be remote from us in time, but it still affects our lives in many ways. One of the most obvious is the importance of the ancient Greek architectural orders on modern architecture and design. The Greeks developed a system of architectural decoration and proportion for columns in their structures that was adapted, with very little change, by other ancient cultures—especially by the Romans (see figs. 4.28, 4.46-4.49). Many Christian churches during the medieval period, particularly in areas that had been colonized by the Greeks or the Romans, used variations on these orders (see figs. 6.10, 6.22, 6.28). During the Italian Renaissance, when many forms and subjects from antiquity were carefully studied and revived, the Greek orders became the dominant architectural decorative device. The orders continued to have an impact in subsequent centuries, and during the Postmodern period (see chapter 13), in which all historical architectural forms became subject to appropriation, the Greek orders again played a major role in architectural design.

An order, however, offers more than mere articulation and decoration, for it also carries the cultural significance of its origins in ancient Greece, and it can be used to impart to a building the dignity, harmony, and sense of philosophical reason that are part of the Western heritage from Greece. The orders are generally regular and predictable, and when the harmonious relationships and proportions are ignored, there is a strong sense of violation.

The Doric order, well established by 600 BCE, is austere: its fluted columns are strong in appearance and

stand directly on the stereobate (stepped platform), without a decorated base. The Doric echinus resembles a resilient cushion tucked between the column and the square abacus, suggesting in a clear, visual manner the nature and even the idea of support. Together, echinus and abacus provide a simple and muscular transition from the vertical column to the horizontal superstructure. The Doric architrave is broad and simple, and the frieze area is decorated with triglyphs, which alternate with metopes (originally metopes seem to have been painted panels of terra-cotta; later they were sculpted). The first-century BCE Roman architect Vitruvius argued that the Doric order was originally derived from wooden architecture and that the tapering of the column was based on the use of tree trunks for early columns.

The lonic order, which was first used in the sixth century BCE, is lighter in proportion and more elegant in detail than the Doric. Columns have richly decorated bases, and the Ionic capital is characterized by a scroll-like motif called a volute. Ionic temples often feature a continuous frieze in place of the triglyphs and metopes. The planar, frontal lonic volutes created a problem at corners, which was solved by the development, during the fifth century BCE, of the Corinthian order, which employs a cylindrical capital decorated with acanthus leaves. The increasing elegance of the Greek orders is revealed by the constantly changing proportions of the column. In the Doric, the relationship of height to diameter is usually 4:1 to 6:1 or even 7:1. For Ionic, it is 7:1 to 8:1; Corinthian can be 8:1 to 9:1. ■

Greek Doric Architecture

Greek Doric temple (fig. 3.69; see also fig. 3.71) is an imposing structure, an autonomous object that is complete within itself. The architectural forms are vigorous and assertive. The vertical fluting of the columns, reinforced by the triglyphs in the frieze above, produces an upward thrust that is held in balance by the horizontal articulation of the entablature and gable roof. The visual forces are in equilibrium, yet the temple is not visually static. Its massive forms communicate an almost muscular vitality.

The walled inner sanctuary, or **naos** (from the Greek "to dwell"), contained the cult statue (see fig. 3.73). On the exterior, the perimeter of the temple is surrounded by a

colonnade, or continuous row of columns, called a **peristyle** (from *peri*, "around," and *style*, "column"); such temples are termed **peripteral** (see fig. 3.72).

A post-and-lintel system forms the peristyle, while walls enclose the naos. Columns support the entablature and roof. The pediments at each end of the gable roof are in some temples filled with sculpted figures. The roof was originally made of wood rafters covered with terra-cotta tiles. It seems that only priests or priestesses and their attendants were allowed inside the temple. Most rituals occurred outside, at an altar in front of the temple. The temple might thus be thought of as a sculptural background for the ritual.

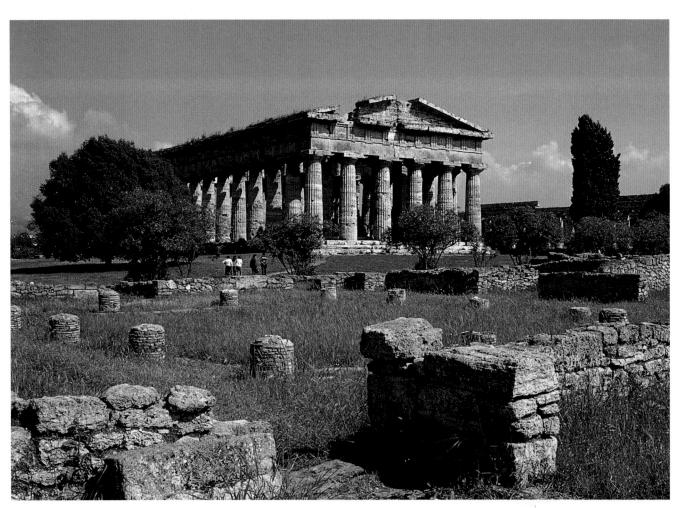

3.69 Second Temple of Hera, Paestum, Italy, c. 460 BCE.

Southern Italy and Sicily were colonized by the Greeks beginning in the seventh century BCE (see map, p. 114). The earliest Greek temples were small shrines containing a cult statue. During the eighth and early seventh centuries BCE, large wood temples with peristyles were built. By the later seventh century BCE, stone construction began to replace wood, partially as a practical response to the problem of supporting the heavy terra-cotta roof tiles. Stone construction, which coincides with the advent of monumental stone sculpture, reflects a confident new spirit—a spirit of permanence and achievement. The temples constructed in these colonies during the sixth and fifth centuries BCE are among the best-preserved examples of Greek architecture.

TECHNIQUE

Greek Temple Construction

Once the size and design for a temple were determined, workers began to cut stone at quarries. The blocks of stone, formed to specifications to reduce transportation weight, were moved to the construction site in specially designed carts pulled by teams of animals. After the temple's foundation had been built, the peristyle was set up. Columns were constructed of unfluted cylindrical units called drums, held in place by wood centering pins. The drums for the columns and the blocks of stone for the walls of the naos were lifted into place with pulleys and cranes. No mortar was used to hold the stones in place. The blocks of the naos walls were secured by iron clamps encased in lead to prevent rusting. The roof was

constructed of wood beams and rafters. A beam supported the apex of the gable roof, while additional support for the roof was provided by columns inside the naos. Finally, as the temple neared completion, the columns were fluted. The fluting disguised the joints of the drums and, by creating patterns of shadows, reinforced the three-dimensionality of the columns.

The changing proportions of the Doric order, seen in the evolution of the proportion of and relationship among column, capital, and entablature (fig. 3.70), reflect the search for an aesthetic harmony that was integral to Greek art. The diagram also reveals the increasing scale of the Doric temple over time.

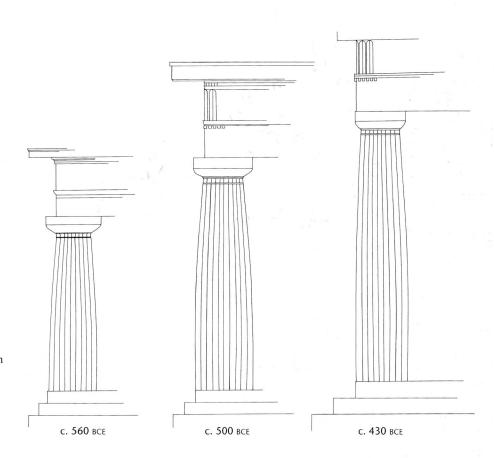

3.70 Diagram of the evolution of Doric proportions to scale. For further discussion of the importance of proportional relationships in Greek art and architecture, see pp. 79-82.

The Parthenon, Athens

n the history of Western art, the Parthenon on the Acropolis in Athens is one of the most famous monuments (figs. 3.71–3.76). Its significance is not due to its basic form, which repeats the Doric temple type developed more than a century earlier (see pp. 86–87). Rather, it is the mathematical rationality of its design and the harmony and grace of its proportions that make the Parthenon great; its fame derives from its beauty.

The Parthenon's scale and materials made it a monument to the wealth, power, taste, and piety of Athens. It was constructed entirely of white Pentelic marble, including the roof. The interior has two chambers—a smaller one where the city's treasures were stored, and the naos, where an ivory and gold statue of Athena in military dress was enshrined (fig. 3.73). Although anyone could look in from the door, only a few individuals were allowed to enter these chambers. The rituals in honor of Athena were held outside, at a sacrificial altar to which the Parthenon was the backdrop.

The grace and beauty of the Parthenon are the culmination of a centuries-long Greek search for the ideal form for a temple. The simple dynamics of the post-and-lintel system became a vehicle that encouraged Greek architects to attempt to achieve the most satisfying equipoise between the upper structure and the columnar supports below. Compared to the Second Temple of Hera at Paestum (see fig. 3.69), the Parthenon offers a number of visual refinements. The horizontal lines of the steps, stereobate, and entablature are raised slightly in the middle, in part to correct the sag that the human eye imparts to a long horizontal (and also to add the practical advantage of helping the run-off of rainwater). Like the other optical refinements of the Parthenon, the lifting of the middle of the horizontals gives the building a sense of elasticity and of life. Such adjustments made the structure more difficult to engineer and construct, for each marble block had to be cut to fit its exact place. Other refinements include the tilting inward of

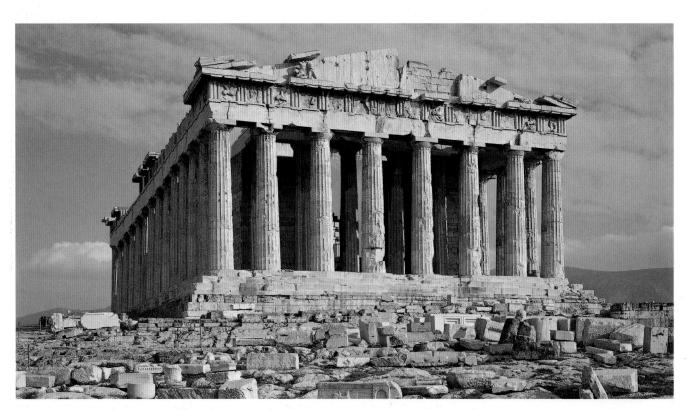

3.71 Kallikrates and Iktinos, Parthenon, Acropolis, Athens, 447–438 BCE; sculpture completed by 432 BCE. Pentelic marble, $111 \times 237'$ at base $(70 \times 31 \text{ m})$. Commissioned by Pericles, ruler of Athens.

This temple to Athena, goddess of wisdom and protector of Athens, was built after the Persian wars. At the time, Athens was controlled by Pericles (see p. 74), who insisted that the Athenians rebuild the temples the Persians had destroyed. The name *Parthenon* means "maiden," and the temple was dedicated to Athena, the maiden (*parthenon* was the name given to the room in a home where unmarried, virginal daughters lived). The Parthenon later served as a Christian church dedicated to Mary and in the later Middle Ages was the cathedral of Athens. After the conquest of Athens by the Turks in the mid-fifteenth century, it served as a mosque. It was severely damaged in 1687, during a war between the Venetians and the Turks, and some of what we see today was reconstructed in modern times.

c. 450 BCE Roman Law codified c. 450 BCE Slaves outnumber citizens in Athens by 2:1

447-438 BCE Kallikrates and Iktinos, Parthenon, Athens (fig. 3.71)

440 BCE Sophocles, Antigone 431 BCF Euripides, Medea

the columns to enhance the effect of stability and compactness, and the placement of the three corner columns closer together to compensate for the dissolving effect of light at the corners; for the same reason, the corner columns themselves were made slightly thicker. The entire base is tilted upward at the southwest corner to make the building more impressive both from the city below and from the entrance to the Acropolis.

Perhaps the most revealing refinement is the entasis of the columns, which do not taper in a straight line from base to capital but rather bulge outward about one-third of the way up from the bottom. This entasis creates an effect of muscular elasticity that helps give the Parthenon an organic quality. Later copies and variations often seem rigid and cold because of the failure of their copyists to incorporate these refinements. The Parthenon reveals the analytical quality of the human mind and how the Greeks sought the harmonious, the ideal, and the beautiful. That the Parthenon was the culmination of the search for the perfect Doric temple is suggested by the fact that later Greek architects turned their attention to the Ionic and Corinthian orders.

The Parthenon's architectural richness was enhanced by the sculpture integrated into the Doric design (see figs. 3.74–3.76). The pediments at both ends were filled with over-lifesize figures, there were ninety-two metopes sculpted in high relief, and a continuous low-relief frieze, 550 feet long, encircled the outside of the naos wall. They survive today in fragmentary form. Like the edifice they adorn, these sculptures display an impressive mastery of form and technique. They were completed in about twelve years, indi-

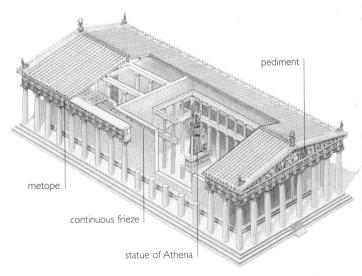

3.72 Cut-away reconstruction of the Parthenon, showing the original location of the various sculptures.

cating that there must have been a large workshop of sculptors and assistants, but their general consistency of design suggests that a single sculptor was in charge. This sculptor was most probably Phidias (c. 490-430 BCE), who also designed the ivory and gold statue of Athena in the naos.

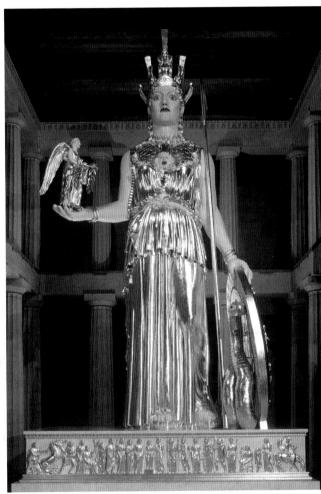

3.73 View of the interior of the Parthenon copy in Nashville, Tennessee, with its reproduction of the lost 40-foot (12.2 m) statue of Athena by Phidias that once adorned the naos of the ancient Greek Parthenon.

The modern version, which sets out to be as accurate as possible given the limited evidence available, was finished by sculptor Alan LeQuire in 1990 and gilded in 2002. LeQuire's sculpture mimics the colors of the original, but in Phidias's original the flesh was composed of carved pieces of ivory while the dress and armor were made of thin sheets of gold; the figure was supported internally by a ship's mast. Phidias's ivory and gold statue of Zeus at Olympia was listed as one of the seven wonders of the world in ancient times. Only the great Egyptian pyramids (see fig. 3.18) survive from this list; the other five were the Lighthouse at Alexandria, the Mausoleum at Hallicarnassus, the Hanging Gardens of Babylon, the Colossus of Rhodes, and the Temple of Diana at Ephesus.

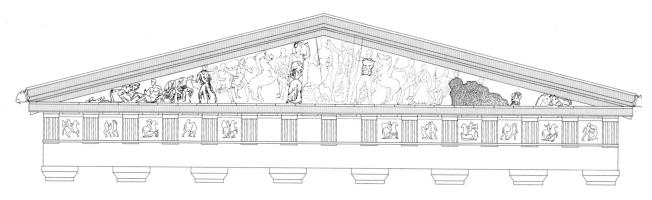

3.74 Reconstruction of the east pediment of the Parthenon, showing the *Birth of Athena* by Phidias and his workshop.

The darkened figures show the original location of the *Three Goddesses* (see fig. 3.75). The darkened sections in the pediment indicate surviving fragments; the light lines are conjectural reconstructions. The Parthenon pediments were more than ninety feet (27.2 m) long, and at the center they rose to a height of more than eleven feet (3.4 m). The platform on which the figures were placed was about three feet (90 cm) deep. The scenes shown in the metopes below are extant.

The consistency of the sculptural conception suggests that Phidias provided drawings—perhaps on the stone itself—to guide those working in the workshop.

The iconographic themes are related to the dedication of the Parthenon to Athena, to the victories of the Greeks over the barbarians, and to Athens's political leadership among the city-states in Greece. The east pediment presented the *Birth of Athena* (fig. **3.74**); the west the *Contest between Athena and Poseidon*. The metopes featured a series

of battle scenes, including a battle between centaurs and men. According to the most common theory, the continuous frieze has been identified as representing the procession of the Great Panathenaea, an Athenian celebration held every four years in honor of Athena, with musicians, elders, horsemen, chariots, and sacrificial cattle and sheep; this ritual must have been one of the highlights of Athenian civic and religious life, and the frieze provides important visual evidence of the participants and activities.

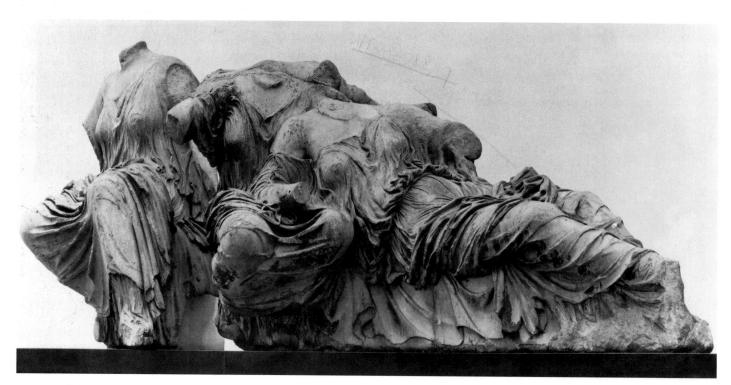

3.75 Phidias and workshop, *Three Goddesses on Mount Olympus*, from the east pediment of the Parthenon, c. 438–432 BCE. Marble, height of center figure 5' (2.33 m); the figures are slightly over-lifesize. The British Museum, London. These three figures have been identified as Hestia, Dione, and Aphrodite.

On the east pediment the news of the dramatic birth of Athena full grown, wearing armor, from the head of her father Zeus is conveyed by figures who move outward from the central episode. The coherent unity of time and place is similar to that which was being developed in contemporary Greek drama. A group of seated goddesses, for example (fig. 3.75), turn slowly toward the center as they become aware of the birth. Composing a complex narrative grouping within the sloping pedimental shape was a challenge for the Greek artist, but these goddesses, shown in graceful, natural poses and unified as a group, do not seem forced into the constricted space. Their voluptuous bodies are clothed in clinging drapery that is gathered and folded into patterns that emphasize the three-dimensionality of the figures. The clarity of the poses is remarkable, as is the graceful and flowing role they play within the triangular composition. Filling the outermost corners of the pediment are, on the left, the heads of the energetic horses who are drawing the sun god's chariot, signifying dawn, while on the right were the heads of the exhausted horses pulling the moon's chariot.

The long Parthenon frieze is a tour de force of lowrelief carving that offers the illusion that as many as six figures and horses overlap within a low relief that is no more than about three inches deep (fig. 3.76; see also fig. 1.15). The relief is carved more deeply near the top as a concession to the placement of the frieze, high above the spectator's head. By thus giving the work greater readability, the Greek sculptor makes it clear that this frieze is for the enjoyment and enlightenment of the human spectator and is not solely a decoration added to the temple in honor of the goddess.

The Parthenon's sculptures had additions made of metal for the armor, straps, and other refinements; some of these were perhaps highlighted in gold leaf. Many of the details were heightened by paint, although there is still controversy over the actual colors used. A bright blue has been proposed as the background for the pediment and a red background for the metopes and frieze. The hair of the figures may have been gilded; the drapery hems probably had painted patterns taken from those on actual Greek garments. Color would have clarified the compositions for the Athenians, who saw the Parthenon as a monument to their success as well as to the generosity of their patron goddess.

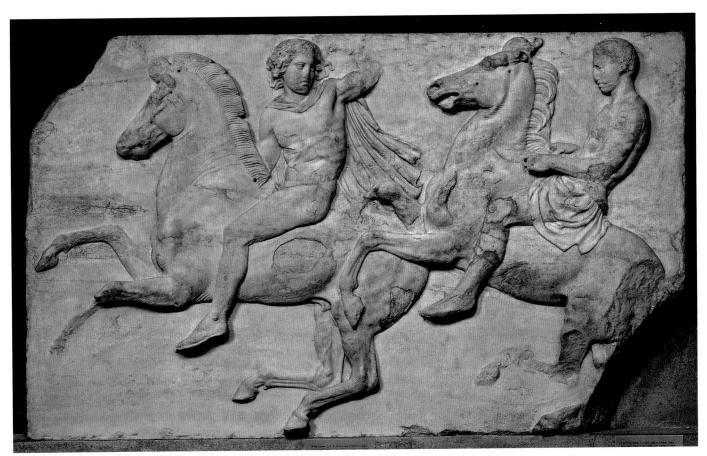

3.76 Phidias and Workshop, Horsemen, from the frieze of the Parthenon. Marble, height approx. 3' 7" (1.1 m), c. 438-432 BCE. The British Museum, London.

Many of the original sculptures from the Parthenon have been exhibited in London since the mid-nineteenth century. They were purchased by Lord Elgin from the Turkish governor of Athens, but this sale is not recognized as legitimate by the Greek government, which has petitioned to have the marbles returned.

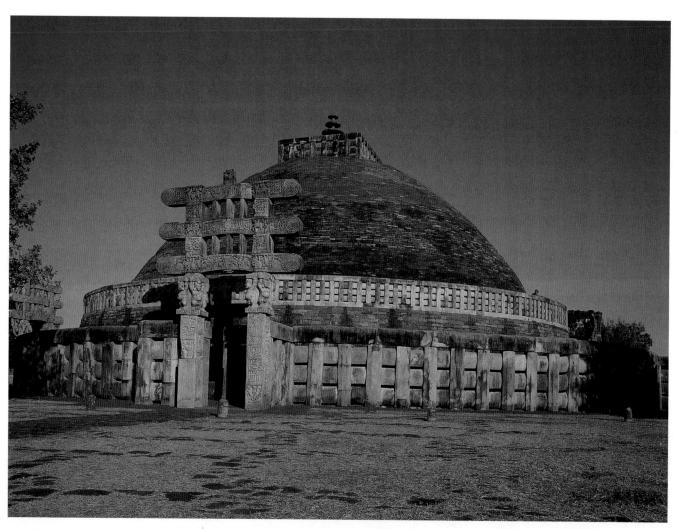

4.1 The Great Stupa and the West Gateway (Torana), Sanchi, India. Begun third century BCE, with later additions and enlargement. Brick and rubble originally faced with painted and gilded stucco decoration, rails and gateways of yellow limestone; height of dome 54' (16.4 m). Originally commissioned by the Indian ruler Ashoka, who is said to have commissioned 84,000 stupas; later supported by the lay Buddhist community.

Here, as in many Indian stupas, the original building was encased in a mass of earth and stone before it was enlarged, for it was considered a sacrilege to destroy any of the original monument. Stupas frequently incorporate within their mass a system of concentric and/or radial supporting walls arranged according to symbolic rather than technical considerations. These walls form a mandala, a symbolic diagram of the cosmos, by marking the points of the compass and representing rays leading out from the center. This pattern, not perceptible from the exterior, was important in underlining the sacred substance of the monument. The importance of the mandala in Buddhist belief and practice is attested by its survival into the present day (see fig. 7.4). As Buddhist beliefs moved to the East, the form of the stupa underwent a gradual transformation, with the mound decreasing and the axial form of the "umbrella" increasing in significance and elaboration. The pagoda that marks Buddhist sites in China, Korea, and Japan (see fig. 5.36) is ultimately derived from the stupa's upper element.

Later Ancient Art, 400 BCE to 200 CE

A BRIEF INSIGHT

uring this later phase of the ancient period, the visual arts were called upon to express increasingly complex religious and political ideas. The Great Stupa at Sanchi (fig. 4.1), which represents the earliest type of permanent Buddhist monument, provides a good example, for it carries a wealth of meaning despite the simplicity of its construction. In form this monumental, solid hemisphere derives from burial mounds that date back to prehistoric times; in early Buddhism, however, stupas mark not only the place where a relic of Buddha or of another holy Buddhist individual was buried but also indicate sites where important events in the Buddha's life occurred.

The goal of Buddhism, nirvana, represents the attainment of enlightenment. Pilgrims to Sanchi could process toward this goal by entering the enclosed sanctuary through the large gates (toranas) and proceeding around the stupa on two different levels. Because the hemispherical form of the stupa was held to represent either the World Mountain or the universe as a whole, moving along these paths became symbolic of walking the Path of Life, following an ancient Indian rite of retracing the path of the sun while making offerings and ritual performances.

The form that surmounts early stupas is a three-part "umbrella" symbolizing the three most basic aspects of Buddhism—the Buddha himself, his law, and the monastic Buddhist community. The rail around the umbrella shaft is thought to reflect the ancient concept of marking off the precinct around a sacred tree. The umbrella also symbolizes both Buddha's royalty and the sacred tree of knowledge found at the center of an Aryan village to suggest the realm of the gods. The axis that it creates through the center of the stupa symbolizes the axis of the universe.

Introduction to Later Ancient Art

uring the later part of the ancient period, which here is dated from about 400 BCE to 200 CE, powerful rulers in several different areas of the world established grand empires, complete with territorial expansion and lavish capital cities. Perhaps the most famous of these was Alexander the Great (fig. 4.2) In his biography of Alexander, the ancient Greek historian Plutarch states that while pursuing King Darius of Persia (see fig. 4.15), Alexander was informed that his troops had captured the king's mother, wife, and two daughters. Nevertheless, Alexander assured the safety of his rival's female relatives, despite the fact that, as Plutarch notes, "[Alexander] was fighting Darius for the empire of Asia...." Alexander's desire to dominate an entire continent expresses the zealous drive for empire characteristic of this period.

Even an object as ordinary as a coin speaks to us about this desire for empire. This 4-drachma coin is valued not just because of its silver and age, but also for its compelling image of Alexander the Great, a portrait that emphasizes his mental and physical alertness through a combination of deeply set eyes, furrowed brow, naturalistically open mouth, and strong neck. The ram horns, symbols of the Egyptian god Amun, refer to both the deification of Alexander and to his conquest of Egypt.

During ancient times, Rome would surpass the empire ushered in by Alexander in the West. At its height, the Roman empire (see pp. 118–37) encompassed the entire Mediterranean, from Spain to the Middle East, North Africa to England. In China, the Qin (see pp. 102–3) and Han Dynasties (see pp. 108–9) established empires that rivaled the extent and complexity of that of Rome. The storied "Silk Road" became the commercial link between these two vast empires; silk and spices were traded to the West, and this trade route facilitated cultural and technological exchange. In Mesoamerica, the city of Teotihuacán (see pp. 138–41) was among the largest in the ancient world, and on the Indian subcontinent, Emperor Ashoka proved to be a remarkable leader, in war and in peace.

The Lion Capital at Sarnath (fig. **4.3**) was one of a number erected by Ashoka throughout his empire as an indication of both his power and his devotion to Buddhism

4.2 Alexander the Great with Amun Horns, 4-drachma coin, issued by Lysimachus, c. 300 BCE. Silver, diameter 1½" (2.9 cm). Commissioned by the Hellenistic ruler Lysimachus, king of Lysimachia.

Alexander was one of the earliest rulers to appear on coins.

4.3 Lion Capital. Sarnath, Uttar Pradesh, India. Maurya Period (4th–2nd century BCE), 3rd century BCE. Polished sandstone, 8' (2.13 m). Sarnath Site Museum, Sarnath, Uttar Pradesh, India. Commissioned during the reign of Emperor Ashoka.

as his personal and imperial religion. These sculptures featuring four lions back to back were originally placed as prominent landmarks atop tall pillars. The pillar at Sarnath marked the site of the first sermon of the Buddha, where he taught the Buddhist doctrine (Dharma) to five monks. This pillar bears one of the Edicts of Ashoka, an inscription against schism within the Buddhist community that reads "No one shall cause division in the order of monks". The base of the pillar is sculpted in high relief with an elephant, a galloping horse, a bull, and a lion separated by intervening chariot wheels over a bell-shaped lotus. The popular interpretation of the Lion Capital is that it is a zoomorphic representation of the sun god. In Buddhist terms, the four animals represent: the Buddha's conception in reference to the dream of Queen Maya of a white elephant that entered her womb (the elephant); the desire Buddha felt during his life as a prince (the bull); Buddha's departure from palace life (the horse); and the attainment of Buddhahood (the lion). The bull is also the Hindu symbol of Siva, and the four animals may also represent Hindu deities who were under the service of Buddha at that time. The four lions surmounting the capital symbolize the kingship of the Buddha and his roar over the four directions.

It is not surprising, however, that the Lion Capital and its pillar would also have a non-religious interpretation, with the four lions representing Ashoka's rule over the four directions, the wheels as symbols of his enlightened rule,

4.4 Arch of Titus, Rome, 81 CE. Marble over concrete core. Commissioned by Titus (see also fig. 4.38).

and the four animals lower animals as symbols of the four surrounding territories of India (the Lion of the north, the Elephant of the east, the Bull of the south, and the Horse of the west).

The Roman emperors reveled in using works of art to commemorate specific conquests. The arcus triumphalis, or triumphal arch, became a favored monument to serve this purpose. The Arch of Titus (fig. 4.4), one of the more than fifty triumphal arches once found in ancient Rome, memorializes Titus's suppression of a Jewish revolt and his capture of Jerusalem in 70-71 CE. The arch itself is simple and well proportioned, with a compact composition of horizontal and vertical members enframing the tunnel vault. The simple basic form, an arch enclosed within a rectangle, is enlivened by architectural details, and originally the whole was surmounted by a bronze sculptural group of Titus in a chariot drawn by four horses The reliefs under the arch represent the triumph of Titus and the parading of the treasures of the Temple of Jerusalem through Rome (see fig. 4.38). The deified Titus, who died shortly before the monument was completed, is shown in the center of the vault, being carried to heaven on the back of an eagle.

POINTS OF CONTACT

The Silk Road

The vitality of trade in the ancient world is demonstrated by the widespread importation of silk from China into ancient Rome. Silk was such an important commodity that the trade route established between East and West during this period became known as the "Silk Road." Spices were another precious commodity carried along the route during the ancient and later periods. The route started in the ancient Chinese capital now known as Xi'an (see pp. 102-3) and extended to the Middle East and into Europe. The ancient Roman historian Pliny the Elder wrote about a nation called Seres that is now identified as China; he cites raw silk as Seres' most important staple, adding that its other products included "silk stuffs, furs, and iron of remarkable quality." The first-century CE historian Tacitus reported that during the rule of the Emperor Tiberius the Roman Senate passed a decree that "men should not defile themselves by wearing garments of silk" but that this prohibition had not been effective. While it is impossible to determine the material worn by the figure in this ancient Roman painting (fig. 4.5), the fluid manner in which it flows around the moving figure suggests that it may well be silk imported from China.

4.5 Flora, from the Villa of Arianna at Castellammare di Stabia, before 79 CE. Fresco, 15½ × 12¼" (39 x 31 cm). Museo Nazionale Archeologico, Naples, Italy.

Engineering

Engineering and Expression

(figs. 4a and 4b) Developments in the science of engineering by the ancient Romans resulted in principles for construction used in the West for millennia. Through a pioneering use of concrete to build arches and vaults (see pp. 132-35), the Romans erected the Colosseum, the Pantheon, and other impressive structures. The new construction techniques supported both pragmatic and symbolic ends. At the Colosseum they made possible an efficient design that allowed the crowds that gathered for public entertainments to disperse quickly. At the Pantheon, the breathtaking dome expresses both political and religious ideas. Such structures conveyed the enduring power of the central government under the control of the Roman emperor. In many examples of architecture around the globe, engineering should be understood as more than just technical know-how; engineering also expresses political, religious, and social realities and aspirations.

Engineering and Religion

(fig. 4c) Engineers have to take into consideration the pull of gravity, especially when dealing with heavy materials such as stone. The design of the typical Gothic cathedral, however, is cleverly engineered to support the tall interior while at the same time visually denying the weight of the stone with which it is constructed and the powerful downward and outward thrusts of its arches and vaults. The apparent lightness of the structure, with its large stained-glass windows, functions as a metaphor for a world beyond the physical, the Christian concept of the Heavenly Jerusalem.

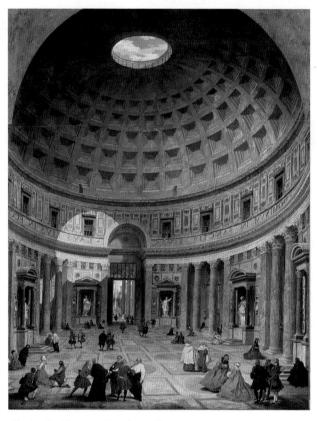

4b Ancient Roman, Pantheon, Rome, 117–25 CE (for further information, see fig. 4.54 and pp. 136–37).

4a Ancient Roman, Flavian Amphitheater (Colosseum), Rome, Italy. Begun 72 CE; dedicated 80 CE (for further information, see fig. 4.46 and pp. 130–31).

4c French Gothic, interior, the Royal Abbey Church of St.-Denis, near Paris, France, 1140–44 (for further information, see fig. 6.22 and pp. 224–29).

4d Dougong-style eaves at the kondo, Horyuji complex, near Nara, Japan, seventh century (for further information, see fig. 5.38 and pp. 176-79).

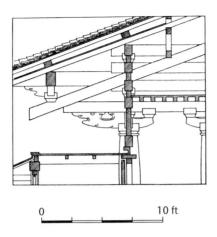

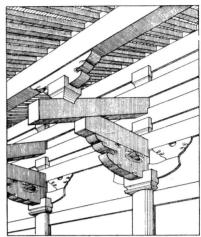

Engineering in Wood

(fig. 4d) The heavy, overhanging eaves of Japanese architecture at Horyuji are only possible through an elaborate construction of superimposed blocks and beams based on the Chinese construction system known as dougong bracketing. Examples from later centuries demonstrate ever more intricate bracketing. Because the most complex examples of Japanese dougong construction are found at religious sites such as Horyuji, the purpose of this engineering development can be related to the desire to decorate and distinguish the sites of public religious ritual.

4e Frank Lloyd Wright, Fallingwater, Bear Run, Pennsylvania, 1936 (for further information, see fig. 1.7 and pp. 8-11).

Factory-Made Modern Materials

(fig. 4e) The large balconies that cantilever out over the landscape at Fallingwater are supported by steel rods in reinforced concrete anchored in the main core of the structure. The tensile strength of these rods explains how these balconies can extend so spectacularly over the landscape. The dramatically modern design and exceptional expense of this country estate were intended to reflect upon the taste and wealth of its patron, the department store owner Edgar Kaufmann.

Ouestions

Search for a building in your area—a house, a barn, a garage, a commercial structure—that is under construction and watch it through successive phases until completion.

- 1. What materials are used? Are some of the materials pre-fabricated? Is heavy machinery required for construction? If possible, speak to workers to determine their specific role in the construction process.
- 2. Are the materials of construction expressed on the exterior or are they ultimately hidden?
- 3. Are the materials of construction and/or the style of the completed structure in some way expressive of the values of your community?

Nomadic Art in Siberia: Pazyryk

his carpet (fig. 4.6) was found in an elaborate barrow—a burial pit—at Pazyryk, a site high in the Altai Mountains of southern Siberia (see map, p. 161). It was at Pazyryk that the chieftains of a seminomadic cattle and horse-breeding society buried their dead. Soon after burial, water seeped into the stone mounds that covered the pits and froze (fig. 4.7), creating permafrost that preserved some 5,000 objects, including examples of ancient materials that are seldom preserved: an embroidered silk textile, this knotted rug, felt appliqués (see fig. 4.9), leather and wood parts of horse equipment, an entire funeral carriage (see fig. 4.10), and even the tattooed body of one of the deceased leaders (fig. 4.8).

Barrow 5 (see fig. 4.7), which was lined with wooden logs, was about 164 feet (50 m) square and from thirteen to

twenty-three feet (4–7 m) deep. The sarcophagus found here, which was hewn from a single log decorated with scenes of animals in combat, contained the bodies of a man and a woman instead of the individual burial that is common. The well preserved bodies showed signs of having been embalmed with vegetable materials, including herbs.

On the skin of the arms, chest, and legs of the male were tattoos of animals and fish. Ritual tattooing is known in other ancient burial contexts, especially in the region of the Altai Mountains and in western China's Xinjiang Province, where tombs of non-Asiatic peoples that date as early as 2000 BCE were recently excavated. Modern examples of ritual practice suggest that tattooing, scarification, and body painting were often associated with shamanistic practices in which the tattooed person was symbolically

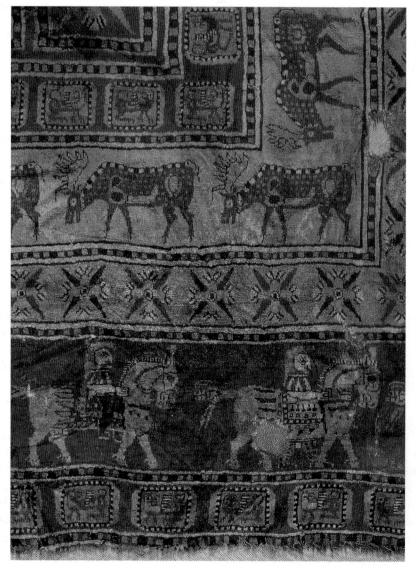

4.6 Detail of carpet from Barrow 5 at Pazyryk, Siberia, Russia, fifth–fourth century BCE. Woolen pile, entire carpet 6' 2" × 3' 3½" (183 × 200 cm). Hermitage, St. Petersburg, Russia.

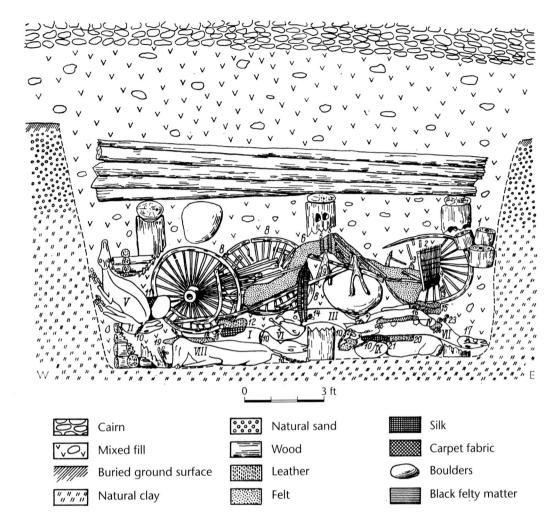

4.7 Line drawing of Barrow 5 at Pazyryk, Siberia, fifth-fourth century BCE. Hermitage, St. Petersburg, Russia. The mounds at Pazyryk were excavated in 1929 and 1947-49.

transformed into another state of being or stage of life. Such markings are administered to initiates in many societies, as depicted on masks of the Bwa culture of western Africa (see pp. 14, 510-11).

The clothing, ornaments, furniture, objects of everyday life, and musical instruments—almost everything that had surrounded the Siberian chief and his wife (or concubine) in life—were placed in their grave. Also found in the tomb was a bronze cauldron with burnt hemp seeds that corroborates accounts of the use of hemp as a hallucinogen mentioned by Herodotus, the fifth-century BCE Greek ethnographer (Book IV, 73-75), in his description of a vigorous nomad people with a unique animal art and a love of the horse whom he called the Scythians. The chiefs buried at Pazyryk were part of a horse-breeding people who roamed between eastern Europe (the Black Sea) and the borders of China in the Altai Mountains. Herodotus told three stories of their origins: that they came from Asia and settled on the north shores of the Black Sea, that their ancestor was a descendent of Heracles and a creature—half-female, halfsnake—who dwelt in the Scythian woodland, and that they descended from parents who hailed from the region of the Dnieper River north of the Black Sea. Archaeology confirms some of those accounts—they were probably a group with a mixed Asian and local heritage.

From the burials at Pazyryk we also learn about Scythian funeral display, for everything used in their funeral processions was buried in a trench near the outer wall. Found in Barrow 5 were the bodies of richly caparisoned horses, a wooden chariot, the woolen carpet illustrated here (see fig. 4.6), a felt wall hanging (part of a funerary tent) with two pictures of a seated woman holding a branch with

4.8 Line drawing of tattooing on the right and left shoulders of male in Barrow 2, at Pazyryk. Fifth–fourth century BCE. Length approx. 1' 6" (60 cm). Hermitage, St. Petersburg, Russia.

a horseman before her (perhaps a holy person), poles for the chariot that had felt swans as finials (see fig. 4.9), and other items. The horses in the tomb were slender and tall, of a different breed than the small range ponies found in common graves. These "parade" horses wore lavishly decorated saddles and bridles, with straps ornamented with wooden fixtures covered with gold or silver that depicted birds, animals, and mythical creatures sculpted in relief. The saddles were decorated with varicolored felt, leather, and even imported Iranian and Chinese textiles. Most of the reliefs depict animals in combat. The two lead horses wore extraordinary masks, one in the shape of a griffin's head, the other in the shape of a reindeer head with enormous antlers.

It is not surprising that the remains of this nomadic culture bear witness to cultural connections between Central and Western Asia, the Far East, and the Scythian world. Found in Barrow 5, for example, was a Chinese silk textile embroidered with birds sitting on branches that had been made into a saddle blanket. The carriage with big wheels (fig. **4.10**) and covered seat was probably Chinese. One of the original excavators suggested that it had been brought as dowry by a Chinese bride for her wedding to an Altai chief. The woolen carpet (see fig. 4.6), decorated with stylized birds' heads and speckled stags, floral patterns, and borders of horsemen cannot be positively identified as Iranian—where the tradition of making such knotted carpets is highly developed at a later date—but many of the other textiles in the tomb are clearly of Iranian origin.

The four-wheeled carriage (see fig 4.10) found in Barrow 5 is of special interest. It is constructed almost entirely of birch, and each of the wheels has thirty-four spokes. It would have been hauled by four horses, and four

were buried with it. The carriage was perhaps either a wedding present or designed for ceremonial journeys; that it had had long use is indicated by heavy wear on the wheel rims. The presence of such a carriage of light but intricate construction with multi-spoked wheels indicates the advanced stage reached in the use of carts, at least in the steppes adjoining the high Altai, since the mountains were unsuited to wheeled transport.

Scythian artisans crafted many distinctive works in wood, bone, and felt. The pounded hair of horses or other animals provided warmth and could be made from readily available products. The swan fashioned out of felt (fig. 4.9) would have been attached to the felt cover of the wagon (see fig. 4.10), and its wings would have fluttered with the movement of the carriage. Certainly their environment inspired the Scythians' concentration on representations of animals, while the ferocious battles depicted in wood, metal, and felt were probably meant to reenact the battles between warring tribes of the Steppe, each of which would have been represented by a wild and ferocious animal totem.

4.9 Sculpted swan, found in Barrow 5 at Pazyryk, fifth-fourth century BCE. Felt, length 1' 1¾" (34.9 cm). Hermitage, St. Petersburg, Russia.

4.10 Reconstruction of a funeral carriage, Barrow 5, Pazyryk, fifth-fourth century BCE. Birch, height of wheels 5' 3" (1.6 m.). Hermitage, St. Petersburg, Russia.

The Qin Empire in China

he great underground army of which a small portion is represented here (fig. 4.11) was discovered near the mausoleum of Emperor Qin Shi Huangdi, the first emperor of China and founder of the short-lived Qin Dynasty (221–206 BCE), just outside of his dynastic capital, near present-day Xi'an. These full-sized replicas of the imperial guards of the emperor evoke the military power and spirit that secured Qin authority, allowing the emperor to rule over a newly unified China after two centuries of civil war. The practice of placing terra-cotta figures at the mausoleum, which replaced the habit of sacrificing human beings and animals, continued throughout imperial, dynastic Chinese history.

Among the figures there is variety in dress, physiognomy, facial expressions, hairstyle, headgear, armor, and weapons, but not in gender: all are male (figs. 1.3, 4.12, 4.13). They represent battalions of army officers and combat corps, including support personnel such as grooms, drawn from all over the empire, and the civil officials that ran the government. Each figure is identifiable in terms of rank and unit by his uniform, in terms of ethnic background by his hairstyle, and in terms of specific task by weapons, horse tack, headdress, and the like. Each head was modeled individually and some figures even bear the seals of the foreman

and workers in charge of their production. The legs of each figure are solid but their bodies are hollow, and each head and arm is formed of an inner core of coiled strips of clay over which a coating of finer clay has been spread. Specific features such as details of armor or manes of horses were worked in the clay by hand, using a tool. These civilian officials and warriors, who originally held bronze swords and other metal or wood attributes, were once brightly painted, heightening their realistic expression.

These detailed, naturalistic renderings offer evidence of the might and majesty of imperial life in the third century BCE. Pit 1 (see fig. 4.11) originally contained approximately 6,000 figures of human beings, horses, and chariots. In one of the smaller pits nearby, chariots, horses, and charioteers, all one-third life-size and cast in bronze washed in gold and silver, were excavated (see fig. 4.13). These are probably replicas of the carriages and drivers who were part of the funeral and whose occupants would have been close associates or relatives of the emperor. Although the actual tomb chamber of the emperor has yet to be excavated, this is already one of the most lavish ancient sites ever excavated in China. The tomb took thirty-six years to build and was part of the extensive construction program that characterized the emperor's reign.

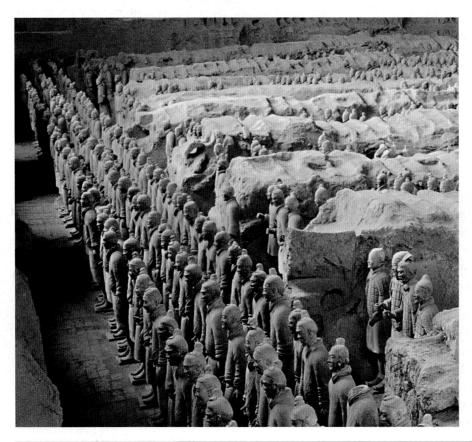

4.11 View of the excavation of the Terracotta Army of the First Emperor of Qin, Pit 1, 210 BCE. Lintong, Xi'an, People's Republic of China. Commissioned by the emperor Qin Shi Huangdi. For another example, see fig. 1.3.

c. 200 BCE Founding of the Teotihuacán state in Mexico (see fig. 4.55)

c. 100 BCE Camel nomadism begins in the Sahara desert

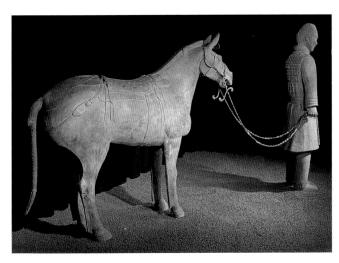

4.12 Terra-cotta Warrior and Saddle Horse, 210 BCE. Terra-cotta, height of male figure 5' 10½" (1.8 m). Lintong, Xi'an, Shaanxi Provincial Museum, People's Republic of China.

Qin Shi Huangdi was a man of remarkable talents and achievements. His military conquests were in part the result of his mastery of the newest arts of war. He abolished the system of land ownership by feudal lords and created a form of centralized, autocratic government that was, in essence, maintained until the fall of the last Chinese dynasty in the twentieth century. He promulgated a uniform code of law and standardized currency, weights and measures, written language, and the axle length for wagons and chariots. He built a vast network of tree-lined roads fifty paces wide that radiated from the Qin capital at Xianyang, northwest of Xi'an. He joined into a single 1,400-mile "Great Wall" a group of separate walls that had been erected earlier in an attempt to deter raiding tribes from the north from entering imperial lands.

So great was Qin Shi Huangdi's power that he was able to build on an unprecedented scale. He strengthened the new state by consolidating the northern frontiers against the Huns, brought south China and Tonkin (Vietnam) into the sphere of Chinese culture, and dispossessed and forcibly moved thousands of the old feudal aristocracy to within his purview in the capital. While the measures he used were often brutal, and he imposed rigid regulations on most citizens and placed a heavy burden on the educated class, under his rule China became, for the first time, a unified political and cultural entity. Qin Shi Huangdi also tried to unify thought, and is alleged to have burned the state government library so that history could be written according to his taste and not that of the past. Although probably most effective as a symbol of his power, this incident has remained one of the most repeated stories among Chinese

historians to express their distaste for his practices. His unification of China only survived the short period of Qin rule and the country was later consolidated along more humane lines in the Han Dynasty (202 BCE-220 CE; see pp. 108-9). Qin Shi Huangdi's ability to unify the Chinese inspired Mao Zedong, the 20th-century revolutionary leader of the People's Republic of China.

For his own glorification and that of the united empire, Qin Shi Huangdi built a number of elaborate palaces. Although the entire mausoleum remains to be explored and excavated, we know from ancient written records that it included an underground palace complex in which the ceiling of the tomb chamber was a model of the heavens and the floor a map of the empire where replicas of the rivers of the Chinese world supposedly ran with mercury (according to Sima Qian, in the Shiji, The Records of the Historian, from the second century BCE). Although he was the most powerful man in China at the time, the emperor lived in fear of assassination and high walls connected the roads joining his many palaces. So great was his fear of death that he untiringly sought the secret of immortality through Daoist practitioners. He sent emissaries in search of an elixir that would provide eternal life, and alchemy became a court-supported activity for the first—but not the last—time in China.

Qin Shi Huangdi died in 210 BCE and the reign of his son was short and bitter. The second emperor was assassinated in 207 BCE at the climax of a rebellion led by a general from the south. The capital was sacked and the Han Dynasty was proclaimed in the new capital of Chang'an, the city of "Enduring Peace" (see pp. 172-75).

4.13 Bronze Chariot and Driver, 210 BCE. Gold and silver washed bronze with paint, height of chariot 3' 7¾" (1.11 m), height of horses 3' %"(93 cm), length of horses 3' 9%" (1.15 m). Qin Shi Huangdi Mausoleum, near Xi'an, People's Republic of China.

Hellenistic Art

espite the loss of head and arms, the Winged Victory of Samothrace expresses heroic triumph (fig. 4.14). The figure's pose creates a dynamic effect of forward movement that is strengthened by the patterns of drapery that envelop the figure and the contrasting position of the unfurled wings. The effect of wind is suggested by the manner in which the drapery both presses against the body's surface and unfurls in vigorous forms that billow into space, echoing the movement of the wings. The dramatic movement of the figure in space displayed by the Winged Victory is typical of the art of the Hellenistic period (c. 400–100 BCE).

HISTORY

In the late fourth century BCE, while the Greek city-states maintained a tenuous political stability, the hereditary kings of Macedonia, a kingdom to the north of Greece, strengthened their political power. Philip II, king of Macedonia, proposed a plan for the unification of Greece under his rule. In 338 BCE, while the Greeks debated his proposal, Philip attacked and defeated them. Philip's union of Greece with Macedonia was the initial step in his grand design to establish an empire that would include Persia. After Philip II was killed by an assassin in 336 BCE, his son Alexander, nineteen years old, ascended the throne (see fig. 4.2). Following the vision of his father, he led a military campaign against Persia and defeated King Darius in 331 BCE (see fig. 4.15). Later conquests extended the boundaries of his empire south through Egypt and east to the borders of India before Alexander died in 323 BCE; by the time of his death, Alexander's successes led him to become known as Alexander the Great. Because the name for ancient Greek was Hellas and the Greeks were known as Hellenes, this huge empire and the art patronized by Alexander and his successors has become known as Hellenistic.

Alexander had been educated by Greek standards, and his tutor was Aristotle, the philosopher and natural scientist. The young conqueror envisioned a unity between the Greeks and the Persians based on the cultural values of Hellenism, the ideas and ideals of Classical Greece. After his death, Alexander's dream of unity was fractured by the reality of political conflict among his own generals. Soon his empire was divided into smaller independent powers. Common to these diverse regions, however, was the unifying influence of Greek culture.

Alexandria, founded by Alexander in Egypt in 332 BCE, became a famous center of learning. The library founded there became the most famous library in the ancient world; it represented the accumulated wealth of knowledge of the

ancient world and may have contained as many as 500,000 volumes (in 2002 a new Library of Alexandria was opened). The library was part of a complex known as the Museum (from the Greek *mouseios*, "of the Muses," referring to the ancient Greek goddesses of art and music). The major centers of Hellenistic art production, which were founded outside the Greek mainland, included Alexandria, the island of Rhodes, and Pergamon in Asia Minor (see map, p. 73).

ART OF THE HELLENISTIC PERIOD

The naturalism that characterized Greek fourth-century sculpture and painting deepened in the Hellenistic period and was united with an interest in realism in subject matter. The appreciation of art was no longer restricted to the educated citizens of the city-states, however; the new empathetic and dramatic art appealed to a wider audience. These displays of human emotion and drama in art paralleled the melodramatic staging of Greek theater at the time.

Portrait busts of Alexander the Great distributed throughout the empire emphasized his mental and physical character; a similar emotional, inspired quality is evident in the portraits on coins created by his successors (see fig. 4.2).

The Hellenistic emphasis on dramatic and emotional naturalism can be related to a changed philosophical outlook epitomized in the teachings of Aristotle (384–322 BCE). Aristotle's teacher, Plato, had viewed material objects as mere imperfect reflections of ideal forms. Aristotle, in contrast, stressed the roles of natural observation and experience in understanding reality. He sought to comprehend nature by perceiving its manifestations in the biological and earth sciences. The direction of Aristotle's philosophy, based on a penetrating observation of nature, parallels the dramatic naturalism of fourth-century and Hellenistic art.

HELLENISTIC PAINTING

Our knowledge of Hellenistic painting is based almost completely on literary sources and Roman copies in fresco or in mosaic—designs composed of a number of small pieces (in various periods, pebbles, stone, tile, and glass have been used for mosaics). The Roman mosaic representing *The Battle of Alexander the Great and King Darius* (fig. 4.15), for example, preserves the composition of a Hellenistic painting mentioned in literary sources. Its representation of energetic activity reveals the continuing advances in illusionism for which Hellenistic painting was famous. Alexander rides into the battle from the left, raising his spear; Darius anxiously looks back toward his pursuer. The foreshortening of the central horse, seen from the rear, and the frantic activity of the team pulling Darius's chariot add complexity to the

c. 260 BCE First Buddhist missionaries arrive in Ceylon

225 BCE Romans defeat the Celts

221 BCE First Chinese Empire (Qin) established

c. 190 BCE Winged Victory of Samothrace (fig. 4.14)

148-46 BCE Rome annexes Macedonia and Greece

4.14 Winged Victory of Samothrace, from the Sanctuary of the Great Gods, Samothrace, c. 190 BCE. Marble, height 8' (3.28 m). The Louvre, Paris, France. Most likely commissioned by a victorious admiral or the ruler he represented.

This figure celebrates a naval victory, perhaps a victory of the navy of Rhodes at Side in 190 BCE. The statue was originally erected on a darker gray marble base in the form of the prow of a ship. To give the effect of a ship coming into harbor, statue and base were set in two pools, one with a rippled marble bottom and a second with huge boulders.

4.15 Battle of Alexander the Great and King Darius of Persia, Roman mosaic copy of a lost Hellenistic painting of c. 300 BCE. Stone and glass mosaic, height 10' 6" (3.13 m). National Museum, Naples, Italy. Commissioned by the owner of the House of the Dancing Faun.

Found in the House of the Dancing Faun at Pompeii, this impressive mosaic uses more than a million small pieces of stone and glass to create the illusion of the battle. The lost Hellenistic original may have been by Philoxenos or by Helena of Alexandria, an early example of a documented woman artist.

tumult of the battle. Within the turbulent scene, the Hellenistic painter added a detail to demonstrate his virtuosity: reflected in a Greek shield below Darius's chariot is the anguished face of a young Persian about to be crushed by its wheels. The representation of suffering and death was common in Hellenistic art, and here the terror reflected on the Persian's face communicates the personal reality of battle.

HELLENISTIC SCULPTURE IN PERGAMON

The *Dying Trumpeter* (fig. **4.16**), one of a group depicting defeated enemies from a large monument at Pergamon, displays the naturalism that characterizes much of Hellenistic art. His matted hair, mustache, and the metal necklace, or torque, around his neck identify him as an invader from the north known as a Gaul; he is represented as defeated in battle. His blood spews from the wound in his side and as viewers we experience his last moments of life. Even in the marble

copy, a keen observation of surface anatomy complements the psychological drama of impending death; body and soul are rendered with unsparing reality.

During the mid-third century BCE, the Hellenistic kingdom of Pergamon became a major political power and art center. In 230 BCE, King Attalus I of Pergamon defeated an invasion by the Gauls, who had entered Asia Minor following their invasion of Greece in 279 BCE. In defeating the foreign invaders, Attalus I was able to establish his kingdom as the principal political force in the Middle East. By commissioning works that represent the noble deaths of the enemy, Attalus made his own victory seem even more impressive. During the Hellenistic period, art no longer exclusively served the worship of the gods or the embellishment of the city-states; as seen from the Gaul monument in Pergamon, it could extol the exploits of a political leader and so act to capture public support.

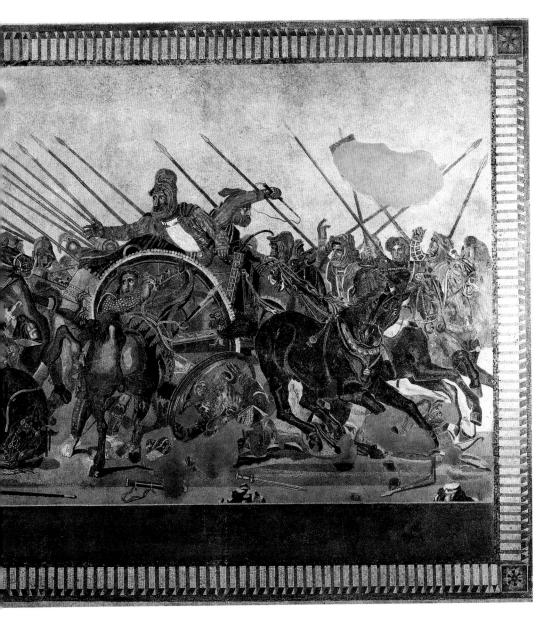

4.16 Dying Trumpeter, Roman marble copy after a lost bronze original of c. 230-220 BCE from Pergamon. Marble, lifesize. Capitoline Museum, Rome, Italy. From a sculptural grouping that featured several figures, including a Gaul who has killed his wife and is committing suicide rather than be captured by the Hellenistic enemy. Commissioned by King Attalus I of Pergamon.

The Han Dynasty in China

his banner (figs. **4.17, 4.18**) was found in 1972 in the first tomb opened at a Han Dynasty site at Mawangdui, near Changsha, the current capital of Hunan Province in south central China. It contained the remains of the Marquise of Dai, a noblewoman who died c. 180 BCE. The chamber contained a thousand objects, including clothing, food (including many kinds of herbs), models of musical instruments, lacquer ware modeled after official ritual vessels (see fig. 4.19), four painted and lacquered coffins and more than one hundred wooden tomb figures, but no precious metals, jade, or jewelry. The woman has been identified as the wife of Li Cang, the first Marquis of Dai, the governor of the region. Two other richly furnished tombs excavated at the same mound were those of her husband (Tomb No. 2) and son (Tomb No. 3).

In the written inventory found here, the large silk banner is described as a "flying garment" (*feiyi*). This notation and its placement over the body of the deceased in burial correspond to the prescribed location for funerary banners (*ming-ching*) after they had been displayed during the funeral and carried in front of the funeral procession.

The banner, one of the earliest surviving Han paintings, was executed in still well-preserved colors on a red field. Tassels extend from the four lower corners. Scholars generally agree that the scenes depicted represent the passage of the souls of the dead to the realm of the immortals. The search for immortality was of utmost concern during

both the Qin and Han (206–220 CE) Dynasties, but this is the first extant work that illustrates visually, and quite literally, the route of the soul (or souls) in that quest. The guiding principles for understanding the painting are preserved in a literary source, *Songs of the South*. The text says that the voyage of souls after death leads in all directions, including to the four quarters of the universe as well as above and below. The banner charts that voyage.

The land of the netherworld, of water creatures and darkness, at the bottom represents the place below the surface of the earth where souls undergo their first metamorphosis. This is the place that the Daoists call the cosmic womb, where the *yin* symbol of female creation dwells. Above this watery realm two scenes are depicted taking place on earth; both describe mortals acting out their parts in mourning rites. The lower scene depicts a shaman, or

4.17 The Marquise of Dai with Attendants, detail of T-shaped Flying Banner found in the Marquise of Dai's Tomb, near Changsha, Hunan Province, People's Republic of China. Han Dynasty, c. 180 BCE. Painted silk, 6' 8¾" (2.05 m), 3' (92 cm) at top. The central figure seen here is about 10" (25.5 cm) tall. Historical Museum, Beijing. Commissioned by the Marquise of Dai or her family.

4.18 Line drawing of Flying Banner, found in Tomb of Lady Dai.

c. 180 BCE Lady Dai with Attendants (fig. 4.17)

c. 165 BCE The Book of Daniel is written

c. 159 BCE The first water clock in

c. 62 BCE Founding of Florence c. 43 CE Founding of London (Londinium)

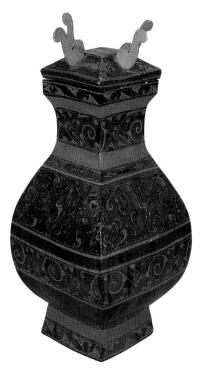

4.19 Painted Lacquer Ritual Vessel, c. 180 BCE. Painted lacquer, height 1' 4½"(42 cm). Tomb of the Marquise of Dai, Hunan Provincial Museum, Changsha, Hunan Province, People's Republic of China. Commissioned by the Marquise of Dai or her family.

holy person, to the left and a group of attendees seated behind ritual vessels used at the sacrifices dedicated to honor ancestors. The duty of the shaman was to call back the soul from "below." The upper scene, set in the land of the immortals, describes the welcoming home of the soul. The large figure standing in profile in the center is thought to be a portrait of the deceased crossing to the "other" world. Wooden lacquered hu and ting, copies of sacral vessels cast in bronze in the Shang and Zhou Dynasties (see pp. 64–65), were also found in the tomb. (fig. 4.19)

The Land of the Immortals depicted at the top of the banner is inhabited by legendary subjects including Sun Crow, Moon Toad, and Celestial Dragon. The gatekeepers and the bell (the sound of which is thought to penetrate without bounds) are transitional images, standing between earth and heaven. The charting of space into registers corresponds to the structure of the cosmos and may even echo the geometric social order advocated by Confucius (see p. 194). Upon death, the path of the souls echoes the birth, life, and rebirth as embodied in the nature of ancestor worship already well established by the Shang Dynasty (c. 1550-1050 BCE).

During the early Western Han period, accepted practices in various matters, such as burial regulations, varied from locality to locality. The tombs at Mancheng in Hebei, in north central China, for instance, were focused on similar concerns about immortality, but the expression of that concern was different from what we see at Mawangdui (see fig. 4.17). The bodies of imperial Crown Prince Liu Sheng and his wife Douwan were completely shrouded in suits of jade plaques sewn together with gold thread (fig. 4.20). Jade was symbolic of eternal life and Daoist immortality, and was especially associated with royal burials.

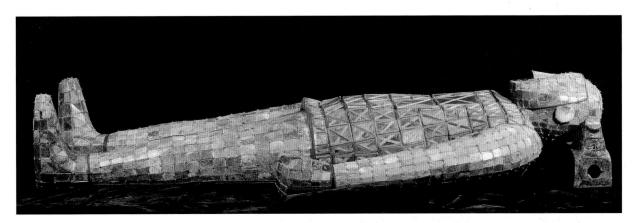

4.20 Jade Suit, burial of Princess Douwan, wife of Liu Sheng, late second century BCE. Jade plaques held together with gold cord, length 5' 74" (1.72 m). Excavated at the Tomb of Liu Sheng, Mancheng, Hebei, Hebei Provincial Museum, People's Republic of China. Commissioned by Liu Sheng or his family.

Early Buddhist Art

he Great Stupa at Sanchi is located on a hill rising out of the plain not far from modern Bhopal in central India (fig. 4.21; see also fig. 4.1 and discussion on p. 93). Access to the sacred area is through four monumental gateways (toranas) oriented to the cardinal directions following the mandala built into the internal structure of the stupa. The uprights and crossbars of the toranas are lavishly carved with illustrations of jataka tales, edifying legends in which the Buddha is shown as compassionate and wise, and guardian figures called yakshis (fig. 4.22), ancient goddesses of fertility. The incorporation of the yakshis related the monument to the people, for these sensuous deities had been worshiped as bearers of human and natural fertility long before Buddhism. The complicated but rhythmic pose of the voluptuous yakshi reveals the early importance of dance in Indian worship; it also refers to the legend that a yakshi could, with one touch of her heel, instantly bring a tree into full fruition. The stupa's lively sculptures, which were originally highlighted with polychrome painting, make a dramatic contrast to the massive character of the stupa and railing.

It is significant that the Buddha himself is not represented in figural form—a kind of symbolism called **aniconic**, or "without image." His presence is suggested by symbols such as a wheel, footprints, a throne, and the Bodhi tree (pipal) where he achieved enlightenment (fig. **4.23**). At that time, it was thought to be impossible to represent the Buddha in human form because he had already passed into nirvana, an otherworldly state of being.

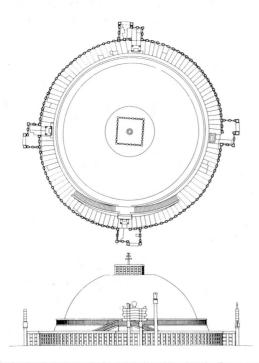

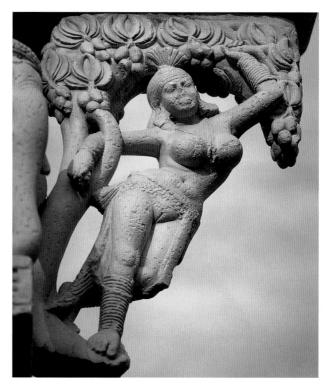

4.22 Yakshi, from the East Torana, Great Stupa, c. 10-30 CE.

These early constructions celebrate the life of the historic Buddha (Sanskrit for "the Enlightened One"), a man called Siddhartha Gautama. Born about 563 BCE of a noble family living in the foothills of the Himalayas, he gave up his princely life to seek out the cause of the suffering that he discovered around him. At the time India was undergoing rapid and violent political and social change. Like many of his contemporaries, Prince Gautama renounced his former life and, as an ascetic, contemplated and discussed the sorrows of the world with other learned recluses on the outskirts of villages. At age thirty-five, he sat under a large pipal

4.21 Plan and elevation of the Great Stupa (see fig. 4.1). Begun third century BCE, with later additions and enlargement. Brick and rubble originally faced with painted and gilded stucco, rails and gateways of yellow limestone; height of dome 54' (16.5 m), height of toranas, 34' (10.4 m). Originally commissioned by the Indian ruler Ashoka; later supported by the lay Buddhist community.

The stone railings that create the enclosure are probably based on wooden prototypes. Why the gates are not on axis with the openings in the fence is uncertain, but the enforced right angles that this placement requires from the worshiper upon entering may also be based on earlier prototypes. Perhaps these changes in direction relate to the swastika design that appears in other earlier Indian contexts, or perhaps they are derived from farm gates designed to keep cattle out of the fields.

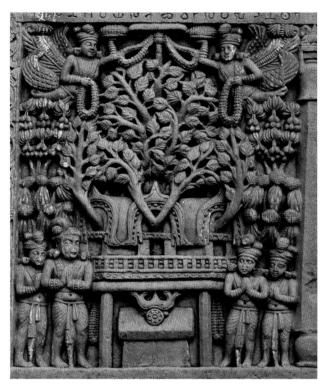

4.23 Sanchi (Madhya Pradesh, central India), Stupa no.1 or Great Stupa (founded by emperor Ashoka during 3rd century BCE; extended at a later state). Detail of east gate, south pillar, adoration of the Bodhi tree, 2nd–1st century BCE. Photo, undated (c.1980?).

tree in the town of Gaya and resolved not to leave until the riddle of suffering was solved. After many temptations, he sank deeper into meditation, and at dawn on the fortyninth day he knew the truth, the secret of suffering and how to overcome it—by releasing the mortal soul from the cycle of rebirth. He had attained personal enlightenment. He remained seated under the Tree of Wisdom (the Bodhi tree), meditating on the truths he had found. He then journeyed to Deer Park (modern Sarnath) where he preached his first sermon—in Buddhist phraseology, he "set the Wheel of the Law in motion." Soon a band of sixty ascetics became his followers as he preached the Buddhist dharma (doctrine), the "Middle Path." For eight months of each year they wandered from place to place, but in the rainy season they stopped to live in huts at one of the parks given by wealthy lay followers. These were the first of the many Buddhist monasteries.

The nirvana Buddha attained was thought to be a state of enduring permanent bliss called the Supreme Truth or Reality. Buddhist dharma claims that there is no existence without suffering, that the cause of suffering is egocentric desire, and that the elimination of desire will end suffering.

After the Buddha's death at age eighty, in about 483 BCE, the religion grew and changed along with the political institutions of India. The third leader of the first great Indian empire, called the Mauryan Dynasty (322-183 BCE), was Ashoka (ruled c. 273–232 BCE), who expanded Mauryan political influence over much of the Indian subcontinent (see fig. 4.3.) According to tradition, Ashoka was moved to remorse and pity by the horrors of war, and came to the conclusion that true power was realized through religion, not force. He became an active patron of Buddhism, and the political might and patronage of the Mauryans brought the full institutionalization of the religion. A set of Buddhist religious offices (services) was created; monks occupied monasteries; the canon of Buddhist texts was expanded, diversified, and refined. Ashoka himself is said to have erected 84,000 stupas over the relics of the Buddha throughout the empire, although this number is surely inflated. Thus, the search for personal enlightenment by one man, the Buddha, became an institution involving millions of people supported by one of the great ancient empires.

Stupas became the center of life in the monasteries, which included buildings used as lecture halls, kitchens, and hostels. These **chaityas** (sacred locations) were to a remarkable degree coincident with trade routes of the day, as the initial spread of religion under the patronage of Ashoka was linked to commerce. Because Buddhists enjoyed the protection of the state, traders associating with them came under the same protective umbrella. Monasteries were safe havens that received the financial support of their visitors. The symbiosis between monks and traders ultimately took Buddhism beyond India to China, Korea, Japan, and Southeast Asia.

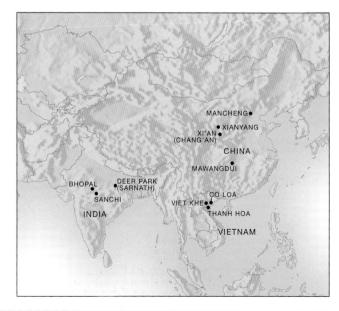

Dongson Culture in Vietnam

he impressive size of this drum (fig. 4.24), created during what is known as the Dongson culture in Vietnam (late Bronze-Iron Age, c. 500 BCE-200 CE), suggests a society given to ritual and display. How such drums were mounted is suggested by inscribed drawings on the exterior that reveal the importance of elegant boats equipped with cabins and fighting platforms (fig. 4.25). The boats were crewed by paddlers and carried plumed warriors bearing spears, halberds, and arrows similar to those found in elite tombs. The drums, mounted in sets of two or four, with drummers seated on a raised platform above them, underscore the importance of music in Dongson ritual activities. Also depicted on the drums are food preparation, the feeding of animals, and music, dance, and ritual performances. Such activities must have been part of a yearly set of Dongson rites related to agricultural production, hunting and fishing, and probably feasting.

A huge drum found at Ca Loa weighed 160 pounds and contained more than one hundred socketed hoes or plow

shares. Like the other drums, it was cast in the lost-wax process. The production of the Ca Loa drum would have required the use of about ten large casting crucibles to pour the molten bronze into the mould.

The use of these drums is debated: were they used to summon communities to war, or to religious services, or to some other as yet unidentified activity?

The creation of great bronze drums such as this one was not confined to northern Vietnam. Several hundred of these kettledrums have been reported from Indonesia, Thailand, and southwest and south China as well. The distribution of the drums probably covers areas where contemporaneous chiefdoms traded with each other. Although the largest number of drums of this type have been found in northern Vietnam and southwest China, they were probably not used for the same purposes, but they were certainly highly valued in both cultures. Bronze drums based on the Dongson model were produced into the twentieth century in south China and Indonesia.

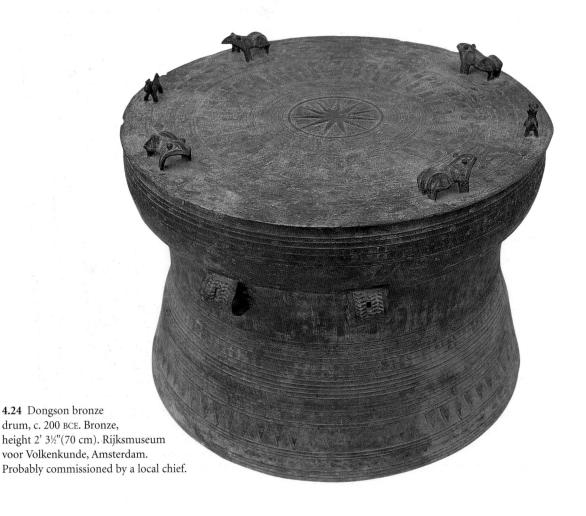

4.25 Line drawing of designs on Dongson drum depicting details of daily and ceremonial life, c. 200 BCE. Rijksmuseum voor Volkenkunde, Amsterdam.

The Dongson culture is named for a site near Than Hoa in northern Vietnam, where a number of bronze drums and other bronze artifacts were excavated in the 1920s. Later excavations led to the identification and dating of late Bronze to early Iron Age sites (about 700 BCE to 200 CE). Bronze had been produced as early as the second millenium BCE in Southeast Asia, and there is evidence that indigenous peoples there developed metallurgical knowledge locally. With abundant and easily accessible copper and tin in the region, they developed their own methods of smelting and casting.

The Vietnamese interpret the Dongson period as an early expression of native culture, before their land became a Chinese province for almost 900 years. Differentiation in size of graves and in number and type of elaborate tomb furnishings supports the idea that these societies were stratified under a powerful leadership. This explanation is confirmed in Chinese documents from the second century BCE that describe the institutionalized customary rights to land that were supported by traditional authorities such as chiefs.

In its later stage, the Dongson culture is identified as the first unified kingdom of Vietnam, with a ruling royal dynasty, a professional administrative class, and a capital at Ca Loa in the Red River Delta. The culture is documented in rich cemeteries where the tombs contain ritual and personal artifacts such as drums, bucket-shaped ladles, musical instruments, buckles, and ornamented daggers. A grave

from Viet Khe (similar to fig. 4.26) features a hollowed-out log coffin more than fifteen feet long that contained about one hundred bronzes, including small drums. More than ninety percent of the tools and weapons from the period are cast from bronze. Toward the end of the period, from about 200 CE, there are an increasingly large number of items imported from Han China, including Chinese bronze mirrors, wine vessels, coins, halberds (ge), and even a seal of the type used by Han emperors.

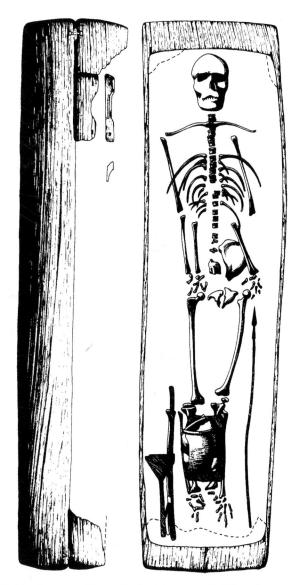

4.26 Line drawing of log coffin burial excavated at Chau Can, Vietnam, c. 500 BCE-200 CE (similar to Viet Khe burials in North Vietnam). 5 feet (1.52 m) in length.

The Art of the Roman Republic

his grave marker (fig. 4.27) exhibits the Roman continuation of the old Mediterranean practice of marking graves with images of the deceased, but the stern man and his dignified wife communicate the austere values and virtues of the Romans of the Republican period (c. 510–31 BCE), as they were defined by ancient writers: he seems sober and determined,

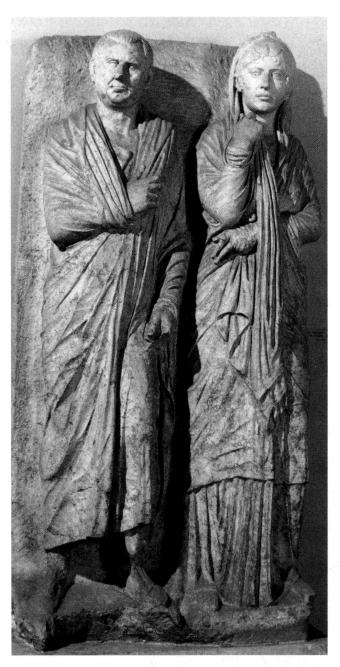

4.27 *Husband and Wife*, grave relief from the Via Statilia, Rome, first century BCE. Marble, height 6' (1.83 m). Capitoline Museum, Rome. Probably commissioned by the couple themselves or their family.

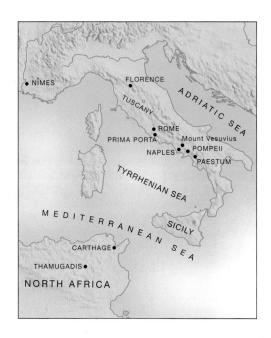

demanding, and uncompromising, while his wife appears dutiful and obedient, consistent with the prescribed role of women during the Republic. The Romans of the early Republic were self-disciplined, devout, conservative, and supporters of traditional values. They admired military valor and prized family, heritage, and the state. They respected law and legal obligations. Their language, Latin, is remarkable for its lucid order and rigid rules.

The Romans of the Republican period showed little interest in art, and even later, during the Roman Empire, Romans seldom indulged in the philosophical debates about the nature of art that had been so important for the Greeks. But a Roman strength that persisted into the Empire was the ability to absorb whatever was useful or good from other traditions. In art, the Romans owed a rich debt to the Etruscans and the Greeks. Only in a few areas did the Romans of the Republic make significant new contributions—most notably in architecture and engineering, especially in the use of concrete, the arch, and the vault (see pp. 132–35).

The Romans' interest in and devotion to the family explains their interest in individual portraiture. It was traditional for patrician families to preserve wax, terra-cotta, or marble portrait heads of their ancestors. These portraits were kept in the most conspicuous position in the house, enclosed in a wooden shrine. When any distinguished member of the family died, the busts were taken to the funeral, according to the first-century-BCE historian Polybius. Roman portraits often emphasize the peculiarities of an individual (moles, wrinkles, large ears) in order to

capture the uniqueness of the specific person. This respect for the individual—although usually limited, as in most early cultures, to the male—can be related to Roman republicanism, for a system of government that encourages individual responsibility seems to lead to the development of naturalistic portraiture in art (for later examples, see seventeenth-century Holland, p. 368, and early America, p. 416).

HISTORY

In the eighth century BCE, the Romans were only one of several groups of people living in villages along the Tiber River. But by the third century BCE, they governed a state that encompassed the Italian peninsula. In the subsequent two centuries, they defeated Carthage in North Africa and annexed Greece, Spain, Asia Minor, and the south of France. The government developed as a republic, with rule by two consuls, a hierarchy of public officials, and a senate.

The early Romans had no defined policy of expansion, but their interest in commerce led them into contact with many of their neighbors. Eventually, the Romans were forced to protect their borders and guarantee their peace after attacks from the outside. The rapid growth of the city of Rome, which by 250 BCE had almost 100,000 residents, required an increasingly large territory to support it. The Romans were generally benevolent conquerors who absorbed rather than suppressed, offering citizenship to the conquered and acknowledging the significance of local traditions. Personal ambitions and the difficulties of governing vast territories and the huge city of Rome, however, led to administrative difficulties and eventually to civil wars and attempts by military figures to seize control. The Republic came to an end in 31 BCE, when Octavian, who later became the emperor Augustus (see fig. 4.32), assumed power and established the Empire, which lasted from 31 BCE to about 400 CE.

REPUBLICAN ARCHITECTURAL **DEVELOPMENTS**

The Temple of Portunus in Rome (fig. 4.28) demonstrates the derivative nature of Republican religious architecture. The high podium, restriction of steps to the front, and deep porch are related to temples created by the Etruscans, while the suggestion of a peripteral colonnade is Greek. Note, however, that only the porch columns are freestanding; those of the sides and back are merely sculpted portions of the wall structure—engaged or half columns. The temple is,

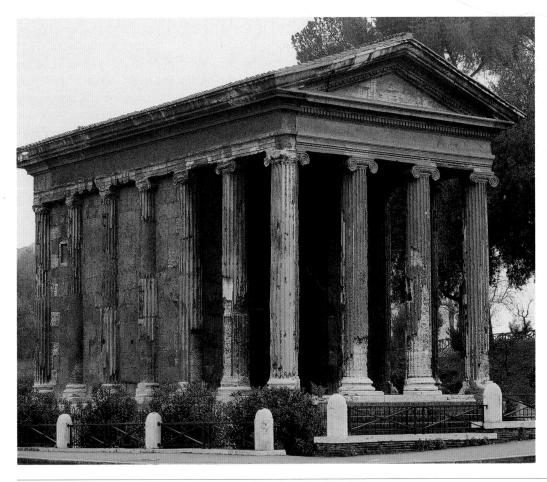

4.28 Temple of Portunus (formerly called Temple of Fortuna Virilis), Rome, late second century BCE.

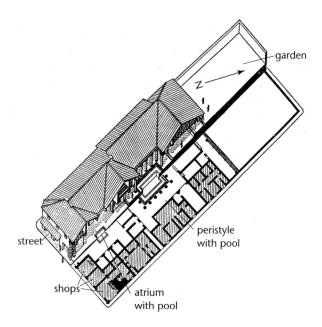

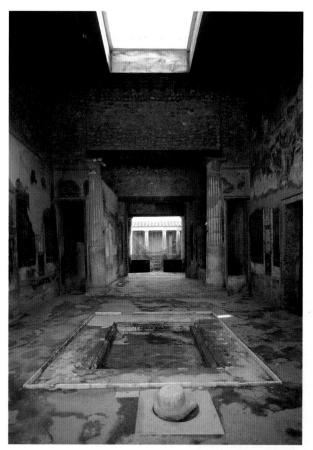

4.30 Atrium, House of Menander, Pompeii, c. 70 CE. House built by Quintus Poppaeius, a relative of Poppeia, the wife of the Roman emperor Nero.

The atrium is a feature well suited to the Mediterranean climate. The outer walls of the house were usually windowless, and the atrium allowed light and fresh air to enter, as well as rainwater, which was gathered in a central pool to flow into a cistern. The atrium functioned as a sitting room and usually contained the shrine for the household gods; on each side were small chambers for dining and sleeping.

4.29 Isometric projection with plan and longitudinal section of the House of Pansa, Pompeii, Italy, second century BCE.

There are shops on each side of the entrance. The women who died in this house during the Vesuvius disaster were wearing gold ear pendants, necklaces, and rings. When the eruption began, a sculpture of Bacchus was placed for safety in a copper kettle in the garden.

therefore, not peripteral but **pseudo-peripteral**. This design emphasizes the enclosed interior space, in contrast to the importance of the exterior in the Greek tradition. The columns provide a graceful rhythm and announce that this structure is a temple, but the pseudo-peripteral design reveals the Romans' lack of interest in the aesthetic unity and logic characteristic of their Greek source.

Architectural innovation during the Roman Republic appeared primarily in great public buildings and engineering projects. The Roman Forum (see figs. 4.34, 4.35) well illustrates several of these characteristics. Here, the arch and vault were combined with the new use of concrete (see p. 135) to make possible the relatively rapid construction of large, impressive complexes. Also, the **forum** design is a clear sequence of public and sacred spaces along an axis through which visitors moved. This molding of space and control of the observer's experience would be important features of Roman imperial architecture.

THE ROMAN HOUSE AND VILLA

Our most vivid knowledge of Roman life is the result of materials preserved by the eruption of the volcano Vesuvius in 79 CE. Volcanic ash buried the seaside town of Pompeii, preserving shops, temples, houses, drainage and sewage systems, furnishings, food, and even the anguished positions of a number of victims. Although this event occurred during the period of the Roman Empire, the houses that were preserved there were little changed from their Republican antecedents. A letter by Pliny the Younger described the disaster:

The buildings were now shaking with violent shocks.... Outside ... there was the danger of falling pumice-stones.... As a protection against falling objects [the people] put pillows on their heads ... they were still in darkness, blacker and denser than any ordinary night ... We also saw the sea sucked away and apparently forced back by the earthquake ... a fearful black cloud was rent by forked and quivering bursts of flame, and parted to reveal great tongues of fire, like flashes of lightning magnified in size.... People bewailed their own fate or that of their relatives, and there were some who prayed for death in their terror of dying. Many besought the aid of the gods, but still more imagined there were no gods left, and that the universe was plunged into eternal darkness forevermore.

The houses and villas of middle- and upper-class Romans followed a regular plan, with rooms arranged along a longitudinal axis from entrance to garden (fig. 4.29). The plan is dominated by the atrium, an open courtyard (fig. 4.30). Rooms were decorated with richly patterned ceilings and wall paintings (fig. 4.31), but actual furnishings were minimal. Couches, used for resting, sleeping, studying, and dining while reclining in the Greek fashion, were usually the most elaborate pieces of furniture. Virtually all houses in Pompeii had water pipes with taps, as well as pipes leading out to a sewer or trench.

The main rooms had mosaic floors, and the decoratively patterned floors of marble and stone in the richest homes copied famous Hellenistic paintings or patterns. One reproduction of a Hellenistic design featured the Unswept Floor (see fig. 3.57), a realistic depiction of the debris one might find underfoot after a banquet, complete with shadows to

make it more realistic—pity the poor servant who had to clean such a design after a night of Roman revelry. Another mosaic was a copy of a famous Hellenistic painting, the Battle of Alexander the Great and King Darius of Persia (see fig. 4.15). Vestibule mosaics feature images of a chained dog and the words "Beware of the Dog" or a human skeleton and "Enjoy life while you have it."

The wall paintings that survive at Pompeii, executed in a durable fresco secco technique (see p. 128), were intended to transform the rooms into an elegant ambience for living and entertaining. The simplest appear to be walls paneled in fine marbles, but in some the wall is "painted away" by an image that suggests continuous space. The subjects include realistic or fantastic views of architecture, landscapes, still lifes, portraits, and themes from Greek and Roman mythology and theater (see pp. 126-29).

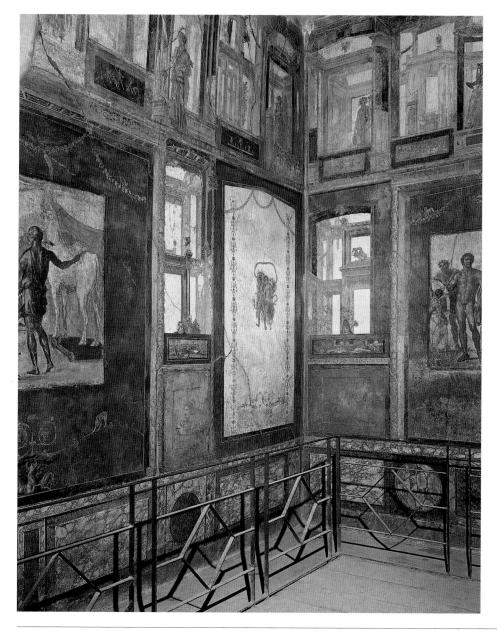

4.31 Frescoed room from the House of the Vettii, Pompeii, 63-79 CE. Commissioned by the Vettius brothers, Conviva and Restitutus.

The Art of the Roman Empire

Remember thou, O Roman, to rule the nations with thy sway—these shall be thine arts—to crown peace with law, to spare the humbled, and to tame the proud in war.

(Virgil, Aeneid, VI, 851-53)

The emperor Augustus, who commands our attention with his declamatory gesture in this over-lifesize statue (fig. **4.32**), claimed descent from Aeneas, whose deeds are recounted in Virgil's epic poem *Aeneid*. Aeneas was the legendary founder of the city of Rome, and Augustus was the founder of the Roman Empire, which lasted from 31 BCE to about 400 CE. Both statue and poem were intended to legit-

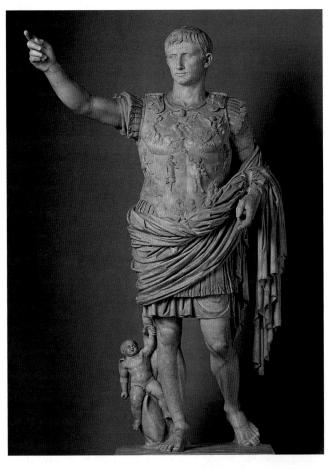

4.32 *Emperor Augustus*, 15 CE. Marble, with traces of paint and perhaps also gilding, height 7' (2.08 m). Vatican Museums, Rome, Italy. Perhaps commissioned by Augustus's wife, Livia.

This work, discovered at the villa of Augustus's wife, Livia, at Prima Porta (see fig. 4.43), nine miles (14.5 km) south of Rome, is sometimes known as the Augustus Prima Porta. The back is not complete, so the statue must have been intended for a niche. It may have been a cult statue, for after his death Livia was made the priestess in charge of the cult of the deified Augustus. Fragments of paint, such as reddish circles for the irises of the eyes, reveal that details were once painted.

imize Augustus's rule and assert his imperial authority. Augustus wears parade armor decorated with reliefs of the Earth Mother with a cornucopia—symbolic of abundance—and of a Parthian, a Roman enemy, surrendering a battle standard in the presence of divinities, an act that refers to a major diplomatic coup. These triumphs were also celebrated in poetry by the first-century BCE Roman poet Horace: "Your age, Augustus, permitted the fields to bear rich harvests once more, and returned to the skies the battle standards, wrenched from the proud barbarians." (Horace, *Carmina*, IV, 15, 4–7)

The sculpture probably dates after Augustus's death, for it represents the emperor without boots, suggesting that he has been deified. The winged baby boy and dolphin by Augustus's right foot helps support the marble figure. The boy probably represents Cupid, the son of Venus, and thus refers to Augustus's divine lineage as a descendant of Aeneas, son of Venus. The facial features identify the figure as Augustus, but they also represent an ideal, for Augustus was always shown in his early maturity, as here, although he was seventy-six when he died. In pose, the model was the Greek Spear Carrier (see fig. 3.66), which the Romans thought was a representation of another Trojan War hero, Achilles; a complimentary comparison between Augustus and Achilles was almost certainly intended. This sculpture, then, is an idealized portrait of a specific emperor; although it is based on classical Greek prototypes, its iconography and scale are specifically Roman, for they exalt the emperor and the Empire.

HISTORY

In 31 BCE, Octavian, grand-nephew and adopted son of Iulius Caesar, became the sole ruler of Rome and all its territories; in 27 BCE, the Roman Senate named him Augustus ("he who augments"), and after his death they declared him a god. Brilliant and resourceful, Augustus—who wrote that he "found Rome a city of brick and left it a city of marble"-became the first emperor and ruled the Empire longer than any who followed him. He continued the expansion of the Roman state, as did his successors, and by the death of Trajan in 117 CE, Rome's population was about 750,000 and the Mediterranean had become a "Roman lake." The difficulties of governing this enormous area and its diverse population made the Romans experts at efficiency and organization. They had little time for or interest in the philosophical speculations that had formed Greek art and culture. Their most significant contributions are in world government and order, encompassing such diverse issues as legal codes and city planning.

The Romans had a strong sense of their historical importance and their contributions to world history. Julius Caesar wrote an account of the Gallic Wars. The emperor Claudius wrote two historical works, now lost, and Augustus made a list of his accomplishments known as the Res Gestae. Roman attitudes toward history and art are expressed in the elaborate marble surround that enclosed the Altar of Peace, or Ara Pacis (fig. 4.33), in Rome. The altar was used in rituals commemorating the Pax Romana ("Roman Peace"), which had been declared by the Roman Senate in 13 BCE to express and celebrate the peace brought by Augustus to Italy and to the Roman state. Although they were aware of the significance of the Pax Romana, they could not know that never again would peace prevail for so many years over so vast an area. The Senate's declaration and the richly decorated altar were intended to bring recognition to this historic fact, and to establish it as a Roman accomplishment and ideal. Augustus, accompanied by his family and friends, appears in the procession representing the altar's dedication. Although the stylistic sources for the reliefs lie in such Greek models as the Parthenon frieze (see figs. 1.15, 3.76), Greek idealism is ignored in favor of documenting a specific historic moment and distinctive individuals. The presence of Augustus and other members of the imperial family at this sacrifice reveals piety and concord; the more important figures are in higher relief for emphasis and focus. Even the decorative motifs glorify the Empire and allude to its peace-giving role, for the garlands below refer to the abundance made possible by peace.

THE CITY OF ROME

Rome, which at its largest had a population of nearly a million, was in many ways similar to a modern city. It had impressive public spaces with state buildings and religious structures, as well as shopping areas, apartment buildings of five or six stories similar to modern apartment blocks, and rooming houses. Most of the population lived in rental housing; a fourth-century CE document lists 46,602 apartment and rooming houses in the city and only 1,797 private homes.

The administrative and religious center of Rome was the Forum. The Roman Forum had been established in the Republican period, beginning in the sixth century BCE. Later, imperial forums, built by different emperors, were unified along a longitudinal axis (see figs. 4.34, 4.35). At the northwestern end of this axis is the Forum of Trajan, with the Basilica Ulpia (see fig. 4.48; Ulpius was Trajan's family name). The Basilica Ulpia adjoined libraries that flanked the Column of Trajan (see fig. 4.39). Given the Basilica's size—it is more than 400 feet long—the Roman architect was confronted with the problem of how to light the vast interior space. To solve this problem, the wooden

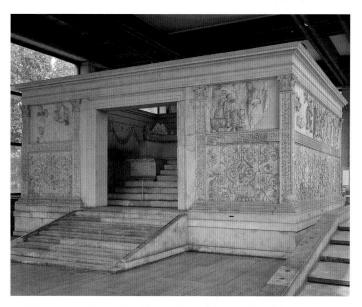

4.33 Reconstruction of the Altar of Peace (Ara Pacis) and its Enclosure, Rome, 13–9 BCE. Marble, approx. 34' 5" × 38' × 23' $(10.52 \times 11.63 \times 6.1 \text{ m})$. Commissioned by the Roman Senate to mark Augustus's victorious return from Gaul and Spain in 13 BCE.

gable roof of the nave was raised above the aisles to permit clerestory windows.

The emperors kept the urban populace happy by providing food, facilities, and entertainment. Elaborate programs of building in the imperial forums (figs. 4.34, 4.35) impressed the public with the power of the emperor and the magnificence of the state. Theaters and amphitheaters provided places of entertainment for tens of thousands. The Roman taste for grand architecture also found expression in the public bath, which offered public facilities for communal bathing and exercise, as well as for social and intellectual gatherings. Visiting the bath, which was built at state expense and could be entered for a nominal fee, was a ritual of daily life for the Roman citizen. There were many baths throughout the Empire, but the most elaborate were those in Rome, built by the emperor Caracalla (ruled 211–17; fig. **4.36**).

The Baths of Caracalla complex covered fifty acres and accommodated approximately 1,600 people at one time. Initially, mixed bathing was permitted, but later the sexes were segregated, with women and men bathing at different times. The plan was organized along a central axis; the tepidarium (warm-water pool), calidarium (hot-water pool, usually circular in shape), and frigidarium (cold-water pool) were all located on the axis. Gymnasia flanked the pools; and gardens, barber and hairdresser shops, libraries, and meeting rooms completed the complex. Water, transported by aqueducts from outside the city and heated by fires in basements, was passed to the pools in clay or lead

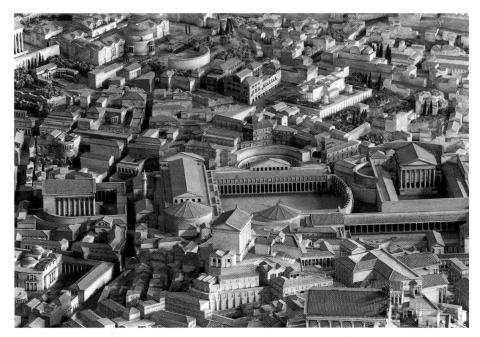

4.34 Reconstruction model of the Roman and Imperial Forums in Rome in the early fourth century CE. Museum of Roman Civilization, Rome, Italy. See below for plan. Forums originally commissioned by the Republican government of Rome; expanded by various Roman emperors.

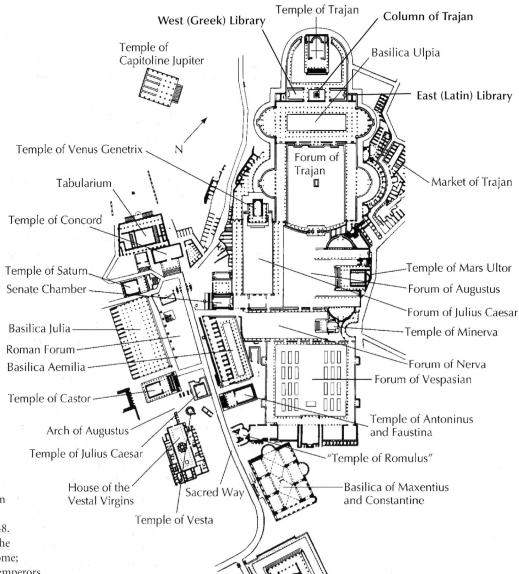

4.35 Plan of the Roman and Imperial Forums, Rome, with the Basilica Ulpia.
Compare to the reconstruction above and the reconstruction of the Basilica Ulpia in fig. 4.48.
Originally commissioned by the Republican government of Rome; expanded by various Roman emperors.

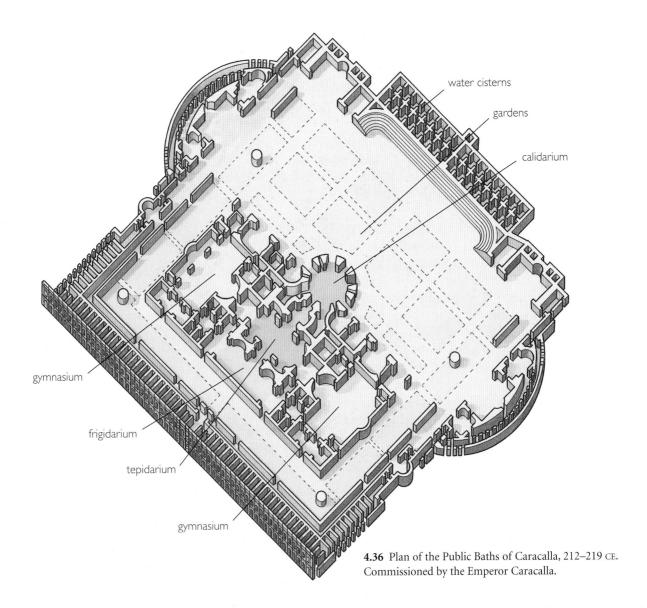

pipes. A visit to the bath usually began with physical exercise, followed by a stay in the steam room. In the calidarium, oil was used to cleanse the body. After cooling down in the tepidarium and frigidarium, a visitor received a massage, which completed the bath. The visitor might then take a walk in the gardens, study in the library, or attend lectures.

ROMAN IMPERIAL ART

The number and diversity of the peoples within the Roman Empire meant that Roman imperial art encompassed a variety of types and styles, especially as local traditions were incorporated into works of art. Here we have chosen to limit our discussion almost exclusively to works of art created within the city of Rome and for its inhabitants. The majority of the artists employed by the Romans were of Greek ancestry. Greek artists were imported as early as 500 BCE, during the Republic, and works of art were also ordered from artists active in Greece. The demand for Greek works, new and old, accelerated after the Romans sacked Corinth in 146 BCE and brought a number of impressive Greek works to Italy.

Among the most characteristic monuments of Roman art are those that honor the Empire and emperor. They are often built on an enormous scale to communicate the size, power, and authority of the Empire and the specific ruler. Huge buildings and interrelated groups of buildings that express the grandiose aspirations of the Empire were made possible by the new techniques of construction that had been developed during the Roman Republic. The Empire's use of the arch, the vault, and concrete—devices that made feasible not only the large and magnificent monuments of ancient Rome, but also the powerful molding of space so important in Roman architecture—is among the most significant of all Roman accomplishments (see pp. 132–37).

The creation of works of art honoring and commemorating an emperor's deeds and victories was a constant challenge to artists in the service of the Empire. One type of monument honoring emperors and generals was the equestrian monument, but the only surviving example is the *Marcus Aurelius* (fig. **4.37**). This figure has the same commanding gesture as the *Augustus* (see fig. 4.32), but here his power is emphasized by his control over his lively and rather nervous horse. Originally, a figure of a defeated enemy was probably shown crouching under the horse's upraised hoof.

Another commemorative monument is the triumphal arch. Although its origins can be traced to the Republican period, the first to be called *arcus triumphalis* were the large and permanent triumphal arches erected during the reign of Augustus. Eventually there were more than fifty in Rome. The Arch of Titus (see fig. 4.4) memorializes Titus's capture of Jerusalem in 70–71 CE. One of the reliefs shows the parading of the seven-branched menorah—the ceremonial candleholder from the Temple in Jerusalem—through the streets of Rome, where the procession is about to pass under a triumphal arch (fig. 4.38).

Commemorating the emperor Trajan's early-secondcentury victories over the Dacians in eastern Europe is a huge freestanding column (fig. 4.39), as tall as a twelvestory building. It was originally topped with a monumental gilded bronze statue of the emperor, which has been replaced with a statue of Saint Peter. The column itself has a spiraling relief, carved in a lively and direct style, that tells in detail the episodes of Trajan's campaigns and victories. Although every detail of every scene is not visible to the viewer, the scale of the column and the length of the relief convey the extent and complexity of Trajan's exploits. Some of the upper scenes could have been read by people on the balconies of the courtyard of Trajan's libraries, which surrounded the column (see fig. 4.35). The column and library were only part of Trajan's contributions to the imperial forums, which he, like other emperors, embellished as a way of asserting his presence and impressing the people with his magnificence.

TECHNOLOGY, ORGANIZATION, AND ENGINEERING

To run a large empire, to communicate and move supplies, and to feed the masses gathered in growing cities demanded important new developments in technology and organization. Innovations such as the arch, the vault, and concrete helped solve engineering and construction problems on a large scale; they ultimately affected the production and style of works of art. The celebrated Roman roads, bridges, and aqueducts were engineered to solve the particular problems of a specific area or terrain, and some are still in use today.

The Roman interest in order, efficiency, and organization is revealed in the proliferation of the Roman town plan (fig. **4.40**) which, once established, was spread throughout the Roman world, from London to North Africa. Even today the street maps of cities that were originally laid out by the

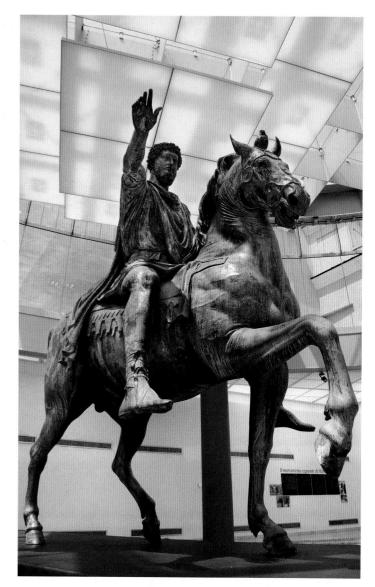

4.37 *Marcus Aurelius*, 161–80 CE. Bronze, over-lifesize. Capitoline Museum, Rome, Italy. Commissioned by Marcus Aurelius.

Marcus Aurelius, who wrote the *Meditations*, has the longish hair and full beard that characterized the "poetic" emperor. A "military" emperor was usually represented as clean-shaven with short hair. The bronze statue is an impressive technical accomplishment, but it survived being melted down only because during the Middle Ages it was thought to represent Constantine, the fourth-century emperor who lifted the ban on Christianity.

Romans reveal the north–south/east–west orientation and regular divisions of their ancient Roman origins. This type of plan was not invented by the Romans, who based their ideas on Egyptian, Greek, and Hellenistic prototypes, nor is it unique to the West, as a look at the plan of Chang'an in China (see fig. 5.32) reveals. In the Roman version, the grid pattern of streets is laid out within fortified walls, and the center of town is marked by the intersection of the *cardo*, running north–south, and the *decumanus*, running east–west. Nearby is the forum—the social, political, and

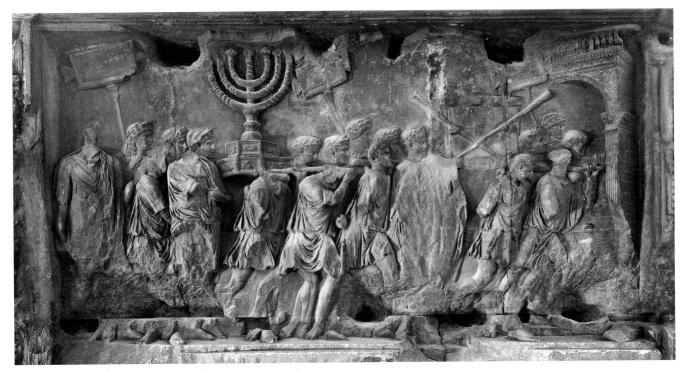

4.38 Spoils of the Temple at Jerusalem Exhibited in Rome, relief from the Arch of Titus, Rome (see fig. 4.4). Marble, height 6' 7" (2.5 m). Commissioned by Titus.

commercial heart of the city. The intersecting cardo and decumanus divided the city into quarters, each of which is further subdivided; only irregular or large buildings such as theaters or public baths disrupted this regular plan.

ROMAN RELIGION AND THE MYSTERY RELIGIONS

The more important official Roman deities were derived from the gods and goddesses of the Greeks, but their names were changed: Zeus became Jupiter, Aphrodite became Venus, and the elusive Dionysos was transformed into Bacchus, for example. But the number of Roman deities gradually expanded, for when the Romans conquered and annexed a new area, the local deities were usually added to the Roman hierarchy of gods. At the Pantheon in Rome (see fig. 4.54), there was even an altar dedicated to those gods whom the Romans had yet to discover.

During the later Empire, the religious life of many Romans was dominated by participation in mystery religions, cults that centered on a savior who promised some kind of life after death. Their widespread popularity and the later acceptance of Christianity as the official Roman religion have been seen as a reaction to the decadence and

4.39 Column of Trajan, Rome, 113 CE. Marble, height originally 128' (38 m). Commissioned by Trajan as part of the Forum of Trajan. If the reliefs on the column were stretched out, they would be more than 650 feet (190 m) long.

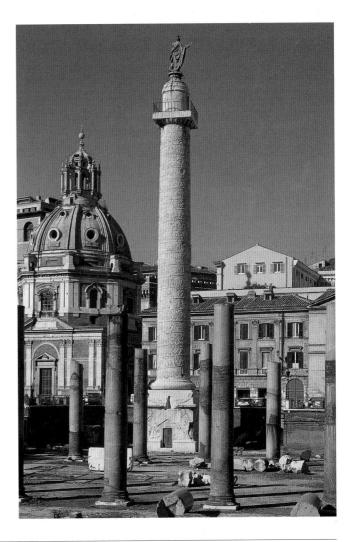

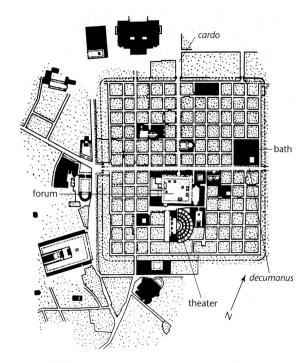

4.40 Plan of Thamugadis (Timgad), Algeria.

Although most Roman town plans were laid out with main axes that were north-south and east-west, Thamugadis, founded c. 100 CE under the emperor Trajan, is slightly off-axis, perhaps because of terrain or some other variable in the site.

materialism that gradually overtook Roman life. Other mystery religions centered around the worship of Isis, an Egyptian goddess whose temple at Pompeii included a shrine with a reservoir of holy water from the Nile, and Cybele, the Great Mother (Magna Mater). An ancient Roman temple of Mithras, a militant god-hero who represented the victorious forces of light over darkness, was discovered in the remains of ancient Roman London during reconstruction after the bombings of World War II. Mithraism, an especially important late Roman cult, was widespread throughout the Empire as a result of its popularity with members of the army.

THE END OF ROME'S EMPIRE

Political, religious, and spiritual turmoil and threats from Northern barbarians characterize the later Empire. Diocletian (ruled 284-305) consolidated imperial rule, but he also banned and persecuted the Christians. Constantine lifted the ban on Christianity in 313 and later may have converted to the religion himself. But Rome lost much of its importance when Constantine shifted the imperial capital to Constantinople, which he had founded at a site on the Bosphorus named Byzantium (present-day Istanbul, see map p. 153). In 395, at the time of the death of the emperor Theodosius I, the Empire was divided in half. But while the Eastern Empire, centered around Constantinople, enjoyed political stability, the Western Empire was beset with uprisings from Germanic peoples, including the Visigoths, who captured and sacked Rome in 410.

THE ROMAN ARTIST

In ancient Greece, artists had been famous and respected, but during both the Republic and the Empire, artists in the service of the Roman state became anonymous laborers once again. Few artists are known by name; not a single painting bears a signature, and only a few are documented as the work of a particular artist. In most cases, the large and elaborate programs of Roman art seem to have been accomplished by groups of artists working together, probably in well-organized workshops, and submerging their individuality in the concept of a unified project.

Most of the few names of artists that are recorded are Greek, and these are names of sculptors. Even during the Republic, it was recognized that Greek sculptors represented a longstanding tradition of excellence. The famous Laocoön and His Sons (fig. 4.41), once thought to be a work of the Greek Hellenistic period imported to Rome, is now believed to be a Roman work created by Greek sculptors working in a revival of the Hellenistic style for a Roman patron.

4.41 Hagesandros, Athenodoros, and Polydoros, Laocoön and His Sons, early first century BCE (?). Marble, height 6' (1.84 m). Vatican Museums, Rome.

This sculptural group was carved by three Greek sculptors from the island of Rhodes. Although they were Greek, they were probably working for a Roman patron who commissioned a work reminiscent of earlier Hellenistic art. The group was excavated in Rome in 1506, and its representation of heroic struggle and powerful muscular anatomy had an immediate impact on Italian Renaissance artists, including Michelangelo. The mythological theme represented here is an episode from the Trojan War. Laocoön was a priest who warned his fellow Trojans not to accept the wooden horse offered by the Greeks. His warning was ignored and as retribution the gods sent serpents who attacked and killed Laocoön and his two sons.

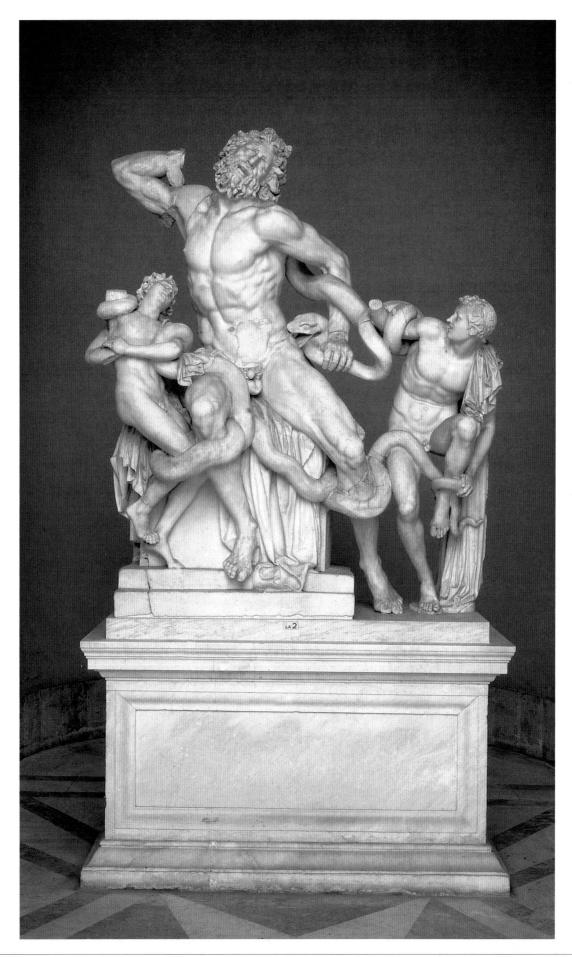

Roman Frescoes and Illusionism

his room of frescoes (fig. 4.42) representing Bacchic (or Dionysiac) mysteries is exceptional in quality and subject, as well as in scale, for nearly life-size figures such as these are rare in Roman painting. In addition, these frescoes are one of the first examples of mural painting—painted wall decoration that is integrated with the physical space and architecture of its setting.

The secret rites depicted here have not yet been fully explained, but this painting reveals the importance of the cult of Bacchus, god of wine and fertility, in Roman life. It has been proposed that the sequence of scenes, which seems to read from left to right, represents either the initiation of a new member into the cult or the transitions in the life of a young woman when she marries and becomes a Roman matron.

The central figures, badly damaged, represent the enthroned Ariadne, with Bacchus reclining on her chest. The initiate, or bride (not visible here), enters on the far left. She is enthroned as a matron on the far right (not visible in this view). In the interim, she encounters various trials and experiences. Among the dramatic episodes is the imminent unveiling of a large phallus to the right of the central figures of Ariadne and Bacchus. The regular, architectural rhythm of the paneling behind the figures sets off their poses, while the strong red background adds an element of drama appropriate for the subject.

The most dramatic episodes are represented at the two corners, where the artist took advantage of the walls meeting at 90-degree angles to represent interacting figures. At

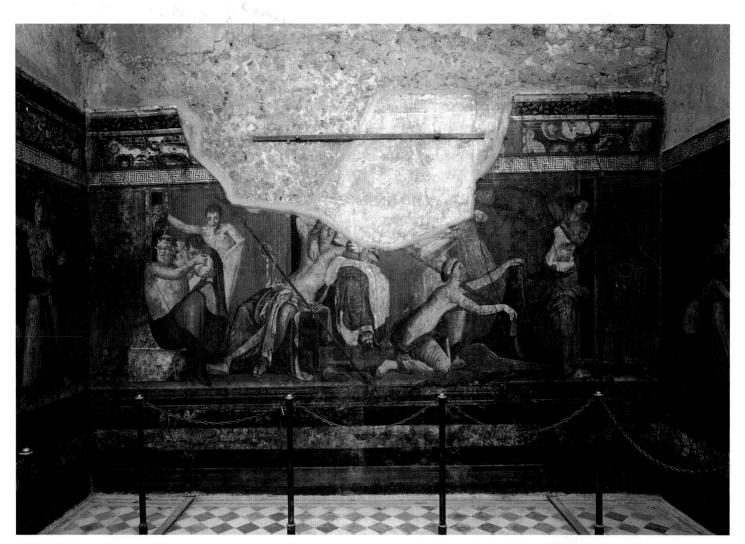

4.42 Bacchic Mysteries, painting in the Villa of the Mysteries, Pompeii, Italy, c. 30 BCE. Fresco, room approx. $29' \times 19'$ (8.9×5.8 m); height of figures approx. 5' (1.5 m). Whether these paintings, which are superb in quality, are original Roman works or copies of a lost Hellenistic program of paintings from Pergamon is still debated by experts. To the right a black-winged figure is shown whipping a kneeling figure seen on the adjacent wall; this episode of whipping may refer to a ritual undertaken to ensure fertility.

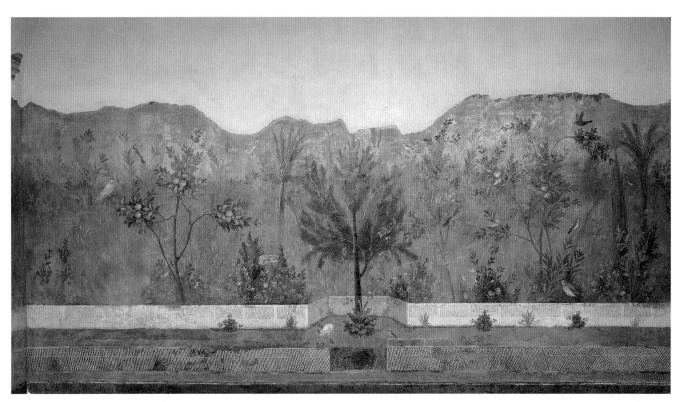

4.43 Garden, painting from the Villa of Livia, wife of the emperor Augustus, at Prima Porta, near Rome, late first century BCE. Fresco, height of wall approximately 10' (3 m). Palazzo Massimo, Rome. Commissioned by Livia. The statue of Augustus in fig. 4.32 was also discovered at Livia's villa.

one corner, a fierce half-man, half-beast woods deity known as a silenus, who may be reading the young woman's fortune in the residue left in a wine cup, looks back at her as she flees in terror. At the other corner, a winged figure in a spiraling movement flogs the initiate or bride, who reclines on the lap of another woman. The large scale and otherwise undocumented subject of this fresco cycle make it one of the most important works preserved by the eruption of Mt. Vesuvius.

One of the most enchanting of all Roman fresco decorations is the illusionistic painting that covered all four walls of a room in the Villa of Livia at Prima Porta (fig. 4.43). It represents a garden with fruit trees, flowers, and songbirds set off by a background of sky. The fresco has all the freshness of nature's colors: the rich greens of the garden; the varied shades of fruit, flowers, and plumage; and a wonderful blue sky. All are executed with a light touch of the brush, as if the wind were just beginning to stir this idyllic environment.

Fresco Painting

Fresco painting (fresco is Italian for "fresh"), which involves painting directly on a plaster wall, was used by the Egyptians, Greeks, Romans, and later civilizations as well. When properly executed, it is durable, and when it is subtly related to its particular architectural setting, as in the cycle at the Villa of the Mysteries at Pompeii (see fig. 4.42), it can be both decorative and dramatic. Generally, fresco painters have to cover large expanses of wall, and they often work quickly; the sketchy and suggestive quality of most Roman and later frescoes creates a lively and vivacious effect. (For a discussion of the somewhat more complex fresco technique that developed in Italy during the later Middle Ages and the Renaissance, see pp. 242–43.)

The Roman fresco painter began by applying two or three layers of fine plaster to the wall surface to be decorated. The background was painted on the top layer of plaster—sometimes while it was still moist—and left to dry. Each plaster patch (fig. 4.44) reveals one day's work. The natural pigments, which were made from earth, minerals, and animal or vegetable sources, were mixed with limewater. Glue and wax were sometimes added to create a hard and shiny surface. Painting onto wet plaster is called buon fresco (buon is Italian for "good" or "true") and painting on the already hardened dry plaster is known as fresco secco (in Italian, secco means "dry")

4.44 Diagram of fresco patches at the Villa of the Mysteries. An examination of the surface of the frescoes reveals that they were painted in patches that follow the outlines of the figures. In later Italian fresco technique, each of these patches would be known as a *giornata* (Italian for "day").

Illusionism

Livia's garden room (see fig. 4.43) is more delightful and seductive than a framed painting of a garden, for it creates the illusion that we are in a natural setting. Such illusionism also played a role in Still Life with Eggs and Thrushes (fig. 4.45), for in both works the artists want to fool us into believing, albeit momentarily, that we are looking out into a real garden or at a real dish of eggs. This type of illusionism, which is also known by the French phrase trompe l'oeil ("fool the eye"), is a pleasant bit of trickery. Such paintings are meant to amuse and delight us, as was recognized by the Roman author Philostratus the Younger, writing about 300 CE:

To confront objects which do not exist as though they existed and ... to believe that they do exist, is not this, since no harm can come of it, a suitable and irreproachable means of providing entertainment?

The illusionism of Roman paintings is inherited from an earlier tradition that developed in Greece (see the discussion of a Greek painting contest on p. 36). The sense of pleasure in experiencing illusionism is not unique to the Greeks and Romans, as is revealed by the popularity of trombe l'oeil in later societies and even today.

There are several criteria for a successful illusionistic, or trompe l'oeil, painting. The objects in the painting should be represented in their natural scale in a clearly structured space, as is the case with both Livia's Garden and the Still Life. In the Garden, the artist has carefully developed the depicted space in overlapping levels within the painted illusion. Cast shadows define the placement of each object within the illusionistic space, as is especially evident in the Still Life, and the objects are naturalistically modeled with transitions from light to dark that indicate both the three-dimensionality of the objects and the source of the light (later, at the time of the Italian Renaissance, this treatment of shading become known as chiaroscuro, from the Italian words for "light" and "dark"). Naturalistic lighting effects suggest the textures of the objects: note the different textures of the eggs and the metal vessels in the Still Life. Often, painters introduce an object in the immediate foreground that establishes the frontal plane of the illusionistic space; this form, known as a repoussoir (French, meaning "to push back"), can be noted in the low, openwork fence in the foreground of Livia's Garden.

The use of the repoussoir in the Still Life is especially interesting, for the illusionism is heightened by painting the bowl of eggs as if it extends over the frontal plane of the base—the repoussoir—to jut out into our space. To make the illusion convincing, the subject matter is usually everyday objects that need no explanation. The goals of such art are obvious, for the purpose, beyond Philostratus's "entertainment," is to impress us with the technical skill of the artist.

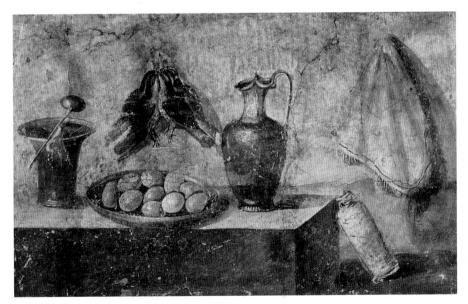

4.45 Still Life with Eggs and Thrushes, painting from the House (or Villa) of Julia Felix, Pompeii, before 79 CE. Fresco, 35 × 48" (89 × 122 cm). National Museum, Naples, Italy. Commissioned by the original owner of the house.

The house where this fresco was found during excavations in 1755-57 is the largest yet discovered at Pompeii. The fresco shown here is one of a sequence of still-life paintings of food.

Roman Architecture: The Flavian Amphitheater

hrough the ages, the Flavian Amphitheater has conveyed the scale and strength of the Ancient Roman Empire (figs. 4.46, 4.47; p. 96, fig. 4a). Begun by Vespasian, a military leader and first emperor of the Flavian Dynasty, it was built in part to reassure the Roman citizenry that the cruelty and self-indulgence of the reign of Nero, the last Julio-Claudian emperor, had ended; to establish a site for the amphitheater, Vespasian destroyed the lake and ostentatious pleasure gardens of Nero's house. The amphitheater was dedicated by Vespasian's son Titus with gladiatorial games that lasted more than a hundred days and featured a thousand gladiators and the deaths of thousands of animals.

The Roman amphitheater, or arena, was so well conceived that it has become the prototype for the modern sports stadium. The oval plan seems to have developed from the idea of facing and enclosing two theaters (amphitheater derives from the Greek amphi, "around," and theatron, "theater"). The Flavian Amphitheater, the largest amphitheater of the ancient Roman world, could hold about 50,000 spectators. They were sheltered from sun and rain by an awning rigged by sailors and supported by horizontal poles anchored in the top level. Eighty arched passageways on the ground floor provided entrance to a double row of annular tunnel vaults encircling the arena, which led to interior stairs to vaulted passages on the upper

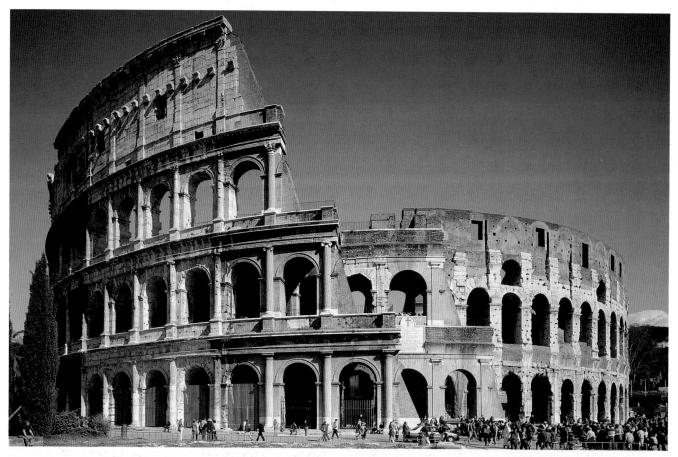

4.46 Flavian Amphitheater (Colosseum), Rome, Italy. Begun 72 CE; dedicated 80 CE; construction completed 96 CE. Approx. 615 × 510' (188 × 156 m). Commissioned by Vespasian; completed by his sons Domitian and Titus.

The building was damaged in later centuries, when much of the dressed stone of the outer surface was taken away to be used in the construction of other buildings; as a result, the Colosseum became a famous ruin, visited by later visitors to the city, who marveled at its scale and the rare plants that had sprung up there, sown from the bodies of the exotic animals who had been killed in the games during ancient Roman times. In 2000, a stage and flooring were constructed over part of the subterranean chambers and passages that had been excavated and now, after almost 1,500 years, the amphitheater is being used to host cultural events.

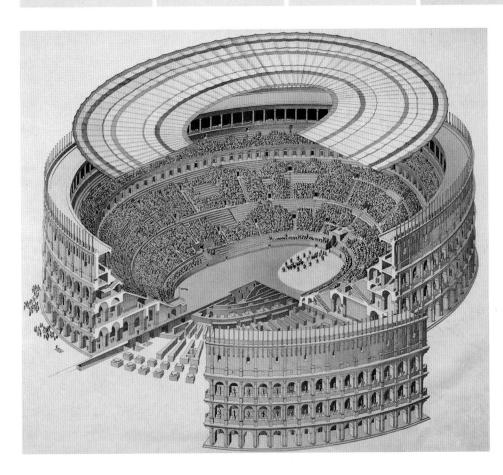

4.47 Reconstruction, with section, of the Flavian Amphitheater. The huge awning supported by timbers around the outer edge is here lifted up slightly to allow us a better view into the interior.

levels. Such a plan permitted easy access and exit by the huge crowd of spectators.

Construction materials included travertine, brick, concrete, and tufa (see p. 135). When finished, the exterior was faced with blocks of local travertine stone, held in place by iron clamps. The exterior design was unified by the repetition of arches flanked by half columns. The capitals on the three arched stories change from Tuscan (a variation of Doric) below to Ionic and Corinthian for the second and third floors; Corinthian pilasters articulate the fourth level.

The amphitheater was an arena for displays of combat: gladiators battled both other gladiators and animals, while animals, especially lions and tigers brought from Africa, were pitted against one another. Women gladiators participated until 200 CE. The fight was usually to the death, a practice that may have evolved from an earlier Etruscan ritual in which a deceased relative was honored by a fight to the death between slaves. The floor of the Flavian Amphitheater was landscaped with trees and large rocks. Animals were raised by lifts from underground chambers, now visible after excavations. Reportedly the amphitheater could be artificially flooded for contests mimicking naval battles. Although a few Romans denounced these games as bloody spectacles, most viewed them as displays of courage and virtue.

To the ruling families of Rome, the games also served a political purpose. At times, the unemployment rate reached approximately 15 percent, and, in addition to religious festivals, approximately 150 days each year were celebrated as holidays. Providing spectacular games became a political scheme to keep an often idle population entertained and content.

During the Early Christian era, some martyrdoms may have occurred here, but most public persecutions were held in the Roman circuses (arenas especially designed for chariot races). After Christianity was legally recognized by the emperor Constantine in 313 CE, growing numbers of Christians argued against the brutality of the games. Gladiatorial contests were banned in the early fifth century, but the animal games continued into the sixth century.

Until at least the mid-fourth century, a colossal (almost one hundred feet tall) bronze statue of Nero as the sun god stood next to the Flavian Amphitheater. In the eighth century, a guidebook to Rome applied the term Colosseum, taken from the colossal sculpture, to the amphitheater itself, and ever since it has been known popularly by this name.

Roman Engineering: The Arch, the Vault, and Concrete

The dramatic contrast between the two ancient Roman interiors seen here is directly related to the materials and engineering used in their construction. The huge Basilica Ulpia from the Forum of Trajan (fig. 4.48) was based on post-and-lintel construction; the even larger and grander Basilica of Maxentius and Constantine (fig. 4.49), begun more than 200 years later, is built with rubble, brick, and concrete using a vaulting system based on the arch. When concrete hardens, it becomes monolithic, and today some of the huge vaults of the Basilica of Maxentius and Constantine are still standing in Rome. Not a column of the Basilica Ulpia is in place, in part because its great columns were reused in new construction during later centuries. Both the Basilica Ulpia and the Basilica of Maxentius and Constantine functioned as law courts when originally constructed.

The arch was known to the peoples of the Middle East, as well as to the Egyptians, the Greeks, and the Etruscans, but it was the Romans, beginning in the Republic, who recognized its utility for engineering projects and its potential for spanning large spaces to create huge public buildings. Post-and-lintel construction spans an opening with a flat beam of wood or stone, but

an **arch** (fig. **4.50**) is a means of construction by which an opening—usually semicircular—is spanned by a number of elements (stone or bricks) that are smaller than the opening itself; these elements are most often wedge-shaped blocks known as **voussoirs**. The central voussoir is called the **keystone**. All the vaults discussed here are based on the arch.

Arches and vaults are constructed upon a wooden support known as **centering**, which can be removed and reused. The point at which the arch or vault begins to curve inward and upward is known as the **springing**; the blocks immediately below the springing may jut out to support the centering (for an example of such blocks still in place, see fig. 4.51). The dynamics of the post-and-lintel systems are relatively simple, with the **thrust** of the weight of the lintel pressing downward on the supporting posts. The dynamics of an arch or vault, however, create outward diagonal thrusts that must be counteracted by **buttressing**, providing a masonry support that counteracts the thrust (as indicated by the arrows in fig. 4.50; for a later example, see fig. 6.31).

A **vault** is a structural system for a ceiling and/or roof that is based on the arch. The simplest type of vault is a

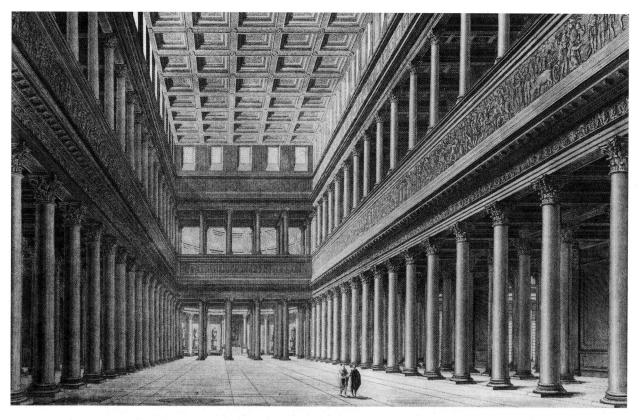

4.48 Reconstruction drawing of the interior of the Basilica Ulpia, Forum of Trajan, Rome, Italy (after Canina), c. 98–117 CE. Commissioned by the emperor Trajan as part of the Forum of Trajan. For a plan of the Basilica Ulpia and its location within the Imperial Forums, see fig. 4.35.

tunnel (or barrel) vault, a deep, continuous arch that can cover a large area. Although light can enter at either end, the buttressing prohibits large openings along the sides. For a bridge and aqueduct such as the Pont du Gard (fig. 4.51), however, short tunnel vaults provide a solution. The lowest row is made up of tunnel vaults that are deep enough to support the road and protect the foundation against the force of the river during spring floods. An identically proportioned row of arches provides the extra height needed for the aqueduct on the top, which is raised on much smaller arches, four over the wider central arch and three over those to the sides. When tunnel vaults and arches are placed in rows, each neutralizes the outward thrust of the adjacent member, but those on the ends must be well buttressed, a function here performed by the riverbanks to either side. The Pont du Gard is, however, more than a remarkable surviving example of Roman engineering skill; its simple design, handsome proportions, and rhythmic subtlety make it an impressive work of art. (For other structures that utilize the tunnel vault, see figs. 4.4, 6.10, 6.45.)

The three great square vaults that spanned the central area of the Basilica of Maxentius and Constantine (see fig.

4.49) were each formed by the intersection at right angles of two tunnel vaults; these are called cross (or groin) vaults. The outward thrusts of a cross vault are concentrated at the corners, and buttressing is only required at these points. When placed in a row, as here, or in groups, cross vaults can span vast areas and still permit large windows. (For other buildings with cross vaults, see figs. 4.46, 4.47, 5.25, 6.22.) The vertical members that support a cross vault are known as piers. The area between each group of piers is known as a bay.

Series of vaults are usually arranged in straight lines, but sometimes the architectural needs demand another arrangement. When a tunnel vault is arranged in a curving or circular configuration, it is known as an annular tunnel vault; a series of cross vaults in a curving configuration are known as annular cross vaults (see figs. 6.11, 6.23, and 6.29).

A dome is a hemispherical structural system that can be understood as an arch rotated 180 degrees on its axis. It must, therefore, be buttressed on all sides. The problem of light can be solved by opening the top of the dome with an oculus, as in the Pantheon (see fig. 4.54), by piercing the edges of the dome with small windows (see fig. 5.1) that are framed by heavy buttresses, or by raising the dome on

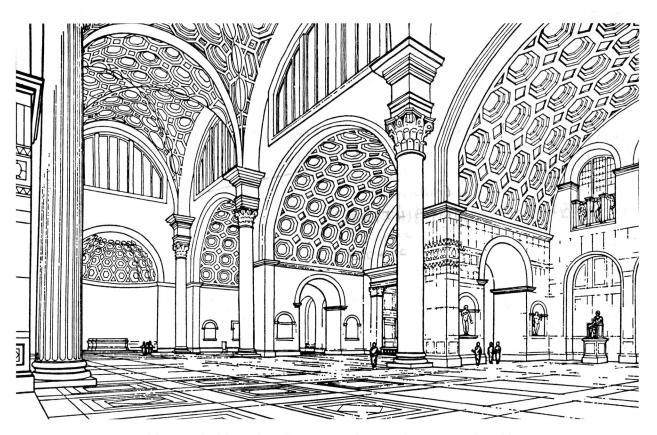

4.49 Reconstruction view of the interior of the Basilica of Maxentius and Constantine, Rome, as planned by Maxentius, c. 306-313 CE. Originally commissioned by Maxentius, completed by his rival Constantine. For a plan and its location in the Imperial Roman Forum, see fig. 4.35.

Roman Engineering (continued)

arches or tunnel vaults (see fig. 8.30). To attain greater height, a dome may be raised upon a **drum**, a cylindrical or polygonal wall that provides continuous support (see fig. 7.31).

When a dome is placed at the juncture of tunnel or barrel vaults, as occurs often in Christian church architecture (see figs. 7.29 and 7.30), it must be located over a square base. The transition from the circular base of the dome to the piers or walls below has traditionally been handled in two ways. One method is the use of four **pendentives**; these are curving triangular segments of a

larger dome that help create a visual and supportive transition from the four supporting piers to the dome above (see fig. 5.1). The second system uses **squinches**: arches, lintels, or corbels that jut across the corners to create an octagonal base for the dome (see fig. 5.44).

In many of the finest Roman buildings and engineering projects, such as the Pont du Gard, the material used was dressed stone: each piece was cut for its specific position and no mortar was employed. Repeated arches, such as those of the Pont du Gard, meant that a certain number of stones of regularized shape could be cut, and the

4.50 Diagrams of a round arch, an arch with centering, a tunnel (or barrel) vault, a cross (or groin) vault, a dome on pendentives, and a dome on squinches. The arrows suggest the general direction of the outward thrusts that must be buttressed, but only the drawing of the arch includes the buttressing that is essential in all vaulted systems.

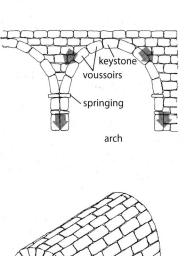

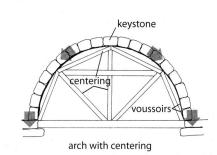

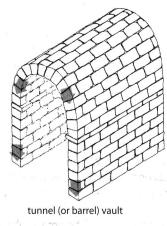

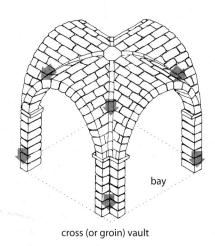

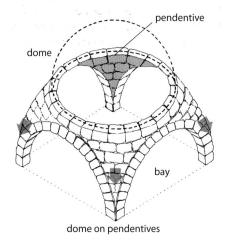

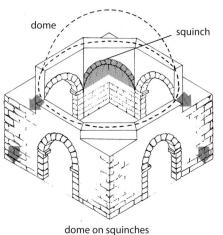

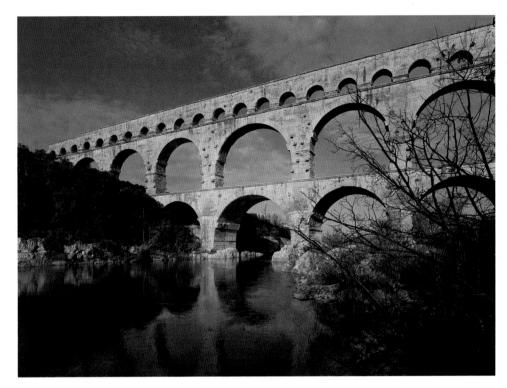

4.51 Pont du Gard (bridge and aqueduct), near Nîmes, France, late first century BCE. Length 900' (273 m), height 162' (49 m). The total length of the aqueduct system of which this was a crucial part was 30 miles (50 km). Commissioned by one of the Roman emperors, perhaps Augustus, to provide water to encourage the settlement of Nîmes.

structure could be fabricated at the site from stones cut and marked at the guarry to indicate their specific placement.

The most revolutionary Roman innovations in arches and vaulting occur in combination with the development of opus caementicium—cement (fast-drying, hardening volcanic sand) used to produce concrete. Roman construction methods were transformed when the Romans began to quarry large amounts of pozzolana, a silicate that functioned as a natural cement, near Naples in the second century BCE. The pozzolana was combined with broken pieces of stone and/or brick and water to provide a building material that hardened into a solid mass. Concrete was cheap, readily available, flexible, and fire-resistant. A lightweight stone was mixed with the cement for vaults, to lighten the weight and reduce the amount of buttressing needed. Cut stone and concrete were to remain the two

most basic building materials of Western culture until the introduction of metal-iron and then steel-during the nineteenth century.

Other materials used by the Romans include brick, mud brick, and various stones that could be quarried nearby. Near Rome, two kinds of stone were common travertine, a kind of marble, and tufa, a soft volcanic rock that hardens on exposure to air. For the finished surface of their buildings, the Romans were not satisfied with concrete, which they usually covered with painted stucco, marble, or opus incertum, a facing of irregularly shaped small blocks of travertine or other stone.

The arch, vaults, and concrete were developed by the Romans precisely because they solved the Roman demands for enormous scale, for efficiency and economy, and for flexibility. They helped to create and to convey the power and majesty of the Roman Empire.

Roman Architecture: The Pantheon, Rome

he Pantheon was regarded in ancient times as one of Rome's most important temples. It joins two disparate architectural designs: a Corinthian portico and a domed rotunda (figs. 4.52-4.54). Viewing the building from today's significantly raised street levels, the modern visitor is immediately aware of the cylindrical walls and dome, but they were not so visible in antiquity. A colonnaded forecourt and the portico, which was raised atop a flight of steps, masked these elements. The impressive entrance, with towering monolithic marble columns and huge bronze doors, gave no hint of the cylindrical walls of the rotunda; an ancient visitor who entered the structure must have been awestruck at the unexpected interior. The concrete dome, the largest built in Europe prior to the twentieth century, is perfectly hemispherical, and the distance from the floor to the top of the dome is the same as

the diameter of the rotunda. The interior proportions, then, are governed by the geometrical purity of a sphere.

A series of transverse barrel vaults hidden within the more than twenty-foot-thick walls concentrates the weight of the dome on eight massive supports. The concrete of the dome must have been poured in sections over a huge mold supported by a centering structure so complex it would have made the interior look like a dense forest of hewn lumber. The weight of the dome is relieved by a series of coffers (the recessed panels—here square—that decorate the interior surface of a vault), which also add geometrical articulation to the hemisphere. The thickness of the dome decreases from twenty feet at the springing, where it is reinforced with stepped buttressing, to only six feet at the oculus, the circular opening thirty feet in diameter at the apex of the dome. The oculus allows adequate light, and the rain

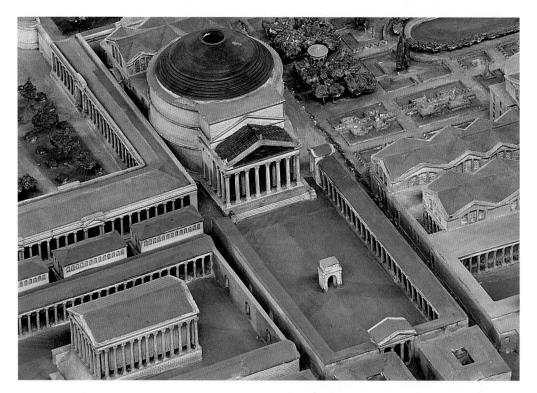

4.52 Model/conjectural reconstruction of the Pantheon and its forecourt in ancient Roman times. Museum of Roman Civilization, Rome, Italy.

The Roman Pantheon was dedicated to all the gods of the Roman religion; its name derives from the Greek pan ("every") and theos ("god"). An earlier building by the emperor Marcus Agrippa stood on this site, but it was replaced by this structure commissioned by the emperor Hadrian. While this reconstruction helps us to understand the site of the Pantheon at the end of a large forecourt, it does not convey the impressive scale of the original structure. The gilding of the exterior dome seen in this reconstruction further enhanced the references to the sun so important for this building.

that enters is drained off by small, inconspicuous openings in the floor, which slopes slightly toward the center of the building.

In the Pantheon, Roman gods were represented by sculptures along the walls, while the dome assumed the symbolic significance of the heavens. Perhaps the most dramatic effect of the Pantheon is the harmony it demonstrates with the natural world. As the sun passes through the sky, a natural spotlight is cast into the rotunda, progressively illuminating the interior. To the Romans, the sun symbolized the eye of Jupiter, and its penetrating presence inside the temple seemed to make the deity manifest.

The Pantheon expresses the vision of the Roman Empire. It is a technological wonder of construction like the vast network of highways, some still in use today, that were built to communicate with the corners of the Empire. The materials used in its construction and decoration, which were transported from lands as distant as Tunisia and Egypt, expressed the extent of Roman domination. The Pantheon relates the order of Roman rule to the Romans' reverence for a universal order.

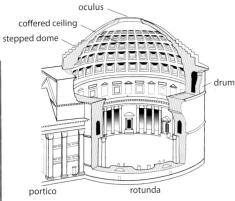

4.53 (above) Cutaway of the Pantheon, showing the stepped buttressing that helps to contain the outward thrust of the dome, 117-25 CE. Height of interior 144' (43.4 m). Commissioned by the emperor Hadrian.

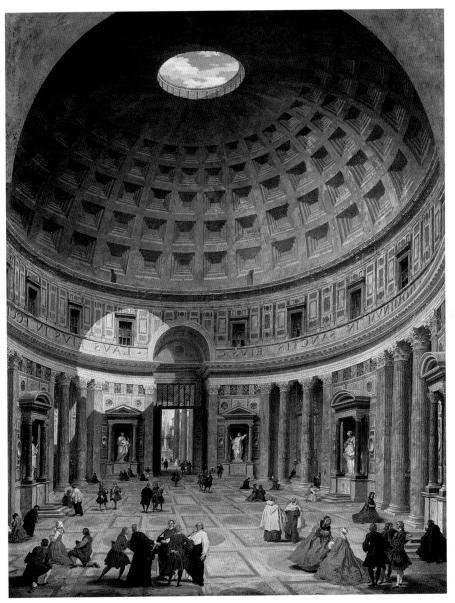

4.54 Interior of the Pantheon, as seen in an eighteenth-century painting of that name by Giovanni Panini, c. 1734. Oil on canvas, 4' 2½" × 3' 3" (128 × 99 cm). National Gallery of Art, Washington, D.C.

Mesoamerican Art: Teotihuacán

fter 1,200 years, Teotihuacán stands today as mute testimony to the genius of unknown creators. Begun around 100 BCE on a dusty tableland north of modern Mexico City, it was both the first metropolis in the Americas and a remarkable example of city planning. At its height, Teotihuacán encompassed about 2,600 major structures, including markets and multifamily apartment compounds set along spacious esplanades. A city of temples, it was dominated by two majestic altars, each set atop a pyramid (fig. 4.55). Its population was greater than that of the Athens of Pericles, and its area was larger than that of Rome during the Empire. It exercised dominion over central Mexico and Honduras in the region known as

but here the scale is gigantic. The ground plan reveals a square base 738 feet (225 m) across. The total height, including a temple that once stood on the upper platform, would have been about 246 feet (75 m).

Built in Teotihuacán somewhat later during the same period is the Pyramid of the Moon (c. 150–225 CE), whose structure is more sharply delineated on its surface and is of more modest size than its counterpart. The placement of the smaller pyramid in the northern part of the valley, on gradually rising terrain, brings the upper platform to roughly the same altitude as that of the Pyramid of the Sun. These two edifices, with their severe contours set against the mountainous landscape on the horizon, dictated the

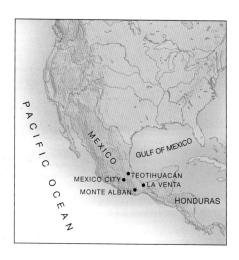

Mesoamerica. By the eighth century, the influence of Teotihuacán was declining. This site was so historically rich and impressive to the Aztecs that they named it Teotihuacán, or the "birthplace of the gods," when they built their capital there in the twelfth century. It is the Aztec names for this place and its gods that we use today.

Monumental architecture such as that of the huge complex at Teotihuacán, which was not common in earlier Mesoamerican cultures, appeared at Teotihuacán in the first century CE with one of the most ambitious undertakings in all of Mesoamerica—the Pyramid of the Sun (see fig. 4.55). Built over a cave held sacred since even earlier times, the Pyramid of the Sun (c. first century CE) retains the stepped outline of earlier pyramids in Mesoamerica,

4.55 Ceremonial plaza at Teotihuacán, Mexico, c. 100 BCE–750 CE. The complex covers 13 square miles. Photo taken from the top of the Pyramid of the Moon, facing south along the 3-mile-long Avenue of the Dead. The Pyramid of the Sun, in the upper left, faces west.

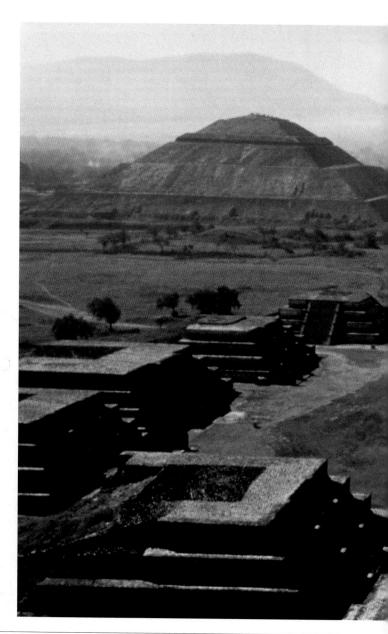

c. 100 BCE-750 CE Teotihuacán, Mexico (fig. 4.55)

115-17 CE The Roman Empire is at its greatest extent

320 CE Gupta Dynasty begins to unify India

325 CE First Christian ecumenical council, at Nicea

1-800 CE Moche culture in Andes

features of the city's growth. For example, the Pyramid of the Sun is oriented precisely at the point on the horizon where the sun sets over Teotihuacán the day it reaches its zenith at the summer solstice. Furthermore, the slightly later Avenue of the Dead, the city's main thoroughfare, runs strictly parallel to the main facade of the Pyramid of the Sun and is perfectly aligned with the axes of the Plaza of the Moon and the Pyramid of the Moon. With these pyramids completed, a gigantic urban plan began to emerge that reflected ideas about astronomy and the desire to identify with the semiarid, serene landscape of this central Mexican plateau.

The fundamentals of these urban complexes were set in Mesoamerica by earlier peoples. The use of truncated pyramids as a temple base, the careful placement of terraces, platforms, and temples to form plazas, and the skill at handling open spaces using fixed axes (probably set according to symbolic considerations) were constant from earlier periods. Such monuments as these pyramids are not strictly architectural since they do not function as enclosures of space; rather, they work as sculpture, with exterior space acting as a constructed, environmental art form.

Teotihuacán was the civic, religious, political, and economic center for the surrounding valleys. Also in the city were foreign enclaves, thousands of artisans in the market places, and a ritual center of monumental proportions. During religious festivals, the city population would swell

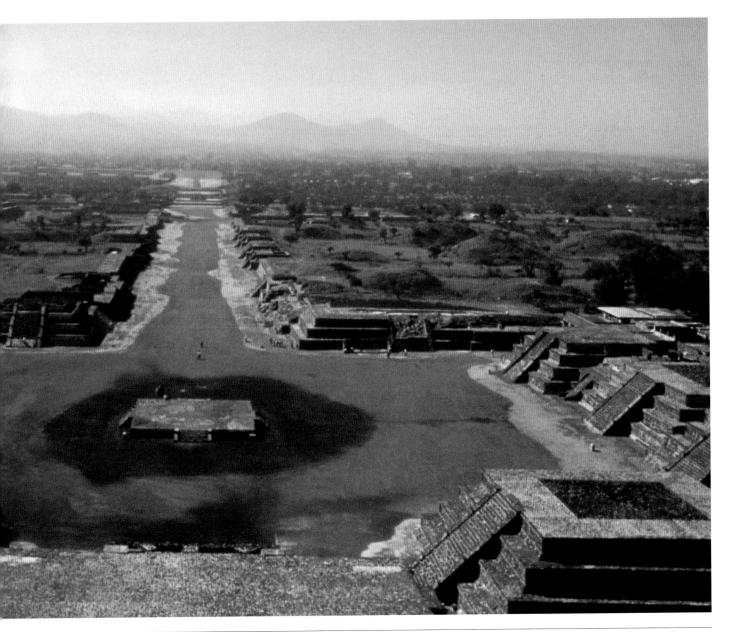

even more with pilgrims. At its peak in the second and third centuries CE, Teotihuacán attained a maximum population of about 200,000. At this time, a second stage of building reflected the abrupt spurt in urban growth. The Avenue of the Dead was laid out, and around it rose a number of ceremonial complexes. Residential sectors that were once mainly to the northwest of the two great pyramids began to grow in all directions.

During this period an important architectural refinement was initiated, the tablero, a heavy, projected, rectangular molding outlined by a thick frame. This detail appeared on all religious structures, whether a simple altar, ceremonial platform, small temple, or majestic pyramid. Perhaps the most splendid example of the tablero is on the Temple of the Feathered Serpent (fig. 4.56). The meaning of feathered serpents is not clear, but they probably carried a double message—political and cosmic. They have been interpreted as symbols of rule, fertility, the calendar, and the beginning of time. The images were later given Aztec names, Quetzalcoatl (plumed serpent) and Tlaloc (deity associated with water). Aside from the symbolic and aesthetic appeal of the Temple of the Feathered Serpent, its structure reflects technological advances. The entire nucleus of the temple is reinforced with a skeleton of limestone. The colossal heads are deeply anchored into the core of the tableros and show

great sophistication in the joining of stone, since use of hard metal tools was not known to these builders.

The plan of the entire city is noteworthy for the regularity of the city blocks and the density of residential sectors. The layout of the city was based on a module of 187 feet, which formed the standard blocks in residential areas. Multiples of the module apparently formed other compounds in the city as well and divided it into a grid, which suggests the existence of rigorous city planning as well as a centralized ruling group, both spiritual and temporal. Rivers were rechanneled, and the city at its height included large reservoirs, steam baths, specialized workshops, openair markets, administrative buildings, theaters, and areas set aside for ball games and other public functions.

The Palace of Zacuala—an excellent example of what must have been the luxurious residence of a rich Teotihuacán merchant or high functionary—included a chapel decorated with brightly colored mural paintings like the one depicted here (fig. 4.57). In this painting representing the Maguey bloodletting ritual, priests are using the plant's spikes to cut their own skin to draw blood as a sacrifice to the great goddess. The opulence and spaciousness of the palace attest to the existence of a powerful upper class and to the importance of spiritual devotion in connection with that wealth.

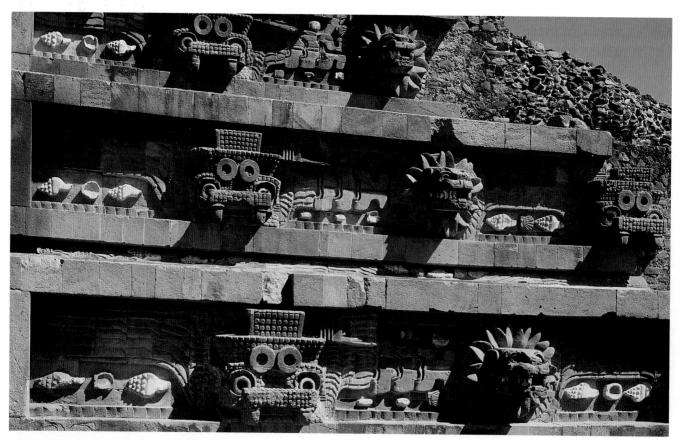

4.56 Facade of the Temple of the Feathered Serpent, Teotihuacán, Mexico, c. 150 CE. Each serpent head weighs 4 tons.

4.57 Maguey Bloodletting Ritual, fragment of a fresco from Teotihuacán, Mexico, 600-750. Pigment on lime plaster, $32\frac{1}{4} \times 45\frac{1}{4}$ " (82 × 116.1 cm). The Cleveland Museum of Art.

Teotihuacán was apparently the most highly urbanized center of its time in the New World. The period of its life span, roughly from 100 BCE to 750 CE, was a spectacular one in Mesoamerica, with high points reached at Teotihuacán, at Monte Albán in Oaxaca, and in the Maya region. Each had a planned urban center with astronomical orientation for streets and buildings, monumental architecture, and intellectual achievements such as the perfection of the calendar, mathematics, writing, and astronomy (the latter especially among the Maya). This was a splendid age for the arts and architecture, which was reflected in the pyramid-temples at Teotihuacán and Tikal, and in mural painting, ceramics, and mosaics. Professional people and artisans were organized into guilds. Traders were also well organized, and large and efficient markets offered goods from many regions. Merchants brought feathers from exotic tropical birds, cotton, cacao, jade, and turquoise into Teotihuacán for sale. The society was sharply stratified, militaristic, and theocratic. The predominance of religious representations in Teotihuacán as well as the presence of altars in the central courtyards of each house attests to the importance of religion in this community. Religious, civic, and secular activities were joined in the centers, which supported priestchieftains, nobles, merchants, poets, musicians, actors (who were highly respected and took part in religious and secular ceremonies), artists, laborers, farmers, servants, and slaves.

After a period of increased internal conflict, the city was attacked. Its palaces were burned and its temples reduced to rubble. This was a process of ritual destruction and desacration that was unprecedented in scope and scale in Mesoamerica. Temple and state were one; to destroy Teotihuacán politically was to destroy it ritually. The artistic legacy of its people, however, endured and was adapted in other times and places in Mesoamerica.

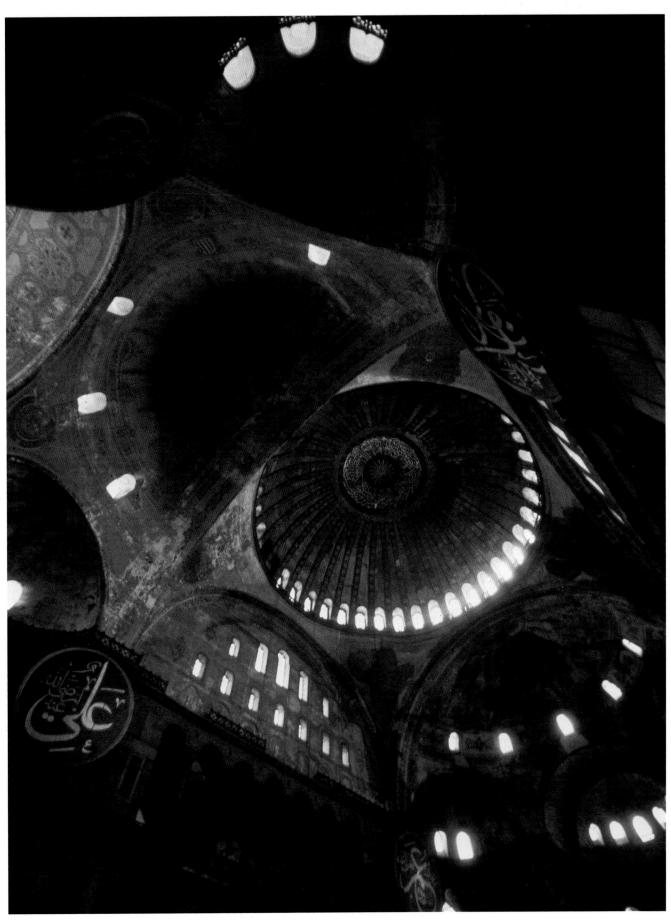

5.1 Anthemius of Tralles and Isidorus of Miletus, architects. Interior, Hagia Sophia (Holy Wisdom), Istanbul (Constantinople), Turkey, 532–37. For more information on Hagia Sophia, see pp. 164–65.

$\frac{CHAPTER}{5}$

Art from 200 to 1000

A BRIEF INSIGHT

Art produced around the world during the period 200 to 1000 is largely religious in nature, and the majority of the works discussed in this chapter can be related to religions still practiced by millions today: Hinduism, Shinto, Judaism, Buddhism, Christianity, and Islam. To understand how artists and architects captured the spirit of these distinctive religions is an important aspect of our examination of this period.

Shortly after the enormous, awe-inspiring interior of the Christian church of Hagia Sophia (fig. 5.1) had been completed, Procopius, an historian, described the effect that entering the building had upon the observer: "The spirit rises toward God and floats in the air, certain that He is not far away, but loves to stay close to those whom He has chosen." First-hand accounts from this period are rare. In the opinion of Procopius, the architects had created an inspiring structure that expressed the spiritual, other-worldly nature of Christianity; the manner in which a single, unifying dome hovered high overhead was an architectural metaphor of the monotheism of Christianity.

Like many religious monuments, Hagia Sophia also carried a political message, for this huge structure served as the palace chapel for the Byzantine emperor (see pp. 164–65); its enormous scale and lavish decoration were also meant to suggest the extent of the power and wealth of the empire. Such combined functions are common during this period, when political entities gained authority by identifying themselves with a religion.

Introduction to Art from 200 to 1000

omparisons between a small Christian icon (fig. 5.2) and a huge Hindu relief carved into the living rock (fig. 5.3) highlight the common concerns of diverse civilizations during the complex period from 200 to 1000.

During this period, religions that continue to be important in today's world—Hinduism, Shinto, Buddhism, Judaism, Christianity, and Islam—consolidated their followings and, in several cases, expanded beyond their places of origin. Monuments were created that served the needs of priests or lay leaders, other members of religious hierarchies, and the people who made up the membership. Art and architecture often played a crucial role in supporting these developments. Although the function of religious art may at first seem self-evident, a study of objects and buildings created at different times and in different places for distinctive religions reveals a variety of purposes, including explaining dogma, confirming believers in the faith, converting nonbelievers, and connecting religious beliefs to political leaders and institutions.

The icon, for example, functioned as a focus for worship. Its **iconography** is Christian, with the Child Christ held by his mother and flanked by saints and, above, angels who look ecstatically upward. The small scale of this work indicates that it probably was owned by an individual, most likely a priest or a member of a religious order.

To understand this work better, the spiritual content of Christianity, which played a crucial role in forming the life and culture of the Middle Ages in Europe, must be examined. This is difficult to summarize, in part because of the many different interpretations of Christian belief that eventually developed. Christianity emphasizes the inner, spiritual life, offering the promise of personal salvation and life after death for the soul in a heavenly eternity known as Paradise. Medieval Christianity emphasized

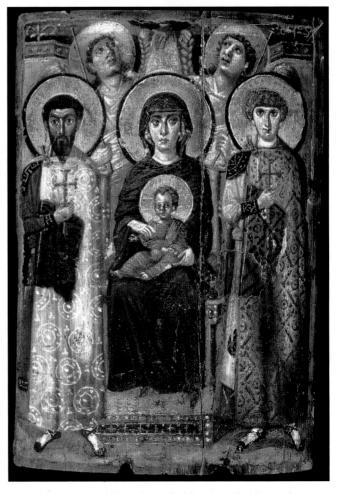

5.2 Madonna and Child Enthroned with Saints Theodore and George and Angels, sixth century. Encaustic on wood, $2' 3'' \times 1' 7\%''$ (68.6 × 49.3 cm). Monastery of St. Catherine, Mount Sinai.

belief in a single God understood as a Trinity—an indivisible unity of God the Father, the creator; Jesus Christ, his son, who assumed human form in what is known as the

ART PAST/ART PRESENT

Naming the Middle Ages in Europe

In Europe, the period between 200 and 1400 CE (and even later in northern Europe) is now known as the Middle Ages, or medieval period. The term "Middle Ages" was invented during the Italian Renaissance to suggest that these centuries were an interruption between the golden age of classical Greece and Rome and the "new" golden age of the Renaissance. The people of the Renaissance dismissed the Middle Ages as an interval of darkness and cultural inactivity (another term sometimes applied to these centuries is the "Dark Ages"), but

historians today refute this characterization. Although the term "Middle Ages" is sometimes also used to refer to the contemporaneous phases of Indian and Chinese art, this usage is avoided here. Instead, the global viewpoint of Art Past Art Present's chronology suggests the simple phrase "from 200 to 1400" to refer to this period of artistic vitality; because of the abundant artistic and cultural traditions that evolved around the world during this lengthy period, this era is divided into two chapters in our book.

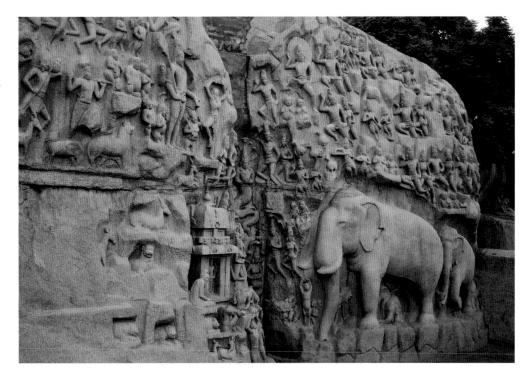

5.3 Descent of the Ganges, Indian Hindu, Mahamallapuram, India. Middle Pallava period, c. 625–74. Carved on a natural granite cliff, height 20' (61 m). Commissioned by the Pallava king Mahendra-Varman I or his son King Mamalla.

Incarnation; and the Holy Spirit, who is believed to be continuously active in the world. Jesus Christ is held to be the son of God, born to a pious woman known as the Virgin Mary. In the course of a life of teaching and healing, Jesus was finally betrayed, arrested, denounced, and executed by being nailed to a cross and left to die in an event known as the crucifixion. Followers who sacrifice their lives for Christ's teachings are identified as saints, as in the figures of Theodore and George in the icon. The relatively static, symmetrical composition of the icon creates a timeless quality, while the intense staring eyes are intended to encourage the worshiper to meditate on the promise of life after death for the virtuous. The subject matter of the icon demonstrates that Mary gradually gained prominence as an advocate for the faithful; Christ is seen as a child to emphasize his humanity.

In the Hindu relief at Mahamallapuram, both form and iconography express religious content. The site, in southern India on the shores of the Indian Ocean (see map, p. 161), was a pilgrimage center for Hindu believers; it may have become identified with the holy because of the unusual rock formations found along the sandy beaches. On some outcroppings of granite, sculptors carved shrines and reliefs of immense proportions. The *Descent of the Ganges* is carved on the face of a cliff below a natural pool. During the rainy season, the overflow cascades down a natural cleft to be collected in a pool at the base. Over millennia, this cleft had been smoothed by the flowing action of the water, and it may have been this natural phenomenon that inspired the carving of the cliff with the story of the gift of holy water from the gods in heaven.

Like many religions, Hinduism developed a set of stories to explain the workings of nature, especially the fertility of crops and procreation, and to establish the relationship between humanity and the divine. Hinduism's single godhead is capable of an infinite number of manifestations—assuming male, female, animal, and mixed animal and human forms—which helps to explain the multitude of figures and animals in the relief. In personal terms, the most important aspect of Hinduism is the belief in reincarnation—each individual will return to life as another living creature, and good behavior in one life will lead to a higher state of existence in the next. The Hindu tradition, as at Mahamallapuram, and its art forms were carried along trade routes to Cambodia and Indonesia.

Although the iconography of some details in the *Descent of the Ganges* is still debated, the composition focuses attention on the cleft near the center. The water flowing down the cleft during the rainy season is usually identified with the Ganges, the sacred Indian river whose water is thought to have life-giving powers. Representatives of the multitudinous living beings of the world—deities of the river, elephants, lions, gods, human beings, and even a cat and mice—are assembled here as the holy river is represented as a gift from heaven to earth. Siva appears several times, expressing both destructive and creative aspects of nature. Because this monument was commissioned by local rulers as they were establishing their kingdom, its impressive scale and choice of subject may have been related to political needs as well.

Buddhism has been discussed previously in an early monument at Sanchi (see pp. 92–93, 110–11), where the

representation of Buddha himself was avoided. This reluctance eventually passed, and a typical later representation shows Buddha seated (fig. **5.4**); characteristic of figures of Buddha created in the Gupta style, as here, are the monumental simplicity, the downcast eyes, the sense of inner calm, and the manner in which tight-fitting drapery reveals the body. As Buddhism spread eastward, it became especial-

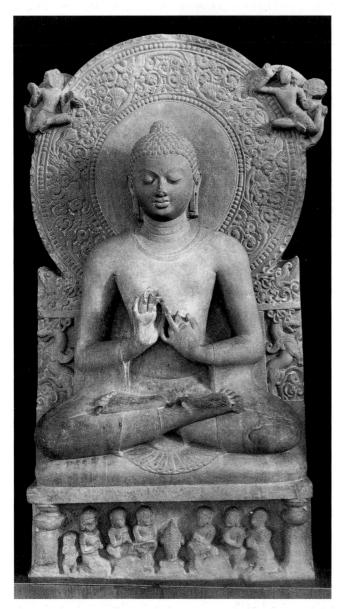

5.4 *The First Sermon*, Indian Buddhist, Sarnath, Uttar Pradesh, India. Gupta period, c. 475. Stela made of Chunar sandstone, height 5' 3" (1.6 m). Museum of Archaeology, Sarnath, India.

The typical Gupta period image of Buddha represents him seated in a cross-legged, yogic pose, with the soles of his feet up and his hands held in the symbolic gesture of teaching, which is referred to as "turning the Wheel of the Law." The fact that Buddha was born into a noble family explains why he is seated on a throne decorated with lions, a symbol of royalty. The halo behind his head indicates the universal nature of this deity, who is viewed as clothed in the sun. While the subject and position were standardized, the refined style of presentation seen here was a contribution of the Gupta sculptors.

ly strong in Tibet and Nepal, where it survives as the predominant religion.

For more on the religions that became important during this period, see pp. 182–85 (Islam), 152–53 (Judaism), 160–61 (Shinto), and 158–59, 176–79, 190–91 (Buddhism).

HISTORY

The growth of powerful proselytizing religions was only one manifestation of worldwide change during the period from 200 to 1000. A number of important political entities flourished at this time, including the Gupta in India; the successive Han, Sui, Tang, and Song in China; the Maya and Aztec in the Americas; and the Carolingian culture in Europe. The establishment of a national identity, the writing of history, and the creation of individualized art forms were important factors in many cultures. This was the period, for example, when the Japanese state defined itself as a political institution—the name it gave itself was Yamato—and the haniwa of a warrior (fig. 5.5) is an example of the kind of distinctive works created there during the period of self-definition.

During this era, commercial, intellectual, cultural, scientific, and religious exchange took place on a large scale over great distances. Many Buddhists, for example, undertook pilgrimages from East Asia to India. An early phase of the Gupta Empire was described by a Chinese pilgrimmonk after his travels to India between 405 and 411. He was impressed with the generous and efficient government of the Guptas, who had established magnificent cities with fine hospitals and seats of learning. He wrote of the general prosperity and commented that "the surprising influence of religion cannot be described." It was a time of cultural expansion and colonization into Central Asia, China, Southeast Asia, and Indonesia. Indian visual arts, especially sculpture and painting produced for Hindu and Buddhist patrons, became an international standard in Asia (see fig. 5.4). The commercial silk routes continued to flourish between East and West (see p. 95). In Japan in the sixth century, the Yamato rulers and the Shinto religion were being challenged by the new religion of Buddhism, which was being imported into Japan through Korea. Commercial, political, and religious travel meant that works of art, foreign styles, scientific inventions, and other intellectual developments were shared across the continents of Europe and Asia.

Islamic writers preserved much of ancient Greek and Roman literature and philosophy, making it possible for these traditions to be reintroduced into European culture during the later Middle Ages, and gradually Islamic science, mathematics, and medicine became known in Europe. Scientific advances included astronomical investigations in India and Mesoamerica, and the invention of gunpowder in China. Other inventions were the wheelbarrow, the com-

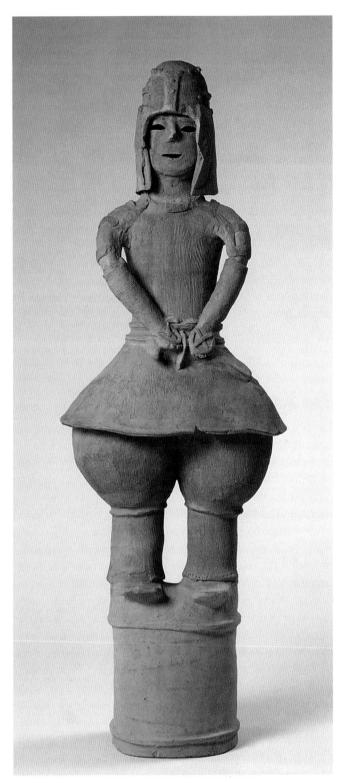

5.5 *Haniwa* of a Warrior. Proto-Historic Japan, Kofun (Old Tomb) Period, third–sixth century. Earthenware, height 3' 11%" (1.2 m). Asian Art Museum of San Francisco, The Avery Brundage Collection, San Francisco, California. Commissioned by a Yamato ruler.

Hundreds of these earthenware figures of warriors, women, and animals—all known as *haniwa*—once encircled the huge mound tombs of the Japanese Yamato rulers, which were shaped like keyholes and surrounded by moats. For a work by a contemporary Japanese artist that uses the *haniwa* figure, see fig. 13.44.

pass, paper, and the spinning wheel. Practical, labor-saving inventions meant that there was less need for the slave labor that had characterized much of the ancient world. An increased awareness of diverse cultures was a hallmark during much of this period.

ART AND THE CHRISTIAN CHURCH

In much of Europe during the period 200–1000, the dominant institution—culturally, educationally, spiritually, and often politically—was the Christian Church. Some Christians withdrew from the world into monasteries and nunneries to follow a life of work and prayer. The Church developed a ruling hierarchy headed by the pope (the bishop of Rome, the first of whom had been Saint Peter), local bishops, and the heads of monasteries and nunneries. The expanding institutions and hierarchy of the Church created a great demand for works of art.

Christianity developed a series of rites and services known as the liturgy. The central Christian rite was the Mass, or Eucharist, a service at which the Last Supper was reenacted and salvation for repentant believers was promised. By the early fourth century, this service was usually held in a church at an altar, which became the focus for the ritual and for works of Christian art. The much later painting shown in fig. **5.6** demonstrates the rich decoration that accompanied the liturgy as it evolved. A priest, dressed in elaborately decorated vestments, stands at an altar with a bejeweled cross, a gold altarpiece, and a brocaded altar frontal. He raises the host, a consecrated piece of bread that stands for the body of Christ. (Missing from this representation is a chalice, the vessel that holds the wine standing for Christ's blood; see fig. 6.24).

A DENIAL OF NATURALISM

Although a single unified style cannot be defined for all art created during the period 200–1000, many works, including those produced in the Islamic tradition, offer a stylistic treatment that emphasizes spiritual values through an intentional denial of the traditions of **naturalism** and **illusionism** that had dominated in the Mediterranean basin during the Greek and Roman periods. This broad generalization offers some unity to the art produced in diverse styles of this period in Europe.

THE SCROLL AND BOOK

In the painting depicting the Christian Mass, the open book that is prominent on the altar suggests the importance of written texts during this period. Judaism, Christianity, and Islam each possess a holy book—a text that is believed to be the word of God. Lettering and decorating a holy text was considered to be an act of religious devotion.

The hand-lettered, decorated book or scroll played a

5.6 Master of Saint Giles, *The Mass of Saint Giles*, c. 1500. Oil on wood, $2' \ ''' \times 1' \ 6" \ (61.6 \times 45.7 \ cm)$. The National Gallery, London.

A late-fifteenth-century painter here represents a ninth-century miracle taking place at a richly decorated altar at the Royal Abbey Church of St.-Denis, near Paris (for a chalice made for use at St. Denis in the twelfth century, see fig. 6.24). The combination of setting, costume, objects, and gestures shown here remind us that rituals in many religions included these as well as additional elements. This representation of ritualistic religious activity should be compared with other examples of ritual behavior, such as the African tribal rituals seen in figs. 1.16, 12.14 and 12.15, and the American tribal ritual seen in fig. 12.28. As a group they remind us that setting, special clothing, objects, and choreographed gestures and movements are important characteristics of the ritual experience.

role in the artistic development of all three of these religions. The Bible, for example, was held to be a compendium of divine proclamations and a record of God's actions in history. It has two sections: the Jewish Bible and the New Testament, composed of four versions of the life of Jesus (the Gospels, written by the Evangelists—Matthew, Mark, Luke, and John) and other writings. Throughout this period, Jewish Torah scrolls, Christian Bibles, Islamic

Korans, and other religious books were written by hand—usually on treated animal skins (**vellum** or **parchment**). Because they represented the word of God, they were often adorned with fine materials and enclosed in a rich, bejeweled container; in addition, many Christian and some Jewish books were elaborately illustrated. Islamic culture generally avoided the representation of human or animal figures (see pp. 182–85), so the decoration of Korans was limited to decorative calligraphic patterns (for a later example, see fig. 8.58).

Handwritten, illustrated, and decorated books were also an important part of religious and secular traditions in other parts of the world. In the Far East, novels and religious tracts were lettered in books or written on hand scrolls, which unrolled from right to left (see fig. 1.21). Readers held the scrolls in both hands, and only a small portion was visible at any one time (for an example of details from a Japanese hand scroll see figs. 6.20, 6.21). Vertical scrolls (see fig. 6.4) were kept stored in boxes except for the rare occasions when they would be hung briefly on the wall for purposes of contemplation.

THE ARTIST

From Europe during this period, we have virtually no signed works of art. The individuality and personal identity of a person making a work of art or architecture was not considered to be important; many of these works were, in fact, produced by groups of artists and artisans working together. The artists of the Middle Ages in Europe included a new important group: monks and nuns who, living within monastic communities, included artistic productivity within the religious life. In Europe, the crafting of manuscripts and other liturgical objects was such an important activity that abbots of monasteries and even bishops continued to be active as artists after they had risen in the ecclesiastical hierarchy. But there were also "lay" artists, who lived in cities and were not connected to any religious order. By the tenth century these lay artists were organizing themselves into professional organizations, rather like trade unions, called guilds.

In many other cultures during this period, artists worked in groups, and the large endeavors required by religious practices were produced by workshops of artists and laborers. There are isolated instances of signed works, but these are not common. One important exception to this attitude toward the artist is in China, where paintings were produced, and signed, by individuals who were recognized as scholar-intellectuals, often working within the court (see figs. 1.4, 6.4).

Muslims in China

The origins of the Great Mosque at Xi'an, at the eastern terminus of the Silk Road (see p. 95) date back to the Tang Dynasty during the reign of Emperor Xuan Zong (685–762), although it was renovated in the Ming period, beginning in 1392, and then again during the Qing (fig. 5.7). The style of the Great Mosque as it stands today is unexpected, for it possesses neither minarets nor domes. In its current manifestation it is completely Chinese in construction and architectural style. It has the layout of a Chinese Buddhist temple complex, with five successive courtyards on a single axis; unlike a Buddhist monument, however, the Great Mosque of Xi'an is aligned from east to west, facing Mecca. Each courtyard has a signature pavilion, screen, or freestanding gateway; these culminate at the prayer hall located at the western end of the axis. Chinese-style pavilions and pagodas are adapted to suit Islamic function. Despite the Chinese style, Arabic lettering and decorations on the buildings and gates identify the structure as a mosque.

5.7 Great Mosque at Xi'an, Shaanxi, China. First built 685-762, renovated in later periods, including the Ming and Qing dynasties. Tradition suggests that it was originally commissioned by the naval admiral and hajji (pilgrim) Cheng Ho, the son of a prestigious Muslim family that was famous for having cleared the China Sea of pirates.

Religious Architecture

5a Synagogue excavated at Dura Europos, 244/245 CE (for further information, see fig. 5.8 and pp. 152–53).

Explaining the Faith

(figs. **5a** and **5b**) The years between 200 to 1400 are a period of exploration and expansion, and it was during this period that four world religions still important today—Buddhism, Judaism, Christianity, and Islam—expanded beyond the locales where they were founded. The Jewish

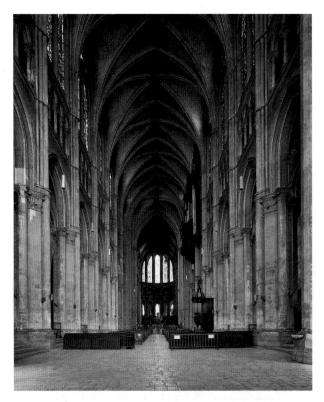

5b Chartres Cathedral, 1194–1220 (for further information, see figs. 6.27–6.31 and pp. 224–29).

synagogue discovered in Dura Europos contains unusual painted scenes from the Old Testament, perhaps created in response to the painted decorations found in the shrines of the other religions that were also flourishing in this small frontier town. More than any other architectural type, religious monuments often incorporate sculpture, painting, or other media, usually to illustrate the stories and/or tenets of the religion, as is the case here. While this synagogue is quite small, religious architecture often uses scale to emphasize its message. The French Gothic cathedral at Chartres is by far the largest structure in the small market town where it was built. Its high vaults and glowing stained-glass windows are meant to be a metaphor for the Heavenly Jerusalem, the paradise longed for by Christians, while the numerous sculptures of holy figures that decorate its exterior are reminders to inspire the faithful. The whole structure, with its decoration, is intended as a religious metaphor, while the soaring weightlessness of its Gothic engineering suggests the promise of Paradise beyond earthbound existence.

Expressing Monotheism

(fig. 5c) Islam is a monotheistic religion (one of the main tenets of Islam is "There is no God but God alone"), and when the Ottoman Turks conquered Constantinople in 1453, they converted all the Byzantine churches, including the sixth-century Hagia Sophia (see figs. 5.1, 5.23, 5.24), into mosques. In the Suleimaniye Mosque, built almost a millennium later, the Byzantine domed model has been appropriated by the Muslims; apparently the manner in which the interior space was unified by the high, floating dome at Hagia Sophia was considered appropriate to express the monotheistic basis of Islam as well as the communal nature of Muslim worship.

5c Suleimaniye Mosque, Istanbul, 1551–58 (for further information, see figs. 8.59-8.61).

Incorporating Nature

(fig. 5d) The great temple at Ellora is not architecture per se because it is not constructed but sculpted. The "buildings" and interiors are carved directly out of a rock cliff, emphasizing the intimate connection with nature that is so much a part of Hindu belief. The multitudinous sculpted figures are related to the infinite number of deities in the Hindu pantheon.

5d Kailasantha Temple, Ellora, India, c. 760–800 (for further information, see figs. 5.40 and 5.41).

5e Tadao Ando, Water Temple, Island of Awaji, Japan, 1989–91 (for further information, see fig. 13.50).

Experiencing the Faith

(fig. 5e) The emphasis on inner knowledge and selfunderstanding in Buddhist belief seems to explain this modern Buddhist temple. Walking down the steps "into" the lotus pond becomes a metaphor for the inward search of Buddhist meditation.

Questions

- 1. Visit an example of religious architecture in your neighborhood during a service or "event."
- 2. Discuss how people are "using" the structure, and ask yourself how the structure and its decoration refer to the beliefs and ideals of the particular religion.

Jewish Art: The Synagogue at Dura Europos

iscovered in 1932, the synagogue at Dura Europos, in modern Syria (fig. 5.8), astonished archaeologists and scholars. Quite unexpectedly, its capacious house of assembly had figurative decoration: a complicated sequence of paintings of Jewish scenes in bands around all four walls. Both Biblical scripture (the second of the Ten Commandments: "You shall not make for yourself a graven image [idol], or any likeness of anything that is in heaven above, or that is in the earth below, or that is in the water under the earth") and historical writings had seemed to imply that it was considered unlawful for Jews to make or have images. That this prohibition was not followed by all Jews is revealed by the archaeological discover-

ies at Dura and elsewhere. The cycle at the Dura synagogue includes such scenes as Moses receiving the Law, Moses leading the chosen people out of Egypt, Exodus and the Crossing of the Red Sea, and even a cityscape with a representation of Jerusalem and the Temple of Solomon.

The Jewish religion is monotheistic and is based on the worship of Yahweh, or God. The origins of Judaism are traced to a covenant made between God and Abraham, in which God promised Abraham that he would give him a powerful race of descendants and a Promised Land if his followers would stop worshiping idols. The emphasis in Jewish services, held in both the synagogue and at home, is on the telling of Jewish history, the reading of Jewish law,

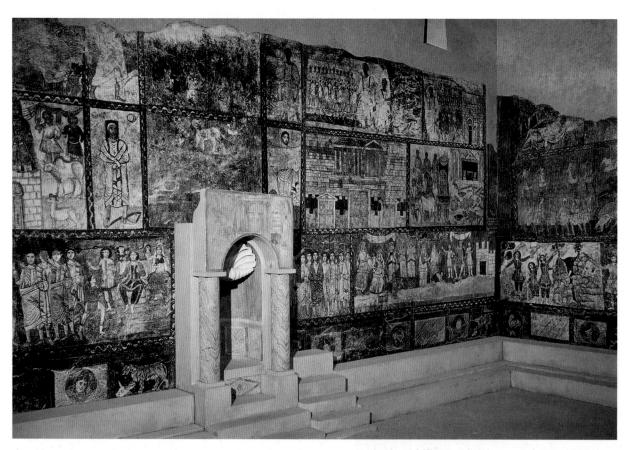

5.8 Reconstruction of the west wall, with the Torah niche, of the synagogue, Dura Europos (modern Syria), 244/45. Tempera on plaster, length of wall approx. 40' (12.2 m). National Museum, Damascus, Syria.

The Roman frontier city of Dura Europos, located in the Middle East, was a crossroads and minor trading center. Archaeological excavation here has provided information about its several places of worship, which included a synagogue, a Christian site with a baptistery with frescoes, and temples to Bel, Zeus, Isis, and Mithras. The Torah niche in the synagogue is decorated with a shell, a motif taken from Roman art, where the shell is often used to signify a holy place. In this niche were placed scrolls that contained the first five books of the Bible, the sacred writings of Judaism. Attributed to Moses, these books contain the basic rules of the Jewish faith, including the Ten Commandments, which tradition holds were given to Moses by God on Mount Sinai.

212 Roman citizenship is granted to every freeborn subject in the **Empire**

c. 240-280 The Roman Empire is regularly attacked by Germanic peoples such as the Goths

244-45 Synagogue paintings, Dura Europos (fig. 5.8)

250 Chinese invent gunpowder

250 Arithmetica by Diophantus of Alexandria includes first book of algebra

and the interpretation of that law. Judaism has a strong scholarly tradition, and it is possible that the narrative cycle in the Dura Europos synagogue was created in part as an educational tool, to illustrate and teach the history and laws of the religion. The large number of competing religions practiced in Dura, each with its own sanctuary, may have encouraged the Jews there to decorate their synagogue with narratives.

In terms of art, Dura Europos was an unimportant provincial city, and the conventions of the figures and the use at the Dura synagogue of iconographic stereotypes and compositions known from other sites suggest that this cycle was derived from a pattern book—a book of images, prepared as an artist's tool, that preserved a tradition of illustrated scenes, in this case from the Jewish Bible. In Moses Giving Water to the Tribes (fig. 5.9), Moses stands in the relaxed **contrapposto** position derived from ancient Greek and Roman art, but both the schematic nature of the composition—with smaller figures representing the tribes of Israel placed evenly around the edge of the scene—and the unnaturalistic representation of streams of water that flow outwards to each tent are consistent with other developments at this time. The Jews, a minority at Dura, created an impressively decorated synagogue that expresses their piety and the dignity of their traditions.

5.9 Moses Giving Water to the Tribes, detail of fig. 5.8. The figures are smaller than lifesize. Moses Giving Water to the Tribes depicts Numbers 21:16-18, when a well was dug after God told Moses to "gather the people together, and I will give them water."

Early Christian Art

The Three Hebrew Youths in the Fiery Furnace, from a Christian cemetery (fig. 5.10), represents the Christian reuse of the Jewish story of three young Hebrew men who were saved by God after being thrown into a furnace for refusing to worship idols. Three frontal figures, their arms raised in a position of prayer, stand amid flames. Their pleas for deliverance are answered, and a dove, symbolic of the Holy Spirit, descends bearing a branch symbolizing victory and/or peace. The message of the painting is direct: faith brings salvation.

Catacombs, underground burial complexes used by Jews and Christians, were originally known by the Greek term *coemeteria* ("places of rest," from which we derive our word "cemetery"). Later, the term *catacomba*, which initially referred to a specific cemetery in Rome, came into general use. The walls of the narrow passages in the catacombs, cut from soft rock, had horizontal niches to hold the bodies of the deceased. Larger chambers, also underground, were used for funerary rites. Catacombs were not secret burial places, as legend has it, although they may have been used as hiding places during times of Christian persecution.

The painting of *The Three Hebrew Youths* expresses the faith of the early Christians by promising salvation in time of need and suffering. The Jewish Bible story (Daniel 3:12–30) was perceived as a precedent for New Testament teachings. Christians understood Christ as the Messiah who fulfilled the prophecies of the Jewish Bible, and theologians and artists associated the two religious traditions. The style of the painting is animated, continuing a Roman manner of painting using fluid paint and flowing brushstrokes. In contrast to Roman style, however, the effect is not illusionistic; the use of strong outlines flattens and dematerializes the figures, while the emphasis on the enlarged eyes enhances the spiritual intent.

HISTORY

By about 40 CE, a few years after Christ's death, the term "Christian" was first used to designate the followers of Christ's teachings. By the early second century, an internal structure and hierarchy were being formed within the Church, and liturgical rites for worship were developed (for further information on Christianity, see pp. 144–45).

5.10 *The Three Hebrew Youths in the Fiery Furnace*, Christian Catacomb of Priscilla, Rome, Italy. Early third century. Fresco, approx. $1' 8" \times 2' 6" (51 \times 76 \text{ cm})$.

Although subject to periodic persecution, the new religion, with its emphasis on spiritual values, spread rapidly. In a letter written to the Roman emperor Trajan in 110, Pliny the Younger warned of what he called this:

extreme superstition ... Many of all ages, of all ranks, of both sexes, are being brought into danger, and will continue to be brought. The blight of this superstition has not been confined to towns and villages; it has even spread to the country.

ART

Early Christian art (c. 150-400 CE) developed gradually, in part because of intermittent persecution. Stylistically, the new art was initially dependent on Roman and Hellenistic developments, and in many early examples only the Christian subject matter indicates its religious function. Early Christian artists worked in a diverse range of media. Painters not only decorated church and catacomb walls but also created book illustrations. Sculptors made marble sarcophagi and ivory carvings. A favored medium for church decoration was mosaic (see pp. 162-69).

One house at the Roman trading post of Dura Europos (today in Syria) was converted for Christian services in 231. It included a baptistery with an image of the Good Shepherd (from the parable in Luke 15:3–7) above a scene of Adam and Eve in the garden. Here Jewish and New Testaments are intellectually related—the Good Shepherd becomes a reference to Christian redemption, overcoming the sin of Adam and Eve. The Good Shepherd image appears often on Early Christian sarcophagi and reliefs, and even as single figures (fig. 5.11), but it is still uncertain whether these beardless youths represent Christ as the Good Shepherd or the more general concept of God caring for his flock. In any case, the humble modesty of the figure is consistent with the spirit of early Christianity.

Early Christian artists were challenged to express the promises and mysteries of their new faith. As in ancient Roman art and in most later medieval art, artists were laborers who worked in a communal situation. They created the means to communicate the ideals of Christianity as it changed and became more public. These anonymous artists, at once conventional and innovative, helped effect a transition from the ancient to the medieval world.

5.11 Good Shepherd, late third century. Marble (restored), height 3' 3" (99 cm). Musei di Vaticani, Rome, Italy. The composition of the standing figure with an animal across his shoulders, as in this sculpture, is derived from ancient Greek representations of Hermes the shepherd or Orpheus with the animals.

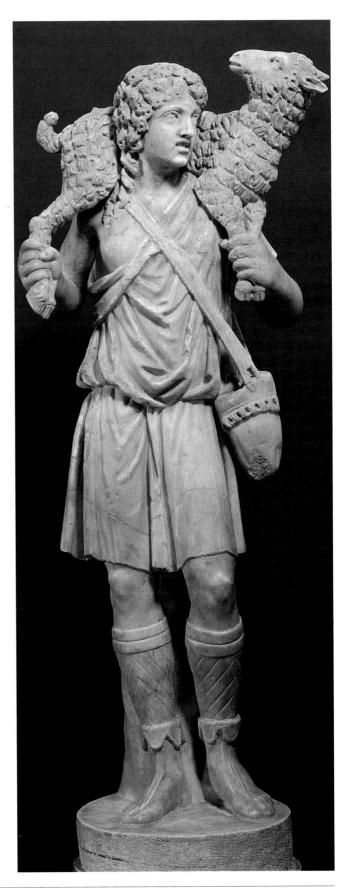

Early Christian Architecture

ld St. Peter's Basilica was a prototype for developments in Christian architecture (figs. 5.12, 5.13). The plan was initially adapted from the Roman basilica (see fig. 4.48), which was usually entered on its long side, but the Christian church was entered through an atrium and narthex (entrance hall) on its short side. This narthex was usually on the west, and the altar was toward the east, an orientation followed in many later Christian churches.

The interior division of space, with a nave flanked by side aisles, is also similar to that of Roman basilicas, but Old St. Peter's had transepts (from the Middle Latin transseptum, "transverse enclosure"), a feature that would become traditional in Christian churches. These architectural spaces, extensions to the north and south, meet the nave at the **crossing**. Transepts create a cross shape; the term cruciform (cross-like) basilica is used to describe Early Christian churches with transepts. At St. Peter's, as in many Roman basilicas, wooden beams supported a gable roof, and clerestory windows allowed light to illuminate the nave. Many of the columns used in building Old St. Peter's were taken from earlier Roman buildings; materials thus reused are known as *spolia* (from the Latin, "spoils"); when the original Constantinian basilica was destroyed in the early sixteenth century, the Renaissance artist

Michelangelo lamented the destruction of the ancient Roman columns. The group of spiral columns that decorated the altar area at Old St. Peter's had a special significance, for they were thought to have been taken from the Temple of Solomon in Jerusalem.

The size of Old St. Peter's mirrors the triumphant attitude of Christianity following the Edict of Milan in 313, in which the emperor Constantine granted religious freedom to the Christians. Constantine personally contributed to the construction of St. John Lateran in Rome (begun 313), the first use of the basilica plan for Christian architecture. Constantine also supported the building of St. Peter's, which was both a martyrium (built over the grave site of Saint Peter, it marked and commemorated his martyrdom) and a basilica used for worship. It is believed that the development of the transept at St. Peter's derived from the need for additional space for worshipers and pilgrims around the shrine.

Old St. Peter's had a rather plain brick exterior, but the interior was adorned with precious materials, including marble Roman columns, mosaics, and frescoes. The decorated interior contrasted with the plain exterior, subtly reminding the visitor that the beauty of the inner spirit was more important than external, physical adornment. From the entrance, one's attention was focused on the high altar,

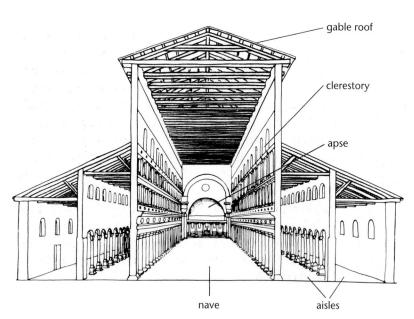

5.12 Cross section and reconstruction of the interior, Old St. Peter's Basilica, Rome, Italy, c. 333-90. Interior length approx. 368' (112 m). Commissioned by the Roman emperor Constantine.

This basilica was demolished in the sixteenth century, when today's imposing edifice (see figs. 8.26–8.30) was begun. The earlier church then became known as Old St. Peter's.

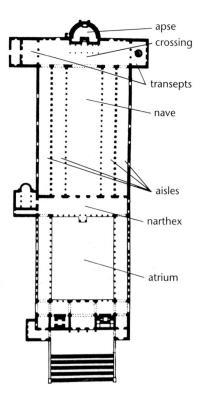

5.13 Plan of Old St. Peter's Basilica.

410 Visigoths sack Rome 455 Pirates from North Africa attack Rome

set below an enormous arch on which a mosaic depicted Christ, Saint Peter, and the emperor Constantine with the inscription: "Because under Your guidance the world rose triumphant to the skies, Constantine, himself a victor, built You this hall."

In the apse, where in a Roman basilica a statue of the emperor might be located, another mosaic displayed an enthroned Christ flanked by Saints Peter and Paul. A reference to Christ as the supreme judge is thus found at a point where, in a Roman basilica, law had been dispensed. Christianity thus transformed the architectural forms and imperial symbolism of ancient Rome.

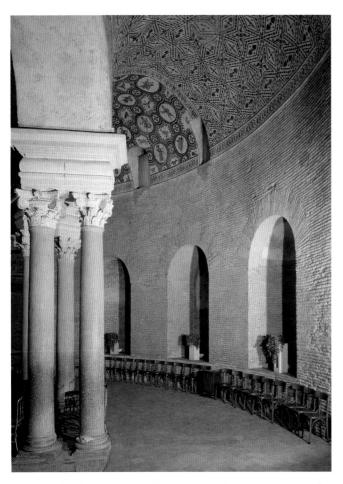

5.14 Interior, Santa Costanza, Rome, Italy, c. 354. Commissioned by the Roman emperor Constantine for the members of his family.

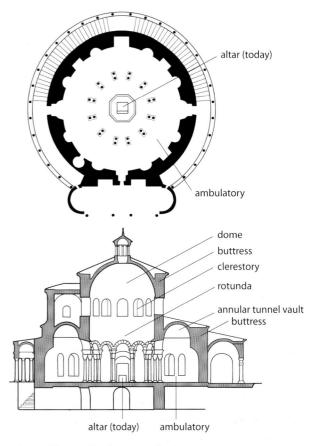

5.15 Plan and longitudinal section of Santa Costanza.

Another type of ancient Roman design adapted by the early Christians was the centrally planned structure, in which the main parts of a building radiate from a central point. It was used for baptisteries and mausoleums. Santa Costanza, built about 354 as a mausoleum for Constantine's family, features a central altar within a ring of paired columns that support the dome and clerestory (figs. 5.14, 5.15). Between the columns and the outer wall is a barrelvaulted circular corridor decorated with mosaics; it is called the ambulatory (ambulare, "to walk"). Four large niches in the walls define the shape of a Greek cross (a cross with four equal arms). The cross circumscribed by the circular plan symbolized salvation and eternal life for the Christian, and was thus an appropriate design for a Christian tomb.

Buddhist Architecture and Painting at Ajanta, India

he Buddhist monastic complex at Ajanta consists of over thirty Buddhist monuments dating from the mid-second century BCE to the late fifth century CE (fig. 5.16); it includes living quarters called *vihara*, assembly halls known as *chaitya*, and devotional areas (numbered in fig. 5.17). All are cut into the curved mountain wall, and many have sculpted facades and elaborately carved images or wall paintings in their interiors. Two worship halls created during the earliest phase offer processional paths around monolithic stupas (see pp. 92–93, 110–111).

Most of the activity at Ajanta dates to the later fifth century, after King Harisena of the Vakataka Dynasty (c. 460–477 CE) secured much of the area and established peaceful conditions. More than twenty of the caves were commissioned by King Harisena's officials, vassals of the Vakataka Dynasty, and Buddhist monks during this period. Ephemeral objects used by the monks and nuns are gone, but study of the caves provides insights into Buddhist theory, practice, and religious expression. When Harisena's reign collapsed, the caves were largely abandoned until rediscovered in the nineteenth century by the British, who labeled the *chaitya* hall a Buddhist cathedral.

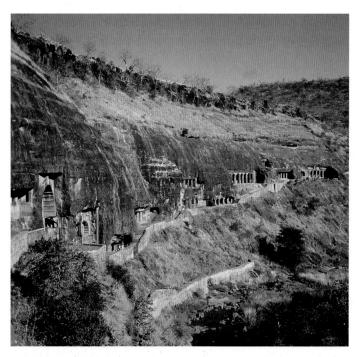

5.16 View of the Ajanta Caves, Deccan, India. First through the ninth centuries, major building during the Vakataka dynasty, c. 460–77 CE. Carved out of living rock. Commissioned by King Harisena's ministers and feudatory princes, and Buddhist monks.

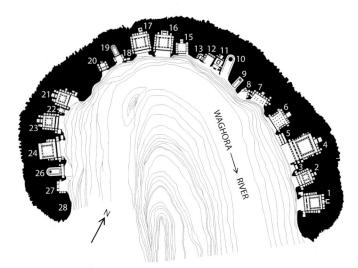

5.17 Ground plan of the Ajanta Caves, Deccan, India.

From the time of Buddha's life, the Buddhist monastic orders and lay followers developed a relationship of mutual dependence. Shunning worldly possessions, monks and nuns survived on the generosity of the laity, which they repaid by offering religious lessons to the faithful, who gained merit through financially supporting the order. Donors from many backgrounds endowed monastic orders and building programs such as those at Ajanta. Monasteries founded as centers of Buddhist learning near towns and sites hallowed by association with the Buddha grew into vast establishments by the second century BCE, and *viharas* and *chaityas* hewn out of durable living rock, as at Ajanta, began competing with centers constructed in the open.

The chaitya, a hall for congregational worship, has a central nave, side aisles, an ambulatory, and a high vaulted ceiling (fig. 5.18). The prototypes for the rock-carved chaitya halls at Ajanta were wooden structures with arched roofs formed of boughs bent in a curve, lashed to upright beams, and thatched. The interior of Cave 26 is characteristic of fifth-century CE chaitya halls. The columns, treated with bands of carved, spiraling designs, have deeply carved capitals, and the friezes above are covered with repetitive images of the Buddha and his attendants. The focal point is the stupa in the apse, which rests on a high drum adorned with sculpted images of the Buddha. The stupa itself commemorates the Parinirvana (or exalted condition) of the Buddha and his teaching, and the principle image of Buddha here, who is represented seated and turning the wheel of the Buddhist Law, is one of the earliest iconic

434 Under Attila, the Huns defeat many Germanic tribes

c. 450 Royal tombs at Monte Albán in present-day Mexico

c. 460-77 Ajanta Caves (fig. 5.16)

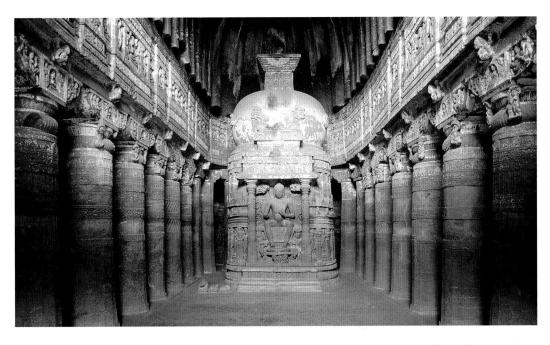

5.18 Interior of chaitya hall, Cave 26, Ajanta, India, c. late fifth century CE. Built during the Vakataka Dynasty, c. 460-77 CE. Living rock. Approx. width 35' × length 65' $(10.7 \times 19.8 \text{ m})$. Built in the reign of King Harisena.

images of the Buddha in human form. When originally painted in polychrome, the interior must have been opulent and dramatic.

One of the most spectacular remains at Ajanta is its wall painting, preserved at least in part because of the isolation of the site after it fell out of use except by the local villagers. The most famous of these paintings represents the Bodhisattva Padmapani (fig. 5.19). Ajanta painters used shading and foreshortening in an attempt to create naturalism. Light yellow and white paint highlight faces, figures, and architectural details. These techniques, together with the use of Greek-style decorative borders, have led scholars to point out the links between this painting style and the legacy of the Greco-Roman tradition left in Gandhara (Afghanistan) from the time of the occupation of Alexander the Great during the fourth century BCE.

The artists at Ajanta emphasized action, drama, and human emotions in their representations of scenes from the Buddha's life, including animated historical battle scenes and miracles of the Buddha and of the jataka tales (stories of previous incarnations of the Buddha). Given these ambitious and well-planned programs of frescoes, one wonders what the workshops or guilds of the artists were like. Varahamihira, author of a seventh-century text called the Brhatsamhita, tells us that the artists, who were organized into guilds, were placed in a low social rank, along with musicians and dancing girls. But apart from this general knowledge of the ancient Indian guilds, we know disappointingly little about the artists who adorned the walls at Ajanta or elsewhere on the peninsula at this time.

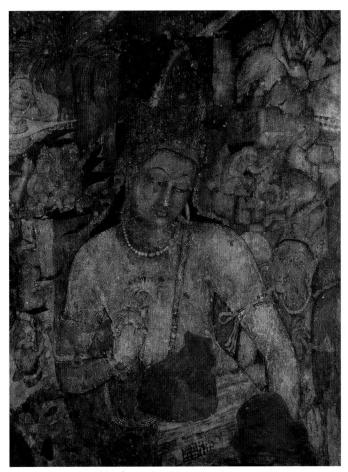

5.19 Bodhisattva Padmapani, Cave 1, Ajanta, Deccan, India. Vakataka Dynasty, c. 460–77 CE. Fresco. Commissioned by King Harisena's ministers and feudatory princes, and Buddhist monks.

The Shinto Shrine at Ise, Japan

hinto, the indigenous religion of the Japanese people, has its origins in animism, the belief that there are spirits in natural phenomena. Followers of Shintoism revere *kami*, the deities and supernatural qualities perceived in such natural objects as trees, rocks, waters, and mountains. The spirits of deceased emperors, heroes, and other famous persons are also revered as *kami*. *Kami* receive tribute at shrines in the form of offerings of food, music, dance, and the performance of such traditional skills as archery and sumo wrestling.

The Ise complex includes the Naiku (Inner, western) Shrine (figs. 5.20, 5.21), which houses the Sun Goddess Amateratsu Omikami, the divine ancestor of the Japanese emperors, and the Geku (Outer, eastern) Shrine, which is dedicated to a local god. From prehistoric times, Ise has been a sacred place and site for pilgrimage. It is the recognized seat of the ancestral deities of the imperial house, and in modern times, under State Shinto, it has become the shrine of the entire Japanese nation.

The initial construction of the Inner Shrine is thought to date from the late fifth to the mid-sixth century. Because only members of the imperial family worshiped there, Ise became the center for imperial rites and thus the shrine also has a political function. In the elaborate annual ritual calendar, the most important ceremonies were the Niiname-sai (first-fruits festival) and the Daijo-sai (enthronement ceremony), during both of which the emperor offers food to the deities and consumes a ceremonial meal that the deities are thought to share.

The main sanctuary of the Naiku complex, known as the *shoden*, and other shrine buildings are all erected in an

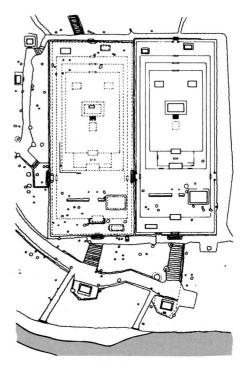

5.21 Plan of the Naiku Shrine buildings and the old shrine compound. The shrine is rebuilt alternately on adjoining sites every twenty years.

ancient style of architecture using undecorated wooden membering and a simple, thatched roof. They are raised above the ground on wooden piles, a custom associated with the humid climate of Oceania, from which this style may have been derived. The natural, unadorned materials

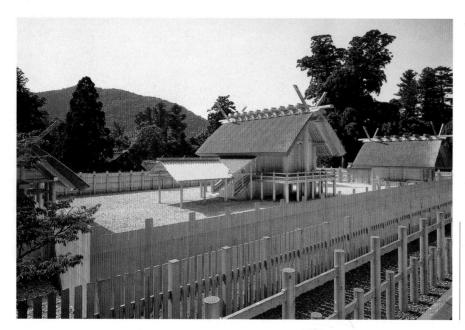

5.20 Naiku (Inner) Shrine complex, Shinto shrine, Ise, Japan. Original construction on this site, late fifth—early sixth century.

Ise, the name of the city in central Japan where the shrine is located, is used to refer to all the shrines collectively, as well as to the land on which they are situated. The original patron is unknown; the patron for rebuilding every twenty years is the Japanese ruling family and the nation of Japan.

of the building are believed to represent a sympathetic association between nature and architecture. According to a tradition that originated with the emperor Temmu (ruled 673–86), the shrines are rebuilt every twenty years in order to approximate the cycle of growth and decay in nature. Although the custom fell into disuse in the Middle Ages, the latest rebuilding at Ise took place in 1993 and repeats exactly the plan of the earliest documented structure of the shoden, dating from 690-97.

The Shinto complex at Ise has roots in prehistoric practices. Early cultivators propitiated the forces in nature, later called kami, to ensure the success of such seasonal activities as sowing, planting, and harvesting. A sacred annual cycle developed, and the rituals of kami worship became a mainstay of everyday activity.

The earliest Shinto sanctuaries were piles of boulders or stones that marked the sacred dwelling places of the kami. In early Japan, the kami were regarded with awe and were segregated from the secular world. Their sanctuaries became hallowed ground, and access was forbidden except on ritual occasions. Priests could only approach the kami during special rites in which they acted as mediators between human beings and the kami world.

In order to make the domain sacred, the physical bounds of the sacred and profane had to be demonstrated. The stone monument in which kami were thought to dwell—the heart pillar (shin no mihashira)—was enclosed by a ring of rocks. At Ise the heart pillar, which lies buried deep in the ground, is dressed in the evergreen boughs sacred to Shintoism. These branches symbolize the tree where the divine mirror (the "literal" body of Amateratsu Omikami) was hung and where the sun goddess was enshrined. A later period saw the development of the torii arch, which marks the entrance to a Shinto sacred area.

Two occurrences led to the establishment of these sanctuaries as Shinto shrines. First, the introduction of Buddhism from China via Korea in the sixth century led the Japanese emperor to welcome Buddha as a great kami whose visible representation was housed in an impressive Buddhist temple. This had a profound influence on the development of Shinto shrines and on the emergence of permanent shrine sanctuaries in particular. Second, the gradual deification of the emperor led to the establishment of an official Shinto shrine. At least as early as the late third and fourth centuries CE, Yamato rulers unified the competing clan lineages in the Yamato Plain under the aegis of their lineage, the sun line. The emperor came to be regarded as a living *kami*, with his divinity surpassing that of other kami. With this new status for the emperor, political and religious authority were joined in a union that was sanctified at the Inner Shrine at Ise. The symbol of succession from the sun goddess to the sun line (descendants of the Sun Goddess Amateratsu Omikami), the sacred necklace of magatama (jewels representing the soul spirit, which can enter the body of the possessor), is still the emblem of enthronement for the emperors of Japan and is kept at Ise, where Shinto doctrines were first systematically expounded. Today, the site is venerated, and pilgrimages there are, in part, an expression of patriotic sentiment.

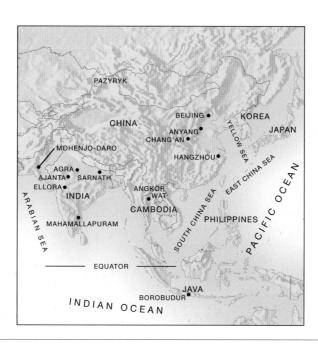

Byzantine Art

n Christian tradition, the Transfiguration occurred when three apostles accompanied Christ to the top of a mountain where Christ was then lifted up into the sky, surrounded by an aura of heavenly light, and flanked by figures of the Old Testament prophets Moses and Elijah (Matthew 17:1-13); suddenly the voice of God the Father was heard from a cloud, saying: "This is my beloved Son: listen to him." In the mosaic of the Transfiguration of Christ at Mount Sinai, Christ is represented surrounded by a mandorla (almond-shaped halo) of blue light (fig. 5.22). Moses and Elijah flank Christ, while the apostles gesture with wondrous exclamation. The scene seems removed from our physical world, for no geographic details are given, and the event is bathed in a golden light symbolic of spiritual enlightenment. Although modeling is used, the linear patterns of the shadowed areas and the absence of cast shadows deny the figures any illusion of weight or mass.

HISTORY

In 323, the emperor Constantine decided to move the capital of the Roman Empire from Rome eastward, to a distant trading center on the Bosphorus named Byzantium (from which we derive the name for the Byzantine civilization). The eastern provinces of the Empire, already strongly Christianized, had become increasingly more important, and the new capital was far from the political instability of Rome and the threats of barbarian invaders. Dedicated in 330, the new capital was named Constantinople.

5.22 *Transfiguration of Christ*, apse mosaic, Monastery of St. Catherine, Mount Sinai, Egypt, c. 560.

The Monastery of St. Catherine is at the foot of Mount Sinai (see map, p. 153), where, according to the lewish Bible, God gave the Ten Commandments to Moses. Isolated in the Sinai Desert, the monastery, which has been in continuous use since the sixth century, is a repository of early manuscripts and other works of art (see fig. 5.2). The original patron of the monastery complex was the Byzantine emperor Justinian.

A port located at a hub of trade routes and surrounded by forests and fields, Constantinople developed rapidly as an economic and cultural center. This growth lead to an increased military capability, and, during the reign of the emperor Justinian (ruled 527–65), areas of the Empire that had been lost—Italy, southern Spain, and North Africa—were again brought under imperial rule. Under Justinian, an intelligent and efficient emperor, Byzantine civilization prospered. His wife, Theodora, a former circus performer, assisted in governing the Empire. Justinian and Theodora shared a vision of reviving the grandeur of the Roman Empire.

But Justinian's military gains proved short-lived. Later, the Empire was reduced through uprisings in western Europe and, beginning in the seventh century, through the rapid advance of Islam, which spread the ideals of the prophet Muhammad to Arabia, Persia, North Africa, and Spain. The location of Constantinople meant that the influence of Roman culture was gradually supplanted by Greek taste and values, and Greek replaced Latin as the official language at court. Disagreements within the Church led to an official split in 1054 between the Western, or Roman, Church and the Byzantine, or Orthodox, Church, with its center in Constantinople. This split helps explain why the Christian Crusaders, on their way to fight the Muslims in 1204, diverted their campaign and captured and sacked Constantinople. Byzantine cultural and political stability was later restored, but in 1453 Constantinople fell to the Ottoman Turks and was later renamed Istanbul.

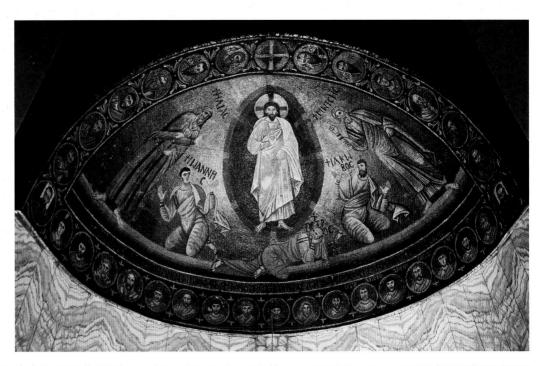

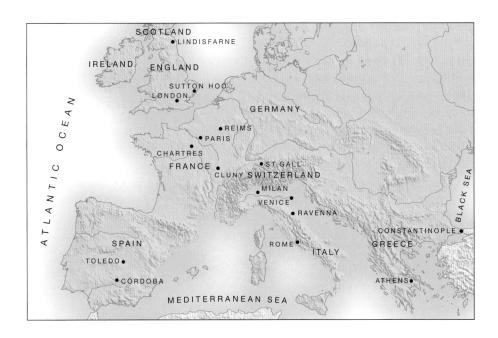

THE ICON AND ICONOCLASM

One unique form of painting that developed in Orthodox Christianity was the icon (Greek for "image"), a consecrated religious painting that displays a holy person or event and is viewed as a vehicle to communicate with the spiritual world. Some icons were believed to date from the time of Jesus, and the most famous were thought to be of divine origin. The Madonna and Child Enthroned with Saints Theodore and George and Angels (see fig. 5.2) is a rare surviving example of a sixth-century icon. The drapery patterns tend to flatten the figures, but the modeling and the slight contrapposto positions seen in the saints continue a classical interest in naturalism that was a strain in Byzantine art and culture. Above the Virgin, two angels look sharply upward to God, whose hand descends into the pictorial space, emitting a strong ray of light. The static composition of the Virgin and saints, with their intense staring eyes, is characterisic of icon paintings. The medium, encaustic (from the Greek enkaiein, "to burn in"), involves mixing dry pigments with hot wax, creating an effect that is both translucent and brilliant.

By the later sixth century, the faithful attributed miraculous powers to certain icons. Conservative factions, called iconoclasts (image destroyers), feared that the icons themselves had become objects of worship, which would be hereti-

cal; the divine nature of Christ, they argued, should not be represented, and to do so would encourage idolatry. They were countered by the iconodules (image venerators), who argued that because Christ had become human (the doctrine of the Incarnation), it was permissible to depict him in this human form. The dispute erupted into open and at times bloody conflict between 726 and 843, a period in Byzantine history known as the Iconoclastic Controversy. During this period, icons and other religious images were damaged or destroyed, accounting for many losses of works of Early Christian and Byzantine art. A final victory for the iconodules occurred in 843; even today, one Sunday in the Orthodox Christian Church calendar celebrates the restoration of images.

THE BYZANTINE ARTIST

Byzantine artists, like their Roman predecessors, were trained and practiced in a workshop system. While they constructed and decorated public buildings and churches, the collective efforts of these artists in different media were coordinated by an official overseer. As is true of much of the Middle Ages, artists worked in anonymity. Large-scale figurative sculpture, one of the cornerstones of Greek and Roman art, was seldom produced during the Byzantine era, perhaps out of fear that such works would have the connotations of earlier idols.

Byzantine Architecture: Hagia Sophia

he interior of Hagia Sophia (see fig. 5.1) offers a dramatic interplay of two crucial architectural elements: space and light. On entering, many visitors find the enormous interior space astonishing and the dome, supported by four gigantic but largely hidden piers, seems to float over us because of the row of windows at its base. Originally, this effect of a light-filled interior was even more intense, for the windows at the base of the dome were decreased when the dome had to be rebuilt after damage from earthquakes in 558, 989, and 1346. The powerful physical and spiritual experience of the church was

recorded by Procopius, the court historian to Justinian, writing shortly after the church was completed:

The sun's light and its shining rays fill the church. One would say that the space is not lit by the sun without, but that the source of light is to be found within, such is the abundance of light.... So light is the construction, the dome seems not to rest on a solid structure, but to cover the space with a sphere of gold suspended in the sky.... The scintillations of the light forbid the spectator's gaze to linger on the details; each one attracts the eye and leads it on to the next. The circular motion of one's gaze

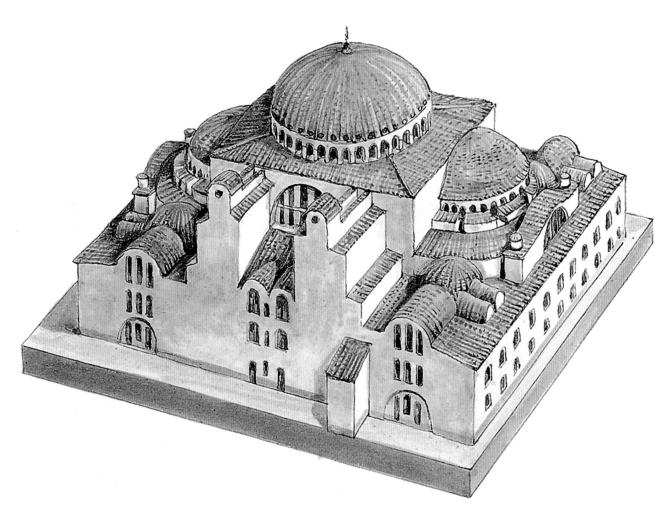

5.23 Anthemius of Tralles and Isidorus of Miletus, architects. Reconstruction of the exterior, Hagia Sophia (Holy Wisdom), Istanbul (Constantinople), Turkey, 532–37. The building is 270' (82 m) in length, covers almost 1.5 acres (6,070 sq m), and the great central dome, 108' in diameter (33 m), crowns at a height of more than 185' (56.4 m). Commissioned by the Byzantine emperor Justinian. Because of the many later additions, this reconstruction drawing provides an idea of the original exterior of the church.

Hagia Sophia served as the palace chapel for the Byzantine emperors and was the site of their coronations. After the Ottoman Turks captured Constantinople in 1453, Hagia Sophia was converted to an Islamic mosque. Towering minarets, from which the faithful were called to prayer, were added to the exterior, while on the interior the Christian mosaics were covered and eight huge discs with sayings from the Koran and names of Muslim prophets were added. Hagia Sophia influenced later developments in Islamic mosque architecture (see figs. 8.59–8.61). Today, it is a state museum.

532-37 Hagia Sophia (fig. 5.23) 542 Plague in Constantinople 550 Saint David takes Christianity to Wales c. 570 Birth of the Prophet Muhammad

reproduces itself to infinity.... The spirit rises toward God and floats in the air, certain that He is not far away, but loves to stay close to those whom He has chosen.

This remarkable synthesis of light and architectural form was conceived by Anthemius of Tralles, an artist and scientist, and Isidorus of Miletus, an architect and engineer. During a brief, six-week period, they evolved a new architectural plan that combined the longitudinal orientation of the basilica with the central plan (figs. 5.23, 5.24). Unlike Roman architects, who preferred to support a dome on a drum, Anthemius and Isidorus raised the central dome on

pendentives, curving triangular segments that provide the transition from the square plan of the supporting piers to the circular base of the dome (see fig. 4.50), and flanked it with semi- or half-domes. The huge piers reduced the loadbearing function of the walls, allowing for large amounts of window space (such nonsupporting walls are known as screen walls). That Hagia Sophia was completed in five years demonstrates the importance of the building in Justinian's plans. It is reported that at its dedication in 537, the emperor compared his accomplishment to that of Solomon, builder of the Temple in Jerusalem, when he proclaimed, "Solomon, I have outdone thee!"

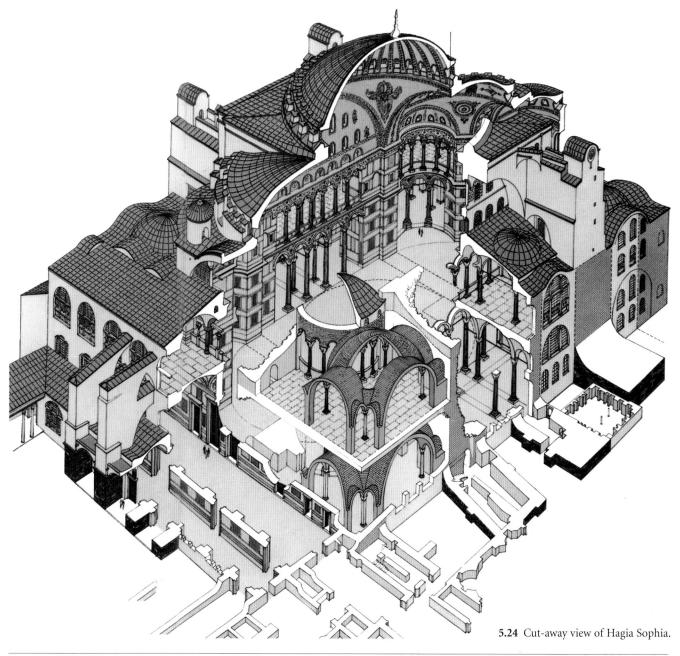

Byzantine Art: San Vitale, Ravenna

he centrally planned church of San Vitale, Ravenna, Italy, has the plain brick exterior that characterized much Early Christian and Byzantine architecture, but inside a comprehensive mosaic program synthesizes Christian iconography with imperial Byzantine politics (figs. 5.25, 5.26). The complex ideological program joins Old Testament and New Testament scenes to symbols, decorative patterns, and imperial portraiture. Images and symbols of Christ appear along the central axis, at the apex of the arch, for example, and at the center of the **groin vault**, where a lamb symbolizes Christ and his sacrifice. Christ's monogram, the *Chi-Rho*, leads to the most important of these references, the youthful Christ seated in the apse mosaic. These references align with the altar, where Christ's sacrifice is reenacted during the Mass.

The offering of bread and wine at the altar is prefigured by scenes from the Jewish Bible. In the semicircular area enclosed by the arch (**lunette**) to the left of the altar, Abraham is depicted offering hospitality to three angels thought to symbolize the Trinity (see fig. 5.26). To the right, Abraham is shown about to sacrifice his son Isaac, a narrative interpreted as prophetic of Christ's sacrifice.

On the left wall of the apse, a rectangular mosaic depicts Justinian with ecclesiastical personnel on his left and civil and military personnel on his right (fig. 5.27). Justinian carries the vessel that held the bread for the Mass; on the soldier's shield at the left border, Christ's Chi-Rho monogram indicates the political importance that Christianity had assumed within the Empire.

Justinian's placement communicates his position as head of both Church and State (in the Byzantine Empire, the emperor appointed the patriarch of Constantinople, the leader of the Eastern, Orthodox, Church). Individualized portraits are restricted to Justinian and his close associates. Although the figures overlap and some modeling is suggested, the gold background denies the illusion of real space. It is as if the earthly court of Justinian has been transfigured into a spiritual realm. As emperor, Justinian wears a jeweled crown, while as the earthly representative of God, he is shown with a halo. A rainbowlike mosaic band rises above his head to descend to the opposite mosaic of the empress Theodora, shown bringing the chalice of wine to the altar (fig. 5.28). The open passageway represented on the left of the mosaic is a subtle indication of the fact that at the time women were expected to observe the religious ceremonies at San Vitale from the galleries on the second floor.

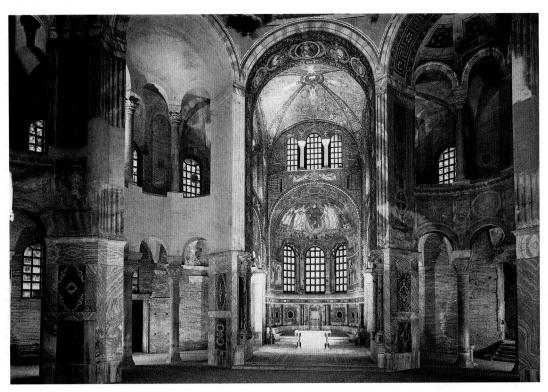

5.25 Interior, San Vitale, Ravenna, Italy, 526-47. Commissioned by the Byzantine emperor Justinian and the local bishop, Maximianus.

Ravenna had been the capital city of the Ostrogoths, a Germanic people who had conquered Italy by 493. In 540, the city was taken by Justinian's army and became a regional Italian capital and the local religious center of the Byzantine Empire.

c. 547 Mosaics, San Vitale, Ravenna (fig. 5.25)

550 Rome is conquered by Totila and the Ostrogoths

552 Justinian has silkworm eggs smuggled from China

596 The English conversion to Christianity begins

609 The Pantheon in Rome is reconsecrated as Santa Maria Rotonda

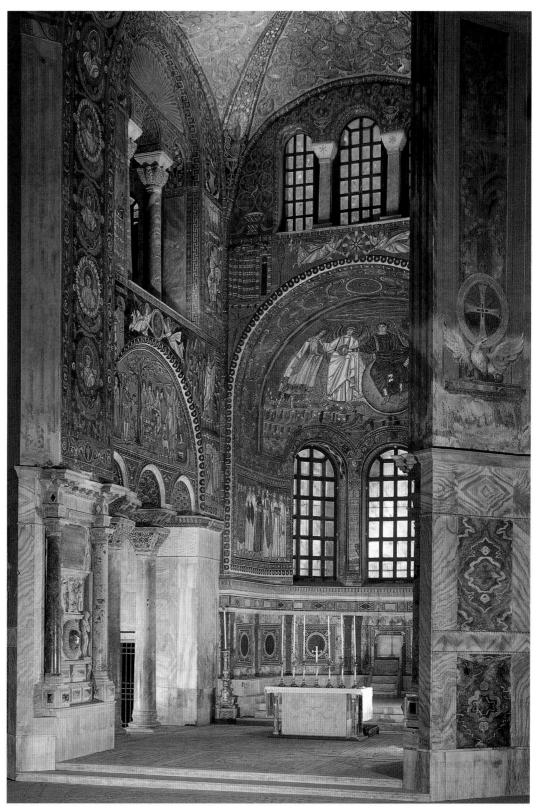

5.26 Mosaics, San Vitale, c. 547. The scene of Abraham Feeding the Three Angels is found in the lunette above the paired columns on the left. Note the inlaid marble decoration on the lower level.

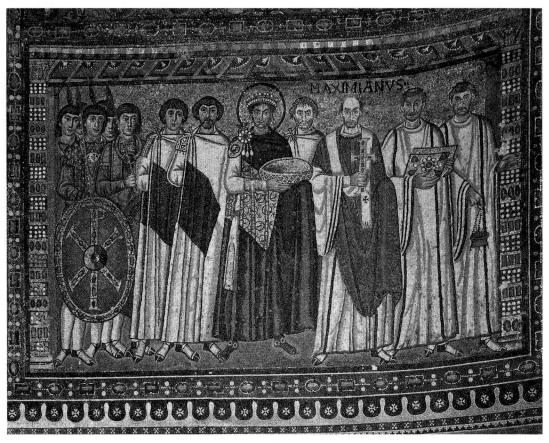

5.27 *Justinian, Archbishop Maximianus of Ravenna, and Attendants,* San Vitale, c. 547. Mosaic, $8' 8'' \times 12' (2.6 \times 3.7 \text{ m})$.

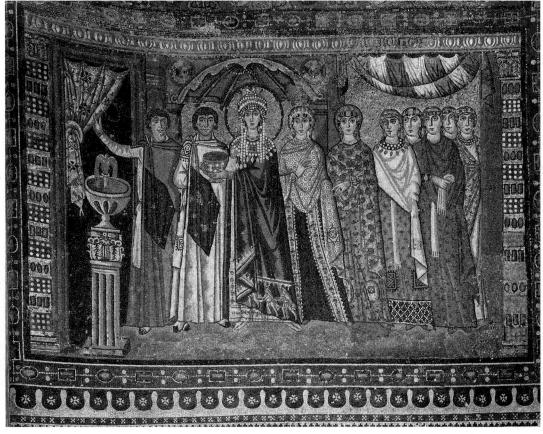

5.28 Theodora and Attendants, San Vitale, c. 547. Mosaic, $8' 8'' \times 12' (2.6 \times 3.7 \text{ m})$.

Mosaic

The technique of mosaic seems to have developed from an earlier technique of pressing pebbles into plaster to form a durable and decorative floor covering. By the late fifth century BCE, Greek artists began arranging the pebbles into abstract and figurative floor designs. Soon, natural stones were replaced by cut pieces of colored stone, especially marble, called tesserae (singular: tessera, from the Greek tesseres, a square). The term tesserae is also used for the pieces of stone and glass in wall mosaics, as at Ravenna (fig. 5.29). At first, Roman mosaic was used primarily on the floors of private homes (see fig. 3.57), but occasionally it also decorated walls. Roman wall mosaics began to use glass tesserae in many colors, as well as gold tesserae, formed by sandwiching gold leaf between two layers of glass. The early Christians used mosaics to embellish the walls of their churches, but it was during the Byzantine era that the most splendid effects were achieved, as walls and vaults were covered with glass and marble mosaics enhanced by the shimmering effect of a gold background.

In creating a mosaic, the image is first outlined on the floor, wall, or vault. Successive areas of this surface are then covered with fresh cement or plaster, and tesserae are placed into it, following the established design. Once the cement or plaster hardens, the tesserae are held in place. When tesserae were set into walls and vaults, care was taken to adjust each so that its surface was at a slight angle to that of the neighboring tesserae. As the changing light from the windows strikes the polished or glass tesserae, the changing angles of refraction create a shimmering and ethereal effect, a vision particularly suited to the mystical values of Christianity.

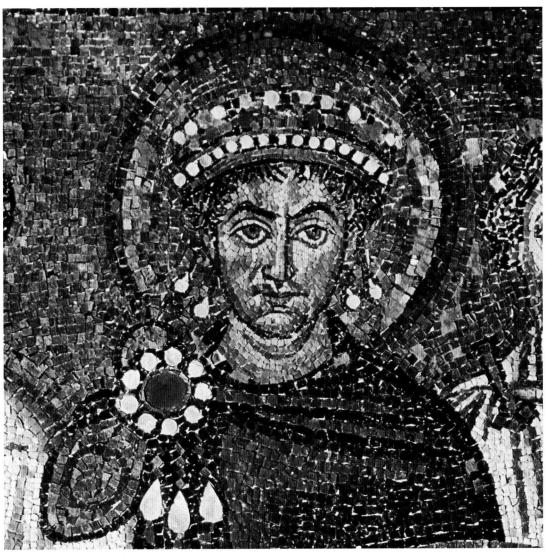

5.29 Justinian, detail of fig. 5.27.

Anglo-Saxon Metalwork and Hiberno-Saxon Illumination

n its use of precious materials and in its emphasis on fine craft, the purse cover found in the Sutton Hoo Ship Burial (fig. 5.30) displays interests typical of pastoral people in objects that are intricate, portable, and a part of personal adornment. Its heavily patterned style is based on the **interlace**, designs composed of a single line that intertwines and overlaps to fill space. In Anglo-Saxon art, the interlaced line is often given an animal head, the mouth of which bites down on its own tail. This is seen here in the animals in the center top of the purse cover and also in the manuscript illumination on the following page.

The discoveries at the Sutton Hoo mound parallel the burial practices described in the somewhat later Anglo-Saxon epic *Beowulf*:

And there they brought the beloved body Of their ring-giving lord, and laid him near The mast. Next to that noble corpse They heaped up treasures, jeweled helmets, Hooked swords and coats of mail, armor Carried from the ends of the earth; no ship Had ever sailed so brightly fitted, No king sent forth more deeply mourned.... Take these treasures, earth, now that no one Living can enjoy them.

The Sutton Hoo treasury offers valuable evidence for a culture about which we have little information, in part because it was largely nomadic. There are few written records and only limited monuments and archaeological remains. Many works were melted down, destroyed by fire, or lost during attacks and invasions.

The few fragments of Anglo-Saxon poetry and documentation that have survived reveal a delight in luminous materials (especially gold) and in the color red. The interest

5.30 Sutton Hoo purse cover, c. 620. Gold with Indian garnets and cloisonné enamels, originally on an ivory or bone background (now lost), length 8" (20 cm). The British Museum, London.

Found in 1939 in a ship-burial mound at Sutton Hoo, England, as part of the treasure of a king who probably died between 625 and 640, this purse lid of precious materials and exceptional technical proficiency once adorned a cloth or leather pouch that would have been attached to the owner's belt. When placed in the burial mound, it contained gold coins and ingots. The ship in which the treasure was buried was almost ninety feet long and would have required thirty-eight rowers. The richness of the treasure, which included a helmet, shield, spears and a sword, bowls, drinking horns, remains of a musical instrument, and twenty-six pieces of gold jewelry, reveals the high status of the deceased, who has not been identified. With the spread of Christianity, the ancient tradition of ship burial, which provided the soul with a vehicle in which to travel to the next world, gradually declined, but some of the objects found suggest that the Sutton Hoo king may have been a convert to Christianity.

638 Muslims capture **Jerusalem**

Arabs invade India

in filling every available space seems to be related to the Anglo-Saxons' Germanic origin. The artists included monks, nuns, and laypeople. By the end of the Anglo-Saxon period, there is some evidence that craft guilds-medieval organizations of lay artists—were beginning to develop in England. When artists are mentioned, special attention is always given to the worker in precious metals, and it is on pieces of fine metalwork that we find the few artists' signatures of this period.

The interlace motif found in Anglo-Saxon metalwork was integrated into a Christian context in a series of manuscripts produced in English and Irish monasteries between 600 and 800. Similarities in style make it difficult to distinguish English from Irish production, so the term Hiberno-Saxon (Hibernia was the ancient Latin name for Ireland, while Saxon refers to England during this period) has been

used to describe these works. The techniques used by the Hiberno-Saxon monks who made these manuscripts are difficult to reconstruct, and exactly how they accomplished such minuscule and complex interlace patterns without the aid of a magnifying glass is unclear. The intensive and time-consuming nature of the design and execution seen here is probably related to the isolated nature of life in a Hiberno-Saxon monastery.

The earliest surviving Hiberno-Saxon religious manuscripts reveal an interest in decorating the letters themselves, a not surprising development when we remember that the words were believed to be proclamations of God. This tendency reaches its peak in the Book of Kells (fig. 5.31). When the text discussing the life of Christ in the Gospel of Saint Matthew (1:22) reaches the point where the Incarnation of Christ is mentioned, the letters burst out into joyful, exuberant patterns. This whole page is devoted to three words—Christi autem generatio ("the birth of Christ")—with most of the page devoted to the first three letters of Christi (XPI). The X is the dominant form, and it surges outward in bold and varied curves to embrace Hiberno-Saxon whorl patterns. Interlace fills other areas, and simple colored frames set off the large initials amid the con-

5.31 Incarnation page, from the Book of Kells, c. 800. Manuscript painting on vellum, 1' 1" \times 9½" (33 \times 24 cm). Trinity College Library, Dublin.

suming excitement. The human head that forms the end of the *P* also dots the *I*. Near the lower left base of the *X*, a small scene shows cats watching while two mice fight over a round wafer similar to those used in the Mass—a scene surely of symbolic intent, even if its meaning is lost to us today.

The pulsating vitality of the word of God is thus visually demonstrated. A twelfth-century writer who was shown a precious manuscript in Ireland—perhaps the Book of Kells itself-wrote:

Look more keenly at it and you will penetrate to the very shrine of art. You will make out intricacies so delicate and subtle, so exact and compact, so full of knots and links, with colors so fresh and vivid, that you might say that all this was the work of an angel and not of a man.

The Chinese Imperial City of Chang'An

uring the Tang Dynasty (618–907), Chang'an, which had flourished earlier, during the Han Dynasty, became the cultural capital of East Asia (fig. 5.32). Laid out on a huge scale following traditional Chinese practices, it was held in such esteem that it became the model for contemporary capitals in Korea and Japan. It was by far the largest city in the world at that time; the present city on the site, Xi'an, occupies only about one-seventh of the area of the Tang capital.

Production of art in Chang'an reflects the city's importance as a Chinese capital as well as its position as an international center for trade. *Court Ladies Preparing Newly Woven Silk* (fig. **5.33**) gives us an intimate view of aristocratic women; the ceramic camel (fig. **5.34**) represents the position of Chang'an as the origin for the caravans that crossed the silk route to the West.

The city that was to become Chang'an began to take shape in the later sixth century, when a man rose to power who reunified the traditional Chinese lands after nearly four centuries of political instability and invasions from outside. In 581, he became Emperor Wendi, the first ruler of the Sui Dynasty, and he and his advisers were determined to build a capital city on a new and unprecedented scale at the site of the Han Dynasty (206 BCE–220 CE) capital. Their project for this "City of the Great Ascendancy" covered thirty-one square miles, but it was merely a skeleton when

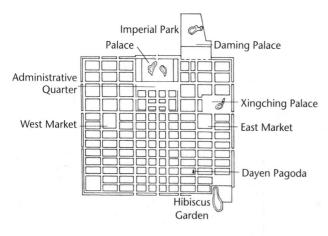

5.32 Plan of Chang'an (see map, p. 161). Tang Dynasty, seventheighth century. Commissioned by the imperial government.

Chang'an (today known as Xi'an) served as the capital of China during the powerful Han (206 BCE—220 CE) and Tang (618—907 CE) Dynasties, and the wall surrounding the city was almost twenty-six miles long and enclosed an area of almost forty-two square miles. It was the eastern terminus of the silk road, which joined China with the markets of western Asia and, as early as the second century, with Europe. Chang'an played an important role as a center for the transmission of the ideas and art forms that poured into China during the Tang Dynasty.

Wendi took up residence in 583. With the founding of the Tang Dynasty in 618, the city was expanded and renamed Chang'an—"City of Enduring Peace." At the height of the Tang, in the late seventh and eighth centuries, the city's population reached more than a million inside the walls, with probably another million in nearby satellite towns. Based on principles of symmetry and axiality, Chang'an was the first totally planned Chinese city. The Tang leaders intended to do more than create a city that would meet their practical needs; they planned a city that could dramatize their social order, express their hierarchy of values, and convey their view of the cosmos and their place in it.

First, to choose an auspicious site they turned to the ancient Chinese divination practice of *fengshui*, which is still used today. Chang'an's location had been venerated for two millennia. Already, in the first century CE, a poet named Pan Gu had summed up the advantages of the location in "Rhapsody on the Western Capital," a poem included in a collection known as the *Wen Xuan*:

In abundance of flowering plants and fruits it is the most fertile of the Nine Provinces.

In natural barriers for protection and defense it is the most impregnable refuge in heaven and earth.

This is why its influence has extended in six directions.

This is why it has thrice become the seat of imperial power.

As a perennial fulcrum of power—strong, fertile, and well populated—the site was practical as well as symbolic. These same kinds of principles were used in establishing the site and plan for the Forbidden City, the later imperial palace in Beijing (see fig. 1.12 and pp. 236–37).

Second, the beginning of construction on the new Tang capital had to be properly timed. The most auspicious time and place to build were determined by centuries-old oracledivination procedures similar to the divinatory rites carried out by Greek, Etruscan, and Roman builders before embarking on the construction of new cities. The orientation of the city was studied to ensure that it would be fully consonant with the natural order. Early descriptions of city planning (from the Zhou li, or Rites of the Zhou, from the first millennium BCE) report that special officers took the shadow of the sun at noon and made observations of the North Star by night on successive days until they came to an accurate calculation of the four cardinal directions that would determine the city's orientation. No doubt astronomers were also employed to assure that the orientation was attuned to the cosmic order.

Once properly sited and oriented, the city was surrounded by a rectangular wall of pounded earth (see fig. 5.32). There were gates in the outer walls except on the north, and broad north—south avenues led to each of the gates on the south wall. The city was subdivided into major zones. To the extreme north was the inner city, where the emperor held court, performed rituals of office, and resided with his harem. To the east and west of the avenue leading to the central southern gate were the imperial ancestral hall and the Altar of Earth.

In 634, the second Tang emperor, Taizong, expanded the city to the northeast of the inner city, beyond the city walls, where he built a complex of palaces and other buildings that came to be known as the Daming Palace. Tang texts record that Hanyuan Hall, which has been excavated, was the site of ceremonies for the New Year and the winter solstice and that it was used for the investiture of new emperors, the changing of reign titles, and the inspection of troops and presentation of captives. Nearby was Linde Hall (fig. 5.35), the other excavated Tang-period building of the Daming Palace, which was used by the emperor for feasting high officials. Both the Linde Hall and the Hanyuan Hall had similar architectural components, including covered arcades (or "flying galleries") that enclosed each building complex, side pavilions, and platforms that raised the entire building above ground level. Linde was a triple hall complex with a two-storied roof over the central building. The three halls lead directly from one to the next, without connecting arcades.

Beginning in the Han Dynasty, ritual halls had weightbearing walls with pillars that supported the main beams at the center. According to building regulations of the Tang, only the most important halls could have the **hipped roofs**, with their triangular, angled ends, as seen in fig. 5.35.

The remaining part of the city, known as the outer city, included 110 wards, most of which were predominantly residential; two were given over to marketplaces built and controlled by the government. The east market connected with the roads leading to the second Tang capital at Louyang, while the west market was the center of foreign trade and foreign residence. The ancient system of walled blocks was used for the whole outer city; the ward gates opened at sunup and closed at dusk, and it was a crime to be found on the streets after curfew. The residential wards were laid out on a grid pattern. The sides of these streets were lined with drainage ditches and planted with shade trees. The mansions of the aristocrats and officials were concentrated in wards near the Daming Palace and the east market, while those of commoners were found in the more densely populated area around the west market. Near the city parks at the extreme southeast corner of the outer city were a number of government-controlled entertainment

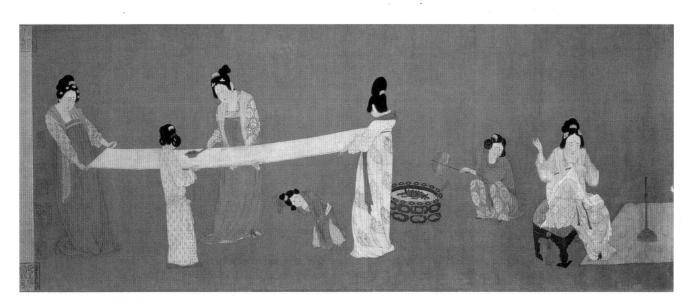

5.33 Copy after Zhang Xuan, *Court Ladies Preparing Newly Woven Silk*. Detail of twelfth-century copy, attributed to the twelfth-century emperor Hui Zong, after an eighth-century hand scroll. Color on silk, 1' 2½" × 4' 9½" (36.8 × 145.4 cm). Commissioned by the imperial academy. Chinese and Japanese Special Fund. Courtesy Museum of Fine Arts, Boston.

Rich, glowing colors describe the scene, while the fabric of the dresses worn by the women is precisely described. For a photo of how hand scrolls are held and viewed, see fig. 1.21.

districts. An elevated, covered roadway connected the parks so that the emperor could enjoy outings without being seen by his subjects.

The international connections of the Tang Dynasty meant that Chang'an was a cosmopolitan capital, and the diplomatic envoys, religious missionaries, merchants, and students from many parts of the world who congregated there brought with them foreign religions, including Zoroastrianism, Manichaeanism, Judaism, Islam (see fig. 5.7), and Nestorian Christianity. The grandest and most numerous religious complexes in Chang'an were Buddhist and Daoist; some even occupied whole wards. The foreign

goods brought by the city's exotic visitors were much sought after by the Chinese aristocracy, as well as by the middle class.

The building of Chang'an was accomplished during an era of peace and prosperity at home and enormous prestige abroad. In the early eighth century, the brilliant leader Xuanzong, known as Ming Huang, assumed the throne. He upheld the Confucian order, and in 745 founded the Imperial Academy of Letters (Hanlin Yuan). Talent and wealth were concentrated in his court. His favorite scholars, poets, and painters, his schools of drama and music, his orchestras (two of which came from Central Asia), and his

5.34 Camel Carrying a Group of Musicians, from a tomb near Xi'an, Shanxi. Tang Dynasty, mid-eighth century. Earthenware, with polychrome lead glaze, height 26½" (66.5 cm). Museum of Chinese History, Beijing.

The Tang Dynasty is notable in the history of Chinese ceramics for the dynamic energy of its shapes, the development of colored glazes, and the perfection of porcelain. Fine white earthenware is often clothed in a polychrome glaze made by mixing copper, iron, or cobalt with a colorless lead silicate to produce a rich range of colors, from blue and green to yellow and brown. Both form and glaze convey the vigor of life at the Tang court in the eighth century. This camel would have been placed in a tomb chamber in order that the deceased could enjoy a camel and musicians in the afterlife.

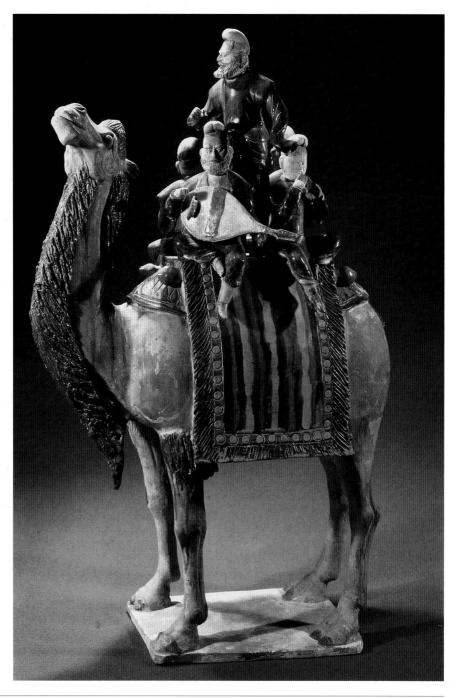

famous mistress, the beautiful Yang Guifei, were in attendance. Court painters and poets were kept busy by the emperor making portraits and recording the cultural and social events of court life.

During the reign of Ming Huang, the court painter Zhang Xuan was celebrated for his paintings of "young nobles, saddle horses, and women of rank." None of his work survives in the original, but one copy, Court Ladies Preparing Newly Woven Silk (see fig. 5.33), is thought to represent the eighth-century Tang court tradition of scroll painting. In the section reproduced here, court women of different ages are shown stretching and ironing a piece of newly woven silk. The dignified and elegant presentation is surely comparable to court life itself at that moment, even though only the essentials of the scene are recorded. The relationship of the women in space is clear, but we are not told where they are, only what their relationship is to each other. Each woman refers to and is intimately connected to another through participation in the task and by gesture and location in space. While this section of the scroll records an actual activity, it also seems to refer to the broader theme of the maturation of court women from childhood (the small figure playing under the stretched silk), to adolescence, the coming of age, and adulthood. Such an interpretation is supported by the manner in which each step is distinguished by position, dress style, coiffure, and size.

The same realism that marks high court painting also characterizes the tomb figurines made during the Tang period. The presence of a camel (see fig. 5.34) in one's tomb must surely have referred to the importance of trade in the life of the deceased. The combination of restrained energy and solidity of modeling seen in this glazed ceramic camel is typical of the best examples of this Tang sculpture, which was made for the burials of both the aristocracy and the gentry.

Late in the ninth century, Chang'an fell victim to the ravages of a rebellion; in 904 many of its buildings were razed, and the royal court activities were transported to the second capital at Louyang. Although its political importance declined, it remained a bustling trading center.

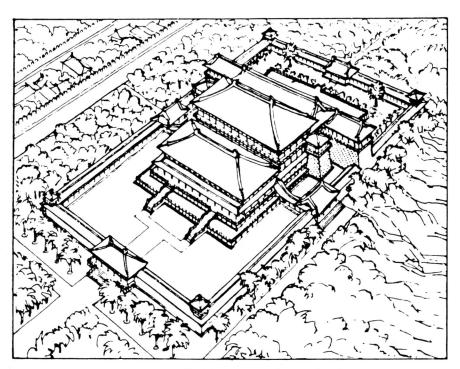

5.35 Reconstruction of the Linde Hall of the Daming Palace at Chang'an. Tang Dynasty, seventh century. Commissioned by the imperial government.

The roof was made of ceramic tiles, and the tiles on the ridges and eave ends were glazed. Green and black tiles were excavated at the site, and based on textual evidence, the exterior wall colors were primarily red and white with gold details. The coloristic effect of the whole would thus have been striking.

Buddhist Art at Horyuji

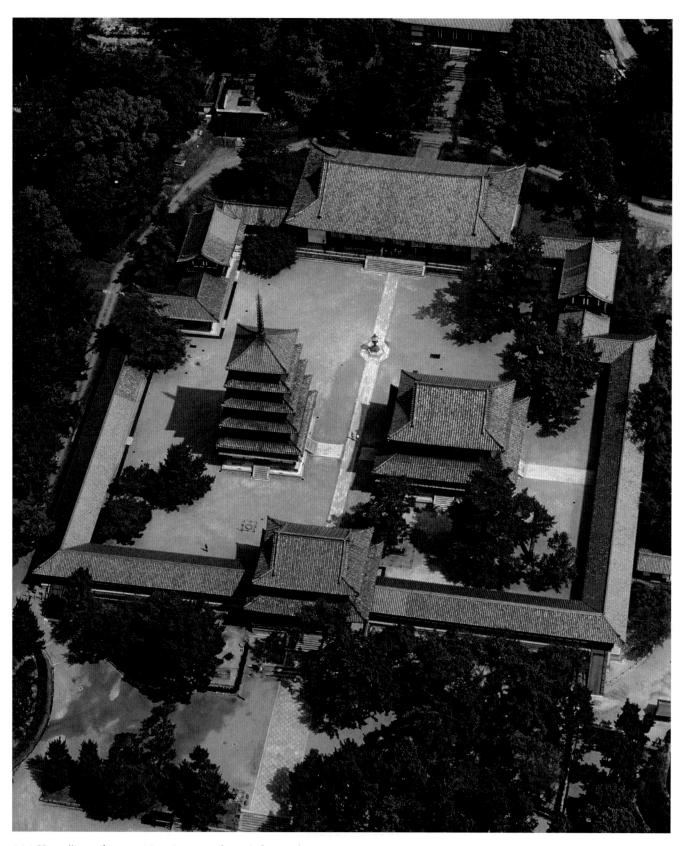

5.36 Horyuji complex, near Nara, Japan. Asuka period, seventh century. Stone, wood, plaster, and tile. Commissioned by Imperial Prince Shotoku.

7th century Horyuji, Nara (fig. 5.36) **7th century**Rise of the Japanese feudal nobility

612 Monastery of St. Gall is founded in Switzerland (see fig. 5.47) 630 Mohammed returns to Mecca

656Standardized text of the Koran is completed

oryuji is the oldest Buddhist temple in East Asia whose main parts have survived (figs. 5.36, 5.37); all examples of the earlier Buddhist temples that must have been built in China or Korea have been destroyed. Founded in 607, it is a treasure house of immense value for this early phase of Buddhist development outside of India. One enters the temple-monastery complex through the *chumon*, the gate on the south face of the encircling cloister, and finds to the left (west) a pagoda and to the right (east) the main hall, or kondo, known as the Golden Hall. The pagoda and the kondo are equidistant from the *chumon* and are simultaneously visible as the worshiper enters. Instead of proceeding into the depths of the compound through a succession of buildings, as was the custom in China, the pilgrim makes a lateral turn. Lateral movement rather than linear penetration is repeatedly favored in Japanese spatial conceptions through history. While the planning of the Horyuji site thus shows Japanese influence, the individual buildings are typically continental—that is, Chinese or Korean—in style. They stand on raised stone bases and are built on a bay system, with postand-lintel construction, tile roofs, and elaborate dougongstyle bracketing (see fig. 5.38) designed to transmit the thrust and weight of the heavy tile roof down through the wooden members to the principal columns that support the structure.

The *kondo* is oriented to the four cardinal directions by a stairway on each side leading to a double door. The interior is almost completely taken up by a platform and numerous statues, including the main statue of the Buddha (see fig. 5.39). This group is the spiritual center of the temple complex. The *kondo* is lavishly embellished: the posts

and beams are painted and **gilded**, and the ceiling is decorated to represent Paradise. On the walls, paintings represent the Buddha and the paradises of the cardinal directions. The program of statues and paintings in the *kondo* makes the temple a terrestrial representation of the Buddha's blissful realm, radiating the light of Buddha's wisdom and mercy to inspire the believer. While the *kondo* enshrined artworks, the *kodo*, on the north end, was set aside for sermons and disputations, and functioned as an assembly hall.

Buddhism was the earliest world religion. From its center of origin in northeastern India, it spread across Asia, radiating outward to the north, east, and south, bringing its doctrine of salvation for human and other living creatures, as well as its philosophy and ethics, its learning and art. It bridged the differences among the rich and creative cultures of India, China, Japan, and Southeast Asia. In the course of the first millennium CE, Buddhism fostered the rise of a farranging spiritual and cultural community that was remarkably similar in patterns of life and thought, as well as in art.

Buddhism first grew to a national religion in India under King Ashoka (ruled c. 273–232 BCE; see p. 94), and by the second century CE missionaries had carried the tradition to northwest India and the provincial Greco-Roman world in Gandhara (Afghanistan). There, new schools developed Mahayana Buddhism, which taught that salvation was open to all people through faith and good works. The Buddha, in their view, ceased to be primarily an earthly teacher and was thought of as pure abstraction, as the "universal principle," the godhead, from whom truth radiates with a blinding light across the universe. The Buddha reached far beyond the grasp of mortal beings, but there

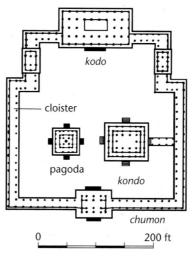

5.37 Plan of Horyuji.

Dougong-style Bracketing

At least as early as 1100 BCE in China, wooden blocks were added at the point where columns supported beams. They served as a type of cushioning that increased the surface of contact and thus made it possible to expand the span. Gradually, brackets were added and, as these forms became more complex, the eaves became very deep, and the overall effect became highly decorative, as in this much later Japanese example (fig. 5.38). In Japanese architecture, the blocks and brackets were carved and painted in brilliant colours, and as a result elaborate bracketing became an important part of the Japanese aesthetic.

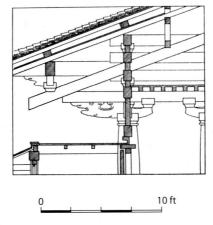

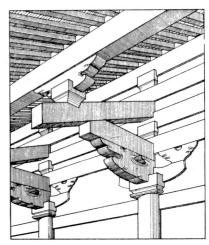

5.38 *Dougong*-style eaves at the Horyuji kondo.

were approachable deities in this newer Buddhism: bodhisattvas, humans destined for enlightenment who had earned the right to enter Nirvana but had postponed it in order to help others.

Buddhism reached Japan in the middle of the sixth century from Korea after centuries of development in China. The introduction of Buddhism had a far-reaching effect on many aspects of Japanese life; in terms of religious beliefs and practices, it challenged the nature religion of Japan (Shinto; see pp. 160-61), which had no specific texts, little defined ritual practices and as deities kami (nature spirits) who had no specified forms or attributes. In contrast, the principles of the Buddhist faith were expounded in Chinese texts by a clergy and communities of nuns and monks who performed minutely prescribed religious functions inside halls filled with the pungent smell of incense and with statues of the holy in human form. Buddhism channeled silent and spontaneous interaction with the spirits into an organized program of ritual observance, and explained the mysteries of life in a set of laws.

The rise of Buddhism in Japan was accelerated during the life of Prince Umayado, better known by his Buddhist name of Prince Shotoku ("Wise and Virtuous," ruled 593–622). He was an avid scholar and learned leader who transformed Japanese culture. Born into a court where Buddhist images had been received from Korea for twenty-one years, Shotoku grew up in an atmosphere of cultural ferment. The beliefs of the pro-Buddhist Soga clan were challenged by traditionalists who supported adherence to Shinto. Buddhist chapels were burned and statues damaged. When Soga no Umako (died 626), as head of the family,

placed his niece on the throne as Empress Suiko (ruled 592-628), he ordered Prince Shotoku, then only nineteen years old, to act as regent. Prince Shotoku set out to centralize power and to unify the clan chiefs, whose rivalries had previously dominated Japanese life, using as a model the Chinese court. He thereby played a leading role in the absorption of Chinese aristocratic culture in Japan. Shotoku built his palace at Ikaruga and next to it erected a Buddhist temple modeled after Korean buildings. By 614, or fifty years after the presentation of the first Buddhist statue to Japan, there were forty-six temples and 1,385 ordained Japanese monks and nuns. During a struggle for power after Shotoku's death, both his palace and temple were destroyed. Shotoku's legacy, the primacy of learning and moral values, was so firmly implanted among the aristocracy and clergy, however, that the ruined temple was soon rebuilt and was called Horyuji.

Buddhist sculpture preceded Buddhist architecture outside of India, for images were brought in the luggage of missionaries, travelers, and pilgrims across the trade routes of Central Asia. Such icons were set up in shrines built in the traditional Chinese style, many of which grew to become palatial temples or monasteries with courtyards, pavilions, galleries, and gardens. No attempt was made to imitate Indian temples, and the stupa form was gradually transformed into the pagoda, the multitiered tower that serves as a relic hall.

The Mahayana Buddhists believe that there will be an infinite number of Buddhas, all of them manifestations of the One Absolute Buddha. Although he was thought to be beyond the limits of human vision, practitioners began to

believe that one manifestation was revealed to the living and could therefore be represented. These images were used to help the beholder to understand existence beyond form and substance. The central image in the kondo at Horyuji is dated 623 and signed by a master craftworker ("Busshi") named Tori who is the first named Japanese sculptor. The Buddha, who wears a monk's robe and is seated in the position of meditation, is represented with a serene and remote aspect (fig. 5.39). The two attendants are the bodhisattvas of the Sun and the Moon. The style here has been called the Elongated Style because of the thinness of the figures and their elongated faces; the "waterfall" drapery falls in graceful, stylized folds on the main figure and appears as "swallow-tail" folds on the bodhisattvas. Buddha's elongated

ears, the result of wearing heavy earrings as a prince, recall his noble birth. The mark on his forehead, the *urna*, symbolizes increased wisdom, while the ushnisha, or cranial protuberance, symbolizes increased spiritual power. The bodhisattvas are dressed in the clothing of Indian princes, with crowns and jewels. Each figure has an almond-shaped mandorla; that of the Buddha surrounds his whole body.

Buddha's frontal, seated pose, his dress, and his hand gestures (mudras) are all prescribed by tradition. This manner of presentation—so similar to prototypes from Korea, China, and even India (see fig. 5.4)—speaks of an ecumenical tradition fueled both by the assimilative nature of Mahayana Buddhism and by the economic and political aspirations of the leaders who embraced the religion.

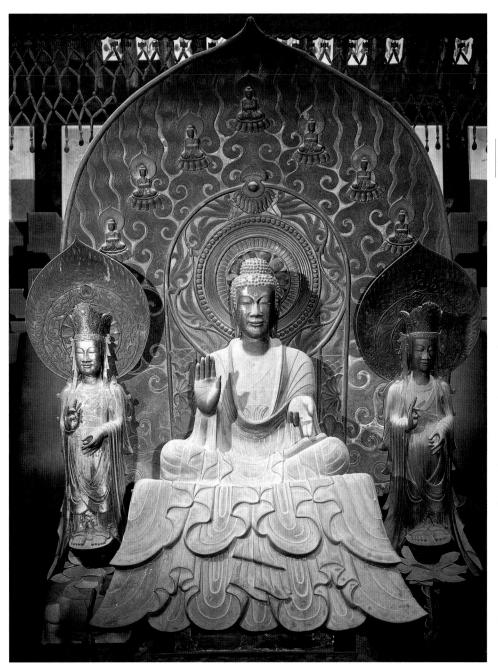

5.39 Tori Busshi (Master Craftworker Tori), Shaka Triad (Buddha flanked by Bodhisattvas), Golden Hall (kondo), Horyuji. Asuka period, 623. Bronze with gilt, height of central figure 5' 91/4" (1.75 m). Commissioned by Imperial Prince Shotoku.

The Buddha's hand gesture is in the abhaya mudra, the gesture of reassurance that suggests "fear not."

Hindu Art at Ellora

he Kailasantha Temple (the name given to the entire eighth-century complex) is carved from a cliff to resemble a freestanding temple complex behind a high screen wall (figs. 5.40, 5.41). Although some sections are dedicated to specific Hindu gods, the monument is literally intended to be a "magic mountain" carved from the living rock where the theme of Mount Kailasa, the sacred mountain abode of Siva and his consort Parvati, is repeated several times. The artists, who wanted to represent the universe in this massive carving, oriented the structure to correspond to the four cardinal directions—the world compass. At the core of the temple is the place intended for individual worship in the Hindu faith; here was buried a box containing earth, stones, gems, herbs, roots, metals, and soils that were intended to tie the temple to ancient fertility beliefs and to emphasize the vitality of the religion.

Because it is carved rather than constructed, the temple is an achievement of sculpture rather than architecture. The open court is 276 feet (84.1 m) long and 154 feet (46.9 m) wide, and a central tower reaches a height of 96 feet (29.3 m). The sheer physical problem of carving this tremendous temple is awesome. Since the sculptors began working at a height above the tower, the total depth of the cut was about 120 feet (36.6 m)—as high as a twelve-story building.

Upon entering this complex, the viewer is aware of the contrast between the strong Indian sunlight and the deep blue shadows cast by the surrounding mountainside, which dramatizes the movement of space along the pathways and across the sculptural reliefs. The sculptural figures' strong gestures enhance an overall sense of drama and, for the believer, of exaltation. The boldness of conception and skill in execution suggest centuries of tradition in which carving techniques and an understanding of the rock medium were developed, enabling craftworkers to push this southern Indian type of rock-cut temple to its limits.

Hinduism encompassed a broad variety of beliefs and practices; not all were shared by all Hindus, and some even contradicted each other. In fact, the religion is unusual in its tolerance of diversity. Completely decentralized, it has no hierarchy of clergy and no supreme authority—unlike Christianity, Islam, and Buddhism. The roots of the religion can be found 4,000 years ago in India, and as it developed it absorbed and reinterpreted the beliefs and practices of diverse groups of people. Assimilation occurred differently in various parts of India, and today, as in the past, the subcontinent is a repository of heterogeneous beliefs. That the worship of deities is a highly personal activity is reflected in the plan of Hindu temples, as well as in their sculptural reliefs. For instance, several of the shrines at the Kailasantha

Temple do not have an interior sanctuary, and the Nandi and main shrines are open only on the second level. Even when they are entered, the interior space is so small that an individual approach to the sacred images is required. Hinduism's personal approach to the gods is indicated in the thousands of different manifestations of the deity. Today this religion is vital to more than 760 million adherents in India, Sri Lanka, Pakistan, and East and South Africa, as well as on a number of islands in the Caribbean and Southeast Asian oceans.

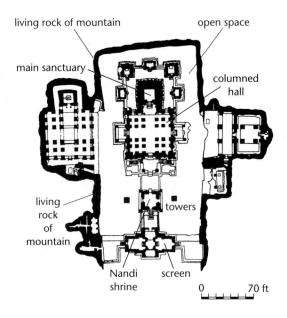

5.40 Plan of the Kailasantha Temple.

The plan reveals the layout more clearly than any view. At the entrance, a large stone screen demarcates secular from religious space. Next is the Nandi shrine, flanked by the two towers. That small shrine is followed by three porches leading to a columned hall, which functioned as a gathering place, and to the main sanctuary. Five subsidiary shrines on a second-story terrace outside the main sanctuary are dedicated to various deities associated with Siva. The sides of the tremendous pit created by the carving of the temple have secondary shrines in the vertical walls: the Shrine of Absolutions (or the Shrine of the Three Rivers), with representations of the three sacred rivers; a long series of sculptures at the rear; a second-story temple carved in the rock with a set of reliefs relating to Siva; a series of reliefs of avatars (incarnations) of Vishnu and aspects of Siva on the ground floor, surrounding the sides and completely enclosing the back wall; and a two-story complex on the right, once connected by a bridge to a porch, with representations of the Great Goddess (Devi) and the Seven Mothers. The large frieze sculptures that narrate the stories of the Mahabharata and the Ramayana on the south wall illustrate sacred literature. Numerous smaller shrines complete the group. Although the building of this great complex took place over a long period of time, it nevertheless represents a single architectural and sculptural conception.

738 First Arab slave raid on West Africa

Chinese troops defeated by Muslims in Central Asia

c. 760-800 Kailasantha Temple, Ellora, India (fig. 5.41)

778 Roland, of the Song of Roland, is killed

800 Charlemagne is crowned as Frankish emperor

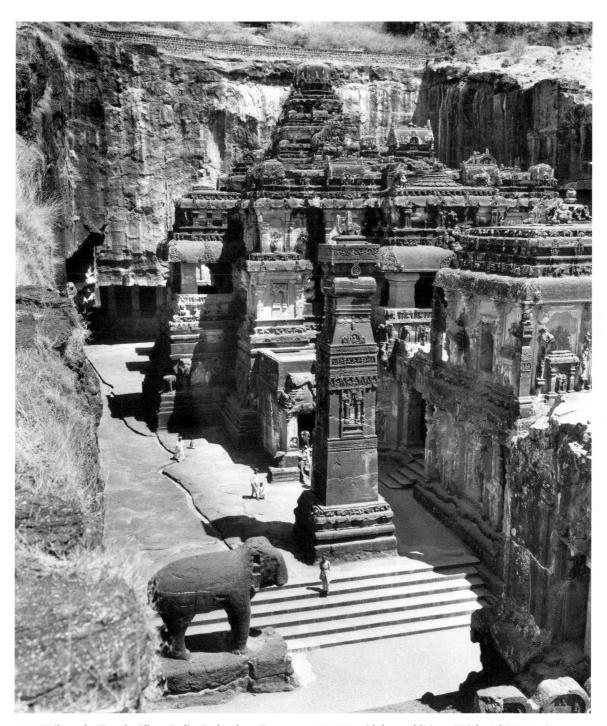

5.41 Kailasantha Temple, Ellora, India. Rashtrakuta Dynasty, c. 760-800, with later additions. Height 96' (29.26 m).

The site at Ellora (see map, p. 161) has thirty-four Hindu, Buddhist, and Jain rock-cut temples that date from the mid-sixth to the tenth century. The earliest temples are dedicated to the worship of the Hindu god Siva. They include elaborate pillared halls leading to shrines in the rear wall, which house lingams (stylized phallic symbols of Siva's procreative energies). By 600, some of the caves became centers for Buddhist worship, with Buddhist images carved both in the shrines of pillared halls and in the apsidal chaitya worship hall, where the Buddha is carved on the front of a monolithic stupa. Later, about 675 to 720, three-storied Buddhist caves focused worship on multiple Buddhas and other deities. A second wave of Siva worship in the eighth century included the building of this Hindu temple under the patronage of the Rashtrakutan monarch Krishna II (ruled 757-83).

Islamic Art at Córdoba

he scale of this enormous mosque built for Islamic worship reveals the religious fervor that characterizes much of the art and architecture produced in the period from 200 to 1400. In its present form, the interior of the Mosque at Córdoba is a vast column-filled space, 584 feet on the north—south axis and 410 feet on the east—west axis (fig. 5.42). It covers an area of 240,000 square feet, a space larger than any Christian church, including St. Peter's in Rome. This interior is viewed neither as a home of the gods nor as a place for liturgical worship. It is a place for the faithful to gather for prayer, facing toward Mecca together to emphasize the unity of the faith.

Today Islam is a worldwide religion of perhaps as many as 1.2 billion believers, with its largest populations in the Middle East, Asia, Africa, and parts of Europe. The term "Islam" refers to the religion, to the body of believ-

ers (who individually are known as Muslims), and to the areas in which they live. The youngest of the world's major religions, Islam developed in Arabia in the seventh century CE (see map, p. 153). The area had been a frontier of the Roman Empire and was a land of independent nomadic peoples, a few trade outposts, and conflicting religious traditions.

The founder of Islam was Muhammad, who was born in Mecca c. 570 and is recognized by Muslims as a prophet of divine revelation. When he was forced to flee Mecca in 622, he established himself in the rival city of Medina, where he gathered converts. The Muslim calendar dates from this flight, or hegira. In 630, Muhammad returned in triumph to Mecca. After his death in 632, the religion gained momentum and began to spread in Arabia and the Middle East.

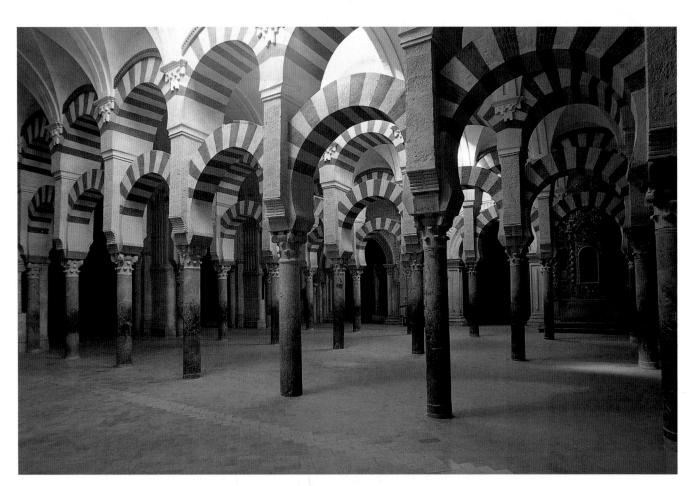

5.42 Interior, Mosque, Córdoba, Spain (see map, p. 163), begun 786. This is a view across the hypostyle hall, looking west. Originally commissioned by Caliph Abd ar-Rahman I ad-Dakhil ("the immigrant"); the later expansions were commissioned by Caliphs Abd ar-Rahman II and III, Al-Hakam II, and Al-Mansur.

When Córdoba was later reconquered by the Christians in 1236, a church (not shown here) was built in the middle of the mosque in an attempt to reclaim the whole structure for Christianity.

712 Japan's first history, the Record of Ancient Times, is completed

777 Charlemagne fails in his attempt to invade Muslim Spain

781 Christian monasteries are built in China

786 Mosque, Córdoba, begun (fig. 5.42)

787 Council of Nicea temporarily rejects iconoclasm

Muhammad himself set up no priesthood and no organized Church. However, the Koran, in which were collected the sayings of God as revealed to Muhammad, in Arabic, became the guide for all life's endeavors. The "Five Pillars" of Islam recorded in the Koran set out duties for all believers. First, one must recite the creed "There is no god but God: Muhammad is the Messenger of God." Second, there is the duty of worship and prayer after ritual washing and while facing the direction of Mecca, five times a day and in the mosque on Fridays. Third, one must completely abstain from food, drink, and sexual activity in the daylight hours during Ramadan, the ninth lunar month, when Muhammad first received revelations from God. Almsgiving is the fourth duty. Fifth is the duty of hadj, a pilgrimage to Mecca, which every Muslim should

undertake before death. The jihad (crusade) is not one of the pillars of Islam.

Islam, which developed later than Judaism, Christianity, and Buddhism, acknowledges the truths of these religions and believes itself to be their fulfillment. Indeed, Muslims believe that Abraham, Moses, and Christ all preached Islam but that their followers changed their teaching into the religions of today. In the Muslim view, only the Koran and Muhammad's preaching preserve unchanged the message of God. While Islam opens its ranks to all, stressing the unity of the faithful before Allah (God), regardless of race or culture, it was also, however, a national religion, firmly centered in Arabia and its political aspirations. As Islam expanded its political control, the purpose was to conquer, not to convert unbelievers. Those

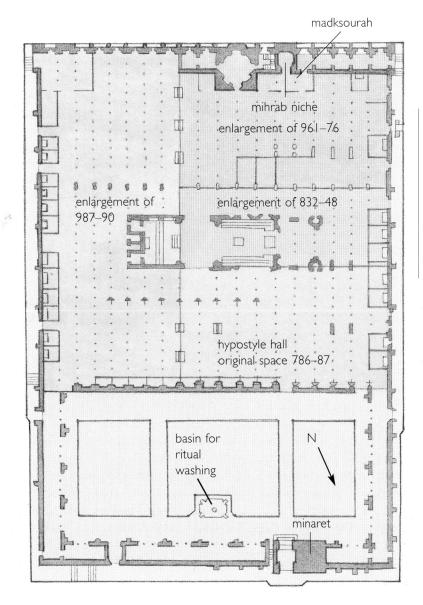

5.43 Plan of the Mosque, Córdoba, 786-990. This plan shows the enlargements of 832-48, 961-76, and 987-90.

The gibla and its mihrab at Córdoba do not literally face Mecca (today in Saudi Arabia), but they do indicate the direction of the road that leaves Córdoba for Mecca. The structure in the center that today interrupts the hypostyle hall is a Christian church erected within the mosque after the Muslims were driven from Spain in the late fifteenth century.

who wanted to share the privileged status could join Islam but they had to become Arabs by adoption, learning the Koran in Arabic and adopting the social, legal, and political framework of the Muslim community. Unlike the spread of Buddhism, Islam absorbed and adapted the conquered and their cultural heritage.

Early in the history of Islam, no demands were made on the visual arts. Muhammad condemned idolatry, and the Koran considered statues among the handiwork of Satan. Painting and representation were not specifically mentioned, but they were also generally avoided. During the fifty years following the death of the prophet, a Muslim place of prayer could be a Christian church or Persian columned hall taken over for the purpose, or even a rectangular field surrounded by a fence or ditch. These were the first **mosques**, or places for prayer.

Mosques of all periods have one element in common: the marking of the **qibla**, a wall that indicates which direction Muslims should turn when they pray; it faces Mecca and was often marked by a colonnade. By the end of the seventh century, Muslim rulers of conquered areas began to erect mosques and palaces on a large scale as symbols of power; their intent was to outdo pre-Islamic structures in both size and splendor. The conquerors drew on craftworkers gathered from Egypt, Syria, Persia, and even Byzantium, and often their designs and decoration echo their west Asian background.

By the eighth century, within a hundred years of the death of Muhammad, the Muslims had conquered and converted most of the Middle East, the African provinces of Byzantium, and even Spain, where they captured Toledo in 711. The Muslims entered Spain as a military force; lacking women, nearly all took Spanish wives. Furthermore, during this time many Christians converted to Islam and retained their Romance language, giving Islamic culture in Spain an unusual flavor that was soon reflected in architecture.

The greatest monument of the reign of the first Muslim ruler of Spain, the caliph Abd ar-Rahman I (ruled 756–88), was the Mosque at Córdoba, which he built in one year, 786–87. The building was necessitated by the increased numbers of Muslims who needed a place of worship. Abd ar-Rahman I purchased part of the site from the Christians, saving the rather short Roman and Visigothic marble columns and capitals that had been taken by the Christians from earlier buildings. These columns and capitals were incorporated into a new mosque. In part this was practical, but probably a more important explanation for their reuse was that it showed that a new religion was replacing the old. The Mosque at Córdoba became famous for the placement of double rows of arches above columns. The superimposition of two tiers of arches gave added height and spacious-

ness, while the long rows of columns and arches helped direct the worshipers' attention toward the qibla and, thus, the road to Mecca. The superimposed arches over columns were repeated by a succession of rulers as they enlarged the mosque in 832–48, 961–76, and 987–90. The first expansions enlarged the mosque in the original direction, but eventually the river that passes through Córdoba required an expansion to the side, as seen in the plan (see fig. 5.43).

The interior "forest of columns" in the mosque emphasizes the democratic nature of Islam and the fact that Muslim worship stresses personal contact with Allah. Individual worshipers who entered the mosque for service would begin praying at their own rate and not in concert with a leader or other worshipers. The red-and-white horseshoe-shaped arches seem to extend endlessly to either side (an effect not adequately conveyed in fig. 5.42), but the view ahead, the direction toward Mecca, is open and direct. The overall plan is a traditional Muslim one (fig. 5.43). Its rectangular perimeter encloses a forecourt with a basin for the required ritual ablution (washing). At one point, the qibla is hollowed out to form the sacred niche, or mihrab. Overlooking the courtyard is the minaret, the tower from which the muezzin ("crier") calls the faithful to prayer five times a day.

In 961–76, the caliph Al-Hakam II built a gleaming mihrab, preceded by a triple **madksourah**, or enclosure reserved for the caliph. The madksourah's three domes rest on interwoven multilayered arches (fig. **5.44**) and are faced with mosaics against a background in gold.

Unlike many other religions, Islam did not permit figurative representations of God or his prophets. Thus no living creature is represented on Islamic religious structures, and the manuscripts of the Koran are embellished with luxurious, calligraphic versions of Arabic lettering called **Kufic** (mistakenly named after the belief that the script originated in Kufa, in Iraq). Kufic script, complemented by abstract ornamental designs, became the main decoration in the form of inscriptions on mosques, secular buildings, and even utilitarian objects in metal, clay, and weavings in wool. At Córdoba, the dome before the mihrab is typical, for it includes a stylized gold inscription in Kufic script at its base and a web of ornament above and below; the various designs are disciplined by symmetry, repetition, and rhythmic order.

Mosques serve both religious and secular functions. Following prayer in the mosque, the man who led the worship or his representative might speak on secular matters. This Arabic respect for learning contributed to advances in astronomy, mathematics, medicine, and optics through centuries of support of its scholars. Such traditions continue in the modern world and predominate in Egypt, Syria, Saudi Arabia, Turkey, Albania, Iraq, Pakistan, Afghanistan, Iran, Yemen, Indonesia, Malaysia, Morocco, Tunisia, and Libya.

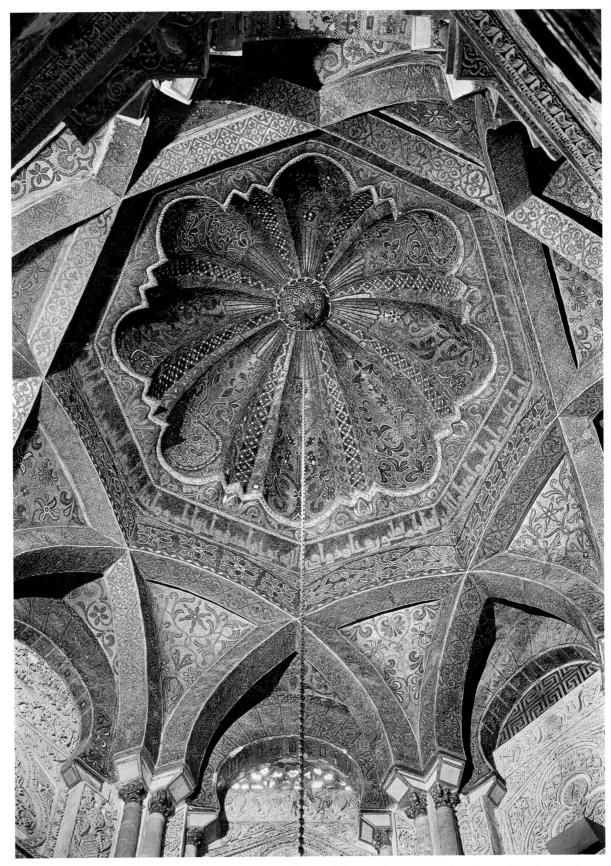

5.44 Central dome of the madksourah, the area in front of the mihrab, Mosque, Córdoba, 961–76. Colored stucco, tile, and glass mosaic. The dome is approximately 18' (5.5 m) in diameter. Commissioned by Caliph Al-Hakam II.

From the chain in the center of this dome was once suspended a silver lamp with 1,000 glass-cupped oil lamps. The ceiling of the small mihrab behind this is covered with a single large piece of stone, carved in the shape of a shell.

Carolingian and Ottonian Art

uring the reign of Charlemagne (ruled as king of the Franks 768-814), there was an interest in restoring the political unity and cultural ideals of the ancient Roman Empire. This can be seen in the image of Saint Matthew (fig. 5.45), which demonstrates how the art of this era could revive aspects of ancient classical style and yet remain true to medieval principles. Matthew wears a toga, and the modeling of the head, hands, and feet creates a sense of three-dimensional illusionism; the artist has clearly been inspired in part by a source imbued with the spirit of Hellenistic illusionism. In addition, the work shows the inspiration of Roman models in the seemingly spontaneous technique, but here the fluid strokes of the brush—developed in Roman art to suggest movement—express a frenzy of divine inspiration that threatens to subsume both figure and landscape. Shimmering gold highlights on the toga, hair, and landscape heighten the liveliness, for they appear and disappear with changes in the reflected light.

The term "Carolingian" refers to the reigns of Charlemagne and his immediate successors, although in terms of art the particular qualities of Carolingian art did not endure long after his empire was divided by three grandsons in 843. Charlemagne, whose seal read *Renovatio Romani imperii* ("the revival of the Roman Empire"), intended to create a Holy (that is, Christian) Roman Empire. He expanded the kingdom he inherited, establishing a buffer between it and the Islamic threat in Spain and the East. On Christmas Day 800, Pope Leo III crowned Charlemagne "Emperor of Rome" at St. Peter's Basilica.

Charlemagne's renewal included an interest in reform and education, and a demand for order and efficiency. He codified law, established a stable currency, ordered the establishment of schools, reformed monastic life, established a library, and encouraged the production of corrected copies of manuscripts. He required the use of a new, more easily readable style of lettering that is the basis of the typeface

5.45 Saint Matthew, from the Gospel Book of Archbishop Ebbo of Reims, produced in Reims, France, 816–23. Manuscript painting on vellum, 10½ × 8½" (26 × 22.2 cm). Bibliothèque Municipale, Épernay, France. Commissioned for Archbishop Ebbo under the direction of Peter, abbot of the monastery of Hautvillers.

816-23 Gospel Book, Reims (fig. 5.45)

c. 862 Earliest Russian state founded at Novgorod

still used in most books. Literacy was a major goal, in part because it would enable people better to understand Christian doctrine and to participate in services. Charlemagne could read, but Einhard, his biographer, tells that he also wanted to learn to write and that he kept notebooks under his pillow, so that "he could try his hand at forming letters during his leisure moments."

The Carolingian ideal of a world that would combine the greatness of the ancient past with the Christian vision is revealed in a letter that was sent to Charlemagne in 799:

If many people became imbued with your ideas, a new Athens would be established in France—nay, an Athens fairer than the Athens of old, for it would be ennobled by the teachings of Christ, and ours would surpass all the wisdom of the ancient academy. For this had only for its instruction the disciples of Plato; yet, molded by the seven liberal arts, it shone with constant splendor. But ours would be endowed with the sevenfold fullness of the Holy Spirit, and would surpass all secular wisdom in dignity.

Like Charlemagne, the Saxon prince Otto I (ruled 936-73) wanted to revive the ancient Roman Empire, and he brought Germany and most of northern Italy, including Rome, under his control before being crowned emperor by the pope in 962. Otto established a centralized government, and his lineage—his son Otto II, who married a Byzantine princess, and his grandson Otto III—ruled until 1002. Their reforms in education and monasticism were similar to those of Charlemagne, and Ottonian art flourished until at least the middle of the eleventh century. Ottonian patrons and artists continued elements of iconography and style from the Carolingian tradition, as well as from the ancient Roman, Early Christian, and Byzantine periods.

The Ottonian manuscript illumination of Christ Washing the Feet of Saint Peter (fig. 5.46), however, reveals some of the particular qualities of Ottonian art. Illusionism and the fluid touch of the brush that derived from the ancient world are here replaced with a flat, abstracted style that uses exaggeration, as in the arm and hand of Christ, to draw attention to his actions. The emphasis is on his divinity, as seen in the gesture of blessing, rather than on the mundane theme of the washing of feet. The placement of his haloed head in the center of the composition, against an empty gold field, emphasizes his majesty. The complicated architectural forms are inconsistent in perspective and out of scale with the figures, and serve only to inform the viewer that this is an indoor scene. The busy patterns of the drapery add energy, and the emphatic, staring eyes of the participants suggest that something significant is taking place. Beginning in the sixth century, Christ was most often represented as bearded; that he is clean-shaven here reveals the influence of Early Christian or Byzantine models.

The Carolingian and Ottonian emperors built largescale architectural projects in stone and supported active centers for manuscript illustration, ivory carving, and metalwork. The importance of political and economic stability for the production of works of art and architecture is clear in both cases, but the Carolingian interest in antique forms and style is replaced in the Ottonian period with an increasing abstraction that leads to later developments in European medieval art in the Romanesque period.

5.46 Christ Washing the Feet of Saint Peter, from the Gospel Book of Otto III, c. 1000. Manuscript painting on vellum, 8 × 6" (20.3 × 15.2 cm). Bavarian State Library, Munich, Germany.

This Gospel Book, created for the Ottonian emperor Otto III, is lavishly decorated with twenty-nine full-page illustrations of the life of lesus Christ and a double-page portrait of the patron.

The Monastery in the West

he **monastery** was perhaps the single most important institution in Europe during the medieval period, and the St. Gall plan reveals the activities of an ideal monastic community (fig. **5.47**). The central structure is the church itself, which has a basilical form following Early Christian models (see figs. 5.12, 5.13); the nave and side aisles provide the numerous altars needed because each priest was required to say Mass daily. At the western end of the church, two towers form an entrance facade known as a **westwork**. A Carolingian innovation in church design, the westwork was the source from which the traditional, two-towered church **facade** later developed (see fig. 6.30).

The subsidiary structures include a house for the abbot who ruled the monastery and, for the monks, a

complex that included a dormitory, latrine, bathhouse, and refectory (dining hall), as well as a cloister for walking and meditation. Outbuildings housed the kitchen, mill, bakery, drying house, brew house, storerooms, barns, workrooms for artisans, and other facilities necessary for a self-sufficient community of approximately one hundred people. There were also, set apart, a chapel and housing (novitiate) for those who were studying to join the monastery. A separate house with a kitchen was reserved for special visitors. The services provided to the public included an infirmary, complete with herb garden, and a hospital for the poor. Usually there was a lodge for travelers. In an area adjacent to the main altar were the library and the scriptorium, where manuscripts were copied and illustrated. The

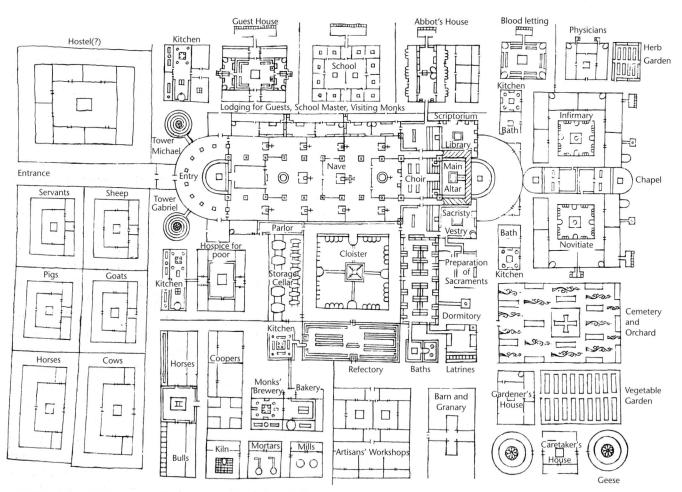

5.47 Plan of St. Gall Monastery, Carolingian, c. 819. Traced and drawn on five pieces of parchment sewn together, $3' 8'' \times 2' 6'' (112 \times 76 \text{ cm})$. Monastery Library, St. Gall, Switzerland.

This Carolingian plan represents an ideal formula to be adjusted for each particular site. It even suggests the appropriate location of furnishings. Its orderly design may be related to the reforms of the monastic system within the Carolingian Empire, discussed at meetings in Aachen, Germany, in 816 and 817. Not a document that normally would have been saved, it may have survived only because a life of Saint Martin was written on the back.

813-33 Literature, theology, philosophy, mathematics, and the natural sciences flourish in Iraq

c. 819 St. Gall monastery plan (fig. 5.47)

826 Crete is conquered by Muslim pirates from Spain

828 Ptolemy's Astronomy translated into Arabic c. 900 Vikings discover Greenland

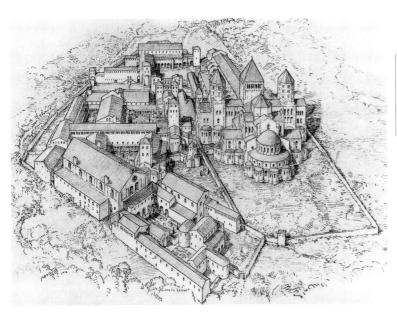

5.48 Reconstruction of the Romanesque monastery and third church, Cluny, France, c. 1157.

The huge Romanesque church seen here, the largest in Europe at the time of its completion, was begun in 1088 under the aegis of the abbot, Hugh de Semur. At the time of this reconstruction, the monastery probably housed about 300 monks and priests. The church and monastery were largely destroyed by Napoleonic edict in 1810.

orchard served as the monastic cemetery. The complex seen here would have been surrounded by vast fields worked by the monks and hired laborers.

Monasticism has its roots in the early days of Christianity in the Middle East and Egypt, when many Christians retreated into the desert or lived in caves in order to spend their lives praying, remote from the distractions and temptations of the world. Many chose to live a life of complete isolation, but some banded into communities that mark the beginnings of the monastic tradition. During the sixth century, Saint Benedict gathered so many followers that he wrote a rule for their behavior. This became the basis for later medieval monastic organization, in part because Charlemagne imposed it on all monasteries in his empire; by the seventh century, a variant of the Benedictine rule was in use for women. Benedict required that the monks remain within the monastery for life and that they observe poverty, chastity, and obedience. A simple, humble garment and hairstyle were specified. The monks swore obedience to an elected abbot; daily life was a well-organized regimen of work, study, and prayer. There were at least eight daily services of psalms, hymns, and prayers. Work included all aspects of labor. Many monks and nuns became skilled in the arts, but Benedict's rule warns against the pride that could accompany artistic achievement:

Let such craftsmen as be in the monastery ply their trade in all lowliness of mind if the abbot allow it. But if any be puffed up by his skill in his craft ... such a one shall be shifted from his handicraft, and not attempt it again until such time as he has learnt a low opinion of himself, and the abbot bids him resume.

Through an emphasis on literacy and education, which were required to participate fully in the Christian life, the monasteries played a vital role in continuing and preserving the Western heritage. A number of ancient works of literature, science, and philosophy survive only in copies handwritten by monks and nuns.

During the Middle Ages, monastic orders proliferated, but their rules were similar. During the Romanesque period, most monasteries were located in the country, away from the temptations of city life and other human beings. In the thirteenth century, two new orders, the Franciscans and the Dominicans, were approved by the pope. They emphasized public service and education in the urban environment, and their monasteries were established within cities to better serve the sick and the urban poor (see p. 209).

No monastery was built that exactly followed the design of the St. Gall plan, in part because any complex of such scale would evolve slowly over time and in relationship to its particular setting. The Romanesque monastery at Cluny, however, can be studied as a fully developed example (fig. 5.48).

Cluny, the mother church of a reformed Benedictine order that played an important role in monastic renewal during the eleventh and twelfth centuries, became a center for learning and patronage of art. It was famous for the splendor and beauty of its services, and its third church, begun about 1085 and consecrated in 1131-32, was, with a length of 555 feet (169.2 m), the largest church in all Europe. The monastic complex at Cluny has virtually all the same facilities as the St. Gall plan; especially impressive is the amount of space given over to the huge public infirmary.

Buddhist Art in Indonesia

he Buddhist temple called Borobudur (fig. **5.49**) is situated on a hill above a fertile plain in central Java (see map, p. 161). According to legend, Borobudur was designed by a divine architect named Gunadharma, whose profile is said to be visible in the outline of nearby mountains. Far from having been the work of a single designer, however, Borobudur was remodeled four times within its first century. Originally the site was recognized as sacred by the Hindus, who began to erect a structure on the hill around 780. Workers cut terraces into the sides of the hills and erected a stone structure with three levels that correspond to the first three levels of the current monument.

The current stepped shape was built by the Buddhists partly to take advantage of the earlier foundation.

From this base rise five square terraces with **balustraded** galleries. The inner and outer walls at each level are covered with carved panels illustrating the path toward enlightenment. The galleries are illustrated with relief carvings of Buddhist scenes: jataka tales, scenes from the life of the historical Buddha, and scenes from the lives of bodhisattvas.

The three circular terraces at the top hold seventy-two stone **stupas**, each about twelve feet high. The diamond-shaped perforations carved into the stupas on the two lower terraces express the idea of change and movement. On the top terrace, the square openings are thought to express calm and stillness. Each stupa contains a sculpted figure of the Buddha visible only as the monument is ascended. The

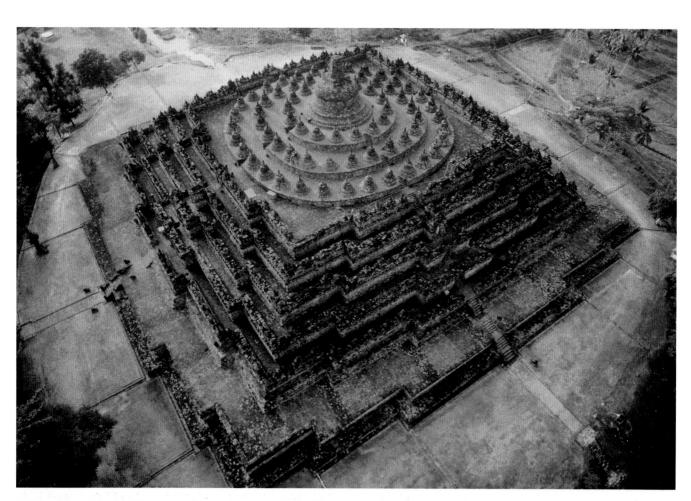

5.49 Buddhist Temple of Borobudur, Java, Indonesia. Sailendra Dynasty, 835–60. Lava stone; perimeter of lowest gallery 1,180' (360 m); diameter of crowning stupa 52' (15.85 m).

Borobudur was rediscovered by Europeans in 1814, but few could understand it because of their inability to read Asian languages and the scripts in which Buddhist texts were written. Although the Javanese are predominantly Muslims today, they prize this monument and rescued it from neglect and severe water and atmospheric conditions through a ten-year restoration that concluded in 1985. Borobudur was built by a family of kings known as the Sailendras, or "Lords of the Mountains." The Buddhist ruler who started work on Borobudur was named Indra, after the god who lives on top of Mount Sumeru and who appears in several sculpted reliefs of the lower galleries.

5.50 Prince Sudhana's Search for Enlightenment, upper terrace, Temple of Borobudur, 835-60. Lava stone, height 20" (50.8 cm).

monument is crowned with an enormous stupa containing an unfinished figure of the Buddha.

Borobudur is thought to have served many purposes, and it has been interpreted in many ways: as a visualization of the doctrine for the initiate; as a mandala for meditation (see fig. 7.4); as a symbolic mountain; and as a stupa that was a center of ritual activity in the Buddhist world. Borobudur's design is most commonly compared to the Diamond World mandala, a type associated with the esoteric Tantric Buddhism practiced in Tibet and Nepal. Borobudur's form and hilltop location recall the setting of the jewel tower on Mount Sumeru (the World Mountain), where the Diamond World mandala was first described as being located in Tantric cosmology. Tantric meditative practice consists of simultaneous control of speech, mind, and body through visualization of divine images or mandalas; the goal is liberation from the cycle of life, death, and rebirth. We have no proof, however, that Borobudur was actually used as a mandala.

Borobudur's most convincing interpretation is as a stupa and symbolic mountain, an interpretation that combines both Javanese and Buddhist concepts. Some scholars argue that the stupa on top of the monument originally contained a Buddhist relic. It seems that Javanese Buddhists came to Borobudur as pilgrims—to climb this holy, human-made mountain and thus attain spiritual merit. This stepped pyramid provided a place where Buddhists could physically and spiritually pass through the ten stages of development that could transform them into bodhisattvas—enlightened disciples of the Buddha.

As a symbolic mountain, this human-made holy monument can be understood as a continuation of the hill on which it sits. Mountains were important religious symbols in both pre-Buddhist Java and in the imagery of Mahayana Buddhism. Mahayana Buddhism taught that salvation was open to all through faith and work, and Buddha became a godhead who was far beyond the reach of mortals. The Javanese tradition of building terraced sanctuaries on high places to evoke the idea of a holy mountain began in prehistoric times and continues today.

Mountains were equated with powerful spiritual forces, and as the pilgrims approached Borobudur they could see hundreds of statues gazing over the surrounding plain. In addition, the statues in niches suggest Javanese ascetics meditating in mountain caves as well as the gods who live in the caves on Mount Sumeru. The statues suggest that the pilgrim may have to endure self-denial and overcome physical discomfort in order to gain the highest stage of development when reaching the stupa at the summit.

In order to follow the complete narrative sculpted in the reliefs, the pilgrim had to make ten circuits—four times around the first gallery and twice around each of the next three. While moving upward, the pilgrim was symbolically retracing the steps of those bodhisattvas who had attained enlightenment by passing through all ten stages of existence. The 1,460 narrative panels on the monument were created to illustrate Buddhist scriptures: the Vision of Worldly Desire; the Jataka Tales, or the Previous Lives of the Buddhas; and the Life of the Guatama Buddha. Fig. 5.50 illustrates a scene describing Prince Sudhana's search for enlightenment from the epic Travels of a Young Man in Search of Wisdom. The content of the relief is absolutely clear, for the figure of the prince is sheltered by a royal umbrella and his elaborate headdress sets him apart from the other figures. The rounded, sensuous treatment of the figures is derived from earlier Indian art.

Chinese Art: Landscape Painting

n this landscape attributed to Li Cheng (active from about 940 to 967), the autumn skies are clearing, leaving mist in the valleys and above the mountain pathways (fig. 5.51). In the immediate foreground are a group of huts and two pavilions built over water. The buildings and figures are painted with such detail that we can distinguish peasants and courtiers at their meals in the rustic inn, and scholars at the wine shops gazing off into the landscape from the pavilions. The temple that occupies the center of the painting is parallel to the peaks that dominate the distance. Such axially-symmetrical configurations of mountains and water have been related to the qualities of the Chinese Empire in the tenth century—grand, ordered, and powerful.

Li Cheng as a person was thought to represent the ideal Chinese literati painter: he was an artist who claimed descent from the imperial clan of the Tang Dynasty (618–907); he was educated in the humanities through study of the *Classical Texts* (ancient writings on history, philosophy, and literature); and he was occupied with painting for his own delight without ambition for honors or advancement. A scholar, he enjoyed a life devoted to the philosophic study of Nature as opposed to merely copying forms in the out-of-doors (nature). **Monochrome** ink paintings of landscape were the preferred type of art produced by Li Cheng and his colleagues.

Like many other landscape painters of the tenth century, Li Cheng had a preference for autumnal or wintry scenes full of bleak, stony crags, gnarled trees with leafless crab-claw-shaped branches, and looming distant peaks. He lays monochrome ink on the silk in broad and jagged strokes to describe the essential outlines of the rocks, trees, and buildings. These shapes are then broken up and modeled with washes of ink, on top of which are placed cun, small brush-strokes dabbed on quickly to create the sense of texture (fig. 5.52). Such paintings were then mounted as a vertical hanging or horizontal hand scroll. Closely associated with calligraphy, the brush paintings of China were produced for and by the intelligentsia, who painted as an avocation. There was no art market in China at this time, but frequently painters would present their works to friends or officials.

The particular Chinese doctrine of realism seen here aims for truth to natural appearance, but not at the expense of suggesting how Nature operates. Li Cheng's bent and twisted trees, for example, are organically constructed to expose their skeletal structure—roots, trunk, branches, as well as dormant buds, ready for spring awakening. This approach to realism also explains the use of **shifting perspective** in Chinese painting. We are invited to "enter" the

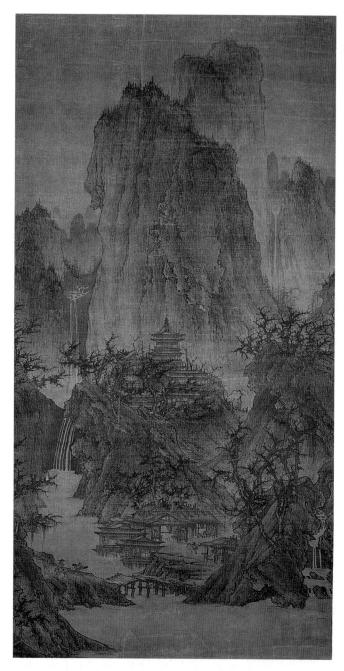

5.51 Li Cheng (attributed), *Buddhist Temple in the Hills after Rain*, Five Dynasties/Northern Song Dynasty, c. 950. Hanging scroll, ink and slight color on silk, height 3' 6" (1.07 m). The Nelson-Atkins Museum of Art, Kansas City, Missouri. Commissioned by the imperial court.

The red ink markings seen in the lower right were stamped using carved stone stamps and were made by later owners of the painting to record their possession. The silk on which this scene was painted has darkened, changing the tonal relationships. The authorship of few tenth-century landscape paintings is known with certainty, but descriptions of the works of these artists by critics of their own time make attributions such as this one possible.

c. 950 Li Cheng (attributed), Buddhist Temple in the Hills after Rain (fig. 5.51) 1002 Leif Eriksson explores the coast of North America

1006 Muslims settle in India

1014 Irish king Brian Boru rules near Dublin

1061-91 Normans drive the Arabs from Sicily

picture on the lower left and to explore Nature as we move through the landscape. We can wander across the bridge, look down at rooftops, up at the pavilions and the temple, and across to the towering peaks, but we cannot encompass a panoramic view from a single position outside (or inside) the painting. Rather, little by little, nature is revealed as if we were actually walking in the out-of-doors. In this sense, the Chinese landscape painter combines the element of time in much the same way as it is experienced in music. Shifting perspective creates the effect of a journey and encourages a powerful personal impact on the viewer. These paintings were meant to be visual exercises that supported an examination of both the structure of Nature or the universe and the contemplation of minute details. The power of these paintings is to take us out of ourselves and to provide spiritual solace and refreshment.

Guo Xi, the most famous pupil of Li Cheng, declared in an essay that "The virtuous man above all delights in landscapes." The virtuous (or Confucian) man during this period accepted his civil responsibilities to society and to the state, which tied him to an urban life as an official, but he could nourish his spirit by taking imaginary trips into nature through viewing a landscape painting such as Guo Xi's Early Spring (see fig. 1.4).

5.52 Buddhist Temple in the Hills after Rain, detail.

There was important support for landscape painters during the Five Dynasties (907–60) and the Northern Song Dynasty (960–1126). The year 953 saw the initial printing of the Classical Texts; for the first time, books became not only inexpensive but also abundant. As a result, the knowledge of ancient literature grew and the number of scholars at court increased. The political consequences of the expansion of the literate class became apparent during the Song Dynasty, the third centralized empire in Chinese history. The unification of this empire was the result of policy rather than conquest, resulting from the goals of an aristocracy weary of disunion. Over time, the traditional civil service examination system returned civilians to positions of prestige and power in government that had been lost to them under the previous military dictatorships. Pacifist policies and a series of sovereigns who were tolerant, humane, artistic, and intellectual provided consistent patronage for the arts. The art collection of the Song emperor Hui Zong (ruled 1100–26; see fig. 5.33), for example, was said to include 159 paintings by Li Cheng. The Song period produced the first important

academy of painting in East Asia; among the early members were the landscape painters.

Intellectual activity during the Song Dynasty included poetry, history, and, especially, philosophy. Characteristic of Song thought was the return to older Chinese sources that resulted from a conscious archaism and cultural introspection. The renaissance of classical literature led to the formation of a new system of philosophy called neo-Confucianism, which enveloped traditional moral and ethical teachings with Daoist thinking about nature and the cosmos, especially as presented in the *I-jing*, or *Book of Changes*. No distinction was made between the laws of nature and moral law. The world was thought to be inspired by the "Supreme Ultimate" (or what the Daoists called the dao, or the Way); the neo-Confucianists referred to this as *li* (law), a moral law that was identical to the Chinese ethical code for human conduct. Song thinkers were also interested in correspondences between life and the laws of the cosmos. The manifestation of li in painting included faithfulness to nature as well as conventionalized symbols for representation of rocks, foliage,

5.53 Xia Gui (attributed), Sailboat in the Rain, Song Dynasty, c. 1180. Fan-shaped album leaf, ink and light color on silk, each $9\% \times 9\%$ " (24 × 25 cm). Chinese and Japanese Special Fund. Courtesy Museum of Fine Arts, Boston. Commissioned by the imperial court.

The inscription in the album leaf to the left of the painting is written by the Emperor Gaozong (1127–1162) of the Southern Song Dynasty, and is based on an earlier poem by Su Shi (1036–1101), a Northern Song poet. The Emperor changed some of the words in the original to suit his own mood:

While sailing through endless rain, I enjoyed a good sleep. While boating all day long, we cut through the wind from the shore. bark, water, and so forth. Li also governed the way a picture was put together.

Under pressure from the Jin Tartars on the northern borders of China, the Song court fled to the south in 1127. In 1135, a new capital was founded at Hangzhou (see map, p. 161), where the academy of painting was reestablished under imperial patronage and an imperial art collection was assembled that was intended to equal that of the Northern Song emperors. The Southern Song rulers were even more concerned with internal affairs than their predecessors, and a new mode of painting evolved that focused on the depiction of the details of nearby nature.

Later Southern Song landscape painters such as Xia Gui (active 1200-1230) concentrated on the rivers, lakes,

and mists of south China (fig. 5.53). Xia Gui developed a shorthand manner in which forms are suggested rather than depicted, as they had been in the earlier style of Li Cheng and Guo Xi. His softer and less literal expression is organized asymmetrically, in a style called a "one-corner" composition by the Chinese. Xia Gui evokes a mood rather than describing a particular place. There is more mist than detail, and his subjective expression omits large sections of the landscape to concentrate on close detail. He and other painters at court were associated with the weak and ineffectual court of the Southern Song in subsequent periods. For later Chinese critics, who commingled aesthetic and moral judgment, these Southern Song paintings were less highly valued than they were in Japan and the West.

ART PAST/ART PRESENT

Chinese Aesthetic Theory

Chinese painting derives from the art of Chinese writing and is, therefore, a linear art, with its brushwork derived from calligraphic formulas. The highest aesthetic aim of the literati painters was to capture the spirit of what was depicted, rather than its appearance (see fig. 6.4). For these painters, the creative process embodied the dao, or Way of Nature, with its holistic vision of the unity between the organic qualities of Nature and Nature's metaphysical properties. In many Chinese paintings, idea and technique become one; both the act of painting and the picture itself carry meaning. Interestingly, these literati artists did not create sculpture or architecture, which were the work of persons who were considered in Chinese society to be highly skilled artisans.

Among the Chinese aristocracy, painting, poetry, and calligraphy preserved social, political, and aesthetic values. The earliest-known treatise on aesthetics was written in China in the second quarter of the sixth century by Xie He (c. 500-c. 535). Called the Gu hua pin lu (Classified Record of Ancient Painters), it ranked earlier painters into six classes. Its Preface lists Six Canons of Painting that were used to judge painters and paintings. Because its language is filled with abstract philosophic thinking and presents generalized and theoretical prescriptions for painting, the canons have been translated and interpreted many times. An approximate translation of the canons is:

- A painting must have spirit or breath of life (qi yun).
- The brushwork must be structurally sound.
- The painting must faithfully portray forms.
- 4. A painting must have fidelity of color.
- A painting must also be a properly planned composition.
- A painting must transmit knowledge of past painting traditions.

The first canon, which can also be translated as "animation through spirit consonance," emphasizes the need for a painting to have qi yun. Qi was identified as the cosmic spirit that vitalized all things, so capturing its essence was fundamental for a "good" painting. Canons 2-5 clearly concentrate on technical matters, while canon 6 emphasizes reverence for tradition. Each generation of artists established a sense of external and internal reality in painting that could be challenged and reconsidered during the following period. Xie He's treatise remained the backbone of aesthetic criticism until the modern period in China, when its imperial, elitist roots were challenged by the new socialist policies that took control during the twentieth century.

The ideals of painting of the tenth century were written down by a contemporary of Li Cheng named Ching Hao. In his essay Record of Brush Methods, or Essay on Landscape Painting, Ching Hao recorded his thoughts through a narrator, an old man whom he pretended to meet while wandering in the mountains. This wise man told him that the six essentials of painting were: "spirit, rhythm, thought, scenery, brush, and ink."

This logical system, based on Xie He, first lays down the concept of painting and then its expression. It also distinguishes between resemblance, which reproduces the outward aspects of what is depicted, and truth (or spirit), which involves knowing and representing the inner reality of the scene being depicted. Attaining the correct balance between representing visible forms of nature and their deeper significance was the ultimate goal of these Chinese painters.

6.1 *Siva Nataraja (Lord of the Dance)*, Indian Hindu. Chola period, eleventh century. Copper, height 3' 7%" (111.5 cm). Cleveland Museum of Art, Ohio.

Art from 1000 to 1400

A BRIEF INSIGHT

n many parts of the world, the interest in the production of religious art continued unabated during this period. In many instances the relationship between political organization and religious art also continued to be important.

To introduce this period, we illustrate a bronze figure of Siva (fig. 6.1), the third member of the Hindu triad, represented in a dancing pose. While ritual dance is still a part of Hindu devotion, the dance of Siva shown here is a dance of cosmic importance. In one of his four hands he holds fire, and the circle of the sun that encloses his dance is edged with flames. The god's dance destroys the universe by fire, but only so it can be born anew. The new creation is symbolized by the drum held in another hand, the rhythmic beat of which encourages cosmic rebirth. That the bronze surface is highly polished is no surprise, for in Hindu mythology the universe becomes a manifestation of the light that reflects off Siva's moving limbs. The dwarf on whom Siva stands is Apasmaru, a symbol of ignorance. As Siva does this dance not just for the world as a whole but also for each individual person, the sculpture would have a strong personal meaning. The use of complex symbolism to represent issues of universal importance is an aspect common to religious art around the world.

When a work such as this one is displayed in museums, its status as a work of art is emphasized while its use as a ritual object is deemphasized. In its devotional context, this figure would probably have had a brilliantly colored cloth draped over his shoulders, and offerings of flowers and fruit placed at his feet.

Introduction to Art from 1000 to 1400

6.2 Reliquary in the shape of a church, from the convent of Hochelten in the Lower Rhine region of Germany. German Romanesque, c. 1170. Gilt cast bronze, enamel, and walrus ivory reliefs on a wooden core, height 1' 9½" (54.6 cm). Victoria and Albert Museum, London, England. This reliquary was probably made by a workshop in Cologne, Germany.

uring the period 1000-1400, the traditions Hinduism, Shinto, Buddhism, Judaism, Christianity, and Islam discussed in the previous chapter flourished and expanded. As an example of the continuing importance of religion during this period, we illustrate a small object shaped like a domed church (fig. 6.2) that functioned as a reliquary—a container for the bones of a holy person or for objects associated with one or more such persons (see also fig. 6.8). Reliquaries like this one were displayed to the Christian faithful, who hoped to benefit from their proximity to such holy things. While the specifically Christian content of this object is evident in the iconography of the reliefs, which feature Christ, the apostles, and scenes from the life of Jesus, including the crucifixion, as well as Jewish prophets whose writings were interpreted as predicting the coming of Christ, the use of reliquaries that preserve remains of holy figures is also found in Buddhism and Islam.

The Christian ideal of the Heavenly Jerusalem as a city surrounded by gold, bejeweled walls, as mentioned in the Bible, may have suggested the richly colored enamels and carved panels of the reliquary. This object was useful in confirming faith and in expressing the spiritual goals of Christianity; because important relics brought pilgrims to a church and, therefore, wealth to the local community, they also had a commercial and political function.

HISTORY

In this era, commercial, intellectual, cultural, scientific, and religious exchange increased, but the period also saw the beginnings of conflict between rival cultures and religions. The pilgrimage roads in Europe led the devout from northern Europe down to Spain and Italy (fig. 6.3). It was a time of cultural expansion and colonization into Central Asia, China, Southeast Asia, and Indonesia. The Crusades, which were preached as "Holy Wars" against the Muslims, led to increased contact between the Christian West and Islam. That the silk road continued to flourish is documented by the Venetian Marco Polo, who traveled east to the China Sea between 1271 and 1295; he wrote about his travels in his Description of the World, which was spread through dozens of translations and hundreds of manuscripts (see fig. 7.11). Polo studied not only China's natural environment but also its economy (which already used paper money), its architecture, its urban planning, and especially its industries, many of which were more advanced than those in Europe at the time. On his return home, he described additional observations and recorded stories he had heard about Java, India, and areas of Africa. His observations influenced Western perceptions of the East for centuries, while the success of his travels encouraged others interested in the trade in exotic goods to undertake similar explorations in hopes of commercial success. Ni Zan's painting of the Rongxi

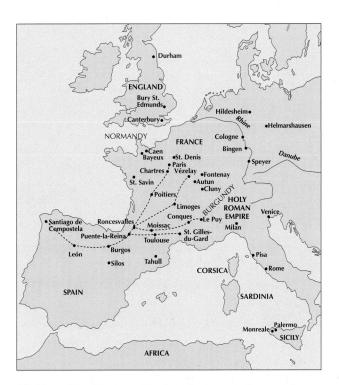

6.3 Map of the Pilgrimage Roads to Santiago de Compostela.

Studio (fig. 6.4) is the style of Chinese painting that Marco Polo might well have seen at the home of the Chinese literati. As large and powerful cultures and religious traditions developed, there was also contact through wars, including the religious and commercial wars in the eleventh, twelfth, and thirteenth centuries known as the Crusades.

For the role of the artist in society during this period, see p. 148. During the period 1000-1400 in the west, gradually more and more artists sign their works or are known through documentation as individuals. In China, however, this was a long established tradition that even included portraits of artists, as in the Portrait of Ni Zan (fig. 6.5).

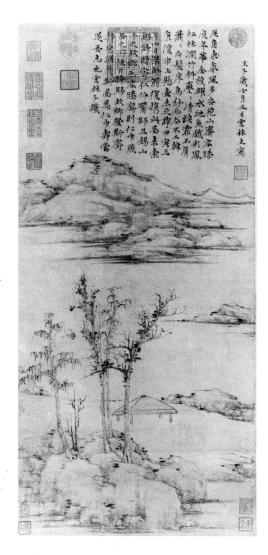

6.4 Ni Zan, Rongxi Studio, 1372. Hanging scroll, ink on paper, height 2' 5¾" (74.68 cm). National Palace Museum, Taiwan, Republic of China. For a portrait of Ni Zan, see fig. 6.5.

6.5 Unknown Chinese painter, Portrait of Ni Zan, Yuan Dynasty, c. 1340. Scroll, ink on paper, 111/8" × 2' (28.5 × 61 cm). National Palace Museum, Taipei, Taiwan, Republic of China.

Chinese literati painters worked alone, seated at desks in their studios. They painted on the flat surface of the table, using natural-bristle brushes in watercolor and ink on silk or paper. For a painting by Ni Zan, see fig. 6.4.

Amber Necklaces in Burials in Eastern Asia

These lavish amber beaded necklaces (fig. 6.6) were found around the neck of Princess Chen (died 1018) when her tomb was opened in 1986. She was royalty of the Liao Empire (907-1125), which ruled from the Sea of Japan to the Altai Mountains, an area equivalent to most of present-day northeast China, Inner Mongolia, and Mongolia. The Liao descended from nomadic peoples of the grasslands of eastern Inner Mongolia, which remained their political, economic, and cultural center where they buried members of the imperial family, including Princess Chen.

One of her necklaces is formed by five strands of irregularly shaped amber beads strung together with five amber plaques of zoomorphs as spacers, while the second is a single strand of beads spaced with similar zoomorphic-shaped spacers and two amulets of a type usually found in the clenched fists of the deceased. The spacers are carved in the shapes of birds, fish, animals, and flowers. These designs each symbolized a wish for good luck and happiness, and acted as charms or talismans against evil.

Although Princess Chen's necklaces were probably made by Chinese artisans, necklaces strung with spacers are Indian in origin and can be seen on certain Buddhist images in India, on much earlier fifth- and sixth-century Chinese images, and on paintings at sites along the Silk Road. The amber used to make the beads for Princess Chen's necklaces is from both the Baltic region in northern Europe and from local sources. These necklaces reflect the development across the whole of Eurasia of an international style that resulted through trade interactions and the exchange of religious ideas.

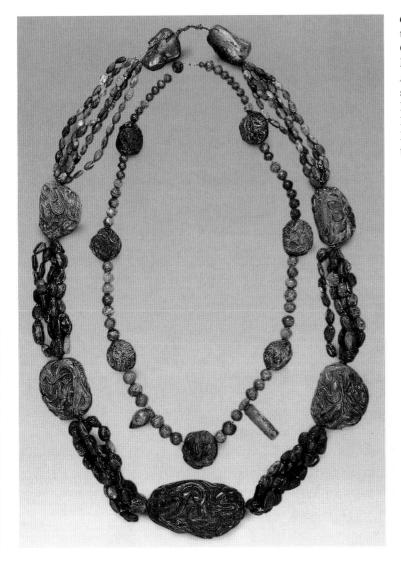

6.6 Two Amber Bead Necklaces, excavated from the tomb of Princess Chen and Xiao Shaoji at Qinglongshan Village, Naimar Banner, Inner Mongolia, PRC. Liao Dynasty, 1018, or earlier. Amber. Necklace, length 5' 21/2" (159 cm); singlestrand necklace, length 3' 8½" (113 cm). Research Institute of Cultural Relics and Archaeology of Inner Mongolia, Hohhot, Inner Mongolia, People's Republic of China. Commissioned by the Princess of the Liao, or her family.

Narrative Art

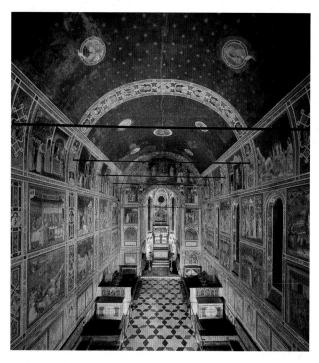

6a Giotto, frescoes, Arena Chapel, c. 1303–05 (for further information, see fig. 6.45 and pp. 240–41).

Telling Stories

(figs. **6a** and **6b**) Everyone loves a good story, whether it is a prolonged tale of personal adventure or a brief joke, and the telling of stories has provided a challenge for artists since prehistoric times. During the period from 1000–1400, a new interest in representing complex narratives is evident in both East and West. Giotto's Arena Chapel frescoes, for example, illustrate the lives of the Virgin Mary and Jesus Christ. Giotto's storytelling proceeds left to right from scene to scene, almost as if it were written as a text. Giotto's painted scenes emphasize major episodes while illustrating subtle details that enrich both

6c Wandjuk Marika, *The Birth of the Djang'kawu Children at Yalanghara*, detail, 1982 (for further information, see fig. 13.36 and p. 593).

the individual scene and the narrative as a whole (see pp. 240-41). The Japanese artist of The Tale of Genji scroll is a less direct storyteller. His scenes of intrigue and tragedy in Japanese court life require contemplative appreciation, with the allusive depictions of architectural space playing an important role in expressing the emotional life of the characters. The Japanese scroll tells its story from right to left, in adherence with the direction in which Japanese is read, and—because the hand scroll is easily viewed by only one or two individuals at one time—it is intended as a more intimate experience than public chapel walls decorated with paintings. This contrast in the treatment of narrative is revealing, for in the Western tradition the goal is usually to logically clarify the story, while in the East more feeling is demanded of the "reader" in understanding the narrative development.

6b Takayoshi (attributed), Illustration from *The Tale of Genji*, c. 1120–30 (for further information, see figs. 6.20, 6.21, and pp. 216–19).

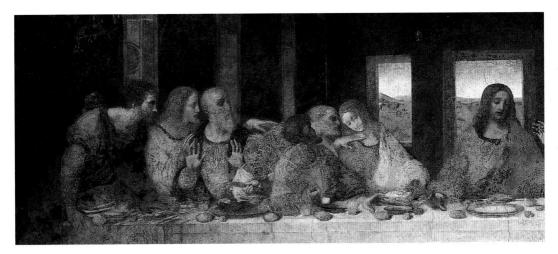

6d Leonardo da Vinci, Last Supper, detail, c. 1495–98 (for further information, see fig. 7.52 and pp. 292–93).

Compressing the Narrative

(fig. 6c) Less than fifteen feet (or two meters) square, this painting by the Australian aboriginal artist Wandjuk Marika nevertheless relates the major components of a complex creation and journey myth. The flattened forms, repetitive patterns, and scale differences aid the artist in conveying the essence of the myth. In this case, the sequence of three scenes reads from top to bottom.

Narrative Simultaneity

(fig. 6d) Leonardo's Last Supper is remarkable for the simple, centralized composition with which it embodies a complex event. Leonardo does not represent a single moment in the narrative, however, but rather he hints at the sequence: the announcement of the betrayal, the blessing of the bread, and the distinctive reactions of the apostles, especially that of Judas, are all represented simultaneously. The thoughtful viewer can sense not only

6e Edvard Munch, Photograph of installation, 1903 (for further information, see fig. 11.77 and pp. 494-95).

the development of the narrative, but also how its several episodes are interrelated.

A Modern Narrative

(fig. 6e) The Norwegian artist Edvard Munch's Scream (see fig. 11.76) stands alone as a powerfully expressive work, but it gains further meaning when seen in the context of an exhibition of works from this same period shown in a sequence designed by the artist. The full title of the exhibition, Motifs from the Life of a Modern Soul, and the titles of other included works—Death and the Child, Angst, Death in the Sickroom—reveal the emotional and psychological traumas that Munch set out to represent. In studying his narrative, the viewer is forced to confront the difficult issues of human existence.

Ouestions

Think of your favorite illustrated childhood book and, if you no longer own a copy, perhaps find one in your local library.

- 1. How is the story being told through the illustrations? Is the illustration style (color, use of line, composition on the page, level of detail) appropriate for this particular story? How?
- 2. An illustrated book is by definition composed of a sequence of individual scenes. What additional scenes do you wish had been included by the original author/illustrator? Which of the images in the book seem superfluous to telling the story, and why do you think they were included?
- 3. Perhaps this story also found its way into the movies. If so, how was the continuous flow of the movie different from the sequential illustrations in the original book? In your opinion, which medium—book or movie captured the essence of the narrative more successfully?

Romanesque Art in Europe

he term "Romanesque" ("Roman-like") was first applied in the nineteenth century to designate European medieval art of the tenth to the midtwelfth century, which is distinguished by a widespread revival of monumental architecture in stone, sculpture, and large-scale mural painting. In the Tahull apse painting (fig. 6.7), the enthroned Christ in Majesty, surrounded by a mandorla, is symmetrically flanked by angels and the tradi-

tional symbols of the Evangelists: the angel stands for St. Matthew; the lion for St. Mark; the ox for St. Luke; and the eagle for St. John (not visible in our illustration). The row of standing saints below includes the Virgin Mary. We have seen the hierarchical presentation and iconlike stare of the figures in Byzantine art (see fig. 5.2), but here the abstraction seen in earlier European medieval art has been intensified and the drapery folds now have a life of their own;

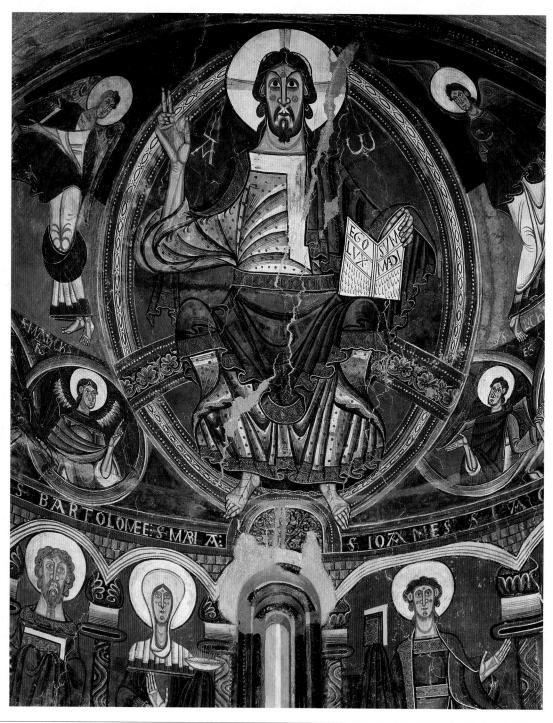

6.7 Christ in Majesty with Angels, Symbols of the Evangelists, and Saints, from San Clemente, Tahull, Spain, c. 1123. Apse fresco, diameter of apse approx. 13' (3.96 m). Museo de Arte de Cataluña, Barcelona, Spain.

instead of being used to reveal the body beneath the drapery, as in the Hellenistic illusionistic tradition, they flutter and fold in abstract patterns. Each body part is treated independently, with heads and hands exaggerated in scale. Foreshortening is avoided, as seen in the unnaturalistic rendering of Christ's book, which bears the inscription "I am the light of the world." The simple composition, harsh modeling, unnatural but bold colors, and frontal stiffness combine here to create the kind of stylization that is characteristic of much Romanesque art.

HISTORY

During the tenth century, Europe stirred with revived economic, social, and cultural life. The attacks of migrating peoples, a source of conflict and political unrest for centuries, abated, in part because of their conversion to Christianity. The split between the Western, or Roman, and the Byzantine, or Orthodox, branches of Christianity that took place in 1054 would never be resolved, despite efforts in later centuries. After the split, the Roman Church consolidated its religious and political power. England was united with much of France after the conquest in 1066, and Norman victories in southern Italy and Sicily freed those areas from Byzantine control. The new political stability fostered an expanded economy.

As the Roman Church increased its influence in secular affairs, it came into conflict with the feudal nobility. The Church's power and energy were manifested in the Crusades, which began in the 1090s as an attempt to capture the "Holy Lands" from the Muslims and to establish commercial activity on a broader scale. The Reconquest, the war against the Muslims in Spain, led to the capture of Córdoba (see pp. 182-85) by Christian forces in 1236.

ART AND THE PILGRIM

The mainstays of earlier medieval workshop production manuscript illumination, ivory carving, and metalwork continued to flourish throughout the Romanesque period, but a significant new development was the widespread revival of monumental architecture and art; for an example of a Romanesque monastery, see the complex at Cluny (see fig. 5.48).

The notion of the pilgrimage, which earlier in the Middle Ages had been prescribed for the atonement of sin, became a regular feature of European life during the Romanesque period. Pilgrims traveled over defined routes known as pilgrimage roads to Rome or to Santiago de Compostela in western Spain. At St. Peter's in Rome or the Church of St. James in Santiago (see fig. 6.3), pilgrims invoked God's intercession. To prepare spiritually for these destinations, the pilgrims visited churches and monasteries along the route, where they could pray before the relics of saints. These relics were usually encased in precious reliquaries such as that of Sainte Foy at Conques (fig. 6.8);

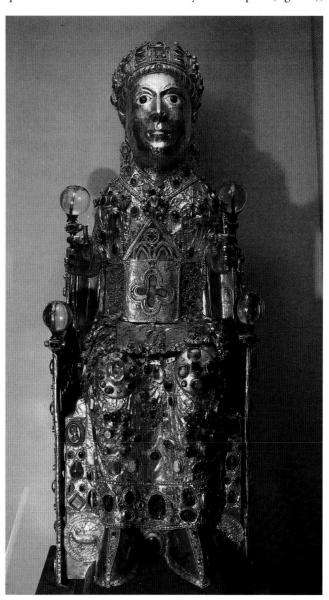

6.8 Ste.-Foy reliquary, later tenth century. Gold with filigree and precious stones over wooden core, height 2' 9½" (85 cm). Cathedral Treasury, Conques, France.

The masklike face of this reliquary, which enshrines the bones of the saint, is made from an ancient Roman gold face guard and parade helmet to which inlaid enameled eyes have been added. The forearms and hands date from a post-Romanesque restoration. For the church at Conques that enshrined Ste.-Foy's remains, see figs. 6.10-6.12.

many of the jewels that adorn her golden cloak were gifts from pilgrims. Pilgrims were sheltered in monasteries, which since the earlier medieval period had functioned as centers of learning and hospitality. During this period, the developments in religious architecture responded to the needs of clergy, citizens, and pilgrims.

THE BAYEUX "TAPESTRY"

The embroidered narrative of the *Bayeux "Tapestry"* (fig. **6.9**) depicts the events that led to the Norman invasion of England and the victory at Hastings in 1066. Our detail shows the English king, Harold, enthroned in his castle. A messenger informs the king that his rival, William, duke of Normandy, has ordered a fleet of ships to be built so that he can cross the English Channel. In the sky to the left of the castle is Halley's Comet, which was visible in England in late April 1066; at the time, the appearance of the comet was interpreted as a signal of impending disaster for Harold. The inscription reads: *Isti mirant[ur]stella* ("These men marvel at the star").

The sequence of historical events is narrated in a lively manner. The curving axes of the figures of Harold and the messenger help to animate the scene, while the abstracted tree to the right, with its undulating rhythm, demonstrates the continuation of Anglo-Saxon **interlace** motifs (see pp. 170–71) and asserts a vitality that permeates much of the work. The limited colors are used decoratively rather than descriptively, and the abstract rhythms of the composition enliven the historic narrative.

THE ROMANESQUE ARTIST IN EUROPE

Benefiting from the economic growth of the period, artists organized **guilds** to ensure quality and control in the production of art and the training of apprentices. Guilds offered protection for the artists as a group, self-regulation, and promoted increased social prestige. Nevertheless, few works of the period are signed and dated.

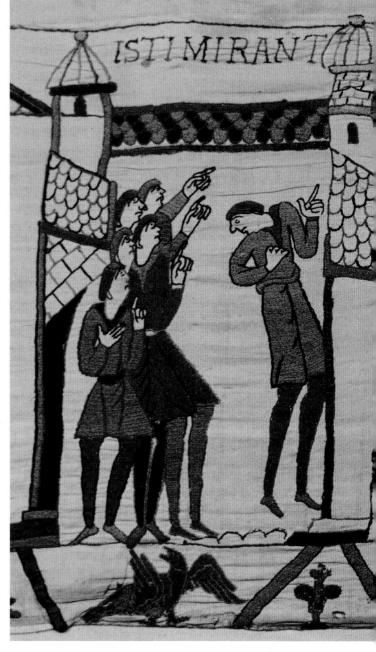

6.9 *King Harold Receiving a Messenger*, detail from the *Bayeux* "*Tapestry*", c. 1070–80. Embroidered wool on linen, height 1' 8" (50.8 cm); total length 231' (70.4 m). Centre Guillaume Le Conquérant, Bayeux, France.

Despite the fact that the technique used was embroidery, this work is traditionally known as the *Bayeux Tapestry*. It was probably executed by a group of women artists who specialized in the needle arts. In more than seventy-five scenes accompanied by Latin inscriptions, the work tells the story of the victory of William the Conqueror over King Harold during the Norman conquest of England, in 1066. The embroidery, probably commissioned by Bishop Odo of Bayeux, half-brother of William, was intended for display in a great secular hall.

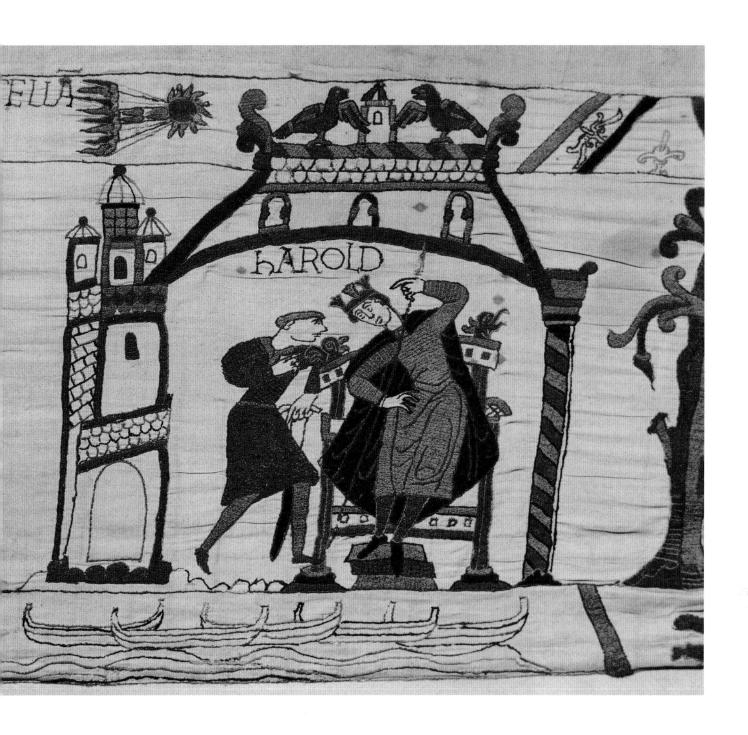

Romanesque Architecture at Conques

6.10 Nave, Abbey Church of Ste.-Foy, Conques, France, c. 1080–1120. Originally commissioned by Abbot Odolric c. 1052; the cloister was begun by Abbot Begon.

The monastic church of Ste.-Foy was located along one of the pilgrimage roads that would eventually lead to Santiago de Compostela in western Spain (see map, fig. 6.3). The Romanesque structure was built around an older church probably begun during the Carolingian period. Conques later remained isolated from the urban development that affected many other medieval towns, and, with the exception of two nineteenthcentury towers, the church has been spared the restoration activity that so often transformed medieval architecture. The church is dedicated to a third-century virgin martyr, Sainte Foy (known in English as Saint Faith), whose relics were brought to Conques about 870 (for the reliquary preserved here, see fig. 6.8).

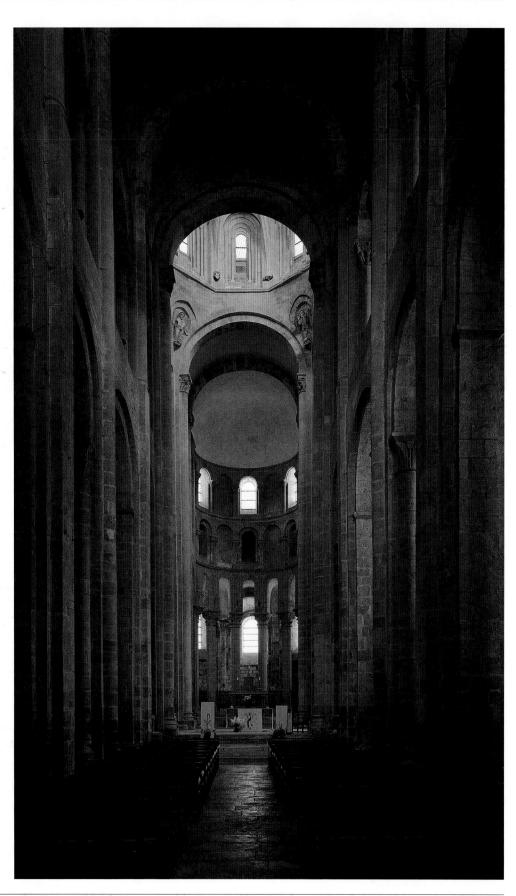

1010 The Shah-nama, Persia's great epic poem, is completed

1054 The Pope excommunicates the Patriarch of Constantinople

1071 The fork is introduced to European society by a Byzantine princess

c. 1080-1120 Ste.-Foy, Conques (fig. 6.10)

c. 1088 The first European university is founded in Bologna

iewing the crossing and the apse of the Abbey Church of Ste.-Foy from the nave (fig. 6.10), we can understand why nineteenth-century historians coined the term "Romanesque" to describe this style. The use of round arches and stone vaults is reminiscent of ancient Roman building practice (see fig. 4.50), and, like Roman architecture, the monumental scale establishes an austere, massive presence. The wooden truss roof common in Early Christian and Carolingian architecture has now given way to the favored construction feature of Roman architecture, the vault. At Ste.-Foy, the barrel vault of the nave is reinforced with transverse arches (arches that traverse the nave). On the exterior, vertical buttresses make the interior rhythm of the bays readable from outside (fig. 6.12). On exterior and interior, then, the articulation of the bays creates an order and unity characteristic of Romanesque architecture. The transverse arches also make it possible for the barrel vault to be lighter in construction and to allow for slightly larger windows. Romanesque stone vaulting also served other purposes: it helped prevent the spread of fire, a prevalent threat with wooden truss-roof buildings, and it acoustically enhanced the chanted services of the monks.

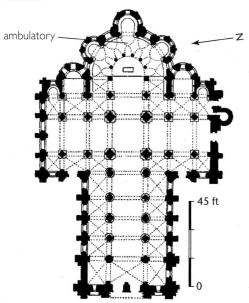

6.11 Plan of the Abbey Church of Ste.-Foy, Conques.

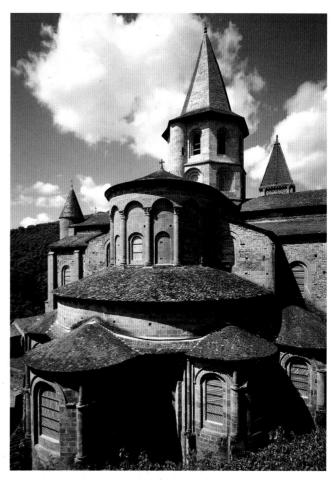

6.12 Abbey Church of Ste.-Foy, Conques. For the tympanum over the central doorway, see fig. 6.14.

Another feature of the Romanesque pilgrimage church was the use of a semicircular ambulatory (fig. 6.11). Adapted from ancient Roman and Early Christian centrally planned buildings (see fig. 5.15), it is here used to solve a specific problem. At churches with monastic foundations, it was necessary that the monks occupy the area around the high altar for their numerous services. The ambulatory connected the side aisles in a continuous passageway that allowed large numbers of pilgrims to move through the church and to stop and pray or to venerate relics in the apsidal chapels without disturbing the monks.

Romanesque Sculpture

n the central **tympanum** (**lunette** above the door) at Vézelay, Christ is on the axis, enthroned in a mandorla with his arms outstretched (fig. **6.13**). Axiality and hierarchical scale convey Christ's significance, while the angularity of his legs and the swirling drapery, similar to those in contemporary works in other media (see fig. 6.9), animate his presence. Rays of illumination and inspiration, the gift of the Holy Spirit, flow from his hands (his left hand has been broken off) to the head of each apostle. Eight **archivolts** (arches of decorative and narrative motifs that enframe the tympanum) show the apostles preaching the

Gospel and healing spiritual and physical ailments. In the outer archivolts, symbols of the zodiac and representations of labors of the twelve months signify that Christ is lord of time and of everything in the world. On the sides of the doors (**jambs**) and on the central post (**trumeau**) are sculpted figures of saints and prophets.

The complex iconography of the Vézelay tympanum reveals the inspired spirituality of the later Middle Ages. Representations of the human race from all over the world—some based on medieval legends of exotic peoples and therefore fantastically conceived—are shown in the

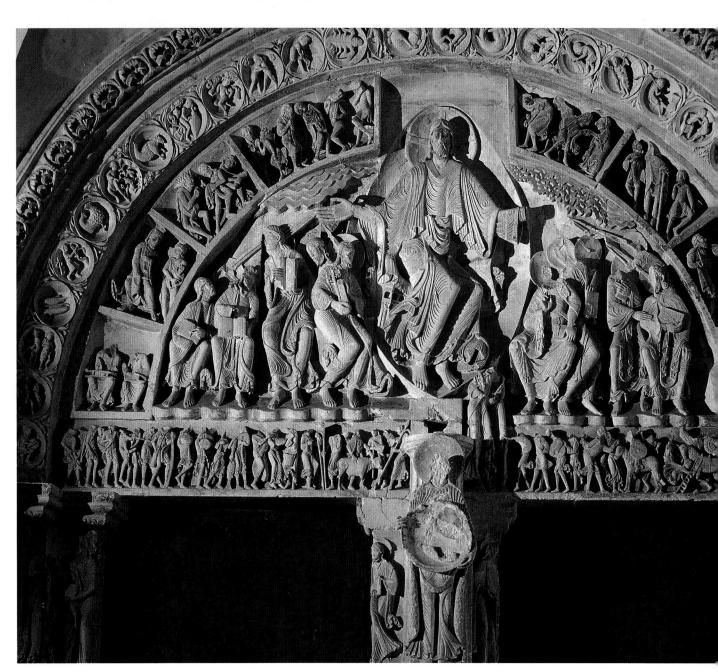

compartments to the sides, while laborers and pilgrims appear in the lintel. John the Baptist, who predicted the coming of Christ, is placed on the trumeau, a position that visually and symbolically expresses his support of Christ. The tympanum, then, is both direct and complex in its iconography and would thus function to illuminate the Christian content for more than one level of society. Such sculptures were important in teaching church doctrine.

The Judgment scene at Conques emphasizes the alternatives of eternal reward or everlasting punishment (fig. 6.14), with extensive literary inscriptions that reinforce Christ's judgment. To the saved he announces: "Come, the blessed of my Father, take possession of the kingdom that has been readied for you." To the damned he proclaims: "Away from me, accursed ones." The distinction between those who will be saved and those who will be damned is clear. To Christ's right (our left), the blessed enjoy their reward in heaven; to his left, the damned begin an eternity of punishment. Such scenes demonstrate visually the ideology that would have been preached in the sermons inside the church.

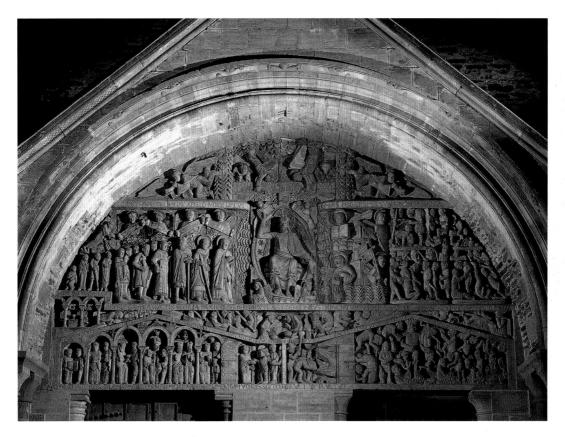

6.14 Last Judgment, tympanum and lintel, west portal, Abbey Church of Ste.-Foy, Conques, France, c. 1120. Stone, approx. 12' \times 22' (3.66 \times 6.71 m). Commissioned by the abbot of Conques. The traces of orginal paint on this tympanum remind us that color once played an important role in the total effect.

6.13 Pentecost, the Peoples of the Earth, and Saint John the Baptist, tympanum and lintel, central portal, Abbey Church of La Madeleine, Vézelay, France, 1120-32. Stone. Probably commissioned by Abbot Pontius.

Moai Ancestor Figures, Polynesia

hese impressive statues were created on Easter Island, a remote Polynesian island that today is five to six hours by jet from the nearest land (fig. 6.15). The ocean pounds so hard on all sides of the island that few boats stop there now that it has an airstrip. Throughout Polynesia, stone temples are placed parallel to the shorelines. In about 1000 CE, Easter Islanders began to erect huge stone figures nearby, perhaps as memorials of dead leaders. Almost 1,000 of these figures, called moai, have been found and documented, including unfinished ones still in the quarries where they were being carved. The figures are cut from a yellowish-brown volcanic rock called tufa, and are about thirty feet in height, although one unfinished figure is almost seventy feet tall. The heads have deep-set eyes, long, concave pointed noses, small mouths, and angular chins. The elongated earlobes suggest that the real-life models for the statues wore heavy ear ornaments. The figures include indications for breastbones and small arms, as well as, in some cases, small legs. Some of the figures seem to be wearing wide necklaces.

Dozens of these statues have detailed designs carved in relief on their backs that seem to represent tattooed or painted symbols of rank (fig. **6.16**). Curved lines at each shoulder combine with a vertical line representing the spine to suggest an abstract human face of a type that is wide-spread in Polynesian art and that appears elsewhere in Easter Island art, for example on wooden ceremonial boat paddles. Between the fingertips and the area below the navel of a typical statue is a bas-relief design thought to be the fold of a loincloth. Lines that curve across the small of the back are likewise thought to represent the sacred loincloth of authority, which denotes the rank of chiefs and priests throughout Polynesia. Examples of loincloths recorded on Easter Island during the nineteenth century were made of human hair.

It is generally assumed that most of the figures are male, even though the majority are unsexed. Gender can be safely assigned only to the few figures found in a quarry that have goatee beards, or to several examples on which a vulva is marked. Many scholars think of the loincloth as a male indicator. Others have suggested that the figures with highly developed nipples are female, but this interpretation is not evidently part of Easter Islanders' conception of the feminine. One or two of the statues have well-rounded breasts, but there is no clear indication that these necessarily signify a female, and images of human beings produced

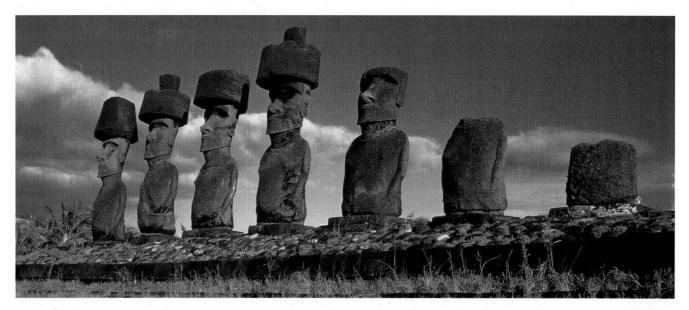

6.15 Moai figures, Ahu Nau Nau, Easter Island, Polynesia, c. 1000-1500. Volcanic stone (tufa), average height approx. 36' (11 m).

Many of these figures were knocked down in later centuries, but most have today been reerected. This photograph shows the figures after their red tufa headdresses and white coral eyes with stone pupils were restored in 1978. Easter Island, a tiny speck in the vastness of the South Pacific Ocean, is roughly triangular and symmetrical in shape with sides of thirteen, eleven, and ten miles in length (21, 17.7, and 16 m); it is thus about sixty-four square miles (166 sq km) in area. Three main peaks, one near each corner of the triangle, rise about 1,675 feet (510 m) above sea level. On the highest rise is a huge circular crater that reveals the island's volcanic origin. The bare landscape of rolling hills has many volcanic craters and reedy lakes, hundreds of stone statues toppled and scattered, and rich designs carved into the stone surfaces of the hills. These artifacts and the abandoned quarries, as well as the ruins of platforms, houses, and other structures, form a remarkable open-air museum.

c. 1000-1500 Polynesian Ancestor Figures (fig.6.15)

c. 1000 Leif Ericson discovers North America (?)

c. 1000 Chinese perfect gunpowder

c. 1180 Glass windows in use in English private homes

c. 1250 Towns and ceremonial centers are built in the Mississippi basin

in Polynesia are often sexually ambiguous.

A distinction can be made between statues erected on platforms and those that, for whatever reason, are most often still found in the quarries. The figures on platforms have prominent eye sockets ready for the inlay of coral, wore headgear, and were perhaps also colored. Their average height is about twenty to twenty-five feet (without headgear), whereas those not found on platforms are often much taller. Many of the figures on platforms are stockier and less angular, and have less accentuated features and less concave or prominent noses and chins than those in the quarries.

Many of the first European visitors to Easter Island commented on the statues. The Dutch commander Jacob Roggeveenn made what seems to be the official European discovery of the island on April 5, 1722. The first sighting was noted in the ship's log:

giving signal of seeing land ... a low flat island ... we gave ... to the land the name Paasch Euland (Easter Island), because it was discovered and found by us on Easter Day.

On the following day the sailors made a brief visit to the island and remarked on the statues:

we merely observed that they set fires before some particularly high erected stone images, and then, sitting down on their heels with bowed heads, they bring the palms of their hands together, moving them up and down. These stone images at first caused us to be struck with astonishment, because we could not comprehend how it was possible that these people, who are devoid of heavy thick timber for making any machines, as well as strong ropes, nevertheless had been able to erect such images, which were fully 30 feet in height and thick in proportion.

Most Europeans expected that the giant statues were gods, but none of the statues is known to have had the name of a deity. Instead, they are known by the collective name aringa ora (living faces), and they are clearly generalized images rather than individualized portraits. From the islanders' testimony and ethnographic study of similar Polynesian examples, it is likely that the statues represented high-ranking ancestors. Such monuments kept the memory of the person alive, and also might have served a funerary purpose. The sheer monumentality of these statues must have created a sense of respect and awe. These giant figures are not works of art that carry on a dialogue with the view-

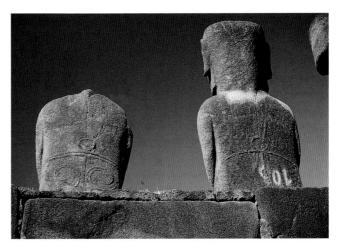

6.16 Moai figures, reverse.

er, but rather exclaim their massive size and difference from all earthly beings.

The statues were probably not commissioned by a population under the control of some central power, but rather by a number of fairly independent kin groups from different parts of the island. There is some evidence that sculptors competed with each other in scale and grandeur, and that the size of the statues was increased over time. The surface of the tufa is steel-hard after being exposed to the weather, but when quarried it is not much harder than chalk and can be cut and shaped quite easily, even with stone tools. Estimates suggest that it would take about fifteen months for six people to rough-cut a figure about twenty feet in height.

Easter Islanders stopped making moai around 1500, when civil wars apparently erupted. While the population of the island may at one time have numbered 10,000, it was nearly eradicated in the nineteenth century by Peruvian slave-traders, who brought with them smallpox and tuberculosis, precipitating epidemics that left only about 600 inhabitants alive on the island.

The settlers of Polynesia developed distinctive cultural traditions while retaining linguistic and cultural affinities that reflect a common origin. Traditional Polynesian societies were stratified, and art objects are often important indicators of rank and status. Because of this function, they are often made of permanent materials, like the stone figures on Eastern Island. European colonization had a disruptive effect on society and art in Polynesia, stemming in part from the interest that Europeans had for the art they found. Collectors avidly purchased it, saving some from total destruction, while also altering the context in which it originally functioned.

Angkor Wat: Cult of the God-King

he word *Angkor* (from *nokor*, Sanskrit for "city") means "the city" or "the capital" in the Khmer language of ancient Cambodia. At Angkor, the temples are spread out over 154.5 square miles (400 sq km) around the modern village of Siem Reap, which is located about 200 miles from Phnom Penh where, between the ninth and thirteenth centuries, Khmer kings constructed their capital cities (see map, p. 161). These centers included a sophisticated irrigation system that helped to control the vagaries of monsoon rains and drought so that rice could be grown to support about a million inhabitants. These cities also included major building complexes in brick and stone. The temple that later became known as Angkor Wat is the largest and most artistically accomplished complex in this area (fig. 6.17, 6.18).

These creations of conquerors and artisans embodied an integrated concept of the universe that was rooted in religious belief. They express a combination of physical and spiritual grandeur similar to those found in Egypt and Greece, among the Maya and Aztecs in Mexico, and in the Gothic cathedrals of Europe.

The monuments built at Angkor testify to the creative energies of the Khmer civilization. Established to the north and west of the floodplain of Kampuchea, the kingdom underwent a sequence of changes in religious faith. Greatly influenced by Indian culture, the Khmer kingdom began in the sixth century. Of the more than thirty rulers who held power in succession, Yasovarman I (ruled 889–900), Suryavarman II (ruled 1113–50), and Jayavarman VII (ruled 1181–1219) are outstanding. They were devotees of Siva, Vishnu, and the Buddha, respectively, but their faith was eclectic. Through the newly designed cult of the *devaraja* (*deva*, "god," and *raja*, "ruler"), or god-king, these rulers derived both sanctity and power through personal identification with the gods.

Concentrating their building activity at Angkor, each emperor set out to outdo his predecessor. Suryavarman II constructed the temple at Angkor Wat in the first half of the

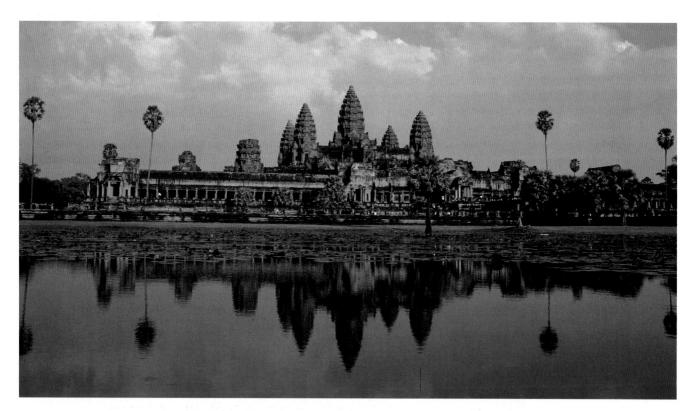

6.17 Temple complex, Angkor Wat, Kampuchea (Cambodia), first half of twelfth century. The inner wall of the temple measures $3,363 \times 2,625$ ' (1025×800 m); the entrance building is 1,148' (350 m) long; the moats that surround the monument are 623' (190 m) wide. Commissioned by Khmer rulers.

It is recognized as the world's largest ancient temple. The site was rediscovered in the nineteenth century, and in the twentieth century modern archaeology retrieved it from the jungle and preserved it. However, it was ravaged again by neglect and the perils of war in the 1970s and by poor restoration techniques in subsequent decades. At this time, there is yet another international effort to save this unique monument under the aegis of UNESCO.

1099 Crusaders capture Jerusalem

First half of 12th century Temple complex, Angkor Wat (fig.6.17)

1100 Earliest recorded English mystery (religious) play

1122 Persian poet Omar Khayyam dies

1150 University of Paris has its beginnings

twelfth century to house his mausoleum. He dedicated it to Vishnu, whose exploits are portrayed in virtually every sector of the temple (fig. 6.19), but Siva and the Buddha also appear at the site. The complex symbolically represents Mount Meru (Sumeru), the World Mountain and, traditionally, the abode of Vishnu.

The centralized plan of the buildings signified the axis of the World Mountain that marks the axis of the universe. The temple at Angkor Wat demonstrates an ingenious application of three-dimensional geometry to create a perfect step pyramid: the rise of the terraces is calculated so that all appear to be of equal height, without obscuring the view of the other terraces.

These monuments of Khmer art were considered the embodiments of the kings and their world and of their continuation after death. After the demise of the Khmer kingdom, these buildings fell into neglect and were gradually repossessed by nature until they were discovered in modern times.

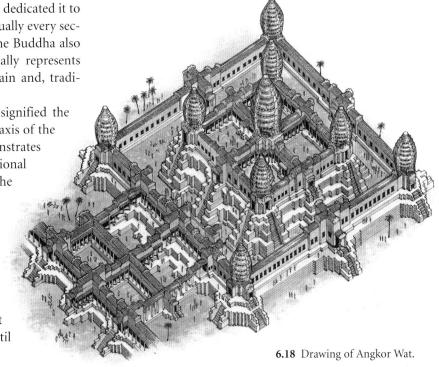

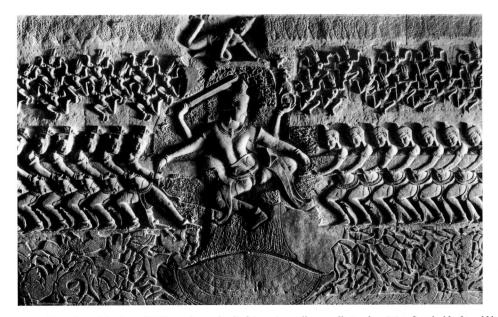

6.19 Churning of the Sea of Milk, sculptural relief, interior gallery wall, Angkor Wat, first half of twelfth century. Stone.

Almost the entire surface of the temple is carved with a variety of decorations, including reliefs of Indian myths and epics, historical triumphs, and dancing figures. More than 1,600 figures of apsaras (celestial nymphs) in different moods and expressions are found at the corners and along the walls of the temple. In Churning of the Sea of Milk, Vishnu, the Hindu deity known as the Preserver, saves the universe from catastrophe by appearing in his avatar (a saving manifestation) as a tortoise. Hoping to obtain the Dew of Immortality, the gods and demons (asuras) agreed to use a serpent wound around the World Mountain to churn the Sea of Milk. When the mountain began to sink into the sea, Vishnu, in the guise of a tortoise, sat beneath it to support it. The sea gave forth delights, including the dew, which Vishnu obtained for the gods by assuming the form of a desirable woman, Mohini, who seduced the asuras into abandoning the elixirs. The gods thus defeated the demons, and Vishnu was credited with reconstituting the balance between good and evil. Carved in a clear style that expresses a ranked order among the participants, the silhouetted and repeated forms are presumed to recreate the ritual dances performed by the court dancers of ancient Cambodia.

The Japanese Narrative Scroll

enji monogatari (The Tale of Genji) is a long work of prose fiction written in the early eleventh century by Murasaki Shikibu (973-1025), a lady-in-waiting at the court of Emperor Ichijo (ruled 986-1011). Often called the world's first novel, The Tale of Genji was an immediate and lasting success, revolutionizing the art of prose fiction in Japan. Nothing like it had been written before, and both its content and romantic mood inspired generations of poets and artists. Well-known themes and episodes from Genji also appear in No plays from the fourteenth century through the Edo period (1615-1868), in puppet and Kabuki theater presentations, and in modern plays and films. Over the centuries, chapter titles and memorable episodes from the novel became popularized as the subjects of parlor games, depictions on folding screens, and in illustrated scrolls, books, and woodblock prints. Perhaps the most remarkable example of the tale's influence is the

fact that the architecture described in the text became an inspiration for later imperial palaces (see figs. 1.6, 9.50, 9.51).

The Tale of Genji survives in fifty-four chapters, although originally there may have been more. The story covers about seventy-five years, beginning with the birth of the hero, Genji, and concluding after his death. The principal setting for the novel is Kyoto (see map, p. 219), then the capital of Japan, and much of the action occurs in the mansions and gardens of the aristocracy and royal family.

Genji, an imperial prince, was born to the favorite wife of the emperor, a woman too low in rank for her son to inherit the throne. A handsome, cultured, and sensitive man, he had many romances. His intrigues and affairs take up two-thirds of the novel, leaving the last third to tell of the loves and lives of two young men who were Genji's heirs in Kyoto. The scene in fig. **6.20** explores the karmic effect of

6.20 Takayoshi (attributed), Third illustration of the "Kashiwagi" chapter of *The Tale of Genji* by Murasaki Shikibu. Late Heian period, c. 1120–30. Hand scroll, ink and color on paper, height 8½" (21.6 cm). Tokugawa Museum of Art, Nagoya, Japan.

c. 1120-30 Takayoshi (attributed), The Tale of Genji illustrations (fig.6.20)

1187 Saladin, Sultan of Syria, recaptures Jerusalem from the Crusaders

1189 Third Crusade to the Holy Land

c. 1200 The first chiefdoms are established in Polynesia

1300 Mixteca-Puebla pottery developed in Mexico

Genji's transgression against his father. In his youth, Genji fell in love with his father's youngest wife, Fujitsubo, a woman whom he was encouraged to see because she looked so much like his birth mother, who had died when he was an infant. This liaison produced a son, a child who was passed off as the emperor's own and who eventually succeeded to the throne. Fujitsubo was so tormented by guilt that she became a nun to expiate her sin. The full consequence of this past deed came to Genji, however, only in middle age, when his youngest wife had an extramarital affair that resulted in a son whom Genji in this scene had to publicly avow as his own, just as his father had had to do with Genji's son. This story can be linked to Buddhist concepts current in Japan in the eleventh and later centuries that all acts have consequences. Good works will be rewarded by good fortune, sins will bring calamity, and there may be retribution for past deeds in one's later life.

The Tale of Genji lent itself well to the format of the horizontal illustrated scroll, the emakimono, a uniquely East Asian format. Because both Chinese and Japanese languages were traditionally written in vertical lines from right to left, the horizontal format of the emakimono, unrolled from right to left, provided a familiar way to relate text and image. The juxtaposition of textual passages of varying lengths with pictorial images was a potent format for narrative development for many centuries and was translated in modern times into the medium of film with ease, for instance. The preference for highly formalized compositions and stylized depictions of figures carries over with little variation into single frames of the twentieth-century films directed by Yasujiro Ozu (see fig. 13.13) and Akira Kurosawa, among others.

The scenes shown here are taken from the earliest known illustrated version of the novel. As the scroll is read

from right to left, the brown surface of the courtyard originally silver—and a verandah placed at a sharp angle would slowly come into view (for an example of how a hand scroll is held and read, see fig. 1.21). The roof and interior walls of the building have been removed, revealing the room's interiors in a technique known as fukinuki yatai, or bird's-eye view. White cloth curtains with loose black ties hang from horizontal poles. At the base of the curtain appears the bottom of a twelve-layered robe, the garment of a lady-in-waiting. Above, red lacquered plates are heaped with food. The colors of the garments and the careful placement of the food dishes indicate that a ceremony is in progress. Two-thirds of the way across the scene, figures appear: Genji at the top with the baby in his arms, and ladies-in-waiting below. In the extreme lower left of the illustration, the child's mother is indicated only by a mound of fabric.

The text accompanying this scene describes Genji's thoughts as he goes through the painful ritual. He knows that the attendants realize that he is not the father. The apparently tranquil scene is deceiving. The emotional tur-

bulance of the moment is disclosed through the isolation of the figures, the disarray of the curtains, and the sharp angles of the drapery. Emotion is not reflected in facial expression. The mask-like faces are done in a technique known as hikime hagihana, in which lines define an eye and a hook can define a nose. Surprise is occasionally indicated through the use of black dots for eyes. This technique is still used today in the popular Japanese art forms of anime (animated films) and manga (graphic novels, see pp. 599). Architecture plays an important role in the telling of this episode—it disrupts the leftward motion of the illustration and confines the figures from view, thus playing out the theme of retribution. The artist illustrates Genji's feeling of shame by placing him where the pictorial space is so cramped that he cannot raise his head. The rewards and punishments for his behavior are pictured as the scroll unfolds.

Despite the centrality of the hero Genji in her novel, Murasaki Shikibu took interest as well in exploring the lives and characters of many of the women in the story. Genji's greatest love, Murasaki, is introduced in the novel as a child,

6.21 Takayoshi (attributed), first illustration of the "Azumaya" chapter of *The Tale of Genji*.

and the author follows her as she matures and finally dies. Few women enjoy thoroughly happy lives in this novel, for the point is made over and over that in a polygamous society delicate distinctions of status often dictate behavior. Murasaki, for instance, is beautiful, talented, and witty, and she is perceived by Genji and her readers alike as the focus of Genji's life. Even so, she is constantly afraid of losing his affection. She suffers two humiliations. First, she is unable to provide him with a child and is charged with raising his daughter by another woman. Second, because of her relatively low status and lack of powerful relatives, she is disqualified as his principal wife, an honor given instead to a woman described as a vapid princess.

Another of the main themes of the novel for both male and female characters is the transient quality of experience and the resulting emotional intensity. The scattered placement of the women in fig. 6.21 and the slightly opened sliding door (fusuma) indicate the casual passing of time. This illustration depicts a group of women and their maids as heads and hands emerging from masses of drapery. Naka no Kimi is having her hair combed after washing. Her half-

sister, Ukifune, faces her and looks at a picture scroll while a maid reads from a text. The dismay that Ukifune is feeling because of an attempted seduction only hours before is suggested by the subtle tension between her half-hidden figure, the slanting floor, and the mundane setting of the scene.

The creation of the Genji scrolls must have been a monumental project. The novel in English translation is nearly 1,000 pages long. Only twenty pictures from this early illustrated version survive, but it must have originally included one or more illustrations for each of the fifty-four chapters. Most estimate that there were ten scrolls in all; only nineteen illustration and twenty narrative pages survive today. Scholars trying to determine how the scrolls were made have concluded that five teams worked on the project. Each team included a nobleman noted for his calligraphy and his cultural sophistication and a group of painters, including a principal artist (the sumigaki, or painter who draws in black ink) and specialists in the application of traditional pigments. Once a particular episode was chosen, the sumigaki planned the composition and sketched it on the scroll in fine black lines. Then the pigment specialists applied layers of paint within the lines. The sumigaki returned to paint in the details of the faces-tiny red mouths, narrow eyes, noses of a single hooked line, thin mustaches, short beards. The application of layers of paint over an underdrawing is called tsukuri-e ("constructed" or "built up"). The technique and style of the Genji and other illustrated narrative scrolls dating from this period came to be known as the *yamato-e* style, or "Japanese pictures."

Gothic Art

he Gothic style, the preeminent style in Europe from about 1140 to 1400, was first defined in architecture, and architectural motifs appear throughout Gothic painting, sculpture, and decorative arts. Gothic is easily identifiable because of its unique vocabulary—a combination of pointed arches, ribbed cross vaults, flying buttresses, cluster piers, and glowing stained-glass windows. The development of Gothic architecture seems to have been developed by Abbot Suger (1081–1151), friend and adviser to the French kings Louis VI and VII, when he had the facade, ambulatory, and radiating chapels of the Royal Abbey Church of St.-Denis rebuilt (figs. 6.22, 6.23). The importance of St.-Denis, the French church where the coronation regalia were stored and kings and queens were buried, helped to popularize the new style throughout

France. The brilliant colors of the large stained-glass windows of chapels and ambulatory were designed to lead the worshiper to imagine the glories of the Heavenly Jerusalem, the holy "City of God" in Paradise. In other words, the architecture was intended to help the observer rise from the physical world to an immaterial, spiritual realm. Suger wrote about how his new architecture created a "crown of light"—a frequent metaphor for the divine in his writings:

Bright is that which is brightly coupled with the bright, And bright is the noble edifice which is pervaded by the new light;

It stands enlarged in our time,

And I, Suger, was the leader while it was being accomplished.

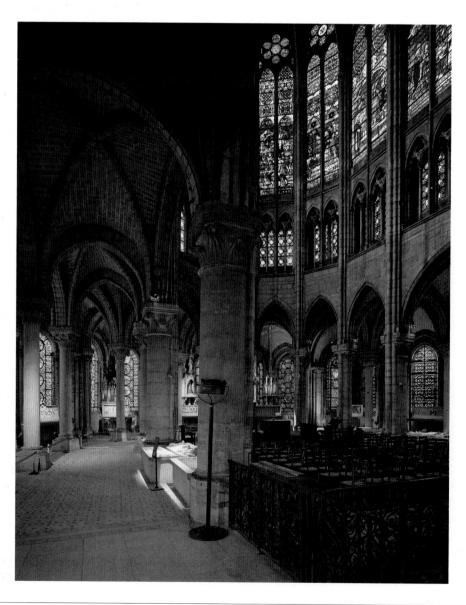

6.22 Interior, the Royal Abbey Church of St.-Denis, near Paris, France, 1140–44. Commissioned by Abbot Suger. This view shows the ambulatory and radiating chapels of Suger's 1140–44 church on the lower level. The higher area visible on the right is a later construction, dating between 1231 and 1281.

Here, where Gothic architecture was invented, we see some of the distinctive attributes of the style in the union of pointed arches, ribbed groin vaults, and large stained-glass windows.

ABBOT SUGER

In an inscription over the west portal of the facade, Abbot Suger takes credit for the rebuilding of St.-Denis; no artists' or architects' names are mentioned. His new vision of architecture is based on his belief that the beauty and splendor of the church would lead worshipers to a new understanding of God and the spiritual realm, as is clarified in an inscription once on the golden doors of the west facade of the church. Suger uses the repetition of words to create a rather mystical, hypnotic effect:

Marvel not at the gold and the expense but at the craftsmanship of the work.

Bright is the noble work; but, being nobly bright, the work

Should brighten the minds, so that they may travel, through the true lights,

To the True Light where Christ is the true door.

6.23 Plan of the Royal Abbey Church of St.-Denis as it exists today, showing the various building campaigns. Abbot Suger rebuilt the facade (consecrated 1140) and the chapels and ambulatory (1140–44). The old Carolingian nave and upper choir were rebuilt in the mature Gothic style between 1231 and 1281.

HISTORY

During the Gothic period life changed dramatically for much of the population. Commerce expanded; cities grew rapidly; international banking developed. Paris became the mercantile hub of Europe, and its popular annual trade fairs brought together Europeans of many cultures. Among the merchandise bought and sold were works of art. The complex life in the cities led to better-educated administrators and bureaucrats.

During the later Middle Ages, France was preeminent in the arts in Europe. In the twelfth and thirteenth centuries Paris was the leading intellectual center in Europe and the capital of a strong monarchy (the Capetian line of French kings ruled from 987 to 1328). The University of Paris, the model for late-medieval universities (including Oxford and Cambridge in England, and Padua and Bologna in Italy), became the focus for a new, rational approach to philosophy and theology known as Scholasticism, which examined, questioned, clarified, and codified Christian dogma and practice. Thomas Aquinas, a professor at the University of Paris and a Dominican monk, wrote *Summa Theologica* (1267–73), an encyclopedia that set out to systematize and encompass all knowledge on theology and the world, every aspect of which he related to God and his created universe.

The Crusades, which had begun in the late eleventh century, continued into the Gothic era, but with little political or military success. Despite being a significant financial and human drain on western Europe, the Crusades also played a role in encouraging the development of banking, new methods of taxation, and a more complex money economy. In western Europe, many scientific and philosophical developments resulted from contact with Islamic culture.

ART

The term "Gothic" originally had a pejorative connotation. It was coined during the Italian Renaissance to refer to the whole of medieval art, which, from the perspective of the Renaissance, seemed crude and irrational. Judged to be the work of barbarians, medieval art was called Gothic after the Visigoths, an early Germanic people who had sacked Rome in 410. During the Gothic period itself, the new architecture was known as *opus modernum* ("modern architecture"), *opere francigena* ("French architecture"), or "pointed architecture."

One aspect of Gothic art is the use of sumptuous, colorful materials. Architecture included churches, urban monastic complexes, and castles. Sculpture was focused on church portals and on elaborate tombs with architectural frames with pointed Gothic arches. Painting was largely limited to manuscript illuminations. The decorative arts—secular and liturgical—encompassed works in gold and

other fine materials (fig. **6.24**), including ivory and precious gems. Increasing personal wealth meant that secular works—personal jewelry, tapestries, ivory boxes, and mirror backs—became more common.

The particular figural pose that characterizes much of Gothic art is revealed in the *Madonna of Jeanne d'Evreux* (fig. **6.25**). The Madonna stands in the Gothic "hip-shot" position, in which one hip juts out to support the Christ Child; the effect is less naturalistic than elegant, giving the body a flowing S-curve shape. The elongated figural proportions and small head of the Madonna are a Late Gothic development. In typical Gothic fashion, the body is completely covered by heavy drapery that is pulled up so that it passes horizontally across the body. The small scale of this statuette, its precious materials, and its delicate figure type and flowing drapery patterns exemplify the sophistication and elegance of the fully developed Gothic style.

The *Annunciation* page from a Parisian **book of hours** (fig. **6.26**) demonstrates the elaborate decoration common in Gothic art. The *Annunciation* was traditionally one of the most ornate of all pages, for it is the moment of the

6.25 *Madonna of Jeanne d'Evreux*, 1339. Silver gilt with enamel, height 2' 3" (68.6 cm). The Louvre, Paris. Commissioned by Jeanne d'Evreux.

This work was presented to the abbey of St.-Denis in 1339 by Jeanne d'Evreux, Queen of France. The stylized iris held by the Madonna is the fleur-de-lis, the symbol of French royalty.

6.24 Abbot Suger's Chalice, c. 1140; reworked later. Silver gilt and agate, with jewels, height 8" (20.32 cm). National Gallery of Art, Washington, D.C. Commissioned by Abbot Suger.

This chalice, created for use during the mass, was made by adding a rim, foot, and handles to an ancient agate cup made in Alexandria, Egypt, during the second century BCE. The chalice was originally inscribed *Suger Abbas* ("Abbot Suger"). For a view of other rich objects in use on an altar at the church of St.-Denis, see fig. 5.6.

Incarnation, when the seed of God was placed in the womb of the Virgin Mary and Christ was conceived and, as the Bible says, "became flesh." In prayer books, it is usually represented before the texts for matins, the first service of the day. It therefore serves as a frontispiece not only to that service but also to the whole of the book. Here the artist sets the scene in an elaborate churchlike structure, complete with altar and altarpiece; all the architectural motifs are Gothic in style. Although Gabriel holds a scroll bearing his message, Mary looks upward toward God, and it is from his figure that the dove of the Holy Spirit emerges. Jewish prophets, whose writings were believed to predict the coming of Christ, appear in the upper stories of the structure, while baby angels playing musical instruments populate the elaborate floral motifs of the borders. Typical of the growing interest in symbolism is the use of complex symbols that elaborate on the narrative. The caged bird behind Mary, for example, which at first seems to be merely a household decoration, is a symbol for Christ's Incarnation, when his soul was "caged" within a physical body, while the mating birds in the border nearby refer by contrast to the nonsexual manner by which God's seed found its way to Mary's womb. The spider and ladybug may refer to the devil, who was understood as being ever-present during human life.

THE FRANCISCANS

The urbanization of Europe was accompanied by significant developments in monasticism that shifted the emphasis from rural retreats of work, prayer, and meditation to large complexes within cities, where the monks could serve the poor and sick and preach the word of God in the language of the people. In the early thirteenth century, Francis of Assisi founded a popular new mendicant (begging) order, the Franciscans, which emphasized poverty and humility. The sermons and writings of his followers reveal a new emphasis on human emotion in interpreting the lives of Jesus and the saints. Legend tells us that it was Francis who first developed the Christmas pageant to make Christianity more immediate and meaningful for the

6.26 Annunciation, from the London Hours, created in Paris by an Italian artist, c. 1400–10. Manuscript painting on vellum, 9×6 " (23 × 15.3 cm). The British Library, London.

This book of hours was made for the Parisian market, for it features the particular devotions and saints common in Paris. The coat of arms at the bottom of each page was left blank in order to be painted later with the arms of the purchaser. This gap reveals that the book was a commercial production made for the art market and was not commissioned by a specific patron. This late phase of Gothic is sometimes called the International Gothic style because it was pervasive throughout Europe during the period c. I 400–25.

people. This innovation is related to the rapid and widespread development of religious drama—the so-called mystery plays—during this period. A Franciscan monk, writing in the late thirteenth century about the birth of Jesus, urges a special kind of imaginary participation. He speaks directly to the reader, advising:

You too ... kneel and adore your Lord God and then His Mother, and reverently greet the saintly old Joseph ... beg His mother to offer to let you hold [the baby Jesus] a while. Pick Him up and hold Him in your arms. Gaze on His face with devotion and reverently kiss Him and delight in Him.

(Meditations on the Life of Christ)

THE GOTHIC ARTIST

During the Gothic period, the vast majority of works of art were not signed, but we begin to find references to specific artists in a few documents and inventories, where named artists are praised for their skill. A number of the architects/contractors who designed and constructed cathedrals are known from inscriptions and documents. Some traveled widely: the Frenchman William of Sens was called to England to rebuild Canterbury Cathedral, and Villard de Honnecourt went to Hungary and Switzerland. Several artists are noted as active in more than one medium; André Beauneveu, for example, who was working for Charles V of France in 1364, was a painter, sculptor, designer of tapestries, and consultant to architectural projects. Nevertheless, the majority of Gothic artists were anonymous. Later, during the Italian Renaissance, the art historian Giorgio Vasari would be puzzled by the Gothic artist's "indifference to fame."

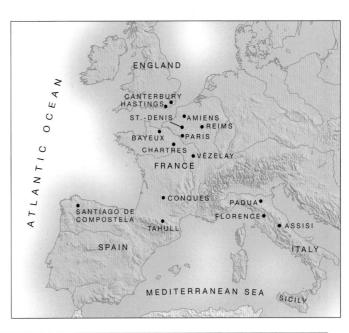

The Gothic Cathedral: Chartres

ntering a great Gothic cathedral is a thrilling, emo- tional, and—many would say—spiritual experience. The emphatic verticality of a Gothic nave urges the viewer to look upward, and to experience a sense of weightlessness and immateriality, a physical response that can be related to spiritual enlightenment (figs. 6.27, 6.28). Space seems to expand not only upward but also outward to the sides as we look both upward and through the nave arcade into the side aisles. Space is also a dominant experience in such earlier architecture as the ancient Roman Pantheon (see fig. 4.54), but the simple, monumental union of dome and cylinder at the Pantheon is in sharp contrast to the complex interrelationships of the Chartres interior. In the Gothic structure, the experience of space is less lucid, and the effect of the combination of height, dark corners, and glowing stained-glass windows is mystical and otherworldly.

From its foundations, sunk twenty-five feet or more into the earth, to the height of its vaults and roof (at Beauvais, the tallest of all cathedrals, the vaults peak at 157 feet [47.9 meters] over the floor and the peak of the roof reaches 223 feet [68 meters]), the Gothic cathedral is a monument to the determination, engineering daring, financial sacrifice, and physical energies of patrons, architects, and builders. Despite construction campaigns that lasted over decades and even centuries, not one of the great French Gothic cathedrals was ever fully completed; the vision of patrons and architects was too ambitious—too glorious—to be realized.

The high, narrow nave of the Gothic cathedral is the climax of a long tradition in Christian art in which architects tried to invent a physical space that would express the

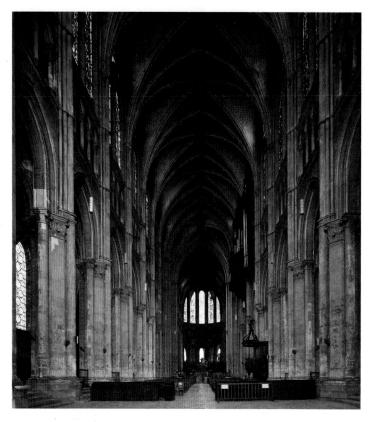

6.27 Nave, Cathedral of Nôtre-Dame, Chartres, France, 1194–1220. Commissioned by the bishops of Chartres.

Chartres Cathedral is the most memorable of French Gothic cathedrals, not only for the quality of its architecture and sculpture but also because it alone preserves virtually all its original stained-glass windows. Begun again after a fire in 1194 destroyed the earlier cathedral (except for the west facade, with its sculpture, the crypt, and some of the stained glass, including "Nôtre Dame de la Belle Verrière," fig. 6.35), the new construction was largely completed by 1220.

TECHNIQUE

Proportions of Gothic Cathedrals, 1160-1230

	Approx. Height of the Nave Vaults	Approx. Width of the Nave	Proportion of Nave Height to Width
Laon, Cathedral, 1160–1205	80' (24.4 m)	37' 6'' (11.4 m)	2.13:1
Paris, Nôtre-Dame, 1163–96	115' (35 m)	40' (12.2 m)	2.88:1
Chartres, Nôtre-Dame, 1194–1220	120' (36.6 m)	45' 6'' (13.9 m)	2.64:1
Bourges, StÉtienne, 1195–c. 1270/80	117' (35.7 m)	44' (13.4 m)	2.66:1
Reims, Nôtre-Dame, designed 1210	125' (38 m)	46' (14 m)	2.72:1
Amiens, Nôtre-Dame, designed 1220	144' (43.9 m)	48' (14.6 m)	3:1
Beauvais, Cathedral (vaults before apse), designed 1230s	157' (47.9 m)	47' (14.3 m)	3.36:1

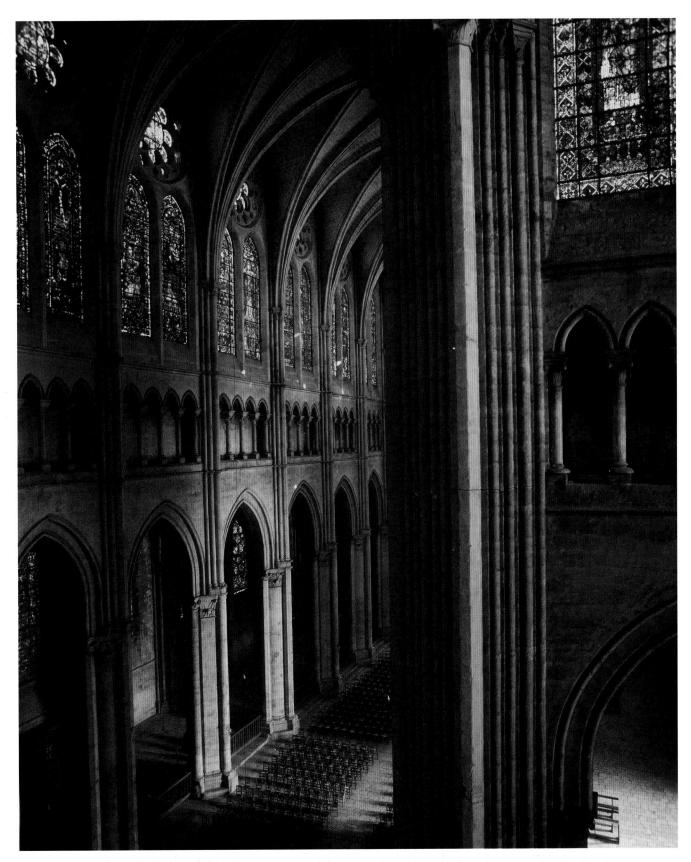

6.28 View of the nave wall, Chartres Cathedral.

spiritual goals of the Christian religion. The Gothic interest in ever-increasing height, lightness, and slenderness of proportion is evidenced by the statistics, given on p. 224.

A tall church was thought to please God. In addition, height could fuel rivalry between neighbors, for during the Middle Ages the local cathedral was the emblem not only of the piety of the town's population but also of its wealth, power, and pride.

The combination of **pointed arch**, **ribbed groin vault**, and flying buttress (see p. 228) defines Gothic architecture. Although each of these elements had been used earlier elsewhere, it is their combination into a coherent system that is new in the Gothic period. The pointed arch, seen everywhere in Chartres's interior, continuously directs our attention upward. The ribs of the vaults define the parts of the architectural structure and create a series of lines that keep the eye moving. The ground plan of Chartres (fig. 6.29) is not remarkably different from earlier Christian developments (see fig. 6.11); the new statement is in the construction and decoration. The rational basis of Gothic architecture demands that each element be explicable and interrelated (as in the Gothic philosophical system known as Scholasticism), and each rib in each vault is related to and visually supported by a colonnette (a thin column) that begins at floor level. These groups of colonnettes turn the supporting **piers** into **cluster piers**. The interior elevation (see fig. 6.31) is composed of a nave arcade, a **triforium** (a narrow gallery that opens the structure where normally there would be an expanse of wall), and a window-filled **clerestory**.

In most structures, we are aware of a continuous and relatively dense wall surface that is punctured and punctuated by doors and windows, but in the Gothic cathedral there is so little wall—and what remains is so dissolved or disguised by the linear patterns of ribs and colonnettes—that windows and wall are no longer alternatives. They are unified into an energetic skeleton with huge openings filled with vibrantly colored stained-glass windows. The flying buttresses—hidden from an interior view by the stained-glass windows—are clearly visible on the exterior and, in addition to their function as crucial supports, visually add lightness and energy to the exterior.

The ideal Gothic church would have had seven spires—twin spires on the western facade (fig. **6.30**, a development from the Carolingian westwork); a spire at the **crossing**; and paired spires at both north and south **transepts**. Such a massing of vertical forms pointing upward suggests the dissolution of the mass of the structure and a denial of gravity consistent with the motivations and aspirations of the cathedral builders.

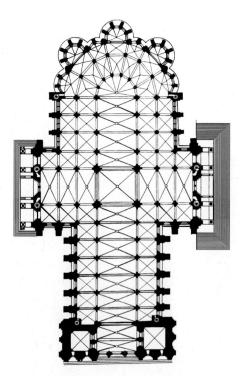

6.29 Plan of Chartres Cathedral.

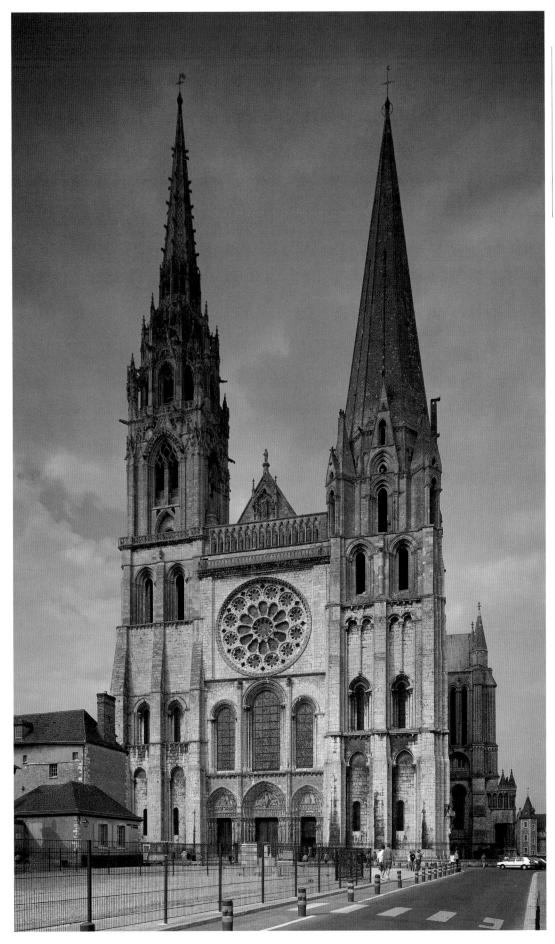

6.30 West facade, Chartres Cathedral.

The mismatched towers of the facade reveal the changing nature of the Gothic style.The shorter, transitional Romanesque-Gothic tower was completed before the fire of 1194; the elaborately decorated, fully Gothic spire was not begun until 1507.

Gothic Engineering

The Gothic cathedral is based on complex engineering principles (fig. 6.31). It is founded on the dynamic interaction/equilibrium between the outward **thrust** of the high cross vaults and the flying buttresses that contain this thrust. The desire for both height and maximum window openings led to the creation of a structure aptly described as "skeletal"; every element is manipulated to help meet these goals. The Gothic cathedral is the result of the union of three distinct constructional elements:

Pointed arch: its design focuses attention upward because our eye is drawn to the apex where the two sides of the arch meet. The pointed arch makes possible the unity of space characteristic of a Gothic structure. Since a pointed arch can rise to any height (fig. 6.32) despite its width (unlike a round arch), it can vault a bay of virtually any shape—such as those of Abbot Suger's ambulatory (see fig. 6.22). The tops of every pointed arch in the structure, despite its size and the shape of the bay below, all reach the same height. Because the outward thrust of a pointed arch is reduced, less buttressing is needed and larger areas of wall can be replaced with stained-glass windows.

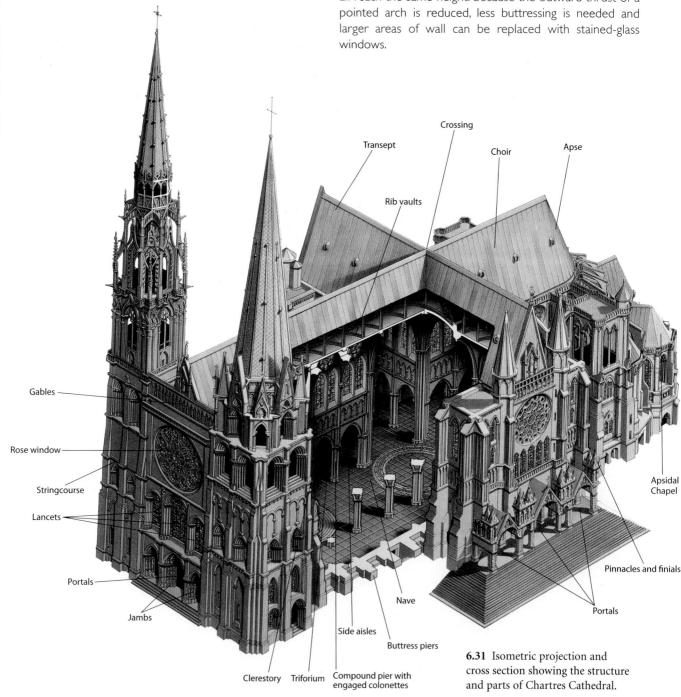

Ribs of the vault: these not only make the vaults appear lighter, but allow for a physically lighter structure. The ribs were constructed first and, because of their weight-bearing potential, the surfaces of the vault could be composed of lighter materials. These surfaces, sometimes called the web, or infilling, seem stretched, like a fabric or skin, between the linear, skeletal supports of the ribs.

Flying buttress: by transferring the thrust and weight to an exterior support some distance from the wall, the flying buttress permits a lighter structure and a broader expanse of windows. In earlier architecture, heavy buttresses created by thickening parts of the wall surface cut down on the amount of light that reached the windows and gave the structure a ponderous exterior and interior appearance.

The structural dynamics of the Gothic cathedralwhich today we can analyze with computers and study through models—were explored by Gothic architects by building three-dimensional models of arches and buttresses. At times, the Gothic desire for height and lightened structure led to difficulties. At Beauvais Cathedral, the choir vaults peak at 157 feet (47.9 meters) above the floor, making the interior of the church as tall as a fifteen-story building; they collapsed due to inadequate foundations, piers, and buttressing, and were rebuilt with additional supports and buttresses. A huge crossing tower—perhaps 500 feet (152.4 meters) tall—was then built, but when this also collapsed, work stopped. Beauvais today consists of little more than a Gothic apse, and even this stump has some modern additional buttressing on the interior. The history of Beauvais's construction reveals not only the continuing search for greater height, but also the experimental nature of Gothic architecture.

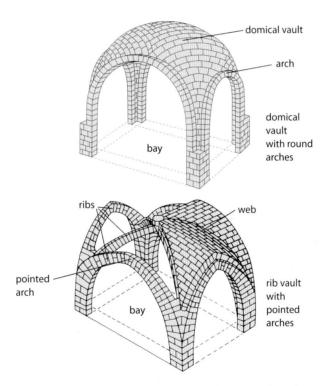

6.32 Vaults constructed using round and pointed arches. The pointed arches enable the openings on each side and at the center to reach a unified height over a rectangular bay.

Gothic Sculpture

s they approached the main, western door of Amiens Cathedral, the faithful were greeted by the trumeau sculpture of Christ holding a book and making a gesture of blessing (fig. 6.33). The book, probably the Gospels, symbolizes Christ's words and deeds, but this image of the teaching Christ is also combined with the victorious Christ, as represented in the lion and the dragon trampled under his feet. In Christian tradition, the dragon symbolized the Devil, and in this context the lion was understood as a symbol of the Antichrist. Unlike Romanesque figures, with their lively abstract patterns (see fig. 6.13), the Amiens Christ projects a quiet, stately presence. The simple verticality of the figure echoes the inherent architectonic role of the trumeau; the drapery falls in a naturalistic manner; and Christ's face has been given a human, solemn dignity.

For a later development in Gothic figural sculpture, see the *Madonna of Jeanne d'Evreux* (see fig. 6.25), in which Mary's body follows an exaggerated curve created by the tilt of the hip to support the arm holding the Christ Child; this is known as the "hip-shot" position. The drapery falls in broad folds, contributing to the statue's elegance, while a warm, affectionate smile plays across Mary's face as she gazes at her son. The reverent dignity of the *Beau Dieu* and the human charm of the *Madonna of Jeanne d'Evreux* express the diverse vitality that occurs in the development of Gothic sculpture.

As in Romanesque church facades, sculpted figures populate the exterior of Gothic churches, not only on the three western portals but also on as many as six transept entrances (three on the north, three on the south). The west facade at Amiens reveals how the number of figurative sculptures has increased (fig. **6.34**). The porches contain rows of **jamb** and **archivolt** figures; narrative reliefs decorate many other areas. The sculptures represent figures and scenes from the Bible, as well as more secular themes, such as the signs of the zodiac and the "labors," a defined set of activities that the Middle Ages thought were characteristic of each month of the year. The facade as a whole is, then, intended to represent all God's creation. Its order, commanded by the axial figure of Christ on the central trumeau, reflects the divine order of the Christian world.

6.33 *Beau Dieu*, trumeau, central portal, west facade, Cathedral of Nôtre-Dame, Amiens, France, c. 1225–35. Stone. Commissioned by the bishops of Amiens.

The popular name for this sober figure of the blessing Christ is the *Beau Dieu*, the "Beautiful Lord." Like most Romanesque and Gothic portal sculpture, this figure was originally polychromed.

c. 1200
Baghdad becomes an important center for the production of books

1222 University of Padua is founded c. 1225–35 Beau Dieu, Amiens Cathedral (fig. 6.33) 1258 Korea becomes a Mongol vassal state 1291 Acre, the last Crusader stronghold, falls to the Mamlukes

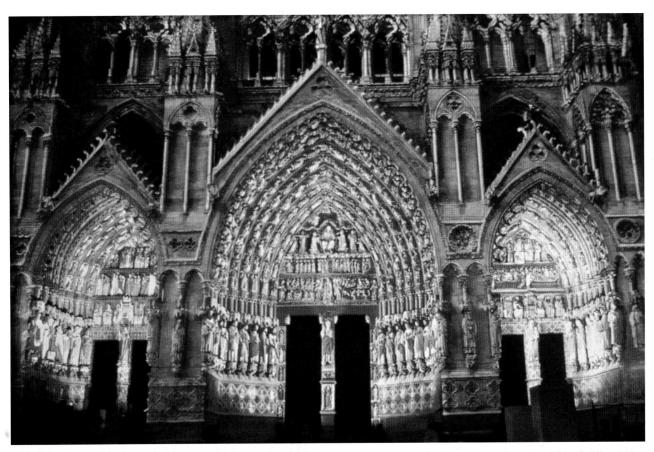

6.34 West facade, Amiens Cathedral, c. 1225–35. Commissioned by the bishops of Amiens. This photo shows a reconstruction of how the facade might have looked when its original paint was intact.

The visual richness of Gothic portal sculpture is evident in this view of the west facade of Amiens Cathedral. There are 52 over-lifesize (approximately 7½ feet [2.29 m] tall) statues flanking the portals, and an even larger figure on the trumeau in the center of each portal. There are also 118 reliefs in Gothic quatrefoil frames on the lowest level, figures in reliefs in the lintels and tympana above each set of doors, and 234 carved sections (voussoirs) with figures and scenes in the Gothic arches that curve about the three portals.

The iconography of the portals is equally complex. Three images of Christ form the central axis of the main portal, with the Beau Dieu (fig. 4.85) as the trumeau. Above, in the tympanum, are images of the Apocalyptic Christ at the apex, and below, Christ the Judge, framed by the walls of the New Jerusalem. Below the judging Christ is the scene of the Resurrection of the Dead, with the Archangel St. Michael Weighing Souls. Among the figures to the sides are allegorical representations of the Church and the Synagogue, the latter blindfolded following medieval tradition. St. Francis also appears, leading a group of souls into Paradise. The voussoir figures include Angels of various orders, Martyr Saints, Virgin Saints, and Hebrew Patriarchs, among others.

The two side portals are equally complex in iconography. The south portal (to the right, above) has the Virgin Mary on the trumeau; as the second Eve, she is shown trampling on the serpent. The column statues include representations of scenes from the Virgin's life, while the *Nativity* is found in one of the quatrefoils. Some of the figures in the north portal refer to local history, including the trumeau figure of *St. Firminus*, who founded the church in Amiens. Above is a scene of his relics being brought back to Amiens.

Figures and reliefs on the south transept portal add to the iconographic complex of the structure as a whole. Here the voussoirs include scenes that start with Adam and Eve and continue into the New Testament. Other motifs here include scenes from the life of St. Honorius.

Gothic Stained Glass

he brilliant contrast between the blues and reds of La Belle Verrière establishes a dynamic equilibrium, while the limited other colors and the black paint used to define faces, drapery, and other details enrich and dramatize the window (fig. 6.35). The glowing, gemlike windows that decorate a Gothic structure support the idea that the building serves as a metaphor for the Heavenly Jerusalem, which was described in the Bible as having foundations composed of precious stones (Revelations 21:19).

La Belle Verrière exemplifies two styles: a transitional style between Romanesque and Gothic in the Madonna and Child in the center, and the fully mature Gothic style of the surrounding angels. The rather rigid axiality of Mary and Christ (whose faces have been restored) is eased only slightly by the tilt of Mary's head. In contrast, the angels in the side panels are more animated.

Like the exterior sculptural program of a Gothic church, the figurative imagery of a stained-glass window

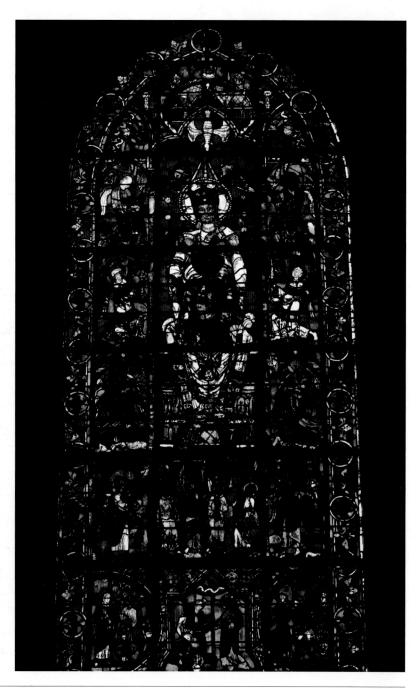

6.35 *Nôtre Dame de la Belle Verrière*, Cathedral of Nôtre-Dame, Chartres, France; twelfth century (central portion); thirteenth century (surrounding angels). Stained glass, approx. 16' × 7' 6" (4.9 × 2.3 m).

This venerated window is popularly known as *Nôtre Dame de la Belle Verrière* ("Our Lady of the Beautiful Window"). The *Enthroned Virgin and Child* in the center survived when Chartres Cathedral burned in 1194. As the cathedral was being rebuilt in the new Gothic style of the thirteenth century, the earlier window was flanked by panels with angels in a more fully Gothic style.

instructed the populace through symbolic imagery and narratives from the Bible. But with stained glass, this instructive purpose was joined with an almost mystical effect. On an average day, when the light level outside has been measured as approximately 9,000 lumens, the reading from the interior space of Chartres is only a few lumens; in other words, there is 1,000 times more light outside than inside. As the viewer's eyes adjust to the dark, cavernous space, a radiance of light seems to burst from the windows, where images in stained glass appear suspended within an aura of colored light. The windows glow with radiance, casting beams and spots of color throughout the interior.

Abbot Suger wrote about how the sumptuous quality of Gothic objects brought him into the mystical presence of the divine:

Thus, when—out of my delight in the beauty of the house of God—the loveliness of the many-colored gems has called me away from external cares, and worthy meditation has induced me to reflect, transferring that which is material to that which is immaterial, on the diversity of the sacred virtues: then it seems to me that I see myself dwelling, as it were, in some strange region of the universe which neither exists entirely in the slime of the earth nor entirely in the purity of Heaven; and that, by the grace of God, I can be transported from this inferior to that higher world in a mystical manner.

TECHNIQUE

Stained-Glass Technique

The origins of stained-glass windows, which are composed of pieces of colored glass joined by lead strips (fig. **6.36**), are uncertain. Colored-glass windows and windows made of thin stone through which light could filter were already in use in Early Christian and Byzantine churches, and although stained-glass windows became more common during the Romanesque period, it was only during the Gothic period that they became an integral part of the architecture and a major means of artistic expression.

The colored glass is produced by adding metallic oxides to molten glass (pot metal glass) or by fusing a

layer of colored glass onto clear glass (flashed glass). During the late Middle Ages, the design for a window would be drawn in chalk on a flat table, then pieces of glass would be cut to fit each small shape or area of the design. The details of faces and drapery were added using black enamel paint, which was then fused to the glass by firing. The fragments of glass were assembled, with lead strips bonding them in place. Because these glass-and-lead designs were heavy, armatures of iron bands were used to strengthen and support the windows when they were installed in the church.

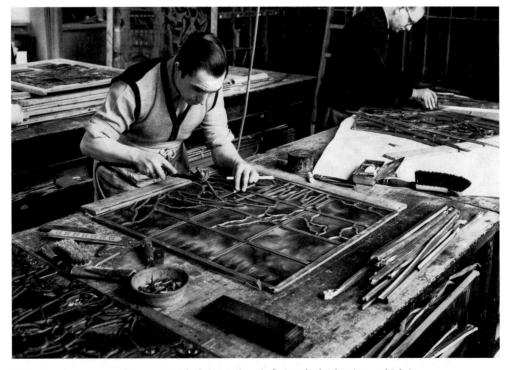

6.36 A craftsperson, making a stained-glass window, is fitting the lead strips—which in section are shaped like a sideways H—around the glass and soldering them into place.

The Great Mosque at Jenne

he Great Mosque at Jenne is a huge adobe construction that dominates the ancient city (fig. 6.37). According to tradition, the first version was built in the thirteenth century (or, in terms of Arab dating, the seventh century), at the time when the king of Jenne converted to Islam. By erecting the mosque on the site of his palace, he incorporated the traditional religious and political power associated with the site into the new religious structure. Subsequent rebuildings reflected the taste of later overlords. In 1907, the French colonial authorities allowed the city to reconstruct the mosque. The location of the mosque in the center of the city, next to the marketplace, is traditional for African mosques.

The strong horizontal nature of the design is countered by the towers and pinnacles along the tops of the walls. The horizontal protrusions that seem to bristle on the exterior of the structure are bundles of wood known as *toron*. Some of the corners of the towers on the qibla wall are set with an ostrich egg. As in many cultures, eggs are interpreted as symbols of fertility and of the cosmos.

A low wall encloses an exterior courtyard that could be used for prayer. The interior (fig. **6.38**) is filled with rows upon rows of closely massed adobe piers, rising to pointed arches, that direct the individual worshiper's attention toward Mecca.

A terra-cotta equestrian figure from this area demonstrates the Jenne sculptural style (fig. **6.39**). The figures seem to have been created by joining cylinders of rolled terra-cotta in a largely horizontal and vertical arrangement that gives both horse and rider not only slender elegance but also an effect of alertness appropriate to the military subject matter. The decorative patterns on the bridle, helmet, and other areas were made by scratching rather than modeling, leaving the basic design of horizontals and verticals intact. Figures such as this one were apparently created during turbulent times for the Mali Empire, when soldiers from Morocco and elsewhere were raiding the region.

Urban life developed as early as the first century CE in this area of the Sahara, and eventually gave rise to several empires that flourished between the ninth and the late sixteenth centuries. The mercantile networks that they established still link the western Sudan to the Atlantic coastline. Over the centuries, some of these peoples converted to Islam, while others remained dedicated to their native belief systems.

For about 6,000 years, this area of the Sahara was well watered, and substantial communities lived along its rivers and lakes, but beginning in the third millennium BCE, it became increasingly uninhabitable. The economy was transformed in the early years CE, when the art of domesticating

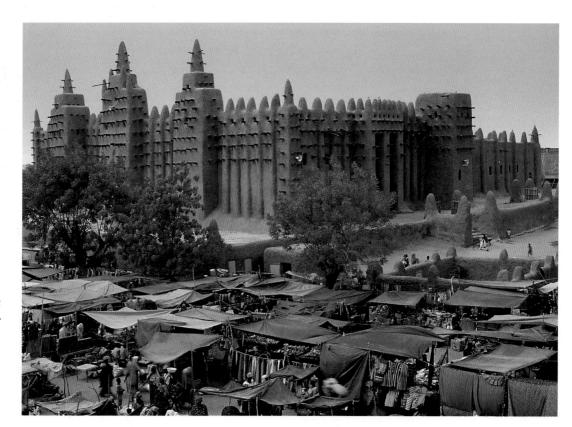

6.37 The Great Mosque at Jenne, Mali, founded thirteenth century, rebuilt 1907. Adobe. Commissioned by the Second King of Jenne.

When the mosque was rebuilt in 1907, the reconstruction was headed by Ismael Traore, head of the local masons' guild.

13th century Great Mosque at Jenne (fig. 6.37)

c. 1204 Founding of Amsterdam

1206 The Muslims are established in north India

1217 Genghis Khan serves as chief prince of the Mongols

c. 1225 The tallest minaret in the world is built in Delhi, India

6.38 Interior, Great Mosque at Jenne.

camels—first practiced in Arabia—spread to this area. Camels carrying heavy loads could cover twenty to twentyfive miles a day without food or water and without needing artificially constructed roads. At this same time, trade in copper, iron, and especially gold increased. Until the sixteenth century, Europe received most of its gold from West Africa.

When the Arabs conquered North Africa, there was a demand for an additional commodity: slaves captured in the sub-Saharan countries were exported across the desert to supplement the traditional supply of slaves to the Mediterranean area from eastern Europe and Central Asia. Many of these slaves worked in North African households. Manufactured luxury goods were imported into West Africa in exchange for minerals and slaves. Horses, too, were imported. Because disease makes horses difficult to breed in West Africa, they were in great demand. Their presence revolutionized warfare in grassland countries and helped the volume of trans-Saharan trade to increase steadily. Although often known as "Arab trade," this was mostly conducted by Africans.

As long-distance trade was established, earlier towns developed into market centers; when powerful individuals took control of the markets, they turned the towns into kingdoms. Sometimes intruders from the desert took over; sometimes local people were in charge. By the twelfth century, the economic and political center was the kingdom of Mali, which controlled the territory southward into the gold-producing forest country and westward to the Atlantic, making it larger than any state in Europe at the same time. The founder of this kingdom, Sunjata, was the hero of several great epics.

Islam spread through trade into the western Sudan. Long-distant traders were usually Muslim, finding in the religion a useful bond for commercial solidarity. The kings of Mali adopted Islam and the most famous one, King Mansa Musa, made a pilgrimage to Mecca with a vast train of attendants and lavished gold on his hosts along the way. But the kings who adopted Islam risked cutting themselves off from their subjects, whose daily life was tied to their local religious observances. Kings had to continue performing the old rituals, and even adopted visual arts that reflected their understanding and allegiance to the old ways. Often only the kings and a few other converts used both the local ritual arts and the newer arts of Islam, such as the mosque at Jenne. It became a symbol of the power of the kings and the potential of Islamic belief.

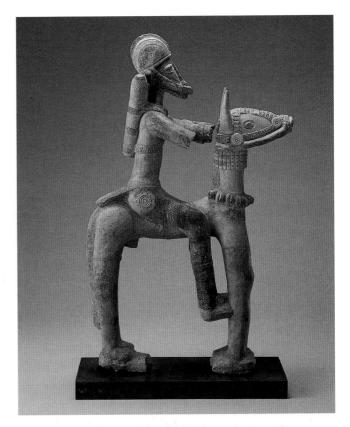

6.39 Equestrian figure, Ancient Mali, thirteenth–sixteenth century. Terra-cotta, height 2' 31/4" (69 cm).

Excavations in the region are limited, but the contemporary tourist trade has fueled interest in terra-cotta figurines such as this one. Without an archaeological context this figure cannot be dated precisely, but testing suggests it was made between the thirteenth and sixteenth centuries.

The Chinese Capital City in Beijing: The Forbidden City

he Mongol leaders of the Yuan Dynasty established their capital city in Beijing in 1267 on a site that had been used as a political center as early as the sixth century BCE (fig. 6.40); it remained the capital of China from the thirteenth century until the end of the imperial era in the early twentieth century, except for a half-century period at the beginning of the Ming Dynasty in the fourteenth century. The Mongols built their city on Chinese principles under the direction of Liu Bingzhong, a classically educated former Chan Buddhist monk who advocated Chinese modes of policy and administration. The Mongol capital, called Dadu, was a triple-walled city of almost perfect geometric regularity, a feature retained until the present-day. Within outer walls, built first, a second wall enclosed administrative buildings and a separately walled palace city in the southern sector. Major northsouth and east-west avenues and a network of subsidiary streets formed 50 wards that subdivided this city. The plan

followed traditional capital cities such as Chang'an (see fig. 5.32) and played an important symbolic role in legitimating Mongol rule over China. Later the Ming removed the northern wall and built another, north of the palace, to centralize the palace in the plan and make it less accessible. Extending the walls further to the south created an Outer City. This Ming period walled precinct encompassed the Temples of Heaven and of Agriculture.

When Marco Polo arrived at Dadu in 1275, he described the city as beautiful beyond description even though it was still under construction. He admired its spacious, straight streets intersecting at right angles that separated blocks of houses, a layout that symbolized the relationships between heaven and earth and between the ancestors and the emperor.

The later Ming capital included three walled cities. Outer walls enclosed the capital proper, within which another set encircled the imperial city; within these another

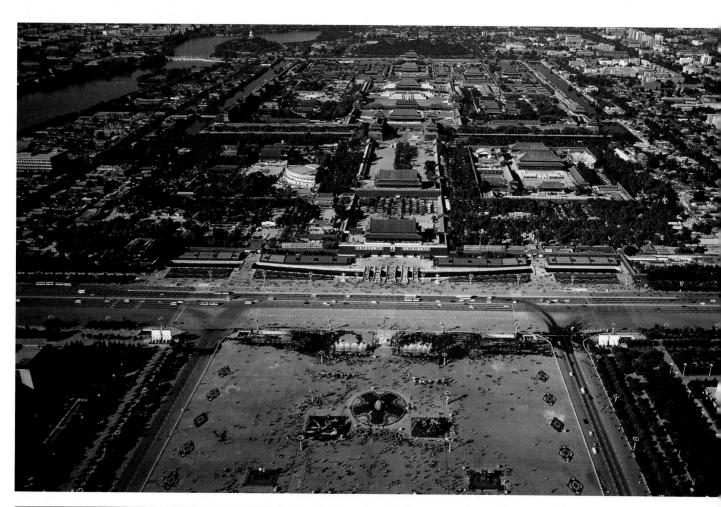

as their capital (fig. 6.40)

set isolated the palace itself, which in Ming and Qing times became known as the Forbidden City (fig. **6.41**).

The Palace is laid out symmetrically on either side of the long avenue that runs from the south wall of the Outer City through the Inner City into the Imperial City and Palace. An embassy approaching from the south would pass through eight increasingly massive gated and impressive courts before arriving at the outer court of the Imperial Palace, the massive Hall of Supreme Harmony, which rises from a three-tiered terrace of white marble and is the first of six ceremonial halls located on a central axis. In this first hall the emperor celebrated important events and occasions with his people, represented symbolically by ministers and officials.

The next building on axis is the Hall of Middle Harmony, a small square building that served as a private chamber where the emperor might rest between audiences or write memorials to the ancestors. Beyond was the Hall of Protecting Harmony, where he received scholars and the major officials of the huge bureaucracy that enabled the empire to function.

The second group of three buildings consists of private buildings for the imperial family. The first was the residence of the emperor; his wives and concubines resided in the more secluded sections of the palace to the north. The second, smaller building was the private throne room of the empress. Her personal residence was the last of these buildings.

6.40 The Forbidden City, Beijing, PRC, aerial view. First built in the Yuan Dynasty (1279–1368); rebuilt in the Ming (1368-1644) and Qing (1644-1911) Dynasties; refurbished in the PRC 1949-present. Commissioned by the Imperial courts of the Yuan, Ming, Qing, and the government of the PRC.

The Forbidden City, which covered about 250 acres (1 sq km), contained the audience halls and residential palaces of the emperor, the empress, and other members of the imperial family. The imperial city—six times larger than that of the Forbidden City—contained the offices of the eunuch bureaucracy that ran the palace, warehouses, workshops, stables, and pleasure palaces.

Work on the Palace began in 1406 and continued for centuries, creating palaces, verandas, belvederes, pavilions, temples, walkways, and gardens. It is estimated that 200,000 artisans and as many as one million people—convicts, military conscripts, and common people—were sent in rotation to work in Beijing. Modern scholars have estimated that more than 20 million bricks were required to pave the palace courtyards, and more than 80 million to face the city walls and gate towers. In all 1.93 million tons of brick were used.

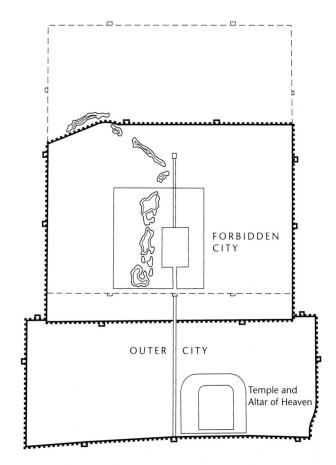

6.41 Map of Dadu in the Yuan Dynasty (broken line) compared to Beijing of the Ming and Qing (unbroken line). The Yuan city walls were 16 miles (25.75 km) in circumference; those of the Ming capital were 14 miles (22.53 km) in circumference after the move of the walls. The total area today is 250 square miles (647.5 sq km).

The Imperial Palace has many well-established gardens. The Kublai Khan created a shallow lake by dredging earth from a swampy area to the west of the city, using the excavated soil to build a hill 600 feet (183 m) high and a half mile (.8 km) long. It provided the mountain necessary to accommodate the principles of fengshui (literally, wind water) to create a setting that was in harmony with Nature. As the Son of Heaven, the emperor was responsible to bring the empire into balance, which he did symbolically as he sat on his throne that straddled the north-south axis of the Forbidden City, which symbolized the axis of the universe.

Early Italian Painting

Once Cimabue thought that in painting
He commanded the field, and now Giotto has the acclaim.

As this quotation from Dante's *Divine Comedy* reveals, Cimabue (c. 1251–1302) was once the most important painter in Florence. His style represented a final statement of the Byzantine influence in Italy. Dante wrote that it was soon superseded by the revolutionary style of Giotto (1266/7 or 1276–1337), an assessment that we share with Giotto's contemporaries. A comparison between their compositions of the Madonna and Child reveals the significance of Giotto's innovations (figs. **6.42**, **6.43**). The size and simple composition of Cimabue's painting create an impressive and severe effect consistent with the expressions of the

faces. In contrast, Giotto reestablishes the connection between the art of painting and the nature of objective reality, an attitude not evident in painting since ancient Roman illusionism (see pp. 126–29). Giotto's figures are represented as massive, weighty forms that seem to exist within a spatial continuum in which gravity is an inescapable factor. These large, bulky figures have strongly modeled, naturalistic drapery, as seen in the flowing folds of the angels kneeling in the foreground. Unfortunately, the darkening of the blue of the Madonna's robe and the repainting of her knees and lap have deprived the central figure of some of its original sense of weight and presence.

The heavy marble throne of Giotto's *Madonna* seems solidly fixed in space, while Cimabue's wooden throne is

6.42 Giotto, Madonna
Enthroned with Angels and
Saints, c. 1300. Tempera on
wood, 10' 8" × 6' 8¼" (3.25 ×
2 m). Galleria degli Uffizi,
Florence, Italy. Originally
commissioned by an
unknown patron for the
Church of Ognissanti (All
Saints) in Florence, this
panel is sometimes called the
Ognissanti Madonna.

lighter and less rational (there are no back legs). In both Cimabue's and Giotto's panels, the figures to the sides overlap, but in Giotto's they seem to stand solidly on the ground; Cimabue's angels seem to be floating in an abstract decorative pattern. The placement of Giotto's figures in space is clearly structured: the kneeling angels overlap the standing angels, who in turn overlap the throne, and in the grouping of saints Giotto lets some of the haloes overlap shoulders and even faces. Giotto surrounds the Madonna and Child with figures placed to create a natural, believable effect, but with no loss of dignity or emphasis.

Equally important for Giotto's revolution is the new responsiveness of the figures, which even in this traditional subject is of such intensity that a dramatic effect is created. The angels respond to the presence of the Madonna and Child with spontaneous expressions of awe. The Madonna and Child have neither the remoteness nor the insubstantiality seen in Byzantine art, and their parted lips and direct gazes convey a significant human presence.

Giotto's painting, with its recognition of both the physical and the psychological natures of human activity, is in direct contrast to the schematic composition and expressionless figures of Cimabue's panel. Giotto transformed the art of painting; by emphasizing the concept of the "painting as a window," he established an approach that would endure until the revolutionary experiments of Cézanne and the Cubists in the late nineteenth and early twentieth centuries (see figs. 11.72, 11.73, 12.21).

6.43 Cimabue, Madonna Enthroned with Angels and Prophets, from the high altar of Santa Trinità, Florence, c. 1285. Tempera on wood, 11' $7'' \times 7'$ 4" $(3.54 \times 2.24 \text{ m})$. Galleria degli Uffizi, Florence, Italy.

Tradition has it that Cimabue was the teacher of Giotto.

Giotto, The Arena Chapel Frescoes

s in his Madonna (see fig. 6.42), the figures in Giotto's Lamentation (fig. 6.44) offer an illusion of weight and mass not seen in painting since antiquity. At the same time, they convey a convincing drama and expression of emotion. Through gesture and placement, the composition, with its sloping hillside setting, focuses attention on the dramatic core of the narrative, the heads of the Virgin and Jesus in the lower left corner. Two figures seen from the back enframe this tender moment and communicate the loss and pain appropriate to the agonized farewell of a mother to her son. The simple landscape of barren hill and dead tree both directs our attention to the narrative focus and expresses the sense of loss communicated by the figures. The Lamentation and the related theme of the Pietà, which are not mentioned in the Bible, are subjects that emerged with the demand for a more emotional religious art in the late medieval period.

Giotto's *Lamentation* must be examined in relation to its context. In the Arena Chapel (fig. **6.45**), Giotto painted a cycle of scenes from the lives of the Virgin and Jesus that starts near the top and, reading left to right, spirals around to culminate in six final scenes on the left wall. The cycle as a whole has a continuous left-to-right development, and

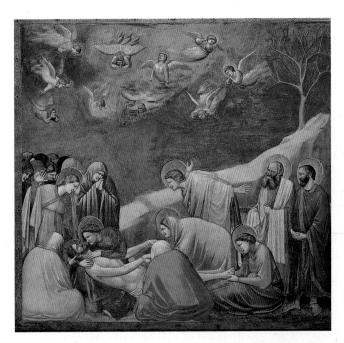

6.44 Giotto, *Lamentation*, fresco in the Arena Chapel, Padua, Italy, c. 1303–05. Approx. $6' \times 6'$ 6'' $(1.85 \times 3 \text{ m})$.

The Arena Chapel was built and decorated for Enrico Scrovegni, a wealthy Paduan businessperson. It was attached to the Scrovegni Palace, which had been built on the site of the ancient Roman arena of Padua, hence the name Arena Chapel.

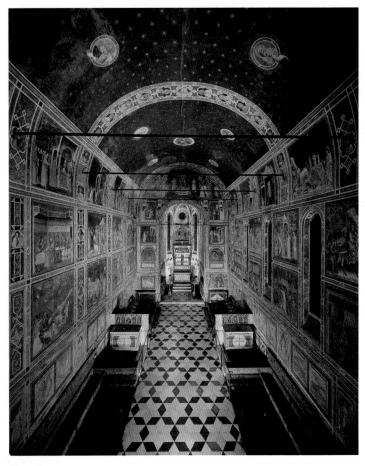

6.45 Giotto, frescoes, Arena Chapel, Padua.

The Arena Chapel has windows on only the right-hand wall; the left is completely filled with the bands of narratives. High on the triumphal arch is a fresco of God sending Gabriel to earth; below, to either side, are the kneeling figures of Gabriel and the Virgin at the moment of the Annunciation and Incarnation. The vault above is decorated with blue sky, gold stars, and holy figures appearing in circular, window-like frames.

the last section begins with an exceptionally strong left-to-right movement in a representation of Jesus carrying the cross. This movement is halted by the centralized composition of the *Crucifixion*, but in the subsequent *Lamentation*, Giotto forces our attention backward and downward to the conjunction of the heads of the Virgin and Jesus. Giotto thus demands that we stop and concentrate on the *Lamentation*. The impact of the event is conveyed to us not only by the variety of human emotions expressed by Jesus's followers as they gather around his body, but also by the reflection of these emotions in the angels who flood the sky with grief. Such a strong emphasis on experience and empathy is surely related to the preachings and writings of the followers of Saint Francis (see p. 223).

In the Last Judgment, Christ appears in the center, flanked by saints and angels; below, on his right side, are the blessed, while to our right are the damned (fig. 6.46). Near the center, to the left of the cross that marks the dividing line between Paradise and eternal damnation, is a representation of Enrico Scrovegni offering his chapel, represented as a model held by a monk, to the Virgin. Scrovegni's purpose in having the chapel erected and painted is thus clarified, for in making this offering he hoped to cleanse his money and that of his father; both had accumulated fortunes by charging exorbitant rates of interest, a sin called usury that the Church condemned. Dante cited Enrico's

father as the arch-usurer, and placed him in the seventh circle of hell in his Divine Comedy.

There are references to virtues and vices in other areas of the chapel. They appear as figures in grisaille (gray and white, simulating sculpture), which alternate with illusionistic marble panels on the lowest level.

The Renaissance artist Lorenzo Ghiberti said the Arena Chapel was "one of the glories of the earth," and the modern artist Henri Matisse announced that, on looking at a scene in the Arena Chapel, "I understood at once the feeling which radiates from it, and which is instinct in the line, the composition, the color."

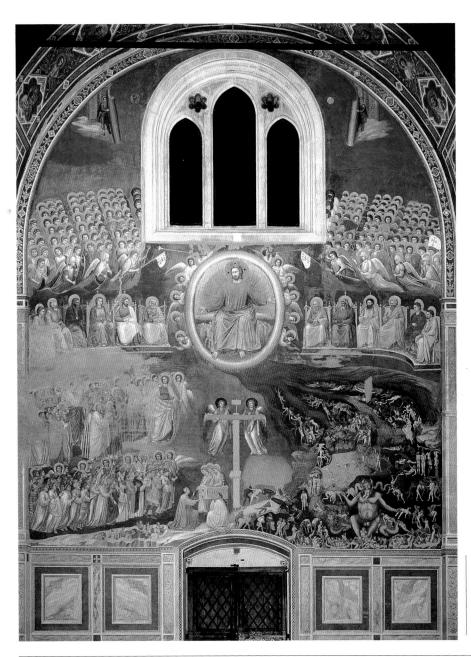

6.46 Giotto, Last Judgment, fresco in the Arena Chapel, Padua, c. 1303-05. Approx. 33' × 27' 6" (10 × 8.4 m).

Filling the inside of the entrance wall, and therefore the last thing viewers see as they leave, is a panoramic representation of the Last Judgment. It was intended as a visual reminder to the faithful of the divergent destinies of the blessed and the sinful.

Tempera and Fresco

During the fourteenth and fifteenth centuries, Giotto, Masaccio, Botticelli, and other Italian artists created paintings using tempera and fresco, two techniques that were as distinctive in appearance as they were in execution. Fresco (see p. 128) and tempera both have their origins in antiquity; in fourteenth-century Europe, they were well established as alternative techniques used by the same artist but for different settings and purposes. In both cases, the painting would first be commissioned and a legal contract drawn up that was binding on both patron and artist. At this point, the painter probably was advanced money to pay for the purchase of necessary materials. Small drawings might be prepared to show to the patron for approval before the contract was signed.

The use of tempera paint dates back to the Egyptians. The support for tempera paint is usually wood (fig. 6.47), and large panels such as those of Giotto and Cimabue (see figs. 6.42, 6.43) are composed of planks glued together, with an integral frame constructed at the same time. To provide an appropriate surface for the paint, the wood panel was covered with linen or canvas and several layers of gesso, a fine plaster made of glue and gypsum and/or chalk. Onto this surface the painter drew preliminary designs, probably with charcoal. The outlines of the final design were scratched into the plaster surface and the charcoal erased. Thin sheets of gold leaf were applied, using red glue, to the background areas. The paint used was composed of ground pigments combined with egg yolk and perhaps a little vinegar. The paint dried quickly and had to be applied in numerous thin layers to prevent flaking.

Finished paintings are characterized by rich colors against a luminous gold ground. Many painters enhanced their work by elaborately decorating the gold background. Using delicate tools, they pressed floral and Gothic decorative patterns into the surface of the gold to create borders and halo designs that caught the light and shimmered on the reflective surface.

As in tempera painting, the creation of a fresco demanded a number of sequential steps (fig. 6.48). After the contract was signed, scaffolding had to be erected, and a layer of rough plaster (arriccio) was applied over the brick or stone wall surface. To mark the subdivisions, a string soaked in red color was held up to the surface and snapped to create horizontal and vertical guidelines. The artist then made preliminary charcoal drawings on the arriccio. These drawings were reinforced with pale ocher paint and the charcoal erased. The ocher painting was then reinforced in sinopia (red paint); such full-scale compositional drawings are called sinopie. At this point the sinopie could be viewed and approved by the patron. The final layer of fine plaster (intonaco) was then applied.

In the true fresco technique (buon fresco), a fresh patch of plaster was applied at the end of a day's work in preparation for painting the next day. Each daily patch is known as a giornata (Italian for "day"). The patches are usually applied in sequence, beginning with the upper left area of the wall, then moving across the top, and ending with the lower right.

The wetness of the plaster, which changes over the course of the day, has to be taken into account by the painter. When the plaster is quite wet, the paint sinks into the plaster surface (up to a quarter of an inch) and bleaches slightly. If the artist is painting a large passage of drapery beginning in the morning and ending in the afternoon, during the later part of the day a little water must be added to the paint so that the last areas painted

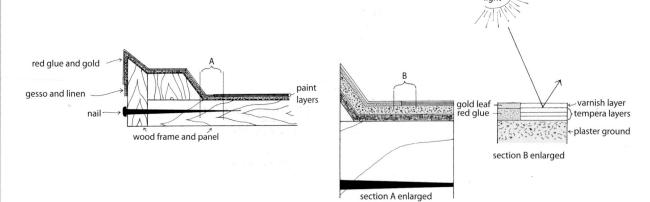

6.47 Schematic diagrams of a section of a typical late-medieval tempera painting, showing the technique that would have been used by Cimabue and Giotto, for example. Tempera is opaque, and the arrow (right) suggests that light penetrates only the upmost, translucent varnish layer on the surface of a tempera painting (section B enlarged, far right). Notice how the frame is integral to the initial construction and not something that is added later (above). The layers of paint in these diagrams are consistently shown as regular for the purposes of clarity, but in reality layers of paint vary greatly in thickness, as has been demonstrated by electronic microscopy examinations of slivers of paint removed from paintings.

will not be darker in hue. As the plaster dries, a chemical reaction takes place: the carbon dioxide of the air combines with the calcium hydrate in the plaster, producing calcium carbonate. After all the giornate are painted, haloes are gilded. Fresco secco (color with glue in the vehicle-egg white or lime) is used for some details. Blue is usually applied in this fashion.

The process and the end results of fresco and tempera are different. Fresco, for example, is faster than tempera. No wooden frame has to be built and laboriously covered with layers of fine plaster, and in fresco painting the artist works on a large scale with a bigger brush and with a relatively thin paint that applies easily. This technique is also much cheaper than tempera because of the speed involved in execution and the fact that the materials are less expensive. Tempera is slower because it is a finer technique, meant to be seen close up. Because the colors dry rapidly, only one thin coat can be applied at a time, and each color must be built up in layers. Tempera works were painted in the bottega (shop), but frescoes had to be painted directly on the wall. This concept of painting in place meant that the painter frequently took into consideration the architecture and lighting of the setting.

Tempera paintings are usually brilliant in color, with deeply saturated hues, while frescoes tend to be slightly washed out, of higher value, and less deeply saturated because the pigment sinks into the plaster. Brighter colors are evident in tempera paintings because finer pigments are employed; in fresco, cheaper, more earthy pigments are used, partly because large quantities are necessary.

Tempera is more conservative and discourages experimentation because the entire conception must be worked out before the carpenter begins to construct the panel. In contrast, fresco encourages experimentation because it is easily corrected if the first effort is not acceptable: the still-damp plaster can be scraped off and the artist can start again the next day. While fresco invites spontaneity, tempera is so methodical that the artist is encouraged to be very precise. Fine detail can be emphasized, whereas frescoes are frequently high on the wall and forms are suggested rather than spelled out in detail. The fresco technique favors a broad style of painting in contrast to the accuracy and precision of the tempera technique. The distance between the viewer and the painted wall also encourages fresco painters to be more dramatic and to use a few prominent gestures to communicate ideas and expression. Frescoes are generally larger, the figures are usually about lifesize, and the style is often illusionistic.

Both media are durable, partly because of the care with which they are executed. Both represent careful refinements of experiments by artists over many years, and both are technically sound. However, frescoes deteriorate if moisture seeps through from behind, and the wood support of the tempera panel can warp, crack, or rot. Another common difficulty with frescoes is that any fine details painted in the fresco secco technique can flake away.

One motivation for an artist to work in both media is the fact that fresco painting is not feasible in the winter, when the increased humidity in Italian churches meant that the plaster did not dry quickly enough (documents survive that tell us about frescoes that grew moldy rather than drying). During the winter, the painter could be busy in the bottega (workshop), making tempera paintings.

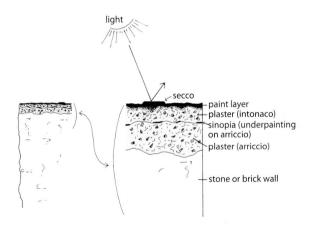

6.48 Schematic diagram of sections of a typical late medieval fresco painting, showing the technique as it was used by Giotto. The arrow emphasizes that light does not penetrate the surface of a fresco painting, as it will in the later development of oil painting (see fig. 7.28).

The Royal Art of African Kingdoms

he main subject of Ife art is the human head, rendered naturalistically but with the regularized features of an idealized portrait (fig. 6.49). The Head of Queen Olokun is presented with a serene and regal countenance that comes from a sculptural tradition known first in clay and then in metal. The more than 15 million Yoruba-speaking people who now live in Nigeria and the Popular Republic of Benin are the descendants of the makers of this head. They have a long history in West Africa, and they continue to be one of the largest and most prolific art-producing groups on the continent.

According to excavations at the sites of Owo and Ife, they had founded cities as early as 800–1000 CE. These were only two of the numerous city-states headed by sacred rulers (both men and women) and councils of elders and chiefs. The city-states best known for their sculpture and cultural life were Ife, Benin, and Owo. Ife, situated in the southwest of what is now Nigeria, is regarded by the Yoruba as the place where life and human civilization originated. The dynasty of kings there remains unbroken to the present day and may be the oldest continuous kingship in the world.

Ife is the oldest of these city-states, but little is known about its rise to power. By 1100, artists there had already refined a highly naturalistic sculptural tradition in terra-

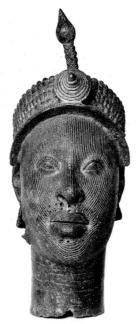

6.49 Head of Queen Olokun, Ife culture, from the Ife kingdom, Nigeria, eleventh–fifteenth century. Brass, height to top of ornament approx. 3' (91 cm). The British Museum, London. Commissioned by an Ife ruler.

The metal used to cast the lfe heads is often called bronze, but as an alloy of copper and zinc, it is more properly classified as brass.

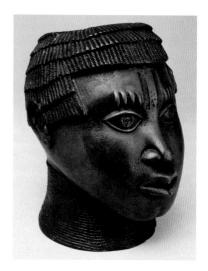

6.50 Altar head, Edo culture, from the Benin kingdom, Nigeria, seventeenth century. Cast alloy of copper and iron, height 8½" (22.2 cm). National Museum of African Art, Smithsonian Institution, Washington, D.C. Commissioned by a Benin ruler. This head once supported a decorated elephant tusk, as in fig. 6.52.

cotta and stone, which was soon followed by works in copper, brass, and bronze. The terra-cotta heads and works cast in brass found at Ife are known to date between the eleventh and sixteenth centuries.

South of Ife was the kingdom of Benin, which built its capital at Benin City. When the Portuguese arrived there in 1485, the highly organized Benin society was headed by a wealthy and militarily powerful monarch called the oba. He presided in a large city with a regular grid pattern of treelined avenues. The *oba* was supported by a large aristocracy and an efficient group of bureaucrats. Artists and craftsworkers, including metal casters and ivory carvers, were organized into guilds, worked exclusively for the king, and lived in special compounds in the city. The system was maintained until 1897, when a British expedition sacked and destroyed the city. The British soldiers went to Benin City to avenge the death of an English consul who had been killed when he entered the city in violation of the orders of the oba. The Benin leader had forbidden the visit of foreigners because he was absorbed in rituals in honor of his ancestors. The thousands of works of art taken as booty by the English were sold in London to cover the cost of the expedition and are now in the major museums of Europe.

The art of Benin is court art, the principal aim of which was the glorification of the ruler. Each newly enthroned *oba* ordered brass memorial heads to be cast in honor of his father (fig. **6.50**). These heads are not individualized portraits intended to portray a particular monarch, but rather their function is to memorialize both one *oba* and all *obas*.

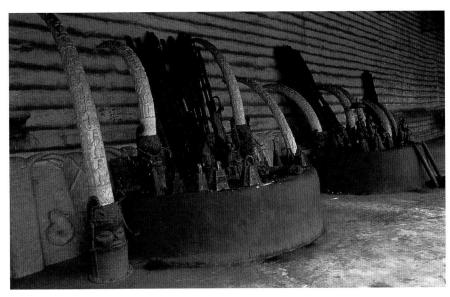

6.51 Royal Ancestral Shrine, Benin culture. Benin kingdom, Nigeria, seventeenth century. Commissioned by various Benin rulers.

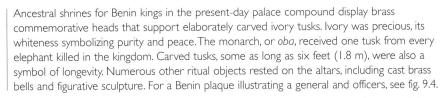

6.52 Head of a Woman, Yoruba culture, from Ugba' Laja site, Owo, Nigeria, fifteenth century. Terra-cotta, height 61/8" (17.3 cm). Nigeria National Museum, Ile-Ifer.

They are testimonies to royal descent and were one of the six essential items (wooden heads, the royal sword, brass bells, sculpted leopards, and carved ivories) to sit on the ancestral altar of the palace to emphasize the king's prestige and power (fig. 6.51). As commemorative images, they represented the enduring power of inherited leadership.

The obas were believed to have both divine and Edo (the local ethnic group) lineage, and all beings, whether living or spiritual, were thought to possess life force, or ase. Priests, initiates, diviners, rulers, and elders could learn to use ase for the benefit of themselves and those around them. The tangible world of the living (aye) interacted with the invisible realm of the spiritual forces (orun), which included gods, ancestors, and spirits. The tangible and spiritual aspects of all obas were meant to be realized in the brass heads.

Another kingdom, Owo, maintained close ties to Ife and also experienced the powerful artistic and cultural influences of Benin City. Excavations at Ugba' Laja uncovered the ruins of a thatched-roof mudhouse, thought to be a shrine, that contained objects associated with rites of sacrifice—terra-cotta heads (fig. 6.52), incomplete small figures, fragments of larger figures and groups, ceramic pots, iron implements, and polished stone axes. In technical execution and style, the head from Ugba' Laja falls within the naturalistic tradition also characteristic of the art of their neighbors, the Ife. The vertical striations that line the face represent the scarification that was performed to signify the rite of passage to adult life. The heirs of this sculptural tradition remain active and influential as artists in West Africa today.

7.1 Deer Bearing a Sacred Mirror with Symbols of the Five Kasuga Honji-Butsu, Japanese, fifteenth century. Gilt bronze, wood, gesso, and paint, 3' $7\frac{1}{2}$ " (1.16 m). Osaka, Hosomi Minoru, Important Cultural Property. Probably commissioned for a family shrine.

Fifteenth-Century Art

A BRIEF INSIGHT

The Japanese deer represented here (fig. 7.1) is naturalistically proportioned, and the textures created in the bronze, which differentiate between fur and antlers, reveal that the artist has closely examined a real animal; this work was chosen to introduce the fifteenth century because such close observation of reality is characteristic of much of the art created during this century not only in the West, especially Italy and Flanders, but also, as this work suggests, in some of the art of the East as well. The fifteenth century is also characterized by impressive technical achievements; in this case, the work demonstrates the artist's mastery of the difficult medium of cast bronze.

Regardless of technical or naturalistic accomplishment, however, many commissions still required artists in both the East and the West to employ traditional religious themes and symbols. Despite its naturalism, the deer, for example, is not a representation of the animal for its own sake, for it has been identified as a representation of Takemikazuchi no Mikoto, a divine messenger who brought good fortune and also functioned as a guardian figure. The object supported on the deer's saddle combines Buddhist imagery with Shinto elements. The large round disk is a reference to the sacred mirror of the Shinto Sun Goddess Amaterasu (see pp. 160–61) and the branch is another Shinto symbol, while the five smaller disks on the mirror contain incised images of Buddhist deities.

The mirror, branch, antlers, and body of the deer were each cast in bronze separately and then joined to create the total ensemble. The curving, flamelike forms of the carved wooden base, which are based on traditional Chinese representations of clouds, imply the ability of this messenger to move swiftly through the air.

Introduction to Fifteenth-Century Art

hree works of religious art introduce us to artistic developments in the fifteenth century. The two examples of Christian subject matter, from Europe, are naturalistic in character, while the Buddhist work, from Asia, is highly abstract. Such a distinction in style is indicative of two diametrically opposing views of how art functions: the two European works represent explicit moments in the life of Christ, while the Asian work is non-narrative and represents a diagram of the structure of the universe.

Also indicative of the differences in cultural viewpoints is the relationship of each work to earlier works in the same tradition. In no case is the subject matter represented here new, but while the European works show new stylistic developments that occurred in the fifteenth century, the Asian work is more traditional in its design.

Many of the European developments that occurred in the fifteenth century in Italy and Flanders can be seen in a comparison of the *Resurrection* (fig. 7.2) by Piero della

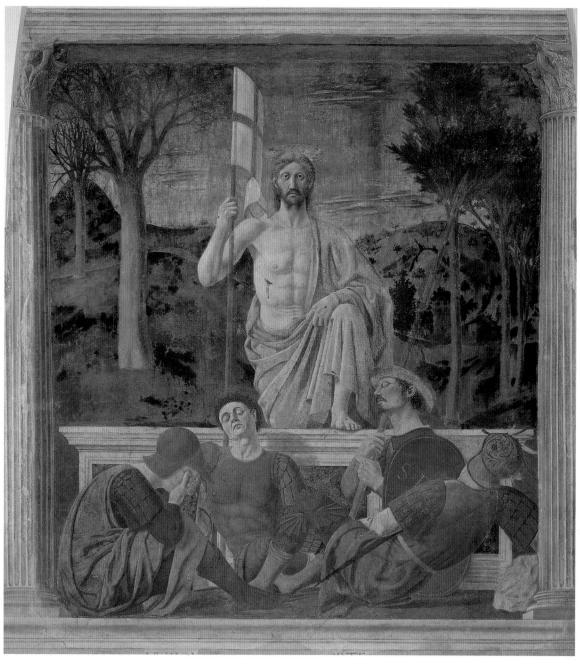

7.2 Piero della Francesca, *Resurrection*, c. 1460. Fresco, approx. $8' \times 6'$ 6" (2.25 \times 2 m); the figures are approx. life-size. Pinacoteca, Sansepolcro, Italy. Commissioned by the chief magistrates of Sansepolcro for their state chamber.

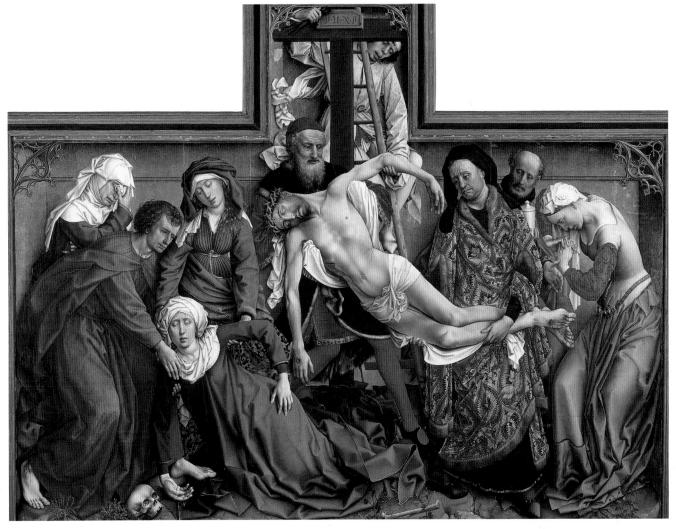

7.3 Rogier van der Weyden, Deposition, c. 1435–38. Oil on wood, 7' 21/8" × 8' 71/8" (2.2 × 2.62 m). Prado, Madrid, Spain. Commissioned by the Crossbowmen's Guild of Louvain for the Church of Nôtre-Dame Hors-les-Murs.

The symbol of the commissioning guild, the crossbow, is used for a decoration in the side spandrels.

Francesca (c. 1420-92) with the Deposition (fig. 7.3) by Rogier van der Weyden (1399?-1449). Both are much larger than earlier European paintings, with life-size figures, and they offer a naturalism not seen in painting since the time of the ancient Romans. The figures are realistically proportioned, seem to have weight and to occupy illusionistic space, and suggest the potential for movement. In addition, they are charged with emotional and psychological tensions that demand a response from the viewer. Piero's resurrected Christ fixes us with a compelling gaze, while in Rogier's painting waves of emotion sweep through the followers as they receive the body lowered from the cross. They weep, convulse, and faint.

Nevertheless, significant differences between the two works suggest the artistic and cultural distinctions between Italy and Flanders at this time: it is during the fifteenth century that we begin to find the development of sharply

different traditions within Europe. Piero's Christ is like a Greek god—his handsome musculature and dignified bearing can be compared to the Apollo from Olympia (see fig. 3.54). Such an interest in classical motifs and types is seldom found in Flemish painting. Piero's forceful triangular composition, with Christ's head at the apex and the sleeping soldiers grouped below, reveals the Italian concern with harmony and order. Rogier's composition is much more visually complex, and its flowing forms weave a pattern of pathos and despair. This concentration is reinforced by Rogier's Flemish attention to precise naturalistic detail, made possible by new developments in oil painting (see pp. 274–75).

While western Europe was undergoing rapid developments and changes in the form and content of its art, much of Asian art was characterized by the continuation of earlier forms, especially within the Buddhist tradition that had, by

this time, spread from its origins in India throughout most of Asia. The form of the fifteenth-century Mandala of Jnanadakini from Tibet (fig. 7.4), for example, follows that of centuries-old examples, but the use of brilliant color is typical of Tibetan art in the fifteenth century. "Mandala" means "circle," and this Buddhist symbol for the structure of the universe was used for meditation and to introduce devotees to a higher spiritual order. A mandala can assume many shapes; it can be painted as here or made in colored sand, it can be rendered in three-dimensions, or it can used as the basis for the Buddhist temple design, as in the substructure of the stupa at Sanchi (see figs. 4.1, 4.21) or as at Borobudur, in Java (see fig. 5.49). In this Tibetan example, the center is controlled by a dakini, a female demigod who represents the absolute principle in Buddhist cosmology. The four quadrants represent the four directions; four cosmic Buddhas, each a different color, preside over the four quadrants. The geometric harmony of this Tibetan mandala has formal similarities with the design of many Italian works of the fifteenth century, creating an unexpected aesthetic parallel between works created in two diverse, unrelated cultures.

FIFTEENTH-CENTURY WORLDWIDE DEVELOPMENTS

In fifteenth-century Europe, the foundations were being laid for many of the developments that help explain later Western attitudes. In fact, the fifteenth through seventeenth centuries have been called the "Early Modern" period in the study of Western history. Because so much of the Western world view has its origins then, European artistic developments of this time must be discussed in some detail.

There were continuing developments in—and increasingly important contacts among—all parts of the world in the fifteenth century. The explosion of publications in the West (the first printed edition of Marco Polo's *Description of the World* was published in Germany in 1477) inspired interest in other cultures, and Columbus's explorations in 1492 were to lead to extensive contacts between Europe and the Americas in the sixteenth century.

In East Asia during this period, China under the Ming Dynasty (1368–1644) was the most stable political entity. The arts were used to revive and reassert the stability of Chinese traditions. In Japan, the fifteenth century was a

7.5 Eagle Warrior, Aztec, fifteenth century. Earthenware and plaster, life-size, height 5' 6%" (1.71 m). Museo Templo Mayor, Mexico City.

This work is formed of five distinct pieces joined together: the head, the chest and arms, the lower torso and thighs, and the two legs. The hands may once have held a wooden weapon. By the end of the fifteenth century, Tenochtitlán, the Aztec capital where this sculpture decorated the Great Temple, was one of the largest and most impressive cities in the world.

period of constant warfare and absence of central authority, although the trades and arts continued to flourish during these troubled times (see fig. 7.1). It was during this period that Zen Buddhism became dominant in Japanese religious and intellectual life. There was a renewed interest by the Japanese in Chinese culture, perhaps because of the stability that China represented in Asia.

In the area that would later be identified as the "Americas," many distinctive cultures thrived. In Mexico, Aztec leaders used military might to control and exact tribute from a large area. The figure shown here (fig. 7.5) represents an Eagle Warrior, one of the elite groups of Aztec soldiers, as indicated by the wings on his arms, the claws at his knees, and the bird helmet. The eagle was one of the

symbols of the sun god Huitzilopochtli, who was also the god of war. This is one of a pair of large figures of eagle warriors discovered flanking the main door of the Great Temple at Tenochtitlán, the Aztec capital on the site of what is today Mexico City. The bold, silhouetted forms of the sculpture seem threatening and would have served to intimidate visitors as they entered the temple.

The people who greeted Columbus when he landed on the Bahamian archipelago on October 12, 1492 were from a culture known as the Taíno; by the middle of the sixteenth century, the Taino, whose artifacts were among the earliest American objects exported to Europe, had disappeared through exploitation and assimilation. One attribute of a Taíno chief was a hammock-like stool carved from a single piece of wood or, less commonly, stone (fig. 7.6). Columbus compared such chief's stools to European thrones. The figure carved on the front of this example, which was found in Haiti, represented a Taíno deity. These deities were known collectively as zemis.

7.6 Chief's Stool, Taíno culture (Haiti), fifteenth century? Wood, height 2' 6%" (78 cm). Musée de l'Homme, Palais de Chaillot, Paris, France.

THE IDEA OF A RENAISSANCE

Our use of the term "Renaissance" (French for "rebirth") is drawn from a conception of history found in the writings of the sixteenth-century Italian painter, architect, and writer Giorgio Vasari, whose historical fame rests primarily on his *Lives of the Most Eminent Painters*, *Sculptors, and Architects* (1550, 1568), a history of Italian art and artists. Vasari champions the work of ancient Greece and Rome, describing medieval art as a "disastrous decline," and argues that in Italy during the fifteenth and sixteenth centuries "art has been reborn and reached perfection in our own times."

Vasari's concept influenced the French historian Jules Michelet, who in 1855 gave the title *La Renaissance* to a volume of his *Histoire de France* and thereby extended the idea of the Renaissance to embrace a cultural phenomenon that included northern Europe. Michelet's Renaissance was characterized by "the discovery of the world and the discovery of man."

The reasons behind the appeal of antiquity in this period are not easy to simplify, but the richness and splendor of antique monuments, even in ruins, had had an impact throughout the Middle Ages, and as society and economic life blossomed at the end of the medieval period, such monuments provided appropriate models for new construction; in 1462 Pope Pius II issued an edict protecting surviving ancient ruins. The new self-confidence expressed in politics, business, and learning in the fifteenth century found important models and inspiration not only in ancient texts but also in ancient sculpture, especially the Greek emphasis on the dignity and beauty of the human figure and the Roman ability to capture the individual in portraiture.

For Italian Renaissance artists, the models of classical antiquity provided an impetus for artistic transformation, but it would be a mistake to view these artists as merely copying ancient works of art. They adapted the classical aesthetic to the attitudes of their own times, creating works of art distinctly different from those of antiquity. This "rebirth" of the antique encompassed not only works of art, but also the recovery of ancient texts and classical literary style. Leonardo Bruni, a diplomat and scholar versed in Latin and Greek, is characteristic of the new scholarship in his careful reading of antique texts and his application of ancient civic values to his own time, which led to a new historical consciousness fundamental to the growth of Renaissance humanism (see p. 253).

NAMING THE STYLES

The transition from the late Middle Ages to the Renaissance in the cosmopolitan European centers of Flanders and Italy was a gradual one, and many aspects of Renaissance society and art evolved slowly from medieval traditions. Historians still debate whether fifteenth-century Flemish painting is best understood as a late manifestation of the Gothic or as a Northern version of the Renaissance. Because neither "Gothic" nor "Renaissance" is a completely appropriate term for these Flemish works, they are here identified under an independent designation: fifteenth-century Flemish painting. In Italy, and especially in Florence, new Renaissance ideas dominate the production of art during most of the fifteenth century. This period is generally known as the Early Renaissance, to distinguish it from the late fifteenth and early sixteenth centuries, when the culmination of earlier ideas resulted in the period called the High Renaissance (see p. 302).

EUROPEAN HISTORY

As our two introductory paintings suggest, much of the artistic activity of western Europe during the fifteenth century was centered in Florence and Flanders. Scholar Leonardo Bruni praised Florence as "the new Athens on the Arno." He likened the civic values of his time to those fostered in democratic Athens and in Rome during the Republic. Although Bruni praised Florentine republicanism, contrasting it to the despotic rule in other Italian citystates, in actuality Florence was led by an oligarchy of commercial interests. The Florentine government was eventually dominated by the Medici family, whose wealth was derived from banking and commerce. Beginning with Cosimo de' Medici, the family consolidated the reins of power behind a facade of republicanism. His descendants firmly tightened their political control, and Lorenzo de' Medici ("Lorenzo the Magnificent") ultimately ruled as a benevolent tyrant. Toward the end of the century, the domination of the Medici and the conspicuous wealth and humanist interests of the Florentine citizenry were challenged by the fiery sermons of the Dominican friar Girolamo Savonarola. Following the exile of the Medici in 1494, Savonarola assisted in restoring a more representative form of government. But as Savonarola continued to act as the harsh conscience of Florence, the Church and some of the citizenry turned against him, and he was executed for heresy in 1498. Florence maintained her republic until 1512, when the Medici regained control.

In Flanders, an area roughly equivalent to present-day Belgium, a prosperous new merchant society based on the wool trade and banking was established during the four-teenth and fifteenth centuries. The flourishing city of Bruges was the most important center, and the presence of foreign bankers, such as the Medici from Florence, made it the banking capital of northern Europe. Other important centers included Ghent and Tournai. As in Italy, trade guilds controlled manufacturing, as well as the production of works of art.

Flanders was distinguished by a rich and diverse culture, which included a revolutionary school of composers

that dominated European musical developments throughout the century. Northern intellectuals, however, were not very interested in the revival of the forms and subject matter of ancient Greece and Rome that were so important to the Italians, and in Flanders some arts, especially architecture and related arts, remained Gothic well into the sixteenth century.

ITALIAN RENAISSANCE HUMANISM AND **ART THEORY**

The Renaissance concept of humanism (as distinct from the modern concepts of humanitarianism and secular humanism) had a profound philosophical foundation. The title "humanist" was originally applied to a teacher of humanistic studies, a curriculum that included rhetoric, grammar, poetry, history, and moral philosophy; at the base of many of these disciplines was the study of ancient texts on these topics in Latin and, eventually, in Greek as well. Already in the fourteenth century, scholars and writers had been inspired by the ideas they found in ancient Greek and Roman texts, which confirmed their new intellectual and scientific interest in understanding the world. The praise for the deeds of great figures from antiquity that the humanists found in the Greek and Roman texts supported the notions of pride and fame that were becoming important in a society whose major figures were successful business entrepreneurs and bankers. During this period, humanism was, with some effort, integrated with Christianity; it sought to supplement faith by insisting on the dignity of the individual and the human potential for achievement. Although the development of humanism was centered in Florence, by midcentury most of the important courts in northern Italy had been significantly influenced by humanism.

Humanism played an important role in the development of art theory. Leon Battista Alberti, well educated in humanistic studies, was attracted to the work of such Florentine artists as Brunelleschi, Donatello, and Masaccio. He noted that these artists revived classical art, and using a literary approach that joined his knowledge of the principles of classical poetry and rhetoric, he wrote about the new art in De pictura (On Painting) in 1435. This cornerstone of Western art theory discusses the noble purpose of painting, the painter as an educated professional, and the use of mathematical principles, including scientific perspective (see pp. 268-69). On Painting gave art and artists a new dignity and opened the way for a new level of literary discussions on art.

Natural observation, an important feature of fifteenthcentury art, was addressed by the late medieval artist Cennino Cennini in his practical manual for painters, The Craftsman's Handbook, written c. 1400. He recommended learning to draw from works of recognized masters:

Now you must forge ahead again, so that you may pursue the course of this theory.... Having first practiced drawing for a while ... take pains and pleasure in constantly copying the best things which you can find done by the hand of the great masters.

Having established the importance of studying great works, Cennini turned to nature:

Mind you, the most perfect steersman that you can have, and the best helm, lie in ... copying from nature. And this outdoes all other models; and always rely on this with a stout heart, especially as you begin to gain some judgment in draftsmanship.

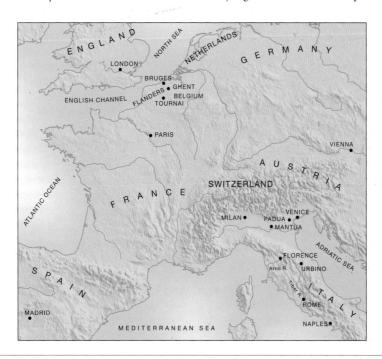

To the Renaissance artist, copying from nature led not only to the heightened perception gained from meticulous observation but also to an attempt to understand the principles that govern the order and processes of nature. This sympathy with the natural world was a decisive aspect of Renaissance art.

The equestrian monument *Gattamelata* (fig. 7.7), by Donatello (c. 1386/90–1466), combines naturalistic observation with a well-known antique type, as exemplified by the *Marcus Aurelius* (see fig. 4.37). *Gattamelata* was the largest sculpture cast in bronze since antiquity—an ambitious feat. With the bronze *David* (see fig. 7.37), probably commissioned for the Medici Palace courtyard (see fig. 7.35), Donatello revived the lifesize, freestanding, nude figure. The acceptance of nudity in art is related to the humanist insistence on the dignity of the individual and the view that the human figure is a microcosm of the macrocosm, a smaller, symbolic reflection of the larger universe.

EUROPEAN INTELLECTUAL ACTIVITY

The Gutenberg Bible—the first complete book to be printed using independent, movable type—was made between 1450 and 1456. By 1460, woodcuts were being used for illustrations in books; as an inexpensive method of producing illustrated books in large quantities, they contributed to the development of the sciences. Knowledge was more easily shared when a printed illustration could offer an exactly repeatable image, unchanged by the hand of a copyist. Through the medium of printing, knowledge reached a level of circulation only recently surpassed by modern media, with the computer and the Internet.

CHANGING PATTERNS OF PATRONAGE IN EUROPE

During the fifteenth century, artists and workshops received a variety of secular and religious commissions.

7.7 Donatello, Equestrian monument of Erasmo da Narni (*Gattamelata*), c. 1445–53. Bronze, originally with gilded details, height 12' 2" (3.7 m). Piazza del Santo, Padua, Italy. Commissioned by the Venetian Senate.

Erasmo da Nami was a famous mercenary general who was employed by the Venetian government to raise and lead its armies; his nickname, Gattamelata, means "honeyed cat."

Rulers continued to employ works of art for the traditional purposes of exalting and consolidating their power, but now their imagery more often had an ancient basis or was inspired by models from antiquity. A relatively new development was patronage by city governments in the Italian communes and patronage by the mercantile class in Flanders and Italy; based on the writings of the humanists, patronage was now viewed as an important activity of the responsible and enlightened citizen. While devotional images were produced in increasing numbers to adorn the rooms of the expanding middle class, new types of artportraits, mythological subjects, and secular decorations were commissioned by individuals to adorn their private palaces, town houses, or country villas. In many instances, patrons and family members were represented in the wings or at the sides of works they commissioned (see fig. 7.16).

In Florence, Cosimo de' Medici was generous in his support of libraries. He took an avid interest in the art of Donatello, and his patronage of scholars helped support the formulation of Neoplatonism, a complex humanist philosophy that sought to fuse Plato's ideals with Christian thinking by emphasizing how the spiritual aspects of life can overcome physical limitations. Cosimo's grandson Lorenzo the Magnificent collected antique works of art and encouraged commissions for Florentine artists; he was also a good friend and supporter of the young Michelangelo. Such involvement with the arts was not solely altruistic, for support of humanist scholarship and the arts demonstrated benevolence and was useful in forming public opinion and securing fame.

Rulers often commissioned portraits. Piero della Francesca gave his patrons, the rulers of Urbino (fig. **7.8**), an almost omnipotent presence. They seem elevated above everyday affairs, and the broad landscape backgrounds suggest the extent of ducal power. On the reverse, they are shown on triumphal carts surrounded by allegorical figures that represent the Virtues.

7.8 Piero della Francesca, *Battista Sforza and Federigo da Montefeltro*, 1474. Oil and tempera on wood, each 1' 6½" × 1' 1" (47 × 33 cm). Galleria degli Uffizi, Florence, Italy. Probably commissioned by Federigo da Montefeltro.

Federigo da Montefeltro ruled Urbino from 1444 until 1482. His wife, Battista Sforza, bore him eight daughters and one son. Federigo was a soldier and a prolific patron of artists and architects.

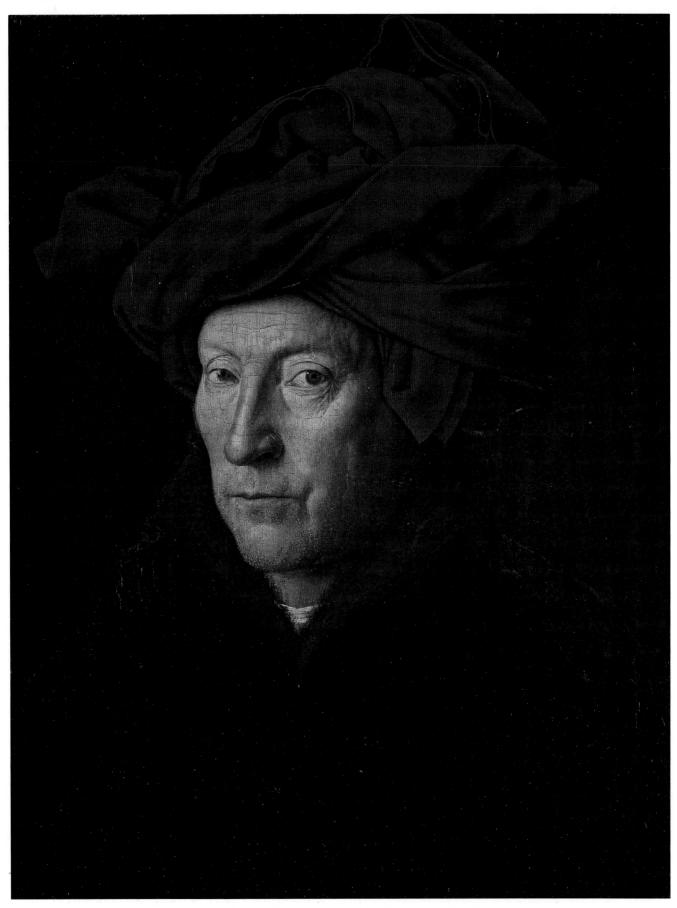

7.9 Jan van Eyck, *Self Portrait*(?), 1433. Oil on wood, $10\% \times 7\%$ " (26 × 19 cm). The National Gallery, London, England. Because of the acute gaze and the motto on the frame, this painting has often been identified as the artist's self-portrait.

THE FIFTEENTH-CENTURY ARTIST IN **EUROPE**

The dignity of the individual and the new self-consciousness promoted by the Italian humanists had an important influence on attitudes about artists. In contrast to the prevalent medieval attitude that the artist was a humble craftsperson serving God, some Renaissance artists were viewed as trained intellectuals, versed in the classics and geometry. Artists became famous; in 1481, for example, an author named Cristoforo Landino made a list of Italian and Flemish artists and praised them for their skill and innovations; he even suggested that Donatello could be "counted among" the ancient masters—the highest praise possible at the time. Artists began to sign their works with more frequency, and one artist, Lorenzo Ghiberti, wrote his autobiography. The modern ideal of the artist as a genius has its origins in these developments in the fifteenth century.

During the first half of the fifteenth century, Flemish and Italian artists began to create self-portraits, a sure indication of their new status. In 1433 Jan van Eyck depicted a man wearing a fantastic turban—a tour de force of painting—and looking out at us with an especially penetrating gaze (fig. 7.9). On the frame are van Eyck's motto ("The best I can do") and the date. Artists even began to include self-portraits within their works. Lorenzo Ghiberti's "Gates of Paradise" have both a self-portrait (fig. 7.10) and a selfpromoting inscription that praises the "marvelous art" with which Ghiberti made the work.

7.10 Lorenzo Ghiberti, Self-Portrait, from the East Doors of the Baptistery (see also fig. 7.22), Florence, Italy. 1425-52. Gilded bronze, approximate height 3" (7.6 cm). Museo dell' Opera dell Duomo, Florence. Commissioned by the Opera of the Baptistery and the Arte di Calimala.

POINTS OF CONTACT

The Travels of Marco Polo

During the Renaissance The Travels of Marco Polo became widely known as the main source of information on the East, especially China (which Marco Polo called Cathay) and Mongol-controlled Central Asia. While copies of the manuscript had been known as early as the 13th century, it was first printed for widespread distribution, in a German edition, in 1477. Marco Polo (c. 1254-c. 1324), the son of a leading merchant of Venice, was the most famous medieval European traveler to East Asia. At that time Venice was the chief center in Europe for eastern trade, and the city's merchants traveled frequently to Constantinople and the Crimea, where they maintained trading stations. Under the Roman Empire, contacts with India and China had been common, but the Muslim conquest of the seventh century had closed trans-Asia routes for Europeans and they remained closed until the Mongols established a pan-Asiatic empire after destroying the caliphate of Baghdad in 1258. Both Marco's father Nicolò and his uncle Maffeo had been to China before Marco traveled with them from Baghdad to the China Sea between 1271 to 1292. An account of his travels were recorded in the Description of the World, which he supposedly dictated while in prison after his return to Europe in 1296.

The editions of Polo's writings were frequently illustrated, giving a Europeanized view of Cathay and its inhabitants. In fig. 7.11, the Great Kahn (the Mongol emperor of the Yuan Dynasty in Chinese territory), sports a split beard and a flowing robe with golden embroidered

trim much like his western imperial counterparts, but his exotic pointed hat and gold belt convey his "otherness" (to the west) and his large size suggests his great power. The Polo brothers kneel before him not in the throne room of a great imperial palace, but outdoors, in front of a yurt, the felt-over-birch lattice tent that characterized and, to western eyes, made exotic the mobile lifestyle of the nomadic Mongols.

7.11 Nicolò and Maffeo Polo meeting the Kubulai Kahn, from The Travels of Marco Polo, fifteenth century. Manuscript painting. Bibliothèque nationale, Paris (fr. 2810, fol. 2v).

Portraiture

Exalting the Individual

(figs. **7a** and **7b**) These two portraits of individuals are just two of hundreds of such portraits produced during the fifteenth century in Italy and northern Europe. This phenomenon reveals a new social development—an interest in an individual who is living and working in the world—that is characteristic of the Renaissance and helps mark this period as the beginning of the modern world. Portraiture offers the possibility of "improving" the actual appearance of the sitter; whether this has been done, however, becomes difficult to determine later. Of greater interest to the historian is what a sculpted or painted portrait tells us about the attitude toward the individual in society at the time when it was made.

A Royal Queen

(fig. 7c) In most early cultures, portraiture was limited to rulers, like this image of an Egyptian queen, or to aristocrats. Like many ruler portraits, the emphasis is on indications of Hatshepsut's rank rather than on the queen as a specific individual.

A New Kind of Portrait

(fig. 7d) The invention and development of photography in the nineteenth century disrupted the livelihoods of artists who expected to continue to earn a living producing portraits of the wealthy and members of the emerging middle class. Julia Margaret Cameron is already using photography as a creative medium, and rather than merely

7a Mino da Fiesole, *Portrait of Piero de' Medici*, 1453 (for further information, see fig. 7.38).

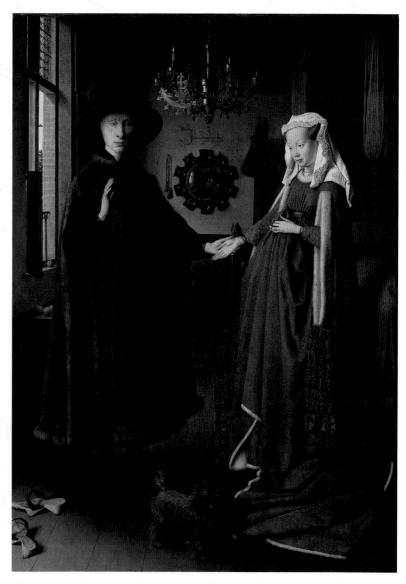

7b Jan van Eyck, *Portrait of Giovanni Arnolfini and Giovanna Cenami* (?), 1434 (for further information, see fig. 7.25 and pp. 272–73).

7c Queen Hatshepsut, Ancient Egyptian, c. 1478–1458 BCE (for further information, see fig. 3.11 and p. 45).

7d Julia Margaret Cameron, *Alfred, Lord Tennyson*, 1865 (for further information, see fig. 11.50, and p. 469).

snapping the famous British poet, she sets up a composition that seems to emphasize the inward nature of his inspiration.

A Modern Artist

(fig. **7e**) Like many twentieth-century works, Jacob Lawrence's *Self-Portrait* sets out to establish an immediate communication with the viewer. The painter is close to us and looks out toward us as he rubs his chin in a traditional gesture of thoughtfulness. It's almost as if he's wondering how he might paint *our* portrait.

7e Jacob Lawrence, *Self-Portrait*, 1977 (for further information, see fig. 13.22 and p. 582).

Questions

- 1. Study a painted or photographic portrait of a living individual in a magazine or newspaper; is the portrait composed or treated in such a way that it emphasizes certain characteristics of the individual?
- 2. How might your own portrait—photographed, painted, or sculpted—be contrived to emphasize specific qualities about yourself that you would like to communicate?
- 3. Would this portrait be intended for your contemporaries, or for the future?

Early Renaissance Sculpture in Florence

onatello's *Saint Mark* (fig. **7.12**) overlooks a Florentine street, surveying the urban scene with an expression that conveys a questioning intelligence. It is reported that when Michelangelo saw the work he proclaimed:

that he had never seen a figure which had more the air of a good man than this one, and that if Saint Mark were such a man, one could believe what he had written. In other words, for Michelangelo the *Saint Mark* expressed integrity. In medieval art, the evangelists had been depicted as figures receiving divine inspiration (see fig. 5.45). Donatello's Renaissance interpretation emphasizes the more human attributes of wisdom and reason. In addition, Donatello's *Saint Mark* attains the dignity we accord an individual, for in physiognomy and body type he suggests a specific, compelling personality. The revival of antiquity, so important for the Italian Renaissance, is readily apparent,

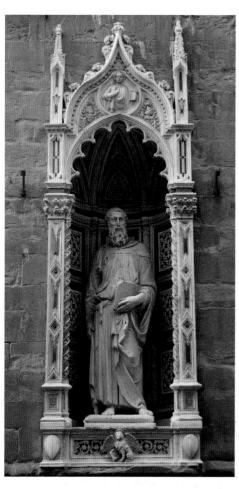

7.12 Donatello, *Saint Mark*, from Orsanmichele, Florence, Italy, c. 1411–14. Marble, originally with some polychromy and metal details, height 7' 10" (2.36 m). Commissioned by the Guild of Linen Weavers and Peddlers.

This statue of the Evangelist is shown in its original Gothic setting in the Guild of Linen Weavers and Peddlers' niche—one of fourteen niches assigned to Florentine trade guilds—on the civic granary and shrine of Orsanmichele. Instead of the usual geometric base traditionally used for figures sculpted in marble (see fig. 3.66), here Donatello suggests that St. Mark is standing on a pillow, a device that increases the illusion that the figure could step out of his niche and into our world. Notice the winged lion on the niche itself; this is a symbol of St. Mark.

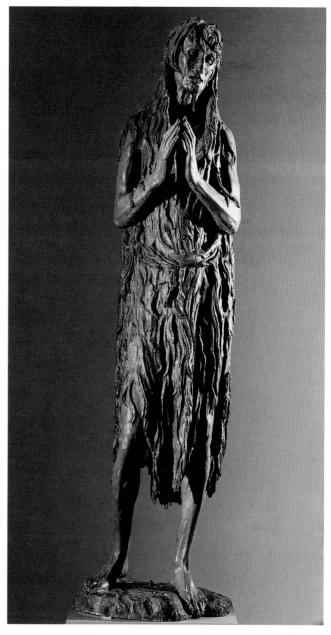

7.13 Donatello, *Penitent Magdalene*, late 1430s–1450s? Wood with polychromy and gilding, height 6' 2" (1.88 m). Museo dell' Opera del Duomo, Florence, Italy.

1394-97 Manuel Chrysoloras teaches Greek in Florence

1405 Florence buys Pisa 1410 Ptolemy's Geography is translated into Latin

c. 1411-14 Donatello, Saint Mark (fig. 7.12)

c. 1420 Temple of Heaven is constructed in Beijing

for Saint Mark is closer to ancient Greek and Roman figures than any work created during the long interval of the Middle Ages. The antique references in this figure could also be viewed as part of an effort to establish historical veracity. What could be more appropriate than to emulate ancient Roman models when creating representations of figures who had lived in the late antique period? The new Renaissance respect for historical accuracy may thus have played a role in Donatello's inspiration from ancient models. The emphatic contrapposto of the saint, which helps establish his naturalism, was also influenced by ancient examples (see fig. 3.66).

Donatello's life-size, polychromed wood sculpture of Penitent Magdalene (fig. 7.13), executed late in his career, is fully naturalistic, with the only reference to classicism found in the contrapposto stance. Polychromed wooden figures were commonly used for popular devotion during the Middle Ages and Renaissance. Such sculptures, sometimes wearing real clothing, still adorn altars or are carried in religious processions; for an earlier example, see the polychromed wood German Gothic Pietà (see fig. 7.55).

By Donatello's day, the legend of Saint Mary Magdalene identified her as a beautiful prostitute who repented when she was forgiven by Jesus; she became one of his most devout followers. Because she was thought to be the woman who used her hair to anoint Jesus's feet, long hair became one of her attributes. She was present at the Crucifixion, where she is often identifiable because of her long flowing red hair, and it was to the Magdalene that Christ first appeared on Easter morning, after his Resurrection. After the Crucifixion, she lived a life of penance in the wilderness, eating little (one legend has it that she was fed by angels) and clothed only in her own long hair. Because of her history, the Magdalene became the patron saint for fallen women and widows.

Donatello's patrons apparently requested that he represent her at the end of a long period of penance, when fasting and living in the desert have reduced her to an old, starving woman. There is still a memory of her former beauty in her refined bone structure and her elegant stance, while her intense devotion is conveyed by the upward tilt of her head and the trembling manner in which her hands are raised in prayer.

TECHNIQUE

Carving in Wood

Wood carving is a subtractive technique, in which the artist starts with a solid piece of material and creates the work by gradually removing areas of that material (for marble carving, which is also subtractive, see p. 309). This is a technique that does not easily forgive mistakes; once a piece of the material is removed, it can be reattached only with difficulty.

Working in wood poses special problems. A variety of metal gouges, chisels, and knives are employed, but particular care is needed to carve with the grain lest the wood fiber split. Some gouges are struck with a wooden mallet; others, in a more delicate but firm manner, can be pushed by hand. Restrictions are imposed by the size of a log; however, large wooden sculptures can be composed of a number of pieces joined together. Because wood expands and contracts widely due to changes in its moisture content, care must be taken to prevent the wood from cracking.

Donatello's Penitent Magdalene (see fig. 7.13) was carved from a single piece of wood, and its technique represents a distinctive break from earlier figurative wood carving. Previous to Donatello, sculpted wood figures usually had a broad expanse of drapery across the front to hide the large hollow space that had to be carved from the rear to prevent the wood from splitting as it dried. This limited the sculpture to a frontal viewpoint but ensured minimal surface cracking because the expansion and contraction of the wood was relieved by the hollow area in the back. The Penitent Magdalene, with its subtle contrapposto pose, is more nearly a sculpture in the round. The hollowed gap between the legs allows for the expansion and contraction of the wood while visually contributing to the naturalism of the figure.

Virtually all medieval and Renaissance wood figures are polychromed to increase their naturalism, and many have gilded details. A thin coat of fine plaster, called gesso, was applied over the wood to provide a neutral base for the paint, and a range of naturalistic color would be painted on the figure. In this case, the skin is a deep tan to suggest her life in the desert and gold tint was added to the brown of the hair to refer to the traditional red hair of the Magdalene.

Flemish Painting: The Limbourg Brothers

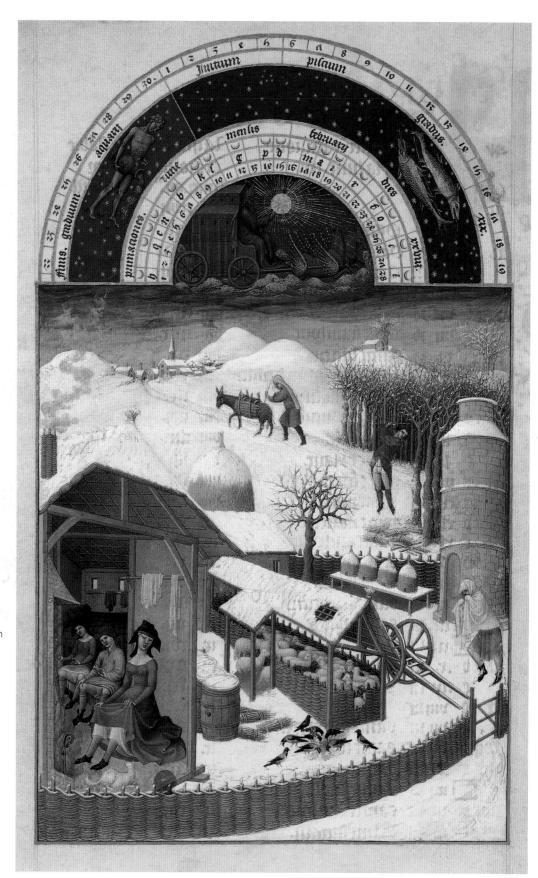

7.14 The Limbourg Brothers, *February*, calendar page from the *Très Riches Heures du Duc de Berry*, before 1416. Manuscript painting on vellum, 11½ × 8½" (29 × 24 cm). Musée Condé, Chantilly, France. Commissioned by John, duke of Berry.

This manuscript is listed in an early inventory as "The Very Rich Hours of the Duke of Berry."The patron was John, Duke of Berry (and brother of King Charles V of France), whose library included more than 300 manuscripts. The artists were three brothers—Pol, Herman, and Jean Limbourg. The calendar pages, which traditionally accompany the listing of saints' feast days, included the labors of the month and zodiac signs with various astrological calculations.

1378-1417 Great Schism damages papal authority

1415 The Portuguese capture Ceuta in Morocco, their first African colony

Before 1416 Limbourg Brothers, Très Riches Heures (fig. 7.14)

Movable type is used by printers at Antwerp

1420 Crusade is proclaimed against the Hussites in Bohemia

he puff of frosty breath from the mouth of the figure hurrying across the farmyard and the smoke curling from the chimney are the kinds of subtle details that characterize the comprehensive realism developing in Flemish painting at the beginning of the fifteenth century (fig. 7.14). The traditional calendar page for February showed people sitting by a fire, but the Limbourg brothers' representation encompasses a modest farm, complete with dovecote, beehives, and sheepfold, set within a vast snowy landscape with a distant village. Several figures reveal the peasants' restricted winter activities. The sky is no longer merely a flat blue background, but offers atmospheric midwinter effects that reveal the Limbourgs' study of natural phenomena.

The Limbourgs' use of naturalistic effects also extends to biblical stories. Taking inspiration from the passage in Matthew's Gospel that, at the time of the crucifixion, "there was darkness over all the land" (27:45), they created a panoramic crucifixion scene in tones of gray that suggest the naturalistic effects of an eclipse (fig. 7.15). In a blaze of gold, blue, and red, God the Father appears to bless his dying son. In the top right roundel, an astronomer surveys the heavens, searching for an explanation for this unexpected phenomenon.

The Très Riches Heures marks a final phase in the development of manuscript painting in the North (for earlier examples of medieval manuscripts, see figs. 5.31, 5.45, 5.46, 6.26). This sumptuous manuscript, with 130 illustrations, includes devotions for different periods of the day in a format that is called a book of hours, thus the book's name. The heightened interest in representing naturalistic lighting effects, panoramic landscapes, and precise details explains why this manuscript has been so admired and so often copied by later artists.

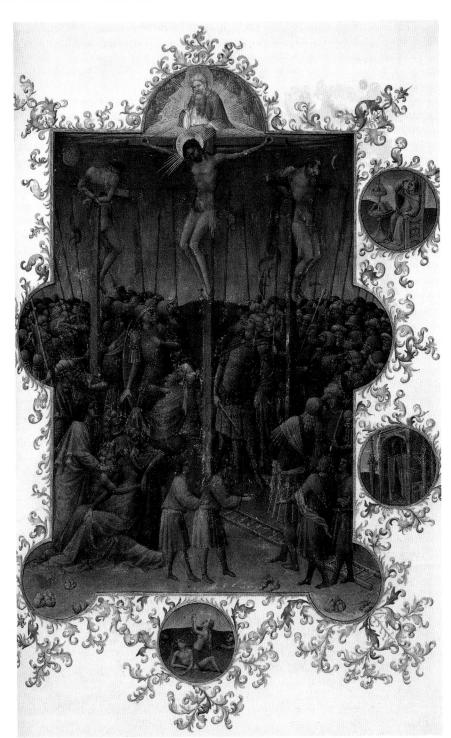

7.15 The Limbourg Brothers, Crucifixion in the Darkness of the Eclipse, from the Très Riches Heures du Duc de Berry, before 1416. Manuscript painting on vellum, 11% × 81/4" (29 × 24 cm). Musée Condé, Chantilly, France.

Flemish Painting: Robert Campin

his folding **triptych**, or three-part devotional picture (fig. 7.16), represents a further development of the revolutionary new qualities evident in Flemish manuscript painting at the beginning of the fifteenth century (see figs. 7.14, 7.15). Perhaps most startling is the precision with which its artist, Robert Campin (documented from 1406, died 1444), rendered objects and figures. Naturally lit, they are modeled with subtle transitions from light to shadow that make them seem three-dimensional and weighty. This naturalism results from the union of the fine detail of oil paint with a revolutionary precision of observation on the part of the artist (see pp. 274-75). It almost seems as if no artist had ever seen shadows with such clarity before—certainly no artist had ever rendered them so precisely. Such naturalism demands intense concentration in both vision and technique.

Accompanying this naturalism of representation is the realistic depiction of the subject, for a biblical event from the distant past is represented as if it were taking place in a fifteenth-century Flemish house. Gabriel enters to announce to a distinctly Flemish Mary that she will be the mother of the son of God, while Mary's husband Joseph, a carpenter, is shown in a fifteenth-century workshop in the right wing. Campin's depiction of this setting offers valuable evidence about woodworkers' shops and tools, including a folding shelf on which Joseph offers a mousetrap for sale directly from his shop. As secular as this may seem, locating the Annunciation within a contemporary setting is intended to make the sacred events more comprehensible and meaningful. Such an approach to religious **iconography** is paralleled in popular devotional literature and is probably also related to the representation of such subjects in contemporary religious theater.

To understand Campin's interpretation, we must look beyond the dazzling surface realism, since pervasive symbolism (sometimes called "disguised symbolism") gives a religious content to virtually every object in the painting. The three lily blossoms on a single stalk that decorate the

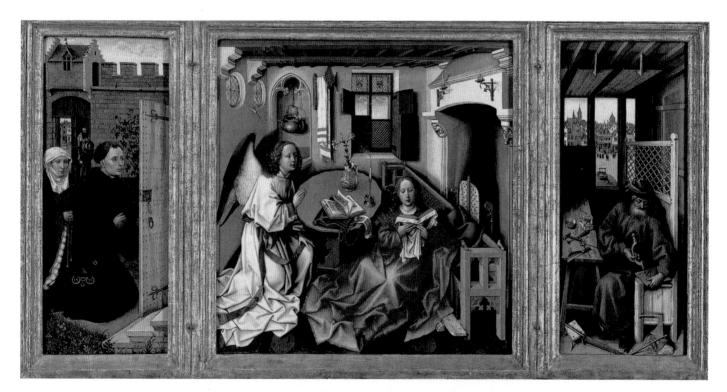

7.16 Robert Campin, Annunciation with Patrons and Saint Joseph in His Workshop, c. 1425–30. Oil on wood, center $2' 1\%'' \times 2' 1\%'' (64.1 \times 63.2 \text{ cm})$; each wing $2' 1\%'' \times 10\%'' (64.5 \times 27.3)$. The Metropolitan Museum of Art, New York. Commissioned by a member of the Ingelbrechts family.

The patron who commissioned this work is represented kneeling in the left wing; his wife, beside him, has been painted over the green grass, suggesting that she was added after the picture was finished, probably at the time of their marriage. It was perhaps at this same time that Campin made the work even more realistic by painting over the gold leaf that had originally filled the central windows, substituting sky, clouds, and coats of arms in the stained-glass windows indicating that the patron was a member of the Ingelbrechts family. This work is often referred to as the Mérode Altarpiece because it was owned by the Mérode family during the nineteenth century. Robert Campin is sometimes known as the Master of Flémalle.

Virgin's table, for example, refer to the Christian Trinity; the bud is Christ. An especially intriguing symbol is Joseph's mousetrap, for it expresses the late medieval notion that God married the Virgin to a devout older man to prevent the Devil from discovering that her child was the Son of God; in such an explanation Joseph became a "mousetrap" set by God.

The candle on the Virgin's table (fig. 7.17), just extinguished, releases a puff of smoke that suggests that the painting represents a precise moment in time. Light is a common metaphor for divinity, and the light of the Virgin's candle is extinguished because of the entry into the room (and into the world) of divine light in the person of Christ, who appears as a minuscule baby entering on rays of light through a round window on the left. The candle might also refer to the late medieval custom of the bridal candle, which was extinguished when the marriage was consummated, or to the symbolism of the extinguished candle as an indication that a vow has been fulfilled. The blowing out of the candle and the presence of Christ within the Virgin's chamber would then express the moment of the Incarnation. Notice that this religious content is expressed by everyday objects and that, in keeping with his naturalistic bias, Campin has not used haloes for his figures.

Robert Campin's style is known from a small number of paintings, all of which are similar in their use of ordinary people as models, their depiction of drapery with sharp, rather abstracted folds, and their crowded compositions, which avoid empty spaces (horror vacui). The use of ordinary people and an everyday setting can be related to a revolution in 1423 in Tournai, where Campin lived. A new democratic government, led by representatives of the craft guilds, was established. This democratic, mercantile culture helps to explain the middle-class setting and virtues of Campin's Annunciation triptych, with its delight in a typical household and the inclusion of Joseph as a hardworking husband and father.

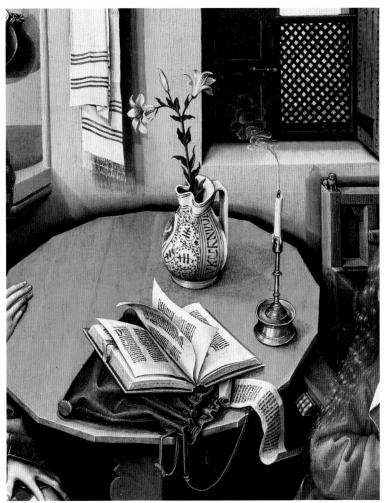

7.17 Robert Campin, Annunciation, detail.

Italian Renaissance Painting: Masaccio

he triangle, symbol of the Trinity, becomes the unifying compositional form in The Trinity with the Virgin Mary, Saint John, and Two Donors (fig. 7.18) by Masaccio (1401–28). With the head of God the Father forming the apex and the donors comprising the base, the triangular composition, popular in the Early Renaissance, is visually clear and easy to read. This clarity is supported by the illusionary space created by the use of **scientific per**spective (see pp. 268-69). To the viewer positioned in front of the painting, the effect is of an actual chapel with real figures. The architectural forms are closely related to the Renaissance architecture being developed by Filippo Brunelleschi at this time (see figs. 7.29–7.31). He may well have assisted Masaccio with this aspect of the painting. The clarity of the composition is combined with boldly threedimensional figures recalling those painted by Giotto. Masaccio here has advanced the innovations of Giotto by combining them with the coherent illusory space that distinguishes Renaissance painting.

A short time before he was commissioned to paint *The* Trinity, Masaccio was employed with another artist, Masolino (c. 1400-40/47), in decorating the Brancacci Chapel with scenes primarily from the life of Saint Peter. In The Tribute Money (based on Matthew 17:24–27), Jesus and his apostles are confronted by a tax collector who requests that a temple tax be paid (fig. 7.19). Jesus instructs Peter to go to the edge of the sea, to our left, where he finds the necessary coin of tribute in the mouth of a fish. To the right, Peter pays the tax collector, an act prophetic of Jesus' words "Pay to the emperor what belongs to him, and pay to God what belongs to God" (Matthew 22:15-22). Because three different episodes take place within the unified space of the composition, The Tribute Money exemplifies continuous **narration**, a thematic device that had been used in ancient Roman painting and sculpture (see fig. 4.39).

The coherent perspective of *The Tribute Money* unifies the space, while boldly modeled figures suggest a light source that corresponds to the real light that falls into the chapel from a single window on the altar wall. The building at the right, which obeys the laws of scientific perspective, draws our attention to the head of Jesus, while **atmospheric perspective** envelops the trees and hills of the background. Within this spatial illusionism, Masaccio's figures act out the story with simple, direct, and dignified movements.

Masaccio's sculpturesque modeling and bold narrative presentation are especially evident in *The Expulsion of Adam and Eve* on the same wall. Having disobeyed God, Adam and Eve are driven out of Paradise by their own guilt and shame. In Masaccio's interpretation, Adam hides his

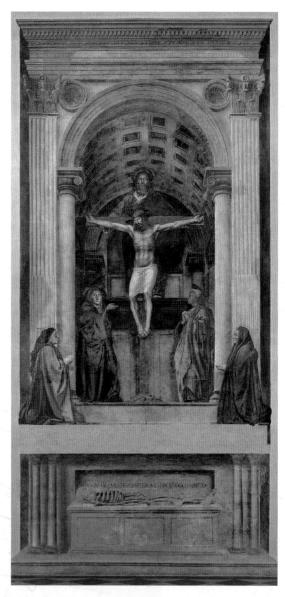

7.18 Masaccio, *The Trinity with the Virgin Mary, Saint John, and Two Donors*, Santa Maria Novella, Florence, c. 1425-28. Fresco, $21'\ 10''' \times 10'\ 5''\ (6.67 \times 3.17\ m)$; the figures are approximately lifesize.

On the vertical axis, God the Father holds the cross, presenting his crucified son to us. A flying dove, symbol of the Holy Spirit, hovers between their heads. At the foot of the cross stand Mary and John the Evangelist; Mary's gesture and outward glance engage our attention. The kneeling profile figures are the donors who commissioned the painting. Their identity remains uncertain, although one wears the red robe of a Florentine official. The bottom portion of the painting contains a skeleton resting on a ledge. Above the skeleton, an inscription in classical lettering reads: "I was once what you are; what I am, you will be:"The inclusion of the skeleton and the inscription add a *memento mori* (a reminder that all must die) context to the theme. Such references to human mortality were popular in the fourteenth and fifteenth centuries, when plagues often ravaged the populace.

1405-33 Zheng He (1371-1435) leads naval expeditions to India, Persia, and Africa

1415 John Hus is tried and convicted of heresy and burned at the stake at Constance

c. 1425-28 Masaccio, The Trinity (fig. 7.18)

1428 Joan of Arc leads the French armies against the English

1431 Joan of Arc is burned at the stake

face in his hands, leaving his genitals uncovered. Masaccio thus emphasizes the psychological rather than physical nature of Adam's shame. The figure of Eve, which was inspired by an ancient sculpture of the Modest Venus, conceals her nakedness but throws her head back in a moan as she bewails their fate.

Masaccio's figures, instilled with psychological presence, recall the human gravity of Donatello's sculpture, while the classicizing architecture and use of the scientific perspective reveal his relationship with Brunelleschi. Although he died in his twenties, Masaccio translated into paint the Renaissance innovations of Donatello and Brunelleschi, and he influenced later generations of Renaissance artists, including Michelangelo. An epitaph, composed in the sixteenth century, recognized Masaccio's contribution: "I painted, and my picture was lifelike, I gave my figures movement, passion, soul: they breathed." (Annibale Caro, as cited in Vasari's Lives of the Artists).

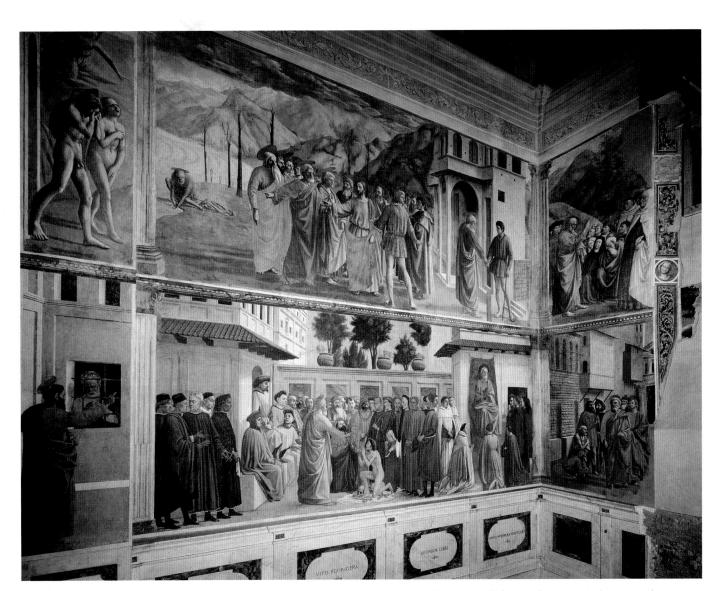

7.19 Left wall and portion of altar walls of Brancacci Chapel, Santa Maria del Carmine, Florence, with frescoes by Masaccio (c. 1425-28), Masolino (c. 1425-28), and Filippino Lippi (1484). Height of each register 8' (2.27 m). Commissioned by a member of the Brancacci family.

Scenes shown here include The Expulsion of Adam and Eve and The Tribute Money by Masaccio (top register, left wall); Preaching of Saint Peter by Masolino (top register, altar wall); Saint Peter in Prison by Filippino Lippi (lower register, left scene on left wall); Resurrection of the Son of Theophilus and the Chairing of Saint Peter by Masaccio and Filippino Lippi (lower register; main scene on left wall); and Saint Peter Healing with His Shadow by Masaccio and Masolino (lower register, altar wall).

Scientific Perspective

The study of perspective—the rendering of figures or objects in illusory space—was an important innovation in Renaissance art, as demonstrated by a work of the next century, Raphael's *Philosophy* (see fig. 1.18). Perspective had been a conscious development in ancient Greek painting, and many examples of Roman art attest to the accomplished use of perspective in antiquity. During the Middle Ages, however, pictorial reproduction of the physical world became less significant within a culture that emphasized spiritual and otherworldly values. Perspective gradually became valued in the later Middle Ages, but a coherent system enabling artists to determine the relative diminution of size of figures and objects was lacking.

That problem was solved by Filippo Brunelleschi (1377–1446), the Early Renaissance architect (see pp. 276–77). Around 1415, Brunelleschi demonstrated a scientific perspective system (also called linear and vanishing-point perspective) in two lost paintings. His new perspective system was incorporated in works by other artists, including Masaccio's *Trinity* and *The Tribute Money* and Leonardo's *Last Supper* (see figs. 7.18, 7.19, 7.52).

Scientific perspective is based on the observation that parallel lines seem to converge as they recede towards the horizon. The diagram of Raphael's fresco demonstrates how these diagonal lines, known as **orthogonals**, converge at what is called a "vanishing point" on the level of the horizon (fig. **7.20**). Scientific perspective assumes that the

diminution in size of objects is in direct proportion to their distance from us and that space is, therefore, quantifiably measurable.

What Brunelleschi arrived at through empirical study, theorist Leon Battista Alberti stated with theoretical reasoning in his book On Painting. By constructing orthogonal lines crossed by transversals (lines that recede parallel to the picture plane) on the planar surface of a painting or relief, a receding modular grid pattern is created, as seen in Raphael's painting. This pattern establishes a coherent, mathematically measurable illusory space within which the artist can determine the proportional diminution of objects distant from the viewer. In a fully developed example of Renaissance illusionistic painting, such as Raphael's, scientific perspective is combined with atmospheric perspective for a unified effect that encompasses vast spaces, correctly proportioned figures, and the subtle qualities of the sky and distant landscape as they appear to the eye.

In the Story of Jacob and Esau, Lorenzo Ghiberti (1378–1455) combines an impressive demonstration of scientific perspective with grand, classicizing architecture and graceful figures gathered into beautiful groupings (fig. 7.21). His ideal and orderly Renaissance world makes no reference to the treachery and emotional trauma inherent in the narrative. Ghiberti chose to subordinate these unpleasant realities to his Renaissance interest in harmony. The fifteenth-century concern for fine detail and

7.20 Diagram of Raphael's Philosophy (see fig. 1.18) showing the orthogonals and transversals of the scientific perspective scheme. The blue sky in the background fades toward white at the horizon as a result of atmospheric perspective, another device for suggesting depth used by painters. Atmospheric perspective also causes forms found in the landscape near the horizon to lose color and to be slightly blurred, but no such forms are included in Raphael's view of this imaginary interior.

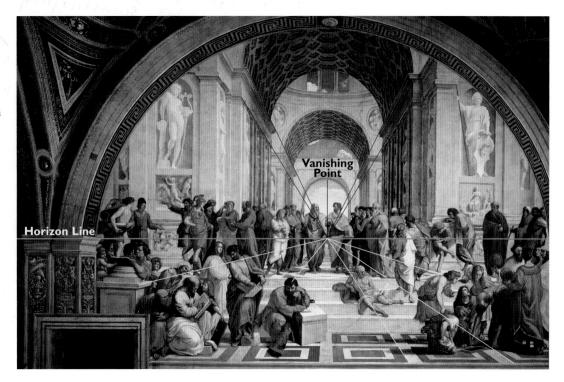

7.21 Lorenzo Ghiberti, Story of Jacob and Esau from the "Gates of Paradise," 1425-52. Gilded bronze, 2' 7¼" (79 cm) square. Museo dell' Opera del Duomo, Florence, Italy. Commissioned by the Opera of the Baptistery and the Arte di Calimala.

The lines drawn over the composition show the scientific perspective system. The story of Jacob and Esau, from the book of Genesis (25:19-28:5), tells how Jacob and his mother, Rebecca, conspired to steal the birthright of Jacob's twin but slightly older brother, Esau, by deceiving the boys' father, the old and nearly blind Isaac, into giving his blessing to Jacob instead of Esau.

Ghiberti's doors (fig. 7.22) are the last of three sets of doors made for the portals of the Florentine Baptistery. The creation of wax models for the ten narratives has been dated 1429 to 1437, and the finishing of the details consumed most of the 1440s. Ghiberti employed a large workshop of assistants and apprentices to help him with the doors, which were the most expensive sculptural work produced in Florence during the fifteenth century. For Ghiberti's selfportrait on the doors and the Latin inscription, see p. 257. The area between a baptistery and a cathedral was known as the paradiso, which helps to explain the name, which is attributed to Michelangelo, who supposedly said that Ghiberti's doors were worthy to serve as the "Gates of Paradise."

exquisite finish is obvious in every area of the relief, from the delicate Corinthian capitals of the architecture to the shaggy fur of Esau's hunting dogs in the foreground. The recession of the Brunelleschian scientific perspective and the subtle diminution in the height of the relief, from the virtually three-dimensional figures of the left foreground to the low-relief figure of Rebecca praying in the upper right corner, create a convincing illusion. The four female figures in the left foreground, who pose with such exquisite grace, play no role in advancing the narrative and have been added by Ghiberti to enhance the beauty of the work of art.

In his autobiography, Ghiberti states that when he was offered the commission for the doors, "I was given a free hand to execute it in whatever way I thought would turn out most perfect and most ornate and richest."

In this he seems to be following the precepts of Alberti, who had defined the qualities of the perfect narrative painting (istoria or historia) in the following manner:

The first thing that gives pleasure in a "historia" is a plentiful variety. Just as with food and music, novel and extraordinary things delight us for various reasons but especially because they are different from the old ones we are used to, so with everything the mind takes great pleasure in variety and abundance.... I would say a picture was richly varied if it contained a properly arranged mixture of old men, youths, boys, matrons, maidens, children, domestic animals, dogs, birds, horses, sheep, buildings and provinces.

7.22 Lorenzo Ghiberti, "Gates of Paradise," 1425–52. Gilded bronze, height approx. 15' (4.6 m). Museo dell' Opera del Duomo, Florence, Italy. Commissioned by the Opera of the Baptistery and the Arte di Calimala.

Flemish Painting: Hubert and Jan van Eyck

7.23 Hubert and Jan van Eyck, *The Altarpiece of the Lamb (The Ghent Altarpiece)* (interior), completed 1432. Oil on wood, 11' 5%" × 15' 1%" (3.53 × 4.62 m). Cathedral of St. Bavo, Ghent, Belgium. Commissioned by Jodocus Vijd, a wealthy landowner and member of the Ghent city government, and his wife, Isabel Borluut.

This work is also known as *The Ghent Altarpiece*. An inscription on the frame identifies the patron as Jodocus Vijd, the date of completion as I432, and the painters as Hubert and Jan van Eyck. Hubert died before September 18, I426, and the role each brother played in the conception and execution of the many panels has been much debated. Scholars today generally agree that the altarpiece includes a number of panels by Hubert, some of which may have been left unfinished at his death, which Jan combined into a totality, adding works conceived by Jan (in particular, the figures of Adam and Eve) to complete the altarpiece. This may explain the juxtapositions in figural scale between the parts of the altarpiece. The luminous technique and fine detail that unify the painting are considered to be the work of Jan, who by the sixteenth century had been credited with the invention of oil painting.

The iconography is complex. The lower panels represent the Triumph of the Lamb of God, with crowds of saints pressing inward to worship the symbolic lamb on the altar. The upper panels include God the Father in the center flanked by the Virgin Mary and Saint John the Baptist, musical angels, and Adam and Eve. Above Adam and Eve are small grisaille scenes of the story of Cain and Abel.

Adam and Eve were among the few subjects that permitted Northern artists to represent the nude, but Jan's virtually lifesize figures are unprecedented. Jan's commitment to naturalism here confronts traditional restrictions, for although the figure of Adam is clearly based on a nude model (notice the sunburned face, neck, and hands), Eve is an imaginative re-creation based on contemporary ideals rather than on observation of a live model. The small, high breasts and bulbous abdomen are Gothic stylizations. The emphasis on the large abdomen stresses the role of childbearer assigned to women in the fifteenth century.

CHAPTER 7

1420–36 Brunelleschi builds dome of Florence Cathedral (fig. 7.31) 1432 Van Eycks, The Altarpiece of the Lamb (figs. 7.23, 7.24) 1432 Azore Islands are discovered 1438 Albert II of Austria, a Hapsburg, is crowned Holy Roman Emperor

c. 1438
Emperor Pachacutec begins rapid Inca expansion

n scale and wealth of detail, The Altarpiece of the Lamb (The Ghent Altarpiece), a large, hinged polyptych (multipaneled altarpiece), is an overaccomplishment—the whelming impressive of all early Flemish paintings (figs. 7.23, 7.24). The diverse scale and size of the panels and the variety of subjects repallowed Hubert van Eyck resented (1370-1426) and Jan van Eyck (before 1390–1441) to paint Flemish interiors, vast landscapes, illusionistic sculpture, portraits of living donors, the male and female nude, elaborate brocades, bejeweled and goldembroidered borders, and musical instruments. Jan van Eyck's ability to re-create the visual world in oil paint is staggering, but among the wealth of details offered by The Ghent Altarpiece, the most unforgettable may be the artist's diffused self-portrait in the studio, which is reflected in one of the pearls in the papal crown worn by God the Father, the central figure of the interior. This tour de force of painting is one of several "reflected" self-portraits found in the work of Jan van Eyck (see also fig. 7.26).

Jan van Eyck's ability to represent textures as if they were real is based on his acute examination of light and how it reacts differently when it strikes and reflects from various surfaces. He composed his paintings to emphasize this phenomenon, juxtaposing materials in order to contrast textures and heighten his illusion. Jan's figures seldom express strong or dramatic emotions. The wonder that his paintings generate comes from his ability to observe reality and to convey in oil paints the excitement of vision.

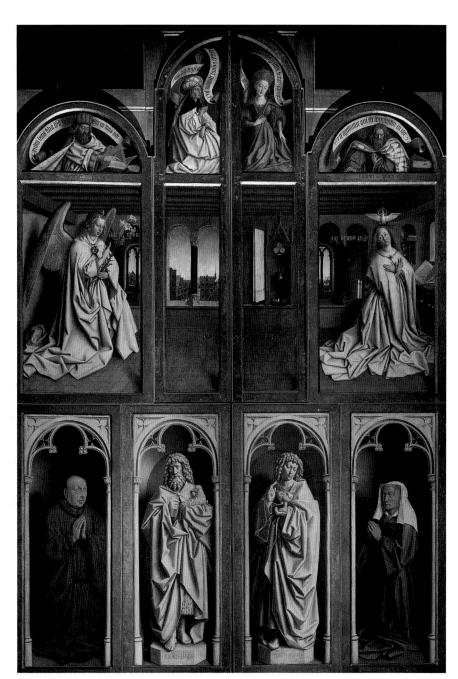

7.24 Hubert and Jan van Eyck, *The Altarpiece of the Lamb (The Ghent Altarpiece)* (exterior). Oil on wood, $11'5\%'' \times 7'6\%''$ (3.53 × 2.31 m).

The donors of the altarpiece, Jodocus Vijd and Isabel Borluut, are shown in the lower panels kneeling before Saints John the Baptist and John the Evangelist, patrons of the city of Ghent. In the upper register is a scene of the Annunciation; the topmost panels show representations of the Old Testament prophets Zachariah and Micah, and two sibyls.

Flemish Painting: Jan van Eyck

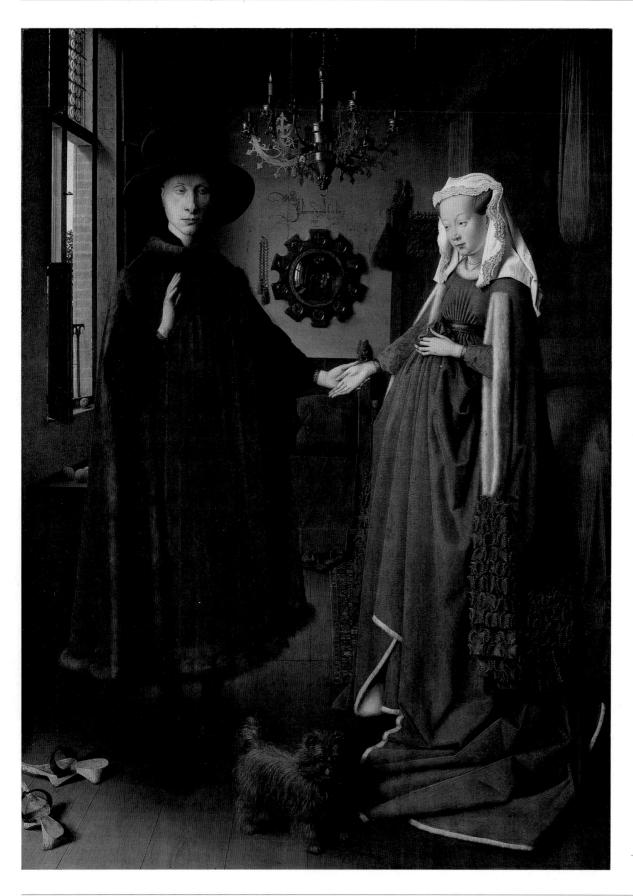

1428-40 Beginning of Aztec expansion

1434 Van Eyck, Arnolfini (?) portrait (fig. 7.25)

1434 Cosimo de' Medici returns from exile to Florence

1441-43 Portuguese navigators explore the coast of west Africa

1455 Gutenberg develops movable type

his tantalizing image (fig. 7.25; see also figs. 7.26 and 7.27) is one of the enigmas of art history. With its compelling characters, its puzzling combination of objects, and the breathtaking detail of its execution, it demands an explanation. But extensive research, numerous articles, and several books examining betrothal and marriage practices and other social behavior have failed to provide a convincing identification for the couple and what it is, exactly, that they are doing; the motivation behind the commission of this painting thus remains uncertain. For the purposes of clarity, we will examine the picture and include some of the many questions and theories about it in parentheses.

The couple is shown standing in elegant dress in a bedchamber (Is this a portrait of a real room?). The positions of their hands seem to indicate that an oath is being taken, suggesting that the painting might have functioned as a kind of legal document (Does the picture document their engagement or their marriage?). The function of the painting as a document is supported by the wording above the mirror: "Jan van Eyck was here, 1434", a signature for the artist that does not follow the usual format for a signature at this time. Two figures standing in the doorway of the room are reflected in the mirror (Is one the painter? Were both required as witnesses?).

The man's huge hat and fur-trimmed cape suggest wealth and status, as do the yards of material in the woman's train, which she holds up in a pose that emphasizes her abdomen (Is this to stress the idea that she is ready to bear children?). Her hair is forced into nets to create the fashionable "horns" of the period, and her head covering is trimmed with ruffles. The fact that both have covered their heads while standing in an interior seems important (But what does it mean?). Both have removed the sandals that they would have worn outside (Is this an example of their

7.25 Jan van Eyck, Portrait of Giovanni Arnolfini and Giovanna Cenami (?), 1434. Oil on wood, 2' 81/4" × 1' 111/2" (26 × 19 cm). The National Gallery, London, England. Probably commissioned by Giovanni Arnolfini and Giovanna Cenami, if these are indeed the two figures represented in the painting.

The identification of the figures is not certain but is based on an early inventory that names them as "Hernoul le Sin with his wife"; a later inventory states that the panel had wooden shutters, painted to resemble jasper, and that the gilded frame had verses from the writings of the Roman poet Ovid. Giovanni Arnolfini was a successful Italian cloth merchant and money lender from Lucca who lived in Flanders; Giovanna Cenami, who was Giovanni's widow when he died in 1472, also came from a wealthy Lucchese family active in Paris and Flanders.

cleanliness, or might it refer to the sacramental nature of marriage, based on the fact that Moses removed his sandals when he encountered God in the burning bush on Mount Sinai; Exodus 3:1–10?).

Wealth and a high standard of living seem evident. The elaborate chandelier is polished, but its single burning candle seems unnecessary. (Could the candle represent the presence of Christ, or could it be an erotic symbol?). The mirror, which is, for the period, large and expensive, is decorated with scenes of Christ's passion; next to it hangs a glass rosary (Is this another indication of piety, or perhaps, because light can pass through glass without changing it, a symbol of the woman's virginity?). The oranges, imported from Spain, would have been rare in northern Europe at this time (Are they another symbol of virginity?). The alert dog in the foreground stands between us and them (Is the dog a symbol of fidelity—Fides, the origin for the popular nickname "Fido"—or of erotic desire?). That the dog might be symbolic is suggested by the fact that he does not appear in the reflection of the scene in the mirror; this is surely not an accidental omission on the part of this precision-minded artist. The bed might be a dowry gift from the groom, and the chair beside it has a statuette of Saint Margaret emerging triumphant from the dragon; Margaret is one of the patron saints of women in childbirth. Jan van Eyck's symmetrical composition stresses the individuality of the figures although the woman is shown, as is traditional, as more passive.

Because there is no similar portrait in all of Italian or Flemish fifteenth-century painting, it seems unlikely that the purpose of this work was simply to record their betrothal or marriage. There must have been something special about the relationship between these two individuals that demanded this representation. One theory proposes that Giovanna's dowry might have been paid to Giovanni when she was too young to be given over to him; the painting might thus have been for her, still living in her father's house, a promise of her future role and prosperity. A related lost painting by van Eyck that represented a nude woman in this same room (Giovanna?) does not seem to be of much help in interpreting this painting. Whatever the portrait's function, the desire of this couple to record their relationship has gained them immortality.

The Development of Oil Painting in Flanders

The details from Jan van Eyck's Arnolfini (?) portrait display impressive virtuosity (figs. **7.26**, **7.27**). The contrasting textures of the various materials are convincingly illusionistic. Such precise detail is made possible not only by the artist's acute perception but also by developments in the use of oil paint, a step that revolutionized Flemish painting in the early years of the fifteenth century.

None of the materials used here (fig. 7.28) is new. The support was similar to that used for tempera painting (see fig. 6.47): a wooden panel would be covered with a layer of fine white plaster (gesso), sometimes with a layer of canvas or linen between the wood and the plaster. Van Eyck probably explored compositional ideas by drawing on the plaster with charcoal and "erasing" unsuccessful designs

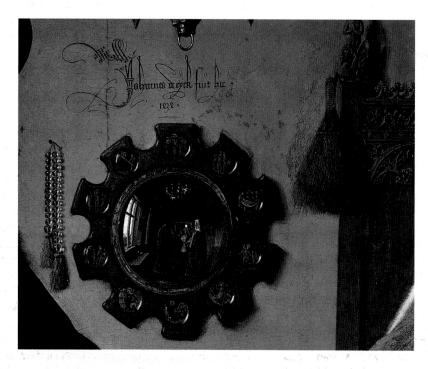

7.26 Jan van Eyck, detail of fig. 7.25.

7.27 Jan van Eyck, detail of fig. 7.25.

with a feather. He would have reinforced a satisfactory composition with fine lines painted with a brush dipped into tempera paint. The pigments used to create the color are the same powdered materials used by artists working in tempera (see pp. 242–43). Drying oils, such as walnut, poppy, hempseed, castor, and linseed, were known and used as early as ancient times; during the medieval period, drying oil was used as the finishing layer over a tempera painting to create a luminous surface finish. Here oil replaces tempera to become the primary vehicle.

Oil is a translucent vehicle; in making oil paint, particles of powdered pigment are suspended in this translucent vehicle, as shown in the diagram of a section of a Flemish panel painting below. When it is applied in many thin layers (glazes), light will penetrate the layers and be reflected, creating a gemlike brilliance of color. This new richness makes Flemish oil paintings such as those of van Eyck and Campin (see figs. 7.16, 7.17) distinctly different in appearance from their tempera antecedents.

Linseed oil dries more slowly than tempera, and its speed of drying can be further slowed by adding additional oil, permitting the artist to blend colors to create the subtle tonal modulations that help suggest light falling on an object. Van Eyck's fine detail is accomplished by using oil and soft, fine brushes, and the resulting transitions from color to color and the smooth surface finish offer virtually no hint of the artist's brushstrokes.

The greater resonance of color and the new realism of Flemish paintings are also due to the changed **color palette**. In tempera painting, a particular **hue**, such as red, would be mixed with white to achieve the transitions from shadow (red at its maximum intensity) to highlight (white). In the oil technique, the same red would usually

be mixed with black to accomplish the change from highlight (red at its maximum intensity) to shadow (black). In tempera paintings, then, colors are modeled upward toward white, while in oil paintings most colors are modeled downward toward black. The greatest intensity of a hue in tempera painting is in the shadows, while in oil it occurs between shadow and highlight. Most importantly, the scheme used in oil paintings is closer to what we observe in reality. Flemish painters learned this laborious craft as apprentices. Only years of watching and practice could prepare a young artist for a career working in such a painstaking and methodical technique. The results of their patient work are evident in the superb condition of many of these paintings today.

To learn how to paint like Campin and van Eyck took more than technical skill, however, for the artist had to learn how to see—how to distinguish the distinct patterns of light and shadow observable on the surface of, for example, velvet, wood, brass, and glass in various lighting conditions. In the work of these two artists, the precision of depiction is intimately related to the fact that all these objects are mirrors of religious truths. A candle is not just a candle and a triple lily is more than a floral oddity. Like other techniques, the development of the fine oil technique of the Flemish painters was a response to a distinct need: they created a technique that would allow them to endow objects with a magical potency—a dazzling realism—that could suggest the deeper meanings that lie behind observation. Their new style is rooted in the complexities of medieval symbolism and theology, but it contains a seed of the new Renaissance concern with the individual and the world. It is no surprise that the motto of Jan van Eyck (see fig. 7.9 and p. 257) is Als ich can ("The best I can do").

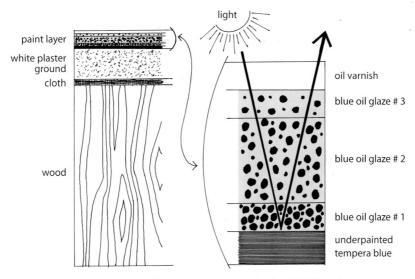

7.28 Schematic diagram of a section of a Flemish fifteenth-century oil painting, demonstrating the luminosity of the medium. The arrow suggests how light penetrates translucent oil glazes.

Italian Renaissance Architecture: Filippo Brunelleschi

he interior of the Church of Santo Spirito (fig. **7.29**) provides a conspicuous contrast to Gothic architecture, which overwhelms us with its towering vertical emphasis (see fig. 6.27). In Brunelleschi's light-filled Renaissance church, on the other hand, we perceive a measured order and harmony. Here the human reason of the architect and faith in a rational God and universe create architecture that is an alternative to the spiritual striving of the Gothic.

The satisfying regularity of Santo Spirito is derived from the use of simple proportional schemes similar to those used in ancient Greek and Roman architecture. The plan (fig. 7.30) makes it clear that each of the square bays of the aisle or the ambulatory can be understood as a basic module. With this in mind, it can be demonstrated that the relationships that govern the interior design of Santo Spirito are few and simple: 1:1, 1:2, 1:4, and 1:8. The square crossing, under the dome, is four times as large in plan as our module, as are the **transept** areas that flank it (1:4). The nave is twice as wide as the module (1:2). An elevation or a view inside the church reveals how this proportional system continues in the three-dimensional structure. The bays of the aisles and ambulatory are four times as tall as they are wide (1:4), and the nave is twice as tall as the aisles and ambulatory, which are each four modules wide, yielding a

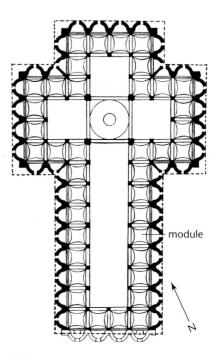

7.30 Filippo Brunelleschi, Plan of the Church of Santo Spirito.

7.29 Filippo Brunelleschi, Nave, Church of Santo Spirito, Florence, Italy, begun 1436. Commissioned by the abbot of the Monastery of Santo Spirito.

In this view, we are looking toward the crossing and high altar; the elaborate canopy over the altar is a later, obtrusive addition.

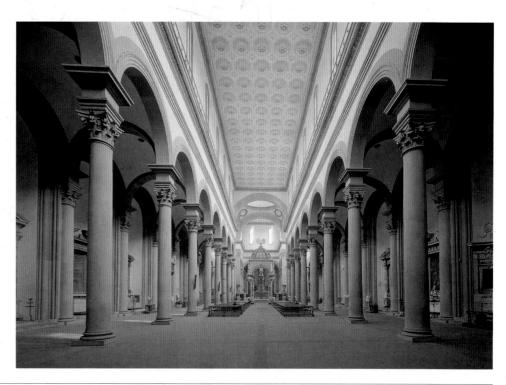

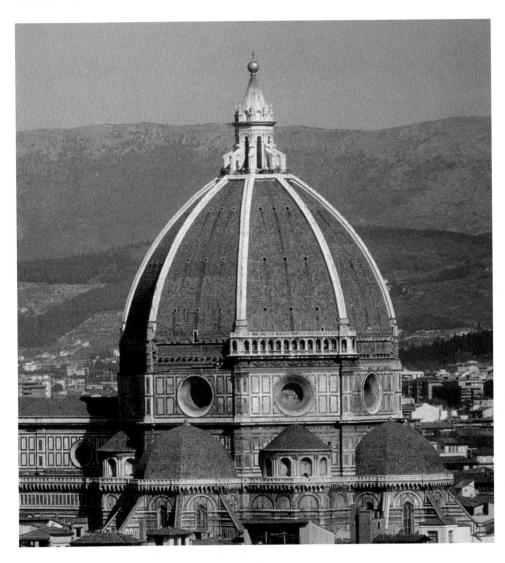

7.31 Filippo Brunelleschi, Dome, Florence Cathedral, 1420-36. Commissioned by the Wool Guild and the Cathedral Administration.

relationship of 4:8 or, relative to the basic module, 1:8. The nave is composed of an arcade (a series of arches supported by columns or piers) and of the clerestory above it. The arcade and clerestory are each as high as the nave is wide. This proportional approach is combined with the use of round arches and capitals based on ancient models. The result is an architecture that revives both the principles and the forms of classical antiquity. The regular placement of windows and the avoidance of both the stained-glass windows of French Gothic and the frescoes of Italian Gothic mean that Brunelleschi's church is well illuminated and free of shadows.

Brunelleschi secured his fame as an architect and engineer by designing the enormous dome for the cathedral in Florence and engineering its construction (fig. 7.31). Florence Cathedral, begun in 1296 to replace an earlier church, is a Gothic structure, but from its inception a dome over the crossing was intended. The difficulties of constructing such an immense dome—the largest in Europe since antiquity—were solved by Brunelleschi in the early fifteenth century with a design that was responsive to and harmonious with the original Gothic design. The pointed profile, with eight external ribs, is more Gothic than Renaissance, yet its grand scale and simple harmony express the clarity characteristic of the new Renaissance architecture. The cathedral dome was an architectural, engineering, and psychological feat. That so large a dome could be constructed without centering (see fig. 4.50; Brunelleschi designed a self-supporting system) was a technological achievement. In this joining of scale, design, and technology, the Florentine people found a source of civic as well as religious pride. Brunelleschi's dome continues to dominate the skyline of Florence, a visual expression of a domineering spirit in the arts.

Machu Picchu: The Peruvian Mountain Retreat

achu Picchu, a royal retreat and sacred center, is built on a narrow ridge between the Machu Picchu (Old Peak) Mountain and the Huayna Picchu (Young Peak) Mountain (fig. 7.32). The snow-covered peaks of the Andes loom on all sides. The ridge drops off steeply to the river some 1,500 feet below. In Inca times, you would have traveled for more than a week on the Inca Trail to get from the capital at Cuzco to Machu Picchu.

Originally the city had grand plazas, hundreds of thatched roof stone buildings, and temples (fig. 7.33). The plan of Machu Picchu is highly structured, with sectors devoted to agriculture, ceremonial plazas, or housing for the various classes each organized as an independent unit. Archaeologists estimate that the domestic buildings would have housed no more than 1,000 people, and that the fields at the site would have yielded food for only about 300 persons. Smaller communities that line the way from the capital at Cuzco must have provided supplementary food supplies. Sensitivity to public health was clearly important,

and stone-lined canals carried pure spring water to the fields and to the heart of the enclave, while drainage ditches carried away the wastewater. The largest building was a great hall with many entrances. Among the potsherds found there drinking vessels predominated; they were probably used to drink *chicha*, a beer made from corn for ceremonial use.

Temples of the Sun and Moon occupied special locations. The Temple of the Sun, set within a walled precinct, is constructed around a natural rock formation; a straight ledge, created by cutting away part of the rock, bisects the sunlight passing through the eastern window at sunrise on June 21, the winter solstice in the southern hemisphere.

Beyond the Temple of the Sun is the Royal Residence. One large room is thought to be the royal bedroom and there was also a "bathroom" with its own drainage system in this complex. In some of the rooms, niches used for storage and raised sleeping platforms were carved out of living stone. The interiors were plastered with light-colored gypsum or fine clay.

7.32 Machu Picchu, c. 1450-1530. Commissioned by the Inca leader Pachacuti. Aerial view of the site. White granite buildings, originally with thatched roofs. Total area about 400 by 325 yards (366 \times 297 m), height above sea level 8,040 feet (2450 m).

The site was used for only about eighty years by Pachacuti and his successors, who continued to improve the site until the Spaniards destroyed the Inca Empire in the 1530s. In 1911, a Peruvian guide and an American explorer named Hiram Bingham rediscovered Machu Picchu, and Bingham spent the next few years reclaiming it from centuries of jungle growth. Bingham's photographs for National Geographic magazine stunned the world.

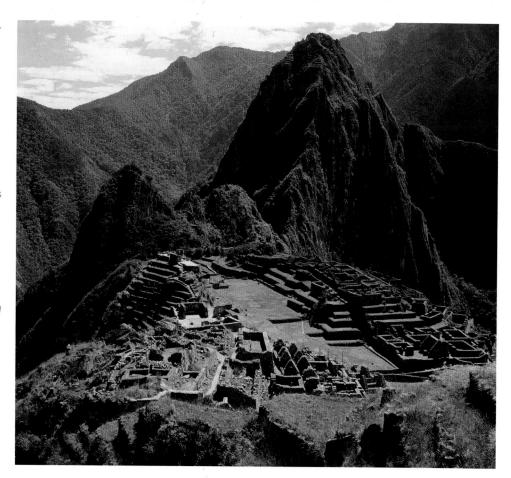

c. 1450-1530 Building of Machu Pichu (fig. 7.32)

1452 Ghiberti completes the Gates of Paradise for Florence Baptistery (see figs. 7.21, 7.22)

1455 Gutenberg Bible printed, first commercially available book

1455-85 Wars of the Roses in England

c. 1463 The Inca of Peru invade southern Ecuador

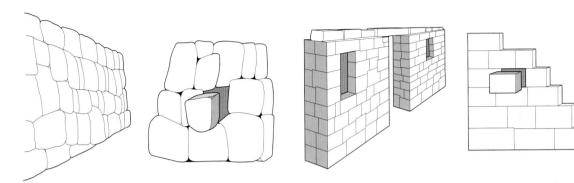

7.33 Detail of masonry.

The masonry at Machu Picchu is noteworthy. Inca stonemasons used hammer stones as well as bronze tools and sand as an abrasive to cut the stone. Even though walls were always carefully constructed, the manner of dressing the stone varied. Some stone was cut to form straight courses of identically sized stones, while others were rough cut and pieced together with mud mortar. The stones in the most remarkable walls are each of a different shape, carefully cut and finished to fit adjacent stones precisely. The finished stones vary in size, with the largest weighing at least twelve tons. Although the stone for construction was quarried locally, it varies in color from white, to gray, to a warm salmon-colored tone.

Most agree that there were three main elements to the belief system of the late Inca Empire. First was a veneration of nature, including the celebration of the changing seasons. Second was veneration of heavenly bodies such as the sun and moon. Throughout the empire, terraced farmlands and herds of llamas were reserved for the "sun," that is for support of the temples and priesthood. The third base of the Inca religion was reverence for the royal family. This principle, the mainstay of Inca power, was carefully fostered by the state.

The tunic illustrated here (fig. 7.34) shows pelicans being carried on litters, in emulation of the manner in which rulers and other important figures were sometimes transported in Inca society.

The Inca were the foremost military power in South America in the early fifteenth century, and by 1493 their suzerainty stretched some 2,500 miles from what is now southern Colombia to Chile's Maule River. Throughout the empire there was a system of roads, garrisons, and storage depots. Having no wheeled vehicles, these roads were used for walkers and trains of llamas. Such roads were often stepped, in order to climb successive mountain ranges, by using considerable engineering and stone-carving skills. This technology was also put to use in the construction of the mountain retreat of Machu Picchu.

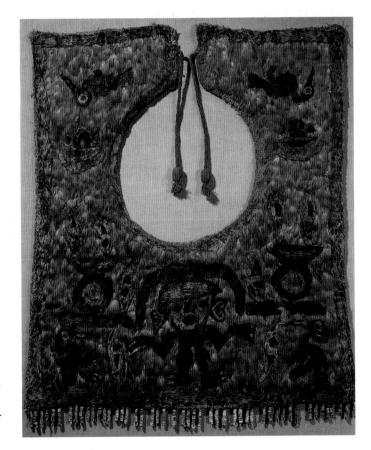

7.34 Tunic, c. 1465. Cotton with applied blue and yellow macaw feathers, 3' $2\frac{1}{2}$ " × 2' $2\frac{3}{4}$ " (99 × 67 cm). The Textile Museum, Washington, D.C.

The Italian Renaissance Palace

he Medici Palace presents a departure in domestic architecture (figs. 7.35, 7.36). The centralized court-yard is decorated with a classical-style arcade reminiscent of the **atrium** or garden **peristyle** of an ancient Roman house (see fig. 4.30). In its references to antiquity and its lucid regularity, this courtyard by Michelozzo (1396–1472) illustrates the new attitudes of the Renaissance. Both architect and patron seem to have known the descriptions of ancient Roman houses found in the writings of the first-century BCE writer Vitruvius, who had

penned the only treatise on ancient Roman architecture to survive into the modern world.

The exterior of the Medici Palace is equally innovative. Earlier Florentine palaces had had an irregular ground plan in order to take full advantage of the available lot size, but this new Renaissance palace is sited on a large regular lot that had been acquired piecemeal by the family over a number of years. The lucidity of the interior courtyard is also found in the massive cubical shape of the exterior. The three-story masonry block had

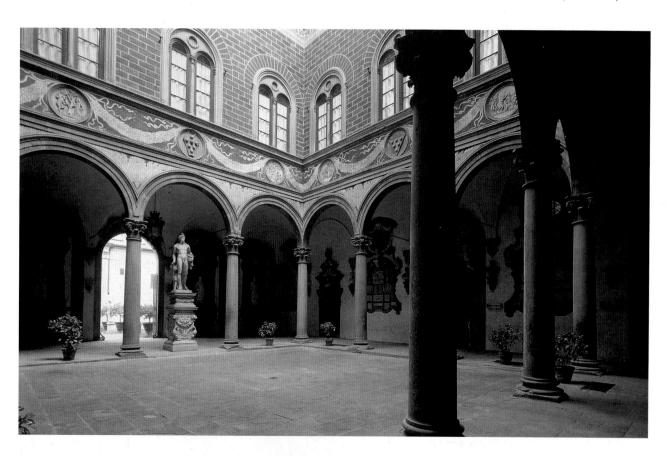

7.35 (above) Michelozzo, *Courtyard*, Medici Palace, Florence, 1445–59. Commissioned by Cosimo de' Medici.

The Medici, who were bankers, were among the richest families in Florence. In the course of the fifteenth century, they gradually assumed control of the Florentine government.

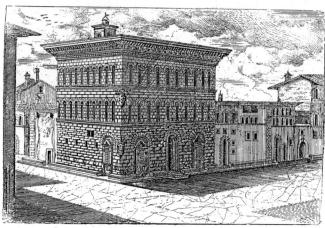

7.36 (left) Exterior, Medici Palace.

This early print shows the palace before later extensions and changes. Unlike medieval castles, the Renaissance palazzo is found within the city, and its owner was as likely to be a merchant or a banker as a noble. Such palaces housed the entire family, including married children and grandchildren.

1441 Africans are sold as slaves in the markets of Lisbon

1445-59 Michelozzo, Medici Palace (fig. 7.35)

1450 European population is about 50 million

c. 1450 Depopulation causes decline of Mississippian

1453 The Ottoman Turks capture Constantinople

regularly spaced windows and a large cornice that completes the design.

The massive and intimidating rusticated blocks of the street-level story gradually give way to a more restrained treatment on the upper two floors, where the family lived. In addition, our print is helpful in demonstrating that the doors of the large, arched openings on the street level could originally be opened to allow views of the courtyard and easy access to the interior. In the sixteenth century, when the Medici were less confident of their control over the Florentine populace, they had these openings closed with walls and barred windows designed by Michelangelo.

Works of art could be found throughout the palace, including portrait busts of the Medici (see fig. 7.38) based on ancient sculptural models. Painted and sculpted representations of ancient Greek myths, including the Labors of Hercules, subtly identified the Medici with the city of Florence by appropriating for them its traditional founders and heroes. This also explains why Donatello's statue of the heroic shepherd boy David (fig. 7.37) was placed in the palace's courtyard, for the youthful David was yet another symbol of the city of Florence taken over by the Medici. Donatello and his patron chose to represent David as a beautiful youth not only because this is a description found in the Biblical text, but also because the boy's youth and beauty underlines that David's victory was made possible through the intervention of God. The presence of the statue at the Medici Palace suggested that, like David, the Medici enjoyed God's favor. The Bible also says that David rejected the adult armor that was offered him; the unexpected nudity of Donatello's representation, after the centuries of prudery of the Middle Ages, is thus justified, but David's beautiful nude body probably was also intended to remind the humanist viewer of the Medici's interest in ancient art. The fact that Donatello's figure is the first life-size nude sculpture in the round since antiquity would have supported the notion that the Medici were sophisticated patrons who commissioned revolutionary art.

7.37 Donatello, David, 1440s? Bronze with gilded details, height 5' 2¼" (1.58 m). Museo Nazionale del Bargello, Florence. Probably commissioned by Cosimo de' Medici.

David is documented in the courtyard of the Medici Palace (see fig. 7.35). Donatello's representation of the Old Testament hero is consistent with the biblical story (I Samuel 17:38-51). The broad shepherd's hat would have cast David's face into shadow, leaving his expression enigmatic.

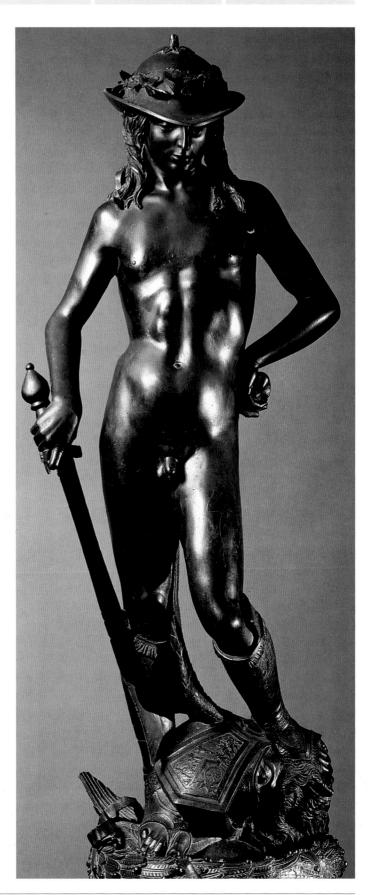

Portraiture

ortraiture was revived in Europe during the fifteenth century, and by the time of Leonardo da Vinci's Mona Lisa (see fig. 8.18), portraiture was a wellestablished subject that continued to provide an important means of support for artists until the advent of photography in the nineteenth century. While there are a few early portraits of women, the great majority of the earliest portraits are of men. It should be no surprise that the earliest surviving marble bust (fig. 7.38) created in Italy during the pre-Modern period represents a male member of the Medici family, the richest and most politically important family in the city. The bust-length portrait type as shown here then became popular during the second half of the fifteenth century in Florence, partly in response to ancient Roman sculptural precedents. These portraits were sometimes placed over the doorways of Renaissance palaces.

In some cases we know that portraits were commissioned as a remembrance after the sitter's death, as is demonstrated by the *Portrait of a Man and a Boy* (fig. **7.39**)

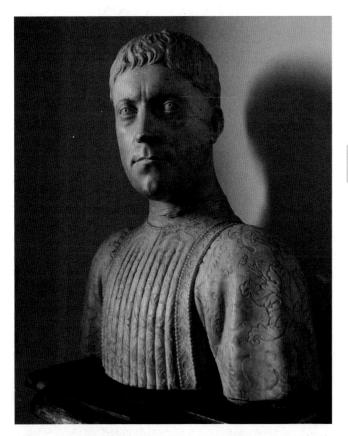

7.38 Mino da Fiesole, *Portrait of Piero de' Medici*, 1453. Marble, height 1' 6" (46 cm). Museo Nazionale del Bargello, Florence, Italy. Probably commissioned by Piero de' Medici.

An inscription on the work identifies the artist, sitter, and date, as is common in male busts of this type.

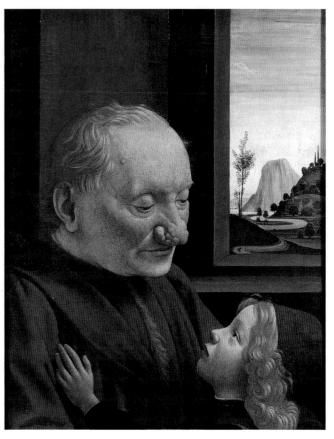

7.39 Domenico Ghirlandaio, *Portrait of a Man and a Boy*, c. 1480. Tempera and oil on wood, $2' \frac{3}{6}'' \times 1' 6\frac{3}{6}'' (62 \times 46 \text{ cm})$. The Louvre, Paris, France.

The artist has used the man's disfiguring disease (rhinophyma) as an aesthetic device, repeating similarly rounded forms for the boy's curls and the trees.

by Domenico Ghirlandaio (1449–94). A drawing that Ghirlandaio made from the man's corpse survives (fig. 7.40). The delicate and beautiful face of the child, unmarked by time, looks up with respect and love toward the old man.

One new phenomenon during the fifteenth century was the increasing number of artists' self-portraits (see pp. 256–57). While portraits of artists are known in Asia before the fifteenth century (see fig. 6.5), the self-portrait is rare. Supporting the identification of the *Portrait of Shen Zhou* (fig. **7.41**) as a self-portrait are the three-quarter pose and the fixed, sidewise gaze of the sitter, both of which are natural for an artist painting his or her own reflected image. One inscription on the work states: "During the first year of the Zhengde reign-era [1506] the old man of the Stone Field [Shen Zhou] inscribed this [portrait] of himself." The poem that follows acknowledges that the painter cannot see

1453 Mino da Fiesole, Portrait of Piero de' Medici (fig. 7.38)

1456 Crusaders defend Belgrade against the Ottoman Turks

1457 "Futeball" and "golfe" are forbidden by Scotland's Parliament

1464 Royal postal service is established in France

1463-79 Venice loses Greek Islands to the Ottoman Turks

7.40 Domenico Ghirlandaio, Portrait of a Man on His Deathbed, c. 1480. Silverpoint and point of the brush, heightened with white on pink prepared paper, 11%" × 1' %" (29.5 × 32 cm). Nationalmuseum, Stockholm, Sweden.

This is a preparatory drawing for fig. 7.39. The beautiful drawing that creates a Mannerist-style frame for Ghirlandaio's portrait was done by the sixteenth-century artist Vasari. He decorated the drawing when it was in his personal collection.

himself as others see him, asserting that it is his spirit, not his appearance, that counts in the image:

Some people say my eyes are too small, While others say my jaw is too narrow I myself have no way of knowing, Nor do I know what is lacking. But why bother to judge appearance, When one should fear only loss of morality; Carefree for eighty years, I am now next door to death.

In a second inscription, added somewhat later, Shen suggests that beyond a certain point such philosophical speculation about the naturalism of the portrait matters little in comparison with the sheer fact of survival.

It is like or not like, true or not true? From bottom to top it only reflects the exterior man. Death and life are both a dream, And heaven and earth are entirely dust. The stream endures within my breast, From spring it will be another year.

In the picture, Shen's angular face with its piercing eyes contrasts sharply with his peaked scholar's hat and undecorated literati's robe. The contrast shows him as an old man with the subtle depth and erudition of a scholar. The features of the face create the strong sense of a specific personality and suggest that the picture was painted from life.

Shen Zhou's introspective portrait contrasts sharply with Chinese official portraits such as the one of the Emperor Hongzhi (fig. 7.42), who was known as a benevolent ruler (1470–1505) of the Ming Dynasty. He is noted for his devotion to one woman who bore all his children. This was unusual since China was a polygamous society and most emperors had only one empress but several wives. The portrait, however, does not dwell on his benign character, but adheres closely to established laws and protocols for imperial portraiture.

Created to expound the glory of the emperor and/or the state, as is the function of most court art in China, this

7.41 Self-Portrait of Shen Zhou, dated to 1506. Hanging scroll, ink, and color on silk, 2' 4" \times 1' 8^{1} %" (71 \times 53 cm). Inscription signed by the artist. Palace Museum, Beijing, People's Republic of China.

7.42 Portrait of the Emperor Hongzhi, sixteenth-seventeenth century. Hanging scroll, ink, and color on silk 17' 5%" × 9' 7" (5.3 × 2.9 m). Palace Museum, Taipei, People's Republic of China.

portrait describes a formal, imperial image of the Son of Heaven. These portraits present and magnify not so much the specific individual, but rather the institution of the eternal throne and its temporary occupant. Such pictures are filled with symbols of the office and carry important messages about the emperor's powers. Beginning in the sixth century, yellow, the color of the northern loess soil of the Middle Kingdom, could only be worn by emperors. The dragon, and especially the five-toed one seen here on Hongzhi's robe, was a general symbol of fertility and of the male principle in nature. In addition, beginning in the second century BCE, it became a symbol of the emperor and can be seen here on the throne, the screen behind it, and the carpet. The phoenixes on the sleeves of his robe are symbols of the female principle and here refer to the empress. The moon and sun embellishing the shoulders of the robe underscore the power of the emperor and his ritual role as the Son of Heaven, the intermediary between Heaven (the Supreme Being) and Earth (his subjects). This is less a portrait of a particular emperor than a representation of his status, and might be compared to

other representations of rulers, such as those of the ancient Roman emperor Augustus (see fig. 4.32) and King Louis XIV of France (see fig. 10.6). The power of the ruler can be suggested in many different ways, and rulers have often picked artists who can express the particular kind of image of themselves that they think should be conveyed to their subjects. The role art has played in the history of politics should not be underestimated. A portrait is often more than just a representation of a specific individual living at a particular time.

The simultaneous evolution of painted portraits in Flanders during the fifteenth century included a devotional type that represented an individual in an attitude of prayer with an image of the Madonna and Child (fig. 7.43). These diptychs, which served as private devotional images, were hinged so they could travel easily and be self-supporting when opened. In this example by Hans Memling (c. 1430–94),

CHAPTER 7

the donor's natural three-quarter view contrasts with the frontal placement of the Madonna; the architectural setting suggests a Flemish room. The realistically depicted stainedglass window behind the donor represents Saint Martin, the patron's name saint, and the donor's place in heaven seems assured by the inclusion of his coat of arms in the window behind the Madonna. The convex mirror behind the Virgin Mary's right shoulder is a symbol of virginity. It reflects the foreground figures, confirming an intimate relationship between the real and sacred worlds.

At the same time, however, the dazzling naturalism of Memling's Flemish style emphasizes that it is contrasting realms that confront each other in the wings of this diptych. While Martin van Nieuwenhove seems physically present through the detailed representation of his flesh, his velvet garment, his freshly washed hair, and the pages of his

prayerbook, which seem to be moving, the Virgin is remote and seems somehow out of place in the context of this discussion of portraiture. She looks down, away from Martin's very direct gaze, and withdraws into her inner world. Her idealized face removes her from the realm of portraiture, while the textures of her garments are almost metallic. The velvet worn by Martin seems warm and soft, but Mary's garments do not encourage the viewer to touch them. The stiff pose of the Christ Child as he reaches for the apple does not suggest the movements of a real baby, and his nakedness, included to suggest the humanity of Christ, also seems unnatural. While Memling gives us an entry into the physical world of Martin van Nieuwenhove in the right half of the diptych, the left half offers us a vision of a world that might best be interpreted as a projection of the patron's spiritual desires.

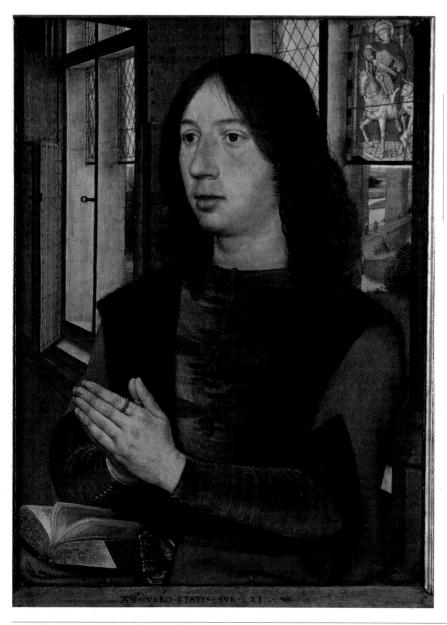

7.43 Hans Memling, Madonna and Child with Martin van Nieuwenhove, 1487. Oil on wood, each 1' 5%" × 1' 1" (44 × 33 cm). Hospital of St. John, Bruges, Flanders, Belgium. Commissioned by Martin van Nieuwenhove.

The inscriptions across the bottom date the work, identify the patron, and state that he was twenty-three years old. A merchant, Martin van Nieuwenhove later served as mayor of Bruges. These two wooden panels are hinged, and they normally would have been displayed not flat, as is suggested here, but angled, a position that would have enhanced the intimacy between the two figures.

Italian Renaissance Painting: Andrea Mantegna

he Camera Picta ("Painted Room") is a dazzling and witty tour de force of illusionism that proves the brilliance of both the artist, Andrea Mantegna (1431–1506), and his patron, Lodovico Gonzaga, Duke of Mantua (fig. 7.44). The magnificence of a Renaissance prince or princess was in part determined by the abilities of the artists at their court. The painted illusion created by Mantegna and his workshop at the Ducal Palace in Mantua completely covers the vaulted ceiling and two walls. Most of the vault is painted with grisaille and gold decorative patterns in a classical style that simulate stucco relief deco-

ration. This design emphasizes the ceiling's flat surface and serves as a foil for the central area, with its unexpected illusion of a circular opening with a balcony and a view up to sky and clouds. The painted figures around the balustrade seem to interact with us and with each other, and a huge pot of plants, precariously supported on a pole, threatens to fall into the room. This fictive space is populated with imaginary figures—baby angels derived from ancient Roman precedents and known in Italian art as putti. One is struggling, for he has caught his head in one of the round openings of the balustrade.

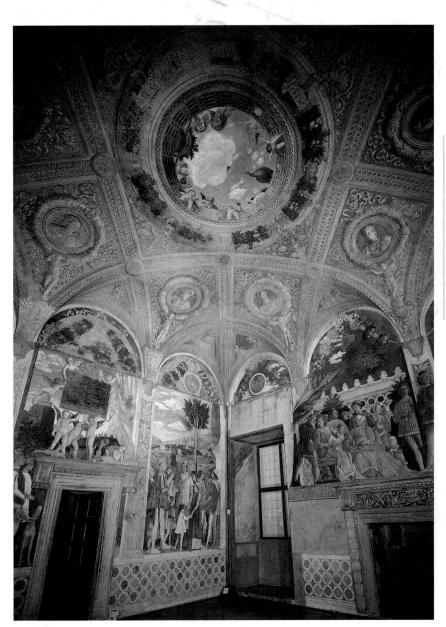

7.44 Andrea Mantegna, Camera Picta, Ducal Palace, Mantua, Lombardy, Italy, 1465-74. Frescoes, wall with fireplace 19' $6'' \times 26'$ 6''; diameter of illusionistic balcony in the middle of the ceiling 8' 9" (2.7 m). The room is approximately 26' 6" (8 m) square. Commissioned by Duke Lodovico Gonzaga.

The figures over the fireplace represent Mantegna's patron, Lodovico Gonzaga, Duke of Mantua, with his family and followers, and the scene to the left depicts a meeting between Lodovico and his son, Cardinal Francesco Gonzaga. The ceiling decoration has illusionistic relief portraits of ancient Roman rulers. The side walls are defined by painted balustrades and pilasters. This room is now popularly known by a later name, the Camera degli Sposi ("Room of the Married Couple"), in reference to the patron and his wife, who are shown seated in the fresco over the fireplace.

CHAPTER 7

1465-74 Mantegna, Camera Picta (fig. 7.44)

1468-96 The shrines of Mecca and Medina are extensively restored

1474 China extends the "Great Wall" because of Mongol attacks

The first book is printed in English

1476 Caxton sets up first printing press in England

TECHNIQUE

Foreshortening

Mantegna's putti in the Camera Picta, represented as if seen from below, are rendered in a technique known as foreshortening. This technique involves representing a figure or object as if seen in sharp recession.

Mantegna's Christ, however, demonstrates how easily we accept an unrealistic representation (fig. 7.45). If we were to look at a corpse from this sharp angle, we would not see it as Mantegna painted it but with much larger feet and a smaller head. Mantegna's treatment, however, serves to pull us into his composition and to fix our attention on the wounds of Christ.

Dürer's woodcut (fig. 7.46) is less a demonstration of an actual technique used by artists than an illustration of the principles of foreshortening and how the technique can be understood (and illustrated in a book). The line of sight of the observer is represented by the cord fastened to the wall on the right. A piece of paper that can be swung aside has been placed in an upright frame. After the end of the cord is held on a place on the lute, the point where the cord passes through the frame is marked by the intersection of two movable threads. The paper is then swung back into place and the point transferred to the paper. The resulting connect-the-dots diagram provides an accurate image of a lute seen in sharp foreshortening, as is evident in the illustration.

For other examples of sharp foreshortening, see the Virgin's left arm in Leonardo's Madonna of the Rocks (see fig. 7.49), the artist's arm in Parmigianino's Self-Portrait in a Convex Mirror (see fig. 8.10), Adam's right arm in Michelangelo's Creation of Adam (see fig. 8.31), the Christ Child's left leg in Titian's Madonna of the Pesaro Family (see fig. 8.47), Europa's left thigh in Titian's Rape of Europa (see fig. 8.49), and the figure of the horse and the body of the recumbent St. Paul in Caravaggio's Conversion of Saint Paul (see fig. 9.15).

7.46 Albrecht Dürer, Artist Drawing a Lute with the Help of a Mechanical Device, 1525. Woodcut, $5\% \times 7\%$ " (13 × 18.4 cm).

This woodcut was designed as an illustration for Dürer's treatise. A Course in the Art of Measurement with Compass and Ruler, published in Germany in 1525.

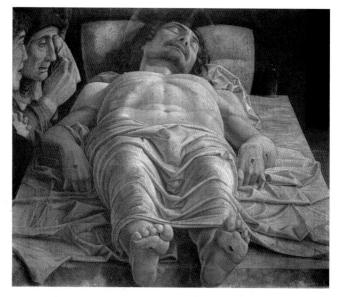

7.45 Andrea Mantegna, A Foreshortened Christ, c. 1466. Tempera on canvas, 2' $2\frac{1}{4}$ " × 2' $7\frac{1}{6}$ " (68 × 81 cm). Brera Gallery, Milan, Italy.

This painting, sometimes called Lamentation over the Dead Christ, is almost certainly identical with the painting listed in an inventory of Mantegna's house as A Foreshortened Christ. It may have been painted by the artist for his personal devotion.

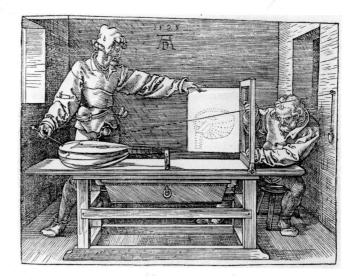

Italian Renaissance Painting: Sandro Botticelli

he Realm of Venus and the Birth of Venus, by Sandro Botticelli (1445–1510), are among the first large-scale paintings to be devoted to mythological themes since antiquity. Botticelli's figures are otherworldly deities who do not belong to the realm of the real. Their exquisite beauty asserts their divine nature.

The Realm of Venus (fig. 7.47) represents Venus reigning in a garden where it is always spring. The citrus fruit shown here was sacred to her. On the left, Mercury drives away the clouds seen in the upper left corner. Venus reigns as goddess of love and marriage, and Botticelli's painting may be a decoration made to celebrate a marriage. The unpredictable nature of love is suggested by the blindfolded Cupid, son of Venus, who shoots an arrow at her attendants. The physical nature

of love is suggested by Zephyr, on the far right, who has the nymph Chloris in his arms. After seducing and marrying her, he returns her to the garden, where we witness her transmogrification into the goddess Flora, who strews flowers. Flora is the goddess of spring (*primavera* in Italian). Her festival, Floralia, was celebrated in April and May, months ruled by the astrological deities Venus and Mercury.

Botticelli's *Birth of Venus* (fig. **7.48**) celebrates the ancient myth that Venus was born full-grown. Here she is blown ashore in a storm of roses by Zephyr and Chloris, to be received by one of her attendants. Her pose is based on ancient sculptures, but she is hardly sculptural. The elegance of the figure is set off by the intertwining patterns of Venus's hair. The enframing figures enhance her unexpectedly

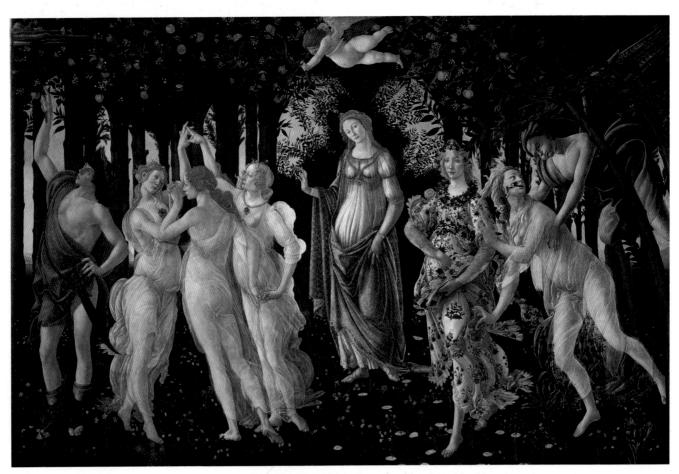

7.47 Sandro Botticelli, *Realm of Venus* (or *Primavera*), c. 1482. Tempera on wood with oil glazes, $6' 8'' \times 10' 4''$ (2.03 \times 3.14 m). Galleria degli Uffizi, Florence, Italy.

This painting is first documented in 1498 in the Florentine palace of Lorenzo di Pierfrancesco de' Medici and Giovanni di Pierfrancesco de' Medici. The former, a cousin of Lorenzo the Magnificent who married in May 1482, was most likely the patron.

1460s-1492 Florentine Platonic Academy holds meetings 1478 Establishment of the Spanish Inquisition

c. 1480 The imperial highway runs between the two Inca capitals of Cuzco and Quito

c. 1482 Botticelli, Realm of Venus (Primavera) (fig. 7.47)

1497-98 Vasco da Gama sails to India

introspective quality. The Birth of Venus is reminiscent of a passage in Alberti's On Painting:

Let [hair] wind itself into a coil as if desiring to knot itself and let it wave in the air like unto flames.... Let no part of the drapery be free from movement.... It will be well to put into the painting the face of the wind Zephyr or Auster blowing among the clouds, showing why the drapery flutters.

Humanist philosophy in Florence during the later fifteenth century was dominated by Neoplatonism, and in Neoplatonic terms, Venus personified beauty, and beauty equaled truth. The Neoplatonic philosopher Marsilio Ficino wrote in a letter:

Venus [is] Humanitas.... Her soul and mind are Love and Charity, her eyes Dignity and Magnanimity.... The whole, then, is Temperance and Honesty, Charm and Splendor.... How beautiful to behold!

The Neoplatonists went even further and equated Venus, source of divine love, with the Virgin Mary. Such an approach to ancient themes may explain why, in the final analysis, Botticelli's figures of Venus seem to be lost in thought.

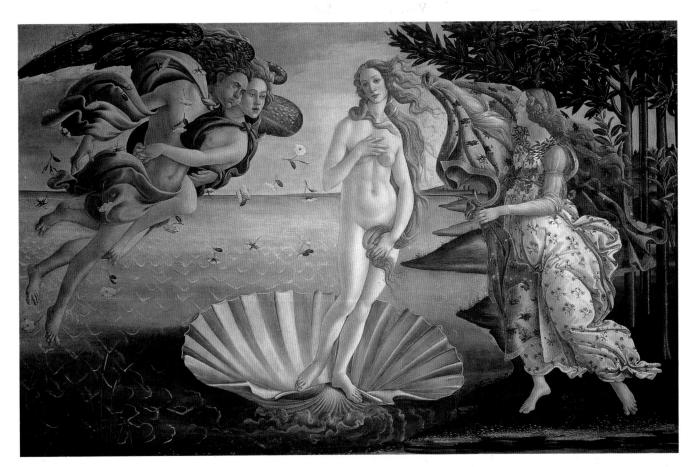

7.48 Sandro Botticelli, *Birth of Venus*, c. 1484–86. Tempera on canvas, $5' 9" \times 9' 2" (1.73 \times 2.77 \text{ m})$. Galleria degli Uffizi, Florence, Italy. Probably commissioned by a member of the Medici family.

Who commissioned this secular, mythological painting is unknown, but most likely the patron chose the subject and suggested the particular interpretation. The most popular previous secular decorations for Florentine palaces had been Flemish tapestries, and the patterns, colors, and gold highlights of Botticelli's painting may be an attempt to relate to and even rival tapestries. The unusual fact that this is painted on canvas suggests that it may originally have functioned as a processional banner.

Italian Renaissance Painting: Leonardo da Vinci

n his *Lives of the Artists*, Vasari viewed the High Renaissance of the late fifteenth and early sixteenth centuries as the perfection and culmination of all the investigation and experimentation that had characterized Early

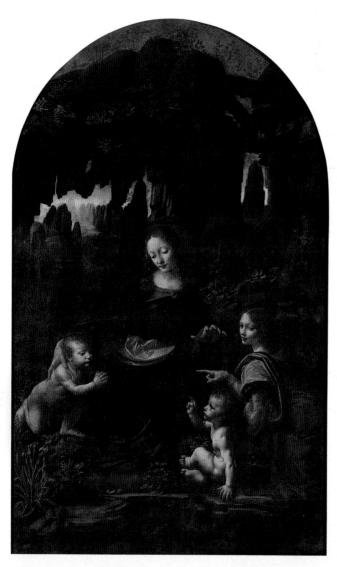

7.49 Leonardo da Vinci, *Madonna of the Rocks*, 1483–85. Oil on wood, transferred to canvas, $6' 2 \%'' \times 4' (2 \times 1.2 \text{ m})$. The Louvre, Paris, France. A second version of this painting is in the National Gallery, London, England. Commissioned by the Confraternity of the Immaculate Conception for their chapel in San Francesco Grande, Milan.

The exact meaning of Leonardo's painting remains mysterious and elusive, with the holy group set within a darkened cave. Detailed foreground naturalism is combined with a background that seems to belong to a primitive world where the forces of nature are still carving the mountainous landscape.

Renaissance art, and he rightly argued that the transition to the High Renaissance occurred with the art of Leonardo da Vinci. One aspect of this transition took place when Leonardo developed a new unified composition in which he grouped figures to suggest a solid geometric form, such as a pyramid or cone. In Leonardo's Madonna of the Rocks, the figures form a pyramid (fig. 7.49). Mary's head is the apex; her right arm extends to embrace the infant Saint John the Baptist, who is worshiping the Christ Child. To our right, the angel's head and billowing red cloak define another side, while the Christ Child, who blesses the Baptist, extends the form forward, anchoring the pyramid. In a splendid example of foreshortening, Mary extends her left hand over the Christ Child, as if to offer protection and blessing. For Leonardo, the achievement of a unified composition did not mean a static presentation—the language of gesture in the Madonna of the Rocks, for example, is varied and complex.

Leonardo's use of the pyramidal composition has multiple meanings. As a compositional scheme, the pyramid offers visual unity and stability, while it also carries the religious association of the Christian Trinity. As a geometric form, the pyramid relates to the Renaissance macrocosmic/microcosmic tradition, based in antiquity, which held that everything in the universe is governed by the order and precision of geometry. This tradition equated the human figure, or microcosm ("small world"), to the universe, the macrocosm. This complex philosophical notion found expression in a number of drawings known as the Vitruvian Man, the most familiar of which is by Leonardo (fig. 7.50). The image of a human figure with arms and legs outstretched to touch both a circle and a square is based on a passage from the ancient Roman writer Vitruvius, who suggested that there is a consonance between the human body and the perfection of geometry that related the body to the mathematical systems inherent in the universe. This almost mystical belief in macrocosmic/microcosmic analogy influenced Italian artists to compose figures in geometric configurations, thus creating a visual harmony alluding to the ideal harmony of the universe. Leonardo experimented with the unified composition in many studies, always seeking to incorporate a variety of poses to reflect the vitality of life.

In the 1480s, Leonardo began to design a series of **centrally planned churches** (fig. **7.51**). These drawings, which evolve from simple to more complex structures, were probably intended for a treatise on architecture. Not one of

1489 First epidemic of typhus in Europe

1497 John Cabot visits North America

Leonardo's designs was built. His involvement with centrally planned structures may have been in part inspired by Alberti's book On Architecture, which dates from about 1450. Alberti, citing the appearance of the circle in bird nests and other forms in nature, recommended the central plan as an ideal one for church architecture. Theologically, the circle, without beginning or end, was considered symbolic of the perfection of God. Leonardo's conceptions of centrally planned churches as embodied in his drawings often combined exterior views with sections and/or plans. Drawn while Leonardo was working in Milan, they influenced Donato Bramante, who would later develop a centrally planned structure for St. Peter's in Rome (see figs. 8.26 - 8.27).

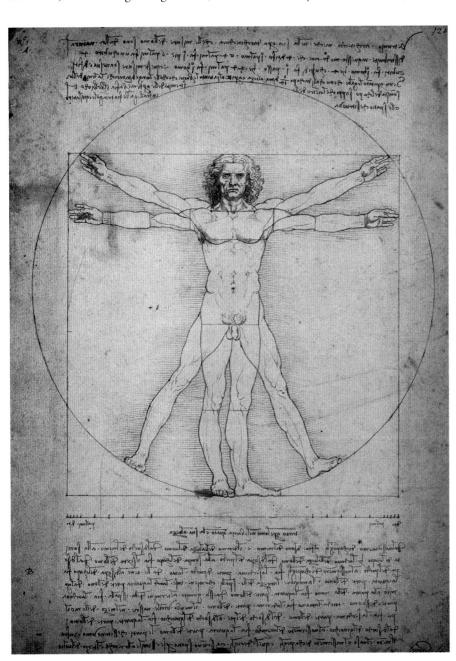

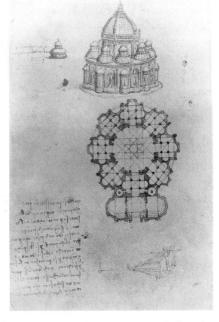

7.51 Leonardo da Vinci, View and plan of a centrally planned church, c. 1489. Pen and ink, $9\frac{1}{6} \times 6\frac{5}{6}$ " (23 × 16 cm). Institut de France, Paris. No patron, but perhaps related to churches commissioned for Milan by Duke Lodovico Sforza.

7.50 Leonardo da Vinci, Vitruvian Man: Study of the Human Body (Le proporzioni del corpo umano), c. 1492. Pen and ink, 1' $1\frac{1}{2}$ " × $9\frac{5}{8}$ " (34.3 × 24.5 cm). Gallerie dell'Accademia, Venice, Italy.

Italian Renaissance Painting: Leonardo's Last Supper

ccording to Leonardo da Vinci, "Painted figures ought to be done in such a way that those who see them will be able to easily recognize from their attitudes the thoughts of their minds."

Leonardo's Last Supper, painted in the dining hall of a monastery, exemplifies his maxim that figures should express emotional and psychological realism (fig. 7.52). The calm figure of Jesus, who is both on the axis and at the focal point of the scientific perspective construction, forms a triangle that, while symbolic of the Trinity, also gives visual stability to the composition and contrasts with the activity of the apostles who flank him.

The agitated movement of the apostles reveals their psychological turmoil in reaction to Jesus's declaration, "I say unto you, that one of you shall betray me" (Matthew 26:21). The impact of these words on the apostles is understandable when we realize that they had left their families, friends, and professions to follow him. Now, when celebrating a Passover meal, Jesus announces that one of them will be a betrayer. The apostles' reactions reveal surprise, piety, uncertainty, and faithfulness.

The powerful emotional drama that we perceive in the Last Supper is but one level of meaning in Leonardo's painting. In earlier Last Supper paintings, Judas had been shown on our side of the table, removed from the space occupied by Jesus and his apostles. Leonardo, however, kept Judas with his fellow apostles. The fourth figure from the left, he is shown recoiling from Jesus. Judas is the only figure whose face is lost in shadow, a subtle indication that he is lost from the light of Jesus.

Leonardo has joined the depiction of these two episodes with a third. The hands of Jesus are directed toward the bread and wine on the table, suggesting the institution of the Eucharist.

The activity of these dramas is contained within an impressive organization. Light from the upper left (following the placement of windows in the refectory) models the figures. The grouping of the apostles on each side of Christ provides symmetry, while the positioning of the apostles in four groups of three discloses the numerical symbolism of the spiritual (3 is the number of the Trinity) and material (4 is the number of the elements) components of creation. This expression of universality is also apparent in the number 12: in keeping Judas with the eleven faithful apostles, Leonardo retains the integrity of the number 12, which refers not only to the apostles but also to the months of the year and the hours of day and of night, extending the numerical symbolism to include the cycles of time.

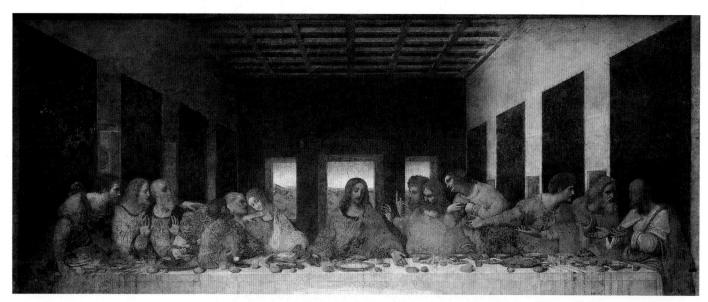

7.52 Leonardo da Vinci, Last Supper (detail), wall painting in the Refectory, Santa Maria delle Grazie, Milan, Italy, c. 1495–98. Oil, tempera, and varnish, $14' \times 28' \cdot 10\%'' \cdot (4.6 \times 8.6 \text{ m})$; the figures are over-lifesize.

The Dominican monastery of Santa Maria delle Grazie was supported by Lodovico Sforza, duke and ruler of Milan, who commissioned Leonardo to paint the Last Supper. This view shows the painting after the recent restoration, which brought to light subtle details of facial expressions and radiant colors that had been covered by earlier restorers, who repainted rather than cleaned the surface.

It is now difficult to discern the subtle details that Leonardo intended. Ever the inventor, he had disavowed the traditional fresco technique (see pp. 242-43), and painted with an oil and egg medium on dry plaster, an experiment that led to an early deterioration of the surface. However, we can glean some sense of the intended effect from surviving preliminary drawings. The study for the head of Judas exhibits Leonardo's understanding of anatomy and physiognomy (fig. 7.53). Such detailed, descriptive observation, found in numerous studies, was joined to a unified yet complex narrative interpretation.

In 1999, Leonardo's restored Last Supper was unveiled after more than twenty years of painstaking work by Pinin Bambilla Barcilon, who, in her own words, restored the painting "centimeter by centimeter," at a total cost of \$7.7 million. Leonardo's work had been in extremely bad repair. Successive repaintings, humidity, pollution, and the abuse of the refectory (the room was used as a stable by French invaders and suffered from bomb damage in World War II) led to an ever-worsening condition. Various art experts have estimated that only 20 percent to 50 percent of Leonardo's painting has survived.

As with many significant art restorations, the Last Supper has received mixed reviews. While new details of the painting were brought to light in the process, such as items of food, finger bowls, wine glasses, and the decoration on the tablecloth, many questions were raised. Some experts were shocked by the intensity of the colors. Had the restorer gone too far, perhaps removing parts of Leonardo's original painting? Is this a restoration or yet another repainting? Were not the earlier repaintings part of the history of the work? Some critics have called the restoration "catastrophic," saying that the painting now looks like a "postcard," while most have hailed it as an important achievement.

7.53 Leonardo da Vinci, Study for the Head of Judas, preparatory drawing for the Last Supper, 1495-97. Red chalk on red prepared paper, $7\% \times 5\%$ " (18.2 × 14.9 cm). Royal Library, Windsor Castle, England. No patron, but related to Leonardo's work for Duke Lodovico Sforza.

Leonardo draws attention to the figure's neck in order to refer to Judas' suicide by hanging after his betrayal.

Italian Renaissance Sculpture: Michelangelo's *Pietà* in St. Peter's

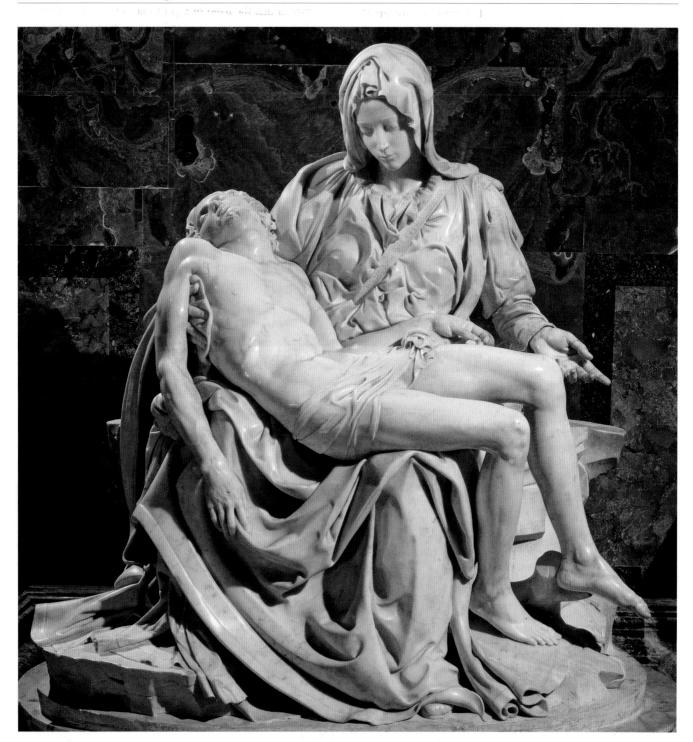

7.54 Michelangelo Buonarroti, *Pietà*, 1498–99. Marble, height 5' 8½" (1.74 m); the figures are over-lifesize. St. Peter's Basilica, Vatican, Rome, Italy. Commissioned by the French Cardinal Jean de Bilhères Lagraulas for the chapel where he planned to be buried at Old St. Peter's (see figs. 5.12 and 5.13).

On August 27, 1498, a twenty-three-year-old sculptor from Florence, Michelangelo Buonarroti, signed a contract in Rome for a Pietà, intended as a tomb sculpture. The contract was repeating tradition when it stated that the completed group should be the "most beautiful work of marble in Rome," but the work Michelangelo created within about a year and a half fulfilled the terms of the contract in a new and unparalleled way.

his *Pietà*, with its harmonious composition and tragic expression, was created with consummate skill from an inert block of marble by Michelangelo Buonarroti (1475–1564; fig. **7.54**). The Virgin Mary, seated on a rock, cradles the lifeless body of her son, which has just been taken down from the cross. With the open gesture of her left hand, she presents her son's sacrifice to us. The design of the sculpture, with its sweeping passages of drapery, is resolved into a pyramidal composition.

The theme that we call the Pietà (Italian for "pity" or "piety") is not found in the Bible. This subject first appears in northern European Gothic sculptures in which anatomical details were exaggerated to emphasize Jesus's suffering and death. The German Gothic *Pietà* illustrated here for comparison purposes was created more than a century before Michelangelo's. It was designed to demand an immediate and powerful devotional response from the devout viewer (fig. 7.55).

One of Michelangelo's biographers wrote in 1553 that with his Pietà the sculptor wanted to show "that the Son of God truly assumed human form," so that his physical suffering could be easily understood. But Michelangelo's conception of the theme is rooted in the idealism of the Italian Renaissance, and he avoided the distortions of the Northern Pietà images to emphasize his views on the beauty of the human body. While still a young man, Michelangelo had studied human anatomy and through dissections had learned the structure of the human body. In this Pietà, created when he was still in his twenties, he demonstrates his prodigious understanding of musculature in a manner that encourages the viewer to better understand Christ's suffering and death. Unlike the wailing mother of the Gothic Pietà, Michelangelo's serene figure of Mary bears her sorrowful burden with meditative resignation. The artist here suggests an inner suffering restrained by dignity.

In describing the St. Peter's *Pietà*, Vasari, in his sixteenth-century book, *Lives of the Artists*, emphasized the beauty and technical achievement of the sculpture:

Among the lovely things to be seen in the work, to say nothing of the divinely beautiful draperies, is the body of Christ; nor let anyone think to see a greater beauty of members or more mastery of art in any body, or a nude with more detail in the muscles, veins and nerves over the framework of the bones, nor yet a corpse more similar than this to a real corpse. Here is perfect sweetness in the expression of the head, harmony in the joints and attachments of the arms, legs, and trunk, and the pulses

and veins so wrought, that in truth Wonder herself must marvel that the hand of a craftsman should have been able to execute so divinely and so perfectly, in so short a time, a work so admirable; and it is certainly a miracle that a stone without any shape at the beginning should ever have been reduced to such perfection as Nature is scarcely able to create in the flesh.

Vasari goes on to report, however, that when the *Pietà* was newly finished, questions arose about the identity of the artist. To end any doubts, Michelangelo carved his signature on the ribbon that crosses Mary's chest. This *Pietà* is the only work Michelangelo ever signed.

7.55 German Gothic, *Pietà*, early fourteenth century. Polychromed wood, height 2' 10½" (87 cm). Provinzialmuseum, Bonn, Germany.

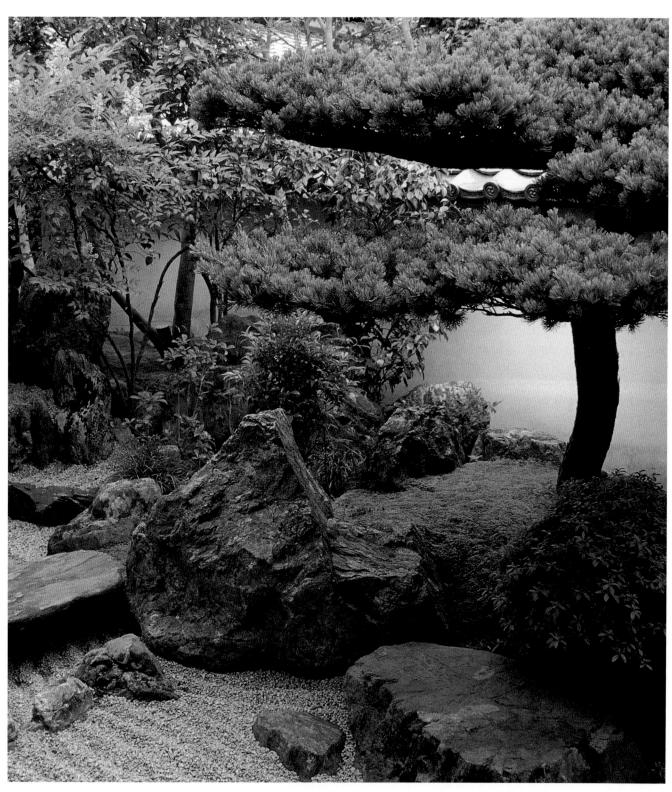

8.1 Soami (attributed), Dry garden of the Daisenin of Daitokuji, Kyoto, Japan. Ashikaga period, early sixteenth century.

Sixteenth-Century Art

A BRIEF INSIGHT

he Japanese temple garden illustrated here demonstrates how art can function in surprising ways. Erected during a period when Japan had been convulsed by unrest and uncertainty for more than a century, its function was to provide an oasis of meditation away from the troubles of the outside world while at the same time making reference to the grandeur of nature. The Japanese garden is understood as a microcosm of the universe reduced to essential elements.

During the sixteenth century, when Zen Buddhism flourished in Japan, gardens became a means for Zen self-examination, spiritual refinement, and ultimate enlightenment; they were not created for idle viewing or simple pleasure. Zen qualities are unmistakable in the dry garden at Daisenin (fig. 8.1), a temple at Daitokuji in Kyoto, which is attributed to Soami—a painter, poet, and practitioner of broad aesthetic knowledge and talent. The garden is sited on a small space on the east side of the building; the depth from the edge of the veranda, where one would meditate, to the wall opposite is no more than about ten feet (about 3 meters). The garden is a miniature landscape in which boulders represent mountains, while smaller stones and gravel suggest a course of water falling over a waterfall, racing along a mountain riverbed, and finally flowing into a broad river. A dramatic, watery landscape is thus suggested without the use of any water:

Introduction to Sixteenth-Century Art

By the middle of the sixteenth century, when Michelangelo's Florence *Pietà* was created, the optimism that had characterized so much of fifteenthand early-sixteenth-century Italian Renaissance art had evaporated. This new pessimistic mood is conveyed by Michelangelo's *Pietà* (fig. 8.2). We sense the dead weight of Jesus's body in the angular arrangement of limbs, the head collapsed to one side, and the efforts needed to support the body. To our right, the Virgin tenderly presses her face against her son's head. Behind, the towering figure of Nicodemus, a follower of Jesus, compassionately helps support his dead master.

Although the legacy of the High Renaissance is evident in the musculature of the body of the central figure, the elongated figures and unstable composition break the norm of Renaissance harmony. Grief has seized the participants, and this emotional impact is reinforced when we realize that Nicodemus is a self-portrait of the artist. Michelangelo (1475–1564), who was about seventy-two years old when he began carving the Florence *Pietà*, intended it to be placed over his own tomb. Its unsettling emotional content reflects his personal psychological condition and may also be related to the tumultuous conflicts of sixteenth-century Europe.

8.2 Michelangelo Buonarroti, *Pietà*, c. 1547–55. Marble, height 7' 8" (2.33 m). Museo dell' Opera del Duomo, Florence, Italy.

After working on this sculpture for almost a decade, Michelangelo smashed it in anger, leaving it seriously damaged. He presented the damaged work to a pupil, who repaired it and laboriously finished the figure of Mary Magdalene on our left. Although based on Michelangelo's design, she is now too small for the composition and no longer seems to be supporting Jesus's right arm. Jesus's left leg, which was once positioned over Mary's, is completely lost. Theories have been advanced as to why Michelangelo attacked the work. Giorgio Vasari, writing in 1568, stated that the artist discovered that the marble was flawed.

HISTORY

During the sixteenth century, contacts between widespread cultures were expanded through the increase in traffic on the high seas, new explorations, and new interest in mapping the globe. The fine goods of one culture, such as porcelain, textiles, and spices, were exchanged for the luxury goods of another; exquisite blue-and-white porcelains of the Chinese Ming Dynasty (see fig. 8.14), were prized in Europe, and even represented in paintings (see Points of Contact box, p. 305, and fig. 8.13). Another example of this taste for the exotic and unusual is the stupendous collection of Chinese and Japanese porcelains ordered by the Turkish sultans and now on display in Istanbul.

Other contacts were less commercial. In 1582, a Jesuit priest named Matteo Ricci brought the Jesuit order to China. He presented the emperor with a mechanical clock, the first in China, and guaranteed his continuing presence there by being the only person who could keep it in working order. The underlying purpose of his mission was to try to establish a Christian base in one of the world's most populous, non-Christian nations.

Throughout the century, expansion across the Atlantic continued. The Spanish were particularly active in colonizing. In 1513, Vasco Múñez de Balboa crossed Panama to reach and name the Pacific Ocean, and Juan Ponce de León established a settlement in Florida. In the late fifteenth and early sixteenth centuries, a Florentine merchant and seafarer, Amerigo Vespucci, charted the eastern coastline areas of South America. In the year 1507, the mapmaker Martin Waldseemüller, drawing on Vespucci's information, demonstrated that Vespucci had reached land masses separate from Asia and suggested that they be named after Vespucci; hence they came to be called the Americas.

Contact between Europeans and the civilizations of the Americas increased, and in 1520-21, when the German artist Albrecht Dürer was visiting in the Netherlands, he saw a room full of Aztec gold treasures sent back by Hernán Cortés. He praised these exotic objects, writing, "I have seen nothing that rejoiced my heart so much as these things, for ... I marveled at the subtle ingenuity of men in foreign lands." Dürer's comment suggests that he was most impressed with the craftsmanship of the artists who made these works, but because they were gold they were soon melted down and these demonstrations of their proficiency were lost to history forever.

Fortunately, archaeological excavations and other discoveries have preserved objects that reveal the skill of these workers and also the function and iconography of the objects they made. Illustrated here is a raft made in the Muisca culture, which flourished in the area we today know as Colombia (fig. 8.3). This elaborate representation of a raft with human figures functioned as a votive offering; Muisca votives, placed in protective ceramic containers, have been discovered in caves and other isolated sites. This particular votive has been interpreted as representing a Muisca ritual known as "El Dorado," or "the gilded man." As part of his investiture, a new ruler would be covered with gold dust and, accompanied by other individuals, propelled

8.3 Raft, Muisca Culture (Colombia), fifteenth century? Cast gold. Museo del Oro, Banco de la República, Bogotá, Columbia. Commissioned as a votive offering for the gods.

The Muisca culture began producing works in gold and copper as early as the seventh century. Other Muisca votives have been discovered that represent warriors, women holding children, animals, snakes, dragons, weapons, and household utensils. This work was found in a cave near Pasca (Cundinamarca), approximately thirty-five miles (56 km) south of Bogotá.

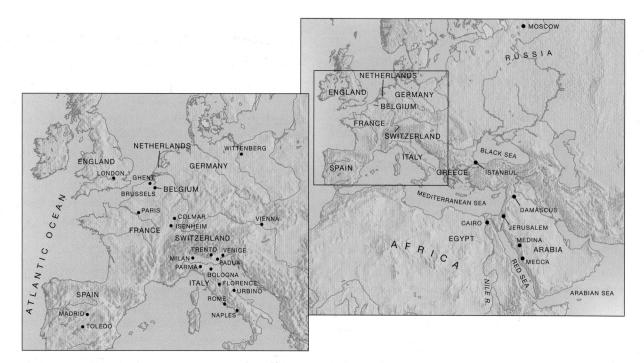

on a raft to the center of Lake Guatavita to the accompaniment of music and chanting. There he would enter the sacred lagoon and he and others would make offerings of gold items and emeralds. The artists who created this and other Muisca works used the same lost wax manner of casting metal as the ancient Greeks (see p. 81). The human figures are stylized and relatively flat; the largest and clearly most important figure wears a complex headdress.

In 1526, the Mughal Empire, which would last until 1756, was established in India. The Muslim emperor Akbar (ruled 1556–1605) attempted to reconcile the Muslim, Hindu, and Christian factions that coexisted in the subcontinent. In this philosophy of reconciliation, Mughal artists incorporated European elements, such as scientific perspective and atmospheric effects, into their paintings. Akbar and the two emperors who succeeded him were avid patrons of the arts.

The main political protagonists of the European sixteenth century were the popes in Rome and the rulers of northern Europe. Pope Julius II established the papacy as a political power early in the century, but the strengthened Church conflicted with the plans of secular rulers in the North, where strife between Emperor Charles V of the Hapsburg line and Francis I, king of France, affected many aspects of sixteenth-century life. In 1520, Charles V was crowned Holy Roman Emperor, a position that Francis I had also sought. The territories ruled by Charles V were vast; they encompassed Spain, the Netherlands, and parts of northern Italy, Germany, and central and northern Europe. France was effectively isolated, but even a brief imprisonment did not deter Francis from his conflict with the emperor. Charles was usually aligned with the pope, but a significant break in this alliance occurred in 1527, after Pope Clement VII backed Francis I in an attempt to check

the increasing power of the emperor. Charles V's troops entered and pillaged Rome that year, and even imprisoned the pope. But the attention of Charles V was also directed toward the East, where he attempted to counter the expansion of the Ottoman Turks under Suleiman the Magnificent, who had extended his empire into eastern Europe and North Africa.

In areas that remained isolated, local traditions sometimes became gradually more extreme and individualized. Russia, Christianized in 988, had adapted the Byzantine style of the multidomed, centrally planned church. Gradually, however, the drums that supported the Russian domes were heightened, while the domes took on a helmet shape, with a point at the top; eventually they evolved into "onion" domes, with heightened curves dominating the shape. The extreme example of this trend came when Ivan the Terrible commissioned a nine-domed church to be built next to the Kremlin on Red Square in Moscow; now known as St. Basil the Blessed, it has become a symbol of Russia precisely because its forms are unparalleled in other cultures (fig. 8.4). The exotic quality of the structure may have been intentional, for Ivan might well have asked the architect(s) to design a structure that, while based on Russian traditions, would also give a new and distinct identity to his capital in Moscow. The later, seventeenth-century decoration of the domes with the forms and colors of Russian folk traditions has given the monument an even more distinct Russian flavor.

INTELLECTUAL AND SCIENTIFIC DEVELOPMENTS

Although the vast majority of Europeans still felt bound to the scientific beliefs and superstitions that had guided life for centuries, important discoveries in the sixteenth century

8.4 Postnik and Barma (?), Cathedral of St. Basil the Blessed, Moscow, Russia, 1554-60 and later. Commissioned by Tsar Ivan IV, the Terrible, to commemorate his victory over the Tartars at Kazan.

No other work of architecture by either of these men is known; the names may be legendary, or Barma ("mumble") may be Postnik's nickname. The structure was initially dedicated to the Virgin Mary, but it became known as St. Basil's when a holy man of that name was buried there in the 1550s.

laid the foundation for the modern development of science. These discoveries were aided, in part, by the expanded publication of books. By 1600, about 2,000 books per year were being produced, a rate double that of a century earlier.

In 1543, two publications appeared that began to overturn many incorrect beliefs about human anatomy and the universe that had been based on the writings of ancient authors. On the Fabric of the Human Body, written by Andreas Vesalius, began to clear away misconceptions about anatomy and provide a base for advances in medicine. In the same year, the astronomer Nicolaus Copernicus, in On the Revolution of the Celestial Spheres, asserted his theory that the planets revolve around the sun. This "modern" view of the universe, which had been held by a minority of philosophers since antiquity, was later popularized by Galileo Galilei, whose teachings, challenged by the Catholic Church, demonstrated the conflict between the new scientific reason and traditional religious authority.

RELIGIOUS REFORM AND ART DURING THE SIXTEENTH CENTURY

The most significant religious event of the European sixteenth century was the Protestant Reformation. Over the centuries, the Catholic Church had become increasingly materialistic, and the rebuilding of St. Peter's in Rome (see pp. 316–17) and the construction of a new papal palace led to the expansion of such unscrupulous practices as the selling of indulgences; payments that allowed a person to "buy" a soul an early entry into heaven by making a "donation" to the church. When indulgences were solicited in Germany, a monk named Martin Luther (fig. 8.5), questioned these practices, arguing that faith alone could "buy" salvation. Aiming at reform from within, Luther drafted ninety-five theses, which he nailed to the doors of Wittenberg Cathedral on October 31, 1517. Among his theses, he argued:

- 27. There is no divine authority for preaching that the soul flies out of purgatory as soon as the money clinks in the bottom of the chest
- 50. Christians should be taught that, if the pope knew the demands of the indulgence-preachers, he would rather the church of Saint Peter were reduced to ashes than be built with the skin, flesh, and bones of his sheep.

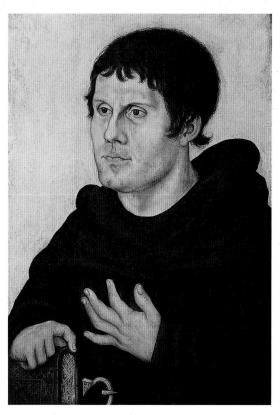

8.5 Lucas Cranach the Elder, Portrait of Martin Luther, 1533. Oil on wood, $8\frac{1}{4} \times 5\frac{1}{6}$ " (21 × 14.9 cm). German National Museum, Nuremberg, Germany. This is one of some fifty portraits of Luther painted by Cranach and his workshop.

Luther was excommunicated by the Church, but many German princes were glad to join in an effort to restrict the power of the Church, which was draining their territories of wealth. Emperor Charles V ordered that measures be taken against those who dissented from the Catholic faith; those who protested the emperor's order became known as Protestants. When, in 1555, the Peace of Augsburg decreed that the religion of a ruler determined the religion of that area, it was a victory for the Protestants. By the end of the century, approximately one-fourth of western Europe's population was Protestant.

The response of the Roman Catholic Church to the Reformation is usually known as the Counter-Reformation. The rapid growth of Protestantism led the Church to call a council at Trent, in north Italy; between 1545 and 1563 the Council of Trent planned a strategy to combat the spread of Protestantism. Enforcement of the Church's policies was granted to the Inquisition, an ecclesiastical court established in the late Middle Ages to punish heretics.

Calls for a better educated priesthood were met by a new order founded by Ignatius of Loyola in 1534. Named the Society of Jesus but commonly referred to as the Jesuits, the order was distinguished by its missionary zeal, preaching, and scholarly interests. As teachers, Jesuits founded influential schools and were counted among the intellectual leaders of the time.

At the Council of Trent, the Church reaffirmed the value of art in promoting religious education, asserting that religious art should appeal to the emotions, be morally acceptable, and use clear compositions. Accuracy in theology was required; failure to meet these requirements made the artist answerable to the Inquisition (see pp. 342–43).

The successive styles of sixteenth-century Italian art—High Renaissance, Mannerism, and early Baroque—can be directly related to the religious developments discussed above; because of the importance of Italy as an artistic center, these styles would have an important impact on the rest of Europe in the sixteenth century and into the seventeenth. Three paintings with a similar theme demonstrate the visual characteristics of each style.

Madonna and Child with Saint John the Baptist by Raphael (1483–1520) exemplifies the union of idealism and naturalism that characterizes the High Renaissance (fig. **8.6**). Bathed in soft gold light, the seated Madonna tenderly embraces the Christ Child. The relaxed pose of the child lends a note of informality. The flowers and plants are painted with precise observation, and naturalism is also evident in the modeling of the figures and in the atmospheric perspective of the distant landscape. Such naturalistic details, however, are part of an idealized composition seen in the pyramidal grouping. In Raphael's painting, the world as it is seen is joined to ideals of perfection. A divergent branch of High Renaissance art would develop in Venice,

with greater experimentation with colors, broader brushstrokes, and more dynamic compositions.

Madonna and Child with Angels and a Prophet (fig. 8.7) by Parmigianino (1503-40) was painted about thirty years after Raphael's Madonna. This Mannerist painting exhibits an aristocratic elegance: elongated figural proportions are evident (note especially the fingers of Mary's right hand), while the languid body of the Christ Child, the prominent leg of the angel, and the drapery clinging to Mary's torso create a distinctly sensual effect. The illusion of space is consciously disjointed, with columns (unfinished) in the background that rise to gigantic proportions. Derived from the Italian term maniera—meaning "style" in the sense of sophistication, elegance, and poise-Mannerist art moved away from the classical values of the High Renaissance. Mannerist artists sought to create an artificial and complex construction to demonstrate their intellectual and technical virtuosity and the sophistication of their patrons.

The *Madonna degli Scalzi* (fig. **8.8**) by Ludovico Carracci (1555–1619) might be seen as a reaction against the visual complexity of Mannerist painting. Dating from

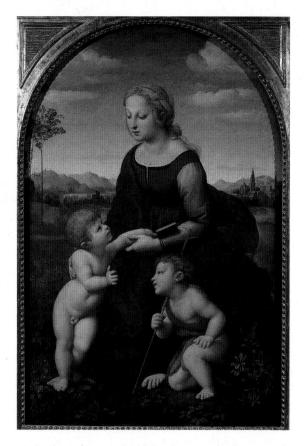

8.6 Raphael, *Madonna and Child with Saint John the Baptist* (also known as *La Belle Jardinière*), 1508. Oil on wood, $4' \times 2'$ $7 \frac{1}{2}$ " (122 × 80 cm.). The Louvre, Paris, France. Commissioned by Filippo Sergardi.

The infant John the Baptist, kneeling in the foreground, holds a cross and wears an animal skin to refer to the time he will spend in the wilderness.

8.7 Parmigianino, Madonna and Child with Angels and a Prophet (known as the Madonna with the Long Neck), 1534-40 (unfinished). Oil on wood, 7' 1" \times 4' 4" (2.19 \times 1.35 m). Galleria degli Uffizi, Florence, Italy. Commissioned by Elena Baiardi for the Church of the Servites, Parma, Italy.

8.8 Ludovico Carracci, Madonna and Child with Saints Jerome and Francis (or Madonna degli Scalzi), 1590-93. Oil on canvas, 7 × 5' (2.13 × 1.52 m). Pinacoteca Nazionale, Bologna, Italy. Commissioned by a member of the Bentivoglio family for their chapel in the Chiesa della Madonna degli Scalzi, Bologna.

late in the century, it can be considered an early Baroque work since the painting displays many of those features that will characterize Baroque art as it develops in the seventeenth century. The figures are rendered with an easily understood naturalism. Mary, raised on the axis on a crescent moon, holds a lively Christ Child. Christ extends his hand to Saint Francis, on our right, while Saint Jerome, with his symbolic lion, looks attentively from the left. A halo of golden light surrounds Mary's head. The light reflects on a host of angels joyously playing musical instruments. Carracci's emphasis on religious expression, visualized in a simple yet forceful composition, has an emotional appeal well suited to communicate the aims of the Counter-Reformation Church.

In northern Europe, the ideality of the Italian High Renaissance art affected many artists, especially Albrecht Dürer (1471–1528). Much of Northern painting, however, continued an adherence to a strict naturalism that can be related to the developments of Flemish painting during the fifteenth century (see pp. 264–65, 270–75). Dürer's drawing of Praying Hands (fig. 8.9), for example, demonstrates the continuing commitment to naturalistic observation and fine detail by Northern artists.

8.9 Albrecht Dürer, Praying Hands, 1508-09. Brush, heightened with white, on blue-grounded paper, $11\% \times 7\%$ " (29.2 × 19.7 cm). Albertina, Vienna, Austria. This is among a number of surviving drawings for one of Dürer's most famous works, the Heller Altarpiece (now destroyed), which was commissioned by Jacob Heller, a merchant of Frankfurt.

THE SIXTEENTH-CENTURY ARTIST

The new respect for the artist as an intellectual, which had developed in the fifteenth century (see pp. 240–41), made impressive gains during the sixteenth century. In Italy, both Michelangelo and Raphael earned the nickname *il divino* ("the divine one"), a sign that the artist was now being viewed as an almost godlike creator. Artists continued to make self-portraits throughout the century. Parmigianino's unusual *Self-Portrait in a Convex Mirror* (fig. **8.10**) reflects the intellectual and aesthetic conceits associated with Mannerist art.

Art theory continued to evolve within an intellectual climate that nourished it, and other types of writings contributed to the elevated social status of the artist. Baldassare Castiglione, an Italian diplomat and literary figure, included witticisms and more serious discussions on art in his *Book of the Courtier*. Benvenuto Cellini's fame as an artist was buttressed by his theoretical writings and a roguish *Autobiography* that still enjoys great popularity.

Giorgio Vasari, an artist active at the Medici court in Florence, published his *Lives of the Most Eminent Painters, Sculptors, and Architects* in 1550 and revised it for a second edition in 1568. Vasari viewed Renaissance art as an evolutionary progression (see p. 321). Beginning with Giotto in the fourteenth century, he argued, Italian art had been rescued from the "dark ages" to be restored in the light of classical eloquence. Each generation of artists had built upon the foundation set by the previous generation until perfection

8.10 Parmigianino, *Self-Portrait in a Convex Mirror*, 1524. Oil on wood, diameter 9½" (24 cm). Kunsthistorisches Museum, Vienna, Austria. Parmigianino's *Self-Portrait* is actually painted on a convex wooden panel to heighten the illusionism.

8.11 Lavinia Fontana, *Self-Portrait*, c. 1577. Oil on copper, diameter 6" (15.24 cm). Galleria degli Uffizi, Florence, Italy.

This self-portrait, which shows the artist in her studio, captures the confident elegance of Mannerist portraiture. Lavinia Fontana, from Bologna, was the daughter of a painter. She married a fellow student in her father's studio on the condition that she be free to follow her career. Her husband apparently assisted her by painting frames or by painting the clothing in some of her portraits. A portrait medal of 1611 shows her painting in an attitude that suggests that she, like Michelangelo, was divinely inspired.

was reached with the High Renaissance. Throughout the *Lives*, Vasari noted the regard in which artists were held by great rulers, enjoying their friendship and advice.

When Vasari wrote the *Lives*, he had more in mind than just art history. He was promoting the establishment of an art academy. His efforts assisted in founding the Florentine Accademia del Disegno (Academy of Design) in 1563. In this academy, and in many other European academies that followed, artists were educated within a broad liberal-arts context. This enhanced education made it more possible for at least some artists to mingle with the higher social ranks. The artistic, intellectual, and social gains made by artists during the sixteenth century gave us a new concept of the artist, that of an inspired genius.

One benefit of these social changes for the artist was that the profession began to open its ranks, however slowly, at first, to women. During the Middle Ages, women artists had been active primarily as embroiderers and manuscript illuminators. By the sixteenth century, women were becoming established as painters as well. In Italy, both Lavinia Fontana (fig. 8.11) and Sophonisba Anguissola (fig. 8.12) developed distinguished reputations.

8.12 Sophonisba Anguissola, Portrait of the Artist's Three Sisters with Their Governess, 1555. Oil on canvas, $2' \, 3\%'' \times 3' \, 1'' \, (70 \times 94 \, \text{cm})$. Muzéum Narodowe Museum, Pozna'n, Poland.

Sophonisba Anguissola, who was also trained in music, languages, and literature, is the first nationally recognized woman artist of whom we have any certain knowledge. She is credited with inventing a new type of group portraiture in which the sitters are shown in lively activity and psychological interaction rather than being merely aligned and accompanied by conventional props. Here she shows her sisters during a game of chess, an intellectual activity usually restricted to men at this time. The picture thus makes an important point about the capabilities of young women during this period, in which so many restrictions on female behavior were accepted. At the same time, it demonstrates the artist's interest in capturing complex personal interrelationships through gesture and expression.

POINTS OF CONTACT

Chinese Porcelain in Europe

In a painting of the Feast of the Gods by the Italian artist Giovanni Bellini (and Titian) (fig. 8.13), the vessels used by the gods are representations of blue-and-white porcelain of the Chinese Ming Dynasty that had been imported from the east (fig. 8.14). The prestige with which such wares were held is clear from the context in which the painter placed them: these are vessels the gods themselves would have chosen. European ceramic artists tried to mimic such wares, but it was only after many

8.13 Giovanni Bellini (and Titian), The Feast of the Gods, 1514/1529. Oil on canvas, 67 × 74" (170.2 × 188 cm). National Gallery of Art, Washington, D.C. Commissioned by Alfonso d'Este, Duke of Ferrara.

Originally completed by Bellini in 1514 with a more static background, in 1529 Titian was apparently asked to repaint the background to create a more dynamic, asymmetrical effect.

8.14 Porcelain dish decorated with chrysanthemum patterns, Chinese. Ming Dynasty, Hung Wu period, 1369-98. Underglaze blue on porcelain, diameter 1' 6" (45.7 cm). Östasiatiska Museet, Stockholm, Sweden.

decades of experimentation that they could begin to approximate the quality of their Chinese models. It is no accident that we still refer to our best dishes as "china."

The Nude/The Body

The Ideal Body

(figs. 8a and 8b) While the nude human figure is now widely accepted as an appropriate subject for art, this was not always the case. The nude was an uncommon subject during the period 200–1400, for example, but it was reintroduced into European art during the Italian Renaissance, the period when these two works were created. Although both Michelangelo's *David* and Titian's reclining nude are idealized representations of the nude body, the role they performed in society was distinct. It is not certain whether Titian's figure was a stereotypically ideal female or was intended to be a portrait, perhaps somewhat idealized, of a real woman, but documents tell us that the work was ordered by a male patron, and it was most likely intended for his personal pleasure and perhaps

to the presumed function of this work in a fertility ritual. Notice the exaggeration of the breasts, abdomen, and thighs: all parts of the body related to childbearing. In this functional object, the ideal of the human body as a beautiful thing is not an issue.

The Sensuous Body

(fig. **8d**) While the voluptuousness of this figure, with its large breasts and dancelike stance, suggests the promise of sexual pleasure, the presence of this figure on the gate at the Buddhist stupa at Sanchi reminds us that in many cultures sexuality is a metaphor for the fruitfulness of nature. This yakshi refers not so much to the sexual act as to the continuation of the family, group, or tribe, and the fecundity necessary for the good harvest needed for survival.

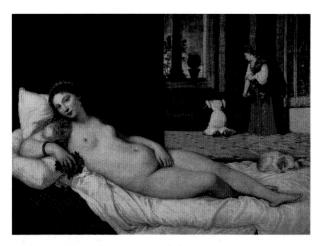

8a Titian, Venus of Urbino, 1538 (for further information, see fig. 8.38).

also for him to show to his male friends. This, then, was a private erotic work. Michelangelo's colossal idealized male nude, on the other hand, was commissioned for a public setting and its purpose was political. The muscular quality and heroic scale of the nude was meant to declare to both the Florentines and their enemies the potential power of the Florentine state. Florence might be small, but like David, the Old Testament boy who slew the giant Goliath, it was a city to be reckoned with. The re-emergence of the idealized nude as a subject in the Renaissance is an important indication of new attitudes about the validity of life in this world in European thought. The idealism seen here is, of course, only one of the many uses to which artists have put the nude human figure.

Exaggerating the Body

(fig. 8c) The choice of the nude female body for representation in the prehistoric era is most likely related

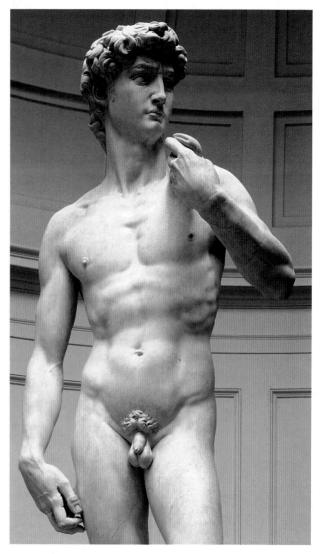

8b Michelangelo Buonarroti, *David*, 1501–04 (for further information, see fig. 8.15).

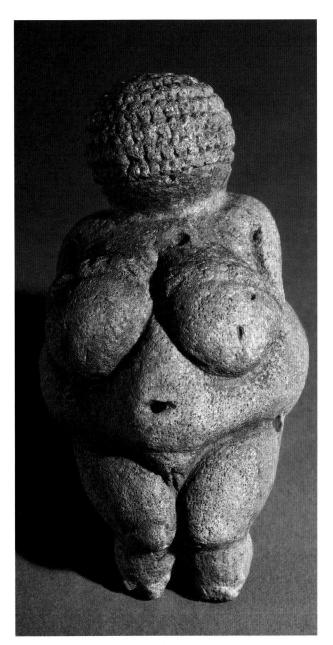

8c Prehistoric statuette of a woman, c. 25,000–20,000 BCE (for further information, see fig. 2.4 and pp. 24–25).

8d Buddhist yakshi, from Sanchi, c. 10–30 CE (for further information, see figs. 4.22 and pp. 110–11).

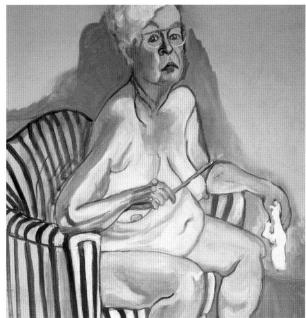

8e Alice Neel, *Nude Self-Portrait*, 1980 (for further information, see fig. 13.34).

Beyond the Body

(fig. **8e**) While the nude has traditionally embodied ideal beauty, sometimes artists choose to represent the body naturalistically, forcing the viewer to confront the facts of physical flaws or aging. Sometimes artists challenge the conventions of the nude tradition, daring to show the ugliness of the body in order to emphasize the psychological, the emotional, or the spiritual. In Alice Neel's nude self-portrait she wears her glasses; by studying herself with an unwavering gaze, she demands that we too see things as they are.

Questions

- 1. Find an example of an advertisement, a billboard, or a television commercial that uses the nude (or almost nude) body, and examine how the body is being used to help sell a product. Is the use of the body related to the product, or is the body irrelevant in this case?
- 2. How do you think individuals or governments in other cultures would respond to this advertisement?

Italian Renaissance Sculpture: Michelangelo

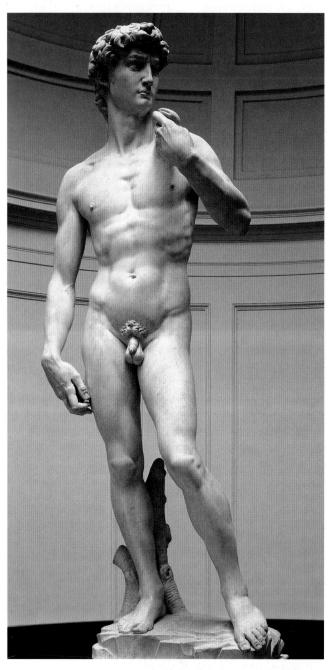

ichelangelo's huge sculpture of the Old Testament hero David is a stirring embodiment of strength and anger (fig. 8.15). Michelangelo chose an unusual moment to represent, for he shows David before his battle with the enemy Goliath. The sling is over his shoulder and the stone rests in his right hand, but his muscles are taut and a defiant scowl seizes his face. The figure recoils momentarily from the implied enemy, and David's apprehension is further indicated in the swelling veins in his hand and the sucking in of his breath revealed in the tensed muscles of his abdomen. In Michelangelo's interpretation, David is anticipating the moment of truth. In his *Lives*, Vasari, referring to the huge block of white marble from which Michelangelo carved the *David*, said that the sculptor had brought "to life a thing that was dead."

In saying that Michelangelo had given life to the stone, Vasari alluded not only to his artistic accomplishment but also to the history of the marble from which the *David* was carved. Quarried in 1464, the enormous block was brought to Florence to be carved as a *David*, one of a series of Old Testament prophets to be placed high above street level on the buttresses of the cathedral. The stone, partially carved, languished in the courtyard of the cathedral workshop for decades.

We do not know to what extent the stone had been carved before Michelangelo received the commission to finish the statue in 1501 and cannot, therefore, judge the difficulties he had to overcome. We do know that it was decided not to hoist the completed sculpture into position on the cathedral buttress. Perhaps there was fear that the sculpture might be damaged, or the work may have been too impressive to be removed from close public attention. A committee that included Leonardo da Vinci and Botticelli decided to place the *David* at the entrance to the Palazzo della Signoria, the center of Florence's civic government. That location gave the *David* an enhanced political significance.

8.15 Michelangelo Buonarroti, *David*, 1501–04. Marble, height of figure without pedestal 17' (5.18 m). Galleria dell' Accademia, Florence, Italy. Commissioned by the Cathedral Administration to be placed on a buttress below the dome of Florence Cathedral (see fig. 7.31).

In 1873, the statue was moved from its original location, at the entrance of the Palazzo della Signoria, to the Accademia, where a special setting had been constructed for it. The medium is white marble from Carrara, near Pisa. These quarries still yield vast quantities of fine-quality marble for artistic and architectural use. On a sheet of paper with drawings for the right arm of *David* and for a bronze statue of the same subject, Michelangelo wrote a couplet: "David with his sling / and I with my bow / Michelangelo." These lines have been interpreted with reference to Michelangelo's psychological state as he was about to carve the *David*. Just as David had the most meager of weapons, a sling, with which to battle Goliath, Michelangelo had only simple hand tools with which to attack the huge block of marble abandoned after earlier attempts to carve it. For Michelangelo, the bow was a sculptor's drill, used for boring into the marble. It was one of the limited number of traditional sculptor's tools used by his predecessors. The drill is still an important tool in carving stone and wood.

Michelangelo's David was carved after the expulsion of the Medici, when the republican traditions of Florence had been reasserted. The Medici would again rule the city in 1512, but at the time of the David, the democracy and liberty of the old Florentine republic reigned, and Michelangelo's sculpture was seen as a manifestation of those civic virtues. Just as the biblical David had triumphed against the physical power of Goliath, so too had the Florentine people courageously restored their republic. The David symbolized the Florentines' defiance of tyranny.

Fulfilling its new role as a political symbol, the David partook of the Renaissance in yet another way. While conforming to the designation statua, as public sculpture had been explained by the ancient Roman writer Pliny the Elder, Michelangelo's David went further, elevating statua to a grand and heroic scale. With the David, Vasari proclaimed that even the cherished art of ancient Greece and Rome had been surpassed:

Without any doubt this figure has put in the shade every other statue, ancient or modern, Greek or Roman ... such were the satisfying proportions and the beauty of the finished work.... To be sure, anyone who has seen Michelangelo's David has no need to see anything else by any other sculptor, living or dead.

TECHNIQUE

Stone Sculpture

Like carving in wood (see p. 261), working in marble is a subtractive technique. Benvenuto Cellini's sixteenthcentury Treatise on Sculpture prescribes that, after the clay model for a sculpture is completed:

you draw the principal views of your statue onto the stone....The best method I ever saw was the one that Michelangelo used; when you have drawn on your principal view you begin to chisel it round as if you wanted to work a half relief, and thus gradually it comes to be cut out.

8.16 Michelangelo Buonarroti, Saint Matthew. 1504-08. Marble, height 8' 10" (2.68 m). Galleria dell' Accademia, Florence, Italy.

This unfinished sculpture is the only figure begun by Michelangelo for a series of twelve apostles originally commissioned for Florence Cathedral. The project was abandoned when Michelangelo was called to Rome to work for Pope Julius II.

This approach is evident in the Saint Matthew (fig. 8.16), which is carved back from one face of the block, with the result that large areas of marble still fill the background. Cellini also describes the chisels used. Excess stone was removed with a pointed chisel, while toothed or clawed chisels were employed as the sculptor neared the surface of the figure. Marks from the toothed chisel are visible in the detail of the Saint Matthew (fig. 8.17). Work with a flat chisel would then remove the ridges left by the toothed chisels, and a series of rasps and files would be used to finish the surface. Drills were utilized for areas of deep undercuts, and polishing was achieved with a close-grained pumice stone. Even today, centuries later, sculptors continue to work with traditional chisels like those used by Michelangelo. Only the electric drill has eased the physically demanding process of carving a figure in stone.

8.17 Michelangelo Buonarroti, Saint Matthew, detail.

Italian High Renaissance Portraiture

he *Mona Lisa*, probably the best-known painting in the history of art, is difficult to appreciate today (fig. **8.18**). Covered by layers of yellowing varnish and a sheet of thick glass, the painting seems to have lost the naturalistic effects reported by Vasari:

The nose, with its beautiful nostrils, rosy and tender, seemed to be alive. The opening of the mouth, united by the red of the lips to the flesh tones of the face, seemed not to be colored but to be living flesh.

Our reconstruction (fig. **8.19**) attempts to recreate some of the original effect that the work must have had.

Leonardo became famous for his ability to represent subtle shadows and to create a sense of mystery by gently modeling forms through a careful blending of tones, and while these effects survive in the *Mona Lisa*, the freshness of his color and observation is obscured. What remains clear is Leonardo's composition, which became a model for later Renaissance portraits. As in his earlier works (see figs. 7.49, 7.52), the basic form is a pyramid. Leonardo naturally integrates the hands into his portrait, adding another vehicle for the expression of personality into the tradition of portraiture.

Even in the Renaissance, the mystery of the sitter must have excited the imagination of the viewer. The somewhat androgynous quality—neither fully female nor fully male—and the self-satisfied expression are tantalizing, but the blurring of the corners of the mouth and eyes make it difficult to determine the exact nature of her expression.

Our uneasiness is also in part created by the unexpected plucked eyebrows and forehead fashionable in the Renaissance. Also disturbing is the fantastic landscape setting, in which the horizon lines on either side of the head are clearly on different levels. Perhaps the most remarkable single aspect of the painting is the manner in which this woman looks directly into the viewer's eyes; for a Renaissance man this would have been

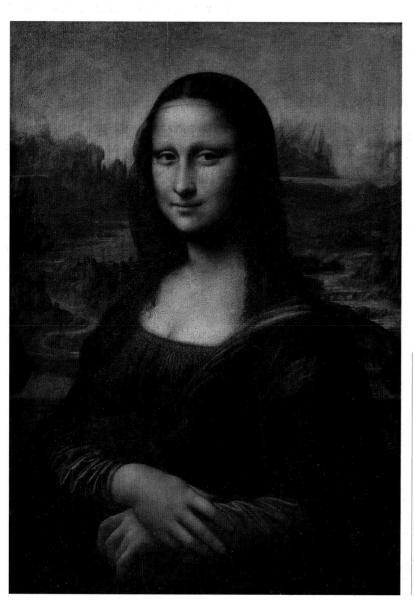

8.18 Leonardo da Vinci, *Portrait of a Woman* (known as the *Mona Lisa*), c. 1503–05. Oil on wood, 2' 6¼" × 1' 9" (77 × 53 cm) (cut down). The Louvre, Paris, France. Commissioned by her husband, Francesco del Gioconda?

The sitter is unknown, despite the traditional title. Vasari said that she was the wife of Francesco del Gioconda, which led to the popular name La Gioconda for the painting. Vasari also tells that Leonardo employed musicians or jesters during the sittings for the portrait to keep her full of merriment and to chase away any trace of melancholy that might arise from the boredom of sitting quietly posed, repeatedly, for long hours. Leonardo, who seems to have worked on the painting over a number of years, took it with him when he went to France, where he died in 1519. After Leonardo's death, the painting was owned by Francis I of France. In the early nineteenth century, Napoleon kept the portrait in his bedroom. The painting has been cut down; it was once wider, and the figure was shown enframed by columns on each side. Today, only the column bases survive.

1511 The pocket watch is first mentioned

1511-15 Spain captures Cuba

unsettling, for Renaissance etiquette books warned women that they should never look directly at a man. Whoever she is, the Mona Lisa continues to project and protect her mysterious secret.

Writing at the close of the nineteenth century, an art historian described Leonardo's Mona Lisa as an "indecipherable and fascinating enigma" that has been affecting admirers for "nearly four centuries." Actually, this particular interpretation of the painting was a more recent development. For almost three and one-half centuries following the painting's creation, the Mona Lisa had been respected as a fine portrait, which demonstrated, in the words of Vasari, how faithfully art can imitate nature.

This view began to change within the context of various philosophical and art movements of the nineteenth century, including the aesthetic doctrine of "art for art's sake." In 1873, the English critic Walter Pater wrote of the painting as follows:

The presence that rose thus so strangely beside the waters, is expressive of what in the ways of a thousand years men had come to desire.... She is older than the rocks among which she sits; like the vampire, she has been dead many times, and learned the secrets of the grave. The fancy of perpetual life is an old one. Certainly Lady Lisa might stand as the embodiment of the old fancy, the symbol of the modern idea.

This interpretation helped to create the foundation for a new range of critical thought concerning the Mona Lisa,

and, in the process, brought a new level of fame to the work. In 1916, Sigmund Freud, the founder of psychoanalysis, concluded through psychosexual analysis that the painting was important to understanding Leonardo's homosexuality. Concerning the famous mysterious smile, Freud wrote, "When in the prime of his life Leonardo reencountered that blissful and ecstatic smile as it had once encircled his mother's mouth in caressing, he had long been under the ban of an inhibition, forbidding him ever again to desire such tenderness from women's lips." Given the increased notoriety of the Mona Lisa, is it any wonder that Marcel Duchamp utilized a reproduction of it in a nihilistic Dada work?

Our views of works of art are often conditioned by critical issues that both challenge and transform our perception of the work through time. The fourteenth-century Italian humanist poet, Petrarch, was right when he wrote that "time alters fame."

8.19 Leonardo da Vinci's Portrait of a Woman in a computerized reconstruction by Naoko Gunji and Jane Vadnal that restores the original proportions of the painting, with the columns to the sides framing the landscape, and attempts to adjust the color to give some effect of what the original may have looked like before layers of varnish darkened and subdued the colors.

German Printmaking: Albrecht Dürer

he increasing contact between Italian and Northern artistic traditions is demonstrated in Dürer's Adam and Eve (fig. 8.20). The precise detail of the heavily wooded background reflects Northern tradition, while the use of antique models for the figures reveals Dürer's contact with Italian Renaissance art. The awkwardness in blending these two styles is evident, for the figures resemble sculptures rather than living beings and seem out of place in this forest setting. Nevertheless, they are striking in their elegance—which is not surprising, for Dürer studied proportional systems for the human body from nature and from classical and Italian

Renaissance sources, and he completed two volumes of a proposed four-volume *Treatise on Human Proportions*. The animals in the background bear an important relationship to the figures, for they symbolize the various "humors," fluids within the body that were believed to control personality. The rabbit, for example, stands for lechery, which will become active as soon as Adam takes a bite of the apple held by Eve.

Dürer's prints brought him international fame. During his lifetime, he was internationally recognized as the leading German artist. When Dürer was in Venice, the Senate offered him a regular salary if he would become a citizen

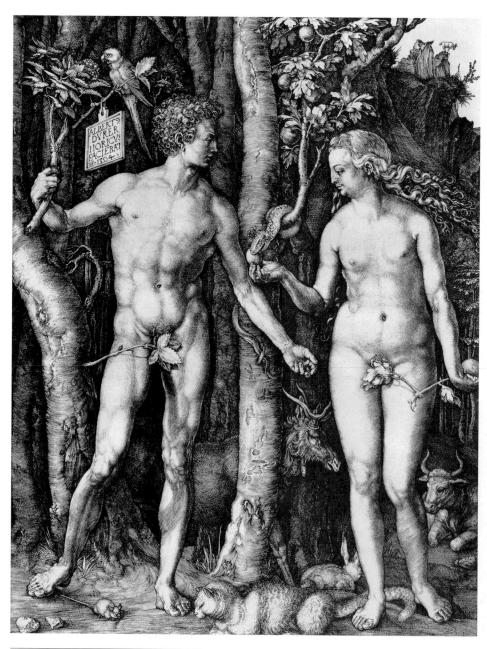

8.20 Albrecht Dürer, *Adam and Eve*, 1504. Engraving, $9\% \times 7\%$ " (24.9 × 19.3 cm) (for a detail, see fig. 8.22). Dürer, one of the first artists to sign and date his works, may have done so because of the lively business in forgeries of his prints. No patron; made as part of a commercial endeavor.

there, and he was also employed by Maximilian I, the Holy Roman Emperor.

Dürer's engravings were intended for a sophisticated audience of wealthy collectors, but he also produced more reasonably priced and easily understood prints in series for a popular audience. These works, executed in the bolder and more direct medium of woodcut, were printed in large quantities to be sold at fairs and carnivals. The subject matter is both more traditional and more direct, as in the *Four Horsemen of the Apocalypse* (fig. **8.21**), drawn from Revelation 6:1–8. Death ("on a pale horse") in the fore-

ground and the other riders follow Revelations' description: Famine has a pair of scales, War a sword, and "the conqueror" (Pestilence, or the Plague) carries a bow. Dürer's patterns reinforce the relentless motion of the horsemen as they ravage humanity. The Apocalypse and Last Judgment were popular themes just before 1500, when it was feared time would end and Christ would appear to judge humanity.

Dürer had sympathies with the Protestant movement, and when he heard a rumor that Martin Luther had been murdered, he wrote, "If Luther is dead, who will explain the Gospel to us now?"

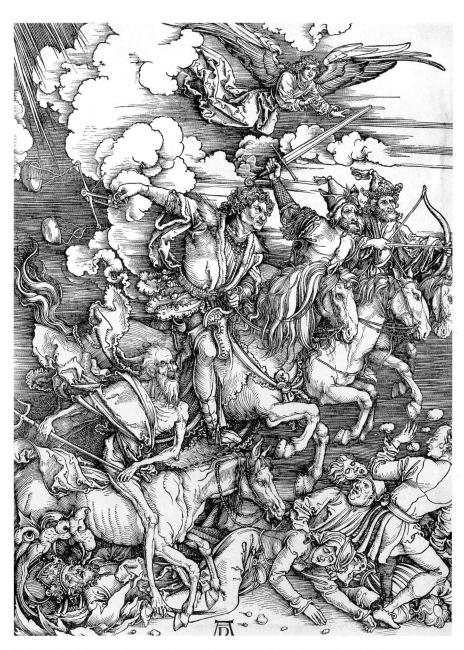

8.21 Albrecht Dürer, *Four Horsemen of the Apocalypse*, c. 1497–98. Woodcut, 1' 3½" × 11" (39.4 × 27.9 cm) (for a detail, see fig. 8.23). The *Apocalypse* series, of which this is a part, was based on the Book of Revelation in the Bible. It consisted of fifteen prints with relevant texts on the back in German or Latin. No patron; made as part of a commercial endeavor.

Printmaking: Engraving and Woodcut

Enlarged details from an engraving and a woodcut by Dürer reveal his acute vision as well as the technical accomplishment and expression he achieved in these two media (figs. 8.22, 8.23). They impressively illustrate the distinctive techniques of these two major types of printmaking. In the engraved head, multiple fine lines, often placed parallel (hatching) and perpendicular (crosshatching) to each other, create highlights, modeling, and subtle pockets of shadow. In combination, these lines suggest the illusion of specific textures. In the woodcut head, the effect is more linear, and the sharp distinctions between light and dark patterns add drama and movement to the work. In woodcuts, the defining lines either follow the naturalistic shapes or are grouped parallel to each other.

Printmaking processes involve pressing a piece of paper (or, rarely, some other absorbent material, such as **vellum** or silk) against a surface to which ink has been

applied (technically known as the **print form**). When the paper is removed, a reversed impression adheres to it; this is known as a **print**. In most print media, the surface of the print form can be re-inked and a number of additional prints (an **edition**) produced. The development of this relatively cheap means of mass-producing an image, which was related to improvements in the quality of paper and a tremendous decrease in its price, had a dramatic impact on western European culture. Now avidly bought by museums and collectors, most of the earliest prints were simple book illustrations or modest, inexpensive religious images intended for popular consumption. In the hands of such skilled artists as Dürer, however, the techniques became sophisticated, their expression more subtle, and the iconography more complex.

Engraving is known as an **intaglio process** (from the Italian *intagliare*, "to carve" or "to cut") because the areas

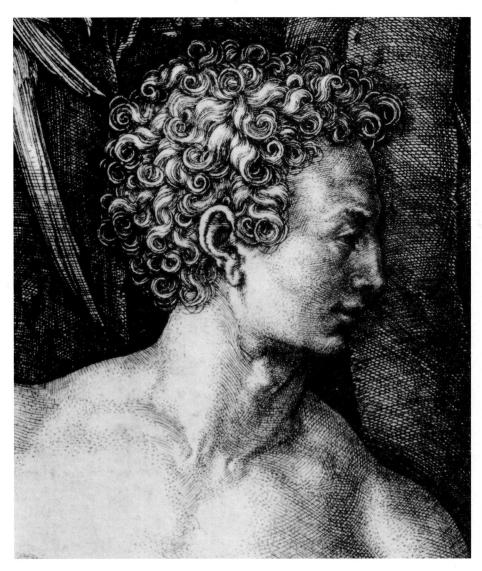

8.22 Albrecht Dürer, *Adam and Eve*, enlarged detail of fig. 8.20. Engraving.

that print are incised into the surface of the print form. In engraving, the print form is a thin metallic plate, usually of copper. With a sharply pointed steel instrument called a burin, the artist incises grooves in the surface of the plate (fig. 8.25). The plate is then inked with a heavy, viscous ink and wiped with a rag (or the palm of the hand), leaving the ink in the grooves. The paper used for printing an engraving is slightly moistened before being applied to the inked plate. Plate and paper are then run through a printing press, which can apply the sufficient pressure (more than is needed to print a woodcut) to force the paper to pick up the ink in the grooves. The printed lines that result are sharply defined and slightly raised. Several hundred highquality prints can be made before weak lines on the print reveal that the copper plate is wearing down.

The woodcut was first developed in China in the late ninth century; the earliest European examples date

from the late fourteenth century. Woodcut is called a relief process because the lines and surfaces to which the ink adheres are higher than the parts that are not to be printed. To create a woodcut, the artist draws the design on a piece of wood sawed lengthwise along the grain (fig. 8.24). Using a knife or chisel, he or she then cuts away the background areas, leaving the raised design. When the woodblock is inked, the ink adheres to the raised surfaces. Dampened paper is applied, and the print can be made by hand or in a printing press. Approximately a thousand good prints can be made before the prints reveal that the block is showing signs of wear. Our understanding of the woodcut technique makes Dürer's accomplishment even more impressive, for, unlike earlier harsh and simple images, his designs suggest the illusion of three-dimensional forms with light playing over them.

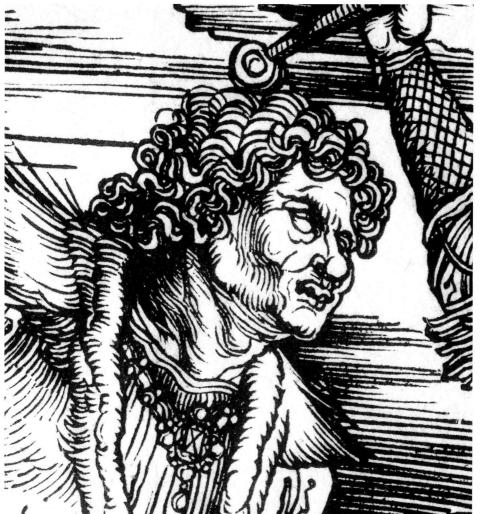

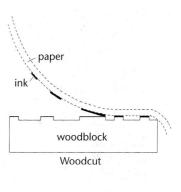

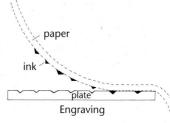

8.24, **8.25** These diagrams of the woodcut and engraving techniques show schematically in section the moment when the paper is being lifted from the woodblock or the plate at the completion of the printing process. Note how the ink is transferred from the print form to the print.

8.23 Albrecht Dürer, Four Horsemen of the Apocalypse, enlarged detail of fig. 8.21. Woodcut.

New St. Peter's, Rome

n April 18, 1506, Pope Julius II, who was aggressive in both religious and political matters, laid the foundation stone for a new St. Peter's. As part of a campaign to restore Rome so that it would be worthy of its status as the capital of Christendom, he commissioned Donato Bramante (1444–1514) to rebuild the structure, an event commemorated in a medal issued that year (fig. 8.26). Since the late fourteenth century, St. Peter's and the Vatican had been home to the popes, and although Old St. Peter's (see figs. 5.12, 5.13) was one of the most revered churches in Christendom, it had fallen into disrepair and no longer seemed grand enough to serve as the church that marked the burial spot of the first pope and, now, the religious center for the papacy.

Bramante's plan (fig. **8.27**), never completed, would have replaced the Early Christian **basilica** with a **centrally planned** church, a plan appropriate to St. Peter's function as a martyrium and consistent with Renaissance philosophical ideals (see pp. 290–91 and fig. 7.51 for a discussion of the intellectual basis for the centrally planned church in the Renaissance). Four equal arms, terminating in **apses**, radiate from a central **crossing** crowned with an immense dome surrounded by smaller domes. The under-

lying geometry of the design is simple, producing a monumental effect not unlike the unified compositions offered in painting and sculpture by Leonardo, Raphael, and Michelangelo.

The boldest aspect of Bramante's conception is its colossal scale. Bramante set out to surpass the monumental architectural remains of ancient Rome, creating a structure that would dominate all Rome. Bramante is reported to have stated that he was inspired to "place the Pantheon [see figs. 4.52–4.54] on top of the Basilica of Constantine [see fig. 4.49]." As completed by Michelangelo, the diameter of the dome of St. Peter's is 138 feet (42 m), only about six feet (2 m) smaller than that of the Pantheon.

Before journeying to Rome, Bramante had known Leonardo in Milan in the 1480s and 1490s, and had experimented with centrally planned church designs. For St. Peter's, Bramante combined a central plan, thought to be symbolic of God's perfection, with a Greek cross pattern. The spaces between the cross arms enclose this central plan within a square. Unlike the **cruciform basilica** plan of Old St. Peter's, where the cross shape emphasized salvation, Bramante's central plan was intended to express the universal harmony of God's created world.

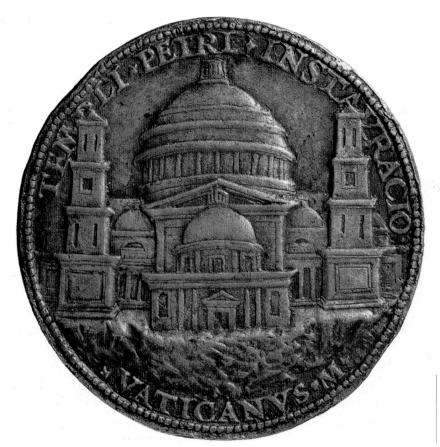

8.26 Donato Bramante, Medal showing Bramante's design for the new St. Peter's, Rome, 1506. The British Museum, London, England. Commissioned by Pope Julius II.

Twelve impressions of this commemorative medal by Caradossa were enclosed in the cornerstone of the new St. Peter's.

1506 Bramante, new St. Peter's basilica (fig. 8.26) 1513 Late Gothic tower of Chartres Cathedral is finished (fig. .30) 1513 Ponce de León plants orange and lemon trees in Florida 1513 Machiavelli, The Prince

The new St. Peter's was not consecrated until November 18, 1626, more than 120 years after Bramante's reconstruction was begun. The work encompassed the reigns of twenty popes and the efforts of fourteen architects, including Raphael, Michelangelo, and Bernini. Each succeeding architect had to contend with Bramante's original plan, as well as the advancing construction of the building under successive architects. Michelangelo took charge of construction in 1546, noting that: "every architect who has departed from Bramante's plan ... has departed from the right way."

Michelangelo's plan (fig. **8.28**) retains the integrity of Bramante's central plan, but it achieves a more cohesive unity by simplifying it, giving a new lucidity to the exterior form and the interior spaces. This unity is further expressed

in the use of the **giant order** (**pilasters** or **columns** that span more than one story of the structure) on both the exterior and the interior. On the exterior, Michelangelo's wall design is more varied than Bramante's, sheathing the building like muscle and flesh over bone and creating an external vitality enveloping the inner, structural core (figs. **8.29**, **8.30**).

The commanding dome of St. Peter's (see fig. 9.23), also based on a design by Michelangelo, was erected by Giacomo della Porta (c. 1540–1602) between 1588 and 1591. Structural reasons dictated that it be slightly more pointed, to exert less thrust, than Michelangelo's original design. The dome retains Michelangelo's grand scale and articulation, and is a worthy climax to Bramante's earlier vision.

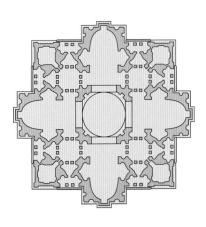

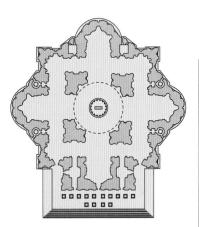

8.27 Donato Bramante, Plan of new St. Peter's, Rome, 1506. Commissioned by Pope Julius II.

8.28 Michelangelo Buonarroti, Plan of new St. Peter's, Rome, 1546–64. Commissioned by Pope Paul III.

Pope Paul III appointed Michelangelo chief architect of St. Peter's. The artist, burdened by his advancing age and numerous other artistic projects, took charge of the construction of St. Peter's without pay and for the "salvation of his soul," as he expressed it. Late in the sixteenth century, an argument developed over whether the design of St. Peter's should be limited to Michelangelo's central plan or whether a nave should be added to create the more traditional axial composition that dates back to Old St. Peter's (see fig. 5.13). In the early seventeenth century, a nave was added by Carlo Maderno that, from both the outside and the inside, obscures the view of the great dome that Bramante and Michelangelo intended would be the central and unifying feature of the church.

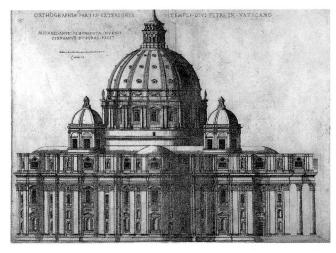

8.29 Michelangelo Buonarroti, Longitudinal elevation of St. Peter's (engraving by Dupérac, 1569).

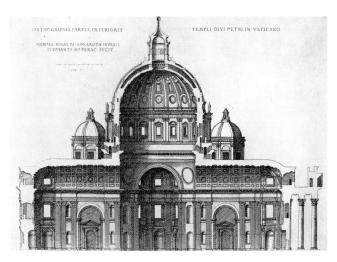

8.30 Michelangelo Buonarroti, Longitudinal section of St. Peter's (engraving by Dupérac, 1569).

Michelangelo, Sistine Chapel Ceiling

He who made everything, made every part, And then chose what was most beautiful, To reveal on earth the excellence of His creation, And the divine art with which He made it.

(Michelangelo, "Sonnet," c. 1510)

In the gap between Adam's listless hand and God's commanding gesture, the energy of creation is concentrated (fig. 8.31). God the Father, his thrusting, forward movement intensified by his billowing cloak, sweeps dramatically toward Adam. A host of putti accompanies God, who with his left arm embraces a female figure who may represent Eve or the Virgin Mary. Adam reclines in a barren land-scape, his arm supported by his upraised knee. His figure is so powerfully muscled that even in repose we sense the energy that will be released once God touches him and endows him with a soul, with life.

Following his triumph in Florence with the colossal *David* (see fig. 8.15), Michelangelo was called to Rome in 1506 by Pope Julius II, nephew of Sixtus IV. It was in this same year that the heroically muscled *Laocoön* group (see fig. 4.41) was excavated in Rome. At first Julius asked Michelangelo to design and execute a grand papal tomb for

himself, but by 1508 he had commissioned him to paint the ceiling of the Sistine Chapel, where fifteenth-century artists had decorated the walls with frescoes (fig. **8.32**). Michelangelo accepted the task grudgingly; as he describes in a sonnet (fig. **8.34**), painting the ceiling was a demanding physical labor:

I've got myself a goiter from this strain ...

My beard toward Heaven, I feel the back of my brain
Upon my neck, I grow the breast of a Harpy;
My brush, above my face continually,
Makes it a splendid floor by dripping down....
Pointless the unseeing steps I go.
In front of me, my skin is being stretched
While it folds up behind and forms a knot,
And I am bending like a Syrian bow....

8.32 (opposite) Michelangelo Buonarroti, Sistine Chapel ceiling frescoes, Vatican, Rome, Italy, 1508–12.

The Sistine Chapel, named after its builder, Pope Sixtus IV, was constructed in the late 1470s. The walls were decorated by such leading artists as Perugino, Botticelli, and Ghirlandaio with scenes from the lives of Moses and Christ. Originally the vault was simply decorated with gold stars on a blue ground.

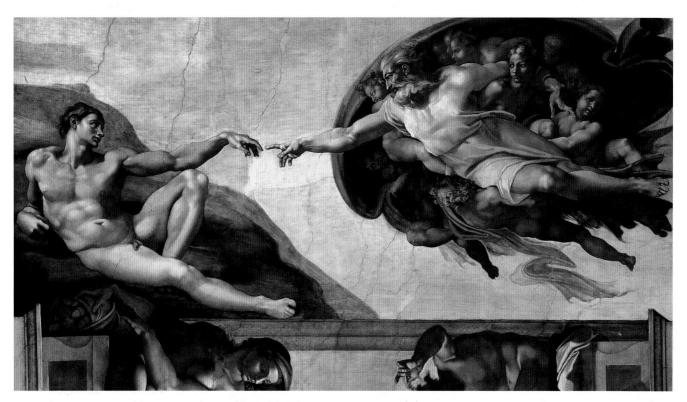

8.31 Michelangelo Buonarroti, *Creation of Adam*, detail of frescoes (after completion of cleaning in 1990) on the Sistine Chapel ceiling, Vatican, Rome, Italy, 1508–12. Commissioned by Pope Julius II.

1506 The armies of the pope, led by Julius II himself,

capture Bologna

1508-12 Michelangelo, Sistine Chapel ceiling (fig. 8.32) 1517 First Europeans reach China by ship

1519-21 Cortés conquers the Aztecs

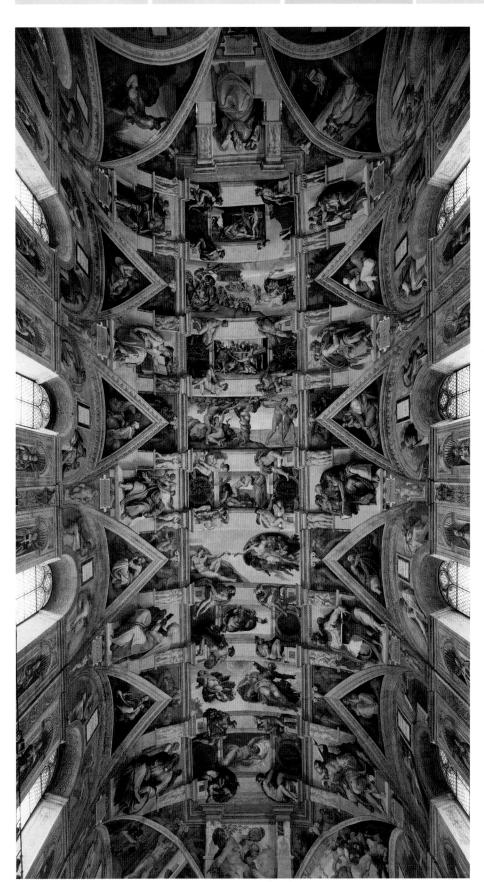

8.33 Diagram of the iconography of the Sistine Chapel ceiling.

Key to Ceiling Panels

- GENESIS
- 1 Drunkeness of Noah;
- 2 Deluge;
- 3 Sacrifice of Noah;
- 4 Original Sin;
- 5 Creation of Eve;
- 6 Creation of Adam;
- Separating Waters from Land;
- 8 Creation of the Sun and Moon;
- 9 God Dividing Light from Darkness
- M Ancestors of Christ
- 10 Solomon with his Mother
- 11 Parents of Jesse
- 12 Rehoboam with Mother
- 13 Asa with Parents
- 14 Uzziah with Parents
- 15 Hezekiah with Parents
- 16 Zerubbabel with Parents
- 17 Josiah with Parents
- PROPHETS
- 18 Jonah
- 19 Jeremiah
- 20 Daniel
- 21 Ezekial
- 22 Isaiah
- 23 Joel
- 24 Zechariah
- SIBYLS
- 25 Libyan Sibyls
- 26 Persian Sibyls
- 27 Cumaean Sibyls
- 28 Erythrean Sibyls
- 29 Delphic Sibyls
- OLD TESTAMENT SCENES OF SALVATION
- 30 Punishment of Haman
- 31 Moses and the Brazen Serpent
- 32 David and Goliath
- 33 Judith and Holofernes

To qua facto ngozo somesto steto
Chome fa lassas agasti Flonbardia over da levo paese Fressi Insisia cha forza lueve apicha focto mesto Labarba alcielo ellamemoria semo Tinko Serignio especto Jo darpra e Connel Copraluiso tuctamia melfa gocciando u ridro panimeto È lobi entrati miso nella pecciae To delcul y chotrapeso groppa e passi séza gho chi muo no Tuano Dimazi misallinga lachoroccia ep pregarsi aduero suagroppa e tédoms Comarcho Corsano po Fallact estrano Engre ilindicio For Camete poren A mal sigra p Cerbostoma torta Camia puturament de fédi orma gionami elmio onore no fedo The bo ne io pretore

8.34 Michelangelo Buonarroti, Sonnet with a caricature of the artist standing, painting a figure on the ceiling over his head, c. 1510. Pen and ink, $11 \times 7''$ (28×17.8 cm). Casa Buonarroti, Florence, Italy.

In the sonnet, Michelangelo complains of the physical difficulties of painting the Sistine Chapel ceiling in terms that reveal he worked standing, not lying down.

Although the scheme is often discussed as if Michelangelo were his own iconographer, the complexity of the cycle suggests that the ceiling's intricate iconography was developed in consultation with his patron and one or more theologians. Our first impression of the ceiling is of a maze of complexly posed human figures that have to be seen from different viewpoints (see fig. 8.32). Order, however, is maintained by the painted architectural framework. The central spine of the ceiling has a sequence of nine scenes, alternating in size from small to large, from passages in Genesis (1:1-9:27). For a diagram of the ceiling's iconography, see fig. **8.33**.

To see the figures along the side walls, the viewer must turn 90 degrees to the left or right. The largest figures are the Old Testament prophets and ancient Sibyls, who, possessed by the spirit of God, foretold the coming of Christ. In the window lunettes and spandrels, Michelangelo portrayed the ancestors of Christ.

Another level of figures, nude males called ignudi ("nudes"), are seated in poses that vary from the decorative to the energetic. They support painted bronze medallions decorated with scenes from the Old Testament that refer to wise and just rule. Garlands of oak leaves and acorns, emblems of Julius II's family, are held by some of the ignudi, but their primary role is to embellish Michelangelo's cycle.

As our eyes ascend from the lower level of the ancestral figures toward the histories, the figures in each horizontal level are distinguished by an increasing freedom of movement. In Neoplatonic philosophy (see p. 289), unrestricted figural movement was symbolic of the freedom of the human soul to ascend to the divine, for as the soul ascended, it was believed to be less and less restricted by the bonds of earthly matter: the eloquent movement displayed by the ignudi is a metaphor for the freedom of the soul.

The symbolism of our aspiration to join God is conveyed by the central histories, which relate God's love in the acts of creation and in the story of Noah. The cycle runs backward in time, but it has an internal logic. Michelangelo begins over the entrance door with the sin and disobedience of Noah, the most righteous man God could find on earth, to stress the sinfulness of all humanity. What redeems this human sin is the love of God, with which the cycle concludes in the first moment of the Creation. God's initial act of love, dividing Light from Darkness, is painted directly over the altar.

ART PAST/ART PRESENT

Vasari and Modern Scholarship

There is no other work to compare with this excellence, nor could there be; and it is scarcely possible even to imitate what Michelangelo accomplished. The ceiling has provided a veritable beacon to our art, of inestimable benefit to all painters, restoring light to a world that for centuries had been plunged into darkness.

With these words, Giorgio Vasari summarizes Michelangelo's achievement in painting the Sistine Chapel ceiling. This quotation, taken from Vasari's Lives of the Most Eminent Painters, Sculptors, and Architects (see p. 252), also betrays the prejudice he held toward the art of the Middle Ages. Vasari perceived the history of art as an organic entity that moved from birth to maturity and then on to perfection and decline, and he advanced the concept of the Italian Renaissance as a "rebirth" that led to perfection in art. Since the publication of the first edition of the Lives in 1550, Vasari's explanation has remained popular, ensuring the continuation of an attitude that exalted the Renaissance at the expense of the previous period. This, along with what seems to be a careless treatment of the facts at some points, has placed Vasari and his work at the center of debate and controversy.

Vasari, however, is at his best when he shares with us the critical thought and language of his time. When he writes of the Renaissance sculptor Donatello (see figs. 7.7, 7.12, 7.13), for example, Vasari concludes that the artist:

possessed invention, design, skill, judgement, and all the other qualities that one may reasonably expect to find in an inspired genius. Donatello was very determined and quick, and he executed his works with the utmost facility.

This list of critical values cited by Vasari gives us insight, from a distance of centuries, into how the culture of the Italian Renaissance viewed the art of its own time.

Raphael, Stanza della Segnatura

aphael's *Philosophy* has long been viewed as the ideal of High Renaissance painting (fig. **8.35**). Figures that represent ancient philosophers in a variety of postures are composed within a classicizing architectural setting. The use of **scientific perspective** directs our attention to the two figures in the center. The vaults and niches with sculpture remind us of Bramante's church of St. Peter's (see fig. **8.27**), being erected nearby by the same patron.

The philosophers in the center are the gray-haired Plato, holding his *Timaeus*, a book on the origin of the universe, and Aristotle, who holds his *Nicomachean Ethics*.

Plato points heavenward to indicate his philosophical approach to the world of ideas, while Aristotle gestures over the earth to suggest that the universe can only be understood through examining the natural world (on the differences between the philosophies of Plato and Aristotle, see p. 104). Other philosophers can be identified by their attributes. Euclid, the geometrician, seen bending over a compass in the right foreground, has the features of Bramante, a friend of Raphael who secured this commission for the painter from Julius II. Plato bears a resemblance to Leonardo, who was in Rome at this time. Raphael's self-portrait near the right border looks out at

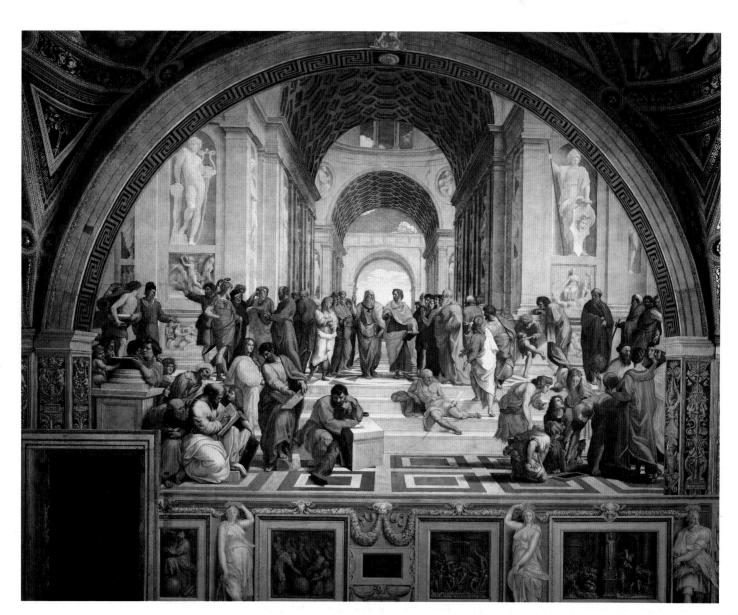

8.35 Raphael, *Philosophy* (popularly known as *The School of Athens*), Stanza della Segnatura, Vatican, Rome, Italy, 1509–11. Fresco, 19 × 27' (5.8 × 8.2 m). Commissioned by Pope Julius II (see also figs. 1.18, 7.20).

1509-11 Raphael, frescoes, Stanza della Segnatura (fig. 8.35)

1514 Papal proclamation against slavery and the slave trade

1515 Thomas More, Utopia

1520 Suleiman the Magnificent becomes Ottoman Sultan

1531-35 Pizarro completes the conquest of the Inca **Empire**

us. By portraying the historical personalities from antiquity with the visages of contemporary people, Raphael gave personal meaning to the ideal of the Renaissance as a revival of classical values.

Another portrait is the brooding figure in the left central foreground, who appears self-absorbed. His inclusion was an afterthought, for he was painted on a fresh patch of plaster. The figure represents the philosopher Heraclitus, who expressed the solitary nature of the creative temperament. In pose, the figure recalls the prophets from the Sistine ceiling, while the face suggests that it is a portrait of Michelangelo. Raphael added the figure in homage to the

older master, probably after the partially completed Sistine Chapel ceiling was unveiled in August 1511.

Theology presents groupings of saints in heaven and theologians on earth, all gathered around a central axis that descends from God the Father, Jesus Christ, and the Holy Spirit to the Eucharist displayed on the altar (fig. 8.36). Raphael's composition suggests an apse, and the fresco visually embodies the concept that it is persons—in heaven and on earth—who make up the Church. Philosophy and Theology in the Stanza della Segnatura express the union the Renaissance forged between Christian theological values and the classical philosophical tradition.

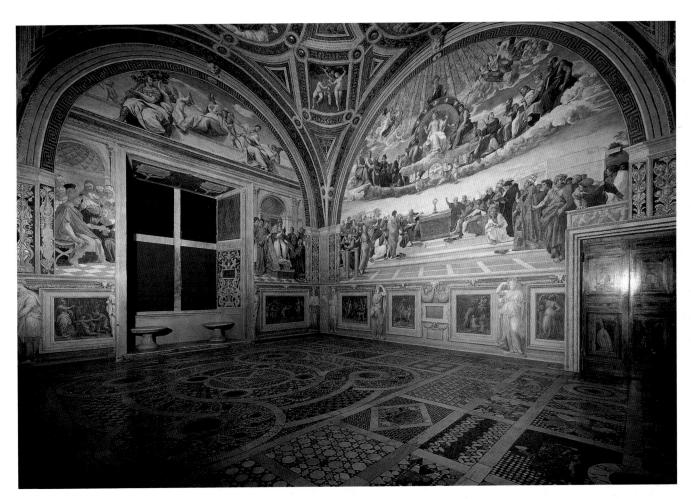

8.36 Raphael, Stanza della Segnatura, 1509–11.

Theology, known as the Disputà, is on the wall opposite Philosophy, and in the lunette over the window are three Virtues. The room originally functioned as Julius II's study and personal library; only later did it receive the name by which it is known today. The themes chosen for the walls— Philosophy, Theology, Justice, and Poetry—relate to its use as a library. The ability of the High Renaissance to simplify and clarify is evident in this program, which encompasses the four basic realms of scholarship and literature. It has also been suggested that the four themes refer to the pope's interest in Truth (Philosophy and Theology), Goodness (Justice), and Beauty (Poetry). Early sources reveal that Pope Julius II himself designed this impressive iconographic program.

High Renaissance Painting in Venice

iorgione's *Sleeping Venus* helped establish the reclining female nude as a standard type in the history of European art (fig. **8.37**, for a later example, see fig. 11.46). This subject is obviously erotic, and Giorgione's composition accentuates the sensuous quality of the female body by contrasting the swelling forms of the upper contour—head, breast, abdomen, and wrist—with the long curve of the bottom edge of the figure. The elegant slenderness of Venus's body is emphasized by her pose, with

the right arm raised and the right ankle and foot hidden behind the left. The shimmering white drapery and deep red pillow accentuate and enhance the warm flesh tones of the body, isolating the figure in a verdant green landscape with a luminous Venetian sky and clouds. Giorgione established a new oil-painting technique in which the forms are rendered without detail (see pp. 332–33). In *Sleeping Venus*, this technique emphasizes the delicacy and softness of the body. The landscape setting removes the figure from the

8.37 Giorgione (completed by Titian), *Sleeping Venus*, c. 1510. Oil on canvas, 3' 6¾" × 5' 9" (1.1 × 1.75 m); the figure is life-size. Staatliche Gemäldegalerie, Dresden, Germany.

The painting was apparently damaged at an early date and a kneeling cupid near the feet of the figure, which is the attribute that identified the main figure as Venus, was painted over. An early source suggests that Titian completed both the cupid and the landscape. Giorgione, who died in the great plague of 1510, may have left the work unfinished. The face of Venus has been repainted, probably in the nineteenth century.

8.38 Titian, *Venus of Urbino*, 1538. Oil on canvas, 3' $11'' \times 5'$ 5'' $(1.19 \times 1.65 \text{ m})$. Galleria degli Uffizi, Florence, Italy.

The work was painted for Duke Guidobaldo II della Rovere of Urbino. Although a letter from Guidobaldo to his agent refers to the painting not as Venus, but as *la donna nuda* ("the nude woman"), the roses in her hand and the myrtle, a symbol of Venus, growing in the pot in the background, support an identification with Venus. The dog at her feet has been recognized as an emblem of marital fidelity.

1501 Venetian printers use movable type to print music

1504 Venetian monopoly on the spice trade is broken by Portugal

1508 The League of Cambrai is formed to attack Venice

c. 1510 Giorgione (and Titian), Sleeping Venus (fig. 8.37)

1516 lewish "ghetto" is established in Venice

more erotic setting of a bed, and by representing Venus with her eyes closed, as if asleep, Giorgione encouraged the male patron and his friends to observe her beauty without embarrassment. At the same time, such a pose establishes a certain distance and restraint, and the kneeling cupid may have served as a guardian figure. The ultimate effect is of a slender figure dreaming in a warm Italian landscape.

It is not surprising that one of the first paintings of the sensuous nude was created in Renaissance Venice. The "Oueen of the Adriatic," Venice had for centuries been the major trading center between Europe and Asia, and it cultivated its reputation as the most cosmopolitan city in Europe with exotic buildings, fine food, and beautiful courtesans.

Titian's painting (fig. 8.38) was modeled on Giorgione's, perhaps at the request of the patron. The same red, white, and green tones enhance the flesh of the painted figure, but now the setting is an interior, complete with a bed with rumpled sheets and bed curtains. Now the nude is awake: she looks directly at us, posing without embarrassment. Titian's ability to suggest texture is especially evident in the locks of wavy red hair that flow onto her shoulders. The maids in the background are gathering her garments from a Renaissance chest.

Giorgione's Tempestuous Landscape with a Gypsy and a Soldier is a difficult work, and scholars have long debated its specific iconographic meaning (fig. 8.39). A young man and a nude woman nursing a child occupy the foreground; their relationship is inexplicable, but the "soldier" seems to be watching over the "gypsy." The landscape that dominates the composition includes both ruins and contemporary buildings. A lightning bolt crosses the background, and the trees are dramatically silhouetted against the eerie light of the stormy sky. The main purpose of this painting may be to set a mood rather than to tell a story, and perhaps we appreciate it best by surrendering logic to feeling. That an emotional sensation should be the main purpose of a work of art is a new idea in the history of art, but one that seems consistent with the Venetian interest in the suggestive and poetic.

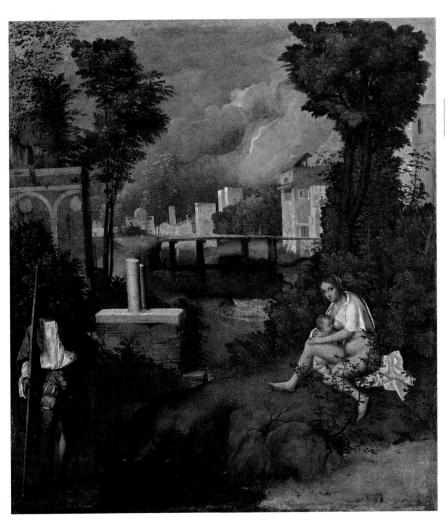

8.39 Giorgione, Tempestuous Landscape with a Gypsy and a Soldier (traditionally known as The Tempest), c. 1505-10. Oil on canvas, 2' 61/4" \times 2' 3¾" (82 \times 73 cm). Galleria dell'Accademia, Venice, Italy.

A reference to the painting in 1530 calls it "the little landscape on canvas with the tempest [and] gypsy and soldier."

Hieronymus Bosch, "Garden of Earthly Delights" Triptych

he left and right wings of the interior of Bosch's triptych represent traditional Christian subjects (fig. 8.40). The left wing shows the Garden of Eden, with God the Father creating Eve as Adam looks on, while the right wing presents a vision of hell after the Last Judgment. Placed between these views of humanity's past and future is the central panel, which has been interpreted as representing the present, when humanity indulges the sins, begun in the Garden of Eden, that can lead to hell. Bosch's moral stance seems evident, and few of the hundreds of naked figures cavorting in the expansive garden of the central panel express even momentary delight. In the central section a man looks up guiltily as he embraces a woman, while nearby figures greedily gather around a giant floating berry (fig. 8.41). A pearl seeps from between

the legs of a couple lying within a giant shell carried by another man. Hundreds of unexpected episodes and surprising details capture our admiration for the painter's imagination in expressing humanity's determined perversity. In the landscape are real and imaginary birds and beasts, including the owl, symbol of perverted wisdom (it can see only in the dark), and huge raspberries, strawberries, and other fruits whose multiple seeds hint at rampant promiscuity. It has been suggested that the theme here is humanity before the great flood, when God, grieving "that he had made man on the earth," destroyed all but Noah and his family (Genesis 6:5-6; 6:11-13). Whatever the exact theme, seldom in the history of humanity has the role of evil in the world been more astonishingly and unexpectedly depicted.

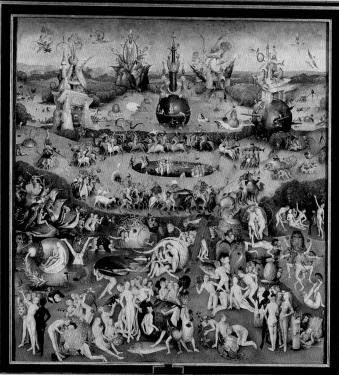

8.40 Hieronymus Bosch, Creation of Eve in the Garden of Eden; "Garden of Earthly Delights"; Hell (interior of the "Garden of Earthly Delights" triptych), c. 1510–15. Oil on wood, center: 7' 2%" × 6' 4%" $(2.19 \times 2 \text{ m})$; each wing: 7' 2%" × 3' 2%" ($2.19 \times 1 \text{ m}$); the figures in the foreground of the central panel are approximately 10-14 inches (25-35 cm) tall. Prado, Madrid, Spain.

The iconography of the work has been much debated, and there is no general agreement as to its meaning or exact purpose; one suggested interpretation relates it to the contemporary interest in alchemy, a subject investigated in some of Bosch's other works. The work may have been commissioned by Hendrik III of Nassau for the palace of the House of Nassau in Brussels, where it was hanging in 1517. In this setting the painting must have been a novel secular decoration and a focus for intellectual discussions.

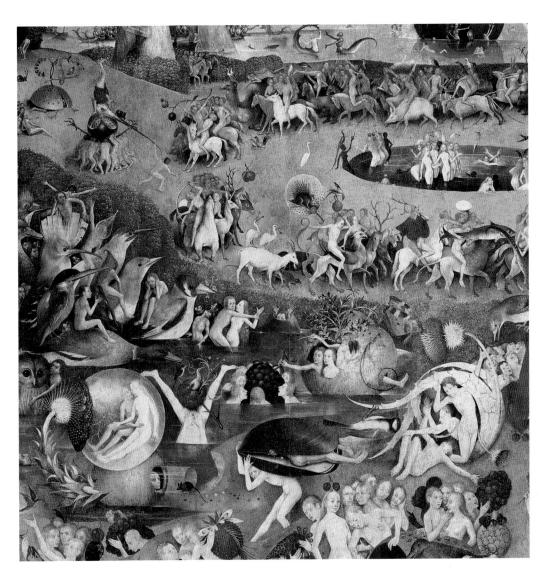

8.41 Hieronymus Bosch, "Garden of Earthly Delights," detail of central panel.

In light of the iconography of the main panel, a reexamination of the wings reveals unusual details. The birds, beasts, and plants that inhabit the Garden of Eden include composite creatures that suggest that even in Eden unnatural cross-fertilization has taken place. Life in God's creation is violent: the animals and birds of Paradise already stalk and devour each other. The expression on Adam's face as he ogles the newly created Eve suggests that, in Bosch's interpretation, sexual pleasure is the first thought of the first man.

The devils that populate Bosch's Hell provide further evidence that he is the first great artist of the fantastic. The ponds in the left and center panels give way in Hell to a wasteland, above which rises an edifice created by a combination of a dead tree and a man that represents the "tavern of lost souls." The Devil is enthroned as a frog with a bird's head who endlessly devours sinners. They are excreted only to face further torment. Although the triptych as a whole is related to Last Judgment paintings, it offers no view of souls in Paradise. In this world, it seems, there is no redemption.

Details about Bosch's life help little in clarifying his art. His grandfather and father were both painters. Bosch himself seems to have had a successful life. He was a member of the Brotherhood of Our Lady, a pious religious group, and through his wife he owned a large estate. Internationally known, he received commissions from the archduke of Austria, and his works were collected by important connoisseurs. It has been suggested that the tree-man in the center of Hell is a self-portrait. The face, which is in sharp contrast to the other, generalized figures, looks askance at the suffering around him. Bosch has been claimed by the twentieth-century Surrealists as their true ancestor.

German Painting: Matthias Grünewald, Isenheim Altarpiece

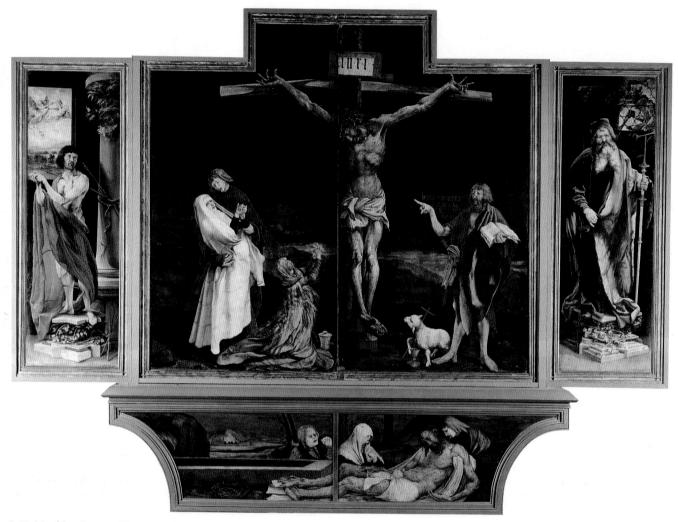

8.42 Matthias Grünewald, *Saint Sebastian; Crucifixion; Saint Anthony*; with the *Lamentation* below, exterior of the *Isenheim Altarpiece*, c. 1512–15. Oil on wood, center: 9' 9%" × 10' 9" (3 × 3.28 m); each wing: 8' 2%" × 3' %" (2.5 × .92 m); base: 2' 5%" × 11' 2" (.76 × 3.4 m). Musée d'Unterlinden, Colmar, France.

The altarpiece was painted for the chapel of the monastic Hospital of St. Anthony at Isenheim, near Colmar. The hospital specialized in treating patients with skin diseases, including leprosy and syphilis, and the monastery chapel was a pilgrimage shrine for those suffering from such diseases. Given the mission of the hospital, the scars and sores on Jesus' body are poignant and appropriate. In the late medieval period, it was believed that all physical illness was a manifestation of spiritual illness, and the first step in treating patients at the Hospital of St. Anthony was to bring them before this *Crucifixion* to pray. Grünewald's representation of Jesus was created so that patients could identify with his sufferings. Probably commissioned by the abbot of the monastery.

he monumental *Crucifixion* by Matthias Grünewald (1455–1528) depicts all the gruesome details with unsparing realism (fig. **8.42**). Jesus is dead: his head falls dramatically to the side, the blood pouring from the wound in his side begins to congeal, and his body is covered with wounds from the flagellation. The weight of his body pulls down on the crossbar, and the torture wrought by the nails in his hands and feet is painful to witness. The lower

abdomen is violently compressed, while the rib cage almost bursts through the skin as a result of the anguished death by suffocation brought about by crucifixion. As the Bible relates, darkness envelopes the scene. The painting also emphasizes the suffering of the Virgin Mary, Saint John the Evangelist, and Mary Magdalene. Saint John the Baptist points to the figure on the cross, stating, "He must become more important, while I must become less important"

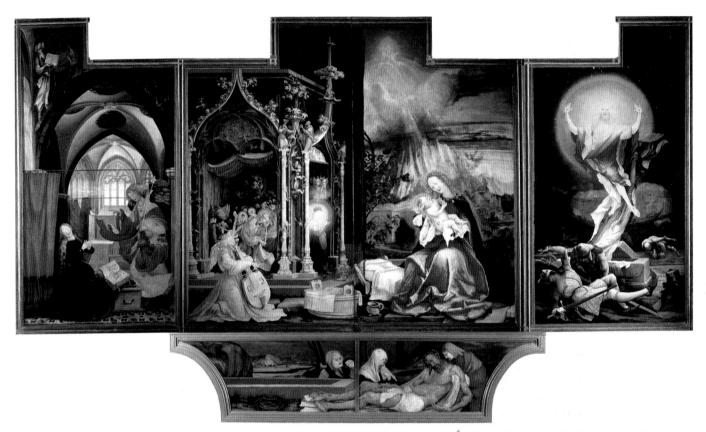

8.43 Matthias Grünewald, Annunciation; Mystical Nativity with Musical Angels; Resurrection, Isenheim Altarpiece, with the outer set of wings open. When the wings seen here were opened, the innermost figures, depicted in sculpture, and two painted wings were visible. For a detail of the Madonna and Child in the Mystical Nativity, see fig. 8.48. Musée d'Unterlinden, Colmar, France.

(John 3:30). The dark sky and red garments add drama.

The choice of subjects and their interpretation can be directly related to the position and role of Grünewald's altarpiece within the monastic and hospital complex at Isenheim. Usually the wings were kept closed to emphasize the Crucifixion and Saint Sebastian, invoked by sufferers of the plague and other diseases, and Saint Anthony, patron saint of the monastery. When the Crucifixion panel was opened (notice that Grünewald has painted Jesus' body to the right of the opening), the joyful scenes of the Annunciation, Mystical Nativity, and Resurrection, painted with vivid, luminous colors, became visible (fig. 8.43). Certainly these inner panels would have been shown on the feast days of the subjects celebrated here—the Annunciation, Christmas, and Easter. And since Christ's resurrection is celebrated every Sunday, they would most

likely have been visible on a weekly basis as well. The innermost decoration, with sculpted figures and two scenes from the life of Anthony, would have been shown on Saint Anthony's feast day.

The contrasts between the various layers of the altarpiece are explicit. In the Resurrection, an immediate contrast to the grisly Crucifixion, Christ's body is healed and his wounds have become glowing, rubylike jewels. He rises weightless and triumphant while the soldiers guarding the grave fall helplessly in confusion below. The restored beauty of Christ's body would have encouraged hope on the part of the hospital's patients. Even in the joyful scenes, however, a sense of the crucifixion as Christ's destiny is found, for the cloth in which Mary holds the Christ Child in the Mystical Nativity (for a detail, see fig. 8.48) is the same tattered fabric that serves as his loincloth when he is crucified.

Titian's Altarpieces

itian's *Pesaro Madonna* pioneered a dynamic new compositional mode that was championed by Venetian painters during the sixteenth century (figs. **8.44**, **8.45**). Nothing in earlier Renaissance art prepares us for this asymmetrical composition, with the Madonna set off to one side before grandiose columns seen in diagonal recession. The six male members of the Pesaro family who gather below, the patron Jacopo on the left and five others to the right, are introduced to the

Madonna and Child by Saints Peter and Francis. The movement inherent in Titian's composition is also found in the twisting figure of Saint Peter at the center and in the Madonna and Child, who direct their attention in opposing directions. The chubby Christ Child kicks his foot and plays with his mother's veil with a liveliness unusual in religious art (see fig. 8.47).

Titian's Assumption of the Virgin maintains the symmetrical, triangular Renaissance composition, but it accom-

8.44 Titian, *Madonna of the Pesaro Family*, 1519–26. Oil on canvas, $16' \times 18' \cdot 10'' \cdot (4.9 \times 2.7 \text{ m})$; the figures are approximately life-size. Santa Maria Gloriosa dei Frari, Venice, Italy. The main patron was Jacopo Pesaro, who led papal troops to victory over the Turks in 1502. The armored figure with the banner and the turbaned Turkish prisoner allude to Pesaro's victory.

8.45 Titian, *Madonna of the Pesaro Family* as seen in situ in its original frame in the Church of Santa Maria Gloriosa dei Frari, Venice, Italy.

Titian's painting was created for this location, in the left side aisle, and his asymmetrical composition is in part inspired by the viewpoint from which one approaches the altar. Titian's huge columns are related to those of the nave of the Gothic structure. X-rays have revealed that Titian tried several solutions to the painting's architectural setting, including one that continued the architectural forms of the painting's frame, before deciding to use dramatic columns to relate his painting to its largest architectural context.

1519–26 Titian, Madonna of the Pesaro Family (fig. 8.44) **I521**Martin Luther is condemned at Worms, Germany

1523Turkeys are introduced into Europe

1529 Martin Luther writes hymn "Away in a Manger" 1534 Henry VIII breaks with the Roman Church

plishes an effect of dynamic spontaneity through movement, strong color, and painterly brushstrokes (fig. **8.46**). The composition is like a target, with the standing figure of the Virgin Mary placed within a circle created by the semicircular frame and a ring of clouds and flying putti below. Above, God the Father sweeps in with open arms to welcome and crown her. The main figures of God the Father and the Virgin wear garments of a brilliant red, and the Virgin's dominance is enhanced by the strong blue cloak

that enfolds her. Titian's triad of primary colors is consistent with High Renaissance practices in Rome. Before a realistic blue sky below, two apostles stand out in the group due to their red garments and eloquent gestures. They create the base of Titian's compositional triangle. The combination of rich color with a simple composition is perfect for the altarpiece's position, which demands that it be legible from the main entrance of the church. The ultimate effect is of grandeur and visual richness.

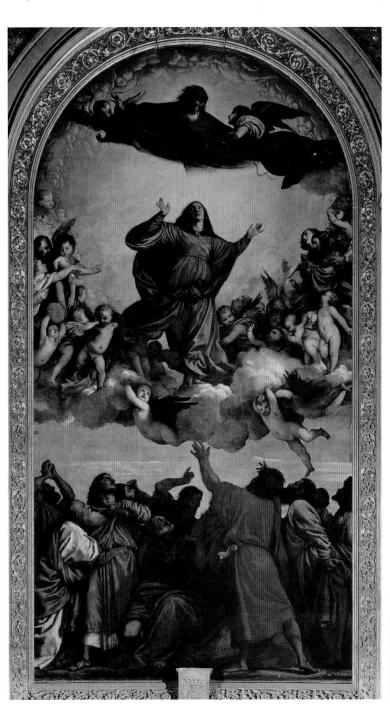

8.46 Titian, Assumption of the Virgin, c. 1516–18. Oil on wood, 22' 6" \times 11' 10" (6.9×3.6 m); the figures are overlifesize. Santa Maria Gloriosa dei Frari, Venice, Italy. Commissioned by Germano da Caiole, the abbot of the Monastery of the Frari.

This huge altarpiece is still in situ in its original Renaissance frame on the main altar of the Frari in Venice. Despite the rivalry of the light that flows in from the Gothic apse windows, the painting's composition is even discernible from the entrance to the church, some 300 feet (about 90 m) away."

Venetian Painting

This detail from Titian's Madonna of the Pesaro family, although substantially reduced in size, reveals the new style of painting pioneered in Venice during the first years of the sixteenth century (fig. 8.47). The traditional techniques of Renaissance painting—tempera on wooden panel and fresco—had proved unsatisfactory in the humid Venetian climate, and by about 1500 oil painting on canvas was becoming the accepted medium. The development of a new technique for painting in oils began with Giorgione (see figs. 8.37, 8.39), who softened his forms and blurred their edges, partly as a result of the influence of Leonardo da Vinci, who visited Venice in 1500. Titian, Giorgione's pupil and friend, went further to develop a style using bold, large strokes that had a profound impact not only on later Venetian painters but also on many other artists in later centuries, including Rubens, Velázquez, and, in the nineteenth century, the Impressionists. Titian's lively, broad brushstrokes have what is known as a painterly quality because the motion of his hand is so evident; these painterly brushstrokes are consistent with his interest in movement and asymmetrical compositions.

In creating a large painting such as the *Pesaro Madonna*, Titian would first paint or stain the canvas a medium brownish-red. He would then boldly outline his forms in dark paint and reinforce them by modeling them in monochrome, from white to black. After this underpainting dried, Titian would add layers and layers of colored translucent oil **glazes** (varnish, often with a small amount of color), building up a rich, sonorous color through their superimposition. Tradition has it that Titian

8.47 Titian (Venetian), *Madonna of the Pesaro Family*, detail of fig. 8.44.

once exclaimed that he used "glazes, thirty or forty!" to achieve this rich effect.

Titian's looser painting technique, as seen in the detail from the *Madonna of the Pesaro Family* gives pictorial unity because of the continuous texture of brushstrokes. In contrast, the detail from the painting by the German Grünewald (fig. **8.48**) demonstrates hidden brushstrokes, an emphasis on precise detail, and the creation of the illusion of varying textures. Grünewald's style represents a continuation of the oil technique first developed by Robert Campin and Jan van Eyck (see pp. 264–65, 270–75).

Later in Titian's life, his brushstrokes became even bolder, and he used large, thick strokes (impasto), often of pure color, to define form. In the Rape of Europa, (figs. 8.49, 8.50), impasto is evident in the scales of the fish in the foreground, the feathers of the cupids flying at the top, the mountains, and the quickly sketched figures of Europa's abandoned friends, waving from the distant shore. The shape and direction of the brushstrokes reinforce the movement of the figures and the directional patterns of the composition. While Titian's rich strokes and bold color accentuate the painting's surface, the diminution of the distant figures and the solidly depicted Europa produce a dramatic effect of space enhanced by the apricot and purple sky in the distance.

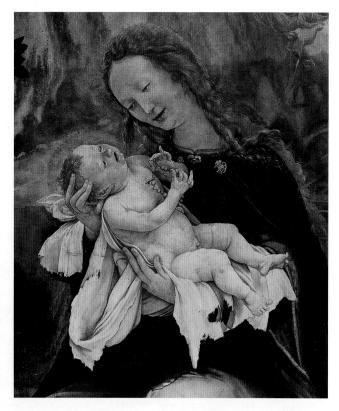

8.48 Matthias Grünewald (German), *Mystical Nativity with Musical Angels*, detail of fig. 8.43.

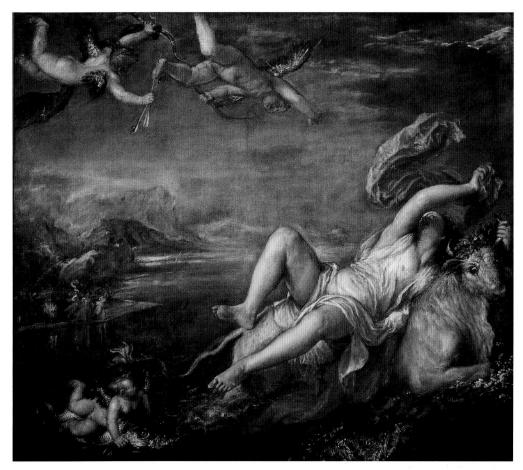

8.49 Titian, Rape of Europa, c. 1559–62. Oil on canvas, 6' 1" \times 6' 9" (1.85 \times 2.05 m). Commissioned by King Philip II of Spain. Isabella Stewart Gardner Museum, Boston, Massachusetts.

One of a series of poesie (poetic mythological themes) painted for Philip II of Spain, this picture depicts the moment when Zeus, having disguised himself as a bull, abducts a beautiful princess. Titian was inspired by the story as it is told in Ovid's Metamorphoses (II, 870-75). The unexpected nature of the abduction is expressed in the awkward position of Europa, who seems about to slip off the back of the bull/Zeus.

8.50 Titian, Rape of Europa, detail of fig. 8.49.

Later Michelangelo and the Development of Mannerism

ichelangelo's *Last Judgment* in the Sistine Chapel (see fig. 8.32) expresses how much art had changed in the two decades since he painted the chapel's ceiling. Rome was a changed city as a result of the brutal sack of Rome in 1527 by imperial troops under Charles V. The impact felt from the Reformation caused further turmoil. The psychological climate was leaden.

Although the ceiling expressed God's love and the promise of salvation, now pessimism broods (fig. **8.51**). Christ, on the axis and surrounded by an aura of light, looks toward hell and raises his right hand against the wicked. Mary recoils next to him, "slightly timid in appearance and

almost as if uncertain of the wrath and mystery of God," wrote the artist's biographer Condivi, in 1553. Angels blow trumpets to awaken the dead.

In the bottom register, to our left, the dead rise. To our right, the damned are being dragged down to eternal torment. Above, figures ascend to heaven. In the semicircular lunettes at the top, angels wrestle with the instruments of Christ's passion. Around Christ, martyrs brandish the weapons used to torture and kill them.

To the right of Christ, Saint Bartholomew, who was flayed, looks to Christ. He holds a knife in his right hand, while his flayed skin hangs from his left hand. The face on

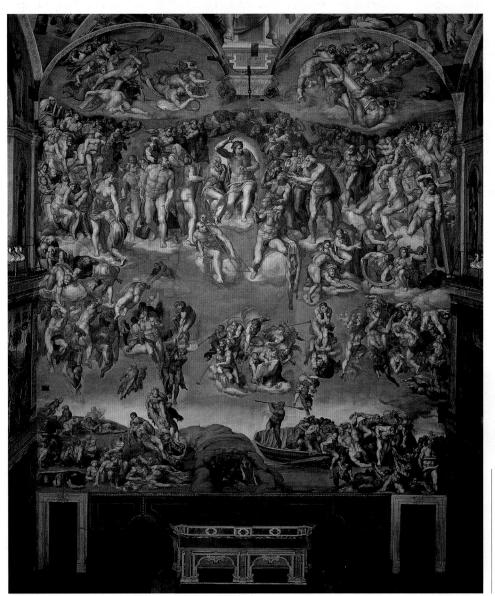

8.51 Michelangelo Buonarroti, *The Last Judgment*, 1534–41. Fresco, approx. 48 × 44' (14.6 × 13.4 m). Sistine Chapel, Vatican, Rome, Italy. Commissioned by Pope Paul III.

Originally, many of the figures in *The Last Judgment* were nude, but in the climate of the Counter-Reformation, some observers found nudity offensive in a papal chapel. Between 1559 and 1565, drapery was added to many of the figures; most of these were not removed during the restoration of 1990–94.

the skin was identified as Michelangelo's self-portrait only in 1925. The anguished facial features add a highly personal message to the painting.

Of Michelangelo's Last Judgment, Condivi wrote: "In this work Michelangelo expressed all that the art of painting can do with the human figure, leaving out no attitude or gesture."

Michelangelo's works were one of the sources for Mannerism, a new style that arose in Italy during the first half of the sixteenth century. Mannerist art was not intended to appeal to a mass audience, and mannerist works offered a stylized, artificial elegance that invited the knowledgeable viewer to appreciate the subtle and hidden conceits of the work.

Cellini's Saltcellar, for example, reveals the artist's delight in demonstrating both technical accomplishment and artistic invention (fig. 8.52). In its graceful refinement, the Saltcellar reflects the conspicuous wealth and refined manner of sixteenth-century European courts. In its decorative treatment of counterbalanced nude figures and complex

iconographic details, it demonstrates the visual and thematic complexities that occur in Mannerist art. The work was created to delight both the eye and the mind.

Rape of the Sabine Woman, by Giambologna (1529-1608), with its twisting, spiraling, upward movement, was given its title only after its completion (fig. 8.53). Contemporary sources reveal that the artist was initially inspired by the challenge of composing a group of multiple interlocking figures in dynamic movement. Giambologna's solution, based on a use of the figura serpentinata, offers varied visual expressions when viewed from different positions. The interplay of the figurative forms, emphatically stressed along diagonals, contributes to the work's dynamism, while the spiraling movement compels us to walk around the sculpture. This complex and energetic spatial involvement is a characteristic of late sixteenth-century sculpture; it continues the course set earlier in the century by Michelangelo's figural style. But whether the sculpture is monumental or more intimate, the dazzling display of the artist as virtuoso performer is apparent.

8.52 Benvenuto Cellini, Saltcellar of Francis I, 1543. Gold and enamel, 10¼" × 1' 1½" $(26.67 \times 33.34 \text{ cm})$ Kunsthistorisches Museum, Vienna, Austria. Cellini's saltcellar (a receptacle for table salt) was commissioned by the French king Francis I.

8.53 (right) Giambologna, Rape of the Sabine Woman, completed 1583. Marble, height 13' 6" (4.1 m). Loggia dei Lanzi, Florence, Italy. No patron, but purchased by Duke Cosimo de' Medici and put on public display in Florence.

The theme is drawn from an event that occurred in the early years of ancient Rome, when the Romans abducted Sabine women as wives.

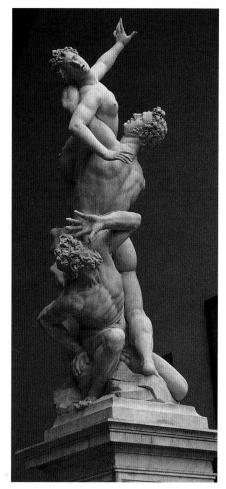

Early European Landscape Painting

ecember Landscape (fig. **8.54**), by Pieter Bruegel the Elder (1525/30–69), emphasizes nature not only by the vast sweep of the terrain but also by the manner in which the season—as expressed by the landscape—dominates and controls the activities of the peasants. Trudging peasants with a pack of motley dogs lead us into a village scene with skaters in the middle ground. The landscape culminates with distant, atmospheric peaks reminiscent of the

Alps, which Bruegel crossed on a trip to Italy. The leaden gray-green of the sky and its subtle transformation in the colors of the frozen ponds, in combination with the stark, silhouetted trees and birds, evoke the time of year, the kind of day, and even the temperature of the moment.

The landscape illustrated here by El Greco (1541–1614) offers another view of the natural world (fig. **8.55**). While the configuration of hills, valleys, and monuments in

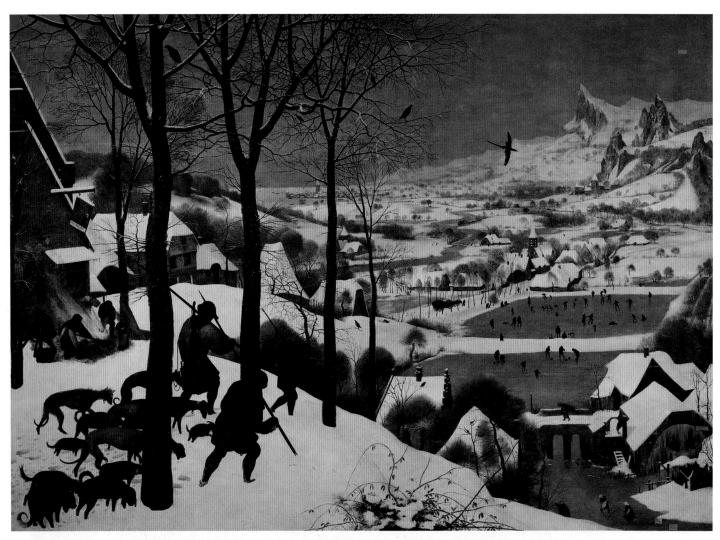

8.54 Pieter Bruegel the Elder, *December Landscape* (commonly known as *Hunters in the Snow*), 1565. Oil and tempera on wood, $3' 10\%'' \times 5' 3\%'' (1.16 \times 1.62 \text{ m})$. Kunsthistorisches Museum, Vienna, Austria.

This landscape is part of a series of six that represented different times of the year; five survive today. They probably were originally displayed in the home of a wealthy Antwerp banker.

1534 The first African slaves are landed in Brazil

1536 Lower California is discovered by Cortés

1554 Palestrina publishes his first book of music for the Mass

1565 Pieter Bruegel the Elder, December Landscape (fig. 8.54)

1569 The Mercator projection map of the world is published in Flanders

this painting identifies the city as Toledo, both the natural forms and the city's structures have been verticalized to create a nervous effect that is further heightened by the somber colors and stormy sky. The tiny human figures along the banks of the river and on the hillsides are threatened by the landscape. El Greco's vision of the city where he lived is less a portrait than a vehicle to convey a mood of drama and, perhaps, religious ecstasy.

In earlier periods, landscape was often viewed as an adversary, a frightening and unpredictable element populated with thieves and the unknown. With the exception of some ancient Roman frescoes and mosaics, landscape as an independent theme developed only late in the history of western art. These examples from the sixteenth century are some of the first paintings to convey an appreciation for landscape.

8.55 El Greco, Toledo, c. 1600–10. Oil on canvas, $47\% \times 42\%$ " (1.2 × 1.1 m). The Metropolitan Museum of Art, New York.

The artist we now know as El Greco ("the Greek") was born Domenikos Theotokopoulos on the island of Crete. He studied in Venice (where he received his nickname) and lived in Toledo, Spain, from about 1575 until his death in 1614.

Sixteenth-Century Painting

n his *Peasant Wedding Feast*, Bruegel emphasizes the rustic nature of peasant life (fig. **8.56**). The grain-filled barn of a prosperous landowner is the site where a wedding feast is being celebrated. In the right foreground, two men carry food on a huge makeshift tray composed of a door balanced on sticks. A guest reaches eagerly to pass the plates. The composition is based on the strong right-to-left diagonal recession of the table, which is opposed by the movement of the figures carrying the food. The lower right corner offers a glimpse of a chair; the left has a figure pouring beer into a miscellany of jugs and a child licking his fingers. Bruegel's palette, with simple browns set off by white, red, and the abundant gold of the grain, suggests the rich simplicity of peasant life.

For the twentieth-century observer, Bruegel's paintings of peasant life provide a fascinating source of knowledge about lower-class life, but the function of these paintings for Bruegel and his contemporaries is uncertain. Details of the present picture suggest some criticism of peasant life: the smugness of the bride, the gluttony of the participants, the fact that the priest and the landowner have withdrawn from the rest of the crowd. In the absence of evidence to the contrary, however, it is reasonable to suggest that Bruegel was recording, not condescending.

Bruegel was a friend of intellectuals, and his works were collected by connoisseurs. During Bruegel's lifetime, the Netherlands was engaged in a long battle for independence against foreign overlords. Some of his paintings representing war refer to this conflict, and in some, details convey the

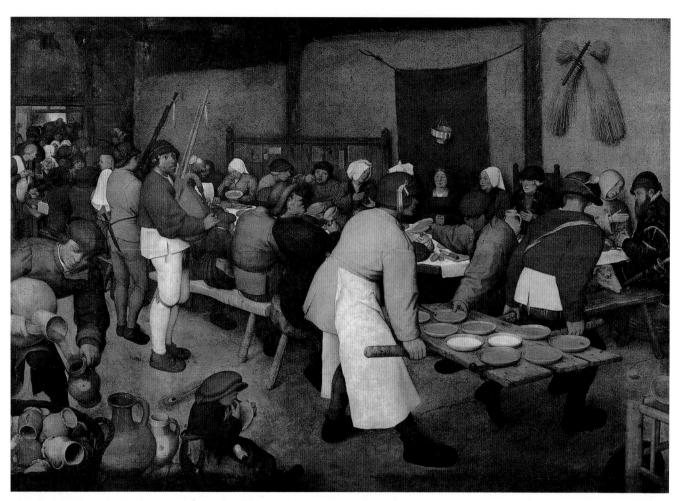

8.56 Pieter Bruegel the Elder, *Peasant Wedding Feast*, c. 1566. Oil on wood, $3' 8\%'' \times 5' 4\%'' (1.16 \times 1.63 \text{ m})$. Kunsthistorisches Museum, Vienna, Austria.

The bride is the smug woman seated in front of the suspended cloth with a crown above her head. To either side are the groom and the couple's parents. To the right, a priest is in conversation with a distinguished-looking man who probably represents the landowner for whom these peasants worked.

1541 Calvin introduces a puritan Protestant society to Geneva

1565-67 Rio de Janeiro is founded by the Portuguese

1565 Tobacco is introduced into Britain

c. 1566 Pieter Bruegel the Elder, Peasant Wedding Feast (fig.8.56)

1578 China's population reaches 60 million

dignity of the local populace. In this light, it is tempting to question whether Bruegel's emphasis on local traditions could also have a patriotic connotation. The peasant pictures represent the vitality of Northern life, but without obvious reference to the Spanish overlords who governed the subservient nation.

In sharp contrast to the earthy naturalism of Bruegel's Peasant Wedding Feast is the elegant richness of color and pattern in Sultan Muhammad's Persian miniature of The Feast of Sadeh (fig. 8.57). The lack of perspective and the emphasis on repeated decorative patterns, typical of much Islamic art, can surely be related to the prohibition on the representation of figures and animals in the Islamic religious tradition. Because the Shah-nameh was a secular, historical text, it was exempt from these restrictions. The vivid contrasts that evolve when

one vivid pattern is contrasted with another has, by the sixteenth century, become a standard quality in Islamic architecture and art. Note here that the figures share the same basic head type and that the repeated poses of the bodies show little interest in the anatomical investigations and the complex positions typical of Western art in the sixteenth century; in other words, the heads and figures serve as additional patterns within the composition, creating an aesthetic unity. Islamic legend tells that fire, here seen in a central position, was accidentally discovered by King Hushang when he threw a rock that hit a stone and caused sparks to fly. The manner in which rocks and plants defy the frame to jut out onto the page is a typical Persian device that extends the vitality of the patterning beyond normal boundaries and adds a sense of life and energy to the scene.

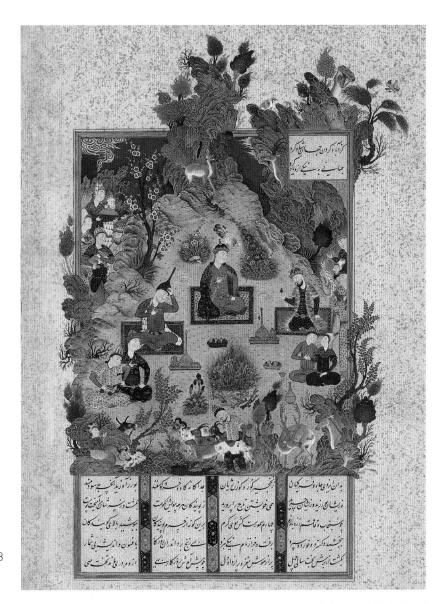

8.57 Sultan Muhammad, The Feast of Sadeh and the Discovery of Fire by the Persian King Hushang, from the Tahmasp Shah-nameh, c. 1520-25. Manuscript illumination, $9\% \times 9\%$ (24 × 23 cm). Metropolitan Museum of Art, New York. Commissioned by Shah Isma'il and his son Tahmasp.

The Persian national epic, the Shah-nameh, was originally composed by the poet Firdawsi between 975 and 1010. This Shah-nameh, which contains 258 miniatures, was created in the royal studios in the Persian capital at Tabriz.

Islamic Art of the Ottomans

uring the mid-sixteenth century, the Ottoman Empire (1299–1922) under the leadership of Sultan Suleiman I (1520–66) extended in the west to Greece, Albania, and Yugoslavia; into central Europe; across North Africa; to the central, historic Islamic lands of Saudi Arabia and the regions along the Arabian Gulf and the Red Sea. The Ottoman sultan—the central political leader, chief military officer, and protector of Islam—was also guardian of Mecca, Medina, and Jerusalem, the holy cities of the Islamic world, and ruled over the cultural centers of Damascus and Cairo.

The centralized administrative structure of the Ottoman state was also applied to artistic production. Societies of artists—including calligraphers, painters, bookbinders, jewelers, metalsmiths, woodworkers, tailors, hatmakers, and bootmakers—were created to respond to the needs of the palace. Each society had a chief, a deputy chief, master workers, and apprentices. All were paid daily wages by the state. The most influential of these groups was the *nakkashane* (imperial painting studio), which formulated decorative themes and designs employed in manuscripts, such as the pages of the Koran illustrated here (fig. **8.58**). The *nakkashane* was the creative source for the Ottoman court style. Its influence could be felt in all parts of the empire.

Suleiman's court architect, Sinan (c. 1491–1588), was responsible for all construction throughout the empire, including roads, bridges, and waterworks. On top of the highest hill in the imperial Ottoman capital of Istanbul, Sinan designed a huge mosque complex (kulliÿe) for Suleiman (figs. 8.59-8.61), which included four colleges, a Koranic school, baths, a hospital, a market street, an inn for travelers, a soup kitchen, and, in the adjoining cemeteries, tombs for Suleiman and his wife Roxelana. The purpose of such a complex was to fulfill Islam's requirement that all Muslims practice charity; the design of the mosque had its roots in Byzantine architecture. When the Ottoman Turks captured Constantinople in 1453, one of Mehmet the Conqueror's first acts was to declare that Hagia Sophia (see figs. 5.1, 5.23, 5.24), the Byzantine palace chapel and coronation church, should become a mosque. The enormous scale of this domed building and its connection to the Byzantine palace meant that it had a political content that Mehmet intended to appropriate. At the same time, Hagia Sophia's grand but ethereal unified space also meant that it would be suitable for the worship of the single god, Allah, of Islam. Later Ottoman mosques were inspired by Hagia Sophia, and Suleiman apparently gave Sinan the challenge of creating a rival to the older structure in the Suleimaniye.

8.58 Illuminated frontispiece of a Koran. Transcribed by Ahmed Karahisari in 953; illuminated edition, commissioned by Sultan Suleiman I the Magnificent, 1546–47. Gold marginal drawings, watercolors on folios, each 11% × 7%.". Topkapi Sarayi Museum, Istanbul, Turkey.

The Ottomans, like other Islamic societies, regarded calligraphy as the noblest of the arts. To copy the holy book, the Koran, was considered an act of piety and devotion.

8.59 Sinan, Suleimaniye Mosque, Istanbul, 1551–58. Commissioned by Sultan Suleiman I the Magnificent.

Second half of 16th century Prayer rug (fig. 8.62)

1558 Elizabeth I ascends to the English throne

1566 Turko-Hungarian War is renewed

1571 The Holy League defeats the Ottoman Turks at Lepanto

1592 Japanese invasion of Korea fails

8.60 Dome, Suleimaniye complex.

Sinan followed the basic design of the Byzantine church, but his space is even more centralized and simplified. He indicates the qibla and the mihrab by a sophisticated use of marble, stained glass with calligraphic designs, and wood, ivory, and mother-of-pearl-decorated doors and shutters.

Originally the mosque at the Suleimaniye was filled with prayer rugs, or seccades (fig. 8.62). Each seccade includes a depiction of a mihrab. The niche oriented the seccade—and the worshiper—toward Mecca.

8.62 Prayer rug, second half of sixteenth century. Silk warp and weft with cotton and wool pile, 5' 8" \times 4' 2" (1.73 \times 1.26 m). The Metropolitan Museum of Art, New York.

The composition symbolizes the gardens of Paradise. In the central compartment hangs a mosque lamp designating a mihrab. The four tiny hexagonal buildings above the central niche represent heavenly pavilions, perhaps the domiciles of the souls of the righteous.

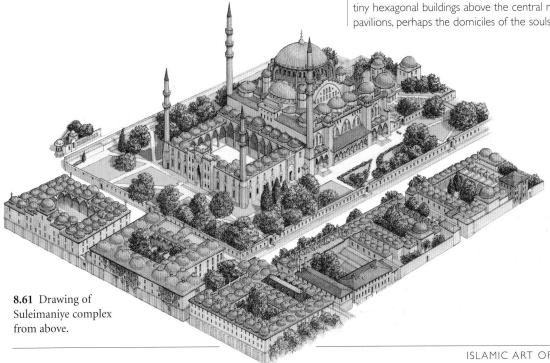

Veronese and the Impact of the Counter-Reformation

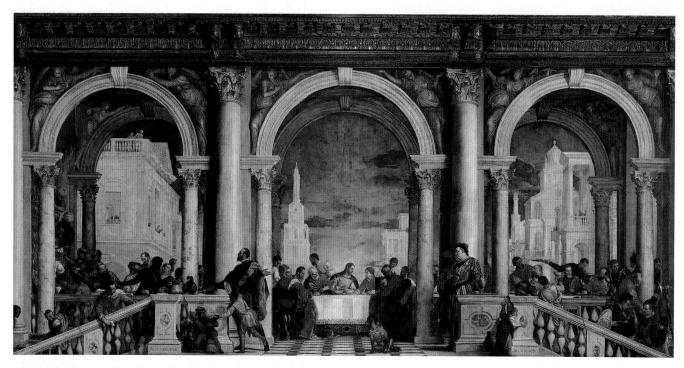

8.63 Paolo Veronese, *Last Supper/Feast in the House of Levi*, 1573. Oil on canvas, 18' 3" × 42' (5.6 × 12.8 m). Galleria dell' Accademia, Venice, Italy. Probably commissioned by Andrea Buono, a friar in the monastery at Santi Giovanni e Paolo.

Veronese continued to paint in the Venetian High Renaissance style.

t first glance, this huge and sumptuous painting by Paolo Veronese (1528–88) seems to represent a secular banquet (fig. **8.63**). The setting is a palatial loggia, and the figures include richly costumed servants. Veronese, however, created this work in response to a commission to paint a Last Supper for the refectory of the monastery of Santi Giovanni e Paolo in Venice. His interpretation of the Last Supper was questioned by the patron, at which point Veronese was called before one of the Inquisition tribunals established by the Catholic Church (see p. 302). The transcript from his trial survives, giving us rare insight into a confrontation between the needs of the Counter-Reformation Church and the nature of artistic freedom during the Renaissance:

INQUISITIONER: What is the significance of those armed men dressed as Germans, each with a halberd [battle weapon] in his hand?

VERONESE: We painters take the same license the poets and jesters take.... They are placed here so that they might be of service because it seemed to me fitting that the master of the house, who was great and rich, should have such servants.

INQUISITIONER: And that man dressed as a buffoon with a parrot on his wrist, for what purpose did you paint him on that canvas?

VERONESE: For ornament, as is customary....

INQUISITIONER: Did anyone commission you to paint Germans, buffoons, and similar things in that picture?

Veronese: No, milords, but I received the commission to decorate the picture as I saw fit. It is large and, it seemed to me, it could hold many figures.

INQUISITIONER: Are not the decorations which you painters are accustomed to add to paintings or pictures supposed to be suitable and proper to the subject...? Does it seem fitting at the Last Supper of the Lord to paint buffoons, drunkards, Germans, dwarfs and similar vulgarities?

VERONESE: No, milords.

INQUISITIONER: Do you not know that in Germany and in other places infected with heresy [Protestanism] it is customary with various pictures ... to mock ... and scorn the things of the Holy Catholic Church in order to teach bad doctrines to foolish and ignorant people?...

1565 St. Augustine, Florida, becomes first permanent settlement in America

1572 Protestant Huguenots are massacred in France

1573 Veronese, Last Supper/Feast in the House of Levi (fig. 8.63)

1575 Thomas Tallis and William Byrd publish music

1577-80 Francis Drake raids Spanish settlements on the Pacific coast

VERONESE: Illustrious Lords, I do not want to defend it, but I thought I was doing right. I did not consider so many things and I did not intend to confuse anyone.

The tribunal contended that Veronese's Last Supper lacked decorum because the inclusion of extra figures was inappropriate to the subject. It was suggested that the secular elements could be viewed as an attempt to confuse and belittle the Church's authority. Veronese's additional figures, however, should be understood as a reflection of the extravagances of Venetian society rather than the ideas of the Reformation, and the artist based his defense on artistic license. He argued that artists should have the right to decorate their work as they saw fit. Ultimately he satisfied the tribunal by changing the name of the painting to suggest that it represented another New Testament story, the feast in the house of Levi (Luke 5:29-39), in which Jesus dined with tax collectors.

The Last Supper (fig. 8.64) by Jacopo Tintoretto (1518-94) shares elements with Veronese's painting, such as the inclusion of servant figures and animals, but it maintains an emphasis on the mystical content of this subject that is in keeping with the attitudes of the Counter-Reformation Church. The strong diagonal of the table is a departure from the traditional Last Supper format, in which the table was placed parallel to the picture plane (see fig. 7.52). The powerful thrust of the table into space creates a visual tension that complements Tintoretto's dynamic treatment of the theme. Jesus rises, his head surrounded by an intense glowing halo, to offer the bread, predicting the Eucharist, to the apostles. The space of the room is energized and spiritualized by ethereal angels, whose transparent, swirling forms emphasize the spirituality of this moment. The visual drama of the painting demands an emotional response from the viewer, while its didactic role promotes the Counter-Reformation ideal of the Church as the path to salvation.

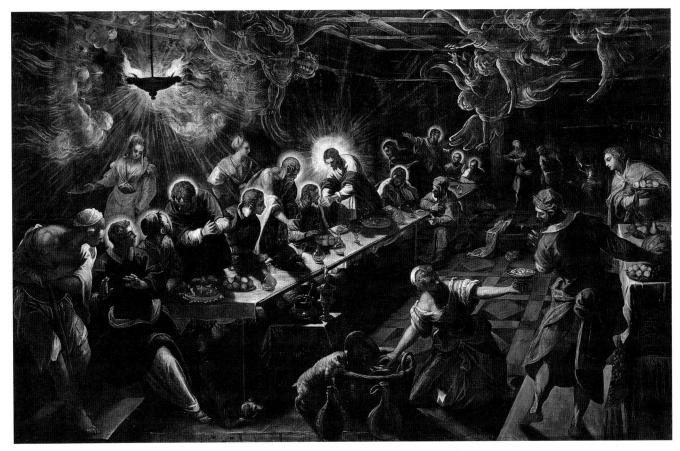

8.64 Jacopo Tintoretto, Last Supper, 1592–94. Oil on canvas, $12' \times 18'$ 8" $(3.7 \times 5.7 \text{ m})$. San Giorgio Maggiore, Venice, Italy. Probably commissioned by Michele Alabardi, prior of San Giorgio Maggiore.

| Tintoretto's painting is stylistically related to Mannerist developments.

The Art of Zen Buddhism in Japan

uring the fifteenth and sixteenth centuries, a period of civil disorder in Japan, islands of repose could be found in many bustling urban centers. The gate into the precinct of a temple or teahouse (fig. **8.65**) led from the ordinary world into a realm devoted to tranquility and beauty. At the teahouse, the host invited friends of like artistic tastes not only to share tea but also to enjoy an inspired choice of art objects. The ceramic (fig. **8.66**) and **lacquer** wares used for serving the tea, the particular scroll painting chosen for that day (fig. **8.67**), and the garden (see fig. **8.1**) all contributed to the harmony of the experience. With the changing seasons and moods, this

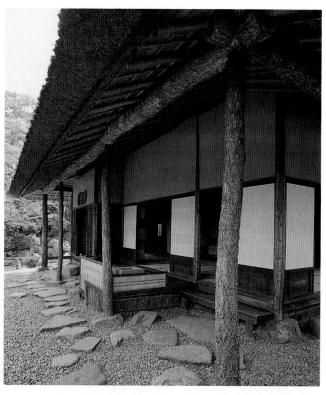

8.65 Teahouse, Japan, Momoyama period, c. 1573–1615. Hara Collection, Yokohama, Japan.

The teahouse, usually small and humble in appearance, was designed out of natural materials in order to blend with its setting. The interior, where the tea ceremony took place, was entered through an entrance that was usually so small that guests had to bend low or even crawl through its opening. This gesture was presumably symbolic of shedding one's status. In the soft interior light, guests were to admire the painting or calligraphy hanging before them and eat the sweets and sip the tea prepared for them by the host and tea master.

8.66 Cold water jar (*mizusashi*), Momoyama period, late sixteenth century. Shino ware, stoneware with feldspathic glaze over painted iron-oxide decoration, height 7" (17.8 cm). Seattle Art Museum, Seattle, Washington.

experience could never be recaptured in quite the same way again.

The animating spirit of the age was Zen, a meditative sect of Buddhism (see p. 297). It was the religion of the samurai, who were the patrons of the arts associated with *cha no yu*—the art of tea. The Zen sensibility is primarily concerned with inner rather than outer form. Thus, each object was intended to speak directly to the heart or fulfill the spirit. Recognition of inward form required mental discipline that was based on the ephemeral, the transience of life. Zen taught that there was no Buddha except the Buddha in your own nature, and that only through meditation could

you realize your own Buddha nature. You achieved enlightenment—an intuitive identification of spirit and object when you realized unity with yourself and with all things. Zen doctrine, simple and direct, had an immediate appeal to the pragmatic, military samurai. The arts were inspired by the Zen apprehension of the spiritual identity of all things, by an appreciation of direct, intuitive perception, and by aesthetic standards that stressed subtlety, allusiveness, and restraint.

Tea was brought to prominence in Japan in the thirteenth century by monks who had gone to China to study Zen Buddhism. The communal drinking of green tea was thought to aid study and enhance meditation. Through Zen teachers the tea ceremony made its way into society, becoming the focus of gatherings of the nobility, the samurai, and, eventually, the common people.

The most famous and revered Zen tea master, Sen no Rikyu, lived in the sixteenth century. He developed a set of aesthetic ideals that became the basis for Japanese etiquette and taste as part of the tea ceremony. The ceremony had four requirements: harmony, respect, purity, and tranquility. Two all-important tea ceremony qualities were sabi (studied nonchalance) and wabi (quiet simplicity). The choice of unadorned, unpretentious tea utensils represented a pursuit of these qualities in material form. The goal was to recognize and appreciate (or create) with discriminating taste the inherent characteristics of all things associated with tea.

The gardens associated with homes and areas surrounding the teahouses are usually "wet" gardens. Guests could wander through them, appreciating the qualities of nature emphasized in the design before eventually arriving at the rustic, intimate house where tea would be served. Zen objects and practices required an expression of restraint, vitality, and intimacy that was intended to capture the "inner form" of life's spirit so essential to the core of Zen thought.

Another kind of Zen garden is the "dry" garden (see fig. 8.1). Dry gardens are gardens composed of boulders, rocks, and pebbles that, with the addition of natural plants, are designed to suggest flowing water and broad ocean expanses. Dry gardens are prized for the manner in which they express the Zen aesthetic requirements for subtlety, allusiveness, and restraint. They are considered to be especially suited to meditation and the individual's search for a direct, intuitive perception of nature.

8.67 Sesshu, Winter Landscape, Ashikaga period, c. 1500. Hanging scroll, ink and slight color on paper, height 1' 64" (46 cm). Tokyo National Museum, Tokyo, Japan. Probably commissioned by the Ouchi family, rulers of Yamaguchi, Honshu's westernmost province.

In 1431, at age eleven, Sesshu entered a Zen monastery and was ordained early as a priest. He became a student of Zen priestpainters, and in 1468 he went to China for a year, where he studied Chinese landscape painting and was honored as a Zen priest. From 1481 to 1484, he made pilgrimages all over Japan to study landscape. His paintings, which gained him a wide reputation in Japan, were intentionally different in temperament and effect from the Chinese paintings that he knew so well (compare fig. 5.51). Sesshu's paintings, spontaneous and natural, deemphasize complexity; Winter Landscape is both direct and simple. His brushstrokes, firm and bold, are thought to be animated with the spirit of transience because they are executed rapidly and spontaneously. These qualities are essential to the Zen conception of the transience of the spirit and of life.

9.1 Jules Hardouin Mansart, Charles Lebrun, and Antoine Coysevox, *Salon de la Guerre* (Room of War), Palace of Versailles, France, begun 1678. Commissioned by Louis XIV.

The "Room of War" offers a rich scheme of seventeenth-century decoration in many different media. It is located at one end of the Hall of Mirrors as a pendant to the Room of Peace at the opposite end; the decoration of these rooms celebrated recent French victories. The sculptor Coysevox is responsible for the huge stucco relief of *Louis XIV on Horseback* over the fireplace. The Hall of Mirrors, seen through the archway, was named for the large mirrors opposite the arched garden windows. As decoration, this room had bejeweled trees and gold and silver furniture, but these were melted down in 1689 and 1709 to help pay for French wars.

Seventeenth-Century Art

A BRIEF INSIGHT

he grandest building in all Europe during the seventeenth century was the palace of the French kings at Versailles; many later European royal palaces were built specifically to rival or even to eclipse Versailles. Rather than providing comfortable lodging for the king and his family, however, the palace and its many rooms were largely didactic and political in nature.

In the Room of War (fig. 9.1), attention is first drawn to the huge oval stucco relief over the fireplace, which features a monumental equestrian figure of King Louis XIV. Below, bronze reliefs represent prisoners in chains, while above, gilt stucco angels trumpet Louis' fame and offer him the hero's crown. The relief in the fireplace shows the muse of history, Clio, recording Louis' many triumphs. The combination of materials—stucco, bronze, gilded stucco, and marble—along with the parquet floors, mirrors, paintings on the ceiling, and crystal-and-gold chandelier, testify to the wealth of the king, while the iconography emphasizes his ambition to be the emperor over all Europe. Such a room was primarily a setting for court rituals and would be in use especially on those occasions when its particular iconography would be most effective. For more views of the palace and garden at Versailles, see pp. 388–89.

Introduction to Seventeenth-Century Art

n their exuberant representation of vivacious movement and in the ways they engage our attention, Bernini's *David* and Hals's *Merry Drinker* (figs. 9.2, 9.3) are characteristic of much of the art produced during the seventeenth century in Europe. In his depiction of the Old Testament hero David, Bernini (1598–1680) has caught the figure coiled in space like a taut spring, about to sling the stone at the giant Goliath. His bursting energy urges us to

move out of the line of fire. In the painting by Frans Hals (c. 1581–1666), a man invites us to join him in a drink: we impulsively want to reach out and grab the glass he holds so precariously. The loose brushstrokes and warm, golden color enhance the movement and naturalism of the painting.

In creating his tour de force, Bernini, an Italian, was certainly aware that his work would be compared to the sculptures of David by his two great predecessors, Donatello and Michelangelo (see figs. 7.37, 8.15). He rivals their accomplishments by representing a new moment in the David narrative. His choice of the instant of greatest action is consistent with much of European seventeenth-century art. Hals's painting is a work virtually without precedent, in part because it is the product of a new kind of society—the mercantile, bourgeois, Protestant nation established in the Netherlands in the seventeenth century. Despite significant differences in medium, size, and function, these works are similar in the artists' determination to involve us in the action they represent and in their emphasis on depicting arrested motion.

The art of the seventeenth century, however, is not this simple. The two qualities cited above, which are part of a movement within the century known as the European Baroque (see pp. 351–52), are not shared by all seventeenth-century works, even in Europe, in part because of increasingly complex and diverse developments in history.

HISTORY

Europe had become steadily more prosperous in the course of the sixteenth century, partly as a result of the influx of wealth from the Americas and the development of new markets there. European wealth continued to increase in the seventeenth century, especially in areas with stable governments and strong commercial and trading interests. The centers of European financial power gradually shifted northward, to the rapidly growing cities of Amsterdam, Paris, and London.

Much of the pluralism of European seventeenthcentury art can be related to historical developments, for it is during this century that many of the national identities recognized today were consolidated and the map of Europe assumed territorial divisions similar to those of the present day. New, or newly powerful, national entities had a profound influence on artistic developments.

9.2 Gianlorenzo Bernini, *David*, 1623. Marble, height 5' 5" (1.65 m). Galleria Borghese, Rome, Italy. Commissioned by Cardinal Scipione Borghese.

The establishment of the new republic of the Netherlands was perhaps the most dramatic historical development of the seventeenth century in Europe. By 1609, the rebels from the northern Netherlands won their independence after a decades-long war against Spanish Catholic overlords. The new nation was unlike any other in Europe, for it was a true republic, with no traditional hereditary aristocracy. It was governed by merchants, who quickly developed a sound commercial basis for the economy. By providing goods at more reasonable prices, they developed markets in Europe and the Americas. Although the Netherlands became largely middle class, a number of successful business entrepreneurs achieved great wealth. Amsterdam became the fastest-growing city in Europe, and the Netherlands soon had a more highly urbanized population than any other European country. In addition, it became Europe's leading maritime power, establishing the East and West India Companies and taking control of much of international commerce, including a monopoly on the spice and slave trades. The Dutch were both Protestant and tolerant, and Jews who fled Poland, Spain, and Portugal during this period largely settled in the Netherlands. Amsterdam also became a lively intellectual community and the most important book-publishing center in Europe. It was in the Netherlands that the new theories of the French philosopher René Descartes, which were founded on the principle of universal doubt, were published. It should be no surprise that important new developments in art occurred here as well.

By the end of the seventeenth century, France, with a population of approximately 19 million, was the largest, strongest, and wealthiest nation in Europe. Reunited by Henry IV at the beginning of the century, the monarchy consolidated its power under a series of energetic and able administrators—Richelieu, Mazarin, and Colbert—during the reigns of Louis XIII and Louis XIV. Under Louis XIV, the "Sun King," who ruled until 1715, the centralization of power and wealth under the monarchy was completed. The power of the traditional nobility in France was broken, and

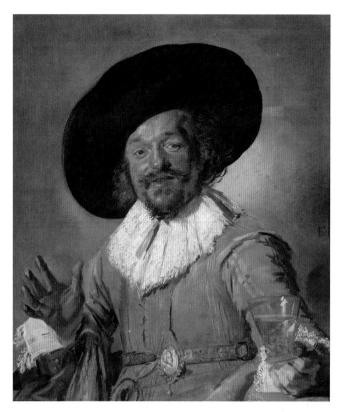

9.3 Frans Hals, Merry Drinker, 1628–30. Oil on canvas, 2' 7%" × 2' 21/4" (81 × 67 cm). Rijksmuseum, Amsterdam, Netherlands.

the king governed as a supreme and autocratic ruler. By the end of the century, France had an army of 150,000 that was feared throughout Europe.

The decline of Spain as a European power, which had begun in the sixteenth century, continued. Spain's economy was stagnant, despite its important territories. It still controlled the southern Netherlands (or Flanders, roughly equivalent to today's Belgium) and all of Italy south of Rome, including the huge shipping port of Naples. But the conservative rigidity of the Spanish court restricted growth. The Spanish Netherlands remained Catholic and under the control of a traditional aristocracy, but it had been substantially weakened by its foreign overlords, and the country's outstanding Baroque artist, Peter Paul Rubens, found his most important commissions outside his homeland.

The central and northern portions of the Italian peninsula were still controlled by local city-states, the largest of which were Milan and Venice. Here, too, the economy stagnated, with Venice gradually losing its traditional maritime supremacy in the Mediterranean to English and Dutch shippers, whose prices were substantially lower. The most powerful political force in Italy was the papacy in Rome, which, during the seventeenth century, flourished under dynamic and ambitious popes. They rebuilt Rome with glorious Baroque monuments, fought Protestantism, and reasserted the authority of the Catholic Church.

Germany was devastated by the Thirty Years' War (1618–48), which destroyed the power of the Holy Roman Empire and killed at least one-third of its population. Political turmoil consumed energies in England, where King Charles I, an important collector and art patron, was overthrown and beheaded in 1649.

In 1644, the Ming Dynasty in China, which had ruled since 1368, fell as a result of an economic depression, governmental incompetence and corruption, and factionalism. It was succeeded by the Qing (Manchu) Dynasty, a group of outsiders who would rule until 1912. The Manchu emperors quickly adopted Chinese ways, supporting literature and the arts by collecting earlier Chinese art and commissioning works in a traditional Chinese style.

Edo (Tokyo) continued to be the capital of Japan during this period. The elegance of the Momoyama period (1573–1615) (see figs. 9.11–9.13) was replaced by the so-called Edo period (1615–1868), a time of military dictatorship. Samurai—warrior aristocrats—and an expanded mercantile class were important patrons of the arts and, following their interests, the developing arts were sometimes secular in tone and content. European traders and missionaries were expelled in 1638, and Japan remained almost totally isolated until the nineteenth century.

In India, the Mughals continued to extend their authority—and the religion of Islam—over North India, which was unified as the Mughal Empire under Shah Jahan. It was this Mughal ruler who brought in international craftspeople, including stonecutters from Italy, to design and build the Taj Mahal in Agra (see fig. 9.26).

In West Africa during this period, one of the traditional societies of continuing importance was the Benin. Among the most important surviving Benin works are nearly 1,000 plaques destined for the royal palace, most of which feature representations of chiefs, members of the court, military figures (fig. 9.4), and even, on occasion, the Portuguese traders who had first come to Benin in the late fifteenth century. The figures, cast in brass using the lost-wax technique, are modeled in high relief on a neutral, textured background. Their stiff, frontal poses suggest that they are enacting a ceremony, and details of their dress are carefully portrayed. They are heraldic in composition and demeanor rather than being narrative. The plaque illustrated here shows a general in elaborate military dress holding a spear in one hand and a ceremonial sword in the other. He wears an elaborate costume that includes the head of a leopard, while his attending officers wear leopard pelts. Live leopards were kept in the royal palace and one of the king's praise names was "leopard of the house," a reference to his authority over the animal kingdom and thus over all creatures. Above the tip of the general's sword is a small figure of a Portuguese soldier.

Although some suggest that these reliefs are mnemonic

devices that record the ranks of various officials and ceremonies at the Benin court, their primary function appears to have been to demonstrate the power of the king. Most are dated during the sixteenth and seventeenth centuries, when contact with the Portuguese was intense. It was the Portuguese who brought to Benin the metal used by the royal brass-casters' guild to make plaques and other important court objects.

INTELLECTUAL AND SCIENTIFIC ACTIVITY

The explosion of printed information that followed the invention of movable type in the fifteenth century led to greatly increasing levels of literacy. By the end of the seventeenth century, almost half of the adult male population of Europe was literate. In addition, scientific questioning, which had been made more possible after the Reformation, led to important advances in medicine and the other sciences by such major figures as Bacon, Galileo, Newton, Harvey, Hobbes, Kepler, Locke, Leeuwenhoek, Descartes, and Pascal. Many of the European capitals developed academies and learned institutions in science and in other areas, which began publishing scholarly periodicals that

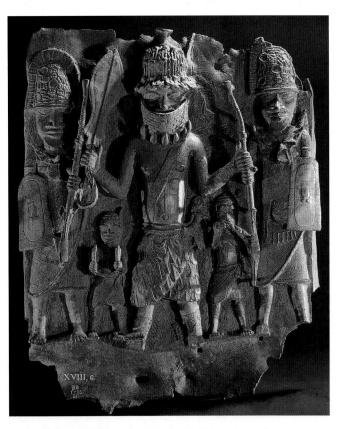

9.4 *General and Officers*, Benin culture, c. 1550–1650. Brass, height 1' 9" (53 cm). National Museum, Lagos, Nigeria. Probably commissioned by a Benin ruler.

This is only one of hundreds of similar plaques that decorated the royal palace in Benin.

promoted the advancement of knowledge. In literature, poetry and drama found a new, more vivid and emotional expressiveness in the works of Milton, Corneille, Molière, Racine, and Shakespeare. The caricature, a humorous or critical portrait based on exaggeration, had been invented earlier, but in the seventeenth century it was popularized and developed by Bernini and Annibale Carracci. At the end of the sixteenth century in Florence, a group interested in reviving ancient Greek drama began to offer musical presentations that led directly to the development of opera. One of the first operas was Jacopo Peri's *Euridice*, which was performed at the marriage by proxy of Marie de' Medici to Henry IV of France in 1600 (see p. 364). One of the guests was the artist Rubens.

THE STYLES OF SEVENTEENTH-CENTURY EUROPEAN ART

Given the complexity of the historical and intellectual developments of this period, it should not be a surprise to learn that seventeenth-century art encompasses a number of different styles. The most typical European style is known as the Baroque, a term sometimes confusingly applied to all art produced in the seventeenth century. In painting, this style is characterized by asymmetrical compositions, powerful effects of movement, and strong lighting in combination with dramatic interpretations of subject matter. Similar effects in sculpture are accomplished, often with rich materials and surprising light sources from hidden windows. In Baroque architecture, the classical orders continue to be used as vocabulary, but they are arranged in new patterns that are dynamic and energetic. The Baroque is a style that was especially suited to the goals of autocratic rulers and the leaders of the Counter-Reformation Catholic Church. The origins of the word "baroque" are uncertain, although some have traced it to the Portuguese word barroco, meaning an irregularly shaped pearl; in any case, the word "baroque" was first used in the eighteenth century as a derogatory term to describe works of art that were considered strange, irregular, and irrational.

During the seventeenth century, there was also interest in continuing the classicism of the High Renaissance, although with a greater complexity of composition and in a grander and more highly decorative manner. These stylistic qualities were usually reserved for subjects drawn from classical mythology or history. This style can be called Baroque Classicism. In painting, the main example is the French artist Nicolas Poussin (see pp. 382–83). Examples of Baroque Classicism in architecture are Versailles (see fig. 9.47) and Christopher Wren's St. Paul's Cathedral in London.

A third style, the Dutch Baroque, is limited to painting. This style is characterized by realism and naturalism. Although some of these paintings can be shown to have

certain elements in common with Baroque works elsewhere (as was demonstrated with Hals's *Merry Drinker*), Dutch Baroque paintings are noted for their relatively small scale and their emphasis on Dutch subjects. Mythological and religious subjects were usually avoided. The exception is the work of Rembrandt (1606–69), who cannot be characterized as a Dutch Baroque artist (as the style has been defined above) and whose style at different times in his life has affinities both with the Baroque and with Baroque Classicism.

Some seventeenth-century works overlap categories, and some fall outside the three that have been defined here (as do those of the Spanish painter Velázquez). The stylistic distinctions drawn here are merely an aid in understanding the complex art of this century. These distinctions will be refined and expanded in subsequent discussions of individual works, but in the final analysis it must be admitted that seventeenth-century works of art cannot be easily categorized.

SEVENTEENTH-CENTURY EUROPEAN ART

In Italy, Flanders, and Spain—countries that remained Catholic—the Counter-Reformation (see pp. 302–3) led to the production of dramatic Baroque religious images, especially of subjects that fostered and supported Catholic beliefs: the lives of Jesus and the Virgin Mary, the miracles and martyrdoms of saints, and the rituals of monks, nuns, and priests. Elaborate cycles of paintings of religious subjects and dramatic sculptural groupings were produced for churches throughout the Catholic world. Architecture in these areas generally followed the same enthusiastic Baroque style.

In the Netherlands, the prevailing religion of Calvinism, which forbade the representation of God or Christ, led to a virtual moratorium on the production of religious subjects (again, Rembrandt stands as a distinct exception). At the same time, the absence of aristocratic or royal patronage meant a decline in interest in mythological subjects. The lively artistic production in the Netherlands specialized in naturalistic paintings of Dutch subjects—landscapes, **genre** themes (the representation of scenes of everyday life), still lifes, portraits—for the home. There was little interest in grand architectural or sculptural projects.

In the countries that had a strong court and aristocracy—France, Flanders, Spain—and in the Italian cities of Florence, Naples, Rome, and Venice, the production of portraits and history paintings continued to provide an important livelihood for painters. Royalty, such as Charles I of England or Marie de' Medici, queen of France; the noble families of Rome; and members of the clergy, not to mention the papacy, provided lucrative commissions for artists. France offered the most extensive development of art and

architecture in the service of European autocracy since the ancient Roman Empire.

Although fountains had played a role in urban planning and garden decoration since ancient Roman times, new possibilities in fountain design were explored by the inventive Baroque genius Bernini. His most triumphal fountain, in the Piazza Navona in Rome (fig. 9.5), has an Egyptian-style obelisk raised over a rocky landscape with four monumental figures—each as big as Michelangelo's David. They symbolize what at the time were considered to be the four main rivers of the world: the Danube, Nile, Rio della Plata, and Ganges. The theme of the fountain, a papal commission, was consistent with the Counter-Reformation, which set out to convert all the peoples of the world to Catholicism through the efforts of an energetic papacy and proseletyzing religious orders. Bernini forces the water of

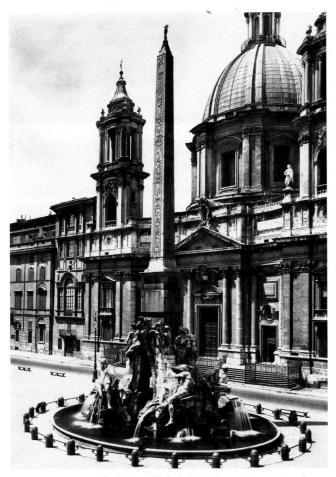

9.5 Gianlorenzo Bernini, Fountain of the Four Rivers, 1648-51. Marble and travertine, with Egyptian-style obelisk. Piazza Navona, Rome, Italy. Commissioned by Pope Innocent X Pamphili.

The obelisk recycled here, long thought to be an ancient Egyptian original, is in reality an ancient Roman imitation commissioned by the emperor Domitian in the first century CE for the circus (a racetrack and site for other games) that he built in Rome at this location. The church in the background, designed by the Italian Baroque architect Francesco Borromini (see pp. 372-73), is Sant'Agnese in Agone.

the fountain to cascade in sheets to create the maximum noise and splash. The water, integral to his conception, is incorporated into both design and theme. He even incorporates the drain into this design, for a smiling, cavorting fish "swallows" the water, adding yet another sound to this lively complex. The fountain has a new energetic dynamism consistent with Baroque attitudes.

One of the most dramatic expressions of the Baroque aesthetic and Counter-Reformation ideals is Baroque ceiling painting. The figures in Gaulli and Bernini's Triumph of the Name of Jesus (fig. 9.6), which is set off by a wide gilded frame held by angels in relief, seem to come to life. Struggling, suffering figures appear to fall down toward us, into the space of the church, while at a vast distance high in the sky, the monogram of Christ (IHS) glows with an unearthly intensity. The painting offers a view of heaven, with angels and ranks of the faithful adoring Christ's name, while the rays of light that flow downward force disbelievers away from this mystic vision, into a realm of shadowy darkness. With a touch of wit, Gaulli here heightens his illusion by interrelating the painted figures with the three-dimensional stucco forms: the foot of one of the stucco angels who surround the frame gives an extra push to one of the sinful figures being cast out of Paradise. A great deal of the success of the illusion painted on the vault of the church of Il Gesù is due to the gilded stucco frame and ceiling coffering, which establish a point of reference for the spatial development. The progressive diminution of the figures is joined with gradually intensifying light to lead us past the frame, beyond the limits of the architecture, while the clouds and figures that overlap the frame seem to be emerging into our space. Their position within the church seems confirmed by the shadows they cast on the coffering. This ensemble seems to fulfill the tenets of the Council of Trent of more than a century earlier. With vigor and enthusiasm, it seduces and overwhelms us in an attempt to convince us of the truth of what we see.

THE SEVENTEENTH-CENTURY ARTIST IN **E**UROPE

Seventeenth-century European artists were willing to undertake huge projects, and the most successful were entrepreneurs such as Bernini and Peter Paul Rubens (1577-1640), who managed large workshops of assistants and apprentices. Only with such help could they have carried out such gargantuan projects as Rubens's Marie de' Medici cycle (see pp. 364-65) and Bernini's sequence of works for St. Peter's (see pp. 366-67). The Baroque is also the period of the virtuoso, in art no less than in drama and music. Artists enjoyed demonstrating their creative powers to enthusiastic patrons, and a typical Baroque work was an incredible tour de force. In Bernini's Apollo and Daphne (see fig. 1.5), marble has been transformed to suggest textures

that convey the metamorphosis: hair becomes leaves and toes take root as bark encompasses the instantaneously frozen figure of Daphne.

Another important development, new in the history of art, took place in the Netherlands in the seventeenth century, where there was such a demand for paintings that a free market in works of art developed. Rather than waiting for a commission to work on a specific project for a specific patron, Dutch artists made more general works for a wide and popular audience. These works were bought not only

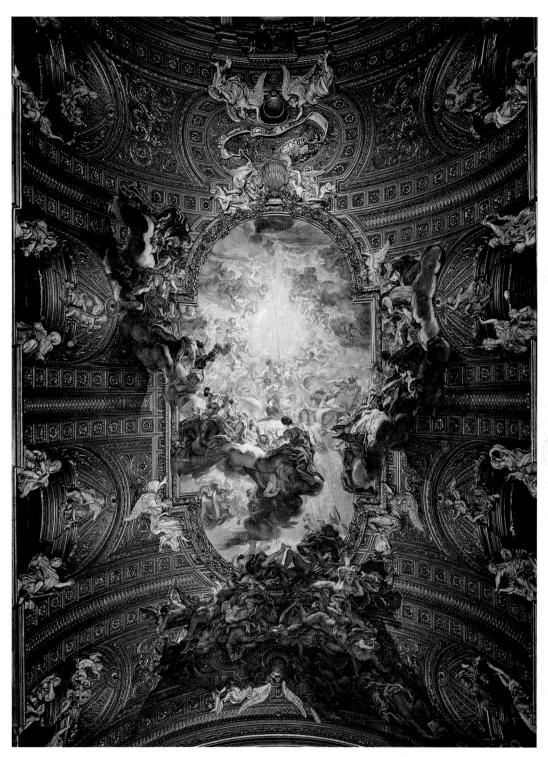

9.6 Giovanni Battista Gaulli (assisted by Gianlorenzo Bernini), Triumph of the Name of Jesus, 1672-85. Ceiling fresco, with gilded stucco surround and white stucco angels by Antonio Raggi. II Gesù, Rome, Italy. Commissioned by Father Oliva, Father General of the Society of Jesus.

Gaulli is also known by the nickname "Baciccio."

by citizens but also by art dealers, who established shops selling art. For the first time, the relationship between the artist and the public began to approach the situation we know today. Speculation in works of art became a part of the commercial activity of the Netherlands. In fact, there was so much activity that artists could support themselves working as specialists in a single category, such as marine painting, flower painting, or genre painting.

In France, where the king and his ministers controlled all aspects of culture, artists were less free than elsewhere. An academy determined production and through lectures and publications enforced the state-favored style of Baroque Classicism. In most of Europe, the Renaissance tradition of the artist as a respected intellectual continued to develop in the seventeenth century, aided by the explosion in art criticism and in writing about art that was part of the enormous increase in publishing during the century.

With the exception of the Netherlands, patronage in Europe during this period was still quite traditional. Rulers

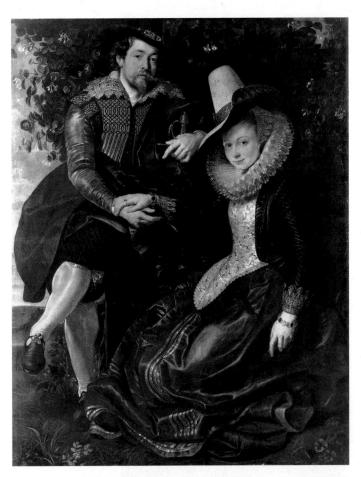

9.7 Peter Paul Rubens, Self-Portrait with Isabella Brant, 1609–10. Oil on canvas, 5' 9" \times 4' 5½" (1.75 \times 1.36 m). Alte Pinakothek, Munich, Germany.

This double portrait was painted at the time of the couple's marriage, apparently for Rubens's own collection. The studied informality of the pose is unexpected, but the elegance of the costumes reveals Rubens's aristocratic aspirations.

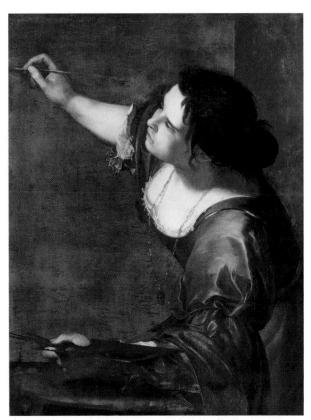

9.8 Artemisia Gentileschi, *Self-Portrait as the Allegory of Painting*, 1630. Oil on canvas, 3' $2'' \times 2'$ 5'' $(97 \times 74 \text{ cm})$. The Royal Collection. Copyright Her Majesty Queen Elizabeth II.

In this unusual allegorical portrait, Artemisia Gentileschi reveals a special identification with her profession. Her unruly hair suggests the divine frenzy that was held to be an important indication of genius during this period.

and popes continued to commission grand projects, and the aristocracy built and decorated palaces and commissioned paintings from well-known artists that would enhance their reputation as sophisticated and knowledgeable individuals. Because of the growing respect for artists, patrons often allowed them more freedom in selecting subject matter and determining its interpretation; in other words, the concept of artistic "genius" led not only to greater respect for the artist, but also to greater independence. As previously mentioned, in the Netherlands the growing art market meant that most artists painted general works for the market and did not work on commission; it is this exceptional circumstance that helps explain Rembrandt's remarkable career and his selection, in later years, of themes that he found psychologically and artistically challenging (see figs. 9.36, 9.37, 9.44). The relative cheapness of canvas meant that artists could take a chance on a little-known subject. Some even produced paintings for their own collections, as is the case with Rubens's painting of his country house (see fig. 9.53). Where patrons are known for the works in this section, they are listed in the captions; where no patron is listed, this means that the

patron is unknown, the work was created for the art market, or it was produced for the artist's own satisfaction. The latter case is true only for a very few works during the seventeenth century, but by the nineteenth century most of the works that we consider to be of exceptional interest were created purely to satisfy the artist.

The public's interest in the artist and the artist's new self-confidence are expressed in the increasing number of self-portraits. In the two preceding centuries, the selfportrait was exceptional, but a much larger percentage of seventeenth-century artists made commanding and impressive representations of themselves. Among the most impressive examples is Rubens's charming Self-Portrait with Isabella Brant (fig. 9.7). It was during this period that the Medici of Florence began a collection of self-portraits.

The interest in self-portraits by women artists that we noted in the sixteenth century continued in the seventeenth. Perhaps the most remarkable is Artemisia Gentileschi's Self-Portrait as the Allegory of Painting (fig. 9.8), a representation in which the painter says, in essence, "I am painting." The Dutch artist Judith Leyster represents herself informally at the easel, smiling out at us with ease and a typical Dutch familiarity (fig. 9.9).

Such an interest in the artist as a distinctive individual is largely a European phenomenon. In many other parts of the world, the production of art and architecture was considered to be a craft like many others, and artistic communities often included whole families who worked together, generation after generation. The notion of the independent genius is largely a European creation.

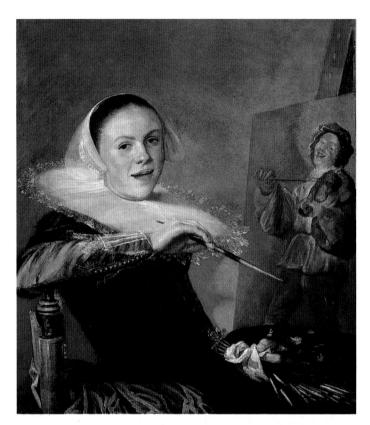

9.9 Judith Leyster, Self-Portrait at the Easel, c. 1635. Oil on canvas, $2' 5\%'' \times 2' 1\%'' (75 \times 65 \text{ cm})$. National Gallery of Art, Washington, D.C.

POINTS OF CONTACT

"Seeing" the New World

Between 1630 and 1654, the Dutch colonized part of what we today know as Brazil; the exotic landscape of this area of the New World became known in Europe through the drawings and paintings of Frans Post (1612-80), who traveled there on a scientific expedition (fig. 9.10). Here the vista of jungle-covered mountains is enhanced by Post's depiction of a market or fair in the foreground. Because Post, who came from a family of artists, had been trained in the naturalistic Dutch tradition (see figs. 9.18, 9.45, 9.52), his paintings would have been accepted as faithful documents.

9.10 Frans Post, A Village in Brazil, after 1644. Oil on canvas,

 $1' 8" \times 1' 3\%"$ (51.1 × 59.1 cm). The Royal Collection, Britain. Post's drawings and paintings of Brazil were presented to King

Christian IV of Denmark; to Frederick William, the Elector of Brandenburg; and to King Louis XIV of France by Count Johan Maurits of Nassau-Siegen, Governor General of Netherlandish Brazil from 1637 to 1644. This example had been owned by an Italian painter and an English collector before it was purchased by King George III in 1762.

Relating to Nature

Politicizing Nature

(figs. 9a and 9b) The representation of landscape in painting and the cultivation of it in garden design reveal a society's attitude about the relationship between humanity and nature. Ruisdael's Dutch Landscape, for example, is profoundly naturalistic. This simple fact reflects how the Dutch were comfortable with their land; by the very fact of representation and display they also reveal their pride. The Dutch had just regained their sovereignty after a long war against Spanish overlords, and they prized representations of their country-flat, with a sky full of clouds, and with Dutch industry flourishing in the foreground—in their homes. Notice that the painting has no central focal point and that the view seems uncontrived and natural. In contrast, the almost contemporary design for the garden at the French royal palace at Versailles reveals how ordering and correcting nature was used to demonstrate royal power and authority. Nature is controlled here, and the vastness of the endeavor (from the palace terraces, the gardens seem almost infinite) suggests a different attitude toward nature than we see in the casual panorama offered by Ruisdael. In the French garden, straight pathways, great bodies of geometrically ordered water with fountains as focal points, and rows of carefully planted trees dominate the experience of the visitor and testify to the ability of the king to bring even nature under his control.

Understanding Nature

(fig. 9c) In prehistoric societies, nature was a life-giver, and understanding how nature worked could mean life or

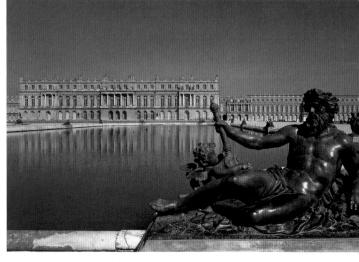

9b Garden facade, Palace of Versailles, 1669–85 (for further information, see figs. 9.47, 9.48).

death for a tribal society. Stonehenge was set in the middle of a Salisbury plain so that the horizon was visible in all directions, allowing the plotting out of the movements of the sun on the horizon. Establishing the timing of the summer and winter solstices permitted early peoples to determine best when spring planting might take place. But Stonehenge is clearly more than just a useful agrarian calendar. The monumental scale of the complex and the labor needed for its construction suggests that it must also have been a center for a religious ritual that honored lifegiving natural forces.

9a Jacob van Ruisdael, *Dutch Landscape from the Dunes at Overveen*, c. 1670 (for further information, see fig. 9.52).

9c Stonehenge, c. 2750–1300 BCE (for further information, see fig. 2.8).

9d Descent of the Ganges, Indian Hindu, relief, c. 625-74 (for further information, see fig. 5.3).

Explaining Nature

(fig. 9d) The idea that nature is a gift from the gods to humanity is common in many cultures, and this concept is vividly expressed in this large scene, which has been sculptured directly into a giant boulder found at the holy Hindu site of Mahamallapuram. Over centuries, a natural crevice had been created on the surface of this boulder by the dramatic fall of water during rain, and this natural phenomenon was used to illustrate the Hindu belief that the Ganges River had flowed down from heaven, a gift from the gods in the distant past. By carving figures of gods, water spirits, humanity, and animals on the rock, the legend was made explicit, and a natural phenomenon came to serve religious belief.

Experiencing Nature

(fig. 9e) Turrell's monumental work, perhaps the largest single work of art in the world, is created of the landscape itself, like the Hindu relief at Mahamallapuram. The pathways and rock-cut chambers that will eventually be created here, however, are not related to any particular religious viewpoint. Rather, they are intended to draw the viewer's attention to the overarching sky and the patterns of movement and of light created by the sun, the moon, and the stars. In this way, Turrell's work is a modern parallel to the prehistoric site at Stonehenge.

9e James Turrell, Roden Crater project, 1974-present (for further information, see fig. 14.18).

Questions

- 1. What is your own relationship with nature and how has it been formed? Did art or nature photography play a role?
- 2. What work of art from the past best expresses how you feel about nature?

Seventeenth-Century Architecture in Japan

wo new forms of building were developed during the sixteenth century and early seventeenth centuries in Japan during what is known as the Momoyama period (1573–1615): the castle (figs. 9.11, 9.12) and the *shoin*-style mansion (fig. 9.13). As the stronghold of the ruling shogun or the provincial feudal lord (*daimyo*), the castle symbolized prestige and military

might, and was therefore appropriately magnificent in structure and size. The *shoin*-style mansions built by samurai retainers, although less grandiose in size, were equally symbols of social standing and military rank. Both were characterized by great dignity of design and by a richness of interior decoration unprecedented in Japanese history.

9.11 Himeji (White Heron) Castle, completed 1601–9, Himeji, Hyogo Prefecture near Osaka, Japan. Commissioned by Ikeda Terumasa.

Castles were usually built atop steep grades, on flat-topped rises, or where the top of a mountain could be leveled. Stone walls were raised around the structures and, toward the end of the sixteenth century, small tenshu were added. Buttressed by the natural setting, and making the best possible use of the surrounding topography, they were difficult to attack directly and siege was the only effective strategy. Castles, therefore, needed residential quarters and storehouses for food and weapons, and tenshu often had a well and a kitchen.

The Japanese castle differed from the castles of Europe and China in that there they were not built within cities with walls to protect citizens from battles. In Japan, civil wars involved warriors rather than peasants and merchants. As a consequence, the town surrounding the castle was seldom regarded as part of the fort, and in most instances, fortifications were concentrated at the borders of the castle, with its tower functioning as the daimyo, or shogun's, headquarters and final refuge.

1603
First performance of Japanese kabuki theater, which incorporates music and dance

1607 The British establish their first American colony at Jamestown, Virginia

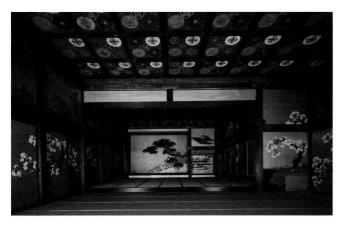

9.12 Great Audience Hall, Nijo Castle, Kyoto, remodeled c. 1625. Commissioned by the Tokugawa Shogun.

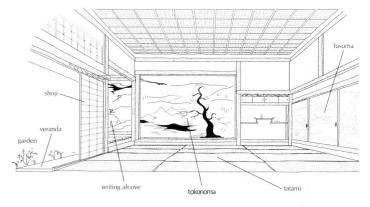

9.13 Cutaway drawing of the main room in a *shoin* building, late sixteenth or early seventeenth century, Japan.

Himeji Castle stands atop a mountain, within a walled compound, and consists of several maze-like enclosures arranged around a central enclosure housing the castle. The enclosure was built for defense, so that visitors or attackers would have to follow a circuitous route up the side of the hill, across a series of concentric rings and interlocking units set at odd angles, in order to pass through gates flanked by fortified watchtowers. The compound consists of three three-storied keeps and a five-storied *tenshu* (tower). The sequence of progressively smaller tiled roofs, punctuated by curved Chinese style gables and sharply pointed triangular gables, has a light ascending rhythm that suggests the flight of the graceful white heron.

Defensive structures such as at Himeji Castle developed in conjunction with strife among clans. Before the late sixteenth century, embankments, stone fences, wooden fences, and moats were used as fortifications. As local warriors became more powerful in the late sixteenth century, after a long period of social and political disorder, and as firearms were introduced by European traders and war tactics became more sophisticated, there was a need for larger fortresses with more complicated defensive structures.

Fortunately, the interior decoration of the Great Audience Hall of Nijo Castle, the residence of the ruling Tokugawa shogun, has survived (see fig. 9.12); it served as the site for formal interviews with the shogun. The room consists of two main areas: a lower level for the shogun's vassals and a raised area where the shogun sat, backed by a *tokonoma*, a shallow, raised alcove where a scroll or painting was hung and a flower arrangement or objects of value might be displayed. The back wall of the Nijo *tokonoma* features a painting of a massive pine tree, a visual

metaphor for the strength and enduring nature of the leader and his rule. To the right of the *tokonoma*, on the long wall facing the garden, sliding doors led to a room where bodyguards stood ready. Panels above the sliding door panels are deeply carved and brilliantly painted with flower and cloud motifs.

The shoin, the second architectural innovation in the Momoyama period was an elaborate form of residence that evolved out of the aristocratic palace (see fig. 9.13; see also pp. 390-91). Its development, which began with the rise of the samurai class during the fifteenth century, reached its mature form in the late sixteenth and seventeenth centuries. The plan of the shoin, and particularly the living-reception room, reflects the formalized relationship between the samurai lord and his retainer. The most important room was the space where the owner entertained either his lord or vassals. In the most elaborated form, there were two levels: the floor of the upper section elevated a few inches above the lower. The highest ranking samurai, whether he was the master of the house or not, sat on the upper level, just as had the Tokugawa shogun at Nijo Palace. In the wall facing the veranda was a large window, often circular or bellshaped in the Chinese style, covered with opaque paper. Below it a set of shelves served as a desk. The shoin also saw the beginning of the use of tatami mats to carpet the floor surface of a room. Tatami came in standard sizes (always in the proportion of 1:2, usually about three feet by six feet), although those sizes might differ from region to region. Room sizes from this period onward were designed according to the number of tatami mats needed to cover the floor. It soon became standard to describe a room as being so many tatami—a six-mat room, an eight-mat room, etc.

Caravaggio and his Influence

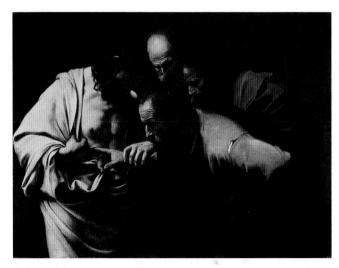

9.14 Caravaggio, *Christ with the Doubting Thomas*, c. 1602–03. Oil on canvas, 3' 6%" × 4' 9%" (1.07 × 1.46 m). Neues Palast, Potsdam, Germany. Commissioned by Vincenzo Giustiniani, an important collector of Caravaggio's work.

aravaggio's Christ with the Doubting Thomas (fig. 9.14) is an arresting painting, for it seems as if we are really there—the figures are naturalistic, the strong light gives them a sharp physical presence, and their actions and emotions are convincing. The manner in which the elbow of one astonished apostle seems to jut out into our space demands that we participate in the dramatic experience of this scene. The lifesize figures are half-length, and our presence as spectators, standing before the picture, completes the semicircular grouping of Christ and the apostles. The painting is clear, direct, and moving.

In the biblical story, Thomas doubts that the figure appearing to the apostles is Christ. Christ tells him that as proof he should stick his finger in the wound in his side. The text implies that Thomas did not do this, but Caravaggio has chosen to represent Christ forcing Thomas's finger into the wound. Such a shocking, physical emphasis is not uncommon in Caravaggio's works. Although the Bible stresses the humble origins of the apostles, Caravaggio is one of the few artists who gives them a compelling reality and dignity.

Two particular qualities characterize this painting as the work of Caravaggio: the strong lighting and the inclusion of lower-class figure types. The light enters in a bold flash, creating strong highlights and deep pockets of shadow. It seems like a sudden illumination in a world full of darkness. The figures are modestly dressed and their wrinkled brows give them a striking actuality. Not everyone appreciated Caravaggio's realism. A seventeenth-century critic said that one of his paintings lacked "proper decorum, grace, and

devotion." But Caravaggio's art was revolutionary precisely because it was not ennobled by a concept of beauty and because he did not adhere to the idealistic theories of art that had evolved during the Renaissance.

Caravaggio's mastery at depicting internal emotion is evident in his representation of the conversion of Saint Paul (fig. 9.15). In the biblical story (Acts 9:1–9), the Roman Saul was traveling toward Damascus to persecute Christians when "suddenly a light flashed from the sky all around him," and he fell to the ground. He heard a voice saying, "Saul, Saul, why do you persecute me?" When Saul asked, "Tell me, Lord, who you are," the reply was, "I am Jesus, whom you are persecuting." Saul, who was blinded by the "brilliance of the light" for three days, was converted to Christianity and baptized with the new name of Paul.

Divine revelations and mystical conversions were common themes in the art of the Counter-Reformation. In Caravaggio's painting, the powerful light comes from almost directly overhead, and Caravaggio suggests that its

9.15 Caravaggio, *Conversion of Saint Paul*, c. 1601. Oil on canvas, 7' 6½" × 5' 10" (2.3 × 1.78 m). Santa Maria del Popolo, Rome, Italy. Commissioned by Tiberio Cerasi, general papal treasurer under Pope Clement VIII.

c. 1601 Dominican monks establish the College of Saint Thomas in Manila, **Phillipines**

1602 The Dutch East India Company is founded

c. 1602-3 Caravaggio, Christ with the Doubting Thomas (fig. 9.14)

1606 First Europeans land in Australia

1612 Tobacco cultivation is introduced in Virginia and becomes a chief source of revenue

force has thrust Paul to the ground. Paul reaches out to embrace the light in a gesture that is both supplicating and receptive.

Although Caravaggio seems to have had no direct pupils, his work had a potent impact on Italian art and on the many foreigners studying and working in Rome. His close followers are known as Caravaggisti. The Caravaggesque movement became international when French, German, Spanish, Flemish, and Dutch artists returned home from Italy to teach and work. Prints copying paintings by Caravaggio and his followers also had an impact on these developments, and artists who never visited Rome and probably never saw an original painting by Caravaggio knew and were inspired by the great Italian painter's innovations.

In the monumental Judith and Her Maidservant, by Artemisia Gentileschi (c. 1597-after 1651), we are intruders-walking in on an episode charged with excitement and fear (fig. 9.16). The Caravaggesque qualities are evident in the dramatic tension, powerful light, and realistic figures. Holofernes has been decapitated and the head is being wrapped for their escape when Judith hears an unexpected sound. The momentary effect achieved as the nervous women look up is dramatized by the light. The painting communicates a mood of tension and emotional drama that few of Caravaggio's followers

could match. Artemisia, daughter of the painter Orazio Gentileschi, specialized in large-scale paintings of biblical or mythological subjects, often choosing themes that featured female heroes. She was proud of her accomplishments, and after finishing a painting for one patron declared: "This will show your Lordship what a woman can do."

Caravaggio never included a source for the strong light that illuminated his subjects, realizing the mystery and drama that an unknown light source can convey. But his followers often chose to introduce the light source into the painting, as is the case with Artemisia Gentileschi's *Iudith*. The addition of the light source opens up new possibilities of expression, as seen in Artemisia's painting: when Judith holds up her hand to shield her eye from the candle's glare, the strong shadow cast on her face adds an additional element of suspense.

9.16 Artemisia Gentileschi, Judith and Her Maidservant with the Head of Holofernes, c. 1625. Oil on canvas, 6' ½" \times 4' 7½" (1.84 \times 1.42 m); the figures are over-lifesize. The Detroit Institute of Arts.

The story of Judith and Holofernes is told in the biblical Old Testament Apocrypha. Judith was a virtuous Jewish widow who saved her people during a siege. Entering the Assyrian camp, she captured the attention of the enemy general Holofernes and, after he became intoxicated at a banquet, beheaded him. She became a symbol of Fortitude and, because she played a role in saving her people, is often seen as a prototype for the Virgin Mary. For Artemisia Gentileschi's Self-Portrait see fig. 9.8.

Baroque Genre Painting

n the *Water Carrier*, by Diego Velázquez (1599–1660), the simple act of sharing a glass of water has dignity and significance (fig. 9.17). The old water seller, who has brought a jug of fresh spring water from the mountains to the city, offers a youth a goblet of water sweetened with a fresh fig. In the shadowy background, a man is drinking. The heat of the day and the coolness of the water are revealed in the rivulets of condensation that run down the earthenware jug in the foreground.

The influence of Caravaggio is evident in the half-length, lifesize figures, dark background, and strong light, as well as in the impressive dignity with which these individuals are represented. The simple, pyramidal composition focuses attention on the expressions: the downcast eyes of the old man, who is seen in profile; the hesitation in the three-quarter face of the boy; the meditation of the central figure, shown frontally. The somber mood suggests that this

scene of everyday life has a deeper significance. The old man seems to be passing on the gift of life to the shy boy. The mood has been described as "sacramental."

Velázquez's profound interpretation of a genre subject is not unique in the seventeenth century, for there are many genre paintings by other European painters that communicate the dignity and seriousness of everyday life. At the same time that Caravaggio gave a new profundity to his religious subjects by infusing them with reality (see fig. 9.14), genre themes were being given a new seriousness as patrons and painters emphasized the sacred and the holy in the everyday.

Genre had its greatest popularity in the newly established nation of the Netherlands, where straightforward representations of home and tavern life were popular; many scenes of everyday life in spotless homes reveal the pride the Dutch took in the quality of middle-class life that their new culture made possible. Johannes Vermeer (1632–75), the

9.17 Diego Velázquez, *Water Carrier*, c. 1619. Oil on canvas, 3' 5½" × 2' 7½" (1.05 × .80 m). Wellington Museum, London, England.

This early work by Velázquez was painted when he was only about twenty. He created this genre painting to be presented to the king of Spain as a demonstration of his skill.

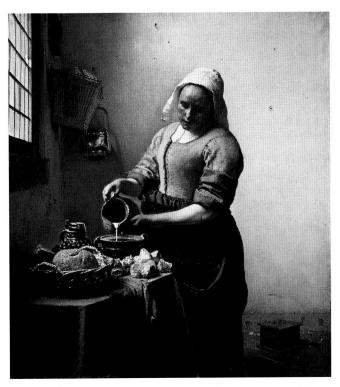

9.18 Johannes Vermeer, A Maidservant Pouring Milk, c. 1660. Oil on canvas, $1' 5\%'' \times 1' 4\%'' (45 \times 41 \text{ cm})$. Rijksmuseum, Amsterdam, The Netherlands.

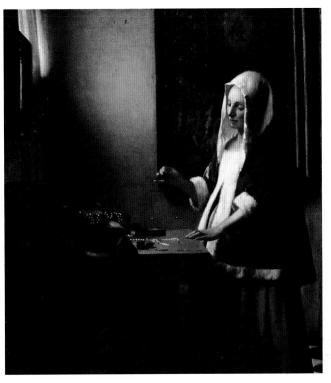

9.19 Johannes Vermeer, Woman Weighing Holding a Balance, c. 1664. Oil on canvas, $15\% \times 14$ " (39.7 × 35.5 cm). National Gallery of Art, Washington, D.C.

Vermeer most often used models in elegant contemporary clothing, and his focus on a humble subject here may have a specific iconographic meaning. The bread and milk provide the basic nourishment necessary for human life, and by portraying the clean kitchen and humble, hardworking maid, Vermeer may be making a statement about the virtues of domestic life.

More traditional symbolism underlies Vermeer's Woman Weighing Holding a Balance (fig. 9.19), which was at one time called Woman Weighing Gold. The name was changed after scholars noted that the two pans of her delicate balance are empty and in perfect equilibrium. When seen in combination with the painting of the Last Judgment behind her, it became clear that Vermeer's painting is intended as a commentary on the need for a balanced life. The privacy of this timeless moment is emphasized by the darkened interior, while the need for self-reflection is suggested by the mirror she faces. Her pregnancy adds to the profundity of meaning Vermeer offers for our contemplation.

Peter Paul Rubens

n Rubens's painting (fig. 9.20), we are thrust into a world of fantasy, where jubilant mermaids and a barebreasted allegorical flying figure celebrate the arrival on French soil of Marie de' Medici, the new wife of the king. The scene represents an historical event transformed to express what the patron felt was its underlying meaning. Marie, who had been married by proxy to Henry IV of France, was not met by her husband, who, history reveals, was at a hunting lodge with his favorite mistress. Rubens

has painted Marie being welcomed by the personification of France. Above, Fame trumpets Marie's arrival. Marie's crossing had been rough, and Neptune, mythological god of the seas, and his mermaids jubilantly celebrate her safe arrival. By allegory, vivid colors, and lively movement, Rubens has created a pageant to satisfy the aspirations of his royal client.

Rubens was one of the best-educated and most intellectual artists of the seventeenth century. He was certainly the

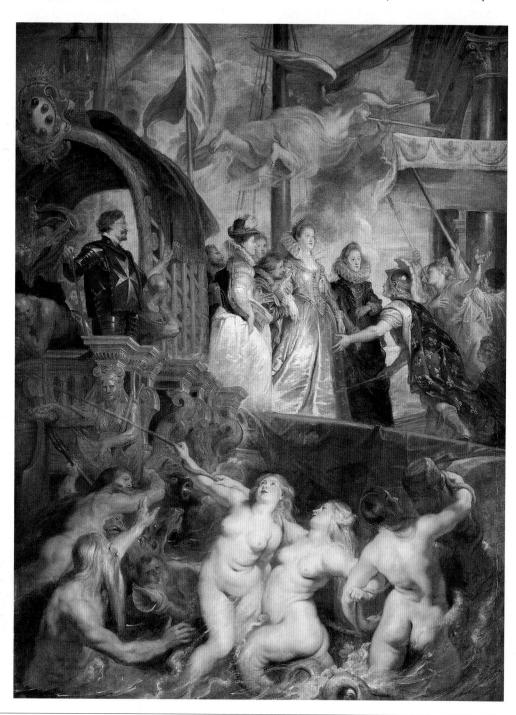

9.20 Peter Paul Rubens and workshop, *Arrival and Reception of Marie de' Medici at Marseilles*, 1621–25. Oil on canvas, 13' × 10' (3.9 × 3 m). The Louvre, Paris, France.

This is one of a series of twentyone huge paintings celebrating Marie de' Medici's life that she commissioned from Rubens for the newly completed Luxembourg Palace in Paris. 1615 Miguel de Cervantes publishes *Don Quixote* 1617 A "pleasure district" is sanctioned in Edo (Tokyo) 1620 Spanish silver shipments from the Americas begin to decline sharply 1620 Mayflower lands at Plymouth Rock 1621–25 Rubens, Arrival and Reception of Marie de' Medici (fig. 9.20)

only artist of the period to receive an honorary degree from Cambridge University. He served as court painter and ambassador for the rulers of the Spanish Netherlands and was as active as a diplomat as he was an artist. He counted many members of the royalty and nobility among his friends. He was widely traveled, and his influence helped to make the Baroque an international style.

As a diplomat, Rubens worked tirelessly to promote peace in Europe. One of his most profound allegorical paintings conveys his opinions on the impact of war on humanity (fig. 9.21). Rubens himself explained the content in a letter:

The principal figure is Mars, who has left the Temple of Janus open (which according to Roman custom remained closed in time of peace) and struts with his shield and his bloodstained sword, threatening all peoples with disaster; he pays little attention to Venus, his lady, who, surrounded by her little love-gods, tries in vain to hold him back with caresses and embraces. On the opposite side, Mars is pulled forward by the Fury Alecto with a torch in her hand. There are also monsters

signifying plague and famine, the inseparable companions of war. Thrown to the ground is a woman with a broken lute, as a symbol that harmony cannot exist beside the discord of war; likewise a mother with a child in her arms indicates that fertility, procreation, and tenderness are opposed by war, which breaks into and destroys everything. There is furthermore an architect fallen backwards, with his tools in his hands, to express the idea that what is built in peace for the benefit and ornament of cities is laid in ruin and razed by the forces of arms ... you will also find on the ground, beneath the feet of Mars, a book and a drawing on paper, to indicate that he tramples on literature and other refinements.... The sorrowing woman ... clothed in black with a torn veil, and deprived of all her jewels and ornaments is unhappy Europe, which for so many years has suffered pillage, degradation, and misery affecting all of us so deeply that it is useless to say more about them.

This passage reveals the intellect of Rubens and his knowledge of traditional subject matter and history.

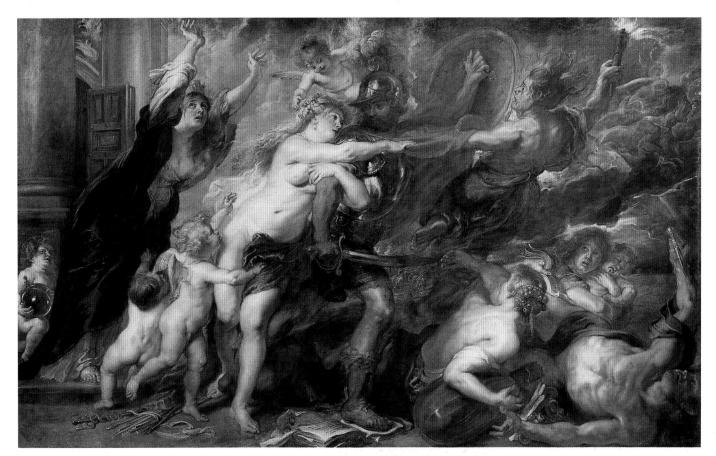

9.21 Peter Paul Rubens and workshop, *Allegory of the Outbreak of War*, 1638. Oil on canvas, 6' 9" \times 11' 3%" (2 \times 3.45 m). Pitti Gallery, Florence, Italy. Commissioned by Ferdinando II, Grand Duke of Tuscany.

Bernini's Works for St. Peter's

s a glowing dove of the Holy Spirit descends, angels and golden rays fill the apse of St. Peter's, and the columns of the **baldacchino** (canopy) over the high altar appear to writhe with excitement (fig. **9.22**). We seem to be witnessing a miracle.

Bernini's *Baldacchino* solved some important problems. It provided a focal point for the vast interior by marking the burial spot of Saint Peter and the high altar of the **basilica**, without blocking the view to the **apse** or over-

whelming the interior. The dark bronze and gilded high-lights stand out against the white marble of the basilica's architecture, as do the dynamic spiral columns and the beautiful angels, curving **volutes**, and the flaps decorated with tassels—all emulating temporary cloth baldacchinos—on the top. Later, Bernini's *Baldacchino* became a frame for the *Cathedra Petri*, a multimedia climax at the end of St. Peter's that enshrines, like a huge reliquary, a wooden and ivory chair said to be the papal throne used by

9.22 Gianlorenzo Bernini, Baldacchino, 1624–33. Bronze with gilding, height 93' (28 m). Cathedra Petri, 1656–66. Marble, bronze with gilding, stucco, alabaster, and stained glass. St. Peter's Basilica, Vatican, Rome, Italy. Commissioned by Popes Urban VIII Barberini and Alexander VII Chigi.

Bernini's use of twisted columns was inspired by a series of ancient twisted columns, once in Old St. Peter's, which were thought to have decorated the Temple of Solomon in Jerusalem.

1623-36 Dutch ships explore the north coast of Australia

1624-33 Bernini, Baldacchino (fig. 9.22)

1626 Purchase of Manhattan island

1628 William Harvey publishes on the circulation of the blood

1632 First coffee shop opens in London

Saint Peter. Four figures of early theologians—Saints Ambrose, Athanasius, John Chrysostom, and Augustinesupport the reliquary just as they had validated the primacy of Saint Peter and the Roman Church in their writings. One of Michelangelo's windows has been changed by the addition of a stained-glass, alabaster, and gilded stucco representation of the Holy Spirit surrounded by golden rays and radiant putti, which sweep out with Baroque splendor to fill Michelangelo's Renaissance apse.

Bernini's Colonnade, which shapes the piazza in front of St. Peter's, is more than just an impressive entrance to the basilica, for it also serves to embrace the space where the faithful gather to receive the papal blessing (fig. 9.23). Bernini's design is based on an oval, and as we enter this huge and richly decorated space, the broad axis creates a dynamic effect and space seems to expand to either side. When Bernini built the piazza, the area was surrounded by medieval houses and narrow, winding streets, an approach that would have rendered the spatial explosion of the piazza even more impressive. Huge travertine columns—284 placed in rows of four—define the piazza without closing it off from the surrounding areas. As a result, it can be quickly emptied when a crowd wants to disperse.

Bernini, who was appointed main architect for St. Peter's in 1637, worked on the building and its decoration for forty-two years, until his death. Among his other works are two papal tombs, another tomb, the altar decoration of the Chapel of the Holy Sacrament, and the nave decorations. From the ancient Roman bridge that was the ceremonial entrance to the Vatican, which Bernini and his assistants adorned with statues of angels in the 1660s, to the dramatic Cathedra Petri, works by Bernini transformed St. Peter's from a Renaissance structure into a Baroque experience.

9.23 Gianlorenzo Bernini, Colonnade, St. Peter's, Rome, Italy, begun 1656, as seen in a print of c. 1750 (artist unknown). Travertine, longitudinal axis approx. 800' (240 m). Commissioned by Pope Alexander VII Chigi.

A drawing reveals that Bernini conceived of the sides of the colonnade as a representation of the embracing arms of the pope and, therefore, of the Catholic Church as an institution.

The Dutch Baroque Group Portrait

he boisterous members of Frans Hals's militia seem to be inviting us to join their celebration in the Banquet of the Officers of the Civic Guard of St. George (fig. 9.24). Just to the right of center, a man holds his glass upside down; he was a brewer, and the artist suggests that he is more than slightly inebriated. The vivacious activity of Hals's life-size figures as they turn, converse, and gesture seems completely spontaneous. Hands are raised, mouths are open, and figures glance in various directions. The suggestion of movement is enhanced by the diagonals in the composition, by repeated strokes of strong color, and by the use of bold diagonal brushstrokes.

The group portrait had its first important development in the democratic, bourgeois Netherlands, and its first great artist was Frans Hals, who overcame the inherent repetitiveness of this subject, in which a painter had to represent a group of individuals, all about the same age and all of whom were similarly dressed. The democratic traditions of the Netherlands demanded that the individuals be shown as equals, and usually each paid the painter an identical amount to be included. Hals is able to capture the individuality of each member, as well as the exuberant union that joins the group into a whole.

Rembrandt's *The Night Watch* is surely the most famous painting known by a completely misleading name. The scene is not represented taking place at night, and the correct title is *Militia Company of Captain Frans Banning Cocq* (fig. 9.25). Rembrandt's dramatically composed and lit portrait of the

members of this Amsterdam militia company offers a radical solution to the problems of the militia portrait. Rembrandt subordinates the democratic ideal to pictorial drama and focus, creating a sense of unified action. The moment chosen is not the indulgent banquet, but the captain and lieutenant ordering the militia to march. The other members of the company, as well as certain additional figures—a young woman with a dressed bird hanging from her belt (the bird's claws were the emblem of the militia guild), a boy firing a rifle, and others—are gathered in seemingly spontaneous groupings. Bold light and lightly colored costumes emphasize the main figures and give focus to the composition. A number of subordinate figures are virtually lost in shadow. They were added by Rembrandt to create variety; they were not militia members who had paid to be included for posterity. The composition, rich and complex, is truly Baroque. The figural composition is set off by the off-center gateway—a reference to an ancient triumphal arch—in the background.

No sound evidence supports the often repeated story that the members of the company themselves were unhappy with Rembrandt's brilliant and unexpected solution to the problem of the group portrait. The painting was praised in the seventeenth century; one of Rembrandt's pupils wrote:

It will outlast all its competitors, being so artistic in conception, so ingenious in the varied placement of figures, and so powerful that, according to some, it makes all the other pieces there look like decks of playing cards.

9.24 Frans Hals, Banquet of the Officers of the Civic Guard of St. George, 1627. Oil on canvas, 5' 10½" × 8' 5½" (1.8 × 2.6 m). Frans Halsmuseum, Haarlem, The Netherlands. Commissioned by the Civic Guard of St. George.

The Dutch civic militia groups of the first half of the seventeenth century descended from groups that played a crucial role in gaining the independence of the Netherlands. They continued to have important functions, including guarding the cities and keeping order, and it became traditional that they have their portraits painted. Often, as here, they are shown at the annual banquet given them by the city.

1626-73 Civil war ravages Vietnam

1627 Hals, Banquet of the Officers of the Civic Guard of St. George (fig. 9.24)

1630 Bubonic plague kills 500,000 Venetians

1633 The Inquisition forces Galileo to retract his defense of the Copernican system

1636 "Haarlem" is founded by Dutch settlers on Manhattan island

Rembrandt was the most famous Dutch artist of the seventeenth century and virtually the only one with an international reputation. As a young man, he had hoped to become a history painter, but his earliest success came as a painter of group and individual portraits. In 1642, the year of this group portrait of the militia company, his wife Saskia died, leaving him with an infant son to raise. His art had already begun to show signs of change, and after 1642 he sought subjects and techniques that would satisfy a personal need for profundity and emotional depth (see figs. 9.36, 9.37, 9.44).

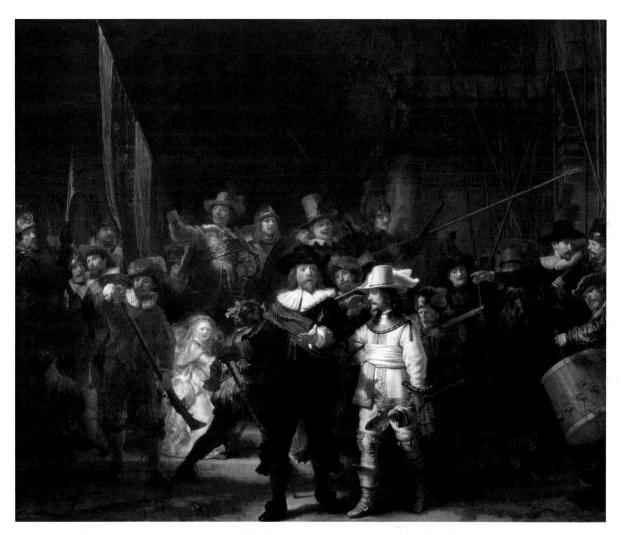

9.25 Rembrandt, Militia Company of Captain Frans Banning Cocq, 1642. Oil on canvas, 12' 2" × 14' 7" (3.7 × 4.5 m). Rijksmuseum, Amsterdam, The Netherlands. Commissioned by Captain Frans Banning Cocq and the members of his militia company.

This group portrait, Rembrandt's largest surviving work, is usually known, inaccurately, as The Night Watch because layers of dirty varnish once made it seem like a night scene. The painting was part of a series of group portraits of militia companies that decorated a great hall in the headquarters of the Amsterdam civic guard. The patrons were members of Cocq's company, each of whom paid a sum consistent with his prominence in the painting. In the eighteenth century, the painting was cut down, and as a result, the composition was transformed. Rembrandt's group portrait was commissioned for a specific position. To reconstruct the angled view that a spectator would have had when approaching the work from the only doorway in the room, hold this book at an angle so that the painting is to your right and sharply receding. This clarifies a number of elements in Rembrandt's composition, including the glance and gesture of Captain Cocq, who, it can now be understood, was looking toward the spectator. Rembrandt adjusted his composition to gain maximum effectiveness, given the intended location of his painting. The other civic militia portraits in the same hall included the artist's self-portrait, and Rembrandt, with wit, represented himself in the back of the crowd. All we see is an eye, part of his nose and forehead, and his painter's beret.

Mughal Art of India: The Taj Mahal

ne of the most celebrated buildings in India, the Taj Mahal was built in the seventeenth century by the Mughal ruler Shah Jahan as a mausoleum for his favorite wife, Mumtaz Mahal, who had died in child-birth (fig. 9.26). Although a myth has grown up that states that it was built as a "love poem in stone," its dimensions and design were intended as concrete symbols of the emperor's absolute power. The concept of the single-domed structure surrounded by four minarets evolved from previous funerary buildings, so its style and function were immediately recognizable.

The setting in a walled garden divided by four water-courses was inspired by descriptions of paradise in the Koran. Although earlier tombs had also signified Paradise, the symbolic program at the Taj Mahal is more complex. The main building probably represents the Throne of God, which according to Islamic thought is situated just above Paradise, on the Day of Judgment. The Koranic inscriptional program found on the building surfaces shows a preoccupation with this final day.

Hindu and Islamic architectural traditions are brought together in the Taj Mahal's design and decoration. While the domed construction was based on Islamic precedents, the stone carving drew from traditional Indian carving techniques and training. Many of the elaborate decorative designs were taken from Persian traditions.

After passing through a monumental gate, one enters a spacious garden with long reflecting pools. Trees and flowers are planted in quadrants framed by wide walkways and stone inlaid in geometric patterns. Toward the rear of this garden, the mausoleum is flanked by two identical structures: a mosque and a resting hall for travelers. Like the gate, they are constructed of local red sandstone; the contrast with the glowing white marble of the tomb emphasizes the differences in the use of the buildings.

The tomb sits on a platform of marble that both raises it above the natural level of the earth and anchors it to the space of mortals. The building is almost square, but each corner is truncated to create a transition to the other sides. Each facade is identical, with a central *iwan*, or vaulted

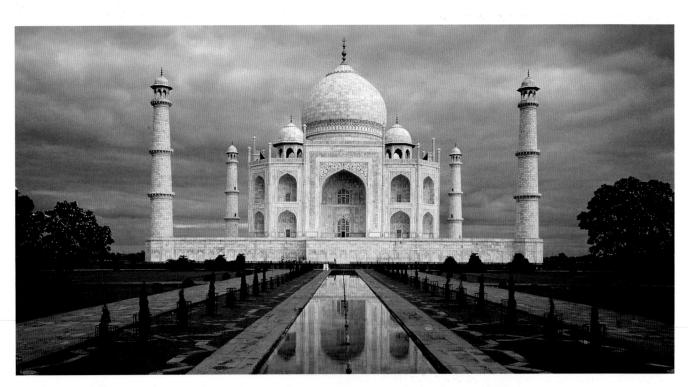

9.26 The Taj Mahal, Agra, India, Mughal period, 1632–48. White marble, with inlaid colored stone, subsidiary buildings in red sandstone, garden with reflecting pools; height of the main structure, 250' (75 m); garden precinct measures 1,000' × 1,860' (300 × 558 m); whole complex covers 42 acres (17 hectares). Commissioned by Shah Jahan.

Shah Jahan and his wife were interred in the crypt below the central building.

Shah Jahan's interest in architecture was shared by his court, and even the women of the royal family commissioned buildings. Literary sources tell us that an appreciation for architecture was common, and that Shah Jahan was expected to provide aesthetic leadership in this area. Architects enjoyed a high reputation, especially Abd al-Karim and Makramat Khan, who were associated with the building of the Taj Mahal.

9.27 The Taj Mahal, detail of stonework.

opening, that emphasizes the arched portal into the interior. These openings create a play of light and dark across each facade that changes according to the angle of the sunlight. The large picturesque lotus dome that crowns the building sits atop a high drum. At each corner of the base is a slender minaret decorated with three levels with walkways and a *chattri*, or pavilion of the type common in traditional Indian buildings, at the top. These match the larger chattri that surround the main dome. The surfaces of the Taj Mahal are embellished with subtly carved and/or inlaid panels of flowers and arabesques, some of which feature semiprecious stones (fig. 9.27). The portals are framed with verses from the Koran inlaid in black marble.

Shah Jahan (fig. 9.28) had a special interest in architecture, which he used to synthesize his aesthetic and political ideals. Although Mughal emperors prior to Shah Jahan presented an architectural ideology that sought to reconcile Hindus and Muslims by combining elements of both traditions, Shah Jahan returned to even earlier roots. His architecture exclaimed formal harmony, enhanced by the materials and plan of the buildings. Bilateral symmetry governs the Taj Mahal through the use of a central axis for the building and grounds. Repetition of a few significant forms and motifs created a symbolic message that reinforced the doctrine of divine kingship. Iranian, Hindu, Buddhist, and even European forms are found in the multifaceted capitals, cusped arches, naturalistic acanthus motifs, baluster columns, semicircular arches, cornucopia motifs, and curved roofs and cornices. The inlay technique that is used on most surfaces had been a feature of Mughal architecture since the founding of the empire, and ultimately recalled the Mongol/Turkish decorative traditions of Shah Jahan's Turko/Mongol nomadic heritage. Clearly the allegorical significance of the compound went far beyond its immediate function.

9.28 Abu'l Hasan (Prince Khurram), Portrait of Shah Jahan, Mughal period, 1618. Opaque mineral, animal, and vegetable colors on paper, $8\frac{3}{4} \times 5\frac{1}{4}$ " (22 × 13 cm). Victoria and Albert Museum, London, England.

This miniature is inscribed by Shah Jahan, who states that the likeness is very good. The golden aigrette he holds tells us that he is a refined man of the world. His robe, scarf, and sash are brilliantly colored, patterned silks.

Baroque Architecture: Francesco Borromini

his dome by Francesco Borromini (1599–1677) almost appears to be a hallucination (fig. **9.29**). The hovering oval form, with its elastic **coffers**, seems to bear no relation to the heavy, solid stuff of architecture. If we blink, will it disappear, descend, or snap back into a circular shape with regular coffering? Startling and unbelievable architecture is typical of the works of Borromini. His Baroque monuments tantalize us with their energy, com-

plexity, and tension. The oval form used here is one that has an inherent dynamism, for an oval establishes an axial direction and presents a variation in curvature, but Borromini also exaggerates the diminution of the coffering to suggest that the dome is larger than reality, and by adding hidden windows at the base of the dome, he creates a floating, levitating sensation. The excitement generated by the dome at San Carlo is resolved by the circle in the middle

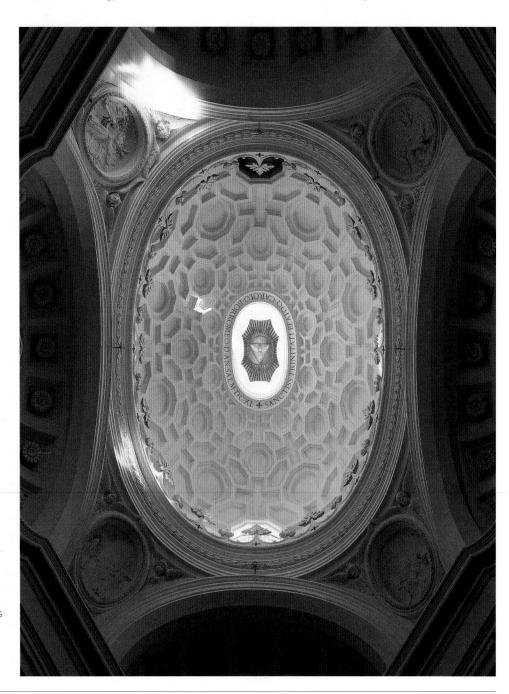

9.29 Francesco Borromini, Dome, San Carlo alle Quattro Fontane, Rome, Italy, 1638–41. Commissioned by the Spanish Discalced Trinitarians.

Dedicated to a recently canonized saint, Carlo Borromeo, this church is also named after its location at an intersection with four fountains (quattro fontane) representing the four seasons, one on each corner.

1638-41 Borromini, Dome, San Carlo alle Quattro Fontane (fig. 9.29)

1639 Smithfield hams from Virginia are sold in London

1643 Death of Louis XIII

1655 English capture Jamaica, establishing a base for the African slave trade

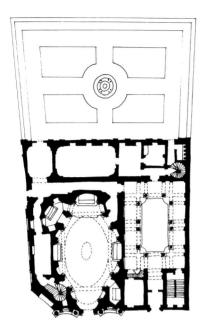

9.30 Francesco Borromini, Plan of San Carlo alle Quattro Fontane, 1638-41. Note how Borromini has located his church within the irregular space available to him.

of the lantern, which is decorated with a triangle, symbol of the Trinity and emblem of the Trinitarian Order, which commissioned the church.

The demand that we be involved, the effect of captured movement, and the dramatic lighting of this architecture are consistent with the Baroque innovations examined in the paintings of Caravaggio and his followers. This small church is only one example of Borromini's inventiveness in creating exciting experiences within the classical vocabulary of architecture.

The complexity that characterizes the interior of San Carlo (fig. 9.30) rivets our attention as we try to discern the logic and order that we expect in a building based on the classical orders. The entablature is composed of contrasting flat and concave sections that surge around the small interior, while the patterns of columns and of triangular and semicircular pediments create two overlapping and interlocked systems. The design is both logical and brilliantly complex. Architectural historians have analyzed the mathematical formulas on which Borromini based his structures. In this case, he evolved his design from the triangle, symbolic of the Trinitarian Order. At its most basic level, then, the shape of San Carlo alle Quattro Fontane has a form and an iconographic content that can be related to both a particular religious order and the Christian religion in general.

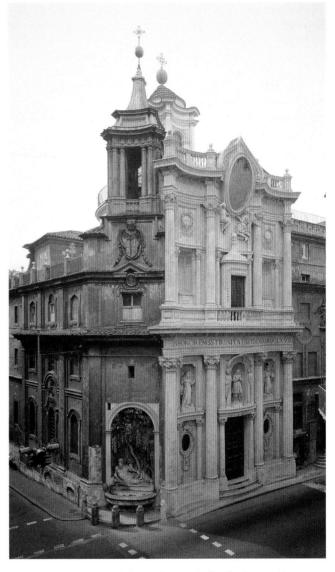

9.31 Francesco Borromini, Facade, San Carlo alle Quattro Fontane, 1665-67.

Although the facade was completed long after the rest of the church, it is probably based on plans that Borromini had drawn earlier. For another Roman Baroque church by Borromini, Sant'Agnese in Agone, see fig. 9.5.

The facade predicts the interior in the grouping of four evenly spaced columns, in the undulation of the surging entablature, and in the scale of the lower story of columns (fig. 9.31). When one is standing in the narrow street before the church, however, the complex energies of contrasting concave and convex forms overwhelm any sense of logic. The upper row of columns completely masks the dome, making it a total surprise for the unsuspecting observer entering the church.

Bernini, Ecstasy of Saint Teresa

It pleased the Lord that I should sometimes see the following vision. I would see beside me ... an angel in bodily form.... He was ... short and very beautiful, his face so aflame that he appeared to be ... all afire.... In his hands I saw a long golden spear and at the end of the iron tip I seemed to see a point of fire. With this he seemed to pierce my heart several times ... he left me completely afire with a great love for God. The pain was so sharp that it made me utter several moans; and so excessive was the sweetness caused me by this intense pain that one can never wish to lose it, nor will one's soul be content with anything less than God. It is not bodily pain, but spiritual, though the body has a share in it—indeed a great share.

(Teresa of Ávila, Autobiography)

Bernini has visualized Teresa's words and experience in his sculpted altarpiece (fig. 9.32), capturing in the pose and facial expression the combination of "sweetness" and pain she describes so vividly. Her figure seems to convulse, her arm is limp, and her head slumps back, her mouth open and her eyes half-closed. The figure of the angel smiles radiantly, and its drapery ripples with flamelike folds that evoke Teresa's words.

Bernini's interpretation, however, encompassed more than just Teresa's description of this single ecstasy. It relates this experience to other aspects and events of her life and to contemporary attitudes about ecstasies and saints. Teresa's miraculous death, as described by those who witnessed it, is evident here in the beauty Bernini gives the saint. Although

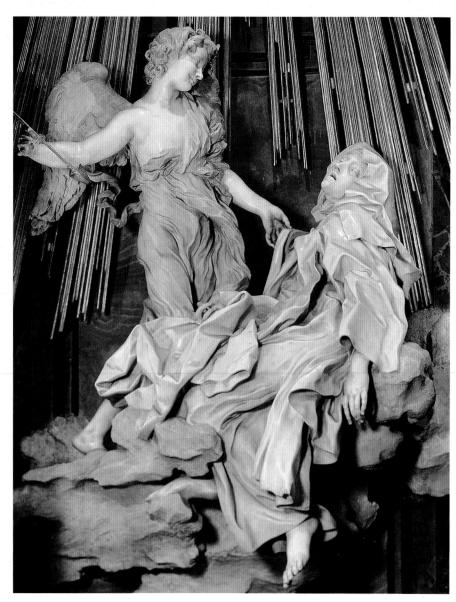

9.32 Gianlorenzo Bernini and workshop, *Ecstasy of Saint Teresa*, 1645–52. Marble and bronze, height approx. 12' (3.5 m); the figures are over-lifesize. Cornaro Chapel, Santa Maria della Vittoria, Rome, Italy. Commissioned by the Venetian Cardinal Federigo Cornaro as part of a burial chapel for his family.

Teresa, a sixteenth-century nun and a leading personality in the Counter-Reformation Church in Spain, founded a strict group of Carmelite nuns known as the barefoot Carmelites. For this reason, she is represented as barefoot in Bernini's sculpture. She wrote a number of works about the mystical life, including a popular and widely read Autobiography in which she detailed the visions and ecstasies she experienced.

her homeliness is documented, at the moment of her death, when she was in her sixties, witnesses testified that she became youthful and beautiful and that she died while in a state of ecstatic love for God. The relationship between ecstasy, death, love of God, and the ideal of the marriage of the soul with the divine can be related to a mystical tradition that has its roots in the love poetry of the Biblical Song of Songs. Teresa herself had written a commentary on the Song of Songs, in which she related Christian death and ecstasy to the desire of the soul to expire in the anguish of divine love. Bernini shows the saint levitating, an experience that Teresa said she often experienced after attending Mass. By levitating the figure, Bernini makes his sculptural group more impressive and its effect more momentary, while in the context of Teresa's life he also refers to her devotion to the Eucharist, an appropriate emphasis in an altarpiece.

Bernini's representation of the ecstasy of Teresa is itself a miraculous apparition, for the large white figures of the angel and the saint seem to float above the altar. Originally they must have glowed in a gentle, mysterious light that flowed dimly down on golden rays from a hidden window filled with stained glass. Today, electric lights make the lighting more dramatic than Bernini intended. The vision of the miraculous ecstasy is enhanced by the enshrinement of the altarpiece group in a pedimented tabernacle. This niche, made of brilliant multicolored marble, is the centerpiece of a sumptuous chapel complex, every detail of which was designed by Bernini (fig. 9.33). The back wall is covered with marble paneling that is broken by the surging pediment above the niche, which undulates outward and upward. The ceiling is frescoed with a burst of heavenly light, and angels seem to pour down into the chapel, accompanying the angel in Teresa's ecstasy. The front of the altar is decorated with a gilded bronze and lapis lazuli relief of the Last Supper, while the floor tombs are decorated with inlaid figures of gesticulating skeletons in foreshortening, as if those buried below were being resurrected to participate in the saint's ecstasy.

Bernini unites painting, sculpture, and architecture in a totality that breaks down the barriers between the world in which we live and the work of art. The tabernacle and figures invade our space, demanding that we become involved. A text on a banner held by angels on the entrance arch offers words that, Teresa wrote, were spoken to her by Christ during one of her visions: "If I had not already created heaven, I would create it for you alone."

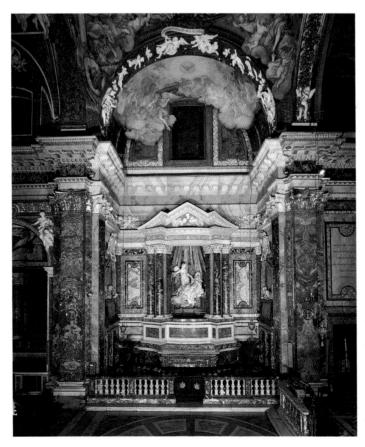

9.33 The Cornaro Chapel.

The Art of Drawing: Rembrandt

The freshness of nature is captured in Rembrandt's spontaneous drawing of a still tributary near Amsterdam (fig. 9.34). A few quick pen strokes capture the wind as it riffles the leaves of the trees around the cottage. Rembrandt applied wash (ink thinned with water) with a brush to achieve the darker shadows that give mass to the cottage and create the reflection of the trees and cottage on the surface of the water. A thin wash at the top suggests the sky, and a bold, dark mass in the lower left corner establishes the *repoussoir*. Rembrandt's economy of means captures the flux of nature.

Throughout the centuries, artists have made and used drawings for a great variety of purposes. We normally think of drawings as being preparatory—studies made in the process of creating a larger, more finished work in another medium—and such is often the case (see fig. 7.53).

Although almost all drawings created before the Renaissance are lost, this does not mean that artists in earlier periods did not use preparatory drawings. Egyptian and Greek stone-carvers, for example, probably drew guidelines on the four sides of their blocks of stone before they began carving (see fig. 3.15), and their contemporaries surely made some kind of sketch or drawing prior to beginning to paint or to construct a building. Many later paintings are based on drawings on the plaster or canvas surface (known as underdrawings because of their position under the finished work). Artists have also made drawings as records of completed works, often as a means of documenting their production. Finely finished drawings were sometimes made to be presented to collectors and friends. These are known as presentation drawings. Drawings were first systematically collected during the

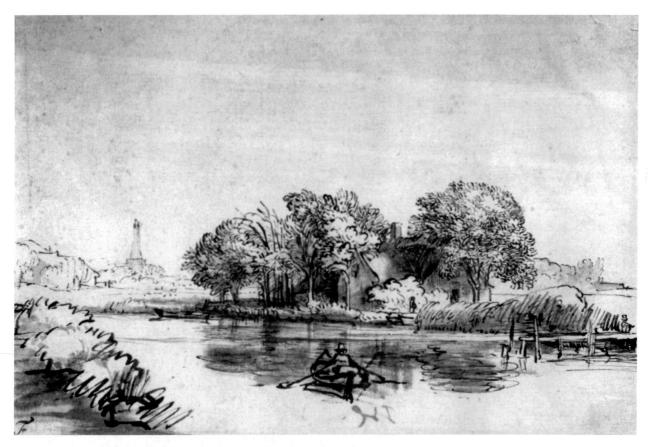

9.34 Rembrandt, *A Man Rowing a Boat on the Bullewyk*, c. 1650. Quill pen and brown wash heightened with white, $5\% \times 7\%$ " (13 × 20 cm). Devonshire Collection, Chatsworth, Derbyshire, England.

The location is a tributary of the Amstel River, near Amsterdam, with the spire of the Ouderkerk (Old Church) in the background. The white used here is an opaque paint that allowed Rembrandt to suggest white highlights.

Renaissance, when the artist was recognized as a genius whose every creative effort was precious and therefore worth preserving.

There are many media in which drawings have been executed: charcoal, lead pencil, pen and ink, chalk in various colors, pastel, and points made of silver, gold, or other metals. Wash, watercolor, and gouache (see p. 483) are also considered drawing techniques, even though they are liquid media applied with a brush. Although paper is the most widely accepted support for drawings, artists have also used vellum, parchment, and other materials.

Hundreds of drawings were executed by Rembrandt in virtually every drawing medium that was available to him. Although some can be identified as studies for paintings or etchings, the majority are sketches of genre scenes, landscapes, and animals. All the evidence suggests that

Rembrandt made his drawing of A Man Rowing for his own pleasure, for none of his landscape paintings are endowed with this kind of naturalism. We know from an inventory of his possessions that Rembrandt sorted his drawings and stored them by subject. The implication is that when he began a new painting or etching, he could look through his drawings for inspiration drawn from life.

In a drawing executed with soft red chalk, Rembrandt has, with incredible economy, captured a hesitant child, wearing a padded hat for protection, in the process of learning to walk (fig. 9.35). The child is encouraged by two women, one of whom, on our right, betrays her age by her stiffness. There is no setting, nor is there a single extraneous detail. It is a tiny drawing of the utmost simplicity, but the moment of life that it captures is precious.

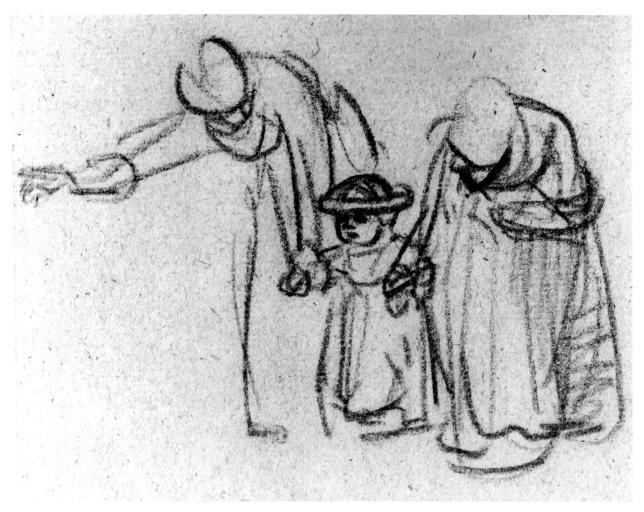

9.35 Rembrandt, Two Women Teaching a Child to Walk, c. 1637. Red chalk drawing on rough grayish paper, $4\% \times 5$ " (10 × 13 cm). The British Museum, London, England.

Printmaking: Etching and Drypoint

Rembrandt presents us not with a specific biblical subject but with an interpretation of Jesus as a humble and gentle teacher who stands within the crowd in a city street to preach (fig. 9.36). He is surrounded by people of all ages, rich and poor, and in Rembrandt's representation they react as individuals to Jesus's words. Some ponder his meaning, but others seem uninterested. A child busies himself drawing in the dust in the foreground.

Rembrandt's technique is etching, and this is one of a number of prints produced from the same plate for collectors of prints. It is the etching technique that permits the creation of blurred lines and a soft, atmospheric quality not possible in woodcut or engraving. Etching is not a new technique—Dürer and other printmakers had experimented with its possibilities—but it was Rembrandt who first realized its potential for expression.

Etching is an intaglio technique (see pp. 314-15), and the same thin copper plate used for engraving functions as the print form (fig. 9.38). To create an etching, one must cover the plate with an etching ground, an acid-resistant, resinous mixture. The artist scratches through this ground with a steel etching needle, creating lines that expose the copper. When the design is completed (or when the artist

wants to test the progress of the composition), diluted acid (nitric, iron chloride, or hydrochloric) is poured over the plate, or the plate is dipped into an acid bath. The acid eats into the copper, creating grooves where the needle has scratched through the ground. The ground is then cleaned off and the plate is inked and printed, as in the process for printing and engraving. If the results are unsatisfactory or incomplete, the ground can be reapplied, the design can be strengthened or completed with the needle, and the acid bath can be used again. Another alternative is to strengthen the lines by using the burin (as in engraving) and/or drypoint (see fig. 9.39). Only about fifty excellent and 200 reasonably good prints can be made from an etched plate.

An eighteenth-century development in the etching process was the soft-ground etching, which uses a greater percentage of tallow or wax in the ground. A thin sheet of paper is laid over the ground, and a drawing is made on the paper. When the paper is lifted, a soft, grainy impression is left on the plate. The plate is then etched, using a weak acid bath.

The etching technique encouraged freedom and spontaneity, for the etching needle moves easily through the ground to scratch the plate (unlike the concentrated

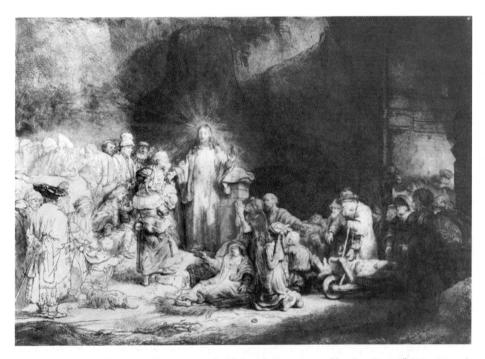

9.36 Rembrandt, Christ Preaching, c. 1652. Etching with drypoint and burin, 6\% × 8\%" (16 × 21 cm).

Rembrandt was internationally famous as a printmaker during his own lifetime, and his prints regularly sold for high prices. Less than twenty years after Rembrandt's death, the Florentine art historian Filippo Baldinucci would write: "This artist truly distinguished himself in a certain most bizarre manner which he invented for etching on copper plates. This manner too was entirely his own, neither used by others nor seen again; with certain scratches of varying strength and irregular and isolated strokes, he produced a deep chiaroscuro of great strength."

pressure needed to push the burin through the resistant copper to create an engraving). Although an etched line lacks the sharp and precise quality of an engraved line, its blurriness creates the atmospheric effect that we admire in Rembrandt's work. Rembrandt's earliest printed works were pure etchings, sometimes with the use of the burin for strengthening. Later, to achieve an even greater effect of atmosphere, he began to add lines in drypoint, as is the case in Christ Preaching (see fig. 9.36).

Drypoint is the technique of scratching directly into the copper plate with the etching needle (fig. 9.39). This method creates grooves that have tiny raised ridges of copper, known as the burr, to either side, where the expelled material is forced by the needle. These drypoint ridges catch the ink and create rich areas of deep, soft shadow. The necessary pressure applied by the press during printing will wear down the burr rather quickly, and only about ten good and twenty reasonably good impressions can be made. In Christ Preaching, drypoint lines are visible in the beard and hair of Jesus and in the deep shadows of his drapery.

A few of Rembrandt's last prints are executed entirely in drypoint, with an additional use of the burin for certain

sharp details. Rembrandt's last print was probably the large Three Crosses (fig. 9.37), which he worked on over a period of years. He created three successive stages, known as states, in 1653 by reworking the plate and a final, almost completely reworked fourth state in the early 1660s. It is a profoundly moving personal interpretation of the Crucifixion based on the text in Luke 23:44-47:

And it was about the sixth hour, and there was a darkness over all the earth until the ninth hour. And the sun was darkened, and the veil of the temple was rent in the midst. And when Jesus had cried with a loud voice, he said, "Father, into thy hands I commend my spirit," and having said thus, he gave up the ghost. Now when the centurion saw what was done, he glorified God, saying, "Certainly this was a righteous man."

The centurion is kneeling, to suggest that Rembrandt is representing the very moment of the death of Jesus. The powerful shaft of light is a momentary blaze, a heavenly response to Jesus's words and his death. In this late work, Rembrandt avoids painstaking detail to emphasize powerful emotional experiences.

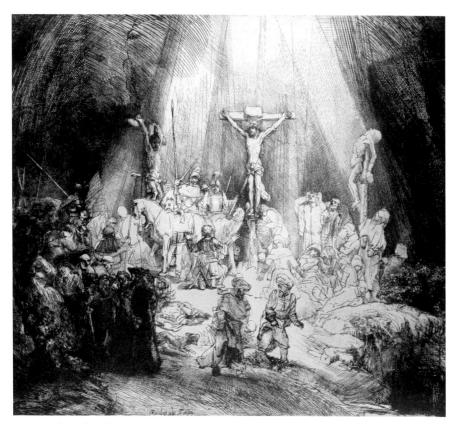

9.37 Rembrandt, Three Crosses, 1653. Drypoint and burin (first state), $1'3\frac{1}{3}$ " × $1'5\frac{3}{4}$ " (39 x 45 cm). Rembrandt made successive changes to the plate in producing later states of this print.

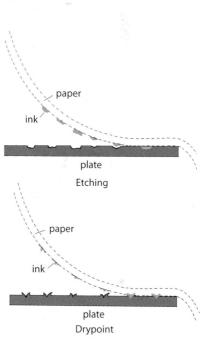

9.38, 9.39 Diagrams of the etching and drypoint techniques. The more blurred lines of the drypoint technique are the result of the burr of the drypoint line.

Spanish Painting: Diego Velázquez

or just a moment, Velázquez's painting convinces us that the little princess and her attendants—including dwarfs and a large dog—are posing just for us (fig. 9.40). Although *Las Meninas* is a large picture, its subject seems intimate and even casual. We glimpse a large dark room in the palace, where the painter is at work on a huge canvas. He looks out and leans back, raising his brush as he prepares to apply a stroke of paint. In the fore-

ground is the five-year-old Margarita, daughter of Philip IV, surrounded by her maids (*las meninas*) and the dwarfs and developmentally disabled people who were a traditional part of life at the Spanish court. With the exception of the princess, all these figures are represented in the midst of movement, as is Velázquez. Note especially the figure to the right who, one hand raised, awakens the dog, which slowly raises its head. Velázquez's illusionism,

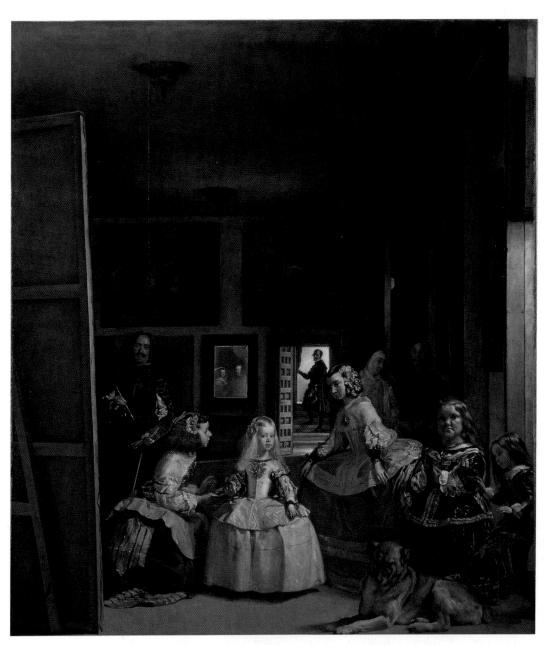

9.40 Diego Velázquez, *Las Meninas (The Maids of Honor)*, 1656. Oil on canvas. $10' 5" \times 9' (3.2 \times 2.7 \text{ m})$; the figures are lifesize. Prado, Madrid, Spain. Probably commissioned by Philip IV of Spain.

The cross on Velázquez's chest indicates that he has been made a Knight of the Order of Santiago. As Velázquez did not receive this honor until 1659, three years after the painting was dated, the cross must have been added later.

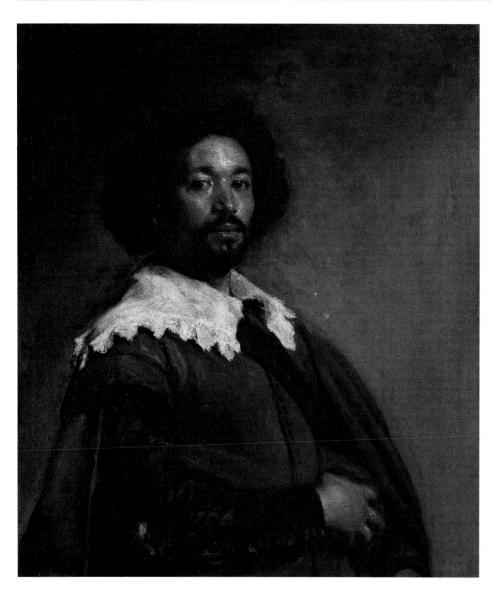

9.41 Diego Velázquez, Portrait of Juan de Pareja, 1650. Oil on canvas, 2' 8" × $2' 3\%'' (81 \times 70 \text{ cm})$. The Metropolitan Museum of Art, New York.

which is supported by his loose brushstrokes and the blurred edges of the forms, attempts to convince us that we are seeing reality.

But is the princess posing for us? The shimmering surface on the back wall is a mirror that reflects the figures of King Philip and Queen Mariana. A real mirror would have reflected the whole room, but Velázquez, with artistic license, includes this reference to his royal patrons as the sole element that reminds us that what we are looking at is indeed a painting.

In Velázquez's Portrait of Juan de Pareja (fig. 9.41), the sitter looks out with calm and assured dignity. Velázquez's loose brushstrokes and subtle light create an effect of immediacy and, again, reality. The painting is a coloristic triumph, for within a restricted palette of white, black, grays, and beiges, Velázquez creates an impressive variety of

tones. The restriction of color is no accident, for this portrait of one of Velázquez's assistants was a practice piece. Velázquez was in Rome, buying paintings and ancient sculptures for King Philip, when he received the commission to paint a portrait of Pope Innocent X. This particular portrait was a difficult task, for the pope, who had a ruddy complexion, had to be painted wearing red papal garments, seated in a red chair in a setting dominated by red hangings.

To prepare himself for this challenge, Velázquez posed a similar problem by painting Juan de Pareja, who was of Moorish descent, using a restricted color palette based on his flesh tones. The picture was a sensational success. After it was exhibited at the Pantheon, Velázquez was elected to the Rome Academy. One contemporary remarked that although all the other paintings in the exhibition were art, "this alone was truth."

Baroque Classicism: Nicolas Poussin

he idealized work of the French painter Nicolas Poussin (1594–1665) transports us to remote antiquity, where we stand with shepherds and a shepherdess by a monumental tomb (fig. **9.42**). Arcadia is the name given to an idyllic region in Greece where, during the ancient golden age, it was believed that humanity had lived peacefully and harmoniously with nature. To the shepherds who lived there, life seemed perfect until they accidentally discovered a tomb and realized that death is a reality that they will someday have to confront. Despite the dramatic

implications of the subject, the mood of the painting is calm and contemplative. In Poussin's approach, even death becomes philosophical.

Poussin's style is consistent with his intellectual interpretation of the subject. The composition is lucid and the poses of the figures are clearly articulated and interrelated. To assure satisfying compositions, Poussin carefully worked them out by arranging miniature wax figures on a stage in a small box until he was pleased with their disposition. The colors are cool and simple, the light regular and

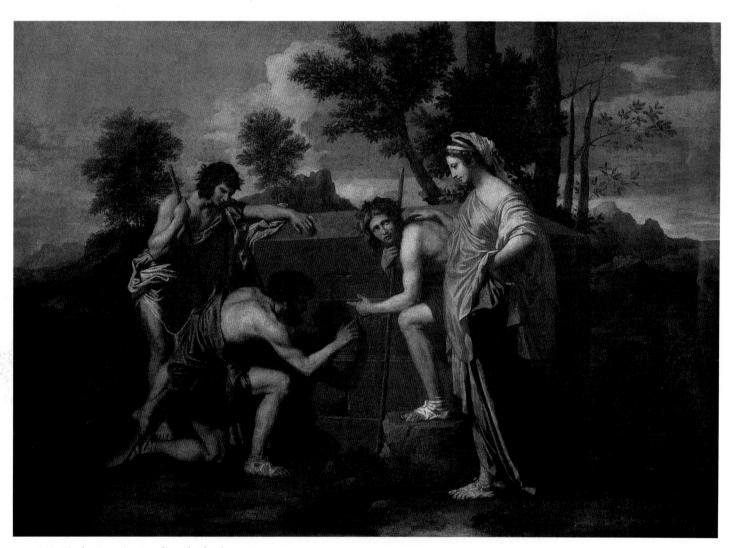

9.42 Nicolas Poussin, *Arcadian Shepherds*, c. 1660. Oil on canvas, 2' 10%" × 3' 11%" (87 × 102 cm). The Louvre, Paris, France. Painted for Cardinal Rospigliosi and bought by Louis XIV in 1685.

The inscription on the tomb is Et in Arcadia Ego ("Even in Arcadia I [Death] am to be found").

1659 Pierre Corneille, Oedipus c. 1660 Poussin, Arcadian Shepherds (fig. 9.42)

1664 Jean Racine, The Thebans Heinrich Schütz. Christmas Oratorio 1666 A branch of the French Royal Academy of Painting and Sculpture is established in Rome

undramatic, the modeling smooth, and the brushstrokes controlled. The influence of the High Renaissance style of Raphael is evident, and the costumes and facial types reveal Poussin's careful study of ancient art. Poussin's paintings are among the finest examples of Baroque Classicism. The landscape is based on the area around Rome, which Poussin knew well.

Nicolas Poussin was probably the most classical, intellectual, and philosophical painter of the seventeenth century. Although born in France, he spent most of his

mature life in Rome. A close circle of similarly minded French friends in Rome and Paris were the patrons for his well-studied, thoughtful compositions. They preferred heroic or stoic themes from antiquity.

Poussin's landscapes always include a narrative subject, usually one drawn from antiquity. In Landscape with the Body of Phocion Carried out of Athens, the landscape setting is clearly not taken from nature (fig. 9.43). Poussin has rearranged nature to provide the properly sober, clear, and balanced setting for his profound theme.

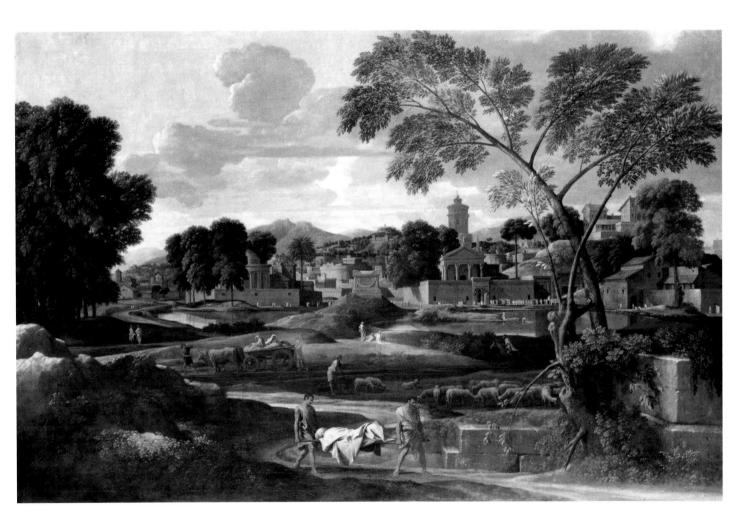

9.43 Nicolas Poussin, Landscape with the Body of Phocion Carried out of Athens, 1648. Oil on canvas, 3' 11" × 5' 10½" (1.19 × 1.79 m). National Museum and Gallery, Cardiff, Wales, on loan from the Earl of Plymouth. Commissioned by Serisier, a Lyons silk merchant.

Phocion was a loyal Athenian general whose character was in many ways like that of Poussin: he was stern, prized economy, and was dedicated to truth. His austerity and moral rectitude, however, made him hated by the popular faction in Athens, which, when it gained power, had Phocion executed on a false charge of treason and decreed that his body be carried outside the city for burial. This is the event shown in Poussin's painting. Later, Phocion was given an honorable burial in Athens.

Rembrandt: Late Paintings

embrandt's later works are characterized by subjects of universal human significance, as in this example of the Return of the Prodigal Son (fig. **9.44**). The subject is a visualization of one of Jesus's parables (Luke 15:11-32) that had been popular with the followers of Caravaggio, and especially with the Dutch Caravaggisti. The parable centers around a selfish young man who desires to receive his share of his father's estate before the father dies. The father agrees, and the young man takes the money and spends it on "riotous living." When he has been reduced to working on a pig farm, he repents of what he has done and decides to return home to ask his father's forgiveness. Rembrandt represents the most profound moment in the story when the son discovers that his father will not only forgive him but will kill a "fatted calf" to celebrate his return to the family. When his brother complains that such treatment is unfair, Jesus states that the father countered that they should rejoice because "this thy brother was dead, and is alive again; and was lost, and is found."

Dutch artists in general avoided emotionally complex themes, but the restriction on religious subjects and the general disinterest in historical and mythological themes in the Calvinist Netherlands were irrelevant to Rembrandt. Perhaps in reaction to the unemotional art being created by other Dutch artists, Rembrandt chose to probe deeply into human life for subject matter and to paint religious subjects if their emotional content interested him.

The Return of the Prodigal Son is Rembrandt's largest history painting and the impressive figures are larger than lifesize. The son, in rags and worn-out shoes, has thrown himself to his knees to indicate his repentance. The aged father bends over him, pulling the young man toward him with stiff hands. The son gently lays his head on his father's chest and closes his eyes. Time seems to stop. The richness of their inner experience is in part expressed abstractly by the textures of the **impasto** (raised brushstrokes of thick paint) with which Rembrandt paints their garments and by the warm, sonorous colors. Jesus used the human story to illustrate a moral: God will forgive sinners who repent.

Rembrandt uses the same story to emphasize a human experience—the forgiving love of a parent for a child.

As with many examples of Rembrandt's later paintings, we do not know whether the Return of the Prodigan Son was commissioned, created for his own personal satisfaction, or made in hope of a potential sale after the work was completed. While the majority of Rembrandt's commissioned paintings were individual portraits of Dutch merchants and members of their families, he showed a personal interest in painting biblical and historical subjects as a young man and he returned to these themes often throughout his career. In the two decades before his death in 1669 at the age of 63, Rembrandt painted a series of self-portraits in which he seems to be assessing his own personality, portraits of elderly Dutch citizens, and a series of works that reveal his interest in understanding some of the universal emotional themes we experience as human beings. Among these works are the so-called Jewish Bride, which explores the psychological and sensual relationship between a man and a woman; Bathsheba, which shows a woman about to be forced into a sexual relationship against her will; and two paintings on the theme of Lucretia, an ancient Roman woman who committed suicide rather than subject her family to dishonor.

The Return of the Prodigal Son deals with the relationships between a father and his two sons, and explores the various emotional dynamics between them—namely, their respective encounters with the father's unconditional forgiveness. The simple composition has none of the energy found so often in Baroque art, while at the same time the off-center placement of the main protagonists avoids the static effect that would have been created by a centralized design. The mood of introspection is enriched by the color palette, which uses deep brown in the shadows to set off the warm gold and rich red of the garments worn by the figures. Rembrandt here has suggested a profound human interaction, and the emotions his figures seem to be experiencing reverberate in the empty space at the top of this huge painting, a device Rembrandt may have learned from studying the works of Caravaggio.

c. 1662-68 Rembrandt, Return of the Prodigal Son, c. 1662-68 (fig. 9.44)

1664 The British take control of New Amsterdam and New Netherlands

1670 Richard Lassels' Voyage of Italy encourages scholars to make a "Grand Tour" of Italy

1673 A French mission brings letters from Pope Clement IX and King Louis XIV to Thailand

1680-92 A pueblo revolt drives the Spanish from New Mexican missions

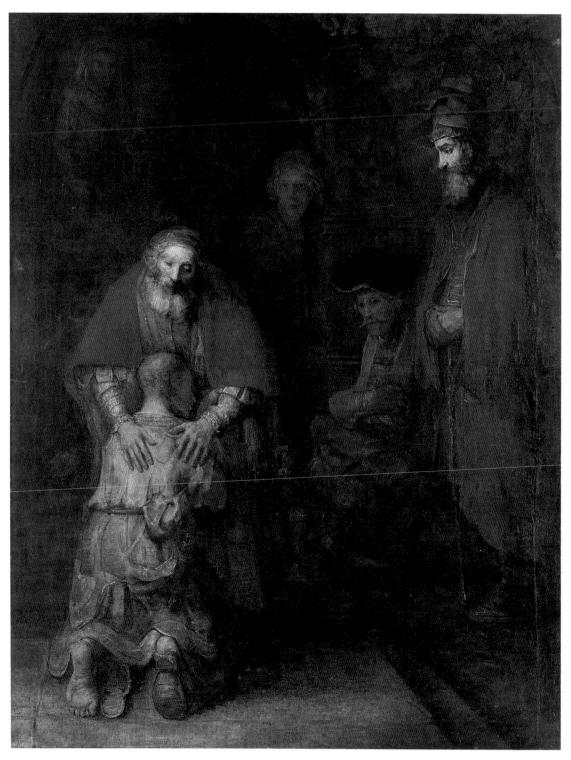

9.44 Rembrandt, Return of the Prodigal Son, c. 1662-68. Oil on canvas, 8' 8" \times 6' 8" (2.6 \times 2 m). Hermitage Museum, St. Petersburg, Russia.

Dutch Still-Life Painting

ealistic still-life painting is a democratic art—one needs no background in aesthetics or art theory to appreciate the ability of Maria van Oosterwyck (1630–93) to render the butterfly that lights on the book or the mouse nibbling at the grain, not to mention the fresh flowers, skull, and globe (fig. 9.45). There is even a fly on a book to the right and a self-portrait of the artist reflected in the flask to the left. It was in the democratic Netherlands that such still lifes were most fully appreciated, and the market for pictures such as this one was so large that artists could become specialists in still-life painting and hone their skills so as to produce increasingly more brilliant depictions of objects in ever more elaborate profusion.

Sixteenth- and seventeenth-century art theorists, however, largely ignored still-life painting, as they also neglected the painting of landscape, genre, and portraits. These types of art were considered unimportant because they were merely copies from nature. A painter's most significant accomplishment, they argued, was a history painting, the conception, design, and execution of which demanded intellectual prowess and academic training. The painter of histories also needed an understanding of anatomy and experience in drawing the male nude. Still-life, landscape, portrait, and genre paintings were considered to be much less valuable than history paintings and generally sold at much lower prices.

During the seventeenth century, a number of women artists excelled at still-life painting, in part, perhaps, because this was a category of art in which they could succeed without seeming to threaten the long-established dominance of male artists. Because at this time women were not admitted to the academies, they hardly had the option of receiving training in creating history paintings. The two artists examined here were both products of the more liberal Dutch culture, but during the sixteenth and seventeenth centuries there are documented French, Flemish, and Italian women still-life artists as well.

The theorists underestimated still-life painting. To select the forms of a still-life painting and arrange them into a satisfying composition, with coordinating and contrasting patterns of textures and colors, demands different skills from those required of the history painter. And still-life paintings are not always purely decorative displays, devoid of any deeper meaning. The title of Van Oosterwyck's painting reveals that it forms part of a distinguished tradition of seventeenth-century paintings on the theme of Vanity, one of the minor vices, which expressed the transience of the things of the world and the inevitability of death. Such paintings were especially popular in the Netherlands, where the tradition of complex symbolism goes back to Campin and Van Eyck (see pp. 264–65, 270–75). In the most impressive of these compositions, of

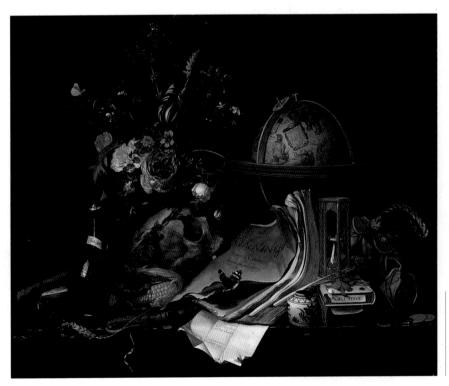

9.45 Maria van Oosterwyck, *Still Life with a Vanitas Theme*, 1668. Oil on canvas, 2' $5" \times 2'$ 11" $(74 \times 89 \text{ cm})$. Kunsthistorisches Museum, Vienna, Austria.

Maria van Oosterwyck did not come from an artistic family, but tradition tells us that she was determined to become a still-life painter. She developed an international reputation and produced works for Louis XIV of France and the members of other European royal houses.

which Van Oosterwyck's is an example, each element contributes its own special content to the meaning of the whole. The hourglass, for example, refers to the inexorable passage of time. The fly is a symbol of sin, ever present in the world, and the mouse symbolizes evil. The large book is labeled "Reckoning. We Live in Order to Die. We Die in Order to Live."

An early source tells us that Van Oosterwyck was pious, and the underlying Christian hope of her still-life painting is expressed in these words and in the butterfly, symbol of the resurrection of Christ and the salvation of humanity. Although the skull is an obvious reference to death, when it is wreathed in ivy, as here, it refers to life after death. All these objects and symbols are united in a skillful composition that takes maximum advantage of contrasting forms, colors, and textures.

Flower Still Life by Rachel Ruysch (1663-1750) is arranged along a prominent diagonal that is enhanced by the curving stems of the blossoms at the upper right and lower left (fig. 9.46). The simple centrality of the vase and niche is enlivened by the diagonal recession of the table and by the contrast in light to either side. On the right, a light area silhouettes the forms and emphasizes their irregularity, while on the left, a completely different effect is accomplished by setting off the complexity of many small blossoms against the dark background. Ruysch's father was a professor of anatomy and botany, and his collection of scientific specimens may have inspired her inclusion of the insects found so often in her paintings. She depicts them with impressive accuracy, a technical precision that reveals her participation in the new scientific interests and investigations of the seventeenth century.

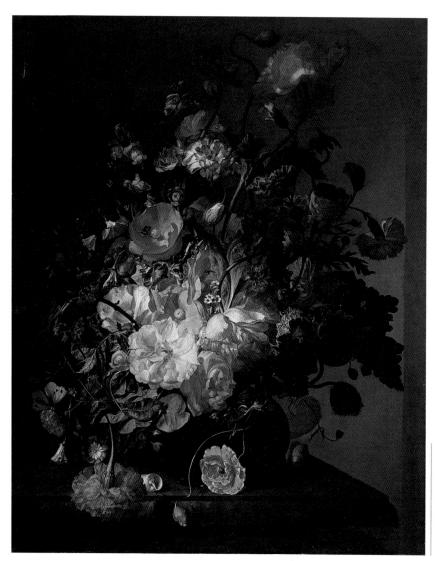

9.46 Rachel Ruysch, Flower Still Life, after 1700. Oil on canvas, $2' 6'' \times 2' (76 \times 61 \text{ cm})$. The Toledo Museum of Art, Toledo, Ohio.

Rachel Ruysch is ranked among the greatest stilllife painters in the Netherlands, and her international reputation continued after her death. She was apprenticed to an important still-life painter at the age of fifteen, and by eighteen was active as a painter in the same genre. From 1708 to 1716, she was court painter to the elector Palatine in Düsseldorf, Germany.

The Palace at Versailles

he palace of the French kings at Versailles is the largest and most emulated royal residence in the world (fig. **9.47**); as it stands today, it is largely the work of two architects, Louis Le Vau (1612–70) and Jules Hardouin Mansart (1646–1708).

The palace has hundreds of rooms, and its facade is almost a half mile long; the garden encompasses 250 acres. Its impressive scale actually made a political statement, for it was intended to assert for the French populace and nobility, as well as for foreigners, the power of the French monarch. In some ways, the very creation of Versailles may have played a role in establishing and perpetuating that power.

The expansive length of the garden facade itself makes a powerful architectural statement, but the architects faced the problem of how to articulate such a long structure. They decided not to break the mass in any dramatic way and chose to emphasize the horizontal sweep by articulating the second floor with **pilasters**. They created punctuation points with columned pavilions that jut out only slightly from the mass of the structure, with sculpture decorating their **cornices**. The design and ornament are completely classical, in keeping with the French interest in drawing a relationship between the principles of order and control and the rule of the French monarchy.

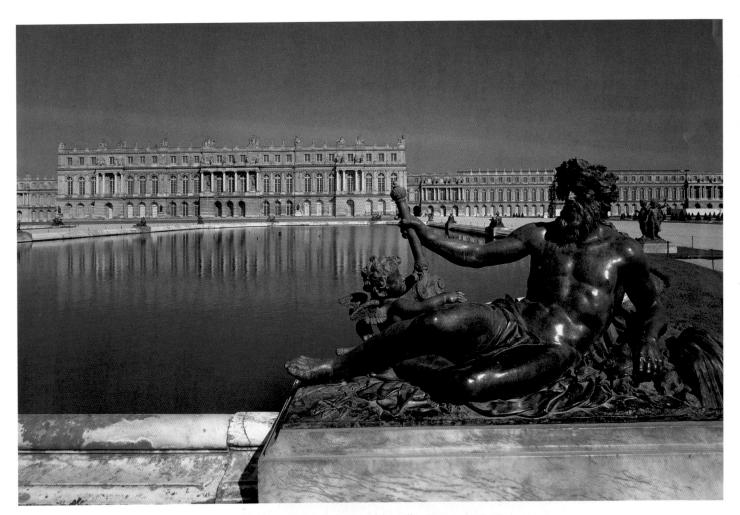

9.47 Louis Le Vau and Jules Hardouin Mansart, Garden facade, Palace of Versailles, France, 1669-85.

Begun by Louis XIV, who decided to enlarge a royal hunting lodge eleven miles southwest of Paris, Versailles officially became not only the main royal residence in 1682 but also the governmental seat. The administrator J.-B. Colbert, who also advised Louis on political, economic, and religious matters, and the painter Charles Lebrun were in charge of the artists and workers—sometimes as many as 30,000 at one time—who created the buildings and grounds. At its height, the palace served a court that totaled almost 20,000 people, including 9,000 soldiers quartered in the town and about 4,000 servants who lived within the palace itself.

1652-1795
Dutch East India
Company occupies Cape
Town on the Cape of
Good Hope

1664 French East India Company is founded

1669 Le Vau and Hardouin Mansart, Versailles begun (fig. 9.47)

1669 Antonio Stradivari makes violins in Cremona, Italy 1670 Jean-Baptiste Poquelin (Molière), Le Bourgeois Gentilhomme

For a discussion of the Salon de la Guerre (fig. 9.1), see p. 347. While its combinations of rich materials is typically Baroque, its iconography further supports Louis XIV's political goals by suggesting that Louis was a triumphant ruler whose victories would bring about the serenity promised in the pendant Salon de la Paix.

In the great park, ponds and pathways seem infinite, and at each crossroad there are several choices of direction in which to proceed (fig. 9.48). The vistas and paths offer surprises: fountains, basins, terraces, flights of steps, sculptural groups, flowerbeds, hedges, and even small architectural monuments. The garden and fountain sculptures

refer, of course, to the power of King Louis, the happy results of his reign, and the glory of the French state. Nature on a vast scale has been tamed and ordered, to provide a place of pleasure for the king and his court. Although the most basic purpose of the park is the same as that of the palace—to reflect the glory of the French monarchy and the king's centralized authority—André Le Nôtre (1613–1700) has also been sensitive to the delights of nature that such a park can offer to the observer. The plan informs us of the general layout; however, Le Nôtre's park was not designed to be seen from above, but by the human spectator, walking, choosing pathways and vistas.

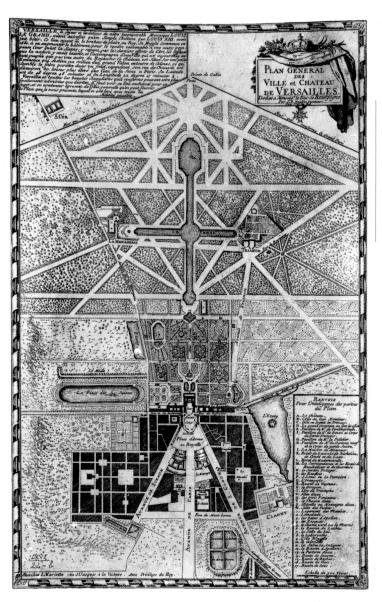

9.48 André Le Nôtre, Plan of the gardens and park, Versailles (17th-century engraving). Garden designed 1661–68; executed 1662–90. Commissioned by Louis XIV.

Note that the main streets of the town of Versailles, at the bottom of the map, converge on the palace to emphasize its significance. André Le Nôtre, son of a royal gardener, became the greatest designer of formal gardens and parks in seventeenth-century Europe. The layout of the garden uses radiating diagonals and dramatic long vistas.

Japanese Screens and Architecture

he highly decorative mode of painting that flour-ished in seventeenth-century Japan was executed on large-scale surfaces: sliding door panels (fusuma) or folding screens (byobu), usually executed in pairs. The style is characterized by the use of bold colors with gold leaf and by the use of stylized motifs. The most popular themes demonstrate a revival of the Japanese

concerns with the natural world, and with people and their activities, including such genre themes as horse races, theatrical performances, bathhouse prostitutes, and even Westerners. This pair of *byobu* (fig. **9.49**) by Tawaraya Sotatsu (active 1600–40) are called the *Matsushima Screens* because they are thought to depict Matsushima, one of the *sankai*, or three most beautiful

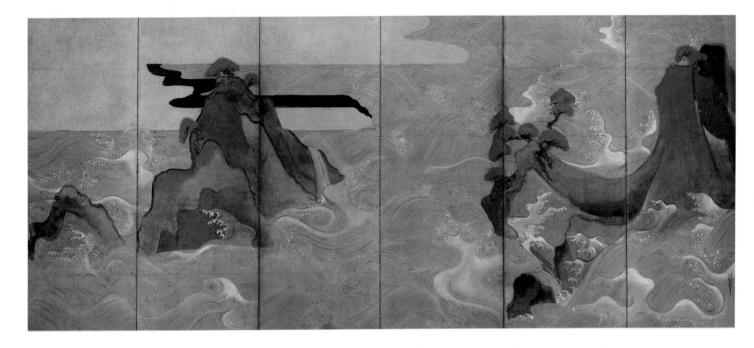

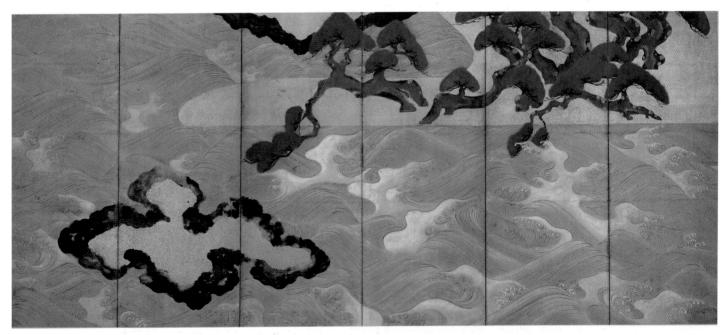

9.49 Tawaraya Sotatsu, Pair of six-panel *byobu*, known as the *Matsushima Screens*, seventeenth century. Ink, color, and gold leaf on paper; each screen is 4' 10" × 11' 9" (1.5 × 3.6 m). Freer Gallery of Art, Smithsonian Institution, Washington, D.C.

17th century Sotatsu, Matsushima Screens (fig. 9.49)

1670 Minute hands are first used on watches

1670 André Le Nôtre lays out the Champs-Elysées in Paris

1680 The Portuguese ban the enslavement of native Brazilian peoples

1703 Tokyo (Edo) is severely damaged by an earthquake

landscapes in Japan. This bay is dotted with small pinecapped islands. Other scholars argue that these byobu are not specific and only represent exceptionally beautiful passages of landscape. Still others argue that because the islands in the pictures resemble rocky configurations along the shore near Ise, these byobu illustrate a poem from The Tales of Ise that deals with the feelings of a man who, banished from the capital, gazes at the surf and white-capped water as he crosses a beach; because the twelfth-century illustrators of The Tale of Genji used natural elements to reflect human emotions, there is historical precedent for this interpretation. Whatever the subject, there is no question that the artist's vision has distorted reality, as is evident in the passage in which gold clouds turn into rocky shores where pine trees cling and grow.

One of the favorite books of Imperial Prince Toshihito (1579–1629) was The Tale of Genji (see pp. 216–19), and many of the details of the Imperial Villa he commissioned at Katsura (see figs. 1.6, 9.50, 9.51), southwest of Kyoto, were inspired by this eleventh-century novel. The last palace built by the novel's main character, Genji, was called Katsura, and it too was located along the Katsura River. As described in the novel, it was subdued and relatively unostentatious. It contained a large lake with several artificial islands, a rustic fishing pavilion, and a lodge next to a racetrack for the games that were held there in conjunction with festivals at the Kamo shrine in Kyoto. Toshihito's new royal seventeenth-century residence consisted of a main shoin (a large residence) with a bamboo-floored moonviewing platform, a smaller shoin, and a music room placed in a garden, all set out in accordance with descriptions in The Tale of Genji.

The imperial family's role in maintaining traditional Japanese culture is evident in all elements of the house—the irregular and asymmetrical planning of room sizes and their positions (fig. 9.50), the use of natural wood structural members (fig. 9.51), sliding paper doors, as illustrated in the Genji manuscripts (see fig. 6.20), and the abrupt contrasts of textures in the rocks, plants, water, and dry areas of the gardens.

At other villas of the period, the rank of individuals, so important in the samurai culture of this period, was emphasized through different floor levels or by other means. Because Katsura Villa was designed for the imperial family as a place where they could put aside issues of class in a relaxed atmosphere, there are no such provisions for emphasizing rank. This less formal character is consistent with The Tale of Genji.

Seventeenth-century art in Japan was dominated by a spirit of reflection and a return to established traditions. The standard set by the nobility focused on the art of tea and on such classics of Japanese literature as The Tale of Genji and The Tales of Ise. Japanese aristocrats were expected to know The Tales of Ise by heart. The Katsura Villa and the screens by Sotatsu are characterized by the self-assuredness and return to historical precedent so important in this period of political stability and economic prosperity.

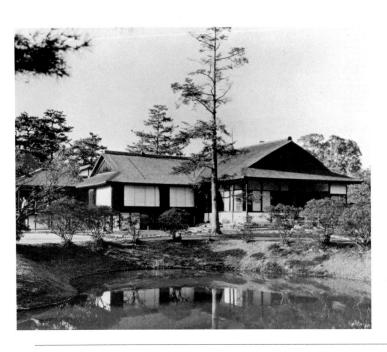

9.50 Plan of shoin, Katsura Imperial Villa.

9.51 General view of shoin, Katsura Imperial Villa, Kyoto, Japan, 1620-63. For an interior view, see fig. 1.6. For a discussion of the villa, see also p. 8. Commissioned by Prince Hachijo Toshihito and his son Toshitada.

European Landscape Painting

uring the seventeenth century, the flat expanses of the Netherlands, reclaimed from the sea and wrested from Spanish domination, were painted thousands of times by Dutch painters. These paintings were avidly collected by the proud and patriotic citizens of the new nation. Although there had been a sporadic interest in landscape among Northern painters during the sixteenth century, it was in the Netherlands in the seventeenth century that, for the first time in the history of Western art, landscape became a truly popular theme. In this century, the Netherlands was more highly urbanized

than any other European nation, and the nostalgia felt by city dwellers for open countryside may have been an additional factor in explaining the popularity of landscape painting.

Despite its relatively small size, *Dutch Landscape from the Dunes at Overveen*, by Jacob van Ruisdael (1628/29–82), captures the salient features of the Dutch countryside: land, sky, and a changing relationship between light and shade (fig. **9.52**). More than two-thirds of the canvas is given over to the clouded sky, which is the dominant feature of the Dutch countryside. The sky becomes the mediator by which

9.52 Jacob van Ruisdael, *Dutch Landscape from the Dunes at Overveen*, c. 1670. Oil on canvas, 1' 9%" \times 2' %" (56×62 cm). Mauritshuis, The Hague, The Netherlands.

we perceive the land as well. As the clouds rush by, the earth is intermittently revealed by patches of bright light. Here Ruisdael has represented the Dutch land not as an idealized vision but as it is, a flat plain below a sky full of clouds, with the sun breaking through in patches.

Ruisdael's landscape is precisely identifiable, for the Gothic church that rises among red tile roofs in the background is St. Bavo in Haarlem. The ubiquitous Dutch windmills, so necessary to keep the land drained of excess water, dot the countryside; in the foreground, small figures stretch linen to be bleached, a proud reference to the prosperous Haarlem linen industry. The function of this realistic representation is clear: to represent and exalt the local countryside and its livelihood. To have such an image hanging in their home would inspire a Dutch merchant and his family with feelings of patriotism.

Although other seventeenth-century painters occasionally demonstrate an interest in landscape—Poussin with his classical landscapes (see fig. 9.43) and Rubens with his view of the Flemish countryside—these are exceptions, and only in the Netherlands did a truly national school of landscape painters develop.

Although the Dutch seem to have preferred realistic views of local scenery, Dutch painters also produced a variety of other types of landscape painting, including seascapes with Dutch vessels and rather fantastic views of wild scenery. A number of Dutch artists settled in Rome, where they painted views of the sun-drenched Italian countryside that were popular back home.

The sixteenth-century Flemish interest in landscape found a successor in Rubens, whose landscapes have the same tumultuous vitality and visual excitement as his religious, mythological, and allegorical pictures. In his landscapes, Rubens puts us in contact with the growth and energies of the world of nature. In his Landscape with Het Steen (fig. 9.53), the rising sun is a shimmering silver-yellow disk near the right edge of the painting. A hunter and his dog in the foreground draw our eyes to a stump, which in turn leads us to an undulating row of trees that surge into the landscape toward the fresh, glowing morning sky. Simultaneously, a peasant family in the shadowy left foreground draws our attention to the opposite direction. Rubens's personal energies and his understanding of the dynamic and ever-changing nature of landscape are here united.

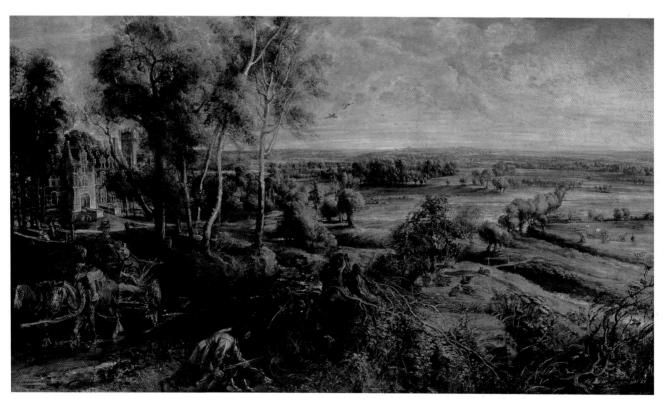

9.53 Peter Paul Rubens, Landscape with Het Steen, c. 1636. Oil on panel, $4' 4'' \times 7' 6'' (1.3 \times 2.3 \text{ m})$. The National Gallery, London, England.

This view of Het Steen, the country estate that Rubens bought in 1635, remained in his possession during his lifetime.

10.1 Joseph Wright of Derby, A Philosopher Giving a Lecture at the Orrery (in which a lamp is put in place of the sun), c. 1763–65. Oil on canvas, $4'10'' \times 6'8''(1.5 \times 2m)$. Derby Museums and Art Gallery, Derby, Derbyshire.

Eighteenth-Century Art

A BRIEF INSIGHT

The eighteenth century was a time of social, scientific, and technological transformation in Western civilization. The philosophy underlying the historical movement of the period, known as the Enlightenment, emphasized the promise of human reason. This painting by Joseph Wright of Derby (1734–1797) possesses the visual eloquence and drama of a grand history painting, yet its subject is contemporary—a philosopher demonstrating the structure of the solar system (fig. 10.1). The device in the center of the composition is an orrery, a mechanical model in which a lamp represents the sun, while the metal spheres are the planets and the curving metal bands the planetary orbits. Within this dramatically lit scene, reminiscent of paintings by Caravaggio, Gentileschi, and Rembrandt, onlookers observe the lesson with rapt attention. That the diverse group includes children, two men—one of whom is taking notes—and a woman is important, for it asserts that scientific understanding belongs to all. Joseph Wright's painting documents not only the growing interest in scientific thought, but also the attitudes necessary to communicate this expanding body of knowledge.

The city of Derby, England, flourished during the Industrial Revolution, and the artist was a member of the "Lunar Society", an organization of philosophers and scientists whose membership included James Watt and Joseph Priestley. The "Lunar Society" met monthly to discuss and demonstrate current ideas and developments in science and technology. While exalting art and science, Joseph Wright's painting also helps to set the stage for a period in which art was intimately aligned with both the status quo and revolution.

Introduction to Eighteenth-Century Art

his interior design for the Princess's Salon (fig. 10.2), by Germain Boffrand (1667–1754) exemplifies the decorative exuberance of the Rococo style, which in eighteenth-century Europe succeeded the Baroque. The decoration of the oval room is animated with carved and painted woodwork, stucco, and a series of integral paintings depicting the tale of the mythological lovers Cupid and Psyche. Webs of gold woodwork and stucco ornament make the white walls seem thin and light, while the undulating movement of the curving cornice joins the rhythm of the delicate arches to further enliven the interior. The effect is elegant and ebullient.

Some similar aesthetic qualities are apparent in the beautiful wooden synagogue of Wolpa, Poland (fig. 10.3), but here the effect is dependent on architectural form and the definition of space rather than on richness of materials and the refinement of decorative patterns. This and other wooden synagogues of this period in Poland provide an important example of how a period style—in this case the Rococo—can be combined with folk traditions to serve a local need. Here the eastern European folk tradition of

10.2 Germain Boffrand, Salon de la Princesse, Hôtel de Soubise, Paris, France, 1736–39. Commissioned by François de Rohan, Prince de Soubise.

The term *hôtel* in this context refers to the lavishly adorned town houses of the French aristocracy.

10.3 Synagogue (now destroyed), Wolpa, Poland, eighteenth century. Wood.

The wooden synagogues in Poland were systematically destroyed during the Holocaust, but fortunately they had been well documented in photographs and drawings.

wooden architecture has been utilized to produce a large religious structure in the fashion of the day. The unknown architects have simultaneously combined a series of balconies, intended for use by the women of the congregation, with elegant curving forms that pull our eyes upward. The four great columns—here timber **piers**—that support the structure were traditional in synagogue design and are a reference to the destroyed Temple of Solomon in Jerusalem.

About twenty years after the Rococo elegance of the Princess's Salon, the English architect Robert Adam (1728–92) began remodeling Osterley Park House. The fireplace niche in the entrance hall (fig. 10.4) demonstrates Adam's use of an alternate eighteenth-century style, Neoclassicism, in which the ornamentation is based on antique prototypes, from the pilasters and coffered half dome to the wall moldings. The axis is visually reinforced by the Neoclassical relief set over the fireplace, while flanking niches with their antique sculptures balance the composition and add further references to the cultures of classical antiquity. In contrast to Boffrand's Rococo interior and the Wolpa synagogue's exuberant spatial effects, Adam's

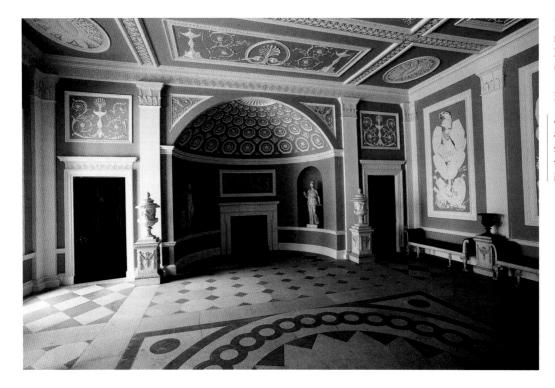

10.4 Robert Adam, Fireplace niche, Entrance Hall, Osterley Park House, Middlesex (London), England. Begun 1761. Commissioned by Francis Child.

Adam's adaptation of classical architectural forms was so successful that one phase of the English Neoclassical style is known as the Adamesque.

Neoclassical design is disciplined and controlled. The antithesis between these designs illustrates the enormous artistic contrasts of the eighteenth century.

HISTORY

The eighteenth century was a period when the difference between the West and the rest of the world became even more pronounced. During this period, traditional values dominated most of the countries of Asia. Both Japan during the Edo period (1615-1868) and China during the Qing Dynasty (1644–1912) continued to be almost exclusively concerned with internal affairs. Both were preoccupied with continuing their own traditions and excluding Western influence. Japan remained closed to the West during this period. During the eighteenth century, Russia and Austria struggled against the Ottoman Turks, although the Ottoman Empire would last until 1918. In northern India, the Mughal Empire was in decline, but in art there was a continuation of traditional values and ideas. In the area we now know as Nepal, the kings of Malla rebuilt their palace (fig. 10.5), which is set on the major city square surrounded by temples. The rectangular form of the palace, with its corner pavilions, suggests a fort, while the large lions that flank the main door are also expressions of royal power. The basic structure is brick, but the elaborately carved and decorated window frames, cornices, and balconies exemplify traditional Nepalese detailing. The main door is emphasized by a carved and gilded composition over the door and an equally elaborate and gilded shrine above it on the third floor.

It was in the West in the eighteenth century, however, that revolutionary currents began to rewrite the face of politics, of social structure, and of art. The memorable opening lines of Charles Dickens's novel about the French Revolution illuminate the European eighteenth century as a whole:

It was the best of times, it was the worst of times, it was the age of wisdom, it was the age of foolishness, it was the epoch of belief, it was the epoch of incredulity, it was the season of Light, it was the season of Darkness.

(Charles Dickens, *A Tale of Two Cities*, first published 1859)

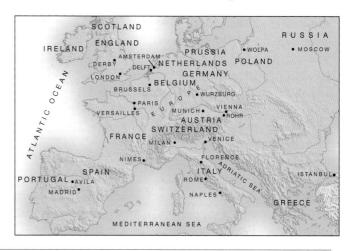

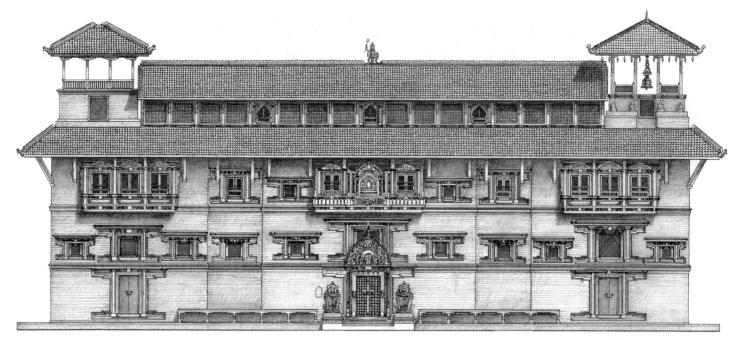

10.5 Keshav Narayan Chowk (Palace of the kings of Nepal), Patan, Nepal. Rebuilt 1734. Commissioned by the kings of Malla.

The palace is located on the main city square, surrounded by thirteen temples and other structures. This urban center, which in 1652 was described by the poet Kunu Sharma as "heaven on earth," was the site for royal and religious ceremonies and processions.

It was a century of social, cultural, and artistic contrasts; prodigious scientific and technological advances; and sweeping political changes. Historians often mark the close of this century as the beginning of modern times.

Politically, the century opened with the dominance of France under Louis XIV. The Baroque portrait by Hyacinthe Rigaud (1659–1743) conveys the solemn majesty of his authority and the opulence with which the French monarchs were surrounded (fig. 10.6). After Louis XIV's death in 1715, however, France's military and political influence began to abate. Frederick the Great, who came to the throne in Prussia in 1740, seized the opportunity to expand and establish the German states as the premier military force on the Continent. To check Prussia's growing political and military strength, France and Austria entered an alliance. In the resulting conflict, known as the Seven Years' War (1756–63), Prussia was victorious. France's holdings and influence in the Americas were diminished when Quebec surrendered to the English in 1759 (see fig. 10.36), effectively ending the French and Indian War in North America. Austria was defeated in the Seven Years' War but prospered in the latter part of the century under Maria Theresa and her son, Joseph II, to become one of Europe's most distinguished centers of culture.

The sumptuousness of eighteenth-century European court life can be seen in *The Ocean's Coach* (fig. **10.7**), which was built to transport the ambassador of the Portuguese king to an audience with Pope Clement XI in 1716. The

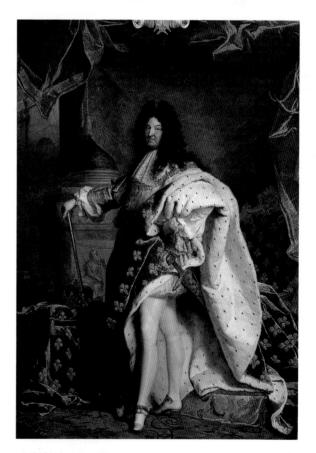

10.6 Hyacinthe Rigaud, *Portrait of King Louis XIV of France*, 1701. Oil on canvas, $9' \times 6'$ (2.7 × 1.8 m). The Louvre, Paris, France. Commissioned by Louis XIV.

elaborate decoration and rich use of color and materials were intended to convey the importance of Portugal—the king was asking the pope to approve two proposals, and it was therefore crucial that the pope be properly impressed with Portugal's significance as a world power. Stylistically,

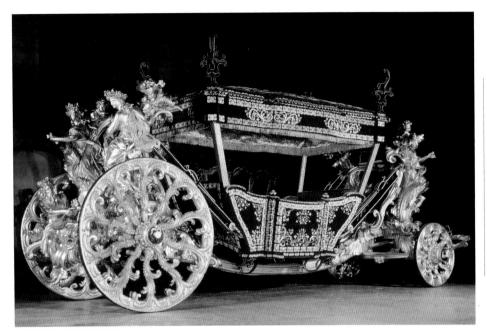

10.7 The Ocean's Coach, 1716, Carved and gilded wood, silk, and iron, 12' × 22' (3.6 × 6.8 m). Museo Nacional dos Coches, Lisbon, Portugal.

This is one of a set of three ceremonial vehicles commissioned from Roman artists by King John V of Portugal to be used by the king's ambassador when he was invited to a papal audience on July 8, 1716. The iconography of the coaches was coordinated. The other two were dedicated to "navigation and conquest" and the "coronation of Lisbon, capital of the empire." It has been proposed that the overall theme may have been designed by the ambassador himself, Rodrigo Anes de Sá Almeida e Meneses, the Marqués de Fontes.

the pope would have recognized the references to the works of Bernini (see figs. 9.2, 9.5, 9.6, 9.22, 9.32), while the figures chosen for the decoration followed well-established conventions for such allegories. Apollo is present, as are figures of the four seasons and a representation of the terrestrial globe with two winged figures representing the north and south poles. The iconography of the coach was intended to remind the pope that it was the Portuguese who had discovered the link between the Atlantic and Indian Oceans. This is emphasized on the back of the coach, where dolphins support figures of allegories of the Atlantic and Indian Oceans as two elderly men shaking hands. Between them, the treacherous Cape of Good Hope is represented as a large, wave-beaten rock.

England's economic stability and political importance grew steadily through the century. By the 1750s, England was established as a maritime power, and the victory over the French in North America gave the English command of much of that continent. By the close of the century, England enjoyed the highest per capita income in western Europe as the new industrial economy took root. London's population grew to more than a million, the first modern European city to reach that size. At the same time, George III, who ruled from 1760 to 1820, saw the power of the monarchy wrested away by Parliament. Increased taxation led the American colonies to declare independence in 1776; and, with French assistance, the colonies defeated the British at Yorktown in 1781. A peace treaty was signed between England and the new American nation in 1783.

The growing desire for self-rule, one of the features of the philosophy of the Enlightenment (see the next section) in response to the authoritarian rule of Europe's traditional absolute monarchs, also affected developments in France. During the reign of Louis XVI and his wife, Marie

Antoinette, lavish government expenditures led to economic depression. As relations between the French aristocracy and the people deteriorated, the National Assembly was formed in 1789 to compose a written constitution for France. During the French Revolution, a constitutional monarchy was established, but internal political factions and outside military pressure threatened the new government. Within France, hostility against the aristocracy rose to a fever pitch by 1792, and in the bloody executions that followed, even Louis XVI and his queen were guillotined. Within this context of domestic uncertainty and foreign wars, a young military commander, Napoleon Bonaparte, rose in power and, at the age of thirty in 1799, was made the first consul of the French Republic.

INTELLECTUAL AND SCIENTIFIC ACTIVITY

The eighteenth century in Europe has been called the Age of Enlightenment. The influence of the Catholic Church declined, and philosophical investigations were directed less to theological than to secular and scientific issues. Descartes' belief in the supremacy of human reason and the centrality of natural sciences, which dates from the seventeenth century, was advanced by eighteenth-century philosophers. The Enlightenment was marked by faith in human reason, natural human rights, science, and progress toward a utopian society. This joining of the natural sciences with philosophical questioning strengthened the belief in empiricism, a view that human knowledge was pragmatically gained from experience and sensation. The foremost proponent of empiricism from the late seventeenth century was the English writer John Locke. Locke's treaties on government, based on his experience with the rise of parliamentary government in England, avowed that

a nation's power derived from its people. The people entered into a social contract with their government and retained the right to dissent and withdraw support if their government proved no longer responsive to their will and needs. Locke's political philosophy guided the American Revolution and the drafting of the U.S. Constitution and, through Voltaire, assisted in fomenting the French Revolution.

Empiricism also fertilized the growth of the natural sciences. Building on Isaac Newton's observations and discoveries, advances continued in physics, mathematics, and astronomy. In 1759, Edmund Halley's name was given to the comet that returns every seventy-six years (see fig. 6.9). Zoology, botany, and mineralogy were established as scientific disciplines. In the 1770s, three different scientists, including Joseph Priestley and Antoine Lavoisier, discovered the reactive element that is essential to life, oxygen. Lavoisier correctly explained the process of combustion, and gave oxygen its name. Constant improvements in devices such as the telescope, microscope, barometer, and thermometer allowed for greater accuracy in scientific observation, which in turn led to more accurate estimates of the structure of the universe, including the planetary orbits (see fig. 10.1).

Technology benefited from this increasing scientific knowledge. New processes in metallurgy contributed to the use of iron as a building material, and the perfection of the steam engine by James Watt in 1769 brought Europe closer to the momentous and far-reaching economic and social changes of the Industrial Revolution.

EIGHTEENTH-CENTURY ART

The Rococo and Neoclassical styles dominated the visual arts in Europe during the eighteenth century. The term "Rococo," derived from the French *rocaille* (literally "rockwork" or "rubble"), was first used to designate a style of French art associated with the reign of Louis XV. In early eighteenth-century France, charm and finesse were the hallmarks of an artificial code of social behavior. The Rococo's light ornamental elegance, as exemplified in the portrait (fig. 10.8) by Elizabeth Vigée-Lebrun (1755–1842), expressed the artificiality of aristocratic values and tastes.

The contact with other cultures that brought new styles and aesthetic ideas into European art reveals both an interest in exotic ideas as well as a superficiality of response to outside cultures and influences. The style known as *chinoiserie*, for example, was popular for chairs, tables, wallpaper, porcelain, clocks, and other decorative arts (see fig. 10.14). Beds were designed that took their decoration from the roofs of Chinese Buddhist pagodas, and pieces of Chinese porcelain of elegant simplicity were enshrined in elaborately decorated Rococo mounts. Although Europeans

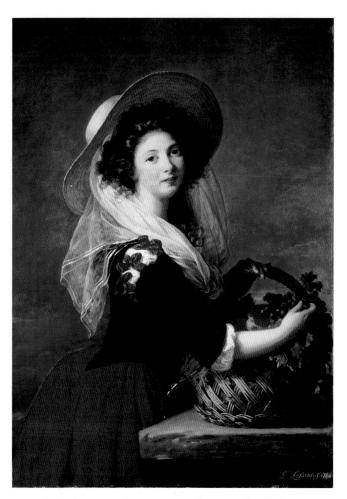

10.8 Elizabeth Vigée-Lebrun, *Portrait of Marie Gabrielle de Gramont, Duchesse de Caderousse*, 1784. Oil on wood, 3' 5%" × 2' 5%" (106 × 76 cm). The Nelson-Atkins Museum of Art, Kansas City, Missouri.

Elizabeth Vigée-Lebrun wrote: "I could not endure powder. I persuaded the handsome Duchess De Gramont-Caderousse to put none on for her sitting. Her hair was ebony black, and I divided it in the forehead, disposing it in irregular curls. After the sitting, which ended at the dinner hour, the Duchess would not change her headdress but go to the theatre as she was. A woman of such good looks would, of course, set a fashion: indeed, this mode of doing the hair soon found imitators, and then gradually became general. This reminds me that in 1786, when I was painting the Queen, I begged her to use no powder, and to part her hair on the forehead. I should be the last to follow that fashion,' said the Queen, laughing; I do not want people to say that I adopted it to hide my large forehead.''

in general made little attempt to understand the Chinese civilization, there were few European eighteenth-century palaces that did not have a room decorated in this style derived from Chinese art and architecture. This approach to foreign cultures—borrowing without understanding—reveals the attitudes typical of Westerners during much of the early modern period. In colonies controlled by European nations, European style was imported although local artists often transformed elements of the design to reflect local taste. Architecture in the areas of the Americas

controlled by Spain and Portugal, for example, reflected the European Baroque but with increased richness and complexity. The facade of Havana Cathedral in Cuba is a case in point (fig. 10.9). Its similarity to the facade of Borromini's San Carlo in Rome (see fig. 9.31) is evident, but here the design is characterized by more elaborate decorative motifs. The broken cornice that creates the silhouette of the top of the facade exemplifies the changes that occurred in the American reinterpretation of the European

The Neoclassical style, first named in the midnineteenth century, developed as an alternative to the Rococo in the eighteenth. Fueling the Neoclassical style at mid-century was a reawakened interest in classical antiquity spurred by the rediscovery of two Roman cities that had been buried by the first-century eruption of Mount Vesuvius: Herculaneum was found in 1738 and Pompeii in 1748 (see pp. 116-17, 126-27). Neoclassicism is the first in a series of revivals—some nostalgic, some ideological—that would flourish in the nineteenth century, and because of this, Neoclassicism is sometimes understood as the first step in the development to the broader movement known as Romanticism (see pp. 431, 444–45).

The most eloquent spokesperson for Neoclassical taste was the German art historian Johann Winckelmann, who had his portrait painted by Angelica Kauffmann, one of the most famous artists of the period. He viewed the rationality and ideality of classical art as the summit of artistic achievement. In his influential Thoughts on the Imitation of Greek Art in Painting and Sculpture of 1755, Winckelmann wrote:

Good taste, which is spreading more and more throughout the world, had its beginning under a Greek sky.... To take ancients for models is our only way to become great, yes, unsurpassable if we can. As someone has said of Homer: he who learns to admire him, learns to understand him; the same is true of the art works of the ancients, especially the Greeks.

Neoclassical art was well suited to the changing political realities of the late eighteenth century. Compared to the lighthearted and aristocratic elegance of Rococo art, the Neoclassical style offered a restrained design that was intended to convey a moral dignity. As ancient classical edifices first bore witness to the representative governments of Athens and Rome, what better style was there to emulate during the new age, which asserted that each individual had natural rights-or, in the words of the Declaration of Independence, "unalienable rights"—and that among these was a voice in government? To the Neoclassicists, the art and history of the classical world offered models to be used as guides for human behavior and achievement.

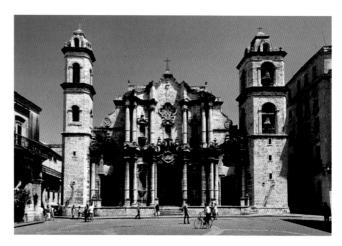

10.9 Havana Cathedral, Cuba, facade. Begun 1748, completed c. 1777.

THE EIGHTEENTH-CENTURY ARTIST

The education of artists in academies was now firmly established in Europe. The Royal Academy of Painting and Sculpture in Paris, founded in 1648, flourished, sending promising students to Rome to study classical art. Its primacy was gradually challenged by the Royal Academy of Arts, founded in London in 1768, which also championed Neoclassicism. The guiding spirit of England's Royal Academy was Joshua Reynolds (1723-92), a painter who had spent two years in Italy studying both ancient and Renaissance art (see fig. 10.27). As the Royal Academy's first president, Reynolds delivered fifteen Discourses which expressed his views on the "grand style" of art and outlined an education based on imitating the perfection of nature as revealed through classical and High Renaissance art:

The moderns are not less convinced than the ancients of [the] superior power existing in art; nor less sensible of its effects.... The gusto grande of the Italians, the beau ideal of the French, and the great style, genius, and taste among the English are but different appellations of the same thing. It is this intellectual dignity ... that ennobles the painter's art ... we must have recourse to the ancients as instructors ... they will suggest many observations, which would probably escape you, if your study were confined to nature alone.

Reynolds also recommended the study of the "great masters" of the Italian Renaissance:

I would chiefly recommend, that an implicit obedience to the Rulers of Art, as established by the practice of the great masters, should be exacted from young students. That those models, which have passed through the approbation of ages, should be considered by them as perfect and infallible guides; as subjects for their imitation, not their criticism.

Although the Royal Academy was founded to raise the status of both the arts and the artists, its conservative dogmatism, as revealed by Reynolds's preemptory language, began to be viewed by some as a constrictive environment. The tradition of the academy, which in the later sixteenth century had begun as part of a liberating ambiance for the artist, was now becoming a conservative cloak, dictating priority to history painting, which was promoted as the most noble of artistic expressions. History painting drew its iconography from the classical past and, less often, the more recent past. Themes were selected that could be interpreted on several levels. Academic history painters most often picked themes that exemplified an elevated code of human behavior. Such themes were considered appropriate for the "grand style" or the "grand manner" in art.

To truly understand the "grand style," every artist who aspired to gain professional fame felt compelled to make a tour of the antiquities of Italy. We can grasp the importance of viewing the actual artistic remains of the classical and Renaissance past from the letters of Benjamin West (see p. 423), an American painter who, en route to London, traveled from 1760 to 1763 through Italy. West later wrote to another American artist, John Singleton Copley, advising him on what to see in Italy:

In regard to your studies in Italy my advice is as follows: That you pursue the higher Excellences in the Art, and for the obtaining of which I recommend to your attention the works of Ancient Sculptors, Raphael, Michelangelo, Correggio, and Titian, as the Source from which true taste in the arts have flowed.

This counsel from Benjamin West to his American colleague was not unique, but rather was repeated in a variety of ways and on numerous occasions as Europeans and Americans prepared for their grand tour of Paris and the major Italian cities. Such a tour, which could last for months or even years, was viewed as an obligatory part of a cultural education; it assisted in the promulgation of Classical and Renaissance artistic values throughout the West. The grand tour also gave rise to the *veduta*, a painting or print that featured a picturesque view of ancient ruins or a romanticized view of the contemporary cityscape. Giovanni Battista Piranesi (1720-1778) became famous for etchings depicting the monumental ruins of ancient Rome as seen within their eighteenth-century urban environment. View of the Piazza della Rotonda (fig. 10.10) is typical of the vedute sold to eager tourists as souvenirs of their visit to Rome. Through the relatively large size of the prints, the

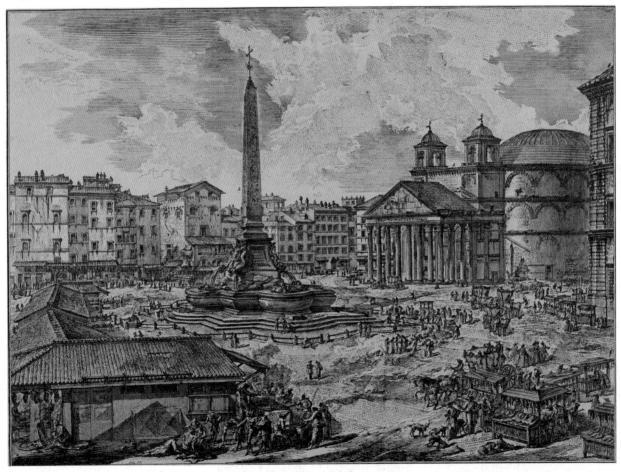

10.10 Giovanni Battista Piranesi, View of the Piazza della Rotonda, 1746-48? Etching, 15%" x 21½" (39 × 54.5 cm).

use of dramatic atmospheric effects, and manipulations of scale, Piranesi aggrandized the monumentality and continuing importance of ancient Rome.

In terms of European patronage, little changed in the eighteenth century. The grandest projects were those commissioned by royalty, nobility, and the Church, but in a democratic society like America the state also began to become an important patron, as revealed in Thomas Jefferson's Capitol for the State of Virginia (see fig. 10.29). Portraits were a staple product for both painters and sculptors. The growing importance of academies and their exhibitions and competitions (such as the Prize of Rome) meant, however, that artists were encouraged to develop large display pieces with a subject of their own choosing. Some artists, such as Hogarth (see fig. 10.17) and David (see fig. 10.32), created works that make a powerful personal statement intended for the public; their belief that art could reform society led to some of the most idealistic art of this period and has influenced our belief in the power of art to the present day.

Eighteenth-century artists' self-portraits reflect the vitality of the different art styles that characterized the Age of Enlightenment. Adélaide Labille-Guiard (1749–1803) continued the Rococo style into the latter years of the century. Noted for her abilities as both an artist and a teacher, she depicted herself, in elegant dress, at her easel with two attentive students (fig. 10.11). An early self-portrait by Angelica Kauffmann (fig. 10.12) shows the young artist between figures representing the classical allegories of Music and Painting. Kauffmann, who was also an accomplished musician, here adapted the Neoclassical style to demonstrate her dilemma at having to choose between music and painting as a career.

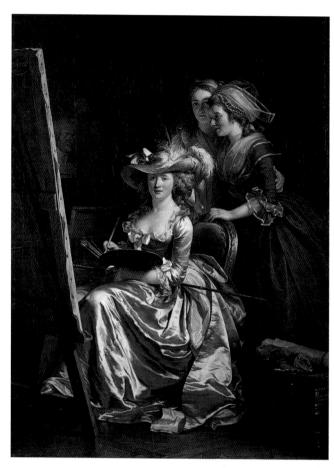

10.11 Adélaide Labille-Guiard, Self-Portrait with Two Pupils, 1785. Oil on canvas, $6' 10\%'' \times 4' 11\%'' (2.1 \times 1.5 \text{ m})$. The Metropolitan Museum of Art, New York.

Labille-Guiard was instrumental in convincing the French Academy to lift its quota on women members, who had been limited to four, and to allow women professors.

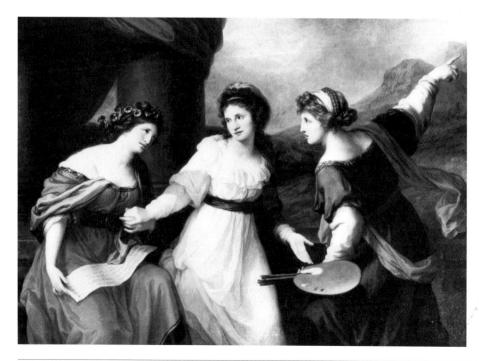

10.12 Angelica Kauffmann, *Self-Portrait Hesitating between the Arts of Music and Painting*, 1791. Oil on canvas, 4' 10" × 7' 2" (1.47 × 2.18 m). Nostell Priory, Yorkshire, England.

Kauffmann's importance to her contemporaries was recognized when she was named a founding member of London's Royal Academy of Arts. Her portrait and that of Mary Moser, the only other woman artist to have membership in 1769, hang on the wall in Johann Zoffany's painting *The Life Drawing Class at the Royal Academy* (fig. 10.13). Although both were members, their absence from the life drawing class because of the use of a nude male model exemplifies the barriers to women that co-existed with more progressive attitudes.

The studio depicted in Zoffany's painting reveals the increasingly conservative aspects of academic education in

the arts. Plaster casts of classical sculpture, which were held to exemplify the highest ideals of art, line the walls, and the emphasis on drawing from the nude male model reinforced the emphasis on the figure as the primary vehicle for artistic expression. By the eighteenth century, academies like this one were found throughout Europe, and a new definition of the fine arts (*les beaux arts*) was developed that included painting, sculpture, poetry, music, and dance on the basis that these are the arts that delight us. Arts that primarily serve a utilitarian purpose continued to be termed mechanical arts, while architecture, which was considered to combine usefulness with beauty, occupied a third, independent category.

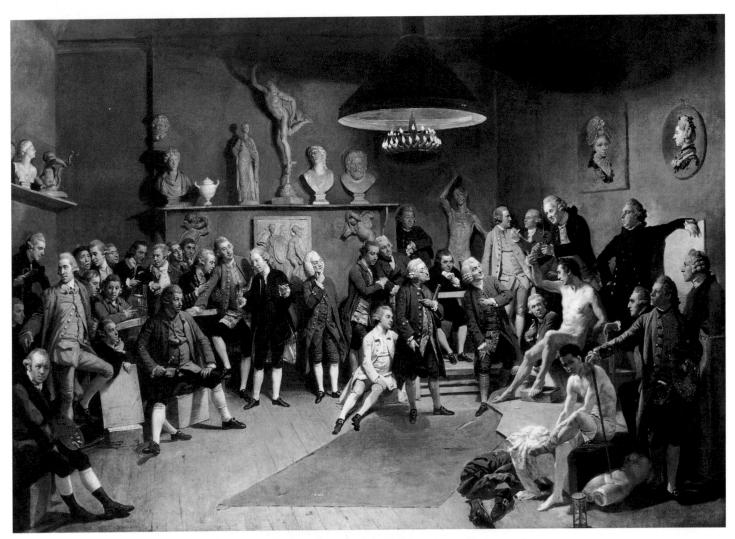

10.13 Johann Zoffany, *The Life Drawing Class at the Royal Academy*, 1772. Oil on canvas, $3' 4" \times 4' 10" (1 \times 1.47 \text{ m})$. Collection Her Majesty the Queen, Windsor Castle, Windsor, Berkshire, England.

Zoffany's painting shows the members of the Royal Academy. The sculpted figure with a raised right arm, just below the lamp, is an écorché, a sculpture of a flayed anatomical figure used to study surface muscles.

CHAPTER 10

Chinoiserie

Chinoiserie is the French word that refers to a European artistic style of the 17th and 18th centuries that is characterized by the use of fanciful imagery of an imaginary China. The earliest hints of Chinoiserie appear in the early 17th century in the arts of two nations with active East India Companies, the Netherlands and England; by the mid-17th century it was found in Portugal as well. Commercial traders imported Asian ceramics, presenting them as exotic, yet representative of the far-away culture of Cathay; some were modified by the addition of Rococo decorative bases and other elements, as seen here (fig. 10.14). Tin-glazed pottery made at Delft adopted Ming blue and white decoration, à la chinoise. Early ceramic wares at Meissen and other European centers of true porcelain imitated Chinese shapes for dishes, vases, and tea wares while duplicating the technical sophistication of Chinese porcelain with only partial success. Chinoiserie décor created a fairyland where mandarins and demigods carried flower parasols and lived in fanciful mountainous landscapes with cobweb bridges.

But Chinoiserie had little to do with China. Instead, such works assumed the look of exotic imports while remaining largely European. Even Antoine Watteau (see fig. 10.15), who certainly saw Chinese paintings and claimed to be painting in the Chinese manner, merely toyed with pseudo-Chinese motifs in a decorative way. We do not know if he actually examined Chinese paintings, and in seems unlikely that he ever seriously thought about one. On the other hand, the situation was quite different among Enlightenment philosophers and writers, whose thinking was affected by their reading of the Chinese classics in translation. It is noteworthy that, in spite of the enthusiasm for things Chinese, the Chinese visual arts had little effect on the course of European art during this period.

10.14 Coffee or Chocolate Urn, c. 1710–30. Glazed Chinese porcelain lidded jar with French gilt-bronze stand and mounts, height 13½" (33.5 cm). Victoria and Albert Museum, London.

Representing Women

Professional Women

(figs. 10a and 10b) It is not always possible to separate the representation of women in art from the subjugation of women in history. Many of the idealized images of women found in museums, for example, were created not simply to celebrate the beauty of women but to establish and maintain their subordinate role in society. These two representations of eighteenth-century women, however, demonstrate that during this period women were gradually claiming new roles in Western culture, especially in the arts. Angelica Kauffmann's self-portrait suggests that she had skills in both music and art, and represents publicly her ability as an individual to choose between them. While in Shakespeare's time the roles of women in plays were taken by men, by the eighteenth century these roles were being played by women, some of whom, like Sarah Siddons, became the media stars of their generation. Thomas Gainsborough's portrait shows an elegantly dressed woman, but the strongly naturalistic quality in the face and pose emphasizes her individuality.

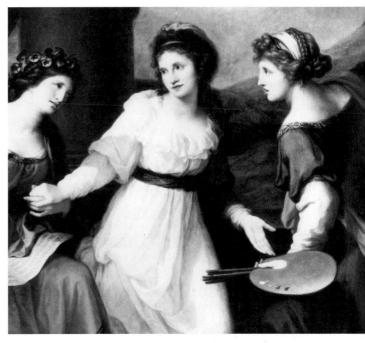

10a Angelica Kauffmann, *Self-Portrait Hesitating between the Arts of Music and Painting*, 1791 (for further information, see fig. 10.12).

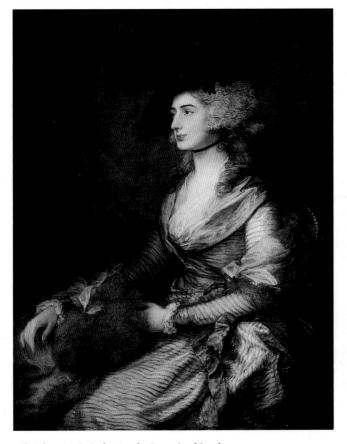

10b Thomas Gainsborough, *Portrait of Sarah Siddons*, 1783–85 (for further information, see fig. 10.28).

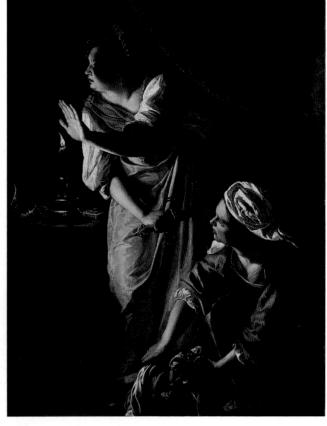

10c Artemisia Gentileschi, *Judith and Her Maidservant with the Head of Holofernes*, c. 1625 (for further information, see fig. 9.16).

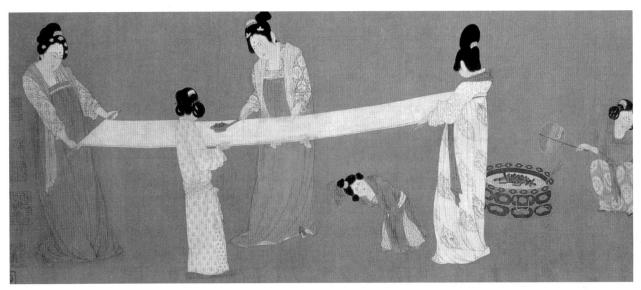

10d Copy after Zhang Xuan, Court Ladies Preparing Newly Woven Silk, twelfth-century copy, after an eighth-century handscroll (for further information, see fig. 5.33).

Woman as Hero

(fig. 10c) Heroic women are not uncommon in literature, mythology, and religion; one of the most impressive of these is the Hebrew woman Judith, who defeated the enemy by cutting off the head of their general, Holofernes. In her painting of this scene, Artemisia Gentileschi exalts Judith and her maid by their large scale (in the original painting the women are larger than life-size), and the danger and suspense of their mission is clear in the moment depicted. Artemisia Gentileschi represented this subject several times, and she surely intended that the brave Judith be understood as a model for female behavior.

The Ages of Women

(fig. 10d) As is the case with many representations of aristocratic women, the artist here has emphasized the elegant costumes, elaborate hairstyles, and refined poses. While many portraits and representations of women from earlier periods suggest that they should be elegant but inactive, in this Chinese scroll painting the women are shown working to prepare one of China's traditional luxury goods, silk.

A Modern View

(fig. 10e) By the mid-twentieth century, commercialism's commodification of goods and ideas pervaded American society. Despite Marilyn Monroe's desire to be recognized as a serious actor, the movie industry sold her to the public as a ditzy, voluptuous blonde. While hugely famous, Monroe felt trapped by being commodified in this way. Gainsborough's 18th-century portrait of Sarah Siddons emphasizes that actress's individuality; on the occasion of Monroe's suicide in 1962, Andy Warhol appropriated a 1953 publicity shot for this screenprinting, memorializing the actress in an ironic stereotype.

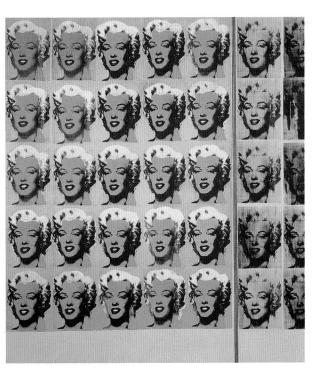

10e Andy Warhol, Marilyn Diptych, 1962 (for further information, see fig. 13.17).

Questions

- 1. Select a representation of a woman from a contemporary magazine, or an advertisement that features a woman. What does this representation tell you about attitudes toward women at this time in history?
- 2. Is this representation typical of broader attitudes, or is it exceptional?

Eighteenth-Century Painting in Europe

Pilgrimage to the Island of Cythera, by Antoine Watteau (1684–1721), combines reality and fantasy to express the transitory nature of romantic love (fig. 10.15). Delicately scaled couples in eighteenth-century dress move slowly toward a fanciful ship that will return them from the island of Cythera, mythical home of Venus, goddess of love. The statue of Venus at the right has been adorned with garlands by these pensive lovers, who came to worship at her shrine and engage in the rituals of her cult. Their reluctance to leave pleasure behind is expressed in their gestures and poses, while muted colors and light brushstrokes express the transience of love. The composition moves from the statue of Venus to the vessel of departure, reversing our normal reading direction and heightening the bittersweet nature of the departure. Watteau evokes the poetry of love and yet suggests how remote it is from everyday reality. Romantic love survives only in the world of imagination.

Fragonard's painting, on the other hand, reaffirms the pleasures of lovers' games (fig. **10.16**). Jean-Honoré Fragonard (1732–1806) received the commission for the painting from Baron de Saint-Julien, who specified the details of the subject. His mistress is in a swing pushed by a bishop:

so high that her slipper falls off the tip of her foot and her skirt shoots upward for the delight of the indiscreet eyes of a charming youth reclining among the flowers beneath her; happily there hovers above him a cupid whose gesture enjoins him to keep the secret of what he has seen. The theme incorporates an obvious pun, for the baron served as the government representative who collected the taxes paid by the Church. His title was *Receveur général des biens du clergé* ("Receiver general of the 'goods' offered by the clergy"). Fragonard's pastel palette, which centers around the pink dress and blue-green trees, and the delicate lightness of his brushstrokes accentuate the frivolity of the subject.

The qualities seen in these two works help define Rococo painting. The colors are usually light, and the thin paint is delicately brushed onto the surface. The figures are generally small and delicate in proportion, and the composition creates a flowing, idyllic movement. Common themes are superficial scenes from court life, especially romance.

Marriage à la Mode, a series of paintings by William Hogarth (1697–1764) that were later also reproduced as prints, satirizes modern life and exposes the difficulties of a loveless "city" marriage of convenience (fig. 10.17). The follies of both the nouveau riche and the nobility are illustrated throughout the series, which begins with the signing of the marriage contract between the daughter of a rich, social-climbing merchant and an impoverished nobleman (Count Squanderfield). In a sequence of six scenes, their marriage progresses through adultery, the murder of the husband by the wife's lover (Silvertongue), and her death by suicide, leaving their only child an orphan. Our scene shows the husband returning at 1:20 P.M. with a hangover after a long night on the town. The dog sniffs at a woman's cap hanging from his pocket. His pose is meant to suggest

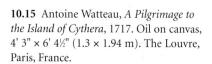

As Watteau's reception piece for the French Royal Academy, this painting was listed as "une fête galante," a new category of painting in which elegant aristocratic men and women are represented partying in a landscape setting.

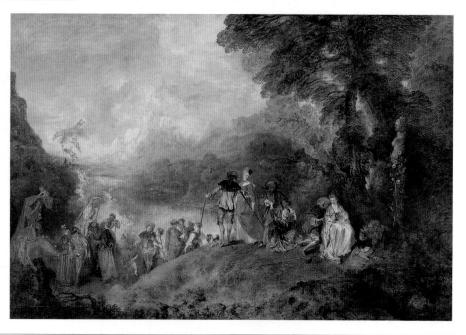

1700 London, Europe's largest city, reaches 550,000 population

1715 Dutch trade with Japan is restricted

1717 Watteau, A Pilgrimage to the Island of Cythera (fig. 10.15)

1724 Convent for Native American women founded, Mexico

1741 V. J. Bering explores the coast of Alaska

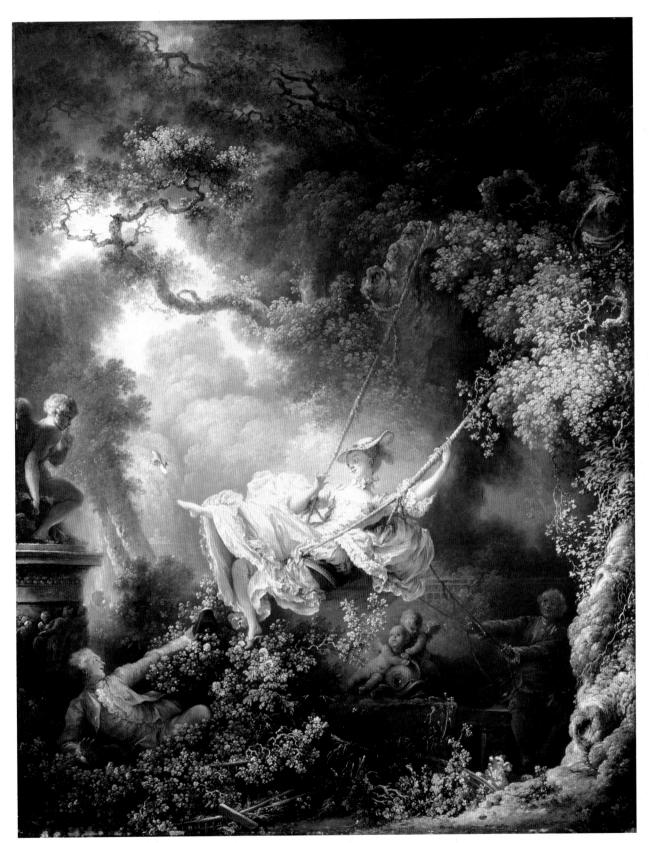

10.16 Jean-Honoré Fragonard, Happy Accidents of the Swing, 1767. Oil on canvas, $31\%" \times 25\%"$ (81 × 64 cm). Wallace Collection, London. Commissioned by Baron de Saint-Julien, Receveur général des biens du clergé.

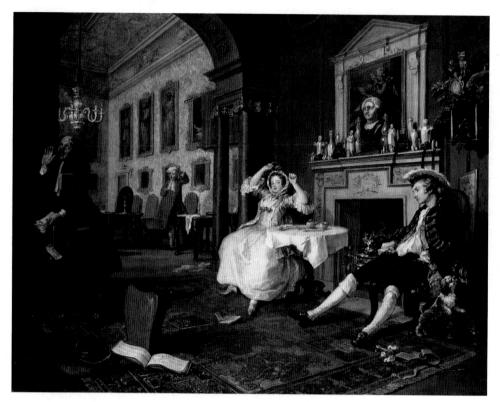

10.17 William Hogarth, *Marriage à la Mode, Scene II*, 1743. Oil on canvas, 2' $3\frac{1}{2}$ " × 2' $11\frac{3}{4}$ " (70 × 91 cm). The National Gallery, London, England.

This is the second scene in a series of six. To Hogarth's contemporaries, "à la mode" implied something fashionable but cheap and short-lived. The series was subtitled Modern Occurrences in High Life. Hogarth's painted series on moral subjects was reproduced as popular engravings. The artist compared himself to dramatists and novelists, saying that he "considered subjects as writers do," adding, "My picture was my stage and men and women my actors." The inspiration of contemporary English theater (Gay) and literature (Fielding, Defoe) on Hogarth is well documented. In two earlier series, Hogarth chronicled A Harlot's Progress (1728–30), which follows an attractive young girl from her arrival in London, where she is discovered by a procuress, to her death, and A Rake's Progress (1735), in which a weak young man wastes his father's fortune, ending up in an asylum, probably the infamous English Bedlam.

sexual exhaustion. His wife's pose, the overturned chair, and scattered music suggest that she has been carrying on with her music teacher, who seems to have departed quickly. Extravagance is evident in the ugly mantelpiece, with its ostentatious display of bric-a-brac, and the stack of bills held by the clerk. The painting over the mantel features a figure of Cupid, Venus's son and assistant, blowing a bagpipe—an inharmonious phallic symbol—amid ruins. The venereal disease that will ultimately infect the couple's child is already evident in the black spot on the husband's neck. In style, the looseness of Hogarth's brushstrokes is indebted to the example of contemporary French painting.

Romantic love—its dreams and disappointments, pleasures and pains, realities and fantasies—becomes a central theme in Rococo art. The variety of interpretation demonstrated in these three examples, as well as their probing character, reveals an important change that is taking place as the themes of art broaden, disclosing an expanding interest in the psychological and emotional states that affect people in their everyday lives.

The darker aspects of the human subconscious were explored by Henry Fuseli (1741-1825), a Swiss artist who studied in Rome from 1770 to 1778 but whose artistic career primarily was based in England. Ignoring the neoclassical attitudes of artists such as Anton Raphael Mengs (see fig. 10.33) and the "grand style" of Reynolds (see fig. 10.27), Fuseli created an intensely subjective response to evocative and emotional psychological states. The Nightmare (fig. 10.18) brings to life the cross-fertilization of mythology and the subconscious. In medieval legend, an incubus is an evil spirit that would descend and rest on the chest of sleeping maidens, causing them to have tormented, erotic nightmares. Fuseli's painting depicts a virgin, symbolized by her white dress, who is limp and exhausted from a terrible encounter. The incubus turns its face to us to defiantly dare our interference, while a dark horse with bulging, frantic eyes adds to the frightfulness of the scene. The Baroque-like exaggeration of light and dark passages contributes to the drama and emotive impact of the composition. Fuseli's painting, which opens us to the world of the

emotive and imaginative, prefigures the later developments of Romanticism (see pp. 431, 444–45).

The genre and still-life paintings (fig. 10.19) of the French artist Jean-Baptiste Siméon Chardin (1699–1779) offer simplicity and a quiet dignity unusual in eighteenthcentury art. Chardin was inspired by Dutch seventeenthcentury artists who conjoined the mastery of naturalistic depiction with underlying moral content (see pp. 362-63, 386-87). The subtle composition of the eggs, meat, fish, cooking utensils, and pottery in his Kitchen Still Life is enhanced by the subtle differentiations of light that emphasize diverse textures; at the same time, Chardin's paint is applied with a liquidity that reminds us of the inherent beauty of the oil medium. Far from the thematic gaiety of Rococo painting or the political weight of Neoclassical art (see pp. 420-23), Chardin's painting, in an almost emblematic way, asserts the fundamental values and simple nobility of human existence.

10.18 Henry Fuseli, The Nightmare, 1781. Oil on canvas, 39¾" × $49\frac{1}{2}$ " (101 × 127 cm). The Detroit Institute of Arts.

10.19 Jean-Baptiste Siméon Chardin, Kitchen Still Life, c. 1731. Oil on canvas, 12½" × 15¾" (32 × 39 cm). The Ashmolean Museum, Oxford. Bequeathed by Mrs. W. F. R. Weldon.

Eighteenth-Century Art in Korea

hile the elegant shape of this jar (fig. 10.20) reflects the continuing influence of Chinese ceramics, the brilliant white glaze was a new, Korean development. During the eighteenth century, delicate white porcelain ware displaced the green celadon ceramics previously preferred in Korea. The restrained quality of the new white porcelain harmonized with Confucian ideals. The somewhat irregular shape creates a gently curving silhouette, while the surfaces appear to be snow-white. Under the influence of the prevailing ideology of self-examination and discovery, this type of ceramic ware was asserted as a classic example of Korean form and expression.

During the Choson Dynasty (1392–1910), Confucianism had gradually replaced Buddhism as the official ideology, and new forms of art that were focused more on this world were developed. The mixture of local customs, shamanism, Buddhism, and Confucianism that had emerged by the late eighteenth century continued until about 1950, and the arts that had emerged during the late Choson shaped the modern arts of Korea.

After the ideological and political disputes in the seventeenth century, philosophy and society stabilized in the eighteenth century in new forms that celebrated Korea's self-sufficiency in philosophy, literature, and painting. In philosophy, this was expressed in the Practical Learning School of thought. In literature, poetry written by lowergrade officials began to be published, a previously unheard-of phenomenon, and novel-writing flourished in the Korean vernacular. True-view landscape paintings, such as those by Chong Son (1676–1759), and genre paintings by Danwon (Kim Hongdo, b. 1745) distinguished the visual arts of the period (see figs. 10.21, 10.22). Even literati paintings introduced Korean elements into their artistic canon and pictures of Korean plants and animals forged a new, local identity.

10.20 Large jar, late Choson period, eighteenth century. Ceramic, height 14 ¾" (37.5 cm). The Metropolitan Museum of Art, New York.

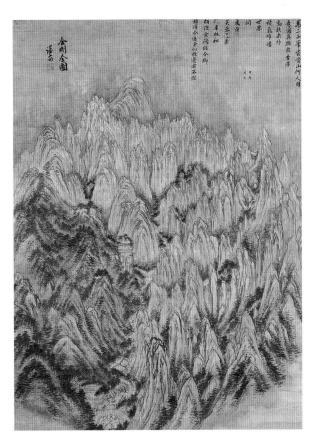

10.21 Chong Son, Twelve Thousand Peaks of Mount Kumgang, 1734. Hanging scroll, ink, and light color on paper, 4' 3% " \times 3' 1" (131 \times 94 cm). Ho-Am Art Museum, Yongin, Korea.

Part of the inscription on the painting reads "... the aura of Kumgang Mountain rose to the far side of the East Sea; its energy bathed the whole world."

Until the late seventeenth century, the Choson monarchy was a subject of China, and Korean Confucianism was idealistic and theoretically pure. By the eighteenth century, a new Korean self-image had coalesced. Along with the emergence of national and self consciousness, the middle class, both rural and urban, was becoming increasingly enfranchised and affluent. Cultivation of the nation and the self replaced dependence on Chinese models.

Korean paintings began to extol the scenic and historic features of Korean sites, such as Mount Kumgang (Diamond), a mountain setting in what is now North Korea (fig. 10.21). Chong Son worked in the Wu landscape style that had been developed by scholar-painters of the Ming Dynasty in China, but while in China this style had focused on expressing a spiritual dimension, Chong Son used it to depict actual places in Korea. Combining the self-consciousness advocated by the School of Practical Learning; traditional Chinese pictorial ideas and brush methods; and a new Korean aesthetic, he rendered his vision of the world in which he lived. The distant peaks are boldly rendered with vertical strokes, while mist or clouds encircle the scene. The dynamism and occasional roughness of Chong Son's brushwork give his subjects a freshness and vitality that were identified as particularly Korean.

Kim Hongdo's genre paintings reflect the growing interest in the lives of the common people during the eighteenth century. The most famous of these are twenty-five album leaves that represent such everyday activities as washing clothes, eating, and tiling a roof (fig. 10.22), as well as such interesting characters as wrestlers, entertainers, schoolboys, peddlers, and farmers. Kim's paintings are characterized by few or no background elements and by a masterful arrangement of figures in space. In Roof Tiling we see a range of tasks: the planing of wooden planks, the lifting of tiles to the roof, and observation by a townsman, perhaps the patron or overseer. The immediacy of the moment is rendered in quick brushstrokes that display Kim's understanding of the activity. Series of small pictures like this one were bound in albums and their engaging subjects were of interest to a broad cross section of Korean society of the eighteenth century.

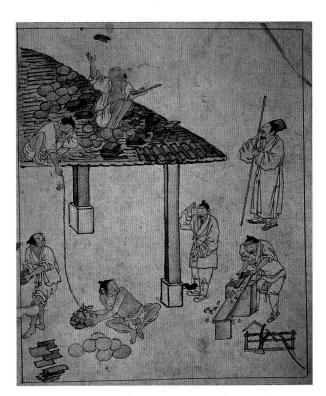

10.22 Kim Hongdo, Roof Tiling, late Choson period, eighteenth century. Album leaf, ink, and light color on paper, 11" × 9½" (28 × 24 cm). National Museum of Seoul, South Korea.

Rococo Architecture and Sculpture

10.23 Johann Balthasar Neumann, Giovanni Battista Tiepolo, and Antonio Bossi, Kaisersaal (Imperial Hall), Episcopal Palace, Würzburg, Germany, 1735–44. Commissioned by the Prince-Bishop of Würzburg.

The 1751–52 frescoes by Tiepolo represent scenes glorifying the twelfth-century German emperor Frederick Barbarossa and the prince-bishop of Würzburg. The stucco work is by Antonio Bossi. The Italian painter Tiepolo spent three years in Würzburg decorating this official residence of the prince-bishops of Würzburg.

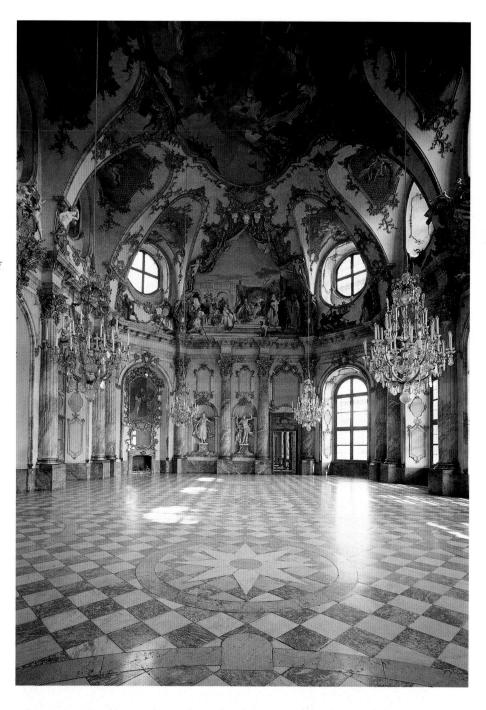

he Kaisersaal documents the life of the aristocracy in the eighteenth century (fig. 10.23). One must imagine it filled with elaborate furniture of the period, its crystal chandeliers lit with flickering candles. The shape of this elegant salon is too complicated to be either an oval or an octagon, but it is surmounted by a high oval dome pierced by windows. The columns seem to be a beautiful pink marble, but like most such columns in Rococo buildings they are stucco, painted and polished to

give the illusion of marble. The lightness of the architecture is enhanced by the large, irregular frescoed oval and by two scenes enframed by elaborate, gilded stucco "curtains." Painted figures and animals by Giovanni Battista Tiepolo (1696–1770) seem to wander out onto the entablature to chat, sit, and look down at us.

The Rococo style in architecture developed in France at Versailles about 1700 and flourished in southern Germany in part because of political connections. The palace at

1721 J. S. Bach, Brandenburg Concertos

1735-44 Neumann, Kaisersaal (fig. 10.23)

1739 John Wesley founds the Methodist movement

1741 George Frederick Handel, Messiah

1762 Catherine the Great becomes Tzarina of Russia

Würzburg was built by a family of local hereditary princebishops who set out to surpass Versailles (see fig. 9.1). The Rococo style is perhaps at its most exuberant here, where all restraint seems to evaporate in gilded decoration, fake marble columns, and an indissoluble union of painting and architecture. Although it owes its origins to the classical vocabulary of the Renaissance, the Rococo offers a new lightness of color and of movement and a new delicate scale of ornament, which are in contrast to the more ponderous forms and colors of Baroque architecture.

At the Monastery Church of Rohr, a light-filled white and gold nave directs attention to the richer colors of the columns behind the high altar that enframe a monumental sculpture group (fig. 10.24). While gesticulating apostles surround a Rococo sarcophagus, we gasp as we seem to witness the Virgin being carried to heaven by angels. The architecture seems to open and a golden stained-glass window offers a portal to heaven. Since the Renaissance, religious drama had used special effects of lighting (candles, torches, fireworks) and theatrical machinery to make transcendent miraculous events seem more realistic and more dramatic, and one of the most successful Counter-Reformation tools employed by the Jesuits in southern Germany was the use of sacred theater as a teaching device. This Assumption, by Egid Quirin Asam (1692–1750), suggests the effectiveness of these theatrical representations.

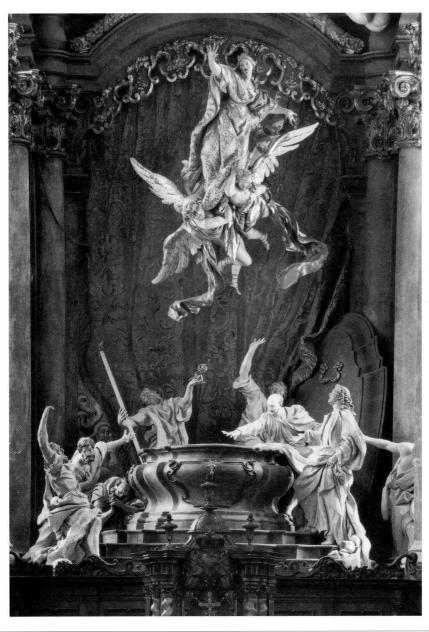

10.24 Egid Quirin Asam, Assumption of the Virgin, detail, 1721-23. Painted and gilded stucco and stained glass. Monastery Church, Rohr, Germany.

Eighteenth-Century Portraiture

he honest and informal portrait of the Boston silversmith and engraver Paul Revere by John Singleton Copley (1738-1815) represents both the New England work ethic and Copley's artistic joy in rendering exact visual detail (fig. 10.25). The darkened background focuses our attention on Revere and the tools and products of his trade in the foreground. He wears the simple work clothes of an artisan. Such a straightforward approach, which dignifies labor and craft, was in keeping with Puritan values. Copley convincingly conveys a sense of immediacy between Revere and ourselves. It is as though we have discovered Revere deep in thought, almost as if he has forgotten the engraving of the teapot and is now engrossed in the contemplation of more difficult issues. Revere's eyes meet ours, his raised right eyebrow an acknowledgment of our presence. It is clear that Copley delighted in the naturalistic representation of figures and objects. Note how the

10.25 John Singleton Copley, *Portrait of Paul Revere*, c. 1768–70. Oil on canvas, $2' 11'' \times 2' 5'' (89 \times 72 \text{ cm})$. Museum of Fine Arts, Boston. Commissioned by Paul Revere.

Paul Revere was a political activist in Boston. His famous night ride to warn Bostonians of the advance of the British army occurred on April 18, 1775. Copley's family was sympathetic to the British, and the artist left the colonies forever on the eve of the Revolution.

10.26 Rosalba Carriera, *Portrait of Louis XV as a Young Man*, 1720–21. Pastel on paper, $1'6\frac{1}{2}" \times 1'2"$ (47 × 36 cm). Museum of Fine Arts, Boston. Most likely commissioned by Louis XIV or Louis XV.

sharp, detailed reflection of Revere's fingers in the silver teapot contrasts with the diffused reflection of his shirt on the polished wooden worktop.

Copley and Benjamin West (see fig. 10.36) are acknowledged as America's first significant artists. Copley's fame in the colonies was established primarily by his ability as a portraitist. His sensitive observation and carefully developed talent earned him a distinguished reputation and a significant financial income, both in the colonies and in his later career in Britain. Although portrait painting ranked behind history and religious painting in the classification of subject matter, it was an economic mainstay for many artists.

Rosalba Carriera (1675–1757), in her painting of France's young king Louis XV (fig. 10.26), demonstrates the elegant grace of Rococo portraiture. The soft, delicate effect is achieved not only by the blending of high-value colors but also by the use of **pastel** as a medium. Carriera, a Venetian artist, became famous for her ability to render

10.27 Joshua Reynolds, Allegorical Portrait of Sarah Siddons as the *Tragic Muse*, 1784. Oil on canvas, $7' 9'' \times 4' 9\%'' (2.36 \times 1.46 \text{ m})$. Henry E. Huntington Library and Art Gallery, San Marino, California. Reynolds painted two versions of this portrait; the second, painted in 1789, was intended for his agent, Desensans.

portraits in pastel. Her influence in France and Italy popularized the medium in the eighteenth century.

In England, two competing artists excelled in portraiture: Joshua Reynolds, president of London's Royal Academy, and Thomas Gainsborough (1727–88). Our two portraits, which display the abilities and different approaches of these two artists, both represent Sarah Kemble Siddons, a popular actress of the period (figs. 10.27, 10.28).

True to his philosophy that painting should aspire to the "grand style," Reynolds depicts Siddons as a classical allegorical figure, the muse of tragic drama. She sits on a throne, head and eyes raised as if in response to divine, creative inspiration. Behind her are figures symbolizing Pity and Terror, the attributes of tragic drama. Reynolds's composition directly recalls Michelangelo's figures of prophets and Sibyls on the Sistine Chapel ceiling (see fig. 8.32) in order to demonstrate his ability to adapt and update the Renaissance style.

When Gainsborough painted the same celebrated actress, he chose to portray her as an elegantly dressed, confident woman. The painting, which recalls the traditions of Venetian and Baroque portraiture, is a sumptuous treat for our eyes. The blues and whites of her dress enhance the warm, golden tones of her shawl and muff, while the magnificent black hat is silhouetted against a deep red curtain. Gainsborough's painterly technique and luxurious colors create an impressive portrait of a dynamic woman.

10.28 Thomas Gainsborough, Portrait of Sarah Siddons, 1783–85. Oil on canvas, $4' \frac{13}{4}'' \times 3' \frac{31}{4}'' (1.26 \times 1 \text{ m})$. The National Gallery, London, England.

Neoclassical Architecture

You see I am an enthusiast in the subject of the arts. But it is an enthusiasm of which I am not ashamed, as its object is to improve the taste of my countrymen, to increase their reputation, to reconcile them to the respect of the world, and procure them its praise.

(Thomas Jefferson, in a letter to James Madison, 1785)

Jefferson's Virginia State Capitol (fig. 10.30) must have surprised many Richmond residents (see map, p. 454), for it was the first public building in the youthful American republic to be modeled on the classical temple form. Thomas Jefferson (1743–1826) designed the building while he was serving as U.S. minister to France, where he was inspired both by French architects already working in the Neoclassical style and by the ruins of the ancient Roman civilization in Gaul. He was especially influenced by a Roman temple at Nîmes, in southern France, which is similar to the Temple of Portunus in Rome in design, although much larger (see fig. 4.28). Jefferson wrote in a letter that he had gazed at the temple for hours, "like a lover at his mistress." While maintaining its basic design, he greatly enlarged it for the Virginia State Capitol. The resulting

structure, with its Ionic portico, pediment, and classical proportions, confers a solemn, dignified appearance—appropriate, as Jefferson himself believed, to the ideals of a young democratic nation.

Such an association between Neoclassical architecture and the values of the Enlightenment had entered English architecture decades earlier. Wishing to revive the austere influence of Palladio's architectural ideas (see pp. 8-9), Richard Boyle (1695–1753), the Third Earl of Burlington, designed Chiswick House (fig. 10.29). When Lord Burlington visited Italy during his grand tour, he had carefully studied the architecture of Palladio, particularly the Villa Rotonda (see fig. 1.8). His design for Chiswick House is an adaptation of the Villa Rotonda, substituting an octagonal dome and a different disposition of interior rooms. In addition, the pedimented portico, which gives unity to the Villa Rotonda on all four sides, features only on the main elevation of Chiswick House. While lacking the organic proportionality of Palladio, nevertheless Chiswick House appears planar and restrained when contrasted against the effusive ornamentation and design of Rococo architecture on the European continent (see fig. 10.2). Its design champions the values of order and rationality that characterized the Enlightenment.

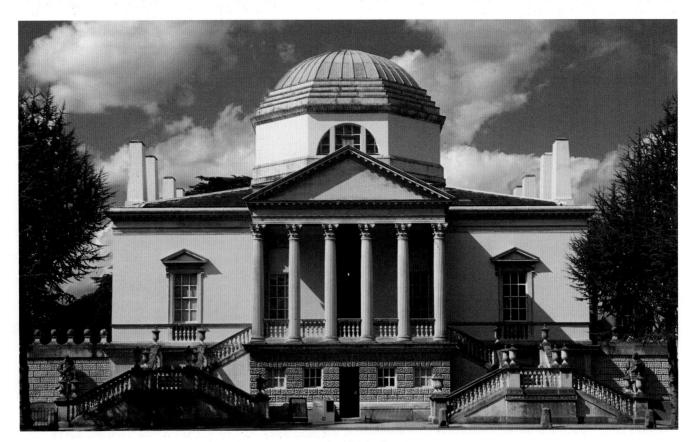

10.29 Richard Boyle, Lord Burlington, Chiswick House, West London, England, 1724–29.

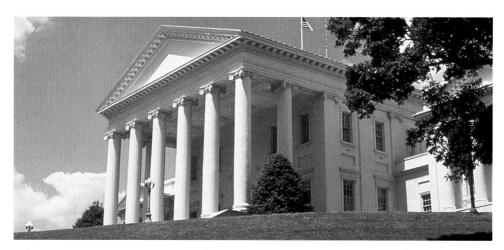

10.30 Thomas Jefferson, State Capitol, Richmond, Virginia, 1785–89. Commissioned by the State of Virginia.

Although the Neoclassical architectural style flourished throughout the Western world, it was particularly meaningful in the United States, as the nation adopted a democratic form of government following the Revolution. The emulation of Roman buildings was viewed as an appropriate vehicle to express architectural dignity and command public respect. For Jefferson, public architecture demanded a moral content. The nobility of his Neoclassical edifice would serve as a guide to the behavior and aspirations of the young republic. The Neoclassical architectural style in the United States is also known as the Federal style because of its prominent use for government buildings.

In 1817, Jefferson, now a former president, began planning the first state university in the United States. The main building was the Rotunda, an adaptation of the ancient Pantheon in Rome (see fig. 4.52) that housed the university library in a grand setting.

Jefferson's design for his country home, Monticello, demonstrates the adaptability of Neoclassical architectural features to domestic buildings (fig. 10.31). The use of antique architectural elements is evident, but Jefferson's sources for the composition here are also drawn from Renaissance buildings that were under the spell of antiquity, and particularly the villas of Palladio. The Villa Rotonda (see fig. 1.8) and others by Palladio inspired the main block, with its domed ballroom, although ultimately the combination of pedimented entrance and dome can be traced back to the ancient Roman Pantheon. Other Palladian villas in the countryside around Venice were the source for wings that Jefferson added, which reach out to embrace the landscape and unify the house with the farms and countryside that supported his estate. Soon houses throughout the United States would sport Doric, Ionic, and Corinthian porticoes as an indication of American democratic ideals.

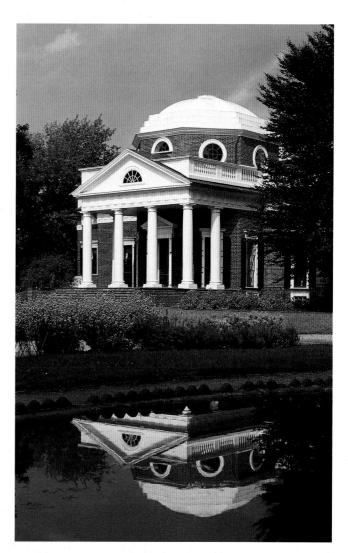

10.31 Thomas Jefferson, Monticello, Charlottesville, Virginia, 1768–82; remodeled 1796–1809.

The Italian name *Monticello* ("Little Mountain") was adopted by Jefferson because of the hilltop setting of his home.

Neoclassical Painting and Sculpture

eroic suicide may seem to be a contradiction in terms, but the purpose of David's theme (fig. 10.32), painted in the unsettled years in France before the Revolution, was to demonstrate the need to live by one's principles and the heroism of the stoic virtue of absolute self-sacrifice. Jacques-Louis David (1748–1825) depicted a muscular Socrates reaching for the cup of poisonous hemlock held by a distraught disciple. With an exclamatory gesture, Socrates points upward, insisting on the truth of his ideals. On viewing the painting, one contemporary observer remarked, "This is the triumph of virtue which is raised higher than all other things by a heroic courage and an inspired soul."

Although the theme of the death of Socrates is taken from the classical past, David's choice and interpretation of the subject are strictly contemporary, and within the cultural context of late eighteenth-century France, they would have been easily understood. In 1758, the Enlightenment philosopher Denis Diderot had outlined a proposed drama on Socrates' death that popularized the theme with artists and writers. Socrates' unwavering devotion to his ideals provides the theme for this history painting. Both the lesson and David's representation were acclaimed by critics and the public. The work offered a guide for moral behavior in the troubled social climate of France. David became a supporter of the French Revolution, and the Death of Socrates illustrates his belief that paintings "of heroism and civic virtue offered the eyes of the people [will] electrify its soul, and plant the seed of glory and devotion to the fatherland." The crisp modeling of the figures creates precise, linear, sculptural forms, revealing David's academic training and approach, while the planar space of the painting suggests that ancient relief sculpture (see figs. 1.15, 3.76) may have been one of David's inspirations.

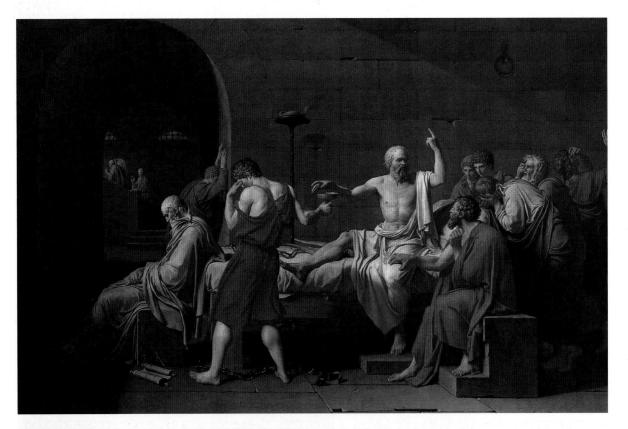

10.32 Jacques-Louis David, *Death of Socrates*, 1787. Oil on canvas, 4' 3" \times 6' 6" (1.3 \times 1.98 m). The Metropolitan Museum of Art, New York. Commissioned by Charles-Michel Trudaine, a lawyer at the French Parliament.

The liberal philosophy of Socrates, the fifth-century BCE Athenian philosopher, stressed the worth of the individual over that of the state in a manner that upset Athenian officials. Because he could not be brought to trial for his philosophical beliefs, he was tried for "impiety," found guilty, and sentenced to death. Had he been willing to renounce his teachings he could have gone free, but Socrates himself pointed out that death had been the verdict of a legitimate court. Following Athenian practice, he drank hemlock.

1787 David, Death of Socrates (fig. 10.32)

1787 Dollar currency is introduced in the United 1787 The Times of London begins publication

1790 U.S. population is almost 4 million

1798 Omiki-san Nakayama, a Japanese woman, founds Tenri Kyo, a major Shinto sect

10.33 Anton Raphel Mengs, Parnassus, ceiling fresco from the Villa Albani, Rome, 1761.

Among his contemporaries, Anton Raffael Mengs (1728-1779) was one of the most celebrated Neoclassical painters of the century. Mengs met Johann Winckelmann (see p. 401) in Rome in 1755, and quickly absorbed Winckelmann's philosophy on the authority of Classical art. At the time, Winckelmann was librarian to Cardinal Allessandro Albani, who possessed one of the largest private collections of ancient art in Rome. Mengs' fresco of Parnassus (fig. 10.33), commissioned by Cardinal Albani, resisted the illusionism of Baroque ceiling painting (see fig. 9.6) while recapturing the compositional order of Italian Renaissance art. Mengs was inspired by both an ancient relief sculpture discovered in the ruins of Herculaneum and the symmetry and balance of High Renaissance paintings by his namesake Raphael (see fig. 8.35). In Ancient Greece, Mount Parnassus was believed to be sacred to Apollo, god

of music and poetry; Mengs depicts a standing Apollo holding his lyre and a laurel branch, symbols of music and immortality, and flanked by Mnemasyne and her daughters, the nine muses who inspire various art forms. The composition reflects the planarity of relief sculpture and reads like a wall painting placed on the ceiling.

Like David's Death of Socrates, Angelica Kauffmann's Cornelia, Mother of the Gracchi (fig. 10.34) communicates a moralizing theme, but on a more personal and emotional level. This painting depicts a Roman woman, Cornelia, who was asked by a friend to display her jewels; the friend was surprised when Cornelia presented her children. This maternal and moralistic theme would have been particularly relevant for a woman artist, of course. Like much of Neoclassical art, Kaufmann's painting is meant to offer instruction on the enduring values of life.

10.34 Angelica Kauffmann, *Cornelia, Mother of the Gracchi*, 1785. Oil on canvas, 3' 4" × 4' 2" (1 × 1.27 m). Virginia Museum of Fine Arts, Richmond. Purchased by George Bowles of Wanstead, Essex, who was an important collector of Kauffmann's works.

In Europe, Antonio Canova (1757–1822) was the leading and much admired proponent of Neoclassicism in sculpture. Although Rome became his professional home from 1781 onward, he traveled throughout Europe for numerous commissions, including grand commemorative monuments as well as smaller, often mythological, works

for private patrons (see fig. 11.15). *Cupid and Psyche* (fig. **10.35**) depicts the moment when Cupid has awakened Psyche from her fateful sleep. Here the classical treatment of the figures and the carefully studied composition reflect a Neoclassical aesthetic, while the tenderness of the emotion points toward a more Romantic sensibility (see pp. 444–45).

10.35 Antonio Canova, *Cupid and Psyche*, 1787–93. Marble, 5' 1" × 5' 8½" (1.55 × 1.73 m). Musée du Louvre, Paris.

In his Death of General Wolfe (fig. 10.36), Benjamin West (1738-1820) popularized a new concept within the category of history painting, for West represented the figures in contemporary costume, avoiding the antique clothing and setting that, according to traditional academic rules, could elevate a subject to its universal significance. West's earliest biographer recounted that Joshua Reynolds, president of the Royal Academy, had advised West to:

adopt the classic costume of antiquity, as much more becoming the inherent greatness of ... [the] subject than the modern garb of war, and that West had replied: "The event intended to be commemorated took place on the 13th of September, 175[9], in a region of the world unknown to the Greeks and Romans, and at a period of time when no such nations, nor heroes in their costume, any longer existed. The subject I have to represent is the conquest of a great province of America by the British troops.... If, instead of the facts of the transaction, I represent classical fictions, how shall I be understood by posterity!... I want to mark the date, the place, and the parties engaged in the event; and if I am not able to dispose of the circumstances in a picturesque manner, no academical distribution of Greek or Roman costume will enable me to do justice to the subject."

West's composition was stimulated by a serious study of classical sculpture and of the works of Renaissance and Baroque artists, and his painting, a popular success, pioneered an important change in the representation of contemporary history. Although he avoided classical costume, West did refer to the tradition by including the Native American as a personification of America. The painting effectively dramatizes the tragedy of the death of Wolfe, an event that exemplified the values of self-sacrifice, courage, and patriotism. King George III commissioned a copy of West's painting and made him the official history painter at the British court.

10.36 Benjamin West, Death of General Wolfe, 1770. Oil on canvas, 4' 11½" × 7' (1.51 × 2.1 m). The National Gallery of Canada, Ottawa.

The story of the death of the British commander James Wolfe on the battlefield at Quebec in 1759 was inspirational. After three months of stalemate, Wolfe led his troops to victory over a much larger French force but, mortally wounded, he died in the arms of his officers at the moment of victory.

11.1 Gustave Eiffel, Eiffel Tower, Paris, France, 1887–89. Wrought-iron superstructure on a reinforced concrete base, original height 984' (295 m); current height 1,052' (316 m). Commissioned by Monsieur Lockroy, Minister for Trade and the General Commissioner for the Exposition of 1889.

Nineteenth-Century Art

A BRIEF INSIGHT

he Eiffel Tower, a well-known symbol of the city of Paris, was the winning entry from 700 submissions in a competition to design a temporary structure for the 1889 World's Fair celebrating the centennial of the French Revolution. As the tallest structure in the world, it became a symbol for the fair, and from its various levels fair-goers had panoramic views over Paris; after the fair was over, the decision was made to keep the tower as a tourist attraction (fig. 11.1).

A structure such as this was made possible by the development of structural steel engineering and the invention of the elevator. Such technological innovation is one of the hallmarks of the nineteenth century, the century famous for the Industrial Revolution.

While today the Eiffel Tower is a symbol of Paris known around the world, many late nineteenth-century Parisians were dismayed by the tower, lamenting the manner in which Eiffel boldly exposed the metal structure. Critics were also appalled because his design made no reference to earlier architecture, as was expected at the time. The controversy around the Eiffel Tower is only one of many raised by the revolutionary and widely debated art that was produced during the nineteenth century.

Introduction to Nineteenth-Century Art

he ideal of revolution so important for the development of the modern world and so central to the history, ideology, and art of the European nineteenth century is expressed in two paintings by Eugène Delacroix (1798–1863) and Claude Monet (1846–1926). Delacroix's subject (fig. 11.2) celebrates the July Revolution of 1830, when an uprising of Parisians mounted a revolutionary red, white, and blue flag—the tricolor—on the spires of Nôtre-Dame Cathedral and forced the abdication of Charles X, as well as the adoption of a new charter that doubled the number of citizens who elected the legislative chamber. This was a modest but important triumph for the liberals, lower bourgeoisie, and skilled workers who had led the revolt. In Delacroix's painting, the personification of Liberty, holding the tricolor, leads an army of Parisian

rebels over the bodies of their dead comrades toward victory. Delacroix's technique, too, is revolutionary, for in reaction to the sharp linearity of the prevailing Neoclassical style (see pp. 420–23, 440–41), he introduces blurred edges, strong colors, and loose brushstrokes in an active style appropriate to his modern subject. Of Delacroix's significance, the later painter Paul Cézanne would say, "We all paint differently because of him."

From later in the century, Monet's revolutionary painting (fig. 11.3) expresses Impressionist ideals. In defiance of the criteria that had been taught in European art academies since the Renaissance, the Impressionists challenged the emphasis given to traditional subject matter and exalted the importance of the momentary glimpse of a real scene. Monet chose this particular cityscape not in response to

11.2 Eugène Delacroix, Liberty Leading the People, 1830. Oil on canvas, 8' 6" × 10' 8" (2.6 × 3.25 m). The Louvre, Paris, France.

11.3 Claude Monet, Rue St.-Denis Festivities on June 30, 1878, 1878. Oil on canvas, $2' \, 5\%'' \times 1' \, 8\%'' \, (76 \times 52 \, \text{cm})$. Musée des Beaux-Arts, Rouen, France.

patriotic fervor, for example, but because he was challenged by the problem of how to represent the visual effect of brilliant colors in ever-changing movement offered by the flags. Monet's goal was to capture a visual "impression" of what the eye sees, regardless of subject. Traditional critics were as upset by this attitude to subject matter as they were by Monet's loose brushstrokes.

HISTORY

Economic, technological, and political revolutions dominate the history of the nineteenth century in Europe and the United States. The Industrial Revolution, with its mechanization of production in factories, transformed life for a

large percentage of the population in Europe and America. The rapidly expanding lower and middle classes, concentrated in the cities near their factory jobs, organized to demand democracy and more humane treatment. The spirit of reform that began in the nineteenth century led eventually to universal suffrage in much of the world. The institutions, lifestyles, and class structures that resulted had an important impact on art.

During the nineteenth century, the world seemed to become a smaller place as steam-powered trains and ships led to increased world trade. The expansion of communications with the establishment of inexpensive newspapers and periodicals, printed on high-speed printing presses, and the

development of the telegraph and telephone, led to greater international awareness. An interconnected world gradually evolved, prompted by world trade and the great international fairs held in the second half of the century. The establishment of European colonies in Africa, Asia, and Australia brought Western culture into contact and conflict with local traditions and beliefs. More and more artists traveled from America, China, Japan, and elsewhere to study in France and Germany, and soon even painters from Pittsburgh were submitting works to the Salon in Paris and the Royal Academy exhibitions in London. Inexpensive reproductions of works of art were widely distributed.

Napoleon dominated European history in the first decade of the nineteenth century, leading French armies to victory until he controlled all of Europe. Only Britain, which defeated Napoleon's navy at Trafalgar, was able to repel the French. Napoleon was proclaimed emperor of France in 1804 and king of Italy in 1805. Determined to break the traditional and historic power of the Catholic Church and its clergy, Napoleon closed monasteries and destroyed symbols of ecclesiastical and monastic power. To enlarge his own private collections and those of the French state, he appropriated many works of art. He attacked Russia in 1812 and took Moscow, but in retreat his army was virtually annihilated. Napoleon abdicated in 1814, returned briefly to power in 1815, and was defeated by the English at Waterloo. The new European borders set at the Congress of Vienna in 1815, after Napoleon's defeat, established a balance of power that endured until World War I.

The French Revolution and later revolutionary uprisings in France in 1830 and 1848, as well as the success of the new democracy in the United States, gave impetus to other revolutionary movements. Throughout Europe there was an increased demand for "liberty, equality, and fraternity [nationalism]"—there were eleven revolutionary uprisings in major European cities in 1848–49. The nineteenth-century demands for revolution, however, would reach their most profound outcome with the Russian Revolution

of 1917. Great Britain remained stable, and the British Empire underwent tremendous expansion accompanied by an astonishing economic development—the result of peace, industrialization, and the world market provided by the empire. The power of the British navy and merchant marine was unrivaled. In the United States, rapid expansion and industrialization led to prosperity and optimism, but this mood was dissipated by the divisive Civil War (1861–65), and after the war American culture became increasingly dependent on conservative European models. By the end of the nineteenth century, nationalistic desires for unification in Italy and in Germany had succeeded.

The British Empire brought the English language and the British bureaucratic system to many different regions of the world; the largest and most dramatic of these was India. India had played an important role in trade since the seventeenth century, when British, Dutch, French, and other European traders had arrived there in search of luxury goods in demand in Europe: spices, fine cottons, silk, opium, and indigo, among others. India prospered from this trade, which was conducted by trading companies that held monopolies; the most important of these was the British East India Company, which also acted as a political and military force, helping to secure British rule in India by the mid-nineteenth century. British officials were in charge of virtually all of India, but there was no single central authority. By the end of the century, India had become a part of the world economy, and, based on the British example, a modern bureaucratic system had been established. Interest among Indian artists in European painting and architecture was another result of the British colonization of India.

During the nineteenth century, Japan was gradually opened to the West. In 1804, a representative of the czar of Russia arrived, and in 1846 and 1853, respectively, Commodores Biddle and Perry of the United States were received. The treaties that were negotiated between Japan and the Western powers led to increased communication, and the delegates who left Japan to take up posts in the Western world returned with the news of Western industrial progress. Japanese students began to go to Europe to study. By 1889, the new Meiji Constitution was in place, and in the next twenty years Japan waged wars against China and Russia; by the end of the nineteenth century, Japan also had become an "imperial" power.

Asian works of art were imported into Europe and collected by individuals and museums, and by the end of the century, the collecting of works from Africa was well under way, aided by European colonization of that continent and the attempt to suppress its local traditions. Although Asian works had a significant impact on the development of art (for example, Impressionism; see pp. 472–75) and on popular taste and collecting during the

nineteenth century (fig. 11.4), the impact of the African works was not felt until the twentieth century. Europeanstyle painting was known in Asia, primarily through the works of Japanese artists returning from Europe and from reproductions in Chinese and Japanese journals, and by the end of the nineteenth century there was a widespread interest in western European art.

It would be oversimplifying to draw direct relationships between each of the global historical events we have summarized and the developments in art with which this chapter deals, but our study of earlier art has often demonstrated the intimate connection between historical events that affected the lives and attitudes of large groups of people and the art that was produced at the same time. As both the world and art have become more complicated and interrelated, we must continue to try to grasp the role of historical change in new developments in art. We also must not neglect the role that art may have played in defining and transforming history.

THE INDUSTRIAL REVOLUTION AROUND THE WORLD

By the mid-nineteenth century, Britain led the world in the mechanized production of inexpensive goods for mass public consumption. Such production became the financial base for England's expansion during the century. Simultaneously, the Industrial Revolution spread through much of Europe and into America, and there was fierce competition for the global markets for mass-produced goods. When power-driven machinery revolutionized the production of textiles, entrepreneurs established huge mills in which hundreds of workers manufactured vast amounts of cheap fabric. Factory-made nails and milled lumber, produced by the power-driven sawmill, revolutionized the housing industry in America. The rapid spread of the railroads transformed transportation, the delivery of merchandise, and communications.

The new industrial production was celebrated in a series of international exhibitions, beginning with the Great Exhibition of the Works of Industry of All Nations at the Crystal Palace in London in 1851 (see fig. 11.38). This exhibition was intended to emphasize England's role as the world's greatest manufacturing center, but it also became a challenge to other countries to compete with England's commercial successes. By bringing together handicrafts and manufactured goods from all over the world, the exhibition introduced new styles and techniques into the prevailing Victorian taste.

The Industrial Revolution raised standards of living for large groups of people, but it also created unsafe working conditions and led to unemployment. The difficulties of urban life were documented in contemporary novels by

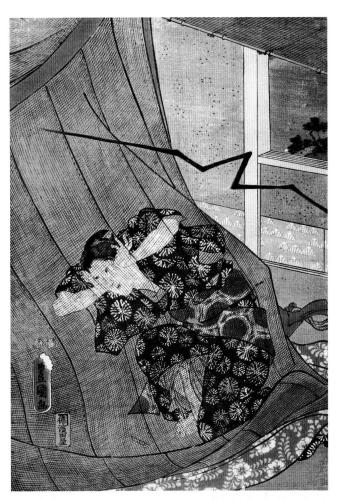

11.4 Utagawa Kunisada, A Woman Frightened by Thunder, 1849-53. Woodblock print, 1' $2\frac{1}{2}$ " × $10\frac{1}{8}$ " (37 × 26 cm).

This print was part of a large collection of more than 200 Japanese prints owned by the Post-Impressionist painter Vincent van Gogh; the artist owned 165 prints by Kunisada alone. Japanese prints were a formative influence on many French nineteenth-century painters, especially Manet, Monet, Degas, and van Gogh. The choice of subjects from everyday life, the bold silhouetting and complex patterning of their designs (especially evident here in the pattern of the mosquito netting over the designs of the woman's costume), the truncation of the forms (note the flying reed shade in the upper right corner and the lightning bolt that flashes into the room), the high viewpoint, and the diagonal recession of the architectural settings were all characteristic of Japanese art, and all had an effect on the development of modern French painting.

Charles Dickens (Oliver Twist, 1838) and Victor Hugo (Les Misérables, 1862). The issue of the isolation and alienation of the individual in the new urban society is captured by Édouard Manet (1832–83) in his depiction of the barmaid, who probably also worked as a prostitute, in A Bar at the Folies-Bergère (fig. 11.5). The Industrial Revolution also transformed art, for the mass production of cheap prints developed a new audience for art. Reproductions of paintings were available virtually everywhere. Illustration flourished, led by such entrepreneurs as Currier & Ives in the

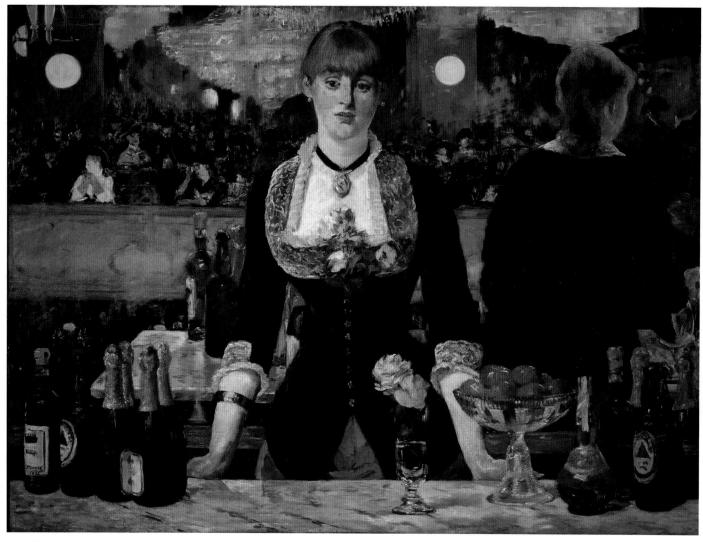

11.5 Édouard Manet, *A Bar at the Folies-Bergère*, 1881–82. Oil on canvas, 3' 1½" × 4' 3" (95 × 130 cm). Courtauld Institute Galleries, Home House Trustees, London, England.

Many of the barmaids who worked at the Folies-Bergère were also prostitutes. Manet's presentation of this woman is as a commodity that is as readily available as the goods on the bar. At the same time, however, her expression creates a strong sense of the woman as an individual with a personal emotional life. In Manet's oil sketch for the painting, the background is more easily read as a mirror reflection; in the final version, the reflection of the woman and her customer is changed to emphasize the flatness of the pictorial surface and the unreal aspect of the painting. In describing the painting while it was in the studio, Georges Jeanniot, one of Manet's friends, noted that "he did not copy nature at all closely; I noted his masterly simplification.... Everything was abbreviated." This painting was exhibited at the Paris Salon in 1882.

United States. The mass production of furniture and other household goods led to a reaction in the second half of the century, when the finely finished works of the individual craftsperson were exalted in the Arts and Crafts and the Art Nouveau movements.

EUROPEAN INTELLECTUAL AND SCIENTIFIC ACTIVITIES

In Europe, the social and financial inequities that were amplified by industrialism led to a number of responses—socialism, anarchism, utopian movements, and revolution-

ary communism. The latter was explicitly defined by Karl Marx and Friedrich Engels in the *Communist Manifesto*, published in 1848. Similar sentiments about inequity led to revolutions in China, Russia, and India in the twentieth century.

Intimately connected with industrialization were advances in science, engineering, and technology. Science replaced philosophy as the most influential university discipline. New scientific theories, especially Charles Darwin's *The Origin of Species* (1859), with its message of the "survival of the fittest," deeply affected attitudes about religion and the meaning of life.

The explosion of activity in the fields of literature and music makes it impossible to mention all the important figures at work during the nineteenth century. Some of the artistic movements had parallel developments in literature and music. Romanticism, for example, was expressed in literature in poetry, historical novels, fantasy and horror tales, and romance and adventure stories by such figures as Lord Byron in England, Johann Wolfgang von Goethe in Germany, Victor Hugo in France, and Aleksander Pushkin in Russia (see box, below). Romanticism and Realism are united in the works of Dickens. The Romantic movement in music includes Frédéric Chopin (who even wrote a piece called "Revolutionary Étude"), Johannes Brahms, Richard Wagner, and Pyotr Tchaikovsky. Impressionism is paralleled in music in the compositions of Claude Debussy. Art criticism flourished, and partisans of both conservative and "modern" art developed.

ART

Communication and interrelationships between parts of the world increased rapidly and dramatically in the course of the nineteenth century, and the chronological structure of this book becomes both more revealing and more logical as we examine the art of this period. In earlier centuries, the chronological organization allowed us to demonstrate the simultaneity of distinctly different developments in art in various parts of the globe and to study broader trends, such as the spread of world religions, in their widest historical context without isolating, for example, Christianity, Islam, and Buddhism. In the nineteenth century, the chronological structure emphasizes the interrelationships that evolved as the world shrank. We can, for example, see how art in Asia began to have an important effect on art in Europe and understand the impact of European developments on art in the United States and Asia. During this period, Japanese prints responded to Western ideas about illusionism and perspective, for example, while at the same time some Japanese aesthetic qualities seen in the prints helped to transform European and, subsequently, American painting. Thomas Eakins (see fig. 11.62) certainly knew the paintings of the Realist Courbet and of the Impressionists, although the Impressionists seem to have had less impact than Courbet; Eakins's student Tanner, however, felt more strongly the influence of the Impressionists (see fig. 11.63).

No brief survey of global art can encompass or even refer to every development in every nation. In surveying the nineteenth century, we shall focus on French developments because they had such a potent impact on art and on attitudes about art and the artist in the nineteenth and twentieth centuries. Many of our current popular attitudes about art have their sources in French nineteenth-century developments. We shall also explore extensively American art and architecture during this century, because they provide

ART PAST/ART PRESENT

Looking Beyond the Art: Romanticism

To understand a culture more fully, comparisons between the visual arts and other cultural manifestations, such as literature or music, can often be helpful. In some periods there may be only tangential connections, but in other instances a revealing consistency in the arts can be discerned: such is the case with Romanticism. The Romantic movement in Europe and America, which flourished in the late eighteenth and the nineteenth centuries, emphasized the importance of each individual's personal and imaginative response to the world. Emotion and intuition were held to be as important as (or more important than) reason, which had dominated the previous period and which can be related to Neoclassical art and the earlier movement known as the Enlightenment. Mysticism or spiritualism also became important, and there was a broad interest in the mysterious, the irrational, and the visionary. It should be clear from this summary that Romanticism in art, music, and literature is an attitude of mind and not a coherent style. Among the artists represented in this book, those who have been identified as Romantic painters are Bingham, Cole, Constable, Delacroix, Friedrich, Géricault, Goya, and Turner. In architecture, Romanticism is characterized by the return to earlier styles, and especially those of the Middle Ages, such as the Gothic (see figs. 11.31, 11.33, 11.39). The picturesque, irregular garden was a Romantic ideal, and the power and sublimity of nature played a role in both Romantic art (see fig. 11.23) and literature.

Some of the greatest names in British literature, such as Lord Byron, Coleridge, Keats, Shelley, and Wordsworth, are thought of as Romantics; in other countries the Romantic writers include Balzac, Goethe, Hugo, and Schiller, and, in America, Emerson, Hawthorne, Longfellow, Melville, Poe, and Thoreau. Romantic composers include Beethoven, Berlioz, Brahms, Chopin, Liszt, Mendelssohn, Schubert, Schumann, Tchaikovsky, Verdi, Wagner, and many others. The most obvious trait of Romantic music is the long and expressive melody, and many Romantic composers were inspired in their opera plots and song cycles by Romantic literature. By 1850 Romanticism in art and literature was being challenged by movements devoted to greater naturalism, but in music Romanticism continued until almost the end of the century.

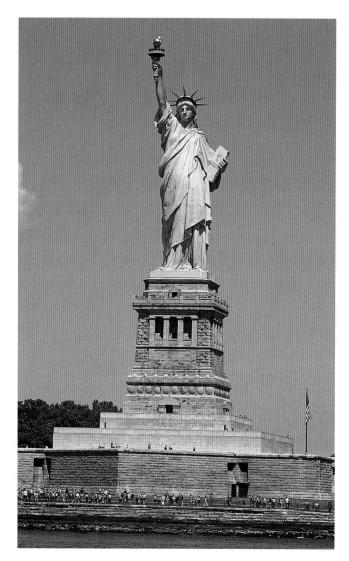

11.6 Frédéric-Auguste Bartholdi, *Liberty Enlightening the World* (now known as the *Statue of Liberty*), 1870–86. Hammered copper over wrought-iron pylon designed by Gustave Eiffel; height from base to top of torch 112' (33.5 m). New York Harbor. Commissioned by the French American Union.

an excellent example of both the dependence of American art on European innovations and a certain independence that leads into American twentieth-century developments.

The subjects of nineteenth-century European and American painters ranged from historical, mythological, and religious themes to scenes of the everyday life of the working classes. By the end of the century, even the vulgar characters and activities of the dance hall had become acceptable as a theme for art. The development of exhibitions, such as those at the Paris Salon and London's Royal Academy, and of art galleries in every major city in Europe and the United States, meant that more and more painters and sculptors were producing works for exhibition and for the general art market. As the percentage of commissioned works declined, there was a growing division between artist and public, and the gulf between conservative artists and revolutionary ones,

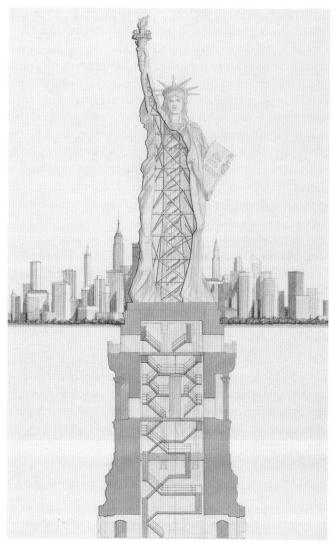

11.7 Gustave Eiffel, Diagram of the interior skeletal structure for the *Statue of Liberty*.

who assumed the title of **avant-garde**, gradually became wider. Although the development of photography robbed painters of a traditional means of support, the elite continued to commission painted portraits. Landscape became a particularly popular subject, perhaps because it was such a good vehicle for expressing aesthetic theories. Despite the significance of the Industrial Revolution, scenes of industry were relatively rare.

The popular print developed with the growth of newspapers and periodicals to become a prominent vehicle for social protest (see pp. 452–53). The photograph, invented in the nineteenth century, was used both as a journalistic and as a documentary tool. In sculpture, the heroic monument dominated the century and was considered to be the primary challenge of the sculptor (figs. 11.6, 11.7; see also fig. 1.13), but the diversity of the century is seen in examples of traditional architectural sculpture and in works that demonstrate revolutionary attitudes about sculpture (see fig. 11.53). In architecture, new forms were demanded by the

increasing pressure of population and business crowded in urban centers. Technological and engineering advances made possible the skyscraper, the railroad station, and the great bridges (see fig. 11.39) and monuments, such as the Statue of Liberty, of the later nineteenth century.

In other parts of the world during the nineteenth century, the idea of modernism, so important in the West, was sometimes an important issue. In India, China, Japan, the continent of Africa, and elsewhere, local traditions in art continued as well. In the Melanesian island nation known as New Ireland, for example, the masks used in traditional island rituals (fig. 11.8) were not changed by contact with European culture. Similar to the ritual practices in Africa and elsewhere, dancers wore these intricate masks for rituals that commemorated ancestors and initiated youths into adulthood. Most of these masks were carved from a single piece of wood; the generous use of openwork, sliverlike projections, and overpainting subdivides the objects into minute geometric patterns that create an elaborate, fragmented appearance. When not in ritual use, the pieces were set up in a tableau at a special house. Only in the twentieth century did such objects command the attention of Western artists for their brilliant and complicated abstracted designs.

Global communication meant that there was an increasing awareness of developments everywhere, and many art students from Asia studied in Paris and other Western centers and quickly introduced an interest in the latest Western styles into their own cultures. When Impressionism was introduced into Japan it was equated

with modernism, and it thereby won approval from some industrialized and political leaders who were seeking economic parity with the West. In general, however, Western styles had little impact on the well-established local traditions, which were closely attached to notions of Japanese cultural identity. Like the importation of Japanese style into the West, in most cases the Japanese interest in Western style was purely aesthetic. The democratic principles that underlay Impressionism, for example, had little impact in Japan despite the number of Japanese artists who had worked in Paris.

THE IMPACT OF FRENCH PAINTING ON WORLD ART

It was developments in French art that gave names to the revolutionary nineteenth-century movements in modern art, and much of the new art created in Europe and the United States reflected the latest French styles. The sequence of movements in France was watched with interest, enthusiasm, and, occasionally, dismay, and in much of the rest of the world it was the French styles that were considered to be "modern." The annual art exhibitions of the French Salon were world-famous, and all serious European and American artists desired to be included. To be represented in a Salon could make one's international reputation.

Conservative interests dominated the Salon exhibitions, however, and when the Salon jury of 1863 rejected a number of works that we would consider modern (for

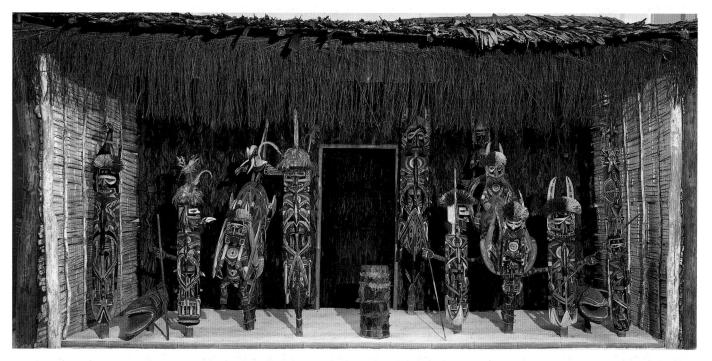

11.8 Tableau, Malanggan culture, New Ireland, nineteenth-twentieth century. Bamboo, palm, and croton leaves, painted wood, approx. 8' (2.4 m) high. Museum für Völkerkund, Basel, Switzerland.

example, see fig. 11.45), there was such an outcry that a special exhibition of the rejected works, known as the Salon des Refusés, was established:

Numerous complaints have reached the Emperor on the subject of works of art which have been refused by the jury of the exhibition. His Majesty, wishing to let the public judge the legitimacy of these complaints, has decided that the rejected works of art are to be exhibited in another part of the Palace of Industry. This exhibition will be voluntary, and artists who may not wish to participate need only inform the administration, which will hasten to return their works to them. This exhibition will open on May 15. Artists have until May 7 to withdraw their works. After this date their pictures will be considered not withdrawn and will be placed in the galleries.

(Proclamation of the Salon des Refusés, 1863)

THE STYLES OF NINETEENTH-CENTURY ART IN THE WEST

The basic styles defined in this century receive their names from terms applied to paintings—to French paintings in particular. The new style at the end of the eighteenth century, Neoclassicism, continued in popularity well into the nineteenth century, especially in the arts of architecture and sculpture (see pp. 440–41). It received a special impetus from Napoleon's enthusiastic support for a variation of Neoclassicism known as Empire, which supported his new status as emperor. Soon, however, the rational and lucid order of the Neoclassical style and its belief that art should express universal truths were challenged by a style that might be considered its antithesis, Romanticism. This style, with its expression of spontaneous, strong, and even violent

individual feelings, is in part based on a new distrust of rationalism. In architecture, Romanticism, in combination with a new interest in history and historical precedent, helps explain the interest in reviving earlier styles, especially the Gothic Revival (see pp. 454–55), so important in American and European architecture. Some critics have included the Neoclassical style within the general category of Romanticism because of the nostalgic manner in which Neoclassical artists looked back to the past.

In France, Romanticism was challenged by two styles: Academic Art and Realism. Academic Art is the term applied to the conservative and even reactionary art—heroic, moral themes rendered in exact verisimilitude—that prevailed in the French Salon exhibitions and in the French academies. Realism encompasses everyday subjects rendered with emphatic boldness. By denying to art the exalted mission preached in the academies, Realism was considered to be revolutionary. Realist attitudes about subject matter and technique influenced the Impressionists, who set out to represent a momentary impression of light, color, and atmosphere in paintings of contemporary subjects. A number of painters who went through an Impressionist phase but later moved on to other styles are known as Post-Impressionists. The end of the century saw the beginnings of new qualities that would lead to the development of expressionist trends in the twentieth-century. In addition, there were styles in architecture and the decorative arts that can be subsumed in the general category of Victorian, which implies a heavy, elaborately decorated style of sumptuous materials, complex silhouettes, and varied textures and colors. In reaction to the Victorian style and to the industrialization of the arts were the utopian style of the Arts and Crafts Movement, as developed by William Morris, and the effulgent Art Nouveau style.

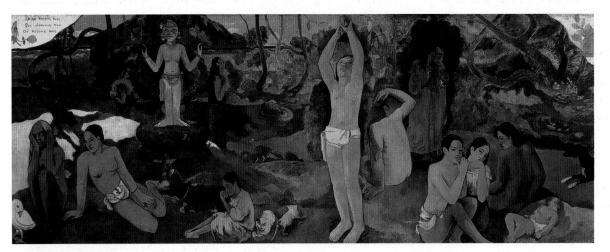

11.9 Paul Gauguin, *Where Do We Come From? What Are We? Where Are We Going?*, 1897. Oil on burlap, 4' 7" × 12' 4" (1.39 × 3.75 m). Museum of Fine Arts, Boston.

When Gauguin painted this work, he was in poor health, nearly broke, depressed, and planning suicide; he intended it to be a summation of his art and life.

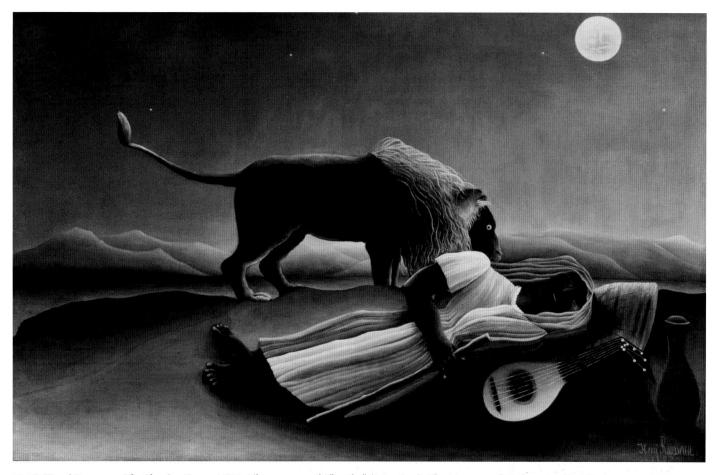

11.10 Henri Rousseau, The Sleeping Gypsy, 1897. Oil on canvas, 4' 3" x 6' 7" (1.3 x 2 m). The Museum of Modern Art, New York.

The revolutionary new French painting styles of Impressionism (see pp. 472-75) and Post-Impressionism (see pp. 484-91) would profoundly impact later developments in art. The break that Post-Impressionism made with past styles and iconography is well expressed by the complex symbolism and abstracted color scheme of Paul Gauguin's Where Do We Come From? What Are We? Where Are We Going? (fig. 11.9). Frustrated with the urbanized industrialization of Paris, Gauguin (1848–1903) fled to remote areas of France and then to Tahiti in the South Seas, where he painted this work in 1897. In a letter he explained that the woman, child, and dog in the right foreground symbolize birth and the innocence of life. The figure near the center tries to pick a fruit from the tree of knowledge in an attempt to understand the meaning of life, while in the left foreground "an old woman approaching death ... reconciled and resigned to her thoughts" is joined by "a strange white bird [that] represents the futility of life." In the right middle ground, two standing clothed figures betray the sorrow that life's knowledge can bring; the idol to our left represents the forces that rule our primitive passions. The abstraction of Gauguin's color contrasts, his depiction of non-Western subject matter, and his invention of a personal symbolism all illustrate the extent to which artists were willing to deny

the heritage of the Renaissance that had governed the course of western art up to this time.

Amid the eclecticism and variety of late-nineteenthcentury art, some uniquely personal styles emerged that would deeply affect the course of early modern art, including that of the self-taught artist Henri Rousseau (1844-1910). Rousseau was working as a toll collector (hence his nickname, "Le Douanier," or "customs officer") when, in his early forties, he retired to devote himself to painting. Such works as The Sleeping Gypsy (fig. 11.10) are a synthesis of naïve vision and serious intent. Although The Sleeping Gypsy recalls the exoticism of Romantic artists, the direct rendering of the forms, the sparse landscape, and the naive foreshortening create an almost hallucinatory scene. Rousseau insisted that he painted images "from life," but his fantastic scenes appealed to Picasso and the avant-garde of Paris, who befriended Rousseau in 1908. The author Guillaume Apollinaire expressed the modernist attitude toward Rousseau when he observed:

His paintings were made without method, system, or mannerisms. From this comes the variety of his work. He did not distrust his imagination any more than he did his head. From this came the grace and richness of his decorative compositions.

THE NINETEENTH-CENTURY ARTIST

During the nineteenth century in Europe and America, the individuality of the artist as a creative and expressive personality took on an even greater importance. One logical outcome of this inclination was more personalized and revealing self-portraits, as in the portrait Francisco Goya (1746–1828) painted of himself on the verge of death (fig. **11.11**). By the end of the century, the revealing personal drama evident in the self-portraits of Vincent van Gogh (1853–90) is not unexpected, although the dramatic evolution of his style away from Impressionism could not have been predicted (fig. **11.12**). The modern Western conception of the artist as a political and social liberal and a revolutionary is largely a product of such nineteenth-century personalities as Théodore Géricault, Gustave Courbet, and

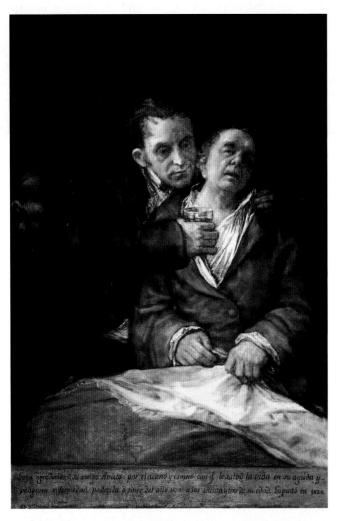

11.11 Francisco Goya, Self-Portrait Being Attended by Dr. Arrieta, 1820. Oil on canvas, 3' $9\frac{1}{2}$ " × 2' $7\frac{1}{6}$ " (116 × 79 cm). The Minneapolis Institute of Arts.

The inscription at the bottom of this painting reads: "Goya, in gratitude, to his friend Arrieta, for the skill and care with which he saved his life in his acute and dangerous illness, suffered at the end of 1819 at the age of 73. Painted in 1820."

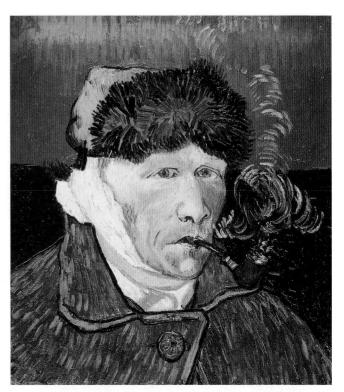

11.12 Vincent van Gogh. Self-Portrait with Bandaged Ear and Pipe, 1889. Oil on canvas, 1' 8" \times 1' 5%" (51 \times 45 cm). Private collection.

James McNeill Whistler. In the Renaissance, artists had worked hard to convince their upper-class and noble patrons that they were individuals worthy of recognition and status. In the nineteenth century, artists began to emphasize their bonds to the middle and lower classes. Georges Seurat planned to write a book about his principles and techniques that would enable anyone to paint a masterpiece.

The change in the status and attitude of the artist is also related to the change in the relationship between the artist and the patron. By the beginning of the nineteenth century, there were probably as many artists painting works for their personal satisfaction and for exhibition as there were artists painting particular works on commission from influential and demanding patrons. The one exception to this generalization might be portraiture, but during the second half of this century the development of the photographic portrait (and the portrait painted over a photograph) meant that only a few artists could hope to earn their living painting portraits. The new democratic ideals so important for nineteenth-century developments encouraged a broader clientele in Europe, America, and Japan to begin collecting art, and artists responded to this climate by an increasing interest in everyday subject matter. Consequently, most of the works listed in Chapter 11 will not have any indication of patronage in the caption.

Throughout the nineteenth century, the educational and professional opportunities that were opening for

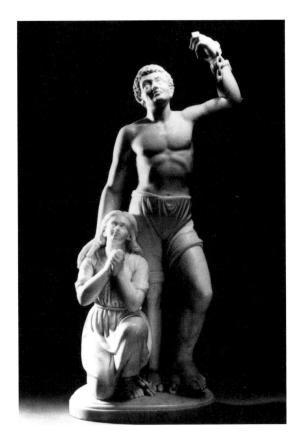

11.13 Edmonia Lewis, Forever Free, 1867. Marble, height 3' 51/4" (1.05 m). The Howard University Gallery of Art, Washington, D.C.

women, however slowly, increased the ranks of women artists. The number of women whose works were exhibited in the annual French Salon swelled from fewer than thirty early in the century to almost 800 in just over 75 years. As was true of the eighteenth century (see p. 400), many American artists studied and worked in Europe. Among them was a group of women sculptors whom the writer Henry James collectively named "the white marmorean flock." Among this group was Edmonia Lewis (1845-90), who arrived in Italy in the 1860s. Lewis's mother was a Native American from the Chippewa nation, and her father was an African American who worked, in Lewis's words, as a "gentleman's servant." Nicknamed "Wildfire," Lewis spent much of her youth with the Chippewas, but at the insistence of her brother she became a student at Oberlin College. Following an incident of racial violence directed toward her, Lewis traveled to Boston in 1863. There she developed her talent as a sculptor and her views as an abolitionist. Forever Free (fig. 11.13) was created shortly after Lewis arrived in Italy; it depicts the moment of the triumph of freedom for African American slaves, whose chains of bondage have just been broken. As a sculptor, Lewis was engaged not only by the theme of her works, which later would be expanded to reflect her Native American heritage, but also by the compositional challenge of creating multifigured groups.

POINTS OF CONTACT

British Architects in India

As Britain consolidated its control in India during the later nineteenth century, a new style of architecture developed that combined the massiveness of western Victorian buildings with motifs drawn from local styles. Many of the architects active in India during this period were British, including those who designed and built the Laxmi Vilas Palace in Vadodara (fig. 11.14); Major Charles Mant (1839-81), who started the project in 1880, had served as an officer in the Royal Engineers before becoming State Architect for the Maharaja of the state of Baroda, while the project was completed after his death by R. F. Chisholm. The style of the palace has been termed "Indo-Saracenic" based on the British use of the term

11.14 Major Charles Mant and R. F. Chisholm, Laxmi Vilas Palace, Vadodara, Gujarat, India, 1878-90. Commissioned by Maharaja Savajirao Gaekwad III, ruler of the local state known in the nineteenth century as Baroda.

The maharaja is known for modernizing his state with reforms in education, medicine, and administration; like many other Indian maharajas active under the British, he collected examples of Western art. A British gardener was brought in from Kew Gardens in London to landscape the 720-acre (2.91sq km) park that surrounds the palace.

"Saracenic" to refer generically to Islamic architectural style. The eclectic combination of decorative motifs drawn from several different traditions, while characteristic of revivalist nineteenth-century architecture in much of the world, can also be understood as part of the imposition of British ideals in the peninsula that they were colonizing; despite the fact that the patron was a local ruler, the Victorian nature of the palace dramatizes the British presence on the subcontinent.

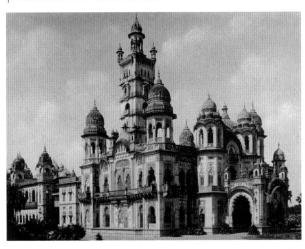

The Artist as a Revolutionary

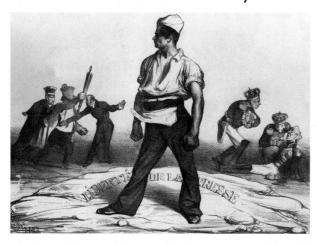

11a Honoré Daumier, Freedom of the Press: Don't Meddle with It, 1834 (for further information, see fig. 11.29).

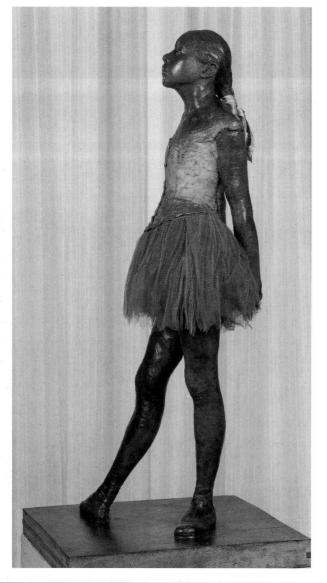

Defying Conventions

(figs. IIa and IIb) The idea that art should be shocking or that an artist should be a revolutionary is a modern one; you'll notice that all the works discussed in this section have been drawn from the nineteenth and twentieth centuries. While the majority of earlier works of art and architecture were created to underscore the status quo and help institutionalize those who were in power, in the course of the nineteenth century this traditional function for art came into question. Daumier's print, for example, champions the public's right to question and challenge those in power. Degas's colored wax sculpture, with its real fabric and applied hair, is a narrower revolution, for it was an attack on the centuries-old tradition that the best sculpture is carved out of marble or cast in bronze.

11c Xu Bing, *Celestial Book*, 1988 (for further information, see fig. 1.17).

Breaking the Rules

(fig. 11c) Xu Bing's Celestial Book with its invented (but Chinese-like) characters, was exhibited in Beijing during the period of political relaxation before the Tiananmen Square Massacre. After that episode it would not have been allowed because of the manner in which its parody of Chinese script mocked conventional values. In tightly controlled societies such as Communist China, challenges by artists to the status quo can be perceived by the authorities as being outright political defiance.

11b Edgar Degas, *Little Dancer, Aged 14*, c. 1879–81 (for further information, see fig. 11.53).

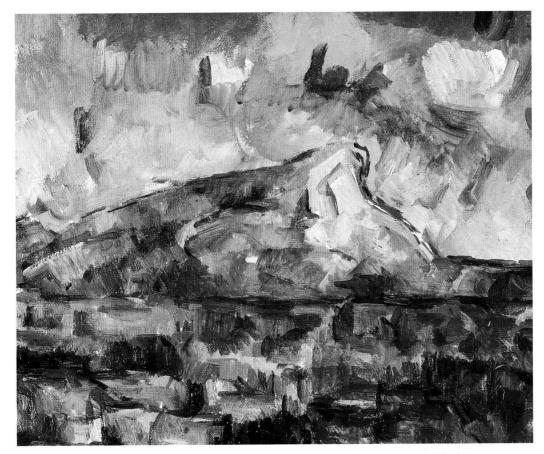

11d Paul Cézanne, Mont Ste.-Victoire, 1904-06 (for further information, see fig. 11.73).

Revolutionizing Vision

(fig. IId) While some artists, such as Daumier and Xu Bing, seem to be most interested in encouraging political reform, other artists, like Degas, set out to challenge conservative artistic agendas. Cézanne, for example, questioned the traditional Western notion of the painting as a window. While we can still recognize the sky, the mountain, the buildings, the road, and the trees, Cézanne's blocky brushstrokes and vivid, repeated colors (notice the purple repeated in the foreground, and the green in the sky) emphasize that a painting is first and foremost a flat object. Even more important for the future of painting was the way in which Cézanne incorporated more than one viewpoint into his image, an idea that influenced the later development of Cubism.

Revolutionizing Technique

(fig. IIe) Jackson Pollock carried Cézanne's revolution even further, by eliminating all representation from his work, and disposing of the idea that the painter must work on a stretched canvas with brushes. By going so far as dribbling house paint from sticks onto a piece of canvas spread on the floor, Pollock asserted the revolutionary significance of the accidental and the automatic in Western art.

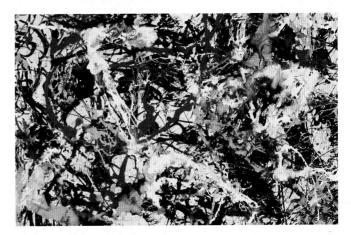

11e Jackson Pollock, Convergence, 1952 (for further information, see fig. 13.3).

Questions

- 1. Study the newest art you can find by visiting local galleries and museums or by studying a recent edition of an art magazine that features contemporary art. What new developments do you find?
- 2. How are they evidence of the continuing revolutionary nature of art today?

The Continuation of Neoclassicism

ow well sculpture conveys political concepts and how quickly the political situation changes are revealed in the monumental representation of Napoleon by Antonio Canova (1757–1822), commissioned by the emperor himself in 1802 (fig. 11.15). Napoleon is represented nude in the guise of Mars, the ancient Roman god of war. By the time the sculpture was delivered, in 1811, Napoleon's position had become less secure. The heroic concept no longer seemed completely relevant, and Napoleon decided not to put the work on public display. After Wellington defeated Napoleon at Waterloo in 1815, he was given the statue as a trophy of victory, as well as a reminder of how quickly the powerful can fall. It is still displayed in Wellington's home in London.

Throughout the nineteenth century, Neoclassical architecture was popular, especially for public buildings and

monuments. The Arc de Triomphe (fig. 11.16) is Napoleon's grandiose version of the ancient Roman triumphal arches (see fig. 4.4) that honored victorious emperors. Unfinished at his death, the sculptures added after it was completed honor instead the heroic people of the French Revolution (see fig. 11.21).

The monumental sculpture of George Washington (fig. 11.17) by Horatio Greenough (1805–52) was inspired by the lost ivory and gold statue of Zeus from Olympia by Phidias, which was reputed to be one of the finest artistic accomplishments of classical civilization. In a typical Neoclassical effort to aggrandize and immortalize Washington after his death, Greenough posed the great founder as the most powerful Olympian god. With rhetorical gestures, Washington offers us a sword and points upward in a declaratory manner, much like David's determined

11.15 Antonio Canova, *Napoleon as Mars the Peacekeeper*, 1803–06. Marble with gilded bronze staff and figure of victory, height 11' (3.3 m). Wellington Museum, London, England.

This work was commissioned by Napoleon, who wanted to be immortalized by Canova, then considered by many to be Europe's greatest sculptor. The sculpture was bought by the British government and presented to the Duke of Wellington, who had defeated Napoleon at Waterloo.

1800 Alessandro Volta invents the electric battery

1800 World population reaches 870 million

1800 U.S. population is 5.3 million; China's is 295 million

1800 Beijing is world's largest city (1,100,000)

1803-06 Canova, Napoleon (fig. 11.15)

11.16 Jean-François Thérèse Chalgrin and others, Arc de Triomphe, Paris, France, 1806–36. Height 164' (49 m).

Inspired by ancient Roman triumphal arches, Napoleon decided to commemorate his military victories with this commission, the largest arch ever built. It was not completed until long after his downfall. For one of the sculptures on the arch, see fig. 11.21.

Socrates (see fig. 10.32). Most nineteenth-century Americans would not have known Greenough's source, and without this reference the statue seemed ridiculous. The abrupt juxtaposition of Washington's portrait set on an idealized semi-nude body led to a disappointed reaction from the statue's patrons and the public. Blaming the harsh interior light of the Rotunda of the U.S. Capitol, Greenough had the sculpture moved outdoors, where it proved to be even less appreciated. The history of Greenough's George Washington reveals the rapid manner in which fashions and attitudes can change—an important feature of the modern world. Even so, the sculpture's monumental scale and commanding impression continue to convey the heroic and even godlike characteristics ascribed to Washington during the period of the early republic.

11.17 Horatio Greenough, George Washington, 1832-41. Marble, height 12' (3.6 m). National Museum of American History, Smithsonian Institution, Washington, D.C. Commissioned by Congress in 1832, this colossal work was intended for the Capitol Rotunda.

Greenough, America's first famous sculptor, was an expatriate who worked in Italy, where his designs were carved by local stone carvers. The George Washington was completed and delivered in 1841, by which time the enthusiasm for Neoclassical sculpture in the United States had passed, and the sculpture was poorly received.

Francisco Goya

espite Goya's commission to perpetuate the "most ... heroic actions ... of our glorious insurrection," *The Execution of Madrileños on the Third of May,* 1808, is a brutal and unsettling painting (fig. 11.18). It emphasizes a confrontation between helpless individuals and the depersonalized power of an anonymous authority.

The universality of Goya's interpretation overwhelms the specific event of the title. These Spaniards are not heroes but victims—perhaps even innocent victims—rounded up to be murdered by French troops. Goya represents the terror and helplessness they feel as they confront death from a faceless firing squad. More victims are marching slowly up

11.18 Francisco Goya, *The Execution of Madrileños on the Third of May, 1808*, 1814–15. Oil on canvas, 8' 9" × 13' 4" (2.67 × 4.06 m); the figures are lifesize. Prado, Madrid, Spain.

Madrileños is the name given to the residents of Madrid. Napoleonic troops occupied Spain from 1808 to 1814, and this painting is one of a pair by Goya that represents an uprising against the French in Madrid on May 2, 1808, and the execution of rebels and innocent victims during the night of May 2–3. This was a decisive act in the consolidation of French power in Spain, and the French commander, Napoleon's brother-in-law Murat, announced that "yesterday's events have given Spain to the emperor." But the riots of May 2 also marked the beginning of Spanish resistance to the French occupation (underground warfare is still called "guerrilla" warfare, from the Spanish term for "little war"). In 1814, after Napoleon was defeated, Goya petitioned the new Spanish government for support to "perpetuate with his brush the most notable and heroic actions or events of our glorious insurrection against the tyrant of Europe."The two paintings were commissioned by the government that same year.

11.19 Francisco Goya, Great Courage! Against Corpses! c. 1810–15. Etching, 4 × 6" (10 × 15 cm) (No. 39 from The Disasters of War series.)

Goya's title for this series was The Fatal Consequences of Spain's Bloody War with Bonaparte and Other Striking Caprichos. The titles of the etchings in this series evoke Goya's intent: With Reason or Without It; One Cannot Bear to See This; No One Can Know Why; They Cry in Vain; And There Is No Remedy; This Is Worse, Even Worse, Barbarians!; Cartloads to the Cemetery; Bury and Shut Up; and I Saw This: Why?

the hill, denoting the extent of the French brutality. Goya commemorates history while simultaneously condemning war and its effect on the individual.

The simple composition and focused light concentrate our attention on the terror and desperate helplessness of the central figure. The night setting, dramatic chiaroscuro contrast, and right-to-left composition heighten the drama, and Goya's loose brushstrokes emphasize the writhing movement of the victims. The color scheme is dull, with the exception of the red for blood splashed on the left foreground.

Goya published several series of prints, including a large group now known as *The Disasters of War*. Begun during the Napoleonic occupation and continued in the repressive political period after the French withdrawal,

they were not published until 1863, after Goya's death. In some of these prints, the nationalities of the French and Spanish soldiers are clear, but which are the torturers and which the tortured alternates. Other scenes, like the one reproduced here (fig. 11.19), are less specific; they provide Goya's comments on the terrible inhumanity created by war. Even the title condemns the futility and cruelty of this act. Many of the prints represent atrocities that Goya witnessed during the occupation, and his cry of "Enough!" resonates across the centuries. The creation of these prints may have helped the artist deal with his emotions of helplessness, frustration, and sorrow, but the demons he expelled remain to haunt us. The **etching** medium, with its rough, scratchy lines, here serves as an appropriate vehicle for Goya's expression.

Romanticism

The Raft of the Medusa, by Théodore Géricault (1791–1824), signals a departure in the development of history painting, for its subject is not a heroic event but a needless modern tragedy (fig. 11.20). When the French frigate Medusa sank off the African coast, the captain and senior officers commandeered the lifeboats, abandoning 150 other survivors to a makeshift raft. After floating for thirteen days, the fifteen who were still alive were rescued. Géricault represents the moment when they sight the ship that will rescue them on the horizon. The inexperienced captain of the Medusa owed his position to his noble birth and his connections with the French government. Géricault's painting is intended both as a dramatic record of the event and as a condemnation of a

government that would allow such a thing to happen. Whereas in the past most works of art that made a political statement were designed to sustain the government in power, Géricault's social and political consciousness demanded that he create a work that was critical.

The precise modeling of the figures and their dramatic gestures and varied poses reflect Géricault's study of the art of Michelangelo and Rubens, while the strong chiaroscuro, diagonal composition, and agitated figurative poses remind us of Baroque painting. But here these visual devices have been adapted to a theme of continuing and uncertain conflict. At the same time that the survivors catch sight of a ship, they are in constant danger of being engulfed by the turbulent sea. Géricault's painting re-creates a frightful, emotional drama.

11.20 Théodore Géricault, *The Raft of the Medusa*, 1818–19. Oil on canvas. $16' \ 1'' \times 23' \ 6'' \ (4.9 \times 7.16 \ m)$. The Louvre, Paris, France.

In preparing for this enormous painting, Géricault read published accounts of the event, interviewed survivors, and visited hospitals and morgues to study dying and dead people.

11.21 François Rude, *The Departure of the Volunteers of 1792* (popularly known as *La Marseillaise*), 1833–36. Limestone, height about 42' (12.6 m). Arc de Triomphe, Paris, France (see fig. 11.16). Commissioned by the French Government of King Louis Philippe.

So stirring was Rude's sculpture that it soon received the nickname "La Marseillaise," after the French national anthem, which was written in 1792 and first gained popularity when it was sung in the streets of Paris by troops from Marseilles.

The Raft of the Medusa introduces us to Romanticism, a new style that challenged the dominance of Neoclassicism in the early nineteenth century (see box, p. 431). Émile Zola, the French novelist and critic, would help define Romanticism when he wrote, "A work of art is part of the universe as seen through a temperament."

Romanticism stressed the subjective view of the artist, which meant that it was not dominated by a single, unified style. Romantic artists freely looked to a variety of past art styles, as well as to nature around them, to express their temperament. Opposing the rational and restrained aesthetic of Neoclassicism, Romanticism

championed the unbridled spirit of the human imagination. The expression of the artist's feelings and convictions became paramount.

The powerful and contagious emotional surge of Romanticism is evident in the enormous high-relief sculpture, by François Rude (1784–1855), that decorates one of the piers of the Arc de Triomphe (fig. 11.21). An angry and determined figure representing the Genius of Liberty urges the people forward with a vigorous right-to-left movement. Despite the specific title, Rude depicts the soldiers in classical nudity or wearing ancient armor to express a universal theme—humanity's fight for liberty.

Romantic Landscape Painting

his interpretation of English scenery by John Constable (1776–1837) is affectionate, with its simple cart, humble cottage, and a dog standing at the river's edge (fig. 11.22). The composition is unaffected and natural, as if we have accidentally come upon this quintessential English scene. But Constable's painting is unified by the cloudy English atmosphere and by flecks of light and color—surprisingly loosely applied—that recreate the sparkling luminosity of the English countryside after the rain. Despite its naturalistic basis, the work can also be termed Romantic. Constable said that "painting is for me but another word for feeling." Here the rush of feeling lies in Constable's love for and exaltation of his native countryside.

In the nineteenth century, landscape painting became a vehicle by which Romantic artists expressed personal thoughts and emotions. One of the earliest was the German painter Caspar David Friedrich (1774–1840), who wrote:

The painter should depict not only what he sees before him, but also what he sees inside himself.... Close your physical eyes so that you see your picture first with your spiritual eye. Then bring forth what you saw inside you so that it works on others from the exterior to their spirit.

Friedrich's paintings represent his meditation on the expressive power of nature, as in *Abbey in the Oak Forest* (fig. 11.23), in which a funeral procession of monks moves slowly past the ruins of a Gothic structure. The skeletal branches of the oak trees, their patterns echoing the window tracery of the Gothic ruins, are set against an expansive somber sky, which, together with the overt symbol of the funeral procession, suggests that Friedrich is reflecting on the void of death. The mood of nature that he has captured here is filled with melancholy by the addition of the procession and the ruin. Winter and time have blanketed both nature and the product of human endeavors, and the tiny

11.22 John Constable, *The Hay Wain*, 1821. Oil on canvas, 4' $3\frac{1}{4}$ " × 6' 1" (1.3 × 1.85 m). The National Gallery, London, England.

Constable's naturalism was in part inspired by his study of the innovations in landscape by Dutch seventeenth-century painters; see Ruisdael's *Dutch Landscape* (fig. 9.52).

1823 Antislavery Society is founded in England

1825 Opening of the Erie Canal from Albany to Buffalo

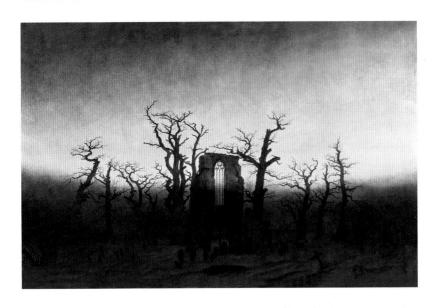

11.23 Caspar David Friedrich, Abbey in the Oak Forest, 1809–10. Oil on canvas, 3' 8" × 5' 8½". Schloss Charlottenburg, Berlin, Germany.

scale of the figures in the procession suggests the grandeur of nature. Friedrich and other nineteenth-century landscape artists (see fig. 11.34) sought to communicate the feelings of grandeur and of the sublime raised by the contemplation of nature. What is amazing is how such a quiet, calm picture can evoke such powerful human emotions.

The concept of struggle was also an important theme of Romanticism. The human struggle against the seemingly overwhelming forces of nature is expressed in The Slave Ship (fig. 11.24), by Joseph Mallord William Turner (1775–1851), which Turner entitled Slavers Throwing Overboard the Dead

and Dying-Typhoon Coming On. This large painting, ablaze with a fiery red sunset that almost overwhelms the theme, depicts the ship heading into a typhoon. Turner's evocative colors and broad brushstrokes create an urgent, anxious feeling. To lighten the ship's load, the captain inhumanely has thrown some of his cargo of slaves overboard. Although we witness their struggle in the water, the destiny of the brutal slavers will be determined by nature, as the ship faces the fury of the storm. Like many other Romantic paintings, the sensational theme offers a kind of political commentary that will become more and more common in the history of art.

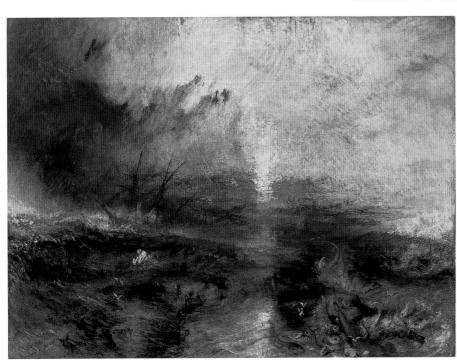

11.24 Joseph Mallord William Turner, The Slave Ship, 1840. Oil on canvas, 2' $11\frac{3}{4}$ " × 4' $\frac{1}{4}$ " (91 × 123 cm). Museum of Fine Arts, Boston.

Japanese Woodblock Prints

he particular combination of subject matter and style seen in these two prints (figs. 11.25, 11.27) is called *ukiyo-e* ("pictures of the floating world"). The term "floating" is here used in the Buddhist sense of something that is transient or evanescent, as experienced in everyday life and especially in the world of pleasure: theater, dancing, love, festivals, and the like. In both examples, we see the fleeting nature of *ukiyo-e*: in one, the rising of a huge wave that enframes a view of Mount Fuji; in the other, the humble but distinctive aspect of the cotton merchants' lane in Tokyo at one moment in time.

The term *ukiyo-e* is especially associated with Japanese woodblock prints. In Japan it is also used more broadly to describe a style that originated in painting and incorporated influences from a number of sources. These sources include the narrative picture scrolls (*emaki*) of the twelfth century; the decorative style brought to its peak by such painters as Sotatsu (see his *byobu*, fig. 9.49); bold Chinese compositions and brushwork incorporated into the tradition of Japanese Kano painting; and aspects of naturalism drawn from both Japanese traditions and the West. These elements came together in *ukiyo-e*, a new art that satisfied

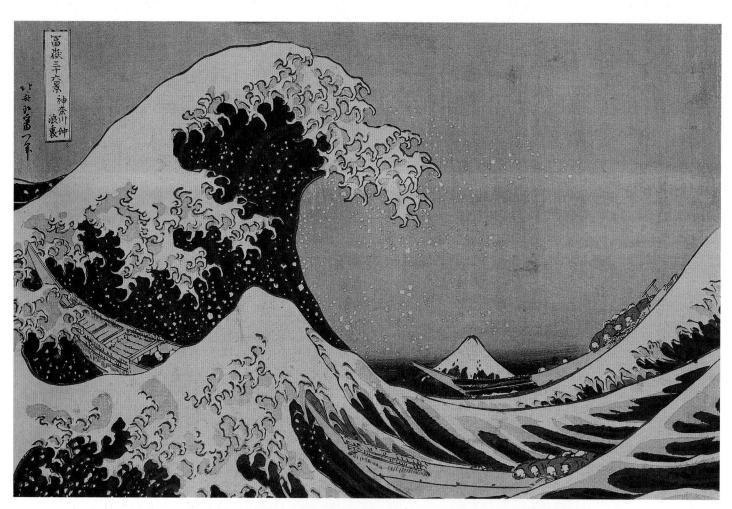

11.25 Katsushika Hokusai, *The Great Wave*, from *Thirty-Six Views of Mount Fuji*, c. 1823–29. Woodblock print, $9\frac{1}{2}$ × 1' $2\frac{1}{4}$ " (24 × 37 cm). Commissioned by the publisher.

The initial impetus behind a *ukiyo*-e woodblock print came from the publisher, who often dictated the subject matter and style. Its creation was the result of close and complex collaboration among a number of individuals. The design, created by the artist-designer, was carved into blocks of wood by a carver, who had to modify the artist's line from the original brush drawing; it was then printed by other specialists. Cooperation was essential, and compromise for aesthetic reasons or to enhance marketing must have been common. The earliest prints were black and white, with color applied by hand. With the development of color printing in about 1741, each color was printed from a separately carved block; the coordination of printing so that each color was properly placed was a difficult technical procedure.

c. 1823-29 Hokusai, The Great Wave (fig. 11.25)

1826 Fenimore Cooper, The Last of the Mohicans

1829 Greece wins its independence from Turkey

1830 (Louis) Hector Berlioz, Symphonie fantastique

1830 U.S. population is 12.9 million, including 3.5 million slaves

TECHNIQUE

Japanese Woodblock Technique

By the nineteenth century, Japanese woodblock prints were being collected by a broad segment of the population. During the second half of the century, they were also widely collected in Europe, where they had a significant impact on artistic developments (see fig. 11.4, which was in the collection of Vincent van Gogh). The technique of making these prints was similar to that described on pp. 314-15, but with some significant refinements.

Japanese prints are made by reproducing an image that has been carved into the surface of one or more wooden blocks onto a sheet of paper (fig. 11.26). The process begins when the artist makes the design on thin, semitransparent paper, which is then pasted face down on the wood block; in Japan these blocks were usually made of wood from cherry trees. The design is then carved through the paper into the wood with a chisel, leaving the lines and solid areas of the design raised above the cut surface of the wood. After any remaining pasted paper is washed off, ink is then brushed onto the raised surfaces of the wood block and a piece of paper is placed over it. The backside of the paper is then rubbed with a baren, a diskshaped pad, which presses the front side of the paper onto the inked portions of the block.

While early woodblock prints used only black ink, as had those in Europe, by about 1760 the use of color was widespread, with as many as twenty colors used to make a single print. The great difficulty here was that a different block had to be carved for each color. This greatly complicated the printing process, for the paper had to be perfectly aligned on each block to create the final print. This also meant that special paper had to be developed that could withstand the multiple rubbings; the commonly used paper was made from mulberry bark. During the late eighteenth and the nineteenth century, three prints were often joined into a triptych.

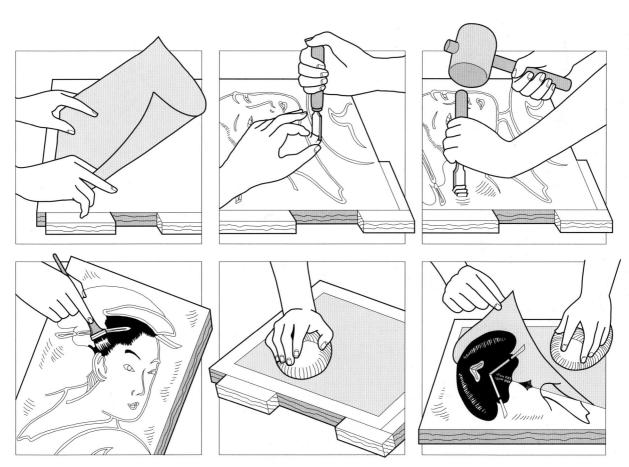

11.26 The technique of making a Japanese woodblock print.

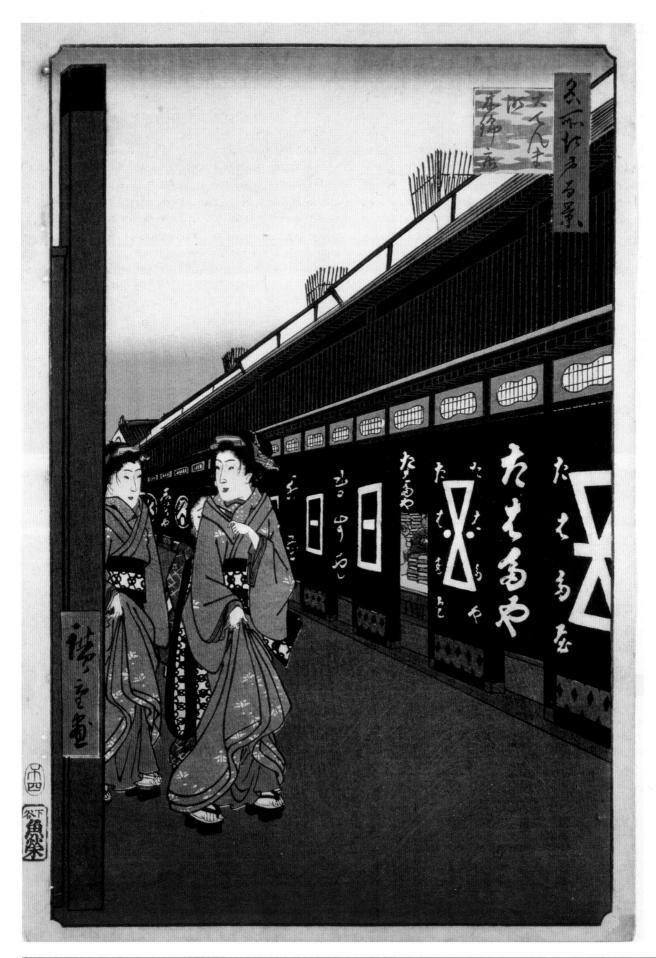

the demands and interests of the merchant and plebeian classes of urban Japan. Ukiyo-e prints, which were relatively inexpensive, were readily available for purchase by these new classes of collectors, and their bold colors and familiar subject matter gave them wide appeal.

Printing had been known in East Asia since the eighth century, but this woodblock technique, traditionally used to produce cheap Buddhist icons, painting manuals, and textbooks, was not fully exploited either technically or aesthetically until the eighteenth century, when a new market among the urban middle classes arose to motivate its swift development. The prints were mass-produced and responded quickly to changing urban fads and fashions.

During the eighteenth century, most ukiyo-e prints were dedicated to the representation of the figure, but some innovative nineteenth-century artist-designers turned to urban and landscape subjects. Some of these were produced in series of prints around a central subject, such as Thirty-Six Views of Mount Fuji by Hokusai (1760-1849) or Fifty-Three Stages of the Tokaido Road (a travel guide) and One Hundred Famous Views of Edo (Tokyo) by Hiroshige (1797-1858).

Hokusai's Thirty-Six Views of Mount Fuji holds the viewer's interest by the inventiveness with which Fuji, the sacred Japanese mountain, is incorporated into the landscape or scenes of everyday life. Often, there are unusual and dramatic juxtapositions, as in The Great Wave (see fig. 11.25), where the men in the skiff are dwarfed by the huge, clawing wave. The sense of imminent danger contrasts with the calm and majestic shape of the ever-present mountain in the background.

Cotton Goods Lane (fig. 11.27) by Hiroshige represents a street in the heart of Tokyo. The care taken with architectural details in the scene is matched in the handling of human activity. Hiroshige has shortened one of the cloth noren (entry curtain) so that we can peer inside a shop, where the merchants sit among piles of cloth, presumably tallying the day's profits. The subtle disarray of the dress of the two geisha suggests that they are returning from providing entertainment and perhaps sharing drinks with patrons.

Although these artists were contemporaries and were both interested in depicting the transitory, Hokusai's style is characterized by willful inventiveness and daring organization, while Hiroshige's works focus on the subtleties of a particular place and mood. Most Japanese print designers were also painters, but interest in their paintings has been eclipsed in the West by the popularity and availability of their prints.

11.27 Ando Hiroshige, Cotton Goods Lane, Odenma-cho Momen Dana, from One Hundred Views of Edo, 1858. Edo is an earlier name for Tokyo. Woodblock print, 1' 2¾" × 10" (37 × 25 cm). Art Institute of Chicago. Commissioned by the publisher.

The pristinely uniform architecture seen here was a particular feature of the Odenma-cho ("the cotton-goods merchants' quarter") and was unusual for wealthy Edo merchants. The enclosure of a row of several shops under a single roof is a house form usually reserved for backstreet tenements. The alternating crests and names identify three separate establishments, which are further defined by the low projecting ridges running down the roof face. According to the authorities, the cotton merchants were entitled to use the boxlike structure running along the entire roof as a distinguishing mark. The enclosures on top of the ridge held buckets that trapped rain water to be used in case of fire.

Honoré Daumier and the Political Print

he dying baby lying under its dead father (fig. 11.28) is the most moving detail provided by Honoré Daumier (1808–79) in his condemnation of the brutality of French governmental policy in dealing with the working classes. The specificity of the title was chosen so that there could be no doubt about the subject. In April 1834, workers in Lyon and Paris, led by the secret Society of the Rights of Man, rioted to demonstrate against harsh working conditions and the passage of a new law forbidding unionization. On the night of April 14–15, a sniper in Paris killed an officer. In retaliation, a number of innocent residents of the sniper's building were killed by the police, including a woman and a child. Daumier's printer, Charles Philipon, wrote of this print:

This is not caricature ... it is a blood-stained page in the history of our days, traced by a vigorous hand and inspired by noble indignation ... he has created a picture which will never lose its worth or duration, even if it consists of only black lines on a sheet of paper.

Daumier's print was publicly displayed and sold in mass quantities in a journal in which Daumier's other political and humorous prints often appeared. Already in 1832, at the age of twenty-four, Daumier had served five months in prison because he had caricatured King Louis Philippe as Gargantua, but this experience did not weaken his determination to make statements through his prints about the moral and political problems and issues of his day.

Daumier made thousands of prints in a long career, and no one was safe from his attacks: radical artists, bored and quarrelsome married couples, naughty children, amateur artists, arrogant connoisseurs, corrupt politicians, and even figures from classical antiquity and mythology were lampooned. One of the popular political periodicals that published Daumier's work was called *La Caricature*. Its name helped popularize the term we use today for exaggerated and humorous representations.

Daumier's heroes most often came from the working classes. In *Freedom of the Press* (fig. 11.29), a youthful typographer, fists clenched, stands ready to defend free speech and the liberty of writers, artists, and publishers to comment on contemporary affairs. The vignette in the right background shows the defeated French king Charles X, who had been driven from power in 1830 in part as a result of criticism leveled by the press. Other European monarchs come to his aid as he is exiled. The sturdy hero looks toward the arrival of the current king, Louis, and his stance indicates that he is again ready to do battle to protect his rights.

The opinions and criticism revealed in popular prints by Daumier and others, however, eventually became too much for the government to bear. In 1835, laws were passed that proclaimed that "Frenchmen have the right to circulate their opinions in published form," but that "drawings" were such an "incitement to action" that complete liberty in this realm was no longer permitted. After this point, Daumier's prints became more humorous and less political.

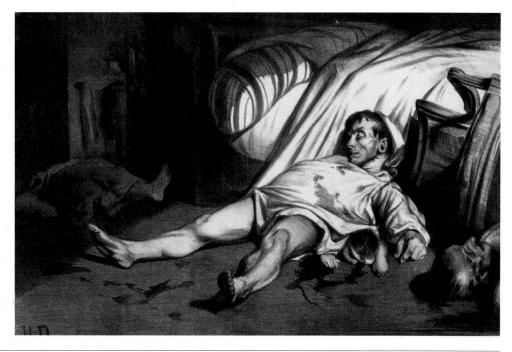

11.28 Honoré Daumier, *Rue Transnonain*, *April 15*, 1834, 1834. Lithograph, 11½" × 1' 5½" (29 × 44 cm). This print was published in *L'Association mensuelle*, July 1834. Probably commissioned by the publisher of the periodical.

CHAPTER II

1834 Britain's Consolidated Trades Union is dissolved

1834 Troops are used for the first time in a U.S. labor conflict

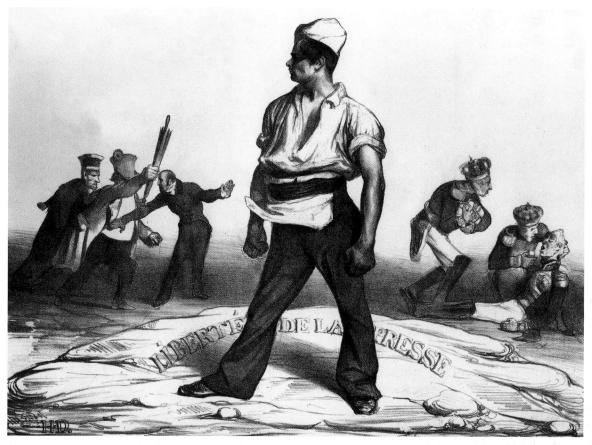

11.29 Honoré Daumier, Freedom of the Press: Don't Meddle with It, 1834. Lithograph, 11½" × 1'5½" (29 × 44 cm). This print appeared in La Caricature, March 1834. Probably commissioned by the publisher of the periodical.

TECHNIQUE

Lithography

Lithography ("stone drawing"), invented in Germany in 1798, became the most popular print medium of the nineteenth century, as lithographs came into use to illustrate newspapers and books (fig. 11.30). Lithography is based on the affinity of grease for grease and the antipathy of water to grease. The print form is usually a very smooth slab of limestone on which the artist creates a composition using either a greasy crayon or lithographic ink applied with a pen or a brush. The resulting design adheres chemically to the surface of the stone. When the stone is moistened, the water stays only in the nongreasy areas and the greasy ink that is subsequently applied with a roller adheres only to the composition. A dampened paper is applied, stone and paper are put through a press, and a lithograph is created. The technique, spontaneous and relatively cheap, was especially appropriate for the mass media of the nineteenth and early twentieth century because the design can be readily transferred from the

original print form to additional stones, allowing a large and rapid print edition.

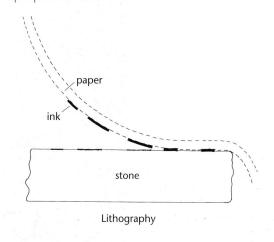

11.30 Diagram of the lithography technique.

Romantic Revival Architecture

11.31 Charles Barry and Augustus W.N. Pugin, Houses of Parliament, London, England, begun 1836; opened 1852; completed 1870. Commissioned by Parliament and King William IV.

Barry, who won the 1835–36 competition to design the new Houses of Parliament, hired Pugin to help with the detailing. The resulting Gothic Revival complex even has Gothic Revival inkwells and coatracks.

he decision to rebuild the Houses of Parliament in London in the Gothic Revival style (fig. 11.31) was not based solely on aesthetic grounds. A more profound cultural and moral basis declared that the Gothic style was historically appropriate, for it had flourished in

England during the late medieval period. And, more important for the nineteenth century, the Gothic was

TORONTO

• PITTSBURGH

WASHINGTON

RICHMOND

ATES

CANADA

perceived as a style that expressed spiritual goodness, truth, and the properly reverent relationship between humanity and God: it thus became the quintessential Christian style. One critic in 1836 described it as:

a style of architecture which belongs peculiarly to Christianity ... whose very ornaments remind one of the joys of life beyond the grave; whose lofty vaults and arches are crowded with the forms of prophets and martyrs and beatified spirits, and seem to resound with the choral hymns of angels and archangels ... the architecture of Christianity, the sublime, the glorious Gothic.

The Romantic architects of the nineteenth century revived a multitude of historical styles, but each was understood within a specific cultural, moral, and historical context that encompassed both the nineteenth century and the period when the style originated. The Greek Revival in the United States, for example, as witnessed in a house in Demopolis ("City of the People"), Alabama (fig. 11.32), and in hundreds of banks, courthouses, churches, and homes

throughout the country, was a response to a movement to find an architectural style appropriate for the political ideals of the young nation. Thomas Jefferson had championed the Neoclassical style (see pp. 418–19), but the early nineteenth century turned more directly to the monuments of ancient Athens, history's first documented democracy, for inspiration.

In the United States, the Greek style was gradually supplanted in popularity by the Gothic Revival style. The house by A. J. Davis in New Bedford, Massachusetts (fig. 11.33) is decorated with the architectural vocabulary invented for the great French Gothic cathedrals. The scalloped decoration (cusping) in the eaves and the lacy patterns of the porch posts-cut from wood-are an American version of the gilded decorations on a medieval Gothic reliquary. The widespread popularity of this "carpenter Gothic" ornament and other revival styles can be explained in part by the cheap pattern books, produced by architects and publishers, that brought such fantasy within the range of every pioneer with a saw.

11.32 Gaineswood, Demopolis, Alabama, 1842-c. 1860. Wood.

The heritage of the early nineteenth-century American enthusiasm for things Greek survives in structures, often by unknown or purely local architects, in the Greek Revival style in stone, wood, and stucco, in coordinating furniture and decorative arts, and in such place names as Demopolis; Troy, New York; Olympia, Washington; and Sparta and Athens, Michigan.

11.33 Alexander Jackson Davis, House for William Rotch, New Bedford, Massachusetts, 1845. Commissioned by William J. Rotch.

American Romantic Painting

A landscape is great in its proportion as it declares the glory of God, not the works of man.

(Asher B. Durand, Letters on Landscape Painting, 1855)

Enthusiasm for the God-given beauty and richness of the American landscape is the subject of this painting (fig. 11.34) by Thomas Cole (1801–48). A dramatic natural confrontation is emphasized as the sweeping peak seems to soar victorious above the clouds. The season is autumn, when the American landscape offers a brilliant display of color. Schroon Mountain is located near the source of the Hudson River in the Adirondack Mountains, in New York State, and after visiting there in 1837, Cole wrote:

The scenery ... has a wild sort of beauty ... quietness—solitude—the world untamed ... an aspect which the scene has worn thousands of years.... I do not remember to have seen in Italy a composition of mountains so beautiful or pictorial as this.

Cole's emphasis on the uniqueness of American scenery is significant, for in his paintings, nationalistic spirit was joined to the ideal of the American landscape as a new Garden of Eden—a God-given paradise that would guarantee the nation's future greatness. Cole himself was to write:

Those scenes of solitude from which the hand of nature has never been lifted affect the mind with more deep-toned emotion than aught which the hand of man has touched. Amid them the consequent associations are of God, the Creator. They are his undefiled works, and the mind is cast into the contemplation of eternal things.

Later, the landscape painter Asher B. Durand wrote that every American family should own a painting of the American landscape, counseling that it should hang in the parlor, over the table where the family Bible was kept.

11.34 Thomas Cole, *Schroon Mountain*, *Adirondacks*, 1838. Oil on canvas, $3' 3\%'' \times 5' 3'' (1 \times 1.6 \text{ m})$. Cleveland Museum of Art.

Philip Hone, who had served as mayor of New York City, in 1838 wrote, "I think every American is proud to prove his love of country by admiring Cole." Although the landscape seems wild and uninhabited, Cole includes two Native Americans wearing red-feathered headdresses in the foreground.

11.35 George Caleb Bingham, Fur Traders Descending the Missouri, 1845. Oil on canvas, 2' 5" × 3' $(74 \times 91 \text{ cm})$. The Metropolitan Museum of Art, New York.

Bingham's original title for this work was French Trader and Half-Breed Son. There is still debate about the identification of the tethered animal, but in a later version of this same theme it is clearly a bear cub.

Earlier American painters had concentrated on portrait painting (see fig. 10.25), an art that flourishes in democratic, mercantile societies. In the late eighteenth and early nineteenth centuries, however, a number of painters went to Europe to study, returning home full of enthusiasm for the style and the themes of Neoclassical history painting (see pp. 420–23). They soon discovered that the intellectual subjects of history painting held little appeal for the American public or patrons. Beginning in the 1820s, American scenery was identified as the ideal subject for American artists, and it was Thomas Cole who was recognized by his contemporaries as the first great painter of the American landscape. Landscape seemed an especially democratic art, for its meaning was immediately accessible to the public, without scholarly reference.

In the painting by George Caleb Bingham (1811–79), our romantic, atmospheric view of the wide American river

is intercepted by a dugout canoe coming downstream, close to us and in sharp focus (fig. 11.35). The trailing smoke from the trader's pipe reveals the speed of the current. The old trader and his son look at us with contrasting expressions—the boy seems bemused, the father serious.

Bingham's composition places the canoe parallel to the picture plane to emphasize both the horizontal vastness of the mighty river and its right-to-left movement. A surprising percentage of the painting is given over to the sky, where the sudden luminosity of dawn highlights the wispy clouds. The subdued colors and blurred forms of the atmospheric setting give emphasis to the foreground forms, which are richer in color and pattern and more precisely executed. These forms are in turn blurred in the splendidly painted reflection. Bingham's painting of life on the frontier, an evocation and exaltation of the American West, was intended for an audience in the urbanized cities of the East.

Revolutionary Art vs. Academic Art

The art of painting can consist only in the representation of objects visible and tangible to the painter. An epoch can be reproduced only by its own artists. I mean by the artists who have lived in it. I hold that the artists of one century are fundamentally incompetent to represent the things of a past or future century.... It is in this sense that I deny the existence of an historical art applied to the past.

(Gustave Courbet, 1861)

To our eyes, there is nothing particularly offensive about A Burial at Ornans (fig. 11.36), by Gustave Courbet (1819–77), for the painting seems to offer an objective view of life in mid-nineteenth century France. When it was first exhibited, however, this and other paintings by Courbet shocked and angered critics and public alike. During the Neoclassical and Romantic eras, the significance of a painting was judged by the didactic virtue of its theme and by the painter's adherence to academic rules of composition and execution. Courbet broke these rules, insisting that the only goal of the artist was to reproduce "objects visible and tangible to the painter." To those schooled in traditional attitudes about art, however, commonplace figures and subjects seemed trite and vulgar. In A Burial at Ornans we seem to be standing at the side of a grave during a funeral in Courbet's hometown outside Paris. Virtually without comment, Courbet records the visual facts: a priest and attendants recite prayers, the rather stoic mourners begin to move away, a dog stands in

the foreground, and the gravedigger kneels by a hole in the ground in the immediate foreground. The composition seems almost accidental, the deceased is not identified, and there is nothing heroic or inspiring about the interpretation of the subject. The emotional pulse of Romantic painting has given way to simple, direct observation.

When A Burial at Ornans and another large painting by Courbet were rejected by the jury of the Universal Exposition of 1855, the infuriated artist withdrew the eleven pictures they had accepted and had his own exhibition building constructed, where he held a solo show in competition with the official exhibition. The "Realist Manifesto," which may have been written in part by the writer and critic Champfleury, was actually the introduction to the catalog of Courbet's private exhibition:

I have studied the art of the masters and the art of the moderns, avoiding any preconceived system and without prejudice. I have no more wanted to imitate the former than to copy the latter; nor have I thought of achieving the idle aim of art for art's sake. No! I have simply wanted to draw from a thorough knowledge of tradition the reasoned and free sense of my own individuality.

To know in order to do: such has been my thought. To be able to translate the customs, ideas, and appearance of my time as I see them—in a word, to create a living art—this has been my aim.

11.36 Gustave Courbet, A Burial at Ornans, 1849–50. Oil on canvas, 123%" × 263" (311.5×668 cm). Musée d'Orsay, Paris, France.

11.37 Emanuel Leutze, Washington Crossing the Delaware, 1851. Oil on canvas, 12' 5" × 21' 3" $(3.78 \times 6.48 \text{ m})$. The Metropolitan Museum of Art, New York.

When this painting was exhibited in New York in 1852, some 50,000 people paid to see it, and the wide sale of a reproductive engraving made it one of the most famous images in the United States. Leutze worked hard to make his painting authentic, but history buffs will note a number of errors.

Courbet's style quickly became known as Realism. In a letter, Courbet wrote to a patron that Realism was "a holy and sacred cause, which is the cause of Liberty and Independence." Throughout the 1850s, Courbet's paintings gained greater public acceptance, although critics also became more vociferous, accusing him of being a propagandist for leftist or socialist causes. At one point he was even thrown into prison. Being in prison didn't stop Courbet from his activity as a realist painter, for he painted still-lifes on small wooden panels of the fruit his family brought him to eat. Courbet's redirection of subject matter toward the realism of the commonplace was an important influence on younger French artists, especially Édouard Manet and the Impressionists (see pp. 466-67 and 472-75).

An example of the kind of art that Courbet was challenging is Emanuel Leutze's (1816-68) Washington Crossing the Delaware (fig. 11.37). Leutze's painting exemplifies the Academic approach to history painting, with its blend of a serious subject, historical fact (or what passes for historical fact), artistic manipulation, precise detail, and a carefully digested blend of elements from the High Renaissance and Baroque. Although he had grown up in the United States, Leutze returned to his native Germany to spend many years teaching and studying at an influential Academy at Düsseldorf. Many American painters studied there, returning to the United States to advocate the strict and precisely painted realistic style for which the Düsseldorf Academy and Leutze were famous.

The highest goal of Academic painters was to create history paintings of significant moral import, paintings that would document the past and provide inspiration and guidance for the future. In his painting, Leutze set out to express the significance of Washington's crossing of the Delaware. His success can be judged by the manner in which his treatment continues to capture the public's enthusiasm. It is through this painting that generations of schoolchildren have come to understand a famous national event; rather than representing history, Leutze's painting has played a role in forming it.

The success of the picture is based on the precise detail that makes its historical theme convincing and on its striking composition, which emphasizes a valiant Washington standing heroically against the wind.

The differences between Courbet's Realism and Leutze's Academicism are irreconcilable, and led to conflict within the artistic community in Paris, as we shall see.

New Materials and Engineering in Architecture

he Crystal Palace (fig. 11.38) exemplifies two developments that transformed architecture during the second half of the nineteenth century: the availability of new, industrial materials, and the advantages of prefabrication. This huge structure of prefabricated cast-iron membering and glass was made and erected in nine months, demonstrating the speed and economy of such a procedure. The basic module used in the design of the building was not based on aesthetic principles but on a practical fact: the maximum width of the glass that could be manufactured was approximately four

feet. The cast-iron components were based on a module of twenty-four feet, and no single prefabricated part was allowed to weigh more than a ton. Because it was intended to be a temporary, utilitarian structure (for exhibits of machinery and industrial arts), the references to earlier architectural styles usually expected in nineteenth-century buildings were not required. One perceptive critic pointed out that "here the standards by which architecture had hitherto been judged no longer held good," but the fact remains that the Crystal Palace was considered to be a utilitarian structure and not an example of high architecture; it

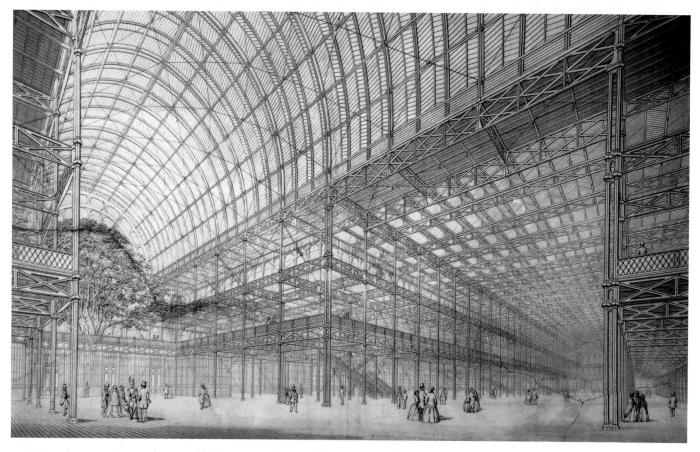

11.38 Joseph Paxton, Detail of the interior, the Crystal Palace, London, England. 1850–51 (destroyed). Cast iron, wrought iron, and glass, length 1,848' (554 m); width 408' (122 m). Commissioned by the Building Committee of the Commissioners of the Great Exhibition of the Works of Industry of All Nations. Engraving by W. B. Brounger. Drawings Collection, Royal Institute of British Architects, London.

The Crystal Palace was an enormous structure erected to house the Great Exhibition of the Works of Industry of All Nations—the first in a series of nineteenth-century international exhibitions that presaged the world's fairs of our own day. The largest single enclosed volume erected up to that date, it covered almost I million square feet of floor space. It was later disassembled and rebuilt on another site.

1855 Sir Henry Bessemer develops steel process

1857 Gustave Flaubert, Madame Bovary

11.39 John A. and Washington A. Roebling, Brooklyn Bridge, New York. 1869–83. Stone piers with steel cables, maximum span 1,595' (479 m). Commissioned by the New York Bridge Company, under an act passed by the New York State Legislature.

John Roebling died in 1869, just as construction on the bridge was beginning, and his son brought his plans for the bridge to completion.

is only in retrospect that the revolutionary nature of Paxton's design has been recognized.

The new technological investigations and accomplishments of the nineteenth century were widely published in books and technical journals, and thus their impact became immediate and widespread. Metal and glass were at first held to be fireproof, but iron proved to be susceptible to melting and collapse in a conflagration. Ironically, the Crystal Palace itself was ultimately destroyed by fire, but only in 1936.

New York City's Brooklyn Bridge, by John A. Roebling (1806-69) and his son Washington A. Roebling (1837-1926), pioneered another new material—steel (fig. 11.39). The advantages of using metal for bridges were first realized in a cast-iron bridge erected in England in 1779. In bridge building, cast iron (an iron alloy that is easily cast but of low tensile strength) was subsequently replaced by wrought iron (a much purer, malleable iron), and then wrought iron was replaced by steel (a malleable iron alloy with very high tensile strength). The Brooklyn Bridge is more than half again

as long as any earlier bridge, and its four huge cables are formed from parallel galvanized drawn-steel wires that were spun in place to create an ultimate strength of 71.5 tons per square inch. But despite the modern technology that made this huge span possible, the dramatic masonry supporting piers were given Gothic arches.

Before he won the competition to build the "Eiffel Tower," Gustave Eiffel (1832–1923) had established an international reputation as an engineer and designer of bridges and locks. Among his important works is the skeletal support system for the *Statue of Liberty* (see figs. 11.6, 11.7). The purpose of the Tower (see fig. 11.1) was to provide a dramatic symbol for the 1889 World's Fair in Paris and, by elevators, to give fairgoers a high vantage point with fabulous views over the city. But Eiffel also set out to design a pleasing structure, and he dressed up its modern grid frame with sweeping curves and classically proportioned relationships. Even so, the design was criticized as a monstrosity, and the architect of the Paris Opéra, Charles Garnier (see p. 464), circulated a petition demanding that it be demolished.

But the most significant development in the later nineteenth century was the invention of the skyscraper (see pp. 492–93). As business and population were concentrated in rapidly growing cities, the need for expansion upward became evident. Louis Sullivan, in his *Autobiography of an* *Idea* (1924), wrote: "The tall commercial building arose from the pressure of land prices, the land prices from pressure of population, the pressure of population from external pressure."

In 1852, Elisha G. Otis invented the Otis safety elevator, which he demonstrated at a New York industrial fair in 1854. By 1857, the first commercial passenger elevator had been installed in a New York building, and in 1861 Otis made a significant improvement by patenting a steampowered elevator. Before Otis's invention, the height of a building had been limited by how many flights of steps the occupants were willing to climb. With an elevator, the height suddenly seemed unlimited.

Before the new developments discussed here, most of the large structures being built in the expanding urban centers were of heavy masonry (that is, stone or brick) construction, and the taller the building, the heavier the lower stories had to be to support the tremendous weight of the increased height. The soaring structures that define a successful world city today are the result of these nineteenth-century innovations in architectural design and materials. During this period the load-bearing steel cage was made more economical by the lower price of steel due to the invention of the Bessemer process (1855), while at the same time the possibilities of reinforced concrete were being explored. Life in the city would never be the same.

New Materials in Architecture

Load-bearing steel-frame construction (fig. 11.40) is based on an earlier development in wood, the balloon frame, in which wood joists are joined horizontally and vertically to create grids that become a skeletal structure for the building. Both outer "skin" and inner walls are attached to and hang from this skeleton.

Load-bearing steel-frame construction resembles wood frame construction, but the load-bearing members are prefabricated steel beams. In tall buildings, the steel frame offers several significant advantages. The high tensile strength of steel makes possible a substantial reduction in both the weight and the thickness of the walls. In a brickor stone-walled structure, the weight of each story that is added to the height requires a significant increase in the thickness of the walls at the base:

It was inherent in the nature of masonry construction to fix a new limit of height; as its ever-thickening walls

ate up ground and floor space of ever-increasing price, as the pressure of population rapidly increased.

(Louis Sullivan, The Autobiography of an Idea, 1924)

While masonry has high compressive strength, the high tensile strength of steel (its strength in tension) gives a steel frame structure elasticity, allowing it to respond to high winds, a problem in a masonry building, which will topple because it cannot sway.

Reinforced concrete (fig. 11.41), in which concrete is strengthened by embedded wire rods or mesh, was developed in France in the second half of the nineteenth century. The steel gives the concrete an impressive tensile strength. Such "ferrocement" is a remarkably flexible composite material and can be either cast in place during construction, or prefabricated and transported to the construction site. As is typical of the nineteenth century, this economical new construction method was first used only for utilitarian structures such as mills.

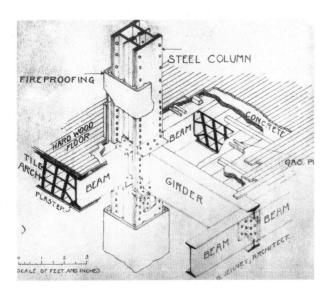

11.40 William Le Baron Jenney, Detail of steel-frame construction, as used in the Fair Store, Chicago, 1890-91.

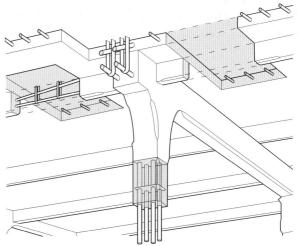

11.41 François Hennebique, Diagram of monolithic reinforced-concrete joint; patented 1892.

Late Nineteenth-Century Revival Architecture

any mid- to late nineteenth-century buildings impress us by their scale, richness of materials, and inventive abundance of historical references. The style of the design for the Paris Opéra (fig. 11.42), by Charles Garnier (1825–98), has been called Second Empire Italianate Neo-Renaissance/Baroque, revealing the eclecticism of this building. More sumptuous than any Baroque structure, it established a standard of extravagant decoration for cultural institutions that would have a wide impact, affecting even the development of the motion picture "palace" in twentieth century America. The opulence of the exterior, with its sculptures (see fig. 11.51), mosaics, and gilded details, is continued in the interior with a magnificent grand staircase, foyer, and auditorium. Garnier stated his philosophy in pointing out that a "staircase crowded with people was a spectacle of pomp and elegance," and that "by arranging fabrics and wall hangings, candelabra and chandeliers, as well as marble and flowers, color everywhere, one makes of this ensemble a brilliant and sumptuous composition." This is the kind of architecture that is

popularly termed Victorian, whether it was built within the empire of Queen Victoria or not.

The courthouse and jail (fig. 11.43) erected in Pittsburgh by Henry Hobson Richardson (1838–86) for one of the world's great industrial centers use a modern version of the Romanesque style that avoids decoration to emphasize mass, weight, and solidity. The heavily rusticated walls, corner pavilions, and tall, centralized tower of the courthouse express the enduring authority of law and government. In contrast, the jail offers irregular masses, a lively silhouette, and the unexpected placement of openings, effects that may refer to lawlessness and a lack of order. This "iconography" is not accidental, for the building specifications from the Allegheny County commissioners required that "the buildings should suggest the purpose for which they were intended." A low bridge, inspired by examples in Venice, allows a secure transfer of the accused to trial in the courthouse. Richardson's particular, personal use of the Romanesque style had a widespread popularity in the 1880s. Perhaps its sheer weight and architectural presence

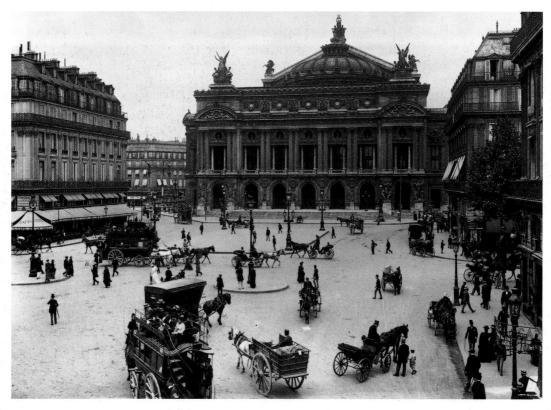

11.42 Charles Garnier, The Opéra, Paris, France, 1861–75 (seen here in a late nineteenth-century photograph). Commissioned by Emperor Napoleon II as one of the focal points for his rebuilding of the center of Paris. For a model for one of the sculptures chosen to decorate the facade, *The Dance* by Jean-Baptiste Carpeaux, see fig. 11.51; for Marcello's Pythia, chosen for the interior, see fig. 11.52.

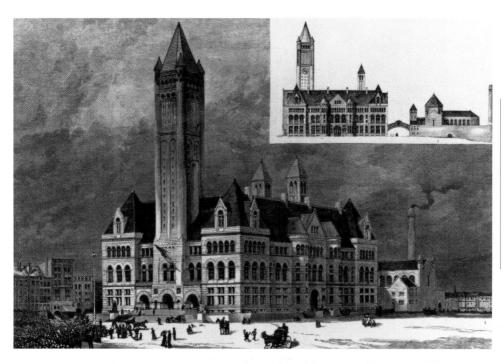

11.43 Henry Hobson Richardson, Allegheny County Courthouse and Jail, Pittsburgh, Pennsylvania, 1884-88. Commissioned by the Allegheny County Commissioners.

Richardson died without seeing these buildings completed; when he realized that he was seriously ill, he wrote: "Let me have time to finish Pittsburgh and I shall be content without another day."This illustration reproduces a print of the design Richardson submitted to win the competition for the project. It preserves the original appearance of the entrance portals and steps, which are today modified.

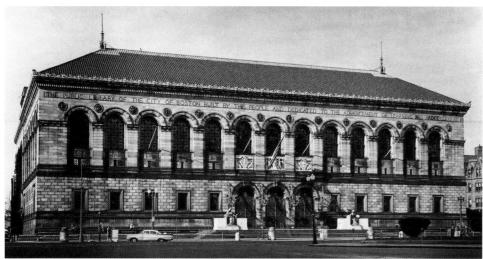

11.44 McKim, Mead, & White, Public Library, Boston, 1887-95. Commissioned by the Trustees of the Library.

were reassuring after the disruptive trauma of the Civil War. Richardson's first biographer wrote of the courthouse:

It is as new as the needs it meets, as American as the community for which it was built. Yet it might stand without loss of prestige in any city in the world.

Richardson himself was most pleased with its massive scale: "If they honor me for the pigmy things I have already done, what will they say when they see Pittsburgh finished?"

In the closing decades of the nineteenth century, a monumental classical style was re-created in the works of

America's most popular architectural firm, McKim, Mead, & White. Their white granite Boston Public Library (fig. 11.44) seems like a grandiose Renaissance palace. A row of impressive round arched windows emphasizes the second floor. The inspiration from Renaissance palaces is perhaps not purely aesthetic, for the trustees' commission was for a "palace for the people." A dignified inscription across the facade states the building's public purpose and patrons: "The Public Library of the City of Boston, Built by the People and Dedicated to the Advancement of Learning." This is the most important building of a movement sometimes known as the American Renaissance.

Édouard Manet

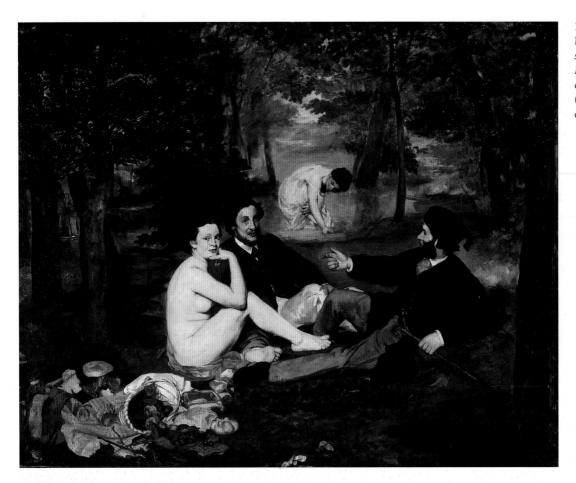

11.45 Édouard Manet, *Le Déjeuner* sur l'herbe (The Picnic), 1863. Oil on canvas, 7' × 8' 10" (2.1 × 2.69 m). Musée d'Orsay, Paris, France.

A commonplace woman of the demimonde, as naked as can be, shamelessly lolls between two dandies dressed to the teeth. These latter look like schoolboys on a holiday, perpetrating an outrage to play the man, and I search in vain for the meaning of this unbecoming rebus.... This is a young man's practical joke, a shameful open sore not worth exhibiting this way.... The landscape is well handled ... but the figures are slipshod.

(A critique of Le Déjeuner sur l'herbe, 1863)

In *Le Déjeuner sur l'herbe* of 1863 (fig. 11.45), Édouard Manet (1832–83) created a scandal, even at the Salon des Refusés (see pp. 433–34). Its subject is perplexing. We are confronted by a female nude, her dress and undergarments thrown down near a basket of fruit in the foreground. She is accompanied by two fully clothed men, while in the middle ground a second woman bathes in a small lake. The visual impact of Manet's style is equally powerful and unexpected, for the startling lack of modeling in the female nude and the large strokes of thick, rich paint had not been seen in earlier French painting. The bold, luscious passages of paint that create the fruit are beautiful on two levels: as brush-strokes and as representations of fruit. Manet based *Le*

Déjeuner sur l'herbe on the combination of dressed men and nude women seen in a well-known Renaissance painting in the Louvre, the Concert Champêtre (Pastoral Concert), which at the time was thought to be by Giorgione (scholars today attribute it to Titian), while he took the figural composition directly from a print after Raphael. Manet's updating of these Renaissance sources may have a deeper social meaning, representing the polarity of French society, with the natural world confronting the artificial, or the painting may simply represent artists picnicking with their models. We shall probably never know the exact meaning or meanings, but we do know that from Manet onward, a new course was set for avant-garde painting of the late nineteenth century, as artists would begin to turn further and further away from prescribed rules in painting.

Two years after the French critics and public were shocked by *Le Déjeuner*, they were sent reeling by Manet's entry in the 1865 Salon (fig. **11.46**). The scandal revolved around both Manet's methods of painting, with loose brushstrokes and flat areas of color, and his disrespect for "proper" subject matter. One of Manet's sources was Titian's *Venus of Urbino* (see fig. 8.38), a painting that had

1853 First railroad opened in India 1861-65 American Civil War 1863 Manet, Le Déjeuner sur l'herbe (fig. 11.45) 1864 Leo Tolstoy, War and Peace 1877 Queen Victoria is proclaimed Empress of India

helped establish the theme of the reclining nude as a subject for art. But now, in the pose usually reserved for an idealized figure, Manet has painted Victorine, a model. In addition, Manet has changed Titian's sleeping dog, a symbol of fidelity, into a lively black cat, a traditional symbol of lust. Titian's servants attend to their work, but Olympia's maid brings flowers—a gift, it would seem, from either a grateful or a prospective client. Even the title (*Olympia* was a generic term for a lower-class prostitute at the time) suggests the shocking subject of Manet's painting.

Manet did have his champions, however. The author Émile Zola, for example, pointed out that Manet's paintings respond to life, rather than to academic traditions of art:

M. Manet's temperament is dry, trenchant. He catches his figures vividly, is not afraid of the brusqueness of nature and renders in all their vigour the different objects which stand out against each other. His whole being causes him to see things in splotches, in simple

and forceful pieces.... Don't bother looking at the neighboring pictures. Look at the living persons in the room. Study the way their bodies look against the floors and walls. Then look at M. Manet's paintings: you will see that there lies truth and strength.

Manet's devotion to painting form as he saw it, irrespective of its meaning, is summarized in Zola's comments after he had sat for Manet to paint his portrait:

I remember posing for hours on end.... Now and again, half dozing as I sat there, I looked at the artist standing at his easel, his features taut, his eyes bright, absorbed in his work. He had forgotten me; he no longer realized that I was there.

When Manet died in 1883, Zola, Degas, and Monet all served as pall-bearers. Renoir and Pissarro paid their respects, and even the reclusive Cézanne came to Paris from Provence.

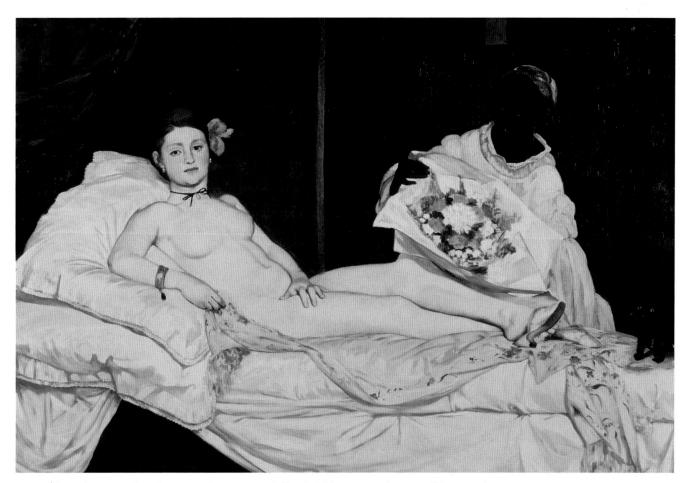

11.46 Édouard Manet, Olympia, 1863. Oil on canvas, 4' 3" × 6' 2¾" (1.3 × 1.9 m). Musée d'Orsay, Paris, France.

Of Manet's Olympia, the later painter Cézanne would say, "Our Renaissance dates from it."

Early Photography and Photographic Technique

adar's portrait of George Sand (fig. 11.47), with its controlled lighting and careful attention to pose and detail, was part of a series that included the major French literary and artistic figures of the midnineteenth century. While such a series of portraits was not novel, that it was produced using the relatively new photographic medium greatly assisted the legitimization of photography. Nadar (1820–1910) pioneered the use of interior studio lighting in portraits that communicated the dignity and individuality of his sitters.

Actually, photography (from the Greek *photo*, "light," and *graphis*, "to write" or "to describe") was based on **camera obscura**, a technique that been used by artists for centuries. The camera obscura (from the Latin, meaning "dark room") was an enclosed box with a pin-hole opening at one end; when rays of light passed through the opening, an inverted image was projected on the opposite wall. The

11.47 Nadar (Gaspard-Félix Tournachon), *George Sand*, 1864. Albumen print, $7\% \times 6\%$ " (20 × 16 cm). George Eastman House, Rochester, New York. "George Sand" was the pen name of Aurore Dupin, a French novelist and feminist.

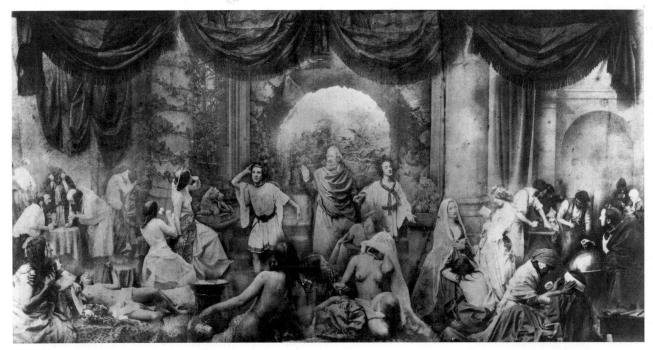

11.48 Oscar Rejlander, *The Two Paths of Life*, 1857. Combination albumen print, $1' 4" \times 2' 7" (41 \times 79 \text{ cm})$. George Eastman House, Rochester, New York.

To achieve this tableaulike effect, Rejlander photographed the background and each of the figures separately. These thirty negatives were then combined and printed on one photographic paper.

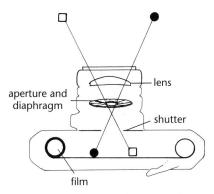

11.49 Diagram of a film camera.

camera obscura had been in use since the Renaissance, primarily as an aid in understanding perspective. Artists used this process to copy the projected image inside the "camera." What was lacking, however, was a method to "fix" that image, a process whereby it could be made permanent. In the early eighteenth century, it was discovered that silver salts were light sensitive, and, building on this and other, more recent, advances, Joseph-Nicéphore Niépce in 1826 created the first photograph by using a camera obscura and a pewter plate coated with bitumen, a light-sensitive substance. Niépce's first photograph required an eight-hour exposure time.

In 1829, the elderly Niépce formed a partnership with Louis Daguerre, who, in 1837, successfully produced the first **daguerreotype**, which used a chemically treated silverplated sheet of copper to retain the image. The result was a far clearer image than Niépce's, with a greatly reduced exposure time. Improvements in the next decade made the daguerreotype practical, with an exposure time of thirty to sixty seconds. Daguerre's excited claim, "I have seized the light, I have arrested its flight," announced the beginning of modern photography.

Developments in photography quickened. In 1839, William Henry Fox Talbot, a British scientist, invented the photographic negative, allowing multiple prints to be made from the same exposed plate, and by midcentury glass-plate negatives were being used to produce remarkably sharp images. Our illustration (fig. 11.49) shows a modern version of a camera.

The early relationship between photography and art was, at best, a difficult one. Some photographers, such as Oscar Rejlander (1813–75), sought to make photography an art by copying the traditional themes found in contemporary Academic Art. *The Two Paths of Life* (fig. 11.48) represents an allegorical subject. As a photograph, it is impressive for its size and technical achievement, for it is a combination

of thirty negatives individually printed on a single sheet of paper. The young men on each side of the elderly father must choose between a life of virtue or a life of vice. Such theatricality derived from the publicly accepted values of Academic Art (see p. 459). Here photography was trying to "copy" painting to win public acceptance.

It was, however, in portraiture that photography found its most immediate and popular use. The reduced exposure time and affordable price made photographic portraits available to almost everyone. Julia Margaret Cameron (1815–79) developed a distinctive style that emphasized the face of the sitter (fig. 11.50). Cameron was fully aware that photography is not just a medium that reproduces reality. Speaking of her portraits, she wrote:

When I have such men before my camera, my whole soul has endeavoured to do its duty toward them in recording faithfully the greatness of the inner man as well as the features of the outer man. The photograph thus taken has been almost the embodiment of a prayer.

11.50 Julia Margaret Cameron, *Alfred, Lord Tennyson*, 1865. Silver print, 10×8 " (25 × 20 cm). Private collection.

Cameron, who began photography only in her late forties, after she received a camera as a gift, was primarily self-taught. The poet Tennyson was a friend and neighbor.

Late Nineteenth-Century Sculpture

s architectural sculpture, *The Dance* (fig. 11.51), by Jean-Baptiste Carpeaux (1827–75), is part of a tradition that includes the Parthenon and Gothic cathedrals (see figs. 3.72, 6.33). Charles Garnier designed the Opéra (see fig. 11.42) with large reliefs by the main entrances representing the various arts. Carpeaux, however, went beyond Garnier's intention, making his figures virtually freestanding, an effect further enhanced by their energetic movement. The exuberant, winged male allegory of Dance leaps upward and outward, while the smiling female nudes encircle him, moving outward into our space in a dance. Carpeaux's allegory communicates the joy of dancing, but at the time its nudity shocked Parisians, who demanded its removal.

Movement conveys a different emotional state in Marcello's *Pythia*, who was the oracle at the sanctuary of

11.51 Jean-Baptiste Carpeaux, *The Dance*, 1867–68. Plaster model, height 15' (4.5 m). Musée de l'Opéra, Paris, France. Commissioned by Charles Garnier, the architect of the Opéra.

Apollo at Delphi and, therefore, the most important prophetess of the ancient Greek world (fig. 11.52). After breathing fumes emanating from the earth, the Pythia, who was believed to be possessed by Apollo, would answer queries and predict future events, employing dramatic gestures and language that were often incomprehensible. Marcello (1836–79) gives the beautiful young woman a pose that conveys her convulsed state. As she jerks forward, her breasts swing out to either side. The smoothness of the flesh is sharply contrasted with the multiple drapery folds and the unruly, flying hair. The snakes hidden in her hair, attributes of Apollo, startle the viewer. *Pythia* is a convincing representation of Greek religious ecstasy as it was understood during the nineteenth century.

Little Dancer, Aged 14 (fig. 11.53), the only sculpture Edgar Degas (1834-1917) ever exhibited publicly, is now one of his most popular works but it is usually viewed in one of the more than twenty bronze casts (with real cloth tutus and satin ribbons) that were produced after his death. The work Degas originally exhibited, however, was executed in wax, a material used for popular sculptures that were meant to be intensely realistic, combined with real fabric and hair (this is the same technique still in use for the naturalistic figures seen in wax museums around the world). Degas followed the popular tradition by coloring the wax to resemble flesh, and he heightened the illusionistic reality of the figure by using a silk faille bodice, a tutu of tulle and gauze, fabric ballet slippers, and a satin ribbon to tie back a wig of real hair partially covered with wax. Degas' appropriation of a multimedia technique that mimics the world of reality is consistent with the attitudes of the French Realist and Impressionist painters. By creating a sculpture that had the colors and textures of reality, he, like the Impressionists, was questioning the relationship between vision and art.

When Degas' sculpture was shown at the Sixth Independent Exhibition in 1881, the critics recognized its novelty but received it with hostility because the model was not attractive:

He chooses her from among the most odiously ugly;... she is sturdy and carefully studied, but what is the use of these things in the art of sculpture? Put them in a museum of zoology, anthropology, or physiology, fine; but, in a museum of art, forget it!

(Nina de Villars, 1881)

I do not always ask that art be graceful, but I do not believe that its role is to represent only ugliness.

(Elie de Mont, 1881)

11.52 Marcello (Adèle d'Affry, Duchess Castiglione-Colonna), Pythia, 1870. Bronze, height 9' 6" (2.9 m). The Opéra, Paris, France.

"Marcello" was the pseudonym used by a talented and successful female sculptor who exhibited at the Paris Salons beginning in 1863. This work was shown at the 1870 Salon, where it was purchased by Charles Garnier to decorate the Grand Foyer of the Paris Opéra (see fig. 11.42).

... a dancer in wax of a strangely attractive, disturbing, and unique Naturalism.... The vicious muzzle of this young, scarcely adolescent girl, this little flower of the gutter, is unforgettable.

(Jules Claretie, 1881)

11.53 Edgar Degas, Little Dancer, Aged 14, c. 1879-81. Wax, silk, satin ribbon, and horsehair, height 3' 3" (99 cm). Washington, D.C., National Gallery of Art, Mellon Collection.

Degas' model was a Belgian girl, Marie van Goethem, who was studying at the Opéra in Paris; she was fired from the Opéra in 1882 after she had missed eleven classes.

The modernity of Degas' work did not go unnoticed, however, as Joris-Karl Huysmans wrote in 1883:

The terrible realism of this statuette makes the public distinctly uneasy, all its ideas about sculpture, about cold, lifeless whiteness [compare fig. 11.17], about those memorable formulas copied again and again for centuries, are demolished. The fact is that on the first blow, M. Degas has knocked over the traditions of sculpture, just as he has for a long time been shaking up the conventions of painting.

Impressionism

mpressionist paintings such as Monet's *Impression-Sunrise* engage us immediately by their subtle depictions of nature (fig. 11.54). Here Monet's representation of the interaction of light, atmosphere, and color heightens our awareness of the beauty in the seascape at dawn. But it is important to realize that Monet did not set out to paint a beautiful picture. His goal was to create a painting that recorded reality as he saw it. As an Impressionist, he wanted to capture in paint the visual effect of reality as it appeared to him at that moment. Monet was especially sensitive to transitory effects of color—how color changes in response

to shifting light and varying atmospheric conditions. In *Impression-Sunrise*, the combination of the moving surface of the water and the red/orange rays of the sun provides a perfect vehicle for his demonstration.

Impressionism had a strong scientific basis, although this is not immediately obvious when looking at Impressionist paintings. A critic of the First Independent Exhibition said that Monet, Renoir, Degas, and Morisot should be called by the "new term *impressionists*. They are impressionists in the sense that they render not the land-scape, but the sensation produced by the landscape."

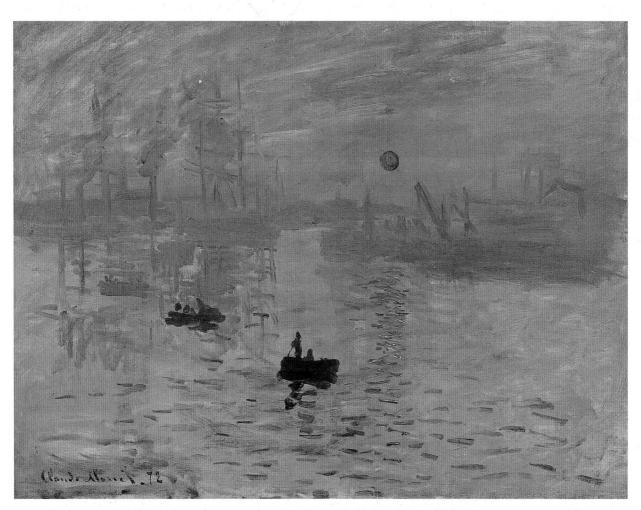

11.54 Claude Monet, *Impression-Sunrise*, 1872. Oil on canvas, 1' $7\frac{1}{2}$ " × 2' $1\frac{1}{2}$ " (50 × 65 cm). Musée Marmottan, Paris, France.

When their paintings were rejected for the Salon exhibitions, a group of painters, some of whom we today classify as Impressionists, decided to hold independent exhibitions. The first of a series of eight such exhibitions was held in Paris in 1874; it included this painting. The exhibition was sponsored by a group that called itself the Anonymous Society of Painters, Sculptors, Engravers, Etc., a title that indicates the diverse nature of the group's members, who had banded together to create independent exhibitions and not because of any notion of stylistic unity. Monet's painting *Rue St-Denis Festivities on June 30, 1878* (see fig. 11.3) was included in the Fourth Independent Exhibition, in 1879.

1869 Suez Canal opens 1870 Rome becomes the capital of Italy 1871 Trade unions legalized in Britain **1872** Monet, Impression-Sunrise (fig. 11.54)

1873–75 Daniel Chester French, Minuteman (fig. 1.13)

The use of the term "Impression" by Monet in his title and the painters' subsequent adoption of the term "Impressionism" suggest the influence of new theories about the physiology of perception. The new color theory emphasized the presence of color within shadows and, in asserting that there was no black in nature, inspired the Impressionists to ban black from their palette. In addition, Impressionism was based on an understanding of the interrelated mechanisms of the camera and the eye: just as a photograph is created by light passing through a lens to make an impression on light-sensitive paper, so is our vision the result of the light and color that create an "impression" on the back surface of the eyeball. By embracing the principles that subject matter is less important than depicting what is perceived and that painting

should represent as closely as possible what the eye sees, the Impressionist painters are clearly related to the earlier Realism of Courbet and the innovations of Manet (see pp. 458–59, 466–67). Their works look very different from Courbet's and Manet's because their interest in how the eye sees led them to try to capture the fleeting richness of color as it exists in nature, whether in light or in shadow.

Monet's emphasis on painting visual reality means that his subjects are scenes or views of the world around him, but it is not accidental that he was one of the first painters of the modern urban cityscape. By painting the city streets and the railroad station, as in the *Gare St.-Lazare* (fig. 11.55), Monet emphasized the actuality of modern life. In the railroad station, the open air in the background interacts with the light that filters down through the glass roof

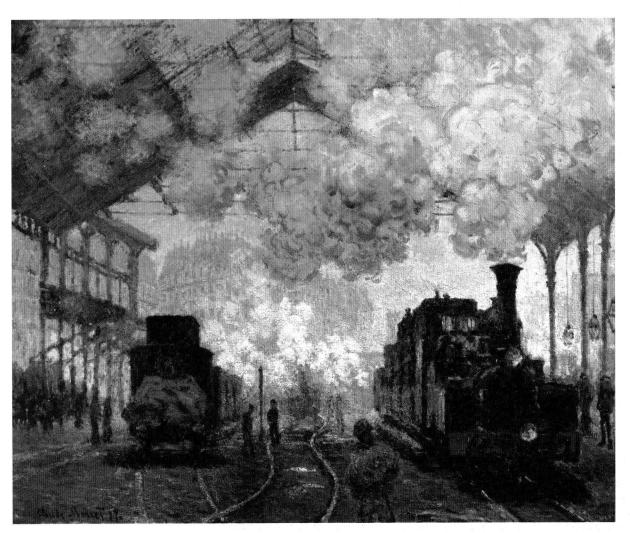

11.55 Claude Monet, *Gare St.-Lazare*, *Paris*, 1877. Oil on canvas, 2' $8\frac{1}{2}$ " × 3' $3\frac{1}{2}$ " (83 × 101 cm). Fogg Art Museum, Harvard University, Cambridge, Massachusetts. This painting was exhibited at the Third Independent Exhibition, in 1877.

and the billowing smoke of the engines to provide another appropriate vehicle for Monet's investigation of the everchanging patterns of light, color, and atmosphere. An Academic painter would never have chosen such a subject but, if required to paint it, would have rendered the clouds of smoke in tonalities of gray. Monet sees not merely gray but shades of blue and lavender as well.

11.56 Cham, "Lady, it would be unwise to enter," Cartoon from the French popular periodical *Le Charivari*, published on the occasion of the Third Independent Exhibition, organized by the Impressionist painters, in 1877.

As an indication of the harsh criticism directed toward the exhibition of paintings being staged by the Impressionist painters and their friends, we reproduce a cartoon from the popular press (fig. 11.56) that refers to the same exhibition that featured Monet's *Gare St.-Lazare*. A guard stationed at the entrance warns away a very pregnant Parisian with the words "Lady, it would be unwise to enter," suggesting that these paintings could even shock her into giving birth prematurely. Other cartoons from the period show Impressionist paintings held up by soldiers during a battle to frighten away the enemy, and a painter throwing paint on a canvas and then smearing it on with his hands.

Although Auguste Renoir (1841–1919) embraced the ideas and employed the techniques of the Impressionists, he was interested in human life and relationships, which led him to favor compositions with human figures rather than landscapes. One of his most popular works is certainly *A Luncheon at Bougival*, with its everyday subject, casual composition, strong strokes of arbitrary color, and bold **impasto**—the latter is especially evident in the beautiful shimmering glasses and bottles of wine on the table (figs. **11.57**, **11.58**).

A Luncheon at Bougival was singled out for praise by critics when it was exhibited in the Seventh Independent Exhibition in 1882, and one critic captured the contemporary, momentary quality of Renoir's subject by writing that the painting is:

a charming work, full of gaiety and spirit, its wild youth caught in the act, radiant and lively, frolicking at high noon in the sun, laughing at everything, seeing only today and mocking tomorrow. For them eternity is in their glass, in their boat, and in their songs.

This emphasis on the momentary and the everyday made paintings such as this unacceptable to the Salon juries, who favored history paintings of literary subjects executed with controlled academic technique.

TECHNIQUE

Impressionism

To capture the subtle effects of ever-changing light, Monet and the other Impressionists painted outside, on the spot, working quickly with loose, bold strokes of color to catch the impression of color in nature before the light changed. The increased brightness of Impressionist paintings (one critic even complained that they made his eyes hurt) was in part made possible by the use of a canvas covered with white underpainting rather than the beige, tan-reddish, or even darker ground that had been traditional since the Renaissance. In addition, an invention of the Industrial Revolution—the collapsible, sealable tube for paint—

made it practical for the Impressionists to work outside, while the development of synthetic pigments meant that the intense colors they preferred were no longer prohibitively expensive. Monet applied paint in rich, thick strokes of virtually pure color, without black. The bold physical presence of these strokes and the heightened color emphasize the surface of the painting. Monet also used a painting stroke that maximized accidental effects of color. By dipping a relatively wide brush into two or more pigments, he allowed the colors to blur and blend as the brush stroked the canvas.

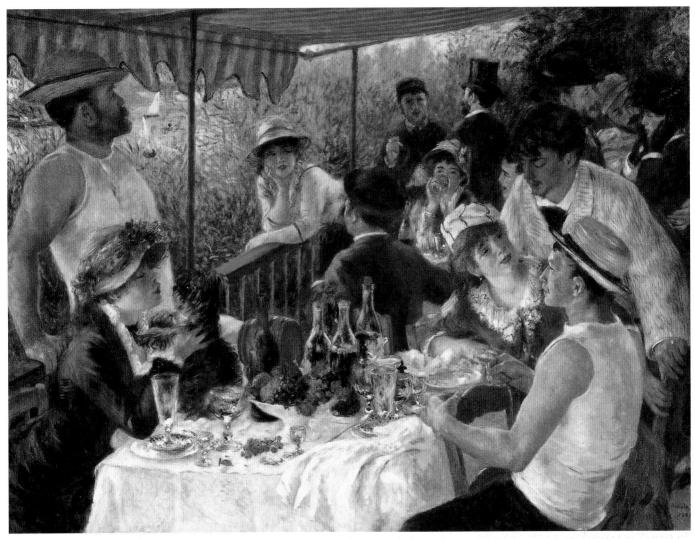

11.57 Auguste Renoir, A Luncheon at Bougival (now known as The Luncheon of the Boating Party), 1880-81. Oil on canvas, 4' 31/4" × 5' 9%" (1.3 × 1.76 m). Phillips Collection, Washington, D.C.

This work was included in the Seventh Independent Exhibition, in 1882. There have been many attempts to identify the figures in this painting. All authorities agree that the woman on the left is Aline Charigot, who in 1890 would become Renoir's wife; their son Jean Renoir, the film director, was born in 1893. The man behind her is probably Alphonse Fournaise, who built the restaurant along the Seine where the luncheon is taking place and whom Renoir often paid in paintings because he was short of cash. The man in top hat at the rear is probably Charles Ephrussi, editor of the art journal Gazette des Beaux-Arts and an early admirer and collector of the Impressionists. The woman in black with her hands raised has been identified as Jeanne Samary, an actress with the Comédie-Française and a frequent model for Renoir; Ellen Andrée, another actress, has been identified as the woman in the right foreground. The man in the straw hat in the right foreground is the Impressionist painter Gustave Caillebotte. Independently wealthy, Caillebotte collected the works of his fellow Impressionists, and when he died prematurely at the age of forty-six in 1894, he left his collection to the French State. The Impressionists were still so controversial, however, that many conservative painters argued against the bequest, and in the end the state agreed to take only about half the paintings; today Caillebotte's bequest forms the foundation for the splendid Impressionist collection at the Musée d'Orsay in Paris.

11.58 Auguste Renoir, A Luncheon at Bougival, detail.

Edgar Degas, Berthe Morisot, and Mary Cassatt

dgar Degas disliked being referred to as an Impressionist and preferred to call himself a realist or an independent (his colleague, the Impressionist painter Camille Pissarro, said he was less an artist than "an anarchist"). His work nevertheless demonstrates many similarities to Impressionist works, and he exhibited in several of the Independent Exhibitions. Degas' realism is in part revealed by his subject matter, for, no matter how romantic we may find his representations of ballerinas today, they were considered neither an appropriate nor a beautiful theme for art in his own day. He was often criticized for picking unattractive dancers by critics who did not realize that, like the other Impressionists, he was emphasizing the realities of modern life. He also shared with the Impressionists a taste for strong and even arbitrary color, despite the fact that most of his work represents figures in rather subdued interiors. The subtlety of natural light in an interior space provided him with a distinct challenge.

In addition to his concern with light and color, Degas had a special interest in the interaction between movement and composition. One contemporary critic wrote, "Degas continues to be passionately devoted to movement, pursuing it even in violent and awkwardly contorted forms." He

found that movement, especially the repeated, choreographed movement of dancers onstage or in rehearsal, had a greater intensity when seen from an unexpected viewpoint. In *The Rehearsal* (fig. 11.59), the strong diagonal recession of the dancers' parallel arms and legs and of the windows in the room creates a thrusting perspective; this in turn is balanced by the empty space in the right foreground. The broad brushstrokes reemphasize the pictorial surface. The influence of Japanese prototypes (see fig. 11.4) on Degas' work is evident in the diagonal recession and in the cutting off of the forms by the edges. Degas' peculiarly realistic viewpoint was discussed by one of his friends, Edmund Duranty, who published a pamphlet, *The New Painting*, in 1876. Duranty pointed out how our visual field is limited by:

the frame that endlessly accompanies us ... cutting off the external view in the most unexpected ways, achieving that endless variety and surprise that is one of reality's greatest pleasures.

We can see the same unusual viewpoint and the compositional motif of the strong diagonal thrust cut off by the edges in *Marine* (fig. 11.60), by Berthe Morisot (1841–95).

11.59 Edgar Degas, *The Rehearsal*, c. 1873–74. Oil on canvas, 1' 6" × 2' (46 × 61 cm). Fogg Art Museum, Harvard University, Cambridge, Massachusetts.

11.60 Berthe Morisot, Marine (The Harbor at Lorient), 1869. Oil on canvas, 1' 5\%" × 2' 4\%" (44 × 73 cm). National Gallery of Art, Washington, D.C.

Berthe Morisot, one of the founders of the Impressionist movement, exhibited in seven of the eight Independent Exhibitions, and her works were also accepted at many of the Salon exhibitions. The artist presented this work to Manet after he admired it. After her death in 1895, a large exhibition of her work was arranged by Monet, Renoir, Degas, and the poet Stéphane Mallarmé.

When this work was shown in the First Independent Exhibition, a critic remarked, "What a lovely vagueness [there is] in the distance at sea where the tiny points of masts tilt!" Morisot, who once wrote, "My ambition is limited to the desire to capture something transient," remains true to Impressionist principles in striving to capture the strong visual qualities of an actual view. The parasol shields the face of the woman-Morisot's sister Edma, also a painter-and as a result her features are left a blur; her identity is less important than her function as a colored form within the composition. Light reflects from the warm brown of the stone railing to create a pink shadow on her white dress.

Mary Cassatt (1845-1926), an American who trained in France and spent most of her life working there, exhibited in several of the Independent Exhibitions. In writing about works by Cassatt at the Sixth Independent Exhibition in 1881, a critic defined Impressionist practice:

Like her brothers in independence, Manet and Degas, Cassatt works relentlessly to bring her eyes to a state of sensitivity, nervous excitement, even irritation, so she can seize the smallest flicker of light, the smallest atom of color, and the slightest tint of shadow.

Another critic, however, voiced the frequent complaint that Impressionist paintings were unfinished, lamenting that Cassatt had changed her style and was now "aspiring to the partially completed image." Cassatt's The Boating Party (fig. 11.61) reveals the inspiration both of Degas and of Japanese prints in the realistic but unexpected viewpoint it

enforces. We are behind the rower, and his dark, bold silhouetted form sets off the pastels of the rest of the composition. Cassatt maximizes realism in the partial profile of the rower and the foreshortening of the child's head. Neither is an attractive view, but both are realistic and skillfully executed. Large areas of unmodeled color and the potent compositional shapes of the green interior of the boat and the partial view of the sail emphasize the twodimensional quality of her composition. In the greater solidity with which she endows her figures, Cassatt reveals her independence within the Impressionist movement.

11.61 Mary Cassatt, The Boating Party, 1893-94. Oil on canvas, 2' 111/2" \times 3' 10%" (2.4 \times 1.95 m). National Gallery of Art, Washington, D.C.

American Realism: Thomas Eakins and Henry Tanner

o Thomas Eakins (1844–1916), Samuel Gross was a heroic figure. Gross, a respected surgeon and professor at Jefferson Medical College, had an international reputation in the then-still controversial area of surgery. A pioneer in using new techniques, he taught medical students both surgical procedures and the human purpose of the medical profession. Gross emphasized the significance of clinical instruction, and Eakins chose to represent him in the operating amphitheater at work (fig. 11.62). Gross is performing an operation in which he specialized, a new, lifesaving treatment for osteomyelitis (infection of the bone), in which the diseased bone is cut away. At the same time, he is also teaching, and Gross looks up from the incision in the thigh of the patient, an expression of concentration on his

face as he searches for words to convey to students the ultimate significance of his life's work. He holds a bloody scalpel, the sudden sight of which makes the elderly woman to the left, most likely the patient's mother, cringe.

The overhead light directs our attention to Gross's head, silhouetting it dramatically against the background. The serious line of the mouth is emphasized and the eyes are thrown into shadow. Eakins emphasizes the light as it catches Gross's bushy hair and vigorous sideburns. This visually electrifying effect suggests that Eakins is searching for a concrete metaphor for the intensity of Gross's thoughts. The painting has an overall warm harmony, the result of red underpainting, which unifies and heightens a palette limited to strong blacks, flesh tones, and areas of

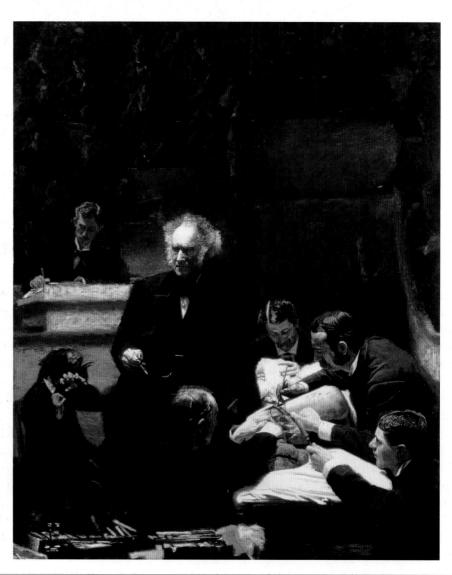

11.62 Thomas Eakins, *Portrait of Dr. Samuel Gross*, 1875. Oil on canvas, $8' \times 6'$ 6" (2.4 × 1.95 m). Philadelphia Museum of Art.

Eakins's realistic portrayal of surgery at Jefferson Medical College in Philadelphia reveals how medical practice has changed. In Eakins's day, surgeons operated in their street clothes, and operations were scheduled between 11:00 A.M. and 3:00 P.M. to take advantage of the daylight in the college's amphitheater. While many surgeons would have amputated this young man's leg, Dr. Gross is demonstrating a difficult surgical procedure designed to save the limb.

2000

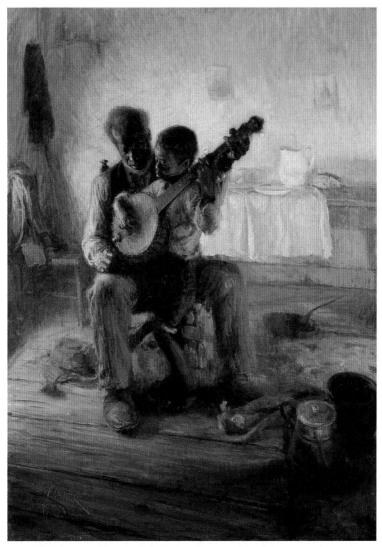

11.63 Henry O. Tanner, The Banjo Lesson, c. 1893. Oil on canvas, $4' \times 2' 11'' (120 \times 89 \text{ cm})$. Hampton University Museum, Hampton, Virginia. Tanner was the first African American artist to achieve an international reputation.

white. Touches of red draw our attention to the pen of the clinical recorder, the incision, and the bloody hand and scalpel of the surgeon. In contrast to the abstract treatment of Gross's head, his hand and scalpel jump out because they seem to be in sharp focus. Eakins, who was also a photographer, seems to have intentionally thrown the other parts of his composition out of focus (note the loose painting of the surgical instruments in the foreground) to make Dr. Gross's hand and its bloody tool the focal point. This contrast in treatment between the head and hand is not accidental: while the physical aspect of Gross's accomplishment is completely comprehensible, the workings of his intellect can only be suggested.

The portrait was not commissioned; Eakins intended to submit it to the arts section at the Centennial Exposition, to be held in Philadelphia in 1876. It was rejected, apparently because the subject was not considered appropriate, although other works by Eakins were accepted. Through the influence of Gross, however, the painting was exhibited in the "hospital" section of the exposition.

The African American painter Henry O. Tanner (1859-1937) studied with Eakins at the Pennsylvania Academy from 1880 to 1884, but his mature style merged Eakins's realism with stylistic effects learned from the French Impressionists. Tanner moved permanently to Paris in 1891; in 1896, he received an honorable mention at the Salon and in 1897 his work was awarded a gold medal. In The Banjo Lesson (fig. 11.63), the choice and interpretation of the insightful musical theme grow from Eakins's example, but the lighter palette and more diffused light and delicate brushstrokes reveal the influence of the new French style of Impressionism.

Auguste Rodin and Camille Claudel

uguste Rodin (1840–1917) was commissioned to create *The Burghers of Calais* (fig. 11.64) as a public monument that would display the courage and civic virtue of the Calais burghers. But the work disappointed many at first because it lacked the traditional heroic antique references that then dominated public sculpture. Rodin's re-creation of the six hostages, with its realism and psychological honesty, however, played an important role in bringing a fresh vision of the human figure to late nineteenth-century sculpture. From his study of the works of such sculptors as Donatello and Michelangelo (see figs. 7.12, 7.13, 7.37, 7.54, 8.2, 8.15, 8.16), Rodin understood how gesture and expression could reveal an inner

psychological state. Here the burghers are represented as individuals engaged in philosophical questioning, acceptance, defiance, and sorrow. Through Rodin's sculpture, the burghers are revealed as human beings like ourselves, not idealized superheroes. Rodin insisted that the connection between these historical figures and the contemporary citizens of Calais be emphasized by eschewing the elevated pedestal that was a traditional aspect of the monumental tradition; the burghers and their descendents were thus on the same level.

Created during a period when Neoclassical and Romantic attitudes still dominated public sculpture, Rodin's physical and psychological naturalism ran counter

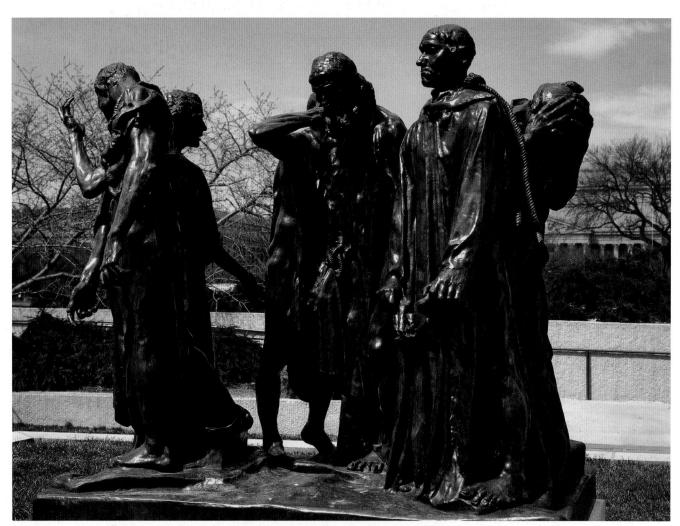

11.64 Auguste Rodin, *The Burghers of Calais*, 1884–86. Bronze, height 6' 10½" (2.1 m). Hirshhorn Museum and Sculpture Garden, Smithsonian Institution, Washington, D.C.

In 1884, the city of Calais in northern France commissioned Rodin to fashion a public monument, to be placed outside the city's cathedral, that would honor six leading citizens (burghers) who, in 1347, had offered themselves as hostages to the English king Edward III, who had laid siege to the city. The burghers were ready to sacrifice their lives if their city would be spared. Edward III was so impressed with their courage that he spared both the burghers and Calais.

1883 Metropolitan Opera House opens in New York

1883 Brooklyn Bridge opens to traffic (fig. 11.39)

1884 Johannes Brahms, Third Symphony

1884 Mark Twain, Huckleberry

1884-86 Rodin, The Burghers of Calais (fig. 11.64)

to critical and public taste, and the psychological complexity of his work was missed by many critics.

The powerful abstraction of form that characterizes Rodin's work inspired the work of Camille Claudel (1864-1943), who was his pupil and an assistant who had worked on the Burghers of Calais. In The Waltz (fig. 11.65), Claudel combines the sweeping lines of the drapery with the stopped motion of the embracing couple to suggest the pulsing rhythm of the dance of the title. Her first version showed the figures completely nude, but she added the drapery after an official from the French Ministry of Beaux-Arts proclaimed the work indecent. Official and/or public censorship became more common in a period when the traditional patronage system was collapsing and many artists chose to defy contemporary standards of taste and decorum in works created largely for their own satisfaction.

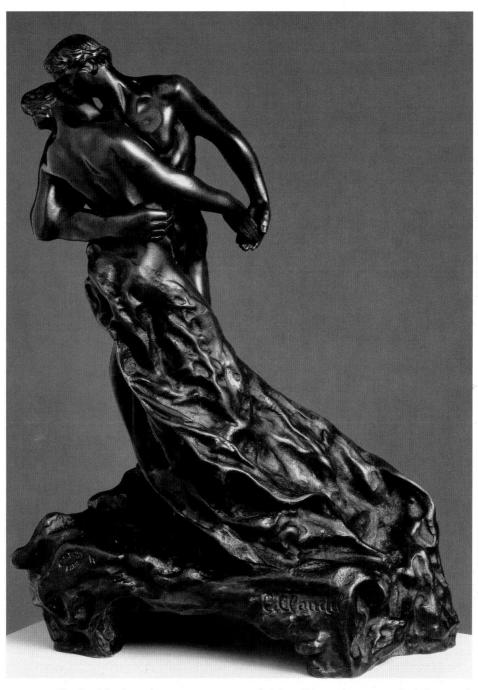

11.65 Camille Claudel, The Waltz, 1892-1905. Bronze, height 9%" (25 cm). Neue Pinakothek, Munich.

Winslow Homer

he unusual cloud bank rolling from the background of *The Fog Warning*, by Winslow Homer (1836–1910), warns the fisherman that he is suddenly in mortal danger, for it signals the arrival of a particularly fast-moving and dangerous fog (fig. 11.66). The hunter, preying on nature, suddenly becomes the hunted. Homer's composition heightens the mood of instability and uncertainty by representing the small rowboat being heaved upward by a large swell. The right-to-left thrust of the rowboat is counter to the movement of the fisherman's home vessel in the background, which seems about to sail out of the range of vision. The realistic colors—yellowish-white for the sky, green for the sea, and shades of brown for

the boat and the fisherman—are somber and appropriate for this theme.

The bold composition, the diagonal thrust of the boat, and the truncated oar reveal the influence of Japanese woodcuts. Homer's brushstrokes are broad and simple; note especially the rough strokes in the foreground that represent the foamy waves.

The power of natural forces and their challenge to humanity are themes that recur in Homer's most significant works. A New England individualist, Homer spent many winters living in isolation along a particularly dramatic and treacherous stretch of the Maine coastline, where he had many opportunities to observe the power of a turbulent sea.

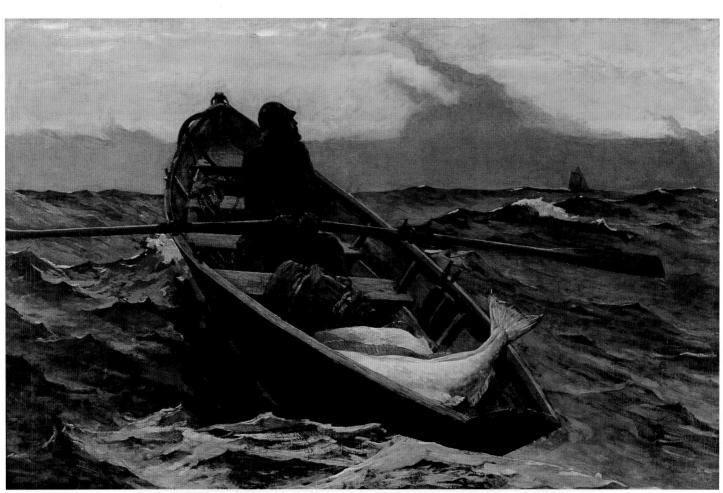

11.66 Winslow Homer, *The Fog Warning*, 1885. Oil on canvas, $2' 8'' \times 4' (81 \times 120 \text{ cm})$. Museum of Fine Arts, Boston.

1885 Homer, The Fog Warning (fig. 11.66)

1885 Louis Pasteur introduces rabies vaccine

1886 Eighth and last Independent Exhibition in Paris

1886 Statue of Liberty is dedicated

1886 American Federation of Labor is founded

TECHNIQUE

Watercolor and Gouache

Watercolor is aptly named, for it is a medium in which ground pigments are mixed with water and, as an adhesive binder, a little gum arabic. It is usually applied to white paper. The brilliant light effects possible in watercolor are evident in The Blue Boat, by Homer (fig. 11.67). The liquidity of the medium is apparent in the broad strokes that convincingly render sky and water. Watercolor is transparent, and in some areas Homer has laid one color over another, creating veils of color. The strong white of the paper shows through in the clouds

and water in The Blue Boat. Homer commonly added a few touches of gouache (an opaque watercolor) to strengthen certain areas (not seen in the example illustrated here).

As early as the 1780s, English artists had begun to work seriously with watercolor. Homer was one of the founders of the American Watercolor Society, an organization that helped popularize the medium among professional artists in the United States. Previously, watercolor had been used for the most part by amateurs.

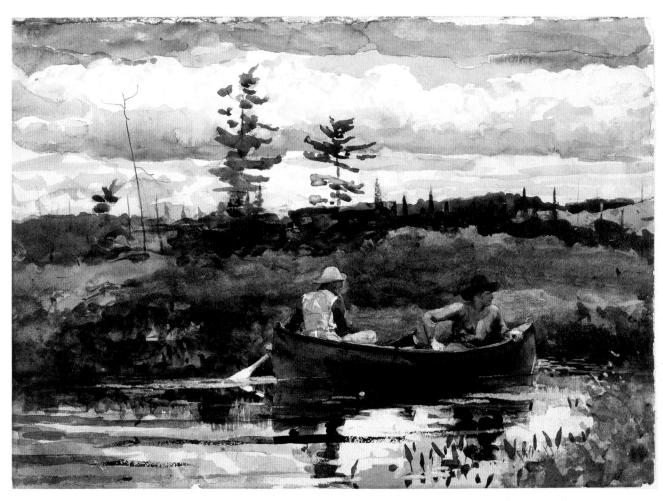

11.67 Winslow Homer, The Blue Boat, 1892. Watercolor over graphite, $1' 3\%" \times 1' 9\%" (38 \times 55 \text{ cm})$. Museum of Fine Arts, Boston.

Post-Impressionism: Gauguin and Seurat

aul Gauguin (1848-1903) painted The Vision after the Sermon in Brittany, in northern France, which he visited in 1888 to escape from what he felt were the restrictive artistic and social pressures of Paris (fig. 11.68). The painting depicts Breton women, deep in prayer, experiencing a vision. We seem to be standing behind the group of women in native dress and a priest in the right foreground. A tree limb creates a strong diagonal across the composition, separating the left middle ground from the "vision" to the right, which represents the Old Testament figure Jacob wrestling with an angel, a story in which God tested Jacob's enduring love. Visual tension results from the conflict between the red ground, which creates a strong planarity, and the perspective suggested by the diminution of size. The heavy outlines of the figures combine with the pattern of the Breton headdresses to create a simple yet forceful composition. Although the red ground may have been inspired by a religious festival that included the blessing of horned animals and bonfires that cast a red glow over the fields at night, Gauguin's choice of color also carries a symbolic content. The red ground symbolizes the theme of struggle, and in choosing it, Gauguin has freed himself from the traditional use of color to describe nature. Here both color and line are used in an abstract, expressive way. Gauguin's discontent with life in urbanized Paris eventually led him to leave his successful brokerage career and his wife and family to seek an unindustrialized environment, first in Martinique, then in Brittany and later Arles in southern France, and finally in Tahiti, in the South Seas (see pp. 434–35, fig. 11.9). In attempting to remove himself from Western centers of civilization, Gauguin was seeking an unbridled artistic and psychological response to nature.

By the time of the last Independent Exhibition in 1886, Impressionism, which a decade earlier had been considered revolutionary, was gaining increasing critical and public acceptance. New avant-garde styles were now being explored by artists such as Gauguin, who had moved from Impressionism to more individualized styles. *Post-Impressionism* is the generic term now used to embrace the diversity of these individual styles—styles that laid the foundation for modern art.

Georges Seurat (1859–91) was the youngest of the Post-Impressionist painters. His monumental painting *A Sunday Afternoon on the Island of La Grande Jatte* (fig. **11.69**) exemplifies his theories of Divisionism, which was also called Neo-Impressionism. Its still, transfixed quality recalls the style of the Renaissance painter Piero della Francesca (see fig. 7.2), whose work Seurat admired. But the classicism of Renaissance art has been updated, joined with the modern perception of light and color begun by the Impressionists.

11.68 Paul Gauguin, *The Vision after the Sermon*, 1888. Oil on canvas, $2' 4\%'' \times 3' \%'' (73 \times 93 \text{ cm})$. National Gallery of Scotland, Edinburgh.

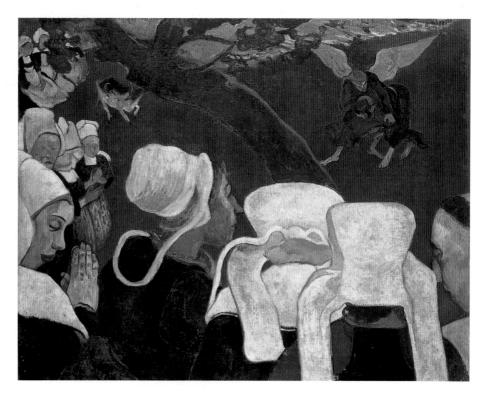

1887 Arthur Conan Doyle's first Sherlock Holmes tale is published

1888 Gauguin, The Vision after the Sermon (fig. 11.68)

1888 J. B. Dunlop invents the pneumatic tire

1888 August Strindberg, Miss

1888 National Geographic begins publication

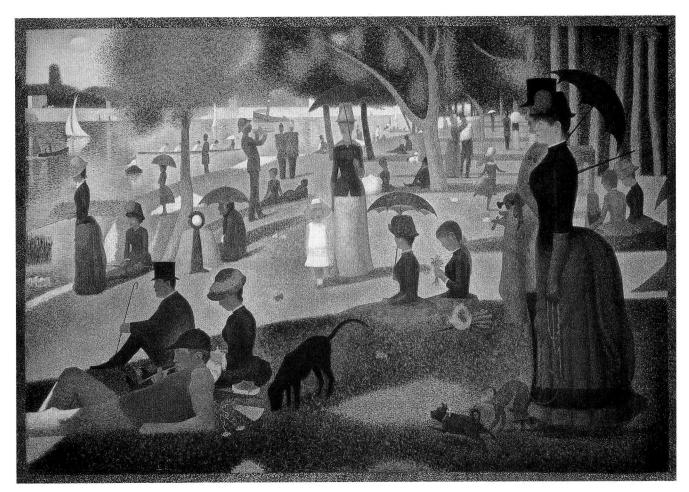

11.69 Georges Seurat, A Sunday Afternoon on the Island of La Grande Jatte, 1884–86. Oil on canvas, 6' 9%" \times 10' 1%" $(2 \times 3.1 \text{ m})$. Art Institute of Chicago.

Seurat systematized contemporary scientific advances in color theory to create what he termed "optical" painting. Colored paint is methodically applied in a series of small dots (now popularly known as Pointillism, a term not used by Seurat), usually in complementary colors. The resulting surface, covered with thousands of controlled spots of color, is both vibrant and luminous, at once relating to the surface of the picture plane and to forms in an illusory depth bathed in natural light.

Post-Impressionism: Vincent van Gogh

Today I am probably going to begin the interior of the Café where I eat, by gas light, in the evening.

It is what they call here a Café de Nuit (they are fairly frequent here), staying open all night. "Night prowlers" can take refuge there when they have no money to pay for a lodging, or are too tight to be taken in. All those things—family, native land—are perhaps more attractive in the imaginations of such people as us ... than they are in reality. I always feel I am a traveller, going somewhere and to some destination.

If I tell myself that the somewhere and the destination do not exist, that seems to me very reasonable and likely enough.... The room is blood red and dark yellow with a green billiard table in the middle; there are four citron-yellow lamps with a glow of orange and green. Everywhere there is a clash and contrast of the most disparate reds and greens in the figures of little sleeping hooligans, in the empty, dreary room, in violet and blue. The blood-red and the yellow-green of the billiard table, for instance, contrast with the soft tender ... green of the counter, on which there is a pink nosegay. The white coat of the landlord, awake in a corner of that furnace, turns citron-yellow, or pale luminous green.

(Vincent van Gogh, letter to his brother Theo from Arles, September 8, 1888)

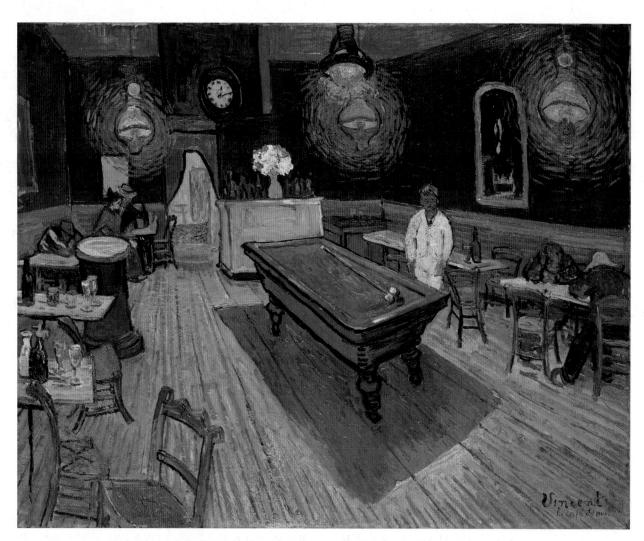

11.70 Vincent van Gogh, *The Night Café*, September 1888. Oil on canvas, $2' 3\frac{1}{2}" \times 2' 11"$ (70×89 cm). Yale University Art Gallery, New Haven, Connecticut.

Van Gogh painted *The Night Café* in Arles, in the south of France, where he lived in 1888–89. Vincent wrote that when he painted this picture he stayed up three consecutive nights, sleeping only during the day. On September 17, 1888, he wrote to his brother Theo that "the problem of painting night scenes and effects on the spot and actually by night, interests me enormously."

1889 Wall Street Journal begins publication

1890 Yosemite National Park is created

1890 Emily Dickinson's poems are published

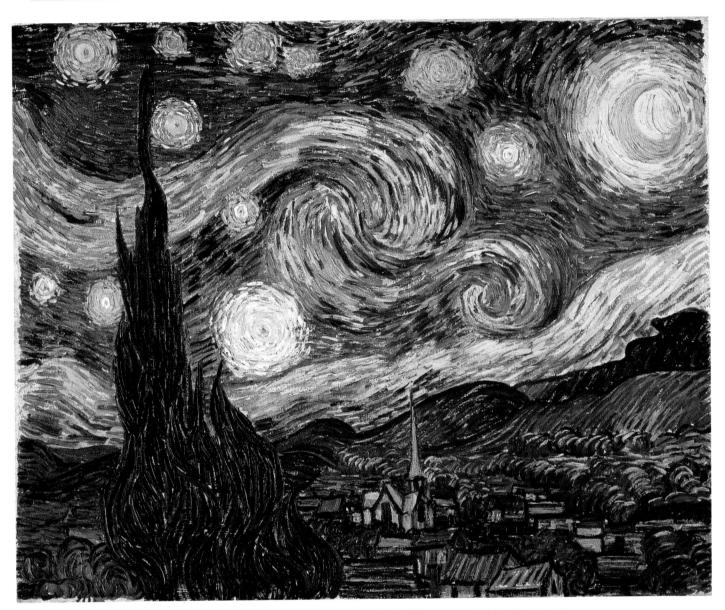

11.71 Vincent van Gogh, The Starry Night, June 1889. Oil on canvas, 2' 5" × 3' ¼" (74 × 92 cm). Collection, The Museum of Modern Art, New York.

Van Gogh can be classified as a Post- or Counter-Impressionist because after painting in the Impressionist style (he saw the Eighth, last Independent Exhibition in 1886 in Paris), he developed his own personal style. Van Gogh eloquently revealed his understanding of his own intense personality and his loneliness by writing, "One may have a blazing hearth in one's soul and yet no one ever comes to sit by it. Passersby see only a wisp of smoke rising from the chimney and continue on their way."

The Night Café is only one of the powerfully emotional paintings in a series of works created during van Gogh's stay in Arles (fig. 11.70). Van Gogh later referred to Arles as the place where "I attain[ed] the high yellow note," suggesting that this was a particularly strong point in his career. Here he adopted the Japanese belief that the color yellow is symbolic of hope. However, Arles was also a place of despair for van Gogh, which may help explain the intensity of the Arles works. He

said that this painting, given to his landlord in exchange for rent, was "one of the ugliest pictures I have done." The ugliness of which he writes is intentional, for in this painting color is used arbitrarily, allowing him to express personal meanings and emotions through the "clash and contrast" of glaring yellow, bright green, and "blood" red. In a letter to his brother Theo, who was living in Paris, he explained the psychological impact that he wanted the painting to have:

I have tried to express the terrible passions of humanity by means of red and green ... the café is a place where one can ruin oneself, run mad, or commit a crime.

Van Gogh's goal is in part conveyed to us by the claustrophobia of the tense and threatening atmosphere. Drunks slump over tables within a tilted and close perspective space that is unnerving for the viewer. Van Gogh was here experimenting with the relationship between color, space, theme, and emotions. His efforts make him one of the forerunners of the expressionist trends that become important in the twentieth century. He wanted to express the mood he senses at the cafe, and in doing so, he reveals some of his feelings about his own alienation.

In the early 1880s, van Gogh was involved briefly in the rapidly changing styles of French painting. Like many other artists, he began to collect Japanese prints (see fig. 11.4), and in The Night Café we sense their influence in the bold delineation of the forms, the intricate patterning of horizontal and vertical lines, the unusual viewpoint, and the vivid, arbitrary colors. The oddly exaggerated perspective of the painting may also be attributed to other influences, for evidence suggests that van Gogh may have suffered from temporal-lobe epilepsy; some aspects of his art may have been influenced by the visions he experienced during the beginning of a seizure. We also know that van Gogh often spent his limited money on alcohol, rather than food, and absinthe, one of the artist's common indulgences, is known to affect the occipital lobe, which controls vision.

In *The Starry Night* (fig. 11.71), painted in 1889, van Gogh displays his fascination with the earth and sky, and his philosophies of life and death and their connection to nature:

For my own part, I declare I know nothing whatever about it, but to look at the stars always makes me dream, as simply as I dream over the black dots of a map representing towns and villages. Why, I ask myself, should the shining dots of the sky not be as accessible as the black dots on the map of France? If we take the train to get to Tarascon or Rouen, we take death to reach a star. One thing undoubtedly true in this reasoning is this, that while we are alive we cannot get to a star, any more than when we are dead we can take the train.

(Vincent van Gogh, letter to his brother Theo, mid-July 1888)

This depiction of night "in situ," as van Gogh described it, reveals his continuing interest in a favorite subject, the

flamelike cypress tree used in France and Italy to mark graves. Almost black, the tree dominates the foreground. The night sky overwhelms the little town of St.-Rémy, but the expansiveness of space and the solidity of the earth are formally linked: the tip of the cypress tree crosses the nebula, and the steeple of the church enters the area of the sky.

In a letter to his brother, van Gogh wrote that he felt that nighttime was more colorful than the day—as is suggested here by the vividness and luminosity of the celestial bodies. Deeply saturated colors—purple and violent green—clash, and a thickly painted "glow" surrounds each star, planet, and the moon. These qualities seem to express van Gogh's testament that there are lives and colors on other planets, and perhaps even better conditions. Here the artist projects his own destiny: death represents not an ending but a metamorphosis.

The significance of nature for van Gogh is apparent in the following quotation, from a letter he wrote to Theo in September 1889, right after Theo was married:

Well, do you know what I hope for, once I let myself begin to hope? It is that a family will be for you what nature, the clods of earth, the grass, the yellow corn, the peasant, are for me, that is to say, that you may find in your love for people something not only to work for, but to comfort and restore you, when there is need for it.

The Self-Portrait of 1889 (see fig. 11.12) was probably painted shortly after van Gogh left the hospital in St.-Rémy in early January 1889. His ear is still bandaged from the self-mutilation he had inflicted in December, when he cut off part of his ear, probably to punish himself because of a quarrel he had had with Paul Gauguin. Van Gogh sent this painting to his family in the Netherlands, probably to reassure them of his health. The very fact that he could paint again revealed his ability to control his feelings, and although he does not deny that he damaged his ear, he shows himself as somber and meditative, smoking his pipe. The placement of the green coat against the red background and the blue cap against orange demonstrate his understanding of how to use complementary colors to achieve rich coloristic and dramatic effects. The violent juxtaposition of the red and orange draws attention to van Gogh's solemn eyes. As he wrote:

[I find myself filled with] a certain undercurrent of vague sadness, difficult to define.... My God, those anxieties—who can live in the modern world without catching his share of them?

The Value of Art: Vincent van Gogh

How is value assigned to art? Certainly personal value the worth of a work of art to you personally, based on the importance of that work to you and, perhaps, your perception of the value of this work to humanity as a whole—is important. But it is not quantifiable unless you are establishing your own collection or a museum for the public at large.

The financial or market value of a work of art is, as with other luxury items, based on market factors. How much a particular painting by a certain artist will bring at auction is dependent on many factors, including the artist's reputation, the historical importance of the work, the availability of similar works by the same artist, the promotion of the work by the auction house, and the presence of at least two enthusiastic bidders. Important works will sometimes be showcased in an impressive book meant to inform prospective bidders about the significance of the particular work.

In a list compiled in 2007 of the ten most expensive paintings ever sold, two were by van Gogh (the fifth and the eighth) and three by Picasso; the other artists on this list were Pollock, Klimt, Renoir, Rubens, and Cézanne. At least forty-four paintings by van Gogh have been sold with a price tag of over I million dollars each.

This was not, of course, always the case. During his lifetime van Gogh gave away and traded some of his works, but it seems that he sold only one painting (The Red Vineyard, now in the collection of the Hermitage in St. Petersburg, Russia). After the deaths of Vincent in 1890 and his brother in 1891, his brother's widow, Johanna van Gogh-Bonger, began to organize exhibitions of Vincent's works; later she also edited and published Vincent's letters to her husband. Eventually there were sales to museums and important collectors, but much of van Gogh's work stayed in the family collection until it was purchased by a foundation with funds provided by the Dutch State in 1962.

In 1973 the van Gogh Museum in Amsterdam was opened to display the collection; designed to accommodate 80,000 visitors a year, in recent years the annual attendance has regularly exceeded I million. Recently the museum underwent an expansion to better serve the growing interest in van Gogh's works. Now, a little more than a century after his death at the age of thirty-seven, van Gogh has become one of the best known and highly prized of artists. The international demand on the part of museums and collectors and the decreasing supply of available paintings and drawings have led to higher and higher prices for his works.

Detail of figure 11.70.

Van Gogh's letter to his brother Theo mentions "a pink nosegay" but today these flowers are almost completely white because the pigment van Gogh used for the flowers is what is known as a fugitive pigment and it has faded over time. The intense color scheme van Gogh intended is thus rendered less dramatic because the contrast between the more delicate pink of the nosegay and the red walls is no longer apparent.

Post-Impressionism: Paul Cézanne

want to make of Impressionism something solid and durable, like the art of the museums," wrote Paul Cézanne (1839-1906). In his paintings, Cézanne set himself an impossible task: he wanted to establish an equilibrium between the vivacious color and solid form of three-dimensional objects and the two-dimensional surface of the picture plane. He sought to achieve both illusionistic solidity and a strong compositional structure in two dimensions. His frustration with Impressionism was twofold: Impressionist painters did not create paintings that were compositionally strong, and they were not interested in endowing painted objects with three-dimensional solidity. Cézanne wrote: "In art, everything is theory, developed and applied in contact with nature." It is the union of nature with the philosophical truth of the flatness of a painting's surface that absorbed Cézanne's attention.

Cézanne's Still Life with Basket of Apples (fig. 11.72) demonstrates his ability to render objects with solidity—note the white napkin, with its deep angular folds and pockets of shadow. The pieces of fruit have a physical presence that is in part the result of an unexpected richness of color, exemplifying Cézanne's dictum that "when color is richest, form is fullest."

He modeled the fruit with pure, unmixed colors, juxtaposing, for example, yellow with green and red. He thereby created a richer effect than that produced by the typical academic practice that rendered modeling by reducing coloristic intensity by adding white or black. Cézanne does not outline his forms to distinguish them from each other. They have rather loosely painted edges, and it is the internal color that creates their solidity. Cézanne once said, "The secret of drawing and modeling resides in the contrasts and relationships of tone."

If we analyze Cézanne's Still Life with Basket of Apples as an illusion or as an exercise in accurate drawing, it is a failure: neither the front nor the back edges of the table, for example, are aligned; the wine bottle, itself tilted, offers a distinctive contour on each side; and the pastries stacked on the plate are tilted upward. But our observations are based on the wrong questions. In Cézanne's work, these pictorial "inaccuracies" reveal the moving viewpoint of the artist relative to the objects being painted. Renaissance scientific perspective required that the artist's (and therefore the viewer's) eye be at a fixed point. Cézanne, on the other hand, expresses a basic fact of vision: our understanding of an object or space is based on our movement relative to that

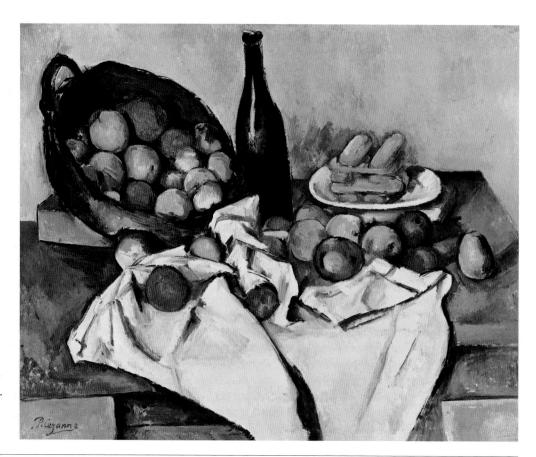

11.72 Paul Cézanne, *Still Life* with Basket of Apples, 1890–94. Oil on canvas, 2' ¾" × 2' 7" (62 × 79 cm). The Art Institute of Chicago.

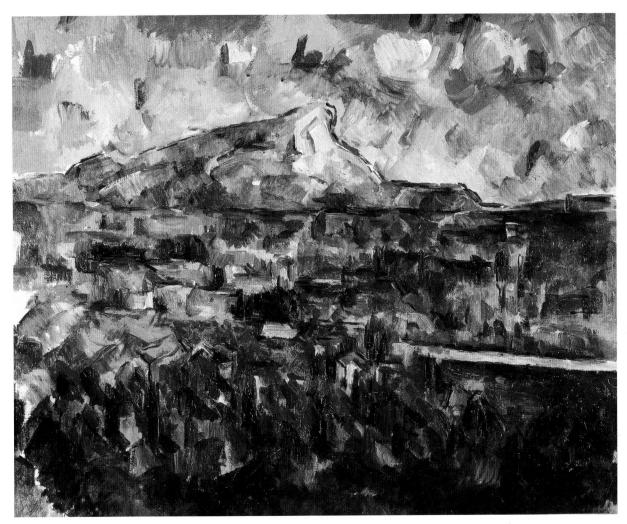

11.73 Paul Cézanne, Mont Ste.-Victoire, 1904-06. Oil on canvas, 2' 1%" × 2' 7%" (65 × 81 cm). Private collection.

Mont Ste.-Victoire in Provence, a symbol of Cézanne's local area, was one of his favorite subjects. In 1901-02, he built a studio in the countryside with a large window facing the mountain.

object or space. The difference in the edges of the table, for example, results because the table edge is seen from lower or higher, closer or farther viewpoints. The issues Cézanne has selected to investigate are difficult ones to resolve. Later, Picasso would praise Cézanne for his "restless striving."

The structured pictorial surface Cézanne accomplished is best expressed in his later works (fig. 11.73). Although the most significant monument in the landscape is the powerful, thrusting mountain, Cézanne has constructed his painting out of blocks of color, and no one area or object is less strong than another. Cézanne urged painters to "see in nature the cylinder, the sphere, the cone," and this painting demonstrates his approach. Surface strength is also accomplished by intermingling blocks of limited color—in this case violet, green, ocher, and blue; the violet of the atmospheric perspective reappears in the foreground, and the green of the middle ground is also found in the sky. When this work is compared to an Impressionist painting, such as Impression-Sunrise (see fig. 11.54), two completely different effects can be noted. Cézanne has sacrificed the ravishing, momentary subtlety of color that forms the foundation of Monet's accomplishment in his attempt to create a landscape that has an enduring strength and power. In ancient times, Mont Ste.-Victoire was believed to be a holy mountain, a home of the gods, and in Cézanne's painting it is once again endowed with a mysterious presence. Cézanne's paintings had an important impact on developments in the twentieth century: Matisse called him the "father of us all."

The Beginnings of the Skyscraper

What is the chief characteristic of the tall office building? And at once we answer, it is lofty.... The force and power of altitude must be in it.... It must be every inch a proud and soaring thing, rising in sheer exultation that from bottom to top it is a unit without a single dissenting line.

(Louis Sullivan, The Tall Office Building Artistically Considered, 1896)

To accomplish his lofty exaltation, Louis Sullivan (1856–1924) based his Wainwright Building on a design concept analogous to that of a column (fig. 11.74). The first

two stories act as a base that supports the unimpeded vertical members, which rise like flutes on a column to support a cornice, decorated with foliage ornament, that crowns the structure like a capital. This intelligible design hides the load-bearing steel-frame construction, which other early skyscraper architects had emphasized by creating a grid of balanced horizontals and verticals. Sullivan chose instead to stress the vertical articulation. Only every second vertical element corresponds to the interior steel cage. In addition, the vertical elements dominate because the windows are recessed between them, and the horizontal membering, obscured behind recessed panels of decorated terra-cotta, is reduced in importance.

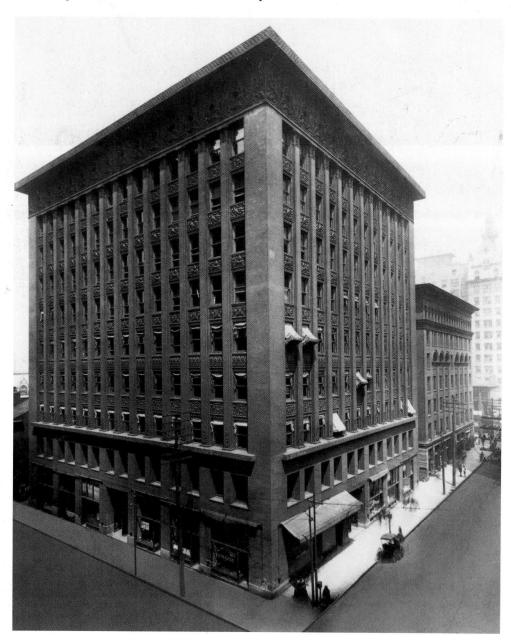

11.74 Louis Sullivan, Wainwright Building, St. Louis, Missouri, 1890–91. Commissioned by Catherine Wainwright and her son, Ellis Wainwright, a brewing magnate and commercial leader.

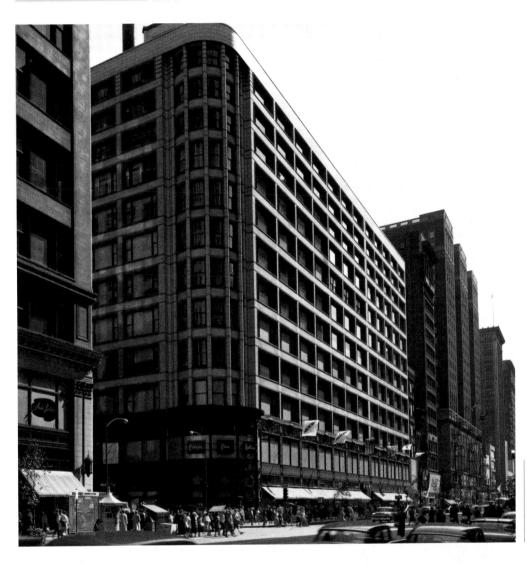

11.75 Louis Sullivan, Carson-Pirie-Scott Store (formerly Schlesinger and Meyer Department Store), Chicago, 1899; enlarged 1903-04 and 1906. Commissioned by Leopold S. and Daniel Meyer.

This photograph shows Sullivan's structure after the removal of the strong cornice that originally capped it and added a culminating horizontal element to the design.

The integrity of the design depends on the proportional relationships between the parts and the whole, which Sullivan has carefully calibrated. The wide corners balance and set off the elegant, narrow verticals between the windows, while the effulgent decorative terra-cotta at the cornice level, a full story high, unites with the narrow uppermost cornice to provide an elegant final closure that defines the mass of the structure. The decorated panels below each window provide a typically Sullivanesque touch, offering a pleasant decoration for office workers in adjacent buildings. The total effect is of a finely articulated mass, elegant and substantial at the same time.

The most impressive developments in skyscraper architecture occurred in Chicago, where a devastating fire in 1871 leveled much of the city. During the closing decades of the century, the city's rapidly increasing population spurred a building boom. Sullivan's last major commission was the

design for the Schlesinger and Meyer Department Store (fig. 11.75). The idea of a huge urban store carrying luxury items for middle- and upper-class patrons was novel, and Sullivan emphasized elegant public entrances and huge plate-glass windows on the lower floor by fantastic castiron ornamentation of his own design. The upper floors, with their huge "Chicago" windows and very plain terracotta decoration, refer in a streamlined fashion to the concealed steel cage, but note that the horizontal members are emphatically wider and therefore dominant. Sullivan's sensitivity to the shape and placement of the building as a whole is evident in the cylindrical tower at the corner, an unexpected element adding a vertical punctuation mark that makes the horizontal sides even more forceful. Here Sullivan completely avoids any historical references, creating a building that is one of the first works of modern architecture.

Edvard Munch

I was walking along the road with two friends. The sun set. I felt a tinge of melancholy. Suddenly the sky became a bloody red.

I stopped, leaned against the railing, dead tired, and I looked at the flaming clouds that hung like blood and a sword over the blue-black fjord of the city.

My friends walked on. I stood there, trembling with fright. And I felt a loud, unending scream piercing nature.

(Edvard Munch, Diary, 1892)

The composition of *The Scream* (fig. 11.76) expresses the personal anxiety of Edvard Munch (1863–1944) by creating a formal tension that reinforces the psychological tension that is the theme. As in Munch's description, the sky is a

blood red. Its undulating rhythms melt into the blue-black waters of the fjord. The perspective of the bridge is unnatural. Its sharp angle creates a visual tension, for it is caught between the flatness of the picture plane, which is emphasized by the shapes of clouds and water, and the illusory space established by the diminution of Munch's companions and the ships of the fjord. The curving rhythm of Munch's body, transformed into an existential symbol, incorporates itself into the rhythms of the environment. He is becoming one with nature, realizing his worst agoraphobic nightmare. As he screams, his face is distorted to resemble a skull, with the iconographic association of death. These visual manipulations communicate an emotional impact not as a representational image, but as a symbol of a schizophrenic psychological state.

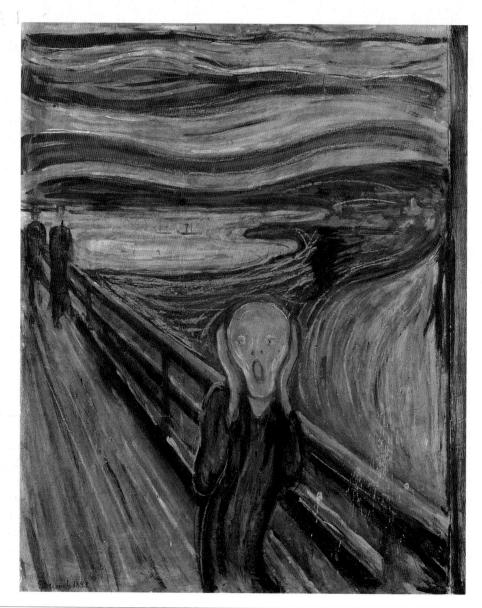

11.76 Edvard Munch, *The Scream*, 1893. Oil, pastel, and casein on cardboard, 2' $11\frac{1}{4}$ " × 2' 5" (91 × 74 cm). National Gallery, Oslo, Norway. Munch originally titled this work *Despair*.

1895 First professional football game 1896 First modern Olympic Games held, in Athens 1898
Pierre and Marie Curie
discover radium

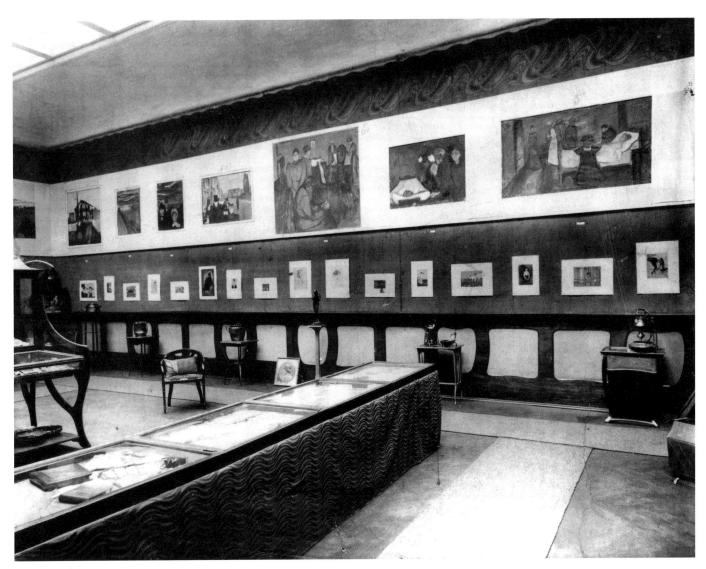

11.77 Edvard Munch, The Frieze of Life exhibition. Photograph of the installation at Leipzig, Germany, 1903.

Munch divided the exhibition into four sections: Seeds of Love; Flowering and Passing of Love; Life Anxiety; and Death. The Scream was exhibited in the Life Anxiety section. The paintings along the wall seen here are, from left to right, The Red Vine, The Scream, Angst, Evening on Karl Johan Street, Death in the Sickroom, By the Deathbed, and Death and the Child.

The terrifying tension Munch felt that evening was in part the result of his alcoholism and a dread of open spaces. In this condition, Munch experienced himself being pulled into his environment, losing his identity. He heard a scream within him, the scream of nature "dying" in flaming bursts at sunset. The inner scream became so intense that Munch, looking at us, screams to relieve the pain within.

The Scream was one of a series of twenty-two paintings and prints that Munch exhibited as a coordinated group in the opening years of the twentieth century. The exhibition was titled Motifs from the Life of a Modern Soul, yet it more

often carried the simpler title *The Frieze of Life* (fig. 11.77), which better suggests Munch's intent to represent the flowering and passing of love, life's anxieties, and death. As a young person growing up in Norway, Munch had led a bohemian life, and the ideas for the paintings began with his personal, subjective experiences, which were then transformed into broader symbolic themes.

For Munch, the emotionally expressive abstraction of forms was a way of creating art that possessed what he termed a "deeper meaning," one that conveyed the content of the human soul. The impact of his art had a profound effect on the development of early modern painting.

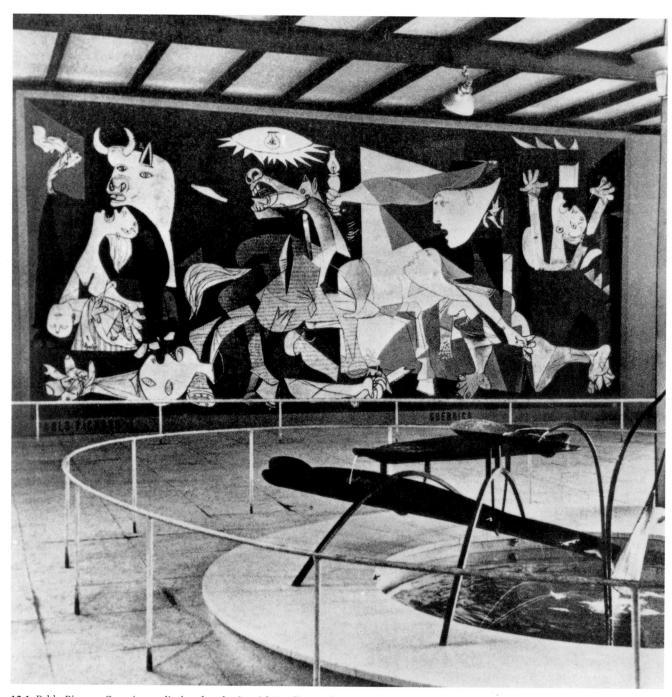

12.1 Pablo Picasso, Guernica, as displayed at the Spanish Pavilion at the 1937 World's Fair in Paris.

In January of 1937 the elected Republican government of Spain commissioned a work for the pavilion from Picasso, but he had yet to choose a subject when the town of Guernica was destroyed by saturation bombing on April 26, an event that is described in more detail on pp. 556–57. Picasso painted the work now known as *Guernica* between May 1 and June 4.

Art from 1900 to 1949

A BRIEF INSIGHT

his historic photograph shows Picasso's painting *Guernica* at its original location, in the Spanish Pavilion at the 1937 World's Fair in Paris; the photograph highlights the original function of one of the twentieth century's most riveting paintings (fig. **12.1**). Picasso had painted modern warfare, as suffered by the citizens of Guernica, in order to draw international attention to the plight of those suffering in the Spanish Civil War (1936–39). This was in line with the intent of the pavilion, which had been designed by the elected government to inform fairgoers of its social and political aims.

The pavilion was designed by Josep Lluis Sert and its determinedly modern style was intended to convey the forward-looking nature of Spain's Republican government; the building was constructed with cheap materials because of the limited resources of the government during the war. When it opened, the first to go through were the construction workers, led by a friend of the architect. When they stopped in front of *Guernica*, he said "If the picture by Picasso has any defect, it is that it is too real, too terribly true, atrociously true." The auditorium at the pavilion showed documentary movies about the war, including *Spanish Earth* by Joris Ivens and Ernest Hemingway, *Madrid '36* by Luis Buñuel, and *Heart of Spain* by Paul Strand. The insurgent Fascist forces under Franco won the war, not Picasso's patrons, but *Guernica* has endured as an emblem for all those who hate the suffering experienced by humanity during political conflicts.

Introduction to Art from 1900 to 1949

roaring motorcar which seems to run on machinegun fire is more beautiful than the *Victory of Samothrace*" [see fig. 4.14], wrote Filippo Marinetti, an Italian poet of the Futurist movement, in 1908–09. The works chosen to introduce the first half of the twentieth century relate the dynamism of modern art to the vigor in Marinetti's words.

Speeding Automobile—Study of Velocity (fig. 12.2), by the Futurist artist Giacomo Balla (1871–1958), is an abstract representation inspired by the 1910 Futurist Manifesto, which declared: "[T]he gesture ... we would reproduce on canvas shall no longer be a fixed moment in universal dynamism. It shall simply be the dynamic sensation itself." Balla's sequential placement of diagonal lines communicates dynamic force. An associate of Marinetti, Balla has visualized the poet's remarks on the new aesthetic of beauty.

The sleek, aerodynamic design of Pininfarina's Cisitalia "202" GT car (fig. 12.3) is both functional—it

cuts the wind resistance—and elegant. Even standing still, the car gives the impression of movement. In function and appearance, both Balla's painting and Pininfarina's automobile are works characteristic of twentieth-century modernism.

HISTORY

The decades that opened the twentieth century were characterized by a population boom; unprecedented improvements in living conditions in the Western world; and a technological revolution of the kind that the poet Marinetti and the painter Balla glorified. By the 1890s, electric lighting and motors became common. The radio, invented by Guglielmo Marconi in 1895, facilitated communication over vast distances. Television was introduced in the 1920s, and computers in the 1940s. One dramatic example of the astounding pace of modern technology was air and space

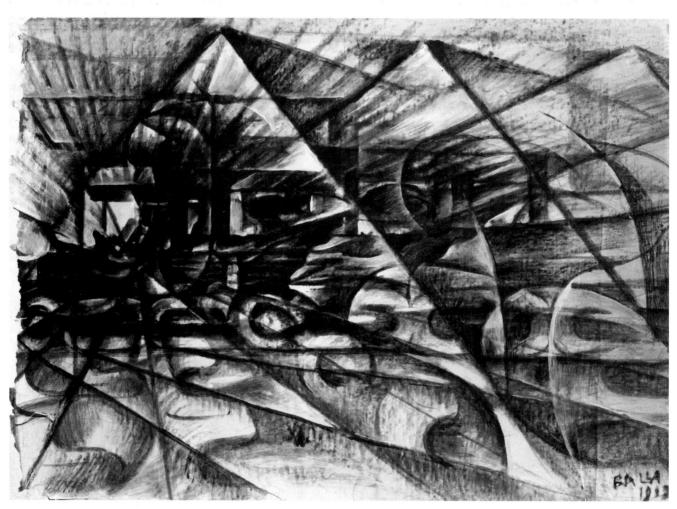

12.2 Giacomo Balla, *Speeding Automobile*—*Study of Velocity*, 1913. Oil on cardboard, 2' 2" × 3' 1½" (66 × 92 cm). Municipal Gallery of Modern Art, Milan, Italy.

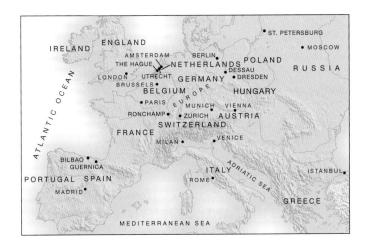

flight. The 1903 flight of the Wright brothers at Kitty Hawk, North Carolina, was followed only twenty-four years later by Charles Lindbergh's solo flight across the Atlantic.

These advances in technology took place against a backdrop of political conflict, war, and violent revolution. By the end of the first decade of the twentieth century, the European nations and Great Britain had built up enormous armed forces. Germany, Austria-Hungary, and Italy were allied against Great Britain, France, and Russia. War became inevitable after Archduke Franz Ferdinand, heir to the throne of Austria-Hungary, was assassinated in 1914. The "Great War," now known as World War I, erupted within months. Although all parties hoped it would be of short duration, it lasted, stagnated in trench warfare, until 1918. The United States committed its armies in 1917. The 1919 Treaty of Versailles ended World War I, but the harsh restrictions it imposed on Germany helped set the foundation for later conflict.

Before World War I ended, events in Russia had brought a new political force to the world scene. A populist revolution of 1917 overthrew Czar Nicholas II, and a "dictatorship of the proletariat" was established by Bolshevik Communists headed by Vladimir Lenin. Lenin withdrew Russia from World War I in 1918, but civil war continued in Russia until 1921. In 1923, the Union of Soviet Socialist Republics (USSR) was formed. Communist parties outside of the USSR had been federated with Soviet Communism in 1919 to form the Third International. Vladimir Tatlin (1885–1953), a Russian artist who had visited the avantgarde art centers of Berlin and Paris in 1913, proposed an ambitious spiraling architectural form to serve as the center of world Communism (fig. 12.4). The dynamic energy of the Communist party was to be expressed by glass-enclosed meeting rooms that would revolve around the building's axis. The lowest level—a cube—would turn once per year; the pyramid in the center once per month; and the upper, cylindrical chamber once per day. This highly original structure, designed to convey the modernity of Communism to the world, was never built, and soon the Soviets abandoned the modern style in favor of realist and classicist cliches.

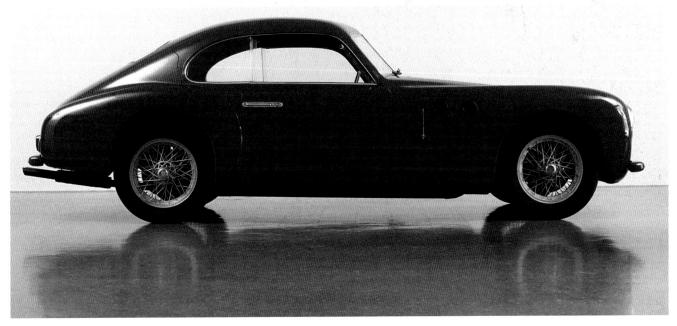

12.3 Pininfarina (designer), Cisitalia "202" GT car, 1946. Aluminum body, length 12' 5" (3.78 m). Manufacturer: S.p.A. Carrozzeria Pininfarina, Turin, Italy. The Museum of Modern Art, New York.

12.4 Vladimir Tatlin, Historic photograph of the model of the Monument to the Third International Communist Conference. 1919–20. The model, sixteen feet (4.9 m) tall, was of wood and netting; the final building, which was to be of iron, painted red, and glass, would have been more than 1,300 feet (400 m) tall.

Following World War I, economic instability arose as nations returned to peacetime industrial production. Prosperity first seemed assured, but an economic collapse in 1929 plunged the world into the Great Depression, which in the United States left one in four workers jobless. In America economic ruin was compounded by a drought that devastated farming in the southwest.

During the 1930s, as the West struggled to regain economic stability, the Nazi government of Adolf Hitler took control in Germany, and the Fascist dictators Benito Mussolini in Italy and Francisco Franco in Spain seized power. In 1939, another world war broke out in Europe. World War II reached global involvement following Japan's attack on the American naval base at Pearl Harbor, Hawaii, in 1941. This war ended with the defeat of Germany and Japan, but the explosion of the atomic bomb over Hiroshima, Japan, on August 6, 1945, ushered in the atomic age and the constant unsettling threat of nuclear war.

The economic depression of the 1930s and World War II a had profound impact around the world. After the war, increasing industrialization and prosperity in the United States, Europe, and Japan led gradually to an even greater distance between the developed nations and other parts of the world. The struggle to be free from foreign domination led to the dissolution of European empires and independence for many countries in Asia and Africa, but in many cases independence did not lead to peaceful stability or to the establishment of effective self-governance. Tension between the industrialized nations and thirdworld countries and the struggle for decreasing resources would grow almost continuously during the second half of the twentieth century.

INTELLECTUAL AND SCIENTIFIC ACTIVITY

Scientific advancements during the early twentieth century were revolutionary in many areas. In physics, Albert Einstein's general theory of relativity demonstrated the relationship of geometry to gravity, and radically modified our concept of space and time. Our understanding of the very essence of matter has been altered, as the atom has been reduced to its subatomic components.

During the first half of the century, major philosophical movements influenced visual expression. The Existentialist writings of Jean-Paul Sartre and Simone de Beauvoir, for example, emphasized the singularity and isolation of the individual in modern society. Meaning, they argued, is not conferred on us by external forces; it is actualized by individual choices, the consequences of which are solely our responsibility. Existentialism also emphasized the importance of the moment and the fact that we live only in the present. Their philosophical arguments can be related to the distinctive figures of Alberto Giacometti (1901-66). While his unnaturalistically elongated figures, as in City Square (fig. 12.5), are recognizably human, upright, and dignified, they lack the features that would give them individuality. Their rough contours make them seem agitated, and they are positioned so that no physical or psychological interaction seems possible. The spaces that separate them become poignant barriers to communication. Although the title of the work suggests a space that would normally be bustling with human activity, here the figures seem to exist only within themselves. In City Square, Giacometti has given visual form to the Existential concepts that were so strongly felt in post-World War II Europe. When an exhibition of Giacometti's works was held in New York City in 1948, the catalogue text was written by Sartre.

Twentieth-century developments in psychology greatly influenced the course of art, especially in the movements of Surrealism and Abstract Expressionism (see pp. 548–51, 566–69). Using therapeutic approaches

12.5 Alberto Giacometti, City Square, 1948. Bronze, 8½" × 2' 1½" × 1' 5½" (21.6 × 64.5 × 43.8 cm). The Museum of Modern Art, New York.

that included free association and the interpretation of dreams in treating his patients, Sigmund Freud established the active and even dynamic role of the human unconscious in guiding behavior. To Freud, unmasking the subconscious was the key to understanding the human mind. Carl Jung extended, modified, and at times countered Freud's theories to develop additional psychological insights into human behavior. Jung advanced the notion of a "collective unconscious," a layer of the unconscious that underlies the personal unconscious and that carries the inherited disposition of our species. Accordingly, the collective unconscious is revealed by the common use of archetypal images, such as the circle, across diverse cultural traditions.

Radical changes were introduced in twentieth-century music. In France, Igor Stravinsky's ballet music for *The Rite*

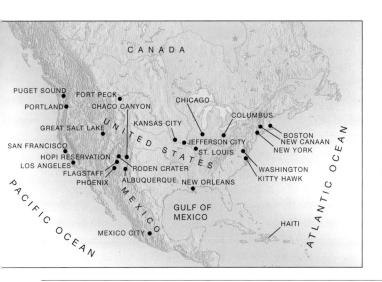

of Spring (1913), with its driving, primal rhythms and fragmented melodies, nearly caused the audience to riot at its first performance. In Germany, the composer Arnold Schönberg devised a new system of musical tonality; Schönberg's pantonality (which is commonly referred to as being atonal) is a free but not unstructured use of musical tones, changing audience expectations away from traditional chord progressions and resolutions.

ART FROM 1900 TO 1949

Early twentieth-century art is often referred to as "modern art," although the terms are not exactly synonymous. The concept of modernism expresses the idea that a current time possesses distinctive attitudes and characteristics that distinguish it from the immediate past. Renaissance artists, for example, felt themselves to be working in a "modern style." In the history of art, developments in the nineteenth century countered well-established traditions in art, laying the foundation for radical and rapid changes. These changes in twentieth-century art seemed so distinctive that the term "modern" was applied in both a chronological and a descriptive sense to the works of avant-garde art that challenged earlier traditions. Until recently, the concept of modernism was limited to Western art. Now, however, modernism has been adopted by artists elsewhere as well, to challenge the status quo or to promote Western values and ideas.

The first half of the twentieth century brought a variety of artistic experiences. The avant-garde expanded the traditional limits of art by developing new styles, by working in new materials, and by questioning accepted artistic

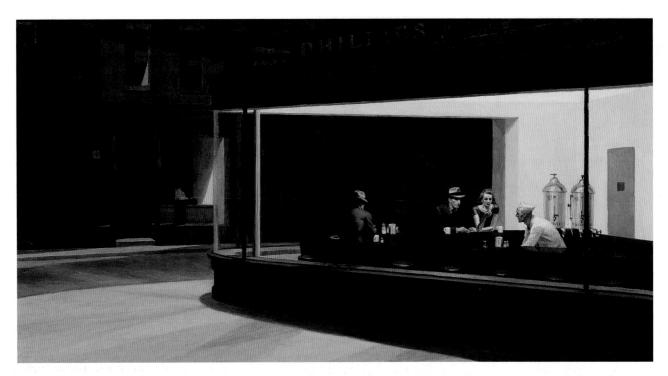

12.6 Edward Hopper, *Nighthawks*, 1942. Oil on canvas, 30×60 " (81.4 × 152.4 cm). The Art Institute of Chicago.

12.7 Constantin Brancusi, *The Kiss*, 1909. Limestone, height 23" (60 cm). Philadelphia Museum of Art.

practice. More traditional currents in art, including realism and illusionism, were also sustained, although critics at times ignored the work of artists who worked outside the "modern" mainstream. Edward Hopper (1882-1967) developed a personal style and iconography devoted to the theme of the loneliness and isolation of the individual. Hopper's settings could be anywhere in America, and his people are ordinary, nameless figures from the middle class. We should be wary of infusing these images with the nostalgia that their settings and costumes can evoke, for Hopper intended his paintings to represent the here and now. In Nighthawks (fig. 12.6), painted in 1942, we are cut off from the quiet individuals inside the diner, and the harsh interior light exposes the lack of communication that Hopper so often emphasizes in his images of modern urban life. Like Hopper, other artists fed the stream of realism that flowed, especially in America, throughout the twentieth century. In the 1920s and 1930s, works by Charles Sheeler (see fig. 12.63), Grant Wood (see fig. 12.64), and Thomas Hart Benton (see fig. 12.66) celebrated various aspects of American life in manners meant to be open and democratically accessible to all viewers.

It is, however, abstraction and nonobjectivity that have become the hallmarks of early twentieth-century art. Continuing formal developments advanced by the Post-Impressionist artists, twentieth-century artists expanded the vocabulary of visual expression. *The Kiss* (fig. 12.7) by Constantin Brancusi (1876–1957), with its compact, rectangular masses joining two abstract figures, conveys the essence of unity. For Brancusi, the expression of a concept,

12.8 André Kertész, Distortion No. 4, 1933. Gelatin silver print, 9¾ × 7" (24.7 × 17.8 cm). Kertész's Distortion photographs, commissioned by a French magazine in 1933, were not published until 1976.

which in this sculpture is the wholeness of two individuals as symbolized by the kiss, overrode concerns of naturalism. Some artists denied any representational aspects in their works, as is the case with certain Russian avant-garde artists working around 1913 (see pp. 530-33).

Abstraction held a particularly powerful hold on artists whose concern was the communication of the emotional forces of life. Early in the century, Ernst Ludwig Kirchner (see fig. 12.39) utilized expressive distortions of form to share his observations on the quickened pulse and anxiety of modern life. But abstraction also served artists like Picasso (see fig. 12.22), whose aim was the more formal manipulation of the visual elements of art.

In the 1930s, André Kertész (1894–1985), a Hungarian photojournalist working in France, captured a unique form of figurative abstraction through "straight" photography (fig. 12.8). Kertész achieved these effects of distortion by photographing models reflected in "fun house" mirrors with varied surfaces. The resulting series of photographs are reminiscent of expressionist tendencies and Surrealism in painting.

Western artists often identified modernism with a search for newness. This search also has led architects to the creation of a more purely formal aesthetic that countered the eclecticism and abundant decoration of the late nineteenth century. At times, this aesthetic was imbued with philosophical meaning, as with the Bauhaus (see pp. 542-43).

One modern international medium of artistic expression is cinema. In the late nineteenth century, experimental photographers succeeded in presenting a "moving picture" by projecting a sequential series of photographs taken at exposures as quick as 1/2000 of a second. The forerunner of our motion-picture projector, however, was the Vitascope, invented by Thomas Armat and manufactured by Thomas Edison in 1895. The projector achieved the illusion of movement by rapidly projecting a series of still photographic images in sequence. The persistence of vision, derived from the momentary retention of optical stimuli on the retina of the eye, lets our minds interpret the rapidly shown still frames as continuous movement. By 1895, the Lumière brothers had opened the first public movie theater in France, and soon their cinématographie was being shown throughout Europe.

Like other art forms, cinema is primarily a visual experience. Techniques of shooting can effectively manipulate our point of view while we remain stationary. But special to film is the depiction of movement over a course of time. The expression of time has been an important element in many works of art, but with cinema not only is time actual but our perception of it is modulated by various methods of editing-the "cutting and pasting" of sequences of film together. Sergei Eisenstein's editing in Battleship Potemkin, rapidly shifting from scenes of Cossacks firing into a crowd to scenes expressing the anguish of the people, inserts us into the event (fig. 12.9). The efficacy of the modern medium of cinema was vividly expressed by the Swedish director Ingmar Bergman when he stated:

I can transport my audience from a given feeling to the feeling that is diametrically opposed to it, as if each spectator were on a pendulum. I can make an audience laugh, scream with terror, smile, believe in legends, become indignant, take offense, become enthusiastic, lower itself, or yawn with boredom.... I am able to mystify, and I have at my disposal the most astounding device [the motion-picture camera] that has ever, since history began, been put into the hands of the juggler.

12.9 Sergei Eisenstein, *Battleship Potemkin*, detail of film still, 1925. Eisenstein's film dealt with the 1905 mutiny aboard the Russian ship *Potemkin* and the failed anti-czarist uprising.

THE ARTIST

Social change, technology, and new artistic freedoms altered traditional notions of the role and identity of the artist during this period. Artists forged a new independence with diverse materials, and many works of art are imbued with a highly introspective content. This leads us to experience many works as a revelation of the artist's inner self. Such self-disclosure, which in the past was usually restricted to self-portraits, is often the main content of twentieth-century works of art. Examples already discussed in this chapter would include Giacometti's *City Square* and Hopper's *Nighthawks* (see figs. 12.5 and 12.6), both of which express the artist's emphasis on the isolation of the individual in modern society.

The impact of the *Self-Portrait* by Käthe Kollwitz (1867–1945), for example, is direct and penetrating (fig. **12.10**). Her face fills the surface, demanding that we confront her expression. Kollwitz published several series of prints depicting the social and political struggles of the poorer classes in Germany in the late nineteenth and early twentieth centuries, and we sense in her portrait that she identified with these struggles. The personal revelation of the artist's involvement in public problems is especially typical of modern works.

The Two Fridas, a double self-portrait by the Mexican artist Frida Kahlo (1910–54), is a complex image filled with

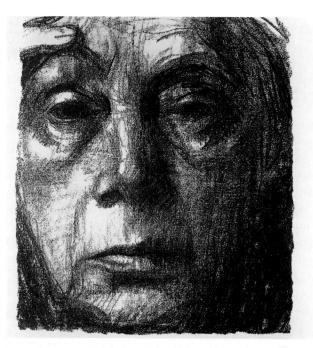

12.10 Käthe Kollwitz, *Self-Portrait*, 1934. Lithograph, $8\% \times 7\%$ (20.5 × 18.4 cm). Philadelphia Museum of Art. Käthe Kollwitz, a German artist, was the first woman to be elected to the Prussian Academy of Arts.

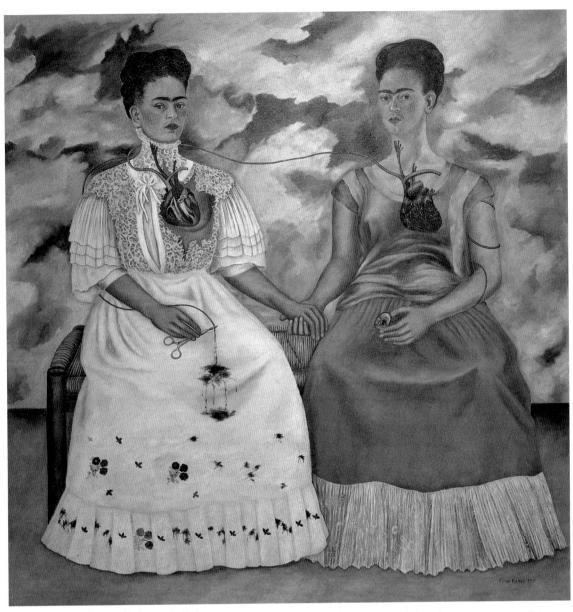

12.11 Frida Kahlo, The Two Fridas, 1939. Oil on canvas, 5' 9" × 5' 9" (1.75 × 1.75 m). Museo de Arte Moderno, Mexico City.

symbolism (fig. 12.11). Although the two figures hold hands and are joined by a common blood system, the duality Kahlo felt is revealed by the contrasting costumes, Mexican and European. Her dual heritage is likewise expressed in the two hearts, for the figure in the European dress has her chest ripped open in a reference to Aztec sacrificial practices, while the other figure's heart resembles Catholic representations of the Sacred Heart of Jesus. This revealing, if enigmatic, work was painted as Kahlo was being divorced, and the open artery on her lap may refer to her suffering at this time. Such self-revelation is not unusual in modern art and introspection can be one of the keys to understanding the modern artist.

The role of the patron, which was becoming less central during the nineteenth century, was reduced even further in the course of the twentieth century. Many artworks were created independently, without a patron or other controlling dictates from the outside. Some fields remained exceptions to this: architecture and public sculpture continued to rely on commissions. Nevertheless, architects and sculptors frequently remained remarkably free to express personal solutions in these large-scale works.

Artists of this period faced a new world. Technology and rapid communication were bringing an era in which isolation was increasingly rare and developments in ecology, economics, political changes, and even local conflicts would have wide impacts across large parts of the world. Artists too were caught up in the global tension, uncertainty, promise, and search for identity that characterized the first half of the twentieth century.

The Home and the Palace

Two Views of the Modern Home

(figs. 12a and 12b) These two images of home are examples of extremes in twentiethcentury art. The abstract simplicity and aesthetic purity seen in Philip Johnson's Glass House are a sharp contrast to the clutter of popular culture parodied by Richard Hamilton's collage representation of a living room. The house that Johnson designed for himself exemplifies the modernist ideal that wishes to impose geometry on life's irregularities; the Pop Art collage, on the other hand, satirizes the extent to which modern life is dominated by advertising slogans and commercialized sex. It is hard to draw a stronger contrast than the one seen here, between the elitist ideals of modernist art and the banal actuality of everyday life (keeping in mind that Hamilton's collage is intended to criticize the commercialism that it seems to glorify). Throughout human history, the home—be it cave, hut, tent, palace, farmhouse, row house, ranch house, apartment, or condominium-reveals the outlook and aspirations of its occupants.

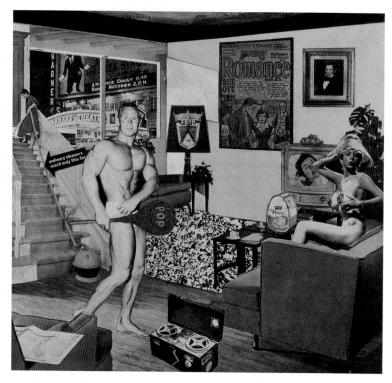

12b Richard Hamilton, *Just What Is It That Makes Today's Homes So Different, So Appealing?*, 1956 (for further information, see fig. 13.9 and pp. 571–72).

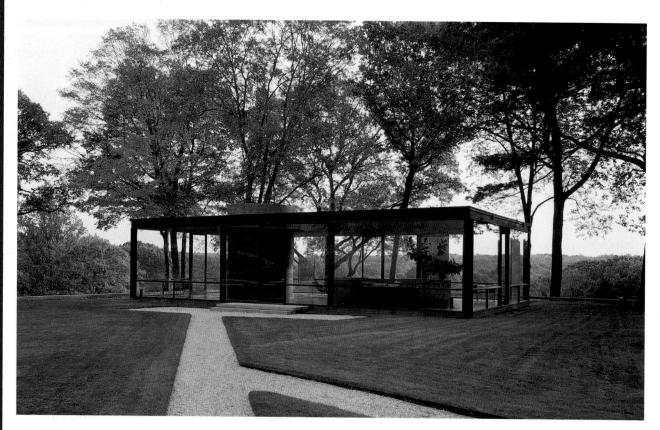

12a Philip Johnson, Glass House, 1949 (for further information, see fig. 12.75 and p. 562).

The Community as Home

(fig. 12c) Materials can limit and condition the character of the home. In this Native American village the limited availability of wood has resulted in a prevalence of mud-brick construction covered with adobe. Such construction methods are in harmony with the surrounding landscape in color and substance, and, as is apparent in this view, the forms of such adobe towns reflect the natural forms in the surrounding area. The manner in which the homes are joined to create a total complex is an indication of tribal unity, as is the lack of any hierarchy of construction.

Domesticating Religion

(fig. 12d) If we look beyond the Christian events of the Annunciation and Incarnation, we realize that Campin has also provided us with a view into a Flemish fifteenth-century living room, complete with furnishings. His goal, of course, was to make the holy events as palpable as possible for his contemporaries, and perhaps also to suggest that Mary and loseph were similar to the ordinary people of his village. Campin's determination to provide a setting with which his peers could identify has the unexpected side-effect of admitting us into their fifteenth-century world.

Expressing Yourself

(fig. 12e) The place where you live is an expression of you as a person even if you've done little to change or modify it. How you live, whom you live with, where you live, and furnishings you surround yourself with: these all indicate things about you, about where you have been, and about where you are going and who you hope to become.

12e "Insert Photo of Your Home Here."

12c Native American, Walpi Village, Hopi Reservation, twentieth century (for further information, see fig. 12.29 and pp. 522-23).

12d Robert Campin, Annunciation, c. 1425-30 (for further information, see figs. 7.16 and 7.17 and pp. 264-65).

Questions

- 1. What form would your ideal home take, and what would it and its furnishings express about you as an individual living in the twenty-first century?
- 2. For what audience would this home be intended: You alone? Other members of your family? Your friends? The "public"? The future?
- 3. Would you be more concerned with expressing the "real" you, or in projecting an "ideal" version of yourself?

Fauvism

I cannot copy nature in a servile way, I must interpret nature and submit it to the spirit of the picture—when I have found the relationship of all the tones the result must be a living harmony of tones, a harmony not unlike that of a musical composition....

The chief aim of color should be to serve expression as well as possible.... What I dream of is an art of balance, of purity and serenity devoid of troubling or depressing subject-matter, an art ... like an appeasing influence, like a mental soother, something like a good armchair in which to rest from physical fatigue.

(Henri Matisse, Notes of a Painter, 1908)

In Matisse's representation of the mythical land of Arcadia (fig. 12.12), lovers embrace and dance to music. The sinuous nudes who inhabit this verdant pasture are drawn with the same curving, rhythmic line that describes the trees and foliage, suggesting a harmony between humanity and the natural order. The colors are intense and vibrant. Matisse's monumental painting descends from a tradition of pastoral images that began in antiquity. In this twentieth-century

interpretation, the broad areas of color and flowing rhythms of line create a patterned, flat composition that adheres to the picture plane.

In the opening years of the twentieth century, Matisse began to make paintings in which color was exalted for its sensuous expression alone, independent of descriptive reality. Matisse worked in Paris with a group of painters who were exploring the liberation of color, and at a Parisian exhibition in 1905 their works were displayed in a room with a classicizing sculpture, causing the critic Louis Vauxcelles to remark: "Donatello au milieu des fauves! ("Donatello among the wild beasts!")." This witty denunciation gave the name "Fauvism" to this new style.

Within a few years, Matisse was further simplifying his style. His boldest experiments were undertaken in a pair of paintings dedicated to Dance and Music created for Sergei Shchukin, a Russian patron. Shchukin's interest in the art of Matisse and Picasso paralleled the Russian interest in revolutionary statements in music, ballet, literature, and politics. He purchased many of their works when he visited their studios in Paris. In *The Dance* (fig. **12.13**), Matisse took the

12.12 Henri Matisse, *The Joy of Life*, 1905–06. Oil on canvas, 5' 8½" × 7' 9¾". The Barnes Foundation, Merion, Pennsylvania.

When it was exhibited in 1906, The Joy of Life was singled out for criticism. The painter Paul Signac complained that Matisse had "gone to the dogs."

1900 Half of U.S. working women are farmhands or servants 1900 World population reaches about 1.65 billion 1900 London is the largest city in the world 1905-06 Matisse, The Joy of Life (fig. 12.12) 1905 Russian sailors mutiny aboard the battleship Potemkin

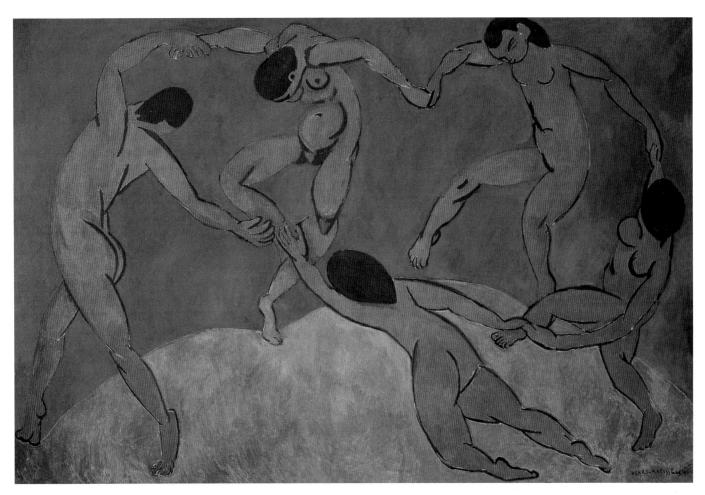

12.13 Henri Matisse, *The Dance*, 1909–10. Oil on canvas, 8' $5" \times 12' \ 8" \ (1.74 \times 2.38 \ m)$. Hermitage, St. Petersburg, Russia. Commissioned by Sergei Shchukin, a wealthy Russian businessman and important patron of both Matisse and Picasso.

Matisse had shown Shchukin a preliminary design in Paris, and Shchukin wrote back to Matisse from Moscow: "I find 'The Dance' of such nobility that I have decided to defy Russian bourgeois attitudes and to place on my staircase a subject with NUDES. It will be necessary to have a second painting, of which the subject might well be music.... In my house we have a great deal of music. Each winter there are some ten classical concerts (Bach, Beethoven, Mozart). The panel 'Music' should indicate in some way the character of the house." Shchukin brought Matisse to Moscow for a visit in 1911.

dancers from the center of *The Joy of Life* and expanded them so that they seem ready to burst out of the boundaries of the huge canvas. The figures are almost lifesize, and the powerful curves of their shapes make their movement seem impulsive and unstoppable. The figures are organic and full of life, and yet Matisse avoided using traditional modeling

to suggest three-dimensionality. Matisse limited the colors to four, setting the warm orangish hue of the figures and their outlines against two hues from the opposite side of the color wheel: blue and green. The exuberance and impulsive movement of the dance are conveyed here with limited means and careful control by the artist.

African Art and Ritual

hese individuals wearing painted wooden masks and fiber body suits (fig. 12.14) are participants in rites that the Bwa perform to sustain social balance in their communities and to mark the seasonal cycle of renewal and rebirth. The masks are constructed of wood planks that extend laterally or above a face. Their decoration is geometric (lozenges, checks, triangles, and chevrons) and can be interpreted both in terms of the animals that

12.14 Ritual dancers wearing painted wooden plank masks and related raffia body suits at annual purification rites. Bwa culture, twentieth century. Plank masks of wood, paint, and raffia. Upper Volta River region, Burkina Faso.

they represent and in terms of the forces or principles with which those animals are associated. The fiber suits and masks incorporate the fruits of the seasonal cycle that is essential to the Bwa's agricultural economy. Such costumes appear according to that cycle—with the coming of rain and the drying of the terrain after the harvest—as well as when social conditions merit attention and community action.

The Bwa, like other traditional societies across Africa, articulate spiritual beliefs that blend the conduct of daily life with the rhythms of the natural environment. For the Bwa, that environment is the savannah just below the desert that stretches across the continent. They live in small kinbased communities surrounded by the land that they farm.

The visual art of sub-Saharan Africa is comprised of objects, acts, and performances that express and affirm beliefs. African artistic expression can be found in masks and costumes, figurative sculpture, body decoration, clothing, decorative arts; in music, dance, and oral performance; and in the ways these separate arts are brought together in ritual life. Each detail has a meaning—sometimes multiple meanings, depending on the audience and the performer. For example, a chevron in contrasting colors may represent the feathers of a particular bird as well as the opposition of dark and light. While artists are recognized for the fullness and effectiveness of their expression, art is understood as a presentation of the recurring themes and unchanging elements of daily life. Repetition, affirmation, and continuity are the messages of the arts in Africa.

Outside the major political centers, the village is the dominant political unit. Although the villages are not isolated from each other, distinct local patterns of culture, including language and arts, are maintained. Nevertheless, local villages share common beliefs about the relationship of human life to nature and perform ritual activities that are outfitted with ritual dress, dance, and music.

In this region, agriculture is the predominant source of livelihood. The fear of drought or of a delay in the arrival of the rainy season is a source of mental stress that the farmers ease through elaborate rites intended to preserve the relationship between nature, the source of all life, and survival. The Bwa see nature as essentially benevolent, but believe that the needs, mistakes, and offenses of people can upset it. The function of ritual performance is to chase away the evil that is bound to occur in human communities. The purifying role of dance is indispensable to the cycle of

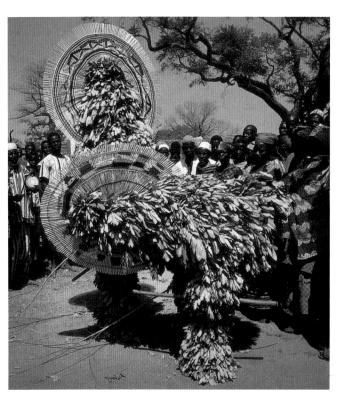

12.15 Ritual dancers wearing leaf masks and related body suits. Bwa culture, twentieth century. Leaves of the karité tree ("bastard mahogany"), fiber, straw, and colored string. Upper Volta River region, Burkina Faso.

renewal and is directly linked to the creation myth. Such rites are necessary at times of transition—birth, entering adult life, death, planting, and harvest.

The Bwa hold that Wuro, the Supreme Being, installed harmonious order among the sun, rain, and earth at creation. Human beings threaten that equilibrium. The techniques of agriculture involve violation of the soil and that outrages Soxo, the divinity of the bush, and through him, Wuro the Creator. Moreover, if one transgresses the taboos (laws) of society, a sequence of calamities will occur: drought leads to starvation, sickness, sterility, and sometimes even death. Wuro gave some of his bounty to Dwo, who acts as mediator between God and human life to restore balance. Dwo is incarnated in the leaf masks of the Bwa.

Leaf masks and body suits cover the entire body of the dancer (fig. 12.15) and are made in the bush after the millet crop is safely stored. The leaves are from a local tree, the karité (a type of mahogany), and are tied together with

vegetable fiber. Feathers or a straw crest indicate that the mask is male. The leaf masks enter the village at dusk and roam the alleys, lightly brushing against storehouses, huts, and the people of the village. The rustling leaves collect all the dust particles, which represent the offenses of human beings. They cleanse what they touch of all their impurities and thus absorb the evil that has accumulated throughout the year. They purify the village. The masks and body suits are perishable and their potency is spent in this activity. They, too, are part of the life cycle and must be regenerated at the end of the next agricultural season.

The human community also is regenerated by participation in renewal rites of nature that take place at the end of the dry season, before the first rain falls and planting begins. These rites signify the end of the period of mourning, are a rite of purification, and appeal to the spirits of the underworld. They require the presence of leaf, fiber, and sculpted masks.

Fiber masks are decorated with clan emblems linked to the veneration of a family lineage. The wooden, sculpted masks are usually rendered in animal form and represent the protective spirits of the village. They include the male flat-horned buffalo, the female buffalo with circularly sectioned horns, the warthog, the cock with its crest, the toucan, the fish, the antelope, and the serpent, which can be as much as ten feet long. The *Bird of the Night*, or butterfly mask and body suit (see fig. 1.16), appears after the first rains of the season. As the fluttering movements of the butterfly are imitated by the dancer, the essence of the animal is invoked.

African masks were collected by Western artists, anthropologists, and collectors in the late nineteenth century for their unusual artistry and powerful formal expression. Usually, however, only the carved and painted wooden masks were collected, while leaf masks and body suits, constructed of more perishable materials, were not preserved. Only recently have these costumes begun to be understood by outsiders in their own ritual context.

Photography

The whole scene fascinated me.... I saw shapes related to each other. I saw a picture of shapes and underlying that of the feeling I had about life. And, as I was deciding, should I try to put down this seemingly new vision that held me—people, the common people, the feeling of ship and ocean and sky and the feeling of release that I was away from the mob called the rich—Rembrandt came into my mind and I wondered—would he have felt as I was feeling?... I had but one plate holder with one exposure plate. Would I get what I saw, what I felt? Finally I released the shutter. My heart thumping Had I gotten my picture? I knew that if I had, another milestone in photography would have been reached. Here would be a picture based on related shapes and on the deepest human feeling.

These insightful words were shared by the photographer Alfred Stieglitz (1864–1946) as he revealed his psychological understanding of the creative perception that led to his photograph titled *The Steerage* (fig. **12.16**). Stieglitz's photograph from 1907 balances the relationship between form and content, and is best understood not as an imitation of art but as a work of art in itself.

12.16 Alfred Stieglitz, *The Steerage*, 1907. Photogravure, $13\% \times 10\%$ " (33.3 × 26.5 cm). George Eastman House, Rochester, New York.

12.17 Alfred Stieglitz, *Equivalent*, 1931. Gelatin silver print, $4\% \times 3\%$ " (11.8 x 9.0 cm). Alfred Stieglitz. Part purchase and part gift of An American Place, ex-collection Georgia O'Keefe. George Eastman House, New York.

In 1902, Stieglitz had broken away from the conservative posture of traditional photography to form the Photo-Secession Group. One year later, he founded *Camera Work*, a quarterly publication that stressed, with numerous illustrations, an ever-widening range of photographic innovation. Edward Steichen, a close friend and associate of Stieglitz, collaborated in this creative exploration of photography.

In 1905, Stieglitz founded an art gallery at 291 Fifth Avenue in New York City. "291," as the gallery was known, brought the art of the European avant-garde to the United States. Exhibitions included works by Cézanne, Brancusi, Picasso, and such American artists as Charles Demuth and Georgia O'Keeffe. In 1917, Stieglitz began to decrease his gallery and publication involvements to devote fuller attention to photography. His photograph *Equivalent* is an evocative image; the moon and its light are diffused through

1907 Stieglitz, The Steerage (fig. 12.16)

1907 Louis Lumière invents a process for color photography

1907 First daily comic strip in U.S. newspaper

1908 Ford Motor Company produces the first Model T

1908 First Mother's Day celebration, Grafton, West Virginia

12.18 Margaret Bourke-White, Fort Peck Dam, Montana, photograph for the cover of the first issue of Life magazine, November 23, 1936, $13 \times 10\%''$ (33.1 × 26.6 cm). Commissioned by the editors of Life magazine.

Bourke-White was one of the original staff photographers for Life magazine. During World War II, she became the first woman photographer to work with the U.S. armed forces.

clouds in the upper left, while to the right, separated by a cloud, an impenetrable darkness enters the composition (fig. 12.17). The photograph was produced without staging or significant darkroom manipulation, but the emphasis is less on the representational quality of the image than on abstract patterns of light and dark to create a somber, pensive mood. The Equivalent series, as well as Stieglitz's earlier work, was guided by a vision that helped establish photography as an independent artistic medium.

An important advance in photography in the 1920s was the development of the handheld, lightweight, 35mm rollfilm camera. No longer burdened by bulky equipment, the photographer now enjoyed a new freedom of mobility. The entire world became the photographer's studio (for an example, see fig. 12.8).

The cover story for the first issue of Life magazine was a photo essay by Margaret Bourke-White (1904-71) about a dam being constructed at Fort Peck, Montana (fig. 12.18). The abstract composition of her photographs suggested how the overwhelming scale of the steel-and-concrete public works project was intended to promote the promise of industrial development.

The French photographer Henri Cartier-Bresson (1908–2004) sought to capture what he termed "the decisive moment" in a photographic image when visible events briefly disclose a deeper truth. In Sunday on the Banks of the Marne (fig. 12.19), Cartier-Bresson has come upon a picnic-couples relax, wine is being poured, and food eaten; life is good. From our viewpoint, we have joined the picnickers for lunch, and we can also observe, with good humor, how their well-fed figures contrast with the sleek

> lines of the boat. Cartier-Bresson believed that a photograph should seize both the scene in front of the eye and what the eye sees when it looks inward, into the self.

12.19 Henri Cartier-Bresson, Sunday on the Banks of the Marne, 1938. Gelatin silver print, $9\% \times 14\%$ " (24.5 × 37 cm).

Cubism and its Influence

es Demoiselles d'Avignon, by Pablo Picasso (1881–1973), is a dissonant painting (fig. 12.20). The scene is a brothel, where we confront five prostitutes whose naked display is rendered in angular facets and discordant curves. Two of these figures wear masks based on African examples that hide their identity while projecting alienated aggression. For Picasso these masks were "magic things" that added a mysterious potency to the work. Compounding the anxiety that these masked figures create is a composition that sets formal elements in visual conflict. Colors clash: warm flesh tones and shades of pink and rust are set against icy blues. The illusion of space disintegrates in flat, abstract shapes, despite the manner in which the nude entering from behind parted drapes and the repoussoir

table and still life suggest perspectival recession. *Les Demoiselles d'Avignon* is a paradox of formal tensions, an affront to the traditions of illusionism that had characterized painting since the Renaissance.

The painting had begun in a traditional spirit when Picasso, a young Spanish artist working in Paris, took up the challenge of painting a monumental composition of female nudes. The preliminary study for the painting was less revolutionary in style and showed two clothed male figures juxtaposed with five female prostitutes; in combination with the still-life arrangement on the table, this composition resembled a traditional *memento mori* theme, expressing the idea that all pleasure is transitory. However, after seeing a retrospective of Cézanne's paintings, Picasso began

12.20 Pablo Picasso, *Les Demoiselles d'Avignon*, 1907. Oil on canvas, 8' × 7' 8" (2.44 × 2.35 m). The Museum of Modern Art, New York. The Avignon to which the title refers is a street in Barcelona's red-light district.

1911 Italy occupies Tripoli

1911 Revolution in Mexico

to simplify the geometry of his forms, faceting the surface structure and dissolving Les Demoiselles into multiple viewpoints. Picasso's eccentric modeling highlights different areas of the figures simultaneously, reinforcing the planarity of the pictorial surface.

Picasso's friend Georges Braque (1882-1963) disliked Les Demoiselles d'Avignon, but found himself intrigued by the possibilities of the new style. Picasso and Braque, working together in Paris, applied this new analytical abstraction to figural and landscape subjects. Reviewing a 1908 exhibition of Braque's experiments, the French art critic Louis Vauxcelles (who had earlier given us the name "Fauvism"), invented the term "Cubism" when he wrote that Braque "despises form, reduces everything to cubes. Let us not make fun of him, since he is honest. And let us wait." Cubism, the style that would result from these experiments, would become one of the most influential movements of twentieth-century art.

By the fall and winter of 1909-10, Picasso and Braque had developed a full-fledged Cubist style. This style is demonstrated in Georges Braque's Violin and Palette (fig. 12.21): a still-life arrangement of a violin, a music stand with sheet music, and a painter's palette hung on a nail at the top, with green folds of drapery as a backdrop. The theme is traditional; however, each of these ordinary elements is broken up into pictorial fragments. The violin, for example, is composed of a combination of planes that represent parts of the violin as seen from different points of view. They have been reconstituted as a highly abstract composition.

Like Picasso, Braque's cubistic approach is in part the result of influences from Cézanne, who introduced planar modeling and multiple viewpoints in his paintings during the late nineteenth century (see figs. 11.72 and 11.73).

Since the Renaissance, naturalistic illusionism had been a primary concern of painting, but Cubism confronted that tradition by asserting a new independence for the painted image. Given the visual clues that Braque offers us in Violin and Palette, we conceptually understand, for example, that one of the images refers to a violin. The image does not represent a particular violin as seen from a specific viewpoint. Rather, the simultaneous viewpoints suggest the essence of a violin—those shapes, forms, and colors that define a violin as a distinct object, different from the music stand, sheet music, palette, or drapery. In

> 12.21 Georges Braque, Violin and Palette, 1909-10. Oil on canvas, 3' 1/8" × 1' 47/8" (91 × 43 cm). Solomon R. Guggenheim Museum, New York.

this process of analysis, seeing becomes both visual and conceptual; we perceive time together with space as a total experience, unlike the illusionistic tradition of painting, which fixes a viewpoint at a moment in time. Even so, it is important to note that while Cubism is a process of abstraction, Cubist works never became nonobjective.

The initial phase of Cubism, as exemplified by Picasso's "Ma Jolie" (fig. 12.22), analyzes objects from different viewpoints to re-create them as planar facets lying

near or on the picture plane and is known as Analytical Cubism. By adding letters and, in some cases, musical symbols, Picasso and Braque further emphasized the surface. "Ma Jolie" contains words, a treble clef sign, and a hint of the five lines of the musical staff. While the letters reinforce the planarity of the painting's surface, they also act as a clue to the meaning, for they were taken from a popular love song. The words are also a reference for the viewer, for above them we can glimpse shapes that suggest a figure holding a stringed instrument. The color has been reduced because Picasso's primary interest is in examining form; color, which depends on light, is deemed extraneous to form. However abstract, the painting offers the persistent observer a representation of a posed model. The network of planar shapes has given a new aesthetic to painting, one that asserts the surface as a two-dimensional field for assembling references to the world.

The upper portion of Picasso's Still Life with Chair Caning (fig. 12.23) of 1911–12 offers the now-familiar fragmentation of Analytical Cubism. The objects represented include an oyster shell, lemon slices, a knife, a pipe, and a wineglass, while the JOU-the beginning of the French word journal ("newspaper")—adds the presence of a newspaper. What is surprising in this abstracted context is the background, which suggests that the objects are resting on the kind of traditional caning used for chairs and table tops in a Parisian cafe. But this caning, which seems to be the most realistic aspect of the work, is itself an illusion, for it is in actuality cheap printed oilcloth pasted onto the canvas in a new technique now known as collage (see box, p. 519). The shape of the work, a horizontal oval, is unexpected in this context (the vertical oval format was used for portraits), but even more surprising is the frame, which Picasso made by wrapping rope around his painting.

12.22 Pablo Picasso, "Ma Jolie" (Woman with a Zither or a Guitar), 1911–12. Oil on canvas, $3' 3\%'' \times 2' 1\%''$ (100 × 64.5 cm). The Museum of Modern Art, New York.

Ma Jolie (French for "My Pretty One") has a double meaning here. It refers both to the words in a popular song and to the name Picasso was using for his new lover, Eva, who probably posed for this painting.

12.23 Pablo Picasso, Still Life with Chair Caning, 1911–12. Collage of oil and pasted oilcloth (simulating chair caning) on canvas, oval 10\%" × 1' 1\%" (26.7 × 35 cm). Musée Picasso, Paris, France.

Picasso's use of collage is an extension of the inquiry raised by Analytical Cubism. Now the issues are compounded, for the reality of the painted Cubist still life is joined to printed oilcloth that looks like yet another reality: caning. With this collage, we are exposed to the paradoxical realities of life and art; although we can recognize the artificial and artful composition of still-life objects, the oilcloth disguises its reality behind the illusion of caning.

Still Life with Chair Caning here introduces a new phase of Cubism in which painted elements juxtapose with commonplace materials. The resulting works combine traditional artistic media with materials previously considered outside the realm of art, such as pieces of textiles, sheet music, and pages from newspapers; this second phase of Cubism is known as Synthetic Cubism. In some subsequent paintings Picasso and Braque will paint areas so that they resemble applied textiles, adding yet another complexity to the Cubist commentary of picture-making.

From Paris to New York, Tokyo, and Moscow, the influence of Cubism on early twentieth-century art was tremendous (see also pp. 498, 524-25, 530-43). The technique of fragmentation, used in Cubism to analyze notions of vision, was subsequently adapted to express different artistic goals.

Marcel Duchamp (1887-1968), for example, used a sequence of fragmented planes to describe the dynamic movement of a figure descending a staircase (fig. 12.24). This work was the butt of much ridicule, but the popular cartoon based on Duchamp's painting (fig. 12.25) also indicates the widespread interest modern art attracted. Such a cartoon is only meaningful when there is an audience who understands why it is funny.

In Italy, the portrayal of the dynamism of modern life was the aim of a group of avant-garde artists who called themselves Futurists. In the 1910 Futurist Manifesto, they stated their goal to free Italy from the weight of its past artistic traditions and to thrust it forward into the twentieth century. The Futurist artists also embraced political anarchy. Among other defiant statements, they declared:

that all subjects previously used must be swept aside in order to express our whirling life of steel, of pride, of fever and of speed.

that the name of "madman" with which it is attempted to gag all innovators should be looked upon as a title of honor.

that universal dynamism must be rendered in painting as a dynamic sensation.

12.24 Marcel Duchamp, Nude Descending a Staircase, No. 2, 1912. Oil on canvas, 4' 10" × 2' 11" (147 × 89.2 cm). Philadelphia Museum of Art.

12.25 J. Amswold, The Rude Descending a Staircase (Rush Hour at the Subway). Published in the New York Evening Sun on March 20,

This cartoon was created when Duchamp's Nude Descending a Staircase, No. 2 was shown at the Armory Show in New York City.

Futurist works in painting and sculpture were responses to the challenge established in the manifesto. The intensity of speed suggested in Balla's Speeding Automobile (see fig. 12.2) expresses their demand for "dynamic sensation," as does the vigorous stride implied by Umberto Boccioni (1882-1916) in Unique Forms of Continuity in Space (fig. 12.26). Forms that suggest both working muscles and sweeping drapery are thrust into space to convey the energy

12.26 Umberto Boccioni, Unique Forms of Continuity in Space, 1913 (cast 1931). Bronze, height 3' 7%" (1.11 m). The Museum of Modern Art, New York.

of a pacing figure. The sculpture is dramatically different when seen from varied viewpoints. Boccioni wrote:

No one can any longer believe that an object ends where another begins....We therefore ... proclaim ... the complete abolition of definite lines and closed sculpture. We break open the figure and enclose it in the environment.

TECHNIQUE

Collage and Assemblage

The term collage, from the French word coller ("to glue"), is used to designate works of art that incorporate such materials as pieces of newspaper, cloth, colored paper, and the like. With their Synthetic Cubist collages and assemblage sculptures, Picasso and Braque extended the range of materials accepted in art and influenced later avant-garde movements, including Futurism, Dada, and Surrealism.

The term "assemblage" has broader connotations than collage, although historically the word has been used to include collage. Assemblage usually involves a combination of three-dimensional objects-some of which may be "found" objects from the household or the junkyard—into a coherent composition. For examples, see the works by Max Ernst and Joseph Cornell (see figs. 12.58, 12.74).

Native American Art

hese wooden figurines (fig. 12.27), called *kachintihus* (or kachina "dolls"), were carved by Hopi people living in northeastern Arizona. The elaborate headdresses, some of them fitted with birds' feathers, are thought to assist in transmitting messages to and from the spirits. Another manifestation of kachinas—supernaturals who act as intermediaries between the gods and human

beings—are human celebrants (fig. 12.28) wearing ritual outfits and headdresses like those on the small wooden figurines. As with most Native American art, these examples must be seen as functional—that is, they are not produced merely as decorative objects but are meant to serve educational and religious purposes. Each example is invested with sacred symbolism.

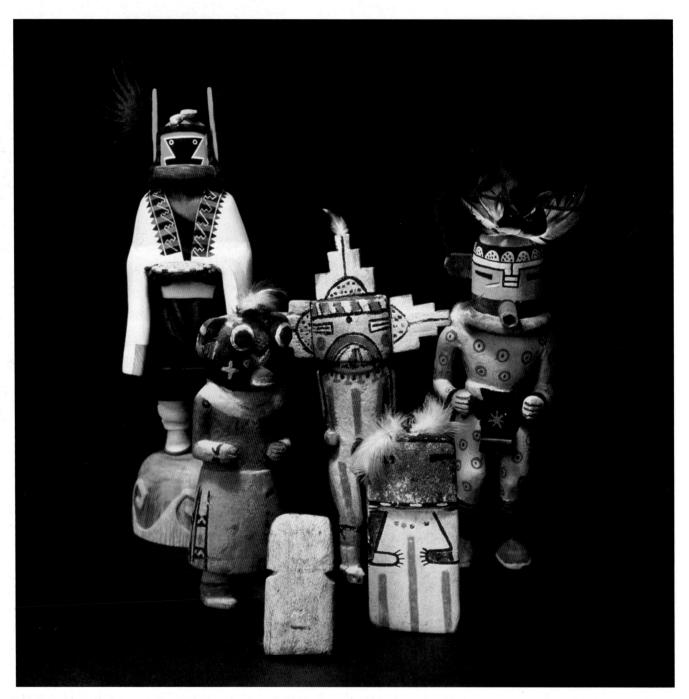

12.27 Kachina figures, Hopi culture, Arizona, twentieth century. Cottonwood roots adorned with mineral paints and other natural materials. The Heard Museum, Phoenix, Arizona.

20th century Hopi kachina figurines (fig. 12.27) 1906 San Francisco earthquake 1907 Oklahoma is admitted as forty-sixth state 1911 Chinese Republic proclaimed 1912 Duchamp, Nude Descending a Staircase, No. 2 (fig. 12.24)

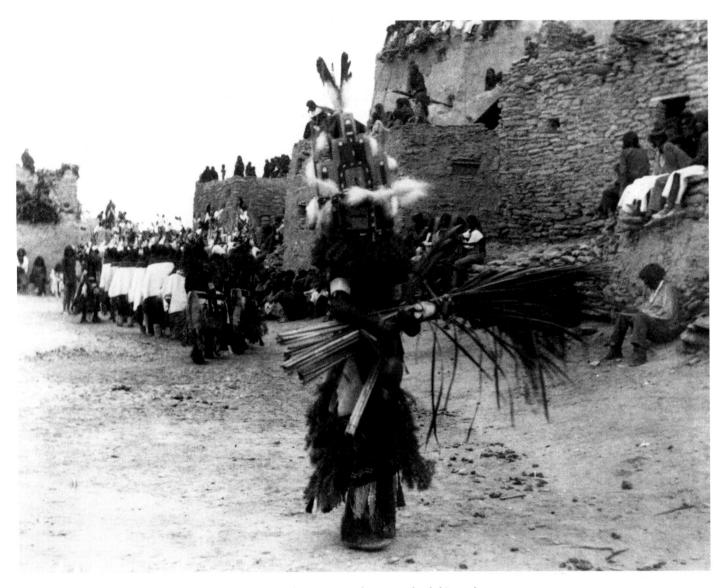

12.28 Hemis Kachina, Hopi culture, New Mexico, twentieth century. Feathers, yarn, buckskin, and grass.

| The design of the headdress, with stepped designs called *tablitas*, refers to clouds. The figure holds cattails.

The spirits with whom these kachinas are thought to communicate are said to live in the San Francisco Peaks and are believed to visit the Hopi at their current home in Arizona during the first half of the year, when the planting of new crops is being prepared. Among their many powers, these important spirits are said to exercise control over weather. The Hopi grow corn, beans, and squash. Because of their dependence on agriculture in this arid region, they have developed a complex religious life centered around rainmaking and crop fertility.

In the Hopi religion, there are three manifestations of kachinas: the spirit; a human acting as a spirit; and a carved figurine. The spirit, which cannot be seen, is impersonated in rituals by members of the Hopi community. By placing masks over their heads and wearing elaborate ritual dress and headdresses, these men and women are regarded as having taken on the supernatural character of the kachina spirit. Through special masks, costumes, paint, and actions of the impersonators, the otherworldly spirits are given power, substance, and personality. Kachina figurines are miniature representations (about eight to ten inches or 20–25 centimeters tall) of the masked impersonators. The kachina figurines serve to teach Hopi religious and social mores to children. They are not toys; they are an integral part of community life and are thought to ensure Hopi survival.

There are about 250 kachina personalities, though a limited number are favored. They personify a variety of natural elements, including clouds, rain, crops, animals, and even such abstract concepts as growth. Archaeological evidence shows that kachina dolls have been in use since the Hopi first inhabited the southwestern United States, between 1350 and 1400.

The Hopi culture was not much disturbed by European influence until the late nineteenth century, and the Hopi claim that they, more than any other North American people, live "in the old way." Since 1882, the Hopi have been officially confined to government reservations in northeastern Arizona (see box, facing page). This is the traditional homeland of the Navajo and the Zuni as well and is typified by steep-walled canyons and isolated mesas formed by the

steady erosion of time. Hopi communities are based on cooperation, as their survival in such a difficult environment depends on shared responsibility. They count on ceremonies to give them unity and cohesiveness. Group rituals require cooperation and are important occasions for the community to experience together.

Hopi villages seem to grow directly out of the mesa top, and their building materials and shapes give them continuity with the living rock on which they are built (fig. 12.29). This is often called an organic mode of building, for there is little separation between what is made by human hands and what is natural environment. Recent research suggests that while the men construct the buildings in the villages, using mud brick, it is the women who, as the figures in charge of the home, are responsible for finishing the structures with

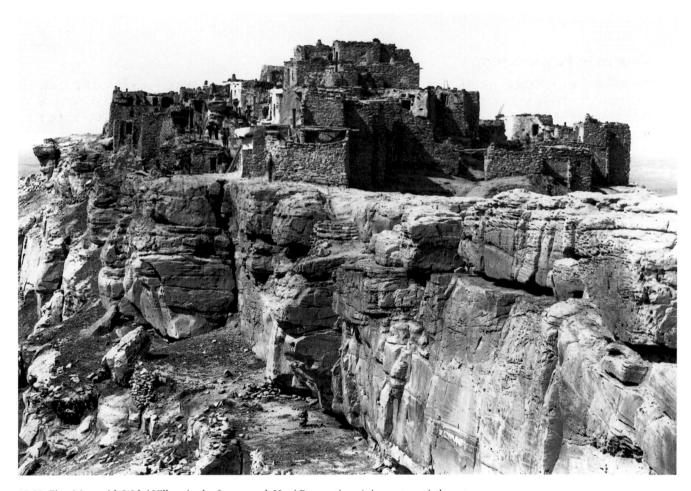

12.29 First Mesa with Walpi Village in the foreground, Hopi Reservation, Arizona, twentieth century. Seaver Center for Western History Research, Los Angeles County Museum of Natural History.

adobe and maintaining the fragile adobe surfaces. After the women put the adobe on a new kiva (see below), they sometimes "sign" the structures with their handprints on the roofbeams.

Hopi village life is organized around the plaza, a central space left open for the performance of ritual dances. Preparation for such rituals takes place in an underground chamber called a kiva, which represents the previous world from which the Hopi believe their people emerged in primordial times as well as the womb of Mother Earth. Among other activities, the ritual of growing new food plants for the coming season takes place in the kiva. This ritual is performed by men, whose upward movement from the dark kiva to the open daylight symbolically reenacts the Hopi "origin myth," in which the Hopi emerged from the chaos of the underworld to begin settled agricultural life on the mesas.

The Hopi ceremony cycle takes place over a sevenmonth period beginning in December. In the winter, when the earth is dormant and covered with snow, kachina rituals are held at night in the kivas. These rituals, which include dancers dressed as warriors and hunters, emphasize combat and death. Spring and summer rituals take place in the outdoor plaza in daylight and are associated with fertility, growth, and regeneration. They are happy occasions including costumed men and women who sing and dance together in a stately fashion. Some kachina dancers, meanwhile, represent ogres, and boisterously admonish everyone, especially children, to obey the rules of Hopi society. In a society that relies on cooperation rather than authoritarian control, such clowning helps preserve social cohesion.

ART PAST/ART PRESENT

Women in Pueblo Society

Traditional Western Pueblo society encompasses both the Hopi culture in New Mexico and the Zuni culture in Arizona. Because the continuity of life is a central goal in these cultures, the role of women as childbearers and nurturers is highly regarded. Women own the houses and all the household possessions, and the society is matrilineal, with inheritance passing through the female line rather than the male. While men commonly play the roles in public rituals, such as that of the kachina, women's rituals are most often private. The men's role in planting and tending the crops is crucial for the continuation of the village, but it is understood that these crops come from the womb of Mother Earth, which is symbolized in the kiva, the underground structure where many rituals take place.

Many of the kachinas represented in the rituals are women, with men taking these roles and becoming the particular female spirits for the duration of the ritual. Among the female kachina spirits are the Mother of the Gods, the Goddess of Hard Substances (turquoise in particular and wealth in general), the Salt Old Woman, and the Seven Corn Maidens.

Frank Lloyd Wright, Robie House

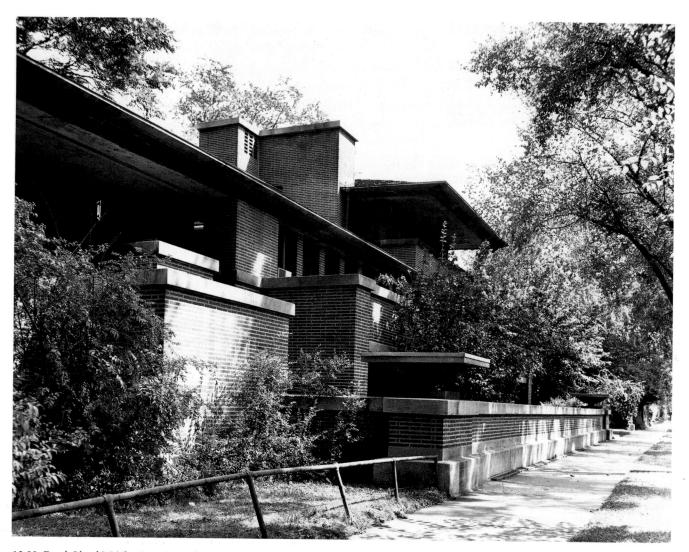

12.30 Frank Lloyd Wright, Exterior, Robie House, Chicago, 1909. Commissioned by Frederick C. Robie, a relatively young and successful manufacturer of bicycles.

Wright's Prairie-style designs, including this house, were published in Europe in 1910. They influenced later developments in modern European architecture, including de Stijl and the Bauhaus (see pp. 540–43).

right's Robie House (fig. 12.30) is distinguished by an emphatic horizontal design, with rooms and porches extending out from a central core defined by the chimney mass. The structure is so severe and modern in appearance that it is a surprise to realize that the Robie House was designed and constructed in the first decade of the twentieth century. Frank Lloyd Wright (1867–1959) worked as an assistant to Louis Sullivan from 1888 to 1893, but by 1900 Wright developed a new and personal style. In the opening years of the twentieth century, he designed a series of private homes in the Chicago area that shared distinctive compositional qualities,

including an emphasis on the horizontal features of the design. Wright's style at this time, which was inspired by the flat terrain of the American Midwest, is known as the Prairie style.

In the Prairie style, Wright developed what he termed his organic theory of architecture. The organic concept governs both the design of the structure and its relationship to the site. Projections cantilevering from the core of the house (see box, p.525) transfigure conventional distinctions between interior and exterior, while the abstract, geometric massing of the architectural forms creates a distinctly modern effect.

The interior design of the rooms continues the geometric emphasis apparent from the outside. Wright's furniture, much of which he created specifically for each house, is distinctive for its severe geometry and handcrafted elegance (fig. 12.31). It reiterates and complements his architectural forms and, in its rich use of wood and modern decorative elements, enhances the intimate scale of the rooms.

Viewing the plan, one becomes aware of another feature of Wright's organic theory (fig. 12.32). The spatial flow

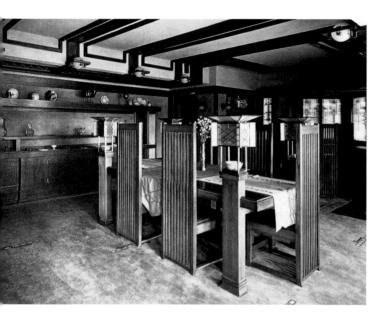

12.31 Frank Lloyd Wright, dining room, Robie House, with original furniture designed by the architect.

The patron wrote later that he selected Wright as his architect in part because he did not want his house to have "a lot of junk—a lot of fabrics, draperies, and what not, or old-fashioned roller shades with the brass fittings on the ends—in my line of vision, gathering dust and interfering with window washing. No sir..." Wright's sleekly modern furniture and his windows, with their integral, stained-glass decoration, fit the client's expectations.

from room to room, around the central core of the fireplace and stairway, is free and unobstructed. Rooms are not boxed off; instead, interior spaces merge with each other. A new continuity of interior spatial design is established.

The decorative features of the house's exterior are minimal. Instead of applying ornament, Wright utilizes the color and texture of the building materials themselves. Red brick contrasts with powerful horizontal accents in stone. The unadorned planarity of the exterior walls would become a distinguishing feature of modern architecture.

Certain aspects of Wright's organic theory are antithetical. For example, the desire to merge the house with the environment is countered by the severely geometric and planar design. Yet it is precisely this balancing of contrasting design features that distinguishes Wright's achievements.

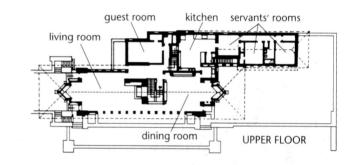

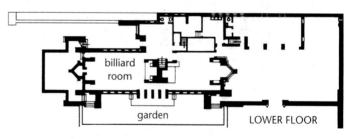

12.32 Frank Lloyd Wright, plan of Robie House.

TECHNIQUE

The Cantilever

The **cantilever**, an architectural support system utilized by Wright in both the Robie House and Fallingwater (see fig. 1.7), projects a horizontal architectural member out into space without external support. It is counterbalanced by a weight on the interior end. The materials used in the

construction of a large cantilever must possess a high tensile strength; usually steel beams and reinforced concrete are used. For this reason, the cantilever as a method of construction first reached its full expression in modern architecture.

Native American Ceremonial Art from the Northwest Coast

extiles produced by the Tlingit (fig. 12.33) have had great prestige among the natives of the Northwest Coast since at least as early as the eighteenth century, when Europeans first documented their use. The newcomers also recorded seven linguistic groups among the approximately 70,000 people living there, who otherwise shared a common environment, similar technologies, and a number of beliefs.

The abstracted representations of animals seen in such textiles refer to legends that explain how primal ancestors received special privileges from supernaturally endowed beings of the earth, sea, and sky. Each family group claims descent from a mythic animal or animal-human ancestor, from whom it derives its name and the right to use certain animals and spirits as totemic emblems or crests; these emblems appear as well on Northwest Coast house crests, poles and

other visual markers (see figs. 12.33, 12.34). Closeness to the mythic ancestor determines rank in the society; chiefs, who are in the most direct line, administer the family's spiritual and material resources, validating their position and status by holding potlatches (ritual feasts) marked by shows of lavish hospitality and extravagant gift-giving.

Traditionally, Tlingit textiles were made collectively, with men drawing the patterns and women doing the weaving. Working without looms, the weavers wove twisted colored woolen threads through warp threads hung from a rod, the ends of the warp becoming the fringe at the bottom. Designs recalled the lineage of the group and included iconography that expressed its mythic background. In the example illustrated here, the small face in the center is probably a stylized representation of a sea bear (fur seal) or an eagle. Its large eyes are repeated at the top, while below we see its legs and claws.

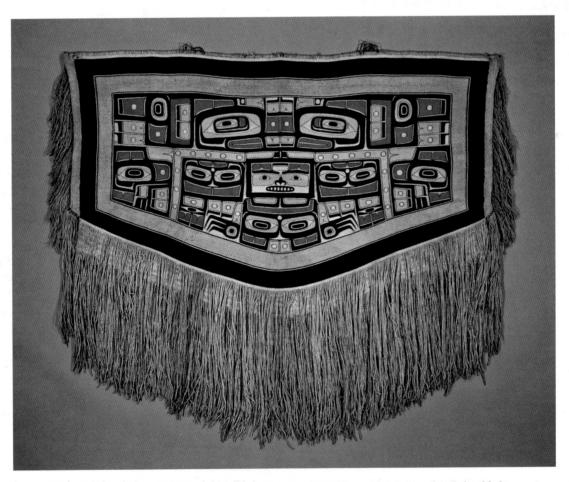

12.33 Chilkat blanket. Tlingit, Northwest Coast, Canada, before 1928. Mountain-goat wool and shredded cedar bark backing, 4' 7%" \times 5' %" (1.62 \times 1.4 m). American Museum of Natural History, New York. Commissioned by the Tlingit Community.

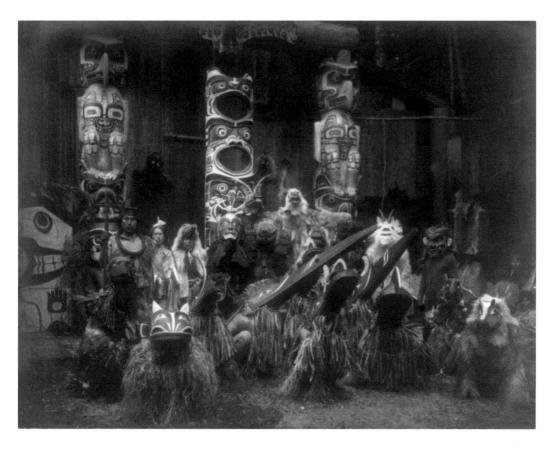

12.34 Edward S. Curtis, Hamatsa dancers, Kwakiutl, Northwest Coast, Canada, photographed 1914. Smithsonian Institution Libraries, Washington, D.C.

The people who made this and other similar items inhabit a long, narrow strip of shoreline from Puget Sound up to the Alaskan panhandle, a coastline deeply indented with fjords and rivers and studded with islands heavily forested with the dark green conifers of a temperate rain forest. From this environment they collected a rich harvest, of salmon especially, and they could support their diet without practicing agriculture. They preserved their catch by smoking, drying, and processing it for oil. During the winter months, they repaired their equipment and devoted themselves to ceremonial life. Villages were made up of large, elaborately painted wooden structures facing the water that housed extended family groups. Skilled sailors who set out to trade, hunt, fish, wage warfare, or make social visits traveled in wooden canoes decorated with animal-based designs like those woven into blankets.

The red cedar of the rain forest, with its straight, soft grain, was used for the building of houses and the production of canoes, totem poles, and house carvings, as well as boxes, masks, and other items of social and domestic life. Cedar fibers slit from the narrow rootlets and bark stripped from its green living trunk were used by the women to weave baskets, hats, blankets, and clothing.

All groups were organized according to social rank. Slaves were taken in warfare and were outside the social system, but all members of the group participated—as donors, recipients, actors, or audience—in the ceremonial life of the community. Shamans, who sometimes were chiefs, mediated between the human and spirit worlds at ceremonies aimed at spiritual renewal and maintenance of social order.

On the occasion of the Winter Ceremony (fig. 12.34) totem poles and heraldic crests in the form of masks, boxes, and apparel were displayed to mark special social ties. Dances, songs, and theatrical performances demonstrated special privileges and recounted the myths that explained how family crests, names, songs, and privileges were obtained. Guests from other tribal areas were often invited and marriage or other alliances could be made at these events. Initiation into the prestigious shamanistic Hamatsa Society took place during the Winter Ceremony, when Hamatsa, a people-eating spirit, and his three attendant bird spirits had to be tamed. Masks that transformed dancers into Hamatsa and the bird attendants allowed them to snap their beaks in a loud and daunting manner as the dance ensued. Once subdued, order was restored and the community could function harmoniously again.

Abstraction in Sculpture

he growing interest in abstraction led to many unexpected developments. In 1904, the Romanian sculptor Constantin Brancusi took up residence in Paris. Working in a variety of traditional sculptural media and often guided by a subjective synthesis of diverse traditions—from the robust simplicity of African sculpture to the economical abstraction of Romanian folk carving—Brancusi reduced representational images to elemental forms. Evolving a style based on organic abstraction, Brancusi noted:

They are imbeciles who call my work abstract; that which they call abstract is the most realist, because what is real is not the exterior form but the idea, the essence of things.

Brancusi's concern with portraying the "essence of things," an artistic philosophy that he shared with other members of the European avant-garde, led to the abstraction evident in *The Newborn* (fig. 12.35). The particulars of a baby's head and facial features have been reduced to a primordial egg form with sweeping arcs uniting the forehead with the nose and gaping mouth; the abstracted forms communicate the essence of the cry of a new life.

One of Brancusi's aphorisms was "simplicity is not an end in art, but one arrives at simplicity in spite of oneself in drawing near to the reality of things." With *Bird in Space* (fig. **12.36**), Brancusi draws us close not to the essence of a natural form, as we met earlier with *The Kiss* (see fig. 12.7), but to the essence of a dynamic sensation. The soaring verticality of the gently swelling bronze form and its mirror-

12.35 Constantin Brancusi, *The Newborn*, 1915. Marble, length 8¼" (14.6 cm). Philadelphia Museum of Art.

1911 Arnold Schönberg, Manual of Harmony

1913 D. H. Lawrence, Sons and Lovers

1913 Armory Show of Modern Art, New York

1915 Brancusi, The Newborn (fig. 12.35)

1916 John Dewey, Democracy and Education

like surface, which further denies its minimal mass, communicate a propulsive yet graceful energy. Here Brancusi distills the essence of flight. The base that supports Bird in Space both contrasts with and complements Brancusi's sculpture. It was, in fact, designed by the sculptor, who is especially notable for his understanding of the role the base plays in enhancing the effect of sculpture. In this case, the dark base provides an unobtrusive sense of stability and ballast, while in geometry and proportion the cylinders of its design are related toand yet distinct from-the shapes of the sculpture it supports.

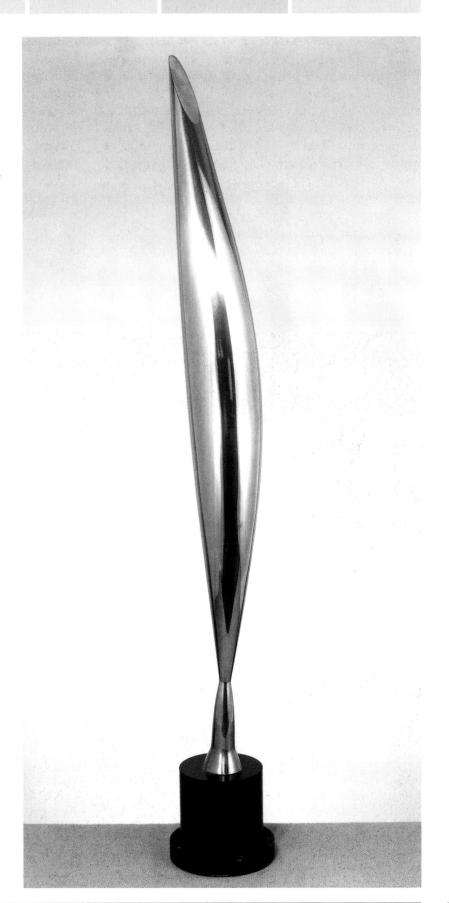

12.36 Constantin Brancusi, Bird in Space, c. 1924. Polished bronze, height 4' 25/6" (1.28 m). Philadelphia Museum of Art.

Malevich and the Russian Avant-Garde

fter its invention, the electric light bulb became a symbol of modern technological advancement. *Electric Light* (fig. 12.37), by Natalya Goncharova (1883–1962), renders an electric lamp not as a static form but as pure radiant energy. The painting pulsates with light; widening, concentric circles of intense colors emit piercing diagonal rays. And just as intense light can seem to

dematerialize its immediate surroundings, in the painting the brilliance of the light seems to float in an indeterminate space. In both concept and presentation, Goncharova's painting proclaims its modernity.

The planar fragmentation of forms seen here is derived from Analytical Cubism, while the iconographic interpretation and dynamic linearity owe a debt to Italian Futurism.

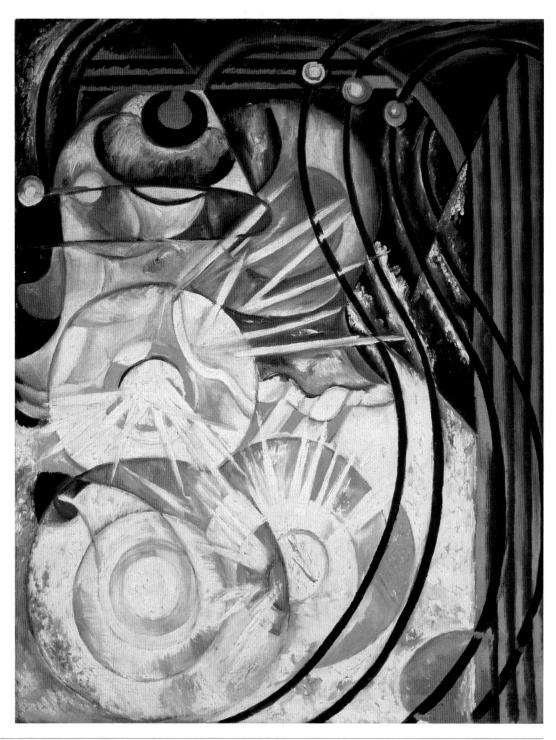

12.37 Natalya Goncharova, *Electric Light*, 1913. Oil on canvas. 3' 5½" × 2' 8" (110 × 81 cm). Musée National d'Art Moderne, Centre National d'Art et de Culture Georges Pompidou, Paris, France.

1910 Halley's comet returns

1913 Goncharova, Electric Light (fig. 12.37)

1913 Suffragists march in Washington, D.C.

1913 First multimotored aircraft

1913 Igor Stravinsky, The Rite of Spring

In the opening decades of the twentieth century, the works of avant-garde artists were known to Russian artists through periodicals, exhibitions, and private collections in Moscow and St. Petersburg. Goncharova's earlier paintings celebrated traditional Russian themes, but under the influence of Cubism and Futurism, she became one of the leaders of the avant-garde in Russia. Beginning in 1911, Goncharova and her husband, Mikhail Larionov (1881-1964), created a new artistic movement that they called Rayonism. This abstract movement, which sought to give visual expression to dynamic forces, was short-lived, but its impact was felt by other artists, including Kasimir Malevich (1878-1935).

Malevich knew and exhibited with Goncharova and Larionov. By about 1913, however, his Cubist-inspired paintings gave way to geometric abstraction in an attempt, as he would later write, "to free art from the burden of the object." The resulting series of paintings consisted of nonrepresentational compositions dominated by simple geometric shapes. One painting, Suprematist Composition: White on White (fig. 12.38), reduces the formal elements of the painting to two squares of white that are separated only by the slightest value contrast. Using geometric and coloristic purity, Malevich intended to communicate pure uncorrupted emotion. He titled this new style Suprematism, writing:

The Suprematists have deliberately given up the objective representation of their surroundings in order to reach the summit of the true "unmasked" art and from this vantage point to view life through the prism of pure artistic feeling.

(Malevich, The Non-Objective World, 1927)

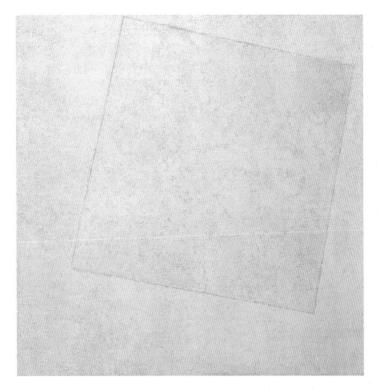

12.38 Kasimir Malevich, Suprematist Composition: White on White, 1918. Oil on canvas, $2' 7\frac{1}{4}'' \times 2' 7\frac{1}{4}''$ (79.4 × 79.4 cm). The Museum of Modern Art, New York.

German Expressionism: Die Brücke and Der Blaue Reiter

The modern light of the cities, the movement in the streets—there are my stimuli.... Observing movement excites my pulse of life, the source of creation.

For Ernst Ludwig Kirchner (1880–1938), who wrote these words, the dynamic interaction of color and movement on a city street was the paragon of modernity. In *Street, Berlin* (fig. **12.39**), arbitrary, intense colors are joined with sharply stylized figures and a distorted perspective to communicate not only the animation of urban life but also the decadence of wealthy Germans on the brink of World War I.

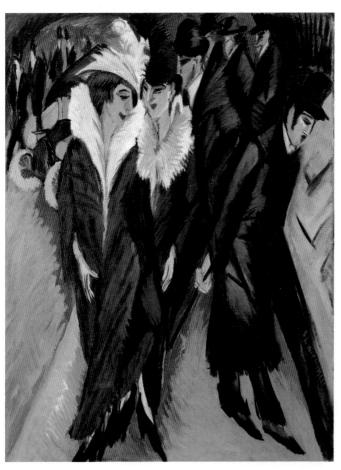

12.39 Ernst Ludwig Kirchner, *Street, Berlin*, 1913. Oil on canvas, $3' \, 11\%'' \times 2' \, 11\%'' \, (120.6 \times 91.1 \, cm)$. The Museum of Modern Art, New York.

This painting was later included in the notorious 1937 exhibition of "degenerate art" organized by Germany's Nazi government. The exhibition was meant to demonstrate that works of modern art were created by artists who were insane and deviant. The show toured Germany until 1941, and was attended by 3,200,000 viewers.

The seeds of the modern movement known as German Expressionism were planted in the late nineteenth and early twentieth centuries by van Gogh, Munch, Matisse, and the Fauves. Expressionist tendencies, such as distortion of form and intensification of color, had surfaced earlier in the history of German art in the work of artists such as Dürer and Grünewald (see figs. 8.20–23, 8.42, 8.43). In the early twentieth century, artists looked to these artistic precedents to find forms that would express the intensity of feeling thought to be part of the Northern cultural tradition.

In 1905, a group of young architectural students in Dresden formed an association that they called Künstler-Gruppe Brücke ("Artists' Group of the Bridge"). Die Brücke was based on the medieval guilds, and the artists lived and worked together as a community. The symbol of the bridge, adopted from Nietzsche's writings, indicated that they conceived their role as a transitionary force by which "revolutionary and surging elements" could bring German art to a new and fulfilling future. They turned away from academicism, looking for inspiration to the stylizations and spirituality that they found in medieval, African, and Oceanic art.

But while these artists searched for artistic sources outside of the Western Classical tradition, they also looked into themselves, probing the psychological relationship between the artist and the world. In 1917, Kirchner wrote:

... with insight into the limits of human interaction, I undertook the withdrawal of the self from itself and its dissolution within the other person's psyche for the sake of a more intense expression. The less I was physically involved, something which quickly occurred as a result of my mood, the more easily and completely I entered into and depicted my subject.

Although not directly related to Die Brücke, the graphic art of Käthe Kollwitz (see fig. 12.10) may be considered within this expressionist context.

Another group of Expressionists working in Germany in 1911 formed a group called Der Blaue Reiter ("The Blue Rider"); the title was derived from a work by Wassily Kandinsky (1866–1944) that depicted a rider and horse unified by a single value of blue. Der Blaue Reiter sought to communicate the spiritual values that lie behind the façade of appearances.

In Kandinsky's abstract watercolor (fig. 12.40), the vibrant passages of color and line that burst on the surface

do not correspond to any reality in nature; the painting can therefore be termed nonobjective.

Kandinsky had begun a career as a law professor when, in 1896, he left Russia to study painting in Germany. His education had included art and music, but the decision to become a professional artist was made in 1895, when he viewed a Moscow exhibition of Impressionist paintings. Particularly impressed by the intense color of Monet's *Haystack* paintings, Kandinsky wrote: "I had the impression that here painting itself comes into the foreground; I wondered if it would not be possible to go further in this direction." As Kandinsky traveled, he studied German Expressionism and Fauvism, and, returning to Munich in 1908, painted a series of landscapes that pulsate with color.

A chance occurrence assisted in clarifying Kandinsky's thoughts about nonobjective painting:

It was the hour of approaching dusk. I was coming home with my box of paints after sketching, still dreaming and caught up in my thoughts about the work I had done, when suddenly I found myself face to face with an indescribably beautiful picture drenched with an inner glow. At first I hesitated, then I rushed toward this mysterious picture in which I could discern no visible subject, but which appeared to be completely made up of bright patches of color. Only then did I discover the key to the puzzle. It was one of my own paintings, standing on its side against the wall.... I knew for certain now that the depiction of objects in my paintings was not only unnecessary but indeed harmful.

The realization that painting could communicate an emotional content without recognizable subject matter was a catalyst in Kandinsky's thoughts about art and the expressive values of color. These issues occupied not just his paintings but also his writings. In late 1911, Kandinsky published *Concerning the Spiritual in Art*, in which he asserted that the function of art was to release us from a "nightmare of materialism" by revealing an "internal truth" that awakens the human spirit. The key to this awakening was the "psychic effect" that colors could evoke:

Color is a power which directly influences the soul. Color is the keyboard, the eyes are the hammers, the soul is the piano with many strings. The artist is the hand which plays, touching one key or another, to cause vibrations in the soul.

In writing *Concerning the Spiritual in Art*, Kandinsky drew from many varied and rich sources, including African and Oceanic art. Expressing a kinship with non-Western artists, Kandinsky wrote: "Like ourselves, these artists sought to express in their work only internal truths, renouncing in consequence all consideration of external form." The musical innovations of Arnold Schönberg added further inspiration:

[Schönberg's] music leads us into a realm where musical experience is a matter not of the ear but of the soul alone—and from this point begins the music of the future.

Kandinsky believed that the emotional power of music could be paralleled by abstraction in painting.

12.40 Wassily Kandinsky, *First Abstract Watercolor*, c. 1913. Watercolor and ink, 1' 7¼" × 2' 1" (48.9 × 63.5 cm). Musée National d'Art Moderne, Centre National d'Art et de Culture Georges Pompidou, Paris, France.

Kandinsky identified this as his first nonobjective watercolor, dating this experiment to 1910, but later scholars have suggested that the work more probably dates to about 1913.

Fantasy

Formerly we used to represent things visible on earth, things we either liked to look at or would have liked to see. Today we reveal the reality that is behind visible things, thus expressing the belief that the visible world is merely an isolated case in relation to the universe and that there are many more other, latent realities.

(Paul Klee, 1920)

The attempt to express visually a reality that supersedes that of the objective, physical world distinguishes the early twentieth-century avant-garde movements of Fauvism, German Expressionism, and Cubism. Another approach to this challenge is found in the works of the artists of fantasy, painters who, questioning rationalist views, explored the expression of their personal, inner visions.

As its title hints, The Melancholy and Mystery of a Street, by Giorgio De Chirico (1888-1978), opens to us a world that is disturbing and possibly even forbidding (fig. 12.41). The forms are representational. The arcaded buildings, the wagon, and even the intense light are features that can be found in many Italian piazzas. In De Chirico's painting, however, stark chiaroscuro is joined with an exaggerated perspective to create an unexpectedly dramatic spatial illusion. The anxiety created by the convergence of diagonals is heightened by the iconography. The setting is void of life except for a young girl, who innocently plays with a hoop. Her path will take her into the menacing emptiness of the piazza, where the shadow of a large statue falls, almost threateningly, across her path. De Chirico's manipulation of representational forms opens the world of the subconscious

12.41 Giorgio De Chirico, The Melancholy and Mystery of a Street, 1914. Oil on canvas, 2' 10¼" × 2' 4½" (87 × 72.4 cm). Private collection.

12.42 Paul Klee, *Ad Parnassum*, 1932. Oil on canvas, 3' 3" × 3' 6" (99 × 107 cm). Kunstmuseum, Bern, Switzerland.

Klee's wife was a piano teacher, and the title of this work may derive from *Gradus ad Parnassum* (Steps to Parnassus), a series of piano exercises based on scales for the beginning piano pupil.

and the frightening exaggeration we often sense in dreams. De Chirico considered his paintings to be metaphysical—that is, they offered encounters with mysterious truths beyond our understanding.

In 1912, De Chirico expressed in words the process of his creative invention. He wrote:

I believe that as from a certain point of view the sight of someone in a dream is a proof of his metaphysical reality, so, from the same point of view, the revelation of a work of art is the proof of the metaphysical reality of certain chance occurrences that we sometimes experience in the way and manner that *something* appears to us and provokes in us the image of a work of art, an image, which in our souls awakens surprise—sometimes, meditation—often, and always, the joy of creation.

The juxtaposition of dissociated objects in De Chirico is intended to beckon the unconscious within us.

The Swiss artist Paul Klee (1879–1940) usually worked on a small scale, but *Ad Parnassum* is one of his larger and most ambitious works (fig. 12.42). Klee set out to discover elemental symbols: here the pyramid suggests not only the mysteries of ancient Egypt but also, because of the title,

Mount Parnassus near Delphi, which was sacred to the ancient Greeks as the home of the Muses, who inspired creative activities. The red circle that suggests the sun may refer to the role of the sun in world religions, as well as to the concept of gradual enlightenment. The division of the surface into tiny squares of pure color creates a precious and beautiful effect that evokes the shimmering nature of light as it illuminates a form. From a multitude of smaller forms, monumental constructions can be created; from stone blocks come pyramids; from musical scales, symphonies. But ultimately the full expressive content of Klee's work becomes a matter of individual perception and understanding. Klee believed that spiritual states have visual equivalents, and as so often in his work, the few simple forms of *Ad Parnassum* suggest deep and elemental mysteries.

Like Henri Rousseau, whose naïvely direct yet purposeful paintings were championed by young avant-garde artists in Paris (see fig. 11.10), these painters of fantasy often did not view themselves as depicting the bizarre or fanciful. They equated reality with an inner vision. In the visual communication of this "interior world," these artists opened a path of artistic exploration that would lead to Dada (see pp. 536–39) and Surrealism (see pp. 548–51).

Dada

arcel Duchamp was an artist of unprecedented and unsettling works that still seem shocking to us today, although some were done more than ninety years ago (fig. 12.43). On the pedestals in the gallery, where we expect to find sculpture, Duchamp has placed a manufactured Bottle Rack, a common object used at the time for drying bottles. In 1914, Duchamp felt that he could confer an artistic dignity on a bottle rack by designating it a work of art. Another pedestal supports an upended porcelain urinal, officially titled Fountain. Duchamp signed the urinal "R. Mutt," a pun on the name of the company that manufactured it, the Mott Works Company. On the wall behind is a reproduction of Leonardo's Mona Lisa (see fig. 8.18), which Duchamp defaced by adding a mustache, goatee, and, at the bottom, the letters L.H.O.O.Q., which suggest the French phrase for "She has a hot ass." If all of this seems absurd to you-and it certainly did to critics and the public in the early twentieth century—then you are beginning to understand the function of these objects as works of art. Duchamp, a Parisian avant-garde artist who came to New York in 1915, asserted that "found objects" or "ready-mades" could be works of art. His intention was to counter the traditional conventions of form and content by dissolving the aesthetic presuppositions of the viewer. Looking back at his ready-mades, Duchamp later commented:

A point which I very much want to establish is that the choice of these "ready-mades" was never dictated by aesthetic delectation. This choice was based on a reaction of visual indifference with at the same time a total absence of good or bad taste ... in fact a complete anaesthesia. Another aspect of the "ready-made" is its lack of uniqueness.

Although they were mass-produced objects intended for a functional use, Duchamp felt that by his saying they were art and by exhibiting them in the art context, ready-mades were transformed into art.

Duchamp never officially declared himself a Dadaist, but his works from 1913 onward, especially the "readymades," are akin to those produced by Dada artists. As an artistic, musical, and literary movement, Dada was officially consecrated in 1916 at the Cabaret Voltaire in Zurich. Dada bred confusion on purpose. Even the origin of its name remains a matter of uncertainty: two of Dada's founders—writers Richard Huelsenbeck and Hugo Ball—state that the word, which is French for "hobbyhorse," was discovered by chance in a German—French dictionary, but another founder—the German painter Hans Richter—holds that it was simply the Slavonic word for "yes," and that *da*, *da* meant only "yes, yes."

12.43 Marcel Duchamp, *Bottle Rack, Fountain*, and other works; reproductions of works originally created between 1914 and 1919. Installation, Moderna Museet, Stockholm, Sweden.

12.44 Kurt Schwitters, *Merzbild*, 1920. Mixed media collage, 41 × 31" (104.5 × 79 cm). Kunstmuseum, Dusseldorf, Germany.

Merz was a word invented by Schwitters to designate a "mode of artistic creation."

Derived, by chance, from the word Kommerz, meaning commerce, Schwitters, in 1921, wrote: "The word 'Merz' had no meaning when I formed it. Now it has the meaning which I gave it. The meaning of the concept 'Merz' changes with the change in the insight of those who continue to work with it. Merz stands for freedom from all fetters, for the sake of artistic creation. Freedom is not lack of restraint, but the product of strict artistic discipline. Merz also means tolerance towards any artistically motivated limitation."

Other theories as to the origin of the term have been advanced, but what defined Dada was a nihilistic mocking of traditional values in the arts and, by extension, Western society as a whole. This artistic anarchy grew from a profound psychological rebellion. Dada glorified the irrational.

In Germany, Dadaist nihilism was connected to a political stance that embraced the ideals of Communism while ridiculing both German militarism and Western capitalism. Kurt Schwitters' trash pictures (fig. **12.44**) owe some allegiance to Synthetic Cubism (see p. 517), but the collage elements include materials literally retrieved from the gutter. Here, content confronts form, as the discarded waste of society is used to compose a work of art.

Schwitters' indictment of traditionalism in art and society is found in this total lack of reverence toward artistic media. In 1921, he wrote:

The medium is as unimportant as I myself. Because the medium is unimportant, I take any material whatsover if the picture demands it.... I have taken a step in advance of mere oil painting.... I play off material against material.... The reproduction of natural elements is not essential to a work of art.

Hannah Höch, working in Berlin, introduced a vast array of photographic images to her collages. The prominent ballbearing and gear photos in *Cut with the Kitchen Knife* (fig. **12.45**) bring to our attention, within the purposeful yet seemingly nonsensical context of Dada, an early twentieth-century perspective on the complex interrelationships between machines and humans. Addressing this issue, Höch stated:

Our whole purpose was to integrate objects from the world of machines and industry in the world of art... to bring together elements borrowed from books, newspapers, posters or leaflets in arrangements that no machine could yet compose.

In yet another way of exploring the irrational in art, Swiss artist Jean Arp (1887–1966), created collages by dropping torn pieces of paper randomly onto a paper surface and then gluing them into place (fig. 12.46). These works were composed according to chance. In the words of Arp:

Dada aimed to destroy the reasonable deceptions of man and recover the natural and unreasonable order. Dada wanted to replace the logical nonsense of men of today by the illogically senseless. That is why we pounded with all our might on the big drum of Dada and trumpeted the praises of unreason. Dada is senseless like nature.

12.45 Hannah Höch, *Cut with the Kitchen Knife*, 1919. Collage of pasted papers, 3' 8%" × 2' 11½" (115 × 90.17 cm). Nationalgalerie, Staatliche Museen, Berlin, Germany.

12.46 Jean (Hans) Arp, Collage Arranged According to the Laws of Chance, 1916–17. Torn and pasted paper, 1' 7" × 1' 1½" (48.5 × 34.6 cm). The Museum of Modern Art, New York.

The senselessness and nihilism of Dada, however absurd, were born from an even greater absurdity, World War I. Dada was an art of social protest, a protest against the senseless slaughter and destruction of life and meaning that, at the time, was continuing without an end in sight. Jean Arp said: "We searched for an elementary art that would, we thought, save mankind from the furious madness of these times." In this profound search, however, Duchamp's ready-mades and works by Dada artists exulted in a liberation of form, content, and artistic processes. In later decades, the ascendance of the idea as art, so nurtured

by Duchamp, would reach a fruition in Conceptual Art (see pp. 576–77), while the innovations of artists at midcentury, such as Joseph Cornell (see fig. 12.74) and Robert Rauschenberg (see fig. 13.7) were firmly rooted in the Dada experience. Duchamp himself understood this. Viewing the art world of the 1960s, he wrote:

This Neo-Dada, which they call new Realism, Pop Art, assemblage etc., is an easy way out and lives on what Dada did. When I discovered ready-mades I thought to discourage aesthetics. In Neo-Dada they have taken my ready-mades and found aesthetic beauty in them.

De Stijl and the Bauhaus

Chröder House, designed by Gerrit Rietveld (1888–1964), is without historical reference. Its simplicity and severity of form make it seem new even today: it offers a timeless modernity (figs. 12-47–12.49). At the same time, it is neither simple nor simplistic. The contrasts between wall and opening, solid and void, horizontal and vertical, and aggressive and recessive forms establish complex interrelationships, and the composition, which is determinedly asymmetric in both two and three dimensions, is enhanced by the precision with which the forms are defined. On both exterior and interior, openness integrates the forms of the house with the surrounding space. The Schröder House is a powerful and convincing example of the "equilibrium of equivalent relationships" that was one of the aesthetic goals of the de Stijl movement.

De Stijl ("The Style") was founded in 1917 in Amsterdam by several Dutch artists who felt a mission to carry abstraction to what they termed "its ultimate goal." The group was motivated in part by the tragic events of World War I and was inspired by such modern philosophical movements as Theosophical Mysticism and Neopositivism. Their utopian aspirations are revealed in the name, which suggests that this is the ultimate style, the perfect style that, mass-produced, could satisfy all humanity for the rest of the world's history. This search to find a visual equivalent for spiritual and philosophical purity led to the development of a completely new and abstract style in architecture, painting, sculpture, and the decorative arts. Their motivation was ethical, for they felt that a perfectly balanced and serene art could carry the qualities of harmony and purity into the very soul and being of the viewer. Their ultimate goal was to bring about world understanding, unity, and peace. They avoided individualism and subjectivity, arguing that these concepts had led the world into war:

The old tends to the individual. The new tends to the universal. The struggle between the individual and the universal is revealed in both the world war and contemporary art.

12.47 Gerrit Rietveld, Schröder House, Utrecht, The Netherlands, 1923–24.

One of many radical aspects of this house is the placement of a large, flexible living space with moving and removable partitions on the upper floor; Rietveld, sensitive to the conservative attitudes of the local authorities, labeled the upper floor as the attic when he submitted his plans for their permission. The patron was Truus Schröder-Schräder, a widowed interior designer with three children who wanted a functional, easy-to-maintain house. Her studio was located on the lower floor, as was the kitchen. She took an active part in the planning of the house.

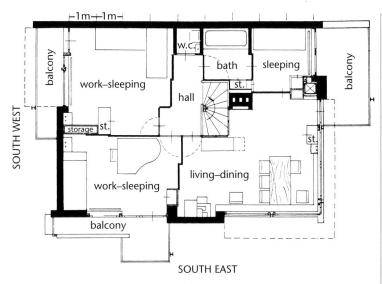

12.48 Gerrit Rietveld, Plan of Schröder House, upper floor.

12.49 (below) Gerrit Rietveld, Interior, Schröder House, upper floor.

Visible in this interior view are the movable sliding walls and some of the built-in furniture that Rietveld designed for the Schröder House. The goal was a completely unified formal and aesthetic expression—what the De Stijl Manifesto called a structural affinity between object and environment. Also visible here is his famous "red and blue" chair, designed about 1918. The forms of the chair are completely geometric: only the need to make some concession to the requirements of the human body explains the two diagonal forms. A durable formal solution, the chair was designed to be mass-produced at a reasonable price for mass consumption. The colors are carefully controlled, with the structure composed of black bars with yellow ends, and the seat and back given over to one blue and one red plane. The restriction to primary colors is typical of the de Stijl philosophy.

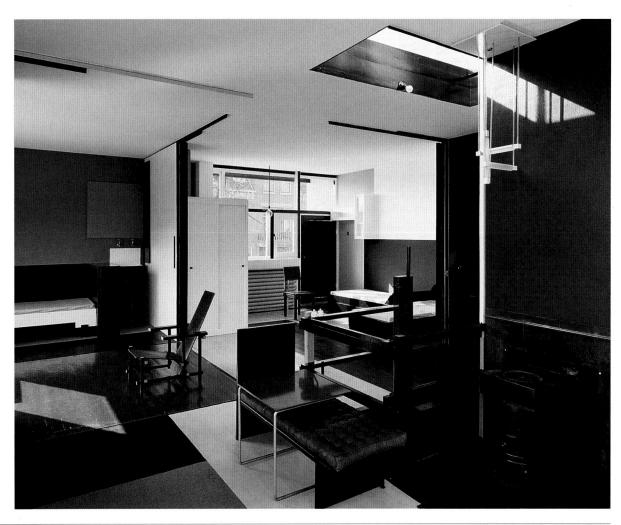

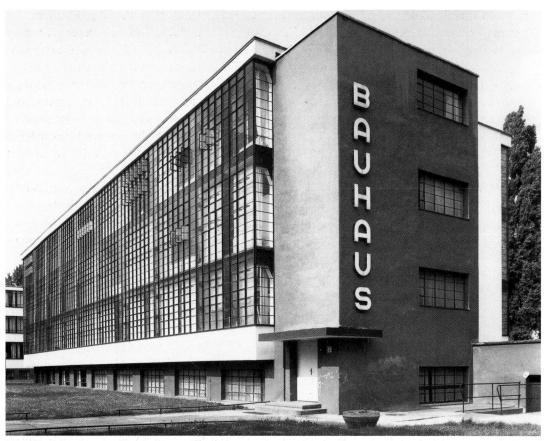

12.50 Walter Gropius, Workshop wing, Bauhaus, Dessau, Germany, 1925–26.

The Bauhaus was an influential modern school of architecture and design.

They wanted to create an art that was universal and comprehensible to all humanity, regardless of nationality or creed. "Man adheres only to what is universal," wrote Piet Mondrian, one of the movement's founders, in 1919.

These profound goals reached fulfillment in a series of works produced by Mondrian between the two world wars (see fig. 1.19). In these abstractions, which are characterized by a studied balance between forms and colors, Mondrian hoped to accomplish, in his words, an "equilibrium of opposites." The universality of this goal, with its search for worldwide peace, is related to the philosophical statements made by other modern thinkers and artists, as well as to the contemporary founding of the World Court and the League of Nations, which led eventually to the establishment of the first worldwide governmental body, the United Nations, after World War II.

Walter Gropius's philosophy on the unity of the arts guided his design for the new home for the Bauhaus at Dessau (figs. 12.50, 12.51). The structure at Dessau exemplified the modernist aesthetic. A complex of classrooms, library, and offices is externally unified by planes of reinforced concrete walls and vast expanses of windows. A rectilinear design, with verticals and horizontals meeting at right angles, governs the plan and determines the exterior articulation. The plain, unornamented surfaces used throughout

the building contribute to its modern, clean appearance. The interior design of the classrooms and even the desks and chairs respond to the design aesthetic that governs the entire structure. Gropius's own office had furniture of his design and a rug, wall hanging, and lighting created in the Bauhaus workshops. The student dormitory room illustrated here

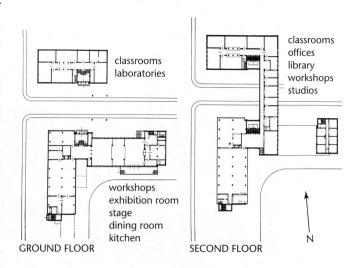

12.51 Walter Gropius, plan of Bauhaus.

reveals how strictly the Bauhaus aesthetic could govern an environment (fig. 12.52). This is what Gropius meant by the "complete building" when, in 1919, he wrote:

The ultimate aim of all visual arts is the complete building! ... Today the arts exist in isolation, from which they can be rescued only through the conscious, co-operative effort of all craftsmen.... Architects, sculptors, painters, we must all return to the crafts! For art is not a "profession." There is no essential difference between the artist and the craftsman.

Gropius, a German architect and industrial designer, had played a leading role in founding the Bauhaus in 1919 at Weimar. The name Bauhaus, chosen by Gropius, is derived from the Bauhütte, the medieval German builders' lodge, which housed the masters and craftspeople who built the great cathedrals of the late Middle Ages. The recent Arts and Crafts Movement and Art Nouveau's unity of design had reinforced Gropius's belief in the total integration of the arts. Unlike those late nineteenth-century movements, however, the Bauhaus philosophy of design was guided by the technology and materials of industrial production.

The design of the building at Dessau, where the Bauhaus relocated in 1924, was itself inspired by the rectilinear massing of Frank Lloyd Wright's Prairie-style designs (see pp. 524-25) and by the geometric planarity of de Stijl architecture. The resulting building, with its clean, precise, and almost mechanistically tuned appearance, does not display a regional or national identity. The Bauhaus style has reduced the essence of design to a visual common denominator. It promised, with the assistance of modern technology, a future in which a total design aesthetic would not be restricted by cultural or national boundaries. Reacting to the horror of World War I, the Bauhaus offered a utopian vision where art and architecture would assist in the realization of our common human heritage.

In 1933, Adolf Hitler, then chancellor of Germany, manifesting the intolerance that totalitarian regimes commonly share toward the avant-garde, ordered the Bauhaus closed. Like apostles to foreign lands, those who had worked at the Bauhaus carried its philosophy throughout Europe and to the United States.

12.52 Walter Gropius, student dormitory room, Bauhaus.

Diego Rivera and Mexican Mural Painting

Only the work of art itself can raise the standard of taste. Art has always been employed by the different social classes who hold the balance of power as one instrument of domination—hence, as a political instrument. One can analyze epoch after epoch—from the stone age to our own day—and see that there is no form of art which does not also play an essential political role.... What is it then that we really need? An art extremely pure, precise, profoundly human, and clarified as to its purpose.

(Diego Rivera, 1929)

These mural paintings by Diego Rivera (1886–1957) are on the third floor of an open courtyard in the Ministry of Education building in Mexico City (figs. 12.53, 12.54). They are but two of 124 murals that the artist painted during the 1920s. The scenes offer a didactic contrast between the rich—who gloat, connive, and debauch to excess—and the poor—who slumber after a hard day's work or study together by lamplight. In the left background of *Night of the Poor*, the Marxist content of the mural is reinforced as bourgeois onlookers disdainfully watch; in *Night of the*

12.53 Diego Rivera, *Night of the Rich*, 1927–28. Fresco, Ministry of Education, Mexico City. Commissioned by José Vasconcelos and Puig Casauranc, ministers of public education.

12.54 Diego Rivera, Night of the Poor, 1927-28. Fresco, Ministry of Education, Mexico City.

These frescoes are from the final cycle of paintings, begun by Rivera in 1927, for the Ministry of Education. The images in this cycle are loosely related to the words of two revolutionary songs (corridos), which appear on the painted festoons. In part, one of the corridos reads: "The clock strikes one, two, and the rich keep awake thinking what to do with their money so that it keeps multiplying. It's only seven o'clock at night and the poor have gone to rest. They sleep very peacefully because they are tired. Blessed the tree that yields fruit, but very ripe fruit. Yes, gentlemen, it is worth more than all the hard dollars."

12.55 José Clemente Orozco, *Modern Human Sacrifice*, one of 24 panels from *The Epic of American Civilization*, 1932-34. Fresco, figures are over lifesize. Baker Library, Dartmouth College, Hanover, New Hampshire.

Rich, revolutionary soldiers observe the decadent behavior of the wealthy ruling class.

These scenes, and indeed the entire cycle of paintings, are unyielding expressions of class struggle. They communicate the purposes and promises of the Mexican Revolution, which began in 1910 with a dramatic demand for economic and social reform. A decade of internal civil strife and bloodshed followed, and only during the 1920s and 1930s would some of the aims of the revolution be realized. Rivera's paintings propagandize the causes and goals of the continuing revolution.

The message of Rivera's murals is direct and immediately comprehensible, for here the artist has avoided modernist abstraction in favor of an easily understood representational form and content. Rivera, who had traveled in Europe, returned home in 1921 to join with other Mexican artists in creating a forceful style that, while borrowing elements from Expressionism and Cubism, was also rooted in bold, severe forms from Central and South American native art. In the hands of the Mexican muralists, art became a vehicle to promote social awareness; in Rivera's words:

Mural painting must help in man's struggle to become a human being, and for that purpose it must live wherever it can; no place is bad for it, so long as it is permitted to fulfill its primary functions of nutrition and enlightenment. Several other Mexican artists followed Rivera's lead in using large public projects to convey didactic messages. José Clemente Orozco (1883–1949), for example, painted a series of 24 panels called *The Epic of American Civilization* (fig. **12.55**) for the Library at Dartmouth College while he was a visiting lecturer there teaching fresco painting. This sweeping historical series depicts Orozco's version of history in the Americas from the Aztecs to the arrival of the modern era. *Modern Human Sacrifice*, shown here, parallels an earlier panel, *Ancient Human Sacrifice*, that shows the cruel practices of the Aztecs. In the later panel, trumpets blare and a flag waves while a pompous speaker hypocritically praises the Unknown Soldier, who has died for nationalistic purposes.

The Dream of Malinche (fig. 12.56) by Antonio Ruiz (1897–1964) was shown in the Mexican International Surrealist Exhibition of 1940. Malinche was a native woman who became a guide to the invading Cortés and then his mistress. In Ruiz's painting, her sleeping body becomes a Mexican landscape decorated with Europeanstyle structures, including a Catholic church at the summit. The artist seems to be suggesting that while Malinche may be the foundation for the colonization of her country, she could still awaken and cast off its impositions. During the first half of the twentieth century, the conflict between colonization and indigenous tradition was a continuing

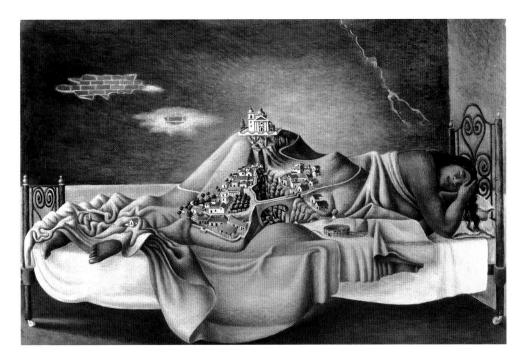

12.56 Antonio Ruiz, The Dream of Malinche, 1939. Oil on wood, 11% \times 15¼" (29.5 \times 40 cm). Collection Mariana Perez Amor.

source of debate and a frequent inspiration for artists (see Frida Kahlo's self-portrait, fig. 12.11).

Mosaics designed by the Mexican artist Juan O'Gorman (1905–82) cover all four sides of the book stack area of the Central Library at Mexico University in Mexico City (fig. 12.57); O'Gorman, who was also trained as an architect, designed both building and mosaics. Rather than telling a story, O'Gorman's mosaic combines large-scale compositional motifs, like the two circles, with an almost infinite number of figures and other details that refer to the history of Mexico. While the theme of this particular façade is the Colonial Past (note the Christian church in the lower center), many of the design motifs are derived from Mexican art made before the arrival of Columbus and Christianity. Without simplifying his subject, O'Gorman uses the library to inspire the university's students to confront their complex heritage. These few examples only begin to suggest how twentieth-century political and social idealism was expressed in the Mexican muralist tradition.

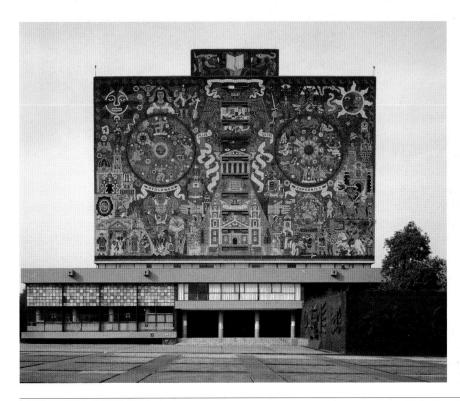

12.57 Juan O'Gorman, The History of Mexico, 1952. Native stone mosaic, 90 × 146' (27.3 × 46.6 m). Central Library, Mexico University, Mexico City, Mexico.

Surrealism

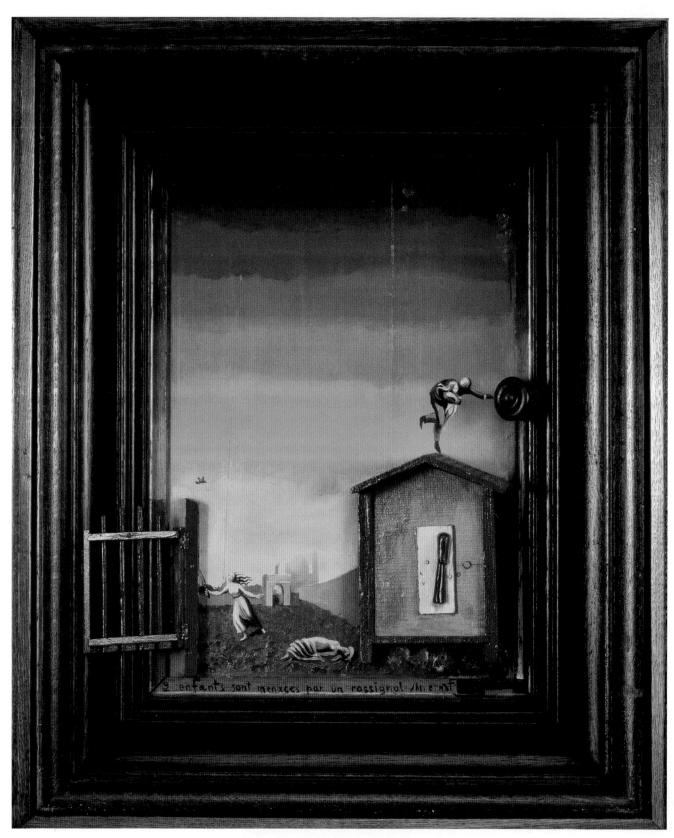

12.58 Max Ernst, *Two Children Are Threatened by a Nightingale*, 1924. Oil on wood, with wood construction; $2' 3\frac{1}{2} \times 1' 10\frac{1}{2} \times 4\frac{1}{2}$ (69.8 × 57.1 × 11.4 cm). Museum of Modern Art, New York.

1924 Ernst, Two Children Are Threatened by a Nightingale (fig. 12.58) **1924** First use of insecticides

1924 First Winter Olympic Games 1925 Scopes trial and evolution debate 1927 Charles Lindbergh is first person to fly the Atlantic alone

ax Ernst's (1891–1976) nightmarish work, *Two Children Are Threatened by a Nightingale* (fig. 12.58), combines two artistic tendencies to create a third, a tendency we call Surrealism. The combination of the little gate, the wooden house, and the pull knob with the redoubling of the picture frame resembles the constructivism of Dada (see pp. 536–39), while the painted perspective and barren architectural landscape recall the metaphysical paintings of the artist Giorgio De Chirico (see fig. 12.41). The scene, along with its inscribed title, is a bizarre juxtaposition of elements. A nightingale is hardly a menacing bird, yet here it elicits hallucinatory fear and horror. This revelation of anxiety and contradiction, of displacement and random association, represents a path of exploration of the subconscious—the path of Surrealism.

In 1936, Ernst recalled the process by which the vision and juxtaposition of representational objects led to an awakening of the artist's subconscious:

One rainy day, in 1919 ... I was struck by the obsession which held under my gaze the pages of an illustrated catalogue showing objects designed for anthropologic, microscopic, psychologic, mineralogic, and paleontologic demonstration. There I found brought together elements of figuration so remote that the sheer absurdity of that collection provoked a sudden intensification of the visionary faculties in me and brought forth an illusive succession of contradictory images ... piling up on each other with the persistence and rapidity which are peculiar to love memories and visions of half-sleep.... It was enough at that time to embellish these catalogue pages, in painting or drawing, and thereby in gently reproducing only that which saw itself in me ... thus I obtained a faithful fixed image of my hallucination and transformed into revealing dramas my most secret desires....

In the hallucinatory world of Salvador Dalí's *The Persistence of Memory* (fig. **12.59**), watches—sturdy, metallic

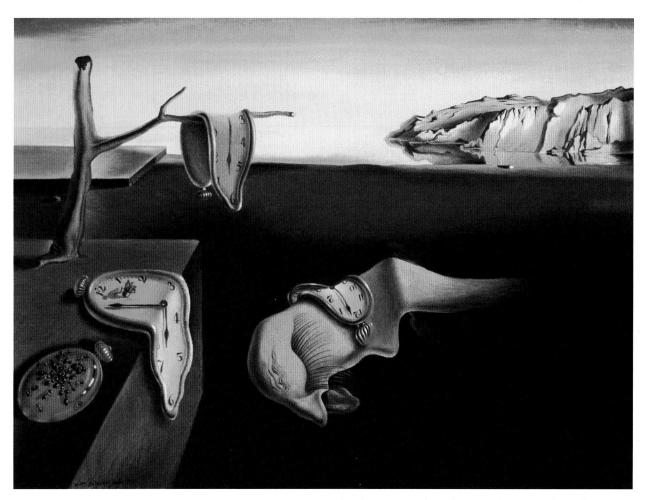

12.59 Salvador Dalí, *The Persistence of Memory*, 1931. Oil on canvas, $9\%" \times 1' 1" (24 \times 33 \text{ cm})$. The Museum of Modern Art, New York.

timekeepers—grow limp and decay like organic refuse; one attracts a fly; ants converge on another. One watch has melted over a biomorphic form that bears a fantastically conceived profile portrait of the artist. A smooth, satiny beach gives onto a limitless expanse of mirror-smooth water abutted by cliffs. Within this landscape of stillness, the limp watches suggest the inevitable decay of the passing of time.

This painting, by Dalí (1904–89), succeeds in conveying its subconscious, dreamlike vision by the uncanny juxtaposition and fantastic manipulation of representational objects. Dalí's fantasy seems frighteningly oppressive in part because its combination of unexpected elements eludes any obvious interpretation.

Surrealism, a literary and artistic avant-garde movement that began in Europe in the early 1920s, was inexorably bound with the psychoanalytic theories of Sigmund Freud; we know, for example, that Dalí read Freud's writ-

ings while he was still a student in Madrid. André Breton, the French writer who authored the first *Surrealist Manifesto* in 1924, acknowledged Freud's revolutionary discoveries when, in defining *Surrealism*, he wrote:

SURREALISM, n. Pure psychic automatism, by which it is intended to express verbally, in writing, or by any other means the real process of thought. Thought's dictation, in the absence of all control exercised by the reason and outside all aesthetic or moral preoccupations.

The Surrealist translation of the unconscious into visual form was realized in the figurative works of Dalí and René Magritte, where representational or fantastically conceived forms are juxtaposed within a spatial illusion.

The abstraction of *Battle of Fishes* (fig. **12.60**), by André Masson (1896–1987), is the result of automatism, a concept related to Freud's use of "free association" to divulge the

12.60 André Masson, *Battle of Fishes*, 1927. Sand, gesso, oil, pencil, and charcoal on canvas, $1' 2''' \times 2' 4''' (36.2 \times 73 \text{ cm})$. The Museum of Modern Art, New York.

subconscious. Breton used the word "automatism" in his definition of Surrealism, and in describing the process for writing an automatist Surrealist composition, Breton suggested that you should "write quickly without any previously chosen subject, quickly enough not to dwell on, and not to be tempted to read over, what you have written." This process of "automatic" writing was viewed as a revelation of the subconscious. In art, lines or colors were quickly set down on a surface, without reference to a preconceived theme. The conscious mind would then associate these nonobjective marks with objective forms. In Masson's work, the ferocious battle among fishes that has evolved exhibits his intense anxieties about the brutality of nature, feelings that were born of the physical and mental wounds he received in World War I.

One of the guiding concepts of Surrealism, central to the works we have discussed, is displacement. Here, displacement means a disorientation, which often is achieved by a shocking juxtaposition of elements. Such a juxtaposition awakens new psychological associations for us, associations that may feed from the subconscious. Meret Oppenheim's *Object (Le Déjeuner en Fourrure)* (fig. **12.61**), first displayed with an exhibition of Surrealist objects in 1936 in Paris, exemplifies this concept. Our tactile associations of the texture and purpose of these objects are jarred by sensations evoked by the fur coverings. In Oppenheim's sculpture, our sense of displacement is derived simultaneously from the recognition of these objects, their altered state, and anthropomorphic associations.

Like Dada, Surrealism opened new avenues of creative investigation for artists. In the late 1940s, the impact of this movement was keenly felt by a group of American artists who brought a new identity to the avant-garde (see pp. 566–68).

12.61 Meret Oppenheim, *Object (Le Déjeuner en Fourrure)* [Luncheon in Fur], 1936. Fur-covered cup, saucer, and spoon; diameter of cup 4¾" (10.9 cm). Museum of Modern Art, New York.

Modernism in American Painting

Among the rain and lights I saw the figure 5 in gold on a red fire truck moving tense unheeded to gong clangs siren howls and wheels rumbling through the dark city.

(William Carlos Williams, "The Great Figure," 1921)

Charles Demuth (1883–1935), inspired by this poem by the distinguished American poet William Carlos Williams, intended this painting as a modern portrait of the poet; "W.C.W.," "Carlos," and the nickname "Bill" appear in the painting (fig. 12.62). This is one of Demuth's "poster portraits," a series inspired by the stark forms and lettering of advertising billboards. The vibrant "5" is repeated, just as the accompanying "gong clangs" and "siren howls" would have echoed off the hard surfaces of the city streets. The blocky red forms refer to the fire truck; the white circles suggest the streetlights; and the pulsating forms of the composition as a whole suggest the jerky rhythm of the poem. The style, with its sharp edges and flat, unmodeled forms, developed in the 1920s in the United States

In the first four decades of the twentieth century, the influence of modern European art played a significant role in the development of modernism in the United States, aided by exhibitions organized by Alfred Stieglitz at Gallery 291 (see pp. 512-13). At the same time, however, the Americans maintained an independent stance and were less willing to give up subject matter than were their European counterparts. Instead, they searched for contemporary American subjects and evolved styles adapted from one or more twentieth-century European styles. Until 1940, American modernism was conservative by European standards, especially when compared with the avant-garde movements of Dada and Surrealism.

and is known as Precisionism.

Precisionist style is evident in *American Landscape* (fig. **12.63**), by Charles Sheeler (1883–1965), but here the tradition of illusionism continues to dominate. The precise linear rendering of the machinery and the industrial buildings is more than a stylistic

12.62 Charles Demuth, *I Saw the Figure 5 in Gold*, 1928. Oil on composition board, $3' \times 2' 5'$ (91.4 × 75.6 cm). The Metropolitan Museum of Art, New York.

device, for it also suggests the role of efficiency in successful industry. Only smoke, sky, and water—now channeled to serve an industrial function—show transient movement. In the nineteenth century, the quintessential American land-scape had been a wilderness scene that resonated with the painter's wonder before sublime nature (see fig. 11.34). Following World War I, the machine and industry emerged as heroes. The satisfying nature of Sheeler's composition lies in his carefully calibrated composition, which reveals his idea "that pictures realistically conceived might have an underlying abstract structure."

A similarly precise treatment of forms is evident in the well-known and much-caricatured *American Gothic* (fig. 12.64) by Grant Wood (1892–1942). Wood grew up in the American Midwest, and his intent in the painting was to capture the qualities of hard work and determination that he saw in his family and in many of the citizens of the small towns of Iowa. Wood intended that his figures, whom he identified as a man and his daughter (note the family

12.63 Charles Sheeler, American Landscape, 1930. Oil on canvas, 2' × 2' 7" (61 × 78.8 cm). The Museum of Modern Art, New York.

While a young art student, Sheeler also worked as an architectural photographer, and this industrial landscape was painted after he was commissioned to document in photographs the Ford Company's River Rouge plant. Sheeler wrote: "Photography is nature seen from the eyes outward, painting from the eyes inward.... Photography records inalterably the single image, while painting records a plurality of images willfully directed by the artist."

resemblance and the difference in ages), suggest how the values of the pioneers were being perpetuated into the modern period by later generations. When the painting was exhibited in 1930, it became clear that it could mean different things to different people; while one critic suggested that the painting "has a touch of humor and a heart of gold," another said that it revealed "what is Right and what is Wrong with America."

An art historian has recently pointed out that a sympathetic and supportive interpretation of the characters was more often found in the Midwest, while harsher interpretations came from critics outside the Midwest. In discussing the characters as he represented them, Wood himself said that he had "no intention of holding them up to ridicule"

12.64 Grant Wood, American Gothic, 1930. Oil on composition board, 30×25 " (78 × 65.3 cm). The Art Institute of Chicago.

The "Gothic" in the title refers to the Gothic Revival window in the modest Iowa farmhouse behind the figures. When American Gothic was shown at an exhibition in Chicago in 1930, it won a prize and was purchased for the museum by the Friends of American Art for \$300. It was Grant Wood's first prize and his first purchase by a museum.

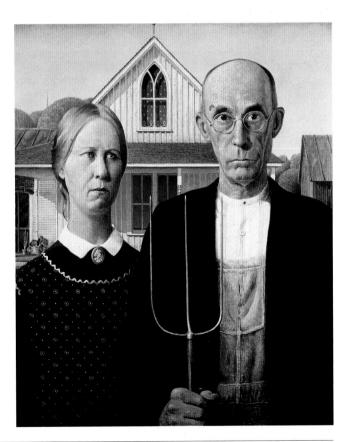

and that although "these people had bad points, to me they were basically good and solid people."

Georgia O'Keeffe's (1887–1986) The Lawrence Tree (fig. 12.65) forces us to take an unusual viewpoint—looking directly up—on a starry evening in the American Southwest. O'Keeffe abstracts from nature, using limited colors and forms that are rendered with almost no modeling. In the subtle organic shape of the tree, she suggests not only its growth patterns but also its arching expansiveness. The poetic, evocative position we assume emphasizes the scope and scale of nature in an almost pantheistic fashion. The appreciation for the majesty of nature that so moved American nineteenth-century artists found a worthy modern successor in O'Keeffe.

The art of Thomas Hart Benton (1889–1975) is a product of Regionalism, an antimodern movement that flourished in the American Midwest in the late 1920s and early 1930s. Regionalist American artists painted local subject matter in a simple, realistic, and comprehensible style. Such an art is determinedly chauvinistic and can perhaps be related to a need during the Great Depression for a reassurance that finds comfort in nostalgia. Benton's large, didactic murals exalted the history and folklore of a specific region: among his ambitious programs is a wall dedicated to Pioneer Days and Early Settlers (fig. 12.66) in the Missouri State Capitol. The wall is divided by painted geometric bands that establish an active compositional pattern. The figures, drawn in Benton's unique and energetic style, reenact local history and legend. The heroism of work, conveyed by the figures to the right—these were inspired by the nudes of Michelangelo (see fig. 8.31)—is a common theme in Benton's art. Such paintings were more than imaginative re-creations of America's past; they were intended to offer criticism, as well as models and inspiration for the future. Benton himself denied the significance of modern art for his work, stating: "I wallowed in every cockeyed 'ism' that came along, and it took me ten years to get all that modernist dirt out of my system."

In summarizing his work, he wrote: "I have a sort of inner conviction that ... I have come to something that is in the image of America and the American people of my time."

The *Toussaint L'Ouverture Series*, by Jacob Lawrence (1917–2000), joined historical research with personal memories of history lectures that the artist had heard during his youth in Harlem (fig. 12.67). Lawrence's work communicates his brutal theme with immediacy: harshly abstract figures, sharp contrast of colors, and even the movement of the tall grass, which is waving like flames, add to the violence of the scene. Like other Social Realist artists in the United States during the 1930s and 1940s, Lawrence uses his work as a vehicle for protest, demonstrating a brutal historical reality. Discussing the purpose of his art in relation to social justice, Lawrence wrote:

Having no Negro history makes the Negro people feel inferior to the rest of the world. I don't see how a history of the United States can be written honestly without including the Negro.... We don't have a physical slavery, but an economic slavery. If these people, who were so much worse off than the people today, could conquer their slavery, we certainly can do the same thing.

12.65 Georgia O'Keeffe, *The Lawrence Tree*, 1929. Oil on canvas, 2' 7½6" × 3' 3½6" (79 × 99 cm). Wadsworth Atheneum, Hartford, Connecticut.

The novelist D. H. Lawrence and his wife, Frieda, were friends of O'Keeffe when she spent the summer of 1929 in New Mexico. O'Keeffe wrote: "I spent several weeks up at the Lawrence ranch that summer. There was a long weathered carpenter's bench under the tall tree in front of the little old house that Lawrence had lived in there. I often lay on the bench looking up into the tree—past the trunk and up into the branches. It was particularly fine at night with the stars above the tree." Lawrence described this tree as "a great pillar of pale, flakyribbed copper" and wrote about the wind "hissing in the needles like a nest of serpents.'

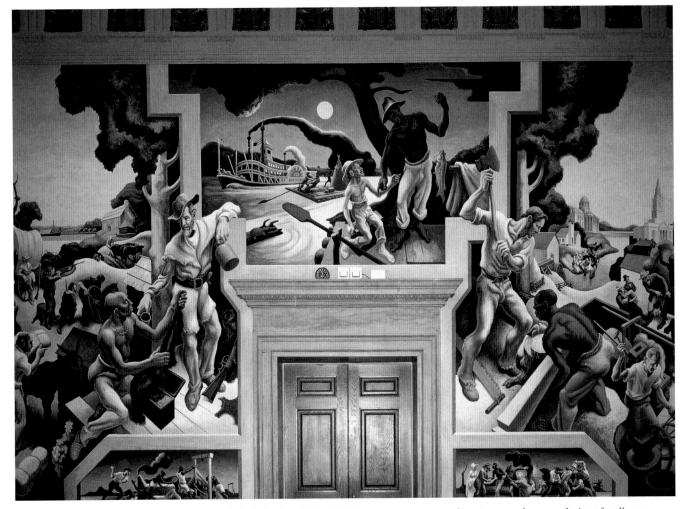

12.66 Thomas Hart Benton, Pioneer Days and Early Settlers, 1935-36. Oil and egg tempera on linen mounted on panel, size of wall $25' \times 14'$ 2" (7.62 × 4.31 m). State Capitol, Jefferson City, Missouri. Commissioned by the Missouri legislature.

Before receiving this important commission in his home state, Benton had received commissions for mural cycles at the New School for Social Research in New York City; in the library of the Whitney Museum of American Art; and for the State of Indiana's exhibition at the 1933 Chicago World's Fair. The Missouri cycle, which Benton called A Social History of Missouri, encompasses three walls. On this wall, Benton depicted early settlers, including a trader giving whiskey to a Native American in exchange for furs, the legend of Huck Finn and Jim with a paddleboat named Sam Clemens, and early construction that leads back to a view of later governmental structures. Benton's portrayal is not completely positive, as seen in the smaller scenes below, with a cruel slave driver and the violent expulsion of the Mormons. The public and the Missouri legislature criticized these works for not being more idealistic, and Benton was accused of degrading his state's history and image.

12.67 Jacob Lawrence, Toussaint L'Ouverture Series, No. 10: The Cruelty of the Planters Led the Slaves to Revolt, 1776. These Revolts Kept Springing Up from Time to Time—Finally Came to a Head in the Rebellion, 1937–38. Gouache on paper, $11'' \times 1' \cdot 5'' \cdot (28 \times 43 \text{ cm})$. Amistad Research Center, Aaron Douglas Collection, Tulane University, New Orleans.

The forty-one panels of Lawrence's Toussaint L'Ouverture Series tell how the hero, a Haitian slave named Toussaint L'Ouverture, freed his country from French rule during the late eighteenth and early nineteenth centuries. The republic of Haiti, founded by L'Ouverture, was the first black republic established in the Western Hemisphere.

Pablo Picasso, Guernica

espite the perplexity of highly abstract shapes, which owe a formal debt to Synthetic Cubism, the *Guernica* mural, inspired by the aerial bombardment of an innocent Spanish town during the civil war of 1936–39, achieves an immediate impact (fig. 12.68). An architectonically stable composition underlies the surface tumult, for the verticality of the two side figures—the woman with upraised arms to the right and the woman cradling the dead child on the left—acts to secure the central group, which is resolved in the shape of a triangle. This underlying geometric order imparts strength to the composition.

The restriction of the color palette to black, white, and values of gray, and the horizontal lines across the body of the horse remind us of the reporting of disastrous events in newspapers. It was by reading such reports that Picasso learned of the disaster at Guernica. Writing later, the American painter Ad Reinhardt considered the *Guernica* a "design that diagrams our whole present dark age," and of the limited color range Picasso used, Reinhardt stated, "The dead have no color."

Picasso refused to elaborate on the particular intentions he invested in each of these tragic figures, preferring

to encourage the viewer to understand the work on an emotional, intuitive level. On the right and left sides of the composition, two women, shrieking in anguish with eyes transformed to the shape of tears, look toward the heavens, source of their pain and death. The figure on the left holding a dead child adapts the Pietà theme (see fig. 7.55) to this nightmare, while the woman to the right cries from the flames that have engulfed her house. Below her, another woman drags her mangled leg and, with arms outstretched, seems to be pleading for help. Above, an oil lamp, reminiscent of the light held by allegorical figures of Truth and Liberty, is thrust into the chaos. This light, however, is overwhelmed by the harsh radiance from the bare electric bulb, added to the composition only in the final stages of painting (compare fig. 12.69). Previously, this area had represented the sun or an eye. The change to the electric light is most likely an allusion to technology, which, during the bombing of Guernica, was unleashed as a malevolent and destructive force.

In the central group, a horse has been lanced; its head is twisted back, and the pointed tongue becomes a silent scream of pain and accusation. Although the horse may symbolize the suffering of Spain, it also expresses the

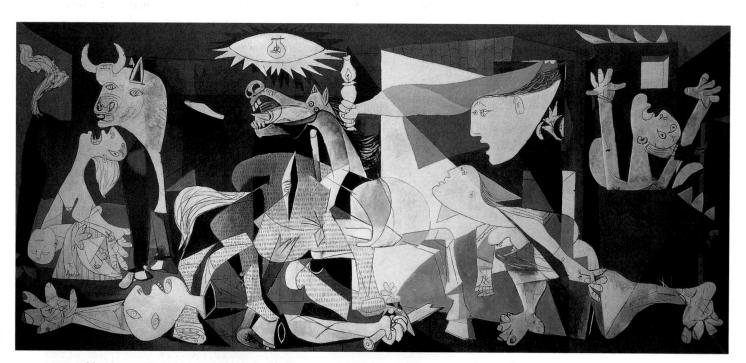

12.68 Pablo Picasso, *Guernica*, May 1–June 4, 1937. Oil on canvas, 11' $5\%'' \times 25'$ 5%'' (3.5 × 7.77 m). Museo Nacional Centro de Arte Reina Sofía, Madrid, Spain. Commissioned by the Republican Government of Spain.

Picasso placed the painting on indefinite loan to the Museum of Modern Art in New York in 1939, stipulating that it be given to Spain and her people only when democracy was restored. The painting was returned to Spain in 1981.

12.69 Pablo Picasso, Guernica, Photograph of the painting on May 11, 1937, by Dora Maar.

This is the first of seven photographs made of the work in progress. Many of the main themes are already established, but virtually all will be dramatically reworked. Note that, at this early point, defiance on the part of the dead warrior is expressed by his upraised arm and fist.

totality of a conflict that involves all of nature. The bull suggests brute power, perhaps in reference to Franco and Fascism. Below the horse are the dismembered remains of a fallen soldier. His hand, while still clutching a broken sword, also clings to a delicate flower, the only promise of hope in this image of suffering and death.

The brutal Spanish Civil War (1936–39) was the result of conflicting political ideologies and of internal tensions that were centuries old. In 1931, the Bourbon monarchy, which had ruled Spain since 1700, was replaced by a Republican government that promised social and economic reform, including the redistribution of land and the secularization of certain governmental functions controlled by the Church. Such reforms, which were aimed at countering the political power of wealthy landowners and the clergy, provoked the formation of conservative alliances. During the increasing civil disorder after the elections of 1936 (won by the Republicans), General Francisco Franco, claiming allegiance to his nation rather than to any political group, led an insurrection that immersed Spain in civil war. Nazi Germany and Fascist Italy aided Franco, while the USSR assisted the leftist coalition, which included the Communists. The major Western democracies maintained an official position of neutrality, but many individuals supported the Republican cause as the cruel reality of Franco's oppression became apparent. After three years and the loss of hundreds of thousands of lives, Franco established an authoritarian rule that continued until his death in 1975.

In January 1937, in the midst of the civil war, the Republican government commissioned Picasso, who was living and working in France, to paint a mural for the Spanish Pavilion at the World's Fair scheduled to open in Paris that year (see fig. 12.1). Picasso had yet to settle upon an exact theme when news of the events of April 26 reached him. On that day, Franco had used his Nazi allies to conduct the first "total" air raid. In what seems to have been an experiment in saturation bombing, the historic city of Guernica, a town of no strategic military significance, was bombarded for more than three hours. When Picasso learned of the bombing, he started to paint a work that would be an invective against both the particular event and the senseless brutality of conflict.

Picasso, whose political sympathies had already been manifested in satirical etchings that were called the Dream and Lie of Franco, wrote:

In the panel on which I am working which I shall call Guernica, and in all my recent works of art, I clearly express my abhorrence of the military caste which has sunk Spain into an ocean of pain and death.

Sculpture of the 1930s and 1940s

ecumbent Figure (fig. 12.70), by Henry Moore (1898-1986), is immediately recognizable as a reclining female figure—one of the traditional themes of Western art. Like many of its antecedents (see figs. 8.37 and 8.38), it suggests a voluptuous figure. Although the positions of the head and breasts are evident and the figure is clearly propped up on one elbow, the torso below the breasts is an open cavity, and other forms suggest hips, a knee, and legs, without informing us of the exact pose. Moore's massive, simple forms also suggest the hills and gullies of a landscape. The sculpture interrelates with its environment through the powerful masses and unexpected openings that surround and mold space. Moore has written that "sculpture in air is possible, where the stone contains only the hole, which is the intended and considered form." The interrelationships of the abstract forms, however, suggest the organic qualities of a living, breathing figure with a potential for movement. Moore never denies the dignity and beauty of the human body, and many of his figures are heroic in scale and in content.

During the 1930s and 1940s, sculptors' interest in abstraction took a number of forms. Henry Moore and Barbara Hepworth (1903–75) guided the development of British abstract art in the 1930s, but Hepworth's sculpture moved further into abstraction. In *Sculpture with Color (Oval Form)*, mass and space become integral elements in a composition that simultaneously reveals itself as exterior form and interior structure (fig. 12.71). The contrast between exterior and interior is reinforced by color, while the taut strings relate the interior cavity to the exterior surface. Hepworth wrote that this structural relationship of color and string was associated with her perception of nature:

The colour in the concavities plunged me into the depth of water, caves, or shadows deeper than the carved concavities themselves. The strings were the tension I felt between myself and the sea, the wind or the hills.

In a later comment, she elaborated on the significance of nature:

12.70 Henry Moore, *Recumbent Figure*, 1938. Gray-green Hornton stone, length about 4' 6" (1.4 m). Tate Britain, London, England.

Moore's sources for this style encompass not only modern European sculpture but also the powerfully abstract forms of African and pre-Hispanic art.

12.71 Barbara Hepworth, Sculpture with Color (Oval Form), Pale Blue and Red, 1943. Painted wood with strings, length 1' 6" (46 cm). Private collection.

In the contemplation of Nature we are perpetually renewed, our sense of mystery and our imagination is kept alive, and rightly understood, it gives us the power to project into a plastic medium some universal or abstract vision of beauty.

A new type of sculpture, named **mobiles** by the artist Marcel Duchamp, was shown at an exhibition in 1932 by the American artist Alexander Calder (1898-1976), who had first been trained as an engineer. Calder's earliest mobiles were moved by hand cranks or motors, but by 1932 they evolved into the lightweight, delicately balanced, suspended sculptures, moved by air currents, that have spawned so many popular variations. Although most of Calder's mobiles are completely abstract, the title of this example suggests that the graceful movements of the curvilinear forms are a reference to swimming fish (fig. 12.72). In Calder's mobiles, the intimate relationship between form and space attains a new complexity as air currents move the forms slowly through space to create ever-new compositions. Calder's work was

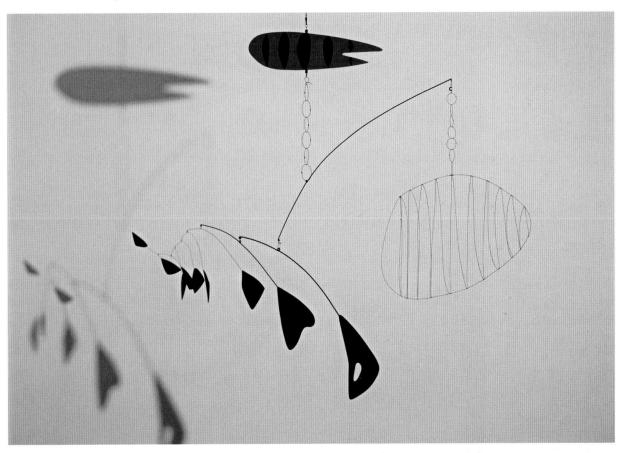

12.72 Alexander Calder, Lobster Trap and Fish Tail, 1939. Hanging mobile: painted steel wire and sheet aluminum, diameter 8' 6" × 9' 6" (2.6 × 2.9 m). The Museum of Modern Art, New York. Commissioned by the Advisory Committee for the stairwell of the museum.

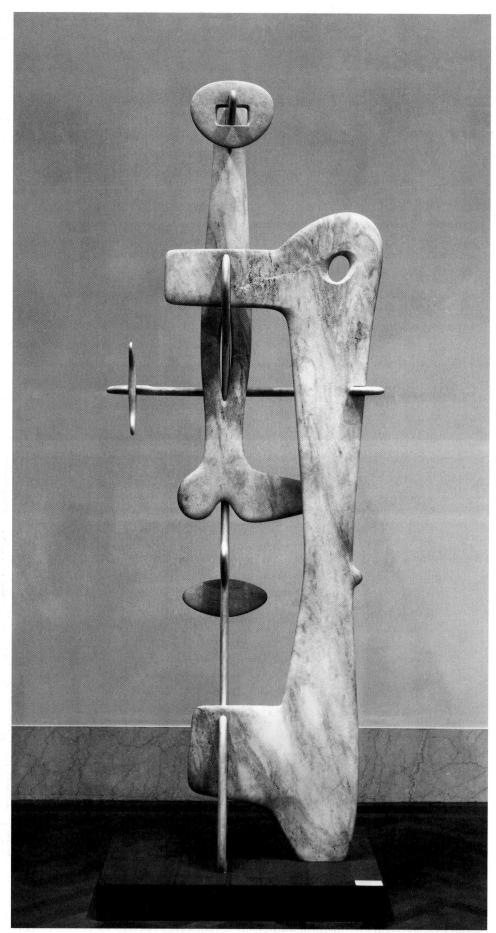

12.73 Isamu Noguchi, *Kouros*, 1944–45. Pink Georgia marble, height 9' 9" (3 m). The Metropolitan Museum of Art, New York.

The slabs of stone are not fastened together, and the sculpture can be disassembled. Noguchi's involvement with Greek themes came in part from his collaboration as a set designer with Martha Graham, the innovative American dancer whose modern ballets were often based on mythic themes.

not limited to mobiles; in his later years he created large abstracted structures that he called "stabiles" because they did not move, and in 1970 he even designed a sidewalk pattern for a city block in Manhattan.

The title that Isamu Noguchi (1904-88) gave his overlifesize Kouros reveals that these abstract forms refer to a standing male figure (fig. 12.73), and we are encouraged to compare the sculpture with idealized ancient Greek statues of the sixth and fifth centuries BCE (see figs. 3.61, 3.63). As a modern artist, Noguchi reinvents the human form, substituting thin slabs of stone that interlock at right angles as support for the solid, rounded mass that is central to the body. The individual slabs are cut in organic shapes with subtly polished edges that interpenetrate in a synergistic yet tenuous balance. The frailty of forms and the instability of structure convey the anxieties that Noguchi endured during 1944-45, near the end of World War II, when he felt a need for "constant transfusions of human meaning into the encroaching void."

In his boxes, Joseph Cornell (1903-75) combines three-dimensional objects and two-dimensional charts, photographs, maps, and/or reproductions of works of art, all joined within shallow, glass-fronted enclosures. His

unexpected juxtapositions of the concrete with the illusory can be poignant, enigmatic, and nostalgic. Each becomes a secluded and private universe intended to stimulate a viewer's imagination and memories. In speaking of a box that made a reference to soap bubbles, Cornell said, "Shadow boxes become poetic theaters or setting wherein are metamorphosed the elements of a childhood pastime."

In Medici Slot Machine (fig. 12.74), a reproduction of a sixteenth-century painting of a young nobleman is viewed through a glass with crossed lines like a gunsight, perhaps to suggest the way that we target the past from a distance. A compass and a watch spring in the circular opening below suggest both space and time. The frame around the boy is covered with old maps of ancient Rome, perhaps a reference to the Renaissance interest in antiquity, while the ball, jacks, and game pieces below refer to the entertainments enjoyed by youth in all periods. These are at best suggestions of Cornell's meanings—the true modernity of Cornell's boxes lies in how they encourage individual, unconscious interpretations. Even the name enhances this quality of personal meaning. Like many modern artists, Cornell avoids reference to specific meaning by selecting names that increase a viewer's sense of wonderment and expectation.

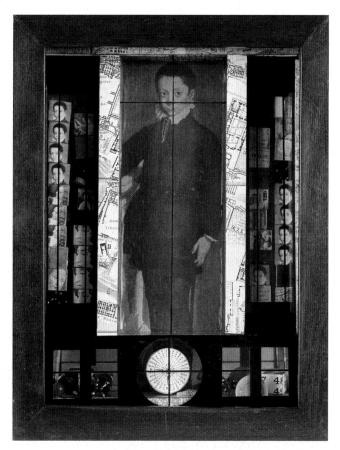

12.74 Joseph Cornell, Medici Slot Machine, 1942. Construction, $1' 1 \%'' \times 1' \times 4 \%'' (34.3 \times 30.5 \times 10.8 \text{ cm})$. Private collection.

Cornell intended that his boxes be held in the hands and moved so that the loose elements could rattle and be rearranged.

International Style Architecture

lass House, by Philip Johnson (1906–2005), is a combination of pure geometric form, subtle proportional relationships, and elegant materials (fig. 12.75)—an outstanding example of the modern architectural movement known as the International Style. This style, named by Johnson in 1932 in the context of an architectural exhibition held at the Museum of Modern Art in New York, is based on the refined glass box. It was expressed as early as the 1920s in works by the German architect Ludwig Mies van der Rohe (1886–1969), who later became the director of the Bauhaus (see pp. 542-43). Mies emigrated to the United States in 1937 and became a citizen in 1944. The International Style came to full fruition after World War II, when Mies was commissioned to create a number of works, including skyscrapers in Chicago and New York and an entire campus for the Illinois Institute of Technology in Chicago. These popularized the style and led to its adaptation throughout the Western world. By the 1960s, virtually every Western capital had many metal and glass skyscrapers.

Even while it was under construction, the Seagram Building was recognized as an especially elegant and impressive modern structure (fig. 12.76). Mies's choice of materials reveals his goals of harmony and elegance, for the exposed bronze is patinated to match the amber-tinted glass. The building is tall and wide when seen from the front, but its relative thinness gives it a soaring refinement. The proportions of the design are based on a simple modular system, much like the Early Renaissance architecture of Brunelleschi (see figs. 7.29, 7.30). The open lower stories, where there are a bank of elevators and a small glassed lobby, lighten the structure and help establish the proportional integrity of the whole. In every way, the building reflects Mies's personal motto, "Less is more."

Because it occupies less than one-half of its site, the building easily conforms to the restrictions of New York City's set-back laws, which ordinarily result in the staggered rooflines seen on many Manhattan buildings. Instead, the structure's placement on a large plaza sets it off as a gigantic sculptural form.

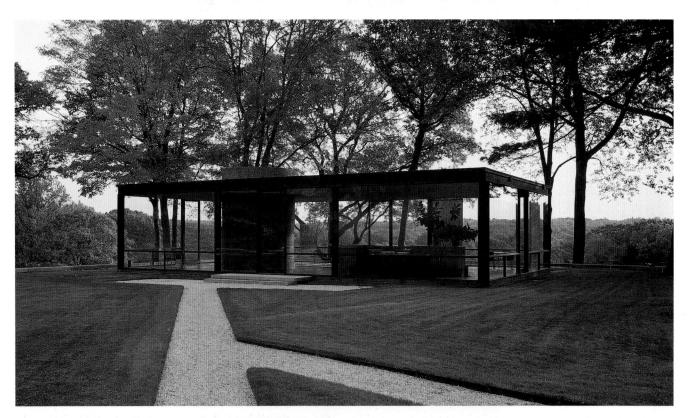

12.75 Philip Johnson, Glass House, New Canaan, Connecticut, 1949.

Originally his graduate thesis project, the Glass House was later built as the architect's own home. Secluded on a large estate, privacy was not a problem. Today it is preserved as a museum. A brick cylinder placed asymmetrically provides a fireplace and the enclosure necessary for the bathroom and mechanical equipment. A counter forms the kitchen area, and a freestanding block of closets provides storage space.

12.76 Ludwig Mies van der Rohe, Seagram Building, New York, 1956-58. Commissioned by Joseph E. Seagram and Sons Corporation, under the advisement of Phyllis Bronfman Lambert. Archival photograph, Alexandre Georges.

The International Style glass-box skyscraper became popular with corporate America because it projected a modern, up-to-date image for the business it housed. Few buildings in this style, however, have the sophisticated elegance of the Seagram Building. Philip Johnson, who assisted Mies in the design of the building, was largely responsible for the creation of the interior spaces.

The glass box makes a pure ideological statement without historical precedent, but in its materials it is a product of the machine culture. Its origins lie in mass production, prefabrication, and the precision of the machine. Equally importantly, it shares in the utopian ideals that inspired de Stijl (see pp. 540-42), one of its sources; as pure architecture, expressing the Platonic ideal with thoroughly modern means and materials, it is a revealing expression of twentieth-century idealism.

Despite the purist, reductive beauty of Johnson's Glass House and Mies's Seagram Building, the International Style quickly reached a dead end. The glass box is an impersonal object, and as cities all over the world became crowded with such buildings, many people found them cold and sterile places in which to live and work. Such buildings, especially in the hands of lesser architects, most often fail to address the needs of human scale or to provide the depth of detail that gives texture to urban living. In their modern purity, International Style buildings ignore the subtle relationships to site, climate, or tradition that are integral to the beauty and joy found in many earlier works of great architecture.

13.1 The Names Project, San Francisco, AIDS Memorial Quilt, as displayed on the Ellipse facing the White House in October 1996.

The last time the quilt was shown in its entirety was during the fall of 1996, when it had expanded to more than 37,000 panels. Portions of the quilt continue to be exhibited, especially in the period around December I, which is World AIDS Day. The official AIDS Quilt website offers a list of where panels of the quilt will be on display. As of 2007, the quilt contained more than 46,000 panels, including contributions from all 50 states and many foreign countries. The total size of the quilt was more than 1,290,000 square feet (393,192 sq m). There are panels dedicated to tennis player Arthur Ashe, fashion designer Perry Ellis, philosopher Michel Foucault, artist Keith Haring (see fig. 13.37), actor Rock Hudson, photographer Robert Mapplethorpe, and the ballet dancer Rudolf Nureyev.

Art from 1950 to 1999

A BRIEF INSIGHT

he AIDS Memorial Quilt is illustrative of changes during the period from 1950 to 1999 that radically transformed art (fig. 13.1). In terms of function, the AIDS quilt is traditional: like the funerary art that stretches back to the beginnings of history, it commemorates individuals. However, what unites the individuals commemorated here is the disease that has claimed them. The artistic technique of quilting fabric is also not new—it was once foremost among the arts practiced by American women—but in this case the quilt is not intended as a family heirloom or show of handicraft. Instead, it is an expression of protest, of social conscience, a national heirloom that can hardly comfort a nation.

The quilt was initiated by the Names Project, which proposed that individual three-bysix foot cloth panels be made in memory of each American who dies of AIDS to be joined to form a single quilt. However, the extent of the epidemic has exceeded the capacity of even the most massive quilt.

Anyone is permitted to design and contribute a panel to the AIDS Quilt. In most cases, the panels are not creations of artists, but rather were made by friends or relatives of the deceased. The individual nature of each memorial is emphasized by the inclusion of such personal objects as articles of clothing, representations of the deceased, and references to favorite activities or places. This memorial acknowledges the scope of this modern disease and offers cogent social commentary.

The 1950s

hroughout the 1950s, painting was dominated by two divergent trends: strict abstraction, and a new version of realism. Homage to the Square: Affectionate (fig. 13.2) is one of a series of virtually identical compositions by Josef Albers (1888-1976); he entitled the series Homage to the Square. In each of these works, square planes of color are set within larger square planes. Differences of color lead to varying perceptions of spatial illusion; in this case, the central green square appears suspended in front of the blue square. This spatial configuration, however, is confounded by the lighter color of the outer square, creating a complicated spatial illusion. In the mid 1960s, Albers reflected on his use of color:

The colors in my paintings are juxtaposed for various and changing effects.... Despite an even and mostly opaque application, the colors will appear above or below each other, in front or behind, or side by side on the same level.

Albers, who studied and then taught at the Bauhaus, moved to the United States in 1933. His preference for controlled, geometric compositions derives from the Bauhaus design aesthetic. The term "Hard-Edge Abstraction" was coined in 1958 to indicate a type of abstract painting, like Homage to the Square: Affectionate, in which shapes meet in

clearly defined edges to emphasize formal qualities related to our perception.

Yet another mode of abstraction opened us to the unconscious journey of artistic creativity:

When I am in my painting, I'm not aware of what I'm doing. It is only after a sort of "get acquainted" period that I see what I have been about. I have no fears about making changes, destroying the image, etc., because the painting has a life of its own. I try to let it come through. It is only when I lose contact with the painting that the result is a mess. Otherwise there is pure harmony, an easy give and take, and the painting comes out well.

(Jackson Pollock, 1947)

Pollock's Convergence (fig. 13.3) is layered in exuberant bursts of undulating paint. This weblike mass of colors and rhythms is the result of a new and provocative approach to painting derived from Surrealist automatism; it records the process by which the artist's unconscious has been laid bare. Pollock (1912-1956) was often described as being in an almost trancelike state and moving with the grace of a dancer while creating such works. As he flings paint onto the canvas, the action of his body is guided by his unconscious (fig. 13.4). He usually used paint bought by the gallon at the hardware store, and instead of brushes he dribbled the paint

13.2 Josef Albers, Homage to the Square: Affectionate, 1954. Oil on canvas, 2' 7%" $\times 2' 7\%" (81 \times 81 \text{ cm}).$ Musée National d'Art Moderne, Centre National d'Art et de Culture Georges Pompidou, Paris, France.

13.3 Jackson Pollock, Convergence, 1952. Oil on canvas, $8 \times 13'$ (2.44 \times 3.96 m). Albright-Knox Art Gallery, Buffalo, New York.

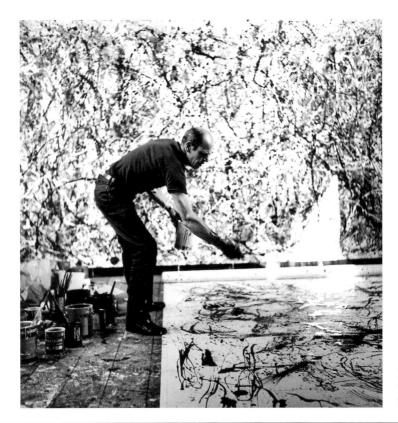

13.4 Photograph of Jackson Pollock painting, by Hans Namuth.

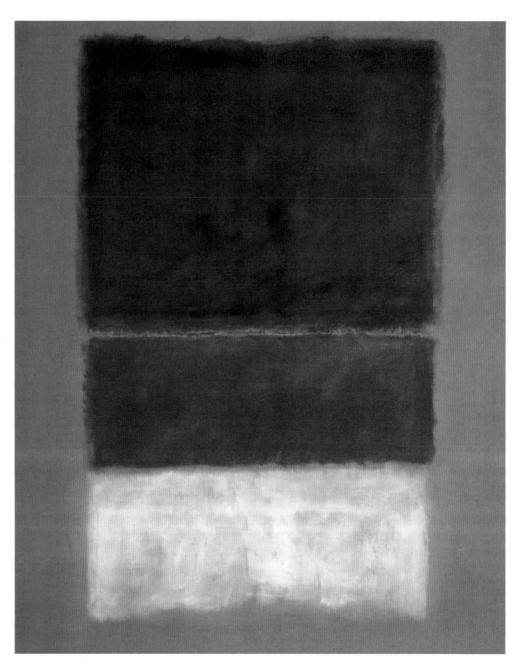

13.5 Mark Rothko, *White and Greens in Blue*, 1957. Oil on canvas, 8' 6" × 7' (2.59 × 2.13 m). Collection Mrs Paul Mellon, Upperville, Virginia.

from sticks. Unlike Surrealist automatism, Pollock did not consciously complete his image to bring it within the realm of objectivity. The painting communicates raw energy.

But what are we to make of all this? What does it mean for us to confront a record of an artist's unconscious behavior? Influenced by the ideas of Freud and Jung, Pollock's large paintings are the culmination of his long effort to correlate artmaking with the psychoanalytic investigation of his own personality. When we come upon one of Pollock's large paintings in a museum, and we become absorbed by its magnitude, the rhythms of its calligraphy, and the intensity of its chaos, we are led to understand how for Pollock mind and nature formed a necessary unity.

The avant-garde movement of which Pollock was a part gained impetus during the 1930s, when the rise of Nazi

Germany cast a foreboding shadow over Europe and many European artists came to the United States. The impact of their work and their presence was felt in a 1936 exhibition of Dada and Surrealism at New York's Museum of Modern Art. European artists, some of whom opened their studios as teachers, found a particularly responsive audience among the younger generation of American artists who were searching for new avenues of expression beyond the nationalistic themes that had predominated during the years of the Great Depression. Pollock's emphasis on energy and experience can also be related to his distaste for the commercialism and consumption, the emphasis on the acquisition of goods, that characterized post-war America.

The term "Abstract Expressionism" had been used earlier in the century to designate the nonobjective paintings of Kandinsky, but it was resurrected in 1946 to describe the works of a group of American painters, including Pollock, centered in New York (these artists are also sometimes referred to as the "New York School"). What joined these artists was not a unified style but a common attitude that stressed the unique individuality of each creative act.

Within the stylistic differences of the Abstract Expressionist painters, we can discern two fundamental approaches; one, termed Action Painting, was a free gestural expression of paint on the canvas. Another mode, exemplified by the work of Mark Rothko (1903–70), is referred to as Color Field Painting. It displayed limited areas of color within simple nonobjective compositions, allowing the shapes and colors to communicate an aesthetic and emotional experience.

Rothko always insisted that paintings must be about something, that they must have a strong content:

It is a widely accepted notion among painters that it does not matter what one paints as long as it is well painted. This is the essence of academicism. There is no such thing as a good painting about nothing. We assert that subject matter is crucial and only that subject matter is valid which is tragic and timeless. In Rothko's *White and Greens in Blue* (fig. 13.5), the hovering horizontal planes carry associations of nature, such as land-scape and sky, while also establishing a hierarchical order. A melancholic sensation from the densely darkened green rectangles weighs down the bottom rectangle of white, conveying unconsciously the suppression of hope. The development of Abstract Expressionism led to the exploration of new techniques; both Pollock and Rothko experimented by staining raw or unprepared artists' canvas with highly liquid acrylic paint, a technique that produced different effects from the traditional application of brushed paint.

The intense subjectivity of Abstract Expressionism, with its association with the subconscious, provoked a reaction in which artists, including Jasper Johns (b. 1930) and Robert Rauschenberg (b. 1925), reintroduced familiar imagery in their work. This return to objectivity, however, required the audience to confront new modes of association. Johns's *Flag* (fig. 13.6), strikes us as a blatantly representational image, even more so when we consider that it was created in the mid-1950s, when nonobjectivity ruled the avant-garde in painting. The composition is clearly and intentionally recognizable, but in place of the solid shapes of red, white, and blue that we expect, Johns has substituted a

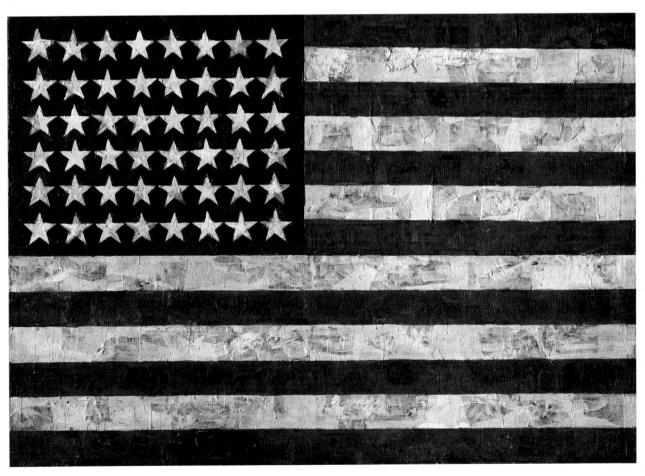

13.6 Jasper Johns, Flag, 1954–55 (dated on reverse 1954). Encaustic, oil, and collage on fabric mounted on plywood, 3' $6\frac{1}{4}$ " \times 5' $\frac{1}{4}$ " (1.07 \times 1.55 m). The Museum of Modern Art, New York.

painterly texture whose thinness in places reveals collage elements underneath; Johns's work is a painting, not a flag of the United States. The artist carefully manipulated the surface to emphasize the reality of the painting as a **mixed media** work of paint and collage. This artistic transformation is intended to drain the image of its immediate symbolic content. Johns thus forces us to realize that the painting itself is first and foremost a composition of shapes and colors—an object.

During the early 1950s, artists such as Johns and Rauschenberg began to incorporate representational imagery and recognizable objects in their work. This served at least two purposes: it avoided the sometimes uncomfortable defensiveness that viewers felt with nonobjective art, especially Abstract Expressionism and Hard-Edge Abstraction, while simultaneously offering an image, sometimes in combination with actual "found objects," as a given fact of our experience, without reference to symbolic comment. There is no precise name for this artistic activity of Johns and Rauschenberg. It is sometimes referred to as Neo-Dada but, although there is a similarity to Dada in the use of found objects, there is more evidence

of the artist at work here; while Duchamp appropriated everyday objects without transformation (see fig. 12.43), works created by Johns and Rauschenberg captivate our attention through the manner in which objects are combined or materials are manipulated.

In *Monogram* (fig. 13.7), for example, Rauschenberg placed a used tire around a stuffed Angora goat and affixed this to a base that joined collage elements and broad, gestural strokes of paint. Rauschenberg referred to these works as "combines" because they associated elements of life with those of art in a "matter of fact" manner that was inspired by the avant-garde musical compositions of John Cage, which went beyond the traditional creation of music to draw attention to the sounds of reality that surround us on all occasions. In the words of Rauschenberg:

Any incentive to paint is as good as any other. There is no poor subject. Painting is always strongest when in spite of composition, color, etc., it appears as a fact, or an inevitability, as opposed to a souvenir or arrangement. Painting relates to both art and life. Neither can be made. (I try to act in the gap between the two.) A pair of socks is

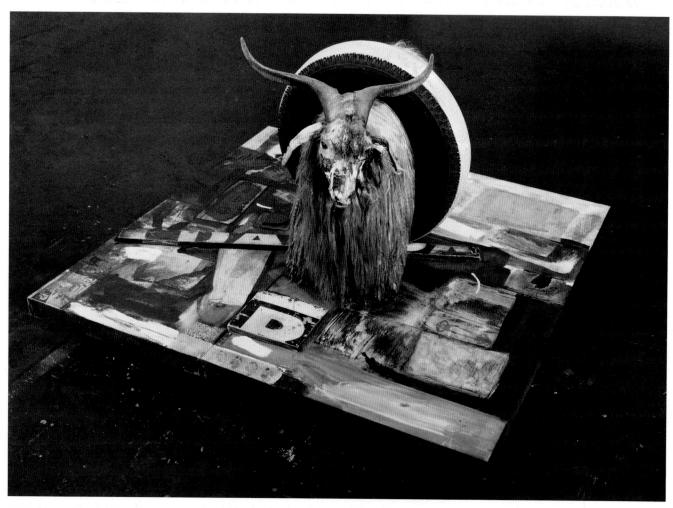

13.7 Robert Rauschenberg, Monogram, 1959. Construction, 3' 6" \times 6' \times 6' \times 6' (1.07 \times 1.83 \times 1.83 m). Moderna Museet, Stockholm, Sweden.

13.8 Robert Frank, *Trolley, New Orleans*, published in *The Americans*, 1958. Gelatin silver print, $7\frac{1}{2}$ × $8\frac{1}{2}$ (19 × 22 cm). The Art Institute of Chicago.

no less suitable to make a painting with than wood, nails, turpentine, oil, and fabric. A canvas is never empty.

Amid the abstraction of the American avant-garde, these works of Johns and Rauschenberg emphasized the literal role of the object in the work of art. At this time, when rock 'n' roll challenged the establishment, transcending racial divisions, the political world was divided into the bipolar camps of the United States and the Union of Soviet Socialist Republics. The ensuing Cold War between these superpowers was anything but cold; as the decade opened, North Korea invaded South Korea, pitting Communist forces against a United Nations multinational force that included the United States. An armistice was signed in 1953, but political and military tensions on the Korean peninsula are still felt today. In 1956, a second Middle East conflict erupted between Israel and neighboring Arab nations, and in 1959 Fidel Castro was named premier of Cuba. Within the United States, Senator Joseph McCarthy's fevered attacks on perceived Communists led to his formal censure in 1954, and the "Space Race" with the U.S.S.R. began with the Soviet launching of Sputnik, the first earth satellite, in 1957. A year later, the U.S. established the National Aeronautics and Space Administration (NASA).

In 1955, African Americans boycotted segregated city buses in Montgomery, Alabama. A year prior, the U.S. Supreme Court had overturned the "separate but equal" doctrine that had legitimated racial segregation in Southern schools. In 1957, Central High School in Little Rock, Arkansas, was integrated with the enrollment of nine African American students escorted by federal troops from the 101st Airborne Division. During these years, the Reverend Martin Luther King, Jr., who protested for equal rights through acts of nonviolent civil disobedience, emerged as the leader of the Civil Rights Movement.

The effect of human alienation and of segregation in the American South during the 1950s is poignantly captured in Robert Frank's (b. 1924) photograph of a trolley in New Orleans (fig. 13.8). The image has the appearance of a common snapshot, yet the effect is precisely calculated. The windows create a grid pattern that formally separates the people, who engage our attention. The formal divisions caused by the windows reinforce the apparent psychological separateness of the people; they do not communicate with each other. Frank's photographic essay *The Americans* (1958) demonstrated the vigor of a new photographic aesthetic that could uncover realities often hidden behind the facade of well-being in postwar America. His "snapshot aesthetic" is one of a number of developments that have distinguished photography since World War II.

A new form of realism emerged in England in the mid-1950s. Richard Hamilton's (b. 1922) collage *Just What Is It That Makes Today's Homes So Different? So Appealing?* was both a visual manifesto and a prophetic statement of a

13.9 Richard Hamilton, *Just What Is It That Makes Today's Homes So Different, So Appealing*?, 1956. Collage, 10½ × 9½" (26 × 25 cm). Kunsthalle, Tübingen, Germany.

Hamilton's collage was part of a 1956 London exhibition titled "This Is Tomorrow."

movement called Pop Art (fig. 13.9). The inspiration for Pop Art was found in the commercialism that developed, particularly in the United States, after World War II. Hamilton's work engages us on different levels; the almostnude figures "update" the tradition of the nude in Western art, yet here they also represent a modern couple and they remind us of one of the rules of advertising—sex sells. They are surrounded by the conveniences and products of modern life, while the "fine arts" include a comic book as a framed picture and a canned ham as a table sculpture. The collage is laced with witticisms, including the use of the word "pop" on the Tootsie Roll wrapper and a portrait of John Ruskin, a conservative nineteenth-century British art critic. Yet within this environment of commercially produced images and intellectual puns, we are confronted with imagery that suggests more universal concerns, for the ceiling design is a photo of the earth taken from space and the "pattern" of the rug is a photograph of densely packed humanity on a beach.

One of the most individual expressions in architecture during the 1950s was Nôtre-Dame-du-Haut by Le Corbusier

(1887–1965). Like French Gothic cathedrals, this structure sets out to astonish and move us by its unexpected and mysterious form and structure (figs. 13.10–13.12). The sweeping roof, thin and billowing as if it were an air-filled sail, creates a relationship with nature, for it seems to respond to the winds that sweep the promontory site. On the interior, the darkness and the thick, roughly textured walls suggest a cave. Irregularly sized and spaced windows are filled with stained glass on which traditional religious symbols (a dove, the sun) and phrases ("Blessed among Women") have been painted. Like sculpture in the round, the building forces us to move to understand it, becoming an adventure and, for some, a journey of personal religious discovery. Le Corbusier called this "totally free architecture," describing the chapel as a:

sculpture "of an acoustical nature," that is to say projecting afar the effect of its form and, in return, receiving the pressure of the surrounding spaces. The key is light and light illuminates shapes and shapes have emotional power.

13.10 Le Corbusier, Exterior, Nôtre-Dame-du-Haut, Ronchamp, near Belfort, France, 1950–54. Commissioned by Canon Lucien Ledeur of Besançon, who hoped the building would help initiate a renaissance in church art and architecture.

Le Corbusier, "the crowlike one," is the pseudonym of the Swiss architect Charles-Édouard Jeanneret. Nôtre-Dame-du-Haut is built in the foothills of the Alps, on the edge of a high promontory. In ancient times, this hilltop had been sanctified by a pagan shrine, but Le Corbusier's chapel replaced one destroyed in World War II that had displayed a statue of the Madonna, now incorporated into the new structure. The outside altar and pulpit seen here are used when pilgrimage crowds become too large to be accommodated within the chapel. The building is constructed of reinforced concrete.

13.11 Le Corbusier, Interior, Nôtre-Damedu-Haut. The interior, approx. $43 \times 72'$ (13×22 m), has pews for only about fifty worshipers.

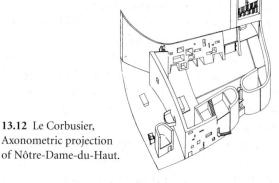

Throughout the decade and in much of the world, movies dominated entertainment. *Tokyo Story* (fig. 13.13), by the filmmaker Yasujiro Ozu (1903–63), focuses on a modern, middle-class Japanese family, the relationships

among its members, and how they are affected by events in their everyday lives. Ozu reveals how events gradually lead to the dissolution of the traditional family structure that had been so important in Japanese life and society. The subject crossed cultural boundaries and gave viewers in the West a glimpse of postwar sentiment in Japan.

Produced in the context of war weariness and disillusion, this film appeared only one year after the end of the Allied occupation of Japan. The reforms carried out during the postwar period were drastic, and *Tokyo Story* reveals the inevitable and unresolved conflict between the demands of life in the modern industrial era and traditional Japanese cultural mores and values.

Tokyo Story is integrated around three elements: story, theme, and cinematography. The story is a complex three-part tale that focuses on the parents' relationships with their children. The first section is set in the town of Onomichi, where the old couple lives. The middle section

13.13 Yasujiro Ozu (director), *Tokyo Story*, 1953. Shukichi Hirayama (the father, played by Chishu Ryn) and Tomi Hirayama (the mother, played by Chieko Higashiyama). Script by Kogo Noda and Yasujiro Ozu; photographed by Yuharu Atsuta. The running time of the film is 135 minutes.

sees the parents at a reunion with their children in Tokyo. Both their son and daughter are busy with their own lives and send the parents off to a hot-springs resort, ostensibly as a treat but actually to get rid of them. The only kindness they experience in Tokyo is from the widow of their third son, who had been killed in the war. The third section, back in Onomichi, depicts the death and funeral of the mother. The children are called to her deathbed, but she is so ill that she cannot recognize them. The children hurry away after the funeral, but the daughter-in-law stays behind to see the old father settled in. Then she, too, must return to Tokyo, leaving the father in the empty house to contemplate the lonely years that lie ahead.

Ozu's central theme is how one comes to terms with the dissolution of the family and, ultimately, with death. Three alternative solutions are examined in the reactions of the children. Several of the characters are resigned and accept these conditions with sensitivity. Others are indifferent and

regard the breakup of the family as inevitable. The youngest tries to shore up the family once again. Resolution is never reached, and the theme of transience triumphs.

Ozu sets a slow pace that echoes the unfolding of real life in the everyday world. The camera is fixed at the eye level of someone seated on the floor on a straw tatami mat in a traditional Japanese house. Ozu uses only three standard shots: long, medium, and close-up. The medium shot is the basic unit, and the scenery in each frame is presented with austere formal symmetry.

Both the framing and the pacing of the film conform to the aesthetic standards that had been held by Japanese artists for centuries. Ozu's films have been compared to Zen temple gardens, where simple, unadorned arrangements of dry rocks and raked sand are meant to elicit complex responses (see fig. 8.1). Ozu's tale, told in the modern medium of film and focused on a problem common to the modern world, expresses traditional Japanese values.

The 1960s

he diversity of directions established during the 1950s continued, with ever-broadening consequences, in the 1960s. Pop Art delighted American audiences, and was awarded iconic status with a 1963 exhibition at New York's Guggenheim Museum. Geometric abstraction reached new modes of expression with Minimal and Op Art, while other avant-garde artists pushed the concept of art further, as boundaries among art forms grew less distinct and traditional definitions of art were called into question.

Redefinitions of art were driven by a decreasing interest among some artists in fashioning an art object. Happenings, which began in the 1950s, were quasi-theatrical events, during which artists directed the activity of the audience often outside the confines of a museum or gallery; spontaneous or unexpected occurrences were prized. Happenings, Conceptual, and Performance Art challenged the definition of the work of art as a tangible object. This was especially true of Conceptual Art, and one of its innovative protagonists, Joseph Kosuth (b. 1945).

One and Three Chairs (fig. 13.14), which Kosuth created in 1965, informs us of three different realities. First, there is the reality of the folding chair, which is placed between a full-scale photograph of the same chair and a printed definition of "chair" taken from a dictionary. The photograph is a second reality, but it bears only an illusory image of the chair. Finally, the definition communicates a verbal description of a chair. The idea that we form from the definition exists in our minds and might therefore be

termed a conceptual reality. One and Three Chairs presents the actuality, the image, and the idea of a chair, thus demonstrating the relationship between an object and communicative methods of signifying that object.

Kosuth's emphasis on the creative idea and the process of expressing that idea are characteristic of Conceptual Art, a name first used in the early 1960s to designate an artistic philosophy that asserted the supremacy of the artist's concept and the process intended to achieve it over the actual execution of the work. This modern tradition of stressing the intellectual creative act began with Dada and the readymades of Marcel Duchamp.

Conceptual Art requires that the concept for a work of art be documented, but that documentation need not take the form of a finished, crafted work. It might, for example, be expressed verbally or in another visual medium. Another contribution from the 1960s that expanded the definitions of art is Performance Art. Historically, such art is related to the Happenings of the 1950s. Performance Art, which celebrates a temporal experience for an audience, is not geared toward making an object; rather, the artist becomes the work of art, freely acting within a theatrical environment. Performance artists often use a multimedia approach. Joseph Beuys (1921-86), a German artist, incorporated a wide variety of props in his "actions" (as he termed his performances), from found objects to live animals. Beuys, who as a pilot had been shot down in a barren frozen area of the Crimea during World War II, used Performance Art as a means to communicate autobiographical experiences in a

13.14 Joseph Kosuth, *One and Three Chairs*, 1965. Wooden folding chair, photographic copy of a chair, and photographic enlargement of a dictionary definition of a chair; chair 2' 8%" × 1' 2%" × 1' 8%" (82 × 37.8 × 53 cm); photo panel, 3' × 2' ½" (91.5 × 61.1 cm); text panel, 2' × 2' ½" (61 × 61.3 cm). The Museum of Modern Art, New York.

1962 Rachel Carson, Silent Spring 1963 Civil rights demonstration in Washington, D.C. 1965 Kosuth, One and Three Chairs (fig. 13.14) 1965 World population reaches 3.3 billion

1969 Sesame Street program is introduced on PBS

symbolic manner, causing us to question the deeper values in our lives. Beuys believed that Performance Art could reawaken the mind and soul (fig. 13.15).

For many, the 1960s, a politically turbulent decade, proved to be a time of profound questioning and confrontation. The Civil Rights Movement intensified with a 1963 march in Washington, D.C., during which the Reverend Martin Luther King proclaimed, before a quarter of a million people on the Mall, "I have a dream that one day ... sons of former slaves and the sons of former slave owners will be able to sit down together at the table of brotherhood." That day, however, would be long in coming, as violence was the segregationist's answer to equal rights

13.15 Joseph Beuys, Photographic negatives with brown-cross between glass plates in iron frame, 2' 4" \times 1' 9" \times 2" (71 \times 53 \times 5 cm) with frame. Photos by Ute Klophaus from Beuys's *Iphigenia/Titus Andronicus*, May 1969.

The performance preserved in this work premiered during an avantgarde theater festival in Frankfurt, Germany. It consisted of selected simultaneous readings of Goethe's *Iphigenie* and Shakespeare's *Titus Andronicus* while Beuys, who designed the "set," acted on stage. Beuys's actions included spreading margarine on the stage floor and occasionally clashing cymbals. for black Americans. Two years later, King led a march from Selma to Montgomery, Alabama, to dramatize the need for a federal voting rights law, which was passed later that year. Racial tensions erupted into riots throughout the decade; this tumult was paralleled by increasingly heated demonstrations protesting U.S. involvement in a conflict between North and South Vietnam. In America, efforts to sustain this military involvement were met with bitter domestic divisiveness. Global conflicts included a six-day war between Israel and Arab nations, and the erection of the Berlin Wall to separate Communist East from West Berlin. The "Cold War" between the U.S. and the U.S.S.R. came to the brink of nuclear conflict in 1962 when Soviet missiles were deployed in Cuba.

A year after the Cuban crisis, President John F. Kennedy was assassinated in Dallas, Texas; five years later his brother, Robert, was killed in Los Angeles. That same year, 1968, witnessed the assassination of Reverend King in Memphis, violent clashes between anti-war protesters and Chicago police at the Democratic National Convention, and the start of peace negotiations between the U.S. and North Vietnam in Paris.

As the Beatles dominated the pop music scene, Pop Art, which also had its beginnings in Great Britain, was a "hit" in America. As I Opened Fire, by Roy Lichtenstein (1923-97), is fashioned after a drawing in an out-of-date adventure comic book that the artist has blown up to an enormous size (fig. 13.16). The captioned thoughts of the pilot and the emblazoned BRAT! are natural adjuncts to the overblown style of the planes and blazing guns. The areas of flat color surrounded by black outlines are composed of enlarged patterns of dots that imitate the process then used to print color illustrations in comic books and newspapers. Lichtenstein thus ambivalently parodies the melodramatic themes of comic books as emblematic of post-World War II popular culture, by exaggerating and magnifying the processes by which images are created for mass consumption.

Nowhere was the monotonous repetition of commercialization expressed more ironically than in the works of Pop Artist Andy Warhol (1928–87), who wrote "The reason I'm painting this way is that I want to be a machine, and I feel that whatever I do and do machine-like is what I want to do." Many of Warhol's images were silk-screened by assistants at his workshop, The Factory, suggesting an equation between the processes of art and consumer production. But if Warhol's rows upon rows of Coke bottles, Campbell Soup cans, images of Marilyn Monroe (fig. 13.17), or accident scenes are born from a commercial environment, they also

13.16 Roy Lichtenstein, *As I Opened Fire*, 1964. Magna on canvas, each panel 5' $8'' \times 4' 8'' (1.72 \times 1.42 \text{ m})$. Stedelijk Museum, Amsterdam, The Netherlands.

communicate how we are in danger of being anaesthetized by that environment. Warhol began the *Marilyn Monroe* series after the actress's death in 1962. The repetitive images and garish, off-register colors accentuate the dehumanization that occurs when a human being is marketed as a product. The irony of Warhol is that the essence of humanity seems lost in the shallow, commercial images that inspired his art.

In the late 1960s, Minimal Art presented the work of art as an object of elemental form divorced from either symbolic or personal content. The roots of Minimal Art extend back in the twentieth century to the structural and spatial considerations of Russian Constructivism, the manufactured ready-mades of Duchamp, and Hard-Edge Abstraction.

The series of eight stainless-steel boxes by Donald Judd (1928–94), set directly on the floor, without the pedestals common to the display of sculpture, exemplify Minimal Art (fig. 13.18). Identical in every regard, they were fabricated by metalworkers to the artist's specifications, and placed at deliberate intervals. Despite being identical, each box retains an individual and objective integrity, while the set of eight boxes form a single sculptural unit. The highly finished surfaces, the precise manner in which they are sited, and the machine-made purity of their geometry all seem to expunge the hand of the artist from their creation. Such art seems determined to dissociate itself from those qualities that we usually ascribe to sculpture. Instead, these boxes

13.17 Andy Warhol, *Marilyn Diptych*, 1962. Acrylic on canvas, 13' $5\frac{1}{4}$ " \times 9' 6' $(4.1 \times 2.9 \text{ m})$. Tate Modern, London, England.

13.18 Donald Judd, Untitled, 1968. Eight stainless-steel boxes, each 4' (1.22 m) square and placed one foot (.30 cm) apart. Private collection.

are, simply, objects located in space. Their proportions and crystalline purity address our own bodily existence, while their exploration of industrial materials as prime matter invite us to reflect on the nature of our own individuality and humanity.

Drift 2 (fig. 13.19), by Bridget Riley (b. 1931), exemplifies another movement from the 1960s known as Op Art, short for Optical Art, which descended from Albers' nonobjective compositions and Hard-Edge Abstraction (see fig. 13.2). Although Drift 2 is a flat canvas, its pattern is composed so that it seems to surge and undulate before our eyes. This illusion of movement, however, is dependent on our perception of the optical effects of pattern. Op Art questions the very process by which we see and understand visual reality.

As the 1960s ended, one event transcended all previous boundaries. On July 20, 1969, half a billion people around the earth watched on television as astronaut Neil Armstrong set foot on the moon with the words "That's one small step for man, one giant leap for mankind."

13.19 Bridget Riley, *Drift 2*, 1966. Emulsion on canvas, 7! $7\frac{1}{2}$ " × 7' $5\frac{1}{2}$ " (2.32 × 2.27 m). Albright-Knox Art Gallery, Buffalo, New York.

The 1970s

ealism was a dominant current in the arts throughout the 1970s. The interaction between art and life, and our perception of both, are explored with the sculptures of Duane Hanson (1923–96). The figures (fig. 13.20) seem as real as the actual clothing, camera, and other props. At exhibitions of Hanson's works, viewers commonly speak to the works of art, having mistaken them for living individuals. Hanson cast these fiberglass figures from molds made from models and painted the "skin" with meticulous attention to pores, surface blemishes, and other individualistic details. Although the resulting figures seem very real, their mute presence and arrested poses create an uncanny gulf between the sculpture and ourselves. Hanson's figures approach, but cannot participate in, life.

Tourists is an example of Hyper-Realist sculpture, itself part of a broader movement known as New Realism

that emerged in the late 1960s and early 1970s. The meticulous crafting of a work of art again became an element to be enjoyed, even if, on a more profound level, the images presented forced viewers to confront the banality of modern life.

The call to realism was met by painters, many of whom developed techniques that utilized photographs, creating works that enable us to explore the conflict between visual reality, photographic information, and the painted surface. The huge objects in *World War II (Vanitas)* (fig. 13.21) by Audrey Flack (b. 1931), for example, command our attention because of their intense realism. Flack begins by arranging a still-life composition that combines objects suggesting both personal and universal meanings. When she is pleased with the arrangement, she photographs it with color-slide film. She then projects the slides onto a

13.20 Duane Hanson, *Tourists*, 1970. Fiberglass and polyester, polychromed, lifesize. Scottish National Gallery of Modern Art, Edinburgh.

As time passes and clothing styles change, Hanson's figures seem more historic and less naturalistic, but when first created they were meticulous re-creations of individuals whom one might meet on the street. Other figures by Hanson include *Traveler with Sunburn*; Couple with Shopping Bag; and Football Player.

1971 Women in Switzerland granted the right to vote 1979 Shah of Iran forced into

13.21 Audrey Flack, World War II (Vanitas), 1976–77. Oil on acrylic canvas, 7' $6" \times 7'$ $6" \times 7'$ $6" \times 2$ m). Private collection. Incorporating a portion of the photograph Buchenwald, April 1945 by Margaret Bourke-White.

canvas and paints following the guidelines offered by the projected image. Her use of an **airbrush** (a small, high-quality paint sprayer) softens the contours of the objects, creating a suggestive and even sensual effect. This soft focus combines with the iconography of the objects to appeal to our emotions in a way that is quite different from the sharp focus and detached objectivity of other photo-realist paintings. Flack's dazzling objects seem to jut forward into our

space with compelling presence. The realism of such painting delights and intrigues us, just as the ancient Romans were entertained by the kinds of art described by Philostratus the Younger (see p. 129).

Flack's painting goes beyond visual and aesthetic effects to make a profound statement. World War II is one of a series of paintings subtitled Vanitas, a reference to a traditional iconographic theme, popular in earlier centuries, in

which the brevity of life is contemplated (see fig. 9.45). In Flack's rendition, objects that conjure up delight—the color and scent of the rose, the shimmer of the pearls, the taste of the fruit and pastries, the freedom of a butterfly—are confronted with a photograph of starving inmates taken at the liberation of the Nazi concentration camp at Buchenwald in 1945 by Margaret Bourke-White; the star of David below the photograph refers to the Jewish heritage that had led to their persecution. The still-burning candle, a hopeful symbol of eternal spirit and the passage of life, contrasts with the stark memory of the Holocaust. The text in the painting, taken from the writings of Nahman of Bratslav, in part reads "You can take everything from me—the pillow from under my head, my house—but you cannot take God from my heart."

Yet another mode of realism is evident in the selfportrait by Jacob Lawrence (fig. 13.22). Lawrence's forceful personal style blends the planarity of Cubism with the expressive figural distortions of Expressionism. Lawrence (see also p. 555) painted this Self-Portrait when he was elected to membership in the National Academy of Design, where it joins the portraits and self-portraits of other members. Lawrence's direct and compelling painting alludes to both the physical and the intellectual processes of creativity. He is surrounded by the attributes of his profession, including, in the upper left background, a work from his Harriet Tubman series, which narrated the life of the former slave who, before the civil war, was responsible for freeing more than 300 slaves. The laborer below the Harriet Tubman painting and the tools and paintings on the shelf refer to Lawrence's Builders theme, which had its roots in the artist's youth in Harlem, where he associated with cabinetmakers and carpenters. For Lawrence, these themes symbolized human aspiration.

The "straight" photographic realism of Diane Arbus (1923-71) opens us to the actuality of the human condition. (A "straight" photograph is one in which the image has not been altered by darkroom manipulation.) Arbus began her career as a fashion photographer, but in the late 1950s she turned toward an introspective use of the medium. Arbus's photograph, taken at a home for developmentally disabled women, is both disturbing and compelling (fig. 13.23). Arbus takes us into a realm that is often ignored; she once commented, "I really believe there are things which nobody would see unless I photographed them."

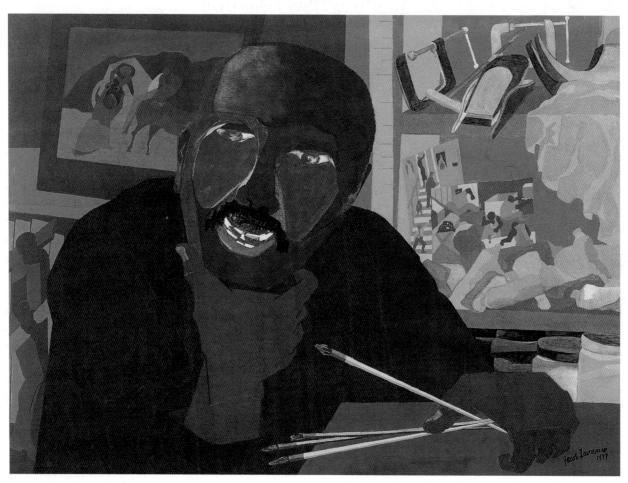

13.22 Jacob Lawrence, Self-Portrait, 1977. Gouache on paper, 1' 11" \times 2' 7" (58.4 \times 78.7 cm). National Academy of Design, New York.

13.23 Diane Arbus, Untitled (6), 1970-71. Gelatin silver print.

As the 1970s opened, four students were killed during an anti-Vietnam War protest at Kent State University in Ohio. Anti-war demonstrations continued until a ceasefire was arranged in 1973. As American troops withdrew, Saigon, the capital of South Vietnam, fell to the Communist North in 1975. Regional conflicts continued in Northern Ireland and in the Middle East, and an anti-apartheid movement began to gather strength in South Africa.

Relations between Communist countries and Western democracies, so severely strained during the Cold War, witnessed a breakthrough when President Richard Nixon visited Communist China in 1972. In 1975, U.S. and U.S.S.R. astronauts linked their orbiting spacecrafts, symbolic of an eventual lessening of tensions between the two nations. Nixon, however, had resigned in 1974, as a result of illegal reelection campaign activity dubbed the "Watergate Scandal." By the end of the decade, the U.S. and Communist China formalized diplomatic relations; conflicts continued in Southeast Asia; and, in 1979, Ayatollah Khomeini established a fundamentalist Islamic theocracy in Iran.

Since about 1970, architecture throughout the world has undergone sweeping transformations. A harbinger of

these newer developments was the Pompidou Center in Paris (fig. 13.24) by Renzo Piano (b. 1937) and Richard Rogers (b. 1933). At first glance, the architecture of the Pompidou Center seems to be completely forthright. Not only are the structural elements exposed-without and within—but HVAC (heating-ventilation-air conditioning) ducts, escalators, and other mechanical equipment are in full view. Leaving the mechanicals exposed allows for their easy repair and replacement. They also function as decoration. Bright colors are used to designate each different mechanical function, so that we are constantly aware of the operating systems that keep the building functioning. Inside, all the walls are movable, and each space can be redesigned as needed. The Pompidou is not only an adventure in architecture, but also a demonstration in understanding the complex workings of the advanced technology of a huge contemporary building. Rogers has written:

I believe in the rich potential of a modern industrial society. Aesthetically one can do what one likes with technology for it is a tool, not an end in itself, but we ignore it at our peril. To our practice its natural functionalism has an intrinsic beauty.

During the 1960s and 1970s, some works of art aspired to an architectural or environmental scale. Among the earliest of these is Spiral Jetty (fig. 13.25), executed in Great Salt Lake by Robert Smithson (1938–73). To create this dramatic gesture, Smithson used the assistance of heavy equipment operators. The resulting form, made by dumping truckloads of gravel to progressively shape a roadbed into the lake, interacts with the ecology of the lake, at times changing the amount and color of the local algae. While Smithson's work is made of stone, he knew that, in the context of geological time, it was a temporary structure that would be transformed, if not obliterated, by the forces of nature. After years of being submerged by a rise in the water level of the lake, recently it has re-emerged encrusted with rock salt. While the geometric purity of the spiral form relates it to Minimalist Art, it possesses other historical and iconographic allusions as well. Smithson learned that early Mormon settlers believed that the Great Salt Lake was bottomless and connected to the Pacific Ocean by an

underground canal, and that from time to time Pacific currents would cause whirlpools to form on the lake's surface. His choice of design was inspired by this legend.

Running Fence by Christo (b. 1935) and Jeanne-Claude (b. 1935) provides another example of how art on a large scale interacts with nature. However, while its temporary installation highlighted rural landforms and the changing effects of light and wind along the California coast, its actual execution underscores the significance of due process in an open society (fig. 13.26). For Christo and Jeanne-Claude, the creative act involves raising funds (through the sale of preparatory drawings and prints), addressing public hearings, acquiring legal permits, finding volunteer workers, and administering affairs so that the work can be completed as planned. Their installations survive only in drawings, photographs, and films, yet their creation and documentation allows us to experience our environment in new ways that refresh our social relationship with the process of art.

13.24 Renzo Piano and Richard Rogers, Centre National d'Art et de Culture Georges Pompidou, Paris, France, 1971–78. Commissioned by Georges Pompidou, president of France, and later named for him.

The center incorporates museum spaces for permanent and temporary exhibitions, also a public library and an audiovisual center.

13.25 Robert Smithson, *Spiral Jetty*, Great Salt Lake, Utah, 1969–70. Black rock, salt crystals, earth, and red water (algae), approximate measurements: diameter 160' (50 m); coil length 1,500' (460 m); width 15' (4.5 m). This photograph shows the jetty soon after it was first completed.

13.26 Christo and Jeanne-Claude, *Running Fence*, *Sonoma and Marin Counties*, *California*, 1972–76 (now removed). 2,050 steel poles set 62' (20 m) apart; 65,000 yards (60,000 m) of white woven synthetic fabric, height 18' (5.5 m); total length 24½ miles (40 km). © Christo 1976. Photographer: Jeanne-Claude.

The planning stages of this work began in 1972. The project was completed in four days and remained standing for fourteen days in 1976. Christo and Jeanne-Claude's determination to create works on such a large scale that they must be executed with the assistance of a large number of workers is related to their interest in involving the broader community; this cooperative and inclusive approach is in direct opposition to the exclusive, individualistic tradition of most modern Western art.

The 1980s

n the heels of politically and socially tumultuous decades, the art world in the 1980s burst open with a variety of styles that countered the reductionism and seemingly impersonal attitude of abstraction with a diversity of individually expressive approaches.

Portland Public Service Building, by Michael Graves (b. 1934) (fig. 13.27), for example, abandoned the "modern" glass box and reintroduced traditional architectural elements and ideas. Postmodernism, which this building exemplifies, viewed itself as a style that moved beyond the modern, simply subsuming modernism as one among many historical styles. Although the Portland Building's simplifications of form are indebted to modernism in numerous ways, its references to historic architectural traditions such as its giant pilasters, its blocklike Doric capitals, and its enormous keystone are thoroughly postmodern. Its exterior décor also revives the use of symbolism, such as the areas of green, terra-cotta, and blue which symbolize water, earth, and sky. The integration of the colossal classicizing figure of Portlandia (executed by Ray Kaskey using the same wrought copper technique used to fashion the Statue of Liberty) over the main entrance represents a conscious break with the abstract sculpture conventionally

13.27 Michael Graves, Portland Public Service Building, Oregon, 1980–82. Commissioned by the City Government of Portland.

This model shows one of the architect's designs for the building. When built, the extravagant bows on the side of the structure were flattened and the "acropolis" of structures on the roof, which was originally intended to house the building's mechanical functions, was omitted. The huge figure of *Portlandia* over the main entrance was made by the American sculptor Raymond Kaskey.

plopped before modernist buildings. Here, the pastiche of ornament expresses a longing to recover the greatness of the past.

According to critic Charles Jencks, the "death of modern architecture" occurred at 3:32 p.m. on July 15, 1972, in St. Louis, Missouri, when the failed Pruitt-Igoe housing project, which had won a national design award in 1951, was dynamited. With its geometric design, flat roofs, and avoidance of ornament, the project had exemplified the purist aesthetic of the International Style (see pp. 562–63), but the impersonal nature of its design did not endear it to its residents, and the project eventually fell victim to vandalism and became a site for drug-dealing. Its destruction by the St. Louis housing authority suggested that the modern style of architecture satisfied neither individual needs nor social realities in a pluralistic world.

The term "Postmodernism," first applied to architecture, is also used to refer to developments in other art forms that are characterized by a pluralistic approach to style, medium, and interpretation. Postmodernism's pluralism makes it difficult to offer a succinct definition, but it is possible to discuss its primary features. Postmodernism, for example, welcomes the artistic past into the present. The process of appropriation, whereby traditional forms enter postmodern expression, necessarily entails an interrogation of tradition and context. Postmodernist art celebrates the diversity that results from such questioning and is keen to acknowledge the social, political, and historical issues that arise through this process. It is a vehicle that can help us find our true selves within our culture. As the architect Robert Stern has written:

The fundamental shift to post-modernism has to do with the reawakening of artists in every field to the public responsibilities of art. Once again art is being regarded as an act of communication.

The Wexner Center for the Visual Arts at the Ohio State University, Columbus, Ohio (fig. 13.28) by Peter Eisenman (b. 1932) challenged traditional architectural form. Set between two existing structures, the Wexner Center is based on a grid that relates it not to the immediate university environment but to the larger grid patterns of the city of Columbus. Eisenman thus makes reference to the historical grid established in the early 1800s, when the area was part of the Northwest Territory. Tradition and history are simultaneously affirmed through the use of forms that assert the modernity of the structure.

Eisenman's fortresslike towers are based on a towered armory that once stood on this site, but a close look reveals

1980–82 Graves, Portland Public Service Building (fig. 13.27) 1984
Desmond Tutu is awarded the Nobel Peace Prize

1986 Nuclear disaster at Chernobyl 1989 Dalai Lama wins Nobel Peace Prize 1989 Tiananmen Square massacre in Beijing

that the towers are dissected. Other architectural elements exhibit a similar interrogation of architectural form: arches are not complete, the supporting function of some columns is denied, and both form and space assume shapes that defy our expectations. The Wexner Center is simultaneously related to and discordant with Western architectural traditions.

Critics are still debating whether the Wexner Center is an example of Deconstructivist Architecture or not, but some of the concepts that we encounter here introduce us to Deconstructivism, an art theory rooted in the literary philosophy of Jacques Derrida and others (see also p. 589). In literary deconstruction, where the concept originated, texts are dismantled and reassembled without regard to original intent or underlying content. Meaning becomes changeable, it is argued, and depends on the context and the relationship to the reader.

In architecture, Deconstructivism requires that we have a familiarity with historic architectural forms so that we can

appreciate the ways in which architectural and aesthetic traditions are countered or violated. New possibilities arise as we question the validity of traditions and ponder their role in current developments; the Wexner Center embodies the idea that real instability is inherent in the process of making structures that intervene in a real world. The architect Ignasi de Sola-Morales summarized the experience of Eisenman's Wexner Center when he wrote:

Eisenman's architecture speaks to us with words for which there are no substitutes about the disorder of the modern world, about the weakness of all human action, about the fallibility of our knowledge, about our alienation from our own places. It is a text which speaks. But its speech does not consist in telling any definite tale....

The personal and, at times, introspective nature of art during the 1980s also introduced a new type of public

13.28 Peter Eisenman, Wexner Center for the Visual Arts, Columbus, Ohio, 1983–88. Commissioned by the Ohio State University and Leslie H. Wexner, Chairman of the Board, the Limited Brands corporation.

monument. In 1981, an open competition was held to select a design for the *Vietnam Veterans Memorial*, in Washington, D.C. The winning design (fig. **13.29**), by Maya Lin (b. 1960), lists the names of the more than 58,000 Americans who lost their lives in that conflict. It is an unprecedented public monument. Simple and direct in design, it creates a solemn environment. The high polish of its black granite reflects the transient life before it, while the sandblasted names silently remind us of the personal suffering and individual loss that are the ultimate costs of conflict.

George Segal's (1924–2000) *Gay Liberation Tableau* (fig. **13.30**) is another type of public art. Although different from Lin's *Vietnam Veterans Memorial*, it too is profoundly human and introspective. The work is located in New York City near the location of the Stonewall Bar, where a riot in 1969 between police and the gay bar's patrons sparked the gay liberation movement. The figures occupy the everyday space of

sidewalk and bench, creating a dichotomy in our perception of the realities of art and life. The detailed figures share in the realism of life, yet their monochromatic color sets them apart from the reality of their setting. This interplay, and the suggestion of communication between each pair of figures, creates an engaging and contemplative tableau before us.

Regional conflicts continued to dominate the news during the 1980s; the Iran–Iraq war led to numerous civilian casualties, many the result of Iraq's use of chemical weapons. A war in Afghanistan proved costly for the Soviet invaders. The British fought to regain the Falkland Islands claimed by Argentina, and in 1989, the U.S. invaded Panama to arrest the country's leader for drug-dealing. Across the world, terrorism increased. In 1988, a bomb aboard Pan Am flight 103 caused the death of 280 people. A year later, hundreds of pro-democracy demonstrators were killed by Chinese troops in Tiananmen Square.

13.29 Maya Lin, *Vietnam Veterans Memorial*, 1982. Black granite, length 500' (150 m). The Mall, Washington, D.C. Chosen by the competition jury appointed by the Vietnam Veterans Memorial Fund.

The jury that selected this winning entry in the competition affirmed that two criteria, stated in the program for the competition, were uppermost in their minds—that the monument should "make no political statement regarding the war or its conduct" and that it should be "reflective and contemplative in nature." Commenting on her conception for the memorial, Lin wrote, "I didn't want a static object that people would just look at, but something they could relate to as on a journey, or passage, that would bring each to his own conclusion." Lin's monument is designed so that the walls point toward the Washington Monument and the Lincoln Memorial.

13.30 George Segal, *Gay Liberation Tableau*, 1983. Bronze, lifesize. Installed in Greenwich Village, New York City.

Medical advances included the birth of the first "test tube" baby and the first artificial heart transplant. But in the early 1980s, AIDS would be identified as a quickly spreading, deadly disease with no known cure. The explosion of the space shuttle *Challenger* in 1986 reminded us that the drive for exploration continues to exert a human cost, even with the rapid advances in technology. In Poland, the workers' union Solidarity went from being an illegal organization to winning that country's first open election in forty years. This victory helped set in motion events that led to the dissolution of the U.S.S.R.

In art, the development of the Postmodernist aesthetic can be related to contemporary developments in French intellectual thought during the 1970s. Critical methods of inquiry based on the writings of Jacques Derrida, Jean Baudrillard, Julia Kristeva, and others offered a new philosophical basis for artistic exploration. The paintings of Mark Tansey (b. 1949) respond to this intellectual current. Tansey's compositions are based on his personal reaction to older images and a thoughtful meditation on history and tradition. In one image, for example, he depicts a man (a self-portrait?) with a paint roller covering up Michelangelo's Last Judgment; in another painting, based on a historic photograph of a military surrender, he represented The Triumph of the New York School, with the European artists Matisse and Picasso surrendering to the American Jackson Pollock and the influential modernist critic Clement Greenberg. Tansey's paintings are often sepia-toned or monochromatic in a reference to old photographs. Although this quality sets up an expectation of veracity with the viewer, it is challenged by the implausible nature of the image.

In Tansey's *Purity Test* (fig. **13.31**), a group of Native Americans on horseback views Robert Smithson's *Spiral Jetty* (see fig. 13.25) from atop a bluff. The juxtaposition poses intriguing questions. The manner in which the Native Americans are represented has a closer resemblance to nineteenth-century caricatures of the American West than to historical accuracy. Nevertheless, the work raises the question of how Native Americans might have responded to *Spiral Jetty*, a modern, abstract

13.31 Mark Tansey, *Purity Test*, 1982. Oil on canvas, $6 \times 8'$ (1.83 \times 2.44 m). Collection of the Chase Manhattan Bank, N.A.

work that resembles prehistoric earthworks created by Native Americans. In the final analysis, Tansey forces us to reluctantly admit that differences do separate cultures and that difficulties can be expected when alien cultures cross paths.

Another Postmodern style, often referred to as P + D (an abbreviation for "Pattern and Decoration") is characterized by *Wonderland* (fig. **13.32**) by Miriam Schapiro (b. 1923), who wrote that:

The painting is me, torn in two. I present myself as the painter who can organize and master a huge canvas and then there's the other side of me which belongs to all women who were not liberated—all my ancestors who were trapped in a world where they were punished for being women, where nothing they did was good enough. That's what the painting is about.

This work resembles a giant quilt; pieces of needlework, collected during the artist's visit to Australia, are assembled and combined with painted areas. The embroidered detail of a woman and kitchen in the center offers a stereotypical view of women's work, a view challenged by Schapiro's artistic creation in the rest of the work.

Schapiro's multimedia *Wonderland* exemplifies what she has termed a "femmage," a contraction of "female" and "image" that is also related to the French words femme ("woman") and hommage ("homage" or "respect"). Schapiro writes that her femmages:

explore and express a part of my life which I had always dismissed—my homemaking, my nesting.... The

collagists who came before me were men who lived in cities and often roamed the streets at night scavenging, collecting material, their junk, from urban spaces. My world, my mother's and grandmother's world, was a different one. My "junk," my fabrics, allude to a particular universe, which I wish to make real, to represent.

Unlike the severe, impersonal abstraction of Hard-Edge or Minimal Art, P + D revels in bold colors and less constrained compositions.

Within the pluralistic world of Postmodernism, Neo-Expressionism arose in the early 1980s as a reaction to what some artists perceived to be the emotional aridness of Minimalism and Conceptualism. Neo-Expressionism is an international movement. Nourished in Germany and Italy, it then found adherents in the United States. These artists revived the emotionally laden gestural brushwork and intense colors of Europe's earlier Expressionist painters. Appropriation of imagery became a means of defining contemporary conflict on many levels, from personal through global. In the United States, the paintings of Robert Colescott (b. 1925) have questioned concepts of identity within a multicultural society. In Les Demoiselles d'Alabama: Vestidas (fig. 13.33), the African American artist parodies Picasso's 1907 painting Les Demoiselles d'Avignon (see fig. 12.20). Picasso's abstracted prostitutes are now dressed (hence the Spanish word Vestidas in the title) in garish and revealing clothing, and explicitly include both black and white women.

Such irreverent exploitation of art-historical masterworks raises questions of cultural authority and its transgression. Colescott's transformation of Picasso's figures

13.32 Miriam Schapiro, Wonderland, 1983. Acrylic, fabric, and plastic beads on canvas, 7' 6" × 12' (2.28 × 3.67 m). National Museum of American Art, Smithsonian Institution, Washington, D.C.

13.33 Robert Colescott, *Les Demoiselles d'Alabama: Vestidas*, 1985. Acrylic on canvas, $8' \times 7'$ 8'' (2.44 \times 2.34 m). "Vestidas" means "dressed." New York, Collection of Hanford Yang.

leads us to recognize the neglect of minority artists in accounts of Western art, as well as the exploitative appropriation of African art by white artists such as Picasso. The issues of individual identity and societal inclusion are communicated through a powerful composition and the expressive use of content, color, and brushwork.

This desire for cultural and individual honesty is revealed in other works from the 1980s. *Nude Self-Portrait* (fig. 13.34) by Alice Neel (1900–84), with its harsh modeling and rather austere pose, portrays a psychological presence that coexists with the unashamed honesty of the nude figure. With similar sincerity, Faith Ringgold's (b. 1930) work (fig. 13.35) shares the realities and dreams of her African American experience growing up in Harlem:

I will always remember when the stars fell down around me and lifted me up above the George Washington Bridge.... Sleeping on Tar Beach was magical. Laying on the roof in the night with stars and skyscraper buildings all around me made me feel rich, like I owned all that I could see.

13.34 Alice Neel, *Nude Self-Portrait*, 1980. Oil on canvas, 4' 6" \times 3' 4" (1.37 \times 1 m). National Portrait Gallery, Washington, D.C.

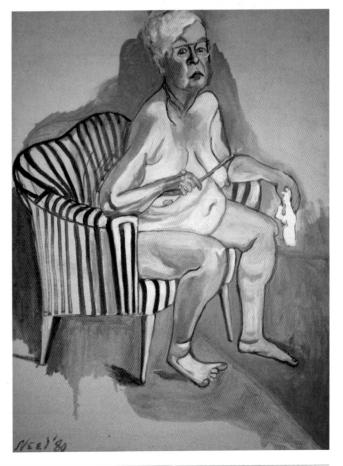

These words form part of the narrative text that Ringgold used to enframe $Tar\ Beach$, the colloquial name given to a rooftop in the inner city at night. Rich in visual, thematic, and psychological association, $Tar\ Beach$ is composed of acrylic paint on canvas, with tie-dyed and pieced fabric attached to the surface. The quilt reference recalls the work of feminist artists in P + D painting, while the abrupt transitions of perspective communicate the naïveté of children as they stare at buildings and stars from the roof. Ringgold's work is simple and direct, yet multilayered.

In Celestial Book: Mirror for Analyzing the World, Xu Bing (b. 1955) fabricated 4,000 characters that no one could read, even though they look like traditional Chinese characters (see fig. 1.17). He then used traditional printing techniques to produce long scrolls and books, which he installed in public spaces (for further discussion of this work see pp. 14–15). Critics argued that Xu Bing's installations expressed nihilist, absurdist, and tragic feelings.

After the Tiananmen Square Massacre and the crushing of the "Democracy Movement" by the Chinese government, avant-garde art in the People's Republic of China changed. At that time, Zhang Peili, an artist working in Hangzhou, said:

Before the Massacre, there was so much noise, a deafening roar of protest. Then the tanks came and everyone immediately feel silent. That silence was more terrifying than the tanks.

After this event, the socially critical aspect of the avant-garde movement in China could no longer be heard. Artists lost faith in the idea that an individual work could change society, but they began to argue that art could function to make the *artist* free—and that to be free was no small matter.

After 1989 and the government attacks on intellectual culture, the avant-garde movement in China weakened.

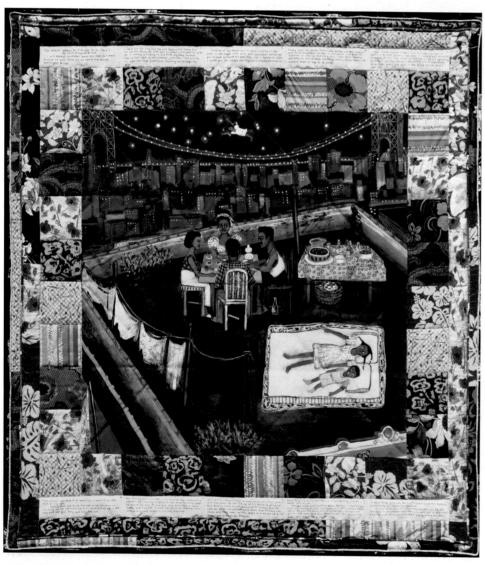

13.35 Faith Ringgold, *Tar Beach*, 1988. Acrylic on canvas and tie-dyed and pieced fabric, 6' 2" × 5' 9" (1.88 × 1.75 m). Solomon R. Guggenheim Museum, New York.

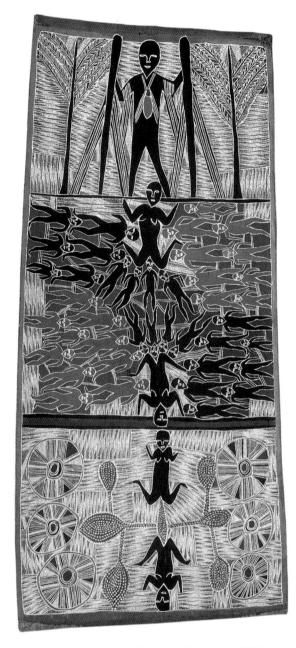

13.36 Wandjuk Marika, *The Birth of the Djang'kawu Children at Yalanghara*, 1982. Natural pigment on bark, 4' 10" \times 2' 2" (147 \times 66 cm). National Gallery of Australia, Canberra.

With the increasing emphasis on economic development, official and popular culture share priorities that differ significantly from those of many Chinese intellectuals. Many avant-garde artists chose to live and work outside of the People's Republic of China, while many of those working inside were forced to exhibit and sell their work abroad. Recently, however, the restrictions have been relaxed and a thriving contemporary art scene, complete with international exhibitions, is flourishing.

In Australia, aboriginal artists were encouraged to continue making works of art in their traditional style and using traditional iconography. *The Birth of the Djang'kawu Children at Yalanghara* (fig. 13.36) by Wandjuk Marika

(1930–87) provides us with an introduction to the distinctive art of the aboriginal peoples. The subject, a creation and journey myth of great complexity, is depicted using flattened, abstracted forms. The Djang'kawu Brother at the top of the image holds digging sticks that he and his sisters will transform into trees during their travels. In the center the two Djang'kawu Sisters give birth to a multitude of people; during their travels they also give birth to sacred objects. Birthing is the subject of the lower panel as well, with the six round disks representing the six clans to which they gave birth. The use of repeated forms, patterns, and colors as seen here gives strength and vigor to the composition. During the past 25 years an active international market in aboriginal art has developed. Whether the integrity of aboriginal art is being corrupted by this commercial activity has become an issue of controversy.

Another thrust of artists late in the twentieth century was to break down the distinctions between "high" and "low" art. In the early 1980s, Keith Haring (1958–90) was inspired by the daring of street graffiti, and he became recognized for his unauthorized chalk drawings on the black paper that is pasted over ads in New York City subway stations when their rental time has expired. This series of more than 5,000 drawings became known as *Art in Transit* (fig. 13.37); the title refers not only to the location of these chalk drawings but also to their removal by the authorities or replacement by new ads and to the manner in which they challenge the traditional notion of art. Haring's energetic images are, in the artist's words, "open to everyone," and he often kept the meaning of a composition ambiguous in order to allow for personal interpretation.

During the 1980s, electronic media was utilized to an ever greater extent as a vehicle for artistic expression. The installations of Jenny Holzer (b. 1950) employ the high-tech media of electronic advertising to present short statements that she calls "truisms." Prompted by graffiti art, Holzer

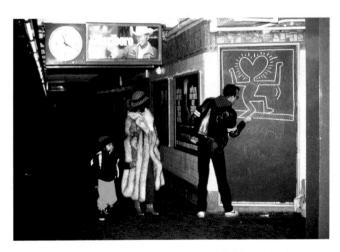

13.37 Keith Haring, *Art in Transit*, 1982. Graffiti in New York City subway station.

clandestinely placed posters in public areas near where she lived in New York City. Each poster contained a philosophical maxim, such as "Absolute Submission Can Be a Form of Freedom," "Money Creates Taste," and "Dying for Love is Beautiful but Stupid," offering ironic commentary on contemporary life. Gradually, Holzer started using computer-controlled light-emitting diode (LED) machines (fig. 13.38). Here, the medium of popular advertising is turned upon itself, parodying how we are manipulated by the media world's use of language. Holzer uses light bars and short, snappy, visual "sound bites" to critique the system and to reveal the mode of manipulation.

The photograph (fig. 13.39) by Osaka-based Yasumasa Morimura (b. 1951), might seem to be a simple re-creation of Manet's *Olympia* (see fig. 11.46). But Morimura has not merely reconstructed Manet's setting and photographed models in poses made famous by Manet; that this is a complex photographic revisualization gradually dawns on us as we realize that the two figures are the same person in different costumes and makeup. This helps explain the term *futago* ("twin") used in the title. The man posed as the reclining figure is, in fact, Morimura himself, who has assumed both female roles in the composition. Most of his work consists of photographs in which he assumes the roles of figures in

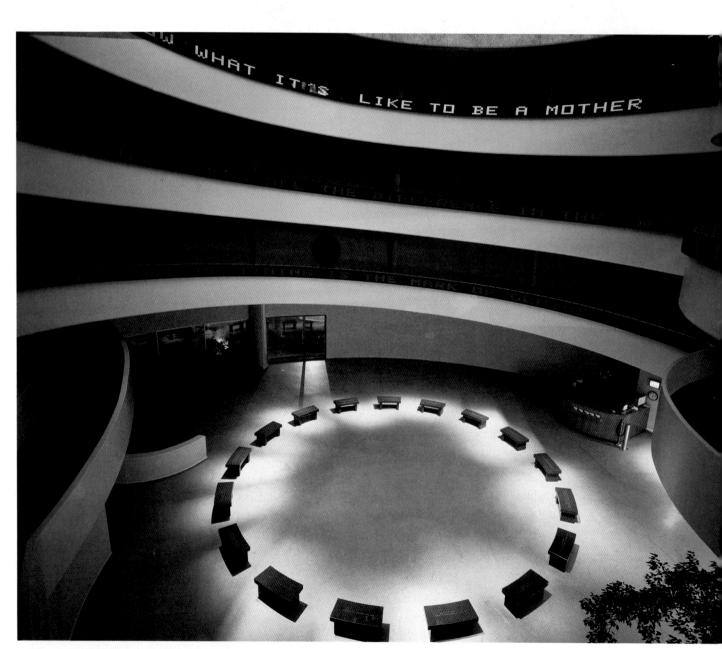

13.38 Jenny Holzer, *Untitled (Selections from Truisms, Inflammatory Essays, The Living Series, The Survival Series, Under a Rock, Laments, and Mother and Child Text)*, Temporary installation with extended helical tricolor LED electronic display signboard, $11" \times 162' \times 4"$ (28 cm \times 50 m \times 10.1 cm). Installed at the Solomon R. Guggenheim Museum, New York, 1989–90. Commissioned by the Guggenheim Museum.

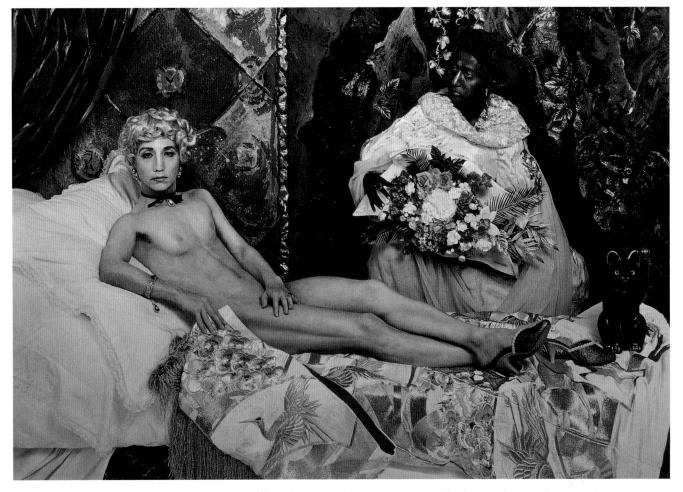

13.39 Yasumasa Morimura, *Portrait (Futago)* (after Édouard Manet, *Olympia*, 1863), 1988. Cibachrome photographs, four panels, 6' 10¹¹/₆" × 9' 10½" (2.11 × 3 m). Carnegie Museum of Art, Pittsburgh. In Japanese, *futago* means "twin."

famous paintings or popular figures from the entertainment world. At first, we feel amused, but gradually the seriousness of Morimura's message asserts itself. His doctored imagery comments on how readily duplicity can be perpetrated when information is transmitted. This photograph may also represent Morimura's attempt to be as shocking today as Manet's painting was to nineteenth-century Paris. The superimposition of a Japanese artist into a Western work alludes to Japan's twentieth-century absorption by Western culture and, at the same time, its retention of its inherently Japanese integrity. On a personal level, Morimura's work probes what it would be like to change sexes, or to be a white prostitute or a black maid in nineteenth-century France. Morimura's art questions Japan's identity at the close of the

twentieth century, raising problems about the role of the artist in society, and asking us to understand our identities in light of our relationships to others and to history.

Morimura's revisualized photograph exemplifies Identity Art, which values self-revelation. Identity may be examined in intensely private ways, involving, for example, race or sexual orientation, or, along broader cultural avenues, the relationship between the individual and the group. Identity Art often finds its voice in artists who have been excluded from the mainstream.

The achievements of recent photographers have helped us appreciate the far-reaching potential of photography in art. Much of their work contradicts the popular adage that "photographs don't lie."

The 1990s

he quest for newness, a driving force in Western art, is not necessarily a dominant feature in art in other parts of the world. In some places, the creation of intentionally repetitive art is part of an effort to link generations of individuals. For important occasions, such as a marriage, the birth of a child, or a festival, for example, women in the villages in Rajasthan, India, paint mandanas, or floor designs, at the threshold, on the walls, and in the inner rooms of their houses (fig. 13.40). The execution of each work follows prescribed styles women learn from their mothers. Most often the purpose is spiritual; the mandana acts as a visual prayer to secure blessings on the household. Mandanas are but one example of a host of temporary art forms that are regularly created throughout the world to assert the continuity of cultural values. In the cultures in which these works are created, they are not thought of as "art," and the women who make them are not thought of as "artists." But the works they create, albeit ephemeral, have a purpose similar to that of many of the works that are considered to be art in the West. As communication makes alien cultures more accessible, we learn to appreciate the integrity of other traditions. In the United States, a traditional art form became the basis of one of the most monumental works of the 1990s, the AIDS Memorial Quilt (see fig. 13.1).

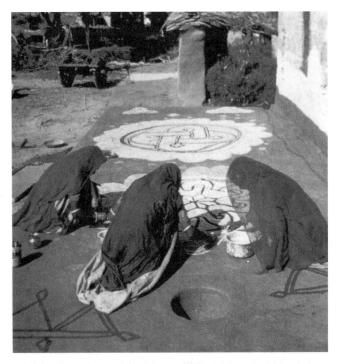

13.40 Indian village women creating a *mandana*, Rajasthan, India, 1994. Rice paste on floor resurfaced with red ocher and cow-dung wash.

The events of the 1990s presented both difficulties and hope. In 1990, Iraq invaded Kuwait; the ensuing "Gulf War" was broadcast on TV. The year 1990 also, however, brought the unification of East and West Germany. Regional strife, especially ethnic conflict, continued in the decade, mostly in Eastern Europe and Africa. Famine and AIDS compounded the political clashes in areas of Africa. Terrorism continued; a nerve gas release in a Japanese subway, and a domestic terrorist bomb that destroyed the Oklahoma City Federal Building were among the attacks on innocent people. Scientific advances in the decade included the introduction of the Pentium Processor and the first cloned mammal, a sheep named Dolly.

Many artists in the 1990s explored installation art, which by fashioning a complex temporary environment denies the tradition of a work of art as a singular permanent object. The spatial context of installation art allowed artists to examine a variety of human interactions on many levels.

Electronic Superhighway (fig. 13.41) by Korean-born Nam June Paik (1932–2006), for example, is a huge neon map of the United States, backed by video monitors of various sizes, that was temporarily installed in a New York City gallery. The images on the screens differed from state to state. Viewed as a whole, the work seemed overwhelming; the steady glare of the neon contrasted with the patterns of color and movement that danced across the video screens.

In Alabama a monitor showed Martin Luther King, Jr., and the early struggles of the civil rights movement, while scenes from the 1943 Rodgers and Hammerstein musical Oklahoma! identified that state; harsh realities were thus juxtaposed with optimistic show tunes. While the monitors from other states primarily depicted historical sequences or scenic views, those within the borders of New York State were linked to closed-circuit video cameras pointed at onlookers. The immediacy of the here-and-now was thus inserted into the work; the feedback images of viewers and their interactions with the "map" instantly became an element of the work itself. The diverse panorama of rapidly changing images was a meditation on the meaning of the United States: perception collided with history, dreams with reality.

A different perspective on national values is offered by a painting entitled *America's Most Wanted* (fig. **13.42**) by the artist team of Vitaly Komar and Alex Melamid. The two artists, born and trained in the Soviet Union, moved to the West in the late 1970s and attracted attention with paintings that wittily commented on Soviet history. Subsequently they employed Marttila & Kiley, a professional polling organization, to take a survey of the aesthetic

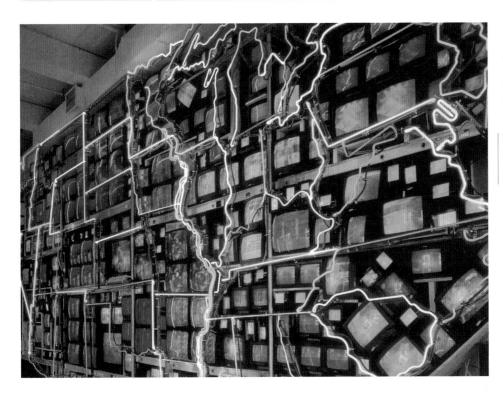

13.41 Nam June Paik, *Electronic Superhighway*, 1995. 49-channel closed-circuit video installation, neon, steel, and electronic components, $15 \times 40 \times 4'$ ($4.6 \times 12.2 \times 1.22$ m). Smithsonian American Art Museum, Washington, D.C.

This work was first shown as a temporary installation at the Holly Solomon Gallery in New York City in 1995.

13.42 Komar and Melamid, *America's Most Wanted*, 1994. Oil on canvas, "dishwasher size."

The sizes of Komar and Melamid's Most Wanted paintings are given not in dimensions but in the size of a consumer good desired in that country.

preferences of 1001 randomly selected American citizens. The results revealed that 88 percent of those surveyed would prefer an outdoor scene rather than an indoor one, and that 60 percent favored realistic, photolike images. Based on their polling data, the pair painted versions of the survey's results, entitled *America's Most Wanted* and

America's Least Wanted, which were then exhibited at the Alternative Museum in New York under the title "People's Choice." Komar and Melamid later surveyed citizens of more than a dozen other countries, including Russia, France, Turkey, China, and Italy; based on the results, they painted other examples of Most Wanted and Least Wanted

paintings, all of which can be viewed on the web. The similarities between the results of their surveys in the United States and Russia were especially interesting. The citizens of both countries suggested that they would find a light-filled, naturalistically rendered landscape most appealing. The figures they would introduce into their landscapes varied; both the American and Russian paintings included children, but while America's Most Wanted painting featured George Washington and two deer, in their ideal painting Russian citizens selected Jesus and a bear. The *Least Wanted* works for citizens of the both countries feature abstract geometric compositions executed in a similar color scheme. Komar and Melamid's projects provide humorous insights into societal values and traditions around the globe. In describing their approach, Melamid has stated:

...we believe in numbers, and numbers never lie. Numbers are innocent. It's absolutely true data. It doesn't say anything about personalities, but it says something about ideals, and about how this world functions. That's really the truth, as much as we can get to the truth.

More recently, the artists have developed a program in which paintings made by elephants are sold in support of the Asian Elephant Art and Conservation Project.

Louise Bourgeois (b. 1911) belongs to a generation of earlier modern artists. An accomplished painter and sculptor who was thoroughly schooled in Surrealism, she first achieved prominence in the 1940s and 1950s with works that reflected on her own past and family relationships. In the 1990s she created a number of monumental sculptures, including a series of spiders all named *Maman* (fig. 13.43). *Maman* is the French word for mama or mother, and the name is in part explained by the eggs — sometimes metal, sometimes marble — suspended in the egg sack hanging below the body. Bourgeois's iconography is often highly personal and reflective of her past; her difficult relationship with her own mother illuminates her choice of title for the series. While the enormous scale at first renders *Maman* terrifying, the slenderness of her legs and the irregularity of their form make her also seem fragile and unexpectedly vulnerable.

The *Hinomaru* series, begun in 1990 by the Japanese artist Yukinori Yanagi (b. circa 1959), aims at deconstructing the myth that the Japanese people are a single "family" ruled by their emperor. Yanagi writes:

The ruling powers of Japan have always resorted to political myths in order to reinforce the country's unity.... As a modern nation state, Japan fabricated a myth of "one people" ... [arguing] that all Japanese, no matter how diverse, are children of the Emperor.

Yanagi's art satirizes nationalism. In *Hinomaru Illumination* (fig. **13.44**), row after row of repetitive figures based on archaic Japanese *haniwa* (see fig. 5.5) face a neon "Rising Sun" flag that has connections with the ancient Shinto Sun Goddess Amateratsu (see p. 161), as well as with the battle flag of imperialist Japan. Although banned

13.43 Louise Bourgeois, *Maman*, 1999. Bronze and steel, height 30' 5" (9.3 m). FMBG Guggenheim Museum, Bilbao. Photograph: Erika Barahona-Ede, 2007.

13.44 Yukinori Yanagi, *Hinomaru Illumination* (*Amateratsu and Haniwa*), 1993. Neon and painted steel, with reproductions of terra-cotta *haniwa* figures; each *haniwa* approx. 3' 3%" (1 m) high. Installation at The Museum of Art, Kochi, Japan, 1993.

Tezuka's tales have tragic undertones. Current *manga* has evolved from Tezuka's innovations. *Excel Saga* by Koushi Rikudou (b. 1970) represents the famous *manga* of the 1990s (fig. 13.45); as of 2006, 16 volumes of the *Excel Saga* story have been published. The complex story centers on the efforts of two female agents of a secret ideological organization (ACROSS) to conquer the city of Fukuoka in order to begin the process of world domination. Known by their code names Excel and Hyatt, the agents work for Il Palazzo, a dreamy individual who is little equipped to assume power. Like

since the end of World War II, this flag has survived as a symbol for ultranationalist groups. *Haniwa* figures were originally created to surround and protect the tombs of early Japanese emperors; here they suggest company employees, whose individuality is suppressed for the sake of corporate harmony. By ridiculing the myth of "racial purity" worshiped by ultranationalists, Yanagi attempts to open Japanese culture to the acceptance of minorities; his is an art of social meaning.

Japanese comic book art, known as manga, has become internationally popular in recent years, but a Japanese affinity for sequential picture stories can already be seen in scroll painting (see for example, Genji monogatari pp. 216-19). The word manga, which literally means "whimsical pictures," was first used to refer to miscellaneous sketches made by the ukiyo-e artist Hokusai in the nineteenth century (see fig. 11.25). Manga became enormously popular in Japan after 1945, when Osamu Tezuka (1928-89) began publishing stories that adapted cinematic techniques to the newspaper comic strip format, resulting in a longer, graphic novel form. Tezuka introduced close-ups, angle shots, story line and action that occurred in episodes with dialogue as the only text, all of which gave his comics a cinematic quality. Inspired by the animated characters of Walt Disney, Tezuka developed the stylized eyes, mouth, eyebrows, and nose we now associate with the exaggerated manner of the manga style and which have been adapted by the animated manga known as anime. Unlike Disney, however, most of

13.45 Koushi Rikudou, Illustration from *Excel Saga*, published in *Young King OURs* beginning in 1997. Tokyo: Shonen Gahosha.

other *manga*, *Excel Saga* is full of sudden surprises and complex developments; in its totality it offers a thinly veiled satire of Japanese society and modern social developments. Beginning in 1999, *Excel Saga* was adapted, with additional subplots, for a 26-episode animated *anime* series shown internationally on television.

With an immense market in Japan, *manga* include a diverse range of subjects and themes. Most are serialized in thick volumes that appear in regular publication. Several major *manga* magazines, which contain about a dozen episodes from different authors, sell several million copies each per week. Unlike in the United States, where the readership of comic books is almost entirely male, in Japan about half the readers of *manga* are female and women's comics (or *shojo*), usually authored by women, make up a large portion of the market.

Electronic media and technology also served performance art in the 1990s. Performance-concerts by Laurie Anderson (b. 1947) synthesize sight and sound. High-tech light displays and projections are synchronized with a pulsating musical background while Anderson's "talking songs" reflect on weighty issues. "The Nerve Bible" (fig. 13.46) was a rapid-fire commentary on a multitude of contemporary issues, from the personal to the historical and political. Reviewing "The Nerve Bible," critic Glenn Ricci commented:

Up there on stage, she appears as the ideal future human living in perfect harmony with all sorts of electronically synchronized equipment. Seeing the expert timing of her stage show is to see a person literally in synch with modern technology.... And here is what really makes Anderson the artist she is: in front of and among all this technological wizardry, that one ... woman is still the most fascinating thing on the stage. What kept the audience entertained ... was not the pile of electronic contraptions so much as the content and context Anderson gave to them.

Time, pace, and social commentary are also elements in the films of William Kentridge (b. 1955). Stereoscope (fig. 13.47) is a fast-paced film about the nature of change, violence, and human responsibility. Kentridge is a South African artist whose films explore the recent history, both convulsive and triumphant, of his country. Through Stereoscope, we follow the quiet deliberations of a fictional businessman who shelters himself from social upheavals. To make his films, Kentridge successively modifies large charcoal drawings; each erasure or addition is photographed to become one frame of the film, which thus becomes an animation of expressionistic charcoal images, interweaving realism and fantasy to communicate social meaning.

13.46 Laurie Anderson, Performance-concert of Stories from "The Nerve Bible," performed at many venues, 1992.

13.47 William Kentridge, Drawing for *Stereoscope*, 1999. Video.

The title of this film, Stereoscope, refers to the optical instrument invented in the nineteenth century that made photographs appear three-dimensional.

The term "appropriation" designates a process that is one aspect of Postmodernism. Canoptic Legerdemain by Nancy Graves (1940-95) is a threedimensional interweaving of formal and iconographic elements (fig. 13.48). In many ways, it is an erudite summation of recent developments in art. Based on the appropriation of art-historical, archaeological, and mythological imagery from the ancient Egyptian, Early Christian, and Byzantine civilizations, some imagery in the work, such as the head of Empress Theodora (see fig. 5.28), is already familiar to us. The uncoiling snake near the center of the composition has associations with many ancient beliefs, particularly the biblical account of Adam and Eve. Although Canoptic Legerdemain is a visual and psychological feast, it is also exemplary of the use of modern technology in art. Laser-cut steel produced by computer program from Graves's drawings is joined by a host of materials, from cast and molded resins to more traditional lithographs.

13.48 Nancy Graves, *Canoptic Legerdemain*, 1990. Stainless steel, aluminum mesh, resin, and paper, 7' 1" \times 7' 11" \times 3' 1" (2.2 \times 2.4 \times .94 m). National Gallery of Art, Washington, D.C.

The title refers to the representation of Egyptian canopic burial jars in the relief and to the artfulness with which the artist has hidden references to several past cultures in a single work.

Although Nancy Graves drew upon art-historical images in the creation of *Canoptic Legerdemain*, other artists have opened themselves to the seemingly endless repertoire of cultural, commercial, and contemporary images. These images, often including printed texts, are extracted from their original context and transformed. Such recontextualization enables artists to make unexpected connections with issues that people face in their daily lives. In Appropriation Art, the formats for works even include commercial media, such as electronic billboards, posters, and T-shirts.

Architecture in the 1990s reached a new level of inventive creativity. Guggenheim Museum in Bilbao, Spain (fig. 13.49) designed by Frank Gehry (b. 1929) resembles a futuristic vision. Located in a Basque industrial port city, Gehry's museum is part of a renewal campaign meant not only to revitalize Spain's fourth-largest city, but also to emphasize a commitment to stability in an area known for political unrest and terrorism. The concentration of industry in Bilbao inspired the massive forms of the design, while the city's shipbuilding and port activities are reflected in the horizontal expanses of the building, which visually recall ships' hulls. Yet while traditional industrial architecture acts as a reference point, the Guggenheim Museum transcends its immediate environment. The imposing horizontal and

vertical aspects of the organic design cluster around an enormous vertical atrium, which the architect refers to as a "metallic flower." The titanium shingles on the exterior offer an interplay of light and atmosphere, which, combined with the expansive curvilinear forms, cause a continuing transformation of the building from different points of view.

The Water Temple (fig. 13.50), by Tadao Ando (b. 1941), was designed as an addition to an older Buddhist temple. Ando's addition breaks decisively with tradition; the new structure has been described by one critic as "less a building than a series of shaped sensual experiences." Ando controls our approach to his temple through a series of concrete walls that lead us to a large, serene pool on which float lotus blossoms, a Buddhist symbol of enlightenment. The controlled spatial passage suggests that Ando is preparing us to enter the spiritual environment of the temple. As paths direct our passage along the edge of the pool, we discover a stairway that descends into the surface of the water, leading us down to a circular shrine that lies underneath. The narrow form of the staircase leads us to expect a dark, underwater space, but the red-painted shrine itself, when reached, is unexpectedly lit from windows set where the hillside drops away. The central circular area, with a statue of the Buddha flanked by the two mandalas, is surrounded by square rooms for the tea ceremony (see pp. 344–45). The

13.49 Frank Gehry, Guggenheim Museum Bilbao, Spain, 1997. Commissioned by the Solomon R. Guggenheim Foundation.

The architect has pointed out that the titanium used on the outer surface of the building is, given the pollution of industry and automobiles, a more appropriate and durable building material for an urban setting than stone.

CHAPTER 13

progression of spaces, materials, and colors Ando has created is a metaphor for the sponsoring religion. Ando himself wrote that his architecture is intended to create a place "for the spirit to rest." Untraditional in its design, Ando's Lotus Pond Hall uses contemporary innovation to fulfill its centuries-old religious and cultural function.

Pop Art, which originated in the 1950s (see p. 572), continued to play a role in the 1990s. Yu Youhan (b. 1943) painted With Love, Whitney (fig. 13.51) by combining ready-made images: the revolutionary leader Mao Zedong is applauding one of his own principles and the American popular singer Whitney Houston smiles for the camera. The two images were copied in acrylic on canvas from official photographs and draw attention to the manners in which public images are created for celebrities. Yu uses his own version of the deadpan style made famous by Andy Warhol (see fig. 13.17). The Chinese call this style Political Pop, and Yu considers himself to be part of the "avant-garde movement" created by a few young artists who were influenced by ideas about their responsibility to society. Artists of the Chinese avant-garde movement consider themselves intellectuals, as opposed to being members of the official or popular culture. Their goal is to encourage freedom of spirit and expression in a society that, through official stricture and internal social control, stifles creative thought.

In the realm of public sculpture, Pop Art overturned the traditional values that had been associated with monumental sculpture in public spaces. Claes Oldenburg (b. 1929) and Coosje van Bruggen (b. 1942) achieved this by magnifying

13.50 Tadao Ando, Water Temple, Island of Awaji, Japan, 1989–91. Commissioned by Honpukuji.

The Buddhist sect of Honpukuji is affiliated with Old Shingon, a Tantric Buddhist sect that emphasizes meditation based on two mandalas.

13.51 Yu Youhan, With Love, Whitney, 1992. Acrylic on canvas, 3' 5" \times 4' 9" (1.04 \times 1.45 m). Courtesy, Hanart T Z Gallery, Hong Kong.

13.52 Claes Oldenburg and Coosje van Bruggen, *Shuttlecocks* (detail; one of four), 1994. Aluminum and fiberglass-reinforced plastic, painted with polyurethane enamel; each approximately 17' 10" (5.5 m) high. Each shuttlecock weighs approximately 5,500 pounds (2,500 kg). The Nelson-Atkins Museum of Art, Kansas City, Missouri. Commissioned by the Nelson-Atkins Museum of Art and the Morton I. Sosland Family.

The artists found many associations between the shuttlecock form and the Western location of this commission, including the visual analogy to Native American feathered headdresses.

commonplace man-made objects (fig. 13.52). The installation of enormous shuttlecocks on both sides of a museum in Kansas City adds a playfully provoking contrast to the classically inspired design of the building and its ostensibly serious purposes. Oldenburg once remarked that "The important thing about humor is that it opens people. They relax their guard and you can get your serious intention across."

Thomas Struth's (b. 1954) monumental photographs recontextualize how we view art. The photograph of the Giovanni Bellini altarpiece in San Zaccaria, Venice (fig. 13.53) focuses on the work of art within its architectural context. The huge scale of the photograph and our viewpoint, from the central aisle looking toward the sidewall, places us as observers of both the altarpiece and the other visitors in the church. We are reminded that viewing art is an active and ever-changing experience. For most of the week, San Zaccaria has been transformed from a place of worship into a museum; we are here to study Bellini's art and thus the function of his altarpiece has been transformed. In Struth's works, this conceptual dialogue with observation and history is complemented by the contemplative drama of the composition and the interplay of light and color.

Chen Zhen's (1955–2000) Jue Chang (50 Strokes to Each; fig. 13.54) is in at least one sense an international

work of art, for it is made up of weathered chairs, beds, and stools from around the world. Chen altered each piece of furniture by stretching animal hide across its frame to transform it into a drum. These "instruments" hang from a large wooden armature that is itself scarred with age. Dangling within arm's reach are wooden sticks with which viewers are invited to beat the drums. Wherever this has been shown, audiences have taken up this invitation with enthusiasm. Boisterous percussion sounds fill the space and often visitors will join together, coordinating their rhythms.

Jue Chang refers to a Chinese maxim that advises that conflicts be resolved by physically striking the disputing parties. But there is also a spiritual dimension, for in the Buddhist tradition, the master must deal the seeker of enlightenment a sharp blow to jolt him or her out of every-day consciousness. By making the blows audible and percussive, Chen Zhen's Jue Chang (50 Strokes to Each) may even be considered to be therapeutic. The international aspect of the work is thus expanded to include both conflict resolution on a global scale and personal self-understanding. Chen Zhen's remarkable work reveals both how greatly art changed during the period 1950 to 1999 and how contemporary artists are still committed to confronting viewers with issues of profound importance to us all.

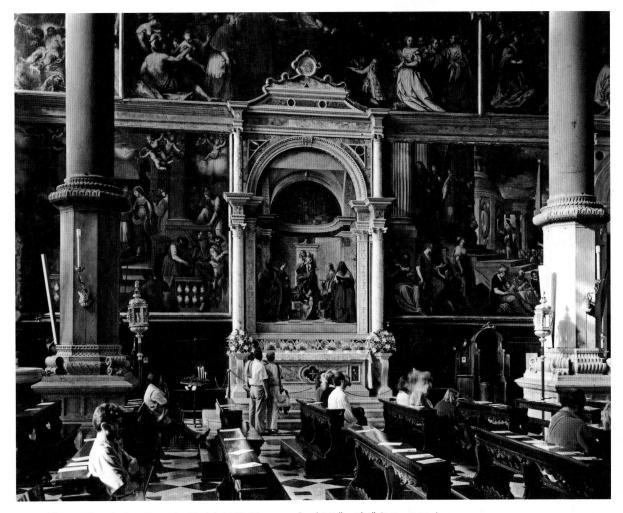

13.53 Thomas Struth, San Zaccaria, Venice, 1995. Photograph, 5' 10%" × 7' 6" (1.8 × 2.3 m).

13.54 Chen Zhen, *Jue Chang (50 Strokes to Each)*, 1998. Wood, iron, chairs, beds, leather, ropes, nails, objects, 8×33 ' (2.44×10 m). Collection of Annie Wong Foundation, Hong Kong.

Zhen was born in Shanghai to an educated family of medical professionals. As an adolescent he was sent to the countryside for "reeducation." When he returned to Shanghai, he studied theater and arts at the Shanghai Fine Arts and Crafts School. He remained in China for another ten years, during which he became one of the leading figures in the Chinese avant-garde movement (see p. 603). When Zhen died suddenly in 2000 at the age of forty-five, he was known for pieces that deliberately produced a "short circuit," a shock of disjunction that might pave the way for more substantial cultural contact. His last works showed a preoccupation with a darker, more personal tone that reflected his philosophical and physical struggle with mortality. His Crystal Landscape of the Inner Body from 2000, for instance, depicts internal human organs crafted out of crystal. His use of such a fragile material reminds us of our own mortality, as well as of the differing approaches in Chinese and Western medicine.

14.1 Cai Guo-qiang, *Transient Rainbow, Fireworks Performance in the Shape of a Rainbow for the Moving of the Museum of Modern Art to Queens*, June 29, 2002. Produced by Fireworks by Grucci Inc. The rapidly moving arch was 500' (152.4 m) wide × 120' (36.6 m) high, and momentarily connected the two banks of the East River at a speed of 100' (30.5 m) per second. Commissioned by the Museum of Modern Art, New York.

Art in the New Millennium

A BRIEF INSIGHT

hen the Museum of Modern Art needed to move for renovations from Manhattan to Queens in 2002, it commissioned Cai Guo-qiang to create a work of art to celebrate the temporary change of address. Cai's response was this pyrotechnic rainbow that arced across the East River toward Queens (fig. 14.1). While the transience of Cai's work corresponds to the temporary nature of the move, the effervescent rainbow was also his personal way of offering a healing message to the citizens of New York after the terrible events of 9/11.

Cai's work combines Chinese philosophy, medicine, geography, and history with the findings of chaos theory, the theory of evolution, and aeronautics.

Cai composes his drawings, installations, and public performances from combinations of extraordinary ingredients and takes advantage of today's cutting-edge technologies, such as interactive computer control systems and synthetic materials.

Transient Rainbow exploded and then disappeared; the philosophy of change and renewal are at the heart of Daoist teaching. How to engage traditional Chinese thinking in the contemporary global world is a common issue among Chinese artists today.

Art in the New Millennium

uch of the world greeted the new millennium with a spirit of optimism. At least in some parts of the world, there were reasons for such hope. Strife in Northern Ireland and the Middle East had diminished, North and South Korea were preparing a peace accord, a moderate government had been installed in Iran, and the deciphering of the human genome promised advances in medicine. All too soon, however, continuing conflicts escalated with even greater ferocity, especially between Israelis and Palestinians, and between Hindus and Muslims in India and Pakistan. Regional disorder bred terrorism across the world, from Bali to Moscow, from the Philippines to Saudi Arabia. On September 11, 2001, al-Qaeda terrorists hijacked four planes, crashing one into the Pentagon and two others into the twin towers of the World Trade Center in New York City. Within two hours of impact, the towers collapsed. The fourth hijacked plane was brought down by its crew and passengers in southwestern Pennsylvania before it could reach its intended target. In response, the U.S. attacked the Taliban regime, who harbored al-Qaeda in Afghanistan. After invading Afghanistan, the U.S. invaded Iraq in 2003 ostensibly to prevent the spread of "weapons of mass destruction." However, after deposing Iraq's dictator of 35 years and dismantling the Iraqi state, American efforts became mired in sectarian violence. Meanwhile elsewhere, North Korea announced that it possessed nuclear weapons and had the capacity to manufacture additional ones. The loss of a second space shuttle, Columbia, and a massive electric power blackout in the U.S. in August 2003 again demonstrated that we are, at times, subjects, not masters, of technology. Dramatic and devastating natural disasters have humbled humanity; in 2004 a massive tsunami in the Indian Ocean killed approximately 230,000 people in South Asia, and a year later, Hurricane Katrina devastated America's Gulf Coast, displacing two million people and destroying 350,000 homes.

The pluralistic and global art that characterized the last decades of the twentieth century and the potent individualism of contemporary society raise the possibility that never again will there be a unified style practiced by a large number of artists working together toward a common goal. The end of the twentieth century may have marked the end of the many "isms" that have characterized art for so many centuries. Our sampling of artists working in this new millennium is intended to reflect this diversity. While we have space to illustrate only a limited number of artists, a brief list of additional artists, whose works can be seen on the Internet, is suggestive of the infinite range that characterizes the art of our time. Unexpected materials used for art in the

last few years, for example, include: dried chilies combined with thrift-store cutlery (Simryn Gill); Nike Air Jordans to make masks evocative of Native American objects (Brian Jungen); chocolate syrup, peanut butter, caviar, spaghetti, dust, sand, nuts, bolts, electronic gear, chains, nets, the contents of a junk yard (Vik Muniz); pastry (Teresita Fernández and Ghada Amer, in collaboration with Reza Farkhondeh); old boats and other derelict watercraft (Nancy Rubins); light bulbs and a mist machine (Olafur Eliasson); a cage with figures of children covered with birdseed and 150 hungry pigeons (Kader Attia); a platinum cast of a human skull covered with 8,601 of the highest-quality diamonds and entitled For the Love of God (Damian Hirst); a giant balloon with a question mark in camouflage pattern (Hiroharu Mori); a wall hanging made of discarded soda cans (El Anatsui); and even the use of slabs of raw meat to create a suit worn by the artist (Zhang Huan).

An installation by Mona Hatoum set a video screen into a plate on a table; in the center of the plate was a continuous video showing a tour of the human digestive tract. Unexpected techniques include prints made by inking scars on the human body and then applying paper to make a direct contact print (Ted Meyer); images made by directly scanning such natural materials as frog skeletons and dried flowers (Robert Creamer); projecting more than 200 smiling faces of New Yorkers onto Rockefeller Center (Agnes Winter); and the creation of an installation by cutting up a Persian rug to create the shape of the maze on the floor of Chartres Cathedral (Su-Mei Tse). Even the settings where we now find art on display can surprise us; for example, Boston's Forest Hills Cemetery now hosts exhibitions of contemporary art within the historic cemetery grounds.

Like a bird set free from a child's hand—this is the metaphor that the Spanish architect Santiago Calatrava (b. 1951) uses to describe his design for the World Trade Center Transportation Hub (fig. 14.2). Following the 9/11 attack on New York's World Trade Center towers, design competitions were held for buildings and memorials to be built where the tower complex had stood. Calatrava's design was selected to replace the underground train terminal that had been destroyed that day; his model joins the metaphoric meaning of flight and hope with an emphasis on revealed structure. Calatrava was trained as both an architect and civil engineer, but his work is also acclaimed as sculpture.

Conforming with architect Daniel Libeskind's master plan for rebuilding on the World Trade Center site, Calatrava orients the station so that "The Wedge of Light" from the sun's rays will illuminate the footprint of the former World Trade Center towers each year on September 11th. *The*

14.2 Santiago Calatrava, World Trade Center Transportation Hub, New York City, 2004-07. Steel and glass. Commissioned by the Port Authority of New York and New Jersey.

New York Times architectural critic Herbert Muschamp captured the spirituality and promise of Calatrava's design when he wrote that it had "the power to shape the future of New York."

One feature of contemporary architecture is the restoration of interesting older buildings to serve new purposes. By the 1990s, the Tate Collection's holdings of modern art had become so extensive that a new museum was needed. Rather than build a new structure, an abandoned London power plant was recycled by the Swiss architectural firm of Herzog & de Meuron, who transformed the huge industrial interior spaces that had once housed boilers and turbines into a clean, almost minimalist environment for the display of modern painting and sculpture. By 2006 the Tate Modern, which with more than four million visitors a year now claimed to be the most visited modern art museum on earth, announced that they had commissioned Herzog & de Meuron to design an eleven-story extension to the original structure (fig. 14.3). In contrast to the simple geometry of the original industrial structure, the extension will be dramatically modern, suggesting a pile of glass boxes that will shimmer by day and glow by night. The new building conforms to the goal of "destination architecture" exemplified by Frank Gehry's Guggenheim Museum in Bilbao, which brought revitalization to a fading industrial center (see fig. 13.49).

14.3 Jacques Herzog and Pierre de Meuron, Tate Modern Extension, 2006-12, London. Commissioned by Tate Modern.

Naturally, destination is also a factor in modern commercial design. Innovative architecture, hi-tech, and haute couture consumerism meet in New York City at the Prada Flagship Store in SoHo (fig. 14.4). Designed by Rem Koolhaas (b. 1944), Prada SoHo might best be described by using the phrase "moveable feast" that was coined by Ernest Hemingway in the early twentieth century, although in the case of Prada SoHo, a "changeable feast" might better capture the store's appeal. Inside the store, areas that seem unfinished contrast with a treasure of commercial technology, from liquid-crystal film glass doors in dressing rooms, which become opaque as the flow of electricity is cut off, to a cylindrical glass elevator and moveable display cages which hang from the ceiling; from video monitors adjacent to mirrors that allow the customer to view the "fit" of clothes on their front and back simultaneously to the latest in information technology to assist customer service. Much of the store's retail space is on the basement level, which connects to the street-level floor by an enormous curving wooden form that Koolhaas has termed a "big wave." The "wave" functions as a huge minimalist sculptural form, a display area, a staircase, and, on occasion, a performance space. The interior spaces of Prada SoHo have the ability to

reinvent themselves, and, when combined with the technological enhancements, create an interactivity between the customer and the store that lifts the act of shopping to the level of artistic engagement.

In his concept for Prada SoHo, Koolhaas incorporated new technology that complimented the design and supported the commercial purpose of the building. In our new millennium, artists often forefront an innovative use of electronic media as a means of creative exploration. Mariko Mori's (b. 1967) art explores the relationship between the individual and an interconnected cosmos. Her Wave UFO (fig. 14.5) sets out to provide an experience that can express the inner self through biofeedback. Mori's futuristic pearl-white fiberglass pod, based on the shape of a drop of water, accommodates three visitors. After reclining in special chairs, electrodes are attached to each visitor and they begin to experience a six-minute "journey" on a domed screen above. The initial part of the journey portrays a descent from the universe toward earth, to the spaceship-like pod in which the visitors are reclining. Brainwave data being gathered from the three participants by the electrodes are then translated by software into animated abstract computer graphics, creating a form of

14.4 Rem Koolhaas, Prada Flagship Store, SoHo, New York City, 2001. Commissioned by the Prada Company.

14.5 Mariko Mori, Wave UFO, 2003. Brain-wave interface, vision dome, projector, computer system, fiberglass, Technogel, acrylic, carbon fiber, aluminum, magnesium, 194 × 446.5 × 208" (4.93 × $113.4 \times 5.28 \text{ m}$).

The fiberglass shell of the pod was made by Modelleria Angelino, an Italian company that makes the bodies for Lamborghini automobiles. When this work was first shown, in Austria, it attracted 10,000 visitors over a period of six weeks.

simultaneous biofeedback for the three participants. This brainwave visualization takes the form of changing patterns of colored shapes that generally represent different psychological states (red shapes, for example, indicated alertness or alarm). The final part of the journey fuses the data from the three individuals with a program based on a series of images created by Mori; the resulting coherence creates, in Mori's words, "a deeper consciousness in which the self and the universe become interconnected."

A completely different experience is offered by Joyce Kozloff (b. 1942), whose Targets (fig. 14.6) is a large wooden globe with one segment removed so that a visitor may enter. The interior is covered with segments of maps from twenty-four countries. Each map is dated to a period during which that country was bombed by the United States (for example, Korea 1950-53, Vietnam 1961-73, Yugoslavia 1999). The maps that Kozloff uses were originally made to aid pilots in locating bombing sites, but each has been

14.6 Joyce Kozloff, Targets, 1999-2000. Wood, maps, 9' (2.74 m) diameter.

14.7 Vito Acconci, *The Island in the Mur*, Graz, Austria, 2003. Acconci himself describes the materials of his island as "steel, glass, rubber, asphalt, water, and light." 10,310 square feet (3,142.5 sq m). Commissioned by the City of Graz.

The original idea for an island in the Mur was evolved by Robert Punkenhofer, who envisioned "a multifunctional, futuristic platform that offers a new public space for communication, adventure, and artistic creation."

enlarged and painted using a distinctive palette. Kozloff's work reacts to sobering statistics about the number of civilians that have been killed by American bombing raids around the world since 1945. When questioned about the work, the artist stated, "I wanted to make a large and public statement, to break through the apathy that I myself have been a part of."

The concept of creating a work of art that physically envelops us also guided, at a much expanded scale, The Island in the Mur (fig. 14.7) by Vito Acconci (b. 1940). The Mur River flows through the heart of Graz, Austria, and to celebrate the city's selection as the 2003 European Capital of Culture, Acconci was commissioned to create a humanmade island that would connect both river banks via footbridges. Interconnected stainless-steel sheets reveal their structural essence in a manner akin to Calatrava's World Trade Center Transportation Hub (see fig. 14.2), while the interplay of interior and exterior space would seem to have its roots in the designs of Frank Lloyd Wright (see figs. 1.7, 1.10-1.11, 12.30-12.32). Acconci's floating island, which offers fluid spaces that can morph from a children's playground to an open-air theater and a café, has become a place of relaxation and pleasure for Graz's residents. And,

from its location in the river, the island affords new viewpoints over to the city, giving the opportunity, as art does, for new perspectives on the familiar.

Perception and discovery are also part of our experience of Richard Serra's (b. 1939) *Torqued Ellipses* (fig. 14.8), a permanent installation of steel sculptures in the largest gallery—longer than a football field—of Frank Gehry's Guggenheim Museum Bilbao (see fig. 13.49). *Torqued Ellipses* represents a culmination of the pure modernist sculpture introduced by Mininalism in the 1960s (see fig. 13.18); here, however, the enormous curving steel forms seem to deny their materiality, as the sheets of steel flow and billow like fabric. Serra's sculptures draw us in, calling to us to wander through their maze—like passages, constantly changing our perception and expectation of our surroundings. In these sculptures, space becomes the dominant feature, as noted by Serra:

In most of the work that preceded the *Torqued Ellipses*, I was forming the space in between the material that I was manipulating.... In these pieces by contrast, I was starting with the void, that is, starting with the space, starting from the inside out ... in order to find the skin.

14.8 Richard Serra, Torqued Ellipses, 2003-05. Weatherproof steel plates, 12-14' (3.7-4.3 m) tall. Guggenheim Museum, Bilbao, Spain. Commissioned by the Guggenheim Museum and the Basque Regional Government.

In creating Torqued Ellipses, Serra was influenced by the elliptical, elastic structure of Borromini's dome in San Carlo alle Quattro Fontane (see figs. 9.29, 9.30) and the meditative quality of Zen gardens (see fig. 8.1). As we walk through the many sculpted passageways create by Serra, we are not permitted a "fixed" view of our environment; rather, our perspective is transformed in a way that, as one critic wrote, "is deeply humane, not least because it counts on individual perception, individual discovery." Individuality has been a hallmark of modern art, and the pluralism of 21st-century art is proof of its continued importance.

Film and video continue to have a significant impact on contemporary art. Matthew Barney's (b. 1967) Cremaster films offer multilayered metaphors that deal with the biological functions centering around reproduction. Such a simple statement, however, belies the inventive extravagance with which Barney relates cellular activities and the bizarre episodes that he has filmed. These often feature characters in exotic costumes in unexpected locales. Cremaster 3 (fig. 14.9), the final film in a series of five, opens with five Chrysler Imperial autos playing demolition derby with a black car in the lobby of New York's Chrysler Building. The film ends with the Rockettes doing

14.9 Matthew Barney, Cremaster 3, 2003. Film still.

a precision dance routine on the ramp of the Guggenheim Museum while two punk bands and their fans clash. The film critic David Finkelstein views the opening sequence as suggestive of "the ruthless and repetitive attacks of the immune system's Killer Cells," and the Guggenheim scene, where angry fans are restrained by museum staff, as emblematic of "the way the body can keep certain infections in a state of constant control," which then becomes a metaphor for "the way violent youth culture is commodified and kept under control by capitalism." Barney's films open themselves to a variety of interpretations, engaging the audience as active participants as they attempt to decipher the layers of meaning of the works.

In Bill Viola's (b. 1951) video installation *Five Angels for the Millennium* (fig. **14.10**), five monitors in a darkened room show large images of human figures slowly emerging from water or plunging into it; the movements of the figures were shot at high speed and then dramatically slowed down. The patterns that are created by their movement as they enter and exit from the water suggest angels, whom

Viola considers to be "messengers between the spiritual world and the world of consciousness." The experience is enhanced by sound effects that suggest both the agitation of water and electronically produced noise, while the viewpoint of the observer shifts between an underwater view and looking down from above at the water's surface. The ethereal movement of the figures in their passage out of the water has a deeper meaning. Viola has said: "Art can have a healing function. What you see on the screen can become part of the life process, it can seep into your body and you can take these things and use them."

Julie Mehretu's (b. 1970) Empirical Construction, Istanbul (fig. 14.11) is an enormous, dynamic, multi-layered, and almost kaleidoscopic vision of an urban environment that illustrates how environment defines civilization and how we engage urban living through maps, architectural forms and plans, as well as through the abstracted energy that constitutes a city's vitality.

Here, representational forms and references are layered within a personal vocabulary of symbols and abstract colors

14.10 Bill Viola, *Five Angels for the Millennium*, 2001. Edition of three. Installation. Five channels of color video projection on walls in large, dark rooms; stereo sound for each projection; projected images 7' $10\frac{1}{2}$ " × 10' 6" $(2.4 \times 3.2 \text{ m})$ each.

Five Angels for the Millennium is one of a series of video works by Bill Viola that he has entitled *The Passions*. The theme that unites the works is the expression of emotion.

14.11 Julie Mehretu, Empirical Construction, Istanbul, 2003. Ink and synthetic polymer on canvas, $10 \times 15'$ (3.05 × 4.57 m). Museum of Modern Art, New York.

and lines, creating an energized visual language that opens us to a psychological encounter with history, expressed through the architectural references and the fragmentary impressions we receive as we enter a new place. Mehretu views this work as "a cultural response to Istanbul," created from her personal experience of the city, panoramic photographs, architectural plans, and other visual inspirations. In a larger sense, Mehretu notes, "I'm making pictures that are about what is happening in the world in abstract terms but is not an illustration of what is going on in current events." Rather than setting out to tell a narrative, the goal is to capture the essence of experience.

The photographs of Andreas Gursky (b. 1955) are enormous in size, visually stunning, and often present a dialogue between architecture and our human presence. Shanghai (fig. 14.12) was created from four negatives. The massive, curving rhythms of the hotel's interior establish visual patterns, on a grand scale, that are somewhat similar to the optical effects of Op Art (see p. 579). The immediate effect of the scene is one of abstract patterns, but the presence of minute human figures transforms it into something more realistic. Confronted by the vastness of contemporary architecture, which itself is encouraged by technological capabilities, we are left wondering about our role in a world

14.12 Andreas Gursky, Shanghai, 2000. Photograph, 9' 2%" × 6' 63/4" $(2.8 \times 2 \text{ m}).$

The picture is a view of a grand hotel lobby in which the guest rooms are accessible from balconies. The extraordinary size of this and other contemporary photographs (see fig. 13.53) is made possible by technological developments.

where technology serves, but can also overcome us. Concerning modern life, Gursky has commented: "We are alone on this planet. It is not a choice. Here we are. This is what everyone has to deal with."

Although relatively small in size, Battle of the Giants (fig. 14.13) by the twins Armit and Rabindra K.D. Kaur Singh (b. 1966) has the visual impact of a huge billboard. Set against a field of prominent "sponsor" logos and two goalposts, two elephants are locked in combat. Their bodies, however, are composed of white American football players and black rugby players. With player number 5 reaching for the ball, we can interpret the action as a scrum, where both teams fight for possession of the ball. The prominence of corporate logos reminds us not only of the ever-increasing commercial sponsorship evident at sporting events but also of the manner in which certain brands shown here have become global. The fact that the referee, who is shown seated atop the white elephant, is Ronald McDonald suggests that the role of American corporations in the game of global business may have an advantage. The New Zealand All Blacks rugby team, depicted here as the black elephant, played its first international competition in 1893, and even as a colonial team gained a reputation as a top-ranked team in the world and offered an early challenge to colonial notions of white superiority. The Singh twins have written that pitting the black team against the white Americans also suggests "the reassertion of traditional cultural identities against the westernizing tendencies of globalization."

The large-scale installations of Kara Walker (b. 1969) continue the lineage of socially conscious art into the twenty-first century. Walker's technique involves cutting out large silhouettes from black paper and mounting them on museum and gallery walls to suggest a narrative progression. These figures often conform to racial stereotypes, and the stories they act out blend fact and fiction, prejudice and the cruelest realities. Set in the antebellum south, *Insurrection!* (Our Tools Were Rudimentary, Yet We Pressed On) (fig. 14.14) combines cut and projected silhouettes. Scenes in the narrative include a plantation owner who propositions a naked slave, a slave woman with a baby who narrowly escapes lynching, and the torture of another slave.

14.13 Armit and Rabindra K.D. Kaur Singh (Singh Twins), *Battle of the Giants*, 2002. Poster-color and gouache on paper, $17\% \times 12\%$ " (47×31.5 cm).

14.14 Kara Walker, Insurrection! (Our Tools Were Rudimentary, Yet We Pressed On), Installation at the Guggenheim Museum, New York City, 2000. Cut paper silhouettes and light projection, site-specific dimensions.

As we view the installation, projected light casts our shadows on the walls, involving us in the convulsive story of race relations in America. Walker presents us with an interpretation of American history that avoids simplification; everyone from slave to slave-owner becomes a victim of the inhumanity inherent in the system. Walker's appropriation of the silhouette technique is historical, for on a much smaller scale silhouettes were popular during the time of slavery.

British artist Andy Goldsworthy (b. 1956) recreates nature in works that both draw our attention to the natural environment and, through their ephemeral quality, partake of the cycle of growth and decay. Working with materials at hand—leaves, pine needles, twigs, stones, snowballs (transported to London in June), and even icicles (fig. 14.15)—Goldsworthy creates

14.15 Andy Goldsworthy, Icicles, January 2002. Scaur Water, Penpont, Dumfriesshire, Scotland.

compositions that respect the physical conditions of the environment while at the same time encouraging our understanding of the possibilities inherent in the natural world. Most of Goldsworthy's works are preserved only through photography and film. Speaking of his art, Goldsworthy comments:

Movement, change, light, growth and decay are the lifeblood of nature, the energies I try to tap through my work. I need the shock of touch, the resistance of place, materials and weather, the earth as my source. Nature is in a state of change and that change is the key to understanding. I want my art to be sensitive and alert to changes in material, season, and weather. Each work grows, stays, decays. Process and decay are implicit. Transience in my work reflects what I find in nature.

In 2003 Ann Hamilton created Corpus (fig. 14.16) for a gallery the size of a football field at the Massachusetts Museum of Contemporary Art. This was installation art on a massive scale that proposed a contemplation on the modes of human communication. During the ten-month period of the exhibition, pneumatic machines lifted to the ceiling, and then dropped, translucent onionskin paper, forty sheets at a time, with a rhythm that resembled breathing. Twenty-four horn-shaped speakers slowly lowered from the rafters to touch the papers on the floor and then raised again to the ceiling. The speakers emitted the sound of human voices, sometimes in unison, and their configuration as they were lowered created a central aisle, like that of a basilica or church (see figs. 4.48, 5.12). The only light entering the gallery was filtered by red or magenta silk fabric on the windows. The effect of the colored light, the implication of a central aisle, and the stream of voices created an effect reminiscent of a church. Accompanying the voices was the sound of visitors as they waded through the

accumulated papers on the floor. In a second, smaller and darker room, four spinning speakers emitted breathing sounds. A third experience was offered on the large gallery's balcony, where rows of rough timber benches offered a place for meditation. The director of the museum expressed the essence of Hamilton's installation when he wrote, "Being in one of her evocative installations engages all the senses: they are experiential, immersive, kinesthetic, and, in this case, grand, liturgical without liturgy."

Like Richard Serra, the artistic career of Chuck Close (b. 1940) reaches back decades. In the 1960s, Close created large portraits in a photo-realist style (see pp. 580-81). To better understand the photographs from which he was working, Close also made small studies in which he broke down the photograph into squares so that he could examine the value and other distinctions from block to block. Determined to continue working as an artist after a brain aneurism in 1988 confined him to a wheelchair, Close developed a system for painting large portraits based on the technique he had earlier developed for his small studies. He now works with a motorized lift and brushes strapped to his wrists. Painting on canvas, Close creates row after row of seemingly quickly painted color blocks that merge at a distance to form a startling likeness of the sitter. These works offer a number of different aesthetic experiences, as the effect of studying them closely is completely different from the totality that emerges from a distant view. Close's new technique, which involves producing visual unity from multiplicity, is exemplified in a recent Self-Portrait (fig. 14.17).

The Roden Crater project (fig. 14.18), by James Turrell (b. 1943), is an ambitious project now nearing completion after decades of planning and activity. Turrell's goal is to transform a long-dormant volcanic crater into an observatory that will be, in many ways, similar to those created by pre-

14.16 Ann Hamilton, *Corpus*, installation for 2 galleries of Building 5 of the Massachusetts Museum of Contemporary Art, North Adams, Massachusetts, 2003–04. Translucent onionskin paper, 24 speakers, red and magenta silk organza, video projection, 30 wooden benches, 4 spinning speakers.

14.17 Chuck Close, Self-Portrait, 2005. Oil on canvas, 108¾ × 84" (2.76 × 2.13 m). Courtesy Pace Wildenstein, New York.

historic peoples at Stonehenge (see fig. 2.8), by the Anasazi at Chaco Canyon, and by other early societies. Using the movements of celestial bodies—the sun, moon, stars, and planets—the crater will track the passage of time. Turrell often uses musical metaphors to discuss his work at Roden Crater, stating "This is my symphony" and that he is conducting "the music of the spheres played out through light." Without damaging the shape of the crater, Turrell is constructing four "celestial observation chambers" that will be oriented to the cardinal directions; each will be designed to catch, reflect, or enclose natural light in a particular manner. Turrell has said, "I want people to actually see light as a tangible entity." Some of the rooms will function like a larger version of the camera obscura that was used by the Dutch seventeenth-century painter Vermeer and others; at Roden Crater, for example, a large-scale image of the moon will be projected onto the wall of one of the chambers once every 19.81 years. Turrell has set out to revive the sensitivity to the rhythms of the sky and the changing seasons that was common among our prehistoric ancestors. Those who have experienced Roden Crater even in its unfinished stage have reported that it "will forever change the way they perceive their place in the universe." Such a response is based in part on understanding that some of the light being projected into Turrell's chambers has had to travel through space for millions of years before arriving. Although computers have played an important role in calculating the design of Roden Crater, the final spaces will be permanent stone chambers and passageways that will function

14.18 James Turrell, Roden Crater project, 1974-present. San Francisco Volcanic Field, near Flagstaff, Arizona.

Turrell plans to complete the Roden Crater project sometime before 2010. It is estimated that the crater was formed about 500,000 years ago. Because ambient light could ruin some of the effects that Turrell intends at Roden Crater, he has acquired almost 150 square miles (241 sq km) of land around the crater.

without technology; nothing will ever wear out. Like Stonehenge, Roden Crater will continue its relationship to the heavens, whether or not anyone is there to watch.

A very different way of connecting with nature is evident in the work of Charwei Tsai (b. 1980), a Taiwanese artist educated in the West. To create *Frog Mantra*, she brushed text onto the body of a living tree frog (fig. **14.19**). Tsai has memorized the *Heart Sutra*, a Buddhist text that equates emptiness with enlightenment, suggesting that we may be released from suffering only when freed from the senses. Using traditional calligraphy, she brushes this text onto tofu, lemons, trees, and, in this case, a frog. The

beauty of her calligraphy transforms these objects, and when you know the meaning of her text you can understand why she has chosen these surfaces for her meditation. Because she works with organic and even living materials, she knows her work will deteriorate, assisting her in her goal to achieve emptiness and, thus, enlightenment.

The new millennium has witnessed continuing innovation in the world of art and architecture, but the world of art has also had to endure attacks. While the destruction of art is not a modern development, it reached a new low with the destruction of two colossal Buddhas in Bamiyan, Afghanistan in March, 2001 (figs. 14.20, 14.21).

14.19 Charwei Tsai, *Frog Mantra*, 2006. Tree frog, olive branch, and ink.

These enormous Buddhas had been carved some time around the fifth century into the side of a cliff at the end of a valley along the ancient Silk Road. The colossal scale of the figures was a deliberate attempt to express the spiritual size of the Buddha when compared to that of an ordinary human; the Buddhas reached almost to the top of the cliff and one suspects that, had the cliff been even taller, the sculptures would have been even larger. Inscriptions and the iconographic context at Bamiyan indicate that this cult was specifically related to Vairocana, the Buddha in whom the totality of the universe is personified, a concept expressed here through the figure's colossal size.

The Taliban, the ruling group at the time in Afghanistan, used dynamite to destroy this Buddha in 2001, a millennium and a half after its creation. This fundamentalist Muslim group had banned the practice of other religions and did not allow the representation of holy persons during their rule. On this basis alone, the Bamiyan Buddha was offensive to the Taliban, but its venerable age and colossal size were apparently also a factor in its destruction. The destruction reached a worldwide audience through television reports and sent a clear message that the Taliban could not tolerate any other religion. Yet, even through its absence, the Bamiyan Buddha reveals how the potency of art survives undiminished in our world.

14.21 After the destruction of the Buddha image, Bamiyan, Afghanistan, March 2001.

14.20 Buddha, Bamiyan, Afghanistan, c. fifth century (destroyed 2001). Native sandstone with mud, plaster, rope, paint; height 120' (37 m).

The figure here was roughly carved from the soft stone of the cliff, while the drapery was created by applying a mixture of mud and lime plaster to the surface. Ropes added to create the ridges of the drapery folds were covered with mud plaster and the whole was then painted. The niche that surrounds the head of the figure created a type of halo; its surface was painted to describe paradise, complete with music-playing apsaras (angels).

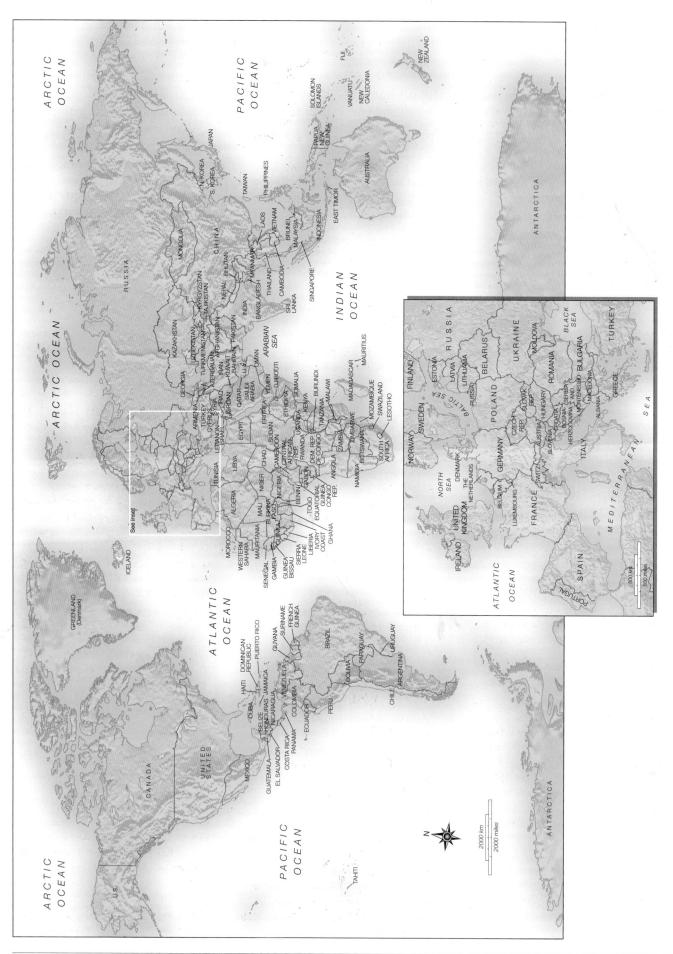

Glossary

Definitions in the glossary are intentionally short; for further information and illustrations, consult the references listed. Words in CAPITAL LETTERS within an entry are defined elsewhere in the glossary.

A

- ABACUS: on a DORIC CAPITAL, the flat slab between the rounded ECHINUS and the ENTABLATURE; see fig. 3.68.
- ACROPOLIS: in ancient Greek cities, a fortified citadel and the site of the most important civic and religious buildings. The most famous is in Athens and is now called simply the Acropolis.
- AERIAL PERSPECTIVE: see ATMOSPHERIC PERSPECTIVE.
- AIRBRUSH: a device for spraying paint or other liquid MEDIA. The medium is mixed with compressed air and sprayed through a nozzle; see fig. 13.21.
- AISLES: corridors flanking a large central area; Old St. Peter's BASILICA has two aisles on either side of its central NAVE (figs. 5.12, 5.13). Also known as side aisles.
- ALTAR: a raised structure, usually table-like, on which offerings are sacrificed, incense burned, or sacred objects kept. Christian altars usually consist of a consecrated slabtraditionally of stone and called a mensaon a base.
- ALTARPIECE: a painted and/or sculpted work of art that stands as a religious image upon and at the back of an ALTAR; see the Van Eycks' Altarpiece of the Lamb (figs. 7.23, 7.24).
- AMBULATORY: a circular or semicircular vaulted passage, as at Chartres (fig. 6.29).
- AMPHITHEATER: a circular or oval building with tiered seats for sports and entertainment, developed by the ancient Romans; e.g., the Colosseum or Flavian Amphitheater (figs. 4.46, 4.47).
- AMPHORA: an ancient Greek vase used to store olive oil, honey, or wine; see fig. 3.59.
- ANICONIC: the representation of a deity by symbols rather than by figural form, as at Sanchi (fig. 4.23).
- ANNULAR VAULT: a structural system composed of a series of vaults arranged in a curving or circular configuration; for examples see the ancient Roman Colosseum (figs. 4.46, 4.47) and the AMBULATORY at Chartres (fig. 6.29).

- APSE: in architecture, an area composed of a half cylinder or semipolygonal form surmounted by a half dome or VAULTING, as an Old St. Peter's (fig. 5.13) and Chartres (fig. 6.29).
- ARCADE: a series of ARCHES with their supporting COLUMNS or PIERS, as in the NAVE arcades at Chartres (fig. 6.27) and Santo Spirito (fig. 7.29).
- ARCH: a means of construction in which an opening, often semicircular, is spanned by a series of wedge-shaped elements (VOUSSOIRS and a KEYSTONE); see fig. 4.50.
- ARCHITRAVE: in architecture, the lowest part of an ENTABLATURE; see fig. 3.68.
- ARCHIVOLTS: the moldings that enframe the TYMPANUM in a Romanesque or Gothic church; often decorated with sculpture, as at Vézelay (fig. 6.13).
- ASSEMBLAGE: a work of art that combines actual three-dimensional objects, some of that may be "found" objects from the household or the junkyard; see fig. 13.7.
- ATMOSPHERIC PERSPECTIVE: a device, used in painting to suggest PERSPECTIVE, in which forms nearer the horizon are blurred and their color is less intense and higher in VALUE, while the sky gradually shades from blue toward white above the horizon, as in Raphael's Philosophy (figs. 1.18, 7.20). Also known as AERIAL PERSPECTIVE.
- ATRIUM: an open courtyard, sometimes surrounded by a COLONNADE, found at the entrance to a Roman house (fig. 4.29) or a Christian church (fig. 5.13).
- AVANT-GARDE: a French term meaning advanced guard, which, in the nineteenth century, was applied to artists or movements considered to be new, radical, and often revolutionary. For example, the ideas and work of Gustave Courbet were regarded as avant-garde within the context of midnineteenth-century French painting; see pp. 458-59.
- AXIAL COMPOSITION or organization: a compositional pattern with a central AXIS and BILATERAL SYMMETRY, giving an impression of balance; see Botticelli's Birth of Venus (fig. 7.48).
- AXIS: the imaginary straight line that passes through the center of figures or forms, or through an architectural composition. An analysis of the axes of a work helps establish its COMPOSITION.

- BALDACCHINO: a canopy over an ALTAR or throne; e.g., Bernini's at St. Peter's (fig. 9.22).
- BALLOON FRAME: an architectural structure in which wooden beams are joined horizontally and vertically to create a gridlike structural system; e.g., Davis's wooden house (fig. 11.33).
- BALUSTRADE: a low parapet or barrier formed of uprights, called balusters, topped by a rail.
- BAREN: a disk-shaped pad used to push ink onto the paper when making a Japanese woodblock print; see fig. 11.26.
- BARREL VAULT: a deep ARCH that normally requires continuous BUTTRESSING; see fig. 4.50. Also known as a tunnel vault.
- BASILICA: to the ancient Romans, a large building used for public administration, as in the Basilica Ulpia in Rome (fig. 4.48). In Christian times, a specific type of structure, with a central NAVE, CLERESTORY, flanking AISLES, and APSE, as at Old St. Peter's (figs. 5.12, 5.13).
- BAS-RELIEF: relief sculpture in which flattened figures or forms project only very slightly from the background; e.g., the Palette of Narmer (fig. 3.17). Also known as LOW RELIEF.
- BATTERED WALL: a wall that slopes or slants inward toward the top, as in ancient Egyptian MASTABAS (fig. 3.21) and PYLONS (fig. 3.25).
- BAYS: individual units of space defined by the PIERS and VAULTS in a vaulted structural system; the plan of the Gothic cathedral of Chartres (fig. 6.29), for example, reveals that the NAVE is seven bays long. Bays also refer to the vertical divisions of the exterior or interior surfaces of a building, as marked by such elements as windows, BUTTRESSES, COLUMNS, etc.
- BILATERAL SYMMETRY: representations of people and objects in which both halves look essentially identical.
- BOOK OF HOURS: a book of private devotions with prayers for the seven canonical hours of the Roman Catholic church. Sometimes contains a calendar and is illustrated with illuminations (figs. 7.14, 7.15).
- BUON FRESCO: see FRESCO.
- BURIN: a tool with a sharp metal point used in the decoration of Greek vases (fig. 3.58)

- and in making ETCHINGS (see pp. 378–79). BURR: the tiny raised fillings of copper on either side of the groove created in the DRYPOINT TECHNIQUE; the burr catches the ink and creates rich areas of deep, soft shadow.
- BUTTRESS, BUTTRESSING: the projecting support that counteracts the outward THRUST of an ARCH or wall; see figs. 4.50, 6.31. See also FLYING BUTTRESS.

C

- CALLIGRAPHY: fine penmanship or beautiful writing (figs. 5.31, 6.26).
- CALYX KRATER: an ancient Greek bowl with handles used for mixing wine with water; see fig. 3.60.
- CAMERA OBSCURA: an enclosed box with an opening that allows an image to be projected inside the box; sometimes used by artists, including Vermeer (fig. 9.18), as a tool for understanding PERSPECTIVE recession.
- CANTILEVER: a support system in which an architectural member projects horizontally into space, beyond its supports, as in Wright's Fallingwater (fig. 1.7).
- CAPITAL: the decorated top of a COLUMN, PIER, or PILASTER; often helps effect an aesthetic transition from the vertical column to the horizontal ENTABLATURE; for examples from the Greek and Roman ORDERS, see fig. 3.68.
- CARVING: in sculpture, a subtractive process in which form is created by cutting into a medium, usually stone or wood, thereby releasing, or subtracting, excess parts of the medium (see fig. 7.13). The term also may refer to works of art fashioned by this technique. See also MODELING.
- CAST SHADOWS: the shadows cast by an object onto surrounding surfaces and objects. In a painting, these shadows help increase the ILLUSIONISM, as in the ancient Roman still life (fig. 4.45).
- CATACOMB: an underground complex of tunnels and rooms, used in ancient Roman times by Romans, Jews, and Christians for burial purposes; for a painting from a catacomb, see fig. 5.10.
- CENTERING: the temporary wooden support upon which an ARCH or VAULT is constructed; see fig. 4.50.
- CENTRALLY PLANNED: denotes an architectural design in which regularized units radiate, usually at 90° angles, from a central area, often surmounted by a dome, as in the original High Renaissance design for St. Peter's in Rome (fig. 8.27).
- CHAITYA HALL: an Indian Buddhist

- architectural form with a pillared, central NAVE, two side AISLES, an AMBULATORY, and a high BARREL VAULT; many are carved out of living rock with a STUPA in the APSE; see figs. 5.18, 5.41.
- CHATTRI: a domed pavilion supported on slender COLONNETTES used in Muslim architecture; see fig. 9.26.
- CHIAROSCURO: in painting and printmaking, the use of a contrast of VALUES to create effects of MODELING; see the Roman still life (figs. 4.45).
- CHOIR: in a Christian church, an enclosed area near the ALTAR where the monks or nuns chant the services, as at Chartres (fig. 6.29).
- CHUMON: the entrance gate to a Japanese Buddhist temple area, as at Horyu-ji (figs. 5.36, 5.37).
- CLERESTORY: in architecture, an area elevated above adjacent rooftops, usually along a central AXIS. Its purpose is to allow light into the interior, and it has windows on the sides, as in the Egyptian HYPOSTYLE hall (fig. 3.26), Old St. Peter's (fig. 5.12), Chartres (figs. 6.27, 6.28), Santo Spirito (fig. 7.29), and elsewhere.
- CLOISTER: an open court within a MONASTERY, usually with an open ARCADE or COLONNADE; see figs. 5.47, 5.48.
- CLUSTER PIER: in the Gothic structural system (fig. 6.31), a PIER with groups of COLONNETTES, as at Chartres (fig. 6.28). Also known as a compound pier.
- COFFERING, COFFERS: in architecture, recessed geometrical panels—often square—that decorate the interior surface of a VAULT; see the coffers to the DOME of the ancient Roman Pantheon (figs. 4.53) and elsewhere (fig. 9.29).
- COLLAGE: when pieces of materials such as newspapers, cloth, or colored paper are glued to a canvas, paper, or other surface, as in Picasso's *Still Life with Chair Caning* (fig. 12.23).
- COLLOCATION: the idea that an artist created a specific work for a specific location and that it is adjusted for that location and the spectator's viewpoint, as in Caravaggio's Conversion of St. Paul (fig. 9.15) and Rembrandt's Militia Company of Captain Frans Banning Cocq (fig. 9.25).
- COLONNADE: a continuous row of COLUMNS supporting an ENTABLATURE or ARCHES; see the Parthenon (fig. 3.71).
- COLONNETTE: a slender, columnar decorative motif, common in Gothic architecture, as at Chartres (fig. 6.28), where groups of colonnettes create compound (or

- CLUSTER) PIERS that support the NAVE ARCADE.
- COLOR PALETTE: the selection of colors used by an artist; for an example of a restricted color palette, see Mondrian's *Composition No.* 8, 1939–42 (fig. 1.19).
- COLUMN: a freestanding cylindrical support, often FLUTED and with a CAPITAL, used in POST-AND-LINTEL construction, as at the Parthenon (fig. 3.71).
- COMPLEMENTARY COLORS: colors found opposite each other on the color wheel (see fig. 1.20), which form a neutral gray when mixed but create a vibrant contrast when placed side by side. The complementary color of each of the PRIMARY COLORS (red, yellow, and blue) is obtained by mixing the remaining two primaries; the complementary of red is green (yellow and blue); the complementary of yellow is violet (red and blue); and the complementary of blue is orange (red and yellow).
- COMPOSITION: the arrangement or organization of the various elements of a work of art; e.g., the balanced symmetry of Raphael's *Philosophy* (fig. 1.18).
- CONCRETE: as developed by the ancient Romans, fast-drying hardening volcanic sand used in architectural construction.
- CONTEXTUALISM: An approach that examines a work of art as the product of a particular time and place.
- CONTINUOUS NARRATION: A narrative in which sequential moments in the story are represented within a single frame, with key figures repeated as needed; see Masaccio's *Tribute Money* (fig. 7.19).
- CONTRAPPOSTO: a term describing the position assumed by the human body when the weight is borne on one leg while the other is relaxed; e.g., the *Doryphorus* (fig. 3.66). Contrapposto creates a figure that seems to be relaxed and yet suggests the potential for movement.
- CORINTHIAN ORDER: one of the ancient Greek architectural ORDERS; see fig. 3.68.
- CORNICE: a projecting MOLDING surmounting and emphasizing a WALL or ARCH. Note the prominent interior cornices of the Pantheon (fig. 4.54) and the heavy cornice capping the Medici Palace (fig. 7.36).
- CROSS-HATCHING: in drawings and PRINTS, superimposed layers of parallel lines (HATCHING) at an angle to one another, used to create shadows and MODELING, as in fig. 8.22.
- CROSSING: in a Christian church, the area where the NAVE intersects the TRANSEPTS; for diagrams, see figs. 5.13, 6.31.

- CROSS SECTION: an architectural diagram that shows how a building would look from the inside if it were cut by a vertical plane from side to side (see fig 5.12). See also LONGITUDINAL SECTION.
- CROSS VAULT: a structural system formed by two tunnel vaults intersecting at right angles; see fig. 4.50.
- CRUCIFORM BASILICA: a BASILICA with TRANSEPTS, forming a Latin cross plan, as at Old St. Peter's (fig. 5.13).
- CUN: in Chinese painting, small brushstrokes dabbed on quickly to create the sense of a particular texture, as in Li Cheng's painting (fig. 5.51).

D

- DAGUERREOTYPE: the earliest practical photographic process; see p. 469.
- DIMINUTION: a device used in drawing and painting to help suggest PERSPECTIVE. Forms are represented as progressively smaller to suggest their distance from the viewer; see Raphael's Philosophy (fig. 1.18, 7.20).
- DIPTYCH: two equal-size panels hinged to fold shut or simply hang side-by-side. Most are painted; some are carved in RELIEF.
- DOME: an architectural structural system that can be understood as an ARCH rotated 180° around a central AXIS; see fig. 4.50.
- DORIC ORDER: the most vigorous and austere of the ancient Greek architectural ORDERS; see fig. 3.68.
- DOUGONG BRACKET: in Chinese and Japanese architecture, CANTILEVERED brackets, often multiple and complex, that support the beams and roof of a structure, as at Horyu-ji (fig. 5.36).
- DRESSED STONE: blocks of stone used for construction, each of which is carefully cut and trimmed for its specific place and purpose, as at the ancient Roman Pont du Gard (fig. 4.51).
- DRUM: a cylindrical or polygonal wall set atop a building and used to support a DOME; see fig. 7.31.
- DRUMS: the individual cylindrical units that are combined to create the shaft of a COLUMN; due to the ravages of time, the drums of the columns of the Parthenon are clearly visible today (fig. 3.71).
- DRYPOINT: an INTAGLIO printmaking process; see fig. 9.38.

Е

ECHINUS: on a DORIC CAPITAL, the rounded, cushion-shaped MOLDING below

- the ABACUS; see fig. 3.68.
- EDITION: a group of prints made from a single PRINT FORM in one of the printmaking processes; see figs. 8.24, 8.25, 11.30. In current practice, artists sign and number each print in an edition.
- ELEVATION: an architectural diagram that shows the exterior or interior surfaces of a building and their decoration diagramatically, without the recession and distortion that would result from a single viewpoint; see fig. 8.29. Elevation can also refer to one exterior side of a building.
- ENCAUSTIC: a technique of painting using PIGMENTS dissolved in hot wax; see fig.
- ENGAGED COLUMN: see HALF COLUMN. ENGRAVING: an INTAGLIO printmaking process; see fig. 8.25.
- ENTABLATURE: the upper part of an architectural ORDER, which usually includes ARCHITRAVE, FRIEZE, and CORNICE; see fig. 3.68.
- ENTASIS: the bulging of a DORIC column about one-third of the way up from the base, creating an effect of muscular elasticity; for a subtle example of entasis see the COLUMNS of the Parthenon (fig. 3.71).
- ETCHING: an INTAGLIO printmaking process; see fig. 9.38.
- ETCHING GROUND: the acid-resistance, resinous mixture used to coat the PRINT FORM (a metal PLATE) in the ETCHING process; see pp. 378-79.
- ETCHING NEEDLE: the sharp steel instrument used in the ETCHING technique; see pp. 378-79.
- EXPRESSIVE CONTENT: the emotions and feelings communicated by a work of art.

F

- FACADE: the front or principal face of a building, as in San Carlo alle Quattro Fontane (fig. 9.31).
- FIGURE-GROUND RELATIONSHIP. the contrast between form (or positive elements) and background (or negative ground) in a work of art; see Piero della Francesca's Battista Sforza and Federigo de Montefeltro (fig. 7.8).
- FLUTES, FLUTING: shallow vertical grooves on the shaft of a COLUMN that accentuate the column's cylindrical quality; see fig. 3.68.
- FLYING BUTTRESS: a structural element in the form of an open half arch that counteracts the outward THRUST of an ARCH or VAULT; see fig. 6.31.
- FORESHORTENING: the technique used in a painting or RELIEF SCULPTURE to suggest

- that figures, parts of the body, or other forms are shown in sharp recession, as in Mantegna's Foreshortened Christ (fig. 7.45).
- FORMAL ANALYSIS: a visual examination and analysis of a work of art that studies how the integral parts of a work of art are united to produce its HISTORICAL and/or INDIVIDUAL STYLE. Introductory formal analyses of works of art are offered for chapter 1.
- FORUM: the official center of an ancient Roman town, with temple, marketplace, and governmental buildings; see the forum in Rome (figs. 4.34, 4.35).
- FRESCO: a technique of painting directly on a plaster wall or ceiling, usually when the plaster is still wet, as in Giotto's Arena Chapel (fig. 6.45) and Michelangelo's Sistine Chapel ceiling (fig. 8.32); see figs. 4.44, 6.48. Also known as buon fresco. See also FRESCO SECCO.
- FRESCO SECCO: a technique of FRESCO painting in which the paint is applied to dry plaster.
- FRIEZE: the middle section of the horizontal ENTABLATURE in the ancient Greek and Roman ORDERS; see fig. 3.65.
- FUNCTION: the purpose for which a work of art was created; e.g. the function of the Egyptian sculpture Khafre (fig. 3.10) was to provide a home for the soul of the king throughout eternity.

G

- GABLE ROOF: the most common type of roof, formed by two planes that slope downward from a central beam, as on the Parthenon (fig. 3.56). Also known as a pitched roof.
- GENRE PAINTING or sculpture: a representation of everyday life.
- GESSO: a mixture of glue (size) and gypsum or chalk used to coat a surface that will be gilded or painted, usually with TEMPERA PAINT. Also used to build up BAS-RELIEF sculpture and to mold elaborate picture frames before GILDING.
- GIANT ORDER: PILASTERS or COLUMNS that span more than one story of a structure; e.g., the pilasters on the exterior and interior of Michelangelo's design for New St. Peter's in Rome (figs. 8.29, 8.30). Also known as colossal order.
- GILDING: the covering of a work of art or part of a work of art with gold leaf or some other gold-colored substance; the background of Giotto's Madonna is gilded (fig. 6.42).
- GIORNATA: from the Italian word meaning

- "day." Giornata lines are produced when areas of plaster (*intonaco*) overlap one another in a FRESCO. In the true fresco technique, these areas of *intonaco* would be painted in one day, before the plaster dried, hence the term *giornata*; see fig. 4.44.
- GLAZES: in the art of oil painting, thin layers of superimposed translucent varnish, often with a small amount of PIGMENT added, to modify color and to build up a rich, sonorous color effect; used by Jan van Eyck (figs. 7.26, 7.27), Titian (figs. 8.44, 8.46), and others. In pottery, the glaze is a thin layer of a colored material that fuses with the surface when heated; the glaze provides the hard and colorful surface of a pottery vessel.
- GOUACHE: opaque WATERCOLOR paint. GREEK CROSS PLAN: a central plan with four arms of equal dimension placed at 90° angles, usually surrounding a DOME, as in Bramante's and Michelangelo's design for
- GRISAILLE: the MONOCHROMATIC painting of objects, often to simulate stone sculpture; see fig. 7.42.
- GROIN VAULT: see CROSS VAULT.

New St. Peter's (figs. 8.27, 8.28).

- GROUND PLAN: an architectural diagram that shows how a building would look from above if it were truncated by a horizontal plane approximately one meter above floor level; see figs. 6.29, 9.30.
- GUILDS: legal organizations of merchants, craftspeople, and artists, rather like trade unions, that flourished in the later Middle Ages and the Renaissance. Guilds established standards for training and production and commissioned works of art; see the niches at Orsanmichele in Florence (figs. 7.12, 7.13).

Н

- HALF COLUMN: a half-round decorative COLUMN attached to a supporting wall. Also known as an engaged column.
- HALO: a radiance of light, visually represented as a golden circle or disc, surrounding the head of a holy figure, as in the Byzantine MOSAIC at Mount Sinai (fig. 5.22).
- HAPPENING: a quasi-theatrical event, common in the 1950s and 1960s, in which artists, usually without a preconceived script, performed and encouraged the spontaneous participation of the audience.
- HATCHING: in drawings and prints, closely spaced series of parallel lines that create effects of MODELING, as in fig. 8.22. See also CROSS-HATCHING.
- HIGH RELIEF: RELIEF SCULPTURE in which the forms project substantially from the background; see fig 3.8.

- HIGH VALUE: a relatively light color, as in the high value of the yellow trousers in Goya's *Execution of Madrileños on the Third of May* (fig. 11.18).
- HIPPED ROOF: a type of roof construction in which the ends are sloped instead of being vertical.
- HISTORICAL CONTEXT: the ideas, beliefs, or attitudes current in the period when a work of art was created. The concept of historical context also encompasses how the work of art was perceived by its audience.
- HISTORICAL SIGNIFICANCE: an understanding of how a work of art reveals the ideas, beliefs, or attitudes current in the period when that work of art was created.
- HISTORICAL STYLE: a clearly recognizable artistic tradition (see FORMAL ANALYSIS) characteristic of a particular historical or artistic period.
- HUE: the property of a color that distinguishes it from others; also the name of a color; see fig. 1.20.
- HYPOSTYLE: a type of architectural construction in which the interior space is crowded with continuous rows of COLUMNS or posts, as in the Egyptian hypostyle hall (fig. 3.26) and the MOSQUE at Córdoba (fig. 5.42).

Ι

- ICON: a special term used in Orthodox Christianity to refer to a painting of a religious subject, as in fig. 5.2.
- ICONOGRAPHY: the art-historical study of the subject matter of a work of art, including the investigation of the symbolism and the meaning of the subject in the culture that produced it,
- ICONOLOGY: the investigation of how the iconography of a work is related to the HISTORICAL CONTEXT.
- ILLUMINATED MANUSCRIPT: a handwritten book with painted decoration, common in medieval and Renaissance Europe; see figs. 5.31, 5.45, 5.46, 6.26, 7.14, 7.15.
- ILLUSIONISM, ILLUSIONISTIC: when the objects represented in a work of art (usually a painting) seem to be tangible and weighty, existing within actual space; e.g., Raphael's *Philosophy* (fig. 1.18, 7.20); see pp. 126–29.
- IMPASTO: raised brushstrokes of thick paint, usually oil, as in Titian's *Rape of Europa* (fig. 8.49).
- INDIVIDUAL STYLE: the particular formal qualities (see FORMAL ANALYSIS) used by an individual artist; e.g., the bold colors, thick paint, and heavy brushstrokes

- characteristic of the works of van Gogh (figs. 11.12, 11.70, 11.71).
- INSTALLATION: a work of art that consists of an ensemble of objects, often threedimensional, that are especially arranged by the artist for a particular location or site (see fig. 13.38).
- INTAGLIO PROCESS: a printmaking process in which the lines to be printed are incised into the surface of the PRINT FORM, such as in the engraving, ETCHING, and DRYPOINT processes; see figs. 8.25, 9.38, 9.39.
- INTENSITY: the level of richness or saturation of a color; note the very intense red used in van Gogh's *Night Café* (fig. 11.70).
- INTERLACE: common in medieval art and architecture, ornament composed of intertwined line-form elements, such as stylized vines and/or animal forms.
- IONIC ORDER: one of the ancient Greek architectural ORDERS; see fig. 3.68.
- ISOMETRIC PROJECTION: an architectural diagram that includes both a GROUND PLAN and a view of the exterior and/or interior from a specific point of view below or above the structure; for an isometric projection of a temple at Karnak, see fig. 3.28.
- IWAN: a large vaulted opening marking an entrance, commonly found on the facades of Islamic structures such as the Taj Mahal; see fig. 9.26.

J

JAMBS: the areas flanking an ARCH, doorway, or window; in Romanesque and Gothic churches, the jambs are often decorated with sculpted figures, as at Amiens (fig. 6.34).

K

- KAMI: in the Shinto religion, Japanese nature spirits thought to endow all things; see the Shinto Shrine at Ise, pp. 160–61.
- KEYSTONE: the central VOUSSOIR of an ARCH, rib, or vault; see fig. 4.50.
- KONDO: the main hall at a Japanese Buddhist temple-MONASTERY complex, as at Horyu-ji (figs. 5.36, 5.37).
- KUFIC: a style of Arabic CALLIGRAPHY, sometimes used as virtually pure ornament.

L

LACQUER: a hard, opaque varnish with a high-polish surface. Originally derived from the sap of a tree native to China, lacquer was used to fashion objects of functional art and religious utensils in East Asia.

- LINEAR: the technique in painting, drawing, or printmaking of creating sharply defined forms of precisely delineated contours, as in Leonardo da Vinci's *Vitruvian Man* (fig. 7.50).
- LINEAR PERSPECTIVE: developed in fifteenth-century Europe, a method of representing three-dimensional objects on a two-dimensional plane. Linear perspective has all parallel edges and lines converging as ORTHOGONALS toward one or more VANISHING POINTS on a two-dimensional surface. Also called SCIENTIFIC PERSPECTIVE; see pp. 268–69.
- LINTEL: the horizontal beam spanning an opening, as in the POST-AND-LINTEL SYSTEM (fig. 3.23).
- LONGITUDINAL SECTION: an architectural diagram that shows how a building would look from the inside if it were sliced by a vertical plane from front to back; see the Pantheon (fig. 4.53) and New St. Peter's (fig. 8.30).
- LOST-WAX BRONZE CASTING: a technique of casting bronze and other metals; see fig. 3.65.
- LOW RELIEF: RELIEF SCULPTURE in which flattened figures or forms project only very slightly from the background, as in the *Palette of Narmer* (fig. 3.17). Also known as BAS-RELIEF.
- LOW VALUE: a relatively dark color, as in the low value of the background in Goya's *Execution of Madrileños on the Third of May* (fig. 11.18).
- LUNETTE: a semicircular area enclosed by an ARCH, as at the Byzantine church of San Vitale (fig. 5.25).

M

- MADKSOURAH: a special enclosure in a MOSQUE reserved for the calif (ruler), as at Córdoba (fig. 5.42).
- MANDALA: a diagram of the Buddhist cosmos, used as a basic design motif in Buddhist art, as at Sanchi (fig. 4.21).
- MANDORLA: an oval or almond-shaped HALO that surrounds the body of a holy figure, as in the Byzantine MOSAIC at Mount Sinai (fig. 5.22).
- MANUSCRIPT: a handwritten book produced in medieval and Renaissance Europe. If it has painted decoration, it is known as an ILLUMINATED MANUSCRIPT; see figs. 5.31 and 7.14, 7.15.
- MASTABA: a rectangular Egyptian burial monument, with BATTERED WALLS and a flat roof; see fig. 3.21.
- MEDIUM/MEDIA: the material or materials

- of which a work of art is composed, or the technique used to create it; e.g., oil paint on canvas (fig. 11.71), bronze (fig. 7.37), and ETCHING (fig. 9.37).
- MEGALITH: a very large stone of irregular shape (not DRESSED) used in prehistoric monuments; see Stonehenge (fig. 2.8).
- METOPES: the square areas between the TRIGLYPHS in the FRIEZE area of the ENTABLATURE of the DORIC ORDER; sometimes decorated with sculpture, as at the Parthenon (fig. 3.71); see fig. 3.68.
- MIHRAB: in a MOSQUE, the ARCH or niche on the QIBLA wall that indicates the direction of Mecca, to which Muslims turn in prayer, as that at Córdoba (figs. 5.42–5.44).
- MINARET: the tower in a MOSQUE complex, usually tall and slender, from which the Muslim faithful are called to prayer five times a day; see Hagia Sophia (fig. 5.23).
- MIXED MEDIA: a term used to describe a work composed of a variety of different materials, usually encompassing elements of painting, sculpture, and even architecture (see fig. 13.7).
- MOBILE: a sculpture that moves, usually a lightweight, delicately balanced suspended work; see the example by Calder (fig. 12.72).
- MODELING/TO MODEL: in painting, drawing, or printmaking, the creation of an effect of weight and mass in an object by the manipulation of VALUE to create highlights and shading, as in fig. 7.49; in sculpture, an additive process in which form is created with a malleable medium such as clay; see CARVING as a subtractive process.
- MONASTERY: a religious establishment that houses a community of persons who have withdrawn from the world to pursue the religious life; see examples from St. Gall and Cluny (figs. 5.47, 5.48).
- MONOCHROMATIC: term used to describe a painting or drawing created by shades of black and white or values of a single color, as in Picasso's *Guernica* (fig. 12.68).
- MOSAIC: a pattern made of small pieces (TESSERAE) of stone, tile, or glass, used on floors, walls, or ceilings; see Roman floor mosaics (figs. 3.57, 4.15) and the wall and ceiling mosaics at San Vitale (figs. 5.25–5.29).
- MOSQUE: a place of worship in the Islamic religion, as at Córdoba (figs. 5.42–5.44).
- MUDRA: a hand gesture of Buddha, as in fig. 5.38. Each traditional gesture conveys its own meaning.
- MURAL PAINTING: large wall decorations; e.g., those at the Villa of the Mysteries (fig. 4.42) and Giotto's Arena Chapel (fig. 6.45).

N

- NAOS: the walled inner sanctuary of a Greek temple, where the cult statue is housed (fig. 3.73).
- NARTHEX: an entrance hall or vestibule, often found in Christian churches, as at Old St. Peter's BASILICA (fig. 5.13).
- NATURALISM, NATURALISTIC: when the elements or forms within a work of art closely resemble the appearance of those forms in nature; e.g., Bernini's *Apollo and Daphne* (fig. 1.5).
- NAVE: the large central hall, usually AXIAL and often with a CLERESTORY, that characterizes the BASILICA plan (see Old St. Peter's, fig. 5.13, and many Christian churches).
- NONOBJECTIVE: when the forms in a work of art do not resemble forms in the visual world; e.g., Mondrian's *Composition No. 8* (fig. 1.19). Also known as NONREPRESENTATIONAL.
- NONREPRESENTATIONAL: see NONOBJECTIVE.

O

- OCULUS: a circular opening in a wall or at the apex of a DOME, as in the ancient Roman Pantheon (fig. 4.54).
- OIL PAINT TECHNIQUE: a method developed in the fifteenth century in which the PIGMENTS are mixed with the slow-drying and flexible MEDIUM of oil; see fig. 7.28.
- ORDERS: a series of Greek and Roman architectural systems that give aesthetic definition and decoration to the POST-AND-LINTEL SYSTEM; see fig. 3.68.
- ORTHOGONALS: the converging diagonal lines that meet at the VANISHING POINT in the SCIENTIFIC PERSPECTIVE system. In reality these lines would be parallel; see fig. 7.20.
- OVERLAPPING: a device used in painting and relief sculpture to help suggest PERSPECTIVE. Forms are placed in front of other forms to suggest their relative placement within the illusion of space.

P

- PAGODA: the European name for a tall tower, often with a series of roofs over successive storeys, that marks sacred Buddhist sites in China and Japan, as at the Horyu-ji complex (figs. 5.36, 5.37).
- PAINTERLY: in painting, the technique of using large brushstrokes and flecks of paint to define form; see figs. 8.47, 9.24.

- PANATHENAIC AMPHORA: an ancient Greek vase awarded as a prize at the Olympic Games; see fig. 3.1.
- PARCHMENT: the skin on a calf, sheep, or other animal which is scraped, stretched, and dried to be used as a surface for writing. Used in the medieval period for MANUSCRIPTS.
- PASTEL: a drawing medium made of ground PIGMENTS mixed with gum water.
- PATRON: the person, persons, or organization that asks an artist or artists to create a work of art. Usually they pay for the work.
- PATTERN BOOK: a book of images, prepared as an artist's tool, that preserves a tradition of images that can be copied; see fig. 5.8.
- PEDIMENT: the triangular end of a GABLE ROOF; in a Greek temple this area is often decorated with sculpture; see figs. 3.54, 3.74, 3.75.
- PENDENTIVES: in a domed structure, the curved triangular segments that provide a transition from the four supporting PIERS to the circular base of the dome, as at the Byzantine church of Hagia Sophia (fig. 5.1). For a diagram see fig. 4.50.
- PERIPTERAL: a term that describes a building with an exterior PERISTYLE; e.g., the Parthenon (fig. 3.71).
- PERISTYLE: a continuous row of COLUMNS that completely surrounds the exterior of a structure, e.g., the ancient Greek Parthenon (fig. 3.71), or an inner courtyard, as in fig. 4.29.
- PERSPECTIVE: depth. An illusion of perspective is suggested in many paintings; e.g., Raphael's *Philosophy* (fig. 7.20). Devices that help suggest the illusion of perspective include LINEAR PERSPECTIVE, ATMOSPHERIC PERSPECTIVE, DIMINUTION, and OVERLAPPING.
- PICTURE PLANE: the flat surface of a picture. The picture plane, denied in such ILLUSIONISTIC work as Raphael's *Philosophy* (fig. 7.20), is emphasized as a positive element in many nineteenth- and twentieth-century paintings, such as Mondrian's *Composition No. 8* (fig. 1.19).
- PIECE-MOLD CASTING: a method of casting metal objects developed in ancient China in which the mold for receiving molten metal is made of a number of sections fitted together and then packed in sand before casting. See fig. 3.42.
- PIERS: the vertical supports used in an ARCHED or VAULTED structural system; see the supports of the ancient Roman Pont du Gard (fig. 4.51) and the piers of the Gothic cathedral at Chartres (figs. 6.27–6.31).

- PIETÀ: an iconographic theme in which the dead Christ is shown being held by his mother, as in Michelangelo's *Pietà* (fig. 7.54).
- PIGMENT: the substance, usually ground, that is used to give color in the TEMPERA, FRESCO, and early OIL PAINTING TECHNIQUES.
- PILASTER: a shallow, virtually flat version of the COLUMNS of the Greek and Roman ORDERS; pilasters are usually decorative, not structural. See fig. 10.4.
- PLAN: see GROUND PLAN.
- PLATE: the thin metallic plate used as a PRINT FORM in ENGRAVING and ETCHING; see figs. 8.25, 9.38.
- POLYCHROME: painted in many colors and often used to describe sculpture.
- POLYPTYCH: a work of art composed of four or more leaves or panels.
- POINTED ARCH: an ARCH in which the sides rise to a point at the apex, as in Gothic architecture (figs. 6.27, 6.31, 6.32).
- POST-AND-LINTEL SYSTEM: a simple system of architectural construction in which horizontal architectural members (LINTELS) are supported by vertical supports (posts); see fig. 3.23.
- POTTER'S WHEEL: a revolving platform on which clay vessels of regular and often graceful shape are formed. Examples of wheel-produced vessels include the ancient Greek pots shown in fig. 3.55.
- PRESENTATION DRAWING: a finely finished drawing made to be given to a collector or friend.
- PRIMARY COLORS: red, yellow, and blue.

 These are HUES that in theory are pure and not the combination of any other hues. On the color wheel (fig. 1.20), all other colors are understood as mixtures of these three hues.
- PRINT: a work of art produced by one of the printmaking processes, including WOODCUT, ENGRAVING, ETCHING, DRYPOINT, LITHOGRAPHY, and silkscreen.
- PRINT FORM: the surface—wood, copper, steel, glass, stone, etc.—to which ink is applied in any of the PRINTMAKING processes; see figs. 8.24, 8.25, 9.38, 9.39, 11.30.
- PRINTMAKING: a series of techniques (WOODCUT, ENGRAVING, ETCHING, DRYPOINT, LITHOGRAPHY, silkscreen, and others) by which prints are produced.
- PSEUDO-PERIPTERAL: a building that seems to have a PERISTYLE, but many of the COLUMNS are HALF COLUMNS or PILASTERS; e.g., the Roman Temple of

- Portunus (fig. 4.28).
- PURE COLORS: the use of colors at maximum or full INTENSITY; a pure color is a HUE without the addition of white, black, or other colors that would reduce the intensity of the color; e.g., the colors used by Mondrian in his *Composition No. 8* (fig. 1.19).
- PYLON: the entrance gate to an Egyptian temple complex, with broad BATTERED towers and flagpoles; see fig. 3.25.

Q

- QI: Chinese cosmic spirit; used in aesthetics to describe the "life" or spirit of a painting; see Chinese landscape painting, pp. 192–95.
- QIBLA: in a MOSQUE, the wall that indicates the direction of Mecca, toward which Muslims turn in prayer; see Córdoba (figs. 5.43, 5.44).

R

- REALISM, REALISTIC: the use of subject matter drawn from actual life and experience; e.g., fig. 9.15. Not to be confused with the nineteenth-century movement known as Realism (figs. 11.36, 11.62).
- RED-FIGURE STYLE: style of Greek vase painting from c. 530 BCE to the third century BCE in which the background of a scene is painted with a clay SLIP that turns black in firing, leaving the designs in the natural reddish tones of the clay. Details are also painted with slip and so appear as black lines.
- REFECTORY: the dining hall in a MONASTERY or nunnery; the location for Leonardo da Vinci's painting of the *Last Supper* (fig. 7.52).
- RELIEF: sculpture in which the design extends from a background surface.
- RELIEF PROCESS: a PRINTMAKING process in which the lines and surfaces to which the ink adheres are higher than the parts that are not to be printed; e.g., the WOODCUT process; see fig. 8.24.
- RELIEF SCULPTURE: sculpture in which the figures or forms are united with a background; examples of relief sculpture types include LOW or BAS-RELIEF (fig. 3.17), HIGH RELIEF (fig. 3.8), SUNKEN RELIEF (fig. 3.12), and pictorial relief (fig. 7.21).
- RELIQUARY: a container for a sacred relic, as in fig. 6.2.
- REPOUSSOIR: an object in the immediate foreground of a painting that establishes the frontal plane of the ILLUSIONISTIC space;

- e.g., the low fence in the FRESCOED room known as Livia's Garden (fig. 4.43).
- REPRESENTATIONAL: when a work of art reproduces the appearance of forms in nature; see Bernini's Apollo and Daphne (fig. 1.5).
- RIBS: raised structural elements that outline and help support a ribbed VAULT, as at the Gothic cathedral of Chartres (figs. 6.27, 6.28); see fig. 6.32.
- ROUND ARCH: also sometimes called a true arch, it is a half-round opening that rises at the SPRINGING from upright supports.
- RUSTICATION: the practice of covering building surfaces with massive, rough-cut stones, often with deep-cut grooves at the joints.

S

- SARCOPHAGUS: a stone coffin, sometimes decorated with sculpture (fig. 3.52).
- SCIENTIFIC PERSPECTIVE: see LINEAR PERSPECTIVE.
- SCREEN WALL: a non-supporting wall, usually with broad expanses of windows, that fills the opening under an ARCH or VAULT, as at the Byzantine church of Hagia Sophia (fig. 5.1). It is screen walls that sheathe the exterior of a modern steel-frame skyscraper.
- SCRIPTORIUM: the room or rooms in a MONASTERY where MANUSCRIPTS are copied and illustrated, as in the St. Gall plan (fig. 5.47).
- SCULPTURE IN THE ROUND: sculpture that is fully three-dimensional and finished on all sides; e.g., French's Minuteman (fig. 1.13). Also known as freestanding.
- SHAMANIST: describing a practice in which individuals, called shamans, claim to make contact with and influence gods, spirits, and forces in unseen realms while in ritualized trance states.
- SHIFTING PERSPECTIVE: the use of multiple viewpoints in a painting or drawing, as in Li Cheng's and Cézanne's paintings (figs. 5.51, 11.72) or in Cubism (figs. 12.22, 12.23).
- SILVERPOINT: a drawing technique using a sharpened point of silver on specially prepared paper or PARCHMENT.
- SIVA: one of the three main Hindu gods, known as the Preserver; see Hindu art at Ellora, pp. 180-81, fig. 6.1.
- SLIP: clay particles and water, sometimes used to decorate a pottery vessel, as in figs. 3.58,
- SOFT-GROUND ETCHING: An etching technique that uses a soft material to cover the copper PLATE, giving the artist greater

- freedom in execution.
- SPANDRELS: in architecture, the triangular surfaces to the sides of an ARCH, between the top of the arch and the SPRINGINGS on
- SPOLIA: materials taken from an earlier structure and reused, as in the COLUMNS and CAPITALS at Old St. Peter's (fig. 5.12) and the MOSQUE in Córdoba (fig. 5.42).
- SPRINGING: the level at which an ARCH or VAULT begins to curve inward and upward; see fig. 4.50.
- SQUINCH: ARCHES, LINTELS, and/or corbels that just across the corners of a square space to support a dome and to make the transition from the square space to a polygonal or round one; see the squinches that support the dome at Córdoba (fig. 5.44). See also fig. 4.50.
- STAINED-GLASS WINDOWS: windows composed of pieces of colored glass joined by lead strips; see fig. 6.36.
- STATES: the successive printed stages of a print, especially common in Rembrandt's ETCHINGS and DRYPOINTS (figs. 9.37, 9.40).
- STEEL-FRAME CONSTRUCTION: an architectural structure in which steel beams are joined horizontally and vertically to create a gridlike structural system; see fig.
- STEREOBATE: the stepped platform that forms the base for a Greek temple; the top step is known as the stylobate; see fig. 3.68.
- STUPA: a large hemispherical Buddhist shrine, erected to hold a relic or mark a holy site, as in the Great Stupa at Sanchi (fig. 4.1, 4.21); the form evolved from earlier burial mounds.
- STYLE: a complex concept with several meanings, including HISTORICAL STYLE and INDIVIDUAL STYLE.
- SUBTRACTIVE TECHNIQUE: A sculptural technique that involves removing material to form the sculpture, as is the case in making sculpture from wood or stone; see Michelangelo's David (fig 8.15), a commission that was rendered more difficult because part of the marble had already been "subtracted" by an earlier artist.
- SUNKEN RELIEF: an Egyptian style of RELIEF SCULPTURE in which the figures are recessed into the surface (fig. 3.12). Also known as incised relief.

T

TABLERO: in Mesoamerican architecture, a heavy, projecting, rectangular MOLDING outlined by a thick frame, as in the Pyramid

- of Quetzalcóatl at Teotihuacán (fig. 4.56). TAOTIE: the stylized monster mask that decorates early Chinese bronzes (fig. 3.4).
- TECHNIOUE: how an artist or artists uses materials (the MEDIUM or MEDIA) to create a work of art; e.g., the vigorous, heavy oil brushstrokes of van Gogh (figs. 11.70, 11.71) or the highly polished finish of Michelangelo's Pietà (fig. 7.54).
- TEMPERA PAINT TECHNIQUE: a painting technique in which the PIGMENTS are combined with egg. The support is usually plaster-coated wood and the background is often decorated with gold leaf, as in Giotto's Madonna (fig. 6.42). See also fig. 6.47.
- TENSILE STRENGTH: the internal longitudinal strength in a stone, steel, or wood beam which enables it to support itself without breaking.
- TERRA-COTTA: a hard earthenware, glazed or
- TESSERAE: the individual cut pieces of stone, glass or other materials used in the MOSAIC technique (see fig. 5.29). One piece is a tessera.
- THRUST: the outward force created by an ARCH or VAULT; this must be counterbalanced by BUTTRESSING; see fig. 4.50.
- TORII ARCH: two posts capped by two beams—the topmost beam flaring upward found at the gateway to the sacred precinct of a Shinto shrine.
- TRANSEPT: in a cross-shaped Christian church, cross arms placed perpendicular to the NAVE; see fig. 5.13.
- TRANSVERSALS: lines that are parallel to each other in reality that recede parallel to the picture frame in the LINEAR PERSPECTIVE system; see fig. 7.20.
- TRANSVERSE ARCH: an ARCH that separates one BAY from the next in a series of arched VAULTS.
- TRAVERTINE: a limestone, found especially along the Tiber River in Italy, pocked with small spongy holes.
- TRIFORIUM: in Gothic construction, an arcaded passageway above the NAVE ARCADE (fig. 6.31) and below the CLERESTORY, as in the cathedral at Chartres (figs. 6.28, 6.31).
- TRIGLYPH: in the DORIC FRIEZE, the area between the METOPES, decorated with vertical grooves; see fig. 3.68.
- TRIPTYCH: a three-part ALTARPIECE or work of art.
- TROMPE L'OEIL: ILLUSIONISTIC painting that emphasizes REALISTIC effects to convince the viewer that the painted scene or object is actually real and not painted, as in Mantegna's Camera Picta FRESCOES (fig. 7.44).

- TRUMEAU: the central supporting post between the two sides of a double door, which in Renaissance and Gothic churches is often decorated with sculpture, as at Amiens (figs. 6.33, 6.34).
- TUFA: a soft, porous rock that hardens with exposure to air; used in construction.
- exposure to air; used in construction.
 TUNNEL VAULT: see BARREL VAULT.
- TYMPANUM: the LUNETTE over the doorway of a church, which is often decorated with sculpture, as in Romanesque (figs. 6.13, 6.14) and Gothic (fig. 6.34) structures.

U

UNDERDRAWING: a preparatory drawing done directly on the plaster or canvas and over which the artist paints the finished work.

V

VALUE: the relative darkness (LOW VALUE) or lightness (HIGH VALUE) of a HUE.

VANISHING POINT: in a work created using the LINEAR PERSPECTIVE system, the vanishing point is the place where the converging ORTHOGONALS would converge if continued, as in Raphael's *Philosophy* (fig. 7.20).

- VANITAS: a type of still life showing objects that symbolize the impermanence of life, such as skulls, withered flowers, and clocks, and intended as reminders of the futility of amassing knowledge, wealth, and earthly possessions represented by stacks of books, coins, and jewels and fancy garments.
- VAULT, VAULTING: a structural system based on the ARCH, including the tunnel (or BARREL) VAULT, the CROSS (or GROIN) VAULT, and the DOME; see fig. 4.50.
- VEHICLE: the drying liquid in which painting PIGMENTS are suspended; as it dries, it adheres the color to the surface.
- VELLUM: fine PARCHMENT prepared from calfskin used for the pages in MANUSCRIPTS.
- VOLUTE: the spiral scroll motif that characterizes the CAPITAL of the IONIC ORDER; see fig. 3.68.
- VOTIVES: Small objects, usually representing figures or parts of figures that are presented in supplication or in thanksgiving to a holy figure. Votives are often made in molds and sold cheaply to pilgrims when they visit a holy site (see fig. 3.17).
- VOUSSOIRS: the individual blocks of stone (or bricks) that compose an ARCH; see fig. 4.50.

W

- WASH: ink thinned with water, applied with a brush to add effects of shadow, as in Rembrandt's *A Man Rowing* (fig. 9.34).
- WATERCOLOR: PIGMENTS mixed with water (and gum arabic as a drying agent); used in Homer's watercolor *The Blue Boat* (fig. 11.67).
- WEB: the surfaces of a Gothic rib vault (see RIBS); see fig. 6.32. Also known as infilling.
- WESTWORK: a church entrance with a centralized APSE enclosing a chapel on the second story and two flanking towers, typical of Carolingian churches, as in the St. Gall MONASTERY plan (fig. 5.47).
- WOODCUT: a relief printmaking process; for a diagram, see fig. 8.24.

Z

- ZEN: a form of Buddhism (known in China as Chan) that teaches that there is no Buddha except that in one's own nature; only through meditation can one reach one's own Buddha nature; see Zen art, pp. 344–45.
- ZIGGURAT: a stepped pyramid of mud brick, used by the Sumerians and the Assyrians as a sacred site; see fig. 3.9.

Bibliography

This is a general, broad bibliography intended to lead the reader to more specific books on individual sites, monuments, artists, and movements. As a rule, it includes only the most important sources, and only those in English.

General

- Addiss, Stephen. How to Look at Japanese Art. New York: Abrams, 1996.
- Art of Art History: A Critical Anthology. New York: Oxford University Press, 1998
- Bloom, Jonathan, and Sheila Blair. Islamic Arts. London: Phaidon, 1997.
- Broude, Norma, and Mary D. Garrard. Feminism and Art History: Questioning the Litany. New York: Harper & Row, 1982.
- Berlo, Janet Catherine, and Ruth B. Phillips. Native North American Art. New York: Oxford University Press, 1998
- Clunas, Craig. Art in China. New York: Oxford University Press, 1997.
- Craven, Roy C. Indian Art: A Concise History. New York: Thames & Hudson, 1997.
- Encyclopedia of World Art. 15 vols. New York: McGraw-Hill, 1959-68.
- Fernie, Eric (selection and commentary by). Art History and Its Methods: A Critical Anthology. San Francisco: Chronicle Books,
- Fisher, Robert E. Buddhist Art and Architecture. New York: Thames & Hudson, 2000.
- Fleming, John, Hugh Honour, and Nikolaus Pevsner. The Penguin Dictionary of Architecture. New York: Viking, 1991.
- Gates, Henry Louis. Africa: The Art of a Continent: 100 Works of Power and Beauty. New York: Abrams, 1996.
- Harle, J. C. Art and Architecture of the Indian Subcontinent. New Haven: Yale University Press, 1994.
- Holt, Elizabeth G. A Documentary History of Art. 2 vols. Garden City, N.Y.: Doubleday,
- Honour, Hugh, and John Fleming. The Visual Arts: A History. Upper Saddle River: Prentice Hall, 2002.
- Janson, H. W., and Anthony F. Janson. History of Art: The Western Tradition. New York: Abrams, 2004.
- Kemal, Salim, and Ivan Gaskell. The Language of Art History. Cambridge: Cambridge University Press, 1992.
- Kostof, Spiro. The Architect: Chapters in the History of the Profession. New York: Oxford University Press, 1986.
- -. A History of Architecture: Settings and Rituals. New York: Oxford University Press, 1995.

- LaPlante, John D. Asian Art. Dubuque: Wm. C. Brown, 1992.
- Lee, Sherman E. A History of Far Eastern Art. New York: Abrams, 1994.
- Mason, Penelope. History of Japanese Art. New York: Abrams, 1993.
- Mitter, Partha. Indian Art. New York: Oxford University Press, 2001.
- Nelson, Robert S., and Richard Shiff, ed. Critical Terms for Art History. Chicago: University of Chicago Press, 2003.
- Nochlin, Linda. Women, Art, and Power and Other Essays. New York: Harper & Row, 1988
- and Ann S. Harris. Women Artists: 1550-1950. Los Angeles: Los Angeles County Museum of Art; New York: distributed by Random House, 1976.
- Phillips, Tom. Africa: The Art of a Continent. New York: te Neues, 1995.
- Stokstad, Marilyn et al. Art History. New York: Abrams, 2002.
- Sullivan, Michael. The Arts of China. Berkeley: University of California Press, 1984.
- Summers, David. Real Spaces: World Art History and the Rise of Western Modernism. London: Phaidon, 2003.
- Trachtenberg, Marvin, and Isabelle Hyman. Architecture, from Prehistory to Post-Modernism, New York: Abrams, 2002.
- Turner, Jane, ed. The Dictionary of Art. 34 vols. New York: Grove's Dictionaries, 1996.
- Visona, Monica Blackmun, Robin Poynor, Herbert Cole, and Michael Harris. A History of Art in Africa. New York: Abrams, 2001.
- West, Shearer. Portraiture. New York: Oxford University Press, 2003.

Prehistory and Ancient

- Adam, Robert. Classical Architecture: A Comprehensive Handbook to the Tradition of Classical Style. New York: Abrams, 1991.
- Adams, Richard E. W. Prehistoric Mesoamerica. Norman, O.K.: University of Oklahoma Press, 1996.
- Aldred, Cyril. Egyptian Art in the Days of the Pharaohs 3100-320 B.C. New York: Thames and Hudson, 1985.
- Amiet, Pierra. The Ancient Art of the Near East. New York: Abrams, 1980.
- Bahn, Paul G. The Cambridge Illustrated History of Prehistoric Art. New York: Cambridge University Press, 1998.
- Beard, Mary. The Parthenon. Cambridge: Harvard University Press, 2003.
- Beard, Mary, and John Henderson. Classical Art: from Greece to Rome. New York: Oxford University Press, 2001.

- Beckwith, John. Early Christian and Byzantine Art. New Haven: Yale University Press, 1993.
- Berrin, Kathleen, and Esther Pasztory, eds. Teotihuacan: Art from the City of the Gods. New York: Thames and Hudson, 1993.
- Boardman, John. Greek Art. London: Thames and Hudson, 1996.
- -. The Oxford History of Classical Art. New York: Oxford University Press, 1993.
- -. The Parthenon and Its Sculptures. Austin: University of Texas Press, 1985.
- Boëthius, Alexander. Etruscan and Early Roman Architecture. New Haven: Yale University Press, 1987.
- Brendel, Otto. Etruscan Art. New Haven: Yale University Press, 1995.
- Brilliant, Richard. Arts of the Ancient Greeks. New York: McGraw-Hill, 1973.
- Collon, Dominique. Ancient Near Eastern Art. Berkeley: University of California Press,
- Eisner, Ja's. Imperial Rome and Christian Triumph: the Art of the Roman Empire AD 100-450. New York: Oxford University Press,
- Frankfort, Henri. Art and Architecture of the Ancient Orient. New Haven: Yale University
- Garlake, Peter. Early Art and Architecture of Africa. New York: Oxford University Press,
- Kubler, George. Art and Architecture of Ancient America. New Haven: Yale University Press, 1993.
- Lawrence, A. W. Greek Architecture. New Haven: Yale University Press, 1996.
- MacDonald, William L. The Architecture of the Roman Empire. 2 vols. New Haven: Yale University Press, 1982.
- Malek, Jaromir. Egypt: 4000 Years of Art. London: Phaidon, 2003.
- Miller, Mary Ellen. The Art of Mesoamerica: From Olmec to Aztec. New York: Thames and Hudson, 1996.
- Osborne, Robin. Archaic and Classical Greek Art. New York: Oxford University Press,
- Pollitt, J. J. The Art of Greece 1400-31 B.C. (Sources and Documents). New York: Cambridge University Press, 1990.
- -. Art and Experience in Classical Greece. New York: Cambridge University Press,
- . Ancient View of Greek Art. New Haven: Yale University Press, 1974.
- -. The Art of Rome c. 753 B.C.-A.D. 337 (Sources and Documents). New York: Cambridge University Press, 1983.

- ——. *Art in the Hellenistic Age*. New York: Cambridge University Press, 1986.
- Preziosi, Donald, and Louisa A. Hitchcock. *Aegean Art and Architecture*. New York: Oxford University Press, 1999.
- Ramage, Nancy H. and Andrew Ramage. Roman Art: Romulus to Constantine. London: Laurence King, 2002.
- Smith, William Stevenson. *The Art and Architecture of Ancient Egypt*. New Haven: Yale University Press, 1998.
- Spivey, Nigel. *Greek Art.* London: Phaidon, 1997.
- Strong, Donald. *Roman Art.* Harmondsworth, Eng.: Penguin, 1988.
- Ward-Perkins, J. B. *Roman Architecture*. New York: Rizzoli, 1988.

Art from 200 to 1400

- Blair, Sheila S. and Jonathan M. Bloom. *Art* and *Architecture of Islam*, 1250–1800. New Haven: Yale University Press, 1995
- Coldstream, Nicola. *Medieval Architecture*. New York: Oxford University Press, 2002.
- Conant, Kenneth J. *Carolingian and Romanesque Architecture*. Harmondsworth,
 Eng.: Penguin, 1978.
- Cormack, Robin. *Byzantine Art.* New York: Oxford University Press, 2000.
- Craven, Roy. *Indian Art: A Concise History*. London: Thames and Hudson, 1997.
- Crossley, Paul. *Gothic Architecture*. New Haven: Yale University Press, 2000.
- Davis-Weyer, C. Early Medieval Art 300–1150 (Sources and Documents). Englewood Cliffs: Prentice Hall, 1986.
- Diebold, William. Word and Image: An Introduction to Early Medieval Art. Boulder: Westview Press, 2001.
- Ettinghausen, Richard, and Oleg Grabar and Marilyn Jenkins-Madina. *Islamic Art and Architecture*, 650–1250. New Haven: Yale University Press, 2001.
- Fisher, Robert E. *Buddhist Art and Architecture*. London: Thames and Hudson, 1993.
- Frisch, T. G. Gothic Art 1140–ca. 1450 (Sources and Documents). Toronto: University of Toronto Press, 1987.
- Grodecki, Louis. *Gothic Architecture*. New York: Rizzoli, 1991.
- Hearn, M. F. Romanesque Sculpture. Ithaca, N.Y.: Cornell University Press, 1981.
- Huntington, Susan. *Art of Ancient India:* Buddhist, Hindu, Jain. New York: Weatherhill, 1985.
- Krautheimer, Richard. Early Christian and Byzantine Architecture. Harmondsworth, Eng.: Penguin, 1986.
- Lowden, John. *Early Christian & Byzantine Art*. London: Phaidon, 1997.
- Mango, Cyril. *The Art of the Byzantine Empire* 312–1453 (Sources and Documents).

 Toronto: University of Toronto Press, 1986.

- Nees, Lawrence. *Early Medieval Art*. New York: Oxford University Press, 2002.
- Os, H. W. van. The Art of Devotion in the Late Middle Ages in Europe, 1300–1500. Princeton: Princeton University Press, 1994.
- Petzold, Andreas. *Romanesque Art.* New York: Abrams, 1995.
- Rodley, Lyn. *Byzantine Art and Architecture*. Cambridge: Cambridge University Press, 1994
- Sekules, Veronica. *Medieval Art*. New York: Oxford University Press, 2001.
- Snyder, James, Henry Luttikhuizen, and Dorothy Verkerk. Art of the Middle Ages, 2nd ed. Englewood Cliffs: Prentice Hall, 2005.
- Stalley, Roger. *Early Medieval Architecture*. New York: Oxford University Press, 1999.
- Watson, William. *Arts of China*, 900–1620. New Haven: Yale University Press, 2000.
- _____. Arts of China to AD 900. New Haven: Yale University Press, 1995.
- White, John. *Art and Architecture in Italy,* 1250–1400. New Haven: Yale University Press, 1993.
- Williamson, Paul. *Gothic Sculpture*, 1140–1300. New Haven: Yale University Press, 1995.
- Wilson, David M. Anglo-Saxon Art from the Seventh Century to the Norman Conquest. Woodstock, N.Y.: Overlook Press, 1984.

Fifteenth and Sixteenth Centuries

- Blair, Sheila. *The Art and Architecture of Islam* 1250–1800. New Haven: Yale University Press, 1994.
- Cole, Alison. Virtue and Magnificence: Art of the Italian Renaissance Courts. New York: Abrams, 1995.
- Cole, Bruce. *The Renaissance Artist at Work*. New York: Harper & Row, 1983.
- Gilbert, Creighton. *Italian Art* 1400–1500 (Sources and Documents). Evanston: Northwestern University Press, 1991.
- Harbison, Craig. The Mirror of the Artist: Northern Renaissance Art in Its Historical Context. New York: Abrams, 1995.
- Hartt, Frederick, and David G. Wilkins. *History* of *Italian Renaissance Art*. New York: Abrams, 2003.
- Heydenreich, Ludwig. *Architecture in Italy* 1400–1500. New Haven: Yale University Press, 1996.
- Klein, Robert, and Henri Zerner. *Italian Art*, 1500–1600 (Sources and Documents). Evanston, Ill.: Northwestern University Press, 1989.
- Lotz, Wolfgang. *Architecture in Italy 1500–1600*. New Haven: Yale University Press, 1995
- Paoletti, John T., and Gary M. Radke. *Art in Renaissance Italy*. New York: Abrams, 2002.
- Rosand, David. Painting in Cinquecento Venice: Titian, Veronese, Tintoretto. New Haven: Yale University Press, 1986.

- Snyder, James. *Northern Renaissance Art.* New York: Abrams, 1985.
- Stechow, Wolfgang. *Northern Renaissance Art* 1400–1600 (Sources and Documents). Evanston, Ill.: Northwestern University Press, 1989.
- Welch, Evelyn. *Art in Renaissance Italy,* 1350–1500. New York: Oxford University Press, 2000.
- Wittkower, Rudolf. Architectural Principles in the Age of Humanism. New York: St. Martin's Press, 1988.

Seventeenth and Eighteenth Centuries

- Andrews, Malcolm. *Landscape and Western Art*. New York: Oxford University Press, 1999.
- Blunt, Anthony. *Art and Architecture in France* 1500–1700. New Haven: Yale University Press, 1999.
- Craske, Matthew. *Art in Europe, 1700–1830*. New York: Oxford University Press, 1997.
- Crow, Thomas E. Painters and Public Life in Eighteenth-Century Paris. New Haven: Yale University Press, 1985.
- Enggass, Robert, and Jonathan Brown. *Italy* and *Spain 1600–1750* (Sources and Documents). Evanston, Ill.: Northwestern University Press, 1993.
- Guth, Christine. Art of Edo Japan: The Artist and the City 1615–1868. New York: Abrams, 1996.
- Harris, Ann Sutherland. *Seventeenth-Century Art and Architecture*. Englewood Cliffs:
 Prentice Hall, 2004.
- Haskell, Francis. Patrons and Painters: A Study in the Relations Between Italian Art and Society in the Age of the Baroque. New Haven: Yale University Press, 1980.
- Irwin, David. *Neoclassicism*. London: Phaidon, 1997.
- Kim, Hongnam, ed. Korean Arts of the Eighteenth Century: Splendor and Simplicity. New York: The Asia Society, 1994.
- Levey, Michael. *Painting and Sculpture in France, 1700–1789*. New Haven: Yale University Press, 1993.
- Minor, Vernon Hyde. Baroque and Rococo: Art and Culture. Englewood Cliffs: Prentice Hall, 2003.
- Rosenberg, Jakob and Seymour Slive. *Dutch Painting 1600–1800*. New Haven: Yale University Press, 1995.
- Schama, Simon. The Embarrassment of Riches: An Interpretation of Dutch Culture in the Golden Age. Berkeley: University of California Press, 1988.
- Varriano, John. Italian Baroque and Rococo Architecture. New York: Oxford University Press, 1986.
- Wittkower, Rudolf. *Art and Architecture in Italy,* 1600 to 1750. New Haven: Yale University Press, 1999.

Nineteenth, Twentieth, and Twenty-First Centuries

- Arnason, H. H. *History of Modern Art*. New York: Abrams, 2003.
- Atkins, Robert. ArtSpeak: A Guide to Contemporary Ideas, Movements and Buzzwords. New York: Abbeville Press, 1990.
- ——. ArtSpoke: A Guide to Modern Ideas, Movements, and Buzzwords 1848–1944. New York: Abbeville Press, 1993.
- Bergdoll, Barry. European Architecture 1750–1890. New York: Oxford University Press, 2000.
- Boimé, Albert. A Social History of Modern Art. Chicago: University of Chicago Press, 1990–93.
- Brettell, Richard R. *Modern Art, 1851–1929:*Capitalism and Representation. Oxford:
 Oxford University Press, 1999.
- Broude, Norma. Impressionism: A Feminist Reading: The Gendering of Art, Science, and Nature in the Nineteenth Century. New York: Rizzoli, 1991.
- Brown, David Blayney. *Romanticism*. London: Phaidon, 2001.
- Causey, Andrew. *Sculpture Since 1945*. iNew York: Oxford University Press, 1998.
- Chu, Petra ten-Doesschate. *Nineteenth*Century Art. Englewood Cliffs: Prentice
 Hall, 2002.
- Clark, Graham. *Photograph*. New York: Oxford University Press, 1997.
- Clark, T. J. Image of the People: Gustave Courbet and the 1848 Revolution. Princeton: Princeton University Press, 1982.
- —. The Painting of Modern Life: Paris in the Art of Manet and His Followers. Princeton: Princeton University Press, 1989.
- Colquhoun, Alan. *Modern Architecture*. New York: Oxford University Press, 2002.
- Cox, Neil. Cubism. London: Phaidon, 2000.
- Craven, Wayne. American Art: History and Context. New York: McGraw-Hill, 2003.
- Cream, Contemporary Art in Culture. London: Phaidon, 1998.
- Cream 3, Contemporary Art in Culture. London: Phaidon, 2003.
- Crow, Thomas. *The Rise of the Sixties*. New York: Abrams, 1996.
- Curtis, Penelope. *Sculpture 1900–1945: After Rodin.* New York: Oxford University Press, 1999.
- Curtis, William J. R. *Modern Architecture Since* 1900. San Francisco: Chronicle Books, 1996.
- Doss, Erika. Twentieth-Century American Art. New York: Oxford University Press, 2002
- Eitner, Lorenz. *Neoclassicism and Romanticism 1750–1850* (Sources and Documents). New York: Harper & Row, 1989.
- Foster, Hal, et.al. *Art Since 1900: Modernism, Antimodernism, Postmodernism.* London: Thames and Hudson, 2005.

- Fresh Cream, *Contemporary Art in Culture*. London: Phaidon, 2000.
- Frascina, Francis, and Jonathan Harris. Art in Modern Culture: An Anthology of Critical Texts. New York: HarperCollins, 1992.
- Gale, Matthew. *Dada & Surrealism*. London: Phaidon, 1997.
- Godfrey, Tony. *Conceptual Art*. London: Phaidon, 1998.
- Groseclose, Barbara. *Nineteenth-Century American Art*. New York: Oxford University

 Press, 2000.
- Green, Christopher. *Art in France: 1900–1940*. New Haven: Yale University Press, 2000
- Hamilton, George H. *Nineteenth and Twentieth* Century Art. New York: Abrams, 1971.
- ——. Painting and Sculpture in Europe 1880–1940. New Haven: Yale University Press, 1993.
- Harrison, Charles, and Paul Wood, eds. Art in Theory, 1900–2000: An Anthology of Changing Ideas. Malden: Blackwell, 2003.
- Herbert, Robert L. *Modern Artists on Art.* Englewood Cliffs: Prentice Hall, 1986.
- —. *Impressionism*. New Haven: Yale University Press, 1991.
- Hitchcock, Henry-Russell. *Architecture*, *Nineteenth and Twentieth Centuries*. New Haven: Yale University Press, 1987.
- Holt, Elizabeth G. From the Classicists to the Impressionists. New Haven: Yale University Press, 1986.
- Hopi, Kachina, *Spirit of Life*. Seattle: University of Washington Press, 1980.
- Hopkins, David. *After Modern Art: 1945–2000*. New York: Oxford University Press, 2000.
- Hughes, Robert. *The Shock of the New*. New York: Knopf, 1992.
- Hunter, Sam, John Jacobus, and Daniel Wheeler. Modern Art: P\u00e4inting, Sculpture, Architecture, 3rd Edition. Englewood Cliffs: Prentice Hall, 2004.
- Hunter, Sam, and John Jacobus. *Modern Art: Painting, Sculpture, Architecture.* New York: Abrams, 1992.
- Janson, H. W. 19th-Century Sculpture. New York: Abrams, 1985.
- Levin, Kim. Beyond Modernism: Essays on Art from the '70s to '80s. New York: HarperCollins, 1989.
- Lovejoy, Margot, Postmodern Currents: Art and Artists in the Age of Electronic Media. Upper Saddle River NJ: Prentice-Hall, 1997.
- Lucie-Smith, Edward. *American Art Now*. New York: Morrow, 1985.
- ----. Art Today. London: Phaidon, 1995.
- ——. *Movements in Art Since 1945*. New York: Thames and Hudson, 1995.
- McCoubrey, John. *American Art 1700–1960* (Sources and Documents). Englewood Cliffs: Prentice Hall, 1965.
- Munroe, Alexandra. *Japanese Art After 1945: Scream Against the Sky.* New York: Abrams, 1994.

- Newhall, Beaumont. *The History of Photography, from 1839 to the Present Day.*New York: Museum of Modern Art, 1982.
- Nochlin, Linda. *Impressionism and Post-Impressionism* (Sources and Documents). Englewood Cliffs: Prentice Hall, 1966.
- ——. Realism and Tradition in Art 1848–1900 (Sources and Documents). Englewood Cliffs: Prentice Hall, 1966.
- Noever, Peter, and Regina Haslinger, eds. Architecture in Transition: Between Deconstruction and New Modernism. New York: te Neues, 1995.
- Patton, Sharon F. *African-American Art.* New York: Oxford University Press, 1998.
- Phillips, Ruth B., and Christopher B. Steiner, eds. *Unpacking Culture: Art and Commodity* in Colonial and Postcolonial Worlds. Berkeley: University of California Press, 1999.
- Pohl, Francis. Framing America: A Social History of American Art. New York: Thames & Hudson, 2002.
- Raizman, David. *A History of Modern Design*. Upper Saddle River: Prentice-Hall, 2003.
- Rewald, John. Post-Impressionism: From Van Gogh to Gauguin. New York: Abrams, 1990.
- —. *The History of Impressionism*. New York: Abrams, 1990.
- —. Studies in Impressionism. New York: Abrams, 1986.
- ——. Studies in Post-Impressionism. New York: Abrams, 1986.
- Rosenblum, Naomi. *A World History of Photography*. New York: Abbeville, 1997.
- Rosenblum, Robert, and H. W. Janson.

 Nineteenth-Century Art. New York: Abrams,
 1984.
- Rubin, James H. *Impressionism*. London: Phaidon, 1999.
- Sandler, Irving. *Art of the Postmodern Era*. New York: Harper Collins, 1996.
- Sayers, Andrew. *Australian Art*. New York: Oxford University Press, 2001.
- Smagula, Howard. *Currents, Contemporary Directions in the Visual Arts*. Englewood Cliffs: Prentice Hall, 1989.
- Thompson, Robert Farris. *African Art in Motion: Icon and Act.* Los Angeles: University of California Press, 1979.
- Upton, Dell. *Architecture in the United States*. New York: Oxford University Press, 1998.
- Varnedoe, Kirk. A Fine Disregard: What Makes Modern Art Modern. New York: Abrams, 1990.
- Wheeler, Daniel. *Art Since Mid-Century*. Englewood Cliffs Prentice Hall, 1991.
- Wood, Paul and Charles Harrison. *Art in Theory, 1900–2000*; 2nd ed. Boston: Blackwell Publishing, 2002.

Index

Figures in italics refer to illustrations.

Abbey in the Oak Forest (Friedrich) 447

A

Abbot Suger's Chalice (agate cup) 222, 222 Abd ar-Rahman I, Caliph 182, 184 Aboriginal art (Australia) 202, 203, 593, 593 Abraham Feeding the Three Angels (Byzantine mosaic) 167 Abstract Expressionism 500, 568-70 abstraction 503, 566; see also Hard-Edge Abstraction Abu Simbel: temple of Ramses II 46, 46 Abu, Temple of (Tell Asmar, modern Iraq) 41 Acconci, Vito (American): The Island in the Mur 612, 612 Achilles and Ajax Playing Draughts (Exekias) 38, 38, 76, 76 Acropolis, Athens 74, 74, 88 Action Painting 569 Adam, Robert (British): Osterley Park House 396, 397 Afghanistan see Buddhas, Bamiyan African art 19, 429, 510-11, 514; Benin 244-45, 245, 350, 350; Bwa 5, 14, 14, 30, 510, 510-11, 511; calabashes 19; Edo culture 245; altar head 244; Ife 244, 244-45, 245; Nok heads 26, 26 AIDS Memorial Quilt (Names Project) 564, 565, 596 airbrushing 581 Ajanta Caves, Deccan, India 158, 158, 159, 159 Akbar, Emperor 300 Akhenaten 45, 45, 46-47 Al'Ubaid, Iraq see Sumer/Sumerian art Albers, Josef (German American) 566: Homage to the Square: Affectionate 566, 566 Alberti, Leon Battista (Italian) 268-69; On Architecture 291; On Painting 253; On Sculpture 23-24 Alexander the Great 46, 74-75, 94, 104, 159; portrait coin 94, 94, 104 Alexandria, Egypt: library 104 Alfred Lord Tennyson (Cameron) 259, 259, 469 Algeria: Thamugadis 124

Allegory of the Outbreak of War (Rubens) 365, 365 Al-Mansur 182 Altamira cave art, Spain 23 Altar of Peace, Rome 119, 119 amber necklaces (Mongolia) 201, 201 Amenhotep III 53 America's Most Wanted (Komar and Melamid) 596-97, 597, 598 American Gothic (Wood) 552-53, 553, 554 American Landscape (Sheeler) 552, 553 American Renaissance 465 Amiens Cathedral, France 230-31, 231; Beau Dieu (trumeau) 83, 230, 230 amphitheaters 119, 130 amphorae 32, 33, 38, 72, 77, 77 Amswold, J. (American): The Rude Descending a Staircase 517, 519 Anderson, Laurie (American) 600, 600 Ando, Tadao (Japanese): Water Temple, Japan 151, 602-603, 603 Andokides Painter (Greek) 76 Angkor Wat, Cambodia 214, 214-15, 215 Anglo-Saxon literature 170-71; metalwork 170, 170-71 Anguissola, Sophonisba (Italian) 304; Portrait of the Artist's Three Sisters with Their Governess 305 Annunciation (Parisian book of hours) 222, Annunciation with Patrons and Saint Joseph in His Workshop (Campin) 264, 264-65, 265 Anthemius of Tralles: Hagia Sophia 164-65 Apelles (Greek) 75 Aphrodite of Knidos (Praxiteles) 82 Apollinaire, Guillaume (French) 435 Apollo and Daphne (Bernini) 6, 6, 7, 352 Apollo and the Battle of the Lapiths and the Centaurs (Olympia) 72 Appropriation Art 601–602 aqueduct 135 Aquinas, Thomas (Italian): Summa Theologica 221 Arbus, Diane (American): Untitled (6) 582, 583 Arcadian Shepherds (Poussin) 382 arch construction 95, 96, 114; see also

building materials and techniques

Arch of Titus, Rome 95, 95, 122, 123 architecture (see also building materials and techniques and specific countries): analyzing 8-12; Baroque 401; Bauhaus movement 503, 524, 542, 542-43, 543, 562, 566; Buddhist 149, 158-59, 177-78,190, 190-91, 191; Byzantine 164-65; Carolingian 187-88, 188, 208-209, 221, 226; Deconstructivist 587; diagrams 55, 55; early Christian 156-57; Gothic 55, 96, 96, 220, 220-21, 221, 223, 224, 224-25, 225, 226, 227, 228, 228-29, 229, 231, 231, 253, 431; Gothic Revival 434, 454, 454–55; Hindu 180, 180-81, 181, 190, 370, 370-71, 371; International style 562, 562-63, 563, 586; Islamic 164, 184, 339, 370, 370-71, 371, 437, see also mosques; Khmer 214, 214-15, 215; Neolithic 25; Ottonian 187; Post-modernist 586; Prairie style 524, 524-25, 525, 543; Romanesque 208, 208, 209, 209; Romantic Revival 454, 454-55, 455 Arena Chapel frescoes (Giotto) 202, 202, 240, 240-41, 241 Aristotle 74, 104, 322 Arp, Jean (Swiss) 538-39; Collage Arranged According to the Laws of Chance 539 Arrival and Reception of Marie de' Medici at Marseilles (Rubens) 364, 364 Art in Transit (Haring) 593 Art nouveau movement 430, 434 Arts and Crafts movement 430, 434, 543 As I Opened Fire (Lichtenstein) 577, 578 Asam, Egid Quirin (German): Assumption of the Virgin 415, 415 Ashoka, Emperor 92, 94, 111, 177 assemblage 519 Assumption of the Virgin (Asam) 415, 415 Assumption of the Virgin (Titian) 330, 331 Assyrian art and architecture 66, 66-67, 67 Athena, sculptures (Phidias) 89-91 Athens 73–74,138, 401, 455; Parthenon 13, 88, 88-89, 89, 90, 90-91, 91, 119 Atlantis, city of 60 Attalus I, of Pergamon 106 Augustus, Emperor 115, 118-19, 122, 127, 135, 284; sculpture of 83, 118

Australia: Aboriginal artists 202, 203, 593, 593

Allegorical Portrait of Sarah Siddons as the

Tragic Muse (Reynolds) 417, 417

avant-garde 19, 432, 435, 466, 484, 499, 501, 503, 512, 531, 534–36, 543, 551, 568, 576; Chinese 592–93 axial composition 6 Aztecs 138, 146, 251, 251, 299, 505, 546; Muisca culture 299

В

Bacchic Mysteries (Roman fresco) 126, 126 Bacchus, worship of 30, 126 Balboa, Vasco Múñez de (Spanish) 299 Baldacchino (Bernini) 366, 366 Baldinucci, Filippo (Italian) 378 Balla, Giacomo (Italian): Speeding Automobile - Study of Velocity 498, 498, 519 balloon frame 463 Banjo Lesson, The (Tanner) 479, 479 banner (Han Dynasty) 108, 108 Banquet of the Officers of the Civic Guard of St. George (Hals) 368, 368 Bar at the Folies-Bergère, A (Manet) 429-30, Barney, Matthew (American): Cremaster films 613, 613-14 Baroque style 302, 351-52, 354; architecture 351, 366, 366-67, 367, 372, 372-73, 373; ceiling painting 352; painting 351, 362, 362-63, 363, 368, 368-69, 369, 382, 382-83, 383, 417, 417, 421, 423; see also Rubens, Peter Paul; sculpture 351 Barry, Charles (British): Houses of Parliament 454, 454 Bartholdi, Frédéric-Auguste (French): Statue of Liberty 432 Basilica of Maxentius and Constantine, Rome 132-33, 133 Basilica Ulpia, Rome, 119, 120, 132, 132 basilicas 156-57, 165, 188, 316, 366 Baths of Caracalla, Rome, 119, 121, 121 battered walls 51, 53 Battista Sforza and Federigo da Montefeltro (Piero della Francesca) 255, 255 Battle of Alexander the Great and King Darius, The (Roman mosaic copy) 104, 106–107, Battle of Fishes (Masson) 550, 550-51 Battle of the Giants (Singh twins) 616, 616 Bauhaus 503, 524, 542, 542-43, 543, 562, 566 Bayeux Tapestry 206, 206-207 Beau Dieu (Gothic sculpture) 83, 230, 230 Beauneveu, André (French) 223

Beauvais Cathedral, France 224, 229

Beijing 11-12; Forbidden City 11, 172, 236, 236-37, 237 Bellini, Giovanni (Italian): altarpiece at San Zaccaria, Venice 604; Feast of the Gods 305, 305 Benedict, Saint 189 Benin art 244-45, 245, 350, 350 Benton, Thomas Hart (American) 502; Pioneer days and Early Settlers 554, 555 Beowulf 170 Bergman, Ingmar (Swedish) 503 Bernini, Gianlorenzo (Italian) 317, 351-52, 399; Apollo and Daphne 6, 6, 7, 352; Baldacchino 366, 366; Cathedra Petri 366; Cornaro Chapel 374-375, 375; David 348, 348; Ecstasy of Saint Teresa 374, 374-75; Fountain of the Four Rivers 352, 352; St. Peter's Colonnade 367, 367; Triumph of the Name of Jesus 352, 353 Bessemer process 462 Beuys, Joseph (German) 576-77; Iphigenia/Titus Andronicus 577, 577 Bible, the 148; Gutenberg Bible 254 Bingham, George Caleb (American): Fur Traders Descending the Missouri 457, 457 Bingham, Hiram (American) 278, 431 Bird in Space (Brancusi) 528, 529 Bird of the Night (Bwa mask) 14, 14, 511 Birth of Athena (Phidias) 90 Birth of the Djang'kawu Children at Yalanghara, The (Marika) 593, 593 Blue Boat, The (Homer) 483, 483 "Blue Rider, the" (der Blaue Reiter) 532 Boating Party, The (Cassatt) 477, 477 Boccioni, Umberto (Italian): Unique Forms of Continuity in Space 519, 519 Bodhi tree 111, 111 Bodhisattva Padmapani painting, Ajanta Caves 159, 159 Boffrand, Germain (French): Princess's Salon, Hôtel de Soubsie, Paris 396, 396 Book of Kells 171, 171 Borghese, Cardinal Scipione 7 Borobudur Temple, Java, Indonesia 190, 190-91, 191, 250 Borromini, Francesco (Italian): Sant'Agnese in Agone 352, 352; San Carlo alle Quattro Fontane, Rome 372, 372-73, 373, 401, 613 Bosch, Hieronymus (Dutch) 327: Garden of Earthly Delights triptych 326, 326-27, 327 Bossi, Antonio (Italian): Kaisersaal (stucco work), Germany 414, 414 Boston Pubic Library (McKim, Mead, & White) 465, 465

Botticelli, Sandro (Italian) 242, 308, 318; Birth of Venus 288, 289; Realm of Venus 288, 288 Bourgeois, Louise (French American) 598; Matman 598, 598 Bourke-White, Margaret (American) 582; Fort Peck Dam 513, 513 Boyle, Richard (British): Chiswick House 418, Bramante, Donato (Italian) 291; St. Peter's, Rome 316, 316–17, 317; 322 Brancusi, Constantin (Romanian) 512 Bird in Space 528, 529; The Kiss 502, 502-503; The Newborn 528, 528 Braque, Georges (French) 515-17, 519; Violin and Palette 514, 514 Breton, André 550 (French) 550-51 Brhatsamhita (Varahamihira) 159 "Bridge, the" (die Brücke) 532 Britain/British 423, 428-29; architecture in India 437, 437; Anglo-Saxon literature 170-71; Anglo-Saxon metalwork 170, 170-71; colonization 428; Great Exhibition of 1851 429, 460; Stonehenge 27, 27, 28, 30, 36, 58, 356, 356-57, 619; Sutton Hoo treasury 170, 170-71; see also London bronze work: Chinese 34, 35, 64-65, 109, 113; Dongson 112, 112–13, 113; Etruscan 70; Greek 80, 80-81, 81; Japanese 246, 247; see also casting Bruegel, Pieter, the Elder (Flemish): December Landscape 336, 336; Peasant Wedding Feast xiii Brunelleschi, Filippo (Italian) 253, 266, 268-69; Florence Cathedral dome 276-77, 277; San Spirito, Forence 276, 276 Bruni, Leonardo (Italian) 252 Buddhas, Bamiyan, Afghanistan 620-21, 621 Buddhism 59, 94, 110-11, 145-46, 161, 174, 177-78, 183, 199, 217, 344, 412, 448, 602, 620-21; architecture xiii, 149, 158-59, 177, 190, 190-91, 191; mandalas 92; pagodas 92; painting 248-50, 250; sculpture 94, 94, 146, 146, 246, 247, 307; stupas 92, 92-93; temples 181; see also Mahayana Buddhism; Tantric Buddhism; Zen Buddhism building materials and techniques: arches 95, 121-22, 131-34, 134, 135, 184, 209-10, 220-21, 226, 228-29, 229, 231, 277, 371, 440, 441, 587; architrave 84, 84; battered walls 51, 53; Bessemer process 462; buttressing 132-33, 134, 209, 226, 228-29; cantilever 11, 525; cast-iron construction 460-61, 493; clerestories 52; columns 84, 84; concrete 114, 121-22, 131-32, 135, 463, 463, 573; cornice 84, 84; dougong construction 97, 97; dougong-style bracketing 177, 178, 178; entablature 84, 84; flutes 84, 84; organic 522; pilasters 84; post-and-lintel 11, 52, 54–55, 84, 86, 88, 132, 177; pylon 52–53; reinforced concrete joint 463; steel 461–63, 463, 492–93; tensile strength 11, 54, 80, 97, 461, 463, 525; tufa 131, 135, 212, 212–13, 213; vaults 114, 121–22, 130, 132–34, 134, 136, 169, 209, 220, 224, 228–29, 229, 286

Bull Leaping (Minoan fresco) 60, 60

buon fresco 17, 128, 242 Burghers of Calais, The (Rodin) 480, 480 Burial at Ornans, A (Courbet) 458, 458 burial mounds 20, 21, 26, 108; Siberian

burins 76

98-101, 99

buttressing 132–33, *134*, 209; flying buttresses 226, 228–29

Bwa, the: masks and rituals 5, 14, 14, 30, 30, 99, 510, 510–11, 511 byobu (Japanese screens) 390, 390–91

Cai Guo-qiang (Chinese): Transient Rainbow

Byzantine art 162-63, 166-67

Caesar, Julius 118-19

\mathbf{C}

fireworks performance 606, 607 calabashes 19 Calatrava, Santiago (Spanish): World Trade Center Transportation Hub 608-609, 609, 612 Calder, Alexander (American) 559, 561; Lobster Trap and Fish Tail 559 calligraphy 184, 192, 195, 219, 620, 620 Calvanism 351, 384 Cambodia: Angkor Wat 214, 214-15, 215 camera 469, 469 camera obscura 363, 468-69, 619 Camera Picta see Ducal Palace Cameron, Julia Margaret (British) 258, 259, 469; Alfred Lord Tennyson 259, 469 Campin, Robert (Flemish) 275, 332, 386; Annunciation with Patrons and Saint Joseph

in His Workshop 264, 264-65, 265, 507, 507

Canoptic Legerdemain (Graves) 601, 601-602

Canova, Antonio (Italian) 422; Cupid and

Psyche 422, 422; Napoleon as Mars the

Canterbury Cathedral, England 223

cantilevers *see* building materials and techniques

Caracalla, Emperor 119

Caravaggio (Italian) 360–63, 384; Christ with the Doubting Thomas xiii, 360, 360; Conversion of Saint Paul 287, 360, 360

Carolingian era: architecture 208, 221, 226; art and culture 146, 186

Carpeaux, Jean-Baptiste (French): *The Dance* 470, 470

carpet (Pazyryk) 98, 98-99

Carracci, Annibale (Italian) 351

Carracci, Ludovico (Italian): Madonna degli Scalzi 302–303, 303

carriage, Siberian funeral 98-101, 101

Carriera, Rosalba (Italian) 416–17: Portrait of Louis XV as a Young Man 416, 416

Carson-Pirie-Scott Store, Chicago (Sullivan) 493, 493

Carter, Howard (British) 47

Cartier-Bresson, Henri (French): Sunday on the Banks of the Marne 513, 513

Cassatt, Mary (American) 477; The Boating Party 477, 477

Castiglione, Baldassare (Italian): Book of the Courtier 304

casting: bronze casting 65, 65; lost-wax casting 81, 112, 300, 350; piece-mold casting 65, 65

cast-iron *see* building materials and techniques

Çatal Hüyük, Turkey 25–26, 26, 28, 28

Cathedra Petri (Bernini) 366–67

Catholicism *see* Counter-Reformation; papacy

cave art 22, 22-23, 23

Celestial Book: Mirror for Analyzing the World (Xu Bing) 14–15, 15, 438, 438, 592

Cellini, Benvenuto (Italian) Autobiography 304; Saltcellar of Francis I 335, 335; Treatise on Sculpture 309

Cennini, Cennino (Italian): *The Craftsman's Handbook* 253

ceramics: Chinese *174*, 175; *see also* porcelain; terra-cottas

Cézanne, Paul (French) 239, 426, 439, 466, 489–91, 512, 514–15; Mont Ste.-Victoire
491, 491, 439, 439; Still Life with Basket of Apples 490, 490

Chalgrin, Jean-François Thérèse (French): Arc de Triomphe 440, 441

Chan Buddhism see Zen Buddhism Chang'an, China 12, 103, 122, 172, 172–75,

175, 236

Chardin, Jean-Baptiste Siméon (French): Kitchen Still Life 411, 411

Charlemagne 186–87, 189 *see also* Carolingian era

Charles I of England 350-51

Charles V, Emperor 223, 300, 302, 334

Charles X of France 426, 452

Chartres Cathedral, France 150, *150*, 232–33, 232, 224, 224–25, 225, 226, *226*, *227*, 228, 228, 608

Chen Zhen (Chinese): *Jue Chang* installation 604, 604

Cheng Ho 149

chiaroscuro 129, 378, 444, 534

Chicago: Carson-Pirie-Scott Store (Sullivan) 493, 493; Cloud Gate (Kapoor) xvi, 1; Fair Store (Jenney) 463; Robie House (Wright) 524, 524–25, 525

China/Chinese 36-37, 413, 430; aesthetic theory 195; architecture 11, 12, 18; avantgarde movement 592-93, 603, 605; bronzes 34, 35, 64-65; calligraphy 5, 18, 195; ceramics/porcelain 174, 175, 299, 305, 305; figurines 29, 29; Five Dynasties 194; Han Dynasty 103, 108–109, 113, 146, 172–73; Hongshan culture 18, 18; jades 18, 65, 109, 109; landscape painting 5, 5, 6-7, 192, 192-93, 193, 194, 194-95, 200, 200, 413; Ming Dynasty 11, 149, 236-37, 250, 283, 299, 350, 413; Political Pop 603; Qin tomb warriors 4, 4, 6-7, 102, 102-103; Qing (Manchu) Dynasty 5, 149, 237, 350, 397; scroll paintings 5, 6, 17, 173, 175, 192, 192, 200, 283, 407, 407, 592; sculpture see jades and Qin tomb warriors; Shang Dynasty 35, 64-65, 109; Song Dynasty 5, 146, 194-95; Sui Dynasty 146, 172; Tang 146, 149, 172-73, 175, 192; Tiananmen Square Massacre 438, 588, 592; Yuan Dynasty 11, 236, 257; Zhou Dynasty 109; 20th-century art 14-15, 15, 438, 438, 592, 603-604, 604, 605, 606, 607; see also Beijing; "Silk Road"

Ching Hao (Chinese): Essay on Landscape Painting 195

chinoiserie 400, 405, 405

Chirico, Giorgio (Greek Italian) 534–35, 549: The Melancholy and Mystery of a Street 534, 534

Chong Son (Korean) 412; Twelve Thousand Peaks of Mount Kumgang 413, 413

Choson Dynasty see Korea

Christ in Majesty with Angels, Symbols of the Evangelists, and Saints (Romanesque fresco) 204, 204

Peacekeeper 440, 440

Christ Preaching (Rembrandt) 378, 378-79 Christ Washing the Feet of Saint Peter (illuminated manuscript) 187, 187 Christ with the Doubting Thomas (Caravaggio) xiii, 360, 360 Christianity 83, 123-24, 131, 143-44, 147, 154–55, 157, 163, 166, 169–71, 174, 180, 18-83, 189, 199, 205, 290, 299-300, 323, 373, 547; integration with humanism 253; see also Crusades; Franciscans; Protestantism Christo (Bulgarian American) and Jeanne-Claude (French American) 584; Running Fence 584, 585 Churning of the Sea of Milk (Khmer relief sculpture) 215, 215 Cimabue 238-39, 242; Madonna Enthroned with Angels and Prophets 239 cinema 503; Lumière brothers 503 City Square (Giacometti) 500, 501, 504 classic/classical: definition 36 Classified Record of Ancient Painter/Gu hua pin lu (Xie He) 195 Claudel, Camille (French): The Waltz 481, 481 Clement VII, Pope 300 Clement XI, Pope 398 Close, Chuck (American) 618; Self-Portrait 618, 619 Cloud Gate (Kapoor) xvi, 1 Cluny, France: monastery 189, 189, 205 coins 94, 94,104 Cole, Thomas (American): Schroon Mountain 431, 456, 456, 457 Colescott, Robert (American): Les Demoiselles d'Alabama: Vestidas 590-91, 591 collage 516-17, 517, 519, 537 Collage Arranged According to the Laws of Chance (Arp) 539 Color Field Painting 569 Colosseum, Rome 84, 96, 96, 130, 130-31, 131 colour wheel 16, 16 Columbus 250-51 Column of Trajan, Rome 119, 123 Communism 499, 500, 537, 571, 583 Conceptual Art 539, 576, 590 Concert Champêtre (Titian) 466 concrete see building materials and techniques Confucianism 109, 412-13; neo-Confucianism 194 Constable, John (British) 446; The Hay Wain 446, 446 Constantine, Emperor 124, 131, 156-57, 162 Constantinople 124, 150, 162, 164, 166, 257,

340; see also Hagia Sofia

contextualism xii contrapposto 79-80, 83, 153, 163, 261 Convergence (Pollock) 439, 566, 567 Conversion of Saint Paul (Caravaggio) 287, 360, 360 Copernicus, Nicolaus (Polish): On the Revolution of the Celestial Spheres 300 Copley, John Singleton (American) 402; Portrait of Paul Revere 416, 416 Corbusier see Le Corbusier Córdoba, Spain: Mosque xiii, 182, 182-83, 183, 184, 185, 205 Corinthian style 131, 419 Cornaro Chapel, Rome 374-375, 375 Cornelia, Mother of the Gracchi (Kauffmann) Cornell, Joseph (American) 519, 539, 561; Medici Slot Machine 561, 561 Corpus installation (Hamilton) 618, 618 Cortés, Hernan 299 Cotton Goods Lane (from One Hundred Views of Edo) (Hiroshige) 450, 451 Counter Reformation 302-303, 334, 342-43, 351, 352, 415 Courbet, Gustave (French) 431, 436, 458-59, 473; A Burial at Ornans 458, 458 Court Ladies Preparing Newly Woven Silk (Zhang Xuan) 172, 173, 407, 407 Cranach, Lucas, the Elder (German) Portrait of Martin Luther 301 Creation of Adam (Michelangelo) 287, 318 Cremaster films (Barney) 613, 613-14 Crete see Knossos cromlechs 27, 199-200, 205, 221 cross-hatching 314 Cuba: architecture 401, 401 Cubi XIX (Smith) 12-13, 13, 14 Cubism 239, 439, 514, 531, 534, 546, 582; Analytical 516-17, 530; Synthetic 517, 519, 537, 556 Cupid and Psyche (Canova) 422, 422 Currier & Ives 429 Curtis, Edward S. (American): Hamatsa dancers (photograph) 527 Cut with the Kitchen Knife (Höch) 538, 538 Cycladic Island figures 34, 35 D

Curtis, Edward S. (American): Hamatsa dancers (photograph) *527 Cut with the Kitchen Knife* (Höch) *538*, *538*Cycladic Island figures *34*, *35*D

Dada *519*, *535*, *536*, *536*–*37*, *537*, *538*, *538*–*39*, *539*, *549*, *551*–*52*, *568*, *576*; Neo-Dada *570*Dadu, China *236*Daguerre, Louis (French) *469*

Dalí, Salvador (Spanish) 549; The Persistence of Memory 549, 549-50 Dance, The (Carpeaux) 470, 470 Dance, The (Matisse) 508-509, 509 Dante (Italian): Divine Comedy 238, 241 Daoism 108-109, 194, 174, 607 Darius, King of Persia 67, 94, 104 Darwin, Charles (English): The Origin of the Species 430 Daumier, Honoré (French) 439, 452; Freedom of the Press 438, 438, 452, 453; Rue Transnonain 452, 452 David (Bernini) 348, 348 David (Donatello) 254, 281, 281 David (Michelangelo) xi, 306, 306, 308, 308-309, 318, 352 David, Jacques-Louis 403; Death of Socrates 420, 420, 421 Death of General Wolfe (West) 423, 423 Death of Sarpedon (Euphronios and Euxitheos) 76, 76-77 Death of Socrates (David) 420, 420, 421 December Landscape (Bruegel) 336, 336 Deconstructivism 587 Deer Bearing a Sacred Mirror with Symbols of the Five Kasuga Honji-Butsu 246 Degas, Edgar (French) 439, 466, 472, 476-77; Little Dancer 438, 438, 470-71, 471; The Rehearsal 476, 476 Déjeuner sur l'herbe, Le (Manet) 466, 466 Delacroix, Eugène (French) 431; Liberty Leading the People 426, 426 Delft chinoiserie 405, 405 Demoiselles d'Alabama: Vestidas, Les (Colescott) 590-91, 591 Demoiselles d'Avignon, Les (Picasso) 514, 514-15, 590 Demuth, Charles (American) 512; I Saw the Figure 5 in Gold 552, 552 Departure of the Volunteers of 1792, The/La Marseillaise (Rude) 445, 445 Deposition (Weden) 249, 249 Derrida, Jaques (French) 587, 589 Descartes, René (French) 349, 399 Descent of the Ganges (Hindu relief), Mahamallapuram 145, 145, 357, 357 de Stijl movement 17, 524, 540, 540-41, 541, 542-43 Dickens, Charles (English) 397, 429, 431 Diderot, Denis (French) 420 Diocletian, Emperor 124 Dionysis 75 diptychs 284

Dipylon vases (Greek) 73, 73

Disasters of War, The (Goya) 443, 443 domes 133-34, 134, 136, 149, 157, 164, 277, 316-17, 371-72, 372, 414, 419; octagonal 418; "onion" 300 Donatello (Italian) 253, 255, 267, 321, 480, 508; David 254, 281, 281; Gattamelata 254, 254; Penitent Magdalene 260, 260-61; Saint Mark 83, 260, 260-61 Dongson culture 112-13 Doric style 131, 419 Doryphoros (Spear Carrier) (Polykleitos) 81, 82, 83, 118 dougong construction 97, 97 dougong-style bracketing 177, 178, 178 drawings 376, 376-77, 377 Dream of Malinche, The (Ruiz) 546, 547 Drift 2 (Riley) 579, 579 drum (Dongson) 112, 112-13, 113 Ducal Palace, Mantua, Italy 286, 286-87 Duchamp, Marcel (French) 517, 536, 539, 559, 570, 576, 578; Bottle Rack 536, 536; Fountain 536, 536; Nude Descending a Staircase 517-18, 518 Dura Europos synagogue, Syria 150, 150, 155, 152, 152-53 Durand, Asher B. (American) 456 Duranty, Edmund 476 Dürer, Albrecht (German) 299, 532; Adam and Eve 312, 312, 314, 314; Artist Drawing a Lute with the Help of a Mechanical Device 287, 287; Four Horsemen of the Apocalypse 313, 313, 315; Praying Hands 303, 303; Treastise on Human Proportions 312 Dutch art and architecture see Netherlands Dutch Landscape from the Dunes at Overveen (Ruisdael) 356, 356, 392, 392, 446 Dying Lioness, Assyrian 67, 67 *Dying Trumpeter, The* (Hellenistic sculpture) 106, 107

E

Portrait of Dr. Samuel Gross 478, 478

Early Spring (Guo Xi) 5, 6–7

Easter Island: Moai figures 212, 212–13, 213

Ecstasy of Saint Teresa (Bernini) 374, 374–75

Edison, Thomas 503

Edward III of England 480

Egypt, ancient 38, 40, 44–57; mastabas 51, 51; mummification 44, 46; relief sculpture 13–14, 44, 44, 45–46, 45–46, 49; sculpture 44–46, 44–46, 78, 80, 259

Eakins, Thomas (American) 431, 478–79;

Eiffel, Gustave (French) 462; Eiffel Tower 424, 425; Statue of Liberty 432, 462 Einstein, Albert 500 Eisenman, Peter (American): Wexner Center, Ohio 586-87, 587 Eisenstein, Sergey (Russian): Potemkin 503, 504 elevator (Otis) 425, 462 Eliade, Mircea (Romanian): Cosmos and History 4-5 Ellora, India: Kailasantha Temple xiii, 180, 180-81, 181 embroidery 206 Empire style 434 Empirical Construction Istanbul (Mehretu) 614-15, 615 engineering 96-97, 425, 433, 460-61; balloon frame 463; cantilever 11, 525; Gothic 224, 228, 228-29, 229; post-and-lintel 11, 52, 54-55, 84, 86, 88; Roman 122, 132-35; steel 461-63, 463, 492-93; tensile strength 11, 54, 80, 97, 463, 525 Enlightenment, the 395, 399, 403, 405, 418, 420 Epic of American Civilization, The (Orozco) 546, 546 Equivalent (Stieglitz) 512, 512-13 Ernst, Max (German 519; Two Children Are Threatened by a Nightingale 548, 549 Essay on Landscape Painting (Ching Hao) 195 etchings see prints/printmaking Etruscans 34, 70-71, 131; bronze mirrors 34, 34, 36; urns 70, 71 Euclid 322 Euphronios and Euxitheos (Greek): Death of Sarpedon 76, 76-77 Excel Saga (Rikudou) 599, 599-600 Execution of Madrileños on the Third of May, The (Goya) 442, 442 Exekias (Greek) Achilles and Ajax Playing Draughts 38, 38, 76, 76; Existentialism 500 Expressionism 546, 582; see also Abstract Expressionism; German Expressionism Eyck, Jan van (Flemish) 271, 332, 386; The Altarpiece of the Lamb (with Hubert van Eyck) 270, 271, 271; Portrait of Giovanni Arnolfini and Giovanna Cenami 258, 272, 272, 274, 274; Self Portrait? 256, 257

F

faience 61, 61 Fallingwater, Bear Run, Pennsylvania (Wright) 8, 9, 10, 10, 11, 97, 97 fang ding (Chinese bronze vessels) 34, 35, 64, 64,65 Fauvism 508, 508-509, 509, 514, 533-34 Feast of Sadeh..., The (Sultan Muhammed) xii, 339, 339 Feast of the Gods (Bellini and Titian) 305, 305 fengshui 172, 237 Ficino, Marsilio (Italian) 289 Fiesole, Mino da (Italian): Portrait of Piero de' Medici 258, 282, 282 figura serpentinata 83, 335 figure-ground relationship 57 figurines: Chinese Neolithic 29, 29; Cycladic Island figures 34, 35; haniwa (Japan) 147, 147, 598-99, 599; Olmec 68-69, 69; Willendorf statuette (Paleolithic) 24, 24, 25 Firdawsi: Shah-nameh 339 First Abstract Watercolour (Kandinsky) 532-33, 533 First Sermon, The, Sarnath, India 146, 146 Five Angels for the Millennium video installation (Viola) 614, 614 Flack, Audrey (American): World War II (Vanitas) 580-81, 581, 582 Flag (Johns) 569, 569-70 Flanders 249, 252-53, 255, 284-85; see also Flemish painting Flavian Amphitheater see Colosseum Flemish painting 249, 249, 256, 258, 258, 262, 262-63, 263, 263-65, 265, 270-75, 284, 284-85, 284, 303 (15th c.), 336, 336, 338, 338-39 (16 th c.); see also Rubens Flora (Roman fresco) 95 Florence 252, 260-61, 306, 351, 355; Accademia del Disegno 304; Baptistery Doors 38, 257, 269, 269; Cathedral xiv, 276–77, 277, 309; Medici Palace 280, 280-81; Palazzo della Signoria 308; San Spirito 276, 276; Santa Maria Novella 266, 266 Flower Still Life (Ruysch) 387, 387 Fog Warning, The (Homer) 482, 482 Fontana, Lavinia (Italian) 304; Self-Portrait 304 Forbidden City see Beijing Foreshortened Christ (Mantegna) 287, 287 foreshortening 77, 205, 287 Fort Ancient culture: "Great Serpent Mound" Fort Peck Dam (Bourke-White) 513, 513 Forum of Trajan, Rome 132, 132; Forum, Rome 116, 119, 120 "found objects" 536, 570 Fountain of the Four Rivers (Bernini) 352, 352 Fragonard, Jean-Honoré (French): Happy

Accidents of the Swing 408, 409

France: Academic Art 434; architecture 208, 208, 209, 209 (Romanesque), 96, 150, 220, 220–21, 221, 223, 224, 224–25, 225, 226, 226, 227, 228, 228–29, 229, 231, 231 (Gothic), 396 (Rococo), 388, 388–89, 389 (17th c.), 418 (18th c.), 464 (19th c.), 572, 573, 574, 583, 584 (20th c.); monasteries 189, 189; painting 400, 400 (Rococo), 388 (17th c.), 398, 398, 408, 408–409, 409, 411, 411, 420 (18th c.), 426, 426–27, 427, 458, 458, 466, 466 (19th c.); prints 452, 452–53, 452; Realism 434; sculpture 224, 230, 230–31, 231 (Gothic), 438, 438, 464, 470, 470–71, 471, 480, 480–81, 481 (19th c.); see also Versailles

Francis I of France 300

Francis, Saint, of Assisi 223, 240

Franciscans 223

Franco, General Francisco 557

Frank, Robert (American): *Trolley, New Orleans* 571, 571

Frederick the Great 398

Freedom of the Press (Daumier) 438, 438, 452, 453

French Revolution 399, 420, 425–26, 428, 440 French, Daniel Chester (American):

Minuteman 12, 12, 13

fresco secco 128, 243

frescoes 17, 128, 152, 202, 202; Arena Chapel frescoes (Giotto) 202, 202, 240, 240–41, 241; Buddhist 159; Kaisersaal, Germany 414, 414; Mesoamerican 140, 141; Minoan 60, 60, 61; Roman 31, 104, 126, 126–127, 127; technique 242–43, 243

Freud, Sigmund (Austrian) 311, 501, 550, 568 Friedrich, Caspar David (German) 431,

446-47; Abbey in the Oak Forest 447

Frieze of Life (Motifs from the Life of a Modern Soul) exhibition (Munch) 203, 203, 495, 495

Frog Mantra (Tsai) 620, 620

fukinuki yatai (bird's eye view) 218

Fur Traders Descending the Missouri (Caleb) 457, 457

Fuseli, Henry (Swiss) 410; *The Nightmare* 410, 411

Futago (Morimura) 39, 39

Futurism/Futurists 498, 517, 519, 530-31

G

Gaineswood house, Demopolis, Alabama (Greek Revival) 454, 455 Gainsborough, Thomas (British): Portrait of Sarah Siddons 406, 406, 417, 417

Galen 81

Galilei, Galileo (Italian) 301

Gallery 291 512

Gaozong, Emperor 194

Garden (Roman fresco) 127, 127, 129

Garden of Earthly Delights triptych (Bosch) 326, 326–27, 327

Garnier, Charles (French): Paris Opéra 462, 464, 464, 470–71

Gattamelata (Donatello) 254, 254

Gaugin, Paul (French) 435, 484, 488; The Vision after the Sermon 484, 484; Where Do We Come From? What Are We? Where Are We Going? 434, 435

Gaulli Triumph of the Name of Jesus 352, 353

Gautama, Siddhartha 110

Gay Liberation Tableau (Segal) 588, 589

Gehry, Frank (American): Guggenheim Museum, Bilbao, Spain 602, 602, 609, 612, 613

Gentileschi, Artemisia (Italian): *Judith and Her Maidservant* 361, 361, 406, 407; *Self-Portrait as the Allegory of Painting* 39, 39, 354, 355

George III, King 399, 423

George Sand (Nadar) 468, 468

George Washington (Greenough statue) 440, 441

Géricault, Theódore (French) 431, 436; *The Raft of the Medusa* 444, 444–45

German Expressionism 532, 532-33, 533, 534

Germany: architecture 414, 414–15 (Rococo); Bauhaus movement 542, 542–43, 543; Dada collages 537, 537–38, 538; Dadaist nihilism 537; Expressionism 532, 532–33, 533, 534; painting 328, 328–29, 329 (16 th c.), 446, 447, 459, 459 (19th c.), 504, 504, 532, 532–33, 533, 566, 566 (20th c.); performance art 576–77, 577

gesso 242, 261, 274

Ghent Altarpiece (van Eyck) see Altarpiece of the Lamb

Ghiberti, Lorenzo (Italian) 241, 257, 269; Florence Baptistry doors 38, 268, 269; Self-Portrait 38, 39, 257

Ghirlandaio, Domenico (Italian) 318; Portrait of a Man and a Boy 282, 282; Portrait of a Man on His Deathbed 282, 283

Giacometti, Alberto (Swiss): *City Square* 500, 501, 504

Giambologna (Italian): Rape of the Sabine Woman 335, 335 Gilgamesh (epic) 40

Giorgione (Italian) 332; Sleeping Venus 324, 324–25; Tempestuous Landscape with a Gypsy and a Soldier 325, 325

Giotto di Bondone (Italian) 238–39, 242–43, 266; Arena Chapel frescoes 202, 202, 240, 240–41, 241; Lamentation 240, 240; Last Judgement 241, 241; Madonna Enthroned with Angels and Saints 238, 240

Giza, Egypt: pyramids 44–45, *50*, 50–51, *51*; sphinx 44, 50, *50*; Temple of Khafre 44, *44*, 52

gladiators 131

Glass House, Connecticut (Johnson) 506, 506, 562, 562

globalization 616

Gogh, Vincent van (Dutch) 429, 436, 449, 486–89, 532; The Night Cafe 486, 489, 486–88; Self-Portrait with Bandaged Ear and Pipe 436, 436, 488; The Starry Night 487, 487–88

gold work: Aztec 299; Mycenaean mask 63, 63; Scythian 37, 37

Goldsworthy, Andy (British): *Icicles 617*, 617–18

Goncharova, Natalya (Russian) 530–31; Electric Light 530, 530

Gonzaga, Ludovico (Italian) 286 Good Shepherd (marble) 83, 155, 155

Gothic Revival 434, 454-55

Gothic style: architecture 220, 220–21, 221, 223, 224, 224–25, 225, 226, 226, 227, 228, 228–29, 229, 231, 231, 253, 431; sculpture 221, 222, 222, 224, 230, 230–31, 231

gouache 483

Goya, Francisco (Spanish) 431, 442–43; The Execution of Madrileños on the Third of May 442, 442; Great Courage! Against Corpses! (Disasters of War) 443; Self-portrait Being Attended by Dr. Arrieta 436, 436

graffiti 593, 593

Graham, Martha 560

grand tour 402

Graves, Michael (American): Portland Public Service Building, Oregon 586, 586

Graves, Nancy (American): Canoptic Legerdemain 601, 601–602

Great Courage! Against Corpses! (Goya) 443

Great Mosque, Mali 234, 234–35, 235

Great Mosque, Xi'an, China 149, 149

"Great Serpent Mound", Ohio (Fort Ancient culture?) 20, 21

Great Stupa, Sanchi 92, 92–93, 110–111, 110, 110–11, 111, 250, 306, 307

Great Wave, The (from Thirty-six Views of Mount Fuji) (Hokusai) 448, 448, 451 Greco, El (Greek Spanish): Toledo 336-37, 337 Greece, ancient 34, 36-37, 72, 470; Archaic period 72, 75, 76, 78-80; architecture 7275, 78, 84-89; Classical period 36, 74-75, 81-82; Corinthian order 84, 84-85, 89; Doric order 84, 84-89; Geometric period 75; Ionic order 84, 84-85, 89; Mount Parnassus 421; sculpture 14, 72, 75, 78–81, 83; Severe style 75, 80; temple construction 86-87, 87; vases 18, 18, 32, 33, 38, 70, 72, 73, 76-77, 76-77; see also Hellenistic art Greenough, Horatio (American): George Washington 440, 441 Gropius, Walter (German) 542-43; Bauhaus, Dessau 542, 542-43, 543 Grünewald, Matthias (German) 532; Isenheim Altarpiece 328, 328-29, 329; Mystical Nativity with Musical Angels 332, 332 Guernica (Picasso) 496, 497, 556, 556-57, 557 Guggenheim Museum, Bilbao, Spain (Gehry) 602, 602, 609, 612, 613 guilds 18, 148, 159, 171, 206, 244, 260, 265, 532 gunpowder 146 Guo Xi (Chinese) 193, 195; Early Spring5, 6-7, 193Gupta period, India 146 Gursky, Andreas (German) 615-16; Shanghai 615, 615 Gutenberg Bible 254

Η

Hadrian, Emperor 136-37 Hagia Sophia, Istanbul 142, 143, 150, 164, 164-65, 165, 340 Halley's Comet 206, 400 Hals, Frans (Dutch): Banquet of the Officers of the Civic Guard of St. George 368, 368; Merry Drinker 348, 351, 349 Hamilton, Ann (American): Corpus installation 31, 618, 618 Hamilton, Richard (British) Just What Is It That Makes Today's Homes So Different, So Appealing? 506, 506, 571-72, 572 Han Dyasty see under China haniwa (Japanese figures) 147, 147, 598-99, 599 Hanson, Duane (American): Tourists 580, 580 Happenings 576

Happy Accidents of the Swing (Fragonard) Hard-Edge Abstraction 570, 578-79, 590 Haring, Keith (American) 564, 593; Art in Transit 593 Harisena, King 158 Hasan, Abu'l (Iranian): Portrait of Shah Jahan Hastings, England: Norman invasion 206 hatching 314 Hatshepsut 45, 45, 47 Havana Cathedral, Cuba 401, 401 Hay Wain, The (Constable) 446, 446 Haystack (Monet) 533 Hellenistic art 75, 104-107, 117, 126, 155, 205; illusionism 205; painting 104–107, 186; sculpture 104-106, 107, 124, 125 hemlock 420 Henry IV of France 349, 351, 364 Hepworth, Barbara (British): Sculpture with Color (Oval Form) 558-59, 559 Hera, Second Temple of 86, 88 Heracleitus (Greek) 323; The Unswept Floor Herculaneum 401, 421; see also Vesuvius Herodotus (Greek) 38, 42, 44, 46, 99 Herzog, Jacques and Meuron, Pierre de (Swiss): Tate Modern Extension, London 609, 609

hikime hagihana 218

Himeji Castle, Osaka, Japan 358, 358–59

Hinduism 59, 94, 145–46, 180–81, 199, 300; architecture 151, 151; scultpure 145, 145, 180, 181, 196, 197; Siva 180–81

Hinomaru series (Yanagi) 598–99, 599

Hiroshige, Ando (Japanese): Cotton Goods

Lane (from One Hundred Views of Edo) 450, 451

Hirst, Damien (British): For the Love of God 608

History of Mexico (O'Gorman) 547, 547 Hitler, Adolph 543

Höch, Hannah (German) 537–38; Cut with the Kitchen Knife 538, 538

Hogarth, William (English) 403; Marriage à la Mode 408, 410, 410

Hokusai, Katsushika (Japanese) 599; *The Great Wave* (from *Thirty-six Views of Mount Fuji*) 448, 448, 451

Holzer, Jenny (American) 593–94; *Untitled* installation 594, *594*

Homage to the Square: Affectionate (Albers) 566, 566

Homer (Greek) 61; Iliad 62, 72, 76; Odyssey 72 Homer, Winslow (American) 482; The Bue Boat 483, 483; The Fog Warning 482, 482 Hongshan culture, China 18, 18 Hongzhi, Emperor: Portrait of the Emperor Hongzhi 283-84, 284 Honnecourt, Villard de (French) 223 Hopi culture (America) 520, 520-21, 521, 522-23; kachina dolls 520, 520-21, 521, 522; Walpi Village, Hopi Reservation 507, 507, 522; women 523 Hopper, Edward (American) 502; Nighthawks 502, 502, 504 Horace (Roman) 118 Horsemen (Phidias) 90 Horyuji complex, Japan 97, 97, 176, 176-77, 177, 178 Hugo, Victor (French) 429, 431 Hui Zong, Emperor 194 humanism/humanists 253, 255, 257, 289 Hunters in the Snow see December Landscape Husband and Wife (Roman grave relief) 114,

I

Ichijo, Emperor 216 Icicles (Goldsworthy) 617, 617-18 Iconoclastic Controversy 163 iconography 7 iconology 7 Identity Art 595 Ife culture 244; heads 244, 244 Iliad see Homer illusionism 129, 147, 186-87, 205, 286, 421, 431, 502, 515 Imhotep (Egyptian) 38, 47, 51 impasto 384, 474 Impressionism/Impressionists 332, 426–28, 431, 433, 435–36, 459, 470–71, 472, 472-73, 473, 474, 464-75, 475, 476, 479, 484, 487, 490-91, 533 Impression-Sunrise (Monet) 472, 472, 491 India 37, 350, 428, 430; British architecture in 437, 437; Buddhism 110-111; Great Stupa, Sanchi 92, 92–93, 110, 110–11, 111; Hindu sculpture 357, 357; Laxmi Vilas Palace, Gujarat 437, 437; Lion Capital, Sarnath 94, 94; mandanas 596, 596; see also Taj Mahal

I Saw the Figure 5 in Gold (Demuth) 552, 552

Indonesia: Temple of Borobudur 190, 190-91, 191, 250 Indus Valley civilization 12, 58-59 Industrial Revolution 425, 427, 429, 432, 474 Inka see Macchu Picchu Innocent X, Pope 381 Inquisition 302, 342 installation art 14-15, 19, 596, 616-17, 617, 618, 618 Insurrection! (Walker) 616-17, 617 International Style 586 Ionic style 131, 419 Iphigenia/Titus Andronicus (Beuys) 577, 577 Iran: carpets 100 Iraq 40, 41, 42, 608; see also Sumer/Sumerian art; Uruk Ise complex, Japan 160, 160-161 Isenheim Altarpiece (Grünewald) 328, 328-29, Isidorus of Miletus: Hagia Sophia 164-65 Islam (Muslims) 146, 149-50, 162, 174, 180, 182-84, 186, 199, 205, 221, 234-35, 300, 339, 340; architecture see mosques; Ramadan 183; see also Ottoman Turks Island in the Mur, The (Acconci) 612, 612 Italy: architecture 8-9, 9, 10, 10, 11, 316-17, 372, 372-73, 373, 266; painting 238, 238-39, 239, 240, 240-41, 241 (13th-14th c.), 242, 248, 248-49, 249, 253-54, 254, 258, 266, 266-67, 267, 268, 268-69, 269, 282, 282, 286, 286-87, 287, 288, 288-89, 289, 290, 290–91, 291, 292, 292–93, 293 (15th c.), 17, 318, 318, 319, 321, 322, 322-23, 323, 324, 324-25, 325, 330, 330-31, 331, 332, 332-33, 333(16th c.), 360, 360-61, 361 (17th c.); Renaissance 38, 85, 144, 221, 223, 321; sculpture 254, 258, 260, 260-61, 281, 281, 282, 294, 295 (15th c.), 306, 306-307, 307, 308, 308-309, 309 (16th c.), 374, 374-75 (17th c); see also Florence; Rome Ivan the Terrible 300

J

jades: Chinese 18, 65, 109, 109; Olmec 68-69, 69 Japan 146, 250, 350, 428, 433; architecture xiii, 216, 358, 358-59, 359, 390-391, 391, 97, 97, 160-61, 177; castles 358, 35859, 359; Daisenin dry garden, Daitokuji temple xiv, 296, 297; dry gardens xiv, 296, 297, 345, 575, 613; Edo (Tokyo) 350, 451; Edo period 214, 350, 397; haniwa 147, 147,

598-99, 599; manga 599, 599-600; Momoyama period 350, 358, 358-59, 359; painting 448, 448, 450, 451; photography 594-95, 595; pottery 344, 344; prints 429, 429, 431, 448, 448-49, 449, 450, 451, 488; screens (byobu) 390, 390-91; scroll paintings 17, 17, 148, 202, 202, 214, 214, 216, 216-17, 217, 218, 218-19, 219, 448, 599; sculpture 179, 598-99, 599; tea ceremony 344-45, 391, 602; teahouse 344, 344; theater 214; Water Temple, Japan (Ando) 151, 602-603, 603; yamato-e style 219; see also Kyoto; Shinto Java, Indonesia: Temple of Borobudur 190, 190-91, 191 Jeffersen, Thomas (American) 417-18, 455; Monticello 419, 419; Virginia State Capitol 403, 418, 419 Jenne, Mali: Great Mosque 234, 234-35, 235 Jenney, William: Fair Store, Chicago 463 Jesuit order (Society of Jesus) 302, 353, 415 Jewish art 152-53 Jewish Bride (Rembrandt) 384 Johns, Jasper (American) 569-71; Flag 569, 569-70 Johnson, Philip (American): Glass House 506, 506, 562, 562 Joseph II of Austria 398 Joy of Life, The (Matisse) 508, 508 Judaism 152-53, 174, 183, 199 Judd, Donald (American): Untitled 578-79, 579 Judith and Her Maidservant (Gentileschi) 361,

361, 406, 407 Jue Chang installation (Chen Zhen) 604, 604 Julius II, Pope 300, 309, 318, 322, 316

Jung, Carl 501, 568 Just What Is It That Makes Today's Homes So Different, So Appealing? (Hamilton) 506, 506, 571-72, 572

Justinian, Emperor 162, 164-66, 168-69, 169; Justinian, Archbishop Maximianus of Ravenna, and Attendants (Byzantine mosaic) 168, 169

K

Kabuki theater see Japan: theater Kahlo, Frida (Mexican) 547; The Two Friedas 504-505, 505 Kailasantha Temple, Ellora, India 151, 151, 180, 180-81, 181 Kandinsky, Wassily (Russian) 532, 569; First

Abstract Watercolour 532-33, 533

Kapoor, Anish (Indian born British): Cloud Gate xvi, 1 Karnak, Egypt 52-53, 54-55 Kaskey, Raymond (American): Portlandia 586 Kauffmann, Angelica (Swiss) 404, 406: Cornelia, Mother of the Gracchi 421, 422; portrait of Johann Winckelmann 401; Self-Portrait Hesitating between the Arts of Music and Painting 403, 403, 406 Kaufmann House (Wright) see Fallingwater Kentridge, William (South African) 600-601; Stereoscope 600, 601 Kertész, André (Hungarian) 503; Distortion No. 4 503 keystone 132 Khafre, King 44, 44, 46, 49, 50, 50, 52 Khmer civilization see Angkor Wat Kim Hongdo (Korean) 412; Roof Tiling 413, King Harold Receiving a Messenger (detail from Bayeux Tapestry) 206-207 King, Martin Luther 571, 577, 596 Kirchner, Ernst Ludwig (German) 503, 532; Street Berlin 532, 532 Kiss, The (Brancusi) 502, 502-503 Klee, Paul (Swiss) 534-35; Ad Parnassum 535, 535 Knossos, Crete 60-61, 61-62; Bull Leaping fresco 60, 60; Snake Goddess 61, 61 Kollwitz, Käthe (German) 532; Self-Portrait 504, 504 Komar, Vitaly (Soviet born American): America's Most Wanted 596-97, 597, 598 Koolhaas, Rem (Dutch): Prada Flagship Store,

SoHo, New York 610, 601 Koran, the 148, 164, 183-84, 340, 340, 370-71 Korea 412-31; ceramics 412, 412; Choson Dynasty 412-13; paintings 412-13, 413;

scrolls 413 Kosuth, Joseph (American): One and Three Chairs 576, 576

Kouros (Noguchi) 560, 561 kouros 78, 78-79, 79, 80; kore 79, 79 Kozloff, Joyce (American): Targets 611, 611-12 Kritian Boy (kouros) 79, 79

Kritios (Greek) 79 Kublai Khan 237, 257

Kunisada, Utagawa (Japanese): A Woman Frightened by Thunder 429 Kurosawa (Japanese) 217

Kyoto, Japan 216; Daisenin dry garden xiv, 296, 297; Katsura Villa 8, 8, 391, 391; Nijo Castle 359, 359

L

Landino, Cristoforo (Italian) 257 landscape paintings: 336, 336-36, 337, 432; American 456, 456-57, 457; Chinese 5, 5, 6-7, 192, 192-93, 193, 194, 194-95, 200, 200; Dutch 351, 356; English 446, 446-47, 447; European 392, 392-93, 393; Korean 412-13, 413; see also Flemish painting Landscape with Het Steen (Rubens) 393, 393 Landscape with the Body of Phocion Carried out of Athens (Poussin) 383, 383 Laocoön and His Sons (Hagesandros, Athenodoros, and Polydoros) 124, 125, 318 Larionov, Mikhail 531 Lascaux cave art, France 22, 22-23, 23 Last Judgement (Giotto) 241, 241 Last Judgement (Michelangelo) 334, 334-35, 589 Last Judgement (stone relief at Ste.-Foy) 211, Last Supper (Leonardo) 268, 292, 292-93, 293 Last Supper (Tintoretto) 343, 343 Last Supper/Feast in the House of Levi (Veronese) 342, 342-43 Lawrence Tree, The (O'Keeffe) 554, 554 Lawrence, Jacob (American): Harriet Tubman series 582; Self-Portrait 259, 259, 582, 582; Toussaint L'Ouverture Series 554, 555 Laxmi Vilas Palace, Gujarat, India (Mant and Chisholm) 437, 437 Le Corbusier (Charles-Édouard Jeanneret) (Swiss): Nôtre-Dame-du-Haut, Ronchamp 572, 573, 574 Le Nôtre, André (French): Versailles (garden and park design) 389, 389 Le Vau, Louis (French): Versailles 388, 388 Lebrun, Charles 388 Leo III, Pope 186 León, Juan Ponce de (Spanish) 299 Leonardo da Vinci (Italian) 308, 316-17, 332; church drawings 290-91, 291; Last Supper 203, 203, 268, 292, 292-93, 293; Madonna of the Rocks 287, 290, 290; Mona Lisa xiv, 282, 310, 310-11, 311, 536; Vitruvian Man 290, 291 642 INDEX

La Venta, Mexico: figurines 69; heads 68, 68;

pavements 68, 68-69; pyramids 69, 69

Labille-Guiard, Adélaide (French) 403; Self-

Portrait with Two Pupils 403, 403

Lamassu, Assyrian 66, 66-67

Lamentation (Giotto) 240, 240

LeQuire, Alan (American): Athena 89, 89 les beaux arts 404 Leutze, Emanuel (German) 459; Washington Crossing the Delaware 459, 459 Lewis, Edmonia (American) 437; Forever Free Leyster, Judith (Dutch): Self-Portrait at the Easel 355, 355 Li Cheng (Chinese) 192, 194-95; Buddhist Temple in the Hills after Rain 192, 193 Liao Empire 201 Liberty Leading the People (Delacroix) 426, 426 Libeskind, Daniel 608 libraries 40; see also Alexandria Lichtenstein, Roy (American): As I Opened Fire 577, 578 Life Drawing Class at the Royal Academy, The (Zoffany) 404, 404 Limbourg Brothers: Très Riches Heures du Duc de Berry 262, 262-63, 263 Lin, Maya (Chinese American): Vietnam Veterans Memorial 588, 588 Lindbergh, Charles 499 Lion Capital, Sarnath, India 94 Lion Gate, Mycenae 60-62, 62 lithography see prints/printmaking Liu Bingzhong (Chinese) 236; Forbidden City Lobster Trap and Fish Tail (Calder) 559 Locke, John 399-400 London: Chiswick House (Boyle) 418, 418; Crystal Palace 460, 460; Houses of Parliament (Barry and Pugin) 454, 454; Kew Gardens 437; Royal Academy 19, 401-402, 404, 417, 423, 428, 432; Tate Modern Extension, London (Herzog & de Meuron) 609, 609; temple of Mithras 124 lost wax casting see casting Louis XIII 349 Louis XIV ("Sun King") 284, 346-47, 349, 386, 388-89, 398; portrait 398 Louis XV 400; portrait 416 Louis XVI 399 Lucian (Greek) 83 Lunar Society 395 Luncheon at Bougival, A (Renoir) 474, 475 Luther, Martin (Germany) 301-302, 313 Luxor, Egypt 52-53, 53

M

Ma Jolie (Picasso) 515–16, *516* Machu Picchu *278*, 278–279, *279*

Madonna and Child Enthroned with Saints Theodore and George and Angels (Byzantine icon) 144, 163 Madonna and Child with Angels and a Prophet (Parmigianino) 302, 303 Madonna and Child with Martin van Nieuwenhove (Memling) 284, 284-85, 284 Madonna and Child with Saint John the Baptist (Raphael) 302, 302 Madonna degli Scalzi (Carracci) 302, 303 Madonna Enthroned with Angels and Prophets (Cimabue) 239 Madonna Enthroned with Angels and Saints (Giotto) 238 Madonna of Jeanne d'Evreux (Gothic statue) 222, 222, 230 Madonna of the Pesaro Family (Titian) 287 Madonna of the Rocks (Leonardo) 287, 290, Magritte, René (Belgian) 550 Maguey Bloodletting Ritual 140, 141 Mahamallapuram, India 145, 145 Mahayana Buddhism 177-79, 191 Maidservant Pouring Milk (Vermeer) 363 Malevich, Kasimir (Russian) 531; Suprematist Composition: White on White 531, 531 Mali empire 234-35 Man Rowing a Boat on the Bullewyk, A (Rembrandt) 376 Mandala of Jnanadakini (Buddhist watercolour) 250, 250 mandalas 92, 110, 191, 250, 602 mandanas 596, 596 Manet, Édouard (French) 459, 466-67, 473, 477; A Bar at the Folies-Bergère 429-30, 430; Déjeuner sur l'herbe, Le 466, 466; Olympia 39, 466-67, 467, 594 manga (Japanese graphic novels) 218, 599, 599-600 Manichaeanism 174 Mannerism 302, 304, 335 Mansa Musa, King 235 Mansart, Hardouin (French): Versailles 388, Mant, Major Charles and Chisholm, R.F. (British): Laxmi Vilas Palace, Gujarat 437, Mantegna, Andrea (Italian): Ducal Palace frescoes 286; A Foreshortened Christ 287, manuscripts 148, 171, 184, 186-87, 205, 221,

Mao Zedong 103, 603

Mapplethorpe, Robert 564

marathon races 73 Marcello (Adèle d'Affry): Pythia 470, 471 Marconi, Guglielmo: radio 498 Marcus Aurelius (Roman bronze) 122, 122, 254 Maria Theresa 398 Marika, Wandjuk (Australian): The Birth of the Djang'kawu Children at Yalanghara 202, 203, 593, 593 Marilyn Diptych (Warhol) 407, 407, 578, 578 Marinetti, Filippo (Italian) 498 Marquise of Dai with Attendants 108 Marriage à la Mode (Hogarth) 408, 410, 410 Marseillaise, La see Departure of the Volunteers Marshall, John (British) 58 Marx, Karl, and Engels, Friedrich: Communist Manifesto 430 Masaccio (Italian) 242, 253; Brancacci Chapel frescoes (The Expulsion of Adam and Eve, The Tribute Money) 266-67, 267, 268; The Trinity with the Virgin Mary, Saint John, and Two Donors, The 266, 266, 268 masks: African 514; Hopi 521; Mycenaean 63, 63; New Ireland 433; Tlingit 527; see also Bwa Mass of Saint Giles, The (Master of Saint Giles) 31, 148 Masson, André (French): Battle of Fishes 550, 550 - 51mastabas, Egypt 51, 51 Matisse, Henri (French) 241, 491, 508, 532, 589; The Dance 508-509, 509; The Joy of Life 508, 508 Matman (Bourgeois) 598, 598 Matsushima Screens (Tawaraya) 390, 390-91 Maximilian I, Emperor 313 Maya, the 141, 146 Mecca 149 Medici Palace see Florence Medici, Cosimo de' (Italian) 252, 255, 280 Medici, Lorenzo de' (Italian) 252, 255, 288 Medici, Marie de' 351, 364 Medici Slot Machine (Cornell) 561, 561 megaliths 27 mehirs 27 Mehmet the Conqueror 340 Mehretu, Julie (American): Empirical Construction Istanbul 614-15, 615 Melamid, Alex (Soviet born American): America's Most Wanted 596-97, 597, 598 Melancholy and Mystery of a Street, The (Chirico) 534, 534

memento mori 514

Memling, Hans (Flemish) Madonna and Child with Martin van Nieuwenhove 284, 284-85, 284 Mengs, Anton Raffael (German) 410, 421; Parnassus 421, 421 Meninas, Las (Velázquez) 380, 380 Mérode Altarpiece see Annunciation with Patrons and Saint Joseph in His Workshop Merry Drinker (Hals) 348, 349, 351 Merzbild (Schwitters) 537 Mesoamerican civilizations 68-69, 138-41 Mesopotamia 40, 58-9, 66 Metamorphoses (Ovid) 333 Mexico 544, 546; Aztec civilization 138, 146, 251, 251, 299, 505, 546; mural painting 544, 544-45, 545, 546, 546-47, 547; 20thcentury paintings 504-505, 505, 544, 544-45, 545, 546, 546-47, 547; see also Teotihuacán Michaelangelo Buonarroti (Italian) 83, 124, 156, 255, 260, 304, 317, 323, 367, 417, 480, 554; Creation of Adam 287, 318; David xi, 306, 306, 308, 308-309, 318, 352; Last Judgement 334, 334-35, 589; Medici Palace 281; Pieta 294, 298, 298; Plan of new St. Peter's 317; Saint Matthew 83, 309, 309; Sistine Chapel frescoes xiv, 318, 318–19, 319, 321, 334, 334-35; Sonnet with caricature 318, 320 Michelet, Jules (French): Histoire de France 252 Michelozzo (Italian): Medici Palace courtyard 280, 280 "Middle Ages" 144 mihrab 341 Mili, Gjon (Albanian): Picasso Drawing with Light 19, 19 Militia Company of Captain Frans Banning Cocq (Rembrandt) xiii, 368-69, 369 minarets 149, 184, 371 Ming Dynasty see under China Ming Huang (Xuanzong) 174-75 Minimal Art 576, 578, 590, 584

Minoan civilization 60-61, 63

mixed media 570

mobiles 559, 559

58-59, 58-59

536

Minuteman (French) 12, *12*, 13, 14 mirrors, Etruscan 34, *34*, 36

Modernism 501, 503, 552, 554, 586

Moai figures, Easter Island 212, 212-13, 213

Mohenjo-Daro, Indus Valley, Pakistan 12,

Mona Lisa (Leonardo) 282, 310, 310-11, 311,

186-87, 188, 188-89, 189, 205-206, 428 Mondrian, Piet (Dutch) 542; Composition No. 8, 1939-42, with Red, Blue, and Yellow 15-16, 16, 17 Monet, Claude (French) 426-27, 466, 472-73; Gare St.-Lazare 473, 473-75; Haystack 533; Impression-Sunrise 472, 472, 491; Rue St.-Denis 426-27, 427, 472 Mongols 12, 236, 257 Monogram (Rauschenberg) 570, 570 Monroe, Marilyn see Marilyn Diptych Mont Ste.-Victoire (Cezanne) 439, 439 Monticello, Charlottesville, Virginia (Jefferson) 419, 419 Moore, Henry (British): Recumbent Figure 558, 558 Mori, Mariko (Japanese): Wave UFO 610-11, Morimura, Yasumasa (Japanese) 594-95; Portrait (Futago) 39, 39, 594, 595 Morisot, Berthe (French) 472; Marine 476-77, 477 Morris, William (British) 434 mosaics 155, 168, 169, 169; Byzantine 166, 167, 169; Christian 157, 162, 162, 164, 169; Greek 75, 75; Islamic 184, 185; Mexican 547; Olmec 68, 68; Roman 104, 117, 169 Moscow: St. Basil's Cathedral 300, 301 Moser, Mary 404 Moses Giving Water to the Tribes, Dura 153, mosques 149, 164, 234, 234-35, 235, 340; Córdoba 182, 182-83, 183, 184, 185; Jenne (Mali) 234, 234-35, 235; see also Hagia Sophia Mughal empire 300, 350, 397; Taj Mahal 370, 370-71, 371 Muhammad, Prophet xiii, 182-84 Muhammad, Sultan: Feast of Sadeh xii, 339, 339 Muisca culture (Columbia): 299, 299-300 mummification 44, 46 Munch, Edvard (Norwegian) 494-95, 532; Frieze of Life (Motifs from the Life of a Modern Soul) exhibition 203, 203, 495, 495; The Scream 203, 494, 494-95 murals 555, 556, 556-57, 557; see also frescoes; Mexico Murasaki Shikibu (Japanese): Tale of Genji, The 216 museum (word origins) 74, 104 Mycenae/Mycenaean civilization 60-63; Lion Gate Mycenae 60-62, 62

monasteries 111, 148, 158, 162, 171, 177-78,

N

Nadar, Gaspard–Félix Tournachon (French): *George Sand* 468, 468 Names Project: *AIDS Memorial Quilt 564*, 565, 596

Napoleon Bonaparte 399, 428, 434, 442; Napoleon as Mars the Peacekeeper (Canova) 440, 440

Narmer, King 48–49; Palette of 48-49 narrative art 202–203; Japanese 216–19 Native Americans: art 520, 520–21, 521, 522–23, 526, 526–27; see also Hopi culture Neel, Alice (American): Self-Portrait 307, 307, 591, 591

Nefertiti 45, 45, 47, 47

Neoclassicism 400–401, 403, 431; in architecture 396–97, 418, 418–19, 419, 434, 440–41, 441, 455; in painting 411, 420, 420–21, 421, 422, 422–23, 423, 426, 434; sculpture 420–23, 422, 434, 440, 440–41, 441

Neo-Expressionism 590
Neolithic art and architecture 25–29, 25–29, 35
Neoplatonism 255, 289
Neopositivism 540
Nepal 397; Malla palace 397–98, 398
Nero, Emperor 116, 130–31
Neshat, Shirin (Iranian): Passage 2, 2–3, 5
Netherlands, the/Dutch artists 349, 362–63, 365; de Stijl movement 540, 540–41, 541, 542–43; painting 353–55, 351 (Dutch Baroque style), 348, 349, 355, 355, 368, 368–69, 369, 384, 385 (17th c), 392, 392–93, 393 (17th c. landscapes), 386, 386–87, 387

Neumann, Johann Balthasar (German): Kaisersaal, Germany 414, 414

New Bedford house, Massachusetts (Gothic Revival) 455, 455

New Ireland: masks 433; Tableau (Malanggan culture) 433

New Realism 580

(still lifes)

New York: Brooklyn Bridge 461, 461–62; Gay Liberation Tableau (Segal) 588, 589; Prada Flagship Store, SoHo (Koolhaas) 610, 610; Seagram Building (Mies) 562–63, 563; Statue of Liberty (Bartholdi) 432, 433, 462, 586; street graffiti 593, 593; World Trade Center Transportation Hub (Calatrava) 608–609, 609, 609, 612

Newborn, The (Brancusi) 528, 528 Newton, Isaac 400 Ni Zan (Chinese): Rongxi Studio 199, 200
Niépce, Joseph-Nicéphore 469
Night Cafe, The (van Gogh) 486, 489, 486–88
Night of the Poor (Rivera) 544–45, 545
Night of the Rich (Rivera) 544, 544–45
Night Watch see Militia Company of Captain
Frans Banning Cocq
Nighthawks (Hopper) 502, 502, 504
Nightmare, The (Fuseli) 410, 411
Nijo Castle, Kyoto, Japan 359, 359
Nimes, Roman temple at 418
Niuheliang, China: statuettes 29, 29
Noguchi, Isamu (Japanese) 561; Kouros 560, 561
Nok heads, Nigeria 26, 26

nomadic art 98–101 Nôtre-Dame-du-Haut, Ronchamp (Le

Corbusier) 572, 573, 574

Nude Descending a Staircase (Duchamp) 517–18, 518

Nude Self-Portrait (Neel) 307, 307, 591, 591 nude, the *306*, 306–307, *307*

o

O'Gorman, Juan (Mexican): The History of Mexico 547, 547 O'Keeffe, Georgia (American) 512; The Lawrence Tree 554, 554 obelisk 352, 352 Object (Le Déjeuner en Fourrure) (Oppenheim) 551, 551 Ocean's Coach, The (Portuguese ceremonial coach) 398, 399 oil painting 17, 275, 275, 332 Old St. Peter's Basilica 156, 156, 186, 294 Oldenburg, Claes (Swedish) and Bruggen, Coosje van (Dutch American) 603: Shuttlecocks 604, 604 Olmec civilzation: Olmec heads 68, 68 Olympia (Manet) 466-67, 467, 594 Olympic Games 33, 72, 75 On the Fabric of the Human Body (Vesalius) 301 On the Revolution of the Celestial Spheres (Copernicus) 300 One and Three Chairs (Kosuth) 576, 576 Oosterwyck, Maria van (Dutch): Still Life with a Vanitas Theme 386, 386 opera 351 opium 428 Oppenheim, Meret (Swiss): Object (Le

Déjeuner en Fourrure) 551, 551

Optical Art 576, 579, 615

Orozco, José Clemente *The Epic of American Civilization* 546, 546
Osterley Park House, England (Adam) 396, 397
Otis, Elish G. (American): elevator 462
Otto I, Prince 187
Ottoman Turks 397; art and architecture 340, 340–41, 341
Ottonian art 187
Ovid (Roman): *Metamorphoses* 7, 333
Owo, Africa 245
Ozu, Yasujiro (Japanese) 217; *Tokyo Story*574–75, 575

P

Pachacuti see Machu Picchu

pagodas 149, 177, 400 Paik, Nam June (Korean): Electronic Superhighway 596, 597 paintings (see also specific countries) 15–17; Abstract Expressionism 500, 568-70; analyzing 15-17; Cubism 239, 439, 514, 516-17, 519, 530-31, 534, 537 546, 556, 582; Expressionism 546, 582; fantasy 534, 534-35, 535; Fauvism 508, 508-509, 509, 514, 533–34; Flemish see Flemish painting; German Expressionist 532, 532-33, 533, 534; gouache 483; Hellenistic 75, 117; Impressionist 332, 426-28, 431, 433, 435-36, 459, 470-71, 472, 472-73, 473, 474, 464-75, 475, 476, 479, 484, 487, 490-91, 533; landscapes 336, 336–36, 337, 432; 456, 456–57, 457 (American), 5, 5, 6–7, 192, 192-93, 193, 194, 194-95, 200, 200 (Chinese), 351, 356 (Dutch), 446, 446-47, 447 (English), 392, 392-93, 393 (European), 412-13, 413 (Korean); oil painting 17, 275, 275, 332; photo-realist 581; Pointillism 485; Post-Impressionist 434-35, 484, 484-85, 485, 486, 486-87, 487, 502; Realist 434, 459, 470, 473, 476, 478–79, 502, 566, 580–81, 581, 582, 582; scroll paintings 5, 6, 17, 173, 175, 192, 192, 200, 283, 407, 407, 592 (Chinese), 17, 17, 148, 202, 202, 214, 214, 216, 216–17, 217, 218, 218-19, 219, 448, 599 (Japanese), 148, 152 (Jewish), 413 (Korean); Surrealist 327, 500, 503, 519, 535, 546, 548, 549, 549, 550, 550-51, 551, 552, 568, 598; tempera painting 152, 242, 242, 274-75; watercolour 483, 483; see also frescoes; portraits; selfportraits Pakistan see Mohenjo-Daro

Paleolithic art 22, 22-23, 23, 24, 24, 25 Palette of Narmer 48, 48-49, 49 Palladio, Andrea (Italian): Villa Rotonda 8-9, 9, 10, 10, 11, 418-19 Pan Gu (Chinese): Wen Xuan 172 Panini, Giovanni (Italian): Interior of the Pantheon 137 Pantheon, Rome 96, 96, 123, 136, 136, 137, 137, 224, 316, 419 papacy 349, 351-2 Paris 221, 433, 452, 508, 514-15, 535, 551; Arc de Triomphe 440, 441; Eiffel Tower 424, 425, 462; Hôtel de Soubsie, Paris 396, 396; Nôtre-Dame Cathedral 426; Paris Opéra (Garnier) 462, 464, 464, 470-71; Pompidou Center 583, 584; Royal Academy of Painting and Sculpture 401; Salon des Refusés 434, 466; Salons 432-34, 437, 466, 472, 479; University of 221 Parmigianino (Italian): Madonna and Child with Angels and a Prophet 302, 303; Self-Portrait in a Convex Mirror 287, 304, 304 Parnassus (Mengs) 421, 421 Parthenon, Athens 13, 88, 88-89, 89, 90, 90-91, 91, 119 pastel works 416, 416-17 Pater, Walter (British) 311 patronage 37, 254-55, 322, 354-55, 403, 436, Pattern and Decoration 590, 590, 592 Paul III, Pope 317 Paxton, Joseph (British) 460-61; Crystal Palace 460, 460-61 Pazyryk, Siberia 98-101 Peasant Wedding Feast (Bruegel) 338, 338-39 Penitent Magdalene (Donatello) 260, 260-61 Pentecost, the Peoples of the Earth, and Saint John the Baptist (stone relief) 210, 210 performance art 19, 576, 600 Pergamon, Turkey 104, 106, 126 Pericles (Greek) 38, 74, 88, 138 Persepolis, Iran: Palace of Darius 67, 67 Persians: art and architecture 66-67, 339, 370, 370-71, 371 perspective: atmospheric 16; scientific 16; shifting perspective 192 Pesaro Madonna (Titian) 330, 330, 332, 332 Petrarch (Italian) 311 Phidias (Greek): Athena 89; Parthenon sculptures 89-90, 89-90; Zeus 89 Philip II of Macedonia 74, 104 Philip IV of Spain 380-81 Philosophy (Raphael) 15, 15, 16-17, 268, 268, 322, 322

Philostratus the Younger 129, 581 Phocion (Athenian general) 383 photography 432, 436, 468, 468-69, 469, 473, 503, 512, 512-13, 513, 537-38, 553, 571, 580, 594-95, 595, 604, 615, 618 Piano, Renzo (Italian): Pompidou Center, Paris 583, 584 Piazza Navona, Rome 352, 352 Picasso, Pablo (Spanish) 19, 435, 489, 491, 503, 508, 512, 515-17, 519, 589; Les Demoiselles d'Avignon 514, 514-15, 591; Drawing with Light (Mili) 19, 19; Guernica 496, 497, 556, 556-57, 557; Ma Jolie 515-16, 516; Still Life with Chair Caning 516-17, 517 piece-mold casting see casting Piero della Francesca (Italian): Battista Sforza and Federigo da Montefeltro 255, 255; Resurrection (Piero della Francesca) 248, 248 Pietà (German wood sculpture) 261, 295, 295 Pieta (Michelangelo) 294, 298, 298 "pig-dragons" (Hongshan culture) 18, 18 Pilgramage to the Island of Cythera (Watteau) pilgrimage roads 199, 199, 205, 208 Pininfarina (Italian): Cisitalia "202" GT car 498, 499 Pioneer days and Early Settlers (Benton) 554, Piranesi, Giovanni Battista (Italian) 402-403; View of the Piazza della Rotonda 402, 402 Pissarro, Camille (French) 476 Pittsburgh County Courthouse and Jail, Pennsylvania (Richardson) 464, 465 Pius II, Pope 252 Plato (Greek) 38, 74, 104; Timaeus 322 Pliny the Elder (Roman) 75, 82, 95, 309; Natural History 36 Pliny the Younger (Roman) 116, 155 Plutarch (Greek) 94 Pointillism 485 Polish architecture 396, 396 Political Pop 603 Pollock, Jackson (American) 439, 489, 566, 567, 568-69, 589; Convergence 439, 566, 567 Polo, Marco (Italian) 12, 199-200, 236, 257; Description of the World 199, 250, 257; Travels of Marco Polo, The 257, 257 Polybius (Roman) 114 Polykleitos (Greek): Doryphoros (Spear Carrier) 38, 81, 82, 83; Canon 38, 83 Polynesian sculpture 212, 212-13, 213 polyptych 271

Pompeii 401: frescoes 117, 117, 126, 126-127, 127, 128, 128; houses 116, 116-17, 117; paintings 117; temple of Isis 124 Pond in a Garden (Egyptian tomb painting) 57, 57 Pont du Gard, Nîmes, France 133-35, 135 Pop Art 506, 572, 572, 576-77, 603 porcelain: Delft chinoiserie 405; Korean 412, 412; Ming 299, 305, 305 Porta, Giacomo della (Italian) 317 Portland Public Service Building, Oregon (Graves) 586, 586 Portlandia (Kaskey) 586 Portrait (Futago) (Morimura) 39, 39, 594, 595 Portrait of a Man and a Boy (Ghirlandaio) 282, 282 Portrait of a Man on His Deathbed (Ghirlandaio) 282, 283 Portrait of Dr. Samuel Gross (Eakins) 478, 478 Portrait of Giovanni Arnolfini and Giovanna Cenami (Eyck) 258, 272, 272, 274, 274 Portrait of Juan de Pareja (Velázquez) 381, 381 Portrait of King Louis XIV of France (Rigaud) 398, 398 Portrait of Louis XV as a Young Man (Carriera) 416, 416 Portrait of Marie Gabrielle de Gramont (Vigée-Lebrun) 400, 400 Portrait of Martin Luther (Cranach) 301 Portrait of Ni Zan (Chinese) 200, 200 Portrait of Paul Revere (Copley) 416, 416 Portrait of Piero de' Medici (Fiesole) 258, 282, Portrait of Queen Hatshepsut (Egyptian statue) 259 Portrait of Sarah Siddons (Gainsborough) 417, 417 Portrait of Shah Jahan (Abu'l Hasan) 371 Portrait of Shen Zhou (self-portrait) 282-83, Portrait of the Artist's Three Sisters with Their Governess (Anguissola) 305 Portrait of the Emperor Hongzhi 283-84, 284 portraits (and see above) 38-39, 166, 200, 200, 258-59, 282-85, 403, 468, 468-69, 469, 618; Chinese 282-83, 283; Dutch group 368, 368-69, 369; Egyptian 258, 259; Flemish 258, 258; Italian 258, 258, 282, 282-83, 283 (paintings), 282, 282 (sculpture); Roman 114-115; 18th-century 416, 416-17, 417; see also self-portraits Post, Frans 355; A Village in Brazil 355 post-and-lintel construction 11, 52, 54-55, 84, 86, 88, 132, 177

Post-Impressionism/Post-Impressionists 434-35, 484, 484–85, 485, 486, 486–87, 487, 502 Postmodernism 75, 586, 589, 590, 601 pottery: Neolithic 25, 25, 29 Poussin, Nicolas (French) 351, 382-83, 393; Arcadian Shepherds 382; Landscape with the Body of Phocion Carried out of Athens 383, 383 Praxiteles (Greek): Aphrodite of Knidos 82, 83 prayer rug, Ottoman 341 Precisionism 552 Priestly, Joseph 395, 400 Prince Sudhana's Search for Enlightenment (Buddhist relief sculpture)191, 191 prints/printmaking 254, 312-15, 378-79, 427, 429, 432, 438, 488; drypoint 379, 379; engravings 312, 312-13, 313, 314-15, 410; etching 378, 379, 402, 443; Japanese woodblocks 448, 448-49, 449, 450, 451; lithography 453, 453; political prints 452, 452-53, 452; woodcuts 314-15, 254, 287, 287, 313-15, 429, 429 Procopius 143, 164 Protagoras 83 Protestantism 302, 313, 348-49 Pugin, Augustus W.N. (British): Houses of Parliament 454, 454 Pushkin, Alexander (Russian) 431 pyramids: Egyptian 44–45, 50–51, 50–51, 89; Khmer 215; Olmec 69, 69; Teotihuacán 138, 138, 139, 141 Pythagorus (Greek) 74, 83

Q

qi 195 Qianlong, Emperor: inscription 5 qibla 341 Qin Dynasty see Qin Shi Huang Qin Shi Huang, Emperor 102–103; tomb warriors 4, 4, 6–7, 102, 102–103 Qing Dynasty see China quilts 564, 565, 590; AIDS Memorial Quilt 564, 565, 596

Pythia (Marcello) 470, 471

R

Raft of the Medusa, The (Géricault) 444, 444–45 Ramses II 46, 46 Rape of Europa (Titian) 332, 333 Rape of the Sabine Woman (Giambologna) 335, 335

Raphael (Italian) 304, 421, 466; Madonna and Child with Saint John the Baptist 302, 302; Philosophy 15, 15, 16-17, 268, 268, 322, 322; Stanza della Segnatura 322, 322-23, 323; Theology 323, 323 Rauschenberg, Robert (American) 539, 569-71; Monogram 570, 570 Ravonism 531 ready mades 576 Realism 434, 459, 470, 473, 476, 502, 566, 580-81, 581, 582, 582; American 478-79 Recumbent Figure (Moore) 558, 558 red-figure style 76 Reformation, Protestant 301 343, 350 Rehearsal, The (Degas) 476, 476 Reinhardt, Ad (American) 556 Rejlander, Oscar (Swedish): The Two Paths of Life 468, 469 relief sculpture 40; Assyrian 66, 66-67, 67; Benin 350, 350; Buddhist 111, 190; Egyptian 45, 45-46, 46, 49, 53; French 470, 470; Greek 89, 90-91; Herculanemum 421; Hindu 145, 145, 357, 357 Indian 94; Khmer 215, 215; Romanesque 210, 210–11, 211; Sumerian 40, 40 reliquaries 198, 199, 205, 205 Rembrandt van Rijn (Dutch) 351, 354, 368-69; Christ Preaching 378, 378-79; Jewish Bride 384; A Man Rowing a Boat on the Bullewyk 376; Militia Company of Captain Frans Banning Cocq xiii, 368-69, 369; Return of the Prodigal Son 384, 385; Three Crosses 379, 379; Two Women Teaching a Child to Walk 377, 377 Renaissance 36, 252, 402; architecture 419; Early Renaissance (definition) 252; High Renaissance (definition) 252; painting 417, 423, 466; portraiture 258-59; sculpture 83, 260, 260-61, 261 Renoir, Auguste (French) 472, 474, 477, 489; A Luncheon at Bougival 474, 475 repoussoir 129, 376, 514 Resurrection (Piero della Francesca) 248, 248 Return of the Prodigal Son (Rembrandt) 384, 385 Revere, Paul 416; portrait of 416 Reynolds, Joshua (British) 401–402, 410, 417, 423; Allegorical Portrait of Sarah Siddons as the Tragic Muse 417, 417 Rhodes, island of 104, 124 Ricci, Glenn 600 Richardson, Henry Hobson (American): Pittsburgh County Courthouse and Jail, Pennsylvania 464, 465

Richter, Hans (German) 536

Rietveld, Gerrit (Dutch): Schröder House 540, 540-41, 541 Rigaud Hyacinthe (French): Portrait of King Louis XIV of France 398, 398 Rikudou, Koushi (Japanese): Excel Saga 599, 599-600 Riley, Bridget (British): Drift 2 579, 579 Ringgold, Faith (American) 591; Tar Beach 592, 592 ritual and art 14, 28-31, 35, 148 Rivera, Diego (Mexican) 544, 546; Night of the Poor 544-45, 545, 546; Night of the Rich 544, 544-46 Robie House (Wright) 524, 524-25, 525 Rococo style 396, 400-401, 403, 405; architecture 418, 414, 414-15; painting 408, 408-409, 409, 410-11, 416, 416; sculpture 414-15, 415 Roden Crater project, Arizona (Turrell) 357, 357, 618–19, 619, 620 Rodin, Auguste (French) 480-81; The Burghers of Calais 480, 480 Roebling, John A. and Washington A. (Americans): Brooklyn Bridge 461, 461-62 Rogers, Richard (British): Pompidou Center, Paris 583, 584 Roggeveenn, Jacob (Dutch) 213 Rohe, Ludwig Mies van der (German) 562: Seagram Building, New York 562-63, 563 Rohr, Monastery Church of (Germany) 415 Roman Empire/Romans 30, 36-37, 114-19, 121, 186-87; architecture 95, 95-96, 96, 115-17, 119, 121, 130-131, 136-37, 165, 209, 419; engineering 122, 132-34, 134, 135; frescoes 31, 117, 117, 104, 126, 126-127, 127; literature see Pliny the Elder and Younger; mosaics 104, 117; Pax Romana 119; public baths 119, 121; sculpture 118, 118, 122, 122-23, 124, 125; town planning 112, 118, 122, 124; see also Rome; Pompeii Romanesque 204-205, 464, 465; architecture 189, 189, 204–205, 208, 208–209, 209; frescoes 204, 204; monasteries see Cluny; reliquary 198, 205, 205; sculpture 210, 210-11, 211, 230 Romanticism 401, 431, 434; in painting 411, 444, 444-45, 445 Rome 70, 118–19, 121, 187, 221, 334, 401-403; Altar of Peace 119, 119; Arch of Titus 95, 95, 122, 123; Basilica of Maxentius and Constantine 132–33, 133; Basilica Ulpia 119, 120, 132, 132; Baths of Caracalla 119, 121, 121; Colosseum 96, 96,

130, 130-31, 131; Column of Trajan 119, 123; Cornaro Chapel 374-375, 375; Forum 116, 119, 120; Forum of Trajan, 132, 132; Old St. Peter's Basilica 156, 156, 186, 294; Pantheon 96, 96, 123, 136, 136, 137, 137, 224, 316, 419; Piazza Navona 352, 352; San Carlo alle Quattro Fontane, Rome 372, 372-73, 373, 401; Santa Costanza 157, 157; Sistine Chapel 318, 318-19, 319, 321, 323, 417; St. Peter's Basilica 186, 301, 316, 316-17, 317, 352, 366, 366-67, 367; Temple of Portunus 115, 418

Rothko, Mark (American) 569; White and Greens in Blue 568, 569

rotunda 136-37

Rousseau, Henri (French) 435, 535: The Sleeping Gypsy 435, 435

Royal Abbey Church of St.-Denis, France 96, 148, 220, 220, 221, 221, 222

Royal Academy (London) 19, 401-402, 404, 417, 423, 428, 432

Rubens, Peter Paul (Flemish) 332, 349, 351-2, 354, 364-65, 489; Allegory of the Outbreak of War 365, 365; Arrival and Reception of Marie de' Medici at Marseilles 364, 364; Landscape with Het Steen 393, 393; Self-Portrait with Isabella Brant 354, 355

Rude Descending a Staircase, The (Amswold) 517, 518, 519

Rude, François (French): The Departure of the Volunteers of 1792/La Marseillaise 445, 445

Rue Transnonain (Daumier) 452, 452

Ruisdael, Jacob van (Dutch): Dutch Landscape from the Dunes at Overveen 356, 356, 392, 392, 446

Ruiz, Antonio (Mexican): The Dream of Malinche 546, 547

Ruskin, John (British) 11-12, 572

Russia 428, 430, 508, 499; architecture 300, 301; Constructivism 578; painting 530, 530-31, 531; revolution 499

Ruysch, Rachel (Dutch): Flower Still Life 387, 387

S

Sailboat in the Rain (Xia Gui) 194 Saint Mark (Donatello) 83, 260, 260-61 Saint Matthew (manuscript painting) 186, 186 Saint Matthew (Michelangelo) 83, 309, 309 Saltcellar of Francis I (Cellini) 335, 335 samurai 350, 358-59

San Carlo alle Quattro Fontane, Rome 372, 372-73, 373, 401

San Vitale, Ravenna, Italy 166, 166-67, 167, 169

San Zaccaria, Venice (photograph) 604, 605

Santa Costanza, Rome 157, 157

Santiago de Compostela, Spain 199, 205, 208

Saggara, Egypt 47, 51, 56, 51

sarcophagi 155: Egyptian 46; Etruscan 70, 70-71; Pazyryk 98; Rococo 415, 415

Sartre, Jean-Paul (French) 500

Savonarola, Girolamo (Italian) 252

Schapiro, Miriam (American): Wonderland 590, 590

Schliemann, Heinrich (German) 62 Schönberg, Arnold (German) 501, 533

Schröder House (Rietveld) 540, 540-41, 541

Schroon Mountain (Cole) 456, 456

Schwitters, Kurt (German) 537; Merzbild 537

Scream, The (Munch) 203, 494, 494-95 scroll paintings: Chinese 5, 6, 17, 173, 175,

192, 192, 200, 283, 407, 407, 592; Japanese 17, 17, 148, 202, 202, 214, 214, 216, 216–17, 217, 218, 218-19, 219, 448, 599; Jewish 148,

152; Korean 413

sculpture (see also specific countries) abstract 528, 528-29, 529; analyzing 12-14; Assyrian 66, 66-67, 67; Aztec 251, 251; Benin 244-45, 245; Buddhist 94, 94, 110, 110-11, 111, 146, 146, 178, 190-91, 191, 307, 307; Byzantine 163; Christian 210, 210-11, 211; early Christian 155, 155; Egyptian 44-46, 44-46, 78, 80, 259; Gothic 221, 222, 222, 224, 230, 230-31, 231; Greek 72, 75, 78-81, 83; Hyper-Realist 580, 580; Ife 244, 244; Neoclassical 404, 480; Paleolithic 24, 24; Polynesian 212, 212-13, 213; Prehistoric 307; Roman 118, 118, 122, 122-23, 124, 125; Romanesque 210, 210-11, 211, 230;

wood 261; Yoruba 245; 20th-century 558,

558-59, 559, 560, 560-61, 561; 21st-century

608, 610-11, 611, 612-13, 613; see also

relief sculpture; wood carving Sculpture with Color (Oval Form) (Hepworth)

558-59, 559

Scythians 37, 99-101

Seagram Building, New York (Mies van der Rohe) 562-63, 563

seals, Indus Valley 58-9, 59

see also Córdoba mosque; Picasso; Santiago de Compostela

Segal, George (American): Gay Liberation Tableau 588, 589

Self-Portrait (Close) 618, 619

Self Portrait? (van Eyck) 256

Self-Portrait (Fontana) 304

Self-Portrait (Ghiberti) 38, 39

Self-Portrait (Kollwitz) 504, 504

Self-Portrait (Lawrence) 259, 259, 582, 582

Self-Portrait as the Allegory of Painting (Gentileschi) 39, 39, 354, 355

Self-Portrait at the Easel (Leyster) 355, 355

Self-portrait Being Attended by Dr. Arrieta (Goya) 436, 436

Self-Portrait Hesitating between the Arts of Music and Painting (Kauffmann) 403, 403,

Self-Portrait in a Convex Mirror (Parmigianino) 287, 304, 304

Self-Portrait with Bandaged Ear and Pipe (van Gogh) 436, 436, 488

Self-Portrait with Two Pupils (Labille-Guiard) 403, 403

self-portraits (and see above) 257, 282, 304, 354-55, 384, 436, 436, 504, 504, 582, 582, 591, 591

Sen no Rikyu (Japanese) 345

Serra, Richard (American) 618; Torqued Ellipses 612-13, 613

Sert, Josep Lluis (Spanish): Spanish Pavilion 497

Sesshu (Japanese): Winter Landscape 345, 345 Seurat, Georges (French) 436, 484; A Sunday Afternoon on the Island of La Grande Jatte 484 485

Seven Years' War 398

Shah Jahan (Mughal emperor) 350, 370-71; portrait 371

Shah-nameh (Firdawsi) xii, 339

shamanism 64, 98, 108-109, 412, 527

Shang Dynasty see under China

Shanghai (Gursky) 615, 615

Sharma, Kunu 398

Shchukin, Sergey 508

Sheeler, Charles (American) 502; American Landscape 552, 553

Shen Zhou (Chinese): Portrait of Shen Zhou 282-83, 283

Shiji, The Records of the Historian (Sima Oian) 103

Shinto 146, 160-61, 178, 199, 598; sculpture 246, 247; shrine at Ise 160, 160-61; Sun Goddess Amaterasu 247, 598

shogun 359

shoin buildings (Japan) 359, 359; see also Katsura Villa, Kyoto

Shotoku, Prince 178-79

Shu Shi (Chinese) 194

Shuttlecocks (Oldenburg and Bruggen) 604, 604 Siberian art 98-101 Siddons, Sarah 406, 417; portraits 406 (Gainsborough), 417 (Reynolds, Gainsborough) Signac, Paul 508 signatures, artists' 38, 75-76, 124, 148, 200 silk 95, 100, 108, 192, 314, 428 "Silk Road" 94–95, 149, 172, 199, 210, 621 Sima Qian (Chinese): Shiji, The Records of the Historian 103 Singh, Armit and Rabindra (British): Battle of the Giants 616, 616 Sistine Chapel 318, 318-19, 319, 321, 323, 417 Siva (Hindu god) 94, 180–81, 197, 214–15; Siva Nataraja (Lord of the Dance) 196 Sixtus IV, Pope 318 skyscrapers 462, 492, 492–93, 493, 562–63, 563 Slave Ship, The (Turner) 447, 447 Sleeping Gypsy, The (Rousseau) 435, 435 Sleeping Venus (Giorgione) 324, 324-25 Smith, David (American) Cubi XIX 12-13, 13 Smithson, Robert (American): Spiral Jetty 584, 585, 589 Snake Goddess (Minoan) 61 Soami (Japanese): (attrib.) dry garden, Daitokuji temple xiv, 296, 297 Social Realists 554 Socrates 74, 420, 420 Sola-Morales, Ignasi de 687 Solomon Temple, Jerusalem 156, 165, 396 Song Dynasty see under China Songs of the South 108 Sophocles (Greek) 38, 75 Sotatsu, Tawaraya (Japanese) 448; Matsushima Screens 390, 390 Spain 349, 442, 497; cave art 23; Guggenheim Museum, Bilbao, Spain (Gehry) 602, 602, 609, 612, 613; Spanish Civil War 497, 557; Spanish Pavilion 497, 557; painting 337, 337, 380, 380-81, 381, 442, 442-43, 443, 549, 549-50, 556, 556-57, 557 Spear Carrier see Doryphoros Speeding Automobile-Study of Velocity (Balla) 498, 498, 519 sphinx, Giza 44, 50, 50 Spiral Jetty (Smithson) 584, 585, 589 spolia 156 St. Paul's Cathedral, London (Wren) 351 St. Peter's Basilica, Rome 186, 301, 316, 316-17, 317, 352, 366, 366-67, 367 stained-glass windows 220, 220, 224, 225, 226, 228, 232, 232-33, 233, 264, 415; La Belle

Stanza della Segnatura (Raphael) 322, 322-23, 323 Starry Night (van Gogh) 487, 487-88 Statue of Liberty (Bartholdi) 432, 433, 462, 586 Ste.-Foy, Conques, France 208, 208, 209, 209; reliquary 205, 205 steel 461-63, 463, 492-93 Steerage, The (Stieglitz) 512, 512 Stereoscope (Kentridge) 600, 601 Stern, Robert (American) 586 Stieglitz, Alfred (American) 512, 552; Equivalent 512, 512-13; The Steerage 512, Still Life with a Vanitas Theme (van Oosterwyck) 386, 386 Still Life with Chair Caning (Picasso) 516-17, 517 Still Life with Eggs and Thrushes (Pompeian fresco) 129, 129 Stonehenge, England 27, 27, 28, 30, 36, 58, 356, 356-57, 619 Stravinsky, Igor (Russian): The Rite of Spring Struth, Thomas (German): San Zaccaria, Venice 604, 605 stupas 92, 92, 110-11, 158, 181, 190, 190, 191, 250, 306 Suger, Abbot (French) 220-21, 228, 233 Suleiman I, Sultan ("the Magnificent") 300, 340 Suleimaniye Mosque, Istanbul 150, 151, 340, 340-41, 341 Sullivan, Louis (American) 492, 524; Autobiography of an Idea 462-63; Carson-Pirie-Scott Store, Chicago 493, 493 Wainright Building, Missouri 492, 492 Sumer/Sumerian art and architecture 40, 40-41, 41, 42, 42-43, 43 Sunday Afternoon on the Island of La Grande Jatte, A (Seurat) 484, 485 Sunday on the Banks of the Marne (Cartier-Bresson) 513, 513 Suprematism 531 Suprematist Composition: White on White (Malevich) 531, 531 Surrealism 327, 500, 503, 519, 535, 546, 548, 549, 549, 550, 550–51, 551, 552, 568, 598; Surrealist automatism 566, 568 Suryavarman II, Emperor 214 Sutton Hoo treasury, England 170, 170-71 swan, felt 101, 101 swastika 110 synagogues 150, 152-53; see also Wolpa, Poland

T tablero 140, 140 Tacitus 95 Taíno culture 251, 251 Taj Mahal, Agra 350, 370, 370-71, 371 Takayoshi (Japanese) (attrib.): The Tale of Genji 202, 202, 216 Talbot, William Henry Fox (British) 469 Tale of Genji, The (Murasaki Shikibu) 216-19, Tales of Ise, The 391 Tanner, Henry (American) 431, 479; The Banjo Lesson 479, 479 Tansey, Mark (American): Purity Test 589, 589 Tantric Buddhism 191 taotie (Shang Dynasty), China, 34, 35, 64 Tar Beach (Ringgold) 592, 592 Targets (Kozloff) 611, 611-12 tatami 359 Tatlin, Vladimir (Russian) 499; Monument to the Third International Communist Conference 500 tattooing 98, 100, 100, 212 tempera painting 152, 242, 242, 274-75 Tempestuous Landscape with a Gypsy and a Soldier (Giorgione) 325, 325 Temple of Portunus, Rome 115, 418 temples: Buddhist 151, 151, 176, 177, 178, 181, 181, 190, 190-91, 191, 250; Egyptian 44, 46, 50, 52, 52–53, 53, 54, 54, 55, 55, 56, 124; Greek 72, 74, 86, 86-87, 87, 88, 88; Hindu 151, 151, 180, 180-81, 181; Inka 278; Japanese 151, 296, 297, 344, 602-603, 603; Khmer 214, 214-15, 215; Nepalese 397-98; Olmec 69; Polynesian 212; Roman 115, 115, 124, 418 (Nîmes); Sumerian 41, 42, 42; Teotihuacán 138-41 tensile strength 11, 54, 80, 97, 461, 463, 525 Teotihuacán, Mexico 94, Great Temple 251; 138-41; Pyramid of the Sun, 138-39; Temple of the Feathered Serpent 140, 140 terra-cottas: 492-93; Chinese warriors 4, 4, 6-7, 102, 102-103; Etruscan 70, 70, 71; Greek 32, 33, 73; Ife 244, 244; Indus Valley 59; Jenne 234, 235; Neolithic pot 25, 25; Nok heads, Nigeria 26, 26; Yoruba 245 terrorism 596, 602, 608 tesserae 169 Tezuka, Osamu (Japanese): manga 599

Thamugadis, Algeria 12, 124

168

Theodora and Attendants (Byzantine mosaic)

Verrière 232, 232; technique 233

Theosophical Mysticism 540 Thoughts on the Imitation of Greek Art in Painting and Scultpure (Winckelmann) 401 Three Crosses (Rembrandt) 379, 379 Three Goddesses on Mount Olympus (Phidias) Three Hebrew Youths in the Fiery Furnac, The (catacomb fresco) 154, 154 Ti Watching a Hippopotamus Hunt (Egyptian tomb painting) 56, 56, 57 Tiepolo, Giambattist (Italian): Kaisersaal frescoes, Germany 414, 414 Tintoretto, Jacopo (Italian): Last Supper 343, 343 Titian (Italian): Assumption of the Virgin 330, 331; Concert Champêtre 466; Feast of the Gods 305, 305; Pesaro Madonna 287, 332, 332, 330, 330; Rape of Europa 332, 333; Venus of Urbino 324, 324-25, 306, 306, 466 Tlingit, the 526-27; textiles 526, 526 Tokyo Story (Ozu) 574-75, 575 Toledo (El Greco) 336-37, 337 Tomb of Hunting and Fishing, Etruscan 71, 71 tomb paintings: Egyptian 46-47, 56, 56, 57, 57, 70-71, 71 tombs: Chinese 64, 64, 102-103, 108-109, 175; Dongson 113; Mycenaean 63, 63; Siberian 98-101, 99 Tori Busshi (Japanese): Shaka Triad 179, 179 Torqued Ellipses (Serra) 612-13, 613 Toshihito, Prince 391 Tourists (Hanson) 580, 580 Toussaint L'Ouverture Series (Lawrence) 554, town planning: Chinese 122, 172-73, 236; Inka 278; Khmer 214; Mohenjo-Daro 58-59; Roman 112, 118, 122, 124; Teotihuacán 138, 140-41 Trajan, Emperor 122, 124, 155 Transfiguration of Christ (Byzantine mosaic) 162, 162 Transient Rainbow fireworks performance (Cai Go-qiang) 606, 607 Très Riches Heures du Duc de Berry (Limbourg Brothers) 262, 262-63, 263 Trinity with the Virgin Mary, Saint John, and Two Donors, The (Masaccio) 266, 266 triptychs 264, 326, 449 Triumph of the Name of Jesus (Gaulli and Bernini) 352, 353 Trojan war 62-63, 76, 118, 124 Trolley, New Orleans (Frank) 571, 571 trompe l'oeil 129 trumeau 231

Tsai, Charwei (Taiwanese): Frog Mantra 620, tufa 131, 135, 212, 212-13, 213 Turner, Joseph M.W. (British) 431; The Slave Ship 447, 447 Turrell, James (American): Roden Crater project 357, 357, 618-19, 619, 620 Tutankhamen 46, 47 Twelve Thousand Peaks of Mount Kumgang (Chong Son) 413, 413 Two Children Are Threatened by a Nightingale (Ernst) 548, 549 Two Friedas, The (Kahlo) 504-505, 505 Two Paths of Life, The (Reilander) 468, 469 Two Women Teaching a Child to Walk (Rembrandt) 377, 377 tympanum 210, 210-11, 211, 231

U

Unique Forms of Continuity in Space (Boccioni) 519, 519 United States 427-28; architecture 418-19, 419 (18th c.), 431, 454-55, 455, 461, 461-63, 463, 465, 465(19th c.), 8-11, 465, 586-87, 587 (20th c.); 586, 586 (Postmodernist), 524, 524-25, 525, 543 (Prairie style), 462, 492, 492-93, 493, 562-63, 563 (skyscrapers); Civil War 428, 465; Constitution 400; depression 500; independence 399, 401; painting 478, 478-79, 479 (realism), 416, 416, 423, 423 (18th c.); 456, 456-57, 457 (19th c.), 552, 552–53, 553, 554, 554–555, 555 (20th c.); sculpture 12, 12, 13, 13, 580, 580, 586 Unswept Floor, The (Heracleitus) 75, 75, 117 Untitled (6) (Arbus) 582, 583 Untitled (Judd) 578-79, 579 Untitled installation (Holzer) 594, 594 Ur, Iraq: ziggarat 42, 42-3 urns, Etruscan 70, 71 Uruk, Iraq: stone vessel 40, 40

V

Vakata dynasty 158
vanishing point 268
Varahamihira: *Brhatsamhita* 159
Vasari, Giorgio (Italian): *Lives of the Most Eminent Painters, Sculptors, and Architects* 223, 252, 267, 290, 295, 298, 304, 308–311, 321

vaults 114, 121-22, 130, 132-34, 134, 136, 169, 209, 220, 224, 228-29, 229, 286 Vauxcelles, Louis 508, 514 veduta 402 Velázquez, Diego (Spanish) 332, 351; Las Meninas 380, 380; Portrait of Juan de Pareja 381, 381; Water Carrier 362, 362 vellum 148, 171, 314 Venice 343, 349; painting 324, 324–25, 325, 330, 330-31, 331, 332, 332-33, 333, 416, 416, 417; Santi Giovanni e Paolo 342; Santa Maria Gloriosa dei Frari (Titian altarpieces) 330, 330-31, 331; villa architecture 419 "Venuses" (Paleolithic) 24, 24 Venus of Urbino (Titian) 306, 306, 324, 324-25, 466 Vermeer, Johannes (Dutch) 362-63, 619; A Maidservant Pouring Milk 363; Woman Weighing Holding a Balance 363 Veronese, Paolo (Italian): Last Supper/Feast in the House of Levi 342, 342-43 Versailles 347, 351, 356, 356, 388, 388-89, 389, 414-15; Room of War 346, 347, 389 Vesalius, Andreas (Flemish): On the Fabric of the Human Body 300 Vespasian, Emperor 130 Vespucci, Amerigo (Italian) 299 Vesuvius, Mount 116, 127, 401 Victorian style 429, 434, 464; architecture 437, 437 video art and installations 2, 2, 3, 19, 614, 614 Vietnam Veterans Memorial (Lin) 588, 588 Vietnam: Dongson culture 112-13 View of the Piazza della Rotonda (Piranesi) 402, 402 Vigée-Lebrun, Elizabeth (French): Portrait of Marie Gabrielle de Gramont 400, 400 Villa of Livia, Prima Porta, Italy 127, 127 Villa of the Mysteries, Roman frescoes 31 Villa Rotonda, Vicenza (Palladio) 8-9, 9, 10, 10, 11, 418-19 Village in Brazil, A (Post) 355 Viola, Bill (American): Five Angels for the Millennium video installation 614, 614 Virgil: Aeneid 118 Virginia State Capitol (Jefferson) 403, 418, 419 Visigoths 184, 124, 221 Vision after the Sermon, The (Gaugin) 484, 484 Vitruvian Man (Leonardo) 290, 291 Vitruvius (Greek) 81, 83, 85, 280, 290 votives 48-49, 78, 299, 299 voussoirs 132, 231

W

Wainright Building, Missouri (Sullivan) 492, 492

Waldseemüller, Martin 299

Walker, Kara (American) 616; *Insurrection!* 616–17, 617

wall paintings: Ajanta Caves 159, 159

Waltz, The (Claudel) 481, 481

Warhol, Andy (American) 577, 603; *Marilyn Diptych* 407, 407, 578, 578

Washington Crossing the Delaware (Leutze) 459, 459

Water Carrier (Velázquez) 362, 362

Water Temple, Japan (Ando) *151*, 602–603, 603

watercolour painting 483, 483

Watt, James 395, 400

Watteau, Antoine (French) 405; Pilgramage to the Island of Cythera 408, 408

Wave UFO (Mori) 610-11, 611

Weden, Rogier van der (Flemish): *Deposition* 249, 249

Wendi, Emperor 172

West, Benjamin (American) 402, 416; Death of General Wolfe 423, 423

Wexner Center, Ohio (Eisenman) 586–87, 587

Where Do We Come From? What Are We? Where Are We Going? (Gaugin) 434, 435

Whistler, James McNeill (American) 436

Willendorf, Austria: statuette of woman 24, 24, 25

William of Sens (French) 223

William the Conqueror 206

Williams, William Carlos (American) 552

Winckelmann, Johann (German) 421; Thoughts on the Imitation of Greek Art in Painting and Scultpure 401

Winged Victory of Samothrace 498, 104, 105 Winter Landscape (Sesshu) 345, 345

With Love, Whitney (Yu Youhan) 603, 603

Wolpa synagogue, Poland 396, 396

Woman Frightened by Thunder, A (Kunisada) 429

Woman Weighing Holding a Balance (Vermeer) 363

women artists 436, 471; representation in art 406–407; sculptors, American 437

Wonderland (Schapiro) 590, 590

wonders of the world, seven ancient 89 wood carving 260, 261

Wood, Grant (American) 502; American

Gothic 552–53, 553, 554 woodblock prints: Japanese 448, 448–49, 449,

450, 451; technique 449, 449 woodcuts 314–15, 254, 287, 287, 313–15,

Japanese 429, 429

World Trade Center Transportation Hub (Calatrava) 608–609, 609, 612

World War I 428, 499–500, 539–40, 543, 551–52

World War II (Vanitas) (Flack) 580-81, 581, 582

World War II 500, 542, 561–62, 571, 573, 576–77

Wren, Christopher (British): St. Paul's Cathedral 351

Wright, Frank Lloyd (American) 524, 543, 612; Fallingwater 8, 9, 10, 10, 11, 97; Robie House 524, 524–25, 525

Wright, Joseph, of Derby (British): *A Philosopher Giving a Lecture at the Orrery*394, 395

X

Xia Gui (Chinese) 194–95; (attrib.) Sailboat in the Rain 5, 194

Xie He (Chinese): Gu hua pin lu (Classified Record of Ancient Painters) 195

Xu Bing (Chinese) 438–39; Celestial Book: Mirror for Analyzing the World 14–15, 15, 438, 438, 592

Xuan Zong, Emperor 149

Y

Yanagi, Yukinori (Japanese): *Hinomaru* series 598–99, 599

Yu Youhan (Chinese) With Love, Whitney 603, 603

Z

Zen Buddhism 8, 14–15, 251, 297, 344–45, 613; dry gardens xiv, 296, 297, 345, 575, 613

Zeus (?) 80, 80-81, 81

Zeus, Temple of 72

Zhang Peili 592

Zhang Xuan (Chinese): Court Ladies
Preparing Newly Woven Silk 175, 407, 407

Zhou Dynasty see under China

ziggurats, Sumerian 42, 42-43

Zoffany, Johann (German): The Life Drawing Class at the Royal Academy 404, 404

Zola, Émile 445, 466

Zoroastrianism 174

Picture Credits

The author and publisher wish to thank the libraries, museums, galleries and private collectors named in either the picture captions or below for permitting the reproduction of works of art in their collections and for supplying the necessary photographs. Photographs from other sources are also gratefully acknowledged below. The publisher has endeavoured to contact all copyright holders. Any corrections or omissions will be noted for future editions. Numbers listed before the sources refer to figure numbers.

p. xii Metropolitan Museum of Art, Gift of Arthur A. Houghton, Jr., 1970 (1970.301, 2) Photograph © 1992 The Metropolitan Museum of Art; p.xiii Art Resource, NY; p. xiv Studio Fotografico Quattrone, Florence

Chapter 1

1.1 Photo: Karina Wang, Chicago; 1.2 © 1999 Shirin Neshat. Photo Larry Barns. Courtesy Barbara Gladstone Gallery, NY; 1.3 The Art Archive/Dagli Orti; 1.5 © Vincenzo Pirozzi; 1.6 Panoramic Images/Getty Images; 1.7, 1.8 David Wilkins; 1.10 @ ARS, NY & DACS, London 2008; 1.11 Hedrich-Blessing/Chicago Historical Society © ARS, NY & DACS 2008; 1.12 © Robert Harding Picture Library; 1.13 Society for the Preservation of New England Antiquities (SPNEA); 1.14 © Estate of David Smith /DACS, London/VAGA New York 2008; 1.15 akg-images/Erich Lessing; 1.16 Liaison Agency Inc.; 1.17 Xu Bing Studio; 1.18 © Photo Scala, Florence/Vatican Museums; 1.19 Kimbell Art Museum AP 1994.05, photographer Michael Bodycomb 2001 © 2008 Mondrian/Holtzman Trust c/o HCR International Warrenton, VA.; 1.21 David Wilkins; 1.23 Robert Estall Photo Library © Carol Beckwith; 1.24 Time & Life Pictures/Getty Images.

Chapter 2

2.1 Ohio Dept of Natural Resources/Tony Linck; 2.2 National Geographic Image Collection; 2.4 Erich Lessing/Art Resource, NY; 2.7 © The Cleveland Museum of Art, Andrew R. and Martha Holden Jennings Fund, 1995.21; 2.8 English Heritage/Simmons-Aerofilms; 2.10 Cultural Relics Press, Beijing.

Chapter 3

3.1 The Metropolitan Museum of Art, Rogers Fund, 1914 (14.120112) Photograph © 1998 The Metropolitan Museum of Art; 3.2 Bridgeman Art Library; 3.3 Nicholas P. Goulandris Foundation. Museum of Cycladic Art; 3.4 Institute of History and Philology/ Academia Sinica; 3.5 Historical Museum, Kiev, Russia/The Bridgeman Art Library, London; 3.6 Erich Lessing/Art Resource, NY; 3.7 The Oriental Institute Museum; 3.8 British Museum; 3.9 Dorling Kinderlsey; 3.10 Araldo de Luca/The Egyptian Museum, Cairo/Index Ricerca Iconografica; 3.11 Metropolitan Museum of Art, Rogers Fund and Edward S. Harkness Gift (29.32) 1929; 3.12 BPK, Berlin; 3.13 David Wilkins; 3.14 akg-images/Andrea Jemolo; 3.15 All rights reserved The Metropolitan Museum of Art, New York; 3.16 BPK/Ägyptisches Museum und Papyrussammlung, Staatliche Museen zu Berlin. Photo: Jürgen Liepe; 3.17 SCALA/Art Resource NY; 3.18 Robert Harding Picture Library © Nigel Francis; 3.19 © Paul M.R. Maeyaert; 3.23 David Wilkins; 3.24 Werner Forman Archive; 3.26 Metropolitan Museum of Art, Levi Hale Willard Bequest, Purchase 1890, 90.35.1; 3.29 Yvonne Vertut; 3.30 British Museum; 3.31 Liverpool Museum, Merseyside/Bridgeman Art Library; 3.32 A.C. Cooper; 3.33 Studio Kontos Photostock; 3.34 © Craig & Marie Mauzy, Athens; 3.35 McRae Books Srl; 3.36 Kostos Kontos/Photostock, Athens; 3.37 Deutsches Archaeologisches Institute, Athens; 3.38 Dorking Kindersley; 3.39 © Craig & Marie Mauzy, Athens; 3.40, 3.41 Cultural Relics Press, Beijing; 3.43 © The Metropolitan Museum of Art, Gift 1996; 3.45 Giraudon/Bridgeman Art Library; 3.46 Bridgeman Art Library; 3.47, 3.48 South American Pictures © Chris Sharp; 3.49 The Art Archive/ National Anthropological Museum, Mexico/Dagli Orti; 3.50 Photograph © The Metropolitan Museum of Art, New York; 3.51 Bardazzi Fotografia, Florence; 3.52 © Villa Giulia; 3.53 The Art Archive; 3.54 Alinari, Florence; 3.55 Art Resource NY; 3.56 Royal Ontario Museum & Walter J. Graham; 3.57 © Photo Scala, Florence/Vatican Museums; 3.58 © 1990 Photo Scala, Florence; 3.60 The Metropolitan Museum of Art, Purchase, Bequest of Joseph H. Durkee, Gift of Darius Ogden Mills and Gift of C. Ruxton Love by exchange, (1972.11.10). Photograph © 1999 The Metropolitan Museum of Art; 3.61 TAP Athens; 3.62, 3.64 @ Craig & Marie Mauzy, Athens; 3.63 Nimatallah/Art Resource, NY; 3.66 © Canali Photobank; 3.67 © Photo Scala, Florence/Vatican Museums; 3.69 Hutchison Library/Eye Ubiquitous © Tony Souter; 3.71

Craig & Marie Mauzy, Athens; 3.72 Dorling Kindersley; 3.73 © Metropolitan Government at Nashville/Gary Layda

Chapter 4

4.1 Robert Harding Picture Library; 4.2 Art Archive; 4.3 akg-images/ Jean-Louis Nou; 4.4 © Photo Scala, Florence; 4.5 Photo: akg-images/ Nimatallah; 4.6, 4.9, 4.10 © The State Hermitage Museum, St. Petersburg; 4.11 National Geographic Image Collection; 4.12 Art Archive/Dagli Orti; 4.13 akg-images, London; 4.14 Musée du Louvre, Paris/Art Resource, NY; 4.15 Art Resource, NY; 4.16 Araldo de Luca/Corbis: 4.17, 4.19 Cultural Relics Press; 4.20 akg-images/Erich Lessing; 4.22 Robert Harding Picture Library © Richard Ashworth; 4.23 akg-images/Jean-Louis Nou; 4.24 Museum Photo © Ben Grishaaver; 4.28 Canali Photobank; 4.30 Fotografica Foglia, Naples; 4.31 © 1990 Photo Scala, Florence courtesy of the Ministero Beni e Att. Cultarali; 4.32 © Araldo de Luca, Roma; 4.33 © Vincenzo Pirozzi, Rome; 4.34 David Wilkins; 4.36 Dorling Kinderlsey; 4.37 Ron Chapple Stock/Alamy; 4.38 Alinari, Florence; 4.39 Vincenzo Pirozzi, Rome; 4.41 M. Sari/Vatican Museums/Art Resource, NY; 4.42 Canali Photobank; 4.43 Fotografica Foglia, Naples; 4.45 Canali Photobank; 4.46 Canali Photobank; 4.47 Dorling Kindersley; 4.48 Avery Library, Columbia University, New York; 4.49 A. Boethius & J.B. Ward-Perkins, Etruscan and Early Roman Architecture; 4.51 @ Paul Maeyaert; 4.52 Museum of Civilisation, Rome; 4.54 National Gallery of Art, Washington, Samuel H. Kress Collection. Photo by Richard Carafelli; 4.55 Minneapolis Institute of Arts, The William Hood Dunwoody Fund; 4.56 Picture Desk Inc; 4.57 The Cleveland Museum of Art.

Chapter 5

5.1 Marvin Trachtenberg, New York; 5.2 Studio Kontos Photostock; 5.3 David Wilkins; Asian Art Museum Foundation of San Francisco. Avery Brundage Collection; 5.5 The Avery Brundage Collection. © Asian Art Museum of San Francisco; 5.6 Photo © National Gallery, London; 5.7 Alain Machet/Alamy; 5.8 akgimages/Erich Lessing; 5.9 Ancient Jewish Art by Gabrielle Sed-Rajna, Chartwell Books Inc. p. 62: 5.10 Hirmer Fotoarchiv; 5.11 © 1990 Photo SCALA, Florence. Vatican Museum, Florence; 5.14 akg-images/Pirozzi; 5.16 The Art Archive/Gianni Dagli Orti; 5.18 Ajanta,

Maharashtra, India/The Bridgeman Art Library, London; 5.19 akg-images/Jean-Louis Nou; 5.20 © Jingu Administration - through the courtesy of the International Society for Educational Information; 5.22 Ekdotike Athenon SA; 5.23 Dorling Kindersley; 5.24 Dorling Kindersley; 5.25 Scala/Art Resource, NY; 5.26 © 1990 Photo Scala, Florence; 5.27, 5.28 © Cameraphoto Arte, Venice; 5.29 akgimages/Nimatallah; 5.30 The British Museum Great Court Ltd; 5.31 Trinity College Library, Dublin/Bridgeman Art Library; 5.33 Museum of Fine Arts Boston, Special Chinese and Japanese Fund 12.886/Bridgeman Art Library; 5.34 Cultural Relics Publishing House; 5.36 Kazuyoshi Miyoshi/Pacific Press service; 5.38 Sankeien Hoshokai Foundation - through the courtesy of the International Society for Educational Information; 5.41 National Museum of African Art, Smithsonian Institution, Eliot Eliofson Archive; 5.43 Dorling Kindersley; 5.44 Raffaello Bencini, Florence; 5.45 Bibliothèque Nationale, Paris/Art Resource, NY; 5.46 Bayerische Staatsbibliothek Munchen 4453 f 237r; 5.48 A.C. Cooper; 5.49 George Gerster, Comstock; 5.50 Asian Art Archives, University of Michigan; 5.51 The Nelson-Atkins Museum of Art, Kansas City, Missouri. Purchase: Nelson Trust, 47-71/Photo: Robert Newcombe; 5.52 The Nelson-Atkins Museum of Art, Kansas City, Missouri. Purchase: Nelson Trust, 47-71. Photographed by Robert Newcombe; 5.53 Museum of Fine Arts Boston Special Chinese and Japanese Fund. Photograph © 2008 Museum of Fine Arts Boston.

Chapter 6

6.1 Cleveland Museum of Art (Purchase from the J.H. Wade Fund 1990.331); 6.2 V&A Images, London; 6.6 Research Institute of Cultural Relics & Archaeology of Inner Mongolia, Hohhot, Inner Mongolia PRC; 6.7 Calveras/Merida/Sagrista/Museu Nacional d'Art de Catalunya; 6.8 Leonard von Matt/Gemeinnutzige Stiftung Leonard von Matt; 6.12 Photo: akg-images/Bildarchiv Monheim; 6.14 akg-images; 6.15 ©Ken Walsh/Bridgeman Art Library; 6.16 Georgia Lee, Easter Island Foundation; 6.17 Powerstock, London; 6.19 B. Arthaud, Grenoble; 6.20, 6.21 The Tokugawa Reimeikai Foundation; 6.22 @ Paul M.R. Maeyaert; 6.24 National Gallery of Art, Washington, Widener Collection; 6.25 Lauros/Giraudon/Bridgeman Art Library; 6.26 By Permission of the British Library, London; 6.27 © Paul M.R Mayaert; 6.28 © Sonia Halliday Photographs, London; 6.30 © Angelo Hornak; 6.31 Peter Bull; 6.34 Courtesy Skertzo, Images Spectavles Espaces;

6.35 Bridgeman Art Library; 6.36 Hulton
Deutsch Collection/Corbis; 6.37 Getty Image; ,
6.38 Hutchison Library/Eye Ubiquitous © Tim
Beddow; 6.39 National Museum of African Art,
Smithsonian Institution. Museum Purchase 8612-2. Photograph by Franko Khoury; 6.40
Robert Harding Picture Library; 6.42 Galleria
degli Uffizi; 6.43 Cimabude (Cenni di
Pepi)/Index Ricerca Iconografica; 6.44, 6.46 ©
Studio Fotografico Quattrone, Florence; 6.45
Alinari/Art Resource, NY; 6.51 National
Museum of Art, Smithsonian Institution, Eliot
Elisofon Photographic Archives.

Chapter 7

7.1 Hosomi Museum through the courtesy the International Society for Educational Information; 7.2 © Studio Fotografico Quattrone, Florence; 7.3 Bridgeman Art Library; 7.4 The Metropolitan Museum of Art, Purchase Lita Annenberg Hazen Charitable Trust Gift 1987 (1987.16). Photograph © 1997 The Metropolitan Museum of Art; 7.5 © John Bigelow-Taylor; 7.7 Bridgeman Art Library; 7.10 The Bridgeman Art Library, London; 7.11 Bibliotheque Nationale, Paris; 7.12 David Wilkins; 7.13 akg-images/ Erich Lessing; 7.14 © Photo RMN – R.G. Ojeda; 7.15 Giraudon/Bridgeman Art Library; 7.16 © The Metropolitan Msueum of Art, New York; 7.17 The Metropolitan Museum of Art, The Cloisters Collection, 1956 (56.70). Photograph © The Metropolitan Museum of Art; 7.18 Scala/Art Resource, NY; 7.19 Studio Mario Quattrone, Florence; 7.20 Musei Vaticani; 7.22 Scala/Art Resource, NY; 7.23 Bridgeman Art Library; 7.24 Scala, Florence; 7.25, 7.26, 7.27 Photo © National Gallery, London; 7.29 © Studio Fotografico Quattrone, Florence; 7.31 Art Resource, NY; 7.32 Dagli Orti/Picture Desk Inc; 7.34 Werner Forman Archive; 7.35 © Studio Fotografico Quattrone; 7.38 David Wilkins; 7.43 Art Resource, NY; 7.44 Studio Fotografico Giovetti, Mantua; 7.45 Alinari, Florence; 7.47, 7.48 Studio Fotografico Quattrone, Florence; 7.49 © Photo Josse, Paris; 7.51 Photographie Bulloz; 7.52 © Ghigo Roli/Index Ricerca Iconografica; 7.53 The Royal Collection © 2008, Her Majesty Queen Elizabeth II; 7.54 © Araldo de Luca, Rome; 7.55 Foto Marburg.

Chapter 8

8.1 David Wilkins; 8.2 © Studio Fotografico Quattrone, Florence; 8.3 South American Pictures © Tony Morrison; 8.4 Robert Harding Picture Library © Ellen Rooney; 8.5, 8.6 Bridgeman Art Library; 8.7 Studio Fotografico Quattrone; 8.8 Fotostudio C.N.B. Bologna; 8.9 Bridgeman Art Library; 8.10 Kunsthistorisches Museum, Vienna; 8.11 Studio Fotografico Quattrone, Florence; 8.13 Image courtesy of the Board of Trustees, National Gallery of Art, Washington; 8.14 Ostasiatiska Museet © Foto Erik Cornelius; 8.16 Alinari, Florence; 8.20, 8.21, 8.22, 8.23 Metropolitan Museum of Art, Fletcher Fund, 1919 19.73.1 and 19.7.203; 8.26 The British Museum Great Court/Art Resource, NY-; 8.29 British Museum; 8.30 The Metropolitan Museum of Art, Harris Brisbane Dick Fund, 1941 (41.72 [3.26]); 8.31 Embassy of Italy, NY; 8.32 Zigrossi Bracchetti/Vatican Musei/IKONA; 8.33 Studio Fotografico Quattrone, Florence; 8.35 Index Ricerca Iconografica; 8.38 Summerfield/Galleria degli Uffizi, Florence/Index Ricerca Iconografica; 8.39 Cameraphoto Arte/Art Resource, NY; 8.40 Museo Nacional del Prado; 8.41 Bridgeman Art Library; 8.42 Musée d'Unterlinden; 8.43 © Musee d'Unterlinden, photo O. Zimmermann; 8.44 Embassy of Italy; 8.45, 8.47 © Cameraphoto Arte, Venice; 8.46 akg-images, London; 8.48 Bridgeman Art Library; 8.49 Bridgeman Art Library; 8.51 Vatican, foto A. Bracchetti-Pzigrossi, Feb. 1995; 8.53 David Wilkins; 8.54 Kunsthistorisches Museum, Vienna/Art Resource, NY; 8.55 Metropolitan Museum of Art, H.O. Havemeyer Coll. Bequest of Mrs. H.O. Havemeyer, 1929 (29.100.6). Photograph © 1992 The Metropolitan Museum of Art; 8.56 Kunsthistorisches Museum, Vienna/Art Resource, NY; 8.57 Gift of Arthur A. Houghton, Jr., 1970 (1970.301, 2). Photograph © 1992 The Metropolitan Museum of Art; 8.59 Photo Boudot-Lamotte; 8.60 David Wilkins; 8.61 Dorling Kindersley; 8.62 The Metropolitan Museum of Art, The James F. Ballard Collection, Gift of James F. Ballard 1922 (22.100.51). Photograph © 1990 The Metropolitan Museum of Art; 8.63 Alinari/Art Resource, NY; 8.64 © Cameraphoto Arte, Venice; 8.66 Seattle Museum, Seattle, Washington/Photo: Paul Macapia; 8.65 Werner Forman Archive: 8.67 TNM Image Archives Source: http://TnmArchives.jp and http://DNPArchives.com Co. Ltd.

Chapter 9

9.1 Peter Willi/Bridgeman Art Library; 9.2 Scala/Art Resource, NY; 9.4 Werner Forman Archive; 9.5 Alinari, Florence; 9.6 Scala/Art Resource, NY; 9.8 The Royal Collection © HM Queen Elizabeth II, photo: Rodney Todd White; 9.9 National Gallery of Art, Washington. Gift of Mr & Mrs Robert Woods Bliss; 9.10 The Royal Collection © 2007, Her Majesty Queen Elizabeth II; 9.11 SuperStock Inc.; 9.12 © Archivo Iconografico, S.A./CORBIS; 9.14 BPK Berlin; 9.15 © Vincenzo Pirozzi, Rome; 9.16 The Detroit

Institute of Arts. Gift of Mr. Leslie H. Green; 9.17 Courtesy of the Trustees of the V&A; 9.19 © Image National Gallery of Art, Washington, D.C.; 9.20 @ Photo Josse, Paris; 9.21 © Studio Fotografico Quattrone, Florence; 9.22 © Achim Bednorz, Cologne, Germany; 9.23 BPK Berlin; 9.26 Scala/Art Resource, NY; 9.27 Hutchison Library/Eye Ubiquitous © Nigel Smith; 9.28 Courtesy of the Trustees of the V&A; 9.29, 9.33 © Vincenzo Pirozzi, Rome; 9.31 © Araldo de Luca, Rome; 9.32 Canali Photobank; 9.37 Bridgeman Art Library; 9.42 The Metropolitan Museum of Art, Fletcher Fund, Rogers Fund and Bequest of Miss Adelaine Milton de Groot (1876-1967), by exchange, supplemented by gifts from friends of the Museum, 1971 (1971.86). Photograph © 1981 The Metropolitan Museum of Art; 9.43 © Photo Josse, Paris; 9.46 Toledo Museum of Art. Purchased with Funds from the Libbey Endowment, Gift of Edward Drummond Libbey, 1956.57; 9.47 © Paul M.R. Maeyaert; 9.48 Library of Congress; 9.49 Freer Gallery of Art, Smithsonian Institution, Washington DC, Gift of Charles Lang Freer (F 1906.231 & 232); 9.51 Japan Information and Cultural Centre/Bridgeman Art Library; 9.53 Photo © The National Gallery London.

Chapter 10

10.1 The Bridgeman Art Library, London; 10.2 The Getty Research Institute for the History of Art and the Humanities; 10.4 AA World Travel Library/Alamy; 10.6 © Photo Josse, Paris; 10.7 Museo Nacional dos Coches, Lisbon, Portugal. Divisao de Documentacao Fotografica -Instituto dos Museus e da Conservação; 10.8 The Nelson-Atkins Museum of Art, Kansas City, Missouri (Purchase: Nelson Trust) 86-20; 10.10 akg-images; 10.11 The Metropolitan Museum of Art, Gift of Julia A. Berwind, 1953 (53.225.4) Photograph © 1980 The Metropolitan Museum of Art; 10.13 The Royal Collection © HM Queen Elizabeth II; 10.14 V&A Images, London; 10.16 @ Photo Josse, Paris; 10.17 Photo © The National Gallery, London; 10.18 Detroit Institue of Arts; 10.19 Ashmolean Museum, Oxford; 10.20 The Metropolitan Museum of Art, The Harry G.C. Packard Collection of Asian Art, Gift of Harry G.C. Packard & Purchase, Fletcher, Rogers, Harris Brisbane Dick and Louis V. Bell Funds, Joseph Pulitzer Bequest and the Annenberg Fund, Inc., 1979 (1979.413.1). Photograph © 1987 The Metropolitan Museum of Art; 10.23 akg-images/Erich Lessing; 10.24 Bildarchiv Foto Marburg; 10.25 Museum of Fine Arts, Boston Gift of Joseph W. Revere, William B. Revere and Edward H.R. Revere 30.781/Bridgeman Art Library; 10.26 Museum

of Fine Arts Boston, Forsyth Wickes Collection; 10.28 Photo © The National Gallery, London; 10.29 Archim Bednorz, Cologne; 10.30 Virginia Tourism Corporation; 10.31 Hutchison Library/Eye Ubiquitous © John Egan; 10.32 The Metropolitan Museum of Art, Catharine Lorillard Wolfe Collection, Wolfe Fund 1931 (31.45). Photograph © 1995 The Metropolitan Museum of Art; 10.33 IKONA; 10.34 © Virginia Museum of Fine Arts, Richmond VA (The Adolph D & Wilkins C. Williams Fund). Photo © Katherine Wetzel; 10.35 Musée du Louvre, Paris/Art Resource, NY; 10.36 National Gallery of Canada, Ottowa. Transfer from the Canadian War memorials, 1921 (gift of the 2nd Duke of Westminster, Eaton Hall, Cheshire, 1918).

Chapter 11

11.1 © Paul M.R. Maeyaert; 11.2 © Photo Josse, Paris; 11.3 Lauros Giraudon/Bridgeman Art Library; 11.5 Courtauld Institute of Art, London; 11.6 @ Angelo Hornak; 11.7 Dorling Kindersley; 11.8 Museum der Kulturen, Basel. Foto: Peter Horner; 11.9 Museum of Fine Arts, Boston. Tompkins Collection; 11.10 © 2008, Digital Image Museum of Modern Art, New York/Scala Florence. Gift of Mrs Simon Guggenheim. 646.1939; 11.11 The Minneapolis Institute of Arts, The Ethel M. Van Derlip Fund, 1952; 11.12 akg-images; 11.14 Mary Evans Picture Library/Margaret Monck; 11.15 © Courtesy of the Trustees of the V&A; 11.16 © Paul M.R. Maeyaert; 11.18 Museo Nacional Del Prado; 11.20 Musée du Louvre, Paris/Art Resource, NY; 11.21 @ Paul M.R. Maeyaert; 11.22 Photo © The National Gallery, London; 11.23 BPK Berlin photo Jorg P. Anders; 11.24 Museum of Fine Arts, Boston. Henry Lillie Pierce Fund; 11.25 Bridgeman Art Library; 11.27 Art Institute of Chicago, Clarence Buckingham Collection 1928-301; 11.28, 11.29 Bibliotheque Nationale, Paris; 11.31 © Peter Ashworth, London; 11.32 Alabama Historical Commission; 11.33 Wayne Andrews/Esto; 11.34 The Cleveland Museum of Art, Hinman B. Hurblur Collection; 11.35 The Metropolitan Museum of Art, Morris K. Jessup Fund, 1933 (33.61). Photograph © 1992 The Metropolitan Museum of Art; 11.36 Musée d'Orsay, Paris/Art Resource, NY; 11.37 The Metropolitan Museum of Art, Gift of John Steward Kennedy, 1897 (97.34). Photograph © 1992 The Metropolitan Museum of Art; 11.38 A.C. Cooper; 11.39 Library of Congress Haer No. NY18-22; 11.42 Bridgeman Art Library; 11.43 Carnegie Library of Pittsburgh; 11.44 Boston Public Library; 11.45 Musée d'Orsay, Paris/Art Resource, NY; 11.46 Musée d'Orsay, Paris/Art Resource, NY; 11.47, 11.48 Courtesy

George Eastman House; 11.50 Bridgeman Art Library; 11.51 © Photo Josse, Paris; 11.52 © Lee Sandstead; 11.53 National Gallery of Art, Washington. Collection of Mr & Mrs. Paul Mellon; 11.54 Bridgeman Art Library; 11.55, 11.59 Fogg Art Museum, Harvard University Art Museums - Maurice Wertheim Bequest, 1951; 11.57 The Phillps Collection; 11.58 The Phillps Collection; 11.60 National Gallery of Art Washington DC. Ailsa Mellon Bruce Collection; 11.61 National Gallery of Art, Washington DC. Chester Dale Collection; 11.65 Bayerische Staatsgemaldesammlungen/ Alte Pinakothek/Artothek; 11.66 Museum of Fine Arts, Boston. Otis Norcross Fund; 11.67 Museum of Fine Arts, Boston. Bequest of William Sturgis Bigelow; 11.68 Bridgeman Art Library; 11.69 Art Institute of Chicago, Helen Birch Bartlett Memorial Collection; 11.70 Yale University Art Gallery. Bequest of Stephen Carlton Clark, B.A. 1903; 11.71 @ Digital Image 2003, Museum of Modern Art, New York/Scala Florence; 11.72 Art Institute of Chicago. Helen Birch Bartlett Memorial Collection; 11.73 Private Collection, Switzerland; 11.74 Missouri Historical Society; 11.75 Library of Congress; 11.76, 11.77 © Munch Museum/Munch-Ellingsen Group, BONO, Oslo, DACS, London 2008.

Chapter 12

12.1 © RMN Paris; 12.2 © DACS, 2008; 12.3 © 2003 Digital Image, Museum of Modern Art, New York/Scala Florence. Gift of the Manufacturer 00409.1972; 12.4 @ DACS 2008; 12.5 © 2003 Digital Image, Museum of Modern Art, New York/Scala, Florence. Purchase 1 @ ADAGP Paris & DACS, London 2008; 12.6 Art Institute of Chicago, Friends of American Art Collection, 1942.51; 12.7 Philadelphia Museum of Art. Louise and Walter Arensberg Collection © ADAGP Paris and DACS London, 2008; 12.8 Estate of Andre Kertesz, 2008; 12.9 Kobal Collection; 12.10 Philadelphia Museum of Art: Gift of Dr & Mrs William Wolgin, 1964-37-3; © DACS 2008; 12.11 The Art Archive © 2008 Banco de Mexico Diego Rivera & Frida Kahlo Museums Trust; 12.12 Barnes Foundation, Pennsylvania. Reproduced with the permission of the Barnes Foundation. All rights reserved © Succession H. Matisse/DACS, London 2008; 12.13 © Succession H. Matisse/DACS, London 2008; 12.14, 12.15 Liaison Agency; 12.16 George Eastman House @ ARS, NY and DACS London 2008; 12.17 George Eastman House, New York/© Licensed by ARS, NY and DACS, London 2008; 12.18 Time Picture Syndication, New York; 12.19 Art Institute of Chicago © Henri Cartier-Bresson/Magnum Photos;

12.20 MOMA © Succession Picasso/DACS London 2008; 12.21 Photograph by Lee B. Wing © The Solomon R. Guggenheim Foundation, New York (54.1412) © ADAGP, Paris & DACS London 2008; 12.22 © Succession Picasso/DACS 2008; 12.23 Bridgeman Art Library © Succession Picasso/DACS 2008; 12.24 Philadelphia Museum of Art © Succession Marcel Duchamp/ADAGP, Paris and DACS London 2008; 12.26 © 2003, Digital Image, The Museum of Modern Art, New York/Scala Flortence. Acquired through the Lillie P. Bliss Bequest; 12.27 Heard Museum, Phoenix photo Jeffrey Crespi; 12.29 Seaver Center for Western History Research, Natural History Museum of Los Angeles; 12.30 Chicago Historical Society; 12.31 Dominos, Chicago; 12.33 @ AMNH/ Stephen S Meyers; 12.34 The Library of Congress, Washington D.C.; 12.35, 12.36 Philadelphia Museum of Art 1950-134-10 and 1950-134-4 @ ADAGP, Paris and DACS, London 2008; 12.37 RMN, Paris © ADAGP Paris & DACS, London 2008; 12.38 Scala, Florence; 12.39 © 2003 Digital Image MOMA/Scala. Purchase 274.1939 © by Dr. Wolfgang & Ingeborg Henze-Ketterer, Wichtrach/Bern; 12.40 @ ADAGP Paris & DACS, London 2008; 12.41 © DACS 2008; 12.42 © DACS 2008; 12.45 BPK Berlin; 12.46 © 2003, Digital Image, MOMA/Scala, Florence Purchase 457.1937 © DACS 2008; 12.47, 12.48 Frank den Oudsten & Associates © DACS 2008; 12.50 akg-images/Eric Bohr; 12.52 Bauhaus Archive, Berlin; 12.53, 12.54 South American Pictures/Tony Morrison © 2008 Banco de Mexico Diego Rivera & Frida Kahlo Museums Trust. Av Cinco de Mayo No. 2, Col. Centro, Del Cuauhtemoc 06059, Mexico, D.F.; 12.55 © Jose Clemente Orozco. Licensed by Varga NY and DACS London 2008; 12.56 Courtesy of Galeria de Arte, Mexico; 12.57 Nicolas Sapieha/Art Resource, NY; 12.58 MOMA @ ADAGP, Paris & DACS, London 2008; 12.59 Museum of Modern Art, New York © Salvador Dalí, Gala-Salvador Dalí Foundation, DACS London 2008; 12.60 Museum of Modern Art, New York @ ADAGP Paris & DACS, London 2008; 12.61 @ 2003 Digital Image, The Museum of Modern Art, New York/Scala, Florence. Purchase 130.1946 a-c © DACS 2008; 12.62 The Metropolitan Museum of Art, Alfred Stieglitz Collection, 1949 (49.59.1). Photograph © 1986 The Metropolitan Museum of Art. © ARS, NY and DACS, London 2008; 12.63 © 2003 Digital Image, Museum of Modern Art, New York/Scala, Florence. Gift of Abby Aldrich Rockefeller 166.1934; 12.64 Art Institute of

Chicago. (Friends of American Art 1930.934) © Estate of Grant Wood/VAGA New York & DACS, London 2008; 12.65 @ ARS, NY & DACS London 2008; 12.66 © T.H. Benton & R.P. Benton Testamentary Trusts/VAGA New York & DACS London 2008; 12.67 @ ARS, NY and DACS, London 2008; 12.68 © Succession Picasso/DACS 2008; 12.69 © Succession Picasso/DACS 2008; 12.70 Reproduced by permission of the Henry Moore Foundation; 12.71 Christie's Images © Bowness, Hepworth Estate; 12.72 © Digital Image, The Museum of Modern Art, New York/Scala Florence @ ARS, NY & DACS, London 2008; 12.73 Metropolitan Museum of Art, Fletcher Fund, 1953 (53.87 a-i) by courtesy of the Noguchi Foundation; 12.74 Hickey-Robertson, Houston; 12.75 © Paul Rocheleau; 12.76 akg-images/Electa.

Chapter 13

13.1 © Royalty Free/Corbis; 13.2 CNAC/MNAM Dist RMN, Paris. Photo Jacqueline Hyde © The Joseph and Anni Albers Foundation/VG Bild-Kunst, Bonn and DACS, London 2008; 13.3 Albright Knox Gallery, Buffalo. Gift of Seymour H. Knox, 1956 © 2008 Pollock-Krasner Foundation/ © ARS, NY and DACS, London 2008; 13.4 Pollock Krasner Foundation © Estate of Hans Namuth; 13.5 Collection Mrs. Paul Mellon, Upperville, on loan to The National Gallery of Art, Washington DC © © 1998 Kate Rothko Prizel & Christopher Rothko ARS, NY and DACS, London 2008; 13.6 © 2003 Digital Image, The Museum of Modern Art, New York/Scala, Florence © Jasper Johns/VAGA, New York & DACS London 2008; 13.7 © Robert Rauschenberg. © DACS/VAGA, New York, 2008; 13.8 Art Institute of Chicago © Robert Frank, courtesy Pace/MacGill Gallery, New York; 13.9 @ Richard Hamilton. All rights reserved DACS 2008; 13.10 © Marian Moffett; 13.11 © FLC/ADAGP, Paris & DACS London 2008; 13.12 Corbis © FLC/ADAGP, Paris & DACS London 2008; 13.13 Kobal Collection; 13.14 © 2003 Digital Image, Museum of Modern Art, New York. Larry Aldrich Foundation Fund @ ARS, NY & DACS London 2008; 13.15 Christie's Images © DACS, 2008; 13.16 © The Estate of Roy Lichtenstein/DACS; 13.17 © Licensed by the Andy Warhol Foundation for the Visual Arts, Inc/ARS, New York and DACS, London 2008; 13.18 Leo Castelli Gallery © Judd Foundation. Licensed by VAGA, New York/DACS, London 2008; 13.19 Albright Knox Gallery Buffalo, New York Gift of Seymour H. Knox 1967; 13.20 © Estate of Duane Hanson/VAGA, New York/DACS, London 2008; 13.21 Louis K. Meisel

Gallery/Photo: Steven Lopez; 13.22 ARS, NY and DACS, London 2008; 13.23 @ Estate of Diane Arbus LLC 1972. Courtesy of the Robert Miller Gallery, New York; 13.24 Robert Harding Picture Library © Alain Everard; 13.25 © Estate Robert Smithson/DACS, London/VAGA, New York 2008; 13.26 © Christo 1976. Photo Jeanne-Claude; 13.27 Michael Graves; 13.29 Robert Harding Picture Library; 13.30 Peter Bennett/Ambient Images Inc, NY @ The George and Helen Segal Foundation/DACS, London/VAGA, New York 2008; 13.31 © Mark Tansey; 13.32 © Miriam Schapiro; 13.33 courtesy Phyllis Kind Gallery, New York; 13.34 Solomon R. Guggenheim Museum, New York, Gift of Dr. & Mrs Gus & Judieth Lieber, 1988 88.3620; 13.35 © Faith Ringgold, Faith Ringgold Inc; 13.36 National Gallery of Australia, Purchased from Gallery Admission Charges © Wandjuk Marika & Aboriginal Artists Agency (AAA), NSW; 13.37 © Estate of Keith Haring. Photo Ivan Dalla Tana; 13.38 Jenny Holzer Studio © ARS, NY & DACS, London 2008; 13.39 Courtesy Carnegie Museum of Art, Pittsburgh, A.W. Mellon Acquisition Endowment Fund, 92.108 A-D; 13.40 Stephen P. Huyler; 13.41 Courtesy Nam June Paik; 13.42 Courtesy Ronald Feldman Fine Arts, New York/Photo D. James Dee; 13.43 FMBG Guggenheim Bilbao Museoa. Photo: Erika Barahona-Ede, 2007. Licensed by DACS, London and VAGA, New York. 2008; 13.44 Yanagi Studio. Hinomaaru Illumination, installation at Nagoya City Art Museum, 1993. Yukinori Yanagi, Hinomaru, collection of Museum of Art, Kochi; 13.45 EXCEL SAGA © 1997 Rikdo Koshi/SHONENGAHOSHA; 13.46 Canal St Communictions Inc.; 13.47 Courtesy William Kentridge; 13.48 National Gallery of Art, Washington @ Nancy Graves Foundation/DACS, London/ VAGA, New York 2008; 13.49 David Wilkins; 13.50 courtesy Tadao Ando; 13.52 The Nelson-Atkins Museum of Art, Kansas City (purchase acquired through the generosity of the Sosland Family) F94-1/2. Photo by Edward Robinson; 13.53 © Atelier Thomas Struth; 13.54 photo courtesy Galleria Continua, San Gimignano.

Chapter 14

14.1 Cai Guo-Qiang photo by Hiro Ihara; 14.2 Calatrava Studio/Courtesy of the Port Authority of New York and New Jersey; 14.3 ODD ANDERSEN/AFP/Getty Images; 14.4 Photo courtesy of OMA/© DACS 2008; 14.5 Photo by Tim Poel Imaging; 14.6 D.C. Moore Gallery, photo Jon and Anne Abbott; 14.7 Acconci Studio; 14.8 Reuters/Photo: Vincent West/© Licensed by ARS, NY and DACS,

London 2008; 14.9 © 2001 Matthew Barney. Photo Chris Winger. Courtesy Barbara Gladstone Gallery; 14.11 Digital image, the Museum of Modern Art, New York/Scala, Florence; 14.12 Courtesy the artist & Matthey Marks Gallery, New York © Courtesy: Monika Sprueth Galerie, Koeln/VG Bild-Kunst, Bonn and DACS, London 2008; 14.13 © The Singh Twins/www.singhtwins.co.uk; 14.14 Solomon R Guggenheim Museum, Purchased with funds contributed by the International Director's Council and Executive Committee Members. 2000.68. Photograph by Ellen Labenski©The Solomon R Guggenheim Foundation, New

York; 14.15 Andy Goldstone Studio; 14.16 Ann Hamilton Studio/Photo: Thibault Jeanson; 14.17 Photo: Kerry Ryan McFate, Courtesy Pace Wildenstein, New York; 14.18 Courtesy the Artist; 14.19 Charwei Tsai/ Photo: John Netherton; 14.20 Asian Art Archives, University of Michigan; 14.21 Corbis.

Text Credits

The authors and publisher wish to acknowledge the following publications from which quotations were taken: p. 7: Ovid, *Metamorphoses*, trans. by R. Humphries, Indiana University Press, Bloomington, 1969; p. 74: Susan Woodford, *The Parthenon*, Cambridge University Press, Cambridge, 1981; p. 172: Arthur F. Wright, "Symbolism and Function: Reflections on Changan and Other Great Cities," *Journal of Asian Studies*, Vol. 24, No. 4, August 1965, p. 669. Reprinted with permission of the Association for Asian Studies, Inc.; p. 295: Georgio Vasari, *Lives of the Most Eminent Painters, Sculptors and Architects*, trans. by Gaston Du C. de Vere, Harry N.

Abrams, Inc., New York, 1979. All rights reserved; p. 309: Giorgio Vasari, *The Lives of the Artists*, Vol. 1, trans. by George Bull, Penguin Classics, Harmondsworth, 1987 © George Bull, 1965; p. 318: Translation by Creighton Gilbert from *Complete Poems and Selected Letters of Michelangelo*, Princeton University Press, Princeton, 1980; p. 401: Sir Joshua Reynolds, *Fifteen Discourses Delivered in the Royal Academy*, E.P. Dutton, New York, 1911; pp. 423, 430, 508 and 544: Robert Goldwater and Marco Treves, *Artists on Art: From the XIV–XX Century*, Pantheon Books, New York © 1945 by Pantheon Books, Inc., renewed 1973 by Goldwater and Treves. By permission of

Pantheon Books, a division of Random House, Inc.; pp. 470–71, 474, 476 and 477: Translation from Charles S. Moffett et al., *The New Painting: Impressionism 1874–1886*, Geneva, Switzerland and R. Burton, Seattle © 1986 by the Fine Arts Museum of San Francisco. Reprinted with permission; p. 552: William Carlos Williams, "The Great Figure," from *The Collected Poems of William Carlos Williams: Volume I, 1909–1939*, edited by Christopher MacGowan © 1938, 1944, 1945 by William Carlos Williams. Reprinted with the permission of New Directions Publishing Corporation.

Acknowledgements

Of course we owe thanks to the generous efforts and insights of many people, including several anonymous readers who have commented on the manuscript in its several editions. We are especially indebted to colleagues and former colleagues at the University of Pittsburgh and West Virginia University who willingly lent their authoritative understanding to different parts of the text:

Robert Anderson Karen Gerhart Kahren Arbitman Robert H. Getscher William Arnett Rosi Gilday Marcia Menihan Vange Beldecos Ed De Carlso Kristina Olson Derek Churchill Patricia Rice Roger Crum Janet Snyder Urban Couch John Super John Whitty Lana Gemas

We especially want to thank our families for their support and advice during the preparation of this edition.

At Prentice-Hall we want to thank Sarah Touborg, Helen Ronan, Barbara Taylor-Laino, Margaret Manos, and Christina DeCesare, and at Laurence King, Kara Hattersley-Smith, Susie May, and Amanda Russell.

The authors and Prentice Hall are grateful to the following academic reviewers who helped shape this new edition:

Gisele Atterberry, Joliet Junior College Diana Chou, John Carroll University Teresa Eckerman-Pfeil, University of Texas Brownsville Alison C. Fleming, College of the Holy Cross Phylis Floyd, Michigan State University Marian J. Hollinger, Fairmont State University Deborah S. Jamieson, University of Florida Jerry D. Meyer, Northern Illinois University

> David G. Wilkins Bernard Schultz Katheryn M. Linduff